1000
SACRED
PLACES

1000

Christoph Engels

SACRED PLACES

The world's most extraordinary spiritual sites

h.f.ullmann

Sacred places are where the gods and spirits live. They are a visible representation of invisible powers, hinting at secrets and recounting ancient stories of the Divine: they are the places where the seen connects with the unseen. Some places are held sacred and yet are so unassuming you would be forgiven for walking right past them; others assault the senses with their exceptional nature and conspicuous magnificence. Sacred places are often connected with our unease in the face of the unknown, confronting humanity with a power greater than itself. A journey to a sacred place happens in the "here and now" (a specific time and place), and yet invokes "the Other and the infinite." Sacred places are in the world, and yet not of the world, and this makes them so different.

Travel broadens the horizons. Legend has it that the young Christopher Columbus stood on the quayside in Genoa and stared out at the horizon, where sea and sky met. There was nothing beyond it but a great chasm, or so people said, but Columbus found himself wondering how far he could sail toward it before reaching the point of no return. Whether or not it began quite like this, his voyage of discovery was to have historic consequences, which undeniably broadened our horizons. A brush with the Divine can be similarly world-changing, whatever the religion of the individual; encountering a sacred place may break down a traveler's prejudices, leading him to be more tolerant and fortifying him on his journey through life. It has been a commonplace since ancient times that man is on a journey, even in some respects just passing through, and many religions represent life as a voyage where setting off requires not kinetic energy, but inner vigor. Departure and arrival, the path and the goal, all are part of the adventure, and if you leave on such a journey, you will return as a different person. A journey through life is a spiritual journey.

What does "sacred" really mean?

Every church is a sacred place, every roadside shrine, every mosque, and every temple. Human beings have always experienced spiritual feelings when faced with natural phenomena, and there are countless sacred places in Africa where tribal ancestors or the spirits are venerated. Shinto shrines in Japan are similarly legion. Mountains, rivers, lakes, caves, springs, forests, rock formations—all these too can be sacred. Holiness transcends the familiar and the mundane, and this transcendence goes beyond the realm of the senses, imparting a feeling of being a fragment of a greater whole. Sacred places are where man encounters the numinous and the sublime, and holiness is a *mysterium fascinosum* and a *mysterium tremendum*—a mystic secret that both fascinates and terrifies. There are more things in heaven and earth than can be seen and touched and called "reality." Indeed, to speak of "realities" in the plural is quite justifiable: things hidden from our eyes and perceptible only when we open

ourselves spiritually are just as real. A thousand sacred places are described in this volume, although anyone compiling such a list will soon find that the actual number is far greater—the thousand locations in this book are a necessarily subjective selection. Many readers may find that "their" sacred place has been omitted, but no value judgment is implied in the selection. Take up this book and come on a very special journey, without even leaving your chair.

The descriptions of the sacred places and the notes on their history and importance are complemented with background information on related cultural history and religious doctrine. As you read, you will make astonishing and intriguing—and sometimes unbelievable—discoveries.

How the book is structured

To help you navigate your way on your spiritual journey around the world, the sacred places have been grouped geographically—the seven main chapters deal with Europe, the Near East, Asia, Africa, North America, Central and South America, and Australia and the Pacific Rim.

Each chapter is color-coded and the destinations featured are arranged geographically from north to south and from east to west, unless there is a more logical reason for grouping certain locations together. Each site is marked with a symbol, making it easy to see which religion or culture holds it special, although here it should be noted that the great number of world beliefs and cultures makes it almost impossible to ascribe them definitively. For this reason, for the purposes of this book, many faiths and cultures have been considered as one, and many denominations within a religion have been omitted for the sake of clarity.

There is a separate chapter at the end of the book that briefly introduces the religions referred to in the book, and a number of explanatory boxes focusing on specific aspects of the Divine contain brief explanations intended to enhance the reader's general understanding of the belief systems discussed. The book also includes a glossary of the most important concepts from art history, architecture, theology, and religion to assist in the understanding of any technical terms.

There is also a comprehensive alphabetical index to help you find the sacred places, and here the interested reader will also be able to look up the GPS co-ordinates for each location.

Descriptions and dates

There are various calendars and ways of measuring time in use throughout the world. The year dates used in this book correspond to the Western division of time into periods before and after the birth of Christ. Alternative year dates are given in brackets where these are absolutely necessary. The Christian calendar was chosen merely as it is the most commonly used system worldwide.

The names of most places, regions, and cities follow English convention. Accents and umlauts have been retained for words in languages using the Roman alphabet, but pronunciation symbols in languages using other alphabets have been omitted for the sake of legibility. Many names and terms, particularly from the Arabic, Hebrew, Japanese, Korean, and Sanskrit, have been similarly transcribed or transliterated. Chinese place names and descriptions have been written using the prevalent Pinyin system.

Important note

Although every effort has been made to ensure the veracity of the material contained in this book, neither the author nor the publisher can guarantee the complete accuracy or currency of the information. The state of repair of a sacred place can change, and it may be destroyed or rebuilt. Natural conditions and climate are necessarily subject to change. Notification of any inaccuracies or errors is welcomed by the publisher.

Political and religious correctness

It is undeniable that cultural roots can diverge. The author of this book is writing from a Western cultural standpoint and belongs to the Christian religion. While writing from a Christian perspective was occasionally unavoidable, I have tried to represent the religions and spiritual beliefs of the peoples of the world without prejudice and always with respect, and have at all times taken great pains to exclude any inaccurate information or pejorative remarks about other religions or traditions.

The astonishing diversity of religious convictions revealed during the researching and writing of this book has been a lasting source of enrichment for my own beliefs.

EUROPE

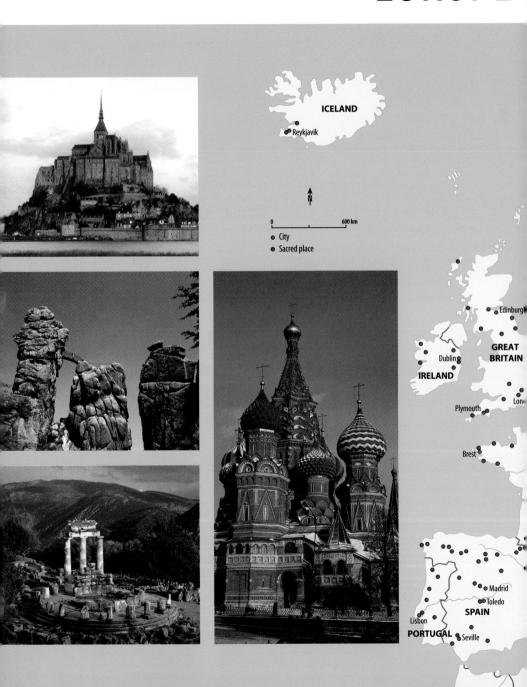

ICELAND

Reykjavik

- City
- Sacred place

0 600 km

Edinburg

GREAT
BRITAIN

Dublin

IRELAND

Plymouth Lon

Brest

Madrid

Toledo

SPAIN

Lisbon

PORTUGAL Seville

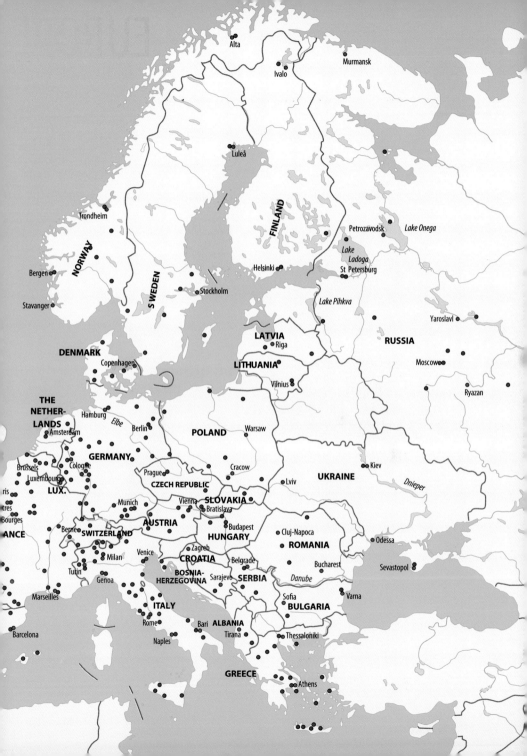

The Thingvellir National Park

The scenery is almost magical here: there are thundering waterfalls whose spray hangs in the air like mist, ice-cold pools and hot springs, volcanoes—and a majestic solitude. During the short summer nights, the mysterious Northern Lights make it abundantly clear why humans feel especially close to nature in this landscape.

Visitors nowadays come for the fishing or the hiking, but in the distant past the ancient inhabitants of Iceland would gather here for councils, a fact reflected in the name—Thingvellir, meaning the "meeting-place of the people." Representatives of the inhabitants would congregate here once every year to consider important issues, surrounded by nature and by the spirits whose power and influence can still be felt in the life of the modern-day populace—in no other land on earth are representatives of the nature spirits, the elves, still consulted to make sure that planned building projects have their seal of approval.

Icelanders regard their myths and legends as national treasures and Thingvellir is regarded as a sacred place. Lake Thingvallavatn, whose surface lies 330 feet (100 m) above sea level, is a substantial body of water reaching a depth of 380 feet (116 m). Godafoss, the "waterfall of the gods," whose cascades—100 feet (30 m) wide—thunder down a drop of 50 feet (15 m), is of major historical and cultural significance in Iceland. It is said that when Thorgeir, a convert to Christianity and a member of the legislative assembly, was chosen as the representative for religious matters for Iceland in the year 1000, he cast all his pagan idols into the waterfall. Confronted with the age-old question of whether pagan practices could be retained alongside Christianity, he ruminated for a day and a night before declaring that while Christianity was the way of the future, the worship of pagan deities and spirits could continue—but only in secret.

The "Gothic Arch" at Hafnarfjörður

Hanseatic merchants erected a small church as Iceland's first (and only) Protestant place of worship in 1533. As trade between Hamburg and Iceland flourished, the word of God was preached here and the church became the spiritual hub of Protestant life in a country that was otherwise largely Catholic.

As trade decreased at the beginning of the 17th century, King Christian IV of Denmark ordered the demolition of all the German buildings on the island, and now nothing remains of the little chapel at Hafnarfjörður, just south of the capital Reykjavik.

However, in 2003 the site became a sacred place once again with the

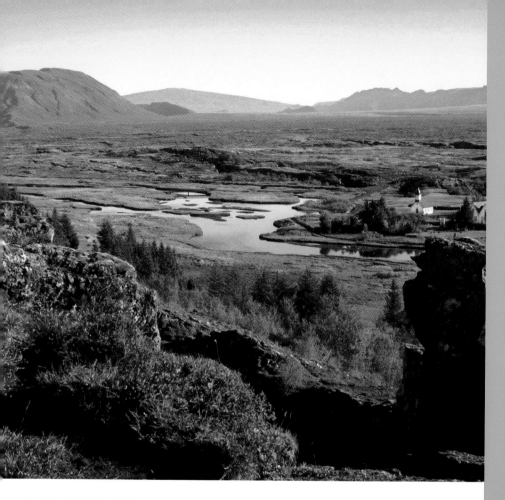

The Thingvellir National Park

erection of the "Gothic Arch," a mighty basalt memorial. The Hamburg artist Hartmut Wolf 's work is an extremely impressive piece, simultaneously representing belonging, friend-ship, and unity, and forging a link between the past and the present.

The artist has created a parabola of Icelandic basalt and stainless steel closely resembling a Gothic arch, and this has truly become a "window," allowing visitors to imagine what it might be like to glimpse eternity. Those who stand before the "Gothic Arch" will find that their gaze is naturally drawn upward to the move-ment of the clouds in the sky. The arch manages to combine art and nature in one irresistible whole.

The rock carvings
of Altafjord

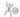

Most people who visit northern Scandinavia come to see the marvels of nature that are found here. As you travel toward the Pole, the landscape grows ever more desolate and deserted. North of the Arctic Circle, the terrain is challenging and the goal of most journeys is the northernmost point of Europe—the North Cape, where the land drops away abruptly into the sea.

Just before the Cape, visitors to Finnmark County will encounter Altafjord, one of the most beautiful fjords in the country and the hidden location of a very special sacred place. More than 5,000 mysterious engra-vings decorate the rocks around Altafjord and the most impressive place to see these is at Jiepmaluokta, just outside the town of Alta, where the carvings are millennia old. Fis-hermen and hunters have carved and chiseled into the rock images of elk, reindeer, bears, geese, salmon, and whales, as well as humans wielding bows and arrows, in boats, or with fishing lines; there are even images of musicians and representations of pregnancy and childbirth. The curious figures gleam enigmatically in the almost magical light of the midnight sun, throwing their outlines into sharp relief. But the majestic, giant car-vings refuse to give up their secrets.

The rock carvings are best viewed from a distance, or from the air. It is almost as if they were not created for

The rock carvings of Altafjord

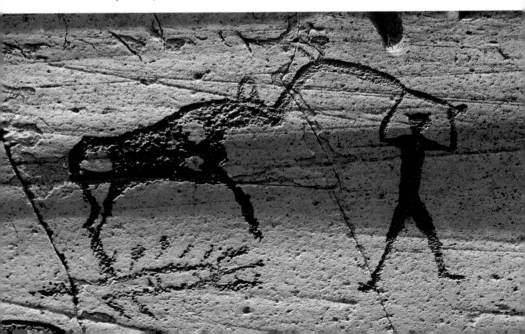

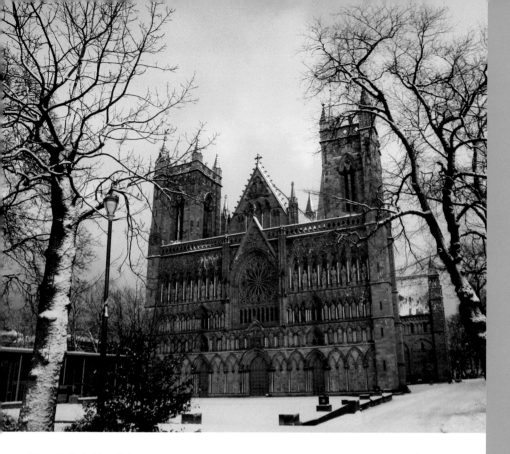

Nidaros Cathedral, Trondheim

human eyes—perhaps they were really intended for the eyes of the gods in heaven. These timeless images are to be found somewhere between land and sea, on the boundary between two worlds, where the dead cross over to the other realm. They remain, to this day, pictures of life on the threshold of eternity. Such images were doubt-less intended to endure throughout the centuries and to compel people to stop and think, something the rock carvings of Altafjord achieve even today.

Nidaros Cathedral, Trondheim

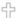

It is well known in folklore that northern Europe is populated by trolls, imps, and elves, along with other fantastical beings that interact with the world of humans—sometimes benevolently, sometimes less so. These mythical creatures are believed to far outnumber the human population,

even today, and old folk beliefs are preserved in legends and stories handed down through the ages.

Missionaries arrived in Scandinavia in the early Middle Ages, and the ensuing period of Christianization was anything but peaceable. The Viking chief Olaf I Tryggvasson, who had been baptized in England in 994, conquered Norway the following year and began to convert the country by force. When Olav II Haraldsson ascended the throne, he pursued his predecessor's aims with equal vigor before he was forced to flee to Russia in 1028 by the Norwegian nobles. He died in an attempt to reconquer and unite his former lands and was canonized a year after his death. He is revered as the country's patron saint to this day.

Construction of a Christian cathedral on his grave site began in 1070, although the oldest surviving portions of the modern church date back only to the 12th century, as the building was destroyed by fire on several occasions. However, it was repeatedly rebuilt, mainly in the Gothic style that is still the hallmark of the exterior. Only the oldest sections of the central nave retain traces of Romanesque architecture.

The west elevation is also the main façade, and this was called the Kristkirken ("Christ Church") in the Middle Ages. The richly decorated church is the largest place of worship in Scandinavia and was a major destination for pilgrims from 1070 until the Reformation. There have been recent attempts (since 1997) to revive this tradition with the opening of a European pilgrims' way to Trondheim.

Ringebu stave church

Ringebu stave church is still used for worship today, and modern congregations gather here on ground that has always been considered sacred; it is generally assumed that the stave churches were built over pagan temples, ritual gathering-places, or *thing* (governing assembly) sites. Although the pagan gods and spirits had been driven out into the most remote parts of the country by the Christians, they were still considered a constant threat to society's well-being. As a result, crosses and dragons were often mounted on rooftops to protect churches and their flocks from evil and the forces of darkness, as at Ringebu in the Gudsbrandsdal Valley, the biggest stave church in the country.

The Borgund-style church was built in 1220 on the site of a previous place of worship. Its modern appearance dates back to 1630–1, when the building was thoroughly renovated and refurbished. A transept was added, giving the church the shape of a Latin cross, and the characteristic red spire also dates from this period. The portal is richly decorated with convoluted dragon motifs, a typical feature of stave churches of the period. The carvings on the portal and the font are assumed to date back to the previous church that stood on the site. Before the Reformation, the church was dedicated to St Lawrence and a 13th-century statue of the saint has survived here to this day. The walls and the ceiling are covered with baroque paintings, but some

medieval representations of animals have been preserved, along with a few runic marks attesting to a time when the old belief in pagan gods had only just been superseded by Christianity. The stave church at Ringebu is not just a relic of old traditions; it is a place of living contact with the Divine.

Urnes stave church

Folk legend has it that two Christian knights settled on either side of the picturesque Lustrafjord and each built a church. When the lord of Solvorn saw that the church in Urnes was in fact far more beautiful than his own, he threw a giant boulder in an attempt to destroy the building. He missed, whereupon the knight from Urnes also threw a boulder, destroying the other's church completely. No trace of the building is left—it is possible it never even existed—but a large rock now stands on the other side of the fjord and there is a large boulder beside the church at Urnes, physical "evidence" that keeps the legend alive.

Urnes stave church was built around 1130. Archeological finds suggest that at least two earlier post churches preceded the current building, and it is highly likely that this was a pagan ritual site that was Christianized with the erection of a church. In contrast to many stave churches, the longitudinal construction and arches of the main structure at Urnes are reminiscent of a Romanesque basilica. The church is noted in particular for the wonderful intricacy and fluidity of its woodcarvings, which have come to stand for their like throughout Scandinavia (the so-called "Urnes style").

Ornamentation in Germanic art is much more than mere decoration. Animal motifs were preferred in the north, and a superb example of this kind

Woodcarvings on the portal of Urnes stave church

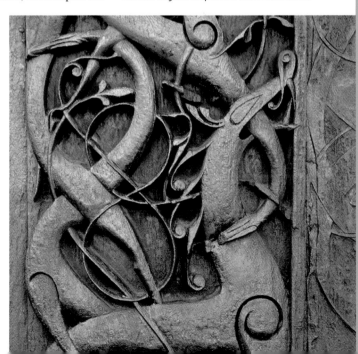

of art is to be found in the north portal of the church, where closely meshed, stylized, sinuous animal bodies dramatically and dynamically intertwine. It is hard to determine what forces are engaged in this struggle—perhaps snakes and lions, the Christian symbols for good and evil. Some have interpreted the coils of the snake as the mythical Níðhöggr, which the Vikings believed would consume the roots of Yggdrasil, the "Tree of Life," at the end of the world. The portal has not given up its secret, and perhaps this is why it still captures our attention. The images inside are more realistic, with a medieval altar lamp in the shape of a ship symbolizing that the light of the world, Christ, reached the country by boat—a reminder of the history of the Christianization of Scandinavia. There is a 17th-century altarpiece sculpture of Christ on the cross with the Virgin Mary and John the Baptist standing to one side. It was a stroke of good fortune that the knight of Solvorn failed to destroy the church at Urnes—it is now the oldest surviving stave church in Norway.

Borgund stave church

Of the 800 to 1,000 stave churches erected in Norway between 1020 and 1400, only a very few have been preserved on their original sites. Some have been dismantled and painstakingly rebuilt elsewhere, but most fell victim to the weather or to fire, in particular. Borgund, a small town southeast

of the Sognefjord, has one of the oldest stave churches to survive. Built between 1150 and 1180, the church is one of the most impressive examples of Old Norwegian craftsmanship in wood. Composed principally of *stav-verk* and *laftverk*, staves and sills, this wonderful stave church exemplifies the skilful workmanship of the shipwrights of the Viking era. The carvings—the dragons' heads on the gable ridges resembling the ornamental prows of longboats—and the decorative animals are all reminders of the vessels used by the daring pillagers from the north.

The Vikings had converted to Christianity, but they seemed not to expect too much from their newfound faith—relics of their pagan beliefs and their fear of demons and spirits are to be found everywhere. The church's interior resembles a ship's cabin—light is admitted not through windows, but through porthole-like openings, and the whole building is supported by a mast-like construction. The six-tiered roof and the extended dragons' tongues on the gables rise high into the air, and there is a covered ambulatory (*sval-gang*) around the church to protect both the building and the congregation from wind and rain. Apart from the altar, the font, and the foundations, the entire church is made of wood.

Access to the church is via two intricately decorated doors, one on the southern and one on the western side. The latter has a deliberately high threshold to prevent evil spirits

A view of the stave church at Borgund

from entering the sacred space. The interior combines 17th-century Christian artwork with a riot of carvings: fabulous animals, mystical symbols, and runic inscriptions. When the wind blows hard, something mysterious happens: the church seems to sigh and, accompanied by audible creaking and groaning, it rocks in the wind until all its joints have settled and peace returns, as if to demonstrate to humans that it has once again defeated the forces of nature.

Fantoft stave church

Many visitors to Bergen also go on to Troldhaugen, the home of the composer Edvard Grieg, who wrote many of his world-famous works here. His music can be heard in the town every summer, and it has become a popular destination for music fans from Norway and all over the world. You might even be tempted to say that this idyllic spot has a kind of holiness, as for many music provides a direct connection with the Divine. The stave church at Fantoft lies only half a mile to the northwest of Troldhaugen, in the middle of a beautiful park. The building we see today is an authentic reproduction of the old church that once stood in Fortun, a small town on one of the tributaries of the Sognefjord, and was constructed between the 12th and 13th centuries in the typical local three-nave style.

A law dating from 1851 decreed that a church had to be able to accommodate 30 percent of its parishioners, and so it was decided to demolish the beautiful old church and build another. However, a Bergen businessman and consul bought the church and had it dismantled and rebuilt on a plot of land south of Bergen. The church suffered an arson attack in 1992 but has been authentically restored using the old plans. The vertical staves of the walls are extremely impressive, as are the gable tips, which seem almost oriental—the picturesque dragons are intended to ward off evil spirits and trolls. The building is surrounded by an open cloister, providing both shelter and a place in which to congregate. The church's interior is richly decorated with murals, some with Christian motifs and some depicting Nordic mythology. The only item preserved from the old church is the altar cross, which was found almost undamaged in the ashes of the old building. Once numerous, only a few stave churches now remain and, following its reconstruction in 1992, the church at Fantoft is one of the most modern. It is, however, an authentic and lovingly executed copy of the old one, and a special place for local people as well as for visitors from afar.

Gamle Aker Kirke, Oslo

Once upon a time, long, long ago, there was a silver lake that held an unimaginably valuable treasure in

its depths. Golden ducks swam on the lake and dragons guarded the precious hoard. However, there were men who wished to remove the treasure in order to make themselves wealthy, and that, so the story goes, is how Norway's oldest silver mine came into being. It was called the Dragon's Cave, and legend had it that the mine shafts had been dug by the dragon sentinels.

The cave was abandoned as it was prone to flooding, but directly above

century, to the time of King Olaf III ("the Silent"). The Gamle Aker Kirke is a Romanesque basilica and the oldest building in Oslo. The church served as a nunnery for many years before undergoing numerous changes in fortune: it was attacked and pillaged several times and survived a number of fires.

A lightning strike in 1703 seemed to spell the end for the by now dilapidated church, and it stood awaiting demolition for many years. However, during the 19th and 20th centuries its great history was properly acknowledged and it was rebuilt in its original form.

The Gamle Aker Kirke in the Norwegian capital

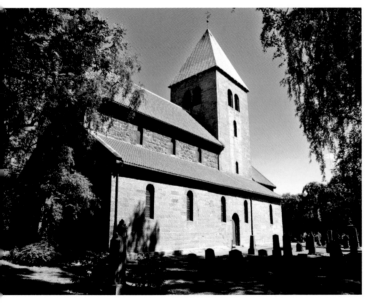

It now serves as a parish church once more and a congregation gathers regularly to worship here—and to enjoy recounting the story of the silver lake. The church's real treasure, however, is a faith that brings greater riches than all the material wealth in the world could provide.

the old mine is the site of the Gamle Aker Kirke, the oldest stone church in Scandinavia. Quite when the construction of the church here first began is a matter of dispute, but it is possible that it dates as far back as the late 11th

Gammelstad

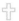

Once the north had embraced Christianity, priests were dispatched to the remote region to build numerous small wooden chapels. Northern Sweden was sparsely populated at the time, and Christians had to reckon with long and arduous journeys when they wished to congregate for worship. The town of Luleå became the hub of an enormous rural community in the 13th century. A hamlet of some 400 small huts was built around the Church of St Peter, complete with stables so that the congregation and their animals could overnight there before returning to their villages.

From this small hamlet, an entire village grew up—Gammelstad—with the church symbolically and quite literally at the center of its spiritual life. Richly decorated with medieval paintings and precious gilt carvings, the tiny Church of St Peter is somewhat of an anomaly in that it is made of stone rather than wood. It may see strange to us today to learn that in Sweden in the 16th century weekly attendance at church was enforced by law, but it is not so surprising to learn that people came here from both near and far to meet, make friends, and to celebrate. The tradition of congregating in the church village is still very much alive, even in an age when distances no longer seem so great. The church town

The church village of Gammelstad in the snow

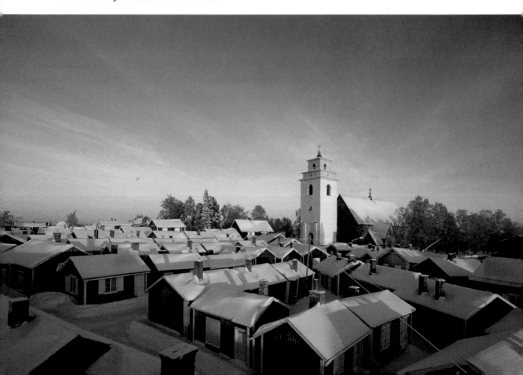

Burial mounds at Old Uppsala

of Gammelstad is not a relic of a long forgotten past but remains a living, thriving community to this day.

The burial mounds of Old Uppsala

Although the medieval historian Adam of Bremen (d. 1081) never visited Sweden and his information was based only on conversations with envoys at the Danish court, he nevertheless knew of the existence of a Viking shrine in Upp-sala where it was said there had been a golden temple sacred to the Vikings' highest gods—Thor, Odin, and Freya. Thor was the god of the air, thunder, and lightning; Odin the god of anger and war; and Freya the goddess of peace and desire. No archeological evidence for the existence of the temple has survived. In his *History of the Bishops of Hamburg* Adam of Bremen goes on to say that near the temple there was an evergreen grove and a holy spring where offerings were brought for the gods. Every nine years a blood ritual was held there, in the course of which nine male crea-tures (both animals and people) were sacrificed and their corpses hung in the boughs of the trees. This story is partly

borne out by the Icelandic historian Snorri Sturluson, whose *History of the Norwegian Kings* (*Heimskringla*) also recounts tales of pagan sacrificial rites at Uppsala, when prayers would be offered for peace and for the king's victory.

From the royal seat and the various ritual and burial sites it seems safe to assume that Uppsala was an important location for the Vikings. Three great barrows still rise mysteriously from the gently undulating plain. They are in all probability royal graves, and were possibly also used in the worship of the three chief gods. The presence of a *thingstead* (council meeting place) nearby, the legend of the golden temple, and the profusion of Iron Age grave sites attest to the significance of the location. A clear indication that the site may have been considered sacred from the earliest times is the fact that a great number of Christian rune stones have been discovered near the tumuli and in the surrounding area. New religions have always adapted to old practices, and one thing is clear from the historians' otherwise unreliable narrative: this was a place where the Divine was sought out and worshiped. Visitors to the barrow graves may still sense something of this even today.

Uppsala Cathedral

A range of influences can be seen in Scandinavian Gothic sacred architecture. As is the case everywhere throughout Europe, the basic church structures are modeled on French examples. However, traces of the English tradition are not uncommon. There was also some influence from Lübeck, as can be seen in the choice of brick as a building material, and St Eric's Cathedral in Uppsala is a good example of such a Gothic brick building. Construction was begun in 1260 but political unrest, war, and the Black Death all hindered its completion and it was not consecrated until 1435. The cathedral is notable not only for its size but also for the relics that are kept here, including a fragment of St Bridget's hip bone which has been in the cathedral's possession since the late 1980s. St Bridget is the patron saint of Sweden and a correspondingly large number of Catholic pilgrims make their way to the cathedral to entrust her with their prayers. She is considered a protector in times of trouble and a companion at the hour of death.

However, more important to the Swedish aristocracy is the shrine housing the remains of St Eric, who was King of Sweden from 1156 to 1160. He died a heroic death in battle not far from the cathedral, and legend has it that a spring appeared at the place of his demise, ensuring a water supply for the whole area. Many tales of miraculous healing at the spring circulated after his death, and a series of legends grew up around the saint. Sovereigns and senior clerics made the pilgrimage to Uppsala in great numbers, although the cult of St Eric found little resonance among the common people. One peculiarity of the cathedral is that it is also the seat of the

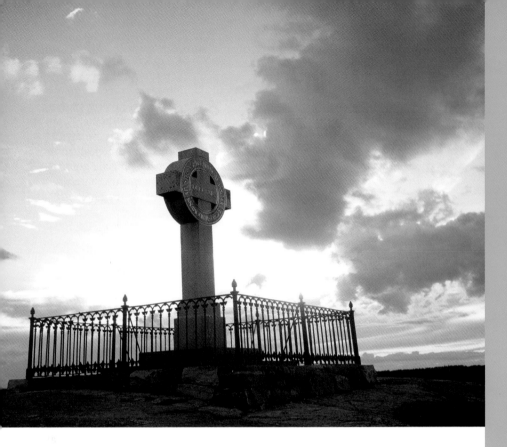

The Ansgar Cross at Birka

Protestant Lutheran bishop. St Eric's Cathedral is thus one of the few churches in which both denominations pray.

Birka

Founded in 750, Birka is often described as Sweden's first town, although it should be remembered that there was no state resembling modern-day Sweden at the time. In any case, Birka was a fortified settlement that grew rich on trade—between the 8th and 10th centuries it was Scandinavia's principal commercial hub. Birka also includes the two neighboring islands of Björkö and Adelsön, the location of the royal seat, the Hovgården. At some point in the late 10th century, and for reasons that remain unclear, the population moved out and the town was almost

completely forgotten. The great number of Viking burial sites found here would suggest that this was considered a sacred place, and a weathered stone cross has been erected on the highest point of the island to preserve the memory of one of Sweden's most popular saints—St Ansgar.

The Ansgar Cross was erected to commemorate the "Apostle of the North," as this patron saint is known throughout Scandinavia. An inscription on the cross suggests it was put in place as early as 829. Ansgar was a courageous missionary—dogged by illness and suffering recurrent setbacks

kened by his work of spreading the gospel, and the physical toll exacted by his failures, Ansgar died in 865.

The ancient cross and the brick church built in 1930 in the southeastern corner of the island are reminders to today's visitors that it is worth holding on to one's convictions, and not to be downhearted—a message that makes a modern saint of the medieval one.

The rock carvings of Tanum

The landscape could be a painting—with smooth rocks protruding from the grass and moss surrounding them, like the backs of whales breaking the surface of the sea, and brightly painted houses hugging the steep cliffs. This is Tanum in the Swedish province of Västra Götaland; the town's coat of arms shows why it has been considered a sacred place

Rock carvings at Tanum

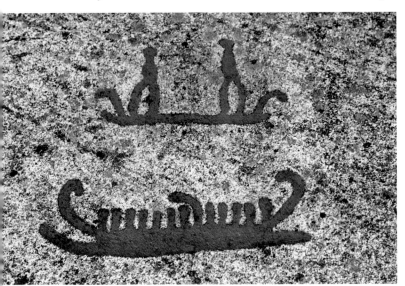

in his efforts to spread the gospel, he nonetheless kept the faith and led an exemplary life of good works. Wea-

for millennia. Set against an orange and red background, the top segment displays an ancient rock carving of a

farmer and the lower segment a boat. These carvings and thousands of designs of a similar nature are to be found on the rocks around Tanum. There are six sites in the area, and more than 10,000 carvings dating back between 2,500 and 3,000 years have been discovered on the surrounding flat rocks. The Bronze Age engravings depict ships with rudders, people, domestic and wild animals, everyday events, and scenes of hunting and battle, along with unexplained but clearly religious symbols such as sun wheels and wind instruments, mysterious channels, and strange handprints and footprints which may signify the presence of gods.

It is difficult to interpret the pictures, but it is likely that these images created outdoors in the open air were used in the worship of gods who were intended to see them from afar and thus engage in the lives of the people. The images are badly weathered in places and have recently been highlighted with red paint; it is not known whether the original artist would have used a similar technique. However, what we do know is that these large flat rocks were used as surfaces for both naturalistic and symbolic illustrations.

Vadstena Abbey

St Bridget, the founder of the abbey, was born into the Swedish aristocracy in 1302. Even as a child she had visions and at the age of seven was visited by the Virgin Mary, who placed a crown on her head.

After a childhood filled with all kinds of miracles, Bridget married at the age of 14. Ulf Gudmarsson, her 18-year-old husband, tutored her in the Christian faith and the couple undertook pilgrimages together, first to Santiago de Compostela in Spain and then to Nidaros, modern-day Trondheim, to visit the tomb of St Olaf II.

They then traveled back to Spain, and on their return journey decided to take holy orders and entered monasteries, where Bridget's husband soon died. His death reawakened an old wish in Bridget. To get closer to God, she abandoned her past and her wedding ring and founded a double monastery for both monks and nuns. Bridget had received the Rule for the Order from God himself in a vision. The king of Sweden donated the castle of Vadstena located on Lake Vättern and the Bridgettine Order was founded, devoting itself to venerating the Passion of Christ. The order's symbol depicts five red flames, resembling drops of blood and intended to represent the wounds inflicted on Jesus.

St Bridget traveled to Rome in 1350 to study and to devote herself to caring for pilgrims. Her order was recognized by Pope Urban V in 1370 and she died in Rome in 1373. After King Gustav Vasa introduced Protestantism as the state religion, the abbey was dissolved in 1595 and the buildings used as a barracks, a prison, and then a hospital. The abbey church has been restored and is now visited by thousands of pilgrims every year.

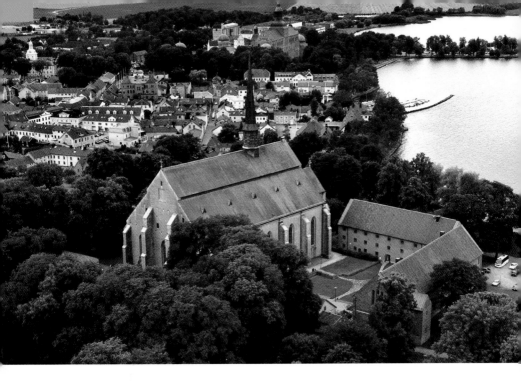

A view of Vadstena and the abbey

The stone ships of Gotland

Gotland is the largest island in the Baltic Sea, and trade flourished here under its 12th-century Hanseatic owners. The name is said to derive from the island's settlement by the original Goths, a rootless and warlike tribe who were to play a part in the fall of the Roman Empire.

During the Stone and Bronze Ages, ritual burial practices developed on Gotland that were closely linked with the landscape and the sea. Impressive evidence of these prehistoric rituals can be found throughout the island—

great numbers of skillfully crafted stone ships, whose purpose it was to convey the dead into the underworld. According to legend, the island was once ruled by evil spirits who caused it to sink beneath the waves during the day, surfacing only at night. Tjelvar, the first man to set foot on the island, broke this spell by lighting a ritual fire and banishing the spirits.

The legend is unmistakably reminiscent of Bronze Age sun cults, where the sun is transported in a chariot or wagon across the sky during the day, and in a ship by night. The island as a whole represented this ship and also symbolized the journey of the dead

soul into the underworld. The magnificent stone labyrinth at Trojeborg near Visby, the capital of Gotland, is another relic from this cult of the dead.

Little is known of Gothic religious practices, but the notion of the soul undertaking a long journey to the other side is common throughout the world. The earth is the realm of the living and in the mind of man the realm of the dead is somehow associated with the chaotic sea—powerful, invisible, and mysterious. The stone ships and labyrinth still convey a vivid impression of the journey into the unknown that each soul must attempt, and the feeling of sublime horror with which the unknown grips mind of modern man even to this day.

Lund Cathedral

Lund Cathedral portrays its own version of the fairy tale of Rumpelstiltskin. The original story relates how the villainous character loses his power when his name is spoken, but in Scandinavia the tale has a different slant. Here, it concerns a giant who has made a pact with St Lawrence: if Lawrence cannot discover the giant's name before the cathedral is completed, he will be blinded. However, Lawrence manages to eavesdrop a conversation between the giant and his mother. When Lawrence hears his mother call the giant by the name of "Finn," the giant loses all his power and the whole

family leaps into the crypt, whereupon they are turned to stone. This legend certainly accounts for the sculpted portrayal of Finn in the undercroft.

Lund Cathedral was built in the early 12th century and is the oldest in Scandinavia. It is a magnificent Romanesque building, displaying clear Lombard influences. For example, the twin towers at the front, dating from the 19th century, are based on the northern Italian campanile, although here they have pointed roofs.

The interior has been extensively rebuilt. Several of the pillars are of particular note, and are decorated with figures of men and women at prayer, which seem to be stepping out of the stone, or figures that appear to be embracing the pillars, lost in religious ecstasy. All seem to be placing their hopes in their faith. An enormous mosaic of Christ, located in the apse, dominates these pious scenes.

With luck, your visit will coincide with the playing of the largest church organ in Scandinavia, whose 7,000 stops and stirring tones combine with the visual spectacle of the beauty of the church to create a reflective mood that touches the heart much more closely than words alone could.

As you look around, you will know what time it is when your gaze falls upon the cathedral's wonderful astronomical clock—the *Horologium Mirabile Ludense* has been telling the time since the 14th century. The ancient images of Christian piety, the precision of the ancient timepiece, and the tones of the organ all combine in delightful harmony.

The Church of Our Lady, Kalundborg

✝

At first glance, the Church of Our Lady resembles a fortress, so it is little wonder that it was long assumed to date back to the time of Esbern Snare, who fortified the town around 1170. However, construction of the church is more likely to have begun in the first decades of the 13th century.

Dedicated to the Virgin Mary, the church is one of the most unusual Romanesque buildings in Denmark, if not Europe—it was built to the architectural proportions conventional for the time, but using units of measurement derived from the Bible. The size of the church was determined according to the 144 units of length decreed by God, the divine architect, for the angels' construction of the heavenly Jerusalem (Revelation, 21:17).

The church was erected on a low hill and laid out in the form of a cross, its five towers creating a holy fortress that was intentionally reminiscent of a medieval castle—an impression only reinforced by the large red bricks of which it is made. The robust exterior contrasts with a delicate interior, where the walls are also red brick. However, the portal and window embrasures have been painted a brilliant white, as has the vaulted ceiling. Surviving mural fragments from the early 13th century suggest that the entire church was once painted—the modern appearance of the building is the result of renovation work in the 19th and early 20th centuries.

The Church of Our Lady in Kalundborg

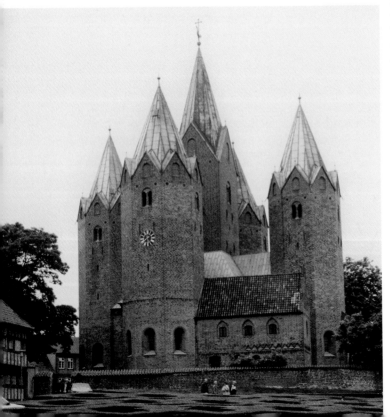

The Tirslundstenen in the forest near Brørup

The Tirslundstenen, Brørup

Medieval literary sources—and Snorri Sturluson's tales of the north in particular—tend to portray Odin as the greatest and oldest of the gods. Such a view is simplistic, however, and open to misinterpretation, as in Norse mythology it is Tyr, not Odin, who was the original father of the gods. It was only during the Viking age that Tyr was subordinated to the gods Odin, Thor, and Freya. There are still places today that serve to remind us of the worship of these gods—they remain sacred sites and sources of power and energy.

One such place is Tirslundstenen, in the middle of a forest near Brørup in southwest Jutland, where there is a granite boulder of impressive dimensions, almost 13 feet (4 m) high and nearly 53 feet (16 m) in circumference. Although there is no real proof, it is thought that this stone was once a place of sacrifice sacred to Tyr, the one-handed father of the gods, who is also the god of war, of courage, and of resolution. The myth relates how he alone among the gods opposed Fenrir the wolf, the monster who is to devour Odin at Ragnarok (the twilight of the gods and the end of the world).

Fenrir was initially raised by the gods at Asgard, but then grew wild and dangerous. Sensing what he would become capable of, the gods elected to restrain him to prevent him from wreaking havoc. The wolf easily broke the first two chains they tried to use, but the third was a fine-spun weave of all the secret and invisible things of the world—the call of a cat, the beard of a woman, the roots of a mountain, the sinews of a bear, the breath of a fish, and the saliva of a bird—creating a magic chain to bind him. Suspecting a trap, Fenrir consented to be bound only on condition that one of the gods placed his hand in the wolf's mouth

as a sign of good faith. Tyr alone was prepared to comply. The more Fenrir struggled, the tighter he pulled the magic chain. Biting off Tyr's hand in fury, he remained caught fast and was consigned to a deep cave in the underworld. It was thanks to these events that Tyr was dubbed "the one-handed" and he became a symbol of courage. Pilgrims still come to the mysterious site of Tirslundstenen to this day to try to recapture something of the strength, courage, and resolve of this ancient god.

Lindholm Høje

The grave forms that are the legacy of Viking funerary practices tell us a great deal about the world view that created them. Nordic beliefs held that death was the beginning of a journey into the next world, which lay to the far north. The Northern Lights would accompany the traveler to the legendary land of Ultima Thule. Quite what this name means is still open to interpretation—the last journey has not yet given up all its secrets.

The mysterious land was located far to the north of the Arctic Circle, beyond the inhabited world, in a place of elemental forces—snow-covered volcanoes, icebergs floating in a foaming sea, marshes, and cliffs. The dead undertook this last journey by sea, so it is little wonder that Nordic burial sites were laid out in the shape of boats, always pointing toward the north.

A particularly striking example is to be found on Lindholm Høje, a 164-foot (50-m) hill above the fjord at Ålborg. More than 700 grave sites have been found here, of which 200 are laid out like ships. The larger stones at each end symbolize the bows and sterns of the ships of the dead. The grave goods found in the round or oval sites often suggest a female occupant; the triangular and boat-shaped sites are reserved for males.

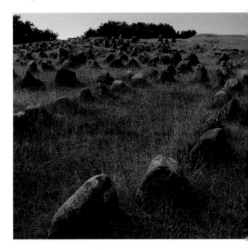

Lindholm Høje burial site

The burial site at Lindholm Høje was covered in sand for centuries, and was only rediscovered in the 20th century. It now attracts flocks of pilgrims from all over the world, who come with their own idea of what is to happen after death and who may derive some comfort from the suggestion offered by the grass-covered graves of this ancient burial site that death is not the end.

The Knuds Kirke, Odense

King Canute IV was a pious man, but could hardly have been called "shy and retiring." He used the Church in his attempts to build a strong state, and ruled his kingdom from the city of Odense, raising the money required to fund his ambitions for his country through increased taxation of the rural population.

The oppressed peasants were hardly models of Christian restraint either—on July 10 1086 they murdered the king and his retinue, including his brother Benedict, at a Mass held in the wooden church that once stood of this site. Canute was canonized by the pope in 1101 and construction of this stone church began in the late 11th century. Canute's relics, and those of his brother Benedict, were stored here and venerated by Denmark's Catholics.

The exterior of the Knuds Kirke (St Canute's Cathedral) is built of red brick in the Lübeck style, and the interior features elegant and richly decorated arcades. Everything is painted a brilliant white, contrasting with the brown and beige flagstones and the simple pews of oak. Standing in the nave, the visitor's eyes are drawn to the choir where a flight of steps leads up to the altar, which was carved in 1521.

The simple elegance of St Canute's Cathedral surely reaffirms a basic tenet of Gothic architecture—that everything should aspire toward heaven and that nothing should distract from the worship of God.

Løgum Abbey

The little town of Løgumkloster is known as *Locus Dei*—the place of God. The foundation of the town dates back to a Cistercian abbey built on the site in 1193. The abbey was dissolved during the Reformation but the abbey church survived as a superb example of Scandinavian Gothic sacred architecture. Layers of whitewash have been removed to reveal the attractive contrast between the bricks and the glazed tiles. The crow-stepped gable with its series of niches is a typical feature of Danish ecclesiastical Gothic architecture and borrows from the secular architecture of Lübeck in northern Germany.

The abbey at Løgumkloster is certainly a local landmark and attraction, but its presence in the small town is not obtrusive—it blends in well, providing a place where those seeking a break from the everyday routine of their lives may find a few moments' peace and where parishioners believe themselves to be in the presence of God. The church is surrounded by the parish graveyard, an idyllic spot where time passes slowly. Løgumkloster may not be the world's most visited sacred site, but it is without doubt a refuge where a troubled soul can find a moment of tranquility.

Lake Inari

There are numerous myths and stories that attempt to account for the creation of the world. Many of them start with the premise that there was only darkness and chaos before the beginning of time, at which point the sun took on a role of vital importance. Arctic peoples in particular set great store by sunlight. The Sami, who inhabit the polar regions, describe themselves as the people of the sun and the wind. They believe that everything on earth has its own energy, which stems in turn from a common creation. This energy is manifested in each individual human, as well as in every animal, river, and lake, and in every cloud—even in the wind that blows the clouds. Every natural phenomenon has a soul, which can be contacted with the aid of a shaman.

For the Sami, **Lake Inari** (Inarijärvi) is sacred. Situated in the far north of Finland, its boundaries are only properly visible on large-scale maps and in reality are only approximate—it is difficult to say where the lake begins and ends. There are numerous islands, although many of these are rocks no larger than a whale's back. **Ukonkivi** (the "stone of the ancient ones") is a mysterious sacrificial site located on one such steep island of rock, jutting out of the middle of the lake, and accessible only after an arduous journey by boat. The stone features in the Sami's myths and legends, including one about an old man, the oldest person in Lapland. According to the legend, thanks to three rays from the Northern Lights he reached an age of almost 2,000 years. The rays of light were the souls of three dead people captured by the old man when they strayed too close to the earth. They made a deal with the old man whereby he would keep them safe in a lantern so that the Northern Lights would be unable to take them back to the realm of the dead. In return they would trap the souls of young people and transfer them to his body, thus prolonging his life. One day a young man saw the old man walking past and followed him. The old man invited him into his home, bolting the door. He released the three souls from the lamp and they attacked the young man, trying to steal his soul. All of a sudden the Northern Lights descended to earth and came in through the window, falling upon the three souls. The young man was saved, the three souls were taken back into the sky, and the old man immediately collapsed and died.

Nowadays most of the Sami people who live around Lake Inari are of Christian faith—medieval missionaries forced them to abandon their old beliefs and accept conversion. Even now, however, many have preserved the roots of their ancient traditions and venerate Lake Inari as one of God's first creations.

Kerimäki Church

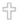

In the distant past East Finland was a wild and much-disputed strip of land separating Sweden and Russia.

Kerimäki is a modern Finnish town with about 5,500 inhabitants that has become famous for its unique church, the largest place of worship built of wood in the world. There is room for a congregation of 5,000, almost the entire population of the town. However, it is filled only once a year, at Christmas; the rest of the time the parish uses a smaller church constructed in 1953, which is easier to heat. The outsize dimensions of Kerimäki Church are due to a misunderstanding, or so the story goes. A Finn who had emigrated to the United States is said to have donated the money for the church, and his measurements in imperial feet were supposedly interpreted as meters by the European builders. The result was a magnificent church, 150 feet (46 m) long, 80 feet (24 m) high, and 148 feet (45 m) wide. It was completed in less than a year and consecrated at Whitsun in 1848. Such a rapid construction was possible only because every resident of the parish between the ages of 15 and 60 was obliged to help with the building work. The two-storey, neoclassical building has a cruciform floor plan and is topped with a cupola. The pale wood of the church's interior gives it a light and airy atmosphere and the visitor's gaze is immediately drawn to one of the building's principal features, the great wooden pulpit on the left-hand side. Located next to the church there is an imposing bell tower

The wooden church in Kerimäki

with a stone plinth. It is said that there are two miraculous things about the wooden church: first, the fact that it was even possible to erect such a large wooden building in the first place and, second, the preservation of its dignified and simple beauty throughout the ages.

Temppeliaukio Church, Helsinki

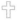

The Protestant parish of Taivallahti, located in the suburb of Töölö in the Finnish capital of Helsinki, has a somewhat unique church whose construction unites the ancient notion of a sheltering cave with expressive modern ecclesiastical architecture.

The interior of the church is carved out of the living granite, and light is admitted only through the 180 window panes that encircle the copper-domed roof. Standing in front of the building, you would hardly recognize it as a church; enter via the wide, gray stone portal and you are immediately transported to an almost magical place. The rough-hewn rock walls are between 17 and 27 feet (5 and 8 m) high and the sense of space is breathtaking; everything conveys the impression of being inside a mountain. The sky is represented by the warm red hues of the copper, with a diffuse light filtering through the apertures around

An interior view of Temppeliaukio Church, Helsinki

the roof. Temppeliaukio is not just used for church services, however—concerts are regularly held here and have become justly famous. Sitting in the simple wooden pews to listen to music is a unique experience; the acoustics in the church are excellent, enriching a moment of spirituality that combines deep, atavistic feelings and poetic imagination.

Helsinki Cathedral

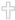

Even if you have never ventured this far north, you will probably be familiar with Helsinki Cathedral—this magnificent building, with its prominent central location, has come to symbolize the city.

Built between 1830 and 1852, the Protestant church was part of the neoclassical development undertaken in the middle of the city between 1820 and 1850. It was initially dedicated to the Russian Czar Nicholas I, but after Finland achieved independence in 1917 it was renamed Suurkirkko ("the great church")—and it is as large as the name suggests. A Lutheran see was established here in 1959 and the church became Helsinki's cathedral. The floor plan of this cross-domed church is in the shape of a Greek cross, with a large central cupola and four smaller domes placed around it. The stark white paint of the exterior is

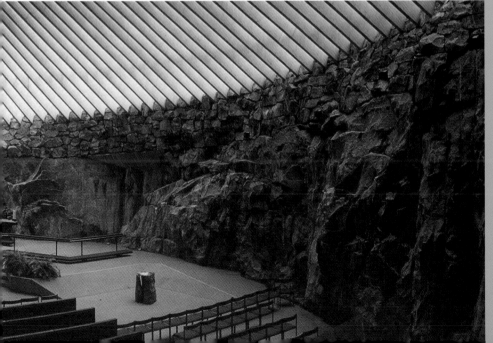

relieved by the Corinthian capitals of the pillars and the tympanon at each gable. The building stands on a raised stone plinth approached via a stepped crepidoma. The four corner towers and the pavilions at either side of the steps are later additions, included only after the death of the architect, Carl Ludvig Engel, who had designed the cathedral along strictly neoclassical lines.

The simplicity of the interior is very elegant—the walls are completely white and without ornament, except for the altar, which depicts Christ's descent from the cross. Three statues of the reformers Luther, Melanchthon, and Agricola underline the use of space. Protestants view experience of the Divine as possible only through the word of God and its interpretation in sermons—Helsinki Cathedral is an excellent structural expression of a theology that allows nothing to detract from acuity of thought.

Helsinki Cathedral

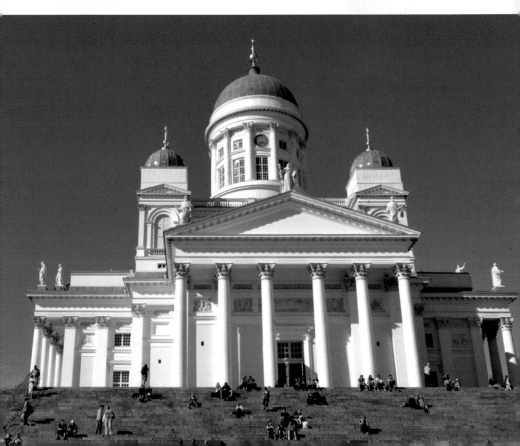

The iconostasis in Uspenski Cathedral

Uspenski Cathedral, Helsinki

Visitors to Uspenski Cathedral might well think they were in Russia, and this is no coincidence—the building is not only a relic of the period of Russian rule here, it is also the principal church of the Finnish Orthodox diocese of Helsinki.

The church was completed in a Russian Byzantine style in 1868 and dedicated to the Dormition of the Theotokos (commemorating the "falling asleep" or death of the Theotokos, the Virgin Mary). The red-brick building has 13 gilt domes, which shine like votive candles in the bright northern sunlight. The interior is lavishly decorated, with four mighty granite pillars supporting the central dome. Look up into the cupola and you will be rewarded with a view of a brilliant firmament of stars.

Miraculous powers have been attributed to one of the many icons in the church. The warm light picks out golds, blues, and deep reds in the mysterious icons, and these combine with the scent of the many candles to create an atmosphere in which visitors can seek to experience the Divine presence. That atmosphere is only intensified when a Mass is held in the Church Slavonic language prescribed by the Russian Orthodox liturgy—the enig-matic words and hymns resound in the ear long after the service has finished.

The Gate of Dawn, Vilnius

Historically, the Baltic has always looked west. The city of Vilnius was known as the "Rome of Lithuania," and you can see why from the very first glance—the skyline is crowded with a similar number of spires and towers in many different architectural styles. The city is a major Catholic pilgrimage destination and is also visited by Russian and Greek Orthodox believers. Vilnius was one of the largest medieval cities in Europe and has a wealth of magnificent Gothic, Renaissance, and baroque buildings.

Apart from the churches, the goal of many pilgrims who came to Vilnius was the Gate of Dawn (Aušros Vartai), situated at the end of a tapering street. Some have suggested that the gate acquired its name because it faces east, but in fact it does not; so we can only guess at the origins of a name that has in any case only been in use since the 20th century. The Gothic gate was built between 1503 and 1522 and the Renaissance extension was added a little later. It has since been considerably rebuilt and renovated; the last refurbishment in 1830–40 united the gate's chapel with St Theresa's Church.

Thousands of people undertake the pilgrimage to the gate to venerate the Blessed Virgin Mary, Mother of Mercy, whose icon is credited with miraculous powers. As with many such icons, the identity of its creator is uncertain. A golden gown was added to the 6-foot (2-m) painting of the Virgin in 1671, with the result that only the hands and face are now visible, and Our Lady of the Gate of Dawn gazes down indulgently on the assembled pilgrims. It is easy to imagine how she would intercede in heaven for those who pray to her.

Icon of the Virgin Mary in the Gate of Dawn, Vilnius

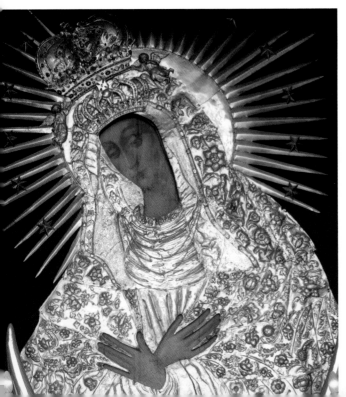

The Hill of Crosses

About 6 miles (10 km) north of the Lithuanian town of Šiauliai there is a low hill covered in a unique forest of crosses, erected by the countless people who make a pilgrimage here. Crosses and crucifixes can be seen everywhere you look, a sign of a deeply rooted faith.

Pilgrims come to the hill to pray for help with their own personal problems and concerns, and most of the crosses are purchased at the neighboring Franciscan monastery, where they can also be given a blessing, if required.

Visiting the Hill of Crosses is a strange form of spiritual experience—the individual is not alone with his prayers and pleas, but rather becomes part of the anonymous community of all those who have come here to endeavor to keep their hopes alive. More than 60,000 crosses of all sizes have been crammed in together on the hill, and the number increases every year.

As the wind gently blows, the rosaries hanging from many of the crosses knock together, producing a strange tinkling and rattling, like a giant wind chime communicating in a language known only to God as it carries spoken and unspoken wishes away to heaven. A Mass is held here once a year, on the last Sunday in July, and people come in their thousands, hoping their petitions will be granted and their dreams fulfilled.

There is something deeply touching about the many requests and notes—the Hill of Crosses is a place of communal devotion. During the Soviet period it was also a place of passive resistance, and this refusal to bow to reality, clinging to one's own hopes against all the odds, is a mark of the Divine.

The Hill of Crosses near Šiauliai

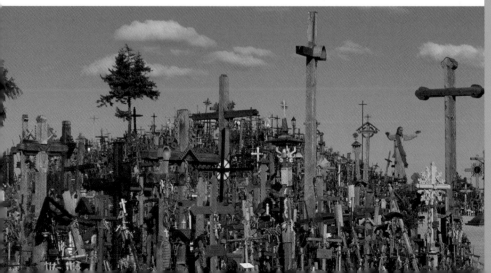

Aglona Basilica

The village of Aglona in southeastern Latvia is only modest in size, but it is a place of great significance and influence, as it houses the largest Marian pilgrimage church in the Baltic. Hundreds of thousands of Catholic pilgrims from all over the country visit the Basilica Aglonensis every year. It was declared a *basilica minor* by Pope John Paul II in 1980, the 200th anniversary of its consecration. The attraction of this site is so great that not even decades of Soviet rule were able to erase it from folk consciousness— the people continued to pray to the Virgin despite every hardship and discouragement.

The site of the Marian church was a sacred place even in pre-Christian times, as a spring located here was thought to have healing properties. A Dominican monastery was built on the site in 1699, but its simple wooden chapel was destroyed by fire in 1766, swiftly followed by the rest of the complex. The construction of the current Church of the Assumption was begun in 1768 and it was consecrated in 1780. The goal of the pilgrimage is an early 17th-century image of the Mother of God, of uncertain provenance; it is likely the Dominican monks brought it with them when they came from Lithuania to Aglona.

A procession on the Feast of the Assumption at Aglona

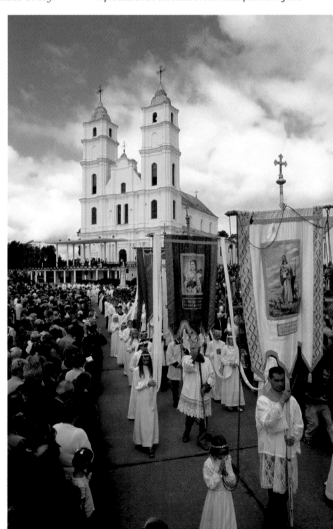

The icon depicts a blue curtain, held in place with four golden tassels, which shelters Mary as she dandles her son on her knee. Beneath them, a host of baroque angels gazes up in adoration. All kinds of miraculous healing powers have been ascribed to the icon. It is normally kept hidden behind a screen and is only brought out before the faithful on religious festivals.

A popular legend relates how a local woman had a vision of the Virgin carrying her child in her arms at the site on August 15 1798, and this appearance, its pre-Christian past, and the miraculous powers of the icon have combined to make the Basilica Aglonensis the most important pilgrimage site in Latvia.

Pokaini Forest, near Dobele

An extraordinary variety of plant and animal life is to be found in the mysterious Pokaini Forest about an hour's drive southwest of Riga, near the town of Dobele. Rare animals and trees, crystal-clear streams, and exceptionally pure air combine to make the spot an oasis of rest and relaxation for body and spirit. Recent archeological finds have shown that the forest was settled by the tribes of the Semgall, who venerated it as a sacred place.

The forest is low-lying, with much of it below sea level, and covers a series of low hills. Many of the mighty oaks have bark on one side only—a strange phenomenon of nature that makes the trees all the more mysterious. The most enigmatic aspect of the forest is provided by the many tumuli, whose provenance is unknown. It is widely assumed that they occupy sites that were considered the source of some kind of energy, and there are many tales of inexplicable occurrences whose supernatural qualities add to the place's fascination. Ivar Viks, a scientist from Riga who wished to research the forest's secrets, encountered strange meteorological phenomena and died soon after of an unexplained illness.

There are other tales of spontaneous cures effected by the trees and the stone mounds. It is little wonder that not only scientists but also healers and soothsayers now visit the miraculous forest of Pokaini in search of the particular magic ascribed to the area, which has become a popular place of pilgrimage in its own right.

St Michaelis Church, Hamburg

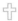

With the signing of the Peace of Westphalia in Münster in 1648, the Thirty Years' War—a conflict that caused unbearable suffering and destruction throughout large parts of Europe—finally came to an end. The foundation stone for the parish church of St Michaelis in Hamburg was laid the same year. It was initially a three-naved basilica with a spire, a traditional design for medieval Catholic religious architecture, but this structure burnt down completely in 1750. The design of its successor was inspired by the Protestant notion of a church that focused attention on the sermon. Construction work started within months of the fire, in the same year (1750), and the new church of St Michaelis was consecrated in 1762. Known to every resident of Hamburg as "Michel," it was to become the most important baroque church in north Germany. Erected 20 years later, the famous spire is both classical and unmistakable, with a geometrically perfect square tower beneath a curved temple dome that betrays its Greek influences. It has been a tradition for 300 years that each day— twice on weekdays—a trumpet should play a chorale from the tower.

A large statue of the archangel Michael guards the great doors. The church's luminous interior is in the shape of a great oval, devoid of columns or supports. The verticals only emphasize

The spire of St Michaelis seen from the harbor

the curves of the oval, and the whites, golds, and grays add a festive touch.

The residents of Hamburg are not alone in loving their church. It has not only become a symbol of the city, with its spire looking down across the magnificent panorama of the port, the gateway to the world, but has also remained a living church, celebrating services for the parish, engaging in social work, and providing a space in which to hear wonderful music. Although the continuing program of repairs has led the church to be described as the "most beautiful building site in the world," the spirit of Christmas is summed up for many with a performance here of Johann Sebastian Bach's *Christmas Oratorio*—the music and the message making a perfect combination. For many Christmas would not be the same without attending the event in this magnificent building.

The "Stone Dance" of Boitin

You could say that the stone circle known as the *Steintanz* ("Stone Dance"), near the little town of Boitin in Mecklenburg-Vorpommern, resembles Stonehenge on a smaller scale. This is of course overstating the case as the two sites are not really comparable at all, but this place possesses a similar magic, which draws people to it even today. Thirty stones about 6 feet (1.8 m) high make up four circles of varying diameters in a clearing in a beech forest. As is the case with all stone circles, the

reason for their construction remains an unexplained mystery—the stones have stood here for 3,000 years, telling a story we no longer wholly understand. It may be a grave or a ritual site; it may even be an astronomical instrument to determine the calendar. Or perhaps the old legend is true—it is said to be an entire wedding procession, turned to stone by an evil old man. A shepherd who had witnessed proceedings was allowed to escape by the old man on the condition that he did not look back. However, since the shepherd did exactly that, he too was turned to stone, along with his dog and his entire flock, and this explains the fourth, rather smaller circle located nearby. The truth of this legend is understandably disputed, but the site is popular with visitors, not least because there is a tale that a brave young man will set the wedding party free by pulling a red thread from the heart of the largest stone. No one has yet fulfilled this prophecy, but the place combines legend and magic from a long-forgotten age about which little is known.

The Cistercian Monastery at Chorin

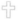

For the German writer Theodore Fontane, Chorin and its deserted Cistercian monastery were almost a mirage. He described it in his book *Journeys through Brandenburg* as "half fairy tale, half ghost story."

Both descriptions could apply today, although the monastery is no longer so dilapidated or indeed so remote.

The monastery was built between 1273 and 1334 as one of the many sister foundations of Cîteaux Abbey and initially flourished, but years of decay began when the Reformation reached

The brick façade of the monastery at Chorin

Brandenburg in 1539–40 and the monastery was dissolved. Walls collapsed and the bricks were used for other building projects. The Thirty Years' War left its mark also, and only a ruin remained for Karl Friedrich Schinkel to inspect in 1817 in his capacity as a civil servant in the Prussian Office of Public Works. His recommendation that such a beautiful monastery should be preserved led to the commencement of restoration work in 1831.

The monastery lies in grassland among low, rolling hills of green and the first thing to strike the observer is the mighty red-brick façade. The still-extant plans attribute the work to a certain Master Conrad; the tripartite west façade of the monastery chapel, with finely decorated tracery, reaches heavenward and is the mason's masterpiece. The red-brick construction lends a harmonious completeness to the whole, giving the impression of a simple but extraordinary beauty.

Inside the building, the emptiness is surprising—it has been gutted and little remains of the past, apart from the walls and the plain, uncluttered floor.

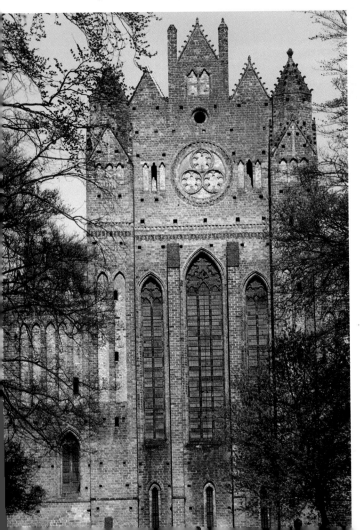

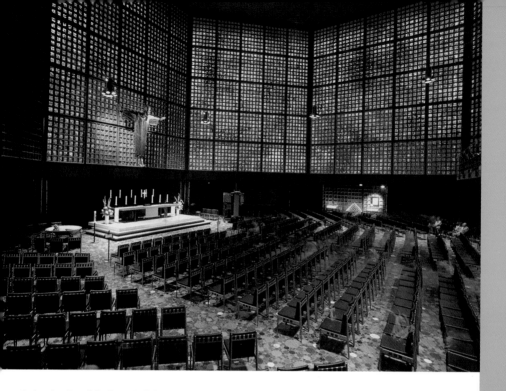

An interior view of the Kaiser Wilhelm Memorial Church

Summer concerts are held in the monastery and the surrounding grounds, blending nature, building, and music to perfection.

The Kaiser Wilhelm Memorial Church, Berlin

The Kaiser Wilhelm Memorial Church was built in the late 19th century as a chapel and as a memorial to the late emperor. This neo-Romanesque building with Gothic elements was consecrated as a Protestant church in 1895, serving the newly built western suburbs of Berlin. The church suffered considerable damage in an air raid in 1943. After hostilities had ceased, the ruined spire became both a war memorial and a symbol of the western half of divided Berlin. Constructed between 1961 and 1963, Egon Eiermann's modern church buildings became emblematic of the city's rebirth. The Berlin architect's design, a simple octagon that was quite controversial for its time, featured an austere chapel, a separate high tower, and a foyer. The old ruin

was incorporated into the middle of the new design, and the memorial and the modern church were united as one.

Blue windows designed by Gabriel Loire, a stained-glass artist from Chartres, were set into the concrete blocks of the walls and the deep azure light flooding in from the huge glazed façade bathes the church in an almost mystical light; the windows have something of the dignity and sacred spirit of a Gothic cathedral. Christ hangs in front of the windows in benediction, his body forming a cross. The 12 candles near the altar symbolize the 12 tribes of Israel, the 12 disciples of Jesus, and the 12 gates of the heavenly Jerusalem. The floor is composed of round tiles of various hues and sizes; the architect intended these to represent the way diversity of origin, age, and culture can be united in one community by holy worship.

The contemplative interior of the new Kaiser Wilhelm Memorial Church forms a stark contrast to the bustling

All Saints' Church, Wittenberg

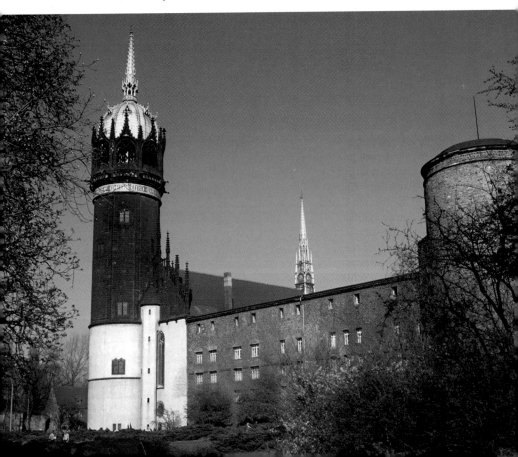

traffic of the Kurfürstendamm outside, creating a space for tranquility and prayer in the middle of the city.

All Saints' Church, Wittenberg

The world-famous All Saints' Church stands on the foundations of what was once the northeastern wing of a cruciform Renaissance chateau, built by Prince Elector Frederick the Wise in 1489. This Catholic church with its richly decorated interior—there are no fewer than 20 altars, each with a precious altarpiece—was consecrated to the congregation of saints in 1503. Its modern-day fame has nothing to do with the saints, however, but is based on an event that was to change the course of world history. On October 31 1517, an Augustinian monk and professor of theology named Martin Luther attached to the portal of All Saints' Church a polemic against the Roman Catholic Church and 95 theses against the sale of indulgences. There is now some controversy over whether these world-changing theses were ever actually nailed to the door, but a schism without parallel in Church history certainly tore through Europe and beyond. The Reformation does not simply represent a caesura in the history of the Christian Church—it influenced every area of culture and politics. The medieval world had come to an irrevocable end.

The tombs of the electors Frederick the Wise and John the Steadfast, both of whom supported the Reformation, are to be found near the altar. In 1546 Martin Luther was also buried in the church; he lies directly beneath the pulpit from which he often preached during his lifetime. In 1560 the famous humanist and theologian Philipp Melanchthon, who had made a major contribution to Luther's translation of the Bible, was interred here too.

Between 1883 and 1892 the church was subjected to extensive neo-Gothic renovations and the modern bell tower was built on the foundations of the old chateau's tower. This Protestant church might seem ill at ease with the Divine, yet this is a sacred place, where a reforming spirit that had long smoldered throughout Europe finally sprang into life. The site is of great significance for the Protestant Church and is both a part of our cultural history and a reminder of the great power that words can wield.

The Brocken in the Harz Mountains

One rock formation in particular stands out in the Harz Mountains, an area in the middle of Germany that is particularly rich in myths and legends. At 3,743 feet (1,141 m), the Brocken is the tallest peak in the Harz; it is also considered a sacred mountain. The

rounded hump of its summit is devoid of trees and the lack of vegetation only increases the air of mystery, which is apparent from afar. The summit is shrouded in mist and fog for more than 300 days a year and its importance as a ritual site forms the basis for many tales and legends. Even the exact origins of its name are unclear—history and myth provide a number of variants, of which "Brocken" and "Blocksberg" have proved most enduring. Perhaps the giant blocks of granite that are common in the area influenced the name. Even though much is known about the Brocken's geological history and composition, there is still plenty of mystery associated with it.

It is assumed by many that the early German tribes worshiped Ostara, the goddess of spring, here, as was common on many other peaks, but the Brocken's real claim to fame is the coven of witches who were said to practice their rites on the mountain. Legend has it that they would assemble with their dark masters on *Walpurgisnacht* (Beltane), between April 30 and May 1, before riding broomsticks to the summit, where they would hold a great feast with the devil. As they arrived at the summit, the last of the snow would be swept away and a great fire would break out. A horse would be butchered and roasted on the witches' altar. The devil would play a tune on the horse's skull and the witches and warlocks would engage in a frenzied dance until daybreak put an end to the eerie proceedings. The story is still well known today thanks to the poet Goethe, whose tragedy *Faust* immor-

An aerial view of Goseck Circle

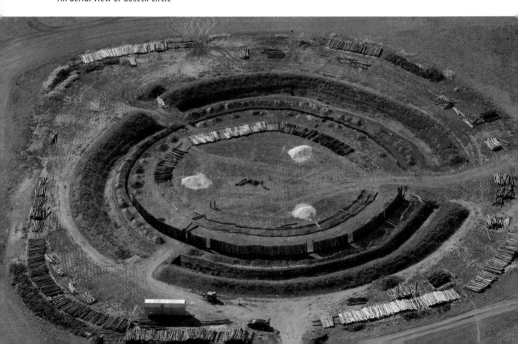

talized the Blocksberg as a mythical and mystic place. How much credence one lends to such long-lost myths is perhaps a matter of faith, but the Brocken is undeniably one of those high places on earth with a special and extraordinary connection to the mysterious. The face of the mountain has changed considerably in recent times as meteorological research stations have spread their way across its curved summit, but in winter especially the rocky peak guards its secrets.

The Goseck Circle

This sacred place is one of the oldest and yet also one of the most modern sites. The Neolithic circle is located in a field just to the northwest of the little town of Goseck in southern Sachsen-Anhalt, and is the oldest solar observatory known to survive. Archeological finds here dating back to the Stone Age have confirmed this, and it seems likely that the summer and winter solstices, the longest and shortest days of the year, were celebrated here 4,800 years before Christ's birth. The Stone Age site has been painstakingly reconstructed and was opened to an amazed public on December 21 2005, the winter solstice. The circular site is 250 feet (75 m) in diameter and marked by a ring of wooden palisades about 8 feet (2.5 m) high. At certain times of the year the sun shines through the three clear exits or entrances, which

allowed the Stone Age observers to regulate the calendar for sowing and harvesting. These people did not just adapt their lives to the rhythm of the sun 7,000 years ago; they worshiped it as a god, and this was a sacred place.

Excavation of tombs has revealed skeletal remains, suggesting that sacrifices were made to the sun. Although it is difficult for us to understand such ancient rituals, especially where human sacrifice is concerned, this is a sacred site, demonstrating that man has known since ancient times what gave him life—without the sun, nothing would live.

St Nicholas' Church, Leipzig

St Nicholas' Church in the heart of Leipzig is clear proof that there is often a very close relationship between the sacred and the political. The famous weekly "Monday prayers for peace" began at the church in 1981, and by the fall of 1989 the church had begun to attract worldwide attention. A plea for peaceful demonstrations went out from the church on September 25, and on October 9 thousands of people congregated in front of the building. A demonstration involving almost 100,000 people took place in the city, and a matter of weeks later the Wall separating the two German states fell. East and West were gripped by an extraordinary euphoria at the success of one of the least violent revolutions in world history.

Today it is almost impossible to stand before the mighty Church of St Nicholas without recalling the events of 1989. Built in 1165, it is the oldest of Leipzig's impressive array of old churches, the base walls of the west elevation and some parts of the north chapel dating back to the earliest times of its construction. The southern chapel is an addition from 1467. Between 1513 and 1536 the Romanesque building was remodeled as a three-naved Gothic basilica with a ceiling of latticed vaulting. First built in the middle of the 16th century, the central tower was topped with a baroque dome in 1730–31. The classical interior was created between 1784 and 1797, and since its last renovation has been lightened with beautiful pastel shades—the dominant white of the columns is set off with delicate apple greens and soft rose pinks.

Various eras have left their mark on this venerable building, deeply imbued with so many positive national feelings, but now the whole world is able to admire the stunning beauty of this church. The sign at the entrance can be interpreted on many levels: St Nicholas' Church—open to all.

The Frauenkirche, Dresden

The mountain of debris that resulted from the bombing of Dresden was part of the city from 1945, a familiar and yet accusing sight—a warning against war, a symbol of civil rights,

and a reminder of the peace movement, right in the middle of the city. As a consequence, there were plenty of voices opposed to the rebuilding of the Church of Our Lady in Dresden, but from the very beginning the people of the city supported the efforts to reconstruct the church. Plans were laid right after the end of World War II, although it was not until 1993 that the rubble was carefully cleared and catalogued so that it could be incorporated into the new structure. The rebuilt Church of Our Lady was finally completed and has many admirers— the top dome with its golden cross was put in place in August 2004, marking the final phase of the reconstruction.

The church is a fine example of municipal baroque architecture— there had been similar centralized constructions in Venice, Florence, and Rome. Although George Bähr, the architect who was commissioned to design a Protestant parish church in 1722, had never been to Italy, he knew these buildings from contemporary prints and was determined that only a symmetrical structure would do. The Church of Our Lady would thus conform to the Protestant notion of the congregation assembling in the round, with no barriers between the minister and the faithful.

A circular interior, surrounded by galleries and topped with a cupola, seemed to Bähr an appropriate solution, and the foundation stone was laid in 1726. A bold church, combining an

The Frauenkirche, Dresden, by night

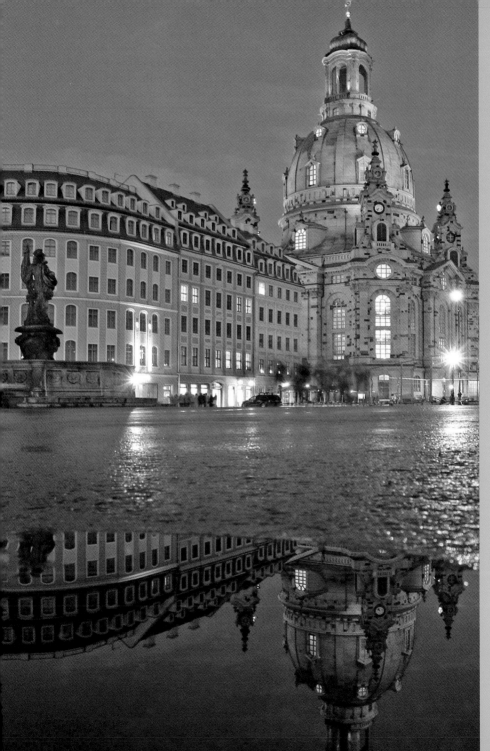

Italianate dome with north German galleries, was erected and was consecrated in 1734. The building is based on the geometric shapes of the square and the circle, and the round arches, the curved galleries, and the bell-shaped cupola are entirely baroque. Every element of the building merges seamlessly with its neighbor, an impression that has only been enhanced by the painstaking restoration work. The new Frauenkirche at Dresden is a miraculous place and a church that belongs largely to the people—the majority of the building costs were met with money from private donations.

The Holy Sepulchre, Görlitz

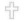

The site of the Holy Sepulchre is a religious work of art intended to elicit a mood of reflection and reconciliation and comprises several stations marking Jesus' route to his crucifixion. Its legendary origins date back to Georg Emmerich, the son of a Görlitz businessman, who fathered a child with a neighbor's daughter but then refused to marry her. In atonement he was ordered to undertake a pilgrimage to Jerusalem, which he completed in 1465. Once there, his mind cleared, his sins were forgiven, and he was created a Knight of the Holy Sepulchre. At some point between the end of the 15th century and the beginning of the 16th, the Stations of the Cross, a symbolic link with events in the Holy Land,

were laid out on an extensive area in his home town. The Chapel of the Holy Sepulchre, a miniature but accurate reproduction of the one in Jerusalem, is the focal point of the entire site.

The pilgrims' path begins in town in the crypt of the Church of St Peter and St Paul. The church symbolizes the trial in Pilate's palace and is the beginning of the Görlitz Via Dolorosa, which passes the Mount of Olives, the garden where the disciples slept, and the stream at Kidron on its way to the Chapel of the Holy Sepulchre. Nearby on the site you will find the Chapel of the Holy Cross, a two-storey church with the Chapel of Adam below and the Chapel of Golgotha above. The Chapel of Adam houses the symbolic grave of the first man and the Golgotha Chapel a raised dais representing the hill of the Crucifixion. Three large holes clearly represent the places where the three crosses were erected. A striking peculiarity of the church is the (intentional) crack that runs from the east wall of the Chapel of Golgotha down to the Chapel of Adam, intended to recall the rent that appeared in the veil of the Temple at the hour of Jesus' death and the turning-point in world history that this represented. In the place where Jesus' body was anointed there is a pietà statue, and at the end of the Via Dolorosa is the final object of veneration, the Chapel of the Holy Sepulchre.

A great procession held here every Good Friday solemnly concludes with an open-air celebration of the Resurrection, and—as once in Jerusalem—the roads are lined with both believers and those who are merely curious.

The Chapel of the Holy Sepulchre, Görlitz

Erfurt Cathedral and St Severus Church, Erfurt

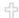

The cathedral square and the beautiful buildings surrounding it have become world-famous. The square is a bustling marketplace, the largest in Germany, and for most people it represents the very heart of the city. However, even this most impressive square is outshone by **St Mary's Cathedral** and St Severus, the two Gothic churches on the cathedral mound.

St Boniface built a church on this site in 724 and the foundations of this first structure were used for a Romanesque basilica in the middle of the 12th century. The mound was enlarged with extensive new foundations and walls in the early 14th century to make room for the construction of a much larger church, St Mary's Cathedral. The high chancel and the crypt were completed in 1370 and the Gothic nave was begun in 1455.

One peculiarity of the church is that the transept is wider than the nave. The transverse high chancel shines with a mysterious light admitted by the almost 66-foot (20-m) windows with their brilliant medieval stained glass. Almost the entire width of the chancel is taken up with a baroque high altar, whose two-storey design features 12 larger-than-life statues—the four evangelists, saints, and martyrs. The Chapel of the Holy Blood houses "Wolfram,"

a Romanesque candelabra in the shape of a man and one of the oldest three-dimensional sculptures in Germany, inviting the congregation to prayer with dignity and solemnity.

The three towers in the façade of the **Church of St Severus** face the cathedral square. Elegant spires sit on top of the stone towers, breaking up the monolithic appearance of the building. The interior of this five-naved church imparts a feeling of uncluttered, simple space, and the visitor's gaze is drawn to the baroque high altar, which almost fills the entire chancel.

Marble-clad columns, statues of saints, and a wealth of ornamentation mark out the altar as a baroque sculptural masterpiece. The relief of the archangel Michael, who is depicted saving souls and defeating the devil—seemingly effortlessly— is particularly arresting.

The two Gothic churches are visually linked by a flight of steps, which tapers toward the top, creating a unified ensemble. It is unusual for two Catholic churches to be located so close together, but the cathedral mound and square in Erfurt combine to form an excellent example of har-

The cathedral and the Church of St Severus, Erfurt

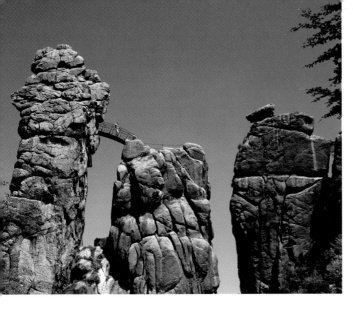

The Extern Stones, Teutoburg Forest

monious municipal planning. Those who ascend the steps will sense the dignity of both these unique churches.

The Extern Stones, Teutoburg Forest

Whether this is the actual location of the spirit of the German people, as the anthroposophist Rudolf Steiner maintained, is perhaps open to doubt, but the whole area surrounding the Extern Stones has undeniably been a sacred place since prehistoric times. Until the 18th century the Teutoburg Forest was known as *Osninghain*, the "grove of the gods." The standing stones are located on the borders of territory once belonging to the nine tribes that inflicted such a crushing defeat on the Roman army in the Battle of the Teutoburg Forest in 9 AD. At the time the site was well known as a shrine and a place of initiation for druids, and the fascination exerted by the 13 sandstone formations jutting up to 125 feet (38 m) out of the ground has remained unbroken to this day. Geologists, nature-lovers, hippies, New Age druids, archeologists, and astronomers from around the world are all drawn here throughout the year as if by magic.

The stones reach up to the sky like relics from another, distant world, looking particularly mysterious in the light of dawn and at dusk. That this site was used as an observatory at some early point is proved by the existence of a round "sun hole," through which the rising sun shines on the morning of June 21, the summer solstice. A grave chiseled out of a stone block at the foot of the rock was presumably used for burial rites and many a modern visitor has briefly lain down within it to "load up" on spiritual energy. The striking carved relief on the main rock formation of the Deposition of the Cross, the largest known statue north of the Alps, is a sign of how the

area has been taken over as a Christian site. Many consider the Extern Stones to represent Germany's greatest natural sacred place; whether this is the case or not, they have always been revered for their power and used since time immemorial as a ritual site.

Kevelaer

Almost a million pilgrims each year make the journey to Kevelaer, after Altötting the most popular place of pilgrimage in Germany and one of the major sites in northwestern Europe. The pilgrims come to kneel before the image of the *consolatrix afflictorium*, the comforter of the afflicted, and to pray for help and support. The venerated portrait is a print no larger than a postcard, depicting the Virgin Mary dressed in a wide gown and standing against a backdrop of the city of Luxembourg; she is carrying her child in her left arm and in her right hand is a scepter.

Hendrik Busman, a commercial traveler from Geldern, happened to be praying on his way home at a wayside cross near the little town of Kevelaer at Christmas in 1641, when he heard a voice clearly telling him to build a chapel on the spot. The strange phenomenon repeated itself several times, and soon afterward Hendrik's wife Mechel had a dream in which she too saw a chapel. Within this chapel there was a devotional picture of "Our Dear Lady of Luxembourg" which had recently been offered to her for sale by some soldiers.

Interior view of the pilgrims' church at Kevelaer

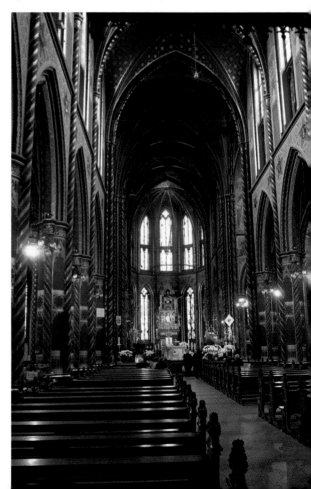

Busman was now prepared to lend the voice more credence and built a small brick shack in which the image was displayed from 1642. Tales of miraculous cures soon began to circulate and in 1647 Kevelaer was acknowledged by the Catholic Church as a place of healing.

The towers of the Sri Kamadchi Ampal Temple in Hamm-Uentrop

There are now several buildings on the pilgrimage site. A 17th-century priests' house, a path with the Stations of the Cross as laid out in 1892 on the site's 250th anniversary, and a nunnery of the Order of Poor Clares have been added to the large neo-Gothic basilica of St Mary's, which was built between 1858 and 1864. The 1643 "candle chapel" was named in response to the hundreds of votive candles lit here. The heart of the pilgrimage site, however, has always been the 1654 hexagonal Chapel of Mercy, in which the tiny image of the comforter of the afflicted is kept.

The Sri Kamadchi Ampal Temple, Hamm-Uentrop

Something strange happens in Hamm-Uentrop every year in May or June—the still rather unexpected sight of tens of thousands of Sri Lankan Tamils assembling for their annual temple festival and parading an icon of the goddess Sri Kamadchi Ampal through the streets. Hindus believe that this will bring her blessing upon the local residents.

Since the conflict between the Sinhalese majority and the Tamil minority in their homeland intensified in the 1980s, many Sri Lankans have been forced to flee, seeking a new home in Germany. Some 60,000 Tamils now live there and the great majority are Hindus. Hamm has been one of their spiritual focal points since 1989.

The faithful initially met in a basement, then in a converted bowling alley, before finally obtaining their own temple in 1997, which is located beyond the residential part of town on an industrial estate. The surroundings are not exactly beautiful—they include an abattoir and a power station—but the location was chosen because local residents had raised objections to a

temple anywhere else, and because Hindu belief dictates that the temple must be built close to running water so that the goddess can be ritually bathed. Tens of thousands of believers now come to Hamm from all over the country to take part in the great procession and then to practice their holy rites beside the Datteln-Hamm Canal.

The temple, with its impressive *gopuram* (entrance tower), is based on South Indian temple architecture and is dedicated to Sri Kamadchi Ampal, the "goddess with the eyes of love." German friends of Siva Sri Paskarakurukkal, the Tamil priest who first suggested the idea of the temple, donated the metal statue of the goddess. The new temple was solemnly consecrated to the goddess in 2002 in a ceremony attended by 14 Hindu priests who had traveled from India, Australia, and Sri Lanka for the purpose. This transference of *shakti* (divine power) now means it is the central place of worship for Germany's Tamil Hindus. It is thus little wonder that so many people turn up to celebrate their old faith in their new homeland and watch the goddess process around the temple in a festival cart. The temple is of course open throughout the rest of the year for daily *pujas* (prayer and services).

St Paul's Cathedral and St Lambert's Church, Münster

In the late 8th century a tiny mission house was established on the River Aa, and it was from this humble building that St Ludgerus began the conversion of the Friesians and the Saxons. A monastery was soon founded on the site, lending its name to the whole

The magnificent towers of the Romanesque cathedral, Münster

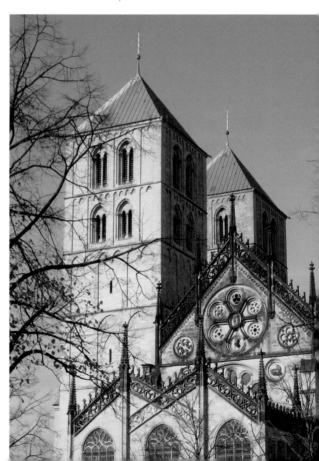

town—*monasterium*, Münster—and in 805 Münster became a bishopric.

Dedicated to St Paul, **Münster Cathedral** is considered the most significant sacred building in North Rhine-Westphalia. It is without doubt the heart of the city and is described by many as a " visible representation of the church invisible." The modern building is the result of ten years of reconstruction (1946–56) after the cathedral was almost completely destroyed during World War II. Although it has retained its basic Romanesque structure and Gothic traits, it has been transformed into a modern place of worship, as can be seen from the arrangement of the liturgical apparatus: the free-standing altar is located in the middle of the crossing and surrounded on three sides by pews for the congregation. Works of art spanning 1,200 years of ecclesiastical history have largely survived, principally because, where possible, they were evacuated from the church in times of strife. Thus the cathedral is now itself a work of art, incorporating elements dating from the Middle Ages to the modern period.

St Lambert's, the magnificent church of the merchants and citizens of Münster, is only a stone's throw from the cathedral square. This late Gothic construction was completed between 1375 and 1450, although the derelict spire was remodeled in the 19th century. The interior gives the impression of a large, wide hallway and the Gothic round and bundle pillars rise up to a ceiling of delicate reticulated vaulting. The choir is not hidden away behind a screen but instead takes up the whole width of the nave, increasing the feeling of gener-osity of proportion. The blue and red stained glass of the high windows in the chancel apse floods the simple space with light, imbuing it with a meditative air. However, the most famous feature of the church is to be found high in the tower, beneath the apertures of the tip of the spire: three cages which once held the corpses of the Anabaptist leaders who conducted a fanatical reign of terror in the city in the 16th century. Once a warning, the cages now serve as a memorial. A light installation has shone out from the cages since 1987—"Three Will-o'-the-Wisps, the Manifestation of Three Souls or Inner Fires Who Can Find No Peace."

The Pilgrimage Church, Neviges

The structure built between 1963 and 1968 by Cologne architect Gottfried Böhm in Neviges, an independent suburb of Velbert, has not been to everyone's taste. The design for his Pilgrimage Church took the form of an angular, irregular block of concrete in the Rhenish Expressionist tradition, which Gottfried had learnt from his father, the Expressionist architect Dominikus Böhm. An almost mystical space based on crystal formations was created, and its special atmosphere is only properly experienced from within. Even today the exterior lives up to the name that was given to this architectural movement

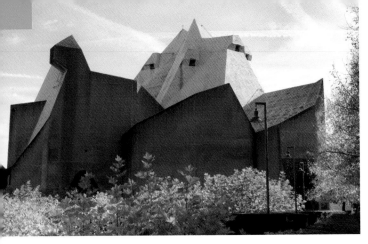

The Pilgrimage Church, Neviges

the altar, bathing the space in a warm, mysterious light. A small icon of Mary is set into a striking pillar and the Virgin and Child seem almost to grow out of the stone. Pilgrims have been coming to Neviges on the Hardenberg Hill since the 17th century: in 1676 a Franciscan monk, Antonius Schirley, had a vision of Mary begging him to build a chapel there.

at the time—"Brutalism"—although on closer inspection the visually rough concrete blocks reveal that they have unexpected sandblasted surfaces, which are almost smooth to the touch.

The Pilgrimage Church of Mary, Queen of Peace, at Neviges is one of the largest ecclesiastical spaces created since World War II and embodies one of the principal findings of the Second Vatican Council, namely the unifying concept that a church should no longer be a "sturdy fortress of belief" but rather a "tent of the nomadic people of God." The idea of movement permeates the whole building—a pilgrims' path beginning at the local rail station follows waves of steps to its goal, a prayer room shaped like a market square. Exterior and interior are linked visually by the pilgrims' footpath, which continues on into the church. The church's interior is enough to delight any pilgrim—there is a recurring rose motif, the symbol of the Mother of God, and sunlight falls through a huge rose window behind

Cologne Cathedral

The identity of the Three Kings who visited Jesus soon after his birth continues to be disputed to this day. Were they astrologers, wise men, or indeed kings who had set off to bring gifts for the newborn king of the world, as Christian sources suggest? And where did they go after they had worshiped the holy child? Whatever happened in the intervening centuries, the kings' relics found their way to the banks of the Rhine in 1164 and have been attracting hordes of pilgrims ever since. It soon became clear that a new building was necessary in order to preserve the relics in an appropriate setting. Archbishop Engelbert I (1216–25) made plans for a new cathedral, but the foundation stone was not laid until August 15 1248. The

building was not only intended to be the most imposing church in the town; it was also to be a "perfect cathedral," the apotheosis of all the Gothic buildings that had preceded it. Master Gerhard, the first cathedral master mason to be mentioned by name, produced coherent plans for the entire structure. The

An aerial view of Cologne Cathedral on the Rhine

appearance of the church, which was not completed until 1880, is essentially that laid down in his plans.

From no matter what direction it is approached, the cathedral towers toward heaven. On summer evenings, especially when the air is mild and the fading daylight bathes the building in a deep blue, the stylistic unity of the magnificent architecture exerts a magical influence—not for nothing is Cologne Cathedral considered one of the greatest ecclesiastical edifices in the world. Despite the many discernible French influences, in particular from the cathedral at Amiens, this symmetrical structure has a form that is all its own, typified by the latticed spires. Visitors to the cathedral will find any number of paintings, sculptures, and carvings representing both the typical iconography found in Christian churches everywhere and the history of Cologne in particular—but the focal point has always been the bones of the Three Kings in their precious golden shrine.

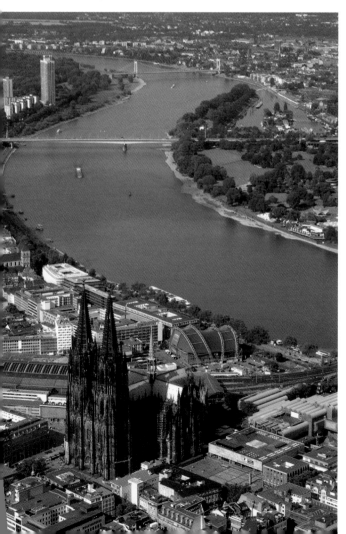

St Gereon's Basilica, Cologne

Although Cologne Cathedral is undeniably the most famous building on the Rhine, it is surrounded by 12 magnificent Romanesque churches, which together with the cathedral form a heritage site of international impor-

The decagon tower, St Gereon's Basilica, Cologne

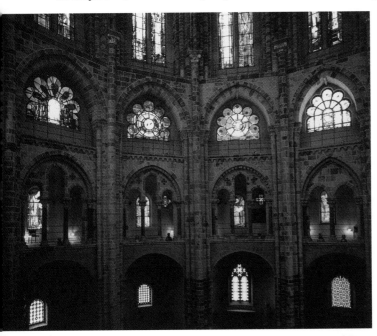

example in the semi-circular niches of the unique decagon towering above the floor. The dome was one of the largest of its time, second only to the Byzantine dome of the 6th-century Hagia Sophia in Constantinople. However, when the mighty Renaissance cupola of the cathedral in Florence was constructed in the early 15th century, it was larger than both.

Legend has it that Helena, the mother of the emperor Constantine, built a church on the site of the tombs of St Gereon and some 300 members of his Theban legion, who had resolutely refused to participate in emperor Maximian's persecution of Christians and suffered a martyr's death as a result. There is little historical evidence that the bodies found in graves on the site were troops from this legion, but the structure is undeniably built over a 4th-century Roman cemetery. Several parts of the

tance. Each church radiates harmony and tranquility and in places the Romanesque architecture is sublime. St Gereon holds a special place among Cologne's Romanesque churches—this wonderful old building still retains the magic of medieval architecture, for

oval with its eight niches and sections of the somewhat larger apsidal niche also date back to classical antiquity and are clearly visible in the walls of the decagon. The old apse was replaced when a longer nave was built between 1060 and 1062, and a splendid fresco

of Christ in a mandorla (an almond-shaped aureole) has been preserved in the new apsidal niche. Christ enthroned is surrounded by the evangelists with their insignia, and Mary and Joseph are recognizable at his side. The dramatic ground floor niches house bishops with drawn swords attacking tiny figures, representing the victory of virtue over vice, while the niches between the windows hold images of knights, perhaps members of the Theban legion.

The original central-plan structure was mostly rebuilt between 1219 and 1227, giving rise to the unique decagon, which still impresses visitors today.

Aachen Cathedral

Aachen is located where three countries meet—Germany, Belgium, and the Netherlands—and this old impe-

The interior of Aachen Cathedral

rial town, with its ancient history and its living tradition as a pilgrimage site, attracts millions of visitors every year.

The cathedral, the episcopal seat of Aachen, represents the goal of many of these journeys. The construction of this great church dates back to Carolingian times: Charlemagne began work on the central octagon of the Palatine Chapel at the end of the 8th century, basing it on the similarly octagonal Byzantine building of San Vitale in Ravenna. The modern building features two later additions, the Gothic choir to the east and several side chapels in the west elevation. Aachen was the hub of the Holy Roman Empire during the reign of Charlemagne and this octagon was the most impressive domed building north of the Alps. Several of the columns date back to classical antiquity. The atmosphere in this part of the cathedral is solemn, without being oppressive, and this is particularly noticeable when the 48 candles of the huge chandelier (the Barbarossa chandelier) are lit to celebrate the Virgin Mary.

Even today there lingers an impression of the power of the emperor, which was second only to that of God himself, and the Carolingian throne, which was originally decorated with items plundered from the Church of the Holy Sepulchre in Jerusalem, is still located on a dais from

which the emperor would have partici-
pated in the Mass. Above all of these
trappings of authority there is in the
cupola a mosaic of Christ in majesty
as the triumphant Ruler of the World.

Charlemagne was buried in the
Palatine Chapel immediately after his
death and the mortal remains of the
emperor, who was later canonized,
are still to be found here. However,
most pilgrimages to Aachen have as
their goal the relics in the Shrine of
the Virgin Mary—the "Aachen Pil-
grimage" began in 1238 and has been
held every seven years since 1349. The
shrine contains the swaddling clothes
and loincloth of Christ, Mary's gown,
and a cloth from the beheading of
John the Baptist. The last pilgrim-
age here took place in 2007 with the
slogan: "Come and see!" For centuries,
people from all over the world have
been drawn to Aachen Cathedral not
just to experience the Divine but also
to witness it with their very own eyes.

door, reminiscent of the eye of God or
the Trinity. The chapel is dedicated to
Nikolaus of Flüe, a Swiss hermit and
holy man. Light penetrates into the
cave-like building via tubes set in the
concrete and closed off with stained
glass, and further illumination comes
in from above through an aperture in
the shape of a raindrop. Rainwater does
indeed fall into the chapel, collect-
ing on the ground, and the floor upon
which visitors stand is made of molten
lead and follows the contours of the
plowed earth beneath; the local area
subsisted on agriculture and lead-ore
mining. The age-old natural elements
of earth, water, and air are joined by
fire. During construction, the concrete
shell of the chapel was surrounded by
scaffolding made of solid tree trunks,
and after it was finished the timber
was carefully burnt inside the chapel.
The scorch marks and the prints of the
trunks can still be seen and smelled,
immortalized in the concrete. Incor-
porating the basic elements of nature
and offering them up to the senses, this
chapel radiates a sense of holiness.

The "Brother Klaus" Chapel, Mechernich-Wachendorf

A chapel was built on the outskirts
of a small village in the Eifel region
a few years ago and the enormous,
reinforced concrete edifice can be seen
for miles around. Rather resembling a
guardhouse, the pentagonal concrete
block conceals its magic behind a thick
wall. Visitors enter via a triangular

Limburg Cathedral

Some Germans may remember the
third issue of West German currency—
Limburg Cathedral was depicted on
the reverse of the 1,000 deutsche

Limburg Cathedral

mark note—but the cathedral is even more impressive in reality. It is viewed by more people than almost any other church in Germany, if only fleetingly—you catch a brief glimpse of this architectural masterpiece, which has stood for 1,000 years on its little island in the Lahn, from the A3 freeway bridge. The first documentary evidence of the church dates back to 910, when Count Konrad Kurzbold established a religious foundation here. The original church, presumed to be a pillar basilica, is preserved only as an outline in the modern nave, and dating of the original construction of the current church is still disputed. It was built as a convent and parish church some time around 1190, combining Romanesque and Gothic elements, and has been the cathedral of the archiepiscopate of Limburg since 1827.

The building occupies a magnificent site on an island right next to the castle. The nave is almost square and the seven spires ascending to heaven seem almost to taper to a single point. The mighty structure has been painted a resplendent white and red, and the building's location and the harmonious interplay of its architectural features make it the peaceful heart of the whole city. The interior is also a source of tranquility, and is a similar mixture of styles: the columns and arcades are Romanesque, while the two vaults above the central nave are Gothic,. The various elements of this beautiful space combine to create a sense of movement and serenity, making it not only a footnote in architectural history but a living place of worship.

Eibingen Abbey

St Hildegard of Bingen has been revered for centuries. Born into the landed nobility in 1098, she died in 1179 and the details of her life are vague. Even as a child she had visions, which became more frequent as she grew older, and these were written down and distributed from 1141. Princes, kings, bishops, and even the pope began to take an interest in her prolific output, and her prophecy of a schism in the Church became particularly well known. Apart from her spiritual works she composed treatises on healing, gardening, herbs, music, and nature, which are still consulted today. Hildegard is considered the first Western doctor to publish her findings.

It is therefore unsurprising that she is venerated by those who undertake the pilgrimage to the abbey and parish church of Eibingen, a small town in the Rheingau area. The Abbey of St Hildegard and St John houses both an altar to St Hildegard and a reliquary, which is visited as part of the annual St Hildegard pilgrimage. The gilded reliquary resembles a miniature building, with the four cardinal virtues represented allegorically on the doors—justice, wisdom, courage, and moderation.

The shrine contains the skull, hair, heart, tongue, and bones of St Hildegard, as well as relics from several other saints. Hildegard was doubtless a remarkable woman and her writings on nature and medicine in particular outline an approach to healing that

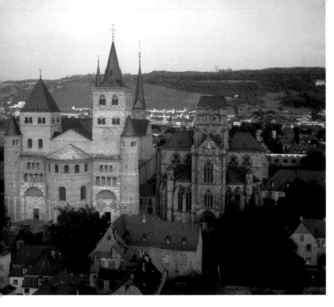

Cathedral and Church of Our Lady, Trier

closely resembles and even antici-
pates modern natural remedies and
complementary medicine. Hildegard,
a medieval lady, reveals herself as
a modern woman who had insights
far ahead of her time—no wonder
she is so highly regarded now.

Cathedral and Church of Our Lady, Trier

Although two separate churches, the
cathedral and the Church of Our Lady
in Trier occupy a single site, attesting to
the long history of Christianity from its
earliest days to the present. The origins
of this twin church complex date back
to the time of Con-
stantine. According to
legend, Helena,
the emperor's
mother, bequeathed
Trier's early Christian
community a relic
of a piece of Christ's
robe and also a part
of the imperial
palace in the city.
The latter became
a mighty complex
of at least two large
basilicas—a south-
ern church, of which
nothing now remains,
and a northern church, of which sec-
tions were incorporated into the basic
structure of the cathedral. **Trier Cathe-
dral** is essentially the oldest church in
Germany and has enjoyed uninter-
rupted use as a meeting place for the
Christian community since ancient
times. The building was extended to
the west by Archbishop Poppo von
Babenberg (1016–47) and the ancient
chapel became a Romanesque church;
the results of this seamless conversion
are still visible today. The pilgrimage
of the Holy Robe is well known—the
cloth is said to be part of the tunic worn
by Christ on his way to his crucifix-
ion, and its arrival in the cathedral
on May 1 1196 is well documented.
Pope Leo X decreed a pilgrimage to
the cloth every seven years starting in
1515. Although the intervals between
pilgrimages later became longer,
hundreds of thousands of people
nonetheless undertake the journey
to Trier when one is announced.

The **Church of Our Lady** (built between 1235 and 1260) was one of the first buildings to be completed during Germany's classic Gothic period, and motifs borrowed from French ecclesiastical architecture, especially Reims Cathedral, are immediately apparent—the double-storey structure, the ribbed vaulting, and the tracery windows are the first instances of these features

Church of the Rock, Idar-Oberstein

recorded in Germany. The design incorporates these elements in a novel way: the church is really a symmetrical building composed of two three-naved elements laid across one another, one of which has been extended to form the apse of the chancel. It is likely that the slightly eccentric design was based on some late classical predecessor, but the result is the creation of a building with a very intimate atmosphere. The eyes and thoughts of visitors are drawn heavenward by the Gothic architecture and a sense of security pervades the space. The church and cathedral form an ensemble that remains the spiritual heart of this city on the Mosel.

Church of the Rock, Idar-Oberstein

This small town on the Nahe and Idarbach rivers is famed for the local deposits of gemstones and the long tradition of its jewelry trade. The striking church that has been built into a natural cave in the cliff above Oberstein has also attracted its share of attention. The castle of Bosselstein, high up on the cliff, was once the home of the Lords of Stein and is first documented in the 11th century. Legend credits the brothers Wyrich and Emich with the

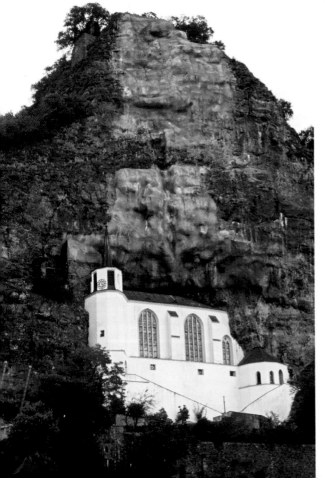

foundation of the church on the "Upper Stone," which gave Oberstein its name. Both brothers loved the same woman, Bertha von Lichtenburg, and when Wyrich, the elder, learnt of her engagement to Emich, his rage and jealousy led him to throw his younger brother out of the window to his death. Overcome with remorse, he left home and went to fight in the wars, hoping to end his own life. Many years later he returned to his home, outwardly unscathed but still nursing guilt in his heart. He confessed the terrible deed, and his penance was to build with his own hands a chapel in the rocks where his brother had been killed. When it was completed, he begged for forgiveness and a spring appeared in the rocks, which still flows to this day. Although he had survived the wars, Wyrich's life was nevertheless cut short—as the chapel was being consecrated, he dropped dead before the altar. Whether the story is actually based on fact is open to question, but it is still recounted today, not just to account for the building of the chapel but also as a warning against hasty action.

The modern church dates back to 1482–4 and was built by Wirich IV, a descendant of the unhappy Wyrich of the legend. This striking medieval building is accessible only through a tunnel, which was excavated in the 1980s. Only the altar triptych depicting the Passion of Christ interrupts the simplicity of the church's interior. The site has been frequently badly damaged by the effects of the spring and of rock slides. Restoration work is regularly undertaken to preserve this beautiful church. It is especially popular for weddings, perhaps because the location is considered romantic or perhaps because it echoes with the old story of Wyrich, Emich, and Bertha.

Mainz Cathedral

The cathedral has been a mighty presence in this city on the Rhine flood plain for more than 1,000 years. Beginning in 746, St Boniface was to make Mainz, the meeting point of several ancient migration routes, the most important Christian hub north of the Alps. During the incumbency of Willigis as Archbishop of Mainz (975–1011) and chancellor of the Holy Roman Empire, the city was known as a "second Rome." Willigis laid the foundation stone of the cathedral in 975, but in 1009, one day before it was due to be consecrated, the building was destroyed by fire and it was not until 1036 that the cathedral was finally blessed. The bronze doors of the market portal, the oldest surviving part of the modern building, date back to this period.

After the cathedral had burnt down a second time, a new building was begun in 1081. Construction work was continually delayed, with Archbishop Siegfried III carrying out the final consecration only in 1239. Even this was not the end of the cathedral's building history—there were constant additions, alterations, and renovations.

The east choir is a Romanesque structure, and the west side of the

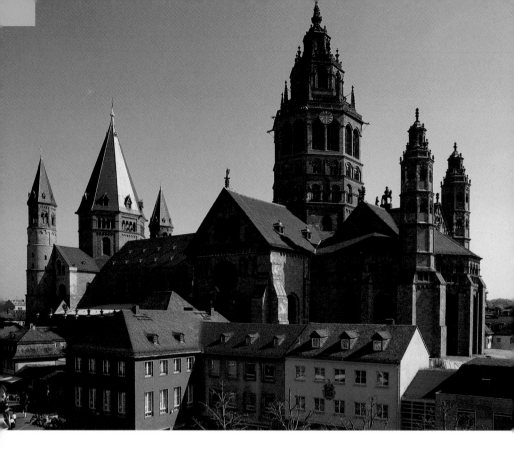

The Cathedral and Old Quarter, Mainz

cathedral is dominated by an enormous spire with a baroque tip designed by Franz Ignaz Michael Neumann, the son of the more famous Balthasar Neumann. The rows of chapels in the interior have Gothic tracery windows whose stained glass, rather than being medieval, was designed and fitted after World War II. The two-storey cloister, built between 1400 and 1410, is an oddity in that it covers only three sides—presumably the fourth was omitted to preserve the windows in the side chapels installed along the nave in the 14th century. The square Gotthard Chapel was built in 1137 beside the north transept as a palace chapel for the archbishop—the episcopal palace used to abut the cathedral here. It is now used for daily Mass.

The architecture and the tombs of influential leaders (both sacred and profane) attest not only to 1,000 years of history but also to the cathedral's role as a living place of Christian faith in the city.

Worms Cathedral

Placing his faith in God, Martin Luther made his journey to Worms in 1521 accompanied by an imperial escort—the young emperor, Charles V, had summoned him for an audience. On April 18 Luther delivered a long speech, first in German and then in Latin, propounding his articles of faith, which were to effect a schism in the Western Christian Church. Having severely criticized ecclesiastical tradition and proposing only the Bible as a proper guide to the conduct of a Christian life, the young monk ended his discourse with the words, "God help me. Amen." The episode was to make Worms Cathedral famous throughout the world.

The foundation stone of the cathedral was laid in 1130 and the building was completed relatively quickly, within 50 years. Narrower and steeper than its cousins in Speyer and Mainz, the cathedral at Worms was built at the highest point of the city, where the forum and temple had stood in Roman times. These had crumbled with the Roman Empire, but rubble from the ruins was incorporated into the new building. The cathedral's history is closely interwoven with that of Burchard of Worms, who became archbishop in 1000 and commissioned the new church soon afterward. The five-naved body of the church has two choirs, and the visitor's gaze is drawn to the groups of towers at the east and west ends of the building. Each crossing tower is octagonal, although the neighboring stair towers are round and lend the building the appearance of a medieval castle. Little remains of the original interior but it is difficult to miss Balthasar Neumann's baroque high altar (1738–40). The cathedral has been under constant threat. The city was besieged by the Swedes during the Thirty Years' War (1618–48), when it served as a Protestant church. The most perilous period came during the Nine Years' War—in one fateful year, 1689, Heidelberg, Speyer, and Worms were all almost completely destroyed by Louis XIV's troops. Worms was occupied by the French in 1792 and the cathedral was used as an ammunition dump and stable. The cloisters were demolished at the beginning of the 19th century and renovation and refurbishment work began again in 1886, finally being completed in 1935. Badly damaged in World War II, the cathedral was once again rebuilt and now stands in mute witness to its turbulent history.

Speyer Cathedral

It is known that there were Celtic settlements at Speyer, although archeological evidence from that period is scanty. The city does, however, possess one of the richest displays of medieval architecture in the Imperial Cathedral Basilica of the Assumption and St Stephen. After the destruction of the monastery at Cluny during the French Revolution, it became

the largest surviving Romanesque church in Central Europe, and its emperor-size dimensions speak for themselves—the building is 436 feet (133 m) long and 100 feet (30 m) highNo other Romanesque church even approaches such proportions.

Speyer Cathedral

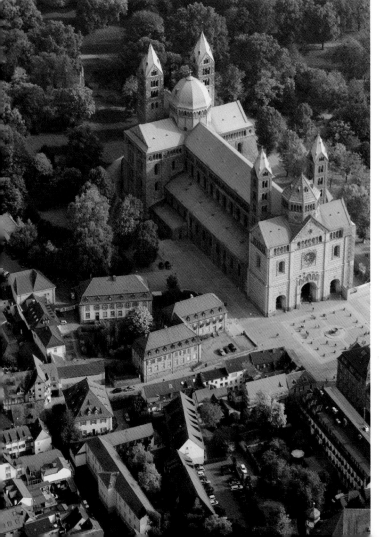

The foundation stone was laid on June 12 1030 during the rule of Conrad II, who had become King of Germany in 1024 and Holy Roman Emperor in 1027 and desired a suitable memorial of his reign. On his death in 1039 he was buried in the still unfinished church, which was not to be completed and consecrated until 1061, by which time his grandson, Henry IV (1056–1106), had ascended the throne. There were further alterations and extensions, with the church's overall modern-day appearance dating back to 1106. The church was ransacked and set on fire so frequently that it became quite dilapidated, and in the 19th century there were serious moves to have it demolished. Fortunately it was left as a ruin before being restored completely in the 19th and 20th centuries so that it once again stands proudly over its home town in the Palatinate on the Rhine.

The cathedral's monumental dimensions and abrupt verticals

pull the observer's eyes upward, making the building seem enormous, and it may well be that the original commission was intended to emphasize the magnificence of its imperial master. However, the Romanesque architecture blends together so harmoniously that, while impressive, it does not intimidate the observer with the power of the Divine. Speyer has always been a destination for pilgrims from all over the Holy Roman Empire. Visiting the cathedral is worthwhile at any time of the year, but the great festival held on August 15, the Feast of the Assumption, promises a very special spiritual experience, with torchlight processions through the cathedral grounds.

The Heiligenberg in Heidelberg

Ascend from the banks of the Neckar in Heidelberg via the Philosopher's Walk and the Celt's Path and after about an hour's walk you will reach a sacred place that was settled as far back as the Neolithic period (5000–4400 BC). Few areas in Germany have a religious and ritual history to compare with this hillock north of the Neckar—there was a shrine here even in Celtic times and the hill was known as the "Mount of the Gods." The Romans later conquered the peak, marking out their own sacred precinct and erecting stone buildings around a temple to Mercury, which has survived in part to this day. There are remnants of a Mithraic temple, and some carved stones suggest the site may also have been a place of worship for the Germanic god Wotan: the Latin inscriptions prove that the temple was sacred to Mercurius Cimbrianus, known to the Cimbri tribe as Wodan. In Roman mythology, Mercury accompanied the soul after death and so it is unsurprising that a Christian shrine was erected here to the archangel Michael, who fulfills a similar function in Christian belief. The Christian monastery of St Michael was founded in 870 and Arnold, a Benedictine monk, built the nearby monastery of St Stephen in 1090. Both buildings are now just ruins.

The location's long history as a sacred place was perhaps what invited the construction in 1935 of a modern *thingstead* (council meeting place) on the site—an unsettling and unmistakably Nazi initiative, it suited the regime to adapt this historic place to their racial ideology and neo-pagan pseudo-religion. Fortunately, little remains of the structure today—visitors will quickly be able to locate the site, but it is fascinating and in a way comforting to discover how in only a generation the forces of nature have turned the martial parade square into a garden of stones, which flourishes in the summer. The sun shines down, lizards warm themselves on the hot stones, and the wonderful scent of thyme, a symbol of strength and power, fills the air.

Cistercian Monastery, Eberbach

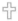

After the monastery was dissolved in 1803, the fortunes of the building were varied—it was used as a mental institution until 1849 and subsequently as a prison until 1912. However, just before it became completely derelict, the authorities took the decision to restore it and conservation work has been underway since 1929. Today, something of its original spirit can now be detected and the monastery has readopted an old Cistercian motto, *Porta patet, cor magis*

Eberbach Monastery

Archbishop Adalbert I of Mainz founded the monastery in 1136, after a meeting with Bernard of Clairvaux. The first monks came to the Rheingau from Bernard's monastery and the community grew rapidly. The monastery was damaged extensively during the Peasants' War (1525) and the Swedish occupation of the Thirty Year's War (1631). However, the building was rejuvenated in the 18th century when a baroque residence for the abbot, an impressive refectory, and a beautiful garden with an orangery were created, and today the monastery retains its 18th century appearance. Construction of the monastery chapel, a long basilica, was begun in 1145 and completed in 1200. The low chapels in the transept are noteworthy, as is the way light falls through the high windows into the simple interior.

This medieval abbey church is a fine example of the austere, balanced architecture favored by the Cistercians, although Eberbach does not just consist of a church but a whole complex of buildings, attesting to its long monastic history. The cloister between the north and east wings is an especially beautiful place of quiet reflection and peace. The 900-year-old church is often used for weddings and Eberbach is also famed for the vineyard adjacent to the monastery.

("The door is open, the heart even more so"), both on its website and in real life.

The "Blautopf," Blaubeuren

This magical place near Blaubeuren in the Swabian Mountains is one of the largest karst watercourses in Germany. The funnel-shaped spring—the source of the Blau stream, which flows into the Danube at Ulm—is 70 feet (21 m) deep and can produce up to 8,450 gallons (32,000 liters) of water per second. Beneath the surface there is a system of caves leading deep into the earth, which has not yet been properly explored and thus still retains its mystery. Far beneath the spring there is a large rock cavern named after the lyric poet Eduard Mörike, creator of the *Story of Beautiful Lau*, a water sprite with long, flowing hair who was banished to the Blautopf until she learned how to laugh. There are still those who believe that the spring is bottomless and that any attempt to explore it will be thwarted by Beautiful Lau. The Blautopf is a truly magical place—try as you might to peer into its pure blue waters it is impossible to see far below the surface, as if another, parallel world, impenetrable to man, lies concealed in its depths. The deep azure color exerts a strange power over people, drawing them in. Blautopf is not sacred because of the stories that surround it, but rather

The "Blautopf," Blaubeuren

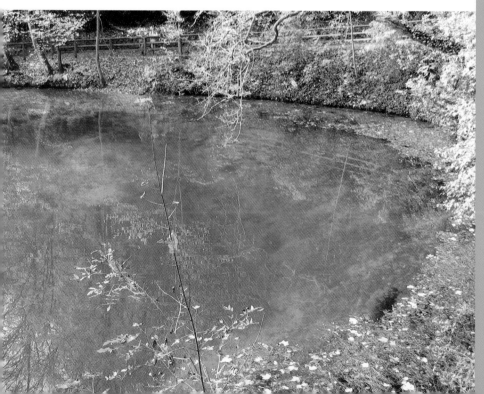

because it evokes a particular mood in the sensitive onlooker, suggesting there is something beneath the surface that banishes all superficial thoughts.

Freiburg Minster

The medieval buildings, small streams and beautiful marketplace of Freiburg's Old Town form a fine sight. The late Romanesque minster has formed the central point of the old district since 1200, when work on it first began. Construction continued from 1230 in the French Gothic style, at which point the 380-foot (116-m) tower topped with a spire—the tallest structure in the city to this day—was added at the west end. The cultural historian Jacob Burckhardt described this in 1869 as the "most beautiful tower in Christian architecture." Its latticed tip and delicate tracery still look down on the city with sublime serenity today.

Construction was halted for a time but the chancel was completed in 1510, and the minster has been the cathedral seat of the episcopate of Freiburg since 1827. The rich sculptural decoration in the vestibule, illustrating tales of salvation from the Old and New Testaments, is an artistic highpoint. The interior features several works of art complementing its architectural beauty—Hans Baldung Grien's high altar, Hans Holbein the

The spires and transept of the Freiburg Minster

Younger's altarpiece, and the medieval stained glass, some of which was donated by the various artisans' guilds.

The famous altar triptych (1512–16) by Hans Baldung Grien depicts the Coronation of the Virgin, the patron saint of the minster. The reverse depicts the Crucifixion. Hans Holbein the Younger's altarpiece (1521) is located in the University Chapel, one of the choir chapels grouped around the high altar. A further feature is the 17th-century "fasting cloth" which is hung across the chancel during Lent.

The harmony of the architecture and the wealth of art treasures make Freiburg Minster a cultural monument of particular importance, but the church is not a museum—it is regularly attended and plays an important part in the life of the community.

Ulm Minster

The first parish church in Ulm was erected in the fields beyond the city walls, but when Charles IV besieged the city in 1376, it was decided to build a church for the community—until that time, the only church to be situated within the city walls belonged to the monastery of Reichenau. At first a church hall was planned, but this was then changed to a basilica with a wide transept. Ulrich Ensinger, one of the leading masons of the period who was at the same time also working on cathedral projects in Strasbourg and

Esslingen, was hired in 1392. He led the building work in Ulm until his death in 1419, designing a mighty west tower that could compete with any spire in France. The nave was completed in 1405 and the church was consecrated, but the tower took a little longer to finish. Some 100 years after completion of the nave, the masons of the time discovered the unforeseen consequences of the plan to build the tallest spire in Christendom—the foundations and central nave would have to be shored up. During the period of the Reformation the church became Protestant. Work was halted in 1543 and was not resumed until 300 years later, when masons returned to the site to complete the mighty tower to Ensinger's original plans. The church was finally completed 513 years after the foundation stone was laid. Its sheer height (530 feet/161 m) and the bold design of the latticed stonework lend the spire an air of delicacy, despite its monumental size.

The interior is similarly impressive. Although reforming iconoclasts removed much of the original decoration, some remarkable works of art have survived. The fresco of the Last Judgment on the arch above the choir is a striking medieval homily: angels with trumpets proclaim the Last Judgment, which no man shall

escape. On the left-hand side, St Peter leads the saved up a flight of steps to heaven, while on the right the devil drags sinners down to hell. Christ is represented as sovereign over all in a mandorla topped with a rainbow, a sign of hope and of the covenant that God made with the world.

The *Man of Sorrows* by the Allgäu sculptor Hans Multscher is similarly exquisite and moving—this devotional work introduced the so-called "beauti-

The tallest spire in Christendom—Ulm Minster

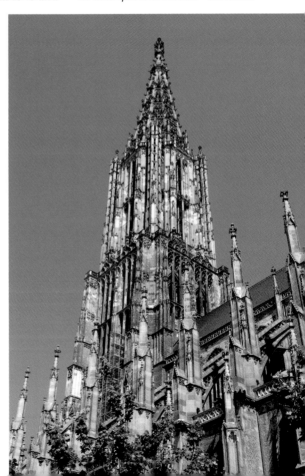

ful style" in 1429, depicting the suffering of Christ in a remarkably realistic manner. The world's pain and the love of God are united in this wonderful statue.

Several modern windows (2001) in the transept have replaced the old ones destroyed in World War II. They use contemporary imagery to represent the world in danger; their modern take on the end of the world merges seamlessly with the church's message.

The source of the Danube, Donaueschingen

Rivers flow downward—as anyone who has ever watched a river as it flows past will have observed. Whether a fast-flowing river or a leisurely, meandering stream, a river is symbolic of what has been and what is to come. But where do rivers come from? It is a question that has been posed for thousands of years. It is only natural therefore that men should seek to find the sources of rivers, and not simply to satisfy our curiosity from the geographical point of view, but also because rivers symbolize origins and the natural essence of things. Many rivers across the world are revered as sacred and are often connected with gods, and this is certainly true of the Danube, which the Romans associated with the river god Danubius, who also featured on Roman coins. The source of a river may not be immediately apparent however, the Danube supposedly had two or even

three sources, each of which appeared to be the real one. The matter has since been settled by experts and the actual source has been found to be the Breg steam at Kolmenhof, near Furtwangen, the furthest point from the mouth of the river. From here the Danube flows a distance of 1,727 miles (2,779 km) across Europe to the Black Sea.

The source of the Danube still retains a simple beauty, even though man has intervened here and erected a stone monument over the spring, which is in the grounds of the castle at Donaueschingen—nevertheless, it has been carried out tastefully and creates a pleasing scene.

In its site near the Fürstenberg stables, the source of the Danube is another place in which people can find peace and reflect upon how futile it is to attach significance to the exact source of something—it is far more important to remember what can become of such small beginnings.

Edigna's lime tree, Puch

A tree is not merely a tree—it stands for much more. A tree has roots and extracts nourishment from the water it takes from the soil. The sun makes it grow and during the course of its life it rises up from the ground; trees connect the earth and the sky. In many cultures, trees are sacred or form a locus of the Divine—the Slavs believed that the gods lived in trees and according to north

German creation myths, humans are descended from trees. In many cultures, trees are believed to possess souls. Trees have time on their side, already present when we are born, they are still there when we die, outliving humans. Trees grow slowly symbolizing patience and the future. Small wonder, therefore, that there are many places on earth where trees are revered as sacred.

One such example is Edigna's lime tree, which grows in the small town of Puch, near Munich. The daughter of Henry I of France and a Ukrainian princess, she refused the marriage that had been arranged for her. Legend has it that in 1074 she was led to this very tree by a cockerel and from then on would receive the sick and desperate here, saying prayers for them and healing them. Edigna is said to have died in 1109 and her remains have been preserved in the church at Puch since the early 17th century. Pilgrims have regularly visited the lime tree in the hope of finding fulfillment and answers to their prayers. This sacred place illustrates how Christian belief and natural religion can intermingle and how such faith can be kept alive over centuries.

Frauenkirche, Munich

More correctly known as the Metropolitan Cathedral of Our Blessed Lady, the church hardly transports you straight to Jerusalem, and yet this is what was intended by the original builder when he designed the characteristic onion domes that top the twin towers. These magnificent Gothic towers are square in shape and consist of seven tiers that taper as they rise, symbolizing the seven days of the Creation. The towers are octagonal in shape at the top, the uppermost tiers with two small windows set into each of their eight sides, blending particularly well with the rest. When the church was consecrated in 1494, the towers were still open to the elements. From their construction it seemed natural to cap them with steep spires, but the familiar onion domes were erected instead, copying the Temple in the Holy Land and perhaps an anticipation of the heavenly Jerusalem.

The Frauenkirche has a simple, elegant appearance. Tall, narrow windows are set into the imposing walls of the nave, which are otherwise devoid of decoration—the windows nearly touch the ceiling, drawing the gaze heavenward. The church seems almost reticent in comparison with other High Gothic edifices, but deliberately so, and this sense of simple beauty continues in the interior. Visitors are always amazed by the light that floods through the windows, only emphasized by the unadorned pillars that shoot up into the vaulted ceiling. Depending on the play of the light, the octagonal columns take on darker or lighter hues, symbolizing the light of divine illumination.

The Frauenkirche is a resplendently beautiful building, especially following its most recent renovation, which replaced the cool feel of the post-war restoration with warmer tones; the gentle ochre of the vaulted ceiling

and the delicate blue-grays and off-whites of the stonework underscore the impression of nobility and elegance.

Andechs Abbey

Sacred places have an almost magnetic attraction—and Andechs Abbey in the diocese of Augsburg, east of Lake Ammer in Upper Bavaria, is no

The Frauenkirche, Munich

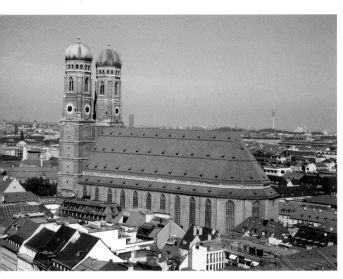

exception, attracting visitors from all over the world. It is principally famous for the beer that is brewed here.

Andechs castle once stood on the site that is now occupied by the abbey.

The monastery's religious history dates back to the 10th century, when a certain Count Rasso brought three Holy Hosts back from the Holy Land. Considered a "holy mountain" by 1128, the castle mound soon became the destination of many pilgrimages and Andechs Abbey has stood here since 1392 to care for the needs of the travelers. It now serves as a Benedictine monastery and the formerly Gothic church has been reconstructed in the rococo style. It was first documented as an inn in 1438, establishing a tradition that still endures to this day.

The abbey's economic concerns now include the brewery, a restaurant, several agricultural enterprises, and a conference center. Modern visitors may not get an immediate sense of the holiness of the hill on which the abbey stands, however— too many people come here just to sample the beer. Andechs Abbey is nonetheless one of the oldest and most significant places of pilgrimage in Germany, and both the Holy Hosts and the skull of St Hedwig, which has been kept here since 1929, are revered by many of the faithful who visit the site. Piety and *joie de vivre* are not mutually exclusive, as this sacred place proves.

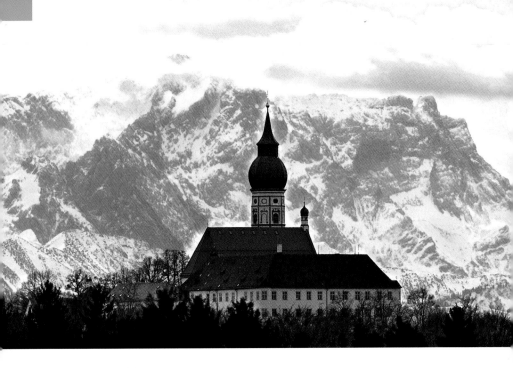

Andechs Abbey and the Zugspitze

Steingaden Abbey

In 1730 the abbot of Steingaden mon-astery decided to hold a procession on the Good Friday of that year, and he commissioned two monks to make a statue of Christ. The monks hurriedly collected parts from other broken statues and assembled them into one figure, before wrapping it in cloth and painting it. It was then attached to a newly made whipping post using heavy chains and carried during the next four processions, before eventu-ally being allowed to retire owing to its rather shabby appearance. It was initially stored in the attic of an inn

and then transferred to the Auf der Wies farm estate belonging to the Lory family, who used it in private worship.

On June 14 1738 the first miracu-lous phenomenon occurred when the farmer's wife thought she saw the figure of the scourged Christ shed-ding tears. She told the prelate of the monastery what she had seen, but he suggested she remain silent. News of the occurrence spread like wild-fire, however, and the first pilgrims to "Christ on the Meadow" began to arrive. The family built a small chapel for the statue; it is still visible today, on the edge of an enormous car park.

This chapel soon became too cramped for the many pilgrims who

came to visit, even after it had been extended. In 1745 construction began on the modern pilgrims' church, which was consecrated in 1754. Viewed from outside, the building is a relatively simple rococo affair, but step inside and you are greeted with an explosion of extravagant ornamentation and decoration.

The two-storey, richly detailed high altar surrounding the statue is the focal point of the church. The visitor's gaze is inexorably drawn up toward the wonderful oval fresco in the low cupola, which was painted by Johann Baptist Zimmermann between 1753 and 1754.

The principal theme of the magnificent fresco is Christ's act of sacrifice and redemption in becoming flesh. One side depicts the gates to the afterlife, which are closed and crowned with a serpent, the symbol of eternity. Chronos (symbolizing time) lies defeated on the floor. The other side shows the throne of the Judge of the World, and a rainbow that connects the heavens above each scene is crowned with an image of the victorious Christ. The fresco signifies that although time will be no more, the covenant made between God and man is eternal, as symbolized by the rainbow.

Benediktbeuren Abbey

The number of churches and monasteries concentrated in the stretch of land bounded to the north by Munich, to the east by the Isar and Loisach

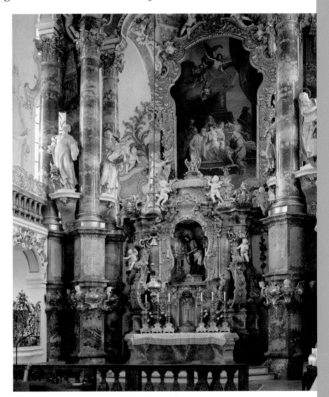

The high altar at Steingaden Abbey

rivers, and to the south by the mountains, have earned it the nickname "Priest's Corner." The imposing abbey of Benediktbeuren is also located in this area; it has given its name to a

nearby town, which was originally called Buron. The present appearance of the monastic complex dates from the 17th century, when it was expanded significantly, although St Boniface founded the Benedictine monastery in 739, establishing a scriptorium and school here. In about 800 Charlemagne gifted the abbey a bone from the forearm of St Benedict of Nursia. This donation saw the monastery's reputation grow until it eventually became one of the major sites of worship of the saint in southern Germany. The abbey was pillaged by the Hungarians in the mid-10th century but was rebuilt soon afterward.

The skull of St Anastasia, the patron saint of the relief of headaches and nerve pain, was brought to Benediktbeuren in 1053. Anastasia is also credited with the miracle of Lake Kochel: in 1704, during the War of the Spanish Succession, Tyrolean soldiers decided to attack the abbey. Seeing them start to approach across the frozen lake, the monks cried out to St Anastasia, who raised the temperature to such a degree that the ice melted and the attackers were forced to beat a hasty retreat. Between 1751 and 1753 Abbot Leonhard Hohenauer built a pilgrims' church dedicated to the saint, which has become a gem of rococo architecture.

A third saint is venerated here, St Leonhard, the patron saint of farmers and farm animals, particularly horses. St Leonhard's Ride is held annually in his honor, when both the horses and their riders are blessed.

Until its dissolution in 1803, the abbey was run by Benedictine monks and was known both as a destination for pilgrims and as a place of learning and scholarship. The heart of the abbey complex is formed by the high baroque church with its twin onion domes. Inside, the gleaming white walls and columns are intended to symbolize light and purity. The broad curves of the vaulted ceiling are decorated with lavish frescos depicting scenes from the life

Benediktbeuren Abbey

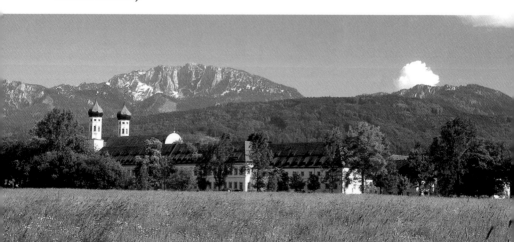

of Christ. The monastery grounds and the serenity of the pretty Romanesque-Gothic cloisters lie to the south of the church. In 1930 the Salesian monks of Don Bosco acquired the dilapidated estate and over the last three decades have restored it to its former glory. Benedikt-beuren is once again a center for scholarship, ecology, and culture, as well as being a pilgrimage site attracting tens of thousands of visitors annually.

The Chapel of the Miraculous Image, Altötting

Altötting

In 877 King Carloman founded a choir collegiate church here, which was later to become his last resting place. It is likely that the small octagonal chapel that now serves as a baptistery also dates from this time. This chapel now also houses a small statue of a Black Madonna and Child, both depicted wearing gowns, which is venerated as a Miraculous Image.

Ötting (present-day Altötting) became a famed center for Marian worship, and although the monastery was destroyed by the Hungarians in the 9th century, the chapel was spared. A new collegiate church was built in 1228 and the chapel was entrusted to the choir school. The original octago-

nal chapel was augmented with a late-Gothic church surrounded by a cloister to shield pilgrims from the weather. The cult of the Virgin Mary here was reinforced when the first miracle was claimed in 1489. News that the Virgin had brought a drowned child back to life quickly spread and books of miracles listing further wonders were soon in circulation.

Up to a million participants undertake the pilgrimage to Altötting every year, including many young people, demonstrating how belief in the miraculous powers of the Virgin Mary can still attract great crowds even today.

De Papeloze Kerk, Schoonoord

The province of Drenthe is among the most sparsely populated in the Netherlands, and its largely fallow fields lend it an unspoiled air in this otherwise bustling country. The east of the province in particular is a rich source of barrow graves and other traces of the so-called "Beaker" people, a Stone Age culture that settled in the area around 2700 BC. Most of the tombs are poorly preserved, but in the 1950s De Papeloze Kerk was restored and reconstructed, in part using stones from other graves.

These prehistoric graves vary in size but have certain features in common—they are long, rectangular passage graves constructed from parallel rows of stones, and the narrow ends are often closed off with a larger stone. The grave entrances also vary in appearance—there is sometimes a narrow passage leading to the entrance and sometimes a small portal with a few steps leading inside. The barrows were topped with flat megaliths, which have gradually become covered with vegetation. The gaps between the larger stones were filled with smaller ones, and an oval ring of stones was placed around the grave to delineate the area.

Such grave sites represent a "house" and final resting place for the deceased. They are thus different from the ship graves of northern Europe, whose purpose was to convey their occupants on a long journey down the river of the dead or to a far country beyond the sea. Some researchers have interpreted graves such as these as the forerunners of modern burial practices.

This grave, which is located near Schoonoord, was given the name "Papeloze Kerk" because it is a documented fact that secret church services were held here during the Reformation in the 16th century, when of course no priest was present. The "priestless church" became a place of refuge for persecuted Christians, who congregated here to pray.

Oude Kerk, Amsterdam

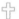

Located in the heart of the city, the Oude Kerk is the oldest surviving building in Amsterdam, and it has a turbulent history behind it.

A wooden parish church stood on this site in the 13th century, before being replaced with a three-naved stone basilica. Further extensions were undertaken until the 16th century, with the Oude Kerk acquiring side chapels, an ambulatory, and additions to the nave and spire.

The interior fell victim to the iconoclastic zeal of the Reformation and the previously Catholic church became Protestant. Between 1584 and 1611 the stock exchange took up residence here and no religious services were held. The old cemetery has disappeared, but the Oude Kerk is the last resting

place for thousands of Amsterdam citizens, both famous and unknown.

The church threatened to collapse in the 1950s and was closed for some 25 years. It has now reopened and is once again drawing in crowds, who come to pray or to

The Oude Kerk, Amsterdam

attend the various cultural events that are held here; the old church has become a modern meeting place.

The choir stalls with their original misericords are an interesting feature of the church, and the original carvings are still being (illicitly) added to! These folding seats are decorated with everyday scenes, mottos, and proverbs which are mostly vernacular, rather than biblical. The earthy truths include amusing maxims such as: "Money is useful, but no good when you're dead" and "Don't use your head to break down a door"— advice perhaps not to attempt the impossible. Anger, one of the deadly sins, is also represented symbolically here, along with moderation and grace. Reading the inscriptions is rewarding as well as entertaining—a chance to understand yourself a little better.

Sint-Servaaskerk, Maastricht

Maastricht is the southernmost and oldest city in the Netherlands, and even though pilgrimage never really took hold in the Low Countries, it became the third most important pilgrimage site in northern Europe, after Aachen and Cologne. This is largely due to St Servatius, to whom this magnificent Romanesque church, which dominates the city skyline, is dedicated.

Maastricht, called *Traiectum ad Mosam* ("the ford across the Maas") by the Romans, is still a popular destination for pilgrims today. In folk belief, people suffering from pains in the feet, chilblains, and rheumatism should pray to St Servatius. However, the saint is more notably remembered for his dream anticipating the attack of the Hun in 450, which allowed him to warn the citizens of Tongeren, enabling them to escape. After his dream he moved his see to Maastricht, where he died "in the odor of sanctity" in 384. He was buried in the *vrijthof*, a cemetery just outside the town. Miraculous powers were attributed to the tomb soon after his death, as the people of the town observed that the earth above his grave was always dry.

If you examine the legend closely, you cannot fail to notice quite how much time had to elapse after his death before the Hun attack could take place in the next century, but modern research suggests that the old legends combine two people of the same name into one character. The later St Servatius now lies in the eponymous church in a Romanesque shrine, the Noodkist ("travel coffin"—it was often processed around the town).

Construction of the church was begun in the 10th century, although only the nave of this basilica in the shape of a Latin cross is actually early Romanesque; the rest of the structure has been substantially rebuilt. Framed by two towers, the magnificent

Sint-Servaaskerk, Maastricht

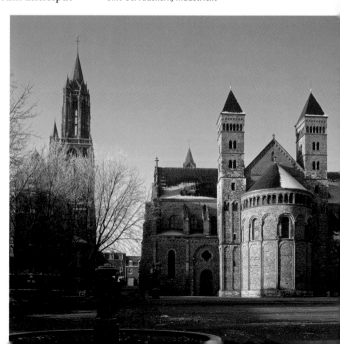

west façade is particularly dramatic. Architectural similarities to Speyer Cathedral, the imperial German burial place, are explained by the fact that no fewer than three German emperors (Henry IV, Frederick Bar-

Beguine Convent, Bruges

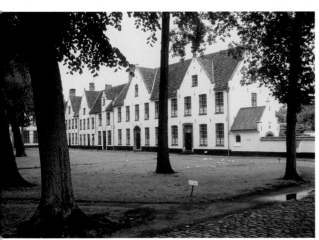

barossa, and Frederick II) declared the church an imperial chapel.

The church interior has a simple beauty. A Romanesque relief serves as the only altarpiece and pilgrims come here to pray and to venerate the plain Romanesque shrine that contains the relics of St Servatius. The shrine resembles a house with a pitched roof and is intended to assure the saint a place to live in the heavenly Jerusalem. The iconography is closely based on the 21st chapter of the Book of Revelation of St John the Divine, in which the New Jerusalem is described.

Beguine Convent, Bruges

The town of Bruges experienced its heyday in the 15th century, when it became the residence of the dukes of Burgundy. As the harbor silted up in the 16th century, the town's economic decline began and Bruges fell into a kind of enchanted sleep, with the result that its historic infrastructure has been extraordinarily well preserved. Bruges has a wealth of cultural treasures, but the town is particularly noted for the Beguine communities, which assured the city its prosperity in the 13th and 14th centuries and are still famous today. There were once many of these semi-monastic communities, especially in Flanders, the Netherlands, France, and Switzerland. Only a few have been preserved and still fewer are active today, but one of these is the Begijnhuisje Ten Wijngaarden in Bruges, which was founded in 1245 by Johanna of Constantinople, the Countess of Flanders.

The Church was initially skeptical of this new form of community, where women lived together and witnessed their Christian faith in their life and works without subjecting themselves to the rule of a religious order.

They lived in piety and chastity but took no vow of poverty, their leader was elected democratically, and members could leave the community at any time. During the Counter-Reformation these women who led independent and autonomous lives were often defamed as heretics and not many of the Beguine convents survived this period. There are now very few working convents—most of the historic buildings have been turned into apartments. The tiny houses were usually grouped around a courtyard with a little chapel and a slightly larger room for the community's meetings.

The idyllic Beguine convent in Bruges is now used as a Benedictine monastery, and as before it is separated from the rest of the city by a moat—a world within a world.

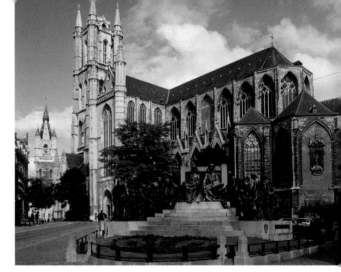

Sint-Baafskathedraal, Ghent

Sint-Baafskathedraal, Ghent

The city's greatest and most famous son is without doubt the emperor Charles V, who was born here in 1500. Modern Ghent is a bustling city with a long and turbulent past

and a wealth of historic and ecclesiastical buildings, of which the most important is the Sint-Baafskathedraal, which dominates the cityscape.

The cathedral was constructed over three phases. Building began in the 13th century and was closely based on the design of earlier French cathedrals. The second phase saw the erection of the west tower, while the third and final phase brought three side naves and a transept to the central nave. The groin vaults date back to the 17th century. The interior is richly decorated with precious works of art, but the true goal of the pilgrims who come here is the legendary Ghent Altarpiece, a two-storey triptych completed in 1432 after a decade of work by Hubert and Jan van Eyck. The painting is a wonderful example of the Flemish school of painting and comprises 26 panels depicting man's salvation.

All but one of these panels have miraculously survived the trials and tribulations of the past, but the last has disappeared: the Just Judges. This was stolen by a gang of robbers in 1934 and has not been seen since. One of the thieves confessed, and the rest either died in quick succession or were murdered, which has doubtless made the current whereabouts of the panel all the more mysterious.

No one is quite sure why this work is so important—is the missing picture a clue to the hiding place of the Holy Grail, as some have suggested? What is the significance of its depiction of the Knights Templar, who were banned by the pope and several kings? Why are the Church Fathers turning away from the Lamb of God? Does the picture hide some covert criticism of the Church, which commissioned the altarpiece?

There are plenty of unanswered questions and there has been much speculation, with the result that more and more people from all over the world have undertaken the pilgrimage to this site, eagerly approaching the divinity it represents.

Onze Lieve Vrouwekerk, Scherpenheuvel

An oak tree once stood on top of Scherpenheuvel (sharp hill), which in pagan times was worshiped for its healing powers. At some time, it is not known exactly when, a vision of the Virgin Mary appeared in the tree and subsequently many miracles took place beneath it so that the oak tree became a place of pilgrimage. A small chapel was erected, but before long this grew too small for the hordes of pilgrims who came from near and far, and it was soon replaced with a church built of stone.

The Onze Lieve Vrouwekerk, Flanders' first baroque church, was built here at the beginning of the 17th century and consecrated in 1627. It is an impressive symmetrical building and there is little left of the previous small pilgrimage chapel. The large dome and belvedere sit on top of a heptagonal structure housing the miraculous image of the Virgin. The 298 seven-pointed stars covering the interior of the cupola are particularly beautiful when illuminated at night, and a soft light fills the darkness.

Thousands of pilgrims come to Scherpenheuvel every year to bring their petitions to the miraculous image of the Virgin. There is a great procession on the Sunday after All Saints', during which the image is carried through the streets and back to the church. A large market is held at the same time so that the *kaarskens-processie* has every appearance of an enormous party—but it is clear from the people taking part in the procession that this is an expression of a deeply held Catholic faith.

Echternach

Every Whitsun, the small town of Echternach becomes the backdrop for a fascinating procession whose roots date back to the Middle Ages.

A combination of religious zeal and tradition brings some 20,000 people out onto the streets, either as part of the parade or as spectators, although the reason why the participants in the procession have to complete the route as a series of little hops and jumps

The spring procession in Echternach

has been lost in the mists of time. The most probable explanation is that it was a form of self-punishment (processions during which the participants would whip themselves took place at one time), a common enough penance during the time of the Black Death.

The procession route begins in the courtyard of the old Benedictine abbey, now the Echternach parish church, and continues across the road to the basilica to venerate the relics of St Willibrord, which are kept in a neo-Romanesque container. He is considered the patron saint of nervous illness and epilepsy, and some believe that the point of the participants jumping and dancing along the procession route is to mimic the effects of nervous illness and epileptic attacks and thus ward off such conditions.

The procession has been banned several times in the past for being "unreasonable" or mere superstition. However, the folk belief has survived, although no procession took place during the German occupation of Luxembourg (1940–44).

There are no particular rules for the movements in the jumps and the procession can be somewhat chaotic. Nowadays, most people jump forward and then step to the side, pausing briefly on one foot, depending on the rhythm of the music being played by the marching band that accompanies the procession.

The Echternach dancing procession is mysterious and yet colorful, an expression of piety rooted deep in the Middle Ages which has survived into the modern day.

Basel Minster

The minster at Basel towers over the Rhine and the old medieval city. The hill on which it stands was settled by the Celts in the 1st century BC, and the Romans later built ramparts on the same site. After the departure of the Romans in the 4th century the Catholic Church claimed the hill for itself, although the minster's history is only documented from the 8th century.

The church was rebuilt between 1185 and 1229 after being destroyed by fire. The Romanesque north door (Gallus portal) is richly decorated with sculptures. Dating from around 1180, the door depicts the Last Judgment, the apostles Paul and Peter, Emperor Henry II and his wife Kunigunde, the minster's patrons, and the seven wise and seven foolish virgins. The figures are expressively carved, in particular the Tempter, whose back is covered with serpents and toads as a sign of evil. The "wheel of fortune," with some figures rising and some falling, is a popular motif in medieval religious iconography.

The twin towers of the west façade (1421–9) were completed during the Middle Ages; the south tower is named after St Martin and the north tower after St George. The delicate ornamentation of the latter, which lends the whole structure a sense of lightness, was much admired by contemporary observers. The façade is similarly rich in decoration, with a wealth of animals, fabulous creatures, and demons. The portals admit visitors into a long five-naved space with galleries and a slightly raised polygonal chancel. The pulpit is a masterpiece of stone carving—it is so finely worked that it appears to be carved from wood.

After the Reformation the Roman Catholic bishop's seat became a Protestant church, so it is all the more surprising that Erasmus of Rotterdam, the great humanist, who was himself a Catholic, is buried here. Many lay flowers on his grave, revering him as a "saint of clear thinking." His wisdom and deeply-held humanity remain a good example that we can strive to follow to this day, showing that the desires of mind and heart need not be mutually exclusive.

The Great Minster, Zurich

Zurich's Great Minster has had a long and complicated history. The church is now a Protestant reformed church, but the earlier monastery church was dedicated to St Felix and St Regula, who were both martyred in Zurich. Even after they had been beheaded, they were able, according to legend, to walk some distance up a hill before collapsing on the place where they were then buried. Much later, so the story goes, Charlemagne had been hunting a stag all the way from Cologne to the area around Zurich when his horse suddenly stopped and fell to its knees to pay homage to the bones of the martyrs Felix and Regula. Charlemagne had the mortal remains of the saints exhumed

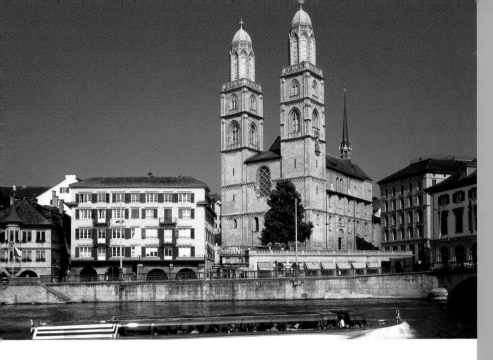

The Great Minster on the River Limmat in Zurich

and ordered the building of a church, although whether the present church retains any connection with him is doubtful. The basic structure dates back to the 11th century but has been continually rebuilt and renovated, incorporating features from the Romanesque to the modern. The baroque elements of the church were largely removed in the 19th century to restore its Romanesque incarnation, but the windows are entirely modern and the work of the contemporary artist Sigmar Polke.

One peculiarity of the church is the modern legacy of Protestantism—the bronze doors, made in 1950, and the inscription over the lintel of the main portal, which emphasizes the central tenet of Protestantism, the correct interpretation of the gospel: "That the word of God may be preached to you in purity / such that your fatherland be preserved / and may it pain the devil / for wherever God is feared / God will lend his aid / Huldrych Zwingli." One of the bronze doors depicts classic Bible stories and the other is decorated with scenes from the history of the Reformation. Dating back to the very beginnings of European Christianity, the Great Minster in Zurich is a sacred place that illustrates the deep divide between Catholicism and Protestantism, the latter having sometimes had an awkward relationship with the mysterious aspects of the Divine. This church appears to have overcome such a division.

Maria Einsiedeln

This famous Benedictine abbey lies beside Lake Sihl in Switzerland. Withdrawing into the solitude of the Finsterwald Forest, St Meinrad built a hermitage here in 828. He was murdered in 861, and in 934 the hermit Eberhard moved into St Meinrad's old hut. He asked others to join him and live according to the Rule of St Benedict, and the monastery and its church slowly grew.

Legend has it that on September 14 948 the church was visited and blessed by Christ in person, surrounded by a retinue of angels and saints. The first church was destroyed in a fire, as was the second, while the baroque building of 1614 was burned down by occupying French troops. The modern church, also baroque, dates back to 1817.

Einsiedeln has always been an important stopping-place on the pilgrimage journey to Santiago de Compostela. Pilgrims here turn to the Virgin Mary, as they do all over the world, to ask for support during the rest of their journey and for other individual requests to be granted.

Since the 18th century the statue of the Virgin Mary has traditionally been clothed in precious fabrics; her wardrobe usually varies according to the liturgical calendar, but many brides send Mary their wedding dresses to place their marriages under her special protection. The clothes also serve to humanize the Mother of God; Mary is revered as the Queen of Heaven, but as a mother she is closer to the people than a distant God may sometimes seem.

The most important feast day at Maria Einsiedeln is September 14, the Consecration of the Holy Angels, when the candles of thousands of pilgrims transform the monastery and church into a sea of light that shines out into the night.

Lausanne Cathedral

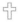

The pilgrims' guide written by the monk Hermann Künig von Vach describes the pilgrimage to Lausanne as follows: "... and then you come to a city called Losan, / Where lies buried St Anna, the mother of Mary, / Both should be praised / And you should not stint your adoration ..." Lausanne has long been one of the most important stages on the Via Francigena, which runs from Canterbury to Rome, as it is situated at the point where the Via Francigena crosses the great pilgrimage route to Santiago de Compostela.

The *Colline de la Cité*, the mound on which Lausanne cathedral stands, was settled in the Neolithic period. A Gallo-Roman temple built on the hilltop during the Roman period was destroyed in the 4th century. For many years the hill continued to be used for ritual purposes, and in the 6th century the extended diocese of the Swiss capital moved its base to Lausanne, enhancing the importance of the town.

The foundations of the modern building date back to these earliest times of Christian rule. The first structure was replaced with a Romanesque building around the turn of the millennium, but this too was relatively short-lived, being replaced by a cluster of Gothic buildings from 1150. Despite the regular fires that delayed the completion of their work, several masons labored concurrently on the cathedral until 1240. Pope Gregory X was finally able to dedicate the finished church to the Virgin Mary in 1275.

Notre-Dame de Lausanne is the most significant Gothic building in Switzerland and was a popular destination for pilgrims until the Reformation, when it became a Protestant church. Despite the many stages of its building history, the church has a harmonious and unified appearance. Created between 1225 and 1235, the striking Painted Portal is a wonderful hymn in stone to the life of the Virgin. The 13th-century rose window in the transept is worthy of note for its portrayal of contemporary cosmological understanding—earth and sea, air and fire, the seasons, months, and astrological houses, monsters lurking at the edge of the world, and a divine light, which shines out over everything. Little remains of the artistic decoration of the interior, which fell victim to the iconoclasm of the Reformation.

Lausanne Cathedral

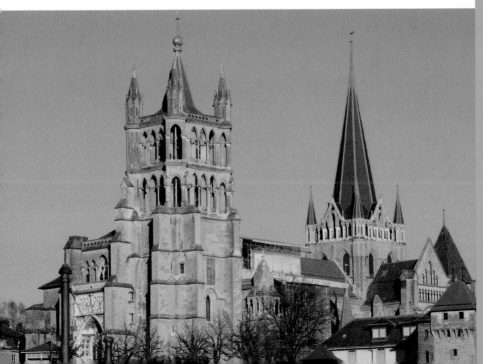

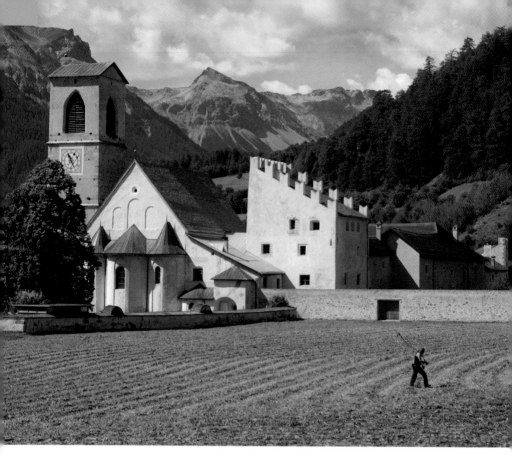

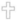

Benedictine abbey, Val Müstair

In 1449 Lausanne Cathedral witnessed a very special event in Christian history, when Pope Felix V doffed his tiara during a Mass, signaling the end of the schism in the Catholic Church.

One extremely popular medieval tradition is still observed to this day: every night, throughout the year, the night watchman climbs the tower to call out the hours across the roofs of the city slumbering below.

Benedictine Convent of St John, Val Müstair ✠

According to the legend, Charlemagne took shelter from a snowstorm in this place, and as a mark of gratitude founded the monastery with a hospital for travelers. The monastery became so famous that it gave its name to the whole valley—Müstair is the

Raetoromanic (Swiss dialect) word for *monasterium* (monastery). Built in the 8th century, the Convent of St John is one of the best-preserved monastic sites from the Carolingian period and has been continuously occupied ever since. The oldest part of the building is the typical Carolingian hall church, which has been altered only by the addition of Gothic vaulting. The church has five apses, of which three are adjacent to the main space and two facilitate access to the bishop's palace (north annex) and the monks' cells (south annex). The extensive living quarters for the monks include cells and offices as well as several chapels and a kitchen garden. The sculptures of the medieval gate tower look down over the whole complex. The convent was initially occupied by Benedictine monks, but since the 12th century the pilgrims' hospital has been run by Benedictine nuns.

At the turn of the 20th century, some Carolingian frescos which had been whitewashed over in the 1400s were discovered, revealing a unique treasure of medieval sacred art. Five horizontal series of well-preserved images cover the north and south walls of the interior: a sequence of scenes from the life of King David, the martyrdom of various saints, the *Flight from Egypt*, which has become famous in its own right, and the most comprehensive painting cycle depicting the life of Christ—33 of the original 48 images—that is known to survive from the Carolingian period. Some of the Romanesque (1200) overpaintings of the Carolingian frescos have now been exposed and lovingly restored.

Madonna del Sasso, Orselina

Madonna del Sasso is undoubtedly one of the most popular destinations for pilgrimages in Switzerland. This may be due to its location perched on a spur of rock high above Locarno, or the fact that in 1949 the miraculous image of the Virgin Mary that had been kept there was carried in a four-month procession of "pilgrimage" down into the depths of the Tessin Valley, earning it the title of the "Peripatetic Madonna."

Legend has it that the shrine was established thanks to a Franciscan monk by the name of Bartolomeo d'Ivrea, whose habit it was to fast on Saturdays and on the days before Marian festivals. In reward for this spiritual devotion, the Virgin Mary herself appeared to the monk on the night before the Feast of the Assumption in 1480. A chapel was soon built at the location of the vision and a seated figure of the Madonna and Child was created according to Bartolomeo's description of the event. Before long, pilgrims began arriving at the chapel.

The modern baroque pilgrims' church of Santa Maria Assunta was consecrated in 1616. In 1621, 12 chapels marking the Stations

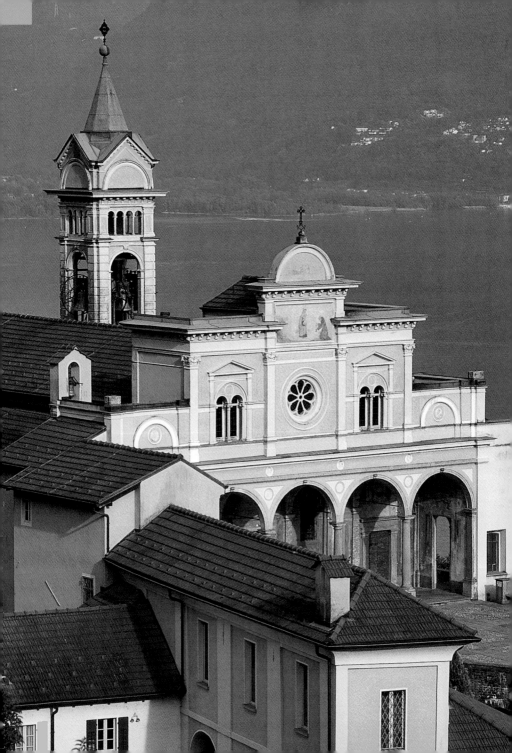

of the Cross were constructed leading up the sacred mountain, some of which have been preserved. The little church of the Madonna dell'Annunziata, in which Fra Bartolomeo was buried in 1513, marks the beginning of the pilgrims' path.

The pilgrims' basilica is filled with precious works of art, including the *Flight into Egypt* (1520–22), a major work by the Milanese painter Bramantino. However, the crowds are not just drawn here by the art—a deeply rooted belief attracts tens of thousands to the sacred mountain to pray to the Madonna, who bestowed her grace on kindergartens and schools, factories and workers, even the inmates of the prisons she encountered on her four-month "pilgrimage."

The Great St Bernard Pass

The approach to the Great St Bernard Pass, one of the most important routes across the Alps since the time of the Romans, begins at Martigny in the canton of Valais. Crossing the Alps has always had its perils, not least for pilgrims to Rome. From ancient times until the Middle Ages the mountain was known as Mons Jovis, the "Mount of Jupiter." In 1130 it was renamed after Bernhard, the monk and arch-

deacon who set up a hospital in the pass in 1050. This burnt down in 1555 but was immediately rebuilt, larger and more beautiful than before.

Until the beginning of the 20th century the monks would help stray travelers, sheltering them on the dangerous track and even using their local knowledge to accompany them on their way down to the valley. The famous St Bernard dogs were also used on these inhospitable paths from the 18th century onward. Travelers were cared for as the Rule of St Augustine prescribed, often being saved from certain death.

The brightly painted and richly decorated hospital chapel is particularly worth seeing, but this place is sacred because it gives visitors a sense of how hospitality and giving welfare to others can save lives today, just as much as in the past. People encounter dangerous paths in their everyday lives, journeys that are best not attempted without the aid of others. It is good to be reminded that it is the help that one person gives to another that sanctifies them.

The pilgrims' church of the Madonna del Sasso overlooks Lake Maggiore

St Stephen's Cathedral, Vienna

Known as "Steffl" (in German, a diminutive form of "Stephen") to the locals, Vienna's Gothic cathedral has become the symbol of the city. If naming a sacred building "Steffl" appears a little disrespectful, it suits the mentality of the

St Stephen's Cathedral, Vienna

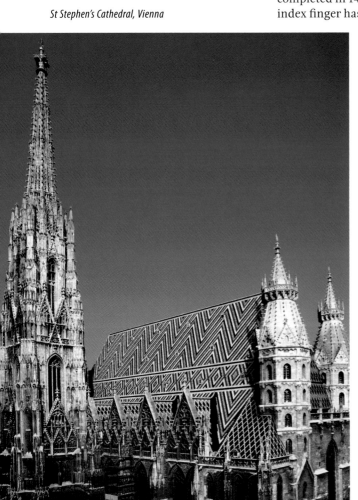

Viennese people, who enjoy the light-hearted and playful. A Romanesque church once stood on the site of the modern cathedral, but of this building only the main doors and the two towers immediately next to it have survived. The new Gothic structure, which retained but altered the west façade, was begun in 1359. The three naves are the same height and almost the same width, retaining the feel of a hall church. The cathedral's south spire was completed in 1443 and this reproachful index finger has pointed heavenward ever since. The Reformation interrupted work on the planned north spire in 1511, and anticipated attacks by the Turks meant that defensive fortifications were in any case more pressing. The project was never completed according to plan, and the unfinished tower was topped off with a small but elegant Italian Renaissance dome. The cathedral's roof immediately catches the attention—the steep pitch is intended to deal with the heavy snowfalls that are common here. The brightly painted tiles are laid out in zigzags and diamonds, lending the roof the appearance of an oriental kilim and bringing a flavor of the exotic.

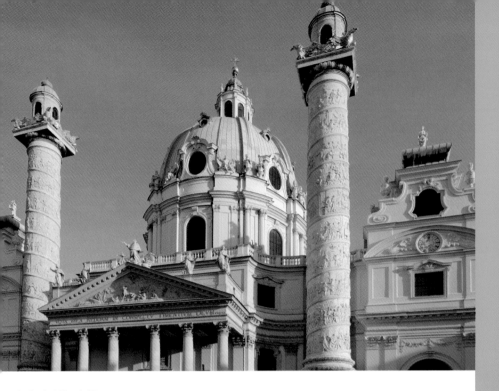

St Charles' Church, Vienna

Such details are a visible representation of what was always true of Vienna—diverse cultures meet and merge here. The cathedral's interior was almost completely destroyed in World War II but has been painstakingly restored; it is now as harmonious and peaceful as ever. An example of the statues that can be seen inside is the "Servants' Madonna." A housemaid, accused of theft, threw herself down before this statue. Her mistress refused to believe that the Virgin Mary would hear a servant's prayer, but after the maid had proved her innocence, the repentant countess donated the statue to the cathedral. It is a typically Gothic work and it is somehow fitting that such a friendly Madonna should have found a home in Vienna.

St Charles' Church, Vienna

The year was 1713, and the Black Death—the plague—was raging in the historic city of Vienna for the seventeenth time. The emperor Charles VI swore to dedicate a church to St Charles Borromeo, the patron saint of plague victims, and to this end he commissioned Johann Bernhard Fischer

von Erlach, a mason whose previous buildings had successfully combined a reverence for Roman architectural forms with an artistic feel for interior decoration. Fischer's Church of St Charles was to become a symbol of Austrian Habsburg rule. He worked on this votive church (which simultaneously expressed the emperor's claims to sovereignty) from 1716 until his death in 1723. His son completed it in 1737.

They built an elegant church, which combined many references to classical architecture with the formal features of the baroque and of neoclassicism. A stark Greek portico forms the focal point of the façade and the relief in the tympanum depicts the trials of the plague. The gable end is topped with an expressive statue of the plague saint and the two triumphal columns flanking the portico are decorated with a winding ribbon of reliefs depicting scenes from the saint's life, harking back to the triumphal columns of Trajan and Anthony in Rome. The extremities of this elevation are marked by two bell towers with passageways modeled on Roman triumphal arches, and the high drum dome covering the extended ellipse of the interior rises up behind the façade. Every detail of St Charles' Church refers back either to St Borromeo or to the emperor's claim to power in Spain; the triumphal columns were not erected to the glory of God, but are surrounded by imperial eagles and pointedly topped with representations of the

Spanish throne. The interior continues in a similar vein—the beautiful frescos in the cupola were Johann Michael Rottmayr's last commission and depict the apotheosis of St Borromeo; even the high altar features this motif, showing the saint ascending to heaven surrounded by a host of angels. *Constantia et fortitudine* (perseverance and strength) was the saint's motto, which could easily apply to Charles VI too.

Cemetery of the Nameless, Vienna

The Viennese are known to have a very particular attitude to death. Influenced by their Catholic, baroque past, whereby everything in life is perfectly presented as if in a play, death, too, has become one of the main characters in this baroque

A grave in the Cemetery of the Nameless, Vienna

drama. When death is exaggerated it loses its sting and becomes a playful variation on life. Vienna's central cemetery is the largest in the world, but this is a rather different sacred place. Vienna has the world's only graveyard for suicides, the Cemetery of the Nameless. The cemetery is no longer in use, but it is still a sacred place, reminding visitors that death is a great leveler. A small path leads off to the right past Port Albern to the meadows beside the Danube, and here you will find a small monument and a row of modest graves. This is where the bodies of those who drowned in the river tended to wash up and they were usually buried on the spot—104 bodies have been interred here. Visitors to such a place, far from life's show and theater, will struggle to avoid thoughts of the brevity of life and the inevitability of death.

Heiligenkreuz Abbey, near Alland

Heiligenkreuz Abbey, near Alland

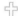

When Count Leopold III of Babenberg challenged his son to name the most dynamic monastic order so that he could found an abbey, the young Otto—who had just become a novice at the monastery of Morimond—perhaps unsurprisingly chose his own, and the Cistercians were duly invited to found Sancta Crucis (Holy Cross) Abbey. The site takes its name from the relic of the True Cross donated by the count to the new abbey. The community grew steadily and is one of the few abbeys that have been occupied continuously. Entering through a gate, visitors find themselves in a fine inner courtyard, bordered by two-tier arcades, in the center of which is an imposing Holy Trinity Column, several old trees, and the large St Joseph's fountain—a different, more tranquil world. A series of inner courtyards follows, some of which are open to the public, while the 80 or so monks who run the monastery occupy the rest.

The Romanesque complex was rebuilt in a baroque style in the 17th

and 18th centuries, but traces of the old structure can still be found. The collegiate church is a harmonious mixture of Gothic and Romanesque elements, and the windows admit a flood of light—although most of these date back only to the 18th and 19th centuries, they have been sympathetically incorporated into the overall design. The chapter house in the cloister contains a number of graves— a large, peaceful room dedicated to the memory of the counts and dukes of Babenberg, many of whom have found their last resting place here.

A visit to the monastery at midday is especially rewarding, as you will be able to attend the monks' sung prayers. Hundreds of thousands of people visit the monastery every year, with many staying for a few days—or even longer—to seek inner peace and to find themselves.

Melk Abbey

The monastery is best approached by river—from the Danube there is a superlative view of this palatial abbey, whose turbulent history began in 1113. The Benedictine monastery was under the special protection of the counts of

View of Melk Abbey from the River Danube

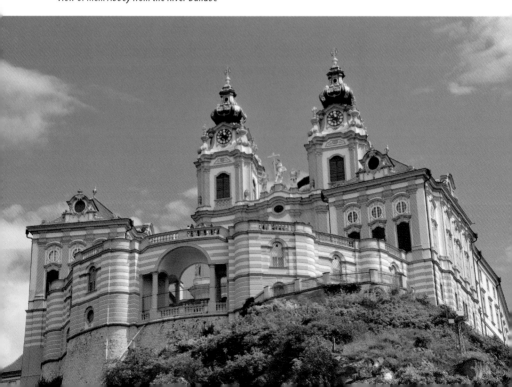

Babenberg until they moved the family seat to Klosterneuburg and transferred their religious allegiance to Heiligenkreuz. In 1297 the abbey was almost completely destroyed in a devastating fire; reconstruction began in 1306. The monastery underwent a brief but bizarre transformation into a Protestant church during the Reformation, but after recurrent fires the structure was entirely rebuilt as a Catholic institution between 1700 and 1726, and its baroque splendor has survived to this day. The worst was avoided when fire once again threatened in 1735, and only the towers had to be replaced.

The abbey is situated on a granite cliff overlooking the Danube—an elevated location that only serves to emphasize the building's magnificence. The collegiate church of St Peter and St Paul forms the heart of the complex of buildings, the delicate pastel shades of its interior creating a soothing atmosphere. The baroque ceiling frescos depict allegories of the *ecclesia triumphans* (the Church Triumphant). The high dome presents a joyful scene, with baroque angels playing heavenly music on various instruments. The imagery decorating the barrel vaults celebrates the life of St Benedict.

The abbey's greatest and most precious treasure is the Melk Cross (1362); decorated with gold and silver tracery and set with gemstones and pearls, it contains a fragment of the True Cross. Melk's library, where monks devote themselves to scholarship in the presence of 70,000 volumes and more than 2,000 manuscripts, is also renowned. For many visitors it is the library that

is the holiest part of the whole abbey, but whatever part of the building draws them the most—the library's treasure trove of learning or the church itself— Austria's largest baroque monastic institution still leaves them with a lasting and awesome impression.

Maria Taferl

The history of this site began with an oak tree and a granite stone, whose ritual uses date back to pre-Christian times. The stone plinth, now surrounded by a stone balustrade, is presumed to be a Celtic sacrificial site, but it became a Christian pilgrimage site of local importance when a crucifix was placed in the hollow of the tree.

The site came to wider attention only in the 17th century, when Alexander Schinagl, a forestry official and magistrate, dreamt that he should install a pietà statue "among the oaks near the little table" to cure himself of his depression and suicidal thoughts. He did indeed feel better afterward and devoted himself with "unbounded energy, much effort, and zeal" to promoting the site as a place of pilgrimage. This was not too difficult, as tales of spontaneous healing, answers to prayers, and visions of wondrous lights soon began to spread, all of which were recorded in the book of miracles that was kept from 1660 onward.

Built right next to the stone, Maria Taferl Basilica has a broad façade with

twin towers and a clock in the small gable. The frescos in the nave depict scenes from the life of St Joseph, while those in the cupola and transept depict scenes from the life of the Virgin. The *Marienbründl* (St Mary's Well), whose waters are said to have healing properties, is to be found in the crypt. A mechanical crib scene made in 1892 is particularly popular and portrays both biblical scenes and the story of the pilgrimage site's creation.

Current extensive renovation work is due to finish in 2010, when the rejuvenated church will once again shine in all its former glory.

The pilgrimage site of Mariazell

Mariazell

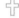

Mariazell is first documented as a pilgrimage site in 1266, but legend has it that pilgrims originally came here on December 21 1157, in the wake of a Benedictine monk from the monastery of St Lambrecht at Murau who came to preach and attached a carved limewood figure of the Virgin Mary to a tree trunk.

The figure was soon credited with miraculous powers. In 1365,

King Louis I of Hungary was able to achieve a major victory against a far larger Turkish army with the aid of the Madonna of Mariazell. In gratitude, he rebuilt the old Romanesque structure as a three-naved Gothic hall church and erected a new tower in 1380. Further alterations were carried out between 1644 and 1704—the nave was extended with side chapels and a transept containing an altar topped with an elliptical cupola replaced the Gothic chancel. Two baroque side spires were added, although the characteristic central tower was retained.

The sacred goal of pilgrimages to Mariazell is a representation of the enthroned Madonna with the Christ Child on her lap. The wooden statue is only 18 inches (50 cm) high but it dominates the red marble Chapel of Mercy, which was built in the middle of the church in 1653.

The Madonna is usually dressed in splendid robes and is only displayed without her ceremonial gown during the two great Mariazell festivals—February 8, Mary's birthday, and December 21, when the anniversary of the founding of the monastery is celebrated. With more than a million annual visitors, Mariazell is Austria's most popular pilgrimage site by far. In 1981 the Mariazell Pilgrimage Path was established—a route of more than 600 miles (1,000 km) comprising historically documented and reconstructed pilgrims' paths which lead visitors across the whole country to the statue in the pilgrims' church.

A view of Salzburg Cathedral in the evening light

Salzburg Cathedral

The first episcopal church was built in Salzburg in 774 and consecrated by Bishop Virgil. Over the course of the next centuries, the cathedral was extended, pillaged, and burnt down. The archbishop of the time allowed the fire of 1598 to burn unchecked, as he had plans for a far grander building. Having been impressed by Rome's baroque churches, he wished to build something similar north of the Alps in his home town of Salzburg. For him the fire could not have been better timed. The rubble of the burnt-out

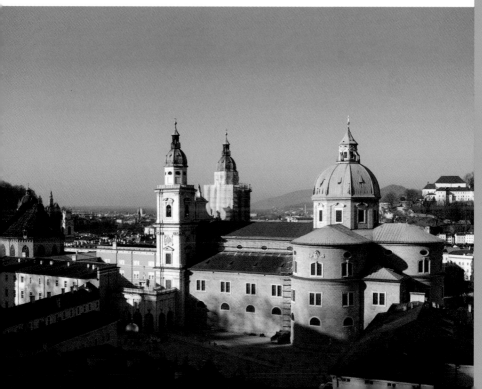

church was removed completely and an Italian architect named Santino Solari was commissioned for the new structure. Work began in 1614.

The cathedral was consecrated in 1628, but the façade was ready only on the completion of the towers, 30 years later. A cathedral had been created that could accommodate a congregation of 10,000, more worshipers than the population of Salzburg at the time. The early baroque structure is simply and harmoniously arranged— the only unexpected feature is the interpolated façade with its twin towers, but even this is not overbearing. The influence of early baroque forms derived from Roman temples is unmistakable. The towers stand out slightly from the façade, almost steering the congregation toward three bronze doors created by 20th-century artists to represent the three divine virtues of faith, hope, and charity.

The interior is dominated by the octagonal cupola, whose windows flood the whole crossing with light, contrasting well with the half-light of the barrel-vaulted nave, which is only indirectly illuminated. The side chapels have interconnecting passages, so that they virtually perform the function of side aisles, and the richly ornamented stucco work of the cupola and vaulting has a cheerful air. The stucco forms a frame for wall and ceiling murals depicting scenes from the lives of Christ, the Virgin Mary, and St Francis. The paintings in the cupola show scenes from the Old Testament and the four evangelists are portrayed on the spandrels. The floor plan of the chancel and transept is shaped like a cloverleaf, and the beautifully balanced and harmonious architecture was soon to be copied in many baroque churches north of the Alps.

Gurk Cathedral

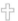

The parish church of the Assumption of Mary is one of the most beautiful Romanesque churches in the country. Construction was begun on the site of a former pagan temple during the incumbency of Bishop Roman I and completed in 1220, although considerable alterations were carried out later. The magnificent towers were topped with baroque onion domes in 1678. The church is closely associated with St Hemma (born c. 995; died c. 1045), a Carinthian aristocrat who founded an independent convent at Gurk in 1043. The saint, who watches over the safe delivery of children and is called upon to alleviate ailments of the eyes, has lain buried in the cathedral crypt since 1174.

The strikingly elongated exterior of the church is visible from afar as it sits on a low terrace in the Gurk Valley. Lattice vaulting was fitted in the nave and transept at a later date, and the chancel was optically divided from the nave by a triumphal arch. The high altar, a Spanish-influenced baroque carving by Michael Hönel with several tiers, 72 figures, and 82 cherubs' heads, is difficult to miss.

The beautiful frescos in the bishop's chapel, which is accessible via steps in the south tower, depict scenes from the Creation of Man, the heavenly Jerusalem, the symbols of prophets and evangelists, and the enthroned Virgin Mary. Some consider the exquisite paintings in this chapel to be the aesthetic highlight of the church, while for others it is the crypt, which houses Hemma's tomb. The square room is reached via two flights of steps from the church above, and a forest of a hundred

The crypt of Gurk Cathedral

slender pillars support the roof over this impressive space, which has a rather mysterious atmosphere.

Hemma's simple coffin originally stood on six columns and women who were hoping to bear children would creep underneath it in the belief that this would increase their fertility and improve their chances of falling pregnant. Denounced by the cathedral authorities as pagan, the custom was forced to cease. The coffin was faced with red marble in the 18th century. Nowadays, Hemma's sarcophagus is piled high with the votive tablets brought by pilgrims in gratitude for answered prayers.

St Vincent's Church, Heiligenblut

The history of the pilgrimage village of Heiligenblut at the foot of the Grossglockner is bound up with the story of Briccius, a Danish knight in the service of Emperor Constantine VIII who had fought at Constantinople. A pious Christian, he was keen to return home to spread the gospel, and sought a sign from God.

At about this time (c. 914) an unknown man used a knife to dig a hole in the cross in the Hagia Sophia in Constantinople, to test whether Christ really was divine—legend has it that blood flowed out of the crucifix and the nonbeliever was converted. The emperor kept the blood in a phial as a "sign from God." Briccius was excused from the imperial army and the emperor gave him the ampoule of blood. Briccius interpreted this event as the signal he had been hoping for. However, a little later the emperor regretted the gift and sent soldiers after Briccius, who fled into the mountains to escape them. He cut open his leg, hiding the holy blood in the wound, but as he tried to cross the Grossglockner pass at Christmas, he was caught in an avalanche and perished.

Soon afterward, three ears of wheat sprouted above where his dead body lay. Astonished at this sight in the middle of winter, the local peasants dug down and discovered that the three ears of wheat were growing out of the dead man's heart. They loaded the body onto a cart with the intention of bringing it into the village, but the oxen pulling the cart refused to move past a particular spot and so the villagers resolved to build a church there, to commemorate the miraculous occurrence.

This first chapel dedicated to St Vincent has not survived, but the unique Gothic structure of the Church of St Vincent (built 1430–90) has stood at the edge of a steep cliff at the foot of the Grossglockner since the 15th century. The stark verticality of the needle spire is reinforced by the double-storey construction of the interior. The 18th-century murals decorating the walls recount the story of Briccius, whose grave is to be found behind iron railings in the crypt.

The precious reliquary, and the blood it contains, are stored in a tabernacle with a 40-foot (12-m) spire on the north wall near the main altar. The pelican visible near the statue of Briccius is a symbol of salvation in the blood of Christ, as the bird is said to pierce its breast in order to feed its young on its own blood.

The pilgrimage church at Heiligenblut

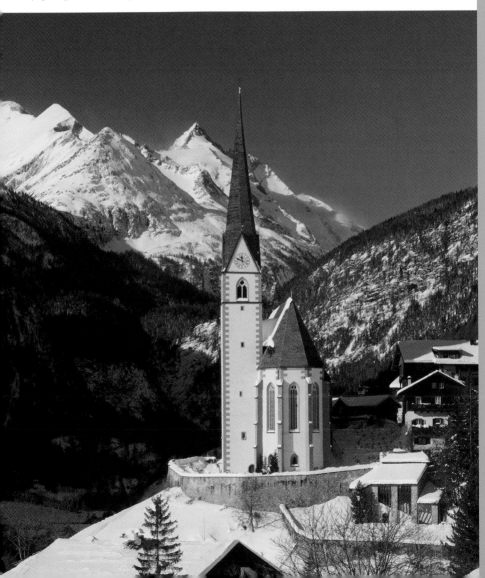

St Vitus' Cathedral, Prague

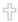

St Vitus the Lesser (martyred c. 300) was raised as a Christian by a pious couple named Modestus and Crescentia and by the age of 12 he had acquired the ability to work miracles. With a sign of the cross he could make the blind see, the lame walk, and the dumb talk.

When his biological father, a pagan, learned of this he dragged Vitus before a judge, who lectured him sternly and sentenced him to a flogging. As the punishment began, the arms of the men carrying it out seized up and would not move freely again until Vitus made the sign of the cross. They stopped the flogging and returned the boy to his father, who attempted to drive his belief out of him

A view across the Vltava of the Hradčany and St Vitus' Cathedral, Prague

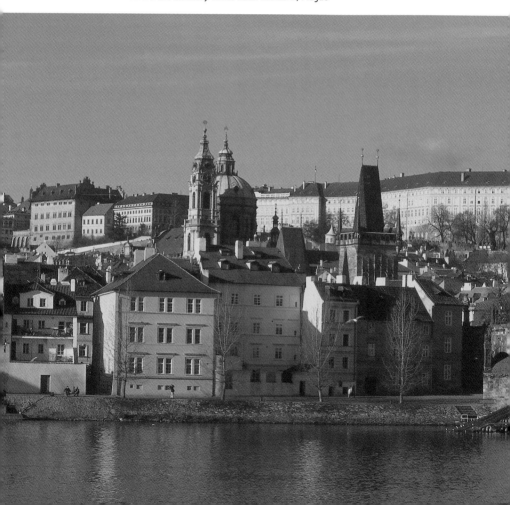

by offering him every earthly temptation. Vitus remained steadfast. The emperor Diocletian later had a disagreement with Vitus on matters of belief and sentenced both him and his adoptive parents to be eaten by lions, but these only licked his feet and left his parents untouched. He also survived unscathed after being immersed in a cauldron of boiling pitch. An angel descended and took Vitus and his adoptive parents away to the Silder River, where they eventually died.

The relic of the head of St Vitus (*Vita* in Czech) was brought to Prague by Charles IV in 1335 and is still venerated in St Vitus' Cathedral. The present Gothic cathedral stands on the site of a Romanesque rotunda built by King Wenceslas in 929 also dedicated to St Vitus. As the church became too small

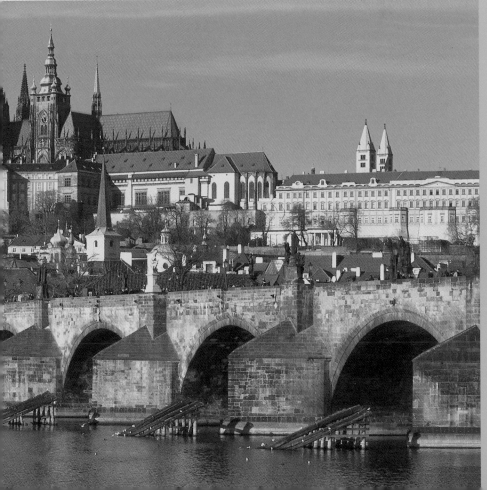

for the hordes of pilgrims, a new and larger Romanesque church was built between 1060 and 1096. Prague became an episcopal see in 1344 and the foundation stone for a new cathedral was laid, as even the new church was too small for ceremonial occasions. The resulting magnificent three-naved Gothic edifice is the largest ecclesiastical building in the country, although construction work was not completed until the 20th century.

The Infant Jesus of Prague

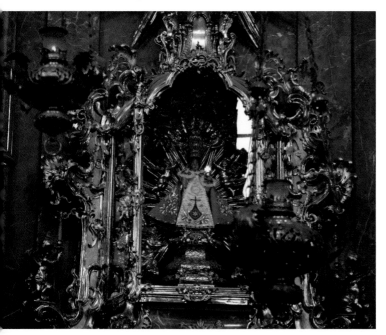

The interior is richly decorated, the finest work being the gilt stucco studded with semiprecious stones of the Wenceslas Chapel and the baroque tomb of St John of Nepomuk.

The Infant Jesus of Prague

Veneration of this image of the baby Jesus dates back to the 13th century, when the custom of worshiping small statues of the Christ Child reflected a particularly personal and private devoutness. Most of these figurines were wooden, but by the baroque period they were increasingly being made out of wax.

Probably the most famous of these statuettes is the Infant Jesus of Prague in the Church of Our Lady Victorious. An 18-inch (46-cm) representation of the Christ Child at the age of about three, the figure extends its right hand in blessing and holds a globe in its left as a symbol of its sovereignty over the whole world. Reproductions of this famous statue are to be found worldwide, but the original came to Prague with a Spanish infanta who married Vratislav of Pernsteijn, a Czech aristocrat. She later gave the figurine to her daughter, who donated it in turn to the Carmelite order in Prague, and their prior displayed the statue statue as an exemplary image of humility for

the brothers. Legend has it that the Infant Jesus of Prague has protected the city on several occasions, particularly from plagues and sicknesses, and it was greatly venerated in the Middle Ages.

It now stands in a magnificent shrine on a marble altar and is dressed in different clothing according to the church calendar—mostly in liturgical vestments, but sometimes in splendid robes or traditional folk dress.

The many votive offerings, both valuable and more modest, are testament to the congregation's sincere adoration of this small statue. Hundreds of thousands of pilgrims arrive every year to see it. The local tram stop has been renamed *U Pražského Jezulátka* (The Infant Jesus of Prague), which helps those from out of town to find their way more easily.

The Basilica of the Assumption of Mary and St Cyril and St Methodius, Velehrad

Velehrad is a town in the southeast of the Czech Republic. It is said to have been the starting point for St Cyril and St Methodius' mission to convert the area—the two brothers are now revered as the Apostles of the Slavs. In their youth they lived at the imperial court at Constantinople before entering a monastery. Both came to Moravia in 863 in answer to King

Ratislaus' call for missionaries, as they spoke Slavic languages. Cyril and Methodius were not just preachers, however—their particular achievement lay in the development of a new alphabet, which was later named after Cyril and is still in use today. The Cyrillic alphabet was used in the education of children and in the translation of the Bible and liturgical texts.

The brothers worked in Hungary before returning to Rome, where Cyril became sick and died at the age of only 42. He is buried in the Basilica of San Clemente in Rome. His brother Methodius was recalled to Moravia, where he became an archbishop. After his death in 885 he was buried in his cathedral, which has not survived; it is said to have stood in Velehrad.

This same site is also thought to be the location of what may have been the first Cistercian monastery in Moravia. The original Romanesque-Gothic complex has not survived: the monastery was destroyed several times by fire and, though rebuilt on each occasion, and now only a few low walls remain as part of an extended baroque church whose portico is flanked by two towers. A much revered icon representing the Virgin Mary as the patron of the unity of all Christendom is to be found in the Chapel of St Mary. The icon's frame is decorated with images of Cyril and Methodius.

Since the turn of the millennium a festival has been held here every year under the maxim "the time of people of good will"—a reminder that belief and Christian charity are inseparable in life and serve to strengthen Christian unity.

UTOPIA

Man's expectations of what is to come are ambivalent: he hopes for happiness and fears misfortune. One may outweigh the other, but then the wheel turns back again. This is as true of the fates of individuals as it is of whole societies. The history of humanity is a cycle of fears and hopes for the future.

Apocalyptic prophecies are always suggesting that the end of the world (and thus the end of mankind) is almost upon us, and the turn of the millennium was particularly laden with gloomy prognostications. Many people, however, have no wish to wait passively, preferring instead to play an active part in the future. Since the 16th century, these visions of future conditions and world orders have been referred to as "utopias." St Thomas More was the first to use the term, in his work *Utopia* published in 1516. Imagining a future world as different from the current one is an age-old practice and part of almost all cultures and religions.

"Utopia" is a play on words deriving from the Greek *ou-tópos* ("no place") or its homonyn *eu-tópos* ("a good place"). The concept of a utopia is not primarily involved with the end of things and the hereafter, utopia is normally sought in this world. Most modern utopias share the assumption that the welfare of humanity is dependent on changes in economic and political circumstances. This idea has often been connected with revolution, although it should be noted that this seldom fulfills the hopes of those who undertake it. Utopians share the dream that a perfect society can be created in this world— they "dream in advance," as the Marxist philosopher Ernst Bloch once said.

A utopian vision can be seen as a negation of a negative,

although social utopias have been largely doomed to failure in human history. Humanist utopias developed the concept of the moral perfection of the individual within an ideal society, but again such notions have proved to be somewhat far removed from the empirical history of mankind. Perhaps the "ideal place" is to be found in "no place," but the aim of realizing an individual's liberty and autonomy within a social structure is no idle dream, and efforts to enrich society sanctify humanity in every culture.

Lindisfarne

Athough it now lies in ruins, Lindis-
farne—also known as Holy Island—
has long been and still is a sacred
place. St Aidan, who had been charged
with Christianizing this rugged land,
founded a monastery here in 635.
Monks from Iona migrated to Lind-
isfarne and it soon became one of the
central Christian sites of northern Eng-
land. It achieved particular fame during
the incumbency of St Cuthbert, who
came to Northumbria in 676 to live at
one with nature in a hermitage. Stories
of his holiness soon spread, attracting
many people to the new religion. The
first bishop of Lindisfarne, he died in
686, greatly venerated, and was buried
in the monastery. When his coffin was
opened ten years later, his body was dis-
covered not to have decomposed at all.

Catastrophe came to Lindisfarne in
793—most of the monks were mur-
dered in a surprise Viking raid, one of
the first to be documented. Fear spread
across the island. When the Vikings
attacked again in 875, the monks
left the monastery, taking with them
the bones of Aidan, the first abbot,
and those of the revered Cuthbert,
which have now found a new home
in Durham Cathedral. Even though
Lindisfarne was long deserted, it con-
tinued to be a pilgrimage site for many
in the north of England, and in 1082
monks returned to the holy island.

Henry VIII's break with the
Catholic Church led to the dissolu-
tion of the monastery in 1536, and the
following centuries saw its gradual
decline into dilapidation. Lindis-
farne has not lost its spiritual draw,
however, and many still undertake
the pilgrimage here to this day.

Durham Cathedral

The Norman Conquest opened a new
chapter in British architectural history.
Most of the existing major buildings
had been left to fall into rack and ruin,
but new castles, fortresses, cathedrals,
and abbeys, all based on northern
French designs, were constructed—
at the turn of the millennium, the
Normans were the most industrious
builders in Europe. The reign of Wil-
liam the Conqueror (1027/8–1087)
saw the highpoint of this work both
in Normandy and, from 1066, in his
new Anglo-Saxon island kingdom.
The apotheosis of this specifically
Anglo-Norman style of building was
reached with Durham Cathedral.

In Norman architecture, a wall
was suddenly no longer regarded
just as a mere structural element—
all sorts of details lent the surface an
impressive and unmistakable spatial
importance. Durham Cathedral
displays a further feature of Norman
design—a clear love of ornamenta-
tion and decoration that was to be
retained well into the Gothic period.

Arches, vaults, columns, and
pillars were all covered in a wealth of
ornamental stonework. This is appar-
ent as soon as you enter the cathedral,

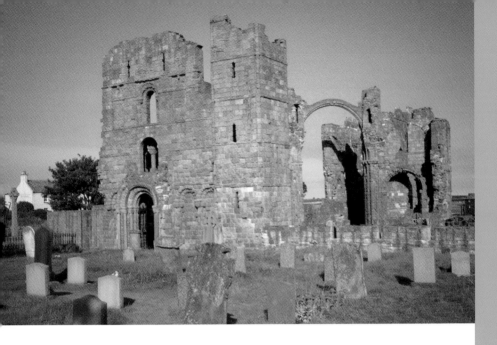

The priory ruins at Lindisfarne

which was begun in 1093. The imposing structure—its full name is "The Cathedral Church of Christ, Blessed Mary the Virgin and St Cuthbert"—is a visual representation of the sacred and profane power of the Norman empire, but it is also a destination for pilgrims from far and wide. The bones of St Cuthbert have rested here since 995, brought from Lindisfarne by monks who fled their monastery in 875. The venerable relics were once stored in a precious shrine made of marble and gold, but this fell victim to the zeal of Henry VIII in 1538 and only a simple stone sarcophagus remains today. Many younger visitors make their own particular form of pilgrimage to the cathedral, as several scenes for the *Harry Potter* films were shot here.

Castlerigg Stone Circle

The locals call this stone circle "Druid's Circle" or "Keswick Carles," hinting at the mystery of the place, which dates back to a time when the druids' access to knowledge hidden from others assured them primacy in religious life.

The stone circle was created between 3500 and 3200 BC and is one of the oldest in the British Isles. Modern visitors to the site are not just surrounded by the stones—with the hills beyond seeming to form another ring, there is a sense of standing in the middle of several concentric circles. The 38 monoliths form a rounded ellipse about 100 feet (30 m) across.

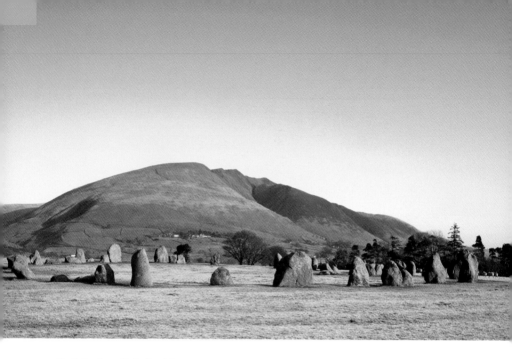

Castlerigg Stone Circle, Keswick

Ten other stones are positioned within the ring and traces of carbon have been discovered nearby—clear evidence that fires once burnt here. Circular sites of this kind usually indicate that the location was used for assemblies, rituals, or religious rites. Spend a few moments within the circle and you will get a real feeling for this sacred place as the light plays over the stones. Sometimes, when the wind blows, it even seems as if a strange music is playing, and there have been reports of unexplained lights and other supernatural phenomena glimpsed between the stones. Many believe the stones to have special healing powers and visit the site to cure their aches and pains; others hope and believe that this magical place can solve their personal problems. Perhaps in the end every visitor finds here what he or she was hoping for. The site is especially popular during the summer and winter solstices.

Walsingham

With its two pilgrimage sites, Walsingham has become the Nazareth of the county of Norfolk in the east of England. The two sites, one Anglican and one Catholic, are in the village of Walsingham and the neighboring hamlet of Noughton Saint Giles.

The site in **Walsingham** was founded in 1061 after Richeldis of Faverches, the Saxon widow of the Lord of Walsingham, had a vision of the Virgin Mary ordering her to build a replica of the house of the Holy Family in Nazareth. A spring welled up at her feet to confirm the command. She procured the necessary building materials and, through miraculous means, the commissioned structure was completed by the following morning—Richeldis prayed throughout the night as the work was carried out. The pilgrimage church of Our Lady of Walsingham soon became known as the Holy House of the Annunciation, and Franciscan monks have run the site since 1347.

A chapel dedicated to St Catherine of Alexandria was built in the nearby hamlet of Houghton Saint Giles in 1340. It became known as the **"Slipper Chapel"**—the last chapel on the road to Walsingham, pilgrims would take off their shoes here and cover the last stretch barefoot. The pilgrimage site soon became famous throughout Europe, not least because of the tales of miraculous cures related by those who had visited it.

The church's statue of the Virgin Mary was removed and burnt when Henry VIII cut the Anglican Church's ties with Roman Catholicism. The church was then closed (1538) and left derelict. The site was only brought back to life in 1895, when Charlotte Boyd purchased the Slipper Chapel and donated it to the diocese.

Two years later the village was recognized as a place of pilgrimage by Pope Leo XIII. Marian worship underwent a revival in the Anglican Church at the turn of the 20th century, and today's pilgrimages have an ecumenical flavor. Hundreds of thousands of pilgrims undertake the journey to the two chapels on this important site, in particular on September 24, when the Archbishop of Canterbury leads a great pilgrimage.

Gloucester Cathedral

The lavishness of the Decorated Style clearly failed to satisfy English tastes for very long, and around 1330 the strict verticals of the Perpendicular Style began to find favor. These new forms were used in decorating walls and windows in particular, creating a unique visual effect.

The Cathedral of the Holy Trinity at Gloucester, a rebuilt Norman structure dating back to 1337–60, is the oldest surviving example of the new style, which enabled large areas to be glazed. The east window of the choir, depicting the coronation of the Virgin Mary as Queen of Heaven, is a fine example of the intensity and luminosity that could be achieved. The coat of arms of Edward the Black Prince is also represented, along with the crests of all the noblemen who distinguished themselves in the Battle of Crécy in 1346.

The window is perhaps the first of the many war memorials that would come to feature in churches all over England. The most important and

Processions—participating in the Divine

Processions—when people walk together in an orderly fashion according to set rules—bring the participants closer to the Divine and form part of the ritual activity of many world religions. The Latin word *processio* means "to proceed" and a procession is a solemn ritual, usually conducted at predetermined intervals, where eternity and man's temporality confront one another.

A procession may recall some act of salvation in the past, or serve to summon the presence of God in the present, or enlist divine assistance in the future. It often involves transporting the divinity itself, which is removed from the seclusion of its shrine to be displayed in the outside world (a theophoric procession). This form of procession is documented as far back as the Bronze and Iron Ages (for example in the rock carvings at Tanum in Sweden) and in Egyptian, Greek, and Roman ritual practices, and also takes place in the great Hindu ceremonies, when mighty carts convey the gods along the prescribed routes. It is also a part of Christian tradition.

All processions allow myths to become real by re-enacting them (a mimetic procession. Even the folk religions of East Asia include theophoric and mimetic processions as part of their religious life, although it should be noted that while every procession is mimetic, not all are theophoric.

Another aspect of processions is the interaction of the human with the Divine: participants reach out to the Divine since the processions always lead to a sacred place. The shrine or temple is approached and circled in a set manner—the most striking example of this occurs during the hajj, the pilgrimage to Mecca, when the faithful walk round the Kaaba seven times. In a similar way, Buddhist pilgrims visiting the holy town of Lhasa in Tibet walk round the Holy of Holies in a regulated fashion. Circular processions take place in other religions too—Hindus and Buddhists walk clockwise round the Kailash in Tibet, while followers of Jainism and Bön walk in the opposite direction.

In Christianity, processions are liturgical ceremonies, with prayer at their heart. Early Christianity soon developed a processional tradition (which retained many pre-Christian elements), including processions of blessing or petition (demonstrative processions) which followed a cyclical timetable (harvest, Corpus Christi), or took place during times of particular hardship (plague, war) or to express thanksgiving (once a threat had passed).

Processions begin and end at sacred places, or locations that are imbued with spiritual energy. They were condemned during the Reformation, as it was believed that only the word of God could grant protection and forgiveness, not shows of piety or participation in such ritualistic events. Some reformed churches have nonetheless retained processions on certain occasions to this day.

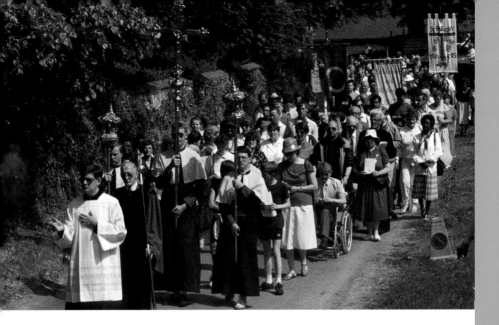

A procession in Walsingham

venerable tomb in the church is that of the murdered King Edward II—an alabaster figure with a noble countenance lies sheltered beneath an ornamental canopy of sandstone. Although the figure was sculpted just four years after Edward's death, it has none of the personal touches of a portrait but rather presents an idealized Christ-like appearance.

The Lady Chapel to the east was incorporated into the church in the 15th century and mimics the form of the main building in miniature. The monks once used the cloister with its impressive fan vaulting as a scriptorium, each monk having his own study carrel in which to write.

The White Horse at Uffington

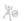

There are many ancient figures carved into hillsides across southern England, and perhaps one of the most graceful of these is the White Horse at Uffington in Oxfordshire. Around 2,500 or 3,000 years ago, sections of turf were removed to expose the chalk beneath and create the figure of a giant, stylized horse.

It is best seen from the air, the image becomes less recognizable the closer you get. It is therefore assumed to be a votive image dedicated to Epona, the Celtic goddess of the moon, fertility, and healing, who also protected horses. One legend

The White Horse at Uffington

maintains it was on this hill that St George defeated the dragon, and the beast's blood poisoned the earth so that only grass would grow here. The figure carved into the gently sloping hillside is thought by some to show the horse of St George and buy others to show the dragon itself.

Depicted in motion, the horse faces east, toward the rising sun, and there is some evidence that local people have practiced religious rites here over the centuries. Although little is known of these rituals, this place is nonetheless considered sacred. The sanctity of such a site is handed down through the generations, even if the original traditions are long lost in time and beyond the comprehension of modern man.

Westminster Abbey, London

Early English, the first phase of English Gothic ecclesiastical architecture, was followed by the Decorated Style, the second Gothic phase, which flourished between 1240 and 1330. With a high degree of attention being paid to the ornamentation of walls, vaults, and windows, the style is aptly named. Architecture and sculpture conspired to create the most impressive works of art. Westminster Abbey was a herald of the Decorated Style and represents the highpoint of High Gothic architecture in England.

The Collegiate Church of St Peter at Westminster is part of the Anglican Church but it is also under the

direct jurisdiction of the monarchy and thus a so-called "royal peculier." A Benedictine monastery was founded around 750, and because the abbey church lay to the west of the city, it became known as Westminster.

Construction of the present church began in 1245 under Henry III, who commissioned the building not only to glorify God but also for political reasons—he wanted a building to compete with the great French churches, so it is perhaps no surprise that the structure is the most "French" of England's cathedrals. The abbey was built by the royal master mason Henry de Reyns—the name may indicate his origins, Reims in France, or is possibly a reference to the clear

The façade of Westminster Abbey, London

structural similarities between the abbey and the cathedral in Reims. The interior is typical of the period, with Early English elements merging with the more dominant ornamentation of the Decorated Style. Later additions also incorporate Perpendicular elements from the third era of English Gothic.

One group of statues on the west façade is unusual—representations of the four Christian virtues are surrounded by ten modern martyrs who were prepared to die for their beliefs: Maximilian Kolbe, Manche Masemola, Janani Luwum, Elisabeth of Hesse-Darmstadt, Martin Luther King, Oscar Romero, Dietrich Bonhoeffer, Esther John, Lucian Tapiedi, and Wang Zhiming. British monarchs are still crowned in Westminster Abbey, which remains a global symbol of the power of reason and belief.

Saint Paul's Cathedral, London

The site occupied by a small wooden church in 604 is now the location of the world-famous Saint Paul's Cathedral, an unmistakable feature of the British capital's skyline. Several churches have stood on the site in the years between the wooden chapel and the present cathedral. The Normans built a church here in 1087 which burnt down and was rebuilt—each

time with alterations—several times during the Middle Ages. The building fell into disrepair during the reign of Henry VIII (1509–47), but disaster struck again in September 1666 when the Great Fire of London reduced much of the city to ashes.

King Charles II commissioned his architects, Christopher Wren, Roger Pratt, and Hugh May, to produce plans for the design and construction of a modern city. Although many of Wren's plans proved impracticable, the construction of 50 churches around the city and the rebuilding of St Paul's represent much of his life's work. The rebuilt Anglican cathedral was initially intended as a domed central-plan church similar to the structure Michelangelo had planned for St Peter's in Rome, but what emerged was a traditional elongated nave with a huge crossing cupola, which has become the cathedral's trademark. It is exactly 365 feet (111 m) from the foundations to the lantern on top of the dome, one foot for every day of the year. The circular Whispering Gallery around the base of the dome has acoustic properties that amplify even the most quietly spoken word. The interior is a mixture of various styles.

The cathedral was built between 1675 and 1711 and is now not only the see of the Anglican Church in London but has also served as a model for many other Anglican buildings— a strange concept in itself, as the adoption of "Catholic" elements had been distinctly unfashionable only a few decades before the cathedral's construction along Roman lines.

Canterbury Cathedral

The history of this sacred place begins in Rome. When a certain monk named Gregory saw several blond, blue-eyed Anglo-Saxons from the British Isles at a Roman slave market, he is supposed to have uttered the prophetic words, "They are angels!" He would have started his missionary journey to the land of mist and fog straightaway, but for Pope Pelagius keeping him in Rome.

When Gregory became pope himself, he chose an abbot named Augustine to lead the mission to convert England, and the latter set off with a group of learned monks in 596.

King Ethelbert of Kent, who was married to a Christian, allowed them to give an address outlining their teachings. His response was critical. He argued that although the speech was very beautiful and made wonderful promises, it seemed to him unlikely that they would ever be fulfilled.

However, the exemplary lives led by the monks and several miracles worked by St Augustine were enough to convert thousands in a very short time, including the skeptical king, who tore down his pagan temple. The Christian church he erected in its place was later to become Canterbury Cathedral and the see of the archbishop and leader of the Anglican Church, whose influence is now global.

Nothing remains of the church built in the Augustine era, and little more of the Romanesque church that succeeded it. The present Norman

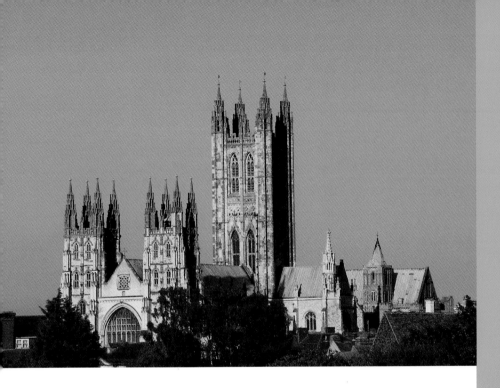

Canterbury Cathedral

Gothic cathedral was built between the early 12th and the mid-15th centuries and incorporates various elements of French Gothic and Norman architectural styles. The interior is filled with brilliant colors and the numerous pillars direct the gaze toward heaven.

Many prelates left their mark on the cathedral as its reputation spread and it became one of the most important pilgrimage sites in Christendom, but no archbishop is more closely associated with the church than Thomas à Becket. On a cold winter's morning in 1170 he was murdered at the altar by four of Henry II's loyal knights after the king had wondered aloud in a fit of rage if there was no one who would rid him of this turbulent priest; the knights interpreted this as a command.

So many miracles came to pass after the murder that two monks were given the task of recording them, and the chapel where the skull of the saint is kept is now a popular destination for many pilgrims from all over the world.

Henry VIII had the shrine torn down in 1538 and in 1642 the whole site was ravaged by the Puritans. There have also been several terrible fires on the site, but this sacred place was never completely destroyed—belief has proved itself stronger than violence.

Via Francigena

This medieval pilgrims' path, which begins in Canterbury before crossing France and Switzerland, ascending the Great St Bernard Pass, and then dropping down through Italy to Rome, was "rediscovered" only in 1994, the year that the Council of Europe recognized it as a major cultural route. Pilgrims and experts from the fields of archeology, history, and cultural studies joined theologians in attempting to reconstruct the old pilgrims' route.

There has never been a "right" path to Rome, but after the Edict of Milan of 313 had established Rome as the center of the Christian world, a flood of pilgrims soon set off, all wishing to visit the tombs of the apostles Peter and Paul. One of the earliest accounts was recorded by the English monk Gildas the Wise (500–70), who visited Rome in 530. Our knowledge of the route through England and parts of France rests entirely on his notes. In Switzerland the Via Francigena follows a route described by Sigerich the Serious, Archbishop of Canterbury, in diary entries detailing his pilgrimage to Rome in 990. The journey through France and Italy is described by St Wilfrid, who was obliged to travel to Rome to lift his excommunication. The convocation of the first Christian Jubilee in 1300 also raised interest in pilgrimage, as Pope Boniface had offered complete remission of sins to all those who undertook the journey to Rome.

The Via Francigena was later to decline considerably in popularity, particularly in the wake of the Enlightenment and the French Revolution in the 18th century, which decreed a general ban on pilgrimages (in France at least). However, a new pilgrimage movement has gathered momentum since the Jubilee in 2000—25 million people journeyed to the Holy City at the turn of the millennium, many of whom crossed Europe along the renovated Via Francigena.

Silbury Hill

As soon as you approach Silbury Hill you realize it is a sacred place. Standing out against the flat landscape near the River Kennet in Wiltshire, this conical mound has been in existence for nearly 5,000 years. Entirely man-made, its construction began around 2600 BC with the excavation of a small ditch, which was built up with turf and chalk.

In a second phase of construction, blocks of chalk were added in a stepped arrangement to the first small tumulus until it had almost doubled in size. This was in turn covered during a third building phase when the mysterious mound that can be seen today was completed. Nearly 130 feet (40 m) high, it is the oldest known artificial hill and has a diameter of 550 feet (167 m); it is flat on the top.

One legend maintains that King Sil himself is buried within the mound, still sitting upright on his horse, but the many excavations carried out at Silbury Hill in the past have revealed no trace of any tomb or grave goods.

Interpretations as to the meaning of the hill vary, from the pregnant belly of an unknown mother god, or a monument to a chieftain or king, to seeing the flattened summit as the "navel of the world" (the Greek omphalos). None of these has managed to find much favor with the experts, however. The hill has held on to its secrets, though the peaceful and powerful energy it radiates is still prized.

Stonehenge

The stones of Stonehenge may be the most famous in the world, but the circles and ditches surrounding the monument in the south of England combine to form an unmistakably spiritual landscape.

The position and distribution of the stones was soon recognized to be a form of calendar and the alignment of the northeastern entrance with sunrise on the summer solstice was also verified. In ancient times there may have been a row of stones indicating the winter solstice. The age of Stonehenge has been estimated at almost 5,000 years and it has been interpreted as a place of pre-Celtic, Neolithic ritual, possibly even a sun cult site. By 2000 BC at the latest it had become the most important ritual site in England.

It is generally assumed that the first ditch was dug around 3000 BC. It was only during a later building phase that the bluestones for the 80 standing stones were transported the 250 miles (400 km) from the Preseli

The stone circle at Stonehenge

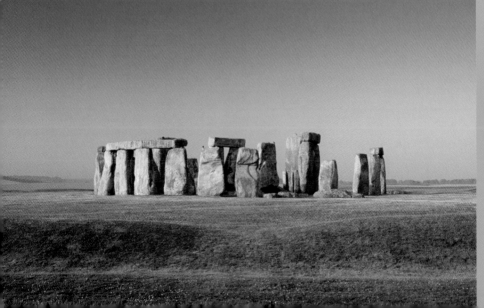

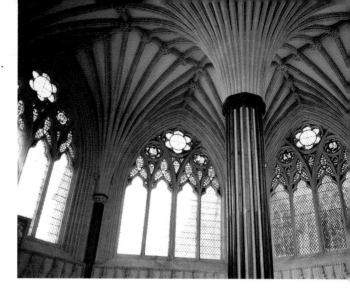

Mountains in Wales. It seems reasonable to assume that the mountain where the stones were quarried was also considered a sacred place. For man, stone has an eternal and seemingly unchanging quality,which may explain why so many cultures have come to associate stone with the eternal, the supernatural, and the Divine. Stones were regarded as the source of some secret or magical power and worshiped accordingly.

The vaulted ceiling of Wells Cathedral

There is a shaped stone in the middle of the site at Stonehenge, which has led some to speculate that sacrifices were carried out here; it is now called the Altar Stone, even though there is no evidence to support such assumptions. The theory at the beginning of the 18th century was that the site was a druid shrine, and at the turn of the 19th century a modern druid order was founded whose priests are still inducted in the stone circle at the summer solstice.

This spiritual place is not just a destination for druid novices, however—it has become popular with all kinds of people and with young people in particular, who come here from all over the world to experience the mystery, secret energy, and power of the huge upright sarsen stones as the sun rises and sets.

Wells Cathedral

St Andrew's Cathedral in Wells may not be one of the largest cathedrals, but it is certainly one of the most beautiful. A gem of English Gothic, compared to many cathedrals it looks almost delicate. The internal and external proportions work together in harmony and the decoration is imaginative without being ostentatious.

Wells became a see in 909, but there are no records of any church pre-dating the present cathedral, construction of which began in 1180 under Bishop Reginald, and was completed in several phases between 1290 and 1340.

English cathedrals are very awe-inspiring structures, particularly in comparison with those on mainland Europe, which are found crowded

among mazes of medieval streets, while their English counterparts are frequently located overlooking leafy green spaces. The English builders also dispensed with the twin tower façade favored on the Continent, preferring a screen façade that often comprised a vast decorative array of statues and windows.

Built between 1230 and 1240, the west façade at Wells Cathedral is an excellent example of this. It originally featured 400 life-size and larger statues (nearly 300 of which have survived), telling the complete story of Man's salvation. The *theatrum mundi* ("theater of the world") was presented in a series of sculptures and reliefs: scenes from the Old and New Testaments, angels and apostles, tyrants and kings, the rich and the poor, and above them all an image of Christ in glory on the gable of the crossing tower.

In the interior the magnificent scissor arches bearing the weight of the crossing tower immediately catch the eye, and the pillar capitals are decorated with luxuriant vegetation or figures from human history. Some of the windows have been constructed from numerous fragments of older windows and refract the light in striking ways. The steps leading to the chapter house have been worn by countless feet—mounting them is like climbing to some unknown level of heaven. The fan-vaulting of the ceiling of the chapter house stirs the emotions like a poem—it is a triumph of the imagination and geometry, above a space full of movement and tranquility.

Glastonbury Tor

This sacred place has become a pilgrimage site for Christians and non-Christians alike, for fans of the esoteric, for druids, and for anyone seeking a meaning in life. Glastonbury is a small town steeped in myths and legends in the county of Somerset in southwestern England. For centuries, pilgrims have been coming to the ruined abbey, the medieval church tower on the tor, and the deep Neolithic terraces, which may mark out a solemn path to a ritual site; their goal is to experience some of the mystery that surrounds the place.

Glastonbury was originally a small island in the middle of an area of wetland, which gradually dried out over the millennia, eventually forming Glastonbury Tor, a 500-foot (158-m) hill. A legend relates how Joseph of Arimathea built a church beneath the hill, bringing to England not only the gospel but also the goblet used by Christ at the Last Supper—the Holy Grail. Joseph is said to have buried the Grail at the foot of the tor, and the spring that has flowed there ever since is supposed to confer health and strength upon those who drink from it. It is even possible that this legend gave rise to the tales of King Arthur and the Knights of the Round Table and their quest for the Holy Grail. The history of this sacred place is inextricably linked with myths, magical stories, and tales of saints—and nowhere is this felt more strongly by visitors than on the climb to the summit of the tor.

Buckfast Abbey, Dartmoor

On Dartmoor it rains on more than 200 days a year and on many other days the moor is covered with a low mist that parts only occasionally to reveal a flash of blue sky. Writer Colin Wilson has called it "a dreaming country." The moor, covered with ferns, moss, and heather, is dotted with birch and pine trees bent over by the wind and crystal-clear streams teeming with fish—it is a landscape that you have to love, a country for enthusiasts.

Set against this landscape is one of the last monasteries still in use—the Benedictine Buckfast Abbey. Deer have grazed the moors here at the source of the River Dart since time immemorial. The monks called the spot Buckfast, the resting place of deer and stags, and the words of the psalm seem to have been borne out: "As pants the hart for cooling streams, so longs my soul for thee, o God" (Psalms 42:2).

People have long been coming here for the same reason, searching for the source of something, searching for God. They are once again being welcomed in the Benedictine abbey, which was established in 1087 by Lord Aylward as a sister foundation to the monastery of Savigny. Until the monastery's dissolution in 1539 by Henry VIII, the monks here belonged to the Cistercian Order.

After the dissolution, the monastery lay derelict for almost three centuries, until those parts that could still be used were first rented and then purchased in 1882 by a group of Benedictine monks who had been expelled from France. Building work soon began on a new monastery in a Norman-Gothic style and this was completed in 1937.

The monastery has since become a popular destination for pilgrims who come in groups or singly—the abbey offers seminars and spiritual courses, which are well attended. The abbey is also economically independent, growing fruit and vegetables, keeping bees, running seminars, and of course producing Buckfast Tonic Wine, which more or less supports the abbey on its own.

Mên-an-Tol in Cornwall

After Stonehenge, Mên-an-Tol is indisputably the most famous megalithic monument in England. It is composed of a row of three stones aligned along an axis running from southwest to northeast. The middle stone has a hole in the center and is flanked by two more or less squared-off menhirs; there are several further stones in close proximity to the menhirs.

These stones were erected 3-4,000 years ago, although archeological investigation has revealed that the position of the individual elements has been altered over time. Experts are still unsure of the exact meaning or

ritual use of the stones—it is generally assumed that the stone with the hole was used for initiation purposes, but it may also have been employed to interpret signs in the heavens.

Whatever its original use, Mên-an-Tol still holds a great fascination for visitors, and it is little wonder that many legends and sacred traditions have grown up around the site. It has long been a tradition that women wishing to conceive should climb backward through the hole seven times during the night of a full moon. Another equally deep-rooted belief holds that passing through the stone will cure back and joint pains—hence the local name of "Crick Stone."

A further tradition maintains that children who are passed through the stone several times will be immune to pain and sickness, and it is said that the stone can be used for divination and to end curses—it is also known as the Devil's Stone.

Ancient spiritual teachings suggest that, in order to receive energy, space must first be made for the energy to flow into. Hundreds of thousands of people have been seeking such energy for millennia—only to find it at places like Mên-an-Tol.

Mên-an-Tol, Cornwall

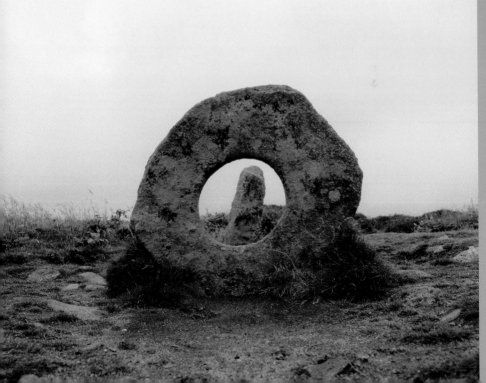

Saint Michael's Mount, Cornwall

A number of sites in high, exposed situations around Europe have been dedicated to the archangel Michael as the protector of travelers. All journeys can be viewed as a kind of crossing of a frontier, and all frontiers, whether on land, at sea, or in the air, are frontiers in life; it is at just such junctures that the archangel Michael appears. In Roman Catholic belief, St Michael is present at both the beginning and the end of the world—he is the guardian of the deserted Garden of Eden, and it is he who weighs the souls on Judgment Day. His name encapsulates a central human question, as the Hebrew Mi ka'el means "who is like God?"

The stretch of coastline near Penzance that includes Mount's Bay, with the island of Saint Michael's Mount lying just offshore is considered one of the most beautiful in England.

According to legend, an angel appeared to some fishermen in 710, Later, in 1050, a group of Benedictine monks settled near where the vision had appeared, taking advantage of Edward the Confessor's offer of the cliff-top site as a location for their monastery, a sister foundation to the French Mont–Saint–Michel.

The building soon became part of St Michael's Way, which begins here and passes Mont Saint-Michel in Brittany, Saint-Michel d'Aiguilhe in the Auvergne, and Sacra di San Michele alla Chiusa in Piedmont, before reaching the pilgrimage church dedicated to St Michael at Monte Sant'Angelo in Apulia. This pilgrims' way across Europe lay forgotten for many years, but is now once again in use.

The church and the later addition of the castle, both built of granite, stand atop a 230-foot (70-m) cliff, also composed of granite, at whose base there nestles a tiny fishing village. Due to the strategic location of the rocky island in the beautiful Mount's Bay, in the past, the needs of the military were frequently put before those of the monks. However, the island has now reverted to what it once was—a place where St Michael, the protector of life's journey is deemed to be present.

Saint Michael's Mount, Cornwall

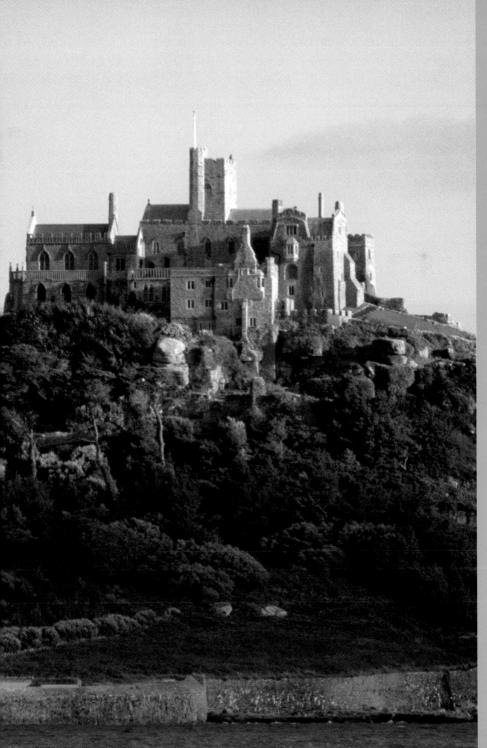

Callanish Stones, Isle of Lewis

Erected some 5,000 years ago, the standing stones at Callanish (Scottish Gaelic: *Calanais*) rival those of Stonehenge and Mên-an-Tol. The interpretation of many Neolithic stone circles, arrangements, and alignments is disputed at best but it is most likely that the Callanish Stones form a giant lunar calendar. The moon reaches the southernmost point of the lunar cycle every 18.5 years, and, when viewed from this location, it appears to travel along the horizon, to the extent that it looks as if the distant moon is actually touching the earth. The site is therefore closely connected to the landscape—it is almost as if the stones have grown out of the land itself. They are threaded with fine veins of quartz, which rapidly absorb the heat of the sun, radiating a gentle warmth and energy to those who touch them. Peripheral stones are arranged around the central circle, forming a giant Celtic cross whose arms indicate the points of the compass. The area's charm is unmistakable; even though it

The monastery on Iona

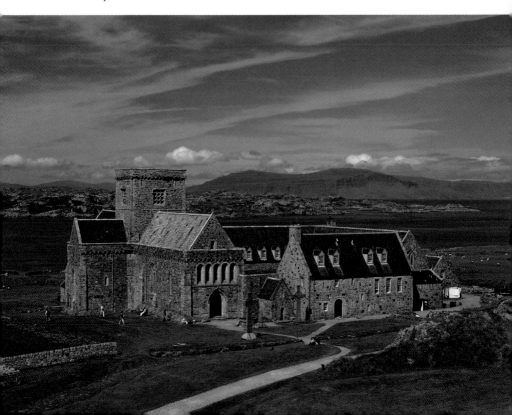

is difficult to say for sure exactly what rituals were celebrated here, It is easy to understand the sacred nature of this place between heaven and earth.

The monastery island of Iona

The monastic orders were the main focus of Celtic Christendom, and this is certainly true of the Scottish island of Iona, the spiritual center of Scotland for many centuries. A monk named Columba came to the island in 563 to found a monastery. He and his few companions spread the Christian gospel and as the fame of his holiness spread, the entire island came to be regarded as blessed. As the place where the *Book of Kells* is thought to have originated, the Island of Iona is now known across the world. Containing the four Gospels, and lavishly produced and illustrated, with whole page depictions of Christ, Mary with her child, and the four evangelists, it is one of the most valuable books in the world. Many of the pages are also decorated with Celtic designs. This unique treasure is now kept in Trinity College, Dublin.

The monastery on Iona was the most important in Celtic Christendom until the 11th century, by which time Roman Catholicism had reached as far as Scotland and a Benedictine monastery was founded. This was dissolved during the reign of Henry VIII and left derelict. In 1938 George McLeod, a Scottish minister from Glasgow, founded the Iona Community, an organization supporting social change and endeavoring to revive the Iro-Scottish tradition. In the ruins on Iona he discovered a place in which to realize his dream, and by 1967 the abbey was once again filled with life. The community is composed of "members," who abide by the community's rules, "associates," who follow the first rule of daily Bible study and prayer, and "friends," who support the Iona Community financially. The regulations are similar to a contemporary monastic rule: community members are obliged to pray and study the Bible daily; they must spend their time and money wisely and promote the causes of peace and justice; they are also obliged to attend regular meetings organized by the community, as they live in family groups. The community meets on Iona itself, and is always seeking new ways to touch the hearts of man, enjoying greatest success with young people, who find stability and orientation in the group. Guests are always welcome in this historic sacred place.

Rosslyn Chapel, Roslin

The tiny village of Roslin near Edinburgh boasts a church that has achieved worldwide fame and whose enigmatic aura has attracted many to join the ranks of the art historians—from

mystics, ghost-hunters, and Masonic conspiracy theorists, to the merely curious. Rosslyn Chapel (more properly, the Collegiate Chapel of Saint Matthew) was begun in 1456 to plans drawn up by William Sinclair, Baron of Roslin. After nearly 40 years of construction work, the baron died and was buried in the still unfinished church in 1484. The crypt, the choir, and the east wall of the transept had been completed, but work was then halted. The chapel is richly ornamented with delicately carved stone-work and covered from floor to ceiling with numerous patterns and designs ranging from mysterious symbols, strange and mythological animals, and monstrous creatures, to plants resembling aloe or corn. If these images date back to the original construction of the church, they present a further conundrum, since America, where aloe and corn originated, was not discovered until 1492. The sculptures recount a wealth of Bible stories but there are also constant reminders of pagan culture.

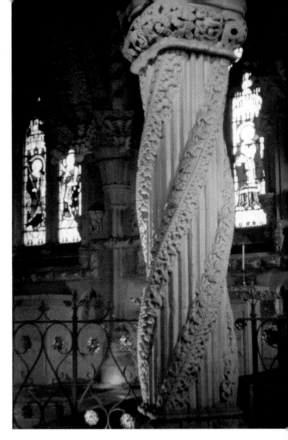

The ornate Apprentice Pillar in Rosslyn Chapel

The so-called Master's Pillar and Apprentice Pillar are particularly worthy of attention—legend has it that a master mason was commissioned to create two especially beautiful pillars, and though he finished one, his imagination failed him for the second. He undertook a trip to Rome, where he hoped to find inspiration, and during his absence his apprentice carved a second pillar with consummate skill, decorating the surface with great volutes and marvelous reliefs. When the mason returned, his rage and envy of the apprentice's skill led him to strike the boy dead with a hammer. The two pillars are also associated with the pillars of Boaz and Jachin, which are significant in freemasonry. Rosslyn Chapel found fame recently after two journalists put forward a theory suggesting that the Freemasons were descended from a group of Knights Templar who had

made their way to Scotland after fleeing France in 1307. Dan Brown's world-famous novel *The Da Vinci Code* is based on this premise, and the book's record sales have drawn an ever-increasing stream of pilgrims to Rosslyn Chapel.

Whithorn Priory and St Ninian's Cave

St Ninian was an early Scottish saint. Born in 360, he soon converted to Christianity. Thirsty for knowledge, he undertook the pilgrimage on foot from his home town of Galloway to Rome, where he learnt much and was confirmed in his faith. On the way back he encountered St Martin, bishop of Tours, and spent some time in France.

Once he had returned to Scotland, Ninian began to preach the gospel of tolerance and love to the tribes of the British and the Picts. He built a chapel

The ruins of Whithorn Priory

whose white walls stood out so clearly against the green landscape that it was named Candida Casa. Ninian also founded the **Whitehorn Priory** here in 379, which according to at least one account was the first on the island.

Ninian was not only a preacher, he also performed miracles and worked as a missionary to bring the Christian faith to his home country. His work came to be so respected that he was eventually canonized. Whatever he may have preached, one aspect of his life could be deemed to bear the mark of a miracle: the spreading of the gospel of tolerance and enabling people to live together.

Situated not far from the priory, in a cliff beside the sea, is a naturally-occurring cave known as **St Ninian's Cave**. According to the legend, Ninian retreated there to pray and meditate as he stared out over the water. People have been coming here for centuries to do the same. St Ninian's Cave looks as if it could have been designed specifically for this purpose, sheltered by the rockface and looking out over the waves as they beat endlessly against the shore. With just the wind and clouds for company, visitors to the cave are soon made aware of just how small and insignificant they really are. The many crosses that have been left here, either made from pebbles or seaweed and driftwood, are mute testimony to the use that people still find for this place in their present-day lives.

The Aran Islands

"There are four stations between heaven and earth where souls can be purified: Adam's Paradise, Rome, Aran, and Jerusalem. No angel who descends from heaven to aid the Gaelic peoples returns without first having visited Aran. If people only knew how much God loved Aran, they would all come to receive a part of this blessing." Bishop Cormac McCuilenáin of Cashel, who died in 908, described thus the three limestone islands lying in the Atlantic some 28 miles (45 km) off the Galway coast. Inis Mór (the big island), Inis Meáin (the middle island), and Inis Óirr (the small island) together form a uniquely ancient and mysterious landscape.

For centuries, thinkers, dreamers, artists, and seekers of all kinds have been drawn to these islands, which were considered one of the most important pilgrimage sites in the early Irish Christian Church. Time seems to have stood still on the islands; they have their own rhythm, which has little in common with the pace of modern life.

The largely unspoiled landscape brings people peace and a new energy, both physical and spiritual. Alongside the megalithic tombs, circular forts, and temple sites, Christian monasteries and a wealth of stone crosses seem to have sprung up directly from the ground. Let the atmosphere of this place wash over you as you watch the mighty waves crashing against the rocks, and you may just get a sense of the eternity described by the Argentinian poet Jorge Luis Borges when he said: "If you want to imagine eternity, picture an angel stroking a block of marble with its wing—until the marble has worn to nothing."

Our Lady of Knock

Knock may not be a large town, but it is one of the principal sites of Marian worship in Irish Catholicism. Knock originally comprised just a few houses located near the parish church, but on August 21 1879 something very strange took place here. The local priest's maid, Maria McLoughlin, and two of her friends had a vision of the Virgin. She was standing beside the church wall in the company of Joseph and St John the Evangelist, to whom the church is dedicated, surrounded by a halo of flames.

At first the girls were unsure what to think of this mysterious event, but soon a crowd of villagers gathered to confirm what the girls had witnessed—a clear vision of the Virgin, in white robes, with a crown on her head and a rose at her forehead. Standing respectfully to one side, Joseph was also dressed in white robes, while John wore a bishop's cassock and carried an open book. His free hand pointed toward the Virgin. Behind the three figures the crowd saw a simple altar and a white lamb. A canonical inquiry was convened, as a result of which the event was recognized by the Catholic Church, confirming the veracity of the two-hour vision.

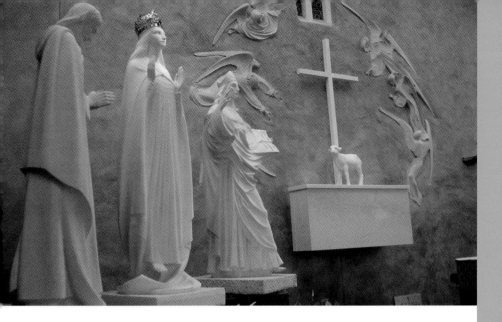

The group of statues at the pilgrimage chapel, Knock

Life quickly changed in Knock. A small glass chapel was erected at the site of the vision, housing a group of statues representing the apparition, and by 1976 the stream of pilgrims had grown to such an extent that a large pilgrimage church was built. Over a million people a year now visit the site and Our Lady of Knock has become one of the major Marian shrines in Europe. On the 100th anniversary of the vision in 1979, Pope John Paul II presented the town with a golden rose, the papal award for shrines to the Virgin. The sacred site is open all year round to pilgrims, but most visit during the nine days from August 14, the day before the Feast of the Assumption, to August 22, the day after the anniversary of the vision, to pray for a stronger faith and for help in adversity.

Croagh Patrick

This conical mountain in County Mayo in the west of Ireland was once known as the "Mount of Eagles" (*Cruachán Aigle*). Archaeological finds have shown that the site has been a special, sacred place for some 6,000 years.

The spring water on the mountain carries traces of gold, and the people who come here have the sense that strange forces are at work. The changing light, the height—even if the mountain is a relatively modest 2,500 feet (764 m) high—the wind, the proximity of the sea and the many islands in the area have all combined to draw people to settle here.

The first settlers arrived during the Neolithic era, and there is evidence

of Bronze Age settlements. A monastery may also have been built here later, but only scant traces remain of any of these structures. Since the 5th century the mountain has been associated with St Patrick, the patron saint of Ireland, who is said to have fasted for 40 days on the summit that now bears his name.

Patrick was born the son of a Roman soldier in 387 and sold as a slave in Ireland, where he learnt the Celtic language. Inspired by a vision of an angel that came to him in a dream, he fled slavery and made his way to Gaul, where he spent some time in the company of St Martin of Tours.

A second vision, in which he saw people standing on the coast of Ireland calling for him, prompted him to return, and in 432 he made landfall in Ireland with 24 companions. The local population was initially reluctant to renounce their old pagan beliefs, so Patrick prayed for an entrance to purgatory to open up and sent them inside. Many never returned, but those who did were so horrified by what they had seen that they converted to Christianity immediately.

During his lifetime Patrick is said to have overseen the construction of 365 churches—one for every day of the year. As his death drew near, he asked God to free Ireland from all pestilent creeping animals, and the Irish still believe that his prayer was heard, as there are no snakes in Ireland to this day. Crowds of pilgrims, many of them barefoot, climb Croagh Patrick on the last Sunday in July.

Pilgrims on Croagh Patrick

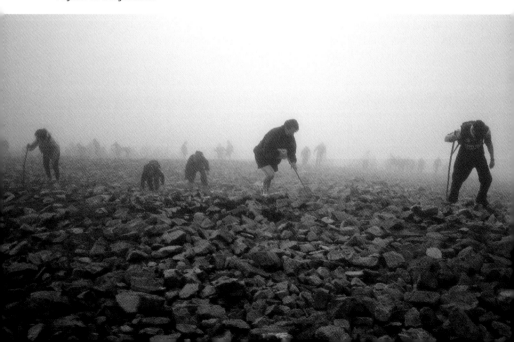

Newgrange

Almost all religions offer some kind of hope of life after death, and this often finds expression in the location and form of burial sites. Ancient made of turf and stones rising to a height of 36 feet (11 m) above the river plain and with a diameter of 250 feet (76 m). The Newgrange site is surrounded by a circle of menhirs, of which 12 of the original 35 have survived. A large stone marks the

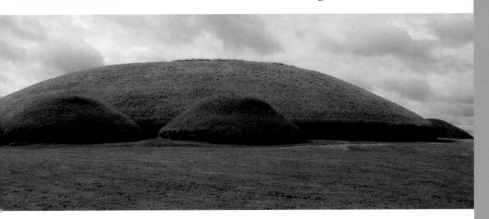

The Newgrange tomb site

graves are frequently situated near springs or rivers, so, it is thought, the dead would not have far to travel to reach water, or are placed near hills, to be closer to the heavens.

In the third millennium BC, a vast tomb was laid out near the Boyne River at Newgrange; it was constructed in such a way as to allow a beam of sunlight to fall through an aperture in the tomb chamber on the winter solstice, perhaps to bring some light to the dead on the shortest and darkest day of the year.

The passage tomb at the Newgrange site was built approximately 5,000 years ago, in the form of a mound entrance to a long corridor leading into the inner chamber. Many of the surrounding stones are decorated with geometric designs. They include diamonds, concentric circles, and most notably spirals, and may represent the wanderings of the soul after death on its journey to eternal peace. In Irish myths and legends such hills were known as *sídhe* (fairy hills), and were considered to be the homes of supernatural creatures.

Nothing is known of the people who may have been buried at this site, but the place still holds an irresistible fascination. People come here to see an affirmation of life in the face of death.

Saint Patrick's Cathedral, Dublin

Ireland's history is a bloody one, full of internecine feuds lasting into modern times, but one person has always commanded respect and reverence—St Patrick, who was responsible for the first Christianization of Ireland.

Patrick, who was born in Britain, was captured at the age of 16 by Irish pirates and taken to Ireland as a slave. He managed to escape and flee to France, but he returned to the Emerald Isle in 432 and spent 30 years fulfilling his vocation as a missionary. His simple piety was characterized by a notion of faithful perseverance and a willingness to undergo privation. He regarded human existence as "exile" in the world, to be followed by redemption on the Day of Judgment.

St Patrick's Cathedral in Dublin is the most important Christian church in Ireland, which brings its own problems, as the building is now Church of Ireland and Protestant. Both Protestants and Catholics revere St Patrick equally as the country's national saint. However, religious and especially political conflicts, which disturb the harmony of human relationships, have yet to be overcome completely.

The church is located on the site of an old well where Patrick is said to have baptized pagans as Christians, and the stone covering the well can still be seen in one corner of the modern cathedral. St Patrick's Cathedral was consecrated in 1192, but the modern building dates

back to extensive renovations undertaken as recently as the 1860s.

Even though it is not the episcopal see of the diocese, the cathedral is regarded as "the people's church." It is surely beneficial that Catholics and Protestants are reminded they worship the same God and that they try to use this insight to see beyond the great divides that all too often seem to separate them.

The monastery village of Glendalough

Glendalough in the Wicklow Mountains is one of the major pilgrimage sites in Ireland; the name in Irish (*Gleann Dá Locha*) can be translated as "vale of the two lakes." The town, with its monastery and tiny church, was founded in the 6th century, when St Kevin retreated here to find peace in solitude and to live at one with nature. Although his only companions in this lonely place were the birds, or so legend has it, many followers came to seek him out and a small monastic community was founded.

The saint's followers built a small village with several churches, chapels, and houses near his hermit's cell. Kevin, who is said to have preferred the company of birds and animals to that of humans, nonetheless served as the abbot of the monastery until his death in 618, at the biblical age of 120.

The monastery village slowly grew, with some 3,000 people living here during its heyday, and seven churches were built. The round tower, 110 feet (33 m) high, is the feature that stands out; it may have served to safeguard valuable books and liturgical apparatus from the Vikings, who constantly attacked the village.

The monastic community survived until 1539, the terrible year (Latin: *annus horribilis*) when Henry VIII dissolved the Irish monasteries. Visitors to this site between the upper and lower lakes will be struck by the peaceful atmosphere, which can be felt even in modern times.

The tiny church is nicknamed "Kevin's Kitchen" as the tower slightly resembles the chimney of a stove, while a Celtic cross—Kevin's Cross—stands serenely over the saint's grave. Pilgrims come here on June 3 in particular to remember this most popular saint.

"Kevin's Kitchen" Church, Glendalough

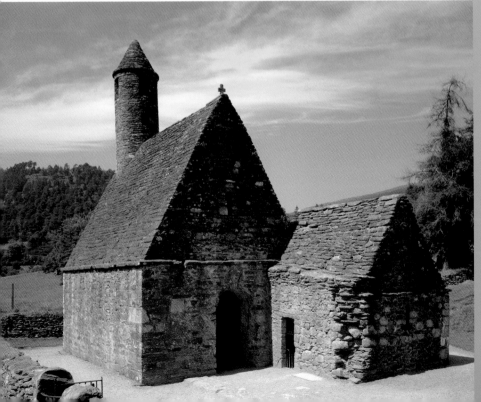

Arras Cathedral

The city of Arras has had a turbulent history, which has seen it destroyed and rebuilt several times over. The Roman emperor Caesar used Arras as a wintering place in the north during his Gallic campaign, and in 451 the city was pillaged by the Hun hordes. After being rebuilt, the city became a diocese when St Vedastus was appointed bishop of Arras in 499. Legend has it that a wild bear lived in the Roman ruins, but the saint managed to tame it through the power of prayer, driving it—and all fear with it—from the city. Its position on the border between France and the Holy Roman Empire made Arras susceptible to attack, and although fortifications were erected in the 9th century, the city was overrun by the Vikings shortly afterward and was destroyed once again.

The city grew steadily from the 11th to the 15th centuries, becoming a major hub for trade and an important stopping-point on the Via Francigena, the pilgrims' route from Canterbury to Rome. Arras was sacked once again in 1477, this time by Louis XI, and after it was rebuilt a certain lassitude set in, with the city falling under the sway of the merchant classes. World War I brought more destruction, and this time Arras was practically razed to the ground. Unparalleled efforts saw the city rebuilt stone for stone to become an architectural gem in this corner of Flanders, famed throughout the world for its wall-hangings, restored town squares, and town hall, whose tower resembles a church spire.

The relics of the town's patron saint, St Vedastus (St Vaast) are particularly revered, and are kept in the cathedral dedicated to his name. The Gothic church is imposing, although of little architectural merit. Pilgrims come here to seek the assistance of a popular saint (whose fame has also spread to England) about whom tales of miracles are told. It is a popular destination for pilgrims en route from northern France and England to Rome, who still have a long journey ahead of them. St Vedastus is also the patron saint of walking and of leg ailments, and his intercession is said to help pilgrims complete the arduous journey in good health.

Amiens Cathedral

In 1206 the cathedral at Amiens obtained a very special relic—part of John the Baptist's skull—and the city soon became one of the major destinations of French pilgrimages. The old Romanesque cathedral burnt down in 1218, and the structure that replaced it was to become the apotheosis of Gothic architecture. The foundation stone was laid in 1220 but the cathedral was not completed until the 18th century. Fires and other catastrophes continually interrupted the building work, and only the intervention of a group of enlightened citizens prevented its total destruction during the French Revolution. The structure shows clear influences from the

cathedrals at Paris and Chartres, and the classic three-tier interior was also adopted here. Visitors to the cathedral will find themselves in a space that is majestic without being ostentatious, endowed with a simplicity that reflects in stone the clarity of medieval scholastic thought. The impression is of power, a feeling that is almost tangible, but a power that is nevertheless contained as it strains heavenward.

The west façade is based on Notre-Dame and the main portico exerts a strange attraction, almost enticing visitors into the church. This effect is achieved by a subtle architectural technique, which is not immediately apparent—the central door projects further than the two side doors. Although the cathedral is dedicated to the glory of God, there are several elements within that concentrate on the human. The bas-reliefs in the quatrefoils at the base of the wall plinths show pairs of virtues and vices, with a series of scenes beneath depicting everyday life through the labors of each month, which are reassuring in their domesticity. A row of 17 figures around the exterior of the south rose window represents the symbolic Wheel of Fortune outlined by Boëthius in his *Consolation of Philosophy.*

The huge windows admit a flood of light into the interior, realizing the medieval dream of a "glass church." The late Gothic choir stalls are also unique, with representations of over 4,700 biblical figures, mostly from the Old Testament, and the canopy over the stalls resembles spreading trees in a forest. It is almost impossible to tear oneself away from this charming cathedral—its structure and decoration

The interior of Amiens Cathedral

are in no way oppressive, offering instead a chance to experience feelings of wonder in a peaceful place.

Saint-Gobain Forest

Very little of France is forested—great swathes of land once covered with ancient trees have been cleared and cultivated since the earliest times, and most of the remaining woodland consists of managed hunting forests, altered from their original state many years ago.

One of the most beautiful and mysterious forests that remains is to be found at Saint-Gobain near Laon, with its mixture of attractive beech, oak, cherry, lime, and horse chestnut trees, often of great size.

The forest is named after St Goban (French: Gobain), a 7th-century Irish monk who settled here on his way back from Rome, living as a hermit at a place now known as Mont de l'Ermitage. He built a small chapel dedicated to St Paul in commemoration of his visit to Rome. Legend has it that this chapel was located on a particularly sacred site near Bronze Age megaliths and dolmens, beneath one of which Goban is said to have lived. The local people persisted in their old beliefs, worshiping the ancient stones more than the new God, about whom they knew little. Not only did they refuse to convert to the new religion, but they also persecuted the hermit, eventually beheading him. A monastic community, about which little is known, settled near his grave and kept his memory alive for centuries. The town of Saint-Gobain now stands where they once lived; only the 12th-century church with its imposing crypt has survived.

As you wander through the forest, discovering menhirs, dolmens, and other enigmatic stones in the clearings, you may find the solitude helps you discover new insights about yourself. The sacredness of this site is undoubted, even if it is no longer clear quite how it was used—the wood and the stones have not given up their secrets. Saint-Gobain Forest confirms what Bernard of Clairvaux once wrote in a letter: "You will find much more in the woods than in books. Wood and stones will teach you things you will never hear from teachers" (*Letters*, 106).

Laon Cathedral

From whatever angle you approach the city of Laon, you cannot miss the hill and its cathedral that rise up out of the Paris basin. The Celts regarded the mound as a sacred site and the Gothic cathedral, which from the exterior resembles a crown, has stood here since the Middle Ages. Laon became an episcopal see in the 5th century, but bloody scuffles between the citizens and the bishop's soldiers in 1112 led to the destruction of the cathedral, which burnt down. A new one was soon constructed, but this

was torn down by the new bishop barely 50 years later to make way for yet another in the new, Gothic style.

Work began between 1155 and 1160 on what was to be the first cathedral to explore Gothic ideas. The west façade is powerful and original, with the equally spaced triple portico clearly representing the concept of the gates of heaven as its doors admit visitors into the interior. The magnificent towers with their open stonework dominate the building. Their huge sculptures of oxen are a unique feature, almost compelling visitors to walk around the cathedral to view them from every angle.

The shape of the towers here was adopted in every other Gothic cathedral, in some attenuated form or other, but the oxen are to be found

The west façade of Laon Cathedral

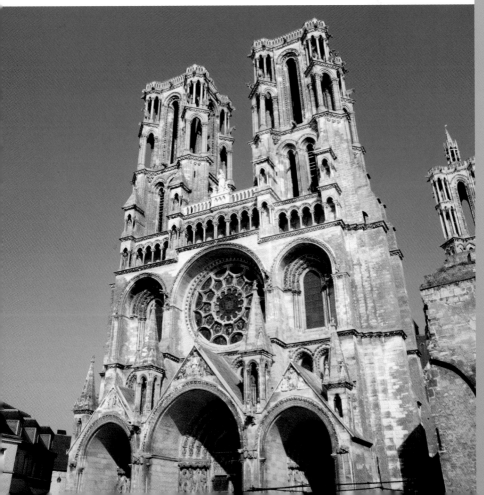

only at Laon, and their presence is due to a local legend. One of the countless oxen used to transport building materials up the hill to the cathedral is said to have collapsed from exhaustion, whereupon another ox descended from heaven to help it, before mysteriously disappearing again. The stone oxen are a reminder that help and mutual support are important to the success of an undertaking.

The sight of the finished church must have been more striking for contemporary observers than for modern man—such a building had never been seen before. The light that floods the interior was another novelty at the time. Some visitors to the church today may simply come to study the architecture; however, standing before the façade and then entering the church may still evoke even for them some of the magic that Abbot Suger wished for every church: that it should be like a gate into paradise.

Soissons

A tour of the great and famous cathedrals of northern France is all too likely to miss out one of the less well-known Gothic churches and the seat of the bishop of Soissons—the unjustly neglected **Cathedral of St Gervais and St Protais**. The building has been subjected to all kinds of ignominies over the years. Construction began in 1180, but the Hundred Years' War prevented the

completion of the north tower; the decorated portico was lost in the Huguenot Wars of the 16th century; and large parts of the cathedral were destroyed in World War I—the repairs are all too apparent in the church's fabric.

The interior is a little more coherent—beautiful, slender columns give an impression of balance and lightness, and the windows admit a flood of daylight and color. The busy, cluttered exterior is forgotten completely and the building is filled with a soothing tranquility.

There is another sacred site in Soissons—the ruined **Abbey of St Jean des Vignes**, founded in 1076 as a monastery for the canons regular, who follow the rule of St Augustine. The Romanesque building was gradually replaced with Gothic structures between the 13th and 16th centuries. The monastery was dissolved after the French Revolution, serving for a while as a barracks, and an explosion in a munitions dump destroyed much of the church and the cloister buildings. Only the twin towers of the Gothic façade, parts of the transept, and the refectory have survived to the present day, yet these few remnants still give an impression of the spirit of the place. Gothic portals were intended to represent the gates of heaven, as perhaps many of the medieval pilgrims understood.

Today, as you look through the windows now open to the sky, or see the grass growing in what was once the vestibule, it is easy to imagine the abbey as a place from which to cross into a kingdom that will endure longer than all the kingdoms on earth.

Reims

The cathedral stands on a site once occupied by a Carolingian building, which burnt down in 1210. By this stage, Reims had been the coronation church of French kings for many centuries, and the foundation stone for a new cathedral was laid immediately. Pope Honorius III encouraged the project, promising a special indulgence to anyone contributing to the building costs. Work was constantly interrupted during the Hundred Years' War and the church was still incomplete at the coronation of Charles VII, which was attended by one Joan of Arc. By 1481 only the spires remained unfinished; these have never been added.

Despite the length of time spent on its construction, the building has a remarkable unity; each subsequent architect remained true to the original plans and the resultant cathedral has a harmonious feel. Many of the decorative elements show classical influences, which may have been prompted by archeological finds. The decorated pillar capitals betray a particular affinity with nature, with acacia leaves, other foliage, and figurative motifs featuring among the carvings of fabulous animals and humans. The Visitation relief above the central portal depicts Elizabeth as

The "Laughing Angel," Notre-Dame de Reims

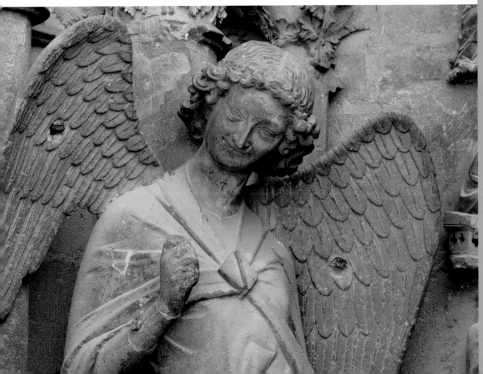

a Roman matron and Mary as Venus—only her serene expression differentiates her from Roman statuary. A later phase saw the addition of delicate and graceful figures such as the famous "Laughing Angel," a statue that seems to have little of the wrath of God about it, instead regarding human failings with divine indulgence. The church's interior is marked by a similar genial serenity, and the view along the nave to the western rose window imparts a sense of the size and balance of the design.

Even nonbelievers will sense the cathedral's appeal—accessible to anyone with an open heart and soul, it speaks to us with intimacy.

Saint-Pierre, Bar-sur-Aube

This neglected medieval town is a little jewel. Narrow canals crisscross the town and there is little to suggest that Bar once grew rich as one of the four principal trade hubs in the Champagne region. Local merchants traded here with visitors from Flanders, Italy, Germany, and even faraway Spain, but only a few remnants of the town's fortifications still attest to this illustrious past. Proximity to Clairvaux certainly boosted the town's importance, and it was a major stopping-point on the Via Francigena, the pilgrimage route from Canterbury to Rome.

The most sacred place in Bar-sur-Aube is the 12th-century Benedictine abbey of Saint-Pierre, a charming and harmonious example of early Burgundian Gothic architecture. A unique wooden veranda was built around the church to shelter any pilgrims or merchants who needed to stay overnight. The church's interior is bright and airy, with high ceilings and plenty of light. It is not particularly ornate, but the atmosphere is relaxed and welcoming. The church is accessed via a flight of steps made of gravestones from the first abbey at Clairvaux. Just entering the abbey is a reminder that life is finite and death merely a step into a better and more peaceful world.

Clairvaux

Established near Ville-sous-la-Ferté as a sister foundation to the monastery at Cîteaux, Clairvaux was first entrusted to the young Bernard of Fontaines. By the time this famed and influential monk died 40 years later, 800 brothers had come to live here and a further 69 foundations had been affiliated.

Under Bernard's leadership, Clairvaux became a religious and even political center of major significance—Bernard was called upon to mediate between the king and the princes, he influenced the election of popes, and his contribution to contemporary theology cannot be underestimated.

The monastery survived the French Revolution more or less unscathed but was converted into a prison in

1808. The old abbey church has disappeared completely, its stones having been reclaimed for other uses in 1812. Clairvaux has long been known across the world, but a strange atmosphere envelops the town. A high wall, 2 miles (3 km) long, surrounds the enormous monastery estate, and everything that happens behind it is hidden from view. The walls of a monastery were symbolic—a visible separation from the sinful world. It was a place of retreat and a representation of a better world, pleasing to God. Still a prison, the walls at Clairvaux are perhaps now also a symbol of the forced incarceration of the prisoners they retain, and a modern jail complex has been built on the site.

Apart from a pond, nothing remains of Clairvaux I (the *Monasterium vetus*), but the building was extended considerably and Clairvaux II, designed by the abbot, arose in a series of construction phases between 1135 and 1145. All that survives of this building are portions of the refectory (dining room) and dormitory (sleeping quarters).

Clairvaux III dates back to the 13th century and the wealth of the monastery at that time is apparent, although the buildings that still remain, which form a cloistered quadrangle, have a certain severity entirely suited to their current use. A strict sect of Trappist monks occupied Clairvaux in the 17th and 18th centuries and the modern prisoners are subject to a similarly unbending regime. Clairvaux is a sacred place, but today is no longer welcoming.

Notre-Dame, Paris

Stand on the Place du Parvis in Paris today and it is unlikely you would imagine yourself to be at the gates of heaven, but that is exactly how the portals of this church were regarded in the Middle Ages. The cathedral, probably one of the most famous in the world, rises majestically from the square in all its considerable beauty.

This has been a place of prayer for 2,000 years—the ruins of a Gallo-Roman temple on the site have been excavated and preserved. An early Christian basilica succeeded this original structure, and Maurice de Sully, the bishop of Paris, began construction of the present building in 1163. The clergy, the aristocracy, and even the king contributed toward the costs, and the common folk assisted in the construction work.

The church was finally completed, true to its original plans, in 1345. In both its unfinished and finished states it provided the backdrop to historic events. A crusade was announced from the pulpit in 1187; St Louis brought Christ's crown of thorns to Paris in 1239; Henri IV ascended the French throne in 1430; Joan of Arc's trial began in the cathedral in 1455; and Mary Stuart was crowned here in 1559. The cathedral knew dark days as well: during the Revolution it became a "Temple of Reason" and Robespierre used it to worship his own personal gods, transforming the chancel into a wine cellar. The building was only returned to the

Church in 1802, becoming the place where Pope Pius VII crowned Napoleon Bonaparte as emperor in 1804.

This is not just a sacred place, but also a center of national consciousness. Road distances are still calculated from here right across France, and the cathedral can be seen as the very heart of the nation. The church is highly ornate and undoubtedly one of the greatest achievements of Gothic ecclesiastical architecture. The portals are slightly asymmetrical, to break up any possible monotony—representing heaven, the central portal is taller and wider than the other two. The Portal of the Virgin, on the left, has an ornate Gothic gable, and the Portal of St Anne on the right is decorated with statues of angels, monarchs, patriarchs, and other saints, as well as a representation of St Marcellus, bishop of Paris in the 5th century.

Notre-Dame is also famous for the hunchbacked bell-ringer immortalized in literature by Victor Hugo. The character of the crippled but kind-hearted Quasimodo may only be a figment of the writer's imagination, but his fame has been sufficiently powerful and widespread to help preserve the cathedral from dilapidation.

Notre-Dame, Paris

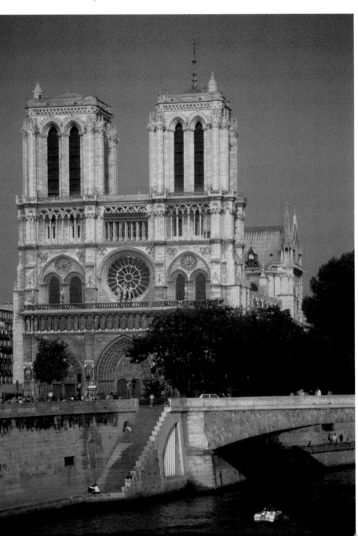

Sainte-Chapelle, Paris

When King Louis IX (St Louis) purchased the Crown of Thorns from Baldwin II, emperor of Constantinople, along with a fragment of the True Cross and the tip of the lance belonging to the Roman centurion Longinus, they were the most precious relics in Christendom and no doubt cost him a small fortune. The pious king then built the Sainte-Chapelle next to the royal palace on the Île de la Cité to house these treasures.

In the Middle Ages the royal chapel was regarded as the "gates of heaven,"

but contemporary access to the relics must have been difficult as the chapel stood within the palace complex. Even today visitors face certain obstacles— once through the admission gates, there are strict security checks (the site is now occupied by the high courts). However, once inside you soon find yourself standing before this delicate and beautiful two-storey chapel. The two-storey portal is an indication of what you will find inside—the lower chapel is unexpectedly squat for a church, its Gothic arches supported on pillars that are little taller than a man. The bold colors of the vaulting give the space a solemn stillness. The lower

Tracery windows in the Sainte-Chapelle, Paris

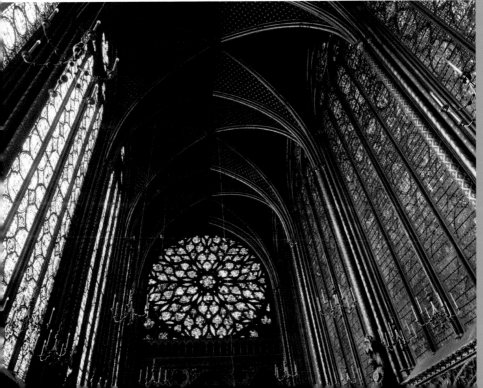

chapel was for the use of courtiers and those few citizens who were allowed access. A narrow staircase leads to the upper chapel. The first impressions are breathtaking—soaring, slender pillars and stained-glass windows, 50 feet (15 m) high, bathe the interior in a wonderful interplay of light and color. The setting sun illuminates the depiction of the Apocalypse in the large rose window of the façade, transforming it into a burning Last Judgment of intoxicating beauty. The narrow pillars in the chapel are decorated with the 12 apostles, their faces radiating dignity and solemnity, all exquisite examples of the skill of the medieval stone masons. There are more than a thousand religious scenes in total, in every color of the rainbow. If you have ever doubted the beauty and variety of life, or have found it gray and dull, you will discover just how wrong you are in Sainte-Chapelle.

Strasbourg Cathedral

Strasbourg's principal place of worship has been unfortunate from the start—by 1176 it had burnt down completely for the fourth time. Undaunted, Bishop Henri I began construction of a new building on the old site, retaining only the old foundations, which were shored up. By 1225 the apse, crossing, and north transept had been completed in a late Romanesque style, but by the time work on the south transept

was underway, fashions had changed to favor Gothic architecture, so the half-finished building was completed in a High Gothic style. The main nave was finished between 1240 and 1275.

Even though the proportions are harmonious, the cathedral lacks the verticality of other Gothic churches. The mix of styles could be obtrusive, but the effect is in fact quite the opposite—Strasbourg Cathedral is one of the greatest ecclesiastical buildings of the Middle Ages. Its beauty is only enhanced by the wealth of ornate decoration and statuary, depicting both sacred and secular themes. Even pagan motifs have crept in, turning it into a true "encyclopedia" of medieval thinking. The "Pillar of Angels" (1225–30) is a unique feature. Its three tiers depict the evangelists, a group of angels, and Christ surrounded by three seraphs bearing the Instruments of the Passion. The pillars beside the statues are completely unadorned, forming a background against which the figures seem to float in the dramatic gloom of the chapel. The portal is flanked by representations of Ecclesia (the Church) and Synagoga (the Synagogue)—carrying a cross and a cup, Ecclesia is of course the Church Triumphant (ecclesia triumphans) and she looks down haughtily on her rival. Exuding an unbowed grace from her whole being, Synagoga is captivatingly beautiful. Her eyes are covered—a symbol of the theology of her time, the "Old Covenant" (Judaism), to which was vouchsafed only half the truth.

The south portal of the west façade depicts the Last Judgment and the parable of the seven wise and

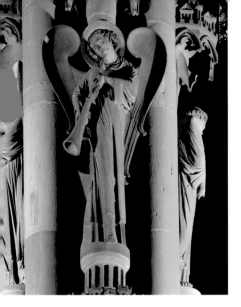

The Pillar of the Angels, Strasbourg Cathedral

justifiably world-famous, you will experience a truly spiritual moment.

Mont Saint-Michel

The holy island of Saint-Michel-au-péril-de-la-mer (literally, "in danger of the sea") lies in a bay on the Breton side of the Normandy/Brittany border. The archangel Michael himself is supposed to have commanded the construction of the building. St Aubert, bishop of Avranches, built an oratory here in the 8th century after the archangel had appeared to him three times in visions.

seven foolish virgins, symbolizing the damned and the saved. The topics are conventional, but the execution is unique: the devil, a young man dressed in contemporary medieval clothing, smiles irresistibly as he offers a young maiden the apple of temptation. Happy and excited, she seems not to notice that toads and snakes are devouring the Tempter's back. It is not hard to stand rapt for hours in front of the cathedral's many sculptures, contemplating your place in the world.

When the spire was completed in 1439, at 466 feet (142 m), the cathedral became the tallest stone building of the era, and was even revered as the eighth wonder of the world.

Tucked away in Strasbourg's Old Town, when you emerge from the narrow streets to stand before this magnificent red stone building, now

Aubert entrusted his foundation to a community of monks whose order is now unknown, but in 966 the Benedictines moved onto the mount, ushering in a phase of continuous expansion and extension. The building complex begins at sea level, rising in several stages to the top, where there is a Romanesque-Gothic abbey. The Gothic elements of the monastery complex are sometimes known as "La Merveille" (the miracle) and rightly so.

The first pilgrims here took their lives in their hands, as the site was accessible only at low tide. The tidal range in the bay (50 feet/15 m) is one of the greatest in the world, and it was not uncommon for returning pilgrims to be overtaken by the rising waters and drowned. People came here to worship St Michael, and the monastery was a stopping-place on the Way of St James

to Santiago de Compostela or on to the Holy Land. The mount is also one of the five major stopping-points on the Way of St Michael, which begins at Saint Michael's Mount in Cornwall and passes through Saint-Michel in Le Puy-en-Velay in the Auvergne and Sacra di San Michele in Piedmont before reaching Monte Sant'Angelo in Apulia. Visitors crossing the causeway to reach Mont Saint-Michel today may possibly struggle to sense the holiness of the place—thousands of tourists jostle in the narrow streets lined with restaurants and souvenir shops.

Walk up to the castle, however, and you will be overwhelmed by the serene beauty of the monastery. Enter the sparse refectory with its simple but beautiful lectern niche and you will get an idea of the power of the meditation conducted here. The monastery cloister is unique—after a fire in 1203, the formerly Romanesque monastery was rebuilt over a number of different levels on the northern cliffs. The uppermost level of the building is now occupied by a superbly graceful and light-filled cloister.

Looking through the arches of the monastery out to sea, feeling the wind and sea spray in the air, you cannot fail to experience a feeling of divine reverence.

Mont Saint-Michel in the English Channel

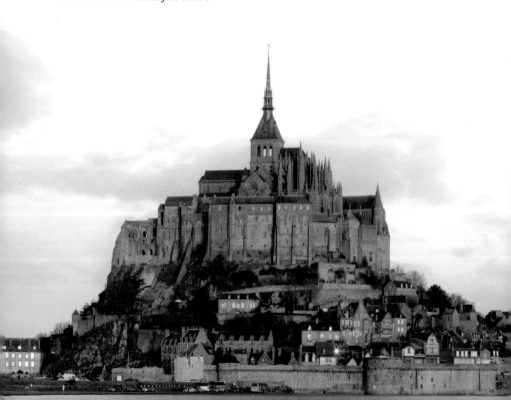

The Chapel of Notre-Dame and Calvary, Tronoën

Brittany remains an enigmatic region to this day: a landscape of wild, rocky bays with the raging Atlantic beyond, thick forests where you can imagine druids cutting sprigs of mistletoe, unspoiled meadows, tiny villages, Celtic tombs and shrines, menhirs and dolmens, and an ancient language that is still in use today. The charm of the scenery attracts holidaymakers and those seeking something a little more profound in equal numbers.

Ancient and mysterious religions have left their mark in Brittany alongside Christianity. A particularly beautiful example is to be found at the *Calvaire* (Calvary) in front of the Gothic church of Notre-Dame de Tronoën, which lies at what feels like the end of the earth—a wide, flat landscape of dunes and sparse moorland in the *département* of Finistère. The church and the Calvary were built here between 1450 and 1470, miles from the nearest town.

A carved male figure known as "The Watcher" peeks out from a crack in the Romanesque portal—a strange and mysterious figure, perhaps meant to remind us that no one goes unobserved. The Calvary in front of the church is indeed impressive,

The Calvary at Notre-Dame de Tronoën

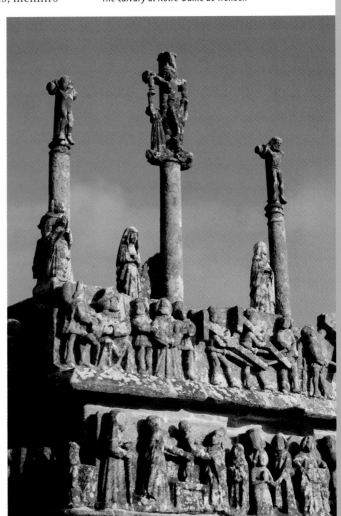

not least because the mound is man-made rather than natural.

The square structure of the Calvary is made of granite and the side facing the prevailing wind is flecked with green and white lichen. There is a frieze on the plinth depicting scenes from the New Testament, but these are hard to decipher. Golgotha's three crosses are mounted on the plinth and are decorated on the reverse with religious images—the veil of Veronica, a pietà, and an image of St James as a pilgrim. All the sculptural details have been at the mercy of the elements since 1450 and are thus somewhat weather-beaten. The site's sacredness is probably the sum of its different parts—the solitude, the weather, the little church, and the homily in stone, now worn and difficult to read.

Dolmens in Brittany

Dolmens are megalithic tombs typically formed of a large capstone supported by two or more upright stones. Dolmens, passage graves, and chamber tombs—the three types of burial site associated with megalithic culture—were once attributed to a single people. However, it is now thought that the proliferation of these tombs in Spain and the Celtic fringes of western Europe is a result of the similarities in the religions of numerous communities, rather than the work of just one group.

The tombs are probably based on the concept of life after death. Often free-standing, they are sometimes constructed on raised mounds and seem to blend into the landscape. These structures are indeed tombs, but beyond this little is known about them, including whether they were erected at what were deemed sacred places or whether such places became sacred because of their presence. Many of these strange tombs were used as hermitages in the past, especially by early Christian monks. They still hold a fascination even for present-day visitors, perhaps because they have guarded their secrets.

Today, in our rational and pragmatic world, these dolmens represent a mysterious union of nature and culture, the juxtaposition of human mortality and the permanence of stone. Yet even stone will not last forever, as is particularly apparent in the tombs, which have been overgrown by lichen and are gradually being reclaimed by nature. These are good places to meditate on the nature of time and eternity.

The most striking dolmens are to be found in Brittany, often near menhirs or stone circles. Several of the most famous are located around Plouharnel (Morbihan), including the **Rondossec dolmens**, **Crucono dolmens**, and **Mane Groh dolmens**, which are to be found in a sparse wood. Locmariaquer (also in Morbihan) is a famous menhir site that also contains dolmens, including those of **Mane Rethual**, an extended and almost overgrown passage-like grave site known locally as the *allée couverte* (covered walkway), and **Mane Lud**, with its

particularly large grave chamber, which is almost completely subterranean.

There are also several impressive examples in the *département* of Finistère, including **Guilliguy**, near Portsall, which is also completely overgrown with heather and lichen, and **Saint-Gonvel,** located near Argenton.

Menhirs in Brittany

The scientific term "menhir" is derived from the Breton words for stone (*maen*) and long (*hir*) and denotes a large, upright stone. Little is known of the original purpose of these stones, but it is assumed that they were erected at locations with some kind of cultural significance.

Many menhirs are to be found in Brittany, an area whose mystery is maintained to this day by its landscape, its weather, and its language. It is almost as if the ancient, Celtic past has survived into the present, but it is not necessary or perhaps even possible to understand such things completely—these relics of the rites practiced by a still largely unknown religion have a monumental power even if they cannot be fully explained. Wonder and imagination are part of being human. Not every puzzle can be solved, nor every question answered, and this might be the case with the menhirs. It is perhaps this very ignorance that makes us regard the places where the stones were erected as sacred.

Dating back to between 3500 and 1500 BC, the monoliths are dotted about the landscape in a haphazard fashion. Legends have quite naturally grown up around them—which is as unsurprising as the fact that the sites where the menhirs stand are still revered as sacred to this day. Where mystery combines with fantasy, they are seen as places where the sacred is made manifest, and where the Divine is revealed or experienced in some way. It is not known whether some kind of death cult was practiced here, or if fertility rights were celebrated, or whether the site was sacred to a mother goddess, but the stones still exert a tremendous fascination.

Most of the menhirs are now badly weathered, but sometimes it is possible to distinguish the faces of animals or humans etched into the surface—perhaps these are images of the gods. Menhirs are frequently situated where it is possible to measure earth energy or electromagnetic energy, and they seem to have functioned as some kind of orientation markers.

The largest of its kind, **Kerloas** at **Plouarzel** (Finistère), is over 30 feet (10 m) tall, and the longest stone is also in Brittany: the **Grand Menhir Brisé** at **Locmariaquer** (Morbihan). This giant monolith has broken into four pieces, a reminder perhaps of how even the mightiest structure erected by man can tumble and be destroyed. At **Kergadiou** (Finistère), two menhirs, one upright and 30 feet (9 m) tall, the other 36 feet (11 m) long and lying on the ground, suggest a human couple. Many young people

visit this site, seeking energy to help make their relationship work.

There is a similar pair of megaliths at **Pergat at Luargat** (Côtes d'Armor)—one of the stones is very small, the other is 25 feet (7.5 m) tall. People make the pilgrimage here, too, seeking good fortune. The **Le Manio menhir** (Morbihan) is decorated with snake-like engravings; in many religions, snakes symbolize life itself, a duality of good and evil, a beginning and an end.

La Tremblais menhir (Côtes d'Armor) has carvings that have been interpreted by several experts as representing a mother goddess. At **Penloïc** near Loctudy (Finistère), there is a particularly unique and enigmatic menhir standing in the sea. Several particularly sacred menhirs have been Christianized, such as the **Saint-Duzec menhir** on the Corniche Bretonne, which is engraved and has been surrounded by a low wall. With just a little imagination, you can see a face with an open mouth carved into the stone. Above this is a stone cross with a crudely carved figure of Christ. The top third of the stone is clearly decorated with representations of the Instruments of the Passion. This menhir has become a particularly popular destination for Breton pilgrims, who are renowned for a deep piety that combines faith and fear of God with a little superstition and belief in myths.

Saint-Duzec menhir

The Carnac Stones

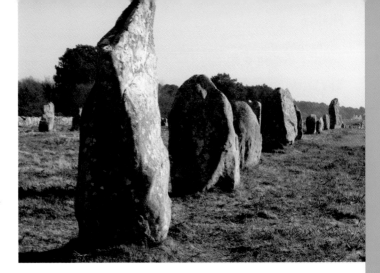

The Carnac Stones

Carnac is a small seaside resort on the Atlantic coast of Brittany— nothing special in itself, but travel a little inland and you will reach the Avenue des Druides, a vast wild meadow. There, among the heather and nettles you will find thousands of standing stones—there are over 3,000 in total—the world-famous alignments of Carnac. Their purpose has long been disputed—something which has no doubt contributed to their fame and they still refuse to give up their secrets.

The granite monoliths were probably erected between 4500 and 3500 BC and may have been used in astronomical calculations, or, as some experts have conjectured, were intended to channel spiritual energy. They may even have been erected to ward off evil spirits, as has been found to be the case in other Stone Age cultures.

As no archeological finds have been made in the area to suggest early domestic settlement, it has been assumed that the site was a sacred place from its very beginnings. Many people attribute properties of healing and fertility to the stones— many women come here to press their stomachs against the stones in the hope of conceiving. Other people come to experience something of the mystery of the stones or hope to benefit from the positive influence of the electromagnetic ley lines that have been detected here.

As their gaze is drawn toward the horizon by the stones, people are reminded that not just their eyes but perhaps also their souls are being led to a place that is as yet unknown. Those who come here are usually seeking something that is beyond rational understanding. Some of them, however, return disillusioned—after his visit, the writer Gustave Flaubert concluded: "The Carnac Stones are big stones."

Sainte-Anne d'Auray, Keranna

There has been a pilgrimage site at Sainte-Anne d'Auray in the small town of Keranna, southern Brittany, since 1625. Local people and visitors from further afield come here to petition St Anne, the grandmother of Jesus Christ, especially with requests concerning family matters. The site has its origins in a vision experienced by a laborer, Yvon Nicolazic, in which St Anne came to

The Holy Steps at Sainte-Anne d'Auray, Keranna

preted symbolically: St Anne wanted to remind people that however important water is for sustaining mortal life, it is essential in baptism for spiritual life. There is a monumental statue in the grounds, which is particularly revered—it depicts Anne instructing her daughter Mary in the Holy Scriptures. The statue is perhaps of no great aesthetic importance, but it demonstrates how important teaching within the family is for individual faith. Pilgrims accordingly place their written requests for the conviction of true faith at the feet of the statue.

Built in 1645, the cloister provides a quiet retreat in the midst of the activity of the pilgrims—the Chapel of Mary the Immaculate is to be found in one corner of it. Initially reserved for the seminarians, the chapel is now used for daily Mass. The Holy Steps, built in 1662, lie at the edge of the complex. Masses are held in the open-air here, but the Holy Steps are of even greater significance to pilgrims who mount them on their knees, reciting the rosary and remembering Christ's Passion, in the hope of effecting a change in their hearts. There is a rather curious little oratory on the left side of the church where priests pray day and night on behalf of the pilgrims. The priests gather together the numerous pieces of paper bearing the petitions that are left by

him and indicated the place as one where she wished to be worshiped.

The presence of a well at the place where the vision appeared can be inter-

the pilgrims around the statue, the sole task of the priests being to bring these requests before God in their prayers.

John Paul II visited this very unpretentious pilgrimage church in 1996. A square was later laid out to commemorate his visit. It is surrounded by 12 standing stones, representing both the 12 local dioceses and the 12 apostles, and prayers are offered here for the unity of the Church, the pope, and the 12 bishops, the successors of the apostles. There is also a memorial to the fallen from the two world wars and a cemetery containing the graves of drowned sailors. Anne is the patron saint of seafarers and is said to guard against shipwreck. She has always played a central role in the religious life of the Bretons, as this very unpretentious shrine amply demonstrates.

site: one of the most precious relics in medieval Christendom, the *Sancta Camisia*, a garment said to have been worn by the Virgin Mary at the birth of Christ, is kept here. The relic has been in Chartres since Charles the Bald donated it to the cathedral authorities in 876 and it has made the cathedral one of the principal sites of Marian worship in France; the Virgin has also become the city's patron saint.

Fortunately the relic survived the fire unscathed and this was interpreted as a sign to build an even bigger and more beautiful cathedral. The project was ambitious, but the anonymous architect

Rose window at Notre-Dame de Chartres

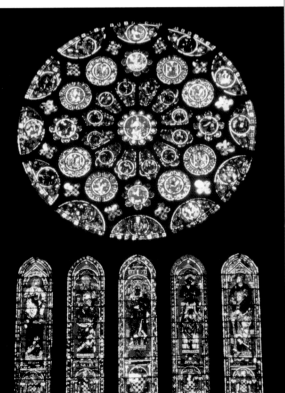

Chartres Cathedral

When the masons embarked on building this cathedral dedicated to the Virgin Mary, they were attempting to erect nothing less than the most exquisite church the world had ever seen. The first cathedral on the site had almost completely collapsed after a devastating fire in 1194. Although Chartres is not a large town, it has always been a pilgrimage

succeeded in creating a unique sacred building, unequalled anywhere on earth. "The mighty roof of the cathedral hangs over the low vault of a provincial town like the stocky body of a great giant, and above it the twin towers reach up to heaven in eternal prayer. This, above all, creates an unforgettable impression of magnificence." Stefan Zweig's stirring words elegantly sum up the first impression visitors have of the monumental building. Immersed in a mysterious darkness as they enter, visitors take a little while to adjust to the conditions inside, as the nave is over 330 feet (100 m) long. Soon, the verticality of the Gothic design becomes apparent and the eye is drawn upward to the bright light that floods in through the windows, illuminating the pillars and walls in blues, reds, greens, and golds.

Nowhere else has Gothic stained glass been so perfectly preserved as in this cathedral; it is as if the walls are made of glass. The images in the windows illustrate the medieval understanding of man's role in the great story of salvation. The last book of the New Testament describes a fantastic vision of a new heaven and a new earth—and a New Jerusalem, inhabited by the glory of God and decorated with precious stones. Visitors to the cathedral experience an immediate physical sense of this vision—this church dedicated to the Virgin is a representation of the New Jerusalem.

Humans shrink in scale when subjected to to this magnificent building's alternation of light and darkness, and yet there is also comfort to

be found here. The rose window in the west façade has 12 sections, the heavenly Jerusalem has 12 gates, and the year has 12 months; the nave has three aisles as a symbol of the Trinity, and the seven spans of the roof vaults represent the seven days in which God created the world and everything in it. There is a world-famous labyrinth on the floor of the nave that is 40-ft (12-m) wide, and the faithful have been treading its eleven rings since the Middle Ages—replicating the pilgrimage of life on a much smaller scale.

Saint-Benoît-sur-Loire

In the early 7th century Benedictine monks founded a monastery in the little town of Fleury on the Loire, which was to become one of the most important in France. Legend has it that a druidic shrine previously stood on the site. In 653 monks from the abbey traveled to Monte Cassino, returning with the bones of St Benedict of Nursia, the founder of the Benedictine Order, and the town was renamed Saint-Benoît-sur-Loire. Possession of the relics soon made the abbey a major pilgrimage site and attracted considerable wealth. Between 930 and 942 the abbey was led by Abbot Odo, one of the most influential ecclesiastical thinkers of the Cluny reform movement, who encouraged the monks to pursue lives similar to those of the early Christian community

in Jerusalem—a life of mutual love, renunciation of personal property, and self-denial that was intended to be both pleasing to God and a continuation of the example of the early Church. The renowned seminary was founded at this time and soon became one of the intellectual centers of France.

The portico in front of the church is topped with a magnificent tower decorated with wonderful floral and ornamental reliefs. The monastery basilica, dating back to the 11th and 13th centuries, is considered one of the most exceptional examples of Romanesque architecture in the country, while the crypt is a special place of worship—the relics of St Benedict are kept safe in its central pillar.

This influential monastery was dissolved and the seminary closed during the French Revolution, but 40 monks now live in the modern institution.

A visit to this peaceful church during daily Mass, celebrated with Gregorian chant, is particularly beautiful. The notes rise up, echoing the sacred atmosphere of belief in all its simplicity yet serenity and at the same time expressing its contact with eternity. In the inner quadrangle of the cloister the newly laid-out monastery garden, with its clean lines and profusion of roses, is an invitation to meditation.

Bourges Cathedral

Bourges, once the capital city of the dukes of Berry, lies in the heart of France. It now seems rather sleepy, but its cathedral is one of the most beautiful of the High Gothic period.

Bourges Cathedral

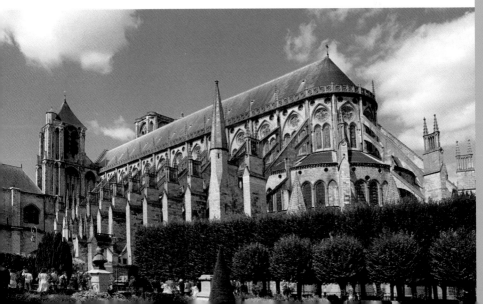

In Bourges, it is easy to understand the contemporary notion that a Gothic portal should represent the entrance to heaven. Standing before the five portals of the west façade, the impression is overwhelming.

Before St Étienne's Cathedral was built, several previous churches dedicated to St Stephen had stood on the same site, and the palace of Leocadius, the first senator of Gaul, who is said to have built a house chapel to St Ursin in the 3rd century, was also supposedly situated here. The palace was built within the Roman city walls, and the unknown architect's plan to construct a large cathedral on the same site had to address the problem of some irregularities in the terrain. The solution was a crypt, an atypical feature for a Gothic church, which in fact became a lower church beneath the main one, as all of its walls were above ground. Large windows flood the wonderfully proportioned crypt with light, illuminating the particularly detailed pillar capital decoration.

The Huguenots occupied the city for several weeks in 1562, destroying all the free-standing statues and a great many of the reliefs, although it was possibly the Calvinist fear of eternal damnation that led them to spare the Last Judgment over the central portal. This relief is a true masterpiece: the lower section depicts the dead rising from the grave, blinded by the bright light of the sun after the gloom of the tomb. They are naked and without physical defect. The central section depicts the archangel Michael with his scales, weighing up good and bad deeds; a child, symbolizing purity of soul, stands by his side. On Michael's left, the damned are being led down to hell by horrendous figures; and on his right, the saved process solemnly into paradise. On one side there is chaos and confusion, on the other order and harmony. The top section depicts an enthroned Christ as the Judge of the World who seems to be examining the living. He is displaying his wounds and four angels are carrying the Instruments of his Passion. Mary and Joseph are kneeling in prayer on either side, as if they believe they can still intercede on behalf of repentant sinners, despite the fact that theologians were in agreement that condemnation to hell or salvation to heaven was irrevocable. Two angelic figures hover over Christ, indicating the sun and the moon.

Visitors to the church at Bourges are overwhelmed by its serenity and the sense of eternity that reign here. Such feelings are made somehow more intense by the lack of a transept. Most of the stained glass has either survived or been authentically restored and the window depicting the Apocalypse is unique: its dark shades seem to be illuminated only by flashes of lightning. The most beautiful of the four-panel windows depicts Christ as the Judge of the World with a double-edged sword in his mouth. His right hand holds the book with seven seals and his left seven stars. Seven lamps stand to his right and left, symbolizing the seven churches.

Sainte-Madeleine, Vézelay

This tiny, picturesque village of only 100 souls was a flourishing town in the Middle Ages, thanks in part to a thriving cult dedicated to Mary Magdalene. There is only one street worthy of the name in the village, and it leads up a steep hill to the pilgrimage church of Sainte-Madeleine. In the 9th century a convent was founded on this site, which soon after became a Benedictine monastery and was subsequently torn down by the Normans. The Cluniac reform movement resurrected the foundation in the 11th century and the Abbot of Cluny took over its administration. A contemporary legend began to circulate that miracles had occurred here, supposedly on the site of Mary Magdalene's tomb, and

Vézelay became a major pilgrimage site for visitors from all over France, in particular those who were on their way to Santiago de Compostela. St Francis founded the first Minorite monastery on French soil here and the church is still run by the few remaining Franciscans.

Nothing remains of the monastery, but the church is still used by the faithful. A Romanesque portal decorated with a wealth of skillful carvings depicting the descent of the Holy Spirit leads visitors into the simple and airy interior. The detailing on the pillar capitals illustrates the opposition of good and evil using images that would be quite familiar to contemporary pilgrims, although they are harder for modern observers to interpret. The extended nave shimmers in the light in an astonishing and moving fashion, an effect caused principally by the

A view of Vézelay and the pilgrimage church of Sainte-Madeleine

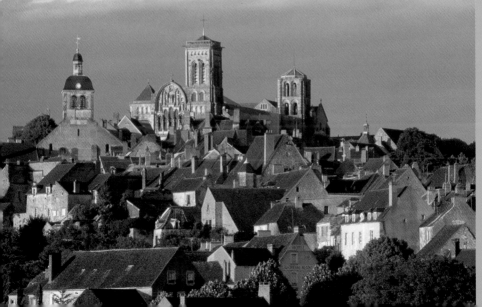

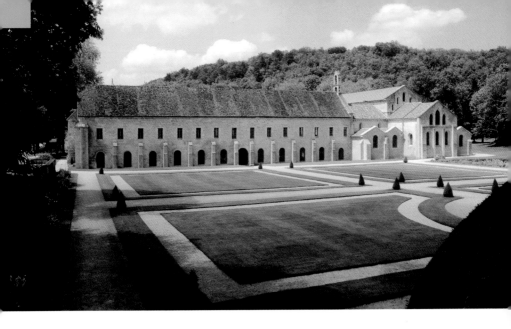

Fontenay Abbey

Gothic chancel, which was added in the 12th century. The alternating hues of the vaulted arches in the nave and transept ceilings lend the church a harmonious yet vibrant atmosphere.

That this wonderful abbey church is in a state to be visited at all after the depredations of its more than 1,000-year history is entirely thanks to sympathetic and faithful restoration work carried out in the 19th century.

Fontenay Abbey

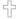

Cistercian monastic architecture is characterized by a spartan simplicity. This basic purity of design has occasionally given rise to structures of unparalleled harmony, and perhaps the most beautiful example of the style is to be found in the monastery complex of Fontenay. The monastery was founded as a subsidiary of Clairvaux in 1119 and although it is now privately owned, it is fortunately open to the public. Fontenay is a meditation represented in stone, and the buildings and grounds are strikingly beautiful from whichever angle you approach them. The monastery ranks without doubt among the most perfect buildings in architectural history. Both its balance and proportion are faultless and every aspect is precise in its execution. The complex as a whole seems to radiate a palpable sense of peace that calms all the senses. You could almost compare the symmetry of the elongated

Romanesque building with the mathematical precision and perfection of baroque music, although it pre-dates such compositions by many centuries.

Numbers and symmetry play a part in the architecture of Fontenay Abbey too, especially in the grouping of the windows (which are arranged in threes, fours, or fives). The result is quite simply breathtaking. It is tempting to see divine perfection in such human work. The three apse windows in the abbey represent the Trinity or the three levels of scriptural interpretation: historical, allegorical, and moral. The groups of four represent the elements, the seasons, the points of the compass, the rivers in the Garden of Eden, and the dimensions of divine measurement—width, length, height, and depth—as described by the apostle Paul in his letter to the Ephesians (Eph. 3:18). The five windows in the triumphal arch wall symbolize the five books of Moses. The groups of six (2×3 by the altar) represent the days of Creation, and 12—the multiple of three and four—represents the disciples. All these numbers inspire and provoke meditations upon the Divine.

The whole space is flooded with light, emphasizing what Bernard of Clairvaux once said in a Christmas sermon: "The night will be consumed by victory, shadows and darkness will be banished and the true light shall penetrate everything, above and below, from within and without" (Christmas Vigil: III, 2). Fontenay is a truly sacred place, an inspiration to those prepared to immerse themselves in medieval symbolism.

Cîteaux

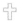

Nothing remains of the little stone chapel from which the Cistercian Order grew but a plaque bears the inscription: "On this site stood the first church at Cîteaux, consecrated by the bishop of Chalon on November 18 1106, where St Bernard and the founding fathers Alberich and Stephen immersed themselves in prayer." The 12th-century church that succeeded the chapel has similarly vanished without trace. The monks now live in a plain, unadorned building more closely resembling a large courtroom than a church. The abbey was rebuilt to its original plans only at the end of the 20th century.

This place is made sacred chiefly by its history, as the strict Rule of the Cistercian Order was conceived here before spreading throughout Europe and the whole world. The basic principle of the order is a combination of spiritual exercises and practical work. Such a combination had almost died out by the 11th century, at least in the opinion of Robert of Molesme, a monk who left his monastery with 21 other brothers (including Alberich and Stephen Harding) to settle on an estate on the edge of a forest at Cîteaux. They practiced great asceticism, following the ideal of the simple lives of the early Christians and adhering strictly to the rule of St Benedict. Alberich became abbot in 1099 and wrote the Cistercian Rule. Such extreme asceticism meant that the order struggled to find new members, and soon only ten remained of the original 22. However, the arrival of Bernard of Fontaines (who was to

become Bernard of Clairvaux) and 30 of his companions signaled a new enthusiasm for the order; four sister foundations were established under a third abbot, Stephen Harding, between 1113 and 1115, of which the most famous is of course Clairvaux. In the 17th century a bitter schism occurred within the brotherhood, which eventually led to the foundation of the reformed Trappist Order in the 19th century. The monastery here is now occupied and run by Trappists.

The Taizé Community

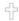

"One insight has not deserted me since my youth: that a communal life can be a sign that God is love and only love.

The conviction gradually grew within me that I was to establish a community of men prepared to give their whole life, and who would attempt always to understand one another and to be reconciled; a community fundamentally devoted to kindess of heart and simplicity." These words of Frère Roger, the founder of the ecumenical Taizé Community, are not just an empty slogan but are lived out every day. Roger and a few monks came to Taizé, a little town near Cluny, in 1940 to found a community, which now attracts members, especially young people, from all over the world.

Hundreds of thousands of people come to attend the prayer meetings and about 100 monks now live here full time. Taizé holds great attractions for many, who are drawn by the sense of community and in particular

A service in the Taizé Community

by the hymns and prayers that touch the soul and heart. These are held several times a day in the Church of Reconciliation. Frère Roger was always at pains to emphasize the importance of music and song in communal life, and the unifying and reconciling powers of communal singing are experienced daily.

People of all religions have devoted themselves to contemplation over the centuries and, indeed the millennia, by reciting mantras of every description, and it seems that these words penetrate even deeper into the heart when they are sung. The fraternity maintains that prayer provides the strength to change destructive circumstances in life and to make the world an easier place to live in. Taizé offers an opportunity to sample all this and the experience is so intense that it forces a shift in the individual's routine. Its intense emotional impact is something the individual never forgets. For this reason Taizé is a truly sacred place in a world in danger of allowing its voice to be suppressed by the sheer volume and weight of words.

Besançon Cathedral

The first thing you see as you approach Besançon is the 17th-century Vauban fortress, which covers the whole hill in the middle of the town. This mound was considered holy even in Celtic times, and Christians built the magnificent Cathedral of Saint-Étienne on its summit. Nothing remains of this church, but pilgrims came here to see an extremely important relic—Christ's shroud. Pilgrims on the Via Francigena seemed unconcerned by the presence of an equally "authentic" Holy Shroud in Turin, perhaps because Turin represented a considerable detour. Besançon has a long Christian past: early chronicles suggest that there was a diocese here as early as 210, but the first Christian bishop is documented in 346, after the Edict of Milan.

The Cathedral of Saint-Jean, dedicated to St John the Evangelist, stands on the foundations of a 4th-century building on a site halfway up Saint-Étienne hill and is a combination of Carolingian, Romanesque, Gothic, and baroque elements, the result of construction work carried out from the 9th to the 18th century. This stylistically varied church was long forgotten, but it is now being increasingly rediscovered by the pilgrims who visit this ancient stopping-point as they follow the Via Francigena. The chapel with the shroud enjoys particular attention, even though everyone knows it is only a copy (the original was moved to Paris in the uproar of the French Revolution before disappearing completely). Perception is influenced by a desire for the Divine, and this is stronger than reality or historical fact. Such an attitude may appear strange to contemporary rationalists, but being able to access another reality in a particular place has always encouraged people to see that place as sacred.

Saint-Germain in Talloires

Some sacred places have achieved worldwide renown and are visited by countless pilgrims, some have a unique appearance or a wealth of art treasures, and some are unimaginably old and have been venerated as shrines since prehistoric times. However, some sacred sites are easily overlooked if they are off the beaten pilgrim track, and one such is the little abbey church of Saint-Germain, lying beside Lac d'Annecy in the French Alps.

Surrounded by Alpine peaks, the turquoise lake glitters in the sun-shine—a place of peace and reflection, and the lake is among the most beauti-ful in France. There is a steep climb from the village of Talloires to the little abbey, which is now run by a small

The church of Saint-Germain, Talloires

number of nuns. Several paces further on stands the simple church, looking a little forlorn and surrounded by a modest graveyard, which is in need of some attention. There is room for only a handful of people to pray or attend a Mass together, and the interior could even be described as slightly shabby.

Resembling a typical Alpine village church, Saint-Germain was built over a cave in which the eponymous saint, the first abbot of the monas-tery, spent the last 27 years of his life (1033–60) in solitude. The hermit-age itself is accessible along a narrow rock path, which has been furnished with the Stations of the Cross, and the cave has a stone altar with a statue of the saint and a pile of votive offerings for answered prayers.

Drink some ice-cold water from the well at the monastery before sitting here and gazing down at the lake— without having to exert yourself or make any effort to mediate you will soon feel enveloped by a deep sense of peace. The only company here is the occasional lizard, sunning itself on the hot rocks. The atmosphere of quiet contemplation in the Alpine setting of such beautiful mountains and lakes makes this a truly sacred place.

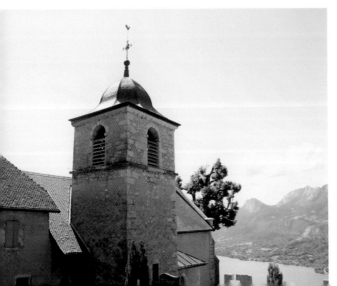

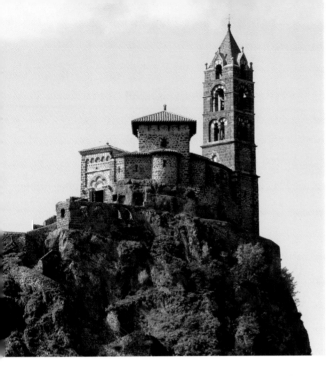

The pilgrimage church of Saint-Michel, perched on the cliff at Le-Puy-en-Velay

Le-Puy-en-Velay

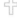

For as long as the Way of St James has been in existence, Le-Puy-en-Velay has been a major destination for pilgrims from southeastern France, all heading for the **Cathedral of Notre-Dame-du-Puy**, which lies perched on its volcanic summit. Inside the cathedral there is a Black Madonna that enjoys special reverence to this day.

The oldest parts of the church date back to the 10th century, but the various alterations and renovation projects undertaken in the meantime have ensured that little of this has survived.

However, the façade and the beautiful cloister have retained some of their original charm. Hordes of visitors throng to the church between April and September and a Mass for pilgrims is said daily. The cathedral is dedicated to the Virgin Mary and visitors pray here for help on the rest of the journey to Santiago.

The little Romanesque **pilgrimage church of Saint-Michel**, built on a steep rocky peak and dedicated to St Michael, the patron saint of heights and depths, looks rather strange in comparison. The chapel was built in the 10th century by Tuannus, one of the cathedral canons, in the hope of incorporating the site into the Way of St Michael, which starts at Saint Michael's Mount in Cornwall and passes Mont Saint-Michel in Brittany and Sacra di San Michele in Piedmont, before reaching Monte Sant'Angelo in Apulia.

The 275-foot (85-m) volcanic peak is reached by a flight of 220 steep and treacherous steps, and it is said that a great number of miracles have been witnessed here since the 10th century. Legend has it that pagan rites were held here in pre-Christian times, which seems very likely, given the location and the striking setting of the rocky peak.

FRANCE

Lascaux

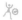

In prehistoric times—10,000 to 20,000 years ago—these caves in the Dordogne were painted with images that remained hidden for millennia before achieving worldwide fame. Man has inhabited the area since unknown artists is striking. The images are largely of animals—mammoths, reindeer, bison, and wild horses— and the coloration is quite subtle and extremely lifelike. Little is known about the belief system suggested in the pictures; various interpretations have been discussed and disputed in research journals. It is unlikely that the

Cave paintings at Lascaux

the Paleolithic era, and in Les Eyzies-de-Tayac, in Pech-Merle, and the area surrounding Montignac, the Vézère Valley contains the most impressive Stone Age cave sites in the world. The most famous of all these caves is at Lascaux. It was the chance finding of a cave entrance by children playing with their dog in 1940 that revealed one of the most important sites of prehistoric culture ever discovered. The cave passages at Lascaux are covered with fantastical paintings, and the technical mastery of the images are purely decorative, as they are located a long distance from any dwelling caves. It seems more probable that these are the earliest evidence of some kind of belief in iconic magic. It is thought that the hunters hoped that painting a picture of their quarry, possibly working on it with spears and stone axes, would be enough to ensure they would successfully hunt it down in real life. The mystical power of the images remains beyond dispute, and those who visit Lascaux today are transported into a magical world.

Bordeaux Cathedral

The original settlement of Bordeaux, once called Burdigala, dates back to pre-Roman times. The imperial con-querors made it a provincial capital, and the city has grown into an elegant and harmonious conurbation of 18th-century townhouses, broad boulevards, and squares lined with colonnades. The banks of the Garonne in particular are lined with architectural jewels and the Old Town boasts the Cathedral of Saint-André, one of the oldest in France.

Construction began in the 11th century and although traces of this Romanesque building have survived to the present day, the clear lines of the later, High Gothic structure over-power any other influ-ence. The cathedral was finally completed in the 15th century. The stained-glass windows, depicting a series of religious motifs and representational scenes from everyday life, fill the interior with a soft, clear light. The Pey-Berland tower is a separate 15th-century campanile, and the view of the city from its viewing platform is simply stunning.

The other churches in Bordeaux are worth a visit too—numerous beautiful places of worship were built here from Gallo-Roman times to the baroque period, not least as Bordeaux was an important staging-post on the Way of St James for those taking the Atlantic coast route. The local cuisine is excellent, but the region

Bordeaux Cathedral

is "sacred" in particular for lovers of "wine that maketh glad the heart of man," as Psalm 104 suggests.

Bordeaux Synagogue

Bordeaux has always been tolerant of other religions. The town became a refuge for Protestants during the Huguenot Wars, although there may have been some self-interest in the economic prosperity their presence brought, and the Jews of the south of France have always found a home here. Some of the town houses display unmistakable signs of their heritage, with Jewish motifs adorning the façades. The central locus of the Jewish faith is the Great Synagogue at the end of the little Rue du Grand Rabbin Joseph Cohen. The old synagogue was destroyed by fire in 1873 and its imposing replacement, consecrated in 1882, was the largest synagogue in France. There is a harmonious interweaving of Romanesque and Byzantine elements in the design: two magnificent towers frame the west façade and delicate pillars made in the workshop of Gustav Eiffel support the women's gallery inside the building.

The Nazis used the synagogue as a jail during World War II, holding prisoners there before their deportation to concentration camps. French fascists looted the building and although the interior was completely destroyed, the shell was left stand-ing. There is a memorial tablet to the murdered Jews of Bordeaux on the square in front of the synagogue.

The building is now predominantly used by Sephardic Jews who have emigrated from North Africa. The modern synagogue's unadorned interior is thus a special place of prayer and reflection. The central focus is the *bimah*, a raised dais with a table on which the Torah scrolls are placed during services. The chairs around the *bimah* are arranged in a horseshoe pattern— in itself an oddity, as the chairs would normally face east, toward Jerusalem.

Flanked by marble columns on golden plinths, the niche where the Torah scrolls are kept is closed off with a dark red, satin curtain; this immediately draws the eye and serves as a constant reminder that, of all things, the Word is the most sacred. A menorah, a seven-branched candelabra, dominates the room. Visitors gain a sense of the solemnity of the Jewish faith, at whose heart lies the study of Holy Scripture.

The cliff churches of Rocamadour

Hidden among densely forested cliffs in a remote location perched high over the Dordogne Valley and the winding River Alzou are the cliff churches of Rocamadour.

The name means "lover of the rocks" and the lover in question is said

to have been none other than the tax-collector Zaccheus mentioned in the Bible; supposedly of small stature, this unpopular official climbed a tree to get a better view of Jesus, who called him down and broke bread with the sinner. This experience was enough to make Zaccheus hand back his ill-gotten gains and follow Jesus. Shunned by society after the Crucifixion, Zaccheus left for Aquitaine, accompanied by his wife Veronica and guarded by an angel. After the death of his wife he climbed up to the place on the cliff where the churches are now situated. Here he built a chapel dedicated to the Virgin Mary and carved a votive statue, which is still visited and venerated by pilgrims today.

The influx of pilgrims in the Middle Ages led to the construction of seven further chapels next to the Chapel of Notre-Dame—tales of miracles had spread far beyond the province and the place had become a European pilgrimage destination.

A legend dating from the 6th century has it that the church bell will ring on its own when a miracle is about to happen. Many people who come in search of healing for physical or mental trauma leave small gifts and requests here. Above the church there is a terrace dedicated to St Michael, who watches over the whole valley from this exalted position, which is reached via 216 steep steps. The view is magnificent, and the terrace is an ideal place to reflect on man's place in the world.

Rocamadour cliff churches

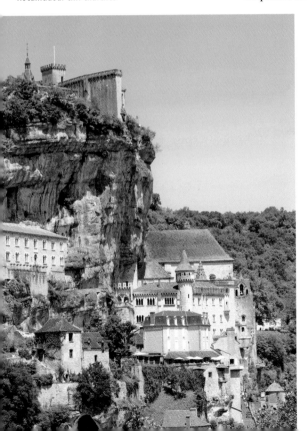

St-Pierre Abbey, Moissac

The cloister of St-Pierre, Moissac

The little town of Moissac lies surrounded by rolling hills in the Tarn Valley, and those who drive straight past will miss seeing perhaps the most beautiful Romanesque portal in all France, with relief carving to equal the most inspiring artworks of the period. Little remains of the 7th-century Benedictine abbey of St-Pierre, but the portal and the cloister suggest something of the beauty and serenity of the structure that once stood here.

The church itself was badly damaged during the Albigensian Crusade between 1207 and 1214, and the ruins of that Romanesque building provided the foundations for a Gothic replacement, built during the 14th and 15th centuries. The portal dates back to between 1120 and 1130, a time when the iconoclastic schism was long over and representational art was slowly beginning to regain a distinct individualism. Visible from a distance, Christ appears to judge the world, and is surrounded by the symbols of the four evangelists, two angels, and the 24 church elders. The door sill is decorated with enigmatic wheels, which possibly symbolize the circle of life. The central trumeau of the portal depicts a motif of interlinked lions. The sermon in stone in the door moldings is particularly striking—visitors are confronted with biblical images and depictions of basic human traits. In addition to the Annunciation, the Visitation, the Adoration, and the Presentation of Jesus at the Temple, there are representations of avarice, greed, pride, gluttony, and sexual incontinence—a constant reminder of the characteristics that medieval theology regarded as mortal sins. Christ, the Judge of the World, wears a calm and unhurried expression that is both arresting and reassuring.

The modern church is overshadowed by this great door, but the portal is not just of aesthetic significance—it simply holds up a mirror to man, exciting neither awe nor fear. This effect is only intensified as visitors enter the cloister, whose size alone is an indication of the major importance the monastery once enjoyed.

It is not just the enclosed space of the ancient cloister that makes an impact—the richly decorated pillar capitals and the great reliefs of scenes from the Old and New Testaments and the lives of the saints also leave a lasting impression. To walk along this cloister is to become part of the history that God has shared with man.

Albi Cathedral

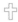

The south of France produced a wealth of Romanesque art, but it has few Gothic cathedrals. One notable exception is the cathedral at Albi, a magnificent red-brick building silhouetted against the sky over the Tarn Valley, above houses that seem to be scrambling up the valley walls.

One of the most horrific episodes in ecclesiastical history was played out near here. The 12th century saw the Albigensian Crusade to outlaw Catharism, and Albi itself witnessed the persecution, torture, and slaughter of men, women, and children. Only 50 families throughout the Languedoc survived the Dominican Inquisition unscathed. When Bernard de Castanet became bishop in 1277 he ordered the building of a new cathedral and the continuation of the bitter war on the "heretics."

Hardly a day passed without more arrests and torture, and the loathing

St Cecilia's Cathedral, Albi

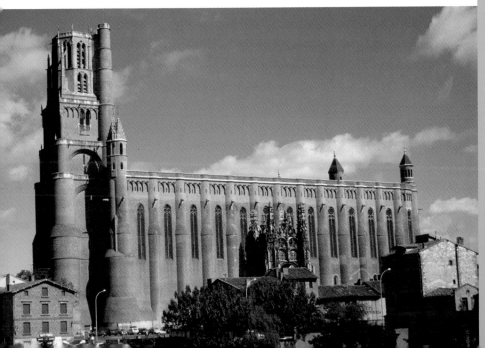

and fear in the town were so great that even the cathedral authorities turned against the bishop. Such were the circumstances in which construction of the cathedral was commissioned, the building coming to represent a portrait in stone of the hated Bishop Castanet.

The church's walls rise from a plinth-like base whose location beside a cliff makes it seem higher and more fortified than it really is. The defensive aspect of the cathedral is particularly evident in the west tower, which more closely resembles a medieval bastion than a church spire. Lined with embrasures, the walls are strong enough to resist a siege. A single gate to the south is the only access to the church, and in more peaceful times this gate would have been surrounded with a mighty Gothic narthex.

The contrast between the stark brick wall and the airy and delicate construction could not be greater: the interior has a surprising, almost

purist simplicity, with no transept and only one nave, a vast single space rising to a height of 100 feet (30 m). The stone choir screen, without doubt the most beautiful in all Europe, is

Basilica of St-Sernin, Toulouse

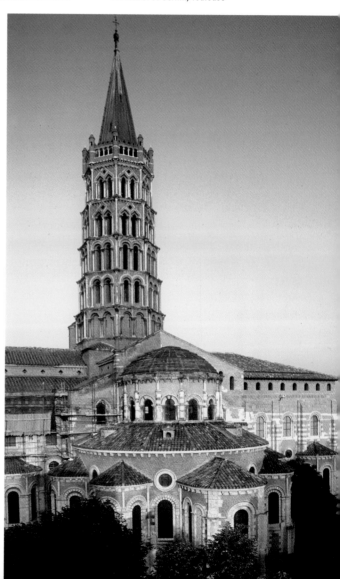

carved with figures from the Old and New Testaments, with superbly delicate work, particularly in the baldachins. The church is a reminder that extreme cruelty, fertile imagination, and a readiness to praise God may all coexist in the human heart.

Basilica of St-Sernin, Toulouse

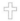

The colored bricks used to build the city have earned Toulouse the nickname "La Rose," and the town on the banks of the Garonne does indeed shimmer pink in the southern sunshine.

Located in the historic Old Town, the Basilica of St-Sernin is the symbol of the city, built of the same colored bricks. Toulouse has always been a major city for pilgrims following the Way of St James on the Via Tolosana.

St-Sernin, one of the most important examples of Romanesque ecclesiastical architecture in the South of France, was built over the tomb of St Saturnin, the first bishop of Toulouse, who was martyred in the year 250. Erected in the 11th and 12th centuries, the basilica has a five-storey, octagonal bell tower, which dominates the building. Each storey is slightly smaller than the one below, giving the massive tower a delicate appearance. Its size is due to the building's importance as a pilgrims'

church. The floor plan is in the shape of a Latin cross; the particularly prominent and spacious transept has its own apses. There are numerous additional chapels arranged around the apse of the nave, lending the rather simple building a feeling of lavishness and magnificence.

The interior greets the visitor with a harmonious combination of stone, wood, white marble, and light, so that the huge church exudes a special feeling of tranquility, which is only enhanced by the 11th-century wall reliefs. These depict a stern and majestic figure of Christ, staring straight out from the wall and surrounded by angels and apostles whose bodies face the viewer but whose faces are turned sideways, as if surveying the other world from which they have come. Their faces are dignified and gracious, and there is nothing in this church to arouse fear, despite its monumental proportions—visitors can feel secure in God's love, not lost but safe.

Les Jacobins in Toulouse

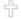

The Dominican Order was founded in Toulouse in 1215 as a mendicant order and a community of preachers. Les Jacobins is thus the mother church of the Dominicans, although their first assembly was held in Paris near a church dedicated to St James (for this reason the French Dominicans are known as "Jacobins" to this day). The

monastery and the Gothic church at Toulouse were built between 1230 and 1292 in three phases and are extremely beautiful; the large complex near the banks of the river dominates the center of town. The interior of the church is almost bare, with light falling through the stained glass of the low side chapels and illuminating the slender, high pillars with all the shades and nuances of the rainbow. The mighty pillars and the palm-frond vaulting above the apse lend the space an extraordinary beauty despite its severity.

One of the greatest and most influential Catholic thinkers, St Thomas

The vaulted chancel at Les Jacobins, Toulouse

Aquinas (himself a Dominican), is especially revered in this church, and his relics have been kept here since Pope Urban V brought them to Toulouse in 1368. Thomas studied in Paris and Cologne under Albertus Magnus and was considered one of the brightest scholars of the Middle Ages. He was deemed able enough to attend university at the age of 14, so it is no surprise that he has become the patron saint of young students.

Legend has it that his body has remained incorruptible and gives off a strong and pleasant odor. Thomas is often depicted with a large sun on his breast, and the abbey church of Les Jacobins is a fitting place for his relics, as Toulouse has always been noted for its sunshine and its scholarship. You will often find students with books in the cloister, seeking inspiration from its atmosphere.

Lourdes

Between February and July 1858, 14-year-old Bernadette Soubirous had 18 visions of a white-clad woman who prophesied that in the not too distant future vast throngs of people would come to this place, where

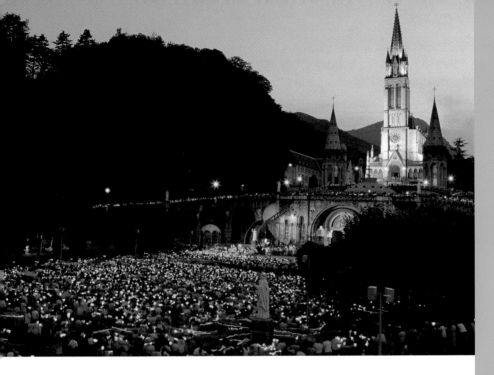

A procession at Lourdes

a chapel should be built. In one of these visions the unknown woman called herself the Immaculate Conception—a name for the Virgin Mary. The woman told Bernadette to wash herself in a spring, but there was no water nearby. The girl began to dig in the earth with her hands and soon discovered water, which collected in a little pool; this became the holy spring to which so many have since made a pilgrimage.

There is nothing to suggest that the site was in any way special before—no prehistoric relics, no enigmatic menhirs, no legends—and yet it has become the most powerful place of healing in Catholicism.

The site was initially revered for Mary's appearance to Bernadette, but at the end of the 19th century the healing powers of the waters were discovered and Lourdes became world-famous. Millions have since made the pilgrimage here and have told how it brought them new strength and courage; many have reported how they have been miraculously restored to health, while others have experienced peace and a deepening of their faith.

The area around the original spring has since become too small and the water has been diverted into numerous pools, in which the pilgrims bathe. A huge basilica has been erected over the original site, but even this is

not big enough to accommodate all the pilgrims. Candles are lit all over Lourdes, not just in the 22 prayer chapels but in front of statues of Mary, beside the pools, and in the pavilions.

The pilgrimage site is open throughout the year, but if you are unable to make the journey there, the healing power of Lourdes can be made available to you—the water is sent out to every country of the world, prayers can be said by special request, and you can ask to have a candle lit.

The town is crowded and bustling throughout the year, and it is hard to imagine that a sick person would want to spend time here. Lourdes nonetheless possesses a power that seems to make the impossible possible. It is this unshakable faith that is perhaps the real secret of Lourdes and has made it such an important site.

Basilica of St Marie-Madeleine, Rennes-le-Château

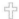

Sometimes a sacred place comes about in a strange way. The tiny medieval village of Rennes-le-Château, about 25 miles (40 km) south of Carcassonne in the south of France, is just such a place. This hamlet of only one hundred inhabitants now attracts more and more people who make the pilgrimage here out of a combination of rever-

ence and curiosity. The little church of St Marie-Madeleine has stood in the village since 1059. At the end of the 19th century Bérenger Saunière, the pastor at the time, renovated this typical village church, decorating it with strange carvings and curious inscriptions. The stories that now circulate mostly feature the Holy Grail, which the priest is said to have found here, along with unimaginable treasure from the time of the Knights Templar.

In 1960 Pierre Plantard incorporated these stories into his history of the Prieuré de Sion (a secret Templar society), ensuring wider attention to the legend. The existence of the society has recently been made widely known through Dan Brown's novel *The Da Vinci Code*. Members of the Prieuré believe that Jesus was not killed but was taken down from the cross while still alive, subsequently fleeing with Mary Magdalene. Members of the Prieuré see themselves as descended from both; according to them, the Holy Grail (the San Graal, derived from *sang réal*, "royal blood") is the bloodline of Christ, which has continued through the centuries to the present day.

There have always been secrets and conspiracy theories associated with the Prieuré, but it is not clear whether they lent any credence to some of the beliefs that have now found worldwide attention. The church in Rennes-le-Château has been the source of many of the legends, and the small village is now visited by those seeking a frisson of the sacred, or even the remains of the Templar treasure.

Abbey of Saint-Michel-de-Cuxa

✝

The small town of Codalet is set in a deserted landscape redolent of rosemary and wild thyme in the Têt Valley near Perpignan. Few make the journey here, but those who do are rewarded with the discovery of a particularly sacred place: the Abbey of Saint-Michel-de-Cuxa. One of the oldest Benedictine monasteries in France and situated at the foot of the Canigou, this architectural gem was founded in the 9th century, although the alterations and annexes date back to the 10th and 11th centuries. The monastery was destroyed and rebuilt several times before its eventual dissolution during the French Revolution and subsequent decline into dilapidation. The complex has since been restored and is open to the public.

The foliage carved into the pillar capitals has an unusually oriental feel and the horseshoe-shaped arches seem almost Moorish. Saint-Michel-de-Cuxa's history stretches back over the centuries, with little to suggest that the monastery was once one of the most important in Catalonia (and later Roussillon). The dominant architectural style is confused, with pre-Romanesque and Romanesque elements combining with Moorish, West Gothic, Carolingian, Lombard, and even Egyptian styles.

The location is idyllic, with the constant chirping of crickets, the wild scenery of the nearby Pyrenees, and

The Abbey of Saint-Michel-de-Cuxa

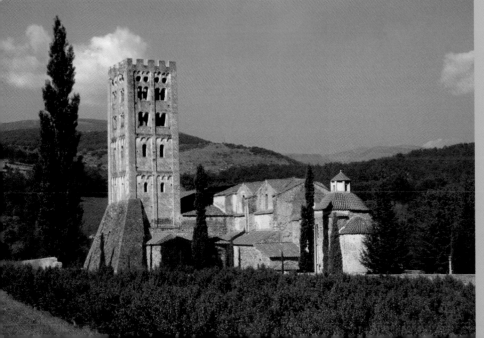

in the middle the monastery, now run by a few monks who welcome pilgrims and look after them. This is the goal of a journey in search of isolation and peace. Classical concerts are held every August within the walls of the abbey, transporting those lucky enough to hear the music from the reality of the present to an enigmatic world that entrances the senses.

Serrabone Monastery

It would be difficult to find a more remote place. This sparsely populated corner of the Pyrenees between the Tech and Têt rivers is covered in forests of cork oaks and chestnuts, with wild thyme and other indigenous herbs growing freely. However, the monastery located here is said to have been one of the most important of its kind in all Europe. The complex was built near Boule d'Amont in the early 11th century, but the only sections to survive from this period are the church and the little gallery that was built instead of a cloister because of the lack of space.

The church features galleries supported by columns with wonderful carvings—intertwining leaf patterns, lions, snakes, birds, and fabulous animals, mostly in pairs. Good and evil, war and peace, body and soul— all the opposing dualities that shape human existence are represented here. The monastery is surrounded by a garden of typical Pyrenean plants, which has rather gone to seed, where time seems to have stood still.

Although the church is a 20th-century reconstruction, the whole site is imbued with the spirit of the Middle Ages, a time when every event was subject to religious interpretation. Visitors need know little of this, however—the place encourages a mood of reflection, which renders the individual receptive to the Divine.

Serrabone Monastery in the Pyrenees

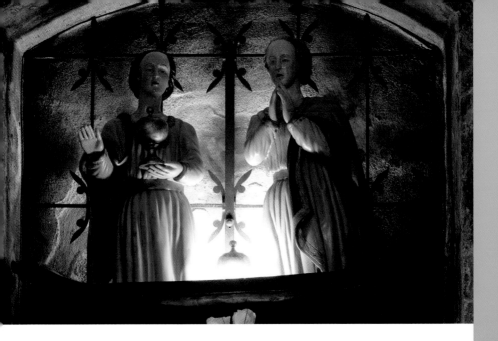

The two Marys in their boat at Saintes-Maries-de-la-Mer

Saintes-Maries-de-la-Mer

Saintes-Maries-de-la-Mer has enjoyed mixed blessings. Overrun with tourists in the summer, this small town in the Camargue is a sleepy hamlet for the rest of the year. The whole village consists of a few streets and the main square with a little arena; beyond that there is only the coast.

The fortified Romanesque church of Notre-Dame in the middle of the village resembles nothing so much as an upturned boat, with pillars for ribs and the spire for a mast. Saintes-Maries-de-la-Mer is dedicated to two St Marys and St Sarah and has been known as a pilgrimage site since the 1st century. Take one or two candles from the machine, enter the dark, single-naved church, and you will notice a cave-like recess behind the altar, with figures representing both Marys (Maria Jacobi and Maria Salome) in a little boat. The execution is not particularly skilled but the statues are revered throughout the area. Tourists, too, have attributed all sorts of different powers to them, of varying degrees of plausibility.

Bouquets of fresh flowers are strewn beneath the niche, their slow decay nevertheless giving off a sweet scent; many people leave plastic flowers instead. There are also little votive tablets giving thanks for healing, and even a few yellowing tourist snap-shots have been put on display.

The dark crypt beneath the church smells of wax and is dedicated to

St Sarah. She has never been formally beatified by the Catholic Church and yet has always been popular, especially during the *Pèlerinage de Sara*, the pilgrimage of the Gitanes, the southern French Romanies.

Groups arrive from all over the south of France and Spain in May, usually in enormous caravans, and the town changes out of all recognition for a few days. On May 24 the flower-bedecked statue of the dark-skinned Sarah is carried into the sea by four bearers, accompanied by riders and pedestrians in traditional garb, and then returned to the crypt to great applause.

The portal of the Church of Saint-Trophime, Arles

The same ritual is carried out the following day with the statues of the two Marys. Dancing, singing, and concerts take place and there are even bloodless *corridas* (bullfights) in the arena. A second pilgrimage in October follows the same pattern as the spring event.

Saint-Trophime, Arles

Emperor Constantine III was a frequent visitor to Arles. Once the capital of Gaul, the majestic amphitheater has been almost perfectly preserved. Bullfights are still held here and the old theater is occasionally used for staging plays.

Apart from the buildings dating from classical antiquity, the most important architectural feature is the former Benedictine abbey of Saint-Trophime. St Trophimus was the first bishop of Arles and is now also the city's patron saint. The locals are fond of the legend that Trophimus was one of the companions of St Paul on his third missionary journey (Acts 20:4 does indeed mention a man of that name),

although the story that this same Trophimus was martyred in Rome along with Paul is definitely apocryphal. What is certain, however, is that there was a Trophimus who spread the gospel throughout Provence, before being made bishop of Arles in 250 and dying there at a later date, and the abbey church is dedicated to him.

The church was built in the mid-12th century and the exterior has retained its Romanesque beauty and clarity to this day. The interior and ambulatory choir are Gothic, but the wonderful extended portal, which takes the form of a Roman triumphal arch and reinterprets it in a Christian tradition, demonstrates the extent of the building's classical influences. The tympanum depicts Christ, for once not as the Judge of the World but as a teacher. Surrounded by the symbols of the evangelists, he sits in majesty on a throne, blessing humanity with one hand and holding the Holy Scriptures, the law of God, in the other. Beneath him sit the 12 disciples, portrayed in the garb of philosophy students, as was typical in classical sculpture.

Built between 1130 (north wing) and the 13th century (east wing), the cloister is especially beautiful, although it remained unfinished for many years—the south and west wings were completed only in the 19th century. The Romanesque corridors are topped with a barrel-vaulted ceiling and the Gothic section is lined with delicate double pillars. The pillar capitals and niches are decorated with a wealth of carvings and sculptures. An atmosphere of peace pervades the cloister, welcoming visitors.

Notre-Dame-de-la-Garde, Marseilles

It is doubtful that the 1.5 million annual visitors who ascend this 500-foot (150-m) cliff all come here to pray. The view of Marseilles and the Mediterranean sea is certainly magnificent, and in a way all the visitors to this mid-19th-century church are pilgrims.

The lofty location has been a sacred site since the Middle Ages, when a little chapel was built on the cliff edge. The modern church was built in a neo-Romanesque-Byzantine style. Countless votive tablets attest to the many hopes and desires that are expressed here. People come to give thanks, to lament, and to offer up requests in the unshakable certainty that the Virgin Mary will hear their prayers.

Notre-Dame-de-la-Garde is a shrine shared by all the inhabitants of Marseilles, no matter what their religion or beliefs may be—the site is truly ecumenical. The contrast between interior and exterior was never more extreme than here. Outside there is a bustling crowd of people, inside an astonishing tranquility and peace; outside bright Mediterranean light, inside cool shade, with only the glitter of mosaics; outside the profane, inside the sacred.

The "good mother" (*Bonne Mère*) presides over everything: a huge gilt statue of the Virgin Mary, surveying the city and the people who cry out to her.

Aix Cathedral

Aix-en-Provence is best known for its university, founded in 1409 and still extremely popular today. Almost a third of the city's population is composed of students, so the university continues to exert an important influence on the city.

Originally settled by Ligurian Celts, this ancient town, dating back to the 2nd century BC, is situated on a hilly site 13 miles (20 km) from the Mediterranean coast and is as lively as you might expect of a student town— Aix is a friendly and cheerful place.

The Cathedral of St Sauveur, located on a square where a Roman temple to Apollo is said to have once stood, is a sturdy presence among the buildings that surround it. The church was continually altered and rebuilt between the 5th and 18th centuries,

Notre-Dame-de-la-Garde, perched on a cliff overlooking Marseilles

such that practically every style of architecture is represented here, from late classical to Renaissance.

The oldest part of the church is the octagonal baptistery, a wonderful early Christian structure surrounded by eight classical pillars. The rest of the church's interior is almost devoid of decoration, only serving to emphasize the serenity of its clear Gothic lines. A flood of light is admitted through the stained-glass windows behind the altar. The First Book of Kings tells us that God is not to be found in the wind, the fire, or the earthquake, but rather in a still, small voice (1 Kings 19: 11–13).

If you are lucky, your visit to the cathedral will coincide with the playing of the two organs, which are located on opposite sides of the central nave. The organ music produces a dialogue of tones and notes that is never strident. Thanks to the beams of the ceiling, the accoustics are very soft, allowing sounds to gently intermingle with no interference or feedback, making this a unique way to experience the Divine inside the cathedral. The 12th-century cloister with its delicate double pillars is also extremely beautiful—a place to pray and reflect on the important things in life.

Saint-Jean-Pied-de-Port

In the Middle Ages more than a million people a year followed the Way of St James, and the pious and the curious are still undertaking this, the most famous pilgrimage of all, to the Cathedral of Santiago de Compostela. The journey would often begin in the little village of Saint-Jean-Pied-de-Port, now a lively French Basque town and the last stop before crossing the Pyrenees into Navarre and Spain. The old part of town still has something of the medieval atmosphere of the pilgrimage village which marked the beginning of the arduous journey. The town is only 600 feet (180 m) above sea level and was the last opportunity for pilgrims to brace themselves for the climb up to the Cisa Pass (4,850 feet/1,480 m), where the "mountains seem to touch the sky," as the *Codex Calixtinus* puts it. The path leaves the town and continues across steep mountain meadows to the pass, which is often obscured by clouds and is foggy and damp, even in the summer months. Saint-Jean-Pied-de-Port is sacred in a very particular sense, as it represents the first serious test of a person's resolve to undertake the pilgrimage before the journey has even begun.

At the start of any journey most people will wonder what lies ahead and will ask what the trip will entail and whether they will arrive safely. These questions are as important for a pilgrim's journey as they are for the passage through life, in search of meaning, in search of oneself.

THE WAY OF ST JAMES

Christian tradition recognizes three ancient pilgrim routes, each of which would earn the traveler a blessing. One was to Rome, to the tomb of St Peter, and is symbolized by the cross. The second was to the tomb of Jesus in Jerusalem and is symbolized by a palm frond, like those used to welcome Jesus into the city. The third way led to the point on the Iberian peninsula where the relics of the apostle James found their last resting place—a field where a shepherd is said to have noticed a particularly bright star one evening. The place was called Compostela ("field of stars") and the city that soon grew up here proved to be a magnet for pious pilgrims. Those who opted for this third way called themselves the brotherhood of St James and chose the scallop shell as their emblem.

The earliest pilgrimages to Santiago, undertaken in the 11th century, did not follow a prescribed route—the pilgrims simply asked their way as they went or were led by experienced guides; the well-developed Roman road network proved particularly useful for this purpose. Soon, however, staging posts and pilgrims' hostels were established, and today there is a well-marked system of Ways of St James crossing Europe, with thousands of waymarkers to guide pilgrims. The oldest and most famous routes are the Via de la Plata (Silver Route) from Seville in southern Spain to Santiago de Compostela; the northern route (the Via Tolosana), which begins in Switzerland and follows the Atlantic coast through Tolosa; the Portuguese route, starting in Lisbon and heading north; the route beginning in Cologne, Aachen, or Liège and passing through Paris, Orléans, and Tours (the Via Turonensis); the route via Trier and Reims, which passes through Vézelay, Cluny, and Le Puy; the route via Limoges and Périgueux (the Via Lemosina); and the route following the southern French Mediterranean coast via Toulouse. Pilgrims from the British Isles threaded their way through Normandy and Brittany in northern France. Even travelers from the east and the far north of Europe found their way to the apostle's tomb.

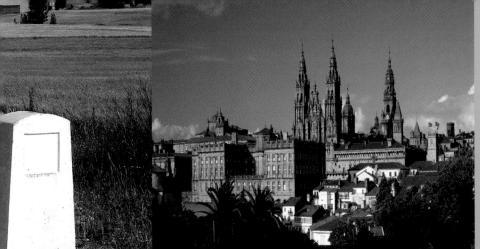

The best-known and most traditional route is still the so-called "Frankish road," the Via Francigena, beginning at St-Jean-Pied-de-Port at the foot of the Pyrenees and leading from east to west through Castile and Rioja to Santiago and on to Finisterre and the Atlantic.

Wherever they come from—and they come from all points of the compass—and however they get there, as they draw near to Santiago de Compostela, pilgrims are firmly focused on the final stage of the journey that will lead to their goal.

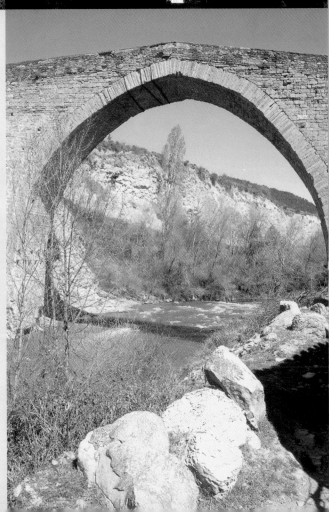

Roncesvalles Monastery

Once pilgrims en route to Santiago have crossed the Cisa Pass and negotiated the heights of Ibañeta, the next stop is the monastery of Roncesvalles. As you emerge from the forest, you are confronted with a complex of buildings dominated by the imposing broad façade of the 12th-century Augustinian monastery. A building set at right angles behind this is the pilgrims' hostel, and to the right there is the early Gothic triple-naved collegiate church, which was also built in the 12th century by French masons. The little medieval burial chapel, named after Charlemagne (Silo de Carlomagno), is said to be the resting place of the heroic Roland's 12 companions. The overall impression is compelling and sets the mood for the road ahead. The small and simple chapel of St James is especially attractive, and the peal of its bells is said to help straying pilgrims to orient themselves.

Local farmers come to Roncesvalles in the week after Ascension and hold a procession to the monastery. Often barefoot, the participants dress in black robes with black hoods and carry a cross to the church, commemorating Christ's route to the Crucifixion and bringing their own suffering before a God who they hope will relieve and redeem them.

Pamplona Cathedral

The kingdom of Navarre, which comprised both Spanish and French provinces, is of major importance in

The monastery at Roncesvalles on the Way of St James

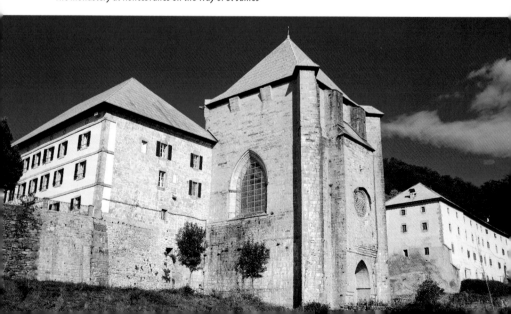

Spanish history. The capital of this medieval realm was Pamplona, a city situated on a plain in the foothills of the Pyrenees, whose citadel and mighty cathedral can be seen from afar. The Gothic Cathedral of Santa María la Real was begun in 1397 and incorporated sections of the Romanesque building that had previously occupied the site. The classic portal on the west façade seems slightly at odds with the otherwise Gothic lines, but the interior is harmonious and graceful.

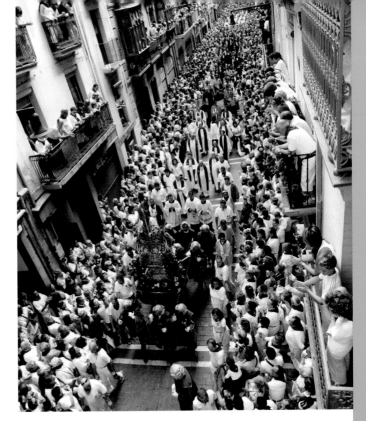

Sanfermines, Pamplona

The cathedral's treasures include a silver reliquary from the Holy Tomb in Jerusalem. An open shrine, decorated with precious carvings, holds three figures of the Virgin Mary and an angel who is pointing at a glass sarcophagus in which the relic, a stone from Jesus' tomb, is housed.

The mullion of the door leading from the church to the cloister is decorated with a statue of the Virgin called *La Nuestra Señora del Amparo*, a carving so revered that fresh flowers are laid at its feet even today. Completed in the 14th and 15th centuries, the monastery cloister is a unique structure and one of the most beautiful in Europe. Almost exactly square, its delicate, late Gothic arcades combine strength and elegance. The fine ornamental lattice-work throws a delightful pattern on the bare walls, which shifts as the light changes. Light and shade, luxuriant ornamentation, and ascetic formal severity are juxtaposed in perfect harmony.

Pamplona's location on the Way of St James brought it great religious significance and filled its population with a pious zeal, which can still be felt

today. Celebrated every July 6–14 since the Middle Ages, the festival of San-fermines involves the procession of a statue of St Fermin of Amiens through the streets and past certain churches. Still more famous than this procession is the *Encierros*, when participants run with bulls through the Old Town, a famous tradition that is still hugely popular despite the many protests.

Jaca Cathedral

The city of Jaca stands on an upland plateau at the foot of the Pyrenees, encircled by two rivers, the Gál-lego and the Aragon. The city has always been a major staging post on the Way of St James. By this point, pilgrims have already crossed the mountains and the Spanish section of the journey is about to begin.

As pilgrims enter the city, they are led almost automatically to its most striking building, the Romanesque Cathedral of San Pedro Apóstol, whose low, broad appearance makes it look almost like an enormous sleeping animal. The building grips the observer, and there is a defi-nite feeling, hard to describe, of a power that is great

but does not express itself in expansive gestures. The fabric and the propor-tions, the size and yet the intimacy of the building, its pale gray stonework, which almost seems to shimmer pink in the evening sunshine, adapting to its surroundings—all these things combine to deeply engage the senses.

Dedicated to St Peter, the triple-naved basilica with its three apses is the oldest Romanesque ecclesiastical building in Spain, having been com-menced in 1063 under King Ramiro I. It was completed in 1130 after several phases of building work. The most recent period of renovations, at the turn of the millennium, has restored the building to its former glory.

The main entrance is in the west façade, and there is an extremely rare relief above the portal—two lions flank a wheel adorned with the chi-rho symbol, and beneath this there lie a man and a snake. One of the lions is fending off a bear with one paw. The finely carved relief refers to a promise

The portal of San Pedro Apóstol, Jaca

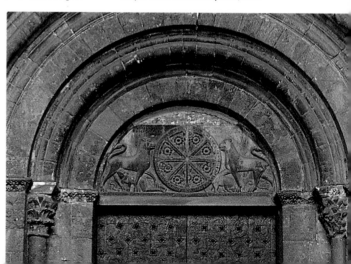

of peace among all the animals (Isaiah 11:6–9). Its meaning is clear to those who wish to understand it, and those who do not will surely comprehend the Latin invocation to live well: *Vivere si qveris qui mortis lege teneris/ Hvc svplicando veni renvens fomenta veneni./ Cor viciis mvnda, pereas ne forte secvnda.* ("If you who are subject to the laws of death wish to live, come here and supplicate, eschew the poisonous nourishment of the world, and cleanse your heart of injustice, so you will not have to die a second time.") A point to consider for any mortal, and what better place to begin such ruminations than the beautiful cloister adjacent to the cathedral.

San Juan de la Peña

The Sierra Interiores, the inner Pyrenees, run parallel to the main chain of mountains. One section of the Way of St James leads for miles through the valley of Berdún before turning off into the forested uplands of the Sierra de San Juan. The path continues to climb through oak forests, offering magnificent mountain views until it reaches the monastery of San Juan de la Peña.

The first impression of the monastery is a reminder of the pilgrims' vulnerability—the building is located beside a steep and forbidding cliff. Parts of it are even built under a threateningly high rock overhang. Initially nothing stood on this site except a tiny hermitage to which some monks had retired in the 8th century after the Moorish invasion of Spain; they lived in a loose community in this inhospitable region. A small monastery was built in 920, although little of the early Romanesque, Moorish-influenced lower church has survived. The courtyard of the upper building contains the tombstones of several Aragonese kings.

The main church was consecrated in 1094 and is set deep into a natural cave. The rounded forms of the naive paintings of scenes from the Old and New Testaments to be found in the ruined cloister are rather beautiful, if a little strange. The circular eyes of the figures are particularly arresting, seeming almost blind and yet looking into a world that only they know exists.

The most important object venerated here is the grail cup, which has been displayed to the faithful since the 13th century—that it is only a copy seems not to diminish the reverence with which it is treated. The story of this mysterious vessel, both the chalice from the Last Supper and a receptacle for blood, has spread throughout Europe as a Christianized version of a pre-existing pagan/Celtic redemption legend. Since the Middle Ages, many people have searched for the Holy Grail and some even claim to have found it here.

Santa María la Real, Sangüesa

Aimery Picaud, a 12th-century monk from Poitiers, is assumed to be one of the authors of the *Codex Calixtinus*, the first pilgrims' guide to the Way of St James. He traveled on horseback and was the first to describe the Way with its staging posts, shrines, and pilgrims' hostels. He spoke from personal experience and seems to have harbored a few personal grudges as well—little else can explain his drastic warnings about the people of Navarre, whom he describes as "evil through and through, with dark skins and ugly faces, reprehensible, perverted, contemptible, disloyal, corrupt, licentious, intemperate, practiced in every manner of violence, depraved and wild, dishonest and false, impious and common, brutal and bellicose, incapable of any decent emotion, and equipped by their very nature with every vice." In other words, he did not view them as the most hospitable of people, an assessment that almost certainly would not have served to reassure those pilgrims who still had some 500 miles (800 km) to travel.

Picaud may have been writing out of personal animosity, or perhaps he was just thinking of the magnificent portal of the Church of Santa María la Real. Instead of a palace, Alfonso I, King of Aragon and Navarre, built this graceful church at Sangüesa. Construction was begun in 1131 and completed in the 13th century. The portal, which pilgrims pass as they follow the Way, contains a particularly striking representation of the Last Judgment. One side depicts the heavenly order, consisting of the blessed departed, surrounded by the symbols of the four evangelists, apostles, and prophets. On the other side, the chaos of this world is shown, along with the underworld of hell and the grimaces of shark-toothed demons. The contrast between the saved and the damned is stark; on one side serenity, on the other wailing and gnashing of teeth. For art historians this is the most significant Romanesque tympanum in Spain, but, more than that, its message is timeless. Those who stand before this portal are confronted with a reality that is quite independent of the nature of their belief.

Santa María de Eunate

The church is situated in meadows near Puente la Reina—there is nothing for miles around, not a town or a village, to draw attention away from this enigmatic building. The remote location alone makes Santa María de Eunate a sacred place, but for some there is a special force field releasing positive energy here, just as at the cathedrals of Chartres or Paris. Whether you believe this or not, Santa María de Eunate has always been one of the major stages on the Way of St James through Aragon as it converges with the Via Francigena.

The church is designed on an octagonal central plan surrounded by an ambulatory. It is a style that has led many to assume it was a Templar building, as the Templars often based their

structures on the Holy Tomb in Jerusalem. The Romanesque church has Mozarabic elements and is assumed to date back to the 12th century. The capitals and the portal are richly decorated and the tiny window moldings are made of alabaster. Archeological finds of skeletons with scallop shells as grave goods support the belief that this was a cemetery chapel for pilgrims on the way to Santiago.

The church radiates a quiet intimacy and a wonderful sense of harmony. Visitors are immediately struck by the tranquility of the place and there is a smiling statue of the Virgin Mary in a niche, which seems to be welcoming pilgrims. Approach the statue and you feel immediately at ease—it almost seems as if the Mother of God and her Son were waiting for just this one pilgrim. There are countless statues of the Virgin Mary throughout the world, yet this figure seems to shine with particular humanity. Grace and goodwill are virtues that benefit everyone, and the Church of Santa María de Eunate gives a sense of how these qualities make life easier. It is little wonder that the building is still a popular venue even today for the celebration of weddings.

Santo Domingo de la Calzada

In the 12th century a stretch of the Way that had previously been difficult to cross was opened up through

The remote Church of Santa María de Eunate

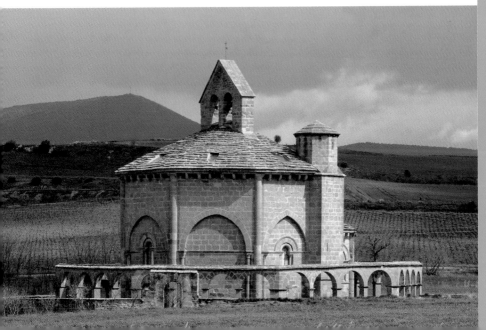

the construction of paths and hostels, and what was little more than a staging post for pilgrims developed into a walled and fortified town. Santo Domingo de la Calzada became a diocese in 1100, acquiring a cathedral with Romanesque, Renaissance, and baroque features.

This church is the site of one of the most famous folk legends associated with St James. A German family was spending the night at Santo Domingo on the way to Santiago. The innkeeper's daughter immediately fell in love with the son, who rejected her advances, and this turned her love to hatred. She hid a silver chalice in his luggage and when the innkeeper noticed the theft, the son was caught, tried, and hanged. The parents continued their pilgrimage in great sadness, but as they passed the gallows on their way home, they heard the voice of their son saying,

"Be of good cheer, I am not dead, St James held me!" The couple ran to the judge and told him what had happened. The judge, who was dining at the time, reacted as any normal person might and said, "Your story is about as true, and your son about as alive, as this hen and cock on my plate." At which point the cock leapt up, confirming the truth of the tale. The lying daughter was hanged in place of the innocent son.

To this day a live cockerel and hen are kept in a cage in the cathedral. This may mean little to the rational mind, but belief in such miracles is still alive today, inspiring hope and confidence in a justice that prevails even when appearances militate against it.

Logroño and San Millán de la Cogolla

The chicken enclosure in the Cathedral of Santo Domingo de la Calzada

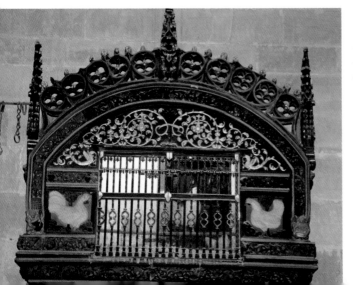

Located at the site of a ford in the Ebro Valley, **Logroño** is the capital of the province of Rioja, which is famous for its wine. The bridge over the river was built in the 1st century, during the Roman period, and by the Middle Ages had acquired a particular significance for pilgrims on the Way of St James. The saying *la ciudad como el camino*

("the town adapts to the path") had become proverbial, and countless towns along the Way were starting to celebrate saints' days, build churches and monasteries, or simply erect signs reminding pilgrims what path they were following and suggesting that they stop off there. Accordingly, every year on June 1, Logroño celebrates a festival dedicated to St Emilianus, and fish, bread, and wine are distributed to commemorate the meal that Jesus shared with his disciples after the Resurrection.

San Millán de la Cogolla is a little off the beaten track, and pilgrims have to take a detour to visit two famous shrines—the monasteries of **San Millán de Yuso** (from the Latin *deorsum*, "lower") and **San Millán de Suso** (from the Latin *sursum*, "upper"). Both monasteries are named after St Emilianus (San Millán), who lived in a nearby hermitage with his companions. After his death, his tomb soon became a place of prayer, and the first part of the upper monastery was built in the 6th century. It was constructed on the cliff where Emilianus and his followers were said to have lived in caves. The relics of the saint and Felix, his master, are still preserved in the lower monastery. Originally run mostly by Benedictines, since 1878 this sacred place has been the preserve of Augustinian monks.

Santo Domingo de Silos

The Benedictine monastery of Santo Domingo de Silos has been a special place since its foundation in 929, but it found world fame only at the end of the second millennium, when the monks, who have always preserved a strong tradition of Gregorian plainsong, recorded a CD of their singing and had an international hit. *Chant* was in the music charts around the world for over a year—perhaps this was a sign on an international scale

Twisted columns in the cloister at Santo Domingo de Silos

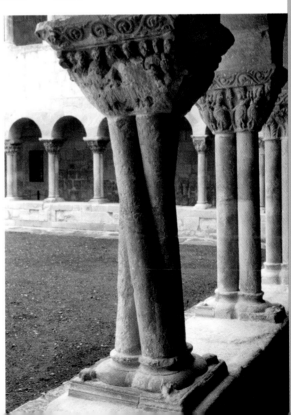

of people's desire to hear music that has an otherworldly quality.

The Benedictine abbey was previously famed for its Romanesque cloister, the most notable architectural feature of the monastery. The capitals are decorated with Persian bird motifs and a great variety of interlocking Arabic designs. In the midst of this wealth of patterns are three columns that differ from all the others—they appear to have been twisted around each other. This oddity seems to say much about life—among all this balance and imposed order, there is still room for exceptions!

The two-storey cloister looks as if it has been cast from a mold until you see the three columns contradicting the uniformity of the rest. Challenging all the imposed straightness, they disturb the balance of the whole and dare to be different. The columns tell those who will listen about the lightness of being. Conveying the message that it is acceptable to be different in such an unassuming way, is a masterstroke of the imagination.

The cloister of Santo Domingo de Silos is a place of wonderful insights, at once unobtrusive and forceful.

Burgos Cathedral

The twin towers of the Gothic cathedral at Burgos immediately catch the eye—it is without doubt the central feature of the town. Dedicated to the Virgin Mary, the building is noted for its size and design, both of which are based on French and German precursors. Construction of a previous Romanesque church on the site began in 1221. The church was consecrated in 1260 and no further building work was attempted until some two centuries later, when Bishop Alfonso de Cartagena commissioned the German master mason Johannes of Cologne to design and complete the structure. Basel Minster and the plans for the spires of Cologne Cathedral, as yet unbuilt, were taken as inspiration. The resultant building is so richly decorated that the poet Pierre Loti was moved to describe the cathedral exterior as a "petrified forest."

The Coronería Portal on the north side has special significance for travelers on the Way of St James, since this was the pilgrims' entrance to the church. Tucked away in a niche between two buttresses, it features larger-than-life statues of the apostles, who process from the left buttress to the edge of the portal and then continue off to the right. The two outermost figures seem to be watching the pilgrims as they enter the church. This entrance has been closed since 1830 to preserve the dignity of the church, as people were inclined to use it as a shortcut to the center of the town.

The other portals of the church, and the interior with its 19 chapels and wealth of Christian iconography, are equally impressive and captivate casual visitors. The pilgrim,

however, is obliged to continue on his path through the heat and dust, getting ever closer to his goal.

León

The path of a pilgrim often leads through seemingly endless stretches of countryside, with no shade in summer and no shelter from the wind and rain in spring, with church spires often the only waymarkers. After climbing the Mostelares Pass (2,995 feet/913 m), pilgrims encounter a monotonous path to challenge their resolve before they reach the Roman and royal town of León.

León was once the capital of its eponymous kingdom, a major forerunner of modern Spain. Founded in 68 AD, León owes its existence to the Roman emperor Galba, who stationed a garrison here. The town was conquered by the Visigoths as the Roman Empire collapsed and then occupied by the Moors in 712. Ordoño II made it his capital in 914, and León has been a major city on the Way of St James ever since.

Among its other attractions, the city has two major Christian shrines, the **Cathedral of Santa María de Regla** and the Basilica of San Isidoro. The cathedral was built between 1255 and 1302 and is testament to the daring and skill of Master Enrique, the mason entrusted with the design. He reduced the profile of the pillars to a minimum, creating a glazed triforium (inner gallery of arches). The original effect of the sunlight penetrating the glass must have constituted a unique experience for the onlooker, but unfortunately many of the arches have had to be bricked up as the building has settled. By the 19th century the whole structure was on the point of collapse and had to be completely renovated.

The mural cycle around the north portal depicts the Ascension of Christ and the walls portray the Annunciation and representations of the apostles Paul and Peter, and St James, after whom the Way is named.

The **Real Basilica de San Isidoro**, a masterpiece of Romanesque architecture, was built between the 10th and 12th centuries. Since 1063 it has been the last resting place of the revered relics of St Isidore, a 7th-century bishop of Seville and one of the most important Visigoth church leaders.

Virgen del Camino

A shepherd named Alvar Simón Fernández once had a unique experience beside the gates of León, when a vision of the Virgin Mary appeared to him. A pilgrimage chapel was soon built on the spot to provide a lasting record of the incident.

By the 16th century a small church had appeared, to be replaced in the 20th century by a larger one. The present structure is a white cube-shaped

building on a plinth with a spire in the form of a cross, pointing to heaven. The portal depicts Pentecost, with Mary and the disciples but no Jesus; each of the 13 statues is more than 20 feet (6 m) high. Despite their size, the intricate portal statues hark back to the iconography of the cathedral at León.

Visitors entering the church will discover a low room with a pietà of indeterminate age, known as the "Virgin of the Way." Many people undertake pilgrimages to this sacred place, believing that the presence of the Mother of God can be felt especially clearly here.

The pilgrimage church of Virgen del Camino, León

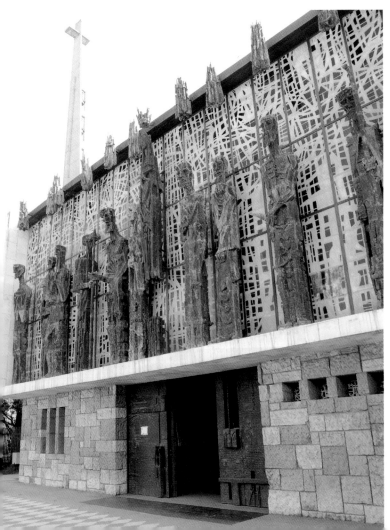

Astorga Cathedral

After a long trudge through rather monotonous countryside, pilgrims finally reach Astorga at the foot of the Montes de León.

The town is located at the convergence of two major paths, the Camino Francés (the Via Francigena, the Way of St James), which runs east–west, and the Via de la Plata (the Silver Route), which runs north–south. Alfonso I reconquered the city from the Moors

and established a diocese here in 850. Benefiting from its location on the Way of St James, Astorga is now a bustling city. The bishop's palace, designed by Gaudí, immediately attracts the attention, but this is not the most sacred place here. That is the Cathedral of Santa María, a late Gothic edifice dedicated to the Virgin Mary, which was built on the ruins of an 8th-century Romanesque church, and is now the home of the Museo de los Caminos, the "Museum of the Ways," which contains much information about the history and legends associated with the route.

Astorga is also famed for its chocolate, which is used in all kinds of products, such as *hojaldres*, a filo pastry confection, and *mantecados*, a crumbly butter biscuit. No doubt many an exhausted pilgrim welcomes the oppotunity to fortify the body before resuming their journey to Santiago.

Villafranca del Bierzo

Once Astorga is behind them, pilgrims can say goodbye to the mountains of the Sierra del Teleno, whose summits are often covered in snow even in summer. The route continues through the foothills of the chain via the Rabanal Pass, crosses the Mara-

The Cathedral of Santa María, Astorga

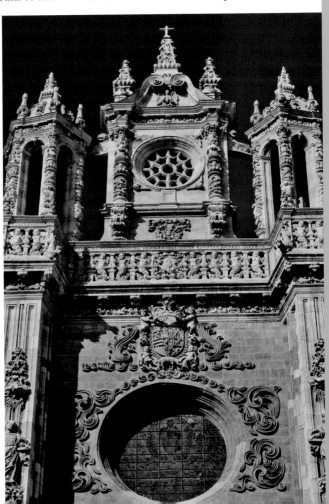

gatería heath, and turns at the wayside cross on Monte Irago before following a steep incline down to Ponferrada.

Leaving behind this town with its mighty Templar fortress, the Way finally approaches Villafranca del Bierzo, whose many churches and monuments have earned it the nickname "Little Compostela." Sick pilgrims who could go no further were granted an indulgence here. Those who made it as far as the north portal, the Puerta del Perdón, of the "Little San-tiago" church, even though they were far from completing their journey, were judged to have done enough to be forgiven their sins, a tradition that assures the sacred-ness of this place.

passes by and ascends the **Cebreiro** itself, reaching a still-occupied Celtic village at a height of 4,260 feet (1,300 m). Many legends surround the place. It is considered sacred not only as it dates back to the earliest settlement of the area but also because evidence of Celtic shrines has been found here.

The dark pilgrim, Cebreiro

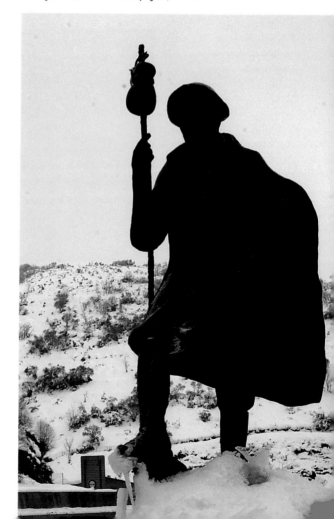

Cebreiro

The steep slopes of the Valcarce Valley leave little room for roads of any description, and modern man has literally moved moun-tains to make room for a freeway here. Such abuse of nature is destroying the last few idyllic places on earth, but the pilgrim

A Marian pilgrimage is conducted on the Cebreiro every September 8 and 9, to venerate the Virgin and ask for assistance. In the Poio Pass there is a shrine of a special kind—a modern **statue of a dark pilgrim**, struggling against the weather, as even in summer the conditions can be extremely unpleasant, with rain, strong winds, and fog. The shrine was established to reassure other pilgrims on their arduous journey—the statue is sacred not because of its religious nature, but rather because of the galvanizing effect it can and does have on weakened travelers.

Pilgrims find peace and an opportunity to recuperate as they descend from the Cebreiro to the ancient slate-gray buildings of the huge **Benedictine monastery of Samos**, nestling in a sheltered corner of the valley. All Benedictine monasteries are sacred places, wherever they are situated, as the Rule of St Benedict of Nursia decrees that monks should pursue a saintly life. The position of a Benedictine monastery is carefully chosen and always represents a locus of the sacred in a secular world.

The fortified church of San Nicolás, Portomarín

This sacred place is situated in new Portomarín—the old town was abandoned when the Miño River was dammed in the 1960s to make a reservoir—and is to be found in the form of the fortified church of San Nicolás, which was dismantled stone by stone and reassembled on a new site. It is not a spectacular church, but it is an example of how the "house of God on earth" can withstand intervention with nature.

From this point onward, shrines and sacred sites along the Way become few and far between. It passes along ancient valley paths, forest tracks, and small roads, before reintroducing the pilgrim to a landscape dominated by agriculture. In the villages there are churches, which might also be considered sacred places, and plenty of wayside crosses attest to the piety of the locals and of those who follow the pilgrims' path. After climbing Montjoi, pilgrims catch their first glimpse of Santiago de Compostela, situated on a plateau between two arms of a river.

The Cathedral of Santiago de Compostela

The list of martyrs compiled by Florus and Usuard in the mid-9th century documents the apostle James' tomb as lying "at the furthest end of Spain near the ocean." The question of whether the list was drawn up out of a desire to seek the tomb, or as a reaction to the news that one of the apostles' tombs had been located, is now as difficult to answer with any certainty as the famed conundrum involving the chicken and the egg.

Although the cult of St James was initially limited to Spain, it soon spread throughout Europe after the *Reconquista*, the reconquering of the country from the Moors. All kinds of healing powers in every situation were ascribed to the saint, as he had been particularly close to

Christ, and many legends grew up around his death, especially after his relics had been brought to Spain.

The authenticity of the relics of St James was never doubted, although skeptics pointed out that he had been martyred in Jerusalem and not in Galicia. The 13th-century *Legenda Aurea* provides an account of how his body came to the Galician coast and how a hermit named Pelayo saw heavenly signs that revealed the burial place. After the tomb had been discovered, the Asturian king Alfonso II built the first church on the site, to be run by monks. The mighty cathedral, completed by the master masons Estéban and Bernhard the Younger in 1128, now stands on the same site.

The *Codex Calixtinus* praises the structure as a church "without cracks or breaks, wonderfully wrought, large, spacious, and bright ... the breadth, width, and depth are each harmoniously accommodated ... and whosoever passes through the upper

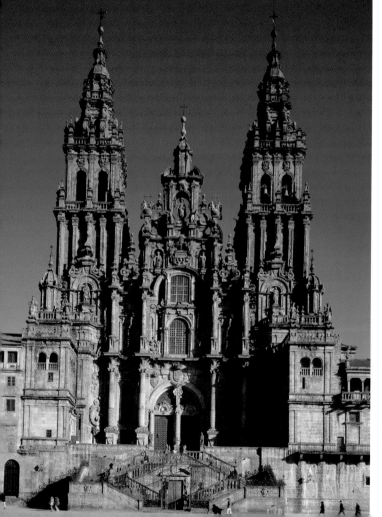

The Cathedral of Santiago de Compostela

galleries, though he climbs in sadness, will be gladdened by the perfect beauty of this church!" (Book 5, ch. IX).

This brief remark goes some way to explaining the importance that this sacred place has retained to the present day for visitors from all corners of the world who come to seek happiness here. Whatever may have led them to undertake their pilgrimage, this is where their journey reaches its end, if they have not fallen by the wayside. Now, on the last day, just before they reach their final destination, the length of their journey and its starting point become irrelevant. All pilgrims will arrive eventually, whether it be at Santiago de Compostela or elsewhere, although how this may change them will only become apparent once ordinary life has been resumed.

Those who have managed the steep ascent of Montjoi, the Mount of Joy, will see the city and cathedral below them, and experience a moment of both happiness and solemnity, both dark and light—conflicting emothions to be reconciled.

Arriving at the main portal, the pilgrim is greeted by a celebrating throng of people from all over the world, exhausted by what now lies behind them and gripped by what constitutes the essence of life: individuality and community.

Finisterre

The end of the world is nigh! And here is where you find it. Not literally—we have known since Copernicus that the earth is round—but this place is not concerned with physical laws and scientific knowledge.

Padrón lies about 13 miles (20 km) beyond Santiago de Compostela. It was once a diocese (Iria Flavia) and, in the Middle Ages, a major Galician port. The ship carrying St James' body is said to have made landfall here, according to one of the many legends, and it is also the place where pilgrims first catch sight of the ocean. The path from Santiago leads through forests, a few small towns, vineyards, and fields, until the tidal bore of the Ulla River betrays the fact that seawater is penetrating into the estuary.

The continuation of the pilgrimage beyond its actual goal has always been one of the puzzles of the Way of St James. The pilgrim has spent weeks or months directing every step toward Santiago de Compostela, has arrived, thanks to decent shoes and the help of God, and has received absolution—and now he wants to carry on walking?

If you have ever completed an arduous journey, you will understand how unsettling it can feel when the destination has finally been reached. Striving toward a goal, for months on end, changes a person—the rhythm of walking day after day, the exposure to the heat, dust, rain, and cold. It is often very difficult to adapt from this back to the normal world. Perhaps this

is what drove, and continues to drive, pilgrims to the "end of the world." There is always a point on the far horizon, although Finisterre has no relics to offer and no salvation awaits visitors here. The charm of the place lies in the magnificent view of the ocean and a glimpse into a far region that has an aura of otherworldliness.

Finis terrae—the end of the world. According to science it cannot exist, and yet, and maybe for this very reason, this is a sacred place.

San Juan de Duero, Soria

The Knights Hospitaller have long since passed into history, but the ruins of the monastery they built in 1100 at Soria on the Camino Monte de las Ánimas can still be seen, and this is an extremely sacred place. Visitors here are transported to another time: the interlinking arches that form the cloister seem to hang suspended in the air, and even though this cloister is today only a ruin, it has remained a place of introspection—perhaps for this very reason. It is now a wild and untended garden

where roses scramble over the walls and columns and wild flowers spread their scent, and the square that was once the middle of the quadrangle has long overgrown into a meadow. The cloister is no longer an enclosed space but is open on all sides, and you stand exposed to the elements. As the wind blows softly, you are both indoors and outdoors. It is easy to imagine how it must have looked in the past, but now the building is a reminder that the "inside" and "outside" can merge into one another. There are a few gravestones with Hebrew inscriptions and many Mudéjar architectural features, although the images on the capitals of the pillars are Christian—three worlds united in one place. This sacred site is not particularly well known, but a restless spirit will find peace here. The nearby River Duero is still quite narrow at this point. Such

Ruined cloister at San Juan de Duero, Soria

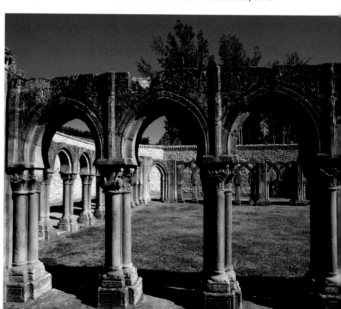

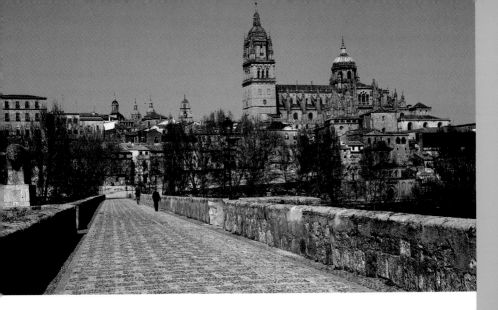

The Old and New Cathedrals, Salamanca

idylls can be found all over Spain. There are many places in this great land where time seems to have stood still—Soria and the monastery of San Juan constitute just one such place.

The Old and New Cathedrals, Salamanca

The Plaza Mayor, perhaps the most beautiful square in Spain, is to be found in Salamanca. Even if it is not the most beautiful—who is the arbiter in these things after all?—it is still a wonderful place: no sidewalks, no distractions, just a perfect square surrounded by fine arcades. People stroll or sit in the shade, chatter, or simply let time pass by in silence. This is a place for those moments of relaxation and recuperation that really make a day. Such moments can be seen as contact with the Divine, even in the absence of a church. This is to be found a few paces further on, if you can bring yourself to leave a spot where you have the distinct urge to remain for ever, fixing the moment in time.

Those who succeed in breaking free are rewarded with the sight of no fewer than two cathedrals, linked to make a single place of worship. The Old Cathedral was begun in 1140 and still bears visible traces of the Spanish Romanesque style, although, as the structure was not completed until a century later, there are also many Gothic elements. The Byzantine-looking spire is particularly striking and has become a symbol of the city.

The original Latin cross floor plan is now no longer immediately apparent, as the entire left-hand section was demolished to build the New Cathedral. There is an enormous and colorful fresco inside, depicting the Last Judgment and the souls of the damned entering hell.

The Virgen de la Vega, the patron saint of Salamanca, enjoys particular reverence here, and a larger and more magnificent church in her honor was mooted in the 15th century. Ferdinand the Catholic did not have the existing cathedral torn down completely, choosing instead to incorporate it into the new structure. Work began in 1513 but was completed only in 1733, more than two centuries later.

The New Cathedral, combining Gothic, Renaissance, and baroque elements, suffered damage to its spire in the aftershocks of the earthquake of 1755 and required considerable shoring up. All in all, the Old and New Cathedrals display a considerable diversity, with the eye finding ever new perspectives. The cathedral complex of Salamanca is testament to a faith that has proved everlasting, outliving every change.

Ávila

First settled during the Roman period, the city itself is very old and its proximity to Toledo soon made it one of the most important centers in Spain. Ávila was under Moorish rule between the 8th and 11th centuries, but as the bitter conflicts between the Muslims and Christians moved south in the 15th century, Ávila was left to flourish.

Though the city was later to decline, it has retained its fame thanks to its most notable daughter, St Teresa of Ávila, who was born here in 1515. This Carmelite nun was to become one of the most renowned mystics of the Roman Catholic Church. Dying in 1582, she was beatified in 1614 and has been the patron saint of Spain since 1617. She was eventually canonized in 1622.

Her health suffered greatly during her lifetime, but at the age of 39 she was so moved at the sight of an image of Christ that she decided to live the remainder of her days in total devotion to him. In 1560 she experienced a vision of hell that only strengthened this adherence. Despite some opposition she obtained permission from Pope Pius IV to found her own order, the Discalced Carmelites. Her rule combines Carmelite traditions of reclusive life with elements of communal living.

Two places in particular commemorate St Teresa: the Convento de San José and the Convento de Santa Teresa. The **Convento de San José**, her first monastery, was founded in 1562. Although not completed until the 17th century, it is still the basis for the design of all subsequent monasteries and churches of the order. The Museum of St Teresa in the monastery is packed full of information about the saint and her life of devotion.

The **Convento de Santa Teresa**, completed in 1636, stands on the site of the house where she was born. Its baroque façade is harmonious and the single-naved interior is richly decorated. Whether Teresa first saw the light of day on this particular site is perhaps questionable, but the two monasteries are undeniably popular with pilgrims—St Teresa has a firm place in the hearts of the Spanish.

People from all over the world have also found a timeless wisdom in St Teresa's sometimes extremely humorous utterances. If only more people took to heart her saying, "Release me from the great desire to order the affairs of others!"

Real Sitio de San Lorenzo de El Escorial

According to most versions of the life of St Lawrence, he was martyred on a griddle, a story that is responsible for the layout of the largest Renaissance palace in the world—the royal palace and the monastery of San Lorenzo de El Escorial are indeed based on a griddle. Located not far from Madrid, the complex was built between 1563 and 1584 by Philip II, who had vowed to found a monastery dedicated to St Lawrence after his defeat of Henry II. The court astrologers chose a site on a low hill near the capital and

The Monastery of San Lorenzo de El Escorial

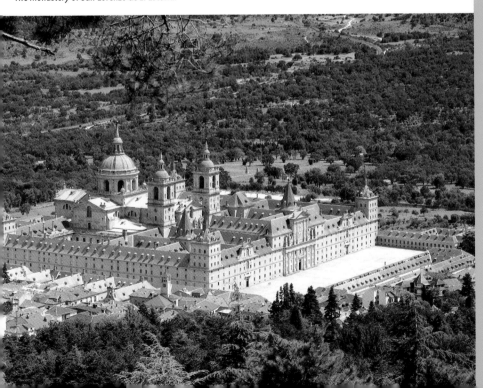

the resulting building was to be one of the finest of the Spanish Renaissance.

Built of light-colored granite blocks, the complex covers an area 680 feet by 531 feet (207 m × 162 m) and is visible from afar on its site above the little town of El Escorial. There are more than 2,000 rooms, 16 court-yards, 15 cloisters, 88 fountains, and a chapel based on St Peter's in Rome. The building was not initially intended as a residence but rather as a retreat—a place of scholarship and prayer. The enormous library of 150,000 valu-able books and manuscripts acquired lasting fame, and the palace is noted for its art collection, which includes works by Titian, El Greco, Dürer, and Hieronymus Bosch in particular. The tombs of many famous Spanish monarchs are also to be found here. However, Philip II's real desire was to build a monastery and a church, and a resplendent central-plan edifice was the result. The church's façade juts out of the central courtyard of the complex and there are statues of six biblical kings guarding the portal. Twin spires frame the entrance and the interior hides no fewer than 40 altars in its various chapels. The sacristy is deco-rated with valuable paintings by Titian and El Greco, while the handsome red marble high altar reinforces the monu-mental proportions of the interior.

The art gallery is a place notable for a very different kind of insight and emotion, as typified by one of the two famous, if slightly unsettling, trip-tychs by Hieronymus Bosch, Philip II's favorite painter. The triptych of the *Haywain*, like the *Garden of Earthly Delights* now on display in the Prado, Madrid, is an allegory of human life. The left inside panel depicts the Garden of Eden and the story of Adam and Eve, the first humans, represent-ing every human life. The rebellious angels are falling from the heavens in the form of insects and sea crea-tures, representing all those who have turned from God. The central section of the painting is dominated by a great haywain drawn by strange beasts, from which humans are trying to steal as much as they possibly can. Some are falling beneath the wheels of the cart as they claw at the hay, and some of those lying on the floor have had their throats cut. The king, the aristocracy, and even the pope are also vying for hay, a young couple are being spied on by a cunning old man, the Devil is playing a flute, and only one angel is looking up to Jesus, who is observing all this sinful activity from a cloud. The results of all this greed and egotism are presented in the next panel, where the humans have descended into hell. The panel is predominantly dark red and orange, and demonic figures and other creatures are building a tower reminiscent of the massive Tower of Babel, erected in defiance of God. The heavens are burning and naked people are being led into the tower by frightening creatures, while others again are being attacked by the hounds of hell. This hell truly represents an absence of God, and anyone who examines the painting in detail will leave it a changed person.

As you walk out into the sun again and see the palace in all its

splendor, you may find you have acquired an insight that will be of use throughout your life.

Santa Maria la Blanca in Toledo

Toledo was once the capital of Spain. It is situated on a rocky hill and surrounded by the green waters of the Tagus, which have cut a deep gorge in the rocks here. The maze of streets is lined with palaces, churches, monasteries, and mosques attesting to the turbulent history of the city. As the light changes during the course of the day, the dominant color of the city changes from lemon yellow to a deep turquoise. There is any amount of evidence of Muslim, Jewish, and Christian occupation—Toledo has been a melting pot of cultures, all of which have left their traces.

The most important Jewish temple in the city was the Synagoge Ibn Shushan, built in the 12th-century Jewish Quarter and now the Church of Santa María la Blanca. The impression of space in this five-naved building, with its delicate Almohadic stucco-work of geometrical patterns and swirling arabesques, is still remarkable. The airy hall of 24 octagonal columns and wide horseshoe arches generates a feeling of both space and intimacy, and it is strange to think that such masterpieces of Almohadic art should be here in a former synagogue

that is now a Christian church, or in a chapel (El Cristo de la Luz) rather than a mosque. It is certainly a reminder of how closely Christian, Jewish, and Muslim cultures and scholarship used to interact—what was once fierce opposition turned into fruitful cooperation, a true sign of tolerance and a readiness to learn from one another.

Toledo Cathedral

After Alfonso VI of Castile had managed to seize power from the Moors in 1085, the oldest Visigoth church was restored to Christian use after some years' service as a mosque. Ferdinand III demolished this church and laid the foundation stone of a new structure in 1227. Several architects were involved and the resulting church, dedicated to the Virgin Mary, is not an entirely harmonious achievement, although it was based on Bourges Cathedral.

However, unlike Bourges, Toledo is wider than it is long, and is hemmed in on three sides by the buildings of the city, which gives it an oriental feel. Only the west façade is easily accessible, opening out onto an irregular square bordered by the bishop's palace, the town hall, and the cathedral itself. Two west towers were originally planned, but it was soon decided to build only the north tower to any height. A frieze of black-and-white marble and colored ceramic tiles ensure that this merges well with the rest of the building,

despite the gray granite of its construc-
tion. The noticeably shorter south tower
has a portal decorated with three scenes

The altarpiece in Toledo Cathedral

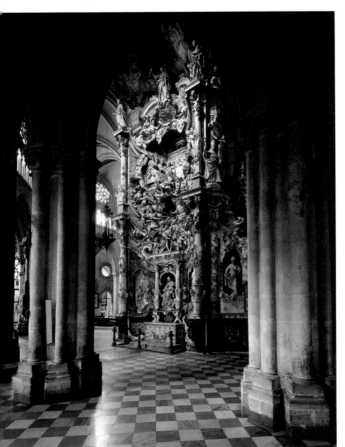

ambulatory, forming an impressive
frame for the building. One reason for
the construction of the new church
was clearly a desire to break away
from Arabic building traditions,
but these are still to be discerned in
the Moorish arches of
the narrow corridors
along the main nave.

The cathedral has pos-
sibly the most beautiful
high altar of the Spanish
Gothic period. The carved
altarpiece (1504) is unique
and depicts episodes
from the Life and Passion
of Christ—a lavishly
carved homily unrivaled
throughout the world. The
carvings almost touch the
vaulted ceilings and the
pillars either side. The
realsitic images engage
the observer like a mystery
play and the effect is only
reinforced by the inter-
play of light and shade.

El Cristo de la Luz, Toledo

of great significance to Christianity: hell
to the left, forgiveness in the middle,
and the Last Judgment to the right.
Like its predecessor, the cathe-
dral has five aisles and a double choir

Muslim and Christian
artifacts are to be found everywhere
in Toledo, and the checkered history
of the city lurks around every corner.
It is therefore no surprise that its
places of worship have been used by

each religion in turn. The old buildings were not razed to the ground—the existing shells were retained and merely adapted to the current belief, as in the case of the Church of El Cristo de la Luz, which was once the Bab-Mardum Mosque. An Arabic inscription dates the completion of the small, angular building to 999. The square structure is further subdivided into nine domed squares and the brick façade is adorned with arcades, which lend the otherwise massive building a certain lightness.

The mosque became a Christian church in the 12th century and the nave was extended with an apse, a typical feature of Christian churches.

Zaragoza Cathedral on the banks of the Ebro

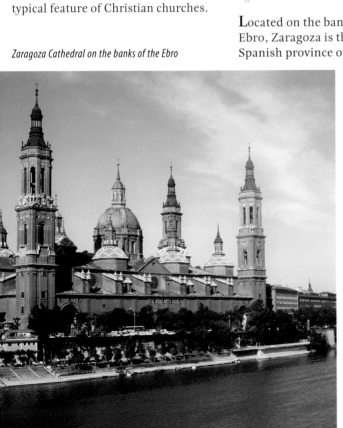

The interior is still redolent of the church's Muslim past, although a walled-up statue of Christ has also been found—presumably in an attempt to keep it safe from looters. This unassuming church is a reminder that sacred places retain their importance even though the beliefs of those who worship there may change.

La Seo Cathedral, Zaragoza

Located on the banks of the River Ebro, Zaragoza is the capital of the Spanish province of the Autonomous Region of Aragon and sits directly on the road that led east from Spain to the Holy Land. The apostle James, who led a mission to Spain, had a vision of the Virgin Mary here as he returned to Jerusalem in sadness at the failure of his proselytizing. Appearing on an ancient column, Mary encouraged the apostle to stay in Spain and announced

that miracles would happen to those who turned to her in their hour of need. There would also never be a lack of the faithful in the city, or so a 13th-century text suggests. The Cathedral of the Virgen del Pilar now stands on the site of this vision.

A Romanesque church was first built here, but this was destroyed by fire in 1434. Begun in 1681, the subsequent baroque cathedral is a massive structure framed by four corner towers, with ten smaller cupolas and one huge central dome. Inside, a chapel is set aside for the original pillar on which Mary once stood. It is covered with the Virgin's robe, so it appears that she is standing on a plinth.

The *Libro de milagros atribuidos a la Virgen del Pilar*, the register of miracles, has been faithfully kept

The apse and transept of Santa Maria de Ripoll

up to date since 1438. Pious pilgrims kneel before the pillar, kissing it in reverence, and over the centuries the stone has been worn away.

Santa María de Ripoll

Not much remains of the original structure, but the abbey church at Ripoll is one of the most important buildings of the Spanish Romanesque period. Count Wilfred the Hairy founded the Benedictine monastery in 879 and its scriptorium and library soon gained a reputation for the production and collection of valuable manuscripts—the library acquired important treatises on astronomy and geometry to complement the theological tracts. Santa María de Ripoll was the intellectual and spiritual center of Catalonia for many years, until an earthquake in 1428 destroyed much of the abbey. It was rebuilt in a Gothic style, but was subsequently abandoned in the early 19th century.

The beautiful buildings slowly fell into decay, but in 1886 restoration work was begun to the

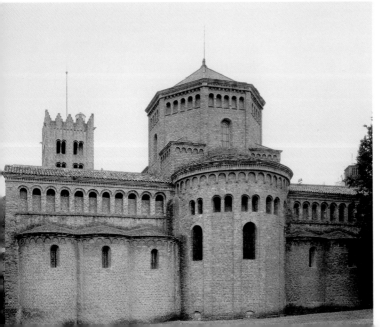

original plans, and this was completed in 1893. After returning from a trip to Rome in 1032, Oliba, the abbot of the day, had the church extended in imitation of the old St Peter's, and his impressive transept with its seven apses can be admired still today.

The church is accessed via a Roman portico and a "sermon in stone" adorns the tympanum of the entrance portal, which is reminiscent of a Roman triumphal arch—Christ, the Ruler of the World, sits surrounded by the four evangelists while countless mythological beasts, representing the deadly sins, frolic beneath him. Representations of each month of the year are incorporated into the whole.

Santa María de Ripoll was the first Romanesque building in Spain to lean more on its Roman influences than the Mozarabic, and it was to set the tone for many monasteries and churches across the country. The interior is extremely dark, as the windows are made of alabaster rather than glass, and the diffuse light creates an almost mystical atmosphere in the three-naved church.

The monastery's two-storey cloister is particularly beautiful and well balanced. The lower section was begun in 1180 and the upper dates back to the 15th or 16th century. The capitals of the rounded arches depict scenes from classical mythology and everyday life, contrasting the one with the other. Spend a few minutes walking or sitting in the peaceful cloister of Santa María de Ripoll and you may come to understand the meaning behind this juxtaposition of the fantastic and the mundane.

The rocky monastery at Montserrat

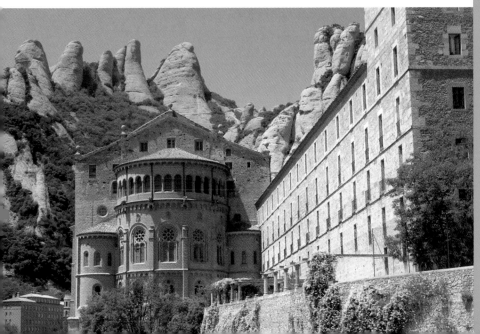

Montserrat Monastery

The 6-mile (10-km) massif of Montserrat is located not far from Barcelona in the middle of the Catalan plateau. Its appearance is anything but ordinary—weathering over the course of millennia has produced a series of spikes and promontories forming a serrated profile that prompted the Romans to name the massif *mons serratus*, the "sawn mountain." The rocks have long stimulated man's imagination, and each one has been named. The Monastery of Montserrat contains a sculpture in which angels are holding a mountain that has been cut with a saw. The area was settled in the Neolithic era and, with its many caves, was an ideal refuge for medieval hermits. Some documents record the presence of religious recluses here as early as 700. The monastery at Montserrat dates back to 900, although the original church, which had proved too small, was replaced with a Romanesque building in the 12th century.

Montserrat has been a major attraction for pilgrims since the 13th century, not least because it stands at the crossroads of routes to Rome and Santiago de Compostela. The replacement church was eventually superseded by the modern Renaissance structure, which was completed in 1592. The monastery was almost totally destroyed by Napoleon's troops in 1811, but in 1880 a long-lost icon of the Virgin, a black Romanesque sculpture with a gilt robe, was discovered in a nearby cave, and the Madonna of Montserrat was declared the patron saint of Catalonia. Benedictine monks returned here in 1952 and the monastery is once again a popular destination for pilgrims.

The most important feast day is celebrated on April 27, the day on which the icon of the Madonna was restored to its place in the pilgrimage chapel. A folk festival falls on the same day, but this is a place sacred to the cult of the Virgin Mary, as is made clear by a 1239 text: "Some have been commanded by heaven to go to Montserrat to see the Virgin who serves the people. Whosoever goes to this place, be he the greatest of sinners, shall always find mercy." Such a prospect is enough to entice people to climb the mountain to this day. Some make an annual or even more frequent pilgrimage.

Sagrada Familia, Barcelona

"My client is not in a hurry!"—or so Antoni Gaudí is said to have responded when the impossibility of finishing one of the most idiosyncratic ecclesiastical buildings of modern times was suggested. God is in no hurry to finish the buildings He has commissioned; a thousand years are to Him as a single day is to Man, and seen *sub specie aeternitatis*—in the aspect of eternity—the period from when work began on the Sagrada Familia in 1882 to the day

Antoni Gaudí's Sagrada Familia, Barcelona

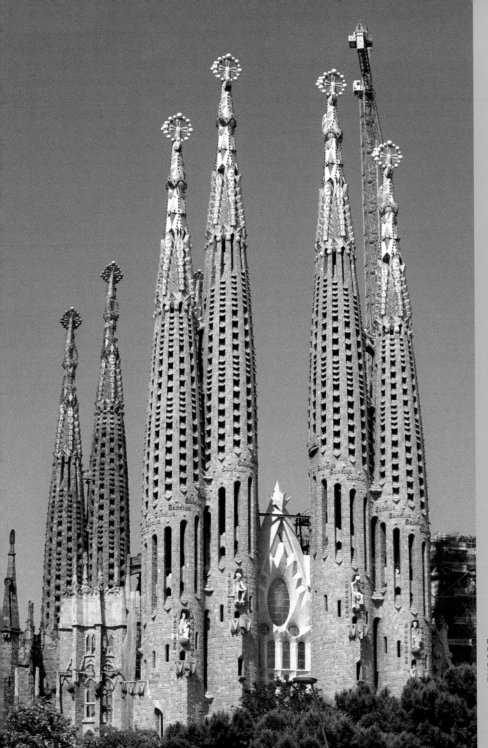

of its completion is but a moment, no matter when that day may be.

There is nothing on earth quite like the Sagrada Familia. Its original patron, José María Bocabella y Verdaguer, the owner of a religious bookstore, had visited Italy and been so impressed by its churches that he desired something similar for his home town. He initially commissioned the diocesan architect, who presented plans in the New Catalan Style (the Spanish equivalent of neo-Gothic, which was very popular at the time) and work was duly commenced. The two soon fell out, however, and Antoni Gaudí was hired to continue the work. The church has been under construction ever since.

Gaudí modified the plans in a Modernist style, and Modernist elements have been creeping in ever since. The current building is a cheerful mixture of various styles, but one which, it must be said, works perfectly. Soaring vaults, neo-Gothic reef-like formations, futuristic Primitivism, hints of art nouveau, roofs recalling Picasso's cubist period, façades so crazy they make the baroque features look restrained, chapels and spires that defy geometry—all this and more is to be found, half-finished, in this truly astounding building.

Gaudí labored for 43 years on his unique creation. He was a shy man, spending much of his time in the crypt, but he was confident in his own ideas and secure in the knowledge that the Almighty was his actual client.

To date, the church has two complete façades, the Birth façade to the east and the Passion façade to the west. The façade of Majesty, facing south, is intended to be the most magnificent of all, but work on this has not yet begun. The delay can be understood symbolically—the final majesty of God will be revealed only at the end of time. A single cloister surrounds almost the whole building, which in itself is a novelty—usually the innermost part of a holy place, the cloister has been turned out on itself.

The church is intended to have 18 towers: 12 for the apostles, four for the evangelists, and one each for the Virgin Mary and for Christ. This last, planned to tower over the crossing cupola, will be the highest church spire in the world. Eight of the 18 towers have been completed so far. With brightly painted tips, some are even linked by little bridges. Most of the pillars in the vast central nave are now in place and have been topped with a vaulted roof, enabling the church to be used for its intended purpose, the celebration of Mass.

This place has been sacred since the first stone was laid—imagination and creativity are united here in a way that is found in very few places on earth.

Barcelona Cathedral

Before the advent of the Sagrada Familia, the most splendid building in Barcelona was without doubt the Cathedral of Santa Eulàlia, dedicated to one of the martyrs of the early Christian Church who died in 305.

A great festival is held every February 12 to commemorate Eulàlia, Barcelona's patron saint, who lies buried under the main altar.

The cathedral is still the city's principal church, but is now used mainly for festivals and cultural events. Construction of this Gothic church began in the 11th century on the foundations of a basilica destroyed

A taula on the island of Minorca

in the sea battle at Lepanto (1571); people still pray at this cross for a miracle to occur in the present day.

One charming oddity is to be found in the cloister, where today a few geese are still kept—historically they were used as "watchdogs" to keep out thieves and intruders with their cackling and hissing. The presence of the geese might make it difficult to imagine this as a place of contemplation, but they are just as much a part of the "furniture" as the columns, the arcades, the small chapels, the palm trees, flowers, and the gently babbling fountains. Some people come just to see the geese—theirs is a refreshing and lively presence among all the religious solemnity that puts visitors leaving the cathedral in a cheerful mood and more able to get on with their daily lives.

The Taulas of Minorca

by the Moors, but the vast nave was not completed until 1448. The neo-Gothic façade was added in 1890. One of the 29 side chapels houses a miraculous crucifix said to have aided in the victory over the Turks

Taula literally means a "tablet" or a "table" and refers to enigmatic stone structures, found only on the island of Minorca, which consist of two or more megaliths forming a T-shape. At least 30 sites have been

recorded on Minorca and some of the structures are quite well preserved. The taulas were used in sacraments, and the table shape is strongly reminiscent of a sacrificial altar. Animal bones have been found in the vicinity of the stones, which would seem to indicate that they featured in some kind of ritual activity. In contrast with most other megalithic shrines in Europe, the taulas are almost always found within walled settlements.

Trépuco was a large village for the prehistoric period, covering an area of almost 2 square miles (5 sq km), and dates back to the so-called Talayotic period (13th to the 2nd century BC). The name is derived from thick-walled towers with central chambers called

talayots, which were initially used as watchtowers but also served as burial places in the late Talayotic period.

There is not much left of the village, but its remote location still seems to exert a fascination on visitors to this sacred place. The impressive shrine at **Trépuco** is the largest taula on the island. These relics from another culture have not yet given up their secrets. The people who come to see them bring with them their own hopes and desires, yet these prehistoric relics seem to address our hearts directly, even though we know little of the religion they once served.

There is another site on the island that contains similar structures. Talayots and taulas are also to be found in a

The Cathedral of La Seu, Palma de Mallorca

walled compound at the complex of **Torralba d'en Salord**. Visitors here are gripped by a similar sense of the unknown.

La Seu Cathedral, Palma, Majorca

The Balearic Islands fell to the conquering Moors very early and were not taken back by the Spanish until 1229. James I's fleet was scattered by bad weather, reaching the island of Majorca in tatters, and Palma, the capital, fell only after a four-month siege. Work began on the cathedral immediately, supposedly in fulfill-ment of a vow the king had made at the height of the storm. The foundation stone was laid in 1230 on the site of a recently demolished mosque. The Capilla Mayor (main chapel) was completed in 1264, but work on the main nave dragged on throughout the 14th and 15th centuries. The cathedral now stands on its rocky outcrop, presenting its broad south side to the city and dominating the bay. The best view of the exterior, silhouetted starkly against wispy clouds in a bright blue sky, is to be had from a boat. The vast main nave of the cathedral has an incredible power and simplicity, with its unadorned buttresses topped with floral pinnacles. Situated on the harbor front, viewed from the side the cathedral façade resembles a palisade.

In the middle of this fortified façade is the 14th-century Mirador portal, with its many sculptures. Visitors entering through this doorway are greeted by the breathtaking sight of the huge rectangular interior. Only 14 plain, octagonal pillars interrupt the space, and there is a large rose window in the east-facing chancel whose tracery reveals unmistakable Arabic influences. The abstract stained-glass motifs flood the church in a riot of color throughout the morning.

The architectural style of the cathedral is uneven—it was begun as a Catalan Gothic structure, but the Renaissance and Mannerist styles influenced the work in the 15th and 16th centuries. Several of the side chapels display baroque elements, and others again are strongly classical. The work of Antoni Gaudí ensured that Modernismo, the Spanish version of art nouveau, is also present in the building, and one of the side chapels is being restored by 21st century Majorcan artist Miquel Barceló.

However, the cathedral is much more than a hodgepodge of styles— the effect of the space and light in this sacred place is overwhelming.

Lluc Sanctuary, Majorca

This must have been a desolate and lonely place at one time, but the thousands of pilgrims and tourists who now come here every day ensure that little is left of any peace

SPAIN

or remoteness. Until the mid-20th century, however, Lluc was still a place of religious devotion and quiet contemplation and only accessible on foot. The Santuari de Lluc is situated at an elevation of 16,000 feet (5,000 m) in a closed valley in the northwest of the island, surrounded by the steep Tramuntana Mountains.

The monastery's history can be traced back to the 13th century, although the first few centuries of its existence saw the complex destroyed and rebuilt several times. The present building dates back to extensive alterations undertaken in the 17th and 18th centuries. There is a boys' boarding school along with stores and restaurants, and the old monks' cells are now slept in by visitors from all over the world.

All the comings and goings cannot hide the fact that this place has been considered sacred for hundreds of years, and a little of this devotion can still be felt when visiting the simple abbey church with its *La Moreneta* shrine—a statue of the Black Madonna, supposedly found by a shepherd boy. The Madonna attracts a stream of pilgrims from Majorca and further afield. The foundation stone of the abbey church was laid in the 17th century but its modern form dates back only to the 20th century. Nevertheless, the mystical power of the Madonna can still be felt in this young church.

A path leads from the church to a nearby Calvary. It is worth paying a visit if you wish to escape the hordes of visitors and experience something more

profound, following the example of the few monks who still run the monastery.

The Mezquita, Córdoba

Although no one knows for certain, it is thought to have been Charles V who said: "I didn't know what was happening here, for had I known, I would not have allowed the old building to be touched. It is possible that you have destroyed something that was unique in the world to build something that can be found anywhere." The speaker was referring to the building of a Christian church in the mosque at Córdoba.

Despite this harsh assessment, the Mezquita at Córdoba is without doubt one of the finest and most remarkable structures in the city. Emir Abd ar-Rahman I commissioned the building in 785 after he had made Córdoba the capital of his empire. San Vicente, a Christian church, had once stood on the site, and before that a Roman temple— traces of the foundations of both structures have been uncovered during archeological excavations.

The banks of the Guadalquivir now boast a building that is larger and more magnificent than either of these. It is divided into a rectangular prayer hall with a mosque courtyard in front of it. The first building was altered and extended considerably during the reign of the intellectual Kalifen

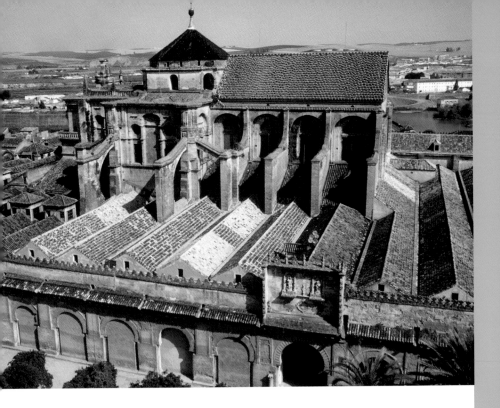

The Mezquita, Córdoba

al-Hakam II (961–76), and the vast prayer hall now consists of 19 naves, each with its own ceiling vaults, running parallel to the qibla wall.

The octagonal structure with a pointed baldachin surrounding the mihrab, the mosque's prayer niche, is clearly recognizable, and the forest of columns in the prayer hall is breathtakingly beautiful and serene. The multicolored horseshoe-shaped arches rest on 856 columns, most of which date back to Roman antiquity, offering ever-shifting perspectives. The soft light falling from the window apertures and the alternation of the columns and arches together evoke a mystical atmosphere, adding to the charm of the room.

The mosque courtyard is unusually large, designed to accommodate the overflow of the faithful from the main prayer hall, and is planted with orange trees, giving it its present name, the Patio de los Naranjas (Patio of Oranges). The old minaret, which is now used as a bell tower, is clearly visible from the courtyard.

The mosque area fell into the hands of the diocese of Córdoba after the island was retaken during the Reconquista, and the decision was taken to build a church right in the middle.

Work was begun in 1523 to make room for the new Christian cathedral, which involved the demolition of 63 columns. The basilica was laid out in the form of a Latin cross and took three centuries to complete.

The drastic plan to build a church in the middle of a mosque attracted protests from the very beginning, and the resulting ensemble is an unintentional reminder of how close to one another the two religions really lie, and how essential mutual respect and understanding will always be.

Seville Cathedral

The chapter authorities of Seville took the momentous decision in July 1401 to rebuild the Great Mosque, which had

The courtyard of Seville Cathedral

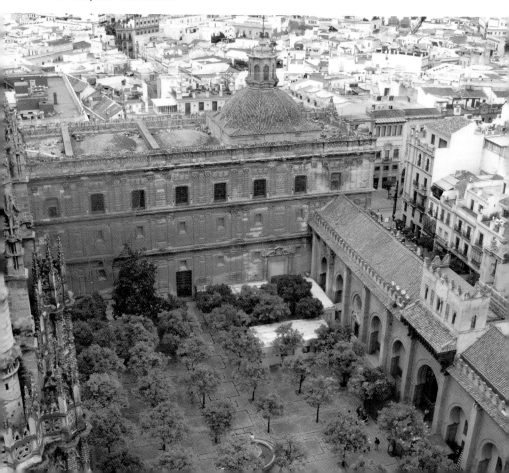

served as a cathedral since 1248. On the one hand, the Almohadic mosque, which had been built in 1172, was showing distinct signs of dilapidation, while on the other there was a desire for a concrete expression of the flourishing town's religious zeal. The chapter resolved to build "such a beautiful church that no other should equal it, and of such a kind that all those who see it should think us mad!" The late Gothic cathedral, which represents a superb harmonization of Arabic and Christian architectural traditions, did indeed astonish upon its completion in 1519, as it still does today.

The Cathedral of Santa María de la Sede de Sevilla is the largest Gothic church ever built, and it is still the third-biggest church in the world. The rectangular floor plan of the mosque has been retained, but the interior of the cathedral gives an impression of space that seems to extend as far as the horizon and beyond. The richly decorated medieval chapels and monuments were supplemented by the tomb of a modern "saint" in the early 20th century—but this was no religious saint.

The tomb of Christopher Columbus is a pilgrimage site of a very different kind, and people come here to honor the memory of the great explorer, an example to all those on a similarly uncertain journey—the journey of life.

The most impressive parts of the building date back to the Almohadic period (1147–1269)—the 250-foot (76-m) Giralda Tower (from the Spanish *girar*, to turn), the former minaret, has not only survived more

or less unscathed, but has become a symbol of this city on the banks of the Guadalquivir. The square tower with its delicate diamond patterning and elegant, balconied double windows is an exquisite example of Arabic architecture. The tower has been topped with a baroque dome, a 13-foot (4-m) statue of the Virgin Mary, and a wind vane.

On the site of the old mosque courtyard, the Patio de Naranjas, an orange grove, is more beautiful still. It contains an ancient fountain, used by the Muslims for ritual washing, and the orange trees with their delicate fragrance are still to be found here. The scent of the oranges and the gentle sound of the fountain make the courtyard—reminiscent of a cloister—an oasis of peace and a place to which to retire to calm the agitated mind.

Nuestra Señora del Rocío, Almonte

It was the dogs that alerted him. Gregorio Medina, as he is traditionally known, was hunting near Almonte, a town in La Rocina, when his dogs ran into some impenetrable undergrowth. They continued to bark until Medina forced his way through the foliage, to discover a dead tree stump and upon it a statue of the Madonna in a white and green linen robe. He freed the statue from the thorns with the intention of taking it to Almonte.

On the way there Medina collapsed in exhaustion, and when he awoke the Madonna was gone. He returned to where he had found the statue to discover it was back in its accustomed place. Priests who examined the site concluded that Mary wished to be worshiped on that very spot and a small pilgrimage chapel was duly erected. The statue was taken to a parish church in Almonte. The modern icon shows the Virgin dressed in green, as is her child.

The 15th-century chapel was altered and extended several times, before finally being destroyed during the devastating Lisbon earthquake of 1755. The modern pilgrimage church, where the Madonna has been kept since 1969, is a 20th-century replacement. Reports of fraternities whose sole purpose it was to undertake the *Romería*—the pilgrimage to the Madonna del Rocío—date back to the 16th century. It is one of the greatest religious festivals in Spain.

Traveling to El Rocío to worship the Virgin and present prayers of intercession, particularly for protection from famine and disease, was an expression of piety and perhaps

The pilgrimage to the Madonna del Rocío

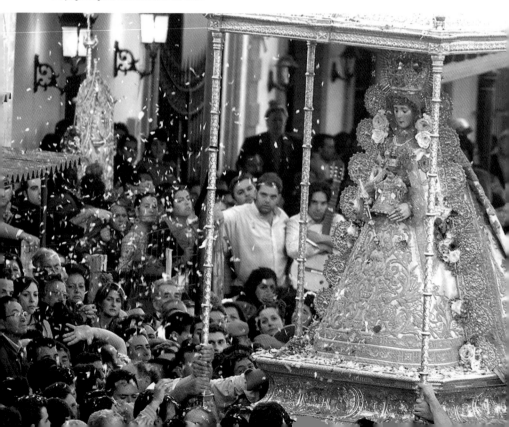

not unwise in an area of Spain where such afflictions were common. More than a million participants from 99 fraternities now undertake the annual pilgrimage. Shouting *"evviva"* ("long may she live!"), the watching crowds scatter flower petals as the icon is carried through the streets during the procession, and the mood of the people slowly rises to fever pitch.

Such heartfelt adoration is perhaps not fully understood by every observer, but it is eloquent testimony to how people can be moved by presenting their concerns to the Mother of God and allowing her to speak for them.

Granada Cathedral

In most cities cathedrals automatically attract attention, wherever they are located. However, in Granada the cathedral is not the most famous building. Here, it is the Alhambra that draws the crowds, indisputably one of the most glorious palace complexes ever built, though a detour to Granada's main church is still worthwhile.

Ferdinand and Isabella, who ruled over the newly united Spain, commissioned the building as soon as the country had been reconquered in 1492. The cathedral was to be built on the foundations of the old central mosque to symbolize the victory of Christian belief over Islam. Some years passed before the work began, however, and although the

Gothic cathedral at Toledo had been chosen as the basis for the design, Diego de Siloé, the master mason who took over the supervision of the project in 1529, adopted a Spanish Renaissance style for his work.

The cathedral's five aisles are separated by rows of imposing columns, and sunlight floods in through the stained glass of the clerestory in vividly contrasting colors. The baroque façade was added in 1667 in the form of a huge triumphal arch. The interior features a circular main chapel whose 12 Corinthian columns reach up to heaven.

The Capilla Real, the royal chapel, retrospectively incorporated into the body of the main church between 1501 and 1521, contains the tombs of Ferdinand and Isabella, although those of Joanna the Mad and Philip the Fair, the parents of Holy Roman Emperor Charles V, are more famous. That the secular rulers of worldly kingdoms are revered as much as saints may surprise some people, but visitors to the cathedral at Granada may see how tombs can serve to bring the dead closer to the living. In their effigies reclining on beds of marble, those who have departed this earth somehow still seem to be present, breathing in the cool air. Tombs help people to overcome their grief—something that is as true of every cemetery as it is of this side chapel in Granada Cathedral.

Braga

There is a Portuguese proverb that suggests you go to "Lisbon to live, Coimbra to study, Porto to work, and Braga to pray." Modern-day Braga is a small town but it is still the hub of Catholic Portugal, a fact of great significance to the population. Braga used to be known as the "Rome of Portugal," perhaps a slight exaggeration,

The steps leading up to the pilgrimage church of Bom Jesús do Monte

but it has been the religious center of the country since the 12th century.

The Sé de Braga Cathedral is just one of more than 30 places of worship within the modest city limits of Braga, many of high architectural and artistic quality. Braga is noted for its extensive Easter Week celebrations, and hundreds of thousands of travelers visit the pilgrimage church of **Bom Jesús do Monte**, where visitors are greeted by the sight of beautifully laid-out, well-tended flower beds. The classical-baroque pilgrimage church of Monte Espinho is at the top of a double set of steps that climb to a height of 1,800 feet (560 m). The route is lined with brightly painted, life-size statues depicting the Stations of the Cross. The rather kitsch *tableaux vivants* are perhaps not to everyone's taste, but many of the pilgrims really appreciate the figures and lay little notes with petitions at their feet. There is a fountain on each terrace representing one of the five human senses. A surprise awaits those who make it to the top—around the church are stalls selling human limbs and body parts made of wax. They are for the pilgrims to buy and take into the church where they will be piled onto the altar by the

faithful in the hope of achieving relief from physical pain. There is an even greater number of notes and slips with requests in the "Chapel of Miracles" and in the many niches around the church, recording the pilgrims' hopes for divine assistance. Many have a passport photo attached, presumably to prevent confusion over identity.

There is another famous and popular place in Braga, very similar to the pilgrimage church of Bom Jesús—the **Santuário da Nossa Senhora do Sameiro**, located at an elevation of 2,000 feet (600 m) on the hills of Sameiro. This modern pilgrimage route, built in 1863, is marked with a stone cross. The adoration of the Virgin that takes place here is in slightly less crowded conditions but just as devout.

Lamego

The city of Lamego, one of the oldest dioceses in Portugal, is huddled around a medieval fortress in a fertile landscape of rolling hills and deep valleys intersected by streams flowing down to the Douro. The city is principally famous for its grapes, which are used to make port.

The cathedral was originally Romanesque but has long since been subjected to Manueline (Portuguese late Gothic) alterations. There are six other smaller churches and chapels, some of which are very beautifully decorated with Azulejo tiles. The

Santuário da Nossa Senhora dos Remédios is extremely popular with pilgrims. Hundreds of thousands of people come here every September 8, the birthday of St Mary, to enlist her help and support in dealing with all manner of complaints and illnesses. The shrine is on the site of an old hermitage, and the first chapel here, dedicated to St Stephen, was built by Bishop Durando in 1361. This was demolished in 1564 and rebuilt, and the stream of pilgrims seeking healing has not abated since.

The much larger modern church dates back to the mid-18th century. Construction of the baroque flights of steps began in the 19th century but was not completed until 1960. The 686 steps leading up to the octagonal terrace take visitors past the Stations of the Cross, biblical statues, and fountains, where pilgrims have ample time to stop and pray in preparation for worship of the Virgin Mary in the granite, single-aisled church at the top.

Coimbra

Coimbra has long been well known for its university (founded in 1290 in Lisbon before moving to Coimbra in 1537), which—along with Bologna, Paris, Salamanca, and Oxford—is one of the five oldest in Europe and still has an influential role today. The city's location on a hill high above the Mondego has earned it the nickname "The Beautiful." It is a mix

of rural and urban elements, with many historic buildings, representing an extremely pleasant combination of the traditional and the vibrant. Coimbra was the national capital between 1139 and 1256, and six Portuguese kings were born here.

The route up to the city passes **Sé Velha**, the old cathedral, which was built between 1162 and 1184. It looks more like a castle than a cathedral and is more impressive than Sé Nova, the new cathedral, whose sandstone façade overlooks a rather unassuming square. The Sé Velha is the largest Romanesque building in Portugal. Its simple exterior belies the extensive ornamentation that awaits visitors inside: a late Gothic main altar, a striking Renaissance font, and 380 Romanesque pillar capitals combine to create a very special atmosphere. The capitals are decorated with mythical animals and floral and human motifs. The handsome early Gothic cloister is usually full of visitors, but it is still possible to get a sense of tranquility amid the bustle.

Perhaps the most arresting sacred place is the picturesque abbey church of **Santa Clara-a-Velha**, built in 1286 but now a ruin, located on the often-flooded banks of the Rio Mondego. The upper Gothic arches are still accessible, although the church began to subside in the 14th century and all attempts to prevent it from flooding were in vain. Balancing on the still exposed parts of the building and peering down through the water to the floor is a spiritual experience of a very special kind. In the 17th century the partailly submerged church was replaced with a new one, Santa Clara-a-Nova, from which there are wonderful views of the city. However, the old sunken church is much more mysterious and one of the better places on earth for contemplating the depths hidden beneath the surface.

Fátima

Fátima is one of the most famous and well-attended pilgrimage sites in Europe. The focus of the town's adoration is the Virgin Mary, and reciting the rosary for her Immaculate Heart is accorded great significance here. Fátima is a relatively new sacred place, and commemorates the six visions of the Virgin Mary that occurred here in 1917 and the three preparatory visits by an angel in 1916. The angel and the Virgin appeared to three children between the ages of seven and ten, and each was affected in a different way. Francisco had visions, but heard nothing; Jacinta had visions, but did not converse with either the Virgin or the angel; Lucía spoke to both. In 1930 the Catholic Church declared the children's visions authentic, dedicating all Portugal to the "Immaculate Heart of Mary," and a stream of pilgrims has been traveling here ever since. Hundreds and thousands come to Fátima, on their own behalf and to ask for help for relatives.

The large pilgrimage church is similar in structure to that of Lourdes.

The tall central spire can be seen from afar, pointing toward heaven like a raised finger, and the colonnades seem to welcome people with open arms. The pilgrims' path begins at the entrance beside a statue of Mary wearing a crown as Queen of Heaven. Visitors enter the holy precinct and assemble in front of a large iron cross, before following the Pista dos Penitentes ("the path of the penitents")—many do this on their knees—to the Capelinha ("the little chapel"). In the pilgrimage church, the path leads on to the tombs of the three children. The faithful complete their pilgrimage either in fulfillment of a personal vow or in thanks for a received blessing.

The pilgrimage to Fátima is for people of all kinds—many of the pilgrims are from Portugal, but the faithful also come from overseas to seek help, support, and comfort.

Convento da Ordem do Cristo, Tomar

The Knights Templar played a not insignificant part in Portugal's history, especially in the expulsion of the Moors from the country. Their

Hordes of pilgrims in front of the church at Fátima

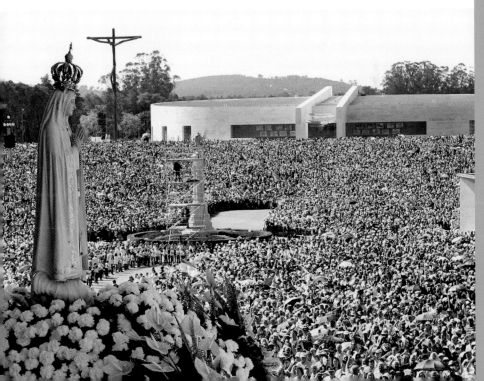

assistance was rewarded with gifts of land and political privileges. One such reward was the castle at Tomar, gifted by Afonso Henriques in 1156. This castle soon fell into ruin, and in 1160 construction of the Convento do Cristo and a new castle was begun on a more strategic site. After the Templar Order was outlawed by Pope Clement V in 1305, its former members joined King Dinis in founding the "Order of the Knights of Christ," which was placed under regal, rather than papal, supervision. Work on the structure and its various extensions was to last into the 17th century, and although only impressive ruins have survived of the castle, the monastery church (known as "Charola") and some of the cloisters are still to be seen.

The monastery of Santa Maria da Vitória, Batalha

The church was originally a 16-sided central-plan Romanesque building with a free-standing octagonal interior based on the Holy Tomb in Jerusalem. Henry the Navigator oversaw the construction of a longitudinal Gothic nave in the 15th century, turning the original Romanesque church into the apse. The interior of both sections of the church is richly decorated with statuary and murals, which display features typically associated with Gothic and Manueline art— imaginative and detailed execution, corals and scallops, and floral patterns and motifs. The church is accessed through one of the side doors, which is decorated with a depiction of the Virgin and Child, flanked on both sides by Old Testament prophets.

The seven cloisters were laid out over the course of the 15th and 16th centuries, with some being built on two storeys. The curving flight of steps leading up to the top storey of King João III's cloister is particularly beautiful, and from the cloister there is an impressive view of the church and monastery.

Mosteiro da Batalha

The name of the town, Batalha, means "battle," so consequently the monastery's name seems rather warlike too. In full, the monastery is called Mosteiro da Santa Maria da

Vitória, the Monastery of St Mary of Victory. The building does indeed have a less than peaceful history.

King Fernando died in 1383 without nominating a successor. His widow Leonor, who had had a Spanish lover even while Fernando was still alive, married their daughter Beatrice off to Juan I of Castile. Fernando's step-brother, João, who had designs on the throne himself, stabbed Leonor's lover and, with the support of his friend General Nuno Alvares Pereira, and the English Duke of Lancaster, began preparations to fend off an attack by Castilian troops. Although outnumbered, they dug countless holes in the fields to trip up the advancing Spanish cavalry so that João's forces could then easily overpower them. Before the battle commenced, João swore to found a monastery should his troops be victorious.

Although work was begun immediately, the building took 150 years to complete. A French Gothic church and monastery were built between 1388 and 1434. The clear influences of English Gothic, which are unmistakable in the building, are less surprising when one considers that João's wife was from England.

The many statues of the apostles and other saints over the west portal are particularly impressive. The three-naved interior is strictly divided. The left aisle leads into the Royal Cloister, enclosed by wonderful Gothic arched colonnades with Manueline decoration, delicately carved from the stone, which lend the cloister a noble air.

The so-called Capelas Imperfeitas, the "unfinished chapel," is located south of the church. Seven chapels are arranged around an octagonal floor plan based on the Holy Sepulchre, and in place of the eighth there is a large and ornate Manueline portal. The effect is probably unintentional, but the unfinished chapel is a pointed reminder that all endeavors have their limits.

Alcobaça Monastery

As you approach this sacred place, you would not think it was a Cistercian monastery—their monastic rule prescribes simplicity in all things, and the façade of Alcobaça Monastery is anything but uncluttered. Its baroque origins may go some way to explaining this, however, and visitors entering the vast extended nave are immediately struck by the solemnity and simple elegance of the building, the largest Cistercian monastery in Europe. Apart from the sheer size, what is immediately apparent is the sense of balanced space inside the building, regulated by the closely spaced columns. The church is devoid of ornamentation and the tone of the building is set by its strict proportions and exacting asceticism.

The monastery's architecture is an excellent expression of a way of life devoted to the Almighty, and the building's great size seems in no way

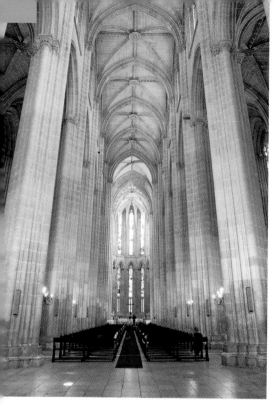

The main aisle of the monastery church at Alcobaça

overly ostentatious. Thought and devotion can be transformed into stone, as this building so clearly illustrates. The monastery was founded in 1153 at the behest of Afonso Henriques I and occupied by monks from Clairvaux. Construction was begun in 1178, but continuing Almohadic incursions delayed the work with the result that the monastery was not completed and consecrated until 1252. The foundation proved popular, attracting monks from Burgundy in particular, and was regularly extended. In its heyday, the monastery was said to house 999 monks. Although this is no longer the case, its great past still resonates today.

Alcobaça Monastery is a popular place of pilgrimage for those who believe in a love that outlasts death. The tombs of Pedro I and his lover Inês de Castro are to be found in the transept, reminders of one of the most tragic love stories in Portuguese history. Pedro, the son of King Alfonso IV, was forced to marry Constanza of Castile for political reasons, although he was in love with one of her courtiers, Inês de Castro. After the death of his wife, Pedro lived with Inês in Coimbra, but his father disapproved of the liaison and had her killed. After his father too had died, Pedro wrought terrible revenge on the murderers, tearing their still-beating hearts from their bodies. Pedro and Inês' richly decorated sarcophagi are arranged so that the lovers will see one another first when they awaken on Judgment Day.

It is a moving tale that speaks to every generation. Whether pilgrims are drawn to this sacred place because of it or for some other reason, it will always touch the heart. The plaques on each sarcophagus read *Até ao Fim do Mundo* ("till the end of the world"), and love can indeed last that long.

Igreja do Carmo, Lisbon

"The great, irregular mass of brightly painted houses that make up Lisbon is spread across seven hills, each

providing a vantage point and the most wonderful panorama. Visitors who arrive by boat see Lisbon from a distance rising up like a vision, sharply silhouetted against a brilliant blue sky lit by the golden sun. The domes, monuments, and the old castle tower over the houses, advance messengers of this charming locality, this blessed region." This was how Fernando Pessoa eulogized "his" Lisbon and modern visitors will be no less enthused by this beautiful city.

Lisbon has a wealth of famous churches and buildings, all of which are rich in history and associated tales. One of the churches, the Igreja do Carmo in the suburb of Chiado, is a special place of art and culture, and also of meditation. The Gothic church was built in the late 14th century but suffered damage in the catastrophic earthquake of 1755. Plans to renovate it in the 19th century fortunately came to nothing, and the impressive ruin still stands proudly on its steep hill, a reminder to locals and visitors alike of the destruction caused by that devastating earthquake.

The Igreja do Carmo, Lisbon

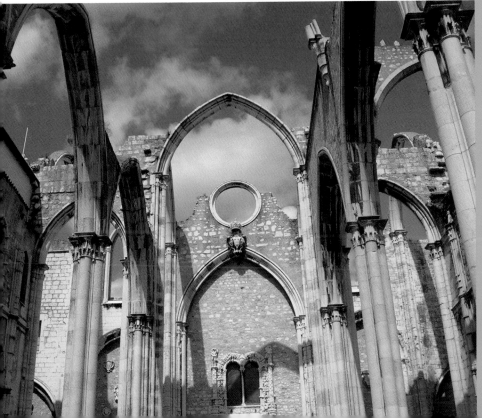

The ruined church has become a sacred place whose special atmosphere emanates from the interplay between man-made architecture and nature—sunlight, clouds, light, and weather. Standing amid the slender columns, buttresses, and walls, visitors can look up into the often brilliant blue of the sky and be transfixed by a strange mood in which mortality and eternity seem to merge together. The Igreja do Carmo has retained its serenity, perhaps for the very reason that it has remained a ruin, and is a place of contemplation amid the bustling, historic city. Concerts are often held in the ruins, only adding to the mystery of the place as the sound of music rises to the heavens and the audience listens entranced beside the old walls beneath the night sky.

Hieronymites Monastery, Lisbon

✠

St Jerome was a young man given to earthly pleasures, who frequently succumbed to his passions, particularly carnal desire. That dissipation did not overtake him entirely is thanks only to perseverance and a thirst for knowledge. After a dream in which he converted to Christianity, he went out into the Syrian desert to devote himself to mastering the passions that were torturing him. He collected a retinue of pious women, some of whom were also later canonized, before moving to Bethlehem to found a monastery and three convents.

Many years later (around 1415), and many miles away, Henry the Navigator—who, incidentally, never undertook a sea voyage—founded a small chapel at Lisbon on the banks of the Tagus. Here Portuguese explorers spent a last night on their knees in prayer before embarking on their journeys into the unknown. In the early 16th century, after one of the explorers, Vasco da Gama, had successfully returned from his first voyage to India, King Manuel I built a huge complex of buildings to replace the little chapel. The architectural detailing and sculptures of the ornate baroque style captured the spirit of the New

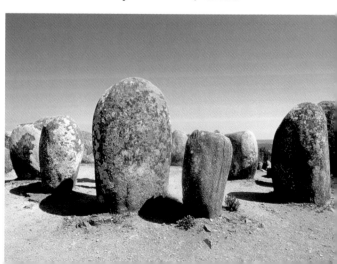

Megalithic stone circle, Almendras

World that the explorers had experienced and brought home with them.

Until 1834, the complex was inhabited by the order named after St Jerome. By that time it comprised the Church of St Mary (Igreja de Santa Maria), the cloister and its chapterhouse, the sacristy, the refectory, and an extensive west wing. The monastery survived the devastating earthquake of 1755 relatively undamaged, but large parts of the site were destroyed under Napoleon Bonaparte.

The building has since been restored to its former glory. The ornate south portal is decorated with a series of scenes from the life of St Jerome, after whom the monastery is named. Next to the row of royal tombs are the resting places of two Portuguese "national treasures"—Vasco da Gama and, directly opposite, Luís de Camões—which are no less sacred for many Portuguese. For those to whom literature is holy, the unassuming, modern tomb of the poet Fernando Pessoa is to be found in the corridor.

Almendras Stone Circle

Southern Europe has mysterious arrangements of megalithic circles similar to those found in the United Kingdom and northern France. The largest of these stone circles is located in Almendras in southern Portugal. This sacred place has been dated to some time between 3500 and 1500 BC—the uncertainty about its age is matched, perhaps appropriately, by that regarding its purpose. It is assumed that most stone circles were used for astronomical observations and calculations—many are composed of 19 stones, reflecting the 19-year cycle followed by the moon across the horizon until it returns to its starting point.

The standing stones at Almendras are thus unusual in that there are more than 90 megaliths. Such a great number might be explained by the fact that the sky is clearer in the south; more heavenly bodies are thus visible, and the people may have been able to orient themselves using numerous stars, rather than just the sun and the moon. A more exact calendar could conceivably have been established in this way. Whether, and in what way, the stone circle at Almendras may have been used in pagan rites is unknown.

The exact function of the stone circles in Europe has been forgotten over the centuries, but they still stand proudly on their impressive original sites. It is therefore no surprise that they are considered sacred places, even though so little is known of their intended design. The enigmatic stones have kept their secrets, stimulating the imaginations of everyone who visits them.

Sant'Orso, Aosta

Aosta has been called the "Rome of the Alps," and with some reason; this old garrison town has managed to preserve its Roman layout through the Middle Ages to the present day. A triumphal arch dedicated to Augustus is located beside the southern city gate, and large sections of the city wall and a theater dating back to Aosta's earliest history

Church and cloister of the Monastery of Sant'Orso, Aosta

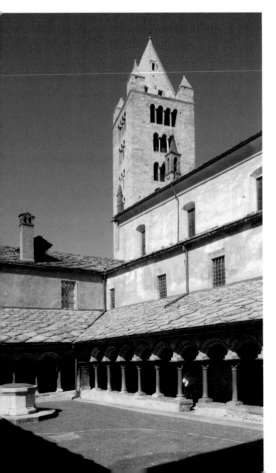

have also survived. The Monastery of Sant'Orso with its wonderful Romanesque cloister, built between 994 and 1025, is situated outside the walls in the old artisans' quarter. The cloister was so well known in its day that it was praised as one of the architectural wonders of the world. This is a little overstated and may be attributable to civic price, but it is without doubt a beautifully proportioned Romanesque work of art, which exudes a sense of tranquility and reflection.

The monastery is named after St Ursus (Italian: Orso), born in Ireland in the mid-5th century, who must therefore have been one of the first Irish Christians. At the time it was common for followers of the Christian faith to undertake a pilgrimage to its holy places. This meant martyrdom for many, as leaving one's homeland brought no guarantee of returning alive. Orso was undaunted by the prospect of potential martyrdom, traveling first to Burgundy and then on to Aosta, where he became archdeacon to the bishop.

A church and a hospice for Irish pilgrims following the Via Francigena was built. The archdeacon went about his business in peace for several years, until darker days came for the young religion of Christianty. A theological schism split the world, the dispute over the Arian heresy, which had political as well as theological ramifications. Arius, an Alexandrine presbyter, had advanced the opinion that Christ, as a creation of the one God, was thus subordinate to Him and therefore not divine. The Trinitarians, however, opposed Arius

and his followers, proposing the unity of Father, Son, and Holy Spirit in one Godhead. The latter view was to prevail, but the struggle was long and bitter. In 528 in Aosta, an Arian bishop was elected and this started what amounted to a war between the Arian town and the Trinitarian artisans' suburb. Provisions were soon in short supply and Orso organized self-help groups, instructing the people in the art of bartering and giving rise to the Fiera di Sant'Orso trade fair, still held today.

Modern pilgrims have learnt to appreciate both the bustling crowds at the Fiera di Sant'Orso and the remoteness of the monastery and its calming cloister; the outside world and the inner world coexist peacefully. The monastery at Aosta is a gentle reminder of how the external and internal are intrinsically connected and complement each other.

Sacra di San Michele

Sacra di San Michele is a world-famous monastery located 3,300 feet (1,000 m) above sea level on the summit of Mount Pirchiriano at the end of the Susa Valley in Piedmont. The view down onto the Turin plain gives an idea of the dramatic height of the mountain and the elevation of the monastery.

The small town of Chiusa di San Michele at the foot of the mountain was conquered by Charlemagne before he marched on the Turin plain in 773 and 774. The monastery, known to the people of Turin simply as La Sacra, is one of the most famous Benedictine foundations and one of the finest examples of Romanesque architecture in Europe.

The monastery of Sacra di San Michele, Turin

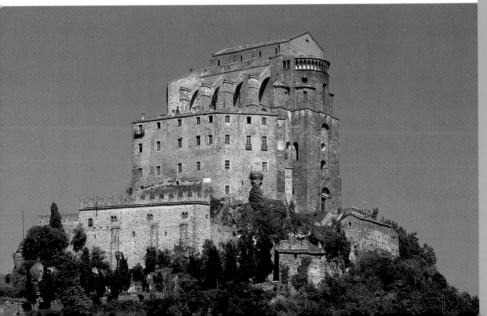

After an arduous climb of 243 steps, visitors reach the monastery complex and are rewarded with a breathtaking, 360-degree panorama of the local mountain peaks. The monastery's solid, almost fortified appearance—with its foundations and steps leading to three chapels and the Church of St Michael seemingly growing out of the rock—leaves a lasting impression.

There was a small oratory on the cliff as early as the 7th or 8th century, before Duke Hugo of Montboissier arrived in 999 and built the monastery and a hostel for pilgrims. The complex is dedicated to the archangel Michael, the guardian of heights and depths. Like other churches and monasteries dedicated to Michael, this one has been built on a site that conceals hidden dangers—the climb to these heavenly heights is steep, and the fall long.

La Sacra's heyday came in the 11th and 12th centuries, as it lies at the convergence of three medieval pilgrims' paths: the Via Francigena from Canterbury to Rome, the Way of St James to Santiago de Compostela, and the Way of St Michael from Mont Saint-Michel in Brittany to Monte Sant'Angelo in Apulia. Pilgrims from across the world are still welcomed here, and are invited to accept the hospitality of the monks and discover a very special spiritual center.

The Sacra di San Michele gained worldwide fame in the 20th century through Umberto Eco's novel *The Name of the Rose*, which was inspired by this magnificent monastery.

Turin Cathedral

Built between 1491 and 1498, the Church of San Giovanni Battista— Turin Cathedral—is the principal place of worship and the episcopal see of the diocese of Turin, which lies at the foot of the Alps. The massive building, a three-naved basilica with a relatively plain façade, immediately instills a sense of reverence. San Giovanni Battista is the last remaining medieval building in the city. A fire damaged part of the dome and the Chapel of the Holy Shroud in 1997, although both

The Turin Shroud

have since been repaired and are once again open to the public.

The holiest place in the church is the Cappella Regia, which has housed the "Holy Shroud of Turin" in its precious shrine since 1668. One of the most sacred and yet most controversial relics in Christendom, it is only displayed to the public every 30 years. This ancient strip of linen— about 12 feet (4 m) long and 3 feet (1 m) wide and covered in pale brown stains—is said to be the grave cloth in which Joseph of Arimathea wrapped Christ's body. The stains reveal the unclear but still recognizable form of a bearded man with traces of wounds on his head, hands, and feet. From the very beginning, the authenticity of the Shroud has been questioned and equally vehemently defended. The Church has remained hesitant— the 14th-century pope Clement VII declared that the Shroud could be venerated by the faithful but only as a replica, thus entering the dispute as to whether or not the image was an *acheiropoieton*, an object not made by human hand. If the Shroud were genuine, it would undoubtedly be the most precious relic in all Christendom, and the debate continues with no sign of any resolution in the near future.

None of this has diminished the reverence shown to the Turin Shroud— thousands make the pilgrimage to catch a glimpse of the relic in Turin Cathedral. Man's yearning for the visibility of God is a great and ancient one—hierophanies (appearances of the Divine) occur in almost every religion, almost everywhere in the world, sometimes in physical representations such as paintings, and sometimes in the form of the spoken or written word.

Sacro Monte di Varallo

The *comune* of Varallo Sesia near Lago d'Orta in Piedmont could almost be called an "open-air museum of devotion." There are no fewer than 45 ecclesiastical buildings of various sizes grouped round the central church. More than 600 life-size terracotta statues and over 4,000 painted figures populate this deceptive place. Many episodes from Christ's life and work are illustrated, as is the famous crib scene, depicting "frozen moments" in religious history and stories told by the Gospel-writers.

The philosopher Friedrich Nietzsche described his visit to this world of imagination as "the most delightful dream of my life."

Sacro Monte di Crea

This sacred mountain is really a low plateau on the plain between Turin and Genoa in the province of Monferrato. The pilgrims' devotional path begins at a pilgrimage church dedicated to the Virgin, constructed on the foundations of a building from the classical period.

The entire path is dedicated to the life of the Virgin Mary and passes several chapels on its steep climb to the Cappella del Paradiso, the "Chapel of Paradise." The symbolic journey begins below in life and leads up to heaven, where paradise awaits the believer.

The path in use today is not the original one. The dilapidated complex was almost completely destroyed in the early 19th century and was restored, in a slightly altered form, only when the old pilgrim tradition of *sacri monti* was revived.

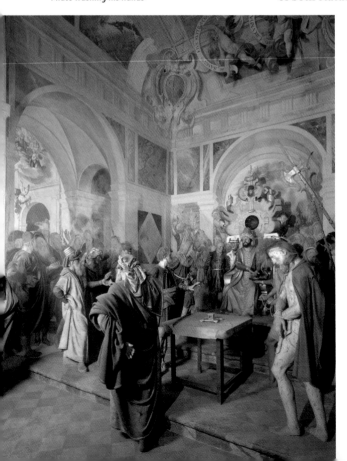

Murals and statues at Sacro Monte di Varallo: Pilate washing his hands

Sacro Monte d'Orta

St Francis of Assisi has been honored for centuries. That this sacred mountain is dedicated to him is a novelty in itself, since religious iconography, in the form of both statues and two-dimensional images, is usually dominated by depictions of the lives of Christ or the Virgin Mary. The complex is situated just above Lago d'Orta, which is surrounded by spectacular and inviting scenery. The little church of San Nicolao was revered in the Middle Ages for its 15th-century wooden Madonna della Pietà. In 1539 the decision was taken to found a monastery on the mountain and surrounded it with chapels dedicated to St Francis. Some 20 were completed between the 18th and 20th centuries, each commanding a view of the lake following a spiral path toward the top. The end result— an impressive blend of Renaissance, baroque,

rococo, and classical elements set in lush vegetation with the beautiful lake in the background—is a magical place that invites you to pause at every turn.

Sacro Monte di Varese

Varese, the capital of the eponymous province, is idyllically located on the shores of Lago di Varese. The *sacro monte*, on a promontory just south of the city, is particularly worth seeing; its grounds include the nature park of Campo dei Fiori.

The devotional path (Via Sacra), with its 14 chapels, follows the slopes of the hills to the little pilgrimage town of Santa Maria del Monte. There was a chapel dedicated to the Virgin here in the Middle Ages, before construction work began on the devotional chapels in the 16th century.

Although constructed in a similar style, and based on the designs of a single architect, all the chapels on the path are different. They feature trompe l'oeil frescos and life-size terracotta statues illustrating the life of the Virgin Mary. This devotional path is one of the most popular pilgrimage routes to be undertaken as part of the cult of the Virgin. More than 60 million pilgrims are said to have followed it over the course of its 300-year history.

As it climbs, the path, which is more than a mile (2 km) long, offers ever more stunning views of the landscape. If you are lucky, as you follow it, you may even have some insights into your own life. The Mysteries of the Rosary are, after the Lord's Prayer, the most important devotional prayers in Roman Catholic Christianity.

Sacri Monti in Piedmont and Lombardy

There are holy mountains all over the world—these are frequently mountains or imposing rock formations that dominate their surroundings and are revered as holy for the way they stimulate the imagination or for their connection to sacred traditions. There are nine particularly "holy" mountains in northern Italy, which have been consciously identified and planned as places of pilgrimage, merging spiritual symbolism into the landscape. Laid out between the 15th and 17th centuries, these places of Christian pilgrimage focus on various aspects of belief and are still actively used in worship today, inviting visitors to examine their lives from such perspectives. The *sacri monti* are principally shrines for the local community, but they are also attracting more and more people from further afield. The many chapels and local, traditional places of worship encourage visitors to search within themselves.

All nine mountains are based on Mount Calvary in Jerusalem, but each has its own character, reflecting a living faith that is to be found in and around the Alps to this day.

Sacro Monte di Oropa

Sacro Monte di Oropa is a "proper" mountain—the pilgrims' path with its churches and chapels climbs through Alpine scenery from an elevation of 2,500 feet (750 m) to 7,800 feet (2,388 m).

Construction of the route up the sacred mountain was begun in 1617 as more churches were added to the already extant pilgrimage church dedicated to the Virgin Mary, and the whole site is consecrated to the Black Madonna. Worship of Black Madonna icons is an ancient tradition and found throughout the world. Some believe that soot from votive candles has caused the dark coloration of the Madonnas, but it is more likely that they represent the adoption and adaptation of a millennia-old tradition: the adoration of dark divinities. The biblical basis for the Black Madonna is found in the Song of Solomon: "I am black, but comely" (Songs 1:5).

Climbing the Sacro Monte di Oropa is a special experience. Once the pilgrims reach their final destination, after the considerable exertion involved in the climb, they are able to see just how small humans are in comparison with the mountain itself.

Sacro Monte di Ossuccio

The mountains around Lake Como and the lake itself form a beautiful setting. The southern sunshine, the glittering lake, the plants, and the rock formations combine to make the area's scenery particularly charming and attractive. Sacro Monte di Ossuccio,

The chapels of the Sacro Monte di Oropa

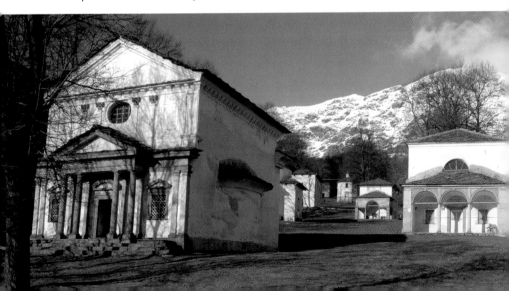

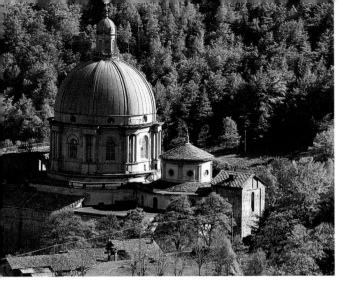

The pilgrimage church at Sacro Monte di Oropa

devotional path on the mountain was begun in 1591. The Chapel of the Coronation of Mary was completed in 1647 and is accessed via a devotional path laid out in the 18th century. Pilgrims climb up through a landscape that still betrays traces of prehistoric occupation. Their goal is a church in which the mystery of God as a Trinity is venerated. Pilgrims may be overtaken by feelings of spirituality and closeness to nature on this quiet, unspectacular, and unassuming path; they may even glimpse their inner selves.

on the western shores of the lake, was integrated into this landscape in 1635. The pilgrims' path passes 14 different chapels, all with traditional figures depicting scenes from the life of Christ and the Virgin Mary, before reaching the pilgrimage church. The path is especially popular with young people.

Sacro Monte di Ghiffa

This sacred mountain is situated in the middle of a densely forested nature park near Ghiffa on Lake Maggiore in Piedmont. The pilgrims' path climbs from an elevation of 1,200 feet (360 m) to 2,300 feet (700 m). An oratory dedicated to the mystery of the Trinity was built here at an early date, and the

Sacro Monte di Domodossola

This area of upland on the Piedmont plain is not much more than 1,300 feet (400 m) high, but the striking rocky tip of the summit is visible from afar. Two Capuchin monks established a shrine on this peak in 1657. The complex is dedicated to the Mysteries of the Rosary, particularly sorrowful episodes in the Passion of Christ. Initially only 14 wooden crosses were erected, 11 to mark the pilgrims' path and three on the summit at the end of the path,

which leads up the Monte Mattarella from the town of Domodossola. The shrine of crucifixes was consecrated in 1690 and work commenced on the 15 chapels of the Stations of the Cross soon after. These are richly decorated with groups of life-size statues and realistic-looking paintings.

The theologian and philosopher Antonio Rosmini moved to the mountain in 1828, founding the Order of the Fathers of Charity with his sister Margharita, and the order still maintains a house of prayer here. The motto of this clever priest, who had been driven from his church, was *adorare, tacere, gaudare* ("worship, be silent, rejoice"), and pilgrims in this magical landscape may attempt to follow these precepts even today. They may perhaps gain insights that will help them to take some control, despite all life's obstacles. This remains an ideal place for those wishing to reflect a little on their religion and spiritual gifts.

Sacro Monte di Belmonte

The most modern of the nine sacred mountains came about thanks to an initiative started by Michelangelo di Montiglio, a Franciscan monk who spent part of his life in Palestine. After returning home, he began creating a place of devotion in the style of those already in existence in Piedmont. The complex took from 1712 to 1825 to complete, but despite such a long construction period it is remarkably uniform in style, lending it a particular charm. The complex includes a pilgrimage church and 13 other chapels dedicated to the Passion of Christ. All the chapels are built to the same format—a round or square building with a loggia from which one can observe a religious tableau of colorful figures and meditate. The delicate, charming figures and frescos are extremely popular with both the locals and the pilgrims who come from further afield.

Milan Cathedral

The power of this cathedral is simply irresistible; this unique late-Gothic building will make any visitor to the cathedral square in Milan stop and stare in amazement. Its gleaming white contrasts with the often azure-blue sky. Yet even when the sky is overcast the cathedral is still resplendent, towering over the square, solemn and dignified and yet delicate and graceful.

One of the largest churches in Christendom, the Cathedral of Santa Maria Nascente was also one of the last to be built in a medieval Gothic style. After two centuries of municipal decline, Gian Galeazzo Visconti took control of Milan in 1385, bringing back prosperity and power. Construction of the cathedral was begun the

The Cathedral of Santa Maria Nascente, Milan

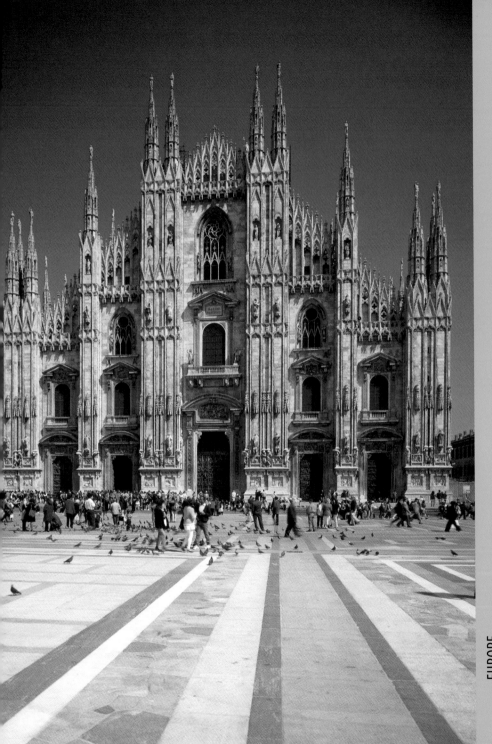

following year on a site once occupied by an early Christian church and a Roman basilica, but it was not completed until 1858. The 500 years of building work were certainly eventful. The Lombard masons and their foreign advisers came to bitter blows—the Italians were guided by their experience with marble and their artistic ability (*ars*), the architects favored theoretical planning (*scientia*), and the dispute escalated. One side maintained that *ars sine scientia nihil est* ("art is nothing without science"); the Italian masons, referring to their great experience, responded that *scientia sine arte nihil est* ("science is nothing without art"). Neither side would back down, and when the French building adviser Jean Mignot returned to his home country, most of his constructive criticism had gone unheeded.

The Italians continued to build, ignoring the faults that had been highlighted—weak foundations and pillars, insufficient buttressing. Yet the cathedral has remained standing to this day. The chancel and transept were completed by 1450, while construction work on the main nave and west façade lasted until 1809. The external decoration is unique, with figures, strange creatures, birds, and fruit. In every niche there is a different statue to delight the eye, from the ground to the tip of the highest spire. In the interior, the marble (from which the entire building is made, inside and out) reflects the slightest change in light conditions, and at dusk it shimmers with a rich spectrum of hues: white, pale red, orange, gold, violet, and faded pink.

One of this mighty building's unusual features is the marble-clad roof, which is only slightly pitched and can therefore be walked upon. It is covered in row upon row of graceful latticed towers, each adorned with a statue, and there is a good view of the great lantern on top of the dome with its colossal gilt statue of the Madonnina, 351 feet (107 m) above the hubbub at ground level. When the weather is fine, you can see the Alps. Milan Cathedral is a truly majestic building and the last and most beautiful expression of Gothic sensibilities.

Santa Maria delle Grazie, Milan

The church and its associated Dominican monastery are famed throughout the world, although this fame has less to do with the building, however remarkable and beautiful it may be, and more to do with a single fresco. Between 1495 and 1498 Leonardo da Vinci decorated the monastery refectory with The Last Supper, one of the most magnificent images in Christendom. Despite the greatly deteriorated state of the work caused by the climatic conditions and an air raid that struck in World War II, restoration of this unique work has made it possible to discern at least its basic forms. You can still imagine the exhilaration the monks must have felt when this huge work was unveiled, with its delicate,

vibrant shades of tempera painted onto the plaster of the far wall of the hall; the presence of the Savior was surely felt in ways previously unknown. Light falls on the lifelike table at whose center Christ is speaking the words that bring every Christian in the world into communion with him. Leonardo was concerned not only with the scene of the Last Supper but also with Christ's tragic utterance that one of his own would betray him, and the consternation of the disciples, the anxious questions, the waving, and the protestations combine to lend the scene a dramatic movement. Jesus alone sits peaceful and composed amid the storm that his words have caused. Despite all the excitement and inner drama, the group is not chaotic. In fact, quite the opposite is true, the disciples are arranged in four groups of three and are carefully juxtaposed through their movements and gazes. The image is clear and unambiguous, and yet is so multilayered that there is always something for the observer to note about the interplay of the relationships depicted.

This amazing painting is ample testimony of Leonardo's genius. His deep insight into human nature with all its highs and lows, his knowledge of psychology, and his artistic mastery make the image unique, as he succeeds in depicting the holy events in such a way that the observer feels physically and mentally present and involved. The *Last Supper* is rightly seen as miraculous.

The Church of Santa Maria delle Grazie, Milan

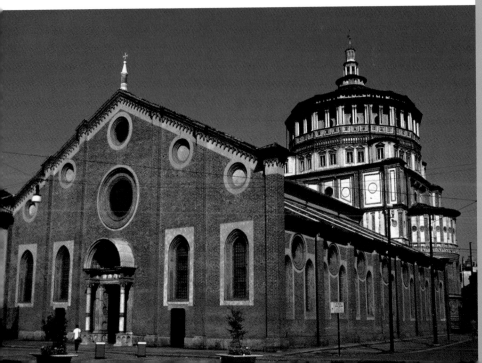

Faced with a work of such genius, it is easy to forget that the church and monastery of Santa Maria delle Grazie are among the most beautiful ecclesiastical buildings in Italy. The Dominican convent and church were built between 1463 and 1482. The church is strictly geometrical in shape—the area beneath the dome is square and the nave is exactly four times the size of this square. This creates a harmonious sense of space, felt at once upon entering the church. At the end of the nave there is a small cloister and a very large sacristy with trompe l'œil murals suggesting an Italian landscape.

The Lombard king Luitprand must have spent a small fortune in acquiring such precious relics, but for him the two men were so holy that he wished to commemorate their mortal remains in Pavia.

The church itself is one of the oldest places of worship in the city. Its simple, almost fortified brick façade seems to blend into the adjoining houses on the piazza, and visitors who enter the church and go down to the crypt will find both tombs there. Pavia and the Basilica of San Pietro in Ciel d'Oro mark the completion of one stage of the Via Francigena, the pilgrims' path through Europe that ends in Rome.

San Pietro in Ciel d'Oro in Pavia

In his main work, the *Consolation of Philosophy*, Severinus Boethius, who taught in 5th-century Pavia, attempted to show how humans can lead happy lives through contemplation and action. For him, philosophy was no purely academic science, but rather a practical tool to find one's way through life. Meanwhile, the Church Father Augustine spent his life trying to fathom the secrets of divine will and the love that God has for the world. Both were to become outstanding figures in the history of Western thought, and the entirely unassuming Basilica of San Pietro in Ciel d'Oro (St Peter in the Golden Heavens) is the final resting place of both.

Rock drawings at Valcamonica

Situated above Lake Iseo, Valcamonica is a long valley on the edge of the Alps in Lombardy through which the Oglio River slowly winds. The first cave drawings were discovered here in 1908, and since then more than 300,000 of these enigmatic rock carvings have been revealed. Since the first discovery the finds have been catalogued, and the engravings are thought to have been carved by the Camunni, the Alpine Celtic tribe after whom the valley is named. This evidence of prehistoric settlement was created between the sixth millennium BC and the Roman period (until about 16 BC).

The finely etched drawings depict the life and ritual activity of the

Camunni. Among everyday scenes of agricultural work, hunting, fighting, and religious practices there are representations of weather phenomena and topographical sketches of the locality. Many of the drawings recount complete narratives of burial ceremonies, ancestor worship, or celebrations with strange dances.

These rock carvings reflect the many facets of the life of prehistoric man and the world of his imagination. Many of the symbols are easy to interpret, while others have guarded their secrets to the present day. The spirals and ring-shaped drawings, symbols of life and eternity, are typical of Western megalithic art. Rounded hollows tend to represent the fertility of objects and phenomena that were particularly revered; eggs, springs, and vessels attest to the power of femininity. Humanoid figures are often seen in a ritual context or engaged in martial activity. Priests and figures at prayer are easily distinguished in many of the drawings; in an archaic society they have the power to lend form to life. The snake is a common cipher, and of all the animal-like figures it seems to be the creature with the most symbolic associations. It represents the double nature of life, the reconciliation of opposites, but can also be interpreted as a riverbed or as an indication of secret ritual activity.

The sun, the most important and revered body in the heavens, is also often depicted. The solar symbol that was chosen by the province of Lombardy as its emblem is carved on a rock called the Rosa Camuna.

Sant'Antonio, Padua

St Anthony is one of the most popular and honored saints to this day. Born in Lisbon, he was originally an Augustinian before becoming a Franciscan in 1220. His preaching in Italy and France was so popular that he often had to set up his pulpit in the open air. When he spoke, you could hear angels, or so the story goes. Even the hardest hearts were softened, the obstinate gave up their heresies, and whole towns repented and turned from sin.

Anthony worked many miracles but by the age of 36 felt so exhausted that he asked to be released from his duties so that he could retire to a remote place to prepare for death. At this point he had a vision of Christ holding open the gospel and subsequently moved to Padua, his favorite city. Completely drained, he preached just a few more sermons before dying on June 13 1231. His relics were to find their final resting place in the church built in his honor some years after his death. When the coffin was opened, the body was seen to have decayed, but the tongue was still whole and unspoiled. It was placed in a valuable container adorned with precious stones and kept in a chapel (the modern-day Treasure Chapel), where it is revered to this day.

Built between 1238 and 1310, the Church of Sant'Antonio in Padua is the largest place of worship in the city. Santa Maria Mater Domini, a small chapel dedicated to the Virgin Mary, had stood on the site during Anthony's lifetime, and this

was incorporated into the basilica, becoming the modern-day Cappella della Madonna Mora. The building is magnificent. In the half-light of the interior the Romanesque and Gothic architectural features blend to form a harmonious whole.

The four cloisters of the monastery are particularly noteworthy, although the elegant novices' cloister can only be visited in the presence of one of the Fathers. With Gothic arches supported by graceful columns, visitors to the novices' cloister are enveloped by a particularly restful silence. The green lawn further calms the senses and an atmosphere of peace and tranquility reigns. From the cloister, there is a fine view of the church's superb exterior.

The Magnolia Cloister has acquired its name from a flourishing specimen of the shrub *Magnolia grandiflora*, planted in 1810. The best time to visit the cloister is the short period when the magnolia is in bloom. The resplendent pink of the flowers contrasts delightfully with the delicate stonework of the cloister walls and columns, which have not been altered since they were erected in 1433.

The next stop is the General's Cloister, built in 1435. The name derives from the General Minister of the order, who resides in the adjacent building when he visits the monastery. This is also the location of the extensive and famous Biblioteca Antoniana.

Built in a Gothic style with Renaissance elements, the cloister of the late Luca Belludi is the largest and sunniest of the four cloisters, and

various religious institutions are based here, including a center for spiritual research and outreach.

St Mark's, Venice

The whole of Venice is like a dream, quite unlike anywhere else in the world. It is almost impossible to list all its treasures and relics—it immediately enchants every visitor. Many of the buildings lining the Grand Canal, the world's most beautiful main street, are famous in their own right. Situated right beside the Doge's Palace, St Mark's Basilica was begun in the second half of the 11th century, and there is a memorable historical footnote to its construction: "As a certain sum of money had become available, the suggestion was made to use it for either a war or a church; the construction of a church was decided upon." Of all the decisions ever taken in Venice, this was surely the best. A small chapel, of which nothing now remains, was built here only four years after the relics of St Mark had been brought to Venice, and the church that replaced it after a fire in 976 has almost disappeared too, only a few traces being visible in the small arcades beside the iconostasis.

The mighty church standing today was begun in 1063. The architect is unknown, but it is clear he was trained by Byzantine master masons. The floor plan is in the shape of a Greek cross, above whose center and four arms are to be found five domes. The

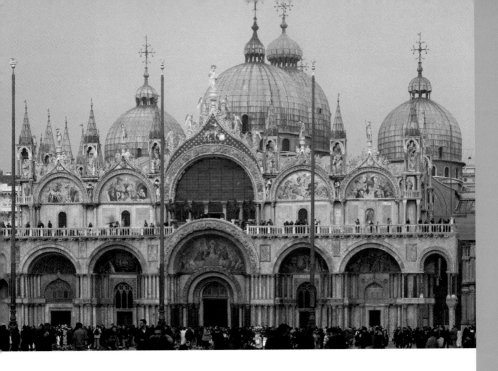

St Mark's Basilica, Venice

mosaic work is the best preserved in the Western world, and the cave-like feel to the building evokes a certain mysterious and spiritual atmosphere.

St Isidor's Chapel and the baptistery were built in the 14th century and by the 15th century the building had also been fitted with small Gothic towers, sculptures, and a great deal of ornamentation. St Mark's has often been compared to a "beached crustacean," and perhaps not entirely unfairly—its broad construction and its domes only reinforce the resemblance.

Inside you can see even more of the church's special character—a magnificent work of art, despite its many differing elements. The mighty cathedral is almost an ecclesiastical museum, filled with treasures collected during a time when the Venetian Republic was a political and economic world force. The impression is one of power and splendor, but reined in by well-balanced proportions. There are also some fine mosaics depicting scenes from the Old and New Testaments. The basilica houses a veritable wealth of relics, the most revered of which include the bodies of St Mark and St Isidor, drops of Christ's blood, nails and slivers of wood from Christ's cross, a pebble from the Mount of the Transfiguration, a relief carved from the rock struck by Moses in the desert from which a spring flowed, a

fragment of John the Baptist's skull, some rocks used to stone St Stephen along with one of his ribs, one of Mary Magdalene's fingers, and many more relics collected from around the world.

St Mark's is a holy place whose timeless charm has been felt by people from all over the world for centuries, and it will continue to be until that unhappy day when Venice finally sinks into the sea.

Santa Maria della Salute seen from the Ponte dell'Accademia

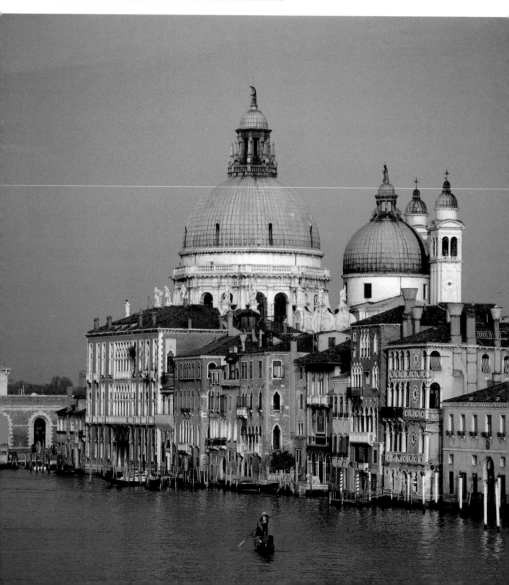

Santa Maria della Salute, Venice

The looting, burning, and pillaging carried out during the Thirty Years' War ravaged Europe and killed millions. These woes were compounded in 1630 by a devastating plague which claimed an additional million lives on the Continent—45,000 died in Venice alone. In desperation, the Venetians flocked to Titian's *Assumption* in the Frari church and swore to build a church dedicated to St Mary of Health if she helped them. When the plague had passed, they kept their word and the beautiful Church of Santa Maria della Salute was the result. The spit of land between the end of the Grand Canal and the Giudecca Canal, was chosen for the site. The vast church that was built there, visible from afar, became the emblem of the city.

The church was consecrated in 1687, after half a century of construction work, and it is truly one of the most beautiful in Venice. Baldassare Longhena, the architect, succeeded in breaking up the structural elements into dynamic, almost cyclical movement. Viewed from any angle, the seemingly weightless elegance of this mighty building is awe-inspiring.

A broad flight of steps leads up to the entrance portal, giving the impression that the gentle motion of the waves continues right into the church. In the interior, a group of marble statues at the High Altar represents the Madonna hearing the Venetians' prayers and banishing the withered figure of the plague. Countless Venetians and other believers from all over the world come to Santa Maria della Salute every November 21 to attend a solemn ceremony commemorating the end of the plague all those years ago. It is both an expression of Venetian piety and an opportunity to bring personal petitions for health and prosperity to the Madonna. The church also boasts several of Titian and Tintoretto's most beautiful paintings. Sitting in front of this wonderful votive church and gazing across the glittering Grand Canal is a very special experience— the distant past and the future seem to merge seamlessly into one.

San Giorgio Maggiore, Venice

There has been a small Benedictine monastery on the little island of San Giorgio Maggiore since the 10th century, and its incomparably beautiful location on the Bay of San Marco gives a breathtaking view of Venice in all its glory. Even if your visit to Venice is short, you should make the excursion here—from the church tower, the view looks out over the beauty of nature and the splendor of the city conceived by human creativity. To one side there is a panorama of the lagoon and the magnificent cityscape, and to the other, in good weather, a view that reaches as far as the foothills

EUROPE

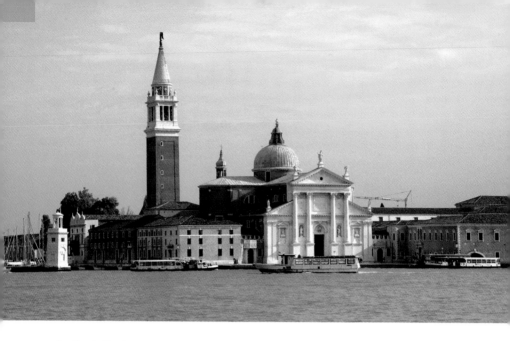

San Giorgio Maggiore

of the Dolomites. There is a seldom-visited park in the rear portion of the island with well-tended flower beds, a small open-air theater, plenty of trees, and some well laid-out lawns. It is a veritable oasis of peace! Visitors are enveloped in an agreeable solitude, far from the bustle of the cramped city.

Andrea Palladio, one of the most influential and talented architects of the Renaissance, started work on the Church of San Giorgio Maggiore in 1566, but it was not completed until 1610, after his death. The church façade alone is an exquisite example of his inspiration: Palladio succeeded in combining two classical temple fronts, merging one that strives toward the heavens and one that spreads across the building's width to form a well-proportioned whole. Looking at the church it is clear that the design is not a demonstration of architectural or artistic whim. Instead it is an expression of the human spirit, influenced and inspired by classical antiquity but persisiting still to this day. It is a measure of how a combination of ambitious thinking and the controlled application of human creativity and genius can take the ordinary to extraordinary heights.

The light and spacious interior contains several masterpieces by Venetian painters, notably Tintoretto, whose pictures always succeed in making the striking interplay of light and shade, brightness and shadow, an almost physical experience for observers. The island and its location,

the delightful park, and of course the Church of San Giorgio Maggiore, all combine to make this a sacred place that leaves a lasting impression on the souls and the hearts of visitors.

Torcello

The enchanting island of Torcello at the northern end of the Venetian lagoon is the cradle of Venice. Settlement of the island began in the 5th century, when the people of the Veneto sought protection from the hordes of barbarians attacking their country. Legend has it that the oppressed inhabitants of the Roman town of Altinum heard a voice telling them to climb a tower and look to the stars. From there they caught sight of a green patch of land in the middle of the lagoon and chose it as their refuge. Taking their possessions and their holy relics, they set about making a new beginning on the island. They even built a tower as a reminder of what had brought them such good fortune, and named the island after the tower (*turris*). When it turned out that the island was smaller than they first thought, the name was changed to *turricellum*, and eventually Torcello.

Torcello was the first major town in the lagoon and soon became a diocese. However, a Torcello merchant brought the body of St Mark from Alexandria and the apostle became Venice's patron saint, whereupon Venice began to flourish and Torcello to decline. The canals silted up, the area became swampy, and the marshes brought malaria. By the end of the 16th century, Torcello had returned to its earlier state, a primordial marshland

The Church of Santa Fosca and, left, the Cathedral of Santa Maria Assunta, Torcello

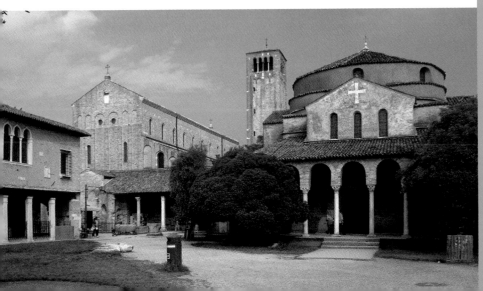

EUROPE

protruding from the waters of the lagoon. Only two churches remain as evidence of the island's heyday. One is the Cathedral of **Santa Maria Assunta**, the lagoon's most splendid shrine. An inscription on the high altar records that it was founded in 639, but was rebuilt between 864 and 1008. The old church is rather plain, but this simplicity carries its own nobility and dignity. Never obtrusive and showy, it nevertheless makes its presence felt.

The worn mosaic floor dates back to the building of 1008, and parts of an even older tiled floor can still be seen here and there. The mosaics are in a Byzantine style, Greek marble columns separate the main and side aisles, and fragments of classical frescos depicting individual apostles, flowers, and foliage are still visible—badly weathered and difficult to make out perhaps, but they are still there. The Cathedral of Santa Maria Assunta is an example of how belief remains even when everything around it changes.

Visiting the second sacred site on the island involves a similar experience. The squat, octagonal Church of **Santa Fosca** was built in the 11th and 12th centuries to accommodate the relics of St Fosca of Ravenna. The interior is almost empty and there are no works of art, but a pleasant, spiritual atmosphere envelops the modern visitor, evoked by the balanced proportions of the building, which revolves around the drum cupola. Nowadays the island is plagued by tourists from Venice in motorboats, especially at lunchtime and in the early afternoon, so it is

worth seeking out the unique ambience of Torcello at some other time of day—and then you may stand a chance of experiencing it as a sacred place.

San Lorenzo, Genoa

Genoa is sacred to every traveler in different ways, although not because of the modern port, a stopping-point for people on their way to Corsica. It is more to do with commemoration of the city's most famous son, Christopher Columbus, who set off from here on his historic journey to explore the New World.

It is difficult to imagine today how much courage was necessary to sail to the "ends of the earth" and beyond. Genoa is a town that encourages both itchy feet and homesickness. Longing for the heavens and a desire for security on earth are both basic human religious feelings, and Genoa makes both of these immediately apparent, almost as physical sensations.

Nestling in the Ligurian hills, the city exerts a strong hold on visitors from the outset, and it is little surprise that Christian churches were built here at an early date. San Lorenzo, Genoa's cathedral, seems to be almost hidden away. Unlike other major churches elsewhere in the world, it is tucked away among the buildings of the Old Town. It is an impressive church that needs no grand square to attract the attention.

Construction was begun on the site of an earlier 5th- or 6th-century church. Pope Gelasius II consecrated the structure in 1118, although it was not properly finished until the end of the 14th century. Gothic elements have been added to the Romanesque shell, and the black and white-striped façade, with its numerous reliefs and a beautiful rose window above the main portal, is a striking addition completed between 1307 and 1312.

A number of chapels and altars were added to the cathedral in the 14th and 15th centuries, and the building we see today was finally completed in the 17th century. The glass vessel in which Joseph of Arimathea is said to have collected the blood of Christ is accorded special reverence.

San Lorenzo, Genoa

Genoa's cathedral is a sacred place that sits side by side with the everyday and the mundane—old and new, sacred and profane, near and far, all these opposites are to be found here, and all play a role in shaping life.

San Vitale, Ravenna

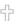

This sacred place is one of the most glorious early Christian buildings in Italy. San Vitale is famed principally for the mosaics gracing its interior, but its architecture is also of note and atypical among churches of the period. Basilicas were usually based on classical Roman precursors, but San Vitale is a Byzantine central-plan church with an octagonal floor design.

Built between 525 and 547 by an unknown architect, the church's central structure is surrounded by a similarly octagonal, two-storey outer layer of two ambulatories. This design, a complete innovation in Christian ecclesiastical architecture, was to feature in many later major buildings such as the Hagia Sophia in Istanbul (begun 532) and Charlemagne's Palatine Chapel in Aachen (built c. 800). The mosaics inside depict the emperor Justinian with his retinue. One of the most important late Roman emperors in Christian

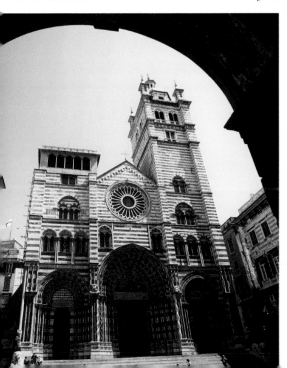

history, Justinian did much to suppress the pagan religions that were beginning to re-establish themselves.

However, it is not merely the architectural features and the skilled decoration that make this place particularly sacred, it is also the feeling that grips every visitor to the

religious feeling and quiet reflection combine. The feeling is of a timeless and arresting beauty. Light and mysterious shadows are an allegory for everything that shapes human life. San Vitale is a sacred place whose holiness can be felt even by those who profess no connection to the Christian faith; it evokes feelings independent of beliefs.

Mosaic in San Vitale in Ravenna depicting Emperor Justinian I with his retinue

church—the sense of space is overwhelming. Light floods in on all sides through three storeys of stained-glass windows, shining through the images of the solemn saints who seem to be watching the flock below.

The stone surfaces are covered with designs and motifs, creating a spiritual atmosphere. The octagonal shape of the building, with its many angles, facades, and different levels, forms a structured space in which

Lucca

Its name meaning "the bringer of light," Lucca is a true city of lights. It was here that St Fredianus, a 6th-century Irish bishop, known as St Finnian in his homeland, founded a small monastery with an adjoining church near an ancient amphitheater. The Basilica of **San Frediano** was rebuilt in a Romanesque style at the beginning of the 12th century. The splendid high gable of the façade is decorated with a gold mosaic depicting the Ascension of Christ. The risen Jesus is being carried aloft by two angels. Beneath these can be seen the apostles, visibly confused by events whose meaning they can't quite grasp. In this they resemble modern observers, as the Ascension has remained a mystery to this day. The adjacent monastery became a rallying-point for supporters of the Reformation in the early 16th century.

They were initially tolerated, but subsequent persecution by the Inquisition led them to move on, principally to Geneva, which soon became the spiritual center of Protestantism.

The Cathedral of **San Martino**, Lucca's episcopal see, is a few minutes' walk away in the south of the city center. Founded in the 6th century and completely rebuilt in the 11th, the church was to undergo further alterations between the 12th and 14th centuries. The richly decorated façade seems to be slightly asymmetrical, leaning toward the old brick and travertine tower, and is divided into two sections. The lower portion consists of three large arches opening out onto the piazza, above which stand three delicate arcades. Each column is decorated differently, with a vast array of lions, dragons, human figures, and geometric and floral patterns. The portals are decorated with scenes from the life of St Martin, after whom the cathedral is named.

An especially important relic is kept in the church: a small, elegant octagonal chapel houses the Volto Santo, the "Holy Face." This crucifix is quite different from all others, as it depicts a stern Christ in flowing Roman robes, staring at the faithful with wide-open eyes. Every September 13 the Volto Santo is wrapped in precious fabrics and carried in procession through the streets of the city. The residents light up their windows and verandas with numerous tiny lamps, in honor both of the crucifix and of the name of their city: Lucca, the bringer of light.

Campo dei Miracoli, Pisa

Pisa is by far the best-known city in Tuscany. The "Leaning Tower" on which its fame rests is still standing, despite its precarious tilt. The Campo dei Miracoli ("the field of miracles") contains a group of buildings: the cathedral (begun 1063), the baptistery (begun 1152), and the famous bell tower (begun 1173). The complex was built over the course of 300 years on a site that was initially beyond the city walls and thus provided enough space for such an extensive building project. The designs were based on classical temple complexes and early Christian architecture, with the addition of elements from the Lombard tradition and oriental motifs.

The Cathedral of **Santa Maria Assunta** has a Latin cross floor plan with five aisles in the nave and three in the transept. The oval dome rises above the crossing. Three portals divide the first storey and above these is a façade of colonnades and narrow galleries. The marble stripes and blind arcades of the lower section reflect the ornamentation of the whole building, lending the overall effect a strong sense of unity. The interior, with its mixture of elements from a variety of styles, is stunning. The huge mosaic in the apse, depicting an enthroned Christ flanked by the Virgin and St John, immediately attracts attention, and Nicola Pisano's pulpit is a sermon in stone, relating stories of Christ's life from his birth to the Crucifixion and the Last Judgment in delicate and graceful detail.

Walk around the pulpit to see the entire biblical story of man's salvation.

The enormous **baptistery** stands surrounded by lawns opposite the main doors of the cathedral. The exterior is impressive but its full spiritual weight is brought to bear only as visitors enter and are immediately immersed in its contemplative atmosphere. The proportions and design of the interior work perfectly together. The noticeably high arcade arches automatically draw the attention upward to a floor of galleries and then further to the vaulted ceiling. Directly beneath this is an octagonal font and beside it a free-standing pulpit, also the work of Pisano and also depicting the story of salvation.

The Leaning Tower of Pisa, the **campanile**, is to the east, a little to one side behind the apse of the chancel. Even without its tilt, the tower would be an oddity in comparison with other Tuscan bell towers in that it is cylindrical and surrounded by eight storeys of arcades, each differentiated from the next by a sharply protruding sill. This unique tower has a delicate and almost playful elegance, and has managed to remain standing over the course of eight centuries despite the relentless pull of gravity, which is no mean feat!

The cathedral of Santa Maria Assunta, the baptistery, and the campanile, Pisa

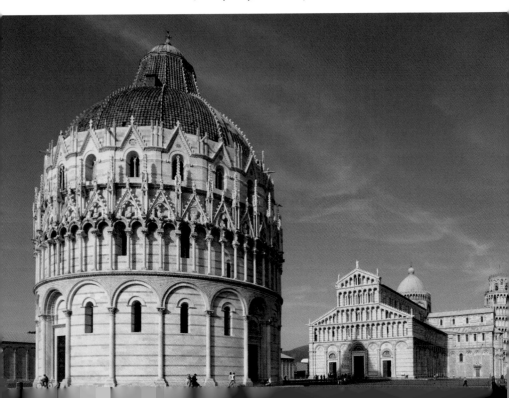

Florence Cathedral

It is almost impossible to list the treasures and spiritual riches of this city—Florence is unique. The town was established during the reign of Augustus and soon flourished. By the 4th century, Florence was the capital of Tuscany and Umbria and had become a Christian center; it was declared an independent diocese in 393. After the collapse of the Western Roman Empire and the advent of strife between the Goths and the Byzantine Empire, Florence fell into decline, which was reversed only in the middle of the 11th century, when the city became the focal point of humanist and religious rebirth.

Arnolfo di Cambio began the construction of Florence Cathedral (Santa Maria del Fiore) in 1296, but not until 1471 was the golden ball set in place on Brunelleschi's dome. The marble façade dates back to the 19th century; the white, green, and pink marble cladding shimmers exquisitely in the soft Tuscan light. The cathedral is one of the largest churches in Christendom, but it is not size alone that makes this a sacred place. The unique harmony of structural and aesthetic elements and the wealth of art treasures

The cathedral of Santa Maria del Fiore, Florence

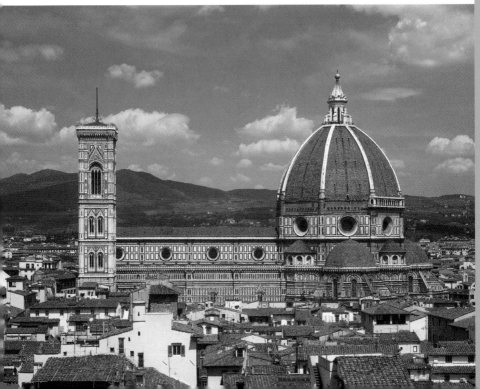

within the church combine to make this a magnificent place of worship.

The three-aisled nave has a simple yet balanced austerity of form and a soft palette of colors. Visitors to the cathedral immediately get a sense of the peace and serenity of a harmonious and thus eternal beauty. The clock on the interior wall beside the main portal fits this mood entirely; it has only one hand and shows the progression of the hours anticlockwise according to the sun. The great fresco of the Last Judgment in the cupola, designed and begun by Vasari in 1572 and masterfully completed by Zuccari after Vasari's death, contributes to the overall mood.

Harmony, the interplay of color and light, and simplicity yet splendor all lie at the heart of the cathedral, so that it is little surprise that Santa Maria del Fiore has become one of the world's most sacred places.

Santa Croce, Florence

The Franciscan church after which the square is named stands majestically over the Piazza Santa Croce, on the site of a small church where the monks once ardently preached their sermons. Construction of a larger church was begun in 1285 under the supervision of the architect Arnolfo di Cambio. The renown of the Franciscans at the time was so great that the construction of a church of huge dimensions had been made possible by generous

donations. The building finally grew to such an extent that it began to cause unrest within the mendicant order.

Nonetheless, the work was continued and finally completed in 1385, although the marble façade at the front dates back to the 19th century. The extremely wide, three-naved interior is reminiscent of early Christian basilicas in Rome, and the gray-brown of the pointed columns and arcades reinforces the impression of simplicity. The frescos by Giotto and his pupils in the main choir and the transept chapels are of a similarly unpretentious beauty. St Francis was well known for his sermons and teachings in praise of Creation, and Santa Croce is a perfect example of the heights of beauty that man can create.

Santa Maria Assunta, San Gimignano

The political and religious centers of San Gimignano, whose famous towers can be seen for miles around, are located right opposite one another on the Piazza Duomo: the Palazzo del Popolo, once the town hall and now a museum, and the Collegiate Church of Santa Maria Assunta.

A broad flight of steps leads up to the two portals of the church, which was consecrated in 1148. The façade is simple yet captivating in its balanced symmetry. Despite later alterations, the underlying Romanesque structure

of the church is still clearly visible. The building is principally famous for its frescos: the left-hand wall of the nave recounts stories from the Old Testament, while the right-hand wall is dedicated to the New Testament. In the Chapel of St Fina, a later addition, a Renaissance painter has masterfully depicted the story of this local saint.

Fina was a pious and chaste maiden who, upon falling sick, lay down on a hard board, never to recover. Her body began to stick to the board, decomposing and emanating a foul smell. Regardless of the stench, the Devil tried to approach her, but she managed to drive him off at the last minute with the sign of the cross. Then she experienced a vision of St Gregory the Great, who told her that she would die on his name day, which duly happened.

Legend has it that when she died, the church bells rang on their own. The smell of her rotting body turned into a pleasant scent and bright flowers began to grow from the board. For this reason the town celebrates the saint on March 12 by decorating every surface with flowers, the "Fiori di Santa Fina," in recognition both of the saint and of the beginning of spring.

Siena Cathedral

Siena is without doubt one of the most beautiful cities in Tuscany. There are many places and squares here that might be considered sacred, but as you approach this city, lying on the Via Francigena, one seizes the attention straightaway: the Church of Santa Maria Assunta, Siena Cathedral. The church is constructed of alternating stripes of green and white marble, with a richly decorated façade. Twelve steps, symbolizing the apostles, lead up to the plinth on which the building is situated.

The cathedral was begun in the 12th century, and the building we see today was completed 100 years later. The tower dominates the east side and the crossing cupola rises above the hexagonal frame. Inside, the alternating dark and light stripes of the marble create an unusual and distinctive effect that surprises when you first enter. The nave is divided into three aisles by tall, slender, rounded arches, and the precious marble floor is noteworthy—there are 56 separate panels with images of philosophers, personifications of virtues, and biblical scenes, all of which combine to narrate the history of Christianity from antiquity to the foundation of the city.

The church houses invaluable works by the greatest Renaissance artists: Donatello's *John the Baptist*, Michelangelo's *St Paul*, Bernini's *Mary Magdalene*, and Pisano's marble pulpit depicting the *Adoration of the Magi*. The overall effect is heightened by the impressive baptistery on the other side of the road and the Nuovo Duomo ("new cathedral"—never completed), the projected size of which was enormous, as indicated by the transept.

The cathedral is dedicated to the Assumption of the Virgin, and the famous

annual *Palio*, the horse-riding competition held on the Piazza del Campo, a race in honor of the Mother of God, is celebrated on July 2 and August 15.

Siena is also sacred because of St Catherine, who was born here in 1347. At the age of seven she decided to live her life according to God's wishes and refused the marriage that her parents arranged for her when she was 12. She entered the Dominican Order when she was 16 and often had visions. In 1376 she persuaded the pope to return to Rome from Avignon, but the French cardinals rebuffed the newly elected Pope Urban VI, instead electing Clement VII as an anti-pope. Catherine vehemently supported the Roman pope

and traveled widely, eventually leaving Siena and moving to Rome, where she died in 1380. She is the patron saint of all Italy, enjoying universal adoration, but she is particularly honored in Rome—where she lies buried in the Church of Santa Maria sopra Minerva—and in her home town of Siena.

Abbazia di Sant'Antimo

Each of us could list a few places on earth to which we feel repeatedly and irresistibly drawn. One such

The roofs of Siena and the cathedral

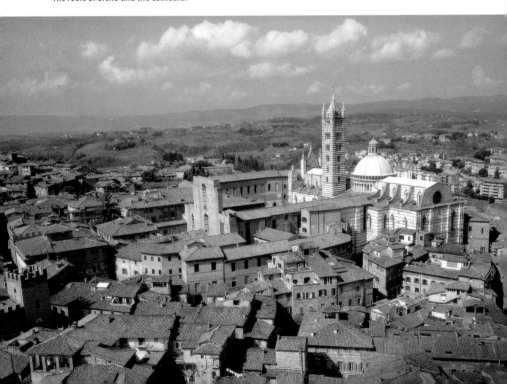

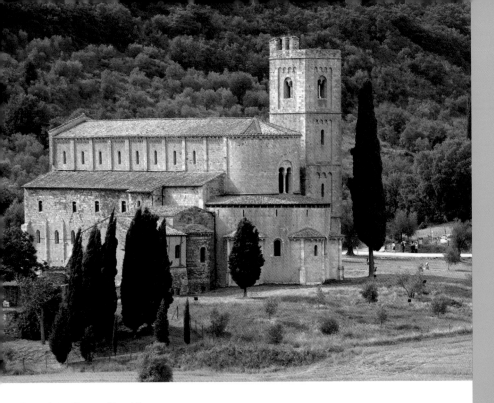

Abbazia di Sant'Antimo, Montalcino

magnetic location is to be found at the end of an uneven and dusty street near Montalcino: the Abbazia di Sant'Antimo, a Benedictine abbey, unique in Tuscany. It is possible that the monastery was founded by Charlemagne around 800, but waning imperial power around the end of the 13th century signaled the decline of the abbey, which was finally abandoned in 1462.

Like many French monasteries, the whole complex is based on the reformed Benedictine monastery at Cluny. Only the separate bell tower, standing a little to one side, follows the Italian architectural tradition. Overall, the building is very plain, but this reinforces the impression of its perfect harmony. The interior also radiates an overwhelming simplicity—the pillar capitals alone are decorated, with representations of animals and plants. There is no transept and the high walls of the nave lend it a particular elegance. The windows of the choir ambulatory allow plenty of golden natural light into the altar space, creating a feeling of security and safekeeping. This is a sacred place where visitors can truly experience the color of happiness.

EUROPE

Assisi and St Francis

Assisi is known and revered throughout the world. Every year hundreds and thousands of people make the pilgrimage here in the footsteps of St Francis to draw strength from his special teachings.

Giovanni di Bernadone was born in Assisi into a wealthy family around 1181. Once he had heard the gospel, he gave up his life of luxury and his worldly ways, becoming a monk and a preacher and finding renown as Francis of Assisi. From then on he lived in harmony with nature, never tiring of praising Creation. His "Canticle of the Sun," a hymn to the beauty and serenity of Creation and living creatures, has become world-famous. He talked to birds and fish, cared for the sick and poor, and continually preached the love of God.

He received the five wounds of Christ from an angel during a painful vision in his cave in La Verna, although he kept these hidden until his death. His naked corpse was laid on the bare ground when he died in 1226, and an eye-witness reported that it looked as though he had just been taken down from the cross, with nail-holes in his hands and feet and a wound in his right side from a lance.

Francis was so famous that he was canonized a mere two years after his death. Various locations in his home town associated with him were soon developed and are revered to this day. Through the fame of its most famous son, Assisi thus became a place of immense spiritual influence.

The Basilica di San Francesco, Assisi

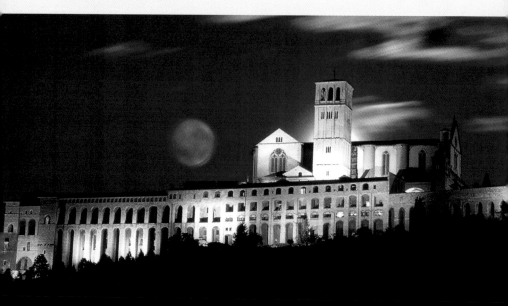

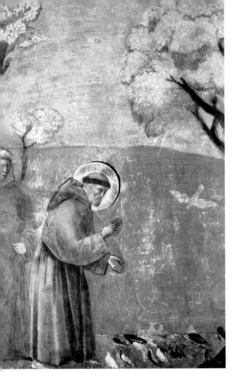

A fresco of St Francis of Assisi

Basilica di San Francesco d'Assisi

Unsurprisingly this lush, green land-scape under an azure-blue sky has been inhabited since the Neolithic period. The Etruscans founded what was to become Assisi on the site of a sacred spring and the Romans recognized the magic of the location, building a temple in honor of Minerva, the goddess of the arts and of medicine. Criminals were later executed here, so as a result the hill acquired the name Colle dell'Inferno ("hill of hell").

After St Francis was canonized in 1228, construction of a basilica was begun on the "hill of hell," trans-forming it into the Colle del Paradiso ("hill of heaven"). The Basilica di San Francesco is composed of an upper and lower church. Exquisite frescos by Giotto and his school cover almost every inch of the nave of the upper church. Painted in vibrant colors, they portray the figures they depict with subtlety. Narrating scenes from the life of the saint, the images are realistic and arresting and have been fascinat-ing observers for centuries. The region suffered an earthquake in 1997 and much of the basilica collapsed, but painstaking and expensive restoration work was begun at once. A vast sum of money was required, an expense incompatible with a vow of poverty, but the people's love of the saint and the unique importance of the works of art were such that there was no argument about rebuilding this sacred place.

The Basilica di San Francesco is thus a narrative of the inspiration, enlightenment, and indomitable will that exists in humans to create something beautiful, and therefore to pay homage to Creation itself.

Santa Chiara

The townscape of Assisi is domi-nated by the monumental complex of the Basilica di San Francesco and the friary buildings alongside, but other

places in the town are also considered sacred, such as Santa Chiara.

The basilica is dedicated to St Clare, the founder of the Order of the Poor Clares. She was canonized in 1256, only three years after her death, and work commenced a year after that on a basilica on the site once occupied by the church of San Giorgio, which had held the relics of St Francis. When these were transferred to San Francesco, a new Italian Gothic church was built on the consecrated ground.

It is plain and yet impressive, commanding respect rather than inspiring fear. The pink stone was quarried from Monte Subasio, the mountain on which Assisi stands. The church's single nave culminates in a polygonal apse. The Chapel of the Sacraments and the Cross, part of the old San Giorgio structure, is where St Francis was canonized in 1228. The famous Cross of St Francis, from which Christ is said to have spoken to him, is still to be seen here.

Along with biblical scenes, many of the church's frescos depict episodes from the life of St Clare. This girl from a well-to-do household heard one of Francis's sermons and decided immediately to renounce all earthly distractions. In conversation with her, Francis soon recognized a kindred spirit and introduced her to a Benedictine convent. Clare's younger sister, 14-year-old Agnes, also followed a vocation to the convent. The family was so enraged at this that they tried to retrieve their still under-age daughter by force. During the attempted kidnap, the girl suddenly became so heavy that

her abductors could no longer carry her and had to abandon their plan. Francis brought both young women to the monastery of San Damiano, creating the first Franciscan convent.

Clare had a rather uncompromising attitude. For her the best route to heaven was to be found in poverty and a lack of possessions, a view that gave rise to the strict Rule of the Poor Clares Order. St Francis himself was obliged to prevent Clare from sleeping on the bare floor and to make sure she ate properly. Shortly before her death, the terminally ill abbess had a kind of telepathic vision of the Christmas midnight Mass at Assisi—700 years later this "seeing from afar" led Pope Pius XII to declare her the patron saint of television. The crypt was restored in a Gothic style in 1935 and now houses the saint's remains, which were rediscovered in 1850.

Assisi Cathedral

After San Francesco and Santa Chiara, the Cathedral of San Rufino is the third major church in Assisi. St Rufinus is said to have been the first bishop of the town, although this is historically questionable. According to another tradition, he was an early Christian martyr whose relics were brought to Assisi by Petrus Damianus. It is difficult to establish the truth for certain, but he is without doubt the town's patron saint.

The Cathedral of San Rufino was significant for St Francis and the order he founded, since it is here that he was baptized, as was St Clare. San Rufino later became the church where St Francis preached. Legend has it that he was giving a sermon here at the same time as he was seen elsewhere, suggesting that a person's presence can be experienced in several places at once.

The cathedral was built in a Romanesque style in 1140 using stone quarried from Monte Subasio, the mountain on which the town of Assisi is built. The façade is somewhat austere, drawing the observer's attention to the Christian iconography on the narrow portal: Christ depicted as the Ruler of the World, situated between the sun and the moon, the Virgin Mary and Child, and St Rufinus. Above this is the central rose window surrounded by the symbols of the four evangelists: bull,

San Rufino, Assisi

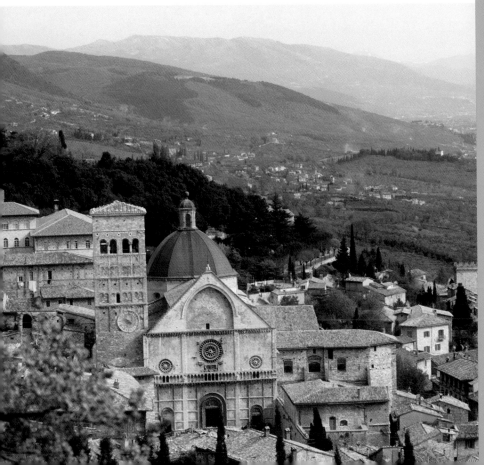

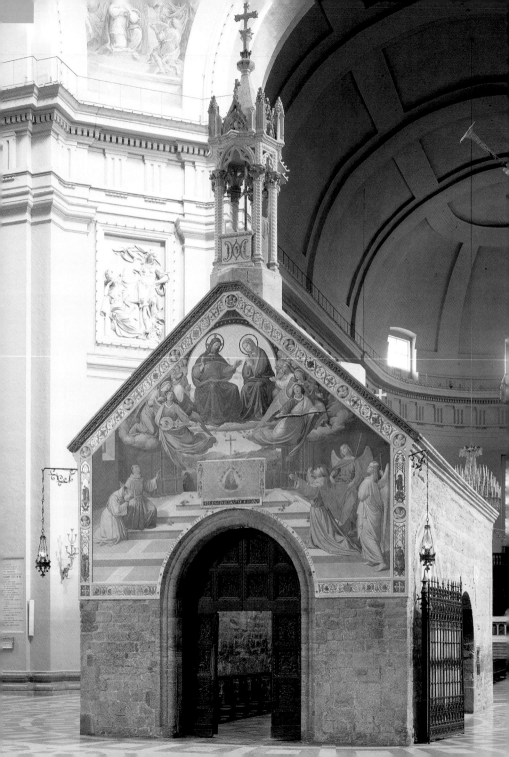

lion, eagle, and angel. The 11th-century campanile features a 24-hour clock, as is often the case in Italy.

The church interior was completely refashioned in an Italian Renaissance style in 1571, although the font in which Francis, Clare, and many of their first followers were baptized can still be found in the entrance area. Some of the early Renaissance frescos, many of which are attributed to the great master painter Giotto, survived the devastating earthquake of 1997 or have been restored.

Santa Maria degli Angeli

Assisi has no shortage of churches and memorials dedicated to St Francis. One of the largest churches in Christendom, Santa Maria degli Angeli is built around a tiny chapel—the Portiuncula Chapel, where in 1208 Francis founded the movement that was to become his order, and where he is later said to have died. The chapel rapidly became a place of pilgrimage for Franciscans from all over the world, and was soon too small to accommodate the huge crowds that came here. It is now situated in the vast main nave inside the Basilica of Santa Maria degli Angeli, which was commissioned by Pope Pius V and built between 1569 and 1679.

The Portiuncula Chapel in the nave of the Basilica of Santa Maria degli Angeli, Assisi

At the turn of the 20th century, the Church of St Mary became the patriarchal basilica of the entire Franciscan Order, and so is regarded as the "head and mother of all the churches of the Order of Friars Minor" (the translation of the Latin *Ordo fratres minorum*, the description of the Franciscan Order). The Virgin Mary is shown enthroned in gold on the roof of the entrance portal. The interior of the three-naved church has retained a uniform Doric style, its simple and austere beauty focusing attention on the small chapel, which is the real object of adoration. After collapsing in one of the many earthquakes that afflict the region, the church was rebuilt to the old plans between 1836 and 1840; by some miracle, the dome and the Portiuncula Chapel survived unscathed. The large square in front of the church is also of note: it has been planted with oak trees in commemoration of the wood that once surrounded the small chapel.

Santa Maria di Rivotorto

About a mile (2 km) beyond Assisi there stands a modern church (built in 1854). Although it has little to recommend it architecturally or artistically, it attracts pilgrims from all over the world. Young people in particular undertake the journey here to learn and experience something of the Rule of the Franciscan Order. They enjoy the opportunity

of mixing with their peers from other countries and cultures at the beginning of their spiritual lives.

The church was built over a small hut (reconstructed) in which Francis is said to have assembled his first followers. The hut, which was probably nothing more than a stable, is revered as the site where the rule was established for the order of brothers and sisters that was later to find worldwide fame.

Places do not have to be particularly grand or impressive in order to be holy—unassuming places that are sometimes almost overlooked can be sacred too. Places commemorating events that have changed the course of history or thought also become the focus of veneration, as with Santa Maria di Rivotorto ("by the winding stream"), the mother church of the Rule of the Order of St Francis.

Eremo delle Carceri Friary

Assisi is located on Monte Subasio, which for centuries has been the source of stone for the town's buildings. Climb the hill a few miles outside the town and you will reach a small former hermitage with a little Franciscan friary beside it. The idyllic, almost enchanted friary of **Eremo delle Carceri** and the adjoining Church of St Mary are located in a steep forest gorge. Built by St Bernardino of Siena around 1400, it was constructed above

the grotto to which St Francis is said to have retreated when he wished to pray in solitude. Besides charity, preaching and prayer would become the basic tenets of the rule of the order he was to found. Since the earliest times, caves and grottos have been places where man has endeavored to commune with nature, or even to be at one with it. This is as true of hermits and Christian monks as well as it is of other religions and cultures. It was only natural, therefore, that this cave soon came to be revered.

The "**Oak of the Birds**" lies not far from the friary, near a stone bridge. This is where, according to the hagiography, the saint preached to his "flock." Francis could speak the language of animals, communicating with birds, dogs, and fish, and had a particularly close relationship with Creation and with the God responsible for it. The little friary is now occupied and run by a few Franciscans who always welcome visitors. This is an idyll, where it is easy to find peace and to reflect on one's position in the whole of Creation.

La Verna

"What moves you, o Man, to leave your house in the city, to desert your relatives and friends, and to move to a rural area of mountains and valleys, if not the natural beauty of the world?" asked Leonardo da Vinci in his *Prophecies*.

This seems to be a direct reference to St Francis, at least the question is certainly very apt in his case.

The impressive monastery at La Verna is situated at an elevation of 3,700 feet (1,128 m) on a steep cliff on the border between Umbria and Tuscany. St Francis would retire to this mountain every year to pray, to fast, and to immerse himself in the Passion of Christ. He had received the mountain as a donation from Count Orlando Cattani di Chiusi in 1213, and at the time it was a wilderness of almost impenetrable vegetation and wild animals. Even today this mysterious, magical tract of land is surrounded by ancient forest. There is a terrace with a view of a deep gorge and steep cliffs, recognizably those climbed by St Francis when the Devil tempted him to throw himself into the abyss. St Francis spent his time on the mountain in a small recess between two rocky outcrops, and it was here that he received his stigmata, the wounds suffered by Christ at the Crucifixion, on September 14 1224 after 40 days of fasting.

The shrine at La Verna is one of the most famous Franciscan hermitages. The Chiesa delle Stimmate, commemorating the miracle of the stigmata, was completed in 1509, after 160 years of building work, but the Chapel of Santa Maria degli Angeli is

The Stigmata of St Francis *by Ghirlandaio*

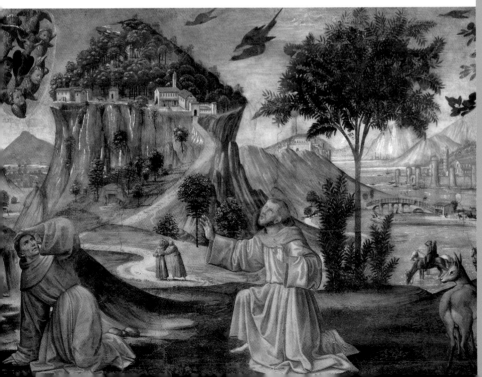

much older, having been built between 1216 and 1218 at the express wish of St Francis. Following the path to the shrine is like taking a pilgrimage into the Middle Ages, to the source of a piety that began here and in Assisi before spreading out into the world.

Orvieto Cathedral

Situated on an almost impregnable cliff, the ancient Etruscan town of Orvieto became a major place of refuge and retreat for medieval popes. The entire Old Town is built on a rocky plateau, which can be seen for miles around and is filled with a warren of cellars, cisterns, and passages. Etruscan tombs have been found right at the foot of the cliff.

The cathedral is situated majestically at the highest point of this elevated cliff-top town. The last rays of the evening sun play across its famous west façade, illuminating the juxtaposition of its vertical buttresses and the black and white stripes of the walls with an almost supernatural light. The mighty buttresses stop just short of the foundations,

Plinth relief, Orvieto Cathedral: The creation of Eve

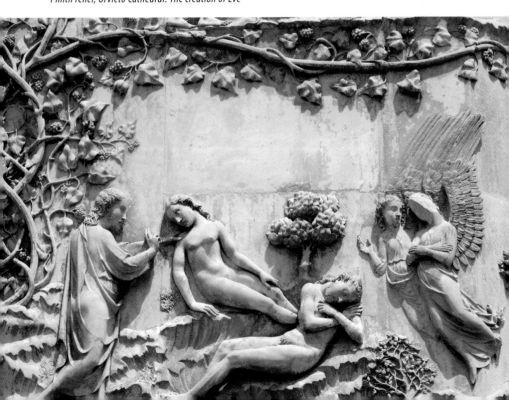

leaving room for what must be the most beautiful pedestal reliefs in Gothic architecture, completed to a design by the master mason Lorenzo Maitani between 1310 and 1330.

The sensitive and lifelike depictions of scenes from the story of Creation are particularly enchanting. There is perhaps no other representation of God the Father on earth to rival the one seen here, carefully removing a rib from Adam to create an Eve of classical grace and beauty. Even the angels, whose wings are just brushing the Tree of Life, are gentle and amiable. The soft, almost lyrical reliefs on the other buttresses are in a similar vein, with prophecies of the Messiah and stories from the New Testament.

The Last Judgment on the fourth buttress is quite different. The torments and suffering of the damned have never been so vividly represented as in the expression of one of the cowering forms, whose arm has already been consumed by a hellish monster as he sinks, exhausted, to his knees. The reliefs take their aesthetic inspiration from classical Roman art, as would have been well known from the likes of Trajan's Column, and the Romanesque nave is based on the Roman Basilica of Santa Maria Maggiore, but the overall appearance of both the interior and exterior is nonetheless of a Gothic church.

If you can bear to tear yourself away from the church's façade, a similarly reverential mood awaits you inside. The relic for which the church was built is kept in a side chapel. In 1263 a skeptical priest from Prague was celebrating Mass in Bolsena. As he broke the Host, blood was seen to fall from it—for the Catholic Church, this was indisputable proof of transubstantiation. The drops of blood can still be seen on the altar at Santa Cristina in Bolsena, but the altar cloth was brought to Orvieto and is now kept securely behind the doors of a skillfully crafted gold and silver shrine. The relic is so holy that it is displayed only infrequently, but for Christians the altar cloth remains an object worthy of veneration. Still celebrated today as one of the most important dates in the Christian calendar, the Catholic feast of Corpus Christi is based on this miracle of the Holy Blood.

In the Cappella Nuova, with its cycle of frescos created by Luca Signorelli from 1499 onward, visitors are confronted with the story of the Antichrist and the end of the world. There are representations of Death, the Last Judgment, Heaven, and Hell—a glorious sermon in visual form for the contemplative mind. Orvieto Cathedral cannot fail to leave a lasting impression on every visitor.

Santa Casa di Loreto

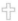

Loreto in the Marche is the home of one of the most important Marian pilgrimage sites in the world, the "Shrine of the Holy House of the Mother of God."

Stone for the construction of this house was brought all the way here from Nazareth by angels, according to legend. The story that the Virgin Mary originally lived in a cave is similarly apocryphal, although there is certainly a grotto in Nazareth that is revered in the Church of the Annunciation there. The walls of the house are said to have been transported to Croatia after the collapse of crusader rule in the Holy Land at the end of the 13th century, and from there to Italy. They were kept at various locations before being set up and worshiped in a wood of laurel trees. The section now regarded as the original central portion of the house was found in the same copse of laurel trees as gave the town of Loreto its name.

The "Holy House" consists of a room with no foundations and walls about 10 feet (3 m) high. The stonework has been faced with tiles in order to protect it and the whole room is enclosed within an ornate Renaissance-style church, commissioned in 1468 by Pope Julius II and completed in 1587. Almost 330 feet (100 m) long, the basilica is cruciform in shape with a curtain wall that looks almost fortress-like. Pilgrimages to Loreto are documented as far back as the early 14th century, but once the church had been built a steady stream of visitors made their way here, and continue to do so to this day.

The object of their reverence is of course the "Holy House of the Virgin," but visitors are also shown some household objects. The niche in the wall in which the liturgical apparatus for the Mass is kept is said to be where Mary stored her provisions, the so-called *Credenza della Madonna* ("the Virgin Mary's larder"). There is also the *Santo Armadio* ("holy cupboard"), in which Mary kept her Bible and where the apostles are thought to have placed the first communion Host, and the *Santo Camino* ("holy fireplace") where Mary is said to have cooked. However, the most important Marian icon is the Black Madonna, a dark cedarwood statue.

The most important festivals are held on September 8, Mary's birthday, and December 10, the anniversary of the arrival of the Holy House in Loreto. Thousands of pilgrims hold a vigil in the church every year on the eve of December 10, and candles and bonfires are lit on the great Piazza della Madonna and in the surrounding hills to show angels the way. This heartfelt folk tradition ends late at night with the waving of white cloths to greet the divine arrival. Many of the faithful kiss the statue of the Man of Sorrows and the face of the Virgin of the Annunciation—as a result of which both works are badly worn.

It was once traditional to remove small pieces of the masonry to provide relics that people could touch, but this practice has fortunately been stopped—there would otherwise be nothing left of this sacred place. Nowadays little bells decorated with sky blue ribbons are sold, and these are said to ward off storms, hail, and all sorts of other misfortunes.

Santa Cristina, Bolsena

Situated on the eponymous volcanic lake in Lazio, the ancient town of Bolsena boasts many relics of its Etruscan past. Researchers have identified the area as a location for the Etruscans' central shrine to the god Voltumna and for this reason alone it is a sacred place, even if little is now known of this ancient civilization's religion.

Veneration of St Christina, a slightly better known tradition, is alive and well here. Mystery plays—a mixture of religious horror story and folk festival— are held in the town on July 24.

Christina was martyred in 304 and did indeed suffer some horrific treatment. Her pagan father took against her even when she was a child, locking her in a tower filled with gold and silver idols of gods. Christina broke up the statues and distributed the valuable fragments to ease the suffering of the local population. Her father was so incensed by this that he had her tortured. After being weighted with stones she was thrown into a nearby lake, but angels supported her above the water. After everything else had failed, her father ordered her beheading. This was not carried out, as he was found dead the next day, but a successor continued the torture. An iron vessel was filled with boiling oil and Christina was placed inside, but she simply praised God for placing her in a cradle like a newborn. Led naked before a statue of Apollo, she praised her God again, whereupon the statue of the pagan god crumbled into dust.

She was thrown to poisonous snakes, which entwined about her feet and left her unscathed. Her breasts were cut off but, instead of blood, only milk flowed out. After her tongue was torn out, she retained the power of speech and continued to praise God. She was finally killed with two arrows, shot into her heart. The Church of Santa Cristina now stands on the site where these gruesome events took place, and where the saint also lies buried.

Another miraculous occurrence has made Bolsena Cathedral an especially sacred place. Strange stains on the altar are said to be drops of blood, which appeared during the visit of a Bohemian priest who had doubts about transubstantiation (the transformation of bread and wine into the body and blood of Christ). According to the legend, blood flowed from the Host as he broke it, and this event lies at the heart of the feast of Corpus Christi, which is of great significance for Roman Catholics. The altar cloth with its bloodstains, the Corporal of Bolsena, is now kept in Orvieto Cathedral.

Cerveteri and Tarquinia

Despite the best efforts of researchers of archeology and art history, there is still much to learn about the Etruscans. It seems that many of their secrets passed into obscurity when they were conquered by the

Romans in the 4th century BC. The high point of Etruscan civilization dates back to the 7th and 6th centuries BC, but the Romans too lost any exact knowledge of Etruscan literature they may once have had. The Roman historian Livy did, however, know of the great importance to the culture of religion and pagan rituals.

Manticism, the divination of the will of the gods through omens, was a central feature of the Etruscan belief system—divine wishes were interpreted from the entrails of sacrificial animals (haruspicy), thunderbolts (ceraunomancy), and bird flight (augury). The instructions for the practice of these arts were recorded in books of oracles. As far as we can tell, the Etruscan pantheon was a varied one, and rather similar to that of the Greeks. Each of the gods had certain allotted tasks, and in addition there were demi-gods and demons of both sexes. There was a realm of the dead inhabited by divine beings, which was similar to the Greek Hades.

Almost everything now understood about Etruscan culture and religion is based on the archeological evidence recovered from their grave sites. It is known that their buildings had stone foundations but that everything else was made of wood. Made entirely of stone, their elaborate tumulus graves were the only artifacts able to withstand the ravages of time. The skillfully fashioned grave goods found in many of the early tombs display Assyrian, Phoenician, and Egyptian characteristics, with Greek influences being most identifiable in later finds.

As their power grew, the Romans wished to eradicate the memory of Etruscan history and to erase all reminders of this ancient civilization's influence. Why remains an unsolved historical puzzle, made all the more intriguing by the fact that the most famous bronzes produced by Etruscan culture were essential to Rome's self-mythologization—the *Capitoline Wolf* and *Brutus*.

The Etruscan burial practices appear to have been quite unique and enigmatic. Many of their tumulus graves are to be found in **Cerveteri**, a site matched in importance only by Tarquinia. An Etruscan grave is typically accessed via a flight of steps made of staggered stone blocks, which culminates in a stone lid. The tomb was then covered with earth and planted with vegetation.

In Cerveteri the graves are located close to one another and are typically family tombs, often with separate entrances. A rough-hewn stone pillar was placed in front of the entrance to indicate the grave of a male, while a small triangular stone house indicated a female. Some of the graves are even arranged like furnished rooms, with the occasional terracotta domestic utensil. It is difficult to escape the hypnotic power of these graves, perhaps for the very reason that our knowledge of the religious obsequies and conceptions of the afterlife that underlie them is so incomplete.

Tarquinia is rather similar, It too is located in Lazio, only 3 miles (5 km) from the Tyrrhenian coast, and the Old Town is situated on a hill above

the Maremma Laziale. The town has changed its name several times, becoming a diocese in the 8th century, and now boasts many impressive monuments from Christian art and culture. However, the really sacred place here is the Monterozzi necropolis about 3 miles (5 km) southeast of modern Tarquinia, featuring more than 6,000 tumuli, carved in the rock between the 6th and 2nd centuries BC. Not all the tombs have been excavated—their number has been estimated using geophysical echo-location—but this is certainly the largest known agglomeration of Etruscan burial sites. Many of the tombs are skillfully decorated with frescos, which provide some clues about the Etruscans' ideas about life and the afterlife.

The most important of the tombs have been named after the motifs used in the decoration: the augury tomb, the hunting and fishing grave, the lionesses grave, the bulls grave, the flogging grave, and the particularly informative grave of Orcus, the god of the underworld. Graves from later than the 4th century BC have been found to contain stone sarcophagi decorated with representations of the departed in a reclining position and reliefs on the coffin walls—stone life stories, opening a window onto the world of the deceased.

Roman culture has significant Etruscan roots, and it is fortunate that at least some of the most important, captivating, and graceful remnants of this otherwise lost culture have survived.

A tumulus grave, Cerveteri

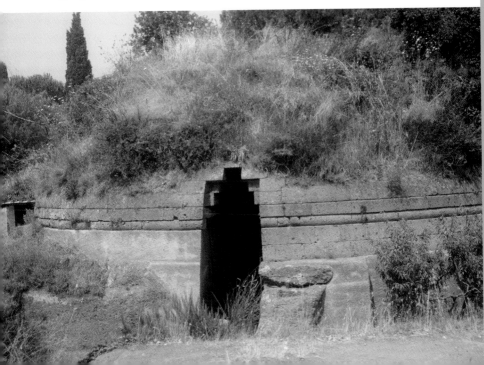

ROME, THE ETERNAL CITY

All roads lead to Rome, as the Romans have always said. Before there was Rome there was nothing, or at least not much, certainly as far as the Romans were concerned.

According to legend and Roman historians, the city of Rome was founded in 753 BC, but this is not entirely correct: in Roman terms the city was of course founded in the year 1. For centuries, into the 8th century AD, the Romans numbered years as a.u.c.—*ab urbe condita*—from the founding of the city.

The founding of the city represented the beginning of an age of achievement and empire, with Rome its capital—*Roma caput mundi*. Rome is the apotheosis of a city—there are and have been in the past many other impressive cities on earth, but Rome remains eternal—*Roma aeterna*. For the Romans, *urbs* referred to Rome and no other city.

The city is built on seven hills (Aventine, Caelian, Capitoline, Esquiline, Palatine, Quirinal, Viminal) and it takes its name from Romulus, the first king of Rome. He and his twin brother Remus were born to the princess Rhea Silvia of Alba Longa (in the Alban Hills) after Mars, the god of war, raped her. According to

a 3rd-century legend still recounted today, Rhea Silvia shunned the twins but the god saved them from death, sending a wolf to suckle them. The most famous Roman sculpture is of the she-wolf suckling the twin boys, which can be seen in the Capitoline Musem, on the shirts of AS Roma's footballers, and at countless other locations across the city.

Having decided to found a city, Romulus climbed the Palatine Hill, and Remus the Aventine; they agreed that whoever saw the most birds in flight would become ruler. Remus saw six birds but Romulus saw 12, and

as the victor he took a plow and carved a square furrow to indicate the boundaries of the settlement and the course of the city walls— *Roma quadrata*. Remus jumped contemptuously over the (rather low) boundary wall and was killed by his brother—the first politically motivated murder in the city, but not the last.

There is so much beauty in Rome that it can be breathtaking, and yet there is also so much chaos that you could almost curse the place. Those who fall in love with Rome usually do so for life. Rome is a unique experience for the senses.

Nowhere else on earth is there so much to overwhelm the visitor: the greatest and richest museums in the world, the finest and most beautiful churches, stunning remnants of a glorious classical past, and countless artistic masterpieces. Rome is unbeatable—even the sunsets are indescribably beautiful, with the sky glowing red, pink, and violet, the countless domes shimmering in a magical light, and the dark green pine trees wafting gently in the breeze.

Rome is almost too beautiful to be true, but it really does exist and it is like no other city on earth. From the head of the Roman Catholic Church to the lowliest priest, from the president of Italy to the humblest street sweeper, from an artist to an ordinary citizen, from the civil servant and craftsman to the owner of one of the tiny kiosks found everywhere on its streets— every inhabitant of Rome wants to be nowhere else but here in this city, where even the cobblestones on the streets, known as *sanpietrini*, are sacred. Today, as ever, all roads lead to Rome.

Monte Mario

Rome has been one of the most important pilgrimage sites since the earliest days of Christianity—everyone who was able to make the journey traveled to Rome at least once in their life. The tradition of regarding a low hill as holy dates back to a time when people journeyed from place to place on foot. Such a hill is to be found on the northeastern edge of the city: Monte Mario. It was also known as the Hill of Joy (*Mons Gaudii*), as new arrivals from the northwest caught their first, splendid panoramic glimpse of the city from here.

Pilgrims coming from this direction had followed the old Via Francigena from Canterbury to Rome, and after a long and arduous trek they were to reach the end of their journey after climbing this last hill. The Eternal City lay at their feet, all the trials and privations suffered en route were entirely forgotten. Those who climbed Monte Mario could see that the object of their longing was within touching distance. This is a particularly affecting moment for anyone who is on a journey: to reach one's destination, to arrive at the end of the road.

Monte Mario, where the joy of achievement can be felt both physically and spiritually, has long been a sacred place. Even if modern visitors usually arrive in town via a different route, with few passing by Monte

St Peter's Square, Rome

The seven pilgrimage churches of Rome

The first pilgrims came to Rome in search of the tombs of the apostles Peter and Paul and the churches built above them (San Pietro and San Paolo fuori le Mura). San Giovanni in Laterano, the papal see, Santa Maria Maggiore, one of the oldest Marian churches in Christendom, and San Lorenzo were later added to the list. The patriarchal basilicas represent the totality of the world to which the Christian gospel was addressed: San Giovanni in Laterano belongs to the Patriarchate of Rome, San Pietro (St Peter's Basilica) to that of Constantinople, San Paolo to Alexandria, Santa Maria Maggiore to Antioch, and San Lorenzo to Jerusalem. This gave rise to a spiritual journey through Rome that offered a treasure house of history and traditional belief. Since the introduction

of the Jubilee in 1300, millions of pilgrims have been on this journey and events in Christ's Passion have become officially associated with certain churches. In 1552 Filippo Neri described a route that is still followed by pilgrims today. It begins at San Pietro (St Peter's) and continues on to San Paolo fuori le Mura. The third station is San Sebastiano, with its catacombs, on the Via Appia Antica. From here the path returns to the city and San Giovanni in Laterano, before reaching Santa Croce in Gerusalemme. Next is San Lorenzo fuori le Mura, and the last station is Santa Maria Maggiore. Pilgrims meditate on the various events of the Passion along the whole route. The path turns Rome into a second Jerusalem, and those who follow it are tracing the last footsteps of Jesus.

Mario, the "Hill of Joy" is a palpable sign that every path has a goal and that those who reach it, when- ever that may be, should rejoice.

St Peter's Basilica, Rome

St Peter's is unique. It is the larg- est, the most famous, and the most magnificent cathedral in Christen- dom and the epicenter of the Catholic Church, a religious institution whose

influence has been felt across the world for more than two millennia. Not only is the pope's residence to be found here, but so too are the "Holy See," as recognized by international law, and the largest palace complex in the world. And in the middle of the capital of Italy there sits the small- est sovereign state on earth. The Basilica di San Pietro and the Vatican are so extraordinary that it is diffi- cult to find the words to describe this astonishing collection of buildings.

St Peter's Square and Basilica are now reached along the Via della Conciliazione, a magnificent boule- vard laid out by Mussolini to cement the Lateran Pacts and as a sign of

reconciliation between the Italian state and the Catholic Church. The end of the avenue links to Bernini's St Peter's Square, an oval-shaped space flanked by two mighty colonnades which seem to welcome and envelop visitors at the same time. In the center of the piazza is a towering Egyptian obelisk erected by Pope Sixtus V.

The building history of St Peter's and the palaces of the Vatican is extremely convoluted. The first church was built over the tomb of the apostle Peter on a little hill beyond the city walls at the beginning of the 4th century. Old St Peter's was built as a five-naved basilica with a transept and an apse, but during the course of the papal exile in Avignon this church fell into disrepair.

Once the papacy had returned early in the 15th century Nicholas V, himself a Roman, called for donations to fund a new building. However, the project was not to be seriously addressed until the reign of Julius II (1503–13), and over the course of the next three centuries almost every pope took a hand in directing the project. More and more designs were produced and the leading artists of each age were employed. Michelangelo proposed a symmetrical cruciform design but changes in the liturgy prompted Paul V (1605–21) to demand alterations to the plans, with an extension of the nave and the transept to form a Latin cross. Carlo Maderna was entrusted with the task and oversaw the addition of the façade and the completion of the building in 1614. Pope Alexander VII commissioned Bernini to design the double piazza in front of the building, and this was completed in 1667.

Two equestrian statues are immediately apparent as you enter the portico, the ancient Roman emperor Constantine to the right and the new, Holy Roman emperor Charlemagne to the left. The huge bronze door, created by Filarete of Florence, was made for the old cathedral and depicts Christ and the Virgin Mary flanked by the apostles Peter and Paul, who are immediately recognizable through the symbols of their martyrdom by crucifixion and beheading. The bands of reliefs depict historical scenes and the frieze around the outside is decorated with motifs from classical mythology. The scenes on the door express the universal claims of the Church

It is impossible to resist entering the basilica. The interior holds untold art treasures, the greatest of which is Michelangelo's *Pietà*. At the age of

The statue of St Peter in St Peter's Basilica

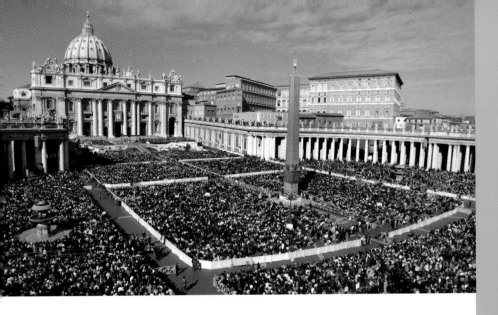

The faithful gather on St Peter's Square in front of St Peter's Basilica

only 25, the artist produced a work whose intimacy and delicate psychodynamic portrayal of pain is without rival. The tombs of various popes are to be found in the side chapels, but the tomb of the apostle Peter occupies the focal point of the church. The saint lies beneath the huge canopy designed by Bernini, which in turn is directly beneath the basilica's enormous dome. Practically every detail of the interior is associated with Peter in some way, including the wonderful bronze of the apostle attributed to the medieval master sculptor Arnolfo di Cambio, which is particularly revered. Visitors come from the four corners of the earth to touch and kiss the apostle's foot, in the process wearing it smooth.

St Peter's Basilica holds other revered relics, four of which are represented by statues in niches in the four pillars that support the dome: a part of the lance used to pierce Christ's side, a piece of St Andrew's cross, a fragment of Christ's cross brought from Jerusalem by Helena, the mother of the emperor Constantine, and St Veronica's veil. The latter, an image on cloth known since the 12th century, is said to be the *sudarium* with which a woman wiped Christ's face on the way to Golgotha. An image of the face of Christ, "not painted by human hand" (a so-called *acheiropoieton*), remained on the cloth as a "true image" (*vera icon*). The unknown woman was thus named Veronica.

Discovering the works of art that are in the basilica is an undeniably thrilling experience, but more important still is the realization that this is a place of faith and the center of a religious conviction. Whether visitors

share this conviction or not, St Peter's and its square exert a compelling fascination that is hard to resist.

The vast underground crypt is known as the Vatican Grottoes. When Antonio da Sangallo raised the floor level by around 10 feet (3 m) in 1546, to protect the building from damp, a space was created in which many of the popes were to find their last resting place. Many of the tombs are the work of the finest artists of their time. Every day, large crowds of the faithful come to pray at the tombs of the late popes Pius XII (d. 1958), John XXIII (d. 1963), and John Paul I (d. 1978). Since spring 2004 the simple grave of John Paul II has attracted an incredible amount of attention.

beheaded around the year 67; after the sword blow, his head bounced three times as it hit the ground, and a spring began to flow at each point. The body was then buried a few miles away on the Via Ostiensis—the small Church of San Paolo fuori le Mura marks the spot.

Little is now known of the early Christian church built by Constantine over the original *tropaeum* (memorial), but the 4th century saw the construction of a massive, five-naved basilica,

The cloisters of San Paolo fuori le Mura, Rome

San Paolo fuori le Mura

The tomb of St Paul is situated a long way outside the city walls. Or so it is assumed— there have been only a few excavations of the site, though St Paul has certainly been worshiped here since the 1st century. He is said to have been

the largest church in Christendom until the building of St Peter's. This burnt to the ground in 1823 but was rebuilt according to the old plans. Many ecclesiastical art treasures can still be found in the huge new church, including an altar ciborium by Arnolfo di Cambio. The Paschal candelabrum is a unique medieval masterpiece combining old pagan motifs with Christian iconography.

By far the most famous of the decorative elements of the church is the frieze of portraits of all the popes, from Peter to the current incumbent. Legend has it that when there are no spaces left in the frieze, the Day of Judgment will be at hand—the day when this world will end, either in catastrophe or with liberation into eternal peace.

The number of free spaces points toward two conclusions: that the end of the world has not yet come, but also that its time is now not too far away. There are only enough spaces for just a few more popes. Whatever your views on this legend, the faces of visitors as they pass by the sequence of portaits reveal a mixture of awe and curiosity, as thoughts of the end of the world pass through their minds.

To ponder the matter more closely you can visit the cloister of the adjoining Benedictine monastery; this dates back to the early 13th century and is considered one of the most beautiful cloisters in the Western world.

San Sebastiano fuori le Mura

Sebastian was captain of the Praetorian Guard to the emperor Diocletian, who had noticed the young man's intelligence and beautiful physique. The emperor was unaware that his favorite had become a Christian and was going to great lengths to help his oppressed and persecuted fellow believers. When Sebastian was finally denounced, the emperor was so enraged that he ordered his archers to kill him. Seemingly dead, Sebastian was nursed back to full health by St Irene and fearlessly continued to bear witness to his faith, even to the emperor, who eventually had him executed.

The Christians buried his body close to the tombs of the apostles Peter and Paul, who at the time were interred in the catacombs on the old Via Appia Antica. A church was later built above the catacombs and this was dedicated to St Sebastian at some point in the 7th or 8th century. The saint's relics are preserved in the crypt of the current single-naved building. An arrow from his martyrdom is kept near the altar, where there is also a piece of marble bearing Christ's footprints— legend has it that Jesus appeared to Peter when the latter was about to flee Rome in fear. San Sebastiano is one of Rome's seven pilgrimage churches, and is visited by pious pilgrims not only to receive remission from sin but also to help them find their way in a confused and confusing world.

San Giovanni in Laterano

The Archbasilica of **St John Lateran** is the ecclesiastical seat of the pope and thus the cathedral of the Church of Rome.

The altar ciborium, San Giovanni in Laterano, Rome

St Peter's is the seat of the head of the Roman Catholic Church, which is also the pope. The two offices are not identical, however, even if the same person fills them—the pope is both the head of the global Church and the bishop of Rome, the latter office lending this church a certain status among Rome's countless places of worship.

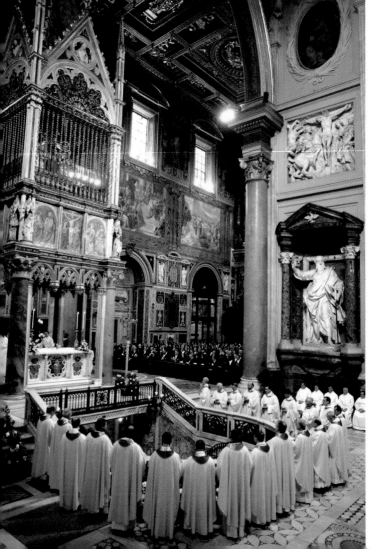

A Christian church has stood here since the early 4th century, and the modern high baroque façade immediately confronts visitors with the Roman Catholic Church's self-proclaimed position as the *mater et caput omnium ecclesiam urbis et orbis* ("the mother and head of all churches in the city and the world"), which is clearly inscribed across two friezes. Construction of a Christian basilica, initially dedicated to the Redeemer, was begun in the year 313. The following centuries saw the church repeatedly damaged, renovated, restored, extended, and altered until extensive

work undertaken in the 16th and 17th centuries gave it the appearance it has retained to this day.

In the Middle Ages, the church was consecrated to two further saints, John the Baptist and John the Evangelist—the name San Giovanni refers to both of these. Flanked by the 12 apostles, they stand in effigy on either side of Christ on the roof of the façade. The monumental statues are over 22 feet (7 m) tall and can be seen from all over Rome. The interior of the five-naved basilica was designed by Borromini, one of the finest baroque architects and sculptors in Rome. The arches of the central nave are supported by mighty buttresses and a colossal statue of one of the 12 apostles stands in a niche in each pillar.

The holy of holies is hidden behind a railing. Dominating the church from its location above the high altar, the ciborium conceals two of the most important relics in Christianity: the heads of the two greatest apostles, St Peter and St Paul. Truly sacred, they are displayed to the faithful for special veneration on high feast days. The mosaics in the apse are exquisite, as are the several papal tombs, the floor, and the ceiling.

The cloister is both an exceptional example of medieval artistry and also a place of reflection and meditation.

On the other side of the street is a much less spectacular building whose interior nonetheless houses a relic of great holiness, the **Sancta Scala** ("sacred staircase"), which according to legend is from the palace of Pontius Pilate in Jerusalem. Helena,

the mother of the emperor Constantine, brought back 28 marble steps from her pilgrimage to the Holy Land. Though these are now clad in wood, the religious practice has remained unchanged: pious pilgrims climb the stairs on their knees, praying on every step, to commemorate Jesus' Passion and in the hope of saving their souls.

Santa Croce in Gerusalemme

As with all the churches in Rome, and indeed sacred sites the world over, there are stories and histories associated with this holy place that have been kept alive over the centuries. Santa Croce in Gerusalemme is one of the seven pilgrimage churches that a pious Christian is supposed to visit in a single day (including the vigil on the previous evening). The modern church's foundations date back to the 4th century. After his mother Helena's death, the emperor Constantine consecrated a hall in her house as a chapel to safeguard the relics she had brought back from the Holy Land, and in the 12th century a Romanesque church was built on the ruins of this hall.

The modern church is in the Roman high baroque style. To the right of the apse is a staircase leading down to the Chapel of St Helena, where there is a statue of the empress carrying a simple wooden crucifix as a symbol of the

fragments of the True Cross that she brought to Rome. In her left hand she holds two of the nails that were hammered through Christ's limbs. At her feet there are countless notes with petitions and prayers written by believers who hope the saint will champion their cause.

The relics are even more sacred, and are kept in a separate chapel to the left of the apse. There is a piece of the Cross, brought from Jerusalem, a nail from the Crucifixion, a fragment of the panel being the inscription INRI (Jesus of Nazareth, King of the Jews) placed on the Cross by Pilate, the index finger of Doubting Thomas, thorns from the Crown of Thorns, and lastly some pieces from the grotto where Jesus' crib is said to have stood. In a wing of the chapel there is a copy—authorized of course—of the Shroud, the original of which is kept in Turin. All in all, as the French diplomat Chateaubriand concluded, this is a place "to make peace with ambition and to consider the world's vanities."

San Lorenzo fuori le Mura

Situated beside the Aurelian Walls, but still technically beyond them (fuori), this sacred site is one of the seven pilgrimage churches of Rome. Believers who visit all seven churches are promised remission of their sins in order to escape the punishment of hell. The route taking in all seven churches may not be an easy one, but it is still far more pleasant than the road to hell, from which there is no escape. This three-naved basilica is dedicated to St Lawrence, who was martyred on a red-hot griddle in 258. The marble slab and the holes through which the flames flickered can be seen in the lower section of the church.

The first structure was begun in 330, during Constantine's rule. This was altered and extended, particularly under Pope Pelagius (578–90). The most recent alterations were undertaken in 1890. San Lorenzo was badly damaged in World War II and subsequently restored according to plans dating from 1864.

The church consists of two separate buildings, constructed so that they adjoined one another with their apses facing. One was consecrated to St Lawrence, the other to the Virgin Mary. The typical structure of this early Christian basilica is serenely beautiful. Elegant, skillfully crafted columns topped by Ionic capitals punctuate the interior at regular intervals. The word of God is proclaimed from two marble pulpits, among the most beautiful in Rome. The Paschal candelabrum and the simple and elegant ciborium reinforce the spiritual atmosphere. Entering the cloister is like stepping into another world distinguished by an old-fashioned simplicity and tranquility. The free-standing Romanesque campanile can be seen for miles around. The Campo Verano, the largest cemetery in Rome, lies next to the church, and here visitors can meditate on life, death, and eternity.

Santa Maria Maggiore

The Virgin Mary appeared to Pope Liberius in a dream on the evening of August 4 352. To his considerable surprise, he was commanded to build a church on the place where it snowed the next day, and indeed, the next

The main façade, Santa Maria Maggiore, Rome

day snow had fallen on the Esquiline Hill in the shape of the floor plan of a basilica, or so the legend has it. Regardless of whether this is actually true or not, the festival of the Miracle of the Snow is still celebrated today. The church has stood here since the 4th or 5th century and is said to be the only church where a Mass has been held every single day since it was built. The original building was later extended and altered several times, and one of the church's peculiarities is that the front looks completely different from the decorative rear façade. The church tower, built in 1377 on the occasion of the return of the pope and his retinue from Avignon, is 250 feet (75 m) high and thus the tallest campanile in Rome. The main façade was designed by Ferdinando Fuga in 1743, and the imposing wooden ceiling is gilded with gold leaf that the Borgia pope Alexander VI is said to have received as a gift from the king of Spain, who had looted it from America. The mosaics on the façade, and especially those in the interior, are without doubt some of the finest and best preserved in Rome. The two side

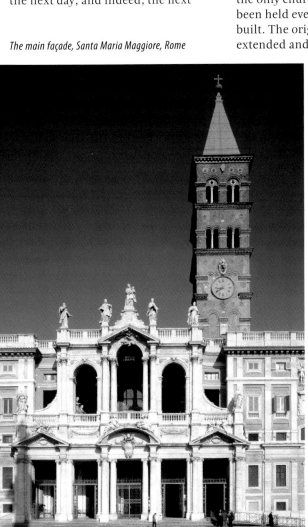

EUROPE

chapels in the transept—the Paolina to the left and the Sistina to the right—are also noteworthy. With many decorative features, both in terms of its detail and taken as a whole, Santa Maria Maggiore is a unique work of art. The interior is one of the most beautiful in Rome and many visitors find it difficult to tear themselves away from this serene place. The mosaics in the apse and on the triumphal arch depict Old and New Testament themes, with particular emphasis on the Crowning of the Queen of Heaven.

Relics from Jesus' crib are kept under the altar, while centrally placed on the richly decorated altar of the Cappella Paolina is a Miraculous Image of the Madonna and Child, which is said to have been painted by the apostle Luke, but actually dates back only to the 13th century.

Santa Prassede

This church is documented toward the end of the 5th century, but its current appearance is the result of extensive alterations undertaken by Pope Paschal I in 882. Further work in subsequent centuries has also left its mark. The church is consecrated to St Praxedis, who proved her mettle during the persecution of the early Christians. The three-aisled nave is separated from the apse by a small transept, and a round slab of porphyry in the middle of the central aisle marks the spot where, it is said, the bodies of numerous martyrs are buried in a chamber. The church is therefore an allegory of how even the dead can find security and protection.

The mosaics in the apse and on the triumphal arch are of particular note, as they illustrate a rather rare theme: the heavenly Jerusalem (from Revelation 21), a utopian divine city in which peace and justice reign and neither pain nor tears exist. This biblical concept alone is enough to make this an especially sacred place. The famous side chapel of St Zeno, also known as the "Garden of Eden," is the funerary chapel built by Paschal I for his mother, Theodora. "Eden" and the "heavenly Jerusalem" together form the beginning and end of God's history with man.

There is an extremely important relic in one of the side niches: an old pillar, brought from Jerusalem by the Roman cardinal Colonna in 1223 after the Sixth Crusade. It is said that Jesus was scourged at this pillar, and it serves as a physical reminder of Christ's Passion. Lastly, the relics of St Praxedis and St Pudentiana, the two daughters of the Roman senator Pudens, are kept beneath the main altar.

The Pantheon

Nothing could be simpler! A cylinder beneath a half sphere—that's all, providing you don't count the portico

with its triangular tympanum and its monolithic columns. Plain, faultless, a work of genius—perfection is always an expression of the simple and the elementary. The architectural harmony of the Pantheon is a lesson in measure and proportion even for modern man. The Pantheon is the best-preserved and least-changed building to survive from Roman antiquity. The inscription above the entrance, M AGRIPPA L F COS

The Pantheon, Rome

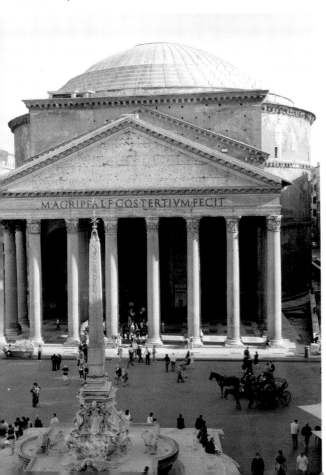

TERTIUM FECIT ("Marcus Agrippa, son of Lucius, had this temple built when he was consul for the third time"), is misleading, as the current building is a replacement constructed by the emperor Hadrian (120–125 BC) to replace the original, which had burnt down. There is still some disagreement over whether the original temple was dedicated to an omnipotent god, the divinities ruling over all the Romans, or the seven sacred planet gods, Neptune, Saturn, Uranus, Jupiter, Mercury, Venus, and Mars. The last suggestion is the most plausible, as the ceiling of the dome is decorated as a starry sky, with a 30-foot (9-m) occulus, representing the sun in this interpretation.

The Pantheon's history has been a turbulent one. This superb building has survived fire, earthquake, flooding from the Tiber, looting, dismantling, alterations and renovations more or less unscathed. The introduction of Christianity as the state religion in the 4th century ended the Pantheon's time as a pagan shrine. When, long after the demise of the Western Roman Empire, the

Byzantine emperor Phocas gave the building to Pope Boniface IV in 609, the pope had the bodies of countless martyrs buried here, consecrating the whole building to the Virgin Mary and all those who had paid in blood for their beliefs. It has since also been known as the Church of Santa Maria ad Martyres. Legend has it that the pope had bones brought into the Pantheon by the wagonload to defeat the pagan gods. The day of the church's consecration (November 1) has since become All Saints' Day, a major feast day and day of remembrance for the Roman Catholic Church.

Every visitor to the Pantheon, whether a believer or not, will get a sense of the sacred order and geometry expressed in its harmonious beauty.

Santa Maria sopra Minerva

During Domitian's reign there was a temple to the immediate southeast of the Pantheon, dedicated to the goddess Minerva. The Marian church built in 1280 on what were believed to be its ruins was thus called "sopra Minerva." It is now known that the church does not stand directly on the site of the temple, but the name has stuck. The plain Renaissance façade of 1453 betrays no sign that the only Gothic church in Rome is hidden behind it. The Dominicans have run the church

for centuries and the order's Vicariate General is located next door, to the left. During the Counter-Reformation, the order's headquarters served as a court of the Inquisition.

The church's interior is serene, with many features both of aesthetic interest and of particular sacredness. The famous Carafa Chapel could be interpreted as a sermon by Thomas Aquinas—the *Scenes from the Lives of the Saints* and the *Triumph of the Saints over the Heretics* are a reminder that wisdom, perseverance, and belief will lead to salvation. The tomb of St Catherine of Siena, a mystic who had agitated for the return of the papacy from exile in Avignon and for the unification of Italy, is accorded special reverence. She died in Rome in 1380 and is remembered fondly for her actions on behalf of her country.

Michelangelo's *Christ the Redeemer* is to be found here, a statue that evoked outrage when it was first unveiled: the Savior resembles a classical hero rather than a suffering servant of God. Worship of the Divine is nonetheless also associated with those people who create art in order to convey to observers that behind the visible lies a hidden world of ideas that can shape and change that visible world.

The central aisle, Santa Maria sopra Minerva, Rome

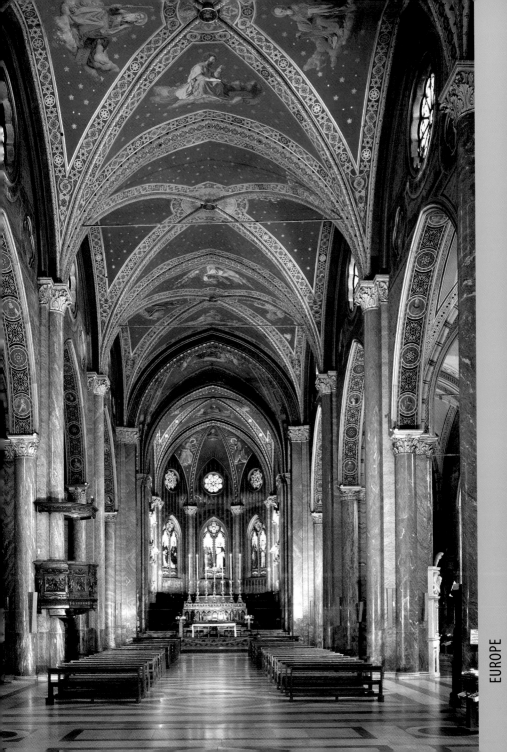

The Capitoline Hill and Santa Maria in Aracoeli

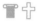

Located in a district that was the most sacred area of classical Rome, the **Capitoline Hill** was the center of religious and political life. It is one of the seven hills on which the city was built, and is certainly the most famous of these—it is no coincidence that the centers of power elsewhere in the world are called capitols. The hill has two flattened summits—on one stood the Arx, the central Roman fortress and the scene of the initial bitter fighting and the place from which the augurs watched the flight of birds to foretell the future. Opposite, on the other, stood the most magnificent and sacred temple in Rome, the Temple of Jupiter, conse- crated to the father of the gods. The

appearance of the Capitoline Hill today dates from the Renaissance.

Visitors approaching the foot of the hill will find themselves at the base of two long flights of steps. The 122 steps on the left lead up to the **Church of Santa Maria in Aracoeli**—visitors climbing these steps could be forgiven for thinking they are climbing a steep stairway to heaven. Once at the top, they are immediately confronted with a severe, 13th-century brick façade. The door on this side of the church is often closed, which could be inter- preted symbolically—a path that is direct occasionally leading to a locked door, making it necessary to reach your destination via a side entrance. Dedicated to the Virgin and run by the Franciscans, this beautiful church has another name—the "Altar of Heaven" (Aracoeli) —taken from an old legend which told how one day Augustus had a vision of a beautiful maiden with a child in her arms, who announced in a voice from on high: "This is the altar of God's son." Augustus, so the story goes, fell to his knees and built an altar for Him.

The church's interior is richly decorated, from the precious floor of Cosmati, inlaid ornamental mosaic-work, to exquisite tombs and the impres- sive coffered ceiling. Columns dating back to the classical period

Santa Maria in Aracoeli on the Capitoline Hill, Rome

support the central nave. The third pillar on the left side is particularly enigmatic, as there is a curious hole at eye level, bored at an angle through the marble and presumably used for ritual observation of the sky and heavenly phenomena. Whether employed in pagan rituals to foretell the future or in Christian worship, this church demonstrates how the Divine survives through the ages, however things change.

Forum Romanum

No other place reflects the fortunes of ancient Rome as closely as the **Forum Romanum**, for many centuries the most splendid square in the Empire. The site was once outside the boundaries of the settlement (*forum* in Latin, *fuori* in Italian = located outside), which is not surprising as the area was originally marshy lowland. However, in the 6th century BC it was dried out for the construction of the Cloaca Maxima, providing a place for assemblies and the building of shrines. After the decline of the Western Roman

The view from the Palatine Hill over the Forum Romanum

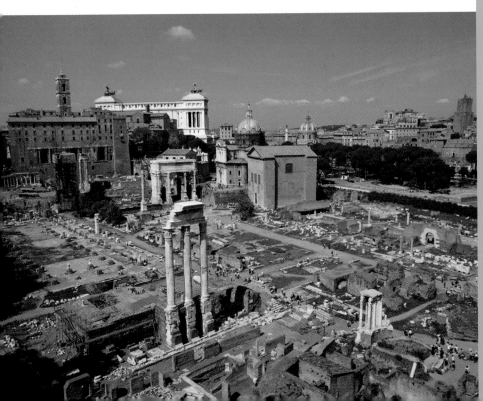

Empire, most of the buildings were left derelict. The forum was later pillaged and looted, and the ancient structures collapsed or were cannibalized to recycle material for other buildings. The last few remnants gradually sank beneath the earth and the Forum Romanum became grazing land.

At the end of the 18th century the forum started to attract interest again and the search began for its ruins. Systematic excavations have been carried out since 1870, after the foundation of the modern Italian state. The remains that have been found are testament to the greatness and audacity of the people who built them. We know that the Roman rulers were worshiped as gods or as incarnations of the gods, but quite what constituted ancient Rome's notion of divinity is still largely unclear.

Perhaps one building is deserving of special mention here, as a symbol of all the others: the **Portico of the Dei Consenti** at the foot of the Tabularium, now the Senatorial Palace. Once part of a pagan shrine, only nine Corinthian columns and a portion of the portico have survived—statues of the 12 most important gods of the classical pantheon were once placed in their niches in pairs (Latin *consentes*). An inscription relates how the statues of the gods were reinstalled in AD 367—a pointed protest against Christianity, which had been recognized as the state religion and was spreading ever more rapidly. This pagan shrine, of which only a few ruins remain, was a visible manifestation of what has always been invisible—the physical presence of the gods.

Santi Cosma e Damiano

The land between the Forum Romanum and Vespasian's Forum constituted one of the most sacred areas in ancient Rome, and a single-naved church consecrated to the two martyred doctors Cosmas and Damian now stands on the site.

Built by Pope Felix IV in the 6th century, it incorporates two separate ancient buildings into its structure. Visitors initially encounter a baroque façade, but the inside is one of the most expressive mosaics from the early Christian period, representing the Giving of the Divine Law. Christ is shown appearing from a dark blue sky, signifying eternity, and handing the scrolls with the eternal law to the apostles Peter and Paul. Two doctors, Cosmas and Damian, accompany the two apostles. That St Theodor and the church's benefactor, Felix IV, also feature at the side of the design is a quirk of art history, but the apse mosaic is, in general terms, a representation of how an eternal law with the power to sanctify a life is passed on.

The largest and most precious Christmas crib scene in the city is to be found in an adjacent room, a sacred place of popular devotion. Christmas nativity scenes are holy in their own way, as they bring into the present for people today the miraculous and world-changing events that took place in Bethlehem.

The Mamertine Prison

This sacred place is in fact anything but—it was one of the oldest and most appalling prisons of ancient Rome. The early 17th-century church of San Giuseppe dei Falegnami stands at the far end of the Forum Romanum, but few people who come here are interested in the church. Instead they climb down into the dungeon, once the only prison in Rome. It consists of two rooms, one above the other. The lower of the two is now accessed via a narrow staircase, although this was once only a hole in the ground. Called the Tullarium, the lower vault dates back to the 6th century BC and is thought to have been constructed as a water cistern.

Many of the enemies of Rome died in this crypt-like room. One medieval legend claims that the apostles Peter and Paul were incarcerated here, awaiting their deaths chained to a pillar, which can still be seen. An altar on the upper floor commemorates the imprisonment of the two great apostles.

Legend or not, this sacred place provides a graphic illustration of how some people are prepared to suffer and even to die for their beliefs. It is a reminder that death means nothing to people of great conviction. Visitors will leave here with a shudder and a sense of relief as they step out into the fresh air and southern sunshine of the Eternal City.

The Mamertine Prison beneath the Church of San Giuseppe dei Falegnami, Rome

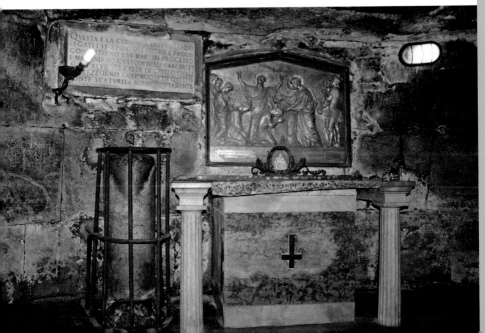

EUROPE

San Clemente

Follow the narrow
street down from
the Colosseum to
the Lateran and you
will reach a church
that has a par-
ticular status among
Rome's countless
places of worship.
The history of the
building of San Cle-
mente is fascinat-
ing, as not only are
there two churches
built one on top of
the other, but there
is also an ancient
Mithraic shrine,
which in the ancient
world was a major
cult, comparable
with Christianity.

The 11th-century
upper church is now
accessed via a side
entrance, revealing
the classic struc-
ture of a Christian place of worship.
There is a courtyard with a little well,
a main portal, and a three-aisled
nave supported by classical columns.
The floor is decorated with Cosmati
inlay work of exquisite beauty, and
the whole area has been decorated
with features from the lower church,
imbuing it with an atmosphere of
blissful solemnity. The apse mosaic
is particularly striking, depicting the
crucified Christ with 12 doves (the

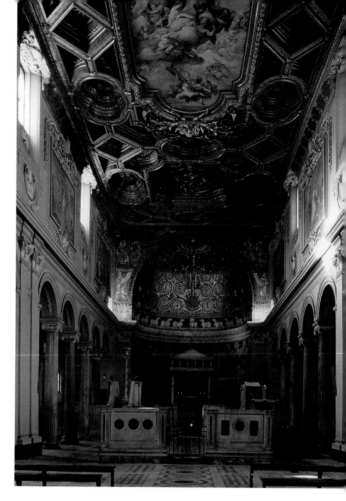

The Upper Church, San Clemente, Rome

apostles) and the Virgin Mary; many
symbolic images are interspersed
among these (deer, peacocks, lambs)
as well as several everyday scenes.
The small side chapel at the back
contains well-preserved Renais-
sance frescos recounting the story of
St Catherine of Alexandria, who was
tied to a wheel and burnt for her faith.

The lower church, which lies about 17 feet (5 m) beneath the modern upper church, was discovered only by chance in 1857 by the Irish abbot of the adjacent monastery and was excavated in the following years. It too is a three-naved pillar basilica, with numerous frescos, some of which are very well preserved. Visitors climb from this lower church into an excavated Roman dwelling, which may have belonged to St Clement's father. This is a long room with a barrel roof and an altar area dedicated to the god Mithras. A statue of this Aryan god of light stands in a niche, but it is only a copy—the original is now in the Vatican Museum. San Clemente exemplifies how the Divine can be still be worshiped at some places, even though the buildings themselves become derelict—the Divine outlasts time.

The ancient icon of the Madonna is said to have had regular conversations with him. The old monastery cemetery and the three chapels of St Barbara, St Andrew, and St Sylvia (Gregory's mother) are located beside the church. The stone table in the Chapel of St Barbara is particularly revered because, according to legend, Gregory would provide food here for 12 pilgrims or paupers every day. This sacred place illustrates how hospitality and generosity can sanctify a person. Both of these are among the ancient virtues, and modern man would do well to observe them, as they have the power to bring peace.

San Gregorio Magno

In 600 St Gregory himself built a Benedictine monastery on the spot where the church now stands. The monastery did not survive, and the church, rebuilt in the Middle Ages, now sports a baroque façade dating back to 1633.

The church is reached via a steep flight of steps and, despite the baroque ornamentation, its original basilica form is still visible inside. You can see St Gregory the Great's cell and the step on which he slept, his episcopal throne, and his reliquary.

Santa Maria della Vittoria

The medium-size Church of Santa Maria della Vittoria is situated at the furthest edge of the Baths of Diocletian, amid the roaring traffic of a bustling crossroads near the main station. It was built at the beginning of the 17th century by Carlo Maderna and is a reminder of the turmoil experienced by Europe after the Reformation. The church was dedicated to the Madonna after the Catholic victory achieved by the Austrians over the Protestants at the Battle of the White Mountain. The rich ornamentation is typical of Roman baroque, and the space is so crammed with imagery and decorative features that visitors will struggle to see individual details.

The sacred place of this church is to be found in the last chapel on the left-hand side. It contains the world-famous statue of the *Ecstasy of St Teresa*, created by the sculptor Bernini in 1648, along with the rest of the chapel. Contemporary reaction to the image of the rejoicing Teresa was mixed, ranging from admiration to outright rejection. The mystical experience described by Teresa in her life story is depicted in such a life-like way that some critics perceived a celebration of physical love, not religious reverence. Even the untutored observer can see how this evocation of a spiritual experience could be mis-interpreted as erotic excitement—the angel aiming his lance at Teresa's heart could just as easily be the clas-sical Eros, and mystic ecstasy could be read as sexual arousal. It is no wonder that the statue was interpreted as an attack on the Church's moral posi-tion, although Bernini never person-ally responded to this criticism. The work of art rises above such reproaches in any case, surprising the observer with the extent to which religious experience can overtake a person, transporting them to another realm.

Santa Maria del Popolo

At one time a nut tree in which devils and demons were said to have lived stood on this site, over Nero's grave. It later became a different kind of sacred place, the site of a gallows, where executions were carried out. In 1099 a small chapel was erected—paid for by the local populace (Italian: *del popolo*)—to try to tame the evil spirits. The church was altered and extended in the 13th, the 15th, and again in the early 16th centuries and is now a three-naved structure with a domed crossing.

The whole church is full of unique chapels and works of art, which are among the greatest treasures of the Renaissance and baroque periods. There are paintings by Pinturicchio and his pupils (especially in the Cappella della Rovere), works by Raphael and Bernini (in the Chigi Chapel), and two magnificent pictures by Caravaggio,

Bernini's Ecstasy of St Teresa

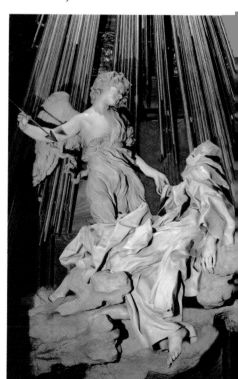

depicting in his individual and inimitable style the *Conversion on the Way to Damascus* and the *Crucifixion of St Peter*. Transposing holy events into the everyday world of Caravaggio's Rome, these two pictures provoke a strong reaction, and not just among art enthusiasts. Caravaggio was criticized for this at the time but it gives the images a timeless quality. Such history and the stories of the saints are not confined to the past, they have an effect that endures to the present day.

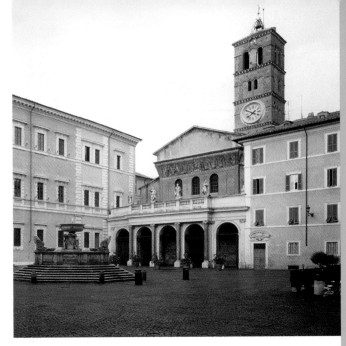

Santa Maria in Trastevere, Rome

The church contains many tombs, some of which are of notable people. One in particular, to the right of the exit, is worth a look. The cardinal interred here has had himself depicted as a living being in the upper section of the tomb and as a skeleton in the lower part, a reminder to all of the ephemerality of life.

Santa Maria in Trastevere

Santa Maria in Trastavere is a particularly sacred place since many people believe it was here that the first public church services were celebrated in Rome. Given their local pride, it would certainly suit the residents of Trastevere if this were a historical fact. However, it is certainly true that this was the first church to be consecrated to the Virgin Mary. Legend has it that it was built on the site where oil sprang from a rock as a sign of the advent of the Redeemer.

There is much to see in this Marian church but the mosaics are surely its greatest treasure—the golden background of the semicircular apse is a radiant symbol of the glory of God, which outshines everything. An enthroned Christ sits with his mother at the center of the image, with a frieze of lambs beneath Him,

an image often seen in churches. The Lamb of God lies at the feet of the Redeemer, and there are other expressive representations of scenes from the life of the Virgin Mary. The majestic nave of the church is separated from the aisles by 22 classical Ionic columns, the floor is inlaid with Cosmeti-style intarsia work, and the gilt ceiling by Domenichino rounds off the overall impression of serenity in this hallowed place. Begun between 217 and 222, the church is one of the oldest in Rome and was completed around 340.

There is something else that makes this a particularly sacred place. Many of Rome's churches are visited mainly for their architecture and art treasures, or their history, but Santa Maria in Trastavere also still functions as an ordinary parish church. The Divine has found its place in people's everyday lives, and people find the Divine in the places where they live.

Santa Cecilia

The modern church stands on a site once occupied by the house of St Cecilia and her husband Valerius. Cecilia was as beautiful as she was headstrong. A legend recounts how she refused to consummate her marriage as she had spoken out in praise of virginity. An angel appeared to her husband Valerius and persuaded him to accept this state of affairs,

whereupon he too became a Christian. Both were later martyred.

Built in the 5th century, the first church over Cecilia's grave was converted to a basilica during the reign of Pope Paschal II (817–24) after he had had a vision of Cecilia's tomb. The church has been renovated and restyled numerous times, as well as redecorated. Today access to the church and the two wings of the monastery is via a wrought-iron gate. Visitors find themselves in a small peaceful garden where a fountain bubbles and flowers bloom.

On entering the church there are several treasures to see, including, in the presbytery, the ciborium dating from 1283, a masterpiece by Arnolfo di Cambio. At the base of the altar is a marble statue of St Cecilia carved by Stefano Maderno around 1600, based on a young woman whose body had been discovered in a grave in just this position. The 9th-century apse mosaic is especially beautiful and depicts the Redeemer in the clouds of heaven. He is surrounded by saints, including Peter, Paul, Cecilia, Valerius, and Agatha, and the pope who commissioned the building; the pope has a square halo, indicating that he was still alive when the mosaic was created. A closer examination of the expressions on the faces of the apostles Paul and Peter, the most important figures of early Christianity, reveals them to be aware of the burden that has been placed upon them and of the threat of failure. The Redeemer looks cheerful and benign, not a severe Judge of the World but a savior who is himself human and who knows human weaknesses.

Sant'Agnese fuori le Mura and Santa Costanza

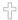

St Agnes found fame in the 4th century by refusing to marry a high official because he was a pagan, preferring to suffer martyrdom rather than accede to his wishes. Costanza, the daughter of the emperor Constantine, commissioned a basilica to be built beyond the Aurelian Walls to commemorate Agnes and to be her funerary church.

The church of **Sant'Agnese fuori le Mura**, was built a little distance from Agnes' tomb by Pope Honorius I (625–38) and has undergone considerable alterations and extensions. The three-naved basilica has a strikingly high and narrow central aisle, lending the church an elegant and yet austere feel. The richly decorated

Apse mosaic, Santa Cecilia, Rome

wooden ceiling is especially beautiful. Beneath the church there are 3rd- and 4th-century catacombs.

The apse mosaic depicts the popes Symmachus and Honorius accompanying the saint, who wields a sword and is engulfed with flames as a sign of her martyrdom. Her robe is adorned with a phoenix, as a symbol of immortality. As with many saints, Agnes' story is one in which perseverance and firm belief— which can be seen as divine virtues— are rewarded by eternal life.

Adjacent to the basilica is another sacred place—the very beautiful funerary church of **Santa Costanza**, a gem of Western architecture built on a circular plan. It was constructed in the first half of the 4th century as a funerary church for Constantina and Helena, the daughters of the emperor Constantine.

The simple and harmonious design and execution of the exterior is impressive, but the elegant and stunning interior is simply exquisite. Encircling the central chamber are 12 pairs of columns with richly decorated capitals supporting a barrel-vaulted roof. Daylight streams in through the windows in the vaulting, creating a mysterious atmosphere. The mosaics in the ambulatory, the oldest to survive

in a Christian church, feature late classical subjects such as vines, animals, and human figures. The apse mosaics represent Christian ideas and stories.

Santa Costanza integrates Roman architecture, late classical art, and early Christian iconography into a single, unique work of art.

Church of Domine Quo Vadis

This church on the Via Appia is of little architectural and aesthetic interest, but for believers it is nonetheless a sacred place. According to legend, Christ appeared here to St Peter when the saint was thinking of fleeing persecution in Rome. The following words are said to have been exchanged between them: "Domine, quo vadis?"—"Vengo Romam iterum crucifigi." ("Lord, where are you going?"—"I am going to Rome to be crucified again.")

The legend recounts how the saint was so ashamed that he returned to the city and was eventually martyred through crucifixion. The stone bearing the footprints of Christ on display here is a copy of the one in San Sebastiano, which is also on the Via Appia.

How much of the legend is true is a matter of some conjecture, but the story demonstrates one thing: even Peter, of whom Jesus said he was the "rock on which I shall build my church," had occasional doubts and

was afraid. Following Christ is not necessarily a matter of heroic courage, which is a message of comfort even for those not facing a martyr's death.

The Monastery of San Benedetto, Subiaco

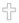

St Benedict was born in Nursia (modern-day Norcia) in 480. He came to Rome to study at the age of 14, but the hustle and bustle of the city disturbed him so much that he retreated into the solitude of the mountain forests of Umbria. He settled in a barely accessible cave above Subiaco, about 44 miles (70 km) east of Rome, and did not leave his hideaway for three years. He practiced the most severe asceticism, eating roots and berries, and occasionally a basket of bread and cheese brought to him by a youth named Romanus. To combat the perils of the flesh he rolled naked in thorn bushes at the mouth of his cave. Benedict's reputation soon spread and followers began to gather around him. Twelve simple cells were carved out of the rock, which eventually became 12 monasteries. Benedict's pupils chose him as the leader of their community and swore allegiance to him. There were those among them who envied him, however, in particular Florentius.

Benedict survived several plots, intrigues, and attempts on his life

before leaving Subiaco in 529 and traveling to Monte Cassino, where he founded a new community. It became the basis for the order that was named after him, which soon spread throughout Italy and Europe.

Several monasteries have been built on the site of Benedict's original hermitage, the most important of which being the Monastery of San Benedetto, known as Sacro Speco ("the Holy Cave"). Buildings were added above Benedict's cave and on the hillside nearby, over several levels, so that the monastery complex looks like a vast

San Benedetto monastery, Subiaco

straggling bird's nest clinging to the mountainside. The upper and lower churches, the various other chapels, and even the walls of the stairwells are decorated with frescos dating back to periods between the 8th and 16th centuries. They depict scenes from the lives of Christ and St Benedict. The cave itself is quite spacious and contains a statue by Antonio Raggi, a pupil of Bernini, of St Benedict at meditation. Monks from the neighboring monastery of Santa Scolastica now run San Benedetto, but it is not just Benedictine monks but also visitors from all over the world who come to this cliff-top monastery to acquaint themselves with the saint and his teachings.

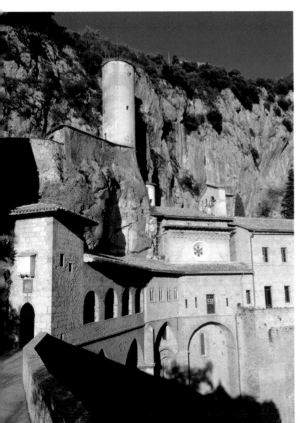

Monte Cassino
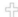

Benedict traveled to Rome to study as a young man, but around the year 500 he retired to the solitude of the mountains of Subiaco to live as a hermit. His life's work was later to become a decisive influence on Western monasticism. The pious life he led soon attracted pupils and kindred spirits. In 529 he moved to Monte Cassino to found his own order. He wrote the rule for the community (the *Regula Benedictini*) that was to

spread throughout the world. The 73 chapters of the Rule of St Benedict set out not only the organization of the monastery but also general rules and precepts that answered practical questions about the right way to lead one's life, both in the monastic and general sense. His relaxation of the ascetic rules handed down from Egyptian monks was exceptional for the time and may have been responsible for the rapid spread of the Rule of St Benedict.

The monastery—situated on the summit of a 1,700-foot (516-m) rocky hill near the town of Cassino, the site of an earlier Roman fortress— soon became a major spiritual center of Western Christianity. The Lombards sacked the complex in 577, but rebuilding work was begun in 717.

The Saracens then pillaged the monastery in 883, but by the turn of the 11th century it was growing in importance both spiritually and politically. In 1349 a powerful earthquake destroyed the monastery for the third time. The next rebuilding phase saw some changes in style and the adoption of predominant Renaissance and baroque elements, which characterized the monastery's appearance until 1944, when the final stages of World War II saw Monte Cassino become a refuge for civilians and also possibly German soldiers. The Allies bombarded the monastery on February 15 1944, razing the entire complex to crypt level. The German Wehrmacht occupied the hill for a few months after this attack and the ensuing bloody Battle of Monte Cassino claimed many lives.

The abbey, Monte Cassino

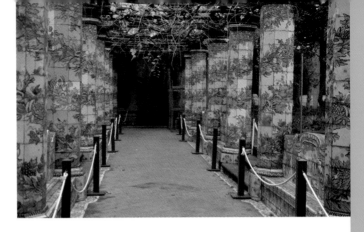

Cloister, Monastery of Santa Chiara, Naples

Rebuilding work to the old plans was begun in 1945.

The monastery is now accessed via an external "entrance cloister" on the site of an old temple dedicated to the Roman god Apollo, which Benedict consecrated to St Martin of Tours. He and his brethren assembled here to pray; it is also said to be where he died, and the cloister is revered accordingly. The corridor leads into an adjoining cloister, attributed to the Renaissance architect Bramante and named after him. The octagonal fountain with its Corinthian columns is particularly impressive. Beside these two cloisters is a third, the "Benefactors' Cloister," a typical example of Renaissance architecture in its simplicity and serenity. Here you will find statues of the popes and rulers who have promoted the monastery's cause in some special way—hence the name of the cloister.

The church itself has been largely reconstructed out of old building materials, although the interior decoration has been lost for ever. This monastery is not concerned with external appearances, however—it is the birthplace of a monastic tradition that was able to adopt Egyptian practices and adapt them to Western culture.

The Monastery of Santa Chiara, Naples

The extensive monastery complex of Santa Chiara is situated in the street of the same name in the middle of the Old Town of Naples. The double Franciscan and Clarissan monastic complex was built by Robert of Anjou between 1310 and 1340, which may explain the Provençal Gothic style.

The monastery church was rebuilt in a baroque style in the 17th and 18th centuries, and the complex's atypical cloister similarly dates back to the 18th century. The painted tiles with which it is richly decorated (giving rise to the name Chiostro delle Maioliche) have a captivating charm. The enormous cloister quadrangle (270 × 236 feet/82 × 72 m) is covered in a network of paths crossing one another at right angles; they are lined with flower beds and stone benches, which are also tiled. A vine-laden pergola provides

protection from the hot southern sun and the atmosphere is welcoming and calming. This is a place in which to relax and reflect, more like a summer retreat than a monastery cloister.

Within the monastery, a Bourbon nativity scene has become a sacred place of prayer and devotion for the Neapolitans. Records of the construction of nativity scenes in Naples date back to the 16th century. This Christmas crib is noted not just for its recounting of the biblical story but also because it reflects the everyday life of the city—many of the skillfully created figures look as if they have been lifted straight from the Old Town and dropped into a miniature biblical world. The practice of building nativity scenes as an expression of popular devotion soon extended throughout Europe. This fine nativity scene is particularly well loved and revered in Naples.

Vesuvius and Naples Cathedral

Johann Gottfried Seume described his encounter with the most famous volcano in Europe thus in 1802: "Although **Vesuvius** is only a molehill in comparison with Etna, its classical

locality makes it more interesting than perhaps any other volcano on earth. The most important scenes in the imagination of the ancients lie all around there; unnoticed, I began to record the objects around the volcano."

Vesuvius is also the only volcano on the European mainland to remain active. It was created about 10,000 years ago, developing over the millennia from an island of pumice in the Gulf of Naples into a mountain some 5,900 feet (1,800 m) high. The nearby ancient cities of Pompeii, Stabiae, and Herculaneum were all

Naples and Vesuvius

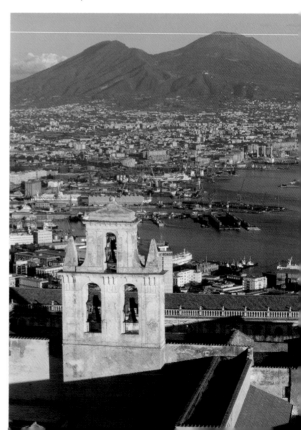

covered with lava and ashes in the most famous eruption, which took place in AD 79 and lasted for three days. The entire region surrounding Vesuvius is volcanic and according to the poet Virgil was once inhabited by giants—many legends have grown up around the fiery mountain.

In the 19th century there was much scholarly debate about the origins of the earth. The Neptunists held that life had begun in the sea; the Vulcanists believed that the earth's surface had been formed by eruptions and extrusions. Each faction combined scientific observations with the myths and mysteries associated with the seas and the mountains, and both theories incorporated the sacred elements of fire and water.

Naples, which is just 10 miles (16 km) west of Vesuvius, venerates St Januarius in particular. His relics have been kept beneath the main apse of **Naples Cathedral** since the 5th century. In the tabernacle there are two *ampullae* containing the saint's blood, which becomes fluid again when the vessels are placed near the saint's head on his feast days (September 19 and May 1). Should this fail to happen, it may presage bad times for the city.

Whether it is giants destroying the mountain or merely the action of geological forces, or even of St Januarius, the sanctity of Vesuvius remains inviolable. The mountain has been loved and feared for centuries, and any encounter with the Divine is marked by the same ambivalence as is found here toward the beautiful landscape of the Gulf of Naples.

Santuario della Beata Virgine del Rosario, Pompeii

Pompeii is famed for its buried ancient city, which was uncovered in the 18th century and has been partly reconstructed. There are many superb examples of richly decorated Roman villas with singularly beautiful frescos, which have justifiaby become famous throughout the world. Many murals and floor mosaics depict garden scenes with flowers, trees, and domestic animals—an almost idyllic world. There is a modern shrine to be found beside the ancient city, which attracts millions of pilgrims every year: the Santuario della Beata Virgine del Rosario di Pompeii ("the Shrine of the Blessed Virgin of the Rosary"), which has been revered here since the end of the 19th century.

The pilgrimage church, the life work of Bartolo Longo, is the central point of the modern city, which has 25,000 inhabitants (approximately the same number as at the time of the ancient catastrophe). Longo began rebuilding this church in Pompeii in 1873, obtaining an icon of the Madonna from Naples for the purpose. The building had to be enlarged twice because of the ever increasing numbers of pilgrims it attracted. Since 2008 the church has been a holder of the "Golden Rose," awarded to the town by Pope Benedict XVI. The "Golden

Rose" is a foot-long (30-cm) flower crafted in gold and filled with holy water and scented essences of balsam and incense. It is the greatest distinction the pope can award a place of pilgrimage. In Pompeii the Divine finds expression in all sorts of ways and across the centuries.

Cloister, Amalfi Cathedral

Amalfi Cathedral

The Amalfitana, one of the most beautiful coast roads in Europe, leads travelers to a once glorious city that has given its name to the whole coast, also known as the "Divine Coast." Amalfi had its heyday in the 10th and 11th centuries and is documented as a city in ancient times. Founded by the Romans, it was allied to Byzantium in 553, and in 786 it achieved considerable autonomy after surviving Saracen and Lombard sieges. It subsequently became one of the mightiest and most influential maritime republics in Italy. In 937, during this period of prosperity, work was begun on the imposing cathedral. From the cathedral square, with its baroque fountain dedicated to St Andrew, a majestic flight of steps leads up to a three-naved church, which was modified in 1203 in an Arab-Norman style; the multicolored façade with its many mosaics is a 19th-century addition. Visitors who climb the steps and enter via the bronze door—cast in Constantinople—will find themselves in an interior whose soft, magical light is only intensified by the gilded coffered ceiling. The cathedral crypt holds some relics of St Andrew, the patron saint of both the town and the surrounding area.

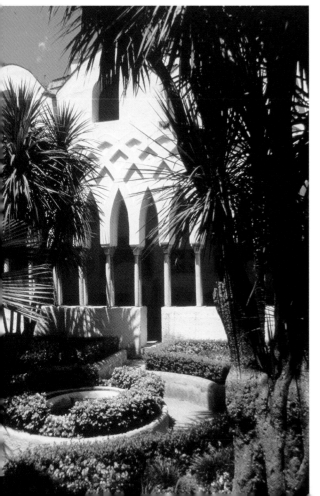

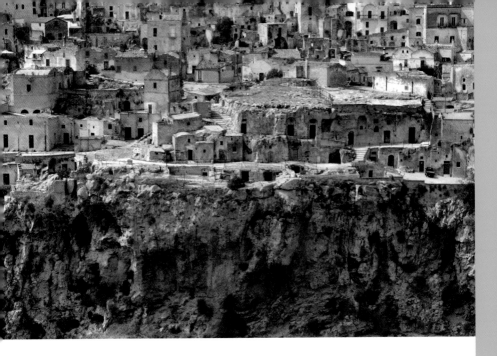

Sassi di Matera

Here, you are just a few steps from heaven—at least according to the name of the mid-13th-century cathedral cloister, the Chiostro del Paradiso. Until significant alterations were undertaken in the 1990s, this little cloister with its straggling plants and flowers really was like a small corner of paradise, and even today it has retained some of its evocative power. This may be due to the incorporation into the façade of palm-shaped designs in the combined Arab-Norman style, which give it a hint of the oriental. The façade's decoration is further accentuated by the palms growing in the inner section of the cloister, creating a vibrant juxtaposition of plants and architecture that is unmatched in cloister design.

Sassi di Matera

Countless impressive places are to be found all over the world, but few are as compelling as the Sassi di Matera. These cave dwellings have been inhabited without interruption since the Neolithic period and are consequently among the oldest continuously occupied settlements in the world. Located in the far south of Italy in the Basilicata, they were until very recently almost inaccessible. The town of Matera was built at the edge of a steep, deep canyon. The medieval part of the town is extremely beautiful but the collection of prehistoric dwellings known as the Sassi is unique.

They comprise the only example of cave dwellings in the Mediterranean region, and they are still inhabited.

Carved out of soft tufa stone, over the years the dwellings have been enlarged and interconnected, creating a dense tangle of alleys, caves, and cellars where the roof of one house is often used as a floor for the house above. Wherever people live they seek a connection to the Divine, so it is little surprise that here too there are many churches also carved out of the rock or made of the local tufa stone. Visitors are transported back to a long forgotten age.

Popular devotion has found a unique expression here. The residents of Matera can rightly claim to live in a settlement that was inhabited by their ancestors 9,000 years ago. The town has many ancient churches, of which the most noteworthy are San Pietro Barisano, San Antonio Abate, the 10th-century Madonna delle Virtù monastery complex, San Nicola dei Greci, the crypt at Madonna degli Angioli, Santa Maria dell'Idris, San Giovanni, and the two Capuchin churches of Cappuccino Vecchio and Cappuccino Nuovo. The Sassi and the rock churches have recently found fame again through Carlo Levi's autobiographical novel *Christ Stopped at Eboli*, and the director Pasolini shot the scene of the birth of Christ here for his film *The Gospel according to St Matthew*. More recently, Matera was once again chosen to provide a biblical backdrop when Mel Gibson used it to shoot the exterior scenes for his controversial film *The Passion of the Christ*.

Such choices are not made by chance. Sassi is a place that brings people closer to tradition than in many other parts of the world, because here tradition is uncompromised. In his autobiography, Carlo Levi compared Sassi with its primitive living conditions and deplorable sanitation, to Dante's *Inferno*, but a medieval chronicler saw in it a "mirror of the starry heavens."

San Giovanni Rotondo

San Giovanni Rotondo, a small, rural town in Gargano, has found fame through a very recently canonized monk who is known and celebrated throughout Italy. Born in 1887, Francesco Forgione entered the Capuchin monastery in Foggia in 1903 as Brother Pio. In 1916 his failing health forced him to move to San Giovanni Rotondo, where he lived until his death in 1968. In 1918 he discovered he bore the stigmata of Christ's wounds, which healed only after his death. The mysterious stigmata soon attracted international attention, bringing people from all over the world to San Giovanni.

Pio was canonized in 2002—the fruit of his life's work is the Casa sollievo della sofferanza, the well-appointed, modern hospital that he founded in the town.

The Capuchin monastery of Santa Maria delle Grazie was erected in 1540, but has been abandoned and reoccupied several times in its history. A large pilgrimage church was built next to the little chapel in 1959 and is visited by thousands of people every year. The Italians honor a modern-day saint here, along with the Virgin Mary. As a contemporary figure, and not an early Christian or a medieval saint, Padre Pio is especially accessible and popular.

San Michele in Monte Sant'Angelo

A strange occurrence took place here on May 8 492, when several local shepherds experienced a vision of the archangel Michael—in Christian tradition, the guardian of the earthly paradise to come, who will appear on the Day of Judgment to weigh the souls of the dead. His most important task is to confront Satan, and he is also regarded as the patron saint of travelers. People appeal to

The pilgrimage church of San Michele in Monte Sant'Angelo

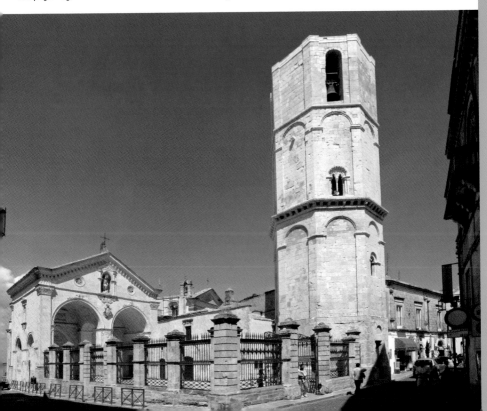

Michael when they are oppressed by Satan and his machinations, His name conceals within it a basic human question—the Hebrew name *Mi ka'el* means "Who is like God?"

The oldest pilgrimage destination dedicated to the angel is the idiosyncratic church of San Michele in Monte Sant'Angelo, in Apulia. Founded around the year 1000, Monte Sant'Angelo was the capital from 1086 until 1105 during the Norman rule of southern Italy. The church represents a special union of nature and the work of man. All that can be seen above ground is the octagonal tower and the two sections of the entrance hall; the rest is located underground in a grotto.

It is certain that pagan rites were conducted here in pre-Christian times, but the town dedicated to St Michael grew up around the pilgrimage church, whose roots can be traced back to the 5th century. A Romanesque portal leads down to the most impressive part of the grotto church. As visitors enter they see a notice with the words: "Where rocks open, sins are forgiven. In this house, all human sins are expunged." Such is the hope and belief of the pilgrims. Inside the grotto there is a large statue of St Michael stamping on the Devil. On Michael's two feast days, May 8 and September 29, thousands come here carrying a stone, representing evil and sin, which they throw into a nearby valley to demonstrate the renouncing of evil.

The archangel Michael is particularly venerated in those places where there are caves and mountains, extreme locations at the greatest heights or the most profound depths. The Way of St Michael passes through western and southern Europe. Apart from San Michele in Monte Sant'Angelo, pilgrims visit Mont Saint-Michel-au-péril-de-la-mer ("in peril of the sea") in Brittany, Saint-Michel d'Aiguilhe in Le Puy in the Auvergne, and Sacra San Michele alla Chiusa in Piedmont.

San Nicola in Bari

This bishop of Myra, who died in 345, is without doubt one of the most famous Christian saints. After Nicholas' parents died of the plague, the young man spent his entire inheritance on easing people's suffering, his virtue and seriousness of purpose earning him the bishopric of Myra. A woman to whom he had shown considerable charity was so pleased at the news that she hurried to church, leaving her baby in front of an open fire. When she returned, she found the child burnt so badly she could not recognize it. In grief she brought the body to Nicholas, who was celebrating Mass. He blessed the child and returned it, alive, to her arms.

This miraculous tale is just one of many that soon spread far and wide. Nicholas was particularly concerned with children—he saved oppressed children from the hands of their persecutors and rescued Myra from famine. He appeared to the emperor

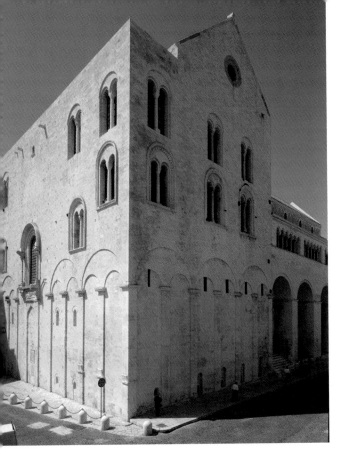

San Nicola, Bari

Bari stole Nicholas' bones from Myra. It seems somewhat ironic therefore that in folk belief Nicholas could be appealed to for help in the recovery of stolen items.

Construction of a church, the Basilica of San Nicola, began a month after the relics arrived in Bari. The simple beauty of this Romanesque building, on which many later Romanesque churches in Apulia were based, combines with its massive façade and sturdy tower to give it an almost fortified appearance. St Nicholas' relics are kept and venerated in a precious shrine in the basilica's crypt. There have been reports of a resinous substance flowing from an opening in the shrine, to which miraculous powers have been attributed. For many, Bari lies at the "end of the world," but the veneration and popularity of St Nicholas have journeyed across the whole world.

Constantine in a dream, causing him to repeal unjust death sentences, and the power of his prayers saved mariners from storms at sea. He is the patron saint of seafarers and shipping throughout the world, but he is, above all, the protector of children.

Veneration of St Nicholas began immediately after his death. In the Catholic Church he is one of the 14 helpers—saints who assist in times of adversity. In 1087 sailors from

Palermo Cathedral

Palermo is a city with a turbulent and poignant history. Inhabited by the Greeks and Carthaginians from the 8th century BC before being conquered and absorbed into the Roman Empire, the city was also subject to brief periods of Arabic and Norman rule, which had a lasting influence on its appearance. The cathedral, the Church of Maria Santissima Assunta, was originally built in an exclusively Arab-Norman style. Thanks to this first phase of building work in 1184–5, the church became known as the "Norman Cathedral." A cathedral has stood here since the 6th century, but the Saracens converted it into a mosque with a library, baths, and a madrasa. When this collection of buildings was badly damaged by an earthquake in 1169, Archbishop Walter resolved to build a new structure. Walter had the ruins of the old church demolished, along with the Muslim annexes, to create a large site for the cathedral that stands today. Additions and alterations were undertaken continuously between the 14th and 16th centuries, and any unity of design that may have existed was lost completely. However, the cathedral has a rare fortress-like dignity.

The large west tower, connected to the main building by a Gothic arcade, immediately attracts the visitor's gaze. Now used as the main entrance, the late Gothic south portal was enhanced in 1465 with a portico, whose tympanum depicts an enthroned Christ flanked by the Virgin Mary and the archangel Gabriel. Between 1781 and 1801 Ferdinando Fuga made significant alterations to the church's appearance, and many consider his cupola somewhat intrusive.

The last phase of major construction work was undertaken in the 19th century, when a neo-Gothic extension was added to the tower, and the interior reveals the influence of classicizing alterations. The church contains the Chapel of St Rosalia, the city's patron saint. Not much is known of this recluse, but the Sicilians have revered her as a plague saint since the mid-17th century and she is still popular today. Besides the saint there are other, more worldly objects of veneration: the royal and imperial tombs of Roger II, Henry VI (with his wife Constanza), and most notably Frederick II.

The temples of Selinunte

Selinunte is undoubtedly sacred as far as archeologists are concerned, and it was certainly sacred when the superb temples of Selinunte were built. The Greek pantheon is now reasonably well known, but there is only scant understanding of the manner and nature of the rites that were conducted in the temples. Oracles were certainly consulted here and the gods and goddesses were appeased and worshiped with

sacrifices—from the fineness of the buildings it is clear that they must have enjoyed the highest reverence.

Visitors to the temples will find themselves in a place where the boundary between the real and unreal is blurred. The **acropolis** today bears the results of the chaotic aftermath of the smashing of dozens of shrines. Those that were not destroyed by the Carthaginians after their victory of 409 BC fell victim to a devastating earthquake in the early Middle Ages. In contrast to other sites, archeologists have avoided giving the various temple ruins the names of gods. Here they are simply known by a letter (A, B, C, D, E, F, G, and—oddly—O). The sanctity of this place is evident— the temple ruins exude a majestic atmosphere—it is as if the boundary between appearance and reality has been lifted. The air almost vibrates in the heat, the sea has a silvery sheen, the cicadas chirp, and the bees buzz in the lush undergrowth. Lizards scamper across nearby stones and fragments of fluted column.

What remains of the monumental temples is testament to the prolific power of human creativity. **The Shrine of Demeter Malophoros**, a 5th-century temple area about 200 × 165 feet (60 × 50 m) in size, is situated just a little to the west. A great number of female votive statues were found here, and it is assumed that the site was sacred to the fertility goddess Demeter. Many of these statues are of the goddess Demeter holding a pomegranate

Temple "E" on the eastern hill, Selinunte

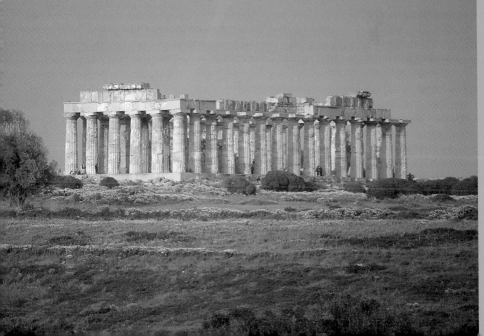

(Greek: *malophorus*, bearing a pomegranate). The columns of the Temple of Demeter, thought to date from the 6th century BC, have not survived.

There was presumably a Temple of Zeus on this site, but no conclusive evidence has been found. Many questions remain to be answered, but one thing is clear: the temples of Selinunte are a place where it is possible to experience something of the ancients' encounters with the gods, deities who were close to man and yet far away, then just as now.

Agrigento

Agrigento attracts visitors for the beauty of its architectural treasures. These are not immediately apparent, as the outer ring of the city is now built up with the same faceless tower blocks as are found all over the world, with the same crammed streets as any modern city. It is difficult to tell at first sight that Agrigento's street plan in fact resembles a giant amphitheater. An eight-mile (13-km) wall with

Temple of Concordia, Agrigento

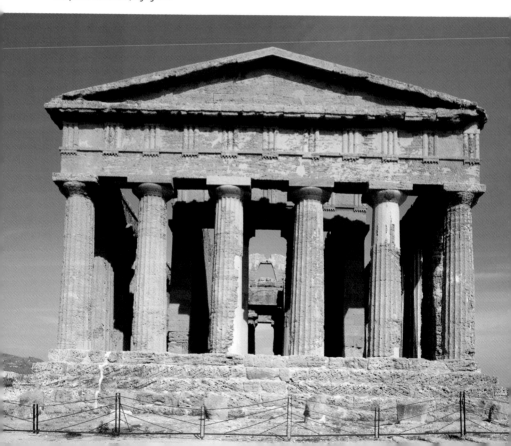

eleven gates once surrounded and pro-
tected the town, and between 200,000
and 800,000 people lived here during
the classical period. Agrigento is
divided into the upper city and the
Valley of the Temples. A stroll through
the upper town will immerse visitors
in the atmosphere of this ancient city
and there are many sites of interest
connected with Christian history.

San Gerlando, Agrigento's Catalan
Gothic cathedral, should certainly not
be missed, as this rather unspectacular
church is home to a strange acoustic
phenomenon—if you stand in
the presbytery beneath the arch
of the apse, you can hear every word
said at the entrance, some 280 feet
(85 m) away. Few people come here
to see the church, however. If you
climb up the steep ridge at the western
end of town to the Rock of Athene,
of which little now remains, you
will have a marvelous panoramic
view of the Valley of the Temples. In
ancient times this rocky ridge was
probably used as a site for judicial
punishment—stonings, or people
were just pushed off the top. A flight
of steps leads down to the **rock shrine
of Demeter and Persephone**, probably the
oldest pagan site (7th century BC),
which consists of three stone cor-
ridors. The attribution of this temple
to the goddess was not difficult, as
excavations revealed a great number
of votive statues and busts of Demeter
and her daughter, Persephone.

The 13th-century **San Nicola Church**
is reached via the Hellenistic-Roman
Quarter, and here stands the famed
sarcophagus of Phaedra, whose

bas-reliefs tell the story of her unhappy
love for her stepson Hippolytus.
Housed in a former Cistercian monas-
tery from the 14th century, the Museum
of Archeology, right next to the church,
provides a fascinating journey through
time into the city's ancient past.

The most impressive part of any
visit to the city begins at the **Valley
of the Temples**. Every step you take is
on consecrated ground, and every
view is breathtakingly beautiful. The
famed Temple of Hera (480–440 BC)
was perhaps never dedicated to the
goddess, according to the arche-
ologists, but this makes it no less
astounding. Legend has it that the
women of the city sought refuge
here with the goddess when they
were sad or when they had argued
with their husbands. Hera, the wife
of the adulterous Zeus, was well
acquainted with human problems.

The Temple of Concordia
(480–430 BC) is one of the best-
preserved Greek temples because
of its use into the 18th century as a
Christian place of worship; it was
dedicated to the apostles Peter and
Paul as early as the 6th century. On
a fine day its beauty is silhouetted
against an azure-blue sky. The annual
almond-blossom festival is held in
front of the temple every February.

The Temple of Heracles (520 BC)
is close by. It is more certain that
the attribution of this temple is
correct—Cicero mentions a statue
of Heracles whose knees have been
worn away by people kissing them,
although the statue has now disap-
peared and little remains of the temple

itself beyond eight of the original 38 columns that once surrounded it.

A little farther on, the Temple of Zeus Olympic (480 BC) was built as a victory temple after the Battle of Himera against the Carthaginians. This enormous building was intended to outshine all that had preceded it, and the shrine covers an area of 370 × 174 feet (113 × 53 m). It had no free-standing columns—instead, the roof was supported by 14 giant figures serving as caryatids. It is presumed that the temple was never completed. The last portions to remain standing collapsed in December 1401 and a good deal of the rubble was used as aggregate elsewhere in the city.

Nearby there is a shrine dedicated to deities of the underworld (7th and 6th centuries BC), where the gods of the netherworld were worshiped. Several fountain grottos and altars can still just about be made out. There was a pagan ritual site here before the temple was constructed. The view of the Temple of Castor and Pollux (5th century BC) is one of the most photographed in all of Sicily. The four columns, reconstructed at one corner of the temple, are particularly striking, although it may be less the temple itself and more the story of the two *Dioscuri* that touches people's hearts—the twins were separated by fate and never found one another again. Stories of this type have the power to affect people to the core.

The buildings in the Valley of the Temples are set in the stunning landscape of west Sicily. There are beautiful views of the temples themselves and from the temple site down to the sea. The power and history of the temples is moderated by a sense of proportion and a harmonious combination of grace, dignity, and beauty that is rarely encountered. You just have to imagine the effect that the brightly painted buildings and statues would have had on the people of the time to understand how sacred this place was then and how it has remained so to this day.

Basilica di San Giovanni, Syracuse

Syracuse is by far the most important city of ancient Sicily and accordingly contains a wealth of treasures. The population of the ancient city numbered up to half a million and modern Syracuse is similarly spread out; visitors have to fight their way through the faceless new town in order to admire the wonderful ancient relics.

Finding your way around is made easier by the division of the Old Town into two clearly separate districts: the island of Ortygia, connected to the mainland by a causeway, and the area of Neapolis, whose Archeological Park is the most comprehensively excavated area of Syracuse, with numerous Greek and Roman monuments. There is a sacred place of a different kind near the park—the **Basilica di San Giovanni**, built between the 6th and 11th centuries and once the focal point of

the island's Christian community.
A destructive earthquake in 1693
left intact only the tripartite portico,
parts of the main portal, and a rose
window. As the place was so sacred
for the monks, they could not bear to
see it decay and become delapidated
and so they transformed the ruins
into a fragrant flower garden. This
lovingly laid out and well-tended
garden is a modern oasis of peace
and relaxation, providing shade and
beautiful aromas when the heat makes
it hard to breathe and the sirocco
blows red desert sand into the city.

The apostle Paul is said to have
preached here in AD 62, and beneath
the ruins of the church is the **Cripta
di San Marziano**, the earliest Christian
church in Syracuse (3rd century),
which still contains the granite pillar
where Marcianus, the first bishop of
Sicily, is said to have been
stoned to death. The church's
modern appearance is the
result of later Norman alter-
ations, and the four pillar
capitals bearing the symbols
of the evangelists date back
to a similar period. There
is an angel for Matthew, a
lion for Mark, an eagle for
John, and an ox for Luke.

The **Catacombe di San Giovanni**
should not go unmentioned,
an enormous underground
necropolis with thousands of
4th-century tombs, entered
via the ruins of a Norman
church. The labyrinth of
catacombs houses several
major frescos telling the life

stories of the deceased, ensuring they
will be remembered in the future.

This collection of three shrines is
without doubt a place that was consid-
ered holy by more than just the monks,
and even now you can feel some of the
restorative power instilled by faith.

Temple of Apollo and Syracuse Cathedral

The island of Ortygia is full of narrow
lanes, picturesque old squares, and
magnificent *palazzi*. There are traces of

The baroque façade of Syracuse Cathedral

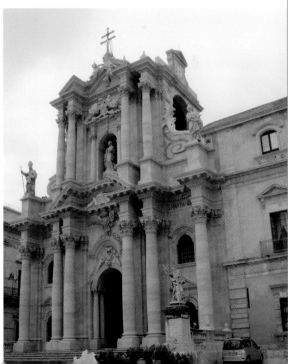

Greek and Roman antiquity everywhere you look—every step takes you further into the rich history of the city.

The first impressive classical feature to be encountered comprises the remains of a pre-Christian temple dating from the 7th or 6th century BC. The **Temple of Apollo** is the oldest Doric temple on Sicily; the serenity of its ruins has outlasted the ages. The longitudinal floor plan and the broad, flat capitals are a typical feature of this ancient period. The temple later became a Christian church and later still a Spanish barracks was built on top of it, although this has since disappeared.

A further stroll through history takes visitors to the Piazza di Duomo, a semi-circular space dominated by the mighty structure of the Cathedral of **Santa Maria delle Colonne**. This ancient church has been venerated for centuries—it is as though the gods have always lived here.

In the 8th century BC, the Greeks erected a temple to Athena here, a mighty building whose columns are still standing and have been incorporated into the Christian basilica, as can be seen especially clearly in the interior. The pagan shrine became a church in the early Christian era, then a mosque, and the period of Norman rule saw it re-emerge as a place of Christian worship.

Despite their disparity, the various elements of the church combine to form a harmonious whole. The splendid baroque portal is reached via a flight of steps. The façade is adorned with statues representing faith: St Marcianus (the first bishop of Sicily), St Lucia (the city's patron saint), St Mary, and the apostles Peter and Paul. Doric columns merge with Saracen crenellations and the faithful pray before an altar that in antiquity graced the Temple of Athena as an architrave. In the baptistery, a huge Hellenist *krater*, with masterly Norman decoration from the 13th century, is used as a font.

The chapel of the city's patron saint, St Lucia, is also to be found in the church. Behind some bronze railings is a statue, nearly 13 feet (4 m) high, which is carried in solemn procession to the Church of Santa Lucia alla Badia (on the opposite side of the square) every December 13, before being returned to its accustomed place a week later.

Veneration of the Divine—something that can be felt very clearly here—is not limited to a particular religion; it takes place at locations where people feel the presence of their god or gods.

Santuario della Madonna delle Lacrime, Syracuse

This sacred site seems slightly out of place in a city replete with so much history and where the ancient world is encountered at every turn, but the Shrine of the Weeping Madonna is nonetheless a holy place. Built in the 1980s, Sicily's most modern

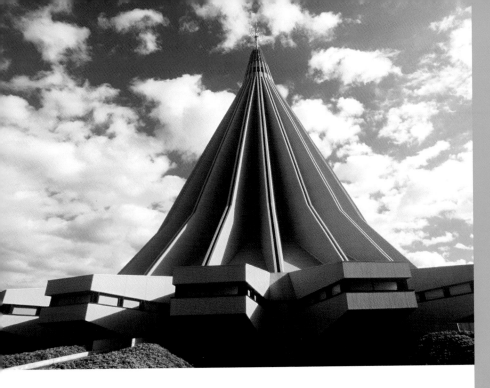

The modern pilgrimage church of the Madonna delle Lacrime, Syracuse

pilgrimage church resembles an outsize paper hat. Rising nearly 265 feet (80 m) into the skyline and the tallest building in the city, this arresting concrete conical structure is the destination of hundreds of thousands of pilgrims every year. On January 29 1953 an unassuming Madonna manufactured from plaster, no different from the thousands of cheap statuettes produced every year, wept in sympathy for the suffering of a seriously ill woman, eventually leading to her remarkable recovery. Further notable miracles were to follow—the blind regained their sight, the dumb could speak again—and

one of the greatest places of pilgrimage in modern times was born.

On entering this sober building, it is not difficult to explain such reverence. The statue of the Madonna has been placed in a little niche in the huge hall. Even though her tears have long since dried up, she exerts an almost magical attraction on people, a mixture of curiosity and the unshakable faith that miracles are possible even today.

The Euphrasian Basilica, Poreč

The construction of this wonderful basilica, one of the best-preserved of all the late classical and Byzantine ecclesiastical buildings on the entire Adriatic coast, is described in a Latin inscription in the apse: "this was once an unsteady and derelict place of worship, threatening to collapse and not shored up with sufficient strength, it was narrow and not decorated with gold [...] When [...] Euphrasius saw that his diocesan cathedral was in danger of collapsing under the weight it bore, his holy purpose thwarted this collapse [...] What you see adorned with gold here was decorated [by him] as he completed what had been started [...] Calling on the name of Christ, he consecrated the church, rejoicing in his work, and thus gladly fulfilled his vow."

Euphrasius is not alone in rejoicing in this work. Built between 543 and 554, the structure incorporated individual sections of the dilapidated

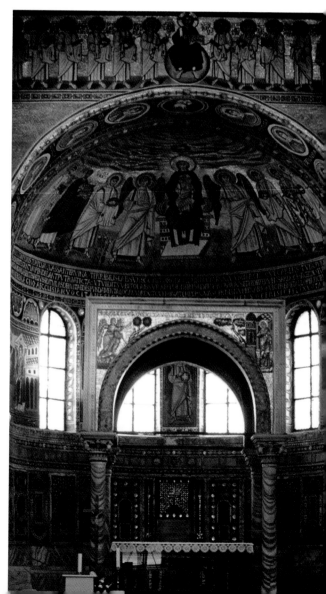

Mosaics in the Euphrasian Basilica, Poreč

earlier building to create a three-naved basilica with three apses, with the later addition of a narthex.

The basilica's clear lines are harmoniously integrated, and the interior features beautiful stone cladding and stucco work using precious materials such as glass, gemstones, marble, and mother-of-pearl. The late classical motifs—vines, ornamental meanders, plants, and birds—are just as resplendent now as the day they were made, and are augmented with precious Byzantine mosaics, some of which are said to have been made by master craftsmen from Constantinople and Ravenna. These reveal extraordinary skill in their execution, and their spiritual effect is undiminished across the centuries.

The airy space is divided up by delicately decorated marble columns and everything in this church radiates a wholesome tranquility to visitors.

The relic collection, Vodnjan

An otherwise unremarkable church in Vodnjan houses a devotional treasure that is known throughout the entire Christian world.

The Church of St Blasius (Sveti Blaž) was built between 1760 and 1800 and is the largest ecclesiastical building in the area, but it is not its size that attracts thousands of pilgrims every year; the church's particular popularity rests on a collection of relics that is unique in Europe. The rooms of the former sacristy house 370 relics from 250 saints and *beati* of the Catholic Church, including numerous incorruptible corpses in glass sarcophagi. How the bodies of the deceased remain preserved without any special process of mummification is still an unsolved mystery, but this enigma is certainly one of the reasons why the *corpi santi* enjoy such veneration.

This enormous collection of relics includes items from 15 centuries of ecclesiastical history, and while some of the saints are world-renowned, many enjoy only local fame—and the level of attention accorded to the different relics is correspondingly varied. The collection is a striking example of a popular piety that has been maintained over centuries and is still alive today.

The relics were originally stored near Venice but were brought to Vodnjan in 1817 to save them from looting by Napoleon's armies; they have been kept and displayed here ever since.

Our Lady of Međugorje

This little town "between the mountains" (the literal meaning of its name) in modern Bosnia-Herzegovina has a mere 5,000 inhabitants, but millions of pilgrims come here every year. The pilgrimage site is composed of the parish church (dedicated to St James since 1897) and two nearby hills in particular—the Mount of Visions and the Mount of Crosses. A strange occurrence was recorded here on June 24 1981: six young people announced they had seen and spoken to the Virgin Mary. On the same date a year later, two eleven-year-olds also reported seeing Mary, who identified herself as the Queen of Peace. These visions recur annually to these visionaries on the same day of the month and have

Pilgrims in front of a statue of the Virgin Mary at Međugorje

continued to the present day. The reports of the visions have made Međugorje a popular pilgrimage site, although the Roman Catholic Church has yet to acknowledge the authenticity of the phenomenon. A Vatican Commission was set up in 2008 to investigate the recurring Marian appearances, but for many of the people who come here official Vatican recognition is less important than the pilgrimage itself, in which they place all their private hopes. Broadcast worldwide on Mir ("Peace"), a dedicated radio channel, and on the internet, the messages that the Virgin gives always address topics such as inner calm, peace in the world, faith, repentance, prayer, fasting, and atonement. What is striking is that it is not just Catholic believers who visit the town, but also thousands of people with no religious affiliation. A pilgrimage to Međugorje comprises a series of events: first a visit to the Chapel of Visions and an ascent of the hill where these first took place; then evening mass in the church of St James, where the most recent messages are interpreted and there is a sevenfold repetition of the *Pater, Ave, Gloria,* a prayer not unlike the rosary; on the next day there are visits to the houses of the "visionaries"; and the climax of the pilgrimage is an ascent of the Mount of Crosses. This is a remarkable example of popular piety—the hill is littered with countless homemade crosses and personal devotional items. The Mount of Crosses represents an expression of an inner impulse supported by sustained prayer. Following a visit to Međugorje pilgrims say they feel uplifted and cheerful, and filled with an inner joy.

Cathedral of St Sava, Belgrade

St Sava (1175–1236) is worshiped as the patron saint of Serbia. He was not only an Orthodox bishop and a great teacher but also a proselytizer of the Christian faith to rival the apostles, as well as being the author of the first Serbian legal code. Enraged by the Serbs' insurrection against the Turks, the Grand Vizier Sinan Pasha took St Sava's mortal remains from their depository in a monastery in Mileševa to Vračar hill in the southern part of Belgrade and had them publicly burnt. A small church dedicated to Sava was subsequently built here, and the site is now occupied by one of the largest Orthodox churches in the world, the Cathedral of St Sava (Hram Svetog Save).

Architectural inspiration for the building was taken from the foremost

The Cathedral of St Sava, Belgrade

church of the Byzantine Empire, the Hagia Sophia in modern Istanbul. In contrast to its forerunner, the enormous structure with its central dome has four additional lower towers, following a Serbian architectural style known from such buildings as the monastery at Studenica. After decades of planning, construction of the church began in 1939. Work was interrupted by the Second World War, and the post-war communist authorities permitted its resumption only in 1985. The political turmoil following the collapse of the former Yugoslavia in 1991 further delayed construction, and the cathedral's topping-out was celebrated only in 2004. A giant gilt crucifix has since been placed on the dome as a sign of the restored self-confidence of the Serbian Orthodox Church.

Even though the interior is still to be finished, the Cathedral of St Sava has already become one of the most important shrines in Serbia. One of the church's altar niches has been completed, and every May 10, the saint's name-day, tens of thousands of people take part in a solemn procession to the cathedral before attending mass.

Studenica Monastery

Medieval Serbia's geopolitical situation was not a straightforward one—the country was located at the meeting-point of the Frankish west and the Byzantine east, a position that demanded considerable political skill of its rulers. As the power of the Byzantine Empire began to wane, Stefan Nemanja succeeded in uniting the Serbian tribes, and his son, later to be celebrated as St Sava, became the first bishop of the Serbian Orthodox Church, which provided the ideological underpinning for a new and united Serbia.

The closing years of the 12th century also saw the founding of the monastery of Studenica in a picturesque forested valley in the mountains; this was soon to become the spiritual and cultural center of the country. Once there were living quarters, palaces, and 12 churches— now only the refectory and three churches remain, the most important of which is the single-naved Church of the Virgin with its dodecagonal crossing cupola, which inspired the architecture of many later Serbian churches. The lions and griffins of the window, pillar, and portal ornamentation are reminiscent of the Western European Romanesque tradition. The interior features frescos from three different periods, the most impressive of which is the monumental crucifixion scene on the western side wall, whose glittering golds and powerful azure blues demonstrate the ability of the painter to translate Byzantine mosaic techniques into painting. The most recent paintings date back to the 16th century and depict the death of the Virgin Mary as well as Stefan Nemanja, the founder of the monastery.

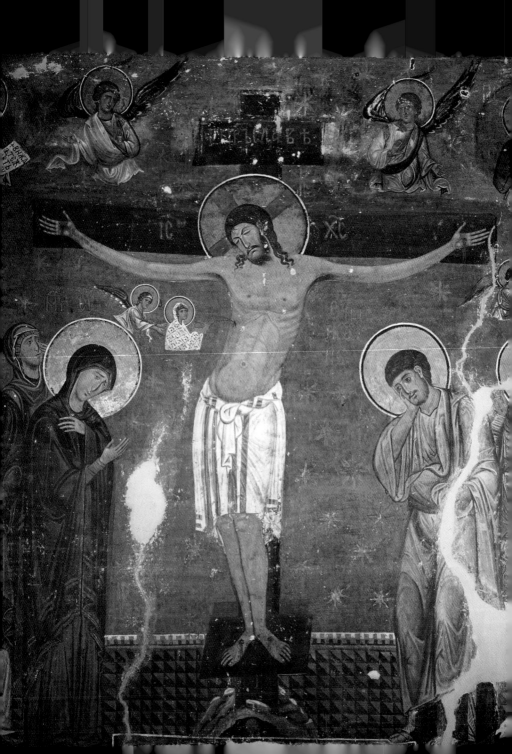

The small, domed Byzantine Church of the King looks rather modest next to the main church, but every inch of its interior is covered with small-scale, lively frescos whose rich detail and bright colors illustrate all sorts of scenes from the life of the Virgin Mary. They are among the best-preserved frescos in Serbia.

The last of the churches to survive is the little church of St Nicholas, which was constructed out of waste stone. Its frescos depicting the entrance of Jesus into Jerusalem have unfortunately only partly survived.

Mileševa Monastery

The architectural history of the monastery at Mileševa, situated in the valley of the eponymous river in the southwestern Serbian mountains, is not apparent at first glance. Although the monastery was founded in the first half of the 13th century by the Serbian king Stephen Vladislav, its modern appearance is a result of the most recent thorough renovations, carried out in 1863. The adjoining Church of the Ascension of Our Lord dates back to 1234.

The monastery has always been a place of scholarship—holy books were translated and printed here, young people were taught to read and write, and the monastery soon gained in renown. In 1447 Stefan Vukšić Kosača declared himself duke of Sveti Sava in the monastery, and was later closely associated with St Sava, the patron saint of Serbia. Although repeatedly pillaged and partially destroyed, the monastery was always rebuilt.

Several revered 13th-century frescos survived these turbulent times. The fresco of St Sava is famed throughout Serbia and attracts great numbers of pilgrims who come to petition him for assistance. Mileševa Monastery is also the last resting place of a major Serbian relic—St Sava's left hand. Besides these treasures, the monastery church also houses the "White Angel," which has achieved worldwide fame: this fresco is one of the most expressive to survive from the 13th century, and is known worldwide, after having been chosen as an emblem by the United Nations.

A fresco in Studenica Monastery

Esztergom Basilica

The Danube, and with it the Slovakian border, describes a large arc at Esztergom. The city has been Catholic for 1,000 years, ever since Stephen I was crowned king here in 1000 and subsequently Christianized the country. Esztergom has numerous churches and convents but the most significant is the basilica, rising up on the steep banks of the river. The basilica is the largest and most senior church in Hungary, being the seat of

Esztergom Basilica

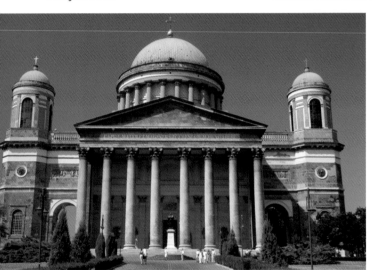

Only one side chapel of this forerunner to the cathedral now remains, and it became Archbishop Tamás Bakócz's funerary chapel in 1507.

Building work on the giant classical basilica was begun in 1822, and after 34 years of construction (interrupted on several occasions when the archiepiscopal see was vacant or because the Hungarian revolution of 1848 was demanding too much money and energy) the church was finally consecrated in 1856 in the presence of the Austro-Hungarian emperor Franz Joseph, to the strains of a mass specially composed by Franz Liszt.

Since the days of Stephen I, the church has served as a symbol of Hungarian national identity and it is no surprise to learn that the king is also revered as a saint. The same is true of Cardinal József Mindszenty (1892–1975), whose tomb is also to be found in the cathedral at Esztergom. He was an outspoken opponent of the communist regime who was obliged to seek sanctuary in the American Embassy in Budapest for

the Primate of the Hungarian Catholic Church. At the very beginning of his reign, Stephen I founded a church here dedicated to St Adalbert that was known as the "Beautiful Church."

years before going into exile in Vienna, where he died. Many Hungarians now consider him a saint whose political and humanitarian stance never wavered, strengthened as it was by his faith.

The Bakócz Chapel adjoins the main nave, which takes the form of a Greek cross surmounted with a round dome. The interior is a major Hungarian-Tuscan masterpiece and the 96 coffered wooden panels of its cladding are unique in Europe. The chapel interior is in red marble decorated with vines and rosettes. Statues of St Stephen and St Ladislaus flank the altar and Bakócz himself is depicted lying face down, at prayer. The chapel is considered a Marian shrine and the altarpiece depicting the Mother of God receiving prayers is said to have miraculous powers; the many votive tablets and notes of thanks attached to the chapel walls attest to this belief.

Matthias Church, Budapest

The baroque Madonna in the Loreto Chapel of this church is blackened with soot from the candles of the thousands of Hungarian pilgrims who have been journeying here for centuries. They consider the Matthias Church (Mátyás templon) to be the "heart of the country." The three-naved Coronation Church of Our Lady at Buda (the original name) was built in the 13th century as a parish church for the German population of the city, and rebuilt in a Gothic style in the 14th century. Its modern appearance dates back to renovation work undertaken between 1874 and 1896. The church has always been a notable site of both Marian

worship and national consciousness, but it only became a Marian shrine when Buda was reconquered from the Turks in 1686. The image of the Virgin in the church had been bricked up for 145 years during the occupation, when the wall concealing the long-forgotten statue suddenly collapsed, revealing the statue to the Turks at prayer in their mosque. The very next day the Christians reconquered the city, ending Turkish rule, and the Virgin Mary was credited with this military victory. In 1695 Pope Innocent XII granted a complete remission of sins to all those who undertook the pilgrimage to the site, and the Matthias Church thus became one of the most important pilgrimage sites for Hungarian Christians.

The majolica work on the smaller of the two towers is extremely impressive, as are the colorful roof tiles and the expressive medieval Marian portal. The church also has a place in musical history, having witnessed the premiere of Franz Liszt's Coronation Mass for the accession of Emperor Franz Joseph I and his consort Elisabeth (1867). The final goal of the pilgrims who come here is, however, the Madonna, whose place in the hearts of Hungarians is assured.

Máriaremete, Budapest

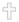

Toward the end of the 17th century, a young German named Katharina Thalwieser married a farmer named Georg Linsenboltz and they settled in

Hungary together. In their luggage they carried a little woodcut (only 7 inches/18 cm high) of the Virgin Mary cradling the Christ child in her right arm and holding a scepter in her left hand; the child is lifting his right hand in blessing and in his left he holds a little bird, the symbol of the soul of the believer. The couple attached the icon to an oak tree and whenever they were troubled by homesickness or some other worry, they would pray before the image. Other people soon discovered the icon and gathered in front of the tree to pray.

The first attested miracle took place in 1800 when a blind woman, who had been brought daily to the tree and had prayed constantly, was eventually healed by her faith and regained her sight. This was not the only miracle, and the site soon grew to become one of the major Marian shrines in Hungary. Thousands of little notes are now to be found in the pilgrimage church, giving thanks for mercies received. The pilgrims who visited the oak tree built a little chapel, but this soon became too small and in 1808 the first stone chapel was consecrated. By 1823, this building too had been overwhelmed by the hordes of pilgrims, and in 1879 work was begun on the modern neo-Gothic Church of Máriaremete. The icon of the Virgin was fixed to a bough from the old oak tree and now stands in the middle of the high altar. Since 1958, an image of the Madonna from Lourdes has stood behind it, a gift from the bishop of Lourdes to the Hungarians; Máriaremete

Matthias Church, Budapest

has since been known as the "Hungarian Lourdes." During the week around September 8, the Virgin's birthday, thousands of visitors take part in a great pilgrimage to the church.

The Holy Mount of Pannonia

This sacred place is impossible to miss—the mighty Benedictine abbey

The Benedictine monastery on the Holy Mount, Pannonia

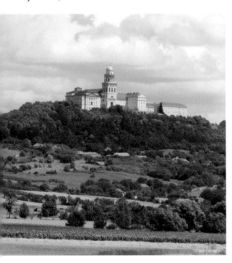

on the Holy Mount of Pannonia is visible from far away. The town of Pannonhalma lies a little to the south of Győr in the Transdanubian hills, where the hill of Pannonia, dominated by the famous monastery

complex, rises up from a plain. The Hungarians were Christianized by their king Stephen I (967–1038), who was later canonized as Hungary's patron saint, but it was his predecessor, King Géza, who in 996 called the Benedictine monks to Pannonhalma, where a chapel had already been dedicated to St Martin. The monks founded the monastery and it later became one of the most important in the country.

A great mosaic on the façade of the library adjoining the monastery indicates its origins: outreach and teaching were the twin pillars of the monks' work. The left side of the mosaic depicts King Stephen receiving permission to proselytize (Latin: *praedicate*) and on the right side Emperor Francis I is handing over a document commanding him to teach (*docete*).

Scholarship and spreading the word of God have always stood at the heart of this monastery, and all this takes place in the spirit of sharing— sharing knowledge of the will of God as well as the knowledge of worldly scholarship. This spirit is commemorated in the mosaic above the Porta Speciosa, the entrance to the three-naved Gothic church, which shows St Martin sharing his cloak with a beggar in an Edenic flower meadow. Hungarian Christians regard Pannonhalma as the cradle of their national and religious identity, revering with the utmost adoration the *sacra destra*, the right hand of the saint-king Stephen I, which is preserved in a precious reliquary in the crypt, the oldest part of the church.

Putna Monastery

Legend has it that Stephen the Great, who was the most powerful man in Romania before he swore fealty to the Ottoman Empire in 1489, shot an arrow in the sparsely populated area around Putna, and had a monastery built on the exact spot where the arrow landed.

Constructed between 1466 and 1469 and consecrated in 1470, the monastery was a flourishing cultural and spiritual center of its day—the resident monks copied manuscripts, wrote chronicles, and decorated religious texts with masterful illuminations. Clerics and chroniclers were also educated in Putna.

The church has a fortified appearance, with concealed arcades and quatrefoil arrowslits. The huge cemetery is worthy of note, and the tomb of the now canonized Stephen the Great is to be found here, along with those of two of his wives and one of his descendants.

The monastery has been destroyed and rebuilt several times and the bell tower on the west side of the complex is the only surviving 15th-century portion of the building. The actual icon that Stephen is said to have carried on his military campaigns can be seen in the monastery museum and enjoys special reverence in Romania.

Sucevița Monastery

Sucevița Monastery is one of the most impressive ecclesiastical buildings in all Romania. Nestling in magnificent scenery, the building still serves as a convent and its mighty defensive walls attest to its role as a refuge for the local populace in times of war.

The building was commissioned and built by Gheorghe Movila, bishop of Radauti, and his brother, Ieremia Movila, the ruler of Moldavia between 1595 and 1606. Solemn silence reigns within the walls. The church is the only one in the world to be completely decorated both inside and out with hundreds of well-preserved mosaics, whose intense coloration lends them a three-dimensional appearance; the maroon, deep purple, and blue figures are set against a dark green background and the gold highlights lend the frescos a particular luster. The images portray biblical and worldly stories and legends, with the stairway to heaven depicted on the north side being especially striking; visitors can meditate here on the knife-edge that separates good and evil. After their perilous ascent of the stairway, the virtuous are met by Christ at the gates of heaven, where angels hover above them; the sinners, on the other hand, are dragged down into the abyss by grinning devils and demons. The "Tree of Life" on the south side includes

Sucevița Monastery

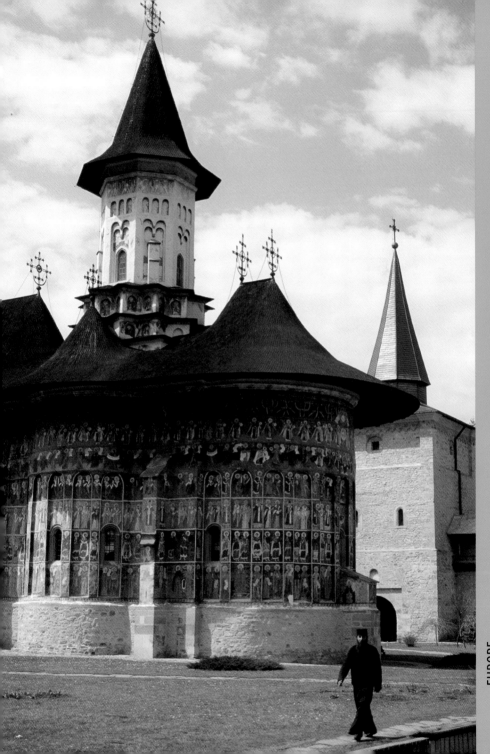

ROMANIA

numerous classical figures, of which the most famous are Plato, Pythagoras, and Aristotle. Even the murderous Queen Elisabeth, who poisoned her husband so that both of her sons could ascend the throne, is immortalized in a small fresco. The unique wealth of iconography has led some to describe this monastery church as the "Romanian Sistine Chapel."

The Madonna of Blaj

Located in the middle of the Transylvanian Mountains about 25 miles (40 km) from Alba Julia, the tiny municipality of Blaj, a town of Roman origins that was once the capital of Romania, has recently revived its long tradition of Marian worship. The pilgrimage church at Blaj contains a richly decorated icon of the Virgin Mary, and "She Who Shows the Way" (the *Hodegetria*) was particularly venerated by Bishop Petru Paul Aron, a zealous proponent of unification of the Romanian and the Roman Catholic churches. When he died in 1764, tears are said to have flowed from the icon's eyes. News of this strange occurrence spread like wildfire, bringing many pilgrims to Blaj, and pilgrimages continued here until 1948, when Romania was incorporated into the Soviet Union and all religious activity was banned. Blaj nonetheless remained a cultural center, becoming a focal point of Catholic resistance to the socialist

regime. The baroque pilgrimage church was returned to the Eastern Catholic Church in 1991 and Blaj has since regained its place as the major center of Marian worship in Romania.

Horezu Monastery, Maldaresti

According to legend, it was the owls calling from the surrounding forests that gave this monastery its name; when in 1690 a search was announced for a place where Constantin Brâncoveanu, the contemporary ruler of Wallachia, could build a monastery for the order he had founded, the owls are said to have called "hurezi" (Horezu).

Built in 1696–7 and dedicated to both Constantine, the first Christian emperor, and his mother, Helena, the monastery's main church established the architectural genre known as the Romanian Renaissance or the Brâncoveanu style. The main church has a clarity of line whose austerity is lightened by the acanthus leaves on the columns and other floral ornamentation. As you enter the narthex, you are greeted by a fresco depicting Christ enthroned in the center of the world and surrounded by a great host of angels; saints and prophets fight with the devil for the souls of the departed, Adam and Eve personify the beginning of the world, and final salvation is represented

with images of the Mother of God and the saints ascending to heaven.

Constantin Brâncoveanu is now revered as a saint in Romania as he and his sons were martyred in 1714 after refusing to convert to Islam; they were executed in the presence of the sultan. There is a marble cenotaph in the church, and an eternal flame burns in front of a mural depicting the martyr with his sons and daughters.

There are four other churches in the monastery grounds near the main church, one at each of the four points of the compass: the Bolnitei Church to the east, the Holy Apostles' Hermitage to the north, the Chapel of St Stephen Brâncoveanu to the west across a little stream, and the Church of St Michael in front of the monastery entrance to the south.

Surrounded by a high wall, the monastery is set in idyllic countryside; there is even a little river babbling through meadows where nut and fruit trees grow. Visitors are warmly received at the entrance to the convent before entering through the large gated arch; they are invited to marvel at the arcade-lined buildings of this unique monastery complex and to experience the peace of a world almost totally removed from society.

Horezu Monastery, Maldaresti

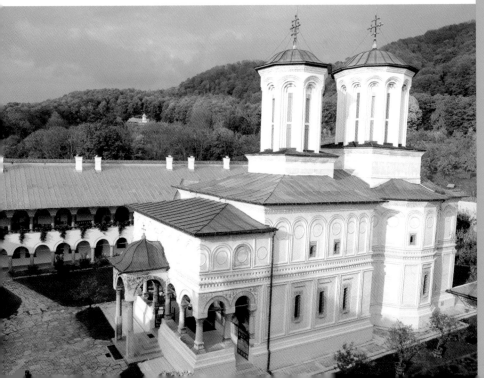

The Magic "Stone Forest," Varna

Countless thousands of years ago, the waves of the sea washed as far as the stone forest we see today, and the boundaries of the water were guarded by immortal titans serving the greatest of the gods. A young man living near the sea was granted immortality by this deity, on condition that he should never reveal the god's name. One day the young man happened to meet a girl whose charms captured his heart. The maiden had already been promised to one of the titans as a wife, but the young man refused to accept this arrangement and asked the titans if they would be prepared to renounce the girl. The titans offered him a deal: they would give up their claim on the girl if he would reveal the name of the god. The young man asked for time to think this over, as he knew that revealing the deity's name would render him mortal, but he finally decided in favor of love rather than eternal life. He told the titans that he would reveal the name, but that each titan should first go and stand in a particular place. He pointed out where each one should stand and then announced he had spelt out the name of the god along the coast with the titans' bodies. The enigmatic god was so astonished at this deed performed in the name of love that he sent down bright rays of sunlight, turning the titans into stone columns. The young man then went in search of his beloved, and a spring of magic water began to flow on the spot where they embraced.

This is the legend, at least; geologists have a different explanation for these hundreds of limestone pillars, suggesting that water currents and sediment formed them over the course of millions of years. Other theories have been mooted to explain their origins, but all agree that the stone columns, some of which reach a height of 23 feet (7 m), are a unique natural phenomenon. Besides popular legends and scientific observation, the stone forest has attracted interest from another quarter: many modern New Age enthusiasts come because of the streams of energy that flow here. They walk around the area—preferably barefoot—and hug the mysterious stone pillars, convinced that this rids them of negative forces and builds up positive energy. Whether there is anything to such notions or not, visitors to this stone forest on the road between Varna and Sofia are immediately gripped by the place's magical aura and feel as if they are in some other world, so supernatural and surreal does the scenery appear.

Rila Monastery

When pupils of St Cyril and St Methodius entered Bulgaria in 885 and introduced a vernacular liturgy, the Bulgarians finally chose to adopt

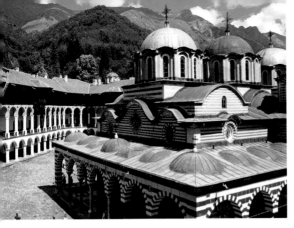

The monastery in the Rila Mountains

the rites of the Orthodox Church. Rila Monastery, located about 75 miles (120 km) south of Sofia near Kocerinovo, was founded soon after and is one of the few contemporary foundations to survive to the present day.

Ivan Rilski was born in Skrino, southwest of Sofia, in 876. After his parents died, he sold all his possessions, distributing the proceeds to the poor, and retreated at the age of 20 to a nearby monastery. A little later he chose a life of absolute solitude, initially in a hut, before settling on the slopes of the Rila Mountains, with which he would be associated after his death. Choosing a hole in a giant hollow tree to live in, he eked out his life by eating wild fruit and chickpeas. He was soon revered as a saint and many pupils sought him out in his fastness, whereupon he retreated to a 330-foot (100-m) high cliff to live as a stylite, resisting the attacks of the devil with penitence and prayer. After his death in 946 he was buried in the monastery founded by

his pupils. He was canonized in 970 and his relics were brought to Sofia.

The monks in this monastery were the first to establish a written grammar of Bulgarian and also taught the local population and passing pilgrims. Bulgaria has been subject to outside rule at several points in its history: it first fell to Byzantium, after which the country was repeatedly attacked by the Mongols, before falling to the Turks in 1341. Their rule lasted until 1878. The monastery's history is correspondingly turbulent: it was destroyed and rebuilt several times, the last occasion being in 1883, when it was restored to resemble the Byzantine monasteries on Mount Athos. Its spacious quadrangle, surrounded by strong, fortified walls, makes it look like a castle. The monastery is entered via a gate in the west wall giving onto a courtyard surrounded on all sides by galleried arcades. The main church, dedicated to the Mother of God, is decorated inside and out with frescos. A 13th-century icon of the Virgin Mary is kept in the apse and the church also houses the Chapel of St Ivan Rilski, built in the 18th century on the site of his first tomb.

Rila Monastery is not just a place of Orthodox worship, it is also a national shrine—the monks here preserved the Slavic language and their national culture through all sorts of troubled times, and the monastery is seen as the guardian of national identity.

EUROPE

The Bektashi Tekke, Qesarake

The Bektashis are an Islamic Alevi community. After being banished from Ottoman Turkey in the 16th century, they settled in what is now Albania, where an estimated 10 percent of the modern population is now Bektashi, making it one of the four largest faith groups in the country. Bektashi beliefs—undogmatic, unorthodox, and unconventional—are particularly popular in rural areas.

Bektashi prayer halls and monasteries are known as *tekke*, and these places where men and women practice their religious devotions in prayer and mystic dance are also the homes of *babas*, the priests of the Bektashi order of dervishes. The best-known and most striking of the dances is the ceremonial and contemplative Semah dance, in which men and women whirl around one another to represent the motion of the planets around the sun.

The *tekke* can take a variety of architectural forms—they sometimes resemble mosques, sometimes temples, occasionally even hermitages. The *tekke* at Qesarake in the southeast is a hermitage and a major pilgrimage site, as it houses the tombs of the *babas* who brought the order to Albania in the 16th century—Hajji Baba and his brother Ali Baba.

The modern building was erected in the mid-18th century, but after the dictator Enver Hoxha declared Albania the world's first officially atheist state in 1967, the *tekke* was dissolved and used as an ammunition dump; the dervish who lived here was murdered and his grave in the rotunda of the complex is now also a pilgrimage site. Besides the rotunda with its tombs of the revered saints, the monastery also has accommodation for the *babas* and a prayer room.

The Tomorr

The Tomorr, one of the highest peaks in southern Albania, is considered a sacred place by the Bektashi, because the mountain was chosen, so their tradition maintains, as a last resting place by Abbas Ali Ibn Talib, the half-brother of Hussein, who is accorded special reverence by the Alevi and Bektashi. Ali's *turbe* (a domed Islamic tomb) stands on the slightly lower southern summit of the mountain.

There is an important Bektashi *tekke* at the Kulmak Pass. Known to the Bektashi as "Father Tomorr," the mountain is usually a remote and lonely place—there are still falcons and wolves here—but this holy peace is disturbed once a year on August 15, when tens of thousands of Bektashi ascend the pass on foot, on donkeys, or in ramshackle lorries and jeeps. The men carry lambs on their shoulders as they climb up the steep, rocky path. Up at the *tekke*, there are four days of celebrations in honor of Hajji

Bektash, the 13th-century Islamic mystic whom the Bektashi revere as the founder of their community. This tradition considers the *dede* (grandfathers) to be the greatest living authorities, and the feast is attended by the *arch-dede*, who dispenses advice to pilgrims. He is responsible for their spiritual welfare and while the crowds of believers do not consider him a saint, they hold him in great esteem and trust his words, which are rooted in Sufic wisdom.

Many of the pilgrims leave the *tekke* to climb up to the summit where Ali's *turbe* stands. Here they bow respectfully, kissing the entrance portal of the tomb. Thousands of candles are lit on the flower-strewn sarcophagus, and money and countless notes with prayers are left there. During the atheist regime, Enver Hoxha's dictatorship forbade pilgrimages to Tomorr, but they are now as popular as ever.

Ali's **turbe** *on the southern peak of Tomorr*

Panagia Acheiropoietos, Saloniki

The remains of prehistoric settlements here suggest that the area has been inhabited since the Iron Age (c. 1000 BC), but the recorded history of Thessaloniki begins in 315 BC, when King Cassander of Macedonia annexed a number of settlements and created the town named after his wife, Thessalonike, Alexander the Great's half-sister. The old heart of the city is bounded by a mighty, crenellated Byzantine wall on the landward side and the coastline of the Thermaic Gulf to the south. The city's past has been turbulent in the extreme, and without doubt one of the most important chapters in this history began with the Turkish conquest of 1430. This ushered in almost 500 years of Ottoman rule, which was overturned only after the First Balkan War in 1912. The city's ancient churches thus often bear clear signs of Islamic use, as any place of worship not immediately razed to the ground was used as a mosque.

There is a wealth of impressive shrines to be found in the rather cramped confines of the lower and upper city, and most of these are still in use today. There is an idyllic park on the Egnatía, one of the lively streets in the center of town, although the little church standing in it is surrounded by high-rise buildings. It is said that this church was not built by human hands—that it was what in Greek is called an *acheiropoieton*—although it is not specified whether it floated down

from heaven or was made by angels. Now dedicated to all the saints of the Orthodox tradition, this 5th-century early Christian church suffered some damage to its fabric and decoration when it became a mosque (Eski Juma) in 1430. A still-visible inscription on one of the marble pillars records the Turkish conquest in the Islamic year 833, or 1430 by the Gregorian calendar. The church was restored in several phases during the 20th century.

As they descend to the entrance, visitors are welcomed by a feeling of protection within the warm walls; the few steps down into the building are certainly instrumental in evoking this sense—it is as if the church is ducking down into the earth. Sadly, only a few portions of the mosaics have survived, but these are of exquisite beauty. Panagia Acheiropoietos, the church not made by human hands, is a truly sacred place among the many churches in the city.

Mount Athos

The Halkidiki peninsula consists of three fingers of rock stretching out into the northern Aegean, of which the easternmost is **Athos**, also known as the Hagion Oros, the Holy Mountain, a uniquely autonomous region of Greece. Apart from the Virgin Mary, no female creature is allowed to stray onto this holy mountain, not even female domestic animals, and women

visitors have been excluded from the monastic republic since 1070. The peninsula has been a holy place since antiquity—Homer describes it as Zeus' first home—and the first hermits moved here in the 7th century.

Construction of the present monasteries began in the 10th century with the **Megistri Lavra** ("Great Monastery"), founded in 963, and by the 11th century there were more than 100 foundations on the peninsula. Their subsequent history has been chaotic, with pirate attacks, war, and internecine conflict all drastically reducing the number of monasteries. There are now 20 large communities and a number of smaller *sketes*—monastic villages—and hermitages in inaccessible caves along the steep cliffs. The

little monastic republic is governed by a legislative assembly, convened twice a year, whose membership is composed of the abbots, who are elected for life. Administration is dealt with by the "Holy Community," to which each monastery sends a representative.

Mount Athos is still densely forested, a rarity in Greece, and the greenery is captivating, as is the tranquility, which is interrupted only by the sounds of nature or the tolling of monastery bells. Many of the paths are narrow and potentially dangerous for inexperienced walkers. The monasteries resemble a string of pearls threaded along the coastline, and both of the typical forms of monasticism are represented on Athos: "koenobites," who live in closed communities, and "anchorites,"

Megistri Lavra, Mount Athos

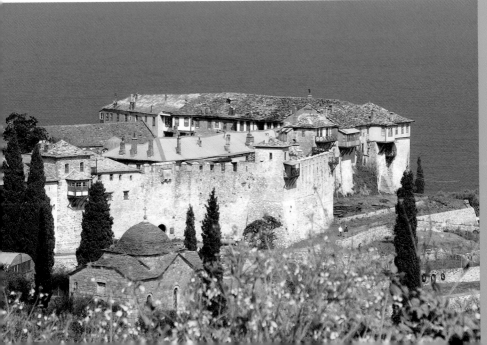

hermits who retreat from society completely, often living for months on end without contacting the other monks. Seeking peace and quiet or communion with nature, they embody the ideal of the completely introspective human being who is at one with God.

Besides the Megistri Lavra, two of the many other sacred places on the mountain are worthy of note. Begin the ascent of Mount Athos (6,700 feet/2,033 m) and about halfway up you will reach the **Panagia Chapel**, which commemorates the all-encompassing divinity of God. The **Chapel of the Metamórphosis Sotirós** ("The Transfiguration of the Savior") stands at the summit, from which there is a magnificent view of the sea. It is easy to imagine ascending to heaven from here; the visitor's gaze can range across the sky and the sea, and thoughts turn to notions of eternity and the everlasting. A visit to Mount Athos can be a moving or even transforming experience for those in search of spiritual insight and the true meaning of things.

Mount Olympus

Greece is the land of the gods, or at least it was. In contrast to the great monotheistic religions for the worship one god whose presence is revealed only occasionally and fleetingly, ancient Greece was full of gods who had very human failings. The world of the gods was a reflection of everyday human life, and the daily routine of the

gods was equally marked by the oppositions of good and evil, love and hate, magnanimity and spiteful guile. The gods embodied man's striving for perfection and yet at the same time were reflections of human weakness, and this led to the great variety of the Greek pantheon. How close the gods were to man is demonstrated by the way they managed to have children with mortals, producing the demi-gods and heroes; humans were worthy to consort with gods and by the same token the gods were never free of humans.

There were countless deities when Homer wrote his epics, the *Iliad* and the *Odyssey*. These works, part of the origins of European culture, are the oldest known record of the world of the Greek gods. Homer introduces a kind of order through the notion of the Olympian pantheon, the 12 gods and goddesses who live on Mount Olympus. This mountain range lies between Thessaly and Macedonia and its several peaks reach heights of up to 9,500 feet (2,900 m).

Once unapproachable and sacred, the seat of the gods is now thronged with hikers in the summer and skiers in the winter. Yet although it has become a popular destination for excursions, it has remained a sacred place. The best time to visit Mount Olympus is in early summer (there can still be snow on the ground into late spring) and in the early morning, to get a sense of the myths that surround this mountain. You might meet some god or other—perhaps in the form of a stone, a mountain goat, or a flowering, scented meadow in one of the gentle valleys—or you may not, but in any case a stroll on Mount

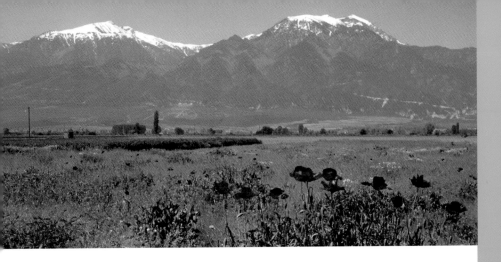

Mount Olympus, the seat of the gods

Olympus will produce the comforting thought that no human experience was strange or unusual to the gods.

The Monasteries of Metéora, Kalambaka

Sometimes, when the morning mist is lying on the cliffs, it looks as if the monasteries nestling among the rocky peaks of Kalambaka are floating. The Greek verb *meteorizo*, meaning "to hover in the air," gives these monasteries their name, and they are among the best-known and most popular shrines from the Byzantine period in Greece. Documents dating back as far as the 9th century record monks retreating to live as hermits in the inaccessible solitude of this rocky landscape, whose dark gray peaks and pinnacles rise to heights of 1,320 feet (400 m) above the low plain. The first monasteries were built in the 12th century as refuges for monks, and the founder of the monastic community is thought to have been Athanasios, a monk who came from Mount Athos to build the monastery of Metamórphosis on the "wide stone" (*Plathis Lithos*). More monasteries were added until the 16th century, by which time there was a total of 24.

The monastic communities were initially generously subsidized by both their Serbian rulers and Byzantine palatines, but toward the end of the 16th century a decline set in, caused by the internecine strife between the monasteries as well as the enormously high taxes imposed by the Turks. Most of the monasteries are now deserted and partially derelict, but six (Metamórphosis or Megálo Metéoro, Varlaám, Rousánou, Agía Triáda, Agios

EUROPE

Stéfanos, and Agios Nikólaos Anapavsás) are still occupied.

It is fascinating to see the inaccessible solitude once sought out by the monks and nuns, and the cliffs and the monasteries hold a great attraction for almost all who visit, not least because of the elevated and isolated location of several of the communities. There is plenty of climbing, and even Roger Moore—as James Bond in the movie *For Your Eyes Only*—had himself carried up to the Agía Triáda monastery in a basket to defeat the ungodly who had hidden themselves away there. Nowadays there are roads, albeit narrow ones, along the cliffs, but given the rocks, the monasteries, and the atmosphere, it is somehow more fitting to use the treacherous footpaths as you draw near to the shrine.

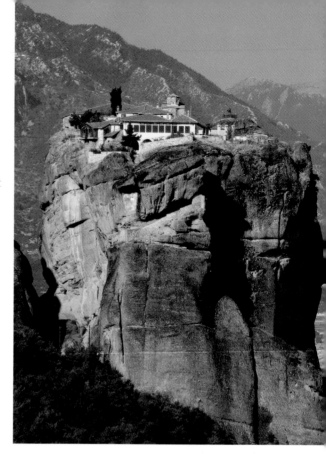

Agios Stéfanos Monastery, Metéora, Kalambaka

Oracle of Zeus, Dodona

The steep cliffs, deep canyons, and dense forests of the rugged mountains of Epirus in northwestern Greece are still home to eagles, lynxes, bears, and wolves. The town of Dordona was once to be found here, although almost nothing survives of it today after its destruction, probably at the hands of the Goths; it was nonetheless the site of one of the most important and sacred Greek shrines, the oracle of Zeus.

Zeus was the father of the gods and the lord of natural phenomena, sending clouds, lightning, thunder, and rain. Living in rugged areas such as distant,

steep mountain peaks and other hard-to-reach places, he granted life, watched over the law, and was the guiding hand in all that transpired; it was thus important to know his will. Zeus' pronouncements were once revealed beneath a mighty oak, in the rustling of whose leaves the priests would hear the voice of the god. Nothing remains of this oak either, but a complete temple complex was erected on the site in the 3rd century BC, and the ruins of one temple dedicated to Aphrodite and two smaller shrines to the local goddess Dione can still be seen here. The ancient theater has also survived: it had seating for 18,000 spectators, and it is easy to imagine the audience watching the eternal laws of human interaction in both peace and war play out in the poetry of the dramas and comedies. You may still detect traces of the will of a god and experience a sense of deep awe.

complex includes two churches: the little Panagia Church, consecrated to all the saints, and the larger Katholicon, the main church. Constructed of bricks and ancient masonry, the two Byzantine cross-domed structures are connected by a colonnade. The monks' accommodation lies near both churches, and the refectory, now a museum, stands a little to one side of the monastery.

Magnificent mosaics with gilt backgrounds adorn the Katholicon, with those in the narthex depicting the washing of Christ's feet, the Crucifixion, the Resurrection, and Doubting Thomas. The mosaics in the smaller Panagia Church are no less beautiful, with representations of the miracle of Pentecost, an icon of the Mother of God, and—in the spandrels of the dome—the

Osios Loukas Monastery, Delphi

Osios Loukas, Delphi

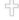

Before his death in 953, the hermit Loukas spent his last years in the enchantingly picturesque countryside surrounding Delphi. He is said to have had the gift of prophecy, much like the world-famous oracle nearby, and some time around 941 supposedly predicted the reconquest of Crete by the Saracens. When this came to pass, many years after his death, people began to worship him and the hermitage he had founded started to attract pilgrims. The current 11th-century monastery

Presentation of Christ at the temple and his Baptism in the River Jordan by John the Baptist. There are also expressive images of apostles, martyrs, and Church Fathers. The mosaic of the Ruler of the World in the cupola was damaged in an earthquake in 1559 and replaced by a fresco. Loukas' tomb is located in the crypt of the main church; the original chapel in his honor was built in 942.

Since its foundation in the 11th century, the monastery has been a center of the Greek Orthodox Church and was instrumental in the Hellenization of the invading barbarian tribes. Even today the monastery attracts many pilgrims, who are always captivated by the scenery and the wonderful mosaics.

The Temple of Apollo, Delphi

Delphi is the center of the world. Legend claims that, to locate this point, Zeus dispatched two eagles from the ends of the earth. Where they met, a great stone fell from heaven to mark the "navel of the world" (the Omphalos). Homer recounts how Apollo chose this site for his shrine by killing Python, a dragon and the son of Gaia; it had been the serpent's task to guard the gorge where Gaia exuded vapors that sent those who inhaled them into a trance, giving them the gift of prophecy. Apollo

Temple ruins, Delphi

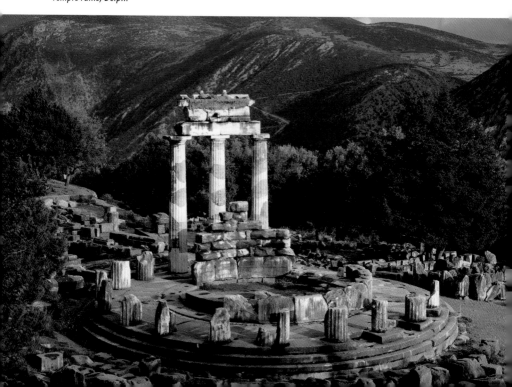

took over the place, installing the priestess Pythia to announce his bidding; this was communicated through ambiguous oracular pronouncements that invariably required interpretation.

The famous shrine was established toward the end of the 9th century BC and soon became an important political and religious center. People traveled from miles around to seek advice, and no political decision was made without first consulting the oracle. A magnificent temple was built to Apollo, and from within its interior he guided the fate of the Greeks with prophecies and responses delivered through the oracle. More and more temples and other structures sprang up on the site, and among the best-known were the treasure houses, small temple-like buildings where the sometimes extremely precious votive gifts for the god were stored.

The shrine is now accessed via a gate in the southeastern corner. This entrance leads onto the "Sacred Road," a cobbled processional route lined with monuments fashioned by the greatest artists of the age. Modern visitors may find it hard to imagine the splendor that once surrounded ancient pilgrims as they walked the Sacred Road to the temple of Apollo, but the mighty Doric tholos beside the temple of Athene, *one* of the most beautiful buildings to survive from classical antiquity (c. 380 BC), gives a hint of its former glory. The purpose of this rotunda temple is still disputed, and although it has been possible to reconstruct only three of its 20 original columns on the multi-level site, the building still exerts an irresistible fascination.

The same is true of the 4th-century BC theater, whose rows of seats are built into the steep sides of Mount Parnassus. The mountain's jagged southwestern slopes, with their scent of wild thyme, and these unique buildings are enough to inspire awe in any visitor, even in the absence of a message from the oracle.

Temple of Nemesis and Themis, Rhamnus

The city of Rhamnus lies on the east coast of Attica, directly opposite Euboea, and here, within sight of the sea, are to be found the ruins of two ancient temples from the 5th century BC. These were dedicated to two goddesses of extreme importance, not just for Attic antiquity but also for modern man. The excavated site has revealed little of the old religion, but it is known that the larger temple was dedicated to Nemesis, the goddess of retributive and restorative justice, and the smaller to Themis, Zeus' advisor in matters of world order.

Even without any archeological background it is tempting to speculate that these temples were an expression of the veneration accorded these gods. They are a reminder for modern visitors of how important it is to lead a just life, and the fact that the highest god had an advisor to deal with ordering



the world is a comforting indication that just such an order exists—providing orientation in an unpredictable world is as important today as in the ancient world. There are plenty of differing opinions about the nature of justice and how it can be attained, but striving toward fairness is certainly a fundamental requirement for human co-existence, and the temples of Rhamnus are a testament to this.

Acropolis, Athens

The refuges of the Greek city states were large and located at the highest (*akros*) point above the city (*polis*). The most important acropolis is the one at Athens on its limestone cliff; even now it is the defining image of the City. The buildings here are all architectural masterpieces, the acme of Greek culture, and the **Parthenon**, dedicated to Pallas Athena Parthenos, the patron deity of Athens, towers over them all. The first structure on this site was begun around 490 BC after the defeat of the Persians at the Battle of Marathon, and the most beautiful Doric building still in existence was completed about 50 years later.

The architectural fine tuning, especially the curvature of the top surface of the plinth (*stylobate*) and the slight swelling of the columns (*entasis*), are unique in their correction of distorted perspective when viewed from below, allowing

the temple to appear harmoniously proportioned. A statue of the goddess originally stood here, but it has vanished without trace. Many of the handsome statues and reliefs can no longer be seen in their proper place; for this visitors have to go to the British Museum in London, where they are on display.

The nearby **Erechtheum**, a temple dedicated to several gods and mythical heroes, was built between 421 and 406 BC. Although much is known of the gods and heroes of Greek antiquity, none of their images has survived here. The caryatids (female figures) supporting the lintel on the south side of the temple are extraordinary, possessing a grace to delight anyone with an eye for beauty and dignity.

The **Theater of Dionysus** at the foot of the sacred mountain offered seating for more than 15,000 spectators, and many ancient classical writers saw their tragedies and comedies performed here. Such performances were intended not just as entertainment but also as a re-enactment and exemplar of real human tragedies and comedies, to help people find their way in the world. Theater visits were sacred as they involved contact with the laws governing mankind and the will of the gods.

One sacred place among all these marvelous buildings should not be forgotten, and it is of special importance to Christian visitors—a modern inscription on a plaque opposite the **Areopagus** commemorates the famous sermon by the apostle Paul

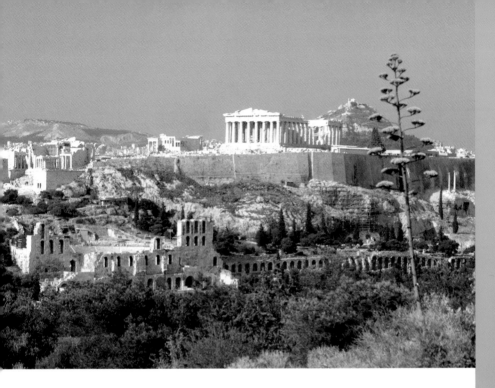

The Acropolis, Athens

that proclaimed his God before the most important Greek gods. The Acropolis in Athens is a unique and sacred place for every European seeking his or her cultural roots.

Temple of Poseidon, Cape Sounion

Poseidon, the brother of Zeus and the ruler of the oceans and seas, was a god of special significance for a people with such a strong connection to the water. He inspired fear by whipping up the seas with his trident and sending storms and earthquakes, and people worshiped and praised him when he allowed them to sail home safely. Seafarers attributed a good passage and a safe return to him, so it is little surprise to learn that one of the most important shrines in classical antiquity was the 5th-century BC Temple of Poseidon on Cape Sounion. The cliffs here plunge 200 feet (60 m) down to the sea and this elevated location on the sea route to Athens was probably used for navigation; on a clear day you can see across the water as far as the Cyclades. Little remains of

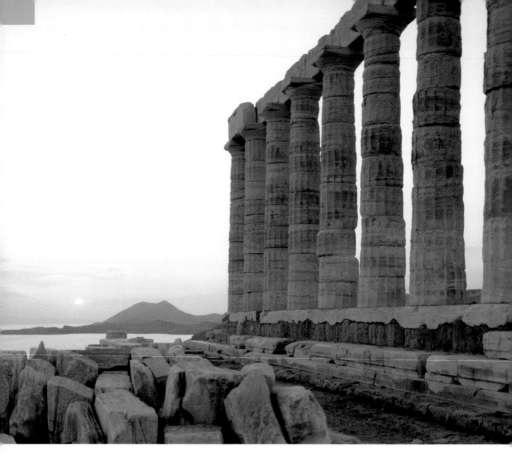

The Temple of Poseidon, Cape Sunion

the temple, but the 12 restored Doric columns give a sense of its majesty. The delicate white pillars shimmer a faint pink in the setting sun, and it is easy to understand why the Greeks held this place sacred, and why it is still considered sacred today. The Greeks built temples not only to honor their gods, but to appease them as well. The Temple of Poseidon is a proof of the importance of this purpose that is visible for miles around.

Asclepeion, Epidaurus

Sick people would once travel for miles to reach this shrine, as Epidaurus was the center of the cult of Asclepius. The temple complex flourished as a place of worship and healing from the late 5th century BC to the late Roman period, but the cult came to an end in 391–2 AD when the Roman emperor Theodosius I banned

all polytheistic cults and established Christianity as the state religion.

Epidaurus was originally dedicated to Apollo, the god of light, moral purity, and proportion, as well as the god of the arts, especially music and poetry. From the 5th century BC, Asclepius came to stand at the side of his divine father, Apollo, who continued to be worshiped in a separate temple that was dedicated to him. Epidaurus only really gained in significance once Asclepius, who had been taught to heal by the wise centaur Cheiron, came to the fore. Asclepius continued to heal people, attracting the ire of Zeus, who blasted him into the underworld with a thunderbolt. Asclepius is known from the countless representations of his staff, around which a snake is entwined—like the snake in mythology, Asclepius knew the healing powers of herbs and other plants, and his staff is the symbol of doctors and chemists even today.

Modern visitors to the shrine in Epidaurus first enter the world-famous theater, the best-preserved in all Greece, where even the slightest whisper is audible in the top rows. Only a few ruins remain of the old Xenon (or Katagogion), the hostel for high-status pilgrims—it once had two floors and 160 rooms, with grounds and fountains. There are some 3rd-century public baths in the near vicinity, and the Gymnasium dates back to a similar period; physical exercise played an important role here, alongside literary, philosophical, and musical training. The Gymnasium was closely connected with the great Stadium standing nearby

in a little dell, in which every four years the Asclepians would hold sporting and musical contests. The actual shrine, of which only the foundations remain, is reached by going through the adjoining Propylaeae (entrance buildings) and the Palaestra (a sports hall with a four-sided portico).

Many regard the tholos (a rotunda used for ritual purposes) as the most beautiful building, and it certainly showcases the genius of Polykleitos the Younger, its architect. The structure is based on six concentric rings—the outermost three support the colonnades and the inner ones, accessible via the temple *cella* (inner chamber), perhaps represent the snake, sacred to Asclepius.

Nea Moni of Chios

After the empress Theodora restored the veneration of icons in 843, Byzantine art rose to its greatest heights between the 9th and the 11th centuries, and the cross-domed church, a cruciform central-plan structure topped with a main dome, became more and more popular. The cupola often depicted Christ as Ruler of the World (*Pantocrator*), usually surrounded by prophets and saints.

Mosaics and painting reached their apotheosis during the so-called "Macedonian Renaissance," a period strongly influenced by the late classical period. One of the most beautiful

examples of this art is the monastery of Nea Moni near Kariés on the island of Chios: the mosaics glow with an inner light, the figures stare straight out at the observer, and

Nea Moni, Chios

emperor commissioned leading artists from Constantinople to execute the mosaics. The monastery went on to flourish for centuries, becoming one of the most important spiritual centers of the Aegean islands.

The depredations of the Ottomans in 1822 and an earthquake in 1881 seemed to spell the end for the monastery, but both the church and the ancillary buildings were restored and now a few nuns live in Nea Moni, which lies in a scented wood of cypresses. Despite its fame, Nea Moni has remained a peaceful haven, as the bus from the town of Chios only goes as far as Kariés and there is still an hour's walk from there to this sacred place.

nothing distracts from concentration on the gospel. The images depict scenes from the life of Christ.

The monastery was founded by the Eastern Roman emperor Constantine IX Monomachos on a site where a shrine was said once to have stood— some monks had discovered an icon of the Virgin in a bush and founded a little church there. A magnificent monastery complex arose, comprising the Katholikon (main church), two smaller churches, a refectory, and a fortress-like curtain wall. The

Monastery of St John, Patmos

This sacred place is located on Patmos, the smallest of the Dodecanese islands. The monastery, dedicated to St John

the Evangelist, who was banished to the island by the emperor Domitian, is a dark presence among the jumbled white houses of Chora, the capital. John experienced a series of visual and auditory revelations on Patmos, the most famous of which he is said to have dictated to his amanuensis Prochoros in a cave: this was the Apocalypse, the Revelation of St John, the last book of the Bible, telling of the Last Judgment and of a new heaven and a new earth where there will be no more sorrow or pain. There is now a little monastery attached to the "Grotto of the Apocalypse."

The mighty, fortress-like Monastery of St John, the main tourist attraction on the little island, was established in 1088, on the foundations of the Temple of Artemis and a nearby Christian basilica. The monastery houses numerous relics, but more important

even than these are the valuable Bible manuscripts that have made Patmos a center of spiritual life. It is clear, from here and elsewhere, that sacred places tend to follow an ancient tradition: a church, a place of worship, is built on the site of an ancient temple, and this is replaced in turn by a monastery where people can study and teach.

Thera, Santorini

Around 1500 BC a huge volcanic eruption occurred in the Aegean. The blast was of such force that it blew up the whole volcano, creating a gigantic tsunami that swept all before it and changed the shape of the Cyclades

Monastery of St John, Patmos

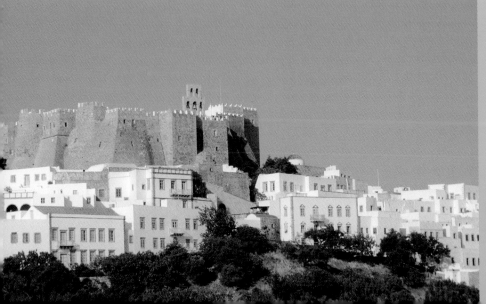

for ever. Many believe that the fabled Atlantis, as mentioned by Plato and sought after ever since, sank beneath the waves as a result of this catastrophe. The eruption produced the island of Santorini, which was known to the ancient world first as Kalliste ("the fairest") and then as Thera ("the wild"), which is also the modern Greek name Thira. The natural disaster covered the island with a layer of lava, ash, and cinders, and a stratum of pumice up to 100 feet (30 m) thick, and these features have shaped the island's unique scenery. The name Santorin (modern Greek: Santorini) is derived from the island's patron saint, St Irene, and dates back only to the 13th century.

The ancient city of Thera (bearing the same name as the island) was founded as a Doric colony in the 10th century BC, and the temple ruins are proof of the prosperity of the so-called Golden Age, during which Thera was the Aegean base for Ptolemy's navy. The ancient city, which was inhabited until the Byzantine period, is reached via a steep path leading up to its cliff-top location. At the end of the path there stands a shrine in honor of Concordia, the goddess of unity, and also temples to Zeus, Apollo, and Poseidon. Dionysus was worshiped in another of the many temples and there is even a shrine to the Egyptian gods. At some point, the temple to Apollo Pythia was converted into a Byzantine church. The ancient city also had the usual garrison buildings, a gymnasium, and a theater, as well as

Santorini island chain

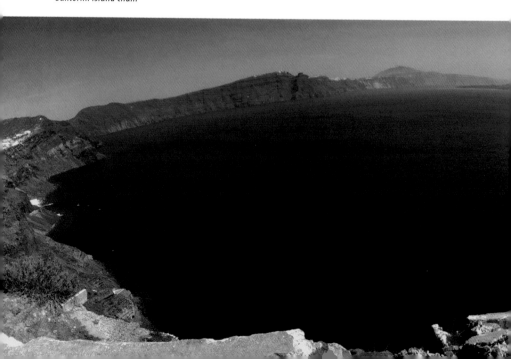

the agora, the central place of assembly. The Sacred Road taking visitors past much of the city's glorious history imparts a powerful sense of the importance of the gods to the Greeks.

Agios Titos Church, Heraklion

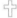

Crete's largest city is not especially beautiful, but it has a long and interesting history. Situated on the edge of a coastal plain, it is dominated on all sides by the Ida Mountains. More or less all of the tourist sights are

located within the old Venetian city wall, including this sacred place. The large Agios Markós Church is used for concerts and exhibitions, but the Agios Titos Church, still in use as a place of worship, is known for its stewardship and veneration of the relic of the skull of Titus, the first bishop of Crete and an important character in the Bible; Paul wrote a letter addressed to Titus.

The Byzantine church was built in 962 but converted into a mosque during the period of Ottoman rule. The building collapsed during an earthquake in 1856 but was rebuilt, and its Arabic-looking façade is a reminder of its time as a mosque. The sacred skull relic has been kept here since 1966, when it was returned to the Cretans from Venice. This church is thought particularly holy by Greek Orthodox Christians, as Titus is considered to have introduced Christianity to the islanders, and around 80 percent of the population is Christian.

The Palace of Knossos

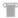

Not much was left of the labyrinthine palace of the fabled King Minos by the time the Romans sacked Knossos in 67 BC, bringing 5,000 years of Minoan history in the civilization's capital to an end. The first palace was built around 2000 BC and lasted 300 years before being destroyed and rebuilt. Around 1500 BC the palace was once again ruined in the gigantic Santorini volcanic eruption, and by

1375 BC at the latest the palace had been finally and completely destroyed. Nonetheless, Knossos remained one of the most important cities on Crete.

Palace of Knossos, Crete

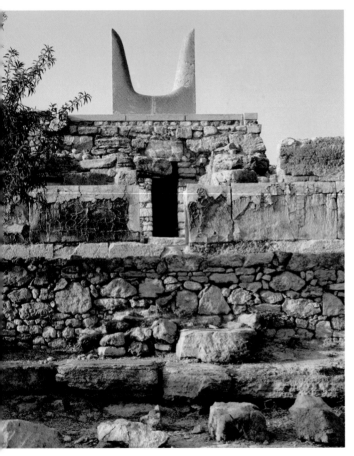

The ruins of the palace and temple precinct were rediscovered only in 1900 by the British archeologist Arthur John Evans, who subsequently reconstructed them. There is some dispute among archeologists about the accuracy of this reconstruction relative to the original city, but it certainly offers visitors a vivid and lasting impression of Minoan culture.

Throughout the cycles of destruction, rebuilding, and reconstruction, one myth connected with the palace (and mentioned by Ovid in his *Metamorphoses*) has survived. After sleeping with a bull, the bride of the Cretan king Minos gave birth to a creature that was half man, half bull— the Minotaur. The king enclosed the beast in a garden that Daedalus had made so convoluted that there was no escaping it. Minos sentenced the Athenians to send seven boys and seven girls into the labyrinth every year as a sacrifice to the monster. Only Theseus, the son of King Aegeus, aided by the blond-haired Ariadne, daughter of Minos, was able to find his way out of the labyrinth, having first slain the Minotaur.

The complex consists of a multitude of buildings forming a truly labyrinthine maze. There are no fortifications and the central point

of the complex is occupied by a rectangular courtyard surrounded by a colonnade and accessed through a monumental gate flanked by columns. Buildings of varying size line the quadrangle and these are accessed by means of winding and interlinked paths; perhaps the architecture is intended as an echo of the legend of the Minotaur in Minos' maze. The great Throne Room in the palace is particularly impressive, with an alabaster throne as its finest feature. The southern walls are topped with large, stylized horns, and this was presumably a shrine or place of sacrifice of some kind. The

mother goddess was worshiped in a nearby temple. Little is known for certain about Minoan religion, but it is believed that worship of a matriarchal mother goddess was combined with phallic elements, symbolized by snakes.

Arkádi Monastery, Crete

The fortified monastery at Arkádi, Crete's national shrine, is located about 16 miles (25 km) southwest of

Arkádi Monastery façade, Crete

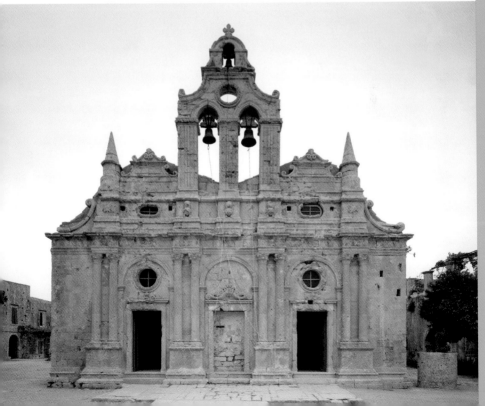

Réthimnon on a 1,640-foot (500-m) high plateau in the Psiloritis Mountains. Records indicate that the monastery was founded in the 5th century, and the twin-naved basilica was built in 1587, during the Venetian occupation. Crete was incorporated into the Ottoman Empire in 1669, but after this conquest the monks were allowed to return to their monastery, and it became a hotbed of resistance to Ottoman rule during the War of Independence from 1830. Disaster struck in 1866, when the complex was lost to the besieging enemy; the entire complement of the monastery withdrew to the gunpowder magazine and blew themselves up. The fight for independence was more important to the monks than their lives, and their bones are preserved in an ossuary. The gunpowder magazine was not restored, although the monastery church was rebuilt with a graceful and harmonious façade combining almost playful baroque and Renaissance forms.

One inscription tells of the struggle that occurred here: "the flame lit in this crypt, illuminating glorious Crete from one end to the other, was a flame of God in which the Cretans burned for their freedom" (Archbishop Timotheos Veneris).

Fighting is not holy, nor is war or destruction, but striving for freedom and autonomy is a sacred cause, and this yearning for liberty is recorded in Arkádi Monastery.

Kera Kardiotissa Monastery, Crete

If you are planning to go hiking on the Lassithi plateau, in the eastern region of Crete, you should take this little detour. Nestling in the luxuriant vegetation of a cypress grove on the northern slopes of the Dikti Mountains, you will find a little pilgrimage church and the monastery of Kera Kardiotissa. The church is a 14th-century structure consisting of a narthex, a main nave, a tiny side chapel, and what is now the chancel, which was once a one-room chapel. The beautiful frescos within, with their glowing colors, are some of the best-preserved on the island.

Under the Ottoman regime, the monastery provided a school for the Greeks and was also a secret meeting place, but the most notable feature of the monastery relates to a legend that tells how the Turks looted a miraculous Marian icon, transporting it to faraway Constantinople; through some strange process, the icon found its way back to the monastery, and it can be seen on a column in the courtyard to this day. The monastery's feast day on September 6 attracts many believers wishing to present a petition to the Mother of God; these pilgrims are both locals and people from all over the world who wish to enlist divine assistance, help, and comfort.

The Church of Panagiá i Kerá, Krítsá

The little mountain village of Krítsá has been used twice as a movie set— the film version of Nikos Kazantzakis' novel *Zorba the Greek* is world- renowned, but Jules Dassin also set

The little church of Panagiá i Kerá, Krítsá

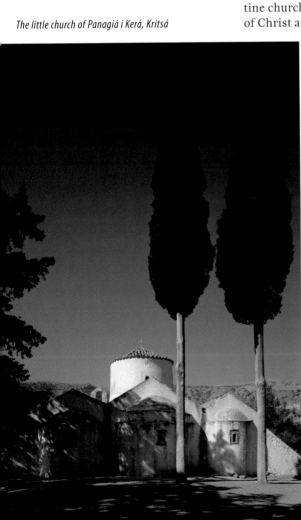

Celui qui doit mourir, a film based on another of Kazantzakis's novels, here. The town is picturesque, attract- ing hundreds of visitors every day, but among the usual souvenir shops, cafés, and bars there is a jewel of Byzantine architecture, the Church of Panagiá i Kerá, with two marvel- ous 15th- to 17th-century frescos, which have survived almost completely intact. In contrast with most Byzan- tine churches, there is no portrayal of Christ as the Pantokrator (Ruler of the World), but instead the frescos show scenes from the whole Bible. The church takes visitors on a visual tour of Bible stories, introducing them to a host of saints, and the iconography ranges from Old Testament prophets to scenes from the life of Christ. Angels, the evangelists Matthew, Mark, Luke, and John, the Virgin Mary, and Jesus himself all feature strongly in the colorful mélange. The west wall depicting the torments of hell is especially impres- sive. Entering this little church is like enter- ing another world—a world of stories and traditions that embrace heaven and earth.

Basilica of Titus, Górtis

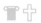

"Paul, a servant of God ... to Titus, mine own son after the common faith! ... for this cause I left thee in Crete, that thou shouldst set in order the things that are wanting ..." These words begin the letter sent by the apostle Paul to his colleague Titus. St Titus became the first bishop of Crete and the 6th-century Basilica of Titus at Górtis is dedicated to him. It is not known for certain that he ever preached in this place, but the relic of his skull was venerated here until 1669. Only fragments now remain of the basilica but even these ruins attest to the importance

that early Christianity had soon gained in the whole Mediterranean area. The basilica is just one of many old buildings in Górtis, a little town that is now almost deserted, but in the Roman period was the island's capital. Nowadays it is possible to stroll through the olive groves and feel as if you are back in ancient times as you explore the site.

As well as the agora and the Roman amphitheater there is a very special artifact of Doric culture, now sadly kept behind railings: 12—of originally 20—law tablets from around 500 BC, a unique specimen of ancient legislation. The civil and penal code of the city of Górtis is laid down in 17,000 characters on 42 blocks of

The ruins of the Basilica of Titus, Górtis, Crete

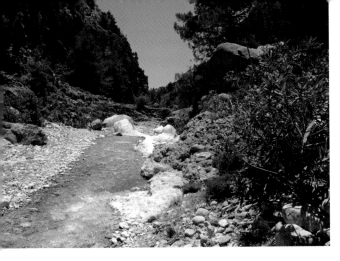

The Samariá Gorge, Crete

stone, with lines running alternately from left to right and then reversed; this is a unique record of ancient lawmaking, giving a sense of how human communities have to create order for communal living to succeed. The law is sacred in the sense that it tells of an order that is stronger than the interests of the individual.

Samariá Gorge, Crete

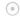

There are plenty of natural wonders on Crete, but it is an experience of a special kind to walk through the Samariá Gorge in Chaniá, probably the longest canyon in Europe at 10 miles (16 km), whose rocky walls tower some 1,640 feet (500 m) above its floor. Starting from the plain of Omalós at an elevation of 4,025 feet (1,227 m),

the hike descends a *xylóskala*, a steep flight of wooden steps leading down to the canyon floor. Along the route is the deserted village of Samariá, which had to be abandoned when the gorge became a national park in 1962. The canyon becomes ever narrower as it progresses, only measuring a few feet across at the "Iron Gates." The last section takes visitors across a flat, exposed coastal plain.

The arduous hike through the Samariá Gorge can be a very special spiritual experience—the landscape of rock formations and rushing streams beneath an azure-blue sky is uplifting, and the occasional peacefully grazing mountain goat seems to welcome visitors. Walkers descend from the mountains, the seat of the gods, to the sea, the source of all life, and the exertion required by the route is felt physically. As you walk through the gorge, you will soon understand the refreshment brought by cool water and learn about the interplay of mind and body. No particular piety, merely a feeling for one's environment, is required to experience how insignificant man is when compared with the surrounding natural world. The fatigue you will experience at the end of the route brings with it a feeling of relaxation and a sense of peace that are rare in everyday life.

PILGRIMAGE—A JOURNEY IN SEARCH OF THE SELF

The famous *dictum panta rhei*, attributed to Heraclitus, suggests that everything is in flux and that nothing remains constant, but this is a general human experience and not just a philosophical insight. Pilgrimage involves movement, and almost every culture and religion features pilgrims on journeys to sacred places. Many different motives have moved people to undertake pilgrimages—some seek a cure for physical or mental afflictions, some travel in atonement for real or perceived wrongdoing, and some hope for spiritual growth and a cleansing of the self. Many cultures see life itself as a pilgrimage; it certainly involves arrival and departure, the two key experiences of human

existence. A person encounters the Self on a pilgrimage, but also the Other—metaphysical and transcendental experiences are as much a part of a pilgrimage as a pilgrim's staff.

A belief in magical or especially sacred places runs like a thread through the entire history of humanity on every continent. It seems to be one of the core values—and, clearly, core requirements—for humans to be on a spiritual quest, either individually or within the framework of communally enacted ritual. A journey to a particular sacred place at a sacred time has had a significance throughout the world—prehistoric stone structures indicate the oldest of such places to this day, even

if the significance of many of these is unclear to us.

The barques of the gods traveled the Nile in Ancient Egypt accompanied by priests, musicians, dancers, the royal court, and countless others. Imposing Aztec and Inca temple complexes attest to their pilgrimages and mysterious sacrificial rites, and in India millions of people congregate for the most important pilgrims' festivals. Buddhists assemble at the places sacred to their faith, the Way is at the heart of Daoist beliefs (the Chinese word *dao* means "the path"), and the same is true of followers of Shintō in Japan, whose name derives from the Chinese *shen dao*, the path of the gods. The folk religions of

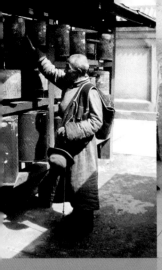

East Asia have a millennia-long tradition of pilgrimage to the temples and shrines of the gods and goddesses of their pantheon, and the three great monotheistic world religions (Judaism, Christianity, and Islam) have featured sacred journeys since their very beginnings; Jerusalem, Rome, and Mecca are just the most famous of the pilgrimage destinations. Pilgrimages are even a part of our modern and mobile world. In times that are lacking orientation and vision, pilgrimage offers the world something to strive for, bringing home the truth of the Chinese proverb: the path is the goal.

The Marian Hill, Levoča

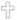

Nestling in the east Slovakian hills, the little town of Levoča, whose foundation dates back to the 13th century,

The pilgrimage church on the Marian Hill, Levoča

once had a leper colony, a little Marian church, and a Carthusian monastery. The monastery was destroyed after the Reformation and the town remained deserted until 1687. After the Franciscans took over the site, they decided to promote worship of the Virgin Mary, particularly on July 2, the Feast of the Visitation. There is now a little neo-Gothic Marian church on the site, built in 1903, whose interior contains a Marian icon with a crown of light. Dating back to the 15th century, the icon, through some miracle, has survived centuries of political and religious upheavals relatively unscathed. Slovakia attracted a steady stream of pilgrims to its Marian shrine despite the rapid spread of the Reformation and later the proscription of religious practices by the Communist regime after 1945. Marian pilgrimages were more than just a religious exercise, they had considerable significance for the resistance against the Soviet regime and in the

maintenance of national identity. Tens of thousands now undertake the journey to the Marian Hill at Levoča (Mariánska Hora v Levoča) on feast days, adopting national dress and carrying crucifixes bedecked with flowers; after the Masses there are parties long into the night in the surrounding woodland. This down-to-earth sacred place demonstrates how closely piety and celebration are connected, providing a break from everyday life.

St Elisabeth's Cathedral, Košice

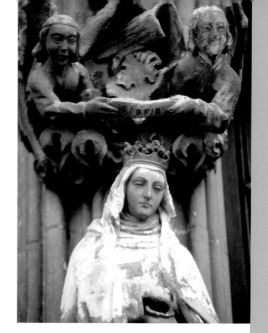

St Elisabeth, as depicted on the façade of Košice Cathedral

Elisabeth of Thuringia, the daughter of the Hungarian king Andreas II, was beatified by Pope Gregory IX in 1231, only four years after her death. She had died at the age of 24 after devoting her short life to the care of the sick and the poor. The beatification process uncovered over 100 miracles that had been brought about by appeals for her help, including the raising of nine people from the dead.

Elisabeth's canonization was important for all of Hungary but had particular consequences for Košice, as the saint enjoys special reverence here and is recognized as the city's patron saint. A papal bull records the existence of a Church of St Elisabeth in Košice in 1238, but this structure was destroyed by fire in 1370. Construction of a larger church was begun

on the same site eight years later and this became St Elisabeth's Cathedral (Dóm svätej Alžbety). The first phase of construction, completed in 1420, saw the erection of a five-naved basilica without a transept; the latter was added at a later date, creating a Latin cross floor plan. Several chapels were added in a third phase of building work lasting until the end of the 15th century. Shortly after this the church was badly damaged, requiring substantial renovations, and a final phase of restoration and alteration dates back to the period between 1877 and 1896. This mighty building now dominates the Old Town of Košice.

The interior of the church features an altar with a cycle of reliefs depicting the short life of St Elisabeth, running

EUROPE

from her birth through her marriage to Count Ludwig of Thuringia to her acts of charity and the miraculous occurrences of her life. Elisabeth is revered for her exemplary charity but also for her patient perseverance. Once, when she was to be punished for some act of perceived disobedience, she is supposed to have said: "We should suffer this gladly, as we are but reeds on the riverbank. When the water rises we are submerged, when it falls, the reeds happily go on living."

Church of St Elisabeth, Bratislava

Many monasteries and hospitals in Europe, as well as many churches, bear the name of St Elisabeth. She is thought of as a figure who, despite her aristocratic birth, early marriage to Count Ludwig, and courtly lifestyle, was a radical adherent to the Franciscan ideal of poverty, devoting her life tirelessly to the care of the poor, sick, and needy. This little Roman Catholic church in Bratislava is dedicated to the saint, and was originally the chapel of a secondary school. The Church of St Elisabeth, an especially beautiful example of early 20th-century Hungarian art nouveau (known as the Secession style), was built in 1907–8. The floor plan is in the form of an ellipse with a cylindrical tower at one end. All of the elements seem to flow or float into one another, just as art nouveau prescribes, and a series of waves and a curved line of blue wall tiles surrounds the building. Both the main and the side portals are flanked by Romanesque double columns, and the main portal is surmounted by a mosaic depicting what must be the greatest miracle ascribed to St Elisabeth—the miracle of the roses. Legend has it that St Elisabeth would hide bread under her coat to take to the needy, although her husband had forbidden her to do so. Cornered one day by her husband and commanded to undo her coat, she produced a bouquet of roses. This miracle enjoys considerable popularity and lies at the heart of the saint's veneration.

The façade is highlighted in shades of blue of varying intensity, and it is no surprise to learn that the church has acquired the nickname "the Blue Church." The structure was originally intended to have a dome, but in the end a hipped roof with glazed tiles was built in a shade of blue. There are art nouveau features to be found in the interior, and here, too, blue is the dominant color. Above the high altar there is a devotional picture of St Elisabeth distributing bread to beggars and paupers.

The Blue Church, Bratislava

St Mary's Church, Gdańsk

A document written in 1271 by Duke Mestwin II mentions a Church of St Mary, although quite where this church stood is disputed. The modern Church of St Mary, one of the largest medieval churches—and one of the most impressive brick buildings— of any period, undeniably dominates the cityscape of Gdańsk. Work was begun on the second St Mary's in 1343, but the structure, a three-naved church with chapels, a deep transept, and a straight chancel, was not completed until 1502. The vaulting over the three naves rests on 26 stout pillars rising to a height of almost 100 feet (30 m), and there is space for a congregation of 25,000. The painted starry sky that covers the vaulted ceiling is a late Gothic artistic masterpiece dating to between 1498 and 1502.

The Roman Catholic Church did not have long to enjoy the building, as Danzig (Gdańsk's former name) allied itself with the Reformation in 1529. The building was fortunately spared from the iconoclasts, except that the interior frescos were white-washed over and some have only very recently been restored. The church remained the property of the

The Church of St Mary, Święta Lipka

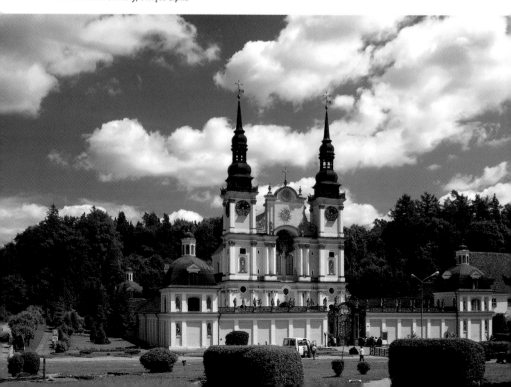

Protestant community until 1945, by which time more than half of the structure had been destroyed in World War II—the roof and the vaulting collapsed and the tower burned down almost completely. Immediately after the war the building was returned to the Catholic Church and renovation work was begun, reaching its completion with reconsecration in 1955. A year later the impressive altar triptych, which had been looted by the Russians during the war, was returned to Gdańsk. For the Poles, the Church of St Mary in Gdańsk is a symbol of their indomitable will to resist the depredations of war and not to give up. The Polish people's deep faith helps them to endure patiently, forever setting out again from the beginning; the new Church of St Mary is an architectural expression of this capacity.

Święta Lipka

Masuria was once occupied by the Prussians, a Baltic tribe with a natural religion that followed two phases: female divinities were worshiped during the older period, which was followed by an Indo-Germanic period with male gods. The story of the founding of the village of Święta Lipka dates back to the Christianization of the area. The Virgin Mary appeared to a prisoner condemned to death, handing him a piece of wood and telling him to carve whatever came into his head. The next day the judge was so amazed by the figure of Mary that the miscreant had produced that he was set free. As he returned to Rössel, his home town, he hung the carving on the first lime tree he encountered, just as the Virgin had commanded him to. Whether by chance or by divine providence, the lime tree he chose had been a ritual site since Prussian times, dedicated to the fertility goddess Puskaite, in whose honor festivals were held in the spring and fall.

Many miracles happened near the lime tree after the figure of the Virgin had been hung there, and a pilgrimage site—Święta Lipka, the holy lime tree—grew up, to which people came in the hope of a miracle. The site was destroyed during the Reformation but rebuilt in the 17th century, and now this village with its population of about 200 is the proud possessor of one of the most magnificent monasteries and pilgrimage churches in all Poland—indeed, the Jesuit monastery and the Church of St Mary built on the site of the legendary lime tree are among the most beautiful baroque buildings in northern Europe.

The church is a three-naved basilica with astonishingly rich decoration, little changed since it was made. As well as the church, the complex also includes a monastery and a spacious cloister with a chapel at each of its four corners. The whole place looks a little unreal; in the middle of the solitude and silence of the swampy Masurian landscape, the monastery complex seems like an emissary from another world.

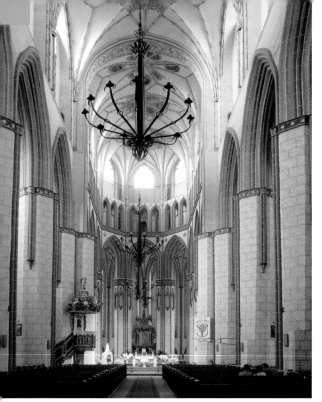

The main aisle, St Mary's Church, Stargard

St Mary's Church, Stargard Szczeciński

The brick church in Stargard is one of the most important Gothic ecclesiastical buildings in Poland. Dominating the Old Town, it stands in the middle of the fortified city and was begun in 1292 as a hall church dedicated to the Virgin Mary. In the 15th century the structure was extended as a basilica, with a ring of chapels around its choir. Pomerania allied itself with the Reformation and from 1524

the Church of St Mary was a place of Protestant worship, with the nearby monastery buildings of St John and St Augustine being dissolved. The church was burned down in 1635 during the Thirty Years' War but was soon rebuilt, and alterations and additions were carried out continuously until the 19th century. The church returned to Catholic possession after World War II.

The church's austere exterior hides an interior that reveals more of the architect's creative imagination. The triforium above the arcades in the choir, unusual in northern Brick Gothic, lends the church an unexpected lightness despite its massive exterior dimensions. The colors and floral patterns used in the decoration of the columns right up to the ceiling vaults are particularly beautiful, and the modern stained-glass windows bathe the church in a softly shimmering light. The side chapels are inviting places of silent prayer, and as you enter the church from the bustling marketplace, you are immersed in an atmosphere of tranquility and harmony.

Kalwaria Zebrzydowska

The name alone of this sacred place near Cracow in southern Poland marks it out—Kalwaria refers to a Calvary, one of the chain of shrines throughout

the world commemorating Christ's Passion, and Zebrzydowska was the name of the founder of this unique shrine. Between 1600 and 1620 Mikolaj Zebrzydowska sought to build a shrine on the slopes of Mount Zary that represented the real events of the Passion of Christ in the most authentic way. To this end he built plaster figures and drew up plans of the landscape of the Holy Land to serve as models for his enterprise. The work he began was continued by his son Jan and his grandson Mikolaj, and by the end of the 17th century 52 chapels had been spread across the site, of which 28 represented episodes in the life and suffering of Christ, with the remaining 24 being consecrated to the Virgin Mary. The first Masses were celebrated in 1608.

The Bernardine church at the center of the complex was declared a *basilica minor* by Pope John Paul II in 1979. It had been presented with a miraculous icon of the Virgin Mary in 1614, and the separate chapel built to house this image is now visited by thousands of pilgrims every year. Holy Week, when Passion plays are performed and several Masses are celebrated every day, attracts great crowds wishing to express their living faith.

Wadowice

A whisper went round the world when Pope John Paul II died at 9.37 p.m. on April 2 2005, and only a few days later St Peter's Square was filled with thousands of believers demanding he be beatified on the spot. They were expressing a sentiment unique in the history of the papacy: on that day a pope had died who even during his lifetime had come to be revered almost as a saint. It is little surprise that the town of his birth soon became a pilgrimage site for Catholics from all over the world. The little town of Wadowice between Cracow and Bielsko was first documented in 1327, but a combination of fires, plagues, and wars prevented it from flourishing and it was all but forgotten. Industrial firms moved in during the 19th century and during the German occupation the border town of Wadowice became part of the Reich, reverting to Polish control at the end of World War II.

A parish church with a history stretching back to the 14th century stands beside the basilica in the town, but most pilgrimages here are to neither church, but instead to the house in which Karol Józef Wojtyła, later to become Pope John Paul II, was born and grew up. The simple house and his parents' modest flat have been turned into a museum since his death, providing visitors with a wealth of information about Karol's childhood and later career as a theologian before he became pope. People seem not to have reserved their veneration for when the Catholic Church eventually beatifies the late pope—the house in Wadowice is a place where he is present, untouched by death.

Góra Świętej Anny

There was a shrine to St Anne, the mother of the Virgin Mary, on this high hill in Upper Silesia in the 15th century. Veneration of St Anne is an important element of popular piety in Europe, as is shown by the votive tablets to be found at her many shrines. A church was built on this sacred site around 1480–5 to house the most significant relic here, a wooden statue of St Anne, and this soon attracted pilgrims. The modern pilgrimage complex includes the basilica (built in 1665), with its cloistered square (1768) known as the Square of Heaven, the icon of St Anne— the very same historic wooden statue— a landscaped Lourdes grotto (1912–14), a Calvary with chapels at the Stations of the Cross, and a Franciscan monastery building begun in 1733. As the pilgrim numbers continued to grow, a pilgrims' hostel was added to the monastery at the beginning of the 20th century. Its location near the border has meant that the worship of St Anne carried out in the church is conducted in both Polish and German. The Franciscans have been obliged to abandon the monastery and the mountain on several occasions—during the dissolution of the monasteries carried

A procession on the Mount of St Anne

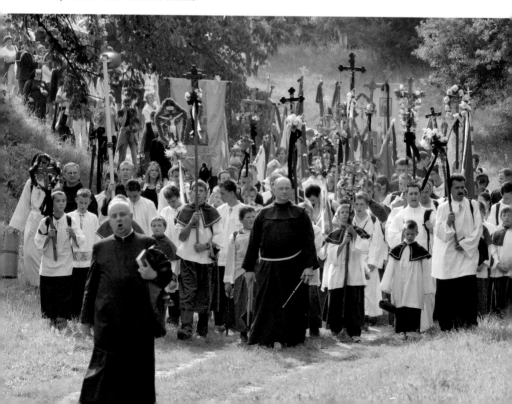

out by the Prussians in 1810, as a result of Catholic repression in the "Cultural Struggle" of 1875, and for the third time in 1940, during World War II.

The Mount of St Anne is an important national monument—both the open-air theater constructed by the Nazis as a kind of neo-pagan *thingstead* (council meeting place) and the "Monument to the Act of Resistance" are a reminder of the mutability of history, not only the history of this place but also that of the fragile relationship between Poland and Germany.

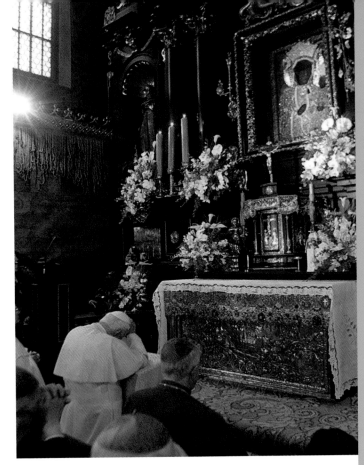

Pope John Paul II praying before the Black Madonna of Częstochowa

The Black Madonna of Częstochowa

Częstochowa, a small town not far from Cracow, is located in a region known as "Little Poland." First documented in 1220, the nearby village of Jasna Góra, the "bright mountain," was the site of a pilgrimage dedicated to the worship of an icon of the Virgin Mary painted in 1430. When the church was captured by the Hussites, the image was divided into three sections and brought to Cracow, where it was repainted on a wooden panel and later solemnly returned to Jasna

Góra. According to legend, the panel is made of wood from a table belonging to the Virgin Mary, on which St Luke is said to be painted. Mary is pointing to her son as the Way, the Truth, and the Light. The picture is thus also known as a *Hodegetria* ("She Who Shows the Way"). As with many such images, the icon is known as a Black Madonna, because the hands and face have been blackened by soot from the candles lit in her honor. The Madonna of Częstochowa is known to believers by several names: Mother, Protector of Those Who Suffer, Bringer of Love, Bringer of Blessings, the Merciful, and Protector in Times of Desperation. All these names attest to the special place of this icon in popular piety, and it has been said that the Icon of the Bright Mountain herself chose the place where she was to be kept.

Jasna Góra was fortified in the 17th century during the Thirty Years' War, and the walls surrounding the site can still be seen today. The icon, to which miraculous powers are ascribed, is attached to the wall above the great wooden altar in the Church of St Mary, and a book of miracles has been kept since the 16th century. Although there are gaps in the record, there are reports of more than 1,400 miracles or miraculous occurrences. The Black Madonna of Częstochowa is visited by more than a million people each year, not only by those seeking divine mercy but also by many wishing to strengthen their allegiance to the Polish nation; the icon of the Madonna is sacred not just for religious reasons, but also as part of Polish national identity.

Church of the Archangel St Michael, Haczów

The Carpathians lie in an idyllic and remote location in southeastern Poland on the border with Slovakia and the Ukraine, and this unspoilt region is a popular destination for nature lovers. The local people live in small, often remote villages and the wide tracts of forest are a habitat for lynxes and wolves. There are many wooden buildings in this charming landscape, and some of them are centuries old. In addition to simple dwelling houses, there are many Orthodox or Catholic churches, generally designed and built not by artists but by local craftsmen, whose piety and love of detail found expression in these ecclesiastical buildings.

The oldest surviving wooden church is the Church of the Archangel St Michael at Haczów, which was built in the 14th century and is still used as a place of worship today. Resembling a ship, the elongated wooden building blends harmoniously into its setting and the lavish and masterly decoration of the interior is especially affecting. The locals carry the church in their hearts, but all Poland carries it in their wallets—the reverse of the two *zloty* coin bears an image of the wooden church of Haczów.

The wooden church at Haczów

Monastery of the Caves, Kiev

Although Russia was subject to Byzantine influence, it was far enough away from the Middle East for the Russian Church to be able to develop largely autonomously, and way beyond the spread of Islam. After the conversion in 988 of Prince Vladimir of Kiev (as what became "Russia" was known at the time), there emerged an Orthodox spirituality with specifically Slavic traits. These included an emphasis on a free acceptance of suffering (as represented by St Boris and St Gleb), mildness and grace (as represented by St Theodosius), and a striving for genuine harmony, whereby the Church is not dominated by worldly rule or vice versa (as represented by St Vladimir).

The first monasteries were soon founded, and the Monastery of the Caves at Kiev was among the earliest of these foundations. It is mentioned

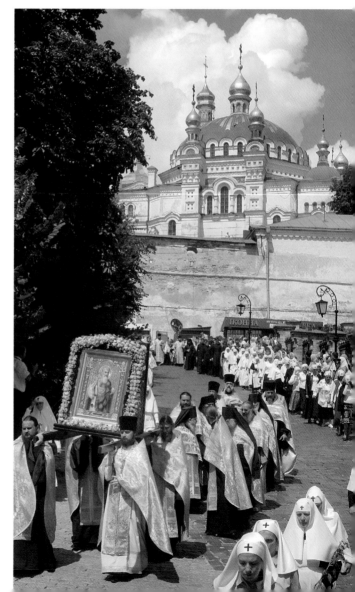

A procession at the Monastery of the Caves, Kiev

in the famous 12th-century Chron-
icle of Nestor, which recounts how
the two anchorite monks Anthony
and Theodosius founded an Ortho-
dox monastery in the old Varangian
caves on the banks of the Dnieper
in 1051. These man-made caves and
little cave churches were occupied
by the first monks, who lived a life
of strict asceticism. The Church of
the Assumption of Mary was built in
the 11th century, and the following
centuries saw the monastery develop
into the most important spiritual
center in the whole of Russia. In 1688
the monastery was awarded the title
of "Lavra," a distinction gained by
very few Orthodox monasteries.

The present buildings date back to
the Ukrainian baroque period during the
18th century and later. The Church of the
Assumption of the Virgin, All Hallows'
Church, the Church of the Exaltation of
the Cross, and the Church of the Nativ-
ity of the Virgin are of particular note.
The great bell tower was constructed
in 1731 and the most recent building is
the refectory, built between 1893 and
1895. After the Russian Revolution, the
monastery was converted into a mili-
tary museum by the new Soviet powers,
but it has been back in the possession
of the monks since 1990. Past damage
has been made good and the monastery
buildings have been restored to their
former glory. Not only do millions of
people make the annual pilgrimage to
this historic site, but monks once again
live in the monastic cells in the caves,
adhering to the ancient prescriptions
of the monastery's ascetic founders in
their search for a life pleasing to God.

The Cathedral of St Vladimir, Sevastopol

In 1892 an impressive Russian-
Byzantine church was consecrated in
Chersones, a modern suburb of Sevas-
topol that was densely populated during
antiquity and the early Middle Ages;
the site of the Cathedral of St Vladimir
has been identified as the place where
Prince Vladimir first converted to
Christianity 900 years earlier. How-
ever, the building suffered repeated
damage, and its successor was built in
the grounds of a monastery at Cher-
sones. This too fell victim to the uneasy
political circumstances of the time and,
closing in 1926, the church continued to
decay during the Soviet era. Only with
the advent of perestroika was it possible
for Russian Orthodox Masses to be cel-
ebrated on the former church premises.

The cathedral has recently been
renovated authentically and has been
in use as an ecclesiastical site since
2005. The Cathedral of St Vladi-
mir is one of the most impressive
and important new church build-
ings of the post-Soviet era, and its
main hall, which is not on ground
level but on the second floor of the
building, is of particular architec-
tural interest. Although the building
spent some time as a memorial to the
dead heroes of the Black Sea Fleet,
it is now a sacred place once more.

Solovetsky Monastery

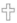

This holy place located on the Solovetsky Islands in the White Sea has a rather unholy history. During its long existence the monastery has had to endure numerous sieges, and in 1926 it was converted into the first work camp of the Soviet era, becoming the prototype for the gulag system and achieving fame and notoriety through Alexander Solzhenitsyn's unflinching description of its regime in his book *The Gulag Archipelago.*

Founded in the late 1420s by two monks called Gherman and Sawatiy, the monastery subsequently expanded its land holdings, acquiring territory on the mainland and becoming the commercial and political center of the White Sea region. Not only was the monastery a home for the monks—350 lived here in the 16th century—it also provided employment for many local people. During the 17th century the monastery was one of the refuges of supporters of the Old Believers during the Russian Orthodox Schism.

The monastery complex has always been an important border post, as is demonstrated by its construction—it is surrounded by mighty walls guarded by eight fortified towers. Gigantic stone blocks, some of which are up to 17 feet (5 m) long, were used for the solid walls, reinforcing the fortress-like impression. Behind the walls there are

Monastery complex on the Solovetsky Islands

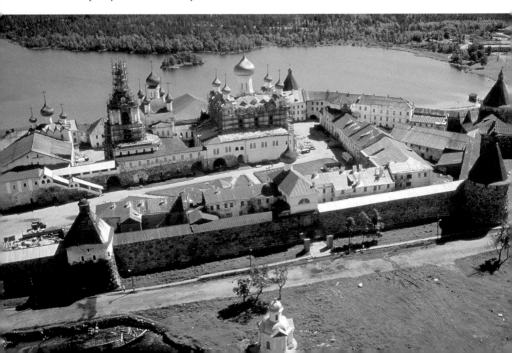

numerous churches, including the Uspensky Cathedral (1552–7), the main monastery church, the Church of the Annunciation (1596–1601), the

Wooden churches at Kizhi Pogost

Preobrazhensky Cathedral (1556–64), and the Church of St Nicholas (1834), as well as a watermill, a bell tower, and various domestic and accommodation buildings. The monastery has been occupied and run by monks since 1991.

The Wooden Churches of Kizhi Pogost

You might not expect an open-air museum to be a sacred place, but visitors to the museum on the island of Kizhi on Lake Onega

will immediately realize that this is a very special kind of place.

There are some 60 historic buildings from Karelia scattered across the site, most of which were not originally built here but were brought from other regions over the course of many years and rebuilt. Besides the many domestic buildings there are the world-famous churches of Kizhi Pogost, made completely of wood and no longer just the preserve of daytrippers—since 1994 people have been allowed to hold services in many of them again.

The oldest building is the Church of Lazarus, built in 1390, which was once part of a monastery, but without doubt the most impressive building on the island is the 120-foot (35-m) high Trans-figuration Church. Built in 1714, this imposing church's design is audacious and unique of its kind, with 22 domes on its roof. The current state of preservation is unfortunately not particularly good, and attempts are being made to recon-struct the church before it rots away completely. After the work has been completed, the church is not intended to be used just as a museum but will be a working place of worship again. The Intercession Church was restored in 1862 and has been in use since

1994, with crowds of people flocking to celebrate Mass at this idyllic spot.

Kizhi Pogost is a vision of bucolic life in harmony with nature, an expression of a yearning for a rural existence that many people in Russia can still remember. It is a place where time is measured not in days or in years, but in centuries.

Valaam Monastery

The most interesting aspect of this sacred place is that it comprises a whole island, high up in the northwest, at Lake Ladoga. The island of Valaam is one of the most interesting historical, cultural, and natural sights in northern Russia. Valaam Monastery, located in the center of the main island, is of uncertain date, although one record claims that it was founded in the 1st century by Andrei Pervosvanni, who discovered pagan ruins on the island and set up a stone cross there. According to legend, this became the foundation stone of the monastery that was built here at a later date.

While such legends are of dubious authority, the monastery is definitely recorded in documents from before the 16th century. As a result of war between Sweden and Russia in the 17th century, the Swedish border was moved to the east and the monastery fell into Swedish hands. It was looted several times between 1611

and 1715, before eventually being razed to the ground. The monastery was rebuilt at the turn of the 18th century and in 1812 was made subject to the Russian Grand Duchy of Finland; at times there were as many as 3,000 monks living here.

When Finland gained its independence in 1917, the monastery became the most important within the Finnish Orthodox Church, changing its calendar from the Julian to the Gregorian, despite the bitter disputes that this liturgical reform caused between the monks. In 1940 the vagaries of war brought Valaam under Russian rule, and many monks left both the monastery and the island to flee west, where they founded a new monastery.

Rebuilding Old Valaam was impossible after World War II, as the island was used as a Soviet military base. The monastery was not rebuilt and reconsecrated until 1989. Now under the patronage of the Russian Patriarch, the monastery has legal ownership of the island and is regaining its former spiritual seclusion.

In addition to the Transfiguration Church (Spaso-Preobrazhensky Sobor), the main church of the monastery, there are ten hermitages on the island where the monks live in strict seclusion. As well as the entrancing scenery, the numerous chapels, way markers, and crosses that are located all over the island encourage the feeling that this is a spiritual place. The climate is milder than in other places in the far north, and the island's lakes, streams, unspoilt meadows, and

tracts of woodland make it a place where it is possible to learn how man can live in harmony with nature.

Valaam Monastery, Karelia

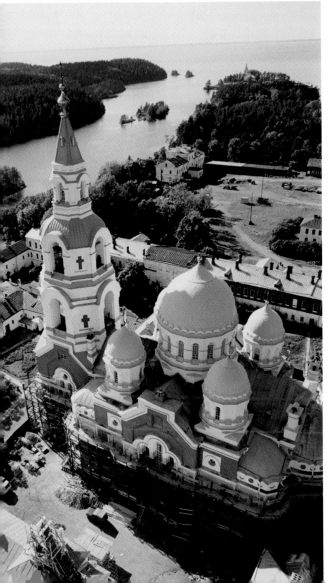

Alexander Nevsky Lavra, St Petersburg

What must be the most famous monastery complex in Russia is named after a man whose name is ubiquitous in northern Russia and the other Baltic states. Alexander Yaroslavich (later to be called Alexander Nevsky) won a great victory against the Swedes in 1240 and was canonized by the Russian Orthodox Church in 1547. His tomb in the monastery is still visited and venerated by modern visitors, as Alexander is considered the patron saint both of the city and of all Russia. A plain wooden church used to stand in the monastery grounds but in 1717 Tsar Peter the Great commissioned the Church of the Annunciation (Blagoveshchenskaya cerkov) and the buildings to the east gradually grew up around it. The classical Church of the Holy Trinity, part of the monastery complex,

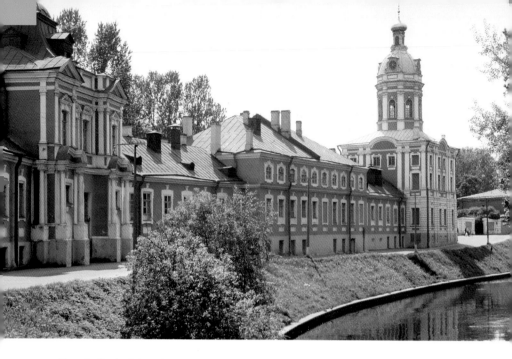

Alexander Nevsky, St Petersburg

was not completed until the end of the 18th century. The building is adorned with a portico on its main façade, two bell towers, and a large central dome. The impos- ing interior contains a large white marble and red agate iconosta- sis hung with copies of paintings by van Dyck, Rubens, and Reni.

The individual galleried build- ings of the Church of the Holy Trinity (Troizkij Sobor) at the heart of the complex are more reminiscent of secular than ecclesiastical architec- ture. In 1797 Tsar Paul I designated the monastery a "Lavra," an honorary title accorded to very few monaster- ies. The monks occupy separate cells and live largely solitary lives, although this solitude is punctuated daily by short periods of communal living. One section of the monastery is still used as a seminary, where the next generation of monks is educated in theology. The Church of the Annunciation houses a museum with a sculpture collection, and the wide cemeteries within the monastery walls have always served as a burial place for famous people.

Chapel of St Xenia, St Petersburg

A *yurodivy* is someone whose faith is such that they are a little at odds with society—an "eccentric." Such people are known in Russia as "fools for Christ," and this description generally implies a criticism by them of societal conditions or the political regime. One such *yurodivaya*, who was subsequently canonized, was Xenia Grigorievna Petrova, who lived in the 18th century and is now revered as St Xenia of St Petersburg. She was the wife of a Russian officer named Petrov, and lived in prosperity and happiness. However, when her husband died, she became aware of the transience of life and the vanity of wealth, a realization that led her to give away all her possessions and retreat to the solitude of a hermitage, where she lived for eight years. At the time of her epiphany she was a young woman of only 26. After her time in the wilderness, she returned to the city, sacrificing her own interests to care for the poor and sick. It is said she slept little and prayed continuously as she worked—miracles were even attributed to her. She continued these activities for 45 years and was both revered and mocked as a "fool for Christ." She died at the age of 71, finding a last resting place in St Petersburg's Smolensky Cemetery. The people's reverence for Xenia did not cease with her death and her tomb attracted large numbers of pilgrims,

with the result that a chapel dedicated to her was built over it. Xenia is considered the protector of the homeless, the neglected, and young offenders.

Images of Xenia are notable for a detail that is unusual in icons of women—she is always shown dressed in her late husband's uniform tunic. She is depicted as an old woman with a wizened face and gray or white hair, and her eyes have a kind of melancholy knowingness. Xenia has always been considered a rather peculiar person, as her name reminds us (Xenia is Greek for "the stranger"), and represents a very untypical type of womanhood. Orthodox spirituality emphasizes the importance of finding the presence of the Divine in one's neighbor, and this saint's authority derives from the way she devoted herself to her neighbors—it is little wonder that women in particular have found in her a saint able to address their concerns.

Kazan Cathedral, St Petersburg

Tsar Paul I was so impressed with St Peter's Basilica on his visit to Rome that he decided to build a similar structure in his own city and commissioned the construction of a cathedral. Andrei Vorochin, the architect, received strict instructions to take his inspiration from Roman models, and after ten years of building

work the cathedral was finally consecrated in 1811. Located in a commanding position on the Nevsky Prospect, this imposing church has a cruciform floor plan flanked by a colonnade of four rows of Corinthian columns. A northern colonnade was originally planned to complement the southern one, but the Patriotic War of 1812 wrecked these intentions. Three entrances, each surrounded by a portico, lead into the interior, where the 233-foot (71-m) high dome towers over the crossing. The bronze doors of the northern

of power emphasized by the double row of stout columns fashioned from pink Finnish granite. The iconostasis near the altar has been only partially preserved but still contains, among other features, the "miraculous image of the Holy Mother of Kazan," which was discovered in Kazan in 1579.

After the defeat of Napoleon in 1812, the cathedral became a national monument. From 1932 until 1990 the church was a museum of the history of religion and atheism, but religious services are now once again held in one wing.

The Kremlin and Cathedral of the Holy Trinity, Pskow

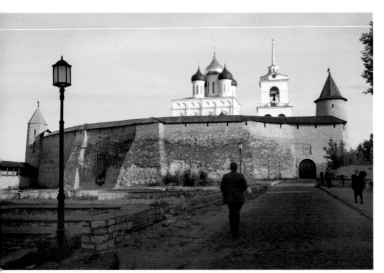

Cathedral of the Holy Trinity, Pskov

The city of Pskov, located in the far northwestern reaches of Russia on the Estonian border, has long been the religious center of this part of Russia. Pskov is

entrance, modeled on those of the Baptistery in Florence, depict the gates of Paradise. The interior more closely resembles the great hall of a palace than a church, with a sense

first documented in 903, but according to legend the city is at least 50 years older. At that time the place was being settled by Russians, Slavs, Sami, and Scandinavians, and the religious

shrines built reflected these diverse ethnicities. The Christianization of the northwest began in 955 and the old ways were largely abandoned, with Pskov slowly becoming a major center of early Russian Christianity. Pskov was famous in the 15th century as a source of icons, which found their way across the entire country.

The city was fortified with a kremlin in the 12th century and this citadel still forms the impressive focal point of the Old Town. Within its walls there is a profusion of buildings both sacred and secular, of which the most important is the Cathedral of the Holy Trinity (Troizkij Sobor). A church was built even as the kremlin was being constructed, proof positive of the centrality of the Christian faith in contemporary life. This first church and its stone successor

have not survived, but the current cathedral, a fortified building towering over the kremlin like a cliff, was built on the same site between 1682 and 1699. Within its interior are to be found the same icons, drawing crowds now as they did back then. The whole complex has been turned into a museum, but since the 1990s Orthodox high holidays have been celebrated in the Cathedral of the Holy Trinity.

Ipatiev Monastery, Kostroma

The first documentary evidence of this important monastery in the city of Kostroma, located on the banks of the river of the same name, dates from 1432, but it is assumed that it was founded some 100 years earlier. Kostroma is the northernmost city of the Golden Ring, the famous circle of ancient Russian cities north of Moscow. The monastery is inseparably associated with the Godunov family, and with Boris Godunov in particular, the successor of Ivan IV (the Terrible). The Godunovs were a Muslim Tatar

Ipatiev Monastery, Kostroma

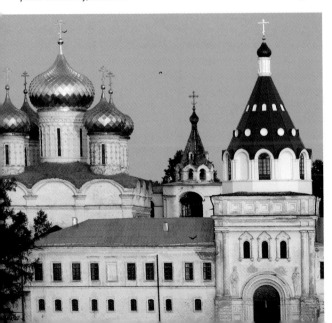

family. The legend of the monastery's foundation maintains that Chet (one of Boris' ancestors) fell seriously ill at Kostroma in 1330, but St Ipatius appeared to him, promising his restoration to health if he renounced his religion and converted to Christianity. Chet agreed, was cured, and subsequently built the Ipatiev in thanks. A regular beneficiary of the Godunovs' patronage, the monastery achieved not only fame but also wealth. Boris Godunov banished Feodor Romanov to Kostroma in 1600 and he was joined there by his son Mikhail when the latter was chosen as tsar in 1613. The Romanovs continued the patronage of the monastery, replacing older wooden buildings with stone edifices and other expensive structures.

Standing at the heart of the complex, the Cathedral of the Holy Trinity was built between 1650 and 1652. This white church is surmounted by five golden domes and the elaborate frescos in the interior are a particularly impressive in their visual narration of a host of biblical stories. The pillar supports are decorated with images of Russian rulers—that of Mikhail Romanov is especially captivating—and the cathedral's iconostasis (icon wall) is a place of reverence for pilgrims. The monastery was closed down by the communist regime in 1919, but it was returned to the Church at the beginning of the 1990s it is now occupied by monks once again and is no longer just a museum.

Iversky Monastery, Valdai/Novgorod

Like many other monasteries, the Russian Orthodox Iversky Monastery has made a significant contribution to the consolidation of Russian national identity. Situated in the town of Valdai in the province of Novgorod, the monastery complex was founded in 1653 by the patriarch Nikon. Its name is a reference to the 13th-century Iviron Monastery founded by Georgian monks on Mount Athos. The most important task performed by the monks living in this monastery dedicated to the Mother of God was the translation of ancient holy texts into Russian in order for them to be accessible to the people.

Disaster struck with the Russian Revolution in 1917, when the monastery was looted and burned; more than 400 valuable volumes from the monastery library were consumed in the flames, although some courageous monks and locals managed to save a portion of the monastery's

Fresco in Uspensky Cathedrale, Vladimir

The Golden Ring

Between the 11th and 17th centuries a series of cities, monasteries, and churches were built that between them feature in much of Russia's history and are among the many places revered as sacred. These Old Russian cities are some of the best-known and greatest tourist destinations in the country. The Golden Ring stretches northeast from Moscow, and visitors to these cities will not only experience something of the splendor and magnificence of Old Russia but also get a sense of its deep faith—since the 1990s many of the old monasteries have been reoccupied by monks and nuns, and their solemn Masses are a unique spiritual experience. The cities of the Golden Ring include **Sergiyev Posad**, with its famous Trinity Lavra of St Sergius, one of the Russian Orthodox Church's major pilgrimage sites; **Pereslavl-Zalesskiy**, one of the oldest cities in central Russia; **Rostov** on Lake Nero, the birthplace of Sergius of Radonezh, the patron saint of Russia, with its impressive kremlin and wonderful carillon of bells and many other important church buildings; **Yaroslawl**, the oldest city on the Volga, with its many ancient churches and monasteries and the old Metropolitan Palace; **Kostroma** with its Ipatievi Monastery, a destination for nationalist and religious pilgrimages; **Ivanovo**, with its art museum exhibiting a wealth of Russian icons from the baroque to the modern period; **Suzdal**, with its wooden houses, churches, and monasteries dating from the 12th to the 19th centuries; **Vladimir**, with its gleaming white Uspensky Cathedral; and lastly **Moscow** itself, with its countless landmarks and pilgrimage sites. These cities have been known as the Golden Ring since the 1970s, and they offer a tantalizing glimpse of Russia's past.

treasures, and these can now be viewed in the monastery museum.

The monastery was closed down in 1927, subsequently serving as a school, workshop, hospital, and sanatorium during the Soviet era. Only after the demise of the Soviet regime in 1991 was the monastery returned to the Church and reopened.

Uspensky Cathedral, Vladimir

The icons of St Andrei Rublev, an itinerant monk born around 1360, are among the most revered in Russia, and their palette of colors and characterization convey a sense of the saint's gentle nature. Combining a powerful theological message with a portrayal of tender emotion, it is no wonder these icons inspire such reverence throughout the country. Deviating from the classic Byzantine style, the expressive figures are reminiscent of Western Renaissance art. The most important of these

icons are the Trinity Icon, now worshiped in the Trinity Lavra of St Sergius in Sergiyev Posad, and the Holy Virgin of Vladimir, now kept in the church of the Tretyakov State Gallery in Moscow.

The original Uspensky Cathedral was built in the 12th century to house the Holy Virgin of Vladimir, to which miraculous powers were attributed, but the first church soon burned down. It was rebuilt between 1185 and 1189 and enlarged in imitation of the Monastery of the Caves cathedral in Kiev. Vladimir was the seat of the metropolitans of Kiev and Rus for a brief period from 1299 until 1321, when the holy office was moved to Moscow. As Rublev's major icons are now kept elsewhere, it is the wonderful frescos in the cathedral's interior that now attract pilgrims, not just for their aesthetic importance but also because of their direct connection with human emotions.

first in a series of foundations to which Sergius appointed his pupils as abbots.

It is said that Sergius was inspired as a youth to lead a monastic life, and at the age of 20 he joined his parents and his brother in entering a monastery. As a rule, Russian monks lived as hermits. Sergius and his brother Stephen settled near the modern town of Sergiyev Posad, building a church dedicated to the Holy Trinity. Stephen soon moved to Moscow, and Sergius, giving up his birth name of Bartholomew, lived for two years in absolute solitude. Legend has it that his only companion was a tame bear. Word of his holiness soon spread and he gained many followers. According to the story, the hermit had a vision of the Virgin Mary, who promised lasting protection for the monastery. Sergius died in 1392 and was beatified in 1448, and the Trinity Lavra was built over his tomb.

The monks in the monastery live in individual cells, leading a life of solitude only occasionally punctuated by periods of communal life. The

Trinity Lavra of St Sergius, Sergiyev Posad

✠

St Sergius of Radonezh (1314–92), the founder of the Trinity Lavra (Monastery), is also considered the founder of Russian monasticism—this monastery was the

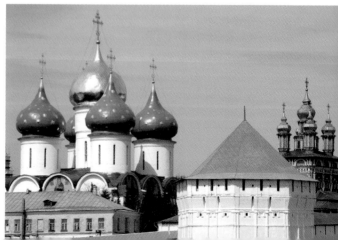

The cathedral in the Trinity Lavra, Sergiyev Posad

entire monastery complex could be regarded as a special kind of sacred place, as the councils of the Russian Orthodox Church are held here.

The entire monastery grounds are surrounded by a fortified wall. Within the walls visitors will find the Church of St John the Baptist with its five domes (1692), the Cathedral of the Assumption commissioned by Ivan the Terrible (1559), the Fountain Chapel (*c.* 1600), the Church of St Sergius with an adjoining, beautifully decorated refectory, and the Trinity Church with its exceptional icons and frescos, whose bell tower is the tallest in Russia. One historical anecdote recounts how Peter the Great sought sanctuary in the monastery in his youth, during his struggle for imperial power. Lenin declared the Lavra a museum in 1920, but the monastery is now occupied and run by about 100 monks and is the seat of the Russian Theological Academy.

Pilgrims to this monastery commemorate the Virgin Mary as a bulwark against the enemies of the faith and of monasticism. Countless pilgrims assemble at the Church of St Sergius for Holy Week, and, after a procession and Masses, holy water is blessed and distributed to the faithful; miraculous healing properties, cleansing body and soul, are attributed to this water.

Kremlin, Moscow

Moscow's history begins in the 12th century with the building of a fortified citadel on a little hill above the river in the middle of a large, wooded plain. A city quickly grew up around the fortress but this was razed to the ground by Genghis Khan's hordes in 1237; the rebuilt city became part of the Mongol protectorate. A white limestone curtain wall was built around the buildings on the hill in 1367; the Mongol word for such a wall is *kreml*, or "kremlin." Built by Ivan III, who reigned from 1462 until 1505, the present wall reaches a height of 59 feet (18 m) and is 17 feet (5 m) thick. There are 18 towers, the most important of which are the Savior Tower, the official entrance to the citadel, the Senate Tower, the Arsenal Tower, the Kutafya Tower, and the Trinity Tower, which is now used by visitors to the Kremlin.

There is a row of notable churches on Cathedral Square, the heart of the Kremlin, including the **Cathedral of the Dormition** (Uspensky Sobor), built between 1475 and 1479, to the design of which the architect, an Italian named Aristotele Fioravanti, contributed Renaissance ideas from his homeland. The white stone church with its five domes represents a particularly successful melding of Russian and Italian ecclesiastical architecture. The tsars were crowned here, and many of the Russian Orthodox patriarchs and metropolitans lie buried inside. In the interior of the church there is a valuable 12th-century

icon of St George, a saint who enjoys special reverence in Russia; the dragon-slayer has even found his way onto Moscow's coat of arms.

The **Cathedral of the Annunciation** (Blagoveschensky Sobor) built between 1482 and 1490, served as the tsars' court chapel. This Old Russian-style church has no fewer than nine golden domes. Nine is a particularly significant figure in Russian belief, as it symbolizes victory, a reference both to the tsarist victory in the war against Kazan and to the church triumphant, defeating its enemies (*ecclesia triumphans*). Ivan the Terrible had the church rebuilt between 1562 and 1564 after a fire, at which point a new portal was added.

The **Cathedral of the Archangel Michael** (Archangelsky Sobor) was built between 1505 and 1508 on the site of a demolished church. The architect, Aloisio Nuovo, was a Venetian, but the cathedral, dedicated to St Michael, nonetheless has the form of a Russian cross-domed church with five domes, although there are aspects of the façade that are reminiscent of the architect's homeland. This church too is considered a national

shrine, as it contains the tombs of all the Grand Dukes of Russia, many of whom are also revered as saints by the Russian Orthodox Church.

The cathedrals in the Kremlin are an expression of both the glory of God and the majesty of the tsars. After the fall of Constantinople in 1453, many relics were brought to Russia, reinforcing and promoting the self-image of the tsars' empire as the New

St Basil's Cathedral, Moscow

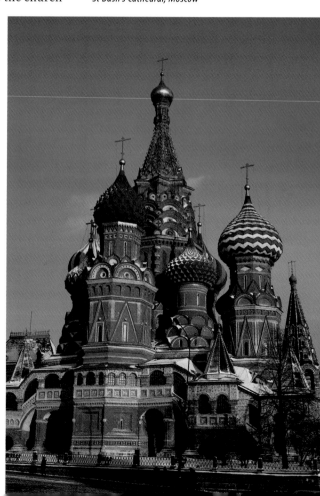

Byzantium. The Kremlin could be described with no exaggeration as the "stone heart of Russia." The Church had to abandon the Kremlin after the Russian Revolution, but since 1990 Masses have once again been said in all the cathedrals on Orthodox feast days.

St Basil's Cathedral, Moscow

Red Square is without doubt the most significant public space in Moscow, and the focal point of the square is the Cathedral of the Intercession of the Mother of God on the moat on its south side. The cathedral, built by Ivan IV (the Terrible) to commemorate a victory over the Tatars in October 1552, was called St Basil's after a "holy fool" of that name who is said to have prophesied the Great Fire of Moscow in 1547. After the building was completed, Ivan lived up to his name, having the architect blinded so that he would no longer be in a position to create anything to compare with it. This legend is probably apocryphal, as the architect is documented as going on to design and erect many buildings in other towns.

The cathedral has nine main domes, each with a different coloration and shape—these onion domes are a reference to the turbans of the Muslim princes defeated by Ivan during his reign. In contrast with many Russian churches, St Basil's is not painted on the outside but has retained a simple red brick exterior. An impression of extreme beauty and serenity results from the contrast between the red brick and the simple white plaster, set off by the colorful domes above. The four octagonal towers surrounding the main church indicate the four cardinal points of the compass. Four further square towers standing at the diagonals between these complete the star-shaped layout. Four and eight were considered sacred numbers in the Middle Ages—there were four elements, and eight was a reference to the Resurrection of Christ and the Last Judgment. The star formed by the architectural elements, connecting earth and sky, points toward the Holy Land, and there is yet another church at each of the eight corners; these are votive chapels commemorating battles for Kazan. The cathedral is now a museum, although Masses have been permitted here since 1991.

Cathedral of Christ the Savior, Moscow

Standing on the left bank of the Moscow River to the west of the Kremlin, the Cathedral of Christ the Savior (Hram Hrista Spasitelja), the central church of the Russian Orthodox faith, can be seen for miles around—with

its 340-foot (103-m) high dome it is one of the tallest ecclesiastical buildings in the world. Finally consecrated in 1883, it was built in commemoration of Russia's defeat of Napoleon. It was a token of the nation's gratitude for the sacrifice of so many lives, but also a demonstration of the power and magnitude of the tsarist Russian empire. The cathedral has been central to the life of the Russian Orthodox Church in Moscow since its consecration, and significant political events are celebrated here as well as Masses.

The church was initially left standing after the Revolution, but in 1922 Stalin devised a plan to build a gigantic Palace of the Soviets on the site. As demolition of the cathedral proved too laborious, it was blown up in 1931; the planned Palace of the Soviets was, however, never completed and a giant open-air swimming pool was built on the site instead. Public opinion in favor of rebuilding the cathedral grew ever stronger during the perestroika years, and on January 7 1995, the Orthodox Christmas Day, the foundation stone of the new church was finally laid. An authentic reconstruction was soon completed and the new Cathedral of Christ the Savior was consecrated in 2000.

The cathedral was built in the backward-looking, so-called "pseudo-Russian" style, drawing on Old Russian traditions and combining them with Byzantine architectural features; the Russian features include the arched windows and the four tapering bell towers with their onion domes. The cathedral's interior is 260 feet (79 m) high and there is room for a congregation of 10,000. The central feature of the interior is the 90-foot (27-m) high iconostasis beside the altar, which is shaped like a chapel. The interior is also notable for its wealth of murals—the frescos depict both biblical figures from the Old and New Testament and numerous saints venerated in the Russian Orthodox tradition. The cathedral buildings include the Church of the Transfiguration, built to commemorate the convent that had stood on the site until the erection of the first cathedral in 1839. The Church of the Transfiguration, an integral part of the building, is located in the basement of the modern cathedral.

Novodevichy Convent, Moscow

Located on a bend in the Moscow River, the Novodevichy Convent founded by Tsar Wassily III in 1524, and known as the Bogoroditse-Smolensky Monastery, is one of the most famous convents in Russia. Immediately after establishing it, Tsar Wassily commissioned the construction of a cathedral to commemorate the freeing of the city of Smolensk from Lithuanian rule, and an impressive cathedral building in the traditional Old Russian style (a cross-domed church with five domes and three apses) was completed in only two years. This cathedral attracts

pilgrims from Moscow and beyond—people come from all over Russia to see the exceptionally well-preserved five-level baroque iconostasis (built 1683–6); for believers, the icon represents a revelation of eternity on earth.

As well as the cathedral, the extensive convent complex includes other buildings and was once part of the city's fortifications, steadily growing through the late 16th and 17th centuries to a size that can still be admired today. All the buildings except the cathedral, were completed in the so-called Naryshkin style (or Moscow baroque), characterized by a retention of Old Russian preferred materials and forms with the addition of Western baroque motifs and decoration. This unmistakable styling

has made the monastery complex one of the most beautiful in Russia. The convent was dissolved in 1922, subsequently becoming a museum, and the cathedral itself and some of the other buildings are still part of the State Historical Museum. Nevertheless nuns have been living in the convent since 1994, and the Novodevichy Convent is once again a pilgrimage destination for the Orthodox Christians of Russia.

Danilov Monastery, Moscow

✠

Established at the end of the 13th century, the Danilov Monastery (Svyato Danilov Monastery) is the oldest monastic foundation in Moscow, and in keeping with many other monasteries it functioned not only as part of the city's spiritual life but also as a component of its defenses, as is still evident from the solid fortified walls and watchtowers. Like other foundations, this monastery had to endure turbulent

Novodevichy Convent, Moscow

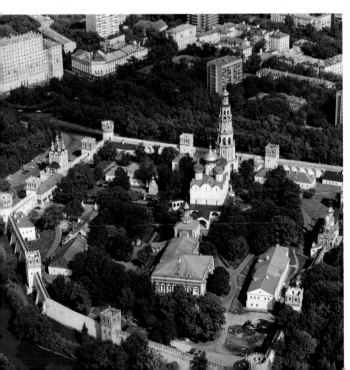

times, being attacked and partially destroyed on many occasions during its history. It was looted by Napoleon's troops in 1812 and had still not recovered from these depreda-

Cathedral of the Holy Trinity, Danilov Monastery, Moscow

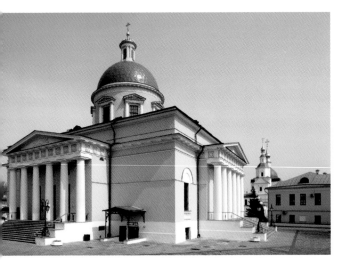

The complex is dominated by the most modern of the three impressive churches within the walls, the Church of the Holy Trinity (Troitsky Sobor), completed in 1838. Its harmonious construction, with a green central dome fronted by a reproduction classical portico, is atypical of Russian churches. The Church of the Seven Holy Fathers (Zerkov' Vo Imya Svyatych Otzov Semi Vselenskish Soborov) is considerably older, having been consecrated in 1729 to commemorate the seven participants at the Seventh Ecumenical Council held in Constantinople in 787. This was the last council to involve both the Western and Eastern Churches, and is especially significant for the Orthodox Church for its discussion of the worship of icons. The oldest church to survive in the monas-

tions by the time of the Revolution of October 1917. It was used as a military hospital for a period during the First World War, and after the Revolution the extensive site with its elongated buildings became a factory. Only in 1988, on the thousandth anniversary of the baptism of Vladimir I, Grand Duke of Kiev, a date regarded as the beginning of Russia's Christianization, was the monastery returned to the Russian Orthodox Church. It is now the official seat of the Patriarch of Moscow and all Russia.

tery is the baroque Simeon Stolpnik Church, consecrated in 1680. The complex also includes modern accommodation for guests, and it is not uncommon for representatives of various denominations to come here for ecumenical discussions. It is a sign of mutual understanding when people of different faiths can meet in an atmosphere promoting discourse, an indication that the monastery has regained its special significance.

Church of the Ascension, Kolomenskoye

Church of the Ascension, Kolomenskoye

"**N**othing has enthused me so much as the monumental Old Russian church in the village of Kolomenskoye [...] I have seen Strasbourg Cathedral, which took several centuries to build, I have stood beside Milan Cathedral, but I have found nothing else to compare with this treasure, where I stand in person before beauty itself [...] I could feel it striving to rise to the heavens, I was completely numbed." Such were the composer Hector Berlioz's conclusions when he visited the Russian capital, of which Kolomenskoye is now a part; at that time it was the tsar's summer residence. Completed in 1532, the Church of the Ascension (Zerkov Voznezenya) does indeed take up the old Gothic notion that everything in a

church should aspire to heaven. The mighty spire at the church's center stands 204 feet (63 m) tall. The base of the church is formed by a low single storey in the form of a cross attached to an octagonal structure forming the base of the spire, which seems to rise to heaven from its tent-like surrounds.

Quite who built the church is still disputed, but the architect was clearly filled with a vision of a building reaching up into the heavens in a manner that was unprecedented in Russia, or at least unknown among stone buildings, which had previously been constructed according to the norms of Byzantine churches. White stone was used and the church shines out—its local nickname is "the white column." Galleried flights of steps wind around the spire, and there are store rooms in the plinth section that are reminders of its other purpose—the church was built not only to praise God but also as a site that could be defended. Lacking the otherwise standard onion domes, the Church of the Ascension is a particular gem of Russian ecclesiastical architecture and served as the inspiration for other churches throughout the 16th and 17th centuries—buildings aspiring to heaven were built in many other places in Russia.

Optina Pustyn Monastery

This monastery has long since regained its position as a place of fellowship and is full of life—hundreds of thousands of pilgrims now make the journey to Optina Pustyn, near the town of Koselsk. The importance of the former hermitage of Optina in the spiritual life of the populace cannot be overestimated. Optina Pustyn is considered the last redoubt of Orthodox doctrine and of a faith that is also concerned with real lives. Many sick and troubled people, and also many of the young, come here, hoping for advice and guidance from the *staretsy* (wise elders). The *staretsy* have always been revered as saints and multitudes of people have been swayed by the wisdom of their words; the ascetic monks are considered spiritual leaders in an unpredictable world. After the October Revolution in 1917, the monks were deported and the monastery was declared a gulag ("correctional camp"), but reverence for the *staretsy* remained in what could be called the "Russian soul."

The now extensive monastery complex, only a few paces from the original monastery, dates back to the 19th century and includes four churches, all built along a central axis leading to the monks' area, which is not open to pilgrims. A reverential silence lies over the whole monastery and yet the peaceful atmosphere is almost joyful, as the people who undertake the pilgrimage here are seldom disappointed in their search for words that have meaning for them. Dostoyevsky's words in *The Brothers Karamazov* once again ring true: "the simplest and the most refined people flocked to our monastery, to prostrate themselves before the *staretsy* and to confess their doubts and sins, begging advice and guidance from them."

Serafimo-Diveevsky Monastery

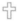

Prochor Moshnin, who was born on July 19 1754, would later take the name of Seraphim and become one of Russia's most important saints. Early in his life he decided to live as a monk, joining the remote monastery of Sarov in 1778. A little later he entered a strict hermitage, spending seven years there devoted entirely to reading Holy Scripture, prayer, and memorizing hymns. After these years had elapsed, he was inducted as a priest monk, receiving the name Seraphim. Following the death of his abbot, he once again sought solitude, practicing the strictest self-denial despite his failing health. Returning to the monastery after 15 years, he kept his vow of silence and retreated to his cell; through sustained meditation he eventually received gifts that allowed him to be a spiritual aid to the many people who sought his advice.

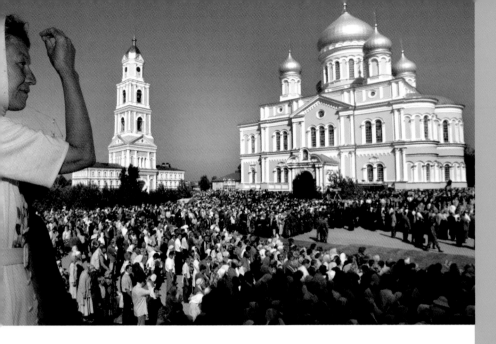

Pilgrims at the Serafino-Diveevsky Monastery

It is said he displayed the utmost gentleness and amiability toward the weak, while presenting the strong with particular challenges. After his death in 1833, the monk came to be revered far and wide and is considered the most important *starets* of the 19th century. He was canonized by the Russian Orthodox Church in 1903.

Two places have a special connection with the saint—the neighboring villages of Diveevo and Sarov, both of which are to be found near the Nizhny Novgorod Oblast. Sarov Monastery, a male institution, is the older of the two spiritual establishments. The foundation of the Serafimo-Diveevsky Monastery, a convent, dates back to the saint himself, and the building houses his relics, which were thought lost until their rediscovery in the Museum of Atheism in Moscow.

The Serafimo-Diveevsky Monastery of the Holy Trinity has become one of the most sacred places in the Russian Orthodox Church, attracting countless pilgrims who come to worship the saint; his utterances and words of advice have been recorded and for many believers these are constant companions through their lives. Both monasteries were closed during the Soviet era; Sarov was destroyed, before being rebuilt in the wake of perestroika. They are now both restored to their former glory and filled with spiritual life as places of living sanctity.

EUROPE

NEAR EAST

GEORGIA
Tbilisi

Istanbul
ARMENIA Yerevan

Bursa Ankara
TURKEY

Konya Van
Antalya

Tehran Mashhad

Hamadan IRAN

SYRIA
Beirut IRAQ
ISRAEL Damascus Baghdad Isfahan
Jerusalem Amman Najaf
Abadan
JORDAN Shiraz

N
0 500 km

● City
● Sacred place

SAUDI ARABIA

Medina

Mecca

Haifa
Jaffa
Jerusalem Bethlehem
Hebron
ISRAEL

N
0 150 km

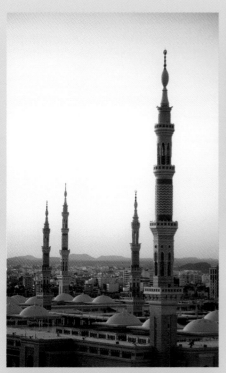
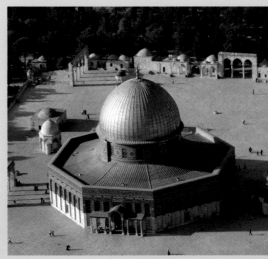
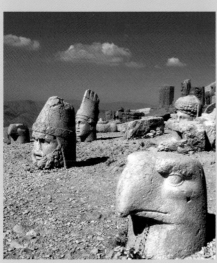
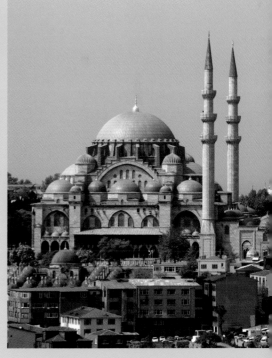

Edirne

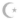

Situated in the far west of the country on the Greek border, Edirne served as the capital of the early Ottoman Empire until this was relocated to Constantinople after 1453. The city was founded by the

beautiful cities in Thrace. Fought over many times, its history has been eventful; it was conquered in turn by Byzantium, Avars, Bulgarians, Crusaders, and lastly the Turks. Even when deposed as capital by Constantinople, Edirne lost none of its attraction. The city has belonged to Turkey since 1923 and has long since

Selimiye Camii, Edirne

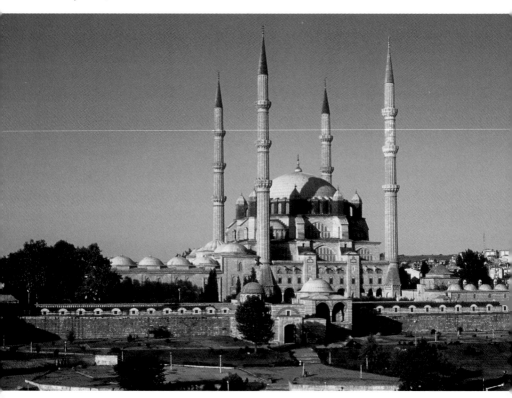

Roman emperor Hadrian in 125—hence its ancient name of Hadrianopolis—and it was one of the most important and

recovered from the turbulence of its past. It is now a bustling metropolis with a wealth of Ottoman buildings.

The **Eski Camii** (Old Mosque) was built between 1403 and 1414 by the three sons of Sultan Beyazit I, among whom there arose a bitter power battle after their father's death. Suleiman began building a mosque for the local populace in 1403. This work was continued by his brother Musa, before being completed in 1414 by Mehmet Çelebi, the third of the brothers and the eventual victor in the struggle, who was crowned as Sultan Mehmet I.

The building is square in plan, and this large square is divided by four pillars into nine equal smaller squares; each of these squares is surmounted by a dome. The interior feels spacious and airy, probably because of the simple decoration. The large-format 19th-century calligraphic representations of the name of God, Allah, are particularly majestic and immediately attract the gaze. Mehmet I had a market laid out around the mosque that has continued to this day.

The **Üç Şerefeli Camii** (Sultan's Mosque), a huge building built by Murat II between 1437 and 1447, is not far from the Eski Camii and has the largest cupola to be found in early Ottoman architecture. The mosque consists of a central rectangular prayer hall with two side wings flanking a prayer niche. The only elements dividing the room are two hexagonal pillars that share the weight of the giant cupola with the entrance wall and the wall housing the mihrab, the niche in the wall that indicates the direction of Mecca. This arrangement lends the structure considerable spaciousness and lightness. There is a rectangular

courtyard in front of the mosque whose dimensions are such that the entire complex forms a square. The square and the globe are the defining geometric forms of this kind of architecture, and they give an impression of balance and order that is intended to glorify God. Slender minarets have been erected at each corner; one of these has a triple entrance known in Turkish as *üç şerefe*, from which the mosque gets its name.

The **Selimiye Camii**, built between 1569 and 1575, has often been called the acme of Ottoman architecture, and it is the architect Sinan's masterpiece. This mosque is surrounded on three sides by an extensive courtyard and its four galleried minarets are 230 feet (70 m) high. As these directly adjoin the prayer hall, the sense of verticality is emphasized still further—everything aspires toward heaven and God. The arcades of the actual mosque courtyard are supported by Byzantine columns, and the arches are made of alternating red stone and white marble. From the graceful ritual ablution fountain standing directly in the center of the courtyard, a large portal leads visitors into the prayer hall of the mosque, whose central feature, the dome, is a perfect work of architectural artistry. The cupola is supported by eight solid pillars. Two of these flank the mihrab, which extends out from the nave like an apse. Adorned with a wealth of tracery, the *minbar* is considered one of the finest prayer pulpits in Turkey. The mosque's decorated tiles are of great beauty and the entire

BYZANTIUM, CONSTANTINOPLE, ISTANBUL—THE CENTER OF THE WORLD

The name alone has a resonance throughout the world—the hearts of two of the most important empires of the past once beat here. The Dardanelles and the Bosphorus, which connect the Black Sea with the Mediterranean via the Sea of Marmara, played a significant role in cultural exchange between southeastern Europe and Asia Minor. The source recording the city's foundation combines historical fact with legends: the town is said to have been built by the legendary Byzas, who settled on the Golden Horn in the 7th century BC and was responsible for the name Byzantium. The city was conquered in 512 BC by the Persian king Darius, and in the 2nd century BC Byzantium was plunged into the extended struggle surrounding the Roman succession that ended only with the accession of Constantine in AD 324. Constantine chose the city on the Bosphorus as the capital of the Roman Empire, naming it Constantinopolis. A peerless period of growth ensued—Christian teachings and art, the achievements of Roman civilization, Greek society, and elements of oriental culture combined in a peculiar mélange to form the Byzantine Empire.

On May 29 1453 Sultan Mehmet II conquered Constantinople and the city received its present name, Istanbul. Hagia Sophia was turned into a mosque, and the wonderful city flourished once again as the center of the Ottoman Empire, which stretched from Algeria to the Persian Gulf and from the Alps to Egypt. By the 17th century, the giant empire had weakened and the Balkan peoples were pressing onto the Bosphorus. The city was occupied by the British and French after World War I, and in 1924 Ankara finally became the capital of modern Turkey. Istanbul remained without equal—its location and the ineffable treasures of its Byzantine and Ottoman history continue to make it one of the major cities of the Mediterranean.

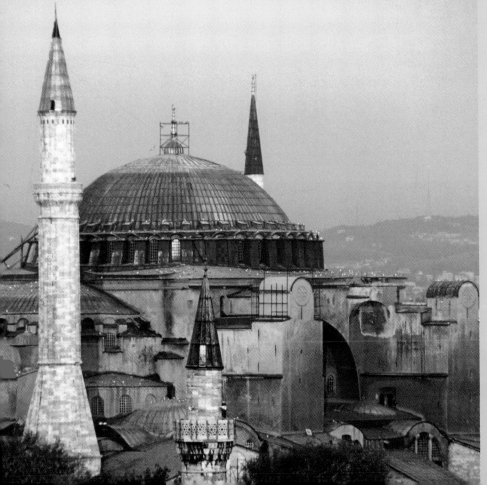

building, a work of art dedicated to God, will captivate any visitor.

Hagia Sophia, Istanbul

✝ ☪

The "Church of Holy Wisdom" at the northeastern end of the ancient hippodrome is undoubtedly the most important Byzantine building in Constantinople. The present structure, built by the Eastern Roman emperor Justinian I, stands on the site of a series of previous buildings dating back to the time of Constantine I. Justinian intended the building to be by far the most auda-cious and magnifi-cent in his empire; with its 184-foot (56-m) high ribbed dome, designed by the architects Anthemios of Tralles and Isidoros of Milet, it towers over the city. The church was completed in only five years, and the emperor was so proud of this achievement that he proclaimed his own fame to be greater than that of the biblical king Solomon, whose Temple was still used at the time as the blueprint for all ecclesiastical buildings. An earth-quake only 20 years later caused the

dome to collapse, and it was raised by 22 feet (7 m) during the restoration work. The church was reconsecrated in 562 and became the undisputed center of Orthodox Christianity.

The precious interior decorations fell victim to looting Crusaders in 1204 and, after the fall of Constantinople

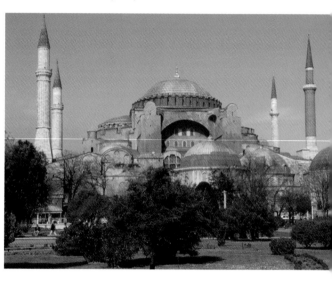

Hagia Sophia, Istanbul

to the Ottoman sultan Mehmet II in 1453, the church was converted into a mosque. The precious mosaics were plastered over and a prayer niche, pulpit, and tribune were added, but apart from this the interior was left unaltered. Two minarets were built outside to celebrate the triumph of Islam; the two additional minarets that can be seen today date back to the time of the Ottoman architect Sinan (1491–1588). The building was

threatening to collapse in the 19th century, but Sultan Abdülmecit had it restored between 1839 and 1848, and several of the old Byzantine mosaics were exposed during this restoration work. Of particular beauty and serenity are the mosaics depicting Constantine I, Justinian, and the Mother of God, and the solemn and dignified portrayal of Christ as the Ruler of the World above the narthex entrance. The most amazing thing about this building is the sense of space that results from the support of the cupola by only four pillars. Hagia Sophia (Aya Sofya) is now a museum and more and more of the mosaics are being uncovered—although the building is no longer in religious use, every visitor will gain a sense of it as a sacred place.

Hagia Irene

The construction of a curtain wall around the Ottoman imperial palace in 1460 finally separated two Byzantine churches, Hagia Sophia and Hagia Irene, which had previously been linked. Hagia Irene, the oldest Byzantine church, with a history stretching back to Constantine I, stands directly beside the imperial gate to the outermost palace courtyard. Due to its long service as an arsenal, Hagia Irene escaped transformation into a mosque and has thus retained its old appearance. It is thought that the building, the first episcopal seat

in the empire, was constructed on the ruins of an ancient temple of Venus. When Constantine II (337–61) built the first Hagia Sophia, the two buildings were connected by an atrium, forming a single complex.

Hagia Irene is a basilica with a central cupola supported by four massive pillars. The church has burnt down several times but was always rebuilt, most recently in the 8th century. It has a powerful and solid appearance, an impression that is emphasized by the fact that the colonnades reach only to the first storey; its solidity radiates strength and calm austerity. The only decoration is a large plain cross on a golden background in the apse. Sunlight falls through the windows onto the bare walls, bathing the interior in a brick-red warmth. Among the many magnificent churches and mosques in the city, Hagia Irene is a place of quiet meditation—somewhere to pause and reflect.

Sultan Ahmed Mosque

Since the transformation of Hagia Sophia into a museum, the Sultan Ahmed Mosque has been the principal mosque in Istanbul. Built between 1609 and 1616 by Mehmet Ağa on the site of an old Byzantine imperial palace, this spacious complex is famous for its wonderful tiles and the blue coloring of its decoration, which has earned it the nickname

of "The Blue Mosque." The mosque sits overlooking the Sea of Marmara as if enthroned, and the complex is surrounded by extensive grounds which are images of Eden.

Inside the building, the eye is overwhelmed by the extravagant

architectural element combine to produce a breathtaking atmosphere.

The six minarets are unique in the Muslim world, and there is a legend accounting for their number: a minaret was commissioned by Mehmet Ağa, who demanded of his architect that it be covered in gold leaf. This would have resulted in the building costs becoming sky-high, so the architect pretended to misunderstand the sultan, supposedly hearing the word *alti* (six) instead of the word *altin* (gold). Whether there is any truth to this story is unclear, but it is a fact that only the Grand Mosque in Mecca has more minarets, with seven. A further legend suggests that the seventh minaret of the Grand Mosque was added only after six minarets had been erected at the Sultan Ahmed Mosque, so that the many voices of the *muezzins* could echo across the peninsula and call the faithful to prayer.

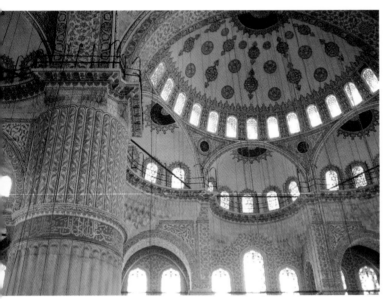

The magnificent interior of the Sultan Ahmed Mosque, Istanbul

decoration—the dome is supported by four giant, round, fluted pillars and the enormous space shimmers in the light from 260 stained-glass windows. An expanse of gleaming tiles with floral motifs and rich ornamentation in blues and greens, decorative features of tortoiseshell, mother-of-pearl, and precious stones, and the frescos that adorn every

The Sultan Ahmed Mosque is the most important in the city for observant Muslims, as it is the starting point for the caravans making the annual pilgrimage to Mecca.

The Süleymaniye Mosque

Hagia Sophia was always a powerful symbol, both of the city and of its various empires. The building has been copied many times, but seldom has its splendor been reproduced. A thousand years after the construction of Hagia Sophia, an architect of genius set about adding a new mosque to the skyline, and this too was to be surmounted by a mighty dome. The result is the complex of buildings surrounding the Sultan's Mosque, the Süleymaniye, which stands in the middle of Istanbul like a separate little city. Suleiman the Magnificent was without doubt the mightiest ruler of the Ottoman Empire, and under his rule (1520–66) the city regained its former greatness, becoming the hub of a world empire. The cityscape changed considerably during his reign, with the building of a great number of mosques.

In 1550 Sinan, Suleiman's favorite architect, began work on the Süleymaniye, which was to become one of the major achievements of Ottoman architecture. In 1558 work was completed on the extended complex of buildings, which includes the mosque, madrasas, a hospital (now a maternity hospital), a caravanserai, a soup kitchen (now a museum), and a Turkish bath (*hamam*). All of these ancillary buildings are still open to the public.

The layout of the Süleymaniye Mosque is based on that of Hagia Sophia. The square prayer hall is surmounted by a gigantic central cupola with two other half-domes along its central axis. The dome is supported by only four pillars, giving an impression of great space; the unity of the space

The Süleymaniye Mosque, Istanbul

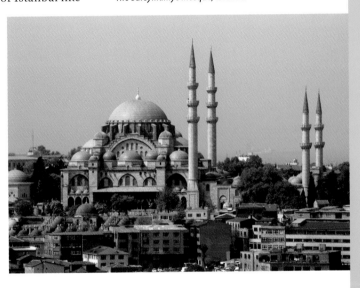

is uninterrupted by any partitions. The appointment and decoration of the mosque's interior are classically beautiful in their simplicity. Marble, ivory, mother-of-pearl, and brightly gleaming tiles are the materials of choice in the decoration of the prayer

NEAR EAST

hall, and behind the qibla (the wall that indicates the direction of Mecca) there is a walled garden containing the sultan's tomb—another jewel of Ottoman architecture—and that of his favorite wife, Hürrem. She was to play a malevolent role in the political intrigues that surrounded the nomination of Suleiman's successor, encouraging her husband to murder his son Mehmed, thus allowing her son Selim, known as "the Drunkard," to ascend the throne. The wonderful Süleymaniye Mosque dominates the city skyline, as the complex lies on an elevated tongue of land beside the Golden Horn.

Chora Church

Much like Hagia Sophia, the Chora Church was also once a Christian place of worship before being turned into a mosque (Kariye Camii), and it is now a museum. It can nonetheless be considered a holy place, even if services are no longer held here, as today's architectural treasure was for centuries a place of mystic meditation. The mosaics and frescos in the Chora Church depicting Jesus and the Virgin Mary are exceptional examples of Byzantine art and piety.

The first version of this church was constructed in the 11th century but its present form dates back to the years 1315 to 1321. The various elements of the building are grouped around a central space with a dome: there is an apse to the east and a southern side nave and side chapel. The real attractions are the esonarthex (a narrow inner entry hall), and the exonarthex (a narrow outer hall) which house the wonderful mosaics. The first mosaic encountered on entering the church is a large representation of Christ as the Ruler of the World. The inscription *I chora ton zonton* ("the land of the living") could be interpreted as suggesting that Christ is showing the way to eternal life. Further peculiarities of the decoration are the mosaics that illustrate Jesus' family tree. The series of images is completed in the interior of the dome with scenes from the life of the Virgin Mary, and stories from Jesus' childhood and his acts of redemption.

Above the entrance to the main space there is a depiction of the Dormition of the Virgin Mary, and in the apse there is an image of Christ with the four evangelists and the Virgin, who is pointing the way (*Maria Hodegetria*)—she too is indicating the path to eternal life. There is a story that this representation of Mary was copied from an icon painted by St Luke himself which used to be carried through the city every August 15, the saint's feast day; its miraculous powers were said to protect Constantinople. The frescos in the *parecclesion* (the southern side chapel) are also of great beauty. The half-dome of the apse is dominated by a depiction of the Resurrection, and the paintings above and below the cornice include pictures of the saints of the Eastern Church, representations of eternal life, the Last Judgment, heaven, and hell, and various scenes from Jesus' acts of

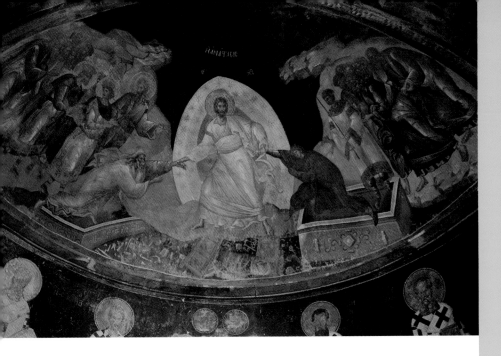

Fresco in the Chora Church, Istanbul

salvation. The Chora Church is a relic of the early Christian empire of Byzantium and, despite the passing of many centuries since its founding, it has lost none of its power to affect deeply.

St George's Monastery, Büyükada

No *Istanbullu* would call the island chain in the southeastern Sea of Marmara by the name used elsewhere in the world, Princes' Islands—for Istanbul residents, they are simply Adalar, "the islands." During the Byzantine period, the islands were used as a prison for princes and princesses who had fallen out of favor or for conspirators against the ruler of the time. Apart from them, the islands' only inhabitants were fishermen, small farmers, and monks, who maintained a number of monasteries on the islands of which several are still inhabited today. Life was changed for ever in the 17th century when a devastating plague forced the rich and powerful of the city to retreat here, and the first magnificent residences sprang up.

Resembling a string of pearls, the chain of nine islands, of which the main island is Büyükada, forms a single community that is devoid of motorized traffic, and the lush vegetation and

tranquil atmosphere are captivating. In the summer, they are overrun by tourists and Istanbul residents looking for a peaceful retreat. On Büyükada there is a place that is revered equally by Muslims and Christians—the church of St George's Monastery (Aya Yorgi) on the summit of the island's peak. Every autumn thousands of people make the pilgrimage up the steep path to be blessed by the monks in the monastery. Readings from Christian and Muslim scriptures are given in the Christian monastery church, ecumenical services are held, and prayers are offered to a common God. St George's Monastery is a truly exceptional place—the things that separate the two religions are ignored, and the focus of the peaceful celebrations is instead on commonality of belief.

missionary journey (AD 54–7), founding a parish and causing such uproar that he was obliged to leave the city. Ephesus retained its importance, and St John the Apostle settled and died in Selçuk; a basilica dedicated to him was built over his tomb. The *Legenda Aurea* (a hagiography) tells of John's exploits in Asia Minor: after refusing to make a heathen offering at the Temple

Ruins of St John's Basilica, Selçuk

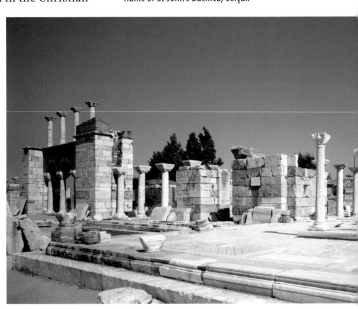

Selçuk

Ephesus, three miles (5 km) to the north of Selçuk, was an important location in early Christianity. The apostle Paul stayed there on his third

of Artemis in Ephesus, John was forced by Aristodemus, the chief priest of the temple, to drink from a poisoned chalice. John made the sign of the cross above the chalice and the poison left it in the form of a snake. John emptied the chalice and threw his cloak over the

bodies of two criminals who had just drunk some of the poison and died; he not only brought them back to life but converted Aristodemus in the process.

John was seized during Domitian's persecution of the Christians and brought to Rome. He was placed in a vat of boiling oil, but the oil turned into a scented bath and he stepped out unharmed. He was then banished to Patmos, where he wrote the Book of Revelation. After the death of the emperor he was able to return to Ephesus to compose his Gospel, and after his last sermon he climbed into the grave that had been prepared for him beside the altar and expired. A funerary chapel was built on the exact spot, with the three-naved basilica of the Theodosian period being replaced by a cross-domed church during the reign of Justinian I. The nave, transept, and crossing of the **Basilica of St John the Apostle** (completed in 565) were surmounted by a total of five domes, although only a few reconstructed arcades from this church can be seen today. The tomb of the evangelist, equally revered by the Eastern and Western Church, lies directly beneath the crossing; dust from the grave is said to have miraculous powers and pilgrims come here to this day.

A second Christian shrine, equally venerated and attractive to pilgrims, is to be found nearby—the **House of the Virgin Mary**, which is located on a little hill about four miles (7 km) outside Selçuk. Whether the little shrine really was the last house of the Mother of God (Turkish, *Meryem ana evi*) or if this story is just a result of visions experienced by Anna Katharina Emmerick, a Westphalian nun and mystic, is uncertain, but it has not harmed this pilgrimage site near ancient Ephesus. Below the house there is a well whose water is supposed to produce miracles. The ecumenical Council that confirmed Mary as the Mother of God was held in Ephesus in 431, and some 1,500 years later (in 1896) Pope Leo XIII declared the house a pilgrimage site. His successor, Pius X, promised complete remission of all sins to anyone completing the journey to Mary's house. Every August 15, the Feast of the Ascension of the Virgin, thousands of pilgrims assemble here to worship the Mother of God and to bring her their petitions.

Temple of Apollo, Didyma

As far as can be ascertained today, Didyma was never an independent town in which people actually lived during Greek antiquity; rather, it was a shrine, located outside Milet's walls and inhabited only by the priests attending the temple.

The shrine provides an experience of the Hellas of Asia Minor which is second to none. In ancient times there was a holy oracle here above a spring, and Pausanias records that the shrine, dedicated to a female divinity, existed before the arrival of the Ionian Greeks. The ancient Temple of Apollo was sacked and destroyed by the Persians

in 494 BC and the site lay in ruins for 200 years until Seleucus began the construction of an extensive temple complex on the old site in about 300 BC. Work continued on the monumental collection of buildings for the next 500 years without ever being completed.

Temple of Apollo, Didyma

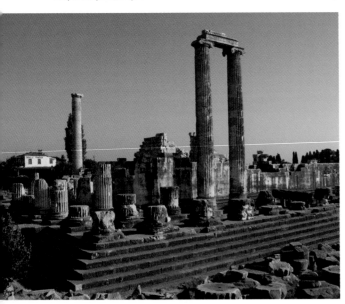

The entire temple is enclosed by a double colonnade and at the end of the Sacred Road (a processional path from the city of Milet to Didyma) there is a giant portal allowing access to the consecrated area with its grove of sacred laurel trees. Two tunnels lead down into the *cella*, which was not roofed and consists of a large, open, inner courtyard with walls of a height of over 66 feet (20 m). There

was another small temple in this *cella* courtyard, and it is likely that this was the location of the shrine to Apollo and the sacred spring. Opposite this little temple there is a large set of steps leading to a space with two Corinthian columns; here there is an outsize doorway opening into the narthex of the temple, upon whose threshold, which is the height of a man, the priests would have announced the utterances of the god.

Towering majestically over the town, the temple complex looks at its best at dusk, when the setting sun makes the secrets of this ancient shrine and oracle site most captivating. The stadium was located beside the southern steps of the great temple, and games in honor of the god were held every five years. Even today it is easy to imagine what Homer described in his hymns to Didyma: "and that is where the long-robed Ionians assembled with their children and their shy wives. They are hospitable, putting on boxing matches, dances, and singing to delight their guests whenever their games are held. You might imagine the Ionians to be immortal and forever young when you see them assembled like this, as they are all extremely graceful; the eye lingers happily on the men and the well-girdled women ..."

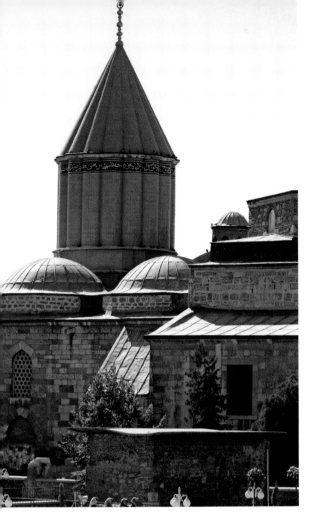

The Mausoleum of Rumi, Konya

Shrine of Rumi, Konya

The thought and works of the Persian poet and mystic Jalal ad-Din Muhammad Rumi (1207–73) had a considerable influence on Sufism. Sufis direct their hearts entirely toward God; not only do

they wish to understand the outer meaning of the Koran and live their lives according to it, but they also strive for an immediate experience of the presence of God. Various meditation techniques are employed to this end. Countless fraternities have arisen during the thousand-year history of Sufism, and all of these have developed their own forms of self-expression. The best-known Sufi fraternity is the Mawlawi Order, whose origins and present headquarters are to be found in Konya. The order was founded by Jalal ad-Din Muhammad Rumi in 1249 in Anatolia, a place known for its whirling dervishes. During this anti-clockwise dance, the left hand is raised to heaven, asking for blessing, while the right hand passes on this benediction to the earth.

Work was begun on the mausoleum in 1274, after Rumi's death, and the original building has been constantly enlarged. The contemporary complex dates back to the Selçuk dynasty (1175–1300) and is set within the grounds of the Selçuk palace; since Turkey's secularization it has been a museum. For Rumi's devotees it will always be the Maulana Turbesi, the green mausoleum of the master, and it is magnificently appointed—Rumi's

marble sarcophagus is covered with a golden pall. Sufis prostrate themselves on the silver steps before the sarcophagus to feel some of the master's spiritual power. Filled with deep devotion to a living God, they are mindful of words spoken by Rumi himself: God is closer to you than your jugular vein!

Church of St Nicholas, Demre

Most people visit Demre (formerly Myra) to see the excavated classical sites. There is some impressive evidence of Lycian civilization here—Myra was one of the major cities in the Lycian Alliance—and the late Roman amphitheater and the Lycian rock-cut tombs attract flocks of tourists. In addition, Demre has been well known as a pilgrimage destination for Christians since the 4th century. Ancient Myra was an early Christian diocese and the home town of St Nicholas, the patron saint of seafarers and of children in particular. Nicholas was venerated even during his lifetime, and people would come from near and far to his church to seek his aid, especially on behalf of their children. The stream of pilgrims increased further after the saint's death, and his relics, which were kept in Myra, were

Interior view of the Church of St Nicholas, Demre

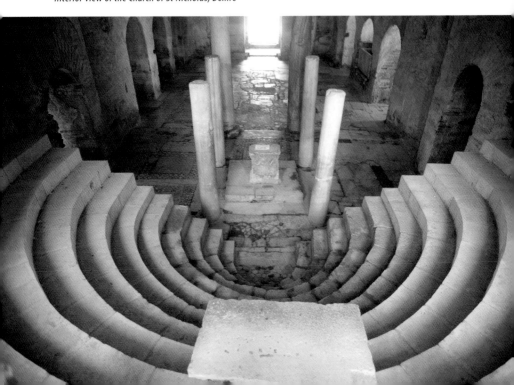

thought to have miraculous powers. Taking advantage of a period of political unrest, a group of sailors from Bari stole the relics in 1087 and took them home, where they have been revered ever since.

A three-naved basilica dedicated to St Nicholas was built in the 11th century on the foundations of two previous churches from the 6th and 8th centuries. A monastery was founded in the second half of the 11th century and its monks took over the running of the pilgrimage site. The city later went into complete decline, as did the monastery, and was only rediscovered in the course of archeological excavations in the 19th century. Demre has since regained its status as a popular pilgrimage site; many visitors come on December 6, St Nicholas' feast day, as Orthodox Masses have recently been permitted again.

Ağrı Dağı (Mount Ararat)

One of the world's best-known stories tells of the biblical Flood, God's punishment of humanity. There is a happy ending, of course: "and God remembered Noah, and every living thing, and all the cattle that was with him on the ark: and God made a wind to pass over the earth, and the waters assuaged [...] and the waters returned from off

the earth continually: and after the end of the one hundred and fifty days the waters were abated. And the ark rested in the seventh month, on the seventeenth day of the month, upon the mountains of Ararat" (Genesis

Mount Ararat

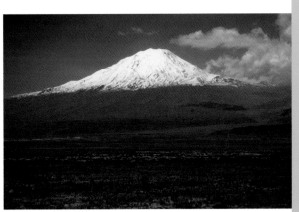

8: 1–4). Noah's legendary landfall on the summit of a mountain on the Turko-Russian border is one of the oldest Armenian legends and continues to attract people to this impressive 16,850-foot (5,137-m) peak. The mountain rises from the surrounding lowlands, which only increases the effect of its majestic appearance.

According to biblical tradition, Ararat is the place from which mankind spread across the earth for the second time. Many of those who climb the mountain think they recognize a fragment of the ark in any wooden splinter they find, taking it with them as a precious souvenir. This may not have been the place

where man first set foot again on the depopulated earth, but for the faithful that is of little importance. More important is the sense of the Divine felt by believers during the ascent and as they glimpse the summit. The English scholar James Bryce recorded his feelings and emotions after climbing the mountain and surveying the landscape in 1876: "No greater place on the earth could be imagined as the starting-point of the history of humanity!"

Hittite Shrine, Yazılıkaya

Modern Boğazkale is a dreamy little peasant village near ancient Hattuša, the former capital of the Hittite empire, which stretched from Mesopotamia to the Aegean. There is no greater site of Hittite civilization than Boğazkale: the fortified terraces, miles of curtain wall, rock passages, and temple sites are just some of the monuments of an empire that had already ceased to exist by 1200 BC, although its cultural legacy lived on for much longer.

The most sacred place was the shrine of Yazılıkaya, about a mile (2 km) from the city. The temple buildings in front of the rock shrine were built during various phases of construction from the 13th century onward. The inner sanctum consists of two natural rock chambers known as the Great Gallery and the Small Gallery. The Great Gallery has carvings depicting a procession of 63 divine figures, with male gods on the left and goddesses on the right. The gods wear pointed hats and typical Hittite boots with curved-up toes. The hierarchical position of the gods is denoted by the number of horns on their helmets— less important gods have only one, whereas the most powerful have up to six. The goddesses have long, plaited hair, floor-length gowns, and belted shawls, and their procession is led by Hebut, the sun goddess. On the left side appears Tesub, the god of weather and the Hittite thunder god. Behind the procession of goddesses there is a magnificent royal relief depicting the ruler wearing a round cap that identifies him as a high priest of the cult.

Hittite documents show that the most important religious festival—the celebration of new year, connected with the beginning of spring and the return of the sun—was celebrated here. The Small Gallery has wonderfully well-preserved reliefs of gods and the sons of gods, and the temple is guarded by demonic sentinels represented as winged lions. This Hittite shrine is not only the most revealing archeological site of pre-Greek culture in Anatolia; it also remains a place where the spiritual experience can seem physical.

Rock churches, Göreme Valley

The Greek word for the Levant, the land where the sun comes up (*anatole*), lives on in the name Anatolia (Turkish,

anadolu). Greek culture has long had an exceptionally strong influence in Anatolia, especially during the period of the Byzantine Empire, the great Christian polity of the earliest years of the Middle Ages. The history of Christianity in Anatolia begins with the apostle Paul's missionary journeys, and the rock churches and monks' refuges in Cappadocia are among the oldest Christian sacred sites. The landscape here is picturesque—erosion has carved steep valleys, strange domes, and obelisks from the volcanic tuff. It was this soft rock, combined with the remoteness of the location, that led the monks to seek their refuge here.

In addition to the monks' caves there are a great many rock churches, most of which have been cut from the soft stone. More than 150 such churches have been recorded, and the majority of the most impressive of these are to be found along the Göreme Valley, with the oldest dating back to the 6th century. The 8th and 9th centuries saw many of the images decorating the churches removed as a result of the iconoclastic schism, and the use of plain symbols and motifs copied from Muslim art was adopted: the columns and vaults of the otherwise plain churches are decorated with a great number of

Rock churches of Göreme

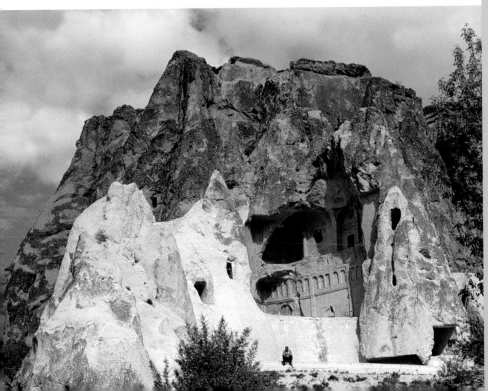

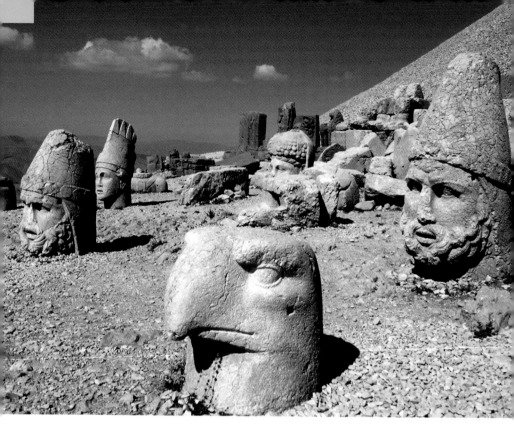

Shrine sculptures on Nemrut Dağı

crosses, plants, and birds. The "dark refuges," tunnels carved up to eight tiers deep in the rock, into which the Christians would retreat in times of danger, are a particularly impressive sight. However, the Christian community did not have much time to enjoy the site—Anatolia could not resist the attacks of the Persians, the Moors, and the Turkish tribes, and the Byzantine Empire in Anatolia was vanquished. The rock churches of Göreme are all that remains of an attempt to cling to faith even in adversity.

Nemrut Dağı

There is a tomb and memorial on the summit of Nemrut Dağı (Mount Nimrod) that has become a pilgrimage site for people from all over the world, and people climb the winding paths through lonely mountain scenery to the 7,220-foot (2,200-m) high summit in often oppressive heat. The place is most beautiful just after sunrise or when the sun is slowly setting. The shrine is the tomb of Antiochus I, who died in 38 BC

and who gave himself the name Epiphanes ("the god incarnate"). The grave mound on the mountain peak is made of large stones and is about 160 feet (50 m) high—a summit upon a summit. There is almost nothing left of the north terrace, but the most holy section is in fact the east terrace, since it faces the rising sun. Five enormous statues were once seated here, flanked to the right and left by a giant eagle and a lion, which were always considered divine animals. Figures from the Persian and Greek pantheon served to illustrate and emphasize Antiochus' divine origins, and these combined several mythological figures in one. The most powerful sun god, a mixture of Apollo, Mithras, and Helios, is found to the left, and beside him sits majestic Tyche, the goddess of destiny. Next along is Zeus, and beside him there is the deified Antiochus himself. The west terrace is laid out in a similar manner, but the gods here sit in a different configuration. For many years their giant heads were left strewn across the terrace, but they have since been reinstalled and now their stern and dignified gaze ranges across breathtaking scenery—or perhaps they are staring into another world that will remain when everything else has passed.

Şanlıurfa

Şanlıurfa (known as Urfa or Edessa), a city in southern Anatolia with a population of some half a million people, has been a sacred place for many millennia. The Göbekli Tepe, the oldest temple site ever recorded, was found in close proximity to the ancient city. Although it was previously thought that man built such sites only after the establishment of permanent settlements, this place suggests that Stone Age hunter-gatherers also built shrines. Situated on a long rock crest, the temple site on the **Göbekli Tepe** ("hill with a navel") is more than 11,000 years old. The monoliths that have been excavated so far are decorated with representations of animals—lions, foxes, snakes, reptiles, and birds—or abstract designs. As no signs of any dwellings have been discovered so far, it is assumed that this must have been a sacred place used exclusively for ritual purposes; this enigmatic temple was used for nothing less than the "decoding of the world," as the Nobel Prize winner Orhan Pamuk has put it.

Şanlıurfa is considered the fifth-holiest city in Islam, as there is a tradition that Abraham and Job lived here on the edge of Mesopotamia. The city is believed to have been Abraham's birthplace and is venerated accordingly. The most important pilgrimage site for Muslims is the **Halil Rahman Mosque** with its "Pool of Abraham," in which sacred carp, untouchable by human hand, swim freely. Visitors to this mosque not only honor God but are immersed in the story of Abraham, who embodies obedience to God in a very specific way. No matter what religion you follow, every life can be seen as a journey through uncertainty—and Abraham is a figure who can teach us what trust and confidence can achieve.

New Athos

Simon the Tanner was a cousin of Jesus and one of the disciples. After Christ's death, he first spread the gospel in Egypt before moving to Abkhazia to establish the new religion there. The town's pagan priests were tireless in inciting the people against Simon and his companions, and eventually Simon was martyred by being sawn in half. The typical Orthodox cross-domed **Church of St Simon the Canaanite** was built in the Middle Ages on the site of his execution, and to this day the church is a burial place for Orthodox clergy. There are other pilgrimage sites close to the church—the spacious **St Simon's Cave** is named after the saint and is where he is said to have lived, and there is also **Lake Simon**, where pilgrims go to bathe and cleanse themselves of their sins. The saint, represented in both Catholic and Orthodox iconography with a saw, is responsible for the remission of sin. He is often depicted with a caption that reads "community of saints, remission of sin."

In 1874 monks from the Greek monastic republic of Athos came to the town, which was now called Psyrtskha, and built an Orthodox monastery on the mountain, calling it **New Athos**; the modern town takes its name—Achali Atoni—from this foundation. The monastery includes the monastery church of St Mary the Protector, a pilgrims' hostel, and a boys' school. Work on the structure began as soon as the monks arrived, but the Russo-Turkish War (1877–8) interrupted proceedings, and it was not until the

New Athos Monastery

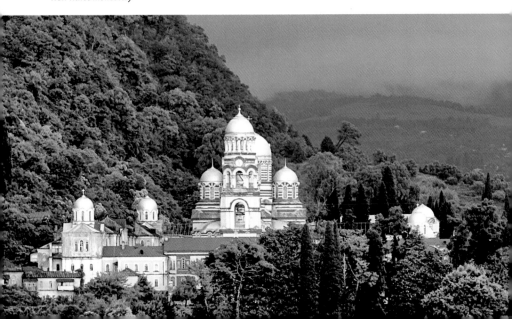

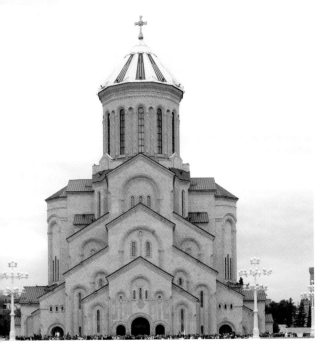

Tbilisi Sioni Cathedral

beginning of the 20th century that the monastery was finally consecrated. It had not stood long before the Russian Revolution caused its closure, but it is now once again occupied and run by monks, who offer accommodation to large numbers of pilgrims.

Tbilisi Sioni Cathedral

Two saints in particular are important in the story of the Christianization of Georgia—St Thomas and St Nino. Thomas, one of Jesus' disciples, was so troubled by the latter's crucifixion

that he was initially unable to believe in the Resurrection. Only when the risen Christ showed Thomas his wounds was he able to dispel his doubts, and Thomas subsequently became a zealous apostle in India and then in distant Asian provinces. Nino was a hermit and healer who had the ability to cure even the mortally sick. Both saints enjoy the highest veneration in the Georgian Orthodox Church and major relics associated with each are preserved in precious shrines in the main iconostasis, icon wall, of Tbilisi Sioni Cathedral—the disciple's skull and Nino's crucifix of vines with its drooping arms.

The old Sioni Cathedral, dedicated to both saints, was built between 575 and 639 and was considered one of the most sacred places in Georgia. The church, consecrated to the Virgin Mary, was named after Mount Zion in Jerusalem. Virtually nothing remains of the old building, but since the area has always been regarded as sacred, the modern church was built on the same site during the 17th to 19th centuries. The old church did not survive the turmoil of history, but belief in the miraculous healing powers of St Nino remains alive to the present day.

Temple of the Sun, Garni

A pagan shrine was established on a little rocky plateau between gaping gorges high above the little Azat River in the 3rd or 2nd century BC.

Temple of Mithras, Garni

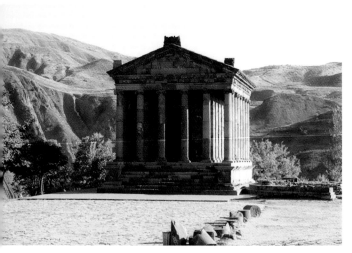

The sun god Mithras was worshiped here; the sun and its light have always been thought holy, and many religions have divinities that are associated with the sun. Imported from Persia and Babylon, the cult of Mithras was widespread during the heyday of Roman rule: Mithras was worshiped as *sol invictus*, the greatest and most victorious god, throughout the empire. His significance was only slowly eclipsed by the rise of Christianity.

The most recent building on the plateau is the 7th-century Church of Zion, built to document Christ's true victory over darkness. Visitors find it hard to leave the area, so appealing is the setting with its combination of harmonious temple and warm, bright sun.

In 66 BC the Armenian ruler Trdat I (later to be called Tiridates), a client king of the emperor Nero, had a Greco-Roman temple built here.

Garni was the seat of the Armenian royal family for centuries and parts of the fortifications have survived, but the fortress is overshadowed by the wonderful temple. The temple is situated on a stepped podium and its square *naos*, or inner chamber, is surrounded by 24 Ionic columns; the eaves of the simple pitched roof are elaborately decorated.

Geghard Monastery, Azat Valley

This sacred place is situated in a remote location in a bleak mountainous landscape. St George, the patron saint of the Armenian Apostolic Church, is credited with founding Geghard Monastery in the 4th century. The Armenian Church is one of the oldest Christian Churches,

Christianity having been declared the state religion as early as 301; some 94 percent of Armenians are members of the Apostolic Church. The monastery was established at the mouth of the Azat Valley on the site of a holy spring dating back to the pagan era. The Moors destroyed the monastery in the 9th century, but it was rebuilt in 1215. The rooms are carved from the living rock, and the use of natural caves as cells for the monks is particularly striking. The full name of the monastery, Geghardavank, means "holy lance," a reference to a relic brought to the country by the apostle Jude, although this is now kept in Echmiadzin, the seat of the Armenian Apostolic Church near Erivan, the capital.

A fine example of Armenian art can be admired in the monastery—a *khachkar* (c. 1213), a typical Armenian *stele* engraved with a cross at its center and decorated with vines, flowers, and other ornamentation. The base of such carvings is usually decorated with biblical motifs and stories. These represented the Crucifixion and Redemption and were used to spread Christianity throughout the country. Others were erected for the saving of souls, and protective powers were ascribed to them, with the result that any location where such a *stele* was set up can be considered a sacred place.

Geghard Monastery church, Azat Valley

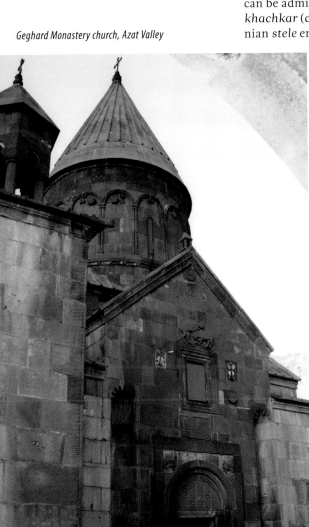

St Simeon's Monastery, Qal'at Sim'an

Simeon was born to Christian parents in the year 390. At the age of 13 he decided to become a monk, spending ten years in the Syrian monastery of Teleda in such self-denying asceticism that he was asked to leave the monastery by the other brothers. He then retreated to the solitude of the mountains located near modern-day Antakya (Turkey). During Lent he even had himself walled up, surviving for 40 days without food; he lived like this for 28 years. From here he moved to the mountain that was to be named after him, Qal'at Sim'an, and had himself chained to a rock. His fame quickly spread and he was visited by many pilgrims, who came seeking advice. They also took threads from his clothes, or so the story goes, as they believed the fibers had miraculous powers.

In 423 Simeon moved to a mountain near Aleppo (modern-day Halab), living on a small platform on a stone pillar that he didn't leave for seven years. This pillar proved to be too low, however—he was constantly bothered by pilgrims who came to see him not just from Syria but from as far away as Rome. So the pillar was raised to a height of almost 65 feet (20 m) and the monk was never to leave it again, staying on the platform for the last 30 years of his life. He ate only once a week, and his food was brought by pilgrims and hauled up in a basket.

Simon preached from the pillar, and his completely autonomous life of abstinence brought him great veneration. He attracted many pupils, who called themselves Stylites and followed his example. After he died in 459, his bones were brought to Antioch (now in Turkey) and a church was built over his tomb. However, the spot where he had lived remained a popular pilgrimage site, and in 490 a monastery was dedicated to him on Qal'at Sim'an.

The monastery complex includes four three-naved basilicas arranged in the form of a Latin cross, and the enormous monastery was for many years the principal pilgrimage site in Syria. Only the ruins of the impressive complex remain, along with the remnants of the pillar on which Simeon spent so much of his life. The place has not lost its fascination, however, and it is still considered one of the most important pilgrimage sites for Christians from all over the world.

Resafa

This city lay forgotten in the Syrian desert for 400 years; the last inhabitants abandoned it in 1269 and it was rediscovered by British merchants only in 1691. Another 200 years were to pass before the excavation of the city in the desert began in 1907, and since 1952 the city, which was an important pilgrimage site for both Christians and Muslims, has been

systematically explored. Besides the city wall and the caliph's residence, several places of worship have survived in part at least, and the most important of these are the **Basilica of St Sergius** and the Grand Mosque.

Resafa's history began in the 1st century AD with the building of a

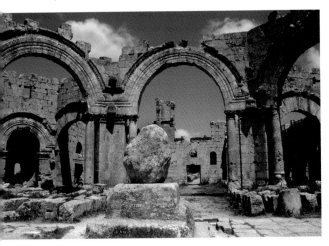

The ruins of the Monastery of St Simeon on the Qal'at Sim'an

Roman fort on the eastern border of the Roman Empire to resist the incursions of the Persians. Sergius, a Roman soldier serving in the fortress, was martyred in 303 after his conversion to Christianity. The city soon became one of the most important Christian pilgrimage sites in the eastern Mediterranean and was even known as Sergiopolis in the 5th and 6th centuries. Surprisingly, the saint was revered by both Christians and the Muslims who conquered the region around

636. About a century later, Caliph Hisham bin Abd al-Malik had the **Grand Mosque** built right beside the Christian basilica housing St Sergius' relics.

Dorothée Sack, a German archeologist who has been studying Resafa and its buildings since 1983, thinks that the mosque is the only known Muslim place of worship that was used in tandem with a neighboring Christian church. There is a door in the mosque that leads onto the northern courtyard of the church, establishing a connection with the shrine of St Sergius. Both were used concurrently until Resafa was abandoned in the wake of Mongol attacks in 1269 and left to decay. Although it now lies in ruins, Resafa remains a symbol of the potential for peaceful co-existence of Christians and Muslims.

Ma'alula

Ma'alula, a town where time seems to have stood still, is located about 31 miles (50 km) north of Damascus. The populace still speak the Aramaic known from the Bible, and the caves, streets, and squares are unchanged from the earliest days of Christianity.

Most of the inhabitants are Christians, which is unusual in an otherwise predominantly Muslim country. The town's low clay-brick buildings nestle at the foot of a mountain chain, although the mountains and the town are barely distinguishable in color and seem to merge into one another.

There are several monasteries in the town. Built on the site of a pagan temple, **Mar Sarkis Monastery** dates back to the 4th century and is named after a Roman soldier who died for his new beliefs. Another monastery is **Mar Taqla**, consecrated to the first female Christian martyr. Thecla was the

Ma'alula and the Mar Sarkis Monastery

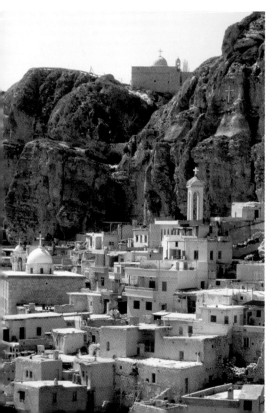

daughter of respected pagan parents and possessed great intelligence and beauty. In AD 45 the apostle Paul came to the city to preach his new religion. She became his pupil and was baptized, subsequently refusing to marry a rich young man. In rage, the latter reported her to a magistrate, but Thecla remained steadfast during her trial in court. She was led into the arena to be set upon by wild beasts, but they lay at her feet and rubbed up against her. After this she was condemned to be burnt to death, but a sudden rainstorm saved her. She fled into some nearby mountains, but ran into a dead end. Despite her predicament she did not abandon her faith, praying instead for divine assistance, whereupon the mountain split with a terrible crack—Ma'alula, which means "entrance," is named after this occurrence. At the same time a spring began to flow from the rock, and its water dripped into a cave where Thecla made her home. Ma'alula is a pilgrimage site for people from all over the world, and not just because of the story of St Thecla—this place possesses a timeless quality and an endless appeal.

Umayyad Mosque, Damascus

The author Rafik Schami was born in Damascus but has lived in Germany for more than 30 years. Yet he

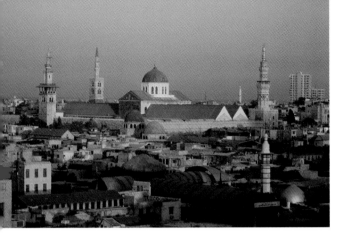

Damascus and the Umayyad Mosque

still calls Damascus his home and for him it combines all the ingredients required for a happy life: bustling activity, different religions co-existing, and great openness among its inhabitants. Damascus is thought to be the oldest continuously occupied city on earth, and the site of the Umayyad Mosque is an index of its turbulent history. Hadad, the Syrian god of thunder and lightning, was worshiped here in ancient times, and during the Roman era a temple to Jupiter stood on the site. From the 4th century the Roman temple was used by Christians as a church and was later also used as a place of worship for Muslims—the two faith groups entered this sacred place by the same door but kept a respectful distance from each other. After many years of communal use of what came to be known as the Basilica of John the Baptist, new rulers had the Christian church more or less demolished between 706 and 714–15, erecting the Umayyad Mosque in its

place. Quite a few elements of the old church remained, however, to bear witness to the structure's history.

The mosque is reached through a bustling souk; once visitors have passed through the ancient Roman columns, they reach an inner courtyard, at the western end of which is the entrance to the shrine (Arabic: *haram*). Directly in front of this stands a symmetrical fountain for ablutions. The shrine to St John the Baptist is within, and the head of the Baptist is believed to be buried here. Whether this is true or not is less important than the symbolic significance of the place for adherents of the Abrahamic religions—Judaism, Christianity, and Islam. John was a Jewish preacher, an ascetic, and a prophet, who announced the advent of the Ruler of the World and later baptized Christ. The shrine attracts those who wish to pray communally and those who are seeking faith. To visit this place is to experience a moment where religions and cultures share fellowship in peace. In 2001 Pope John Paul II visited the mosque and made a plea for the tolerant and respectful co-existence of Christians and Muslims. The existence of the Umayyad Mosque is a visible sign that this is not impossible.

Baniyas

The Tetrarch Herod Philip II ruled the region north of the Yarmouk River from AD 4 to AD 34. His sovereign territory included the cosmopolitan city of Caesarea Philippi, where there was a small Jewish community whose

The Shrine of Pan and the Nymphs, Baniyas

The "Shrine of Pan and the Nymphs" is located on a site once used by pagan Baal-worshipers, and a grotto beside the river source still has recognizable niches carved in the rock where in all probability idols were placed. It was supposedly here that Peter declared Christ to be the promised Son of God (Matthew 16:16). This site has been sacred for centuries to people of various beliefs—certain natural phenomena have always attracted veneration as sacred places.

Safed

This city is dominated by the ruins of an old Crusader castle from the 11th century. The castle was taken over by the Templars in the 13th century, although these occupants were eventually banished by the Muslims in 1266.

spiritual and cultural life bore strong traces of Greek influence. The city lay beside one of the three sources of the Jordan. Its modern name, Baniyas, is the Arabic transliteration of the Greek Paneas, referring to the ancient Hellenistic cult of Pan, which was practiced here. The little Baniyas River (Hebrew: Nachal Hermon, the stream of Hermon) rises at the foot of a rocky cliff as a strong and fast-flowing spring, before merging with the Jordan only nine miles (15 km) further on.

Safed became a predominantly Jewish city in the 16th century, with many Sephardic Jews coming here to settle in the Holy Land. Centuries later, at the time of the Israeli War of Independence, there were more Arabs than Jews living here, but when the war ended in May 1948, almost all of the Arabs left the city. Since then Safed's population has been almost exclusively Jewish.

Along with Jerusalem, Tiberias, and Hebron, this town in Galilee in northern Israel is one of Judaism's four sacred

cities. Many famous scholars settled in Safed, establishing the enduring fame of the city through their teachings. It has always been considered a center of Jewish scholarship and of Kabbalistic mysticism in particular. Well known in traditional Judaism, this way of looking at the world is currently once again exerting a great influence on many people's thinking, not just that of Jewish believers. Kabbalah combines traditional Jewish scriptural study, with elements of Gnostic and neo-Pythagorean philosophy and an exclusive and mystical piety. The essence of the belief is based on the idea of four worlds and ten spheres within which divine powers are revealed, influencing events in the visible world. Significantly, the piety of an individual can have an effect upon events in the material world, and evil exists alongside good as an independent force. Kabbalah combines Messianic hope with folk belief and magical elements, especially numerology, to explain the world. It spread rapidly from Safed throughout the entire diaspora, and the city has thus become a pilgrimage site for adherents of this belief.

Capernaum

Jesus' life and work was mainly concentrated in the area around the Sea of Galilee. After he had been rejected in Nazareth, he traveled on to Capernaum, which at the time was little more than a tiny fishing village on the northern shores of the lake. In contrast with many towns in this region, Capernaum is well documented, for example by Flavius Josephus in his *Antiquities of the Jews*. Jesus visited Capernaum several times and the town witnessed numerous miraculous healings: Jesus healed a possessed man here in the synagogue on the Sabbath, earning bitter criticism. The Gospels record two further miracles that took place in Peter's house: Jesus healed Peter's mother-in-law and another individual whose name is not recorded, who was let down to Jesus through the roof by his friends. Excavations have revealed the walls of a house with murals that seem to suggest a Christian shrine. The most famous miracle performed in Capernaum was the healing of the servant of a Roman centurion who—while an unbeliever, by his own admission—had such strong trust in Jesus that he knelt before him and begged him to heal his servant.

In the 4th century streams of pilgrims visited Capernaum. In 743 the village was hit by an earthquake but was soon resettled, before finally being abandoned in the 11th century and left to decay. The old town was only rediscovered by archeologists in the 19th century, and one house has been identified as that of Peter. The town's striking synagogue, built in 1926, is of interest, with the historic cobbled floor beneath it dating back in all probability to the time of Christ. As it is much more difficult to pinpoint the locations of other events in Jesus' life around Galilee, Capernaum is an important pilgrimage site for Christians who wish to follow in Christ's footsteps.

The Sermon on the Mount

This sacred place on the western shores of the Sea of Galilee, very near Tabgha is of particular significance for Christians. And not just for Christians—every civilized person recognizes in the words of Jesus the fundamental ethic of learning to live alongside others. Like the Ten Commandments, the Sermon on the Mount provides a set of basic principles for a fulfilling and tolerant life. The actual historical location is difficult to establish for certain. Matthew reports that Jesus spoke his famous words from a rocky hill, whereas Luke's Gospel records that he stood in a field. All agree, however, that the place where this sermon was actually delivered is of less consequence than the message it carried.

The location of the modern Church of the Beatitudes, built in 1937, was deliberate: it is directly above the Cave of Eremos, which was once considered the site of the Sermon on the Mount. The church has a wonderful view of the lake, but this is not the reason why people come here. Pilgrims to this sacred place wish to remind themselves of the words that more than any others show how an individual can achieve happiness; they concern nothing less than being blessed. Blessed are those who seek, who hope, who make peace, those who are merciful, and those who are meek—they shall inherit the earth. This is a message that is intended not only for Christians but is spoken from the heart to the heart of Man.

The site of the Sermon on the Mount on the western shores of the Sea of Galilee

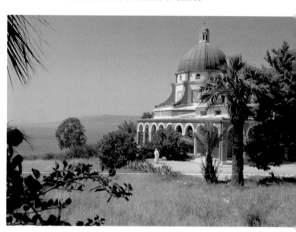

Church of the Multiplication, Tabgha

That everybody would have enough to live on if only people would share is a commonplace insight that is paid lip service in both private and political life, though it has yet to be given any practical meaning through a more equitable distribution of the world's resources. All four Gospels record Jesus' miraculous feeding of a great crowd with just few loaves and a few fish. Though the exact site of this miracle is unknown,

from an early date streams of Christian pilgrims have headed for Tabgha on the northwestern shores of the Sea of Galilee, where Christian tradition locates the miracle of the feeding of the five thousand. Since the earliest days of Christianity, a stone has been venerated here upon which, according to a pilgrim's report of 390, Jesus laid the bread before he multiplied and shared it.

Nothing remains of the first church to be built on the site, but a large, triple-naved basilica was erected in Tabgha in the 5th century. The sacred stone was placed under the altar. Along with almost all the other churches in the region, this one was destroyed by the Persians, but the beautiful floor mosaics survived in part. These now adorn the floor of the Church of the Multiplication, built at the end of the 19th century on the Byzantine foundations. The monastery and the church, both run by Benedictines, are a popular pilgrimage site for Christians from all over the world. The church's interior is very plain, almost austere, apart from the mosaics that depict the feeding of the five thousand. The five loaves and two fishes are a reminder to visitors that

wealth requires moderation and poverty alleviation, in order that everyone can live well. The message of sharing is not intended solely for Christians but is meant to encourage all people to be well-disposed to their neighbors and aware of their responsibilities toward others.

Tiberias and the Sea of Galilee

The Sea of Galilee has a mild climate, which helps to explain why the city of Tiberias is such a popular global tourist destination. Market gardening is widespread here, particularly the cultivation of dates and grapes. The city, which reaches an elevation of 800 feet (245 m), is situated on the shore of the lake, 695 feet (212 m) below sea level.

Currently the largest city in the Jordan Valley, **Tiberias** was founded by Herod Antipas in AD 17, replacing Sepphoris as the provincial capital. Herod named the city after Tiberius, the Roman emperor, and the architectural style and layout adopted for the ancient city were classically Roman, with a forum, various temples to Roman divinities, and arenas. These were partly built over Jewish cemeteries, and for this reason the city was long considered "unclean" by Jews, although it has since become a major pilgrimage site.

Floor mosaic in the Church of the Multiplication

For Jews, Tiberias is one of the four holy cities (along with Jerusalem, Safed, and Hebron). In AD 210 the Mishnah, a collection of religious prescriptions that had hitherto been passed down orally, was first written down here, and the Jewish Talmud, a collection of principles for leading an everyday life according to the will of God, was also completed in the city. These texts have always had enormous significance for Jews and so, not surprisingly, the place where these great books were completed is regarded as sacred.

Christians come here mainly to find the place where Jesus preached the Sermon on the Mount. This forms the basis of Christian ethics, and modern visitors who stand on this hill find it easy to imagine themselves back in Jesus' era. The **Sea of Galilee**, where Jesus miraculously walked on water, is also where he stilled the storm, a story of essential importance in Christian tradition as exemplifying the centrality of trust to human life. This is a place of particular spiritual experience for Christians, as it is where the promise made by Jesus came to pass: "See, I am with you always, even unto the end of the world" (Matthew 28:20).

Basilica of the Annunciation, Nazareth

At the time of Christ, Nazareth was an insignificant town—so insignificant, in fact, that at times its very existence has been questioned. The discovery of Bronze Age settlement ruins and Jewish tombs from the Roman period have dispelled any such doubts, however. Nazareth was the home town of Jesus, the man who was to shape the course of world history like no other. Jesus grew up in the house of Joseph the carpenter, watching craftsmen at work and farmers in their fields—it was here that he experienced everyday life. Despite Nazareth's importance in Jesus' life, it was to be many years before it became a destination for Christian pilgrims. Egeria, a pilgrim who came to Nazareth in 383, was shown a large cave where Mary was supposed to have lived and where a large altar had been built. Roman Catholic tradition holds that this is the place where the archangel Gabriel announced to Mary that she was going to bear a son. A church was built over the cave in 570.

During the Byzantine era, pilgrims were taken to two further locations— a smaller cave with a spring from which Mary is said to have drunk, and the site of a synagogue where Jesus is supposed to have read from the book of Isaiah, an episode recounted in the only biblical story from Christ's childhood. Contemporary accounts confirm that churches once stood on all three sites, but when the Crusaders reached Nazareth all they found was ruins. A magnificent new church was soon constructed, but this fell victim to an earthquake in 1170. Only in 1730 was permission granted to the Franciscan order to build another church.

The modern Basilica of the Annunciation is on two levels. The upper church has the same floorplan as the 12th-century Crusader basilica, and the lower church houses the Byzantine grotto. The new basilica is the largest Christian ecclesiastical building in the Near East, and the regular ecumenical services are a promising sign of peaceful co-existence here. Because of the constant conflicts breaking out between world religions that should, in truth, be able to co-exist quite happily, it is unfortunately often the case that visitors make only a brief stop at Nazareth before traveling on.

Christian tradition has considered **Mount Tabor** to be the place of Christ's Transfiguration since the 4th century. The Gospels of Matthew, Mark, and

Basilica of the Transfiguration, Mount Tabor

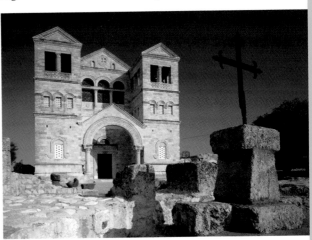

Mount Tabor

At the eastern end of the Jezreel plain, near the town of Nazareth in northern Israel, there is a small mountain that has been a place of worship for millennia and has remained so to this day. Although it is only 1,930 feet (588 m) high, Mount Tabor's isolated location makes it particularly noticeable, and it is perhaps not surprising that people came to think of it as a sacred place—the Canaanites worshiped their fertility god Baal here 4,000 years ago, and the mountain is mentioned several times in the Old Testament as a place of worship.

Luke all record how Jesus appeared to his disciples in a divine form—a shining light that was to illuminate their paths from then on. The first churches were built on the summit quite early on—the Benedictine order built three chapels along with a monastery, one dedicated to Moses, one for Elijah, and one for Christ. In this they were continuing a biblical tradition, as Peter had wanted to build covered huts for these three great Judeo-Christian religious figures here. The abbey and the chapels were destroyed by the Muslims in 1263, however.

Modern visitors will find the Greek Orthodox **Church of Elias**, built on the ruins of a 15th-century chapel

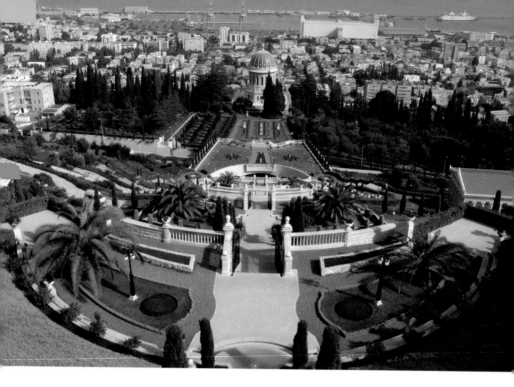

Hanging gardens in the Bahá'í World Center, Haifa

commemorating the legendary hermit and king Melchizedek. It is said that this king lived here in a cave and meditated for seven years before visiting Abraham to bless him.

The beginning of the 20th century saw the Franciscan order build their **Basilica of the Transfiguration** on the foundations of old Byzantine buildings located here, and the basilica is now the most prominent landmark on the eastern side of the plateau. Standing among the flowers on the plain and looking up at the mountain, it is easy to understand why it has always been thought of as a place of sanctity and revelation.

Bahá'í World Center, Haifa

The Bahá'í, a global religious community founded in the 19th century, represent an independent branch of Islam. Siyyid Ali Muhammad, one of the two founders of this religion, who called himself *Báb* (Arabic: "the gate"), was born in Shiraz in Persia (now Iran) in 1819 and first claimed to have received a divine revelation in 1844. The other founder, Mírzá Husayn `Alí Núrí, was also born in Iran, in 1817, and actually established the religion, receiving the name *Baha'u'llah* (Arabic: "the glory

of God"). This post-Islamic revelation attracted followers with the same speed as it was condemned as apostasy by Islam, and formal separation from the Muslim faith was achieved in 1848. As he was preaching a religion divorced from Islam, Baha'u'llah was banished, initially living in the prison city of Acre in Haifa Bay. Baha'u'llah died in Bahji, north of Acre, in 1892 and is now buried there; nine paths, arranged like the points of a star, lead to his simple and dignified tomb. The grave is visited by many Bahá'í every day for silent prayer and meditation, and the faithful throughout the world turn toward Baha'u'llah's tomb for their daily prayers.

The golden dome of the Shrine of the Báb is located on Mount Carmel on the other side of Haifa Bay. Beside the temple there are "Hanging Gardens," which were laid out at the turn of the 20th century by Shoghi Effendi, the leader of the Bahá'í community. They were completed in their current form and opened to the public only in 2001. Nine terraces are laid out in front of the building, and nine further floral terraces, like a giant staircase, show the way up to Mount Carmel, symbolizing the ascent of man into the heavenly spheres. The "House of Justice," from which the global Bahá'í community has been led since 1963, is located close by. The Bahá'í shrines on Mount Carmel and in Haifa Bay form the spiritual center of this global community and are considered a sacred site by its adherents. Even those who have never heard of the Bahá'í's teachings will be captivated by the beauty and harmony of the buildings.

Mount Carmel

It has never been easy to discern false prophets from true ones. Mount Carmel was the scene of a strange contest between the gods, who were represented by their prophets. This was the dispute between Elijah and the prophets of Baal, which according to tradition took place on the summit of **Mount Carmel** at a point on the southern edge of the mountain chain, where the crests of the two main arms of the range come together. The conditions of the divine contest were as follows: each party was to pray to their god and command fire from heaven to consume the sacrifice upon the altar. A total of 450 prophets of Baal faced Elijah, but all of their prayers and invocations, even their strange dances and self-inflicted wounds, were in vain. Only when Elijah called upon the God of Israel did a great tongue of fire—perhaps a lightning bolt—descend from heaven and consume not only the sacrifice but also the water in the ditch surrounding the altar. This sealed the fate of the prophets of Baal and they were killed in the valley of the Kishon Stream on the Jezreel plain, to which a path does indeed lead from the summit of Mount Carmel.

It is impossible to prove with any certainty that this prophets' contest actually took place here, but the site has been considered a sacred place for centuries. It is not implausible that the altar that played such a major part in the competition once stood here in this striking landscape. Just beneath the mountain's peak there is

now a monastery, **Muhraqa**, the mother foundation of the Carmelite order. Founded in 1150, it still maintains an eremitic tradition—the Carmelites have always considered the ascetic prophet Elijah to be the exemplar of a life pleasing to God. There is another institution run by the same fraternity, the **Monastery of Stella Maris**, on the slopes at the northern end of the mountain chain. Beneath the modern church there is a grotto that is said to have been Elijah's home.

Jaffa/Tel Aviv

Jaffa/Tel Aviv is now world-famous for its oranges exported around the world, but Jaffa (Jafo, Joppe) is one of the oldest cities on the southern Mediterranean. Its natural harbor is documented in Egyptian sources from the 15th century BC, and Jaffa has remained the major port in Palestine right into the modern period. Visit the city today and you will find a pulsating modern metropolis which retains its oriental atmosphere and is the site of several sacred places.

The Franciscan **Monastery of St Peter** is located high on a hill dominating the cityscape. It was built in the 17th century on the ruined walls of an old Crusader castle. Close to it there is the **Grand Mosque**, with its lofty minaret under which, according to Christian legend, the house of Simon the Tanner was located;

the apostle Paul is supposed to have stayed here for a while. Stand on the quayside looking out to sea and you will soon make out the bizarre **Rock of Andromeda**, which brings Greek mythology to life. Legend recounts how Andromeda was chained to this rock to be eaten by a sea monster as a sacrifice by her father, King Cepheus. She had already resigned herself to death, when her lover Perseus, spurred on by the winged sandals of Hermes, the messenger of the gods, killed the monster and freed her.

This city has shrines for all three great world religions in close proximity to one another; like every other city in the Holy Land, Jaffa/Tel Aviv is a reminder of the tolerance that enables people to co-exist. There is a sense of *joie de vivre* to be felt on the "Hill of Spring" (the translation of the Hebrew *Tel Aviv*). A well-known Israeli proverb states: "In Jerusalem they pray, in Haifa they work, and in Tel Aviv they live and celebrate!"

Beth-El Temple

West Bank

The town of Beth-El, now known as Beitin, is situated on the southern edge of the Bethel Mountains at the convergence of two ancient roads, one running east–west and the other north–south. There was sufficient spring water here for it to be thought

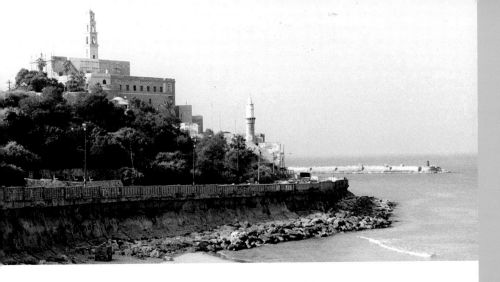

The old port of Jaffa with St Peter's Monastery and the minaret of the Grand Mosque

a good place to settle. Beth-El is best known for the biblical story of Jacob: it was here that he had his dream of the ladder to heaven, with angels ascending and descending (Genesis 28:10–22). Stone pillars of considerable size have been found to the north of the old settlement, and are thought by some to be connected with this biblical story. Giant stones appear to have been piled up here to form columns up to 10 feet (3 m) in height. However, these pillars are not in fact the work of man but instead of a striking natural phenomenon.

In view of these rock formations, it is perhaps to be expected that this would be the spot that Jacob would choose to erect a stone pillar of his own, anointing it with oil and making a shrine. Beth-El soon became one of the major sacred places in the northern kingdom of Israel. During the time of the Judges (1100–1000 BC)

the Ark of the Covenant containing the tablets of the Ten Commandments was kept here, and Beth-El became a place of worship and sacrifice for the people of Israel. Later, in the mid-8th century BC, the prophet Amos chided the city and its religious practices in the harshest manner; he thought that the cult in Beth-El was an insult to God, as the people there did not please Him with their other activities, especially those to do with social justice (Amos 3:13–15). Amos' judgment was crushing—sacrifice alone was not enough for this God. The shrine slowly declined in significance, finally disappearing when the northern and southern kingdoms were combined and David made Jerusalem the capital of a united Israel. The memory of this sacred place has lasted into the present and, ideally, so will Amos' censure, that only those who strive for justice live lives pleasing to God.

NEAR EAST

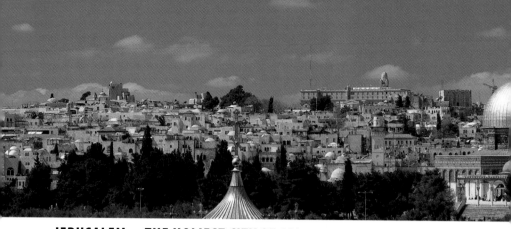

JERUSALEM—THE HOLIEST CITY OF ALL

It is hard to describe quite what constitutes the magic and fascination of this city. Visitors to Jerusalem are plunged into a bustling present and—just as intensively—into 3,000 years of history. The city has countless faces and is exceptionally striking. Jerusalem is located 2,620 feet (800 m) above sea level, and Jews "go up" to Jerusalem, to a city in the mountains, close to the "circles of heaven [Jannah]," as the Muslims believe. Like Rome, Jerusalem is built on seven hills, and each of these hills offers a magnificent view across the Old City. The view takes in the fields, extensive olive groves, and fruit orchards of the plain, reaching as far as the gleaming cupola of the Dome of the Rock. Turn around and you will see the glittering peaks of the Judean desert with the shimmering blue of the Dead Sea in the distance. Jerusalem has also always been a place of desire—"next year in Jerusalem" is the good wish that Jews share with one another as their new year begins, a sentiment that is full of hope and optimism.

Jerusalem is the intellectual and religious capital of the Jewish faith, but it is also a holy city for Muslims and Christians. People come here from all over the world, and are transported by the atmos-phere of sanctity. The prophets often compared Jerusalem to a beautiful woman, and her charms will ensnare anyone with even the slightest feeling for a city that has endured such a turbulent history. Jerusalem has so many stories that it would take more than a lifetime to hear them properly.

People from all over the world live in Jerusalem: Orthodox and Reform Jews, Muslims and Christian Arabs, Europeans, Armenians, Ethiopian Christians, Catholics, and Protestants. Western cultures and Middle Eastern lifestyles meet and merge in Jerusalem, making this place unique.

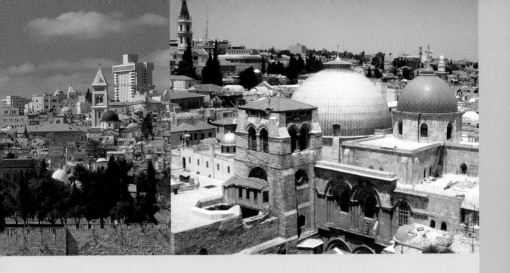

Anyone wishing to understand Jerusalem should visit the Old City with its maze of streets, oriental markets, and countless sacred places—mosques, Christian churches and monasteries, synagogues, and yeshivas. Anyone wishing to understand Jerusalem should sit beneath an old olive tree, drinking cool water and allowing their gaze to wander. Anyone aiming to understand Jerusalem should embrace the adventure of encountering living embodiments of different cultures and religions, and also embrace the chance to encounter the self.

In addition to the Jerusalem of the present and the past,

there is yet another: the "New Jerusalem," the heavenly city mentioned at the beginning and the end of Revelation, the last book of the Bible. The city is described in some detail: there will be no temple in the New Jerusalem, as the whole city will be a temple to God, the city's gates will no longer close, and nothing evil will exist within its bounds. There will be no more crying and no more pain, God will wipe away all tears, and people will live in peace, in an all-encompassing accord (Hebrew: *shalom*; Arabic: *salam*) that is already indicated in the city's name. The old Jerusalem was a place where God was present, but the New Jerusalem will resem-

ble a new heaven and be the home of a great host of God's people. In some respects, you could say that this is not just a wish for the future; the city already has the makings of such a place—Jerusalem, the holiest city of all.

The Golden Gate

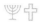

When thinking of Jerusalem, it is the Old City that most readily springs to mind. This is a precinct only half a mile (1 km) square, surrounded by a wall built by the Ottoman Turks in the 16th century—here, countless traces of the Divine are to to be found. The entire area bounded by the wall is full of history and stories, and packed with consecrated places of great significance for Jews, Christians, and Muslims. There are relics of long-past epochs on every corner: ruins from the Old Testament era; buildings and monuments from Herod's Temple; Roman triumphal arches, pillars, and tombs; Byzantine churches and other municipal facilities; and shrines that have been considered sacred for centuries by followers of the three great monotheistic religions.

Crossing the imposing stone boundary means entering another world. Visitors used to reach the city through one of eight gates. The Golden Gate (Arabic: *Bab al-Dhahabi*), now walled up, has a special significance for pilgrims the world over. It is possible that the original gate to Herod's Temple was located here, the entrance through which the scapegoat was driven every year on the Day of Atonement, symbolically carrying the sins of the whole

The Golden Gate—one of eight entrances to the Old City of Jerusalem

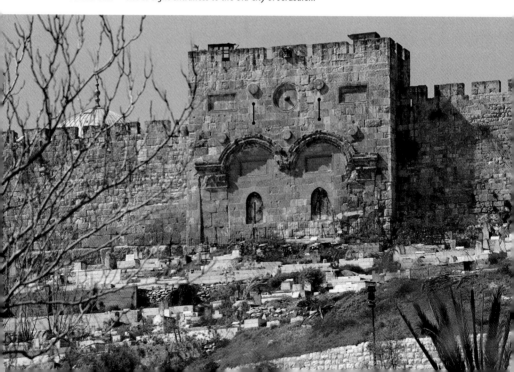

populace. During the time of the Crusaders, the gate was opened only twice a year—for a solemn procession on Palm Sunday, commemorating Jesus' entrance into Jerusalem, and on the Feast of the Exaltation of the Cross. Quite why Suleiman had the gate blocked is unclear, but it is not beyond the bounds of possibility that he wished to deny access to the Temple Mount to the "infidels."

One belief associated with this gate divides Judaism and Christianity. The Christians believe that Jesus, the hoped-for redeemer of the world, has already passed through this gate, and this makes it a holy object of worship and commemoration on Palm Sunday. The Jews, however, still await the coming of the Messiah, although they too believe he will enter the city via this eastern gate. With him the virtuous will accede to eternal life through the Golden Gate.

The Temple Mount

There is perhaps no location on earth accorded more religious veneration than this hill looking down on the Kidron Valley from the southeastern section of the Old City of Jerusalem. A man-made plateau tops the mount and the world-famous buildings upon it can be seen for miles around. Even those who have never visited this holy city will recognize pictures of the Temple Mount with the golden cupola of the Dome of the Rock and the great al-Aqsa Mosque. The sanctity of this place is reflected in the bitterness of the historical struggles for its possession, and it has a corresponding wealth of stories to tell. The Temple Mount (Arabic: *Al Haram ash-Sharif*, Hebrew: *Har haBáyit*) is the heart of the city. Its 34 acres (14 ha) make up a sixth of Jerusalem's total surface area, and it is of particular holiness for each of the three great monotheistic world religions.

The Jews revere this mountain because the first Temple of Solomon stood here, housing the Holy of Holies, the Ark of the Covenant that contained the Ten Commandments. The subsequent Temple of Herod also stood here. The western retaining wall, now called the Wailing Wall, is one of the most important and fascinating shrines of modern-day Judaism. One Talmudic legend maintains that God took the dust from which he made Adam from this spot. After the final destruction of the Jewish Temple by the Romans in AD 70, a temple to Jupiter was erected on the plateau, and during the Crusader era there was a Marian church; this was later rebuilt as the modern al-Aqsa Mosque.

The mountain is significant for Muslims as the place from where the Prophet Muhammad is said to have ascended to heaven on his steed Buraq, to be met by the other prophets and by God. The place also has a special significance for Christians, as they regard a mark in the central rock as a footprint of Christ.

The Temple Mount has always been contested, for political as well as religious reasons. Its history has at times been less than holy, but this does not diminish its very special and unique aura, which seems both timeless and eternal. The Temple Mount in Jerusalem stands as an advocate of tolerance, a human virtue that remains valid regardless of the religious affiliations of the individual.

The Temple Mount in the middle of the Old City of Jerusalem

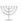

The Wailing Wall

Since the destruction of the Jewish Temple by the legionaries of the Roman emperor Titus in AD 70, the western wall of the Temple, the Wailing Wall, has served to unite Jews from all over the world. As the Romans, the land's new rulers, denied the Jews access to their sacred mountain, Mount Moriah, the wall, an everlasting symbol of the Temple, soon became a sacred place in its own right. The destruction of the Temple was a traumatic episode for the Jewish people and the anniversary of this catastrophe is still observed as a day of mourning. Jews have been visiting this wall for hundreds of generations to bewail their fate—hence the name. According to Orthodox Jewish tradition, the Temple will be rebuilt only when the long-awaited Messiah returns.

When the Muslims reclaimed the Temple Mount, building the Dome of the Rock and the al-Aqsa Mosque in the 7th century, Jews were banished from the city for a long period; the wall became an unreachable symbol of yearning and complaint. They

were not permitted to return to live in Jerusalem until the 13th century, and since this time Jews have regularly visited the wall to pray. A law of 1930 declared the entire precinct of the Temple Mount to be consecrated Muslim ground, while simultaneously providing that every Jew should have free access to it. After the war in 1948, which saw this part of Jerusalem fall to Jordan, the wall once again became inaccessible to Jews, only reverting back to their possession in 1967, after the reunification of Jerusalem.

The wall is without doubt one of the most important sacred places for Jews—not only for those resident in Jerusalem, but also for those scattered throughout the world. Stand in front of it and you will see the many little slips of paper tucked into the joints of the giant stones—these are prayers and special petitions to the Shekinah, the presence of God, which according to Jewish belief has resided in the wall since the destruction of the Temple. Jews undertake pilgrimages to the wall throughout the year, but during the greatest feast of the Jewish calendar, Yom Kippur, the Day of Atonement, tens of thousands flock to the Wailing Wall to pray for the coming year.

Orthodox Jews praying at the Wailing Wall

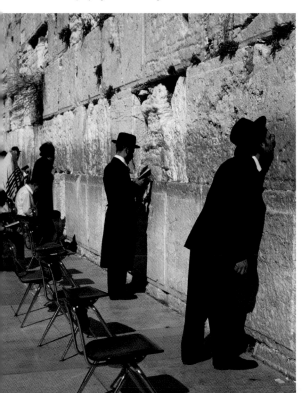

The Dome of the Rock

The Dome of the Rock is without doubt one of the oldest and most beautiful buildings in Islam. Its exterior is often compared to a magnificent precious stone, and with good reason; the shining gold, turquoise, and green of the dome can be seen for miles. The Jews regard this as the place where Abraham was called upon to sacrifice his son, only to be prevented at the last moment by God himself. Muslims interpret a depression in the main rock as a footprint made by the Prophet Muhammad,

while Christian Crusaders saw it as the footstep of Christ. After conquering Jerusalem they thus built a church on the site, calling it the "Temple of the Lord." As soon as Saladin had retaken the city in 1187, he had all reminders of Christianity removed and the site became a Muslim shrine again.

The Dome is not in fact a mosque, and no believers assemble here for worship. Instead, it is essentially a protective roof built over the holy rock. However, the Dome remains a place of reverence and was soon to become the focus of Muslim pilgrimage from around the world. It has an octagonal plan and the walls of the twin octagonal rings, which in places reach a height of 27 feet (8 m), are made of rough-hewn natural stones fitted together without mortar. A round ring on top of the flat roof supports the golden cupola. The walls of the Dome are elaborately decorated inside and out with floral and geometric patterns and Arabic calligraphy. The inscriptions contain information about the building's construction history. Some are paraphrases of Koranic verses praising God's power:

The Domes of the Rock and of the Chain on the Temple Mount, with the al-Mawazeen to the left

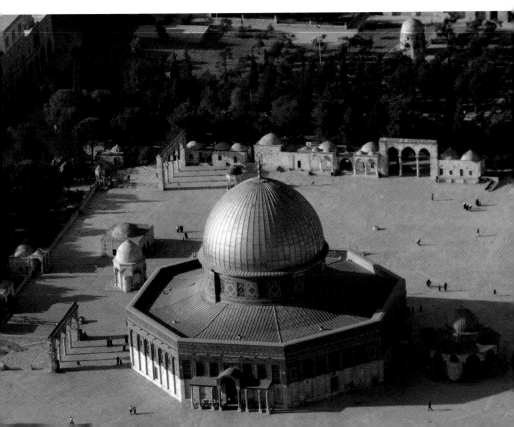

"He has dominion over heaven and earth, he commands life and death and has power over everything" (Sura 57:2). The interior octagon is decorated inside with an inscription that may refer to Christ: "praise be to him on the day of his birth, the day of his death, and the day when he is brought back to life" (Sura 19:33). Along with masterly representations of paradise, the interior also features inscriptions that are polemically anti-Christian. This wonderful building is thus not only a place of pilgrimage for Muslims, but also stands as a kind of admonition—a reminder of the importance of religious tolerance, even when this is difficult to summon or practice.

The Dome of the Chain

☾٭

Immediately to the east of the Dome of the Rock stands the Dome of the Chain, similar in appearance but considerably smaller and less ornate. Various theories have been advanced to explain its original use. One Islamic tradition suggests it marks where David hung chains used for judicial purposes—only the innocent and honest could reach out and touch them. Others assume that this was the site of the treasure chamber in which Abd al-Malik kept the funds to build the Dome of the Rock. The building was free-standing and never surrounded by a wall, and probably featured a pulpit facing the

al-Aqsa Mosque opposite and thus looking toward Mecca. This sacred place is rather overshadowed by the Dome of the Rock, but the concepts of honesty and "right living" find concrete expression here.

Al-Aqsa Mosque

☾٭

"Celebrated be the praises of Him who took His servant on a journey by night from the Sacred Mosque to the Remote Mosque, the precinct of which we have blessed, to show him of our signs! Verily, He both hears and looks." These words begin the "Night Journey," the 17th *sura* of the Koran. The "Remote Mosque" is the al-Aqsa Mosque on the Temple Mount in the middle of Jerusalem, regarded as the third-most sacred mosque in Islam after those in Mecca and Medina. Until AD 70 the second Jewish Temple, of which only the western wall (the modern Wailing Wall) now remains, stood on the site, to be followed by a Christian basilica. A simple mosque was probably built here shortly after the Islamic reconquest and enlarged extensively under al-Walid I.

The Temple Mount has always been a place of worship and is still in use today, but it has also witnessed bloodthirsty scenes. The entire Temple complex was destroyed in AD 70 during the First Jewish–Roman War, and when in 1099 crowds sought refuge in the mosque from

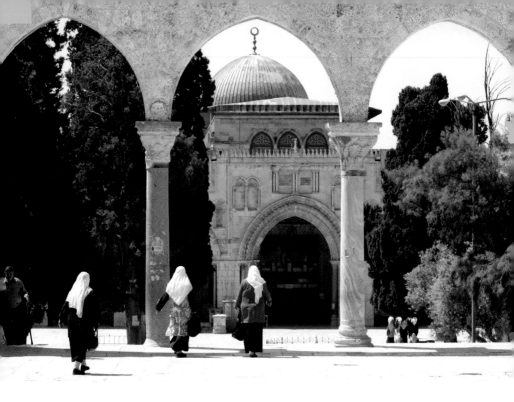

The al-Aqsa Mosque on the Temple Mount

the knights of the First Crusade, so much blood flowed here that the few survivors were left wading ankle-deep in the blood of those who were slaughtered. After their victory, the Crusaders initially used the building as a royal palace, before the Templar Order took up residence in one of the side wings in 1118. The Templars eventually converted the building into a fortress, but after the Muslim reconquest the fortress was turned back into a place of worship—the "Remote Mosque"—and the mosque, the Dome of the Rock, and the entire Temple Mount have remained a unique Muslim shrine to this day.

Radical Orthodox wings of Judaism have long demanded the rebuilding of the Temple, but this has been vehemently opposed by the Muslims and by large sections of the Jewish population, and so the Temple Mount still stands, with the gleaming cupola of the Dome of the Rock and the imposing building of the al-Aqsa Mosque. Non-Muslims are not allowed into the mosque and may visit only with special permission from the Temple Mount authorities.

al-Mawazeen

A wealth of commands and prescriptions govern the life of an observing Muslim. These are intended to help believers find their way through life in a way that is pleasing to God, and striving for honesty is an essential part of this. On the day of resurrection, all deeds and misdeeds will be weighed in the balance by God, and Islamic tradition suggests that scales with two pans will be used—one side will be a collection of all the things that please God, and all the sins will be thrown into the other pan.

Tradition has it that the Archangel Gabriel, who will be an incorruptible judge, will be entrusted with the scales on this day. As you might expect, al-Mawazeen (the scales) located beside the Dome of the Rock and the al-Aqsa Mosque on the Temple Mount are of especial importance for Muslims. There is an arcade situated at the top of the steps leading to the Dome that affords access to the top platform. The inner sanctum, and thus salvation, will be reached only if an individual does not shy away from the court and its judgment; this eschatological concept, also to be found in many other religions, is presented in a physical, concrete fashion by these slender Byzantine columns.

Via Dolorosa

Almost every Catholic church, and certainly every Calvary, makes reference to a certain ancient road; pilgrims move from station to station, meditating and praying on the path of Christ's Passion. The model for this religious practice is the Via Dolorosa, the "way of suffering." Beginning at the Lions' Gate (now called St Stephen's Gate), it starts in the Old City of Jerusalem and ends at the Church of the Holy Sepulchre. Christians believe that, after his trial by Pontius Pilate, Jesus followed this path to Golgotha, the place of his crucifixion. The road winds its way through the Old City and is marked at 14 points for prayer and meditation. Eight of these are located on the road itself and the remainder are in and around the Church of the Holy Sepulchre.

The road begins at the Ecce Homo (Latin: "behold, what a man!") arch—so called because here, on the ancient cobbles of the courtyard, Pilate is said to have sentenced Jesus, although it is now thought unlikely that this was the actual site of the trial. Station I, commemorating the condemnation of Christ, is located in the playground of a girls' school, once the site of a Roman fortress. Station II, the spot where Jesus took up his cross, is in the Franciscan Church of the Flagellation. The road leads on from here to Station III beside a Polish Catholic chapel, marking the spot where Christ is said to have collapsed under the weight of his cross. Station IV is

situated on a shopping street beside an Armenian oratory and marks the point where Jesus encountered Mary, his mother. Station V lies beside a Franciscan oratory on a little crossroads, and here Simon Cyrene is said to have helped Christ carry his cross. Station VI, the point where Veronica wiped the

Ecce Homo Arch at the start of the Via Dolorosa

sweat from Jesus' face, is to be found in the French church of St Veronica. Station VII, in the nearby Franciscan chapel, is where Christ stumbled for the second time under the weight of the cross. Station VIII, where Jesus is said to have encountered the pious women, is commemorated by a cross on the wall of the Greek monastery behind the Church of the Holy Sepulchre. Station IX on the roof of the Church of the Holy Sepulchre, beside the Coptic Patriarchate, is where Christ stumbled for the third time. Station X, in the Chapel of the Division of Holy Robes, lies beside the now walled-up original entrance to the Church of the Holy Sepulchre. The last few stations are all within the church's interior. Station XI is the Chapel of the Crucifixion right beside Golgotha, the place where Jesus was crucified. A hole beneath the Greek Orthodox altar marks Station XII, the place where the cross stood. Station XIII is the so-called "Stone of the Unction" in the entrance hall of the church, marking the spot where the body was taken down from the cross. Station XIV is the Holy Sepulchre itself.

The street level and the road layout of the city have altered considerably in 2,000 years, with the result that visitors can no longer be sure of following Jesus' exact route. But this whole path is a sacred way, connecting the stations on the road of Christ's Passion. The Franciscan order, which is responsible for most of the stations, pray along the route daily, and many Christians from all over the world also follow this path, if their chosen pilgrimage takes them to Jerusalem.

Church of the Holy Sepulchre

It is not implausible that the Church of the Holy Sepulchre in the Old City of Jerusalem is indeed located on the site of Jesus' burial. In some senses, it could be considered the most important church in Christendom. It can be proved that Christ was crucified on Golgotha, a little rocky hill in the immediate vicinity, and that Christians celebrated religious rites on the site soon after. When the Christian emperor Constantine decided to build a church on the site of the Resurrection, he enlisted local knowledge and chose this location. First, a temple to Aphrodite had to be demolished, and, in the course of excavating the church foundations, workers found a grave carved from the rock at a place known locally as Golgotha. There was also an old cistern with the remains of some Roman execution crosses. The church was consecrated in 335. The spot where Golgotha is thought to have been located and where the "true cross" stood is now an open courtyard. A rotunda covers the place where the tomb is thought to have been. There was once a five-naved basilica, but this has not survived.

The complex was almost completely destroyed by Caliph Al-Hakim in 1009; reconstruction work was begun in 1048, although only the rotunda and the inner courtyard were restored to their old appearance. During the First Crusade, the Christians lost no time in occupying the church and then rebuilt it. The work was completed in 1149, at which point the complex consisted of a Romanesque church, the rotunda, and the inner courtyard. When the sultan Saladin reconquered the city in 1187, he did not demolish the church, restricting himself merely to removing the cross and the bells and bricking up the entrances. The city was closed to Christians immediately after Saladin's victory, but these restrictions were gradually loosened and by the 14th century Christians had regained access to the church. Continual disputes have meant that the Muslims have retained the master keys to this day.

Modern visitors to the church are often disappointed; it cannot compete with the magnificence and solemnity of many other Christian church buildings and is extremely difficult to find, being tucked away in the maze of streets in the Old City. The interior is rather gloomy and in addition the church is always packed full of believers from six different Christian denominations, all of which lay claim to this sacred place: Roman Catholic, Greek Orthodox, Armenian, Coptic, Syrian, and Ethiopian Christians all pray and celebrate services here, often at the same time, although never communally. This perpetual coming and going raises the noise to levels that can disturb a devotional frame of mind. Arguments between the representatives of the various Churches are not uncommon and have occasionally resulted in scuffles—hardly devout behavior in a holy place of such great significance.

A monastic community of Ethiopian monks lives on the roof of the church in closely packed clay huts that form a little village. On a level lower than

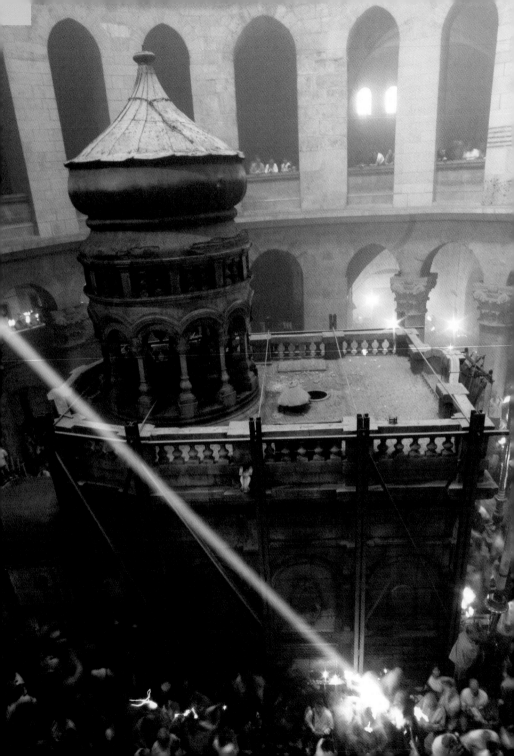

the entrance to the Church of the Holy Sepulchre there is the Armenian St Helena Chapel, named after the mother of the emperor Constantine, and the Roman Catholic Church of the Invention of the Cross, built on the site of the supposed discovery of the "true cross" of Christ. The small marble Chapel of the Holy Sepulchre has stood over the site of Christ's tomb since the 19th century. Accessed through a low door, it represents the last of the Stations of the Cross. It is constructed in a Turkish rococo style, and there are 43 lamps above the entrance portal—13 each for the Armenian, Latin, and Greek Orthodox Churches, and four for the Coptic Church.

Church of St Anne

Jerusalem is full of churches—the city is of particular significance for every Christian denomination—and, as you might expect, there is a Christian church to be found at almost every Old City location associated with Christ's Passion. Some have not been preserved, but others have survived the centuries. A particularly impressive example, the Church of St Anne, dedicated to Jesus' grandmother, is situated immediately beside the Pool of Bethesda near the Lions' Gate (now St Stephen's Gate). There was a church dedicated to the

Rotunda of the Chapel of the Holy Sepulchre

Virgin Mary on the site as early as the 5th century, but this was destroyed by the Persians in 614. It was rebuilt, but the new structure was destroyed by the Fatamid Caliph Al-Hakim. The Crusaders then built a place of worship on the site dedicated to St Anne. The severe but unobtrusive simplicity of this building, which still stands today, has led many to consider it the finest Romanesque church in all Jerusalem.

Its preservation in such a good state of repair is largely thanks to its having been presented to the French by the sultan in the 19th century; it had previously been left derelict, serving for a long period as a stable. The church's façade leans slightly forward, a peculiarity of French Romanesque architecture intended to symbolize and embody the posture of the suffering Son of God. The interior is decorated in a Burgundian Romanesque style, with robust pillars supporting the central nave of a three-naved basilica. The 20th-century altar depicts the Annunciation, and the birth and deposition of Christ. The acoustics of the church are of interest—the interior has a particularly strong echo, allowing the stirring sounds of the choral psalms to ring out and move the listener.

Pool of Bethesda

St John's Gospel says of this holy place: "Now there is at Jerusalem by the sheep market a pool, which is

called in the Hebrew tongue Bethesda, having five porches. In these lay a great multitude of impotent folk, of blind, halt, withered, waiting for the moving of the water. For an angel went down at a certain season into the pool, and troubled the water: whosoever then first after the troubling of the water stepped in was made whole of whatsoever disease he had. And a certain man was there, which had an infirmity thirty and eight years. When Jesus saw him lie, and knew that he had been now a long time in that case, he saith unto him, Wilt thou be made whole? The impotent man answered him, Sir, I have no man, when the water is troubled, to put me into the pool: but while I am coming, another steppeth down before me. Jesus saith unto him, Rise, take up thy bed, and walk. And immediately the man was made whole, and took up his bed, and walked: and on the same day was the Sabbath. The Jews therefore said unto him that was cured, It is the sabbath day: it is not lawful for thee to carry thy bed. He answered them, He that made me whole, the same said unto me, Take up thy bed, and walk. Then asked they him, What man is that which said unto thee, Take up thy bed, and walk? And he that was healed wist not who it was: for Jesus had conveyed himself away, a multitude being in that place" (John 5:2–13).

Pool of Bethesda

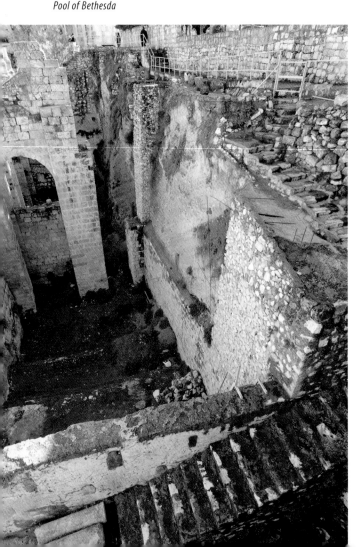

The Pool of Bethesda, where Jesus performed this miracle, is situated immediately beside the Church of St Anne. It seems to have consisted of two pools, the northernmost of which was laid out in the 8th century BC to provide water for the First Temple. Sources indicate that the Romans were aware of the healing powers of the water, and a shrine to Asclepius, the ancient god of healing, was built on the site in the 2nd century; gifts for this divinity were discovered during excavations in the 19th century. The Byzantines built a basilica here in the 5th century, but it was destroyed and nothing now remains of it. Little of the pool's surroundings remain to be seen today, but this unspectacular place is a reminder that people throughout the ages have hoped for release from physical and spiritual afflictions and that the goals of their pilgrimages, the places of healing, were considered sacred.

Syriac Orthodox Monastery of St Mark

One old source maintains that the Last Supper and the miracle of Pentecost took place in Mark's house, and this site in the south of the Old City between the Jewish and the Armenian quarters is now occupied by an old monastery belonging to the Syriac Orthodox Church, the oldest Christian community in the Holy Land. It was built in the 12th century on the foundations of a previous structure, although it is difficult to say for sure whether these were the ruins of Mark's house. When the Crusaders were obliged to leave the country in 1187, they gave the church and monastery back to the Syrian Christians. Time seems to have stood still here, and Syriac is still spoken in the monastery, a language no longer used anywhere else. The monastery and the church are from another era entirely, and their ancient language and traditions, maintained to this day, afford a glimpse of how the first Christians lived and prayed.

Cathedral of St James

The Armenian quarter in Jerusalem is a little world apart. Visitors enter via a heavy iron gate before emerging into a picturesque setting: the area is characterized by ancient cobbles, narrow streets, and lush courtyards with bubbling fountains and blooming flowers. The Armenians are from the Caucasus, the area surrounding the legendary Mount Ararat. The majority of the Armenians in Jerusalem are Georgian Christians, speaking their own language and retaining a separate identity to this day.

The Church of St James is a 12th-century, triple-naved, domed church with the later addition of a

17th-century narthex. It stands on the site where James the Greater is said to have been executed on the orders of Herod Agrippa II (Acts 12:2). Relics said to be from his skull are kept in the church. All the other relics of St James are to be found in Santiago de Compostela. The treasure chamber of the neighboring Patriarchate contains extremely valuable manuscripts; the library has a manuscript by St Toros and other major scriptural works of the Armenian tradition.

Lutheran Church of the Redeemer

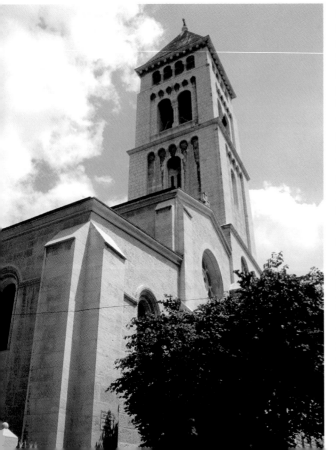

Lutheran Church of the Redeemer

Like most other Christian denominations, the Protestant Lutheran Church has its own church in Jerusalem. It is situated at the end of the Via Dolorosa, the "way of suffering" trod by Jesus on his path to crucifixion. The Church of the Holy Sepulchre, shared by Christians of six denominations, is to be found nearby, but the Protestant community has had its own place of worship in the Church of the Redeemer since the beginning of the 19th century. The Lutheran Church is not very old, but since its foundation it has become a center for preaching and worship for German-speaking Protestant Christians as well as a center of outreach for Christians, Jews, and Arabs. The light sandstone interior of the church is extremely plain, and pleasantly soothing on the eye after the riot of colors in this sometimes chaotic city.

Protestants have always set great store by preaching—in their eyes, God's presence is principally to be found and experienced through the Word. This may seem rather sober and rational to some visitors, but anyone entering this

church will experience something of the serene value of the Spirit and the Word that needs no illumination, and of a belief that seems to address the reason rather than the senses. Nevertheless, the Church of the Redeemer is a place where the sensuous power of the Divine can be experienced. Climb to the church tower to enjoy a magnificent panorama over the Old City and a view down into the cloister of the old medieval monastery hospice, an oasis of tranquility amid all the hustle and bustle of the city.

Hurva Synagogue, Jewish Quarter

The history of this place starts with a great plan and its failure. At the beginning of the 18th century, a group of Polish Ashkenazi Jews attempted to build a synagogue here, but due to the internecine strife within the Polish community it was never completed. The eternal bickering meant that the community never had enough money and was obliged to rely on the aid of local Muslims. When the Ashkenazim could no longer service their debts, the half-finished building was confiscated by the money-

Hurva Arch before the rebuilding of the synagogue

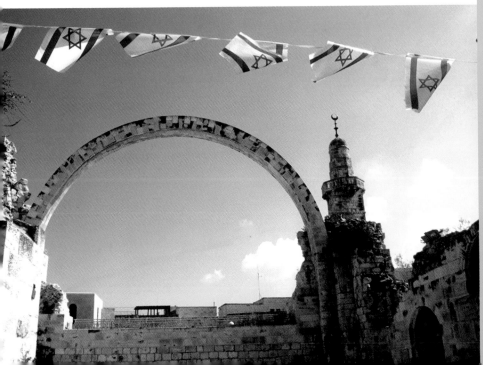

lenders and burned down; it rapidly became a ruin (Arabic: *hurva*).

The building, then known as the "Ruin Synagogue," was given back to the Jewish community by Ibrahim Pasha in 1838. Reconstruction work was begun immediately and completed in 1856, but the synagogue was destroyed again in 1948. The area was recaptured by the Israelis in 1967 and though many plans were subsequently made, none led to the rebuilding of the synagogue. The beautiful and slender Great Arch was built in 1977, but the old synagogue remained a ruin and a reminder of past disagreements. Reconstruction work to plans by Assad Effendi was begun at the turn of the millennium, and since 2007 the neo-Byzantine Hurva Synagogue has stood on the old site; it is now considered one of the most important synagogues in the Old City of Jerusalem.

Mount of Olives

Mount Olivet, or the Mount of Olives, is a low chain of hills, once covered with ancient olive trees, to the east and northeast of the Temple Mount and the Old City of Jerusalem. The actual summit, only 2,650 feet (850 m) high, affords a marvelous vista of the city and the Temple Mount. However, it is not the view that has made this a sacred place but the religious importance accorded to the Mount by Jews, Muslims, and Christians alike.

In Jewish belief, when the Messiah comes, he will enter Jerusalem over the Mount of Olives, before holding the Last Judgment in the Kidron Valley at the foot of the mountain. For this reason a large Jewish cemetery has been laid out, and observant Jews from all over the world lie buried here. Muslims too consider the Kidron Valley to be the location of the Last Judgment, and good deeds and sins will be weighed up on the Temple Mount. On that day, a rope will be stretched across from the Temple Mount to the Mount of Olives, and the just will use this rope to reach eternal life.

Christian tradition associates the Mount of Olives with stories from the New Testament. Jesus entered Jerusalem from the Mount of Olives, and for this reason a procession starts here every year on Palm Sunday, ending at the Lions' Gate (now St Stephen's Gate). Jesus was arrested in the Garden of Gethsemane at the foot of the Mount and ascended from here into heaven. To mark this, Christians are permitted to hold a service in the Muslim Church of the Ascension.

The Mount of Olives in Jerusalem is a wonderful place to encounter the God believed by Jews, Muslims, and Christians to be the creator of heaven and earth, who has shown Himself to be greater than any political conflict.

Garden of Gethsemane

The Bible knows words of woe, of grief, of lamentation, of fear, and of pain; it knows of the distress that can drive people to the limits of endurance. This Holy Book embraces all there is to know about human emotions and motives. Jesus too was human, and he too knew fear. This Jesus was not God carved in stone but, mysteriously, had a nature both human and divine. The Garden of Gethsemane (Aramaic: "oil press"), lying on the western slopes of the Mount of Olives, is a place of contemplation; some of the many olive trees growing here are said to be more than 2,000 years old and thus date back to the time of Christ. Jesus retired to this garden to pray when he felt deserted by God and the world. Betrayed by Judas' kiss, he was arrested here. Now this place, over which thousands of years of history hang, draws people from all over the world, irrespective of their beliefs.

Among the flowers and the beautiful trees it is possible to spend time in the shade and allow one's thoughts to wander. Uneasy souls will find comfort here, and the past and the present can co-exist peacefully. The Garden of Gethsemane is a place of refuge from all the external and internal discord that continually intrudes upon life. Rational explanation is impossible, but those with hearts open to the Divine will find peace, confidence, and hope to comfort and sustain them through life's voyage.

Basilica of the Agony (Church of all Nations)

A very old source shows that the modern Gethsemane is the same garden to which Jesus, in mortal fear

Church of All Nations in the Garden of Gethsemane

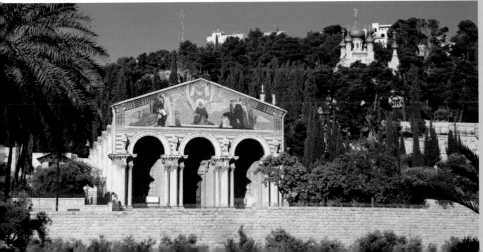

of what was facing him, retired to pray. An oil press stood here in ancient times; the fruit from the nearby olive groves were pressed and processed in this place, giving rise to the name of the garden: Gat Shemanim (Aramaic: "oil press"). It is claimed that some of the olive trees standing here are more than 2,000 years old. The place has a particular magic, and the façade of the Roman Catholic Basilica of the Agony can be glimpsed through the dense trees. Jesus came to the basilica in anguish to pray before his crucifixion, hence its name, and it was also here that he was finally arrested after receiving the traitor's kiss from Judas. Jesus, divine by nature, does not rise above the world in power but instead knows human fear and has to endure suffering; his nature remains a holy mystery.

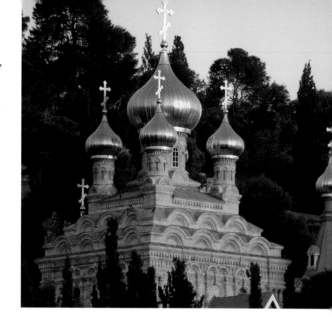

Church of Mary Magdalene on the slopes of the Mount of Olives

The church, especially its interior, radiates something of this mystery. The general feel is gloomy; the altar stands on bare rock, surrounded by a wire fence symbolizing the crown of thorns. The impression from outside is quite different, the surrounding dark greens calming the senses. The triple-naved basilica has no tower; instead there are 12 domes, representing the apostles. The church stands on the ruins of an early Christian church from the 4th century that was destroyed in an earthquake. The Crusaders erected another church here in the 12th century but this was abandoned in 1345. The site lay deserted for a long period until the construction of the modern church between 1919 and 1924. Its other name, the "Church of All Nations," is a reference to the 12 states who met the building costs.

The façade is covered with a full-length mosaic depicting a praying Christ as the mediator between God and man, offering hope to people of all nations. The alpha and omega refer to God himself: he is the beginning and the end, who is and will always be. The church's pillars bear statues of the four evangelists, Matthew, Mark, Luke, and John, and two deer standing opposite one another on the

tympanum represent the soul, panting for God as pants the hart for cooling streams, as it says in the Psalms.

The Church of Mary Magdalene

✝

Rising up out of the Garden of Gethsemane, the Russian Orthodox Church of Mary Magdalene, built in 1888 by Tsar Alexander III in honor of Maria Alexandrovna, his late mother, is an entirely unexpected feature of the area. In biblical tradition, Mary Magdalene, to whom this church is dedicated, was the first to see the resurrected Christ. The church is a typical example of 16th- or 17th-century Russian ecclesiastical architecture, with its seven gilded onion domes gleaming in the sunlight for miles around; even at night the magnificence of the illuminated church makes it appear strangely otherworldly. The crosses, with the classic diagonal crossbars of the Russian Church, symbolize resurrection and ascension, the goal of every pious Orthodox Christian. The church and the adjoining monastery are owned by the Russian Orthodox Church Outside Russia, now based in the USA.

In the monastery courtyard are the ruins of a few stone

steps that may be part of the flight of stairs that once formed the eastern entrance to Jerusalem. A 9th-century manuscript affirms that there was a total of 537 steps from the Mount of Olives down to the Kidron Valley, and from there a further 195 steps back up to the Lions' Gate, now known as St Stephen's Gate. It is a compelling idea that Jesus himself may have ascended these stairs. Located beside the magnificent architecture of the church, the place has a distinctly

A view from the western window of the Dominus Flevit Church

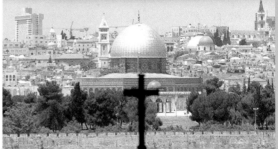

spiritual feel, even though it is a matter of just a few steps. Religious people sometimes need no more than a symbol to witness the invisible.

venerated as a sacred place—even those who are not religious will be captivated by the holiness of this location.

Dominus Flevit Church

Medieval pilgrims identified this as the place where Jesus, mindful of the destruction that was to befall Jerusalem, wept as he surveyed the city; the modern church's name, "The Lord Wept," refers to this incident. It was built for the Franciscan order in 1955 on the ruins of a 5th-century Byzantine church, and its form is reminiscent of a stylized teardrop rising from a Greek cross floorplan. The interior has retained sections of the precious mosaic floor from the old church, of which nothing else remains. The church is located on the processional route leading from the Mount of Olives to the Temple Mount. Although the great majority of Christian churches are oriented toward the east, this church faces west, toward the Church of the Holy Sepulchre, which like no other Christian church in Jerusalem is a symbol of redemption from death.

The view from the finely chased western window, taking in the Temple Mount surmounted by the golden cupola of the Dome of the Rock, is particularly famous and justifiably features on a million photographs. From this spot in a little modern chapel you need no words to help you see why Jerusalem is

Church of the Pater Noster

The Church of the Pater Noster on the slopes of the Mount of Olives is a place of special importance to Christians from all over the world. The first church on this site was built by the emperor Constantine between 326 and 333, above a cave that was thought to be the place from which Jesus ascended into heaven. More recently, however, it has been suggested that this event took place somewhat further up the hill. The church was destroyed by the Persians in 614 and later rebuilt on the same site by the Crusaders. By the 19th century the church lay in ruins, with its masonry being sold for gravestones, but the site was not completely forgotten. A monastery with a church attached was built here under the patronage of a French princess of the house de la Tour d'Auvergne.

As the entire monastery complex is dedicated to the Lord's Prayer, the walls are decorated with faïence tiles featuring this most famous of Christian prayers in 68 languages. From their very beginnings, men have tried to contact their gods either by conducting sacred rituals or through prayer, and for just as long they have puzzled over how they should pray. Christians are in the fortunate position that Jesus himself showed them

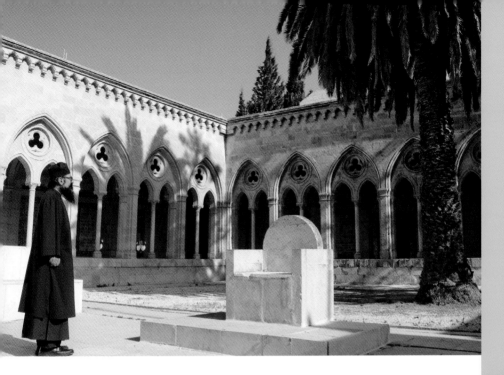

A priest in the cloister of the Church of the Pater Noster

how to pray by teaching them the Lord's Prayer, a text that is used the world over. The words of the Lord's Prayer are sacred and this church dedicated to them is a sacred place, capable of uniting people of every tongue in one faith.

Chapel of the Ascension

In the beginning there was only a rock here, found on the summit of the Mount of Olives. The rock's significance and veneration are the result of a mark that Christians believe to be a footprint left by Christ as he ascended from here to heaven. The New Testament recounts this mysterious event, which according to Luke, took place 40 days after Easter. A little church was built here in 392. It was destroyed by the Persians in 614, like so many other Christian churches in the city, and was rebuilt by the Crusaders in 1102. The church is a small and plain octagon with a dome. After Saladin's conquest of Jerusalem it was converted into a mosque in 1187 and has been a Muslim place of worship ever since. It is a small but uplifting sign of tolerance that Roman Catholics, despite all the differences in faith, are allowed to hold an annual service here on Ascension Day.

Cenacle (the room of the Last Supper)

On the evening before his arrest, Jesus met his friends. It was the time of the Jewish Feast of the Passover. The Passover is a reminder of the past, of the flight of the people of Israel from Egypt, and of the covenant made by God with his people. Jesus broke bread with his friends; he knew that it was for the last time, and that this was the last meal he would share with them—he knew what was going to happen to him. Through this meal Jesus linked the past to the future, and to this day Christians celebrate the presence of Christ in their services by sharing bread and wine.

The Cenacle, the room where the Last Supper was held, is situated on Mount Zion, southwest of the Old City of Jerusalem and a little beyond the city walls. According to legend, this was the place where Jesus sat down with his disciples for the last time. A church has stood on the site since the 12th century; this original basilica was replaced by the Crusaders with a new structure, of which a few sections remain from its destruction by the sultan Saladin.

The current Gothic Franciscan church has stood here since 1335 and

Cenacle on the upper floor of the Franciscan church on Mount Zion

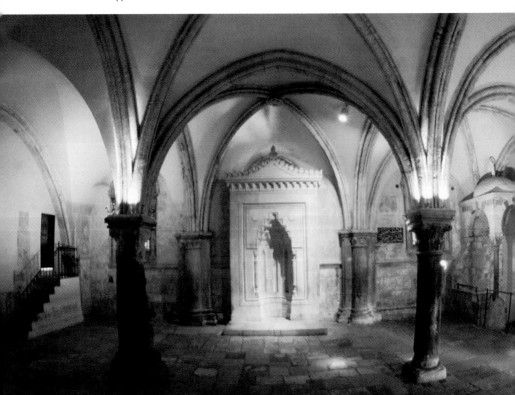

has periodically been used as a place of worship by Muslims, as is indicated not only by the minaret but also by the prayer niche pointed toward Mecca in the church's interior. The church has two storeys, with the tomb of David below and the Cenacle on the upper floor. There is unfortunately no proof that the Last Supper took place here; it is more likely that this was the site where the disciples witnessed the later miracle of Pentecost—the gift of the Holy Spirit. Christian tradition has made one location for these two events, and this church thus commemorates two things in particular: communal eating and drinking, and fellowship guided by a good spirit. Both of these experiences can sanctify our lives.

has been a tradition that David's tomb was located on Mount Zion, which has remained a sacred place to this day. The funerary shrine contains a cenotaph, an empty grave, swathed in bright material decorated with verses in Hebrew describing events from David's life. This is a memorial in remembrance of a king who succeeded in uniting Israel and helped the people to find a national identity. The site has been under Israeli control since 1948 and is revered as a particularly important shrine. For the people of Israel, David has always been not merely another of their many rulers, but the one who represented in an important and special way the leadership and caring nature of their God.

Tomb of David

David's tomb, on the lower floor of the Franciscan church on Mount Zion, is a particularly sacred place for Jews. The Mount is not part of the Jewish quarter, but it is nonetheless greatly venerated by the Jewish community. During the period of their banishment from the city (7th–13th centuries), when they also had no access to the western wall of Herod's Temple, the Jews revered this place as the tomb of King David. It is now reasonably certain that this is not the actual burial place of the great king—according to the Bible, it was on the southeastern hill of the city (1 Kings 2:10)—but since the 11th century there

Hagia Maria Sion Abbey

Hagia Maria Sion Abbey, the Church of the Dormition, situated right next to the Franciscan church on Mount Zion, commemorates the spot where the Virgin Mary is said to have gone to her rest. There was a Byzantine church on this site in the 5th century, but this was destroyed by the Persians. The Crusaders built a new church dedicated to the Dormition of the Virgin, but this was demolished by the conquering Muslims in 1200. The present building was begun in 1889 after the Turkish sultan Abdul Hamid presented Kaiser Wilhem II with a plot of land on the Mount. The Kaiser gave the plot to the archiepiscopal see of

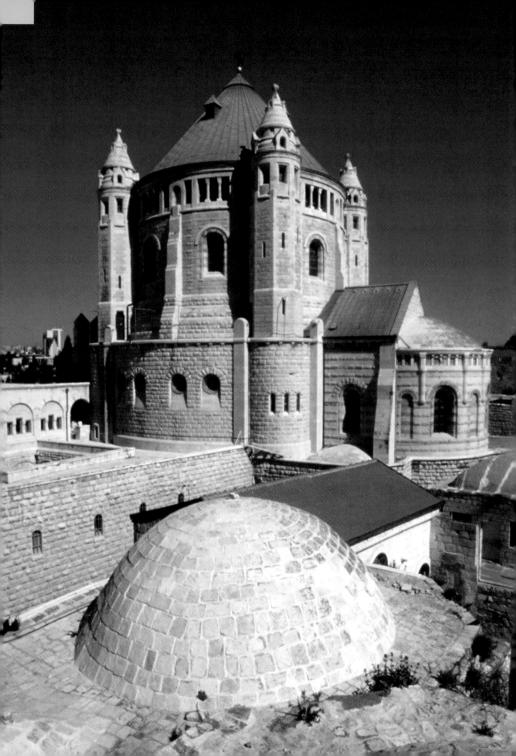

Cologne, which in turn commissioned the building of a church whose rotunda form was to echo Charlemagne's Palatine Chapel in Aachen Cathedral.

The church was consecrated in 1906 and entrusted to the Benedictine order. Its black conical roof and the free-standing bell tower beside it make this church perhaps the most striking of all those on Mount Zion; the interior floor mosaic is particularly worth seeing. The circular mosaic depicts the 12 signs of the Zodiac, the names of the 12 apostles, and four portraits of the great prophets Daniel, Isaiah, Jeremiah, and Ezekiel. Three interlinked rings discernible in the center represent the trinity of the Christian God. The church and the adjoining monastery are popular destinations for pilgrims, especially for visitors to the Holy Land from Germany. Particular veneration is shown to the Virgin Mary by those who climb down into the "Crypt of the Dormition of the Virgin."

Church of St Peter in Gallicantu

Biblical tradition locates the house of Caiaphas, the high priest who first interrogated Jesus after his arrest, on the eastern slopes of Mount Zion. It was in the courtyard of this house that Peter shed bitter tears after denying

Church of the Dormition on Mount Zion

Christ three times before cock-crow, and thus the modern church, built on the remains of an ancient 4th-century Christian pilgrimage site, is known as St Peter in Gallicantu ("at cock-crow"). It has since proven unlikely that the high priest's house was actually situated here. It is more plausible that it lay beyond the contemporary city walls. The site has in any case been a Christian pilgrimage destination for centuries, and excavations have uncovered walls, steps, and tombs from the time of Herod. Special reverence is reserved for the Byzantine-era flight of steps beside the church leading down into the valley and connecting the upper and lower churches; sources suggest that these steps were used by Christ when he ascended the Mount of Olives after the Last Supper. The cupola of the modern church, a rotunda built between 1928 and 1932, has a cruciform window that admits a soft light into the interior, where there are mosaics depicting Jesus before the High Council, a weeping Peter, and other penitent figures. The church commemorates the arrest of Christ and his trial, ending in a death sentence, that marked the last week of Christ's life.

Mount Calvary

Outside the gates of Jerusalem there is a noticeable mound. Legend has it that this hillock was the site of Jesus' execution, the infamous "place of the

skull," as the rock really does resemble a skull—the impression is heightened by two depressions that could be seen as eye sockets. The assumption that this is the actual site where Christ was crucified is supported by its location outside the ancient city walls, although it is far more likely that the place of the Crucifixion is the site of the Church of the Holy Sepulchre. Despite the dispute over its authenticity, this mound has always been a place of worship and commemoration, where Christian pilgrims follow in Christ's footsteps.

The tradition of following the route of Christ's Passion is known across the globe and Calvaries are found throughout the Christian world; these are all based on the site in Jerusalem. The name is derived from the Aramaic term Golgotha, which is glossed as "of the skull" (Latin: *calvariae*) in the Vulgate. These monuments, most often found in rural areas of Europe, usually comprise 14 stations of the cross erected on a pilgrimage hill or a local mountain. Mount Calvary in Jerusalem and all the Calvaries elsewhere are evidence of a living faith commemorating the suffering and death of Christ, and yet also celebrating life.

the gates of Jerusalem, a little to the north of the Damascus Gate, as the tomb of Christ. It is a Roman-era tomb carved from a rock wall three feet (1 m) high. Gordon's supporting evidence included its location beyond the city walls of the time and the shape of a hill in the immediate vicinity, which looked like a skull; he and many of his contemporaries considered this to be the place of Christ's execution, called the "place of the skull" in the Bible. It has since proved more likely that Jesus' tomb is actually situated on the site of the modern Church of the Holy Sepulchre, but this place remains a sacred one and visitors to Jerusalem come here to this day. The pleasant and peaceful atmosphere of the beautiful gardens now surrounding the tomb is certainly much more conducive to devout reflection than the gloomy and crowded Church of the Sepulchre. This place is a reminder that it is not necessarily the authenticity of a place that makes it sacred—the Divine reveals itself in those places where we seek it and where we believe we have found it.

Garden Tomb

Charles Gordon, the British general later to become the hero of Khartoum, was captivated by the Holy Land, and in 1882 he identified this tomb outside

Akeldama and the St Onuphrius Monastery

The Field of Blood, the literal translation of the Aramaic *hakel dama*, is the place where Judas Iscariot is said to have hanged himself after betraying Jesus, although we cannot know for

certain whether this suicide actually took place. The **Akeldama** was supposed to have been bought for the 30 *denarii* Judas received from the high priests for his treachery. Regretting his actions, Judas returned the money to the temple a little later. The high priests did not want the money, which in a sense had "blood on it," to remain in the temple's treasury and so used it to buy this field as a burial place for foreigners.

The Greek **St Onuphrius Monastery** now stands on the site; the hermit Onuphrius was an Abyssinian prince who retreated to the wilderness to find and serve God. He was famed for his beard, which he never cut throughout his life and which eventually grew so long that he could wrap himself in it and thereby dispense with clothing. The monastery is now a destination for Orthodox Christian pilgrims from all over the world, and it is no coincidence that it was built on a site that has has known to have been a cemetery since the 3rd century. Since the 7th century the Coptic Church has revered the saint as a helper in the hour of death.

Yad Vashem

There is something irresistibly moving about the atmosphere in this place on the "Mount of Remembrance," Mount Herzl in Jerusalem. People come here from all over the world to remember the Holocaust's millions of victims. Yad Vashem, the most important memorial to the European Jews murdered by the Nazi regime, is a place to pause and reflect on the most horrific evil ever carried out by mankind. In 1953 the Knesset, the Israeli parliament, passed a law designating Yad Vashem an "eternal monument." At the entrance, visitors may read the comforting words of the Prophet: "Even unto them will I give in mine house and within my walls a place and a name better than of sons and of daughters: I will give them an everlasting name, that shall not be cut off" (Isaiah 56:4a–5).

The memorial is approached along the Avenue of the Righteous among the Nations, dedicated to those who risked their lives to save Jews from extermination. The main space in Yad Vashem is the "Hall of Remembrance," a rectangular building made of blocks of basalt with a poured concrete roof. The stone plaques in this giant, windowless building bear in Hebrew and Roman letters the names of the 22 largest concentration camps, places of evil and terror. The ashes of those murdered in the camps have been brought to Israel and buried in a crypt. The "Eternal Flame" in front of it is never extinguished and keeps alive the memory of more than six million victims. The "Hall of Children," an underground room dedicated to the 1.5 million young people who were murdered, is equally moving. The "Hall of Names" is a collection of the names and details of the victims; it is not yet complete as additions are still being made. The complex of buildings is surrounded by sculptures inspired by memories of the Holocaust and attempting an artistic representation

of evil; they are striking, involving, and disturbing. Yad Vashem is one of the sacred places that the world definitely needs; as the poet Theodor Kramer has written: "Were we to forget, we would be giving up our own selves!"

Bethphage

West Bank

"And it came to pass, when he was come nigh to Bethphage and Bethany, at the mount called the Mount of Olives, he sent two of his disciples, saying, 'Go ye into the village over against you; in the which at your entering ye shall find a colt tied, whereon yet never man sat: loose him, and bring him hither.'" Such are the words of Luke's Gospel describing the preparations for Jesus' entrance into Jerusalem (Luke 19:29–30). The Bethphage of the Bible also features in rabbinical sources, but little seems to remain of it today. The location given in the Gospels is inexact; it is a fact only that Jesus' entrance into Jerusalem began in a nearby village. Bethphage must have been a small town between Bethany and the Mount of Olives, and is the modern Et-Tur.

Hall of Remembrance, Yad Vashem

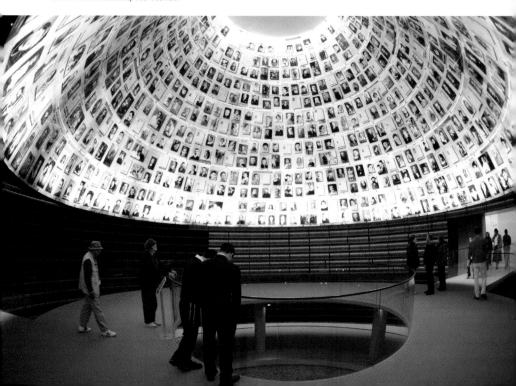

Palm Sunday procession, Bethphage

Although the location of the Bethphage of the Bible may be uncertain and inexact, a small Franciscan monastery now stands at the edge of the assumed site, about half a mile (1 km) east of the city gates of Jerusalem. In this church there is a stone from which Jesus is said to have climbed onto the donkey he used to enter the city. Many modern Catholic pilgrims use the church for ritual cleansing before taking the road to Jerusalem. The place has symbolic value because of the prophecy that was interpreted as applying to Jesus: "Rejoice greatly, O daughter of Zion; shout, O daughter of Jerusalem: behold, your King comes to you: he is just, and having salvation; lowly, and riding on an ass, and on a colt the foal of an ass" (Zachariah 9:9). Hopes of a political conqueror or a triumphant king were dashed soon after, and the Jews are still awaiting the longed-for Messiah. Christians, however, believe that Jesus is the promised savior of the world and are firmly convinced that Jesus' last journey began in this little town. For this reason they have been following their own road here for centuries, to pray, meditate, and prepare themselves for the goal of their pilgrimage.

Bethany

West Bank

The Bethany of the New Testament (now called al-Eizariya), where Lazarus was raised from the dead, is located a few miles east of Jerusalem. During Christ's lifetime, Bethany was an idyllic town with olive groves, fig plantations, and vineyards, and his friend Lazarus lived here with his sisters Mary and Martha. Jesus came to visit several times before his entrance into Jerusalem. The pilgrimage site includes the modern Church of Lazarus, built on the remains of Byzantine buildings, the Tomb of Lazarus, and a mosque. The church's strict cruciform floorplan is more reminiscent of a mausoleum than a place of worship, and there are no windows—although the dome admits a warm, diffuse light to illuminate the four floor mosaics recounting the biblical story. Inscribed above the high altar of Jordanian marble are Jesus' comforting words: "I am the Resurrection and the Light."

After Christians had been banned from Lazarus' tomb and a mosque built here, the Franciscan order received permission in 1612 to tunnel another entrance through the rock, and this low, narrow gate is the modern way into the tomb. This is a place sacred to Christians of all denominations, as it witnessed Jesus' forceful demonstration of his dominion over death. The Franciscan church and the mosque co-exist peacefully, and a few paces away there is a Greek Orthodox monastery on the spot where Jesus is said to have encountered Martha. Bethany is a place of contemplation and certainly not as impressive or magnificent as nearby Jerusalem. It is a place where people encounter divine events in an unspectacular setting, but the location is no less affecting for all that. Here, on a gentle green hill beneath a shimmering sunlit sky, it is possible to share something of the atmosphere that might have been felt in biblical times.

Bethlehem

West Bank

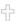

Bethlehem is one of the most important Christian sacred places, for Jesus is said to have been born here in a grotto. The place has been venerated since the 2nd century—the Roman emperor Hadrian had it converted into a grove dedicated to Adonis, but in 339 the emperor Constantine, a convert to Christianity, built a church here. However, this was destroyed in the 6th century. The Eastern Roman emperor Justinian renovated what remained of the church in 540, creating a five-naved basilica.

One of the few early churches to have survived almost undamaged, this is also one of the oldest Christian places of worship. Quite how it escaped the depredations of the

Persians is an enigma, and various legends have grown up around it. When the Persians invaded Israel in 614, destroying almost all the churches, they eventually came to Bethlehem. To their great astonishment they discovered a mosaic above the entrance portal here showing the adoration of the child by three wise men from the east—and the wise men were dressed as Persians. In deference to their ancestors they spared the church and Caliph Omar specifically forbade its destruction. As Jesus is revered as a prophet in Islam, and the apse of the church faced toward Mecca, the church became a Muslim place of worship. Whether there is any historical truth to this story or it is merely a pious legend, the town is revered as the birthplace of Christ to this day. The old grotto has been clad in marble and its center is marked with a star indicating where the crib is said to have stood. The grotto is reached by a flight of stairs from the church's interior and the entrance has been narrowed so that visitors have to crouch to enter this reverential place. Many people have visited it—rulers, kings, presidents—and they have all had to bow their heads, a recognition that whoever wishes to encounter God must first display humility.

Grotto of the Birth of Christ, Bethlehem

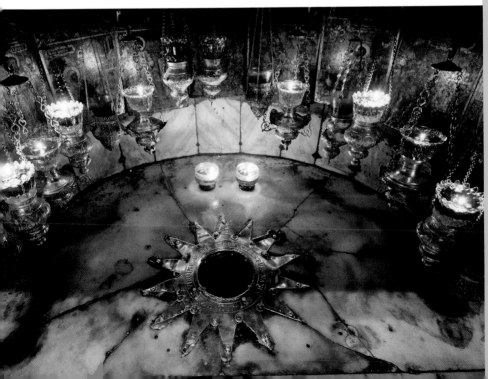

Hebron

West Bank

The city of Hebron in the West Bank is one of the oldest continuously occupied cities in the world, with archeological evidence suggesting the presence of settlements dating back 4,000 years. At the time of the Canaanites, Hebron was a royal city—David is said to have been anointed king here before uniting the tribes of Israel and moving the capital to Jerusalem.

The **Patriarchs' Tombs** in the nearby Cave of Machpelah date back to the time of Herod. Abraham, his wife Sarah, Isaac, Rebecca, Jacob, and Leah are all buried here, making Hebron an important pilgrimage site and one of the four holy cities of Judaism, along with Jerusalem, Tiberias, and Safed. Muslims also worship at the Patriarchs' Tombs. During the era of the Crusaders, Hebron was a diocese of the Christian Church, but any traces of Christianity have since been erased.

In the suburb of Mamre, an oak tree that may be over 5,000 years old is revered as a holy relic—**Abraham's Oak** (or the "Oak of Mamre") stands at the spot where Abraham received the three messengers from God who told him he would father a son, thus beginning the fulfillment of the prophecy that he would be the father of a whole nation (Genesis 18:1–15). The sacred oak now stands in the courtyard of a Russian Orthodox monastery that is not open to the public, although the tradition of its veneration continues.

The **Mosque of Abraham**, with its fortress-like defensive walls, is a Muslim shrine in the middle of the city. A 12th-century prayer stool kept in the mosque is the last of its kind to remain from the age of Saladin; it was fashioned from a single block of wood. Jews and Muslims are often in unfortunate conflict in Hebron. The antipathetic relationship between the two religions was demonstrated in a particularly terrible manner when the extremist Jewish settler Baruch Goldstein caused a bloodbath at the Mosque of Abraham in 1994, attacking praying Muslims with an assault rifle and killing and wounding many worshipers. Hebron is a sacred place with a turbulent and at times gruesome past and present; a clear reminder to us of how important is the need for tolerance.

The Dead Sea and the Qumran Caves

West Bank

Most of the cultures and religions in our world regard the sea as the source of life, and scientific study of the oceans supports the same conclusion. A large part (some 70 percent) of the earth's surface is covered in water and when viewed from space ours is a blue planet. The oceans lie in the deep and wide folds of the earth's

crust; they are inexhaustible and full of hidden power. Currents keep these bodies of water in constant motion so that the sea is formless, bounded only by its coastlines and shores. It is both glorious, beautiful and threat-ening; in modern psychology, the sea is a symbol of the unknown.

The **Dead Sea** (Arabic: *Al-Bahr el-Mayyit*; Hebrew: *Yām Ha-Melah*) is a salt lake in the Jordan Rift Valley with a special place among the seas of the

Qumran Caves

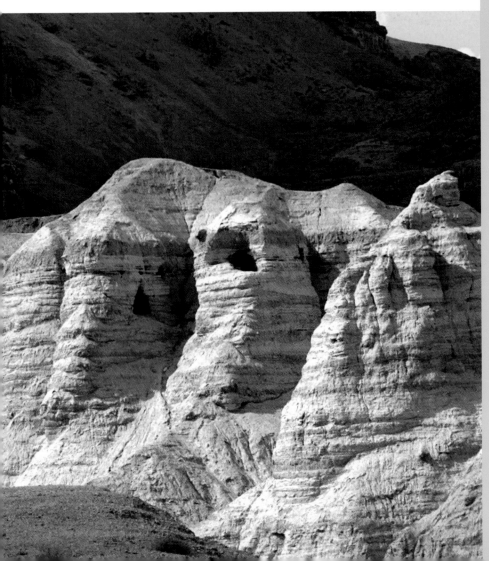

world. It consists of a smaller, shallower northern section and a somewhat larger basin to the south. The Dead Sea floor is 2,720 feet (829 m) below sea level and its major source of fresh water is the Jordan River. Its shallow depth (no more than 1,300 feet/400 m) and the limited water flow from the Jordan result in strong evaporation, such that the water level is constantly sinking (more than 20 feet/6 m in the last decade), and the salt content, at up to 33 percent, is extremely high. The Israelis have put the sea to therapeutic use for some time, particularly in the treatment of psoriasis.

It is not these peculiarities that make the Dead Sea a sacred place, however. In Hebrew scripture, this inhospitable and enigmatic place is considered a spiritual wilderness. The wicked biblical cities of Sodom and Gomorrah are said to have stood on the southern shores of the sea, and this was the home of Lot and his family. God assured them of their survival if they would leave their home town and not look behind them, but Lot's wife glanced back fleetingly and was turned into a pillar of salt. This Bible story is one of mankind's most insightful narratives, with its suggestion that life must be lived looking forward and that those who look back to a past that cannot be changed are missing their way. The future is open to those who take up the journey. Stand in the rugged mountains above the sea and you will agree.

On the northwestern shores of the Dead Sea, visitors will find the world-famous **Qumran Caves** and the ruins of a monastery-like complex. Hebrew and Arabic manuscripts found here between 1947 and 1960 are believed by some to have been written by the Essenes, a religious sect that flourished more than 2,000 years ago. Modern interest in the Essenes has been reawakened by their reputation for having lived in harmony with nature and recognizing the sacred unity of all living things. These ancient sites could lead 21st-century people to realizations that might change their lives.

Masada Fortress

This place has been a shrine for Jews from all over the world for nearly two millennia, but it holds a special significance for Israeli Jews. Herod the Great built one of his most daring complexes here, on a mighty rocky plateau high above the Dead Sea, surrounded by a curtain wall with 40 parapets. Numerous buildings sprang up within the walls, including a multistorey palace in the north wall with a magnificent view into the distance across the Judean Desert. Originally accessed via three narrow paths, the fortress was considered impregnable.

The First Jewish–Roman War (AD 66–74) was comprehensively documented by the historian Flavius Josephus. He tells how, after the Romans had conquered Jerusalem and destroyed the Temple, Masada became the last

bastion of Jewish resistance to the Romans. Some 1,000 Zealots, the bitterest opponents of the empire in the Jewish–Roman Wars, made a final, hopeless stand against a numerically superior force of 15,000 Roman troops. The Jews' last hope died when the fortress was besieged by the Roman Tenth Legion, who built a gigantic ramp up the flatter, western hillside to the wall. From here the besieging troops eventually stormed the fortress. Faced with a desperate situation, those within chose to die in freedom rather than live in misery as slaves. Lots were drawn and a few men were chosen to kill the others before killing themselves.

Rock of Masada

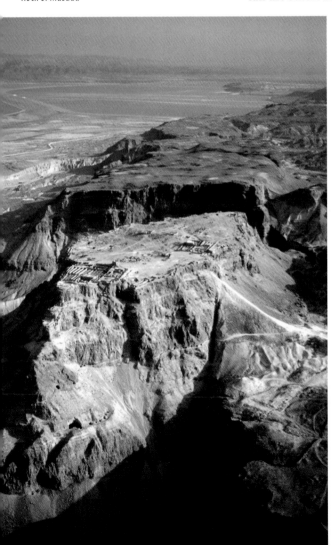

Masada thus became a myth, and for the Jews it is a lasting symbol of an unshakable desire for liberty.

After its fall, the rocky fortress lay deserted. Christian monks settled here during the 5th and 6th centuries, building a church whose remains can still be seen today, but Masada was almost forgotten for centuries. The site has only been systematically excavated and researched since the 1960s. The buildings, which have been partially uncovered and reconstructed, are indeed impressive, but the most affecting find has been eleven *ostraca*, clay tablets that seem to record the names of the last of the defenders, chosen by lot for their terrible task.

Around Mount Nebo

Located about 19 miles (30 km) south of Amman, the capital of Jordan, Mount Nebo's various peaks look down across the Dead Sea and the Jordan Valley. One early Christian legend suggests that one of the summits, the 2,330-foot (710-m) high Ras es-Syagha, is the burial place of Moses, who led the people of Israel out of captivity in Egypt to wander for 40 years in the desert before reaching the borders of the Promised Land. Moses himself was forbidden to enter the Promised Land, and he died on this mountain. There is now a Franciscan monastery beside the ruins of a basilica once dedicated to Moses on the summit plateau, and Franciscan monks have restored and preserved the wonderful Roman and Byzantine mosaics in the many local churches.

The city of Madaba lies about 6 miles (10 km) to the east of **Mount Nebo**. It is now a marketplace for the Bedouins living in the area and is also famed for its uniquely patterned carpets, which are woven by men. In biblical times, Madaba was initially part of the Moabite Empire before falling under the imperial control of the Nabataeans, and under the Romans it was incorporated into the Province of Syria. Its wealth grew in this period, although nothing remains of the magnificent contemporary buildings.

In 1884 construction of the Greek Orthodox **Church of St George** was begun on the ruins of a Byzantine church, and this work uncovered wonderful mosaics. The most famous of these is a map representing the entire Holy Land and its surroundings. The range of this unique relic from the period around AD 550 stretches from the Nile Delta to southern Lebanon and from the Mediterranean to the Arabian Desert. Besides such geographical locations the map also depicts animals and people. A number of icons, the earliest of which dates back to the 6th century, are also of particular beauty, not least as they were created before the iconoclastic schism and thus still display strong influences of the spirit of late antiquity.

The magnificent landscape and the biblical stories make Mount Nebo and its surroundings a destination for all those pilgrims seeking the oldest biblical sources. Mount Nebo has always been a place of worship and remains a sacred place to this day.

The Rock City of Petra

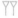

Many would consider the Jordan Desert between the Dead Sea and the Gulf of Aqaba to be the most impressive in the world. In the shimmering red mountains rising up from the pink and white sand lies the city of Petra, a unique triumph of ancient architecture. Petra was built in the 3rd century BC by the Nabataeans, a

The The Memorial Church of Moses on Mount Nebo

peace-loving and pious people who disavowed slavery and practiced some kind of death cult, worshiping the sun and the moon as divinities. According to the Bible, the city was later destroyed by the wrath of God. During its heyday, Petra, the "rock city," was a staging-post for caravans to Gaza, Syria, and the Persian Gulf. After being absorbed into the Roman province of Arabia in AD 106, Petra flourished before falling to the Muslims in the 7th century and the Crusaders in the 12th. The city was subsequently almost completely forgotten and neglected until its rediscovery by Jacob Burckhardt, a Swiss, in 1812; he was overwhelmed by its architecture and breathtaking location.

Petra is not easy to reach; surrounded by deep gorges, it can be accessed via a narrow canyon. Visitors will be astounded at the wealth of Hellenistic features decorating the

A temple in the rock city of Petra

buildings, especially the temple nestling in the rocks, and the impressive amphitheater, with seating for more than 3,000 spectators. There are numerous tombs along the cliff sides, and many of these are of particular aesthetic value. Much has been discovered about the contemporary significance of this ancient city but it has also guarded many secrets. As a result, it has become sacred not only to those interested in ancient architecture and cultural history, but also to those wanting to know more about the desert and the way of life in this part of the world.

Ğabal Harun

Ğabal Harun (Mount Aaron) near Petra was a Nabataean shrine in pre-Christian times. It has been traditionally considered the location of the death of Aaron, the brother of Moses, since the Roman-Byzantine era, and the site is venerated by Jews and Christians alike. A small church has been constructed on the summit of the mountain, and at one corner of the building a few steps lead up to a vaulted room thought to be Aaron's tomb. A monastery was built on a little plateau beneath the church during the Byzantine period to offer hospitality to the many pilgrims who came here. The church was later turned into a mosque; although the Koran says nothing about the death and burial of Aaron (Harun),

he is considered a prophet and the equal of Abraham, Moses, and Jesus. It is therefore no surprise that Muslims also considered this to be a sacred place within their tradition. Jewish and Christian pilgrims nonetheless continued to visit the site. A cenotaph has been erected near the entrance to the mosque and in the wall nearby there is a gleaming piece of obsidian touched with great respect by the faithful in the hope of divine blessing.

The Ğabal Harun has a mysterious aura that can be felt throughout the surrounding desert. It draws not only Jewish, Christian, and Muslim pilgrims, but also members of the local community, especially from Bedouin tribes. Women follow the grueling path up to the site to ask to become pregnant or to give thanks after the birth of a child. Even pilgrims on their way to Mecca often take a detour from the hajj to the mountain. The significance of the mountain as the ritual center of a whole region is shown by the Nabataean inscriptions on the cliffs, the Hebrew and Greek inscriptions on the cenotaph, the Christian crosses by the wayside, and the carved graffiti indicating the way to the shrine.

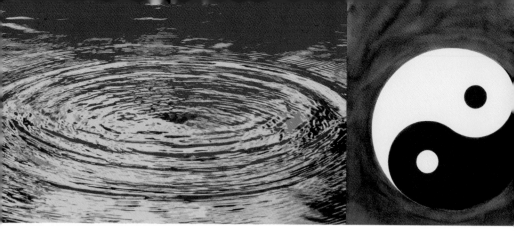

SACRED NUMBERS

Space and time are measured with numbers, along with sizes and amounts—numbers help to create order in things. World religions have always shrouded numbers in mystery, and human belief has ascribed a deeper meaning to many numbers. They are used almost everywhere in the world as symbols for profound truths and wisdom. Numbers are a shorthand for the concepts they represent.

"0" is a symbol of "nothing," the absence of any quantity. In the Jewish Kabbalah, 0 represents all that is boundless and beyond human control. The form of a 0 resembles a circle, having neither a beginning nor

an end, and its elliptical shape symbolizes rise and fall. The round disk of the sun was the emblem of an omnipresent deity in Ancient Egyptian sun worship, and for the Inca it represented both rulers and the gods.

Before "1" there is only emptiness or chaos. 1 is the smallest positive integer—unity. It represents completeness, created from the nothingness preceding it; in monotheistic religions, 1 belongs to the one true God. Denoting indivisibility and uniqueness, it also symbolizes individuality (translated literally from Latin, individuality means nothing more than indivis-

ibility). All other numbers are produced from 1 through multiplication, just as the whole world was produced from one mythical mountain—or so the Hindus, Buddhists, Jains, and Bön believe, not to mention many Native North American tribes.

"2," the smallest number necessary for a binary system, is the only even prime number. 2 is considered the number of oppositions and completions, implying that one thing cannot be fully understood without the other. The integrity inherent in the unit original is fractured, and this is an experience that is quintessentially human—there

is good and evil, light and dark, life and death, up and down, odd and even, conscious and unconscious, man and woman; in Daoism, yin and yang are the two basic energies that shape the world. 2 is also the number of choice, between yes and no, between either and or.

"**3**" is the smallest odd prime number. It is a symbol of the tripartite division of the cosmos into heaven, earth, and underworld. The world is contained within the three dimensions of length, breadth, and depth (a spatial interpretation), and 3 also comprises past, present, and future (a temporal interpretation). Love (1) gives rise

to wisdom (2) and results in action (3). In Christianity, 3 represents the Trinity of God, Jesus Christ, and the Holy Spirit; in Hinduism there is the *Trimurti* of Brahma, Vishnu, and Shiva. 3 also represents the human trichotomy, standing for body, soul, and mind. It is also the number of a family, the smallest social unit of father, mother, and child, as well as the cycle of life from childhood via adulthood to old age. In the mysticism of many religions, 3 represents a striving for a unity of head, heart, and understanding.

"**4**" is the smallest composite number. It represents the four cardinal points of the

compass and is the number of the world and of space, as in effect it symbolizes everything: the four seasons, the four rivers bounding Paradise in every tradition, the four elements of fire, earth, air, and water. In the Jewish Kabbalah, 4 is the number of God's name, the Tetragrammaton. The four sacred mountains of Chinese Buddhism represent the four metals of iron, bronze, silver, and gold. For the North American Navajo, their settlement areas are bounded by four sacred mountains surrounding an original central, mythical mountain which has no actual geographical location. 4 was sacred to the Ancient Egyptian religion, as

SACRED NUMBERS

it was the smallest number permitting the construction of a solid body, the pyramid. The cross, the symbol of Christianity, combines four points in a vertical and a horizontal axis, thus including the whole world.

There are five Platonic solids. "**5**" symbolizes spirit, the fifth element constituting the world along with fire, earth, air, and water, although it is only an abstract. When a human stretches out their arms and legs, their limbs and head form a pentagram, a five-pointed star. The five sacred mountains of Chinese Daoism point to the middle—China considers itself the "Land of the Middle

Kingdom." The sign of the quincunx, an arrangement like the five on a die, with four external points indicating the center, symbolizes concentration and constancy. In Greek mythology, 5 stands for sensuality and sexuality. 5 is the number of the planets that have been known since the earliest history of man: Venus, Earth, Mars, Jupiter, Saturn.

"**6**" is the smallest "ideal" number: $6 = 1 + 2 + 3 = 1 \times 2 \times 3$. 6 represents harmony and equilibrium, and the six-pointed Star of David unites the two triangles of sacred and profane order. The hexagram is also the symbol of Tantric Hindu-

ism, and Buddhism divides the world into six planes of existence: those of the gods, jealous gods, people, animals, hungry spirits, and of hell. The Bible claims that the creation of the whole world took six days. 6 is the number of the Mesopotamian god of weather and the year was divided into six double months.

"**7**" is the number of fullness and perfection: the sun and the moon are added to the five known planets to make up the sevenfold nature of the heavens. A, B, C, D, E, F, and G, the seven notes of the diatonic scale, have been known since ancient times, and there are seven days in a

week; the Bible tells us that only with a day of rest does Creation become perfect. Roman Catholic Christianity has seven sacraments (baptism, Eucharist, penance and reconciliation, confession, matrimony, holy orders, and anointing of the sick), seven gifts of the spirit (wisdom, justice, ministry, strength, insight, piety, and reverence), and seven works of charity (feeding the hungry, giving drink to the thirsty, welcoming strangers, clothing the naked, caring for the sick, visiting prisoners, and burying the dead). Ancient cultures knew that adding the first seven whole numbers described the rhythm of the world: $1 + 2 + 3$ $+ 4 + 5 + 6 + 7 = 28$.

"**8**" is the number of new beginnings. Buddhist teachings tell of the eightfold path, represented by an eight-spoked wheel, the *dharmachakra*. Winds are classified according to eight directions. Chinese culture considers 8 a lucky number as it sounds the same as the word for "forward." The ancient Chinese "Book of Changes" (*I Ching*) describes eight trigrams. The Gnostics knew of eight celestial spheres and the Etruscans listed eight ages of the world. For Christianity, 8 is the number associated with the Resurrection and the beginning of a new life, ritually represented through baptism; hence the octagonal structure of many baptisteries and fonts. Eight days after birth, Jewish boys are circumcised and ritually welcomed into the community. Daoism considers the eight Immortals to be saints and the eight arms of the Hindu god Vishnu encircle the whole world. An 8 on its side represents endlessness and eternity.

"**9**" is the square of the sacred number "3." In Chinese numerology, 9 stands for dragons, prosperity, and good fortune. Ancient Egyptian mythology included nine creator deities, and human pregnancy lasts for nine months. For

SACRED NUMBERS

the Baha'i, 9 is the number of man's splendor and unity, as well as the number of religions. 9 contains all the other one-digit numbers and is produced through the addition of two of them, with no exceptions (1 + 8; 2 + 7; 3 + 6; 4 + 5). Every one-digit number multiplied by 9 produces a number whose digits add up to nine, and for this reason 9 is the number of immutable truth in Judaism. The mystic symbol of the enneagram, although its origin is disputed, is a nine-pointed star indicating the nine facets of personality: each of the three centers of human intelligence (head, heart, and stomach) is ascribed to one of three types. Categorization of personality type is an introspective process.

"**10**" represents a rounded whole. Human hands have ten fingers, and most people count in base ten. The Roman number for 10, X, consists of two Vs, the symbol for 5, placed tip-to-tip. Both Judaism and Christianity regard the Ten Commandments as the basic rules for successful living. The first three commandments, describing man's relationship with God, were written on one tablet, the other seven, regulating man's relationship with his neighbor, were written on the other. The traditional tax is a tithe, and a just ruler used never to exact more taxes from his subjects than the tenth part.

Many cultures consider "**12**" to be a sacred number: it contains the divine 3 four times, and the secular 4 three times. Time has been measured in multiples of 12 for thousands of years: the day has 12 hours, as does the night. In a year, the sun journeys through 12 signs of the Zodiac, whose names were fixed at an early point: Aries, Taurus, Gemini, Cancer, Leo, Virgo, Libra, Scorpio, Sagittarius, Capricorn, Aquarius, and Pisces. The Chinese year has other symbols, but there are are still 12 of them. According to legend, the

Buddha invited the animals to a New Year's party, but only 12 turned up; in gratitude, the Buddha granted to each of these a year with the animal's characteristics, to be arranged in the order of their appearance at the feast. This gave rise to the year of the rat, followed by the ox, tiger, rabbit, dragon, snake, horse, goat, monkey, rooster, dog, and pig.

Ancient Greek mythology placed 12 principal gods on Mount Olympus, and the heavenly Jerusalem anticipated by both Christians and Jews has 12 gates guarded by 12 angels. The Imami, the largest branch of Shia Islam, venerate 12 imams—eleven have died and the twelfth, Muhammad al-Mahdi, is considered the "hidden" imam who will return to redeem the world. 12 always symbolizes completion and is an ideal measure for everything harmonious.

Many other numbers are considered sacred in various religions; this may be the result of traditions in their holy scriptures or a combination of other numbers: 24 is twice 12, 40 corresponds roughly to a human generation, 70 is the number of a completed rotation, 360 is the great circle of the world. For Jews and Christians, $1,000$ represents a period of time that is inconceivable for humans but negligible for God. Chinese numerology recognizes $10,000$ things created from an original unity, and in good luck charms the character is a symbol of immortality. The temples of the Ancient Egyptians were built for their gods for $1,000,000$ years—in other words, for eternity.

The Prophet's Mosque

Apart from their pilgrimage to Mecca, all Muslims will make a journey once in their lifetime to a city simply known as "the city," for such is the literal translation of Medina in western Saudi, now home to more than a million inhabitants. It is the second-most holy site in Islam and closed to non-Muslims by Islamic law—it is a sacred place reserved only for believers.

As circumstances in Mecca became too perilous in 622, Muhammad fled to Medina, or Yathrib as it was then known. From that point on he made the city the center of his ministry and later the capital of the Muslim state. His house was not only a home for his family but in a way also a meeting-place for the entire Islamic community. Shortly after his death the site was turned into a mosque.

In the early 8th century this building was converted into a "typical" mosque layout with a courtyard— typical in the sense that it has remained the model for mosques all over the world to this day. Galleries of various depths indicated the direction of prayer or served merely as shade from the sun, and doors that were initially purely functional gained symbolic meaning in the course of time.

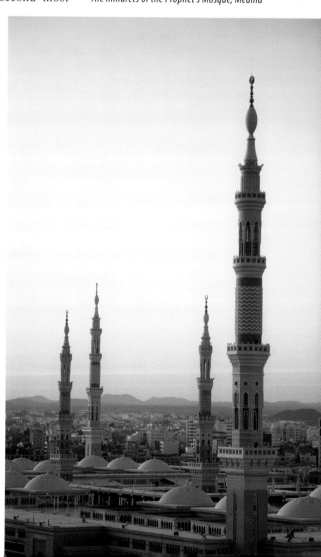

The minarets of the Prophet's Mosque, Medina

A mosque was originally just a place to pray that faced toward Mecca, with no symbols and no barriers—nothing should disturb the concentration of those at prayer. This prototype "mosque" was an open square surrounded by a wall, with living accommodation on one side. Muslim tradition teaches that the Prophet would sit, reclining against a date palm in the square, and teach, and guests were also received here.

Muhammad's tomb can now be found in the mosque, its location emphasized by a special surround in the roofed southeastern section of the site. In principle this goes against the tradition forbidding the worship of saints, and several especially strict theologians have demanded the removal of the tomb from the mosque.

It is probably the fact that this was once the Prophet's actual house that makes Medina and the Prophet's Mosque so special for Muslims. While not compulsory, a detour to Medina on the pilgrimage to Mecca is highly desirable.

Quba Mosque, Medina

This sacred place is located a little outside Medina. The Masjid al-Quba is considered the first purpose-built mosque, and many consider it the fourth-holiest site in Islam after the Sacred Mosque in Mecca, the Prophet's Mosque in Medina, and the Dome of the Rock in Jerusalem.

Legend has it that the first stones of its construction were laid by the Prophet Muhammad himself after his flight from Mecca to Medina, and it was completed by his companions. There is a tradition that two morning prayers in this mosque equate to a minor pilgrimage. Little is left of the historic and traditional part of the mosque, as many significant alterations were undertaken over the years and a completely new structure was built in gleaming white stone in 1986. The mosque has remained a place of historical consciousness, however, and more than a few Muslims consider it the quietest and most peaceful of their sacred places. Islamic law forbids entry to non-believers.

Arafat

About 13 miles (20 km) east of Mecca there is an area called Arafat, and here you will find a hill of no particular geographical note. This 1,480-foot (450-m) high hillock is especially sacred to observing Muslims, however, for this is the "Mount of Mercy." Not only did the devil appear here in person to Abraham the Patriarch, but Islamic tradition relates that Muhammad gave his last sermon here during his farewell pilgrimage, setting out the stations of Muslim pilgrimage to Mecca. These prescripts still apply and are respected by every observing Muslim. The entire area around Arafat

is a "place of dwelling in the presence of God." Believers spend the ninth day of the pilgrimage month here, from midday until late into the afternoon, before continuing their journey to Mecca. This pause is an essential element of Muslim observance and a pilgrimage is invalidated if a stop for prayer is not made at Arafat.

Stopping and pausing is a practice that precedes Islam; it is a kind of passive activity, adopted not only by Islam but of significance for every religious system. Only after this pause may participants continue to the "Sunset Prayer" and the night vigil that then follows. Whether visitors are Muslim, and coming to Arafat as part of a pilgrimage, or of another faith entirely, this is a general truth for all religions: there are places and times where all action is stilled, and such times are important and the places where they occur will always be sacred. They force people to step away from the racing treadmill of time, providing another, more profound way of experiencing time.

Sacred Mosque, Mecca

Mecca is the most sacred place for every Muslim throughout the world. Before Islam there was an Arabian religion of which little is now known, but it is assumed that it was based on nature worship and a reverence for celestial bodies such as the sun, moon, and Venus. The world-famous meteorite, the walled-in "Black Stone," probably dates back to this pre-Islamic time known to believers as the "Age of Ignorance," or *djahiliya*. Ancient Arabic worship was principally focused on the male god Hubal, in addition to whom there were female deities that later came to be known as the daughters of Allah. At the heart of this polytheistic religion there was a square temple, the Kaaba, which was said to have been used by Abraham as a sacrificial altar. Muslims consider Abraham *hanif*, a seeker after truth who abandoned polytheistic worship and sought the One True God. Tradition has it that he was blessed by God and is the ancestor of all Muslims. The Quraishi tribe, of which Muhammad himself was a member, were the guardians of the central shrine in Mecca for many generations.

The site of the old shrine is also the location of the most sacred place in Islam, the Sacred Mosque with the Kaaba in its inner courtyard. This "place of submission" (the literal translation of *masjid*, or mosque) is visited by millions of Muslims every year; they come to fortify themselves through prayer and to experience a particularly intense feeling of community that shines out around the whole world. At the end of a pilgrimage to Mecca (Arabic: hajj), the most popular pilgrimage in the world, believers walk around the Kaaba (*tawaf*) seven times, kissing the Black Stone set in the southeastern corner of the Kaaba if at all possible.

The faithful in the Sacred Mosque, Mecca

The Sacred Mosque and its surrounding buildings and prayer space take up a huge area of the city and can accommodate up to four million worshipers. The mosque, built by Muhammad in 630, currently has nine minarets, and is an instantly recognizable feature of the city's skyline. Whole districts of the city were cleared to make way for the expansion of the mosque, and its present form dates back to alterations undertaken during the reign of the sultan Selim II between 1572 and 1577, in the course of which a great number of whitewashed domes were placed on the flat roof.

The Sacred Mosque in Mecca is renowned throughout the world, even among non-Muslims. It is the indisputable center of Islamic might, and five times every day some 900 million Muslims kneel down facing toward it. The pilgrims who come here put on seamless white robes—a symbol of purity and cleansing of sin, as the hajj is considered a new beginning in life. The city is closed to other faiths, but the fame of its sanctity has spread worldwide.

Mina Valley, Mecca

This valley near Mecca is not very spectacular, but once a year it becomes one of the most sacred places in Islam, as it

Pilgrims in the Mina Valley near Mecca

is one of the stations on the pilgrimage to Mecca. Mina means "valley of love," and oral tradition relates that this was the valley where Adam, the first man, knew paradise—a paradise that was also the place of the Devil, the Tempter.

If the pilgrims have already reached Mecca and completed their first seven circuits of the Kaaba, shortly before sundown on the tenth day of Dhu al-Hijjah, the pilgrimage month and the last of the Muslim calendar, they make their way to Mina to take part in the ritual of stoning the Devil. This involves throwing seven pebbles at walls symbolizing the Evil One. Once this is done, the men submit to a ritual haircut. The women also cut off a strand of hair as a symbol of the beginning of a new period in their lives. The great sacrificial festival of Eid al-Adha, the most important Muslim religious holiday, takes place on the same day. The feast is celebrated all over the world and on this day Muslims truly experience the international community of their faith.

The next day pilgrims leave Mina for Mecca and the Holy of Holies. Here they execute another seven circuits of the Kaaba, saying the prayer of departure twice. Strengthened by the sense of community and the experiences of their pilgrimage, many Muslims regard themsevles as embarking on a "new life." They try with renewed vigor to live according to God's will, for this is what "Muslim" means: one devoted to God.

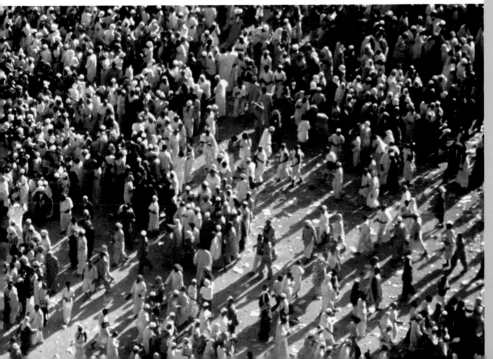

Samarra

After the death of the Abbasid caliph Harun al-Rashid in 809, the caliphate was plunged into a serious crisis as various candidates struggled for the succession. His son, al-Mu'tasim, eventually emerged victorious from the skirmishing, and in 836 he decided to move the capital and the entire administration from Baghdad to a newly founded city that was to become Samarra. A desire for peace and security prompted the caliph to put as much distance between himself and the people of Baghdad as possible. However, the new capital was not to prove long-lived. Only 50 years later the capital was on the move again, when Caliph al-Muta moved it back to Baghdad, and Samarra's decline began.

Although the Abbasid Caliphs were only briefly based in Samarra, the city's buildings are legendary and include some of the principal Shi'ite pilgrimage sites. The **Grand Mosque** is particularly famous. Although not much of it has survived, its spiral minaret (al-Malwiya) has remained

The ruins of the Grand Mosque in Samarra with its famous spiral minaret

a symbol of triumphant Islam. The mosque, completed in 852, is made of clay bricks and in its time was the largest in the world. Surrounded by a giant wall, the magnificent collection of buildings was a clear expression of the Abbasid rulers' imperial ambition.

A destination more important for Muslim pilgrims even than the remains of this world-famous mosque is the **Golden Mosque**, named after its gilded dome, which was completed only in the 20th century. A bomb was placed in the dome in 2006 and the building has only recently been re-opened to the public. The mosque contains the tombs of the imams al-Hadi and Hassan al-Askari (the tenth and eleventh imams of the Twelve), who both lived in the 9th century. These are visited by Shi'ite pilgrims touring the holy sites associated with the imams. Beneath the mosque there is a cellar in which the twelfth imam, Muhammad al-Mahdi, is said to have been hidden away in 874, while still a child. This too is a place of great veneration.

Al-Kadhimiya Mosque, Baghdad

Modern Baghdad is a metropolis of some 7.5 million on the banks of the Tigris, with a sea of houses covering

Believers at prayer in the Al-Kadhimiya Mosque, Baghdad

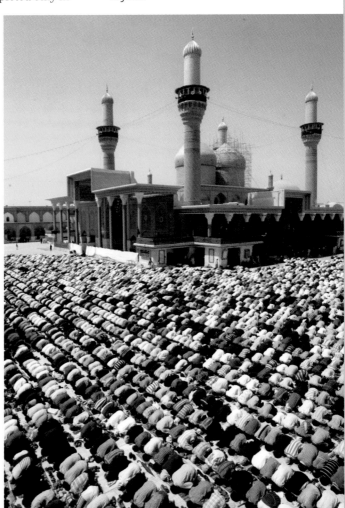

the site of what was once a circular city. The Abbasid caliph al-Mansur began construction of his new capital on the western banks of the river in 762, choosing a ring as the basic shape of the city. Three concentric walls enclosed the various areas, with the inner wall defending the caliph's palace and the mosque, the middle wall enclosing the military emplacements, and the outermost wall protecting the residential areas. Four gates in the outer wall, one at each point of the compass, allowed access to the city. Baghdad's heyday came in the 9th century under Caliph Harun al-Rashid, when it became the religious, economic, intellectual, and cultural center of the country.

Modern-day Baghdad, which covers large stretches of both banks of the Tigris, is a city of countless mosques. The Al-Kadhimiya Mosque in the northwest of the city, one of the most important Shi'ite shrines, is not only used on great feast days but is visited daily by pilgrims who come here to pray. Completed in 1515, the mosque contains the tombs of Musa ibn Jafar al-Kadhim and his grandson Muhammad al-Jawad at-Taqi, the seventh and the ninth imams. Both are greatly revered, and the mosque in Baghdad is considered the third most sacred Shi'ite pilgrimage destination after those at Karbala and Najaf.

Baghdad is currently caught up in political unrest and it is impossible to predict how events in Iraq will unfold. In all this turmoil, however, the Al-Kadhimiya Mosque has remained a center of faith.

Imam Husayn Shrine, Karbala

In 680 a tragic battle took place in the Iraqi desert near Karbala that lodges in the Shi'ite collective consciousness to this day. A schism had developed over political succession among the descendants of the Prophet, between the Sunni majority and the supporters of the caliph, Ali bin Abi Talib. The Sunnis owe allegiance to the *Sunna*, the words and deeds of the Prophet, while the Shi'ites follow "Ali's faction" (*Shi'atu Ali*). One of the major figures in Shia history is Husayn, the third imam and one of Muhammad's grandsons, who laid claim to the caliphate after the death of the Umayyad caliph Muawiya. Imagining he had the support of the Iraqi people, Husayn marched on Kufa with a small army. His opponents besieged him near Karbala with the intention of starving him out. The expected relief never came and Husayn was killed at the historic Battle of Karbala.

Shi'ites consider Husayn a defender of the faith and a martyr who died for his beliefs, and his fate still has the power to move the faithful. Husayn's tomb in Karbala, covered with a golden dome, is an important religious site for Shi'ites and Alevi. Millions of pilgrims every year make the pilgrimage to Karbala, in particular on the tenth day of the

The pilgrimage to Husayn's tomb, Karbala

Islamic month of Muharram for the Day of Ashura, during which the pilgrims' religious zeal often leads them to strike themselves in self-chastisement. There are passion plays and processions in remembrance of Imam Husayn and his suffering.

Imam Ali Mosque, Najaf

☪*

Ali bin Abi Talib was the fourth Sunni caliph and the first Shi'ite imam. He was also a cousin and son-in-law of the Prophet Muhammad, having married his daughter, Fatima. For the Shi'ites and Alevi, an imam is the rightful successor to the Prophet Muhammad and in Shia belief only the imams are in a position to interpret the deeper meaning of the Koran. Both the mosque and the tomb of Imam Ali are to be found in the Iraqi city of Najaf, founded in the 8th century, and all the streets in the star-shaped city run toward the large central square where the building is located. For the world's approximately 120 million Shi'ites, this is one of the most sacred places on earth. A golden gate forms the entrance to the impressive mosque, whose giant dome, covered with golden tiles, radiates a majestic authority.

The Imam Ali Mosque, with its attendant religious university and library of valuable manuscripts from Islam's early history, is the center of the Shia faith. Sadly, the mosque remains the focus of bloody confrontations between the various branches of Islam, and violent struggles and suicide bombings in which many believers have lost their lives have continued to this day. The walls surrounding the mosque area have been destroyed many times, and the Shi'ites interpret this as a sign of the end times to come. More than two million Shi'ites lie buried in the cemetery near the mosque—even in death, being close to the first imam is of great importance to them, and millions of believers undertake the pilgrimage here every year to bewail their fate before him.

The Great Ziggurat of Ur

𒀀𒀀

Many anthropologists consider Mesopotamia, the land between the two rivers (Euphrates and Tigris), as the cradle of human civilization; there are certainly traces of human settlements here dating back more than 10,000 years. The houses were made of clay bricks and, if they collapsed, new ones were built on the ruins.

The Sumerians lived on the flood plain at the southern end of the Euphrates and Tigris. Their city of Ur is more than 4,000 years old and experienced its heyday during the Third Dynasty (2113–2004 BC). Everything we know of Sumerian culture and religion has been interpreted from cuneiform tablets. The most important gods were the gods of heaven, Enlil

of Nippur, Enki of Eridu, and Inanna of Uruk. These were followed by the gods of the stars: Utu the sun, Nanna the moon, and Inanna, Venus. Each god had a household consisting of the individual deity, a spouse, children, and divine servants. There were also a plethora of evil spirits and demons who could cast spells and inflict curses.

One impressive relic of Sumerian culture has remained in Ur—the Zig-gurat of Nanna, the god of the moon, who was also considered the patron deity of the city. The building was surrounded by a further delineated area and is thought to have been the central religious site of the city. A monumental flight of steps leads up to the top platform of the ziggurat, and it is assumed that the structure was intended to symbolize a mountain—the mythical mount of creation from which all life grew.

Shia pilgrimages

Pilgrimages to the tombs of their imams are an important part of the lives of Shi'ite Muslims. They consider these sites to be sacred places and locations of divine blessing and remembrance. Pilgrims enter a sacred space separated from the outside world, returning to their everyday lives with the blessing of the late imam. Such pilgrimages are a peculiarity of Shia Islam—in the Sunni tradition, an imam is anyone who leads prayers, but for Shia theologians the term is reserved exclusively for Ali bin Abi Talib and 11 of his successors. These 12 imams are direct descendants of the Prophet Muhammad, and pilgrimages to their tombs are recorded from as early as the 10th century.

Considered infallible religious leaders, Shi'ite imams are themselves filled with divine spirituality and revered as holy men. The spirits of the deceased are thought to dwell at their tombs and this supernatural holy power can ease life crises or even work miracles. Iraq's greatest pilgrimage sites are the tombs of Ali bin Abi Talib (d. 661) in Najaf and Husayn (d. 680) in Karbala; those of Musa al-Kadhim (d. 799) and Muhammad al-Jawad al-Taqi (d. 835) in Kazimiya (now a suburb of Baghdad); and the tombs of Ali al-Hadi al-Naqi (d. 865) and Hassan al-Askari (d. 873) in Samarra. The twelfth imam, Muhammad al-Mahdi, who disappeared as a child and is considered the "hidden" imam, is also venerated in Samarra. The tombs of the fifth imam (Muhammad al-Baqir, died c. 733) and the sixth (Jafar al-Sadiq, d. 765) are now lost. The shrines to the second (al-Hasan, d. 669) and the fourth (Ali Zain al-Abidin, died c. 713) are to be found in Medina in Saudi Arabia. The eighth imam, Ali bin Musa ar-Rida (d. 818), is the only Shi'ite imam to lie buried in Iran (in Mashhad).

Besides these sacred places, pilgrims also visit other places of remembrance: the tombs of pre-Islamic saints or prophets of the Koran, the tombs of Muhammad's companions, and memorials to Husayn's supporters at the Battle of Karbala. The tombs of Sufi masters of Islamic mysticism are also considered sacred places where visitors can experience the power of the divine.

Goharshad Mosque, Mashhad

The modern name of the city (it was previously known as Sanabad) is an indication of its importance as a Shi'ite pilgrimage site—Mashhad means

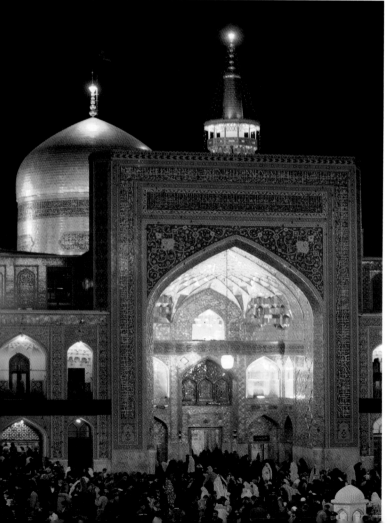

Goharshad Mosque and the tomb of Imam Reza, Mashhad

"the place of the martyrs," and Ali bin Musa ar-Rida (known as Ali Reza), the eighth of the 12 Shi'ite imams, is considered one such. Like almost all the other imams, Reza did not die a natural death—he was poisoned in 818 at the behest of al-Mamun, the caliph, although the latter had the decency to erect a tomb for his victim in the mausoleum of his father, Harun al-Rashid, who had also died in Sanabad in 809. As a result, Mashhad soon became a pilgrimage site.

The Goharshad Mosque is a giant complex of more than 20 individual buildings, madrasas, and museums. A wide avenue leads directly to the shrine, which can be seen glinting in the sun from afar. The mosque is illuminated at night and shimmers in a mysterious and majestic fashion. Adorned with gold and precious mosaics, Imam Reza's tomb is one of the most magnificent Shia shrines and is visited by hundreds

of thousands of black-clad Iranian Shi'ites every year in remembrance of the martyrs to the faith, especially on the Day of Ashura on the tenth day of the Islamic month of Muharram. Long lines of men slowly inch up to the shrine, striking themselves on the chest as a sign of their grief. Non-Muslims are not permitted to visit the inner sanctum of the mosque. Mashhad has achieved this exceptional status as a pilgrimage site as Ali bin Musa ar-Rida is the only Shi'ite imam to be buried on Iranian soil.

The Mausoleum of Esther, Hamadan

Founded in the 2nd millennium BC, Hamadan, once known as Ekbatana, is one of the oldest cities in modern Iran. There are various tourist attractions, both ancient and modern, in Hamadan, including the mausoleum of Esther. Esther, who lived in 5th century BC Persia, was the adopted daughter of her cousin Mordechai. The Bible story recounts how she thwarted a planned massacre of the Jews, turning events around so that it was not the Jews but their enemies who were slaughtered. The joyful festival of Purim, celebrated to this day as one of the most important Jewish feasts, remembers the same Queen Esther, but the Mausoleum of Esther in Hamadan may commemorate a different monarch—the Jewish

wife of the Sassanid ruler Yazdegerd I. Irrespective of the original occupant of the structure, the mausoleum has become a shrine to the Esther of the Bible. Many Jews have made the pilgrimage here over the centuries, commemorating Esther's act of salvation—a deed that for Jews has had a lasting symbolic importance, granting strength in every tribulation.

Isfahan

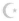

"If you would come with me to see the roses blossom in Isfahan, you must choose to walk slowly at my side. If you would come with me to see the roses blossom in Isfahan, you must expect the dangers of a ride on treacherous ground and the confusions of the caravanserai." With these words, Pierre Loti, a French envoy and writer, began a travelogue of his journey through what in April 1900 was still called Persia. Visitors to the Isfahan of today will encounter a modern city of concrete buildings and crazy traffic, and the center of the Iranian nuclear industry, but behind all this they will also find a magnificent old city and one of the most impressive Muslim shrines. They may even discover themselves as they journey through the ages, far from European civilization.

The threat posed by the Ottoman Empire twice forced the Safavids to move their capital from Tabriz, first to Qazvin and then later, at the end of

Madrasa, Isfahan

a later addition—are now filled with stores. North of the square lies the Great Gate, the entrance to the bazaar and the link between the old and the new city. The Ali Qapu, the gate to the palace precinct, lies to the west, and to the east there is the small Mosque of Sheikh Lutfallah. The most impressive structure is, however, the Grand Mosque (once called the Shah Mosque, now known as the Imam Mosque) on the southern side of the square; the white, gold, and shades of blue in every richly decorated portal and dome gleam in the sun.

the 16th century, to Isfahan, a city in the Iranian highlands that had previously been the capital in the 11th and 12th centuries. Restructuring of the city undertaken by Shah Abbas after 1590 saw the political, economic, and religious center of the city move toward the banks of the Zayanderud ("life-giving river"), and the many magnificent buildings built during this period earned the city the nickname the "Pearl of Islam." The centerpiece of Shah Abbas' city was the Maidan-e Shah, a large public square whose arcades—

Isfahan was a center of science and faith with well-stocked libraries and major Koran schools. The Maidan-e Shah, the symbol of the new city, impressed travelers more than anything else. Originally, it was not cobbled but covered in white gravel, and at night 5,000 lamps were hung on slender poles in front of the buildings, immersing everything in a magical light. Old Isfahan is a tangible, visible example of how the desire for beauty can sustain people through their often arduous lives.

Tomb of Daniel, Susa

One of the most significant collections of tales of the prophets in Arabic is from the hand of the scholar at-Ta'labi (d. 1035), who also achieved fame with a comprehensive commentary on the Koran. He recounts the story of the young Daniel, who along with other Israelites had been carried off by King Nebuchadnezzar to the empire of Babylon.

As the Bible relates, Daniel was a particularly devout young man, holding on to his faith and refusing to pay homage to the king. This sealed his fate, and he was imprisoned. Daniel had received the gift of the interpretation of dreams, and when the king was troubled by nightmares whose message he was unable to understand, he called for the young Israelite. His interpretation was that Nebuchadnezzar's dreams all involved various transformations of the king, although he always retained a human heart so that he could recognize the power of the one true God. There is some debate as to whether Nebuchadnezzar died as a heathen or as a convert, but, whichever it was, he allowed the Israelites to return to Jerusalem.

Daniel, however, was kept near the king in Babylon and was once again imprisoned under his successor, Belshazzar. He interpreted an inauspicious dream for the new king as well, deciphering some enigmatic writing on the wall (*mene tekel upharsin*) as predicting the rapid decline of the Babylonian Empire; Belshazzar died soon afterward. Daniel remained in Babylon until his death, and Ta'labi recounts the discovery of his remains within the framework of the story of the early Islamic conquest of Iran by Abu Musa al-As'ari. Daniel also makes an appearance in the *Tales of 1001 Nights* as a wise judge in the "Tale of the Devout Israelite," and his memory lives on into the present day in a memorial on the banks of the Karkh at Susa (now called Šuš).

The original tomb, dating back to the 12th century in all probability, was destroyed in a flood in 1869 and rebuilt according to the old plans. The Tomb of Daniel is now a significant destination for Jewish and Muslim pilgrims alike, with Jews commemorating the young Daniel's piety, and Muslims venerating him as an upright and just man (*sadiq*).

The Ziggurat of Chogha Zanbil

The story of the Elamite Empire is an ancient one—from as early as the 4th millennium BC, Elam, with its capital at Susa, had been the center of a major ancient Oriental civilization that experienced its high point during the 13th and 12th centuries BC. The gigantic temple buildings of Dur-Untash (now called Chogha Zanbil), 25 miles (40 km) south of the modern city of Šuš (formerly Susa),

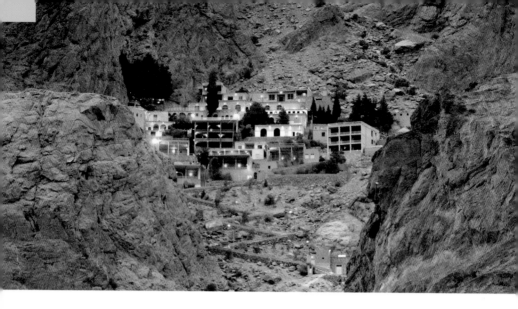

Chak Chak Shrine on the cliffs at Yazd

date back to this period. The ruined
city covers an area of about 250 acres
(100 ha) and at its center there still
stands the walled temple precinct,
dominated by a giant ziggurat.

The High Temple had four ter-
races where the gods were worshiped
with sacrifices. Inšušinak, the greatest
of the gods, was not only the patron
deity of Susa but also the god of the
underworld and the judge of the dead.
An inscription on the back of a statue
of a bull by the temple portal proves
beyond any doubt that the temple
was dedicated to him. The uppermost
terraces are not accessed by external
steps or ramps, as was the case with
other Mesopotamian buildings of this
kind, but via internal staircases.

The temple is assumed once to have
been clad in glazed tiles, but nothing
remains of these. Forming the center

of the site, the ziggurat was accessed
along a processional road surrounded
by other temples. The characteris-
tic structure of the ziggurat plays an
important role in ancient Oriental
mythology—the famed Tower of Babel,
which biblical tradition presents as
a symbol of mankind's overween-
ing ambition, was of a similar design.
Modern visitors to the ruined city may
do well to remember that arrogance
never achieved its desired goal.

Yazd

Zoroastrianism is an ancient Oriental
religion that still has adherents. It is
named after its founder, Zarathustra

(or Zoroaster), who is thought to have lived about 1000 BC. The religion was especially widespread among the nomadic peoples living on the border between modern Afghanistan and Iran. Gradually attracting more and more followers, the faith eventually became the main religion of pre-Islamic Persia (now Iran). One of the first monotheistic religions, Zoroastrianism is nonetheless based on a dualist principle. Ahura Mazda, the "Wise Lord" revered as the highest being, has two twin children: Spenta Mainyu, representing good, and Angra Mainyu, representing evil. Rituals and prayer in the presence of fire, the religion's symbol, have great significance and the shrines are called "Houses of Fire." Such shrines have survived to the present day.

The desert city of Yazd in central Iran is one of the most important Zoroastrian cities. Although most of the religion's adherents live in Tehran, in India (where they are known as Parsees), and among members of the diaspora in the West, Yazd still retains an important connection to the belief, as can be seen from the pilgrimages undertaken to the city.

Zoroastrian temples are the settings for ceremonies that mark the stages of an entire lifespan. There are records of initiation rites at the beginning of life; there are marriage rites, during which the priest leads the pair around the fire; and there are (now forbidden) burial rituals. Corpses were once placed on the highest point of a cliff or on the uppermost platform of a so-called "Tower of Silence" to be eaten by dogs, crows, and vultures. Only when no flesh was left on the bones could the skeleton be buried in an *astodan*, an ossuary cut into the rock.

Zoroastrian shrines (*pir*), sometimes no bigger than a niche, are built when divine beings appear to individuals in dreams, and the flame in the shrines is sometimes kept burning for years. Besides the countless small private shrines there are also "Great Shrines" (*pir-e bozorg*) to which the faithful journey on fixed annual pilgrimages. The six Great Shrines lie at the foot of

Inside Chak Chak Shrine, Yazd

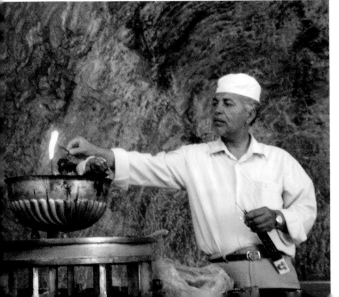

mountains in the desert around Yazd. The **Pir-e-Banu-Pars**, the "Shrine of the Lady of Pars," is a low shrine with a small vault and a room, surmounted by a dome, in which the fire bowl for the rituals is kept. There is a pilgrimage every year in July.

Pir-e-Naraki, situated at the foot of an impressive desert cliff, is associated with a legend that identifies this spot as the place where the Sassanid ruler Yazdegerd III was hidden on his flight from Arabic conquerors. The pilgrimage here is held in August.

The third desert shrine, **Pir-e-Herisht** to the north of Yazd, has extensive buildings offering accommodation to pilgrims, and the object of adoration at this shrine is a rock representing a servant of Yazdegerd's who once rescued a child of the royal household from danger. Countless candles are lit in front of the rock during the pilgrimage.

The fourth shrine is **Pir-e-Narestane**, which is visited in late June. Here it is possible to feel how cliffs, trees, and water can serve as objects of worship.

The fifth shrine is **Pir-e-Seti** on the outskirts of Yazd. This is visited in mid-June, usually in conjunction with a pilgrimage to the most famous of the shrines, **Pir-e-Sabz-e-Chak Chak** ("The Green Shrine of the Dripping Mountain")—"chak chak" is the onomatopoeic Persian transliteration of the sound of dripping water—about 44 miles (70 km) from Yazd. Legend has it that Nikbanu, the daughter of King Yazdegerd, found refuge here from the Arabs. After she had devoutly prayed to Ahura Mazda, the mountain

miraculously opened up and concealed her from her pursuers. Water runs out where the shrine nestles in the steep rocky wall of the desert mountains, and there is a little vegetation here amid the surrounding aridity. The shrine has become an international pilgrimage center for Zoroastrians, with thousands of believers turning up for the annual pilgrimage season between June 14 and 18. This sacred place attracts visitors not only from Iran, but also from India, Australia, and North America.

Those unable to make the journey to all six "Great Shrines" can undertake a kind of "virtual pilgrimage" at the fire temple of **Kuce-e-boyuk** in Yazd, where there is a cycle of paintings depicting the six most important sites.

One peculiarity of Zoroastrian piety is the palpable joy and merriment that accompany their communal festivals. Joy is a basic trait of this religion and sadness is forbidden, as it strengthens the forces of Ahriman, the destructive spirit who makes people greedy, brutal, lethargic, and sick—tears also make it more difficult for souls to cross over to the other side.

Shiraz

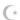

Shiraz, the location of the Shah Cheragh, the mausoleum of Amir Ahmad and Mir Muhammad, is a major Shia pilgrimage site. These were the brothers of the eighth imam, Ali bin Musa ar-Rida, who sought

refuge in Shiraz when pursued by the Abbasids. The tomb itself, masterfully decorated with tiny shards of glass, painted tiles, and mirrors, fully lives up to its name Shah Cheragh—"King of Light" in Arabic.

Shiraz is a city of wine, of roses, and especially of poetry, and a place sacred to all lovers of verse. Hafis and Saadi, the most famous Persian poets, both lie buried in Shiraz and each has been accorded an almost princely tomb. People visit the tombs to take photographs and to recite the writers' verse. All of Shiraz is filled with luxuriant gardens and flowers, giving the city a bright and airy feel. It is truly the "Garden of Iran."

Omar Khayyam, who has gone down in history as one of the earliest polymaths, lived and worked in Shiraz, and his mathematical and astronomical calculations still form the basis of the Iranian calendar. His philosophical observations were known throughout the medieval world and his melancholy poetry addresses the heart of every individual. One of his quatrains reads thus: "If life were an eternal feast— what then? / If the last day were then to dawn—what then? / If your good fortune last a hundred years / And a hundred more—what then?"

Shiraz Mosque

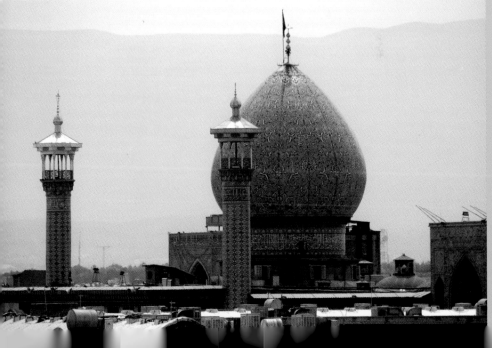

ASIA

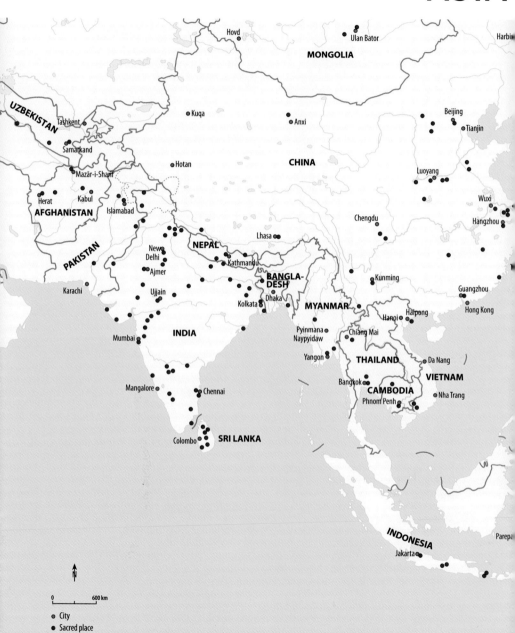

UZBEKISTAN
Tashkent
Samarkand

Kuqa

Hovd

MONGOLIA

Ulan Bator

Harbi

Anxi

Beijing
Tianjin

CHINA

Mazâr-i-Sharif
Herat Kabul
AFGHANISTAN Islamabad

Hotan

Luoyang

Chengdu

Wuxi

Hangzhou

PAKISTAN

New
Delhi
Ajmer

NEPAL

Lhasa

Kathmandu

Kunming

Guangzhou

Karachi

Ujjain

BANGLA-
DESH

Hong Kong

Kolkata

Dhaka

MYANMAR

Haipong

Mumbai

INDIA

Pyinmana
Naypyidaw

Hanoi

Chiang Mai

Da Nang

Mangalore

Chennai

Yangon

THAILAND

VIETNAM

Bangkok

CAMBODIA

Nha Trang

Phnom Penh

Colombo

SRI LANKA

INDONESIA

Parepa

Jakarta

N

0 600 km

● City
● Sacred place

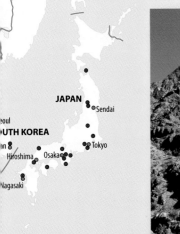

JAPAN
Sendai
eoul
UTH KOREA
an
Hiroshima
Osaka
Tokyo
Nagasaki

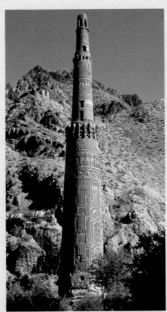

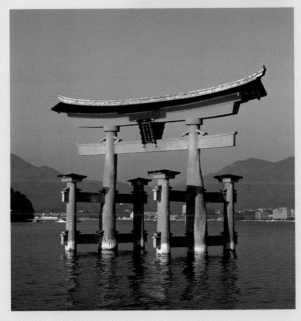

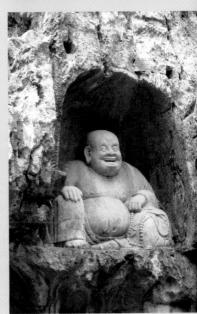

The Mausoleum of Pahlavan Mahmoud, Khiva

☾⋆

Khiva, the "Least of the Noble," as this ancient oasis city on the Silk Road was known, holds a very particular attraction for visitors when taken as a whole. A city of many mosques and madrasas, it still attracts many visitors today. The tomb of Pahlavan Mahmoud (1247–1326), a local divine known as "the strong man," has achieved wide fame; the turquoise tiles of the mausoleum's dome shine out across the roofs of the city. Pahlavan was renowned not only for his courage but also for his poetry and his powers of healing—a true folk saint. After his death he was buried by his companions in the same workshop where he had lived and worked.

There is a relatively plain 14th-century building on the site but the modern mausoleum dates back only to 1810. The building is impressively harmonious in its proportions, with a skillfully decorated façade and an interior clad entirely in painted majolica tiles. The white designs on a blue background depict countless floral ornaments, arabesques with flowers, and foliage, all representing spring. The beauty of the entire mausoleum, which also serves as a tomb for several khans, takes one's breath away. The actual shrine, Pahlavan Mahmoud's cenotaph, stands in a separate anteroom. Above the door lintel there are a few lines by the poet, displaying his wise irony: "It is easier for me to say the same words a hundred times, to spend a hundred years in prison, or to turn a hundred mountains to sand, than to teach wisdom to a single idiot."

A view of the Old City of Khiva with the Mausoleum of Pahlavan Mahmoud

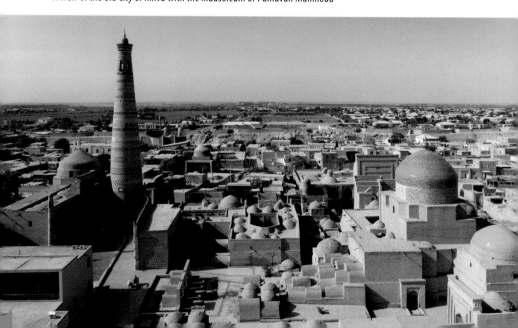

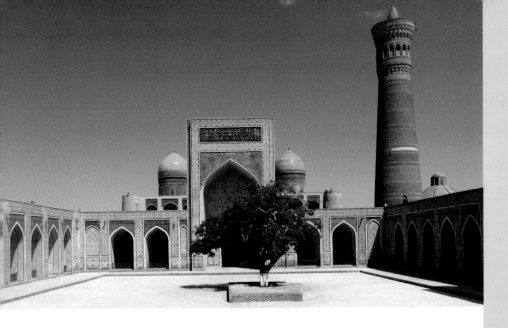

Inner courtyard of the Kalan Mosque, Bukhara

Bukhara

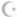

Modern visitors stop in astonish-
ment at the sight of the skyline of this
town, which has not changed since
the Middle Ages. The town was first
settled in the 3rd century BC, and as
Bukhara lies on the old Silk Road,
merchants brought not only their
wares but also their religion. People
came from all over the known world,
from Persia, India, even from China,
and the town adopted a multitude of
faiths. Zoroastrians, Buddhists, Mus-
lims, and even a few Christians settled
here and practiced their religious ritu-
als. Bukhara is a city of many fountains
and its wonderful buildings shimmer
in the heat, lending the city an almost
supernatural appearance. Bukhara

has always been a center of Muslim
scholarship, as can be seen from one
of the more modern and impressive
buildings, the **Mir-e-Arab Madrasa**, built
in 1807. There is a mosque attached to
the madrasa, but the greatest empha-
sis has always been laid on teaching,
with students attending lectures in
the most important subjects, par-
ticularly religious education.

The minarets, symbolizing the
link between heaven and earth, house
muezzins who call the faithful to
prayer in locations all over the city,
such as the **Kalan (or Kalyan) Mosque**, a
striking feature of the skyline built in
1515. The tiles at the entrance portal
are decorated with thousands of
inscriptions and geometrical pat-
terns and the glazed turquoise dome
towers over the entire complex. The

ASIA

architecture and decoration of this mosque must surely have helped to establish Bukhara's reputation as the "noble and glorious fortress of the faith." Another building contributing to the impression of magnificence is the **Samani Mausoleum** built between 892 and 943 for Ismael Samani, the founder of the eponymous ruling dynasty. The façade, which looks like delicately woven fabric, is in fact made of clay bricks. As a city, Bukhara is certainly the stuff of dreams, past, present and future.

Samarkand

Toward the end of the 14th century, Muslim Asia was overtaken by a great catastrophe—the incursions of Tamburlaine (Timur-e Lang) and his troops. The wild adventurer's speedy and merciless raiding missions conquered large portions of Asia, especially the territory now covered by Afghanistan, Iran, and Uzbekistan. Timur was a resolute fighter for the cause of Orthodox Islam and his goal was to be instrumental in the re-establishment of a unified Muslim state, although his campaigns were almost exclusively conducted against fellow believers. Timur's raids inspired dread and he often left whole tracts of land behind him where the livelihoods of the local farmers had been wiped out wholly. Toward the end of his life, his empire stretched

from Russia to China. In 1404 he returned to Samarkand, his capital, and died at the age of almost 70 while preparing a campaign against China.

Along with his legacy of terror, Timur also left behind one of the most beautiful cities in the world, Samarkand, which has lost none of its charm to this day. This oasis in the Zarafshan river valley had been conquered by Alexander the Great in the 4th century BC, but in AD 712 it was retaken by the Arabs, who built the first mosques. Samarkand was an important station on the Silk Road and soon attained prosperity and renown. The town reached its heyday during Timur-e Lang's lifetime, when the best artisans and artists were brought to the city, constructing buildings so impressive that they led some to describe Samarkand in yearning tones as the "most beautiful city in the world." The mosques, madrasas, and mausoleums built during Timur's reign are among the most beautiful edifices in the whole of Islamic art.

The central focus of the city has always been the Registan, but the **Friday Mosque of Bibi-Khanym**, built between 1399 and 1404, is also exceptional. The giant mosque's blue and green tiles, gilt ornamentation, and the beautiful inscriptions on its ribbed dome once shone out as if from the *Tales of 1001 Nights*. Flanked by round towers, the mosque's main portal opened out onto the square, inviting the faithful into the spacious inner courtyard lined with domed arcades supported by marble pillars. The façades were covered with multi-colored glazed

cladding and slender minarets rose to heaven from each of the corners. Restoration work on the mosque, which was collapsing under its own weight even as it was being constructed and was completely destroyed in an earthquake of 1887, has been going on for the last 30 years. Although it is still little more than a building site, the Bibi-Khanym Mosque is a place where heaven and earth seem to touch.

Muslim scholarship in 15th- to 17th-century central Asia was concentrated in the **Ulugh Beg Madrasa**, an imposing building where, as well as theology, mathematics and astronomy in particular were taught. A striving for knowledge is an important attribute of Islam.

The city's mausoleums are equally impressive, and those who built them not only constructed a monument for themselves but also a destination for pilgrims from all over central Asia, who find an affirmation of their faith in the presence of their ancestors in such places.

One key building is the **Mausoleum of Gur-i-Amir** with its characteristic melon-shaped, ribbed dome housing the tomb of Timur. The entrance *iwan* is a later addition of 1434, constructed during the reign of Ulugh Beg. Ulugh Beg is buried in the same mausoleum and is also greatly venerated. The city has many other beautiful buildings as well, several of which have been restored gradually since the 1950s.

Minaret and dome of the Bibi-Khanym Mosque, Samarkand

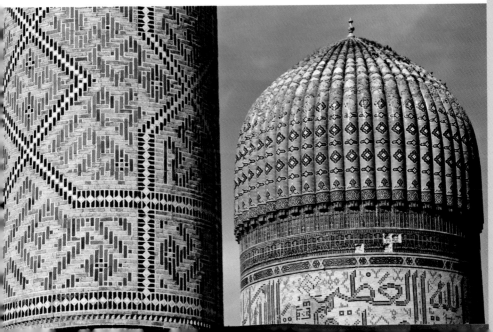

The Blue Mosque of Mazar-i-Sharif

☾

It is likely that the fact that this city in Balkh province in northern Afghanistan is one of the most sacred places in Islam is largely based on an error. Although the tomb of the first imam, Ali bin Abi Talib, is venerated here, Shia theologians are in agreement that his actual grave is in Najaf in Iraq. It is rather more plausible that the ancient Persian prophet Zarathustra lies buried here, as the place is associated with tales of a holy man from the pre-Islamic period. Whatever the truth, Mazar-i-Sharif is the most important pilgrimage site for Shi'ites in Afghanistan, more than a few of whom regard the Blue Mosque as the most beautiful in the world. This may be a slight exaggeration and a function of Afghan pride, but the mosque is without doubt a singular gem of Islamic architecture.

The mosque lies at the physical center of the old city and is approached from all directions by main thoroughfares; it is also the religious center of the city, whose name means "tomb of the saint." The mosque is completely covered in blue, turquoise, green, and gold tiles and glimmers with a blue light in the sunshine. It is surrounded by extensive gardens, making the whole complex an oasis of peace and quiet, although any tranquility and harmony are currently in short supply. The chaos and the consequences of the war that

The Blue Mosque, Mazar-i-Sharif

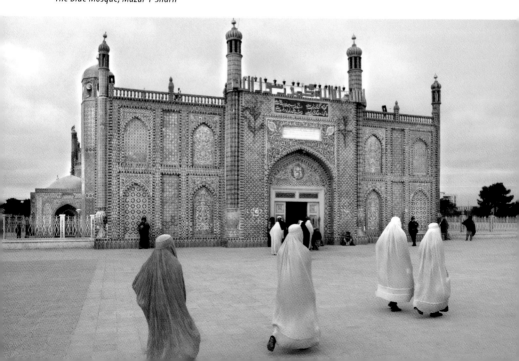

ended Taliban rule here still continue, and at the end of the first decade of the 21st century there is no indication of how this country, weakened by war, will find peace.

The Blue Mosque in Mazar-i-Sharif is a shining example of how beauty and prayer can be stronger than destruction and power, and the people of Afghanistan share this feeling, journeying in great numbers to the place to pray in the hope of a life of peace. The mosques are particularly full in spring, during the festival of Nowruz (the celebration of spring and the old Iranian new year).

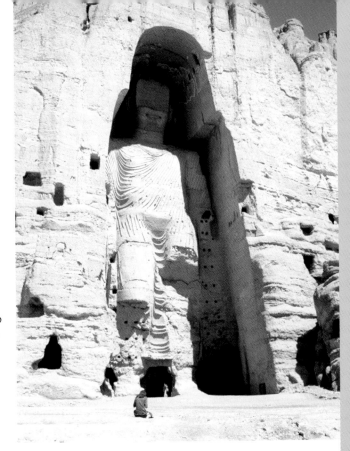

Buddha statue, Bamiyan

Bamiyan

This deeply sacred place no longer exists. The world-famous Buddhas of Bamiyan were the largest known Buddha statues in existence until they were destroyed by the Taliban in March 2001. The Bamiyan Valley is located at an elevation of 8,200 feet (2,500 m) between the Hindu Kush and the Koh-i-Baba Mountains, and the gigantic statues were carved out of the cliff in the 6th century. The smaller figure was about 115 feet (35 m) tall, and the larger about 175 feet (53 m) tall. The large statue was a representation of the Buddha Dipankara, a Buddha of the Past; the smaller represented Buddha Shakyamuni, the Buddha of the Present. Some people have suggested that the size of the two Buddhas was determined by a kind of mystical numerology: 53 units for the large statue,

35, the former number reversed, for the smaller. Adding the two digits together yields 8, symbolizing the eightfold path. Besides these two Buddhas, there is said to have been a reclining Buddha figure that has never been located.

Many years previously, King Kanishka, the 1st-century ruler of the area around Bamiyan and himself a convert to Buddhism, had been at pains to make this region on the Silk Road an important center for scholars, poets, and pilgrims. The Chinese traveler Xuanzang recorded that the statues were once plated with gold, and at one time thousands of Buddhist monks lived in the caves in the rocky valley until the triumphal procession of Islam reached the Afghan mountains in the 7th century. After that the statues lost their religious significance and were subject to repeated attempts to destroy them. On March 12 2001 the Taliban blew up the two Buddhas. An international team of archeologists and experts have since been trying to preserve the sacred site, and there have been attempts to reconstruct the Buddhas. Whatever their future holds, this place remains a sacred site to many.

in what remains of the Friday Mosque at Herat. After the original building on the site was destroyed by fire, the Ghurid ruler Ghiyath ad-Din commissioned a replacement in 1200 or 1201 which was to become one of the architectural gems of Afghanistan. The central inner courtyard was flanked by four *iwans* decorated with glazed tiles bearing Kufic calligraphy, floral motifs, and geometric patterns, and the main portal was embellished with inscriptions and images made from hand-cut terracotta tesserae. Sadly, little remains today of the wonderful Ghurid building, but a glass tile workshop utilizing traditional techniques has recently opened and the mosque is being painstakingly and authentically restored with the support of the German Society for the Preservation of Afghan Culture.

The Great Mosque has remained a sacred place despite the lasting turmoil in the country, as can be seen from the large bronze cauldron from the year 1375, which once served as a vessel for refreshments for the faithful and which is now set up under an arcade to collect donations. People give from the little that they have for the rebuilding of the mosque.

Great Mosque, Herat

The creative arts enjoyed unparalleled growth under the rule of the Ghaznavids and the Ghurids in the 11th and 12th centuries. The fruits of this period of expansion can still be seen

The Minaret of Jam

This sacred place is rather strange, as it is the last remnant of what was once a great complex of palace

buildings with its own Friday Mosque. The other buildings have been destroyed, eroded, or washed away in flash floods in the course of the centuries, and only the magical minaret has been preserved, standing like a lighthouse in the middle of an area where no lighthouse was ever required. The term "minaret" is derived from the Arabic word *manara*, a "place where there is light," perhaps a reminder of the tradition of lighting high signal beacons to provide orientation for sailors on treacherous seas. Nowadays the call to prayer is heard from minarets, its role and purpose to guide the faithful through the sea of life.

Built in the 12th century, the 207-foot (63-m) high structure is situated at the confluence of the Hari Rud and the Jam Rud rivers. The free-standing tower was located on the Silk Road and so it is likely that it was seen and visited by great numbers of people. Villagers and archeologists have found ancient artifacts here suggesting the presence of people of the Jewish, Zoroastrian, Buddhist, and Hindu faiths. The minaret is constructed of bricks that stand out impressively against the ocher yellow rocks of the surrounding mountains, and the woven pattern of the masonry makes the structure look particularly delicate. It is decorated with turquoise inscriptions of verses from the Koran that still retain their enigmatic glimmer. This is a place of faith in the middle of a raw and inhospitable landscape, a place of light, both past and present.

The Minaret of Jam

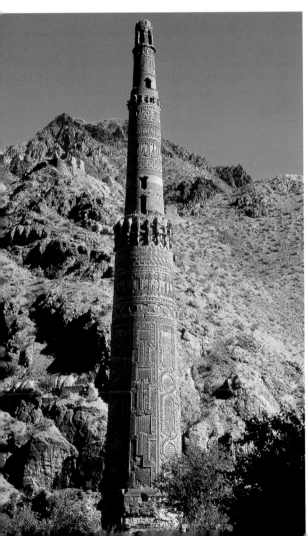

ASIA

Gandan Monastery, Ulan Bator

Mongolian Buddhism combines elements of ancient religious culture with the basic principles of the Tibetan "Yellow Cap" sect. The Gelugpa (Yellow Caps) emphasize monastic disci-

Part of the Gandan Monastery, Ulan Bator

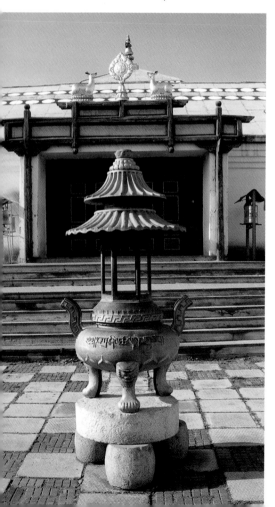

pline and the application of logical reason in debate. They also believe that the status of "Buddhahood" can be achieved on earth. Since Mongolian Buddhism is a monastic religion, it is no surprise to learn that there were some 600 monasteries in Mongolia at the turn of the 20th century.

Gandan Monastery, the largest foundation, was built in Ulan Bator, the capital, in 1838 and is now once again run by monks. Thousands of monks once lived and meditated here, but now there are only about 100 running the monastery. It has become an important pilgrimage site, not only for Mongolian Buddhists but also for the global Tibetan Buddhist (Lamaist) community. Special veneration is reserved for the great statue of the Bodhisattva Avalokiteshvara—known here as Janrasig—at whose feet there is always a large pile of money, presented by pilgrims as votive offerings. Gandantegchinlen Khiid, the monastery's full name, means the "island of complete joy," and this is the hope of the many pilgrims who visit the shrine every year.

There is one small room in the monastery where people wait patiently to be allowed in. This is the room of the astrologers, and people with worries or personal petitions come here to seek the advice of experienced stargazers, from whom they hope to receive help for the future. Fortune-tellers, adopting the role of the traditional shaman, are a fixed part of Mongolian culture. Their mixture of esoteric wisdom and practical suggestions guarantees long queues of people seeking counsel.

Erdene Zuu Monastery, Kharkhorin

✴

This monastery is another important pilgrimage site for Mongolian Buddhists. In the 13th century Kharkhorin (once known as Karakorum) was the capital of the Mongolian Empire, but nowadays it is a small town. Its importance has grown since the 1990s, however, thanks to the increasing

The wall of the Erdene Zuu Monastery, Kharkhorin

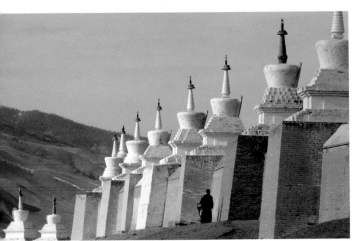

popularity of the 16th-century Erdene Zuu Monastery. Most of the monastery's buildings, which were begun in 1585, were destroyed during the period of communist rule and only the impressive curtain wall and four of the original 60 temples remain. The wall is punctuated by 108 stupas, memorial monuments containing relics, and the

monastery setting is simply extraordinary. Masonry from the earlier city of Karakorum was used to build the wall.

The temples, which are now used as museums, are built in the Tibetan Buddhist (Lamaist) style and contain an impressive collection of Lamaist artworks, but modern pilgrims are more concerned with the valuable artifacts for meditation and prayer that can be purchased at the monastery. The prayer wheels, incense bowls, incense paraphernalia, prayer flags, and prayer scarves are not old, but they are of high quality, and in purchasing them pilgrims are supporting the rebuilding of the monastery and the school for the nomadic children of the thinly populated steppes.

Special veneration is reserved for a large stone turtle that stands like a temple guard in front of the monastery. In Buddhism, the turtle embodies longevity stretching into immortality, and turtles are considered refuges for human souls on their long path to nirvana. The turtle also represents reflection and wisdom, and you can expect to find this stone animal draped in huge numbers of prayer scarves.

Mogao Caves

The Diamond Sutra, one of the most important texts in Mahayana Buddhism, talks of the "perfection of wisdom which can cleave even a diamond"; this is indeed the literal translation of the title. The teachings of the Buddha, as clear and as pure as a diamond, concern the dispelling of the illusions and false impressions that prevent mankind from breaking

Entrance to the Mogao Caves, Dunhuang

free from the circle of suffering. The Diamond Sutra was first recorded on a wooden tablet dating back to 868 that is now preserved in the British Museum. The sacred text was found in one of the grottos at Mogao near the city of Dunhuang in northwestern China, a complex of nearly 1,000 caves dug out by Buddhist monks between the 4th and the 12th centuries. They are filled with every conceivable Buddhist motif and statue, and scenes from the life of the Buddha. About half of the caves are still accessible today and these represent a holy pilgrimage site for Buddhists.

Impressive even from the outside, the giant complex commands reverence from visitors. The temples have been masterfully worked into the local sandstone. The interior reveals a wealth of lively images, a collection of Buddhist precepts or a sermon by the Buddha turned into pictures, a form understandable even to an illiterate populace. Those who came here to join the monks were able to meditate on their teachings and on the eightfold path; in the remote rock temple there was nothing to distract from complete immersion in thought. The monastery is no longer inhabited by monks, but it is still possible to gain an impression of the holy solemnity in which the monks attempted to lead a righteous life.

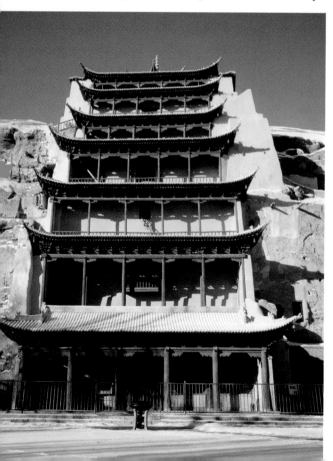

Yonghegong Temple, Beijing

The Palace of Harmony and Peace (Yonghegong) is the largest Tibetan Buddhist (Lamaist) temple in the city and its history dates back to 1694. The site was originally earmarked as a residence for Prince Yinzheng, but upon his succession to the throne he gave the palace to Buddhist monks. The complex only became a monastery and a temple in 1744, however, and at times housed up to 1,800 Lamaist monks from Tibet, Mongolia, and Manchuria.

Enter through the two ornamental gates and you will see the temple precinct and a graceful little garden leading into the first courtyard, where there is a bell tower and a drum tower. The opening and closing of the temple gates in the mornings and evenings is signaled with bells and percussion. Pilgrims are welcomed into the adjoining Hall of the Celestial Kings by the friendly smile of a portly Buddha (Mile Fo) surrounded by four fierce-looking Celestial Kings. A statue of Skanda stands in the background—according to legend, he was the disciple of Shakyamuni who took care of the relics of the Buddha after his death. Then follows the Hall of Harmony and Peace (Yonghegong) after which the temple is named, and here visitors will find the Buddhas of the three ages: Shakyamuni, the Buddha of the Present, Maitreya, the Buddha of the Future, and Kashyapa, the Buddha of the Past. They

The Great Buddha, Yonghegong Temple, Beijing

ASIA

Temple of Heaven, Beijing

are surrounded by 18 *arhats*, the enlight-
ened ones who will never enter nirvana
who keep the teachings of the Buddha
alive and help others toward redemption.

From here, visitors proceed to
the Hall of Everlasting Protection
(Youngyou Dian), where three tran-
scendental Buddhas are venerated—
Amitabha, the Buddha of Ineffable Light,
Simhanada, the Buddha of the Voice
of God, and Bhaisajyaguru (Chinese:
Yaoshi Fo), the Buddha of Medicine.

After this, there is the Hall of the
Wheel of the Law (Falun Dian), the
assembly room and meditation space of
the monks of the monastery. This hall
was once completely empty, symbol-
izing the highest wisdom and the goal
of all being. In the middle of the room
there is now an almost 20-foot (6-m)
high statue of Tsongkhapa, the founder

of the Buddhist Yellow Cap sect of which
the Dalai Lama is also a member. The
holy scriptures of Tibetan Buddhism are
kept in this hall, wrapped in silk cloths.
One feature of the hall is the depic-
tion of the Mountain of the 500 Luohan
(*arhats*), the disciples of Buddha—the
figures are made of gold, silver, bronze,
tin, and copper. Some of the figures are
covered with cloths as they show sexual
positions that may be revealed only to
advanced students of Buddhist doctrine.

The last in the row of temple buildings
is the Pavilion of Ten Thousand Happi-
nesses (Wanfu Ge), which, at 100 feet (30
m) in height, is considerably taller than all
the other buildings. It was built in 1750 to
house a giant sandalwood tree trunk pre-
sented to the monastery by the 7th Dalai
Lama. An image of Maitreya, the Buddha
of the Future, carved into the wood is

greatly revered. The hall is also called the House of the Great Buddha (Dafo Lou) in his honor. With its rich iconography and precious decoration, the Lama Temple has remained an important pilgrimage site for Chinese Lamaist Buddhists to this day.

Temple of Heaven, Beijing

No one comes to Beijing without visiting the imposing complex of the Temple of Heaven (Tiantan Si) in the southern suburbs. Even the emperor would come here to commune with heaven at least twice a year. The temple was founded at the behest of the Yongle Emperor of the Ming Dynasty (1420), and acquired its present appearance during the reigns of later emperors of the Ming and Qing Dynasties.

The basic forms of the complex are the circle and the square, the two geometric forms representing the harmony of the cosmos, with the square of the earth being surrounded by the circle of the heavens. Much of this temple symbolizes the sky, from the cloud motifs to the blue enameled tiles of the temple roofs. Heaven and earth in their ideal states form perfect harmony, and harmony ensures prosperity and a long and happy life. Balance in nature was a further concern: if the emperor no longer acted in harmony with nature, this disjunction would be expressed in the form of storms, floods, droughts, and other catastrophes.

In addition to the geometrical shapes, the entire complex is covered in forms dictated by Chinese numerology. Odd numbers are assigned to heaven, in particular the nines and threes encountered in the temple. Nine is considered particularly fortunate. The three terraces of the Altar of Heaven (Tian Tian) built in the mid-16th century represent the three levels of the world: heaven, earth, and humanity. The concentric rings of cobbles in which the terraces are laid out always produce a multiple of nine, as do the marble columns surrounding the terrace. Three lots of nine steps, aligned to the four cardinal points of the compass, lead up to the top terrace, precisely in the middle of which there is a round stone considered to be the center of the world.

The Imperial Vault of Heaven (Huang Qiong Yu), lying exactly along an axis running north–south from the Altar of Heaven, is also covered with blue tiles; here too, the heavens are worshiped and divine help enlisted. This part of the temple is surrounded by a circular wall—the famous Echo Wall, where any word spoken reverberates in such a way as to be heard on the opposite side of the circle without difficulty.

The Hall of Prayer for Good Harvest (Qinian Dian), the most imposing part of the complex, is approached via a processional route about 1,640 feet (500 m) long that begins at the Gate of Prevailing Virtue (Chengzhen Men). The circular hall rises to a height of almost 130 feet (30 m) from its three-tiered terrace and its roof is supported by four mighty wooden pillars decorated in red and gold, symbolizing the four points of the compass. Around these four columns there are two further rings,

each of 12 smaller columns. These can be seen to represent the 12 Chinese seasons and the 12 double hours into which the Chinese divide the day. The whole hall is richly ornamented with painted abstract designs. Completed in 1420, the Hall of Prayer for Good Harvest is the oldest building in the complex.

The Temple of Heaven in Beijing is truly a divine ensemble of impressive beauty, and rich in symbolic references linking mankind and heaven.

Baiyun Guan, Beijing

At the entrance portal of the most important Daoist temple in Beijing, the Temple of the White Cloud (Baiyun Guan), there is a sign with the words: "The Wonderful Place of the Grotto of Heaven." Heavens and mountains are both represented in this temple, which has been a center of North Chinese Daoist spirituality

Sacred mountains in China

Sacred places in China are either holy (*sheng*) or powerful (*ling*). Literally translated from the Chinese, pilgrimage (*chaoshan jinxiang*) means "showing respect to the mountain" (*chaoshan*) by bringing it incense (*jinxiang*). This latter is done to commune with the gods. "Shan" denotes either a single peak or a chain of mountains, and can also refer to mountain grottos or even islands; it describes any part of a mountain range. In China, mountain peaks, however modest they may be, have always been regarded as gates into heaven and the seats of the gods, and those who climb mountains do so in the hope of getting closer to heaven. They are attending a "celestial audience," so it is no surprise that this millennia-old tradition of mountain-worship is still maintained today. For Daoism, climbing a mountain is a sacred undertaking; it causes a transformation, and a climber returns a changed person from the one who began the ascent. Setting foot on a sacred mountain opens a "heavenly gate." A Chinese

proverb says: "He who enters the gate to the Celestial Mountain puts his life in the hands of the gods; only when he returns does he become a citizen of this world again."

Daoism's sacred mountains include **Mount Tai** ("the mountain of utter peace and total redemption") in Shandong, which is the Eastern Peak. **Hengshan** (the "horizontal, diagonal mountain") in Hunan is the Southern Peak. **Mount Hua** ("blossom mountain") in Shaanxi is the Western Peak, and **Hengshan** (the "mountain of constancy") in Shanxi is the Northern Peak. **Songshan** ("high, serene mountain") in Henan, the sacred mountain of the Center, was a later addition.

For similar reasons, Chinese Buddhism also considers mountains to be sacred and associates them with metals, the basic substances of the earth: **Jiuhuashan** in Anhui represents iron, **Emeishan** in Sichuan bronze, **Wutaishan** in Shanxi gold, and **Putuoshan** in Zhejiang denotes silver.

since the days of Mongolian rule. A monastery founded on the site during the Tang Dynasty (618–906) rose to particular importance in the 13th century, when the khan appointed the renowned priest Qiu Chuki as the supreme Patriarch of all Daoists. The present temple dates back to the Qing Dynasty (1644–1911) and many of the buildings have been restored only in the last few years. The temple was closed during the Cultural Revolution, when it served as factory space, but it has now once again become a sacred place for Daoists, who regained possession of the temple in the 1980s.

The temple complex has a classic layout, with six main halls aligned along a north–south axis and the entrance to the consecrated area marked with a large ornamental gate. A small courtyard then leads to a gatehouse guarded by lions, where three gates symbolize the three worlds: the world of desire, the world of physicality, and the world of the spirit.

The next hall (Ling Gong Dian) contains the four officials of the Celestial Council, who enjoin visitors to show respect. The following hall is that of the Jade Emperor (Yuhuang Dian), the highest deity in the Daoist pantheon. There then follows the Hall of the Old Law (Laolü Dian) where the monks read holy scriptures. In front of this hall there is a copper donkey that enjoys special reverence, as people believe it can cure sickness. In the Hall of the Ancestors (Qiuzu Dian) there is a statue of Qiu Chuji. Behind this there is a two-tiered pavilion; the first floor is dedicated to the worship of the four Celestial Emperors, the top floor to the "Three Pure Ones."

The "Protectors of 60 Years" situated in a side pavilion represent a firmly entrenched tenet of Daoist belief. The universal life-cycle of mankind amounts to 60 years, a number generated by multiplying the 12 signs of the Zodiac (rat, ox, tiger, rabbit, dragon, snake, horse, goat, monkey, rooster, dog, and pig) by the five elements (earth, water, fire, wood, and metal), and this combination has formed the basis for Chinese horoscopes for more than 2,000 years. The cycle repeats every 60 years, and for each of these 60-year periods there is a guardian spirit sitting in this pavilion. As you would expect, it attracts many believers who come here to pray.

Mount Heng, Shanxi

Hengshan, or **Mount Heng**, one of the five holy mountains of Daoism, is located in the northeast of Shanxi Province. The mountain's highest point (6,617 feet/2017 m) is known as Xuanwufeng.

There are several tourist sights in the mountain range, but the most famous is without doubt the **Hanging Monastery** built on a steep cliff near the Pass of the Golden Dragon. Constructed in the 6th century, the monastery consists of 40 pavilions and halls perched on elaborate frames anchored in cracks in the rock. The buildings nestle in the rocks like a bird's nest, seemingly linking the earth and sky.

The Chinese character for the universe is "heaven-earth." The earthly world comprises soft forces (yin) and strong forces (yang). The soft forces rise up, forming the heavens, and the strong ones sink down to form the earth. The summits of mountains touch the sky, the rocks lend mountains solidity, and so it is with people: the head is round like the sky, the feet are flat like the earth on which they stand. In Daoism, mountains and human bodies are alike. Both sky and earth are interconnected, however, and enlivened by the forces of yin and yang, which effect a kind of circulation and eternal exchange. For Daoists, all mountains basically represent their own bodies, and those who reach their summits come closer to themselves. Mountain climbing is thus not a recreational pursuit but a spiritual exercise containing two elements: a striving for heaven and a return to ground level.

Yungang Grottos

Mountains were always of great significance in the life of the Buddha, and the same is true for Buddhist cosmology. Buddhists consider mountains among the most sacred of places, and temples and statues are often carved into the living rock of mountains. The tradition of building temples among rocks came from India and Afghanistan. A particularly striking example of this is to be found in the 252 caves at Yungang on the southern face of the Wuzhou Shan, where 5th- and 6th-century Chinese

Hanging Monastery, Mount Heng, Shanxi

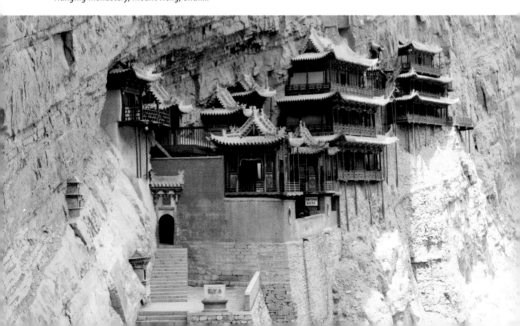

Yungang Grottos, Datong

masons created astonishing sculptures and reliefs. The caves contain more than 50,000 statues of the Buddha, the smallest of which are little more than an inch high (2.5 cm), with the largest approaching 57 feet (17 m). Even before the caves received this ornamentation, the location was a sacred place thought to radiate mysterious powers.

The monk Tan Yao persuaded the emperor to back the project and work began in 460. It took more than 60 years before everything was complete. Modern visitors can see the effects of time and weathering; the façade has been eroded and little of the original decoration is now visible. The interior is a different matter; here you can still admire the bright tones chosen by the artists and get an idea of the extensive scope of the whole project. The statues of the Buddha are accorded the highest reverence, and the figure is usually represented executing one of his typical gestures, the

"*Mudra* of Fearlessness," with his right hand extended upward, the palm open to his interlocutor. There is a story that the Buddha once calmed a raging elephant with this simple gesture. It is impossible to say for sure whether this actually happened or if indeed it belongs in the realms of myth, but one thing is certain: a gesture can be enough to quell hostility, and a hand that is apparently raised in defense can encourage others to be fearless. In this sacred place, even non-Buddhists can learn about how to deal with people.

Mount Wutai

This chain of mountains in the north of Shanxi Province is one of the four sacred mountains of Buddhism in China, along with Jiuhuashan, Emeishan, and Putuoshan. The **Five-Terrace Mountain** (the literal translation of Wutaishan) is consecrated to Manjusri, the Bodhisattva of Wisdom, as legend has it that he lived on the five peaks of the mountain as he spread his teachings. The five peaks are arranged in a crescent formation, beginning with Dongtaifeng in the east, then Beitaifeng to the north, followed by Zhongtaifeng,

the central peak, then Xitaifeng to the west, and finally Nantaifeng, the southern summit.

For Buddhists, the most important summit of all is the northern summit (10,006 feet/3,050 m), at whose feet a cluster of temples and monasteries has been built in and around the village of Taihuai. Dominating the village is the gleaming white **Dagoba Pagoda**, 164 feet (50 m) high, which is said to house a hair from the head of the Manjusri. The pagoda's plinth is surrounded by prayer wheels. The library has achieved considerable fame for its extensive collection of sutras, which fill two floors and are intensively studied and recited by the monks, thereby following the way of the Manjusri and striving for wisdom.

Founded in the 1st century, **Xiantong Si** (Temple of the Manifestation) is the oldest and largest of the temple complexes and features an architectural form that is extremely rare in China: the Joistless Hall is made of brick, with vaults of masonry. The real destination for pilgrims to the temple is, however, the early 17th-century Bronze Hall, now devoted to worship of the Dragon King, whose interior walls are adorned with almost 10,000 reliefs of the Buddha.

Temple of the Golden Hall, Mount Wutai, Shanxi

North of the temple there are 108 steps up to the **Bodhisattva Summit** (Pusa Ding). This area is mainly the preserve of monks and pious pilgrims, and foreign visitors feel like intruders into a closed world.

A little to the south of the village you will find the **Shuxiang Si** (Temple of the Image of Manjusri) with its monumental statue of the Bodhisattva riding on a blue lion, at whose feet there are always large numbers of votive offerings.

The **Jinge Si** (Temple of the Golden Hall) is a popular destination for pilgrims for its 66-foot (20-m) high statue of Guanyin, the Goddess of Compassion, depicted here with 1,000

arms and 1,000 eyes. This deity is particularly well-liked by women throughout China, as her kind-heartedness promises the blessing of children.

There is a very special atmosphere, a mixture of homecoming and leaving, at the **Bishan Si** (Temple of the Emerald Green Mountains), one of the most extensive temple complexes, which is used as accommodation for the many pilgrims who visit the mountain range. Crowds of people bustle around, all of them seekers and all protected by a Jade Buddha who seems to watch over them from his vantage point in the main hall of the temple.

Mount Tai

The ancient Chinese conception of the world saw the "Land of the Middle Kingdom" as a square, with Mount Tai forming its eastern corner. The mountain is located north of the city of Tai'an in Shandong Province. At 5,070 feet (1,545 m) it is not excessively high, but in ancient China it was

thought to be the highest mountain in the world, and rulers would make a pilgrimage here to offer sacrifices and pay homage to the spirits of heaven and earth. The ascent is arduous but not particularly dangerous, as there is a flight of steps almost six miles (10 km)

Steps up to the Temple of the Jade Emperor, Mount Tai

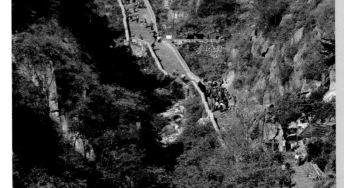

long leading to the summit, with a total of 6,293 steps; those who reach the top will have risen 4,430 feet (1,350 m).

There are a number of gates and palaces along the way, and at the summit stands the Temple of the Jade Emperor, who is revered as a god at the pinnacle of the Daoist pantheon. The Palace of the Jade Emperor, a sacred area of particular significance, represents the mountain as a whole; entrance to this place is seen as an ascent of, or an entrance into, the mountain. The mountain, a micro-cosm of the world itself, consists of three levels: the lowest is the under-ground world of water, the middle one is the earth, and the topmost is the heavens. The heavens and the earth together form the universe.

Qufu

Qufu is rather a small city, but it has been the most important pilgrimage site for Confucianism for 2,500 years. In 551 BC Kongzi, possibly the most influential philosopher in history, and better known throughout the world under his Latinized name of Confucius, was born in Qufu. The great Temple of Confucius (Kong Miao) now stands in the city in his honor, and legend has it that it dates back to 478 BC, supposedly being erected on the site of the philoso-pher's house only a year after his death. Such an early dating cannot be verified, however, and the modern buildings,

nine halls and gates spread along a north–south axis about half a mile (1 km) long, all date back to between the 16th and the 18th centuries.

The **Temple of Confucius** can be thought of as a temple only up to a point, as people generally come here not to pray but to pay their respects to the great philosopher. Civil servants have been visiting the place for centuries after passing their examinations. The complex nonetheless resembles a classic temple precinct, and the Apricot Altar (Xing Tan), built in 1018 on the spot where Confucius is said to have debated with his students beneath an apricot tree, is accorded particular reverence. Directly behind this is the beautiful and serene Hall of Great Achievements (Dacheng Dian). A great festival has been held in the hall every September 28 to this day, with processions and chant-ing to celebrate Confucius' birth-day. There are 120 engraved stone tablets decorated with scenes from the life of the philosopher in the Hall of the Signs of the Wise Man.

A little to the north of the exten-sive temple area is the **Forest of the Kong Family**, a large wooded area of ancient trees. This forest conceals the tomb of the master, who is revered here like a saint. The stone sculptures of people and animals to be found at every turn in the forest make it a magical place, full of inspiration for the imagina-tion. Confucius' tomb is a small, grassy mound; it is not known for sure that the philosopher is in fact buried here, but this does not detract from peoples' reverence for the site.

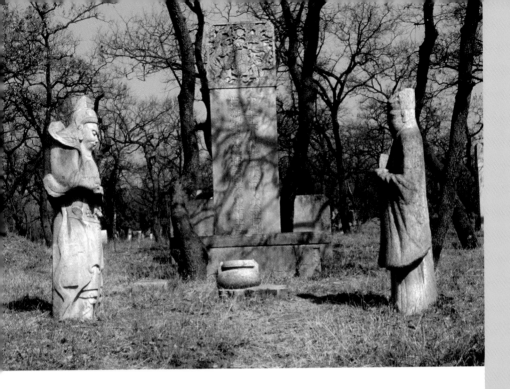

Confucius' tomb, Qufu

Mount Hua

Mount Hua (Huashan), located in
the east of Shaanxi Province, is one of
the five sacred mountains of Daoism.
There are five summits set starkly
against the sky, and each is considered
holy, as the mountain represents a
sacred unity. Each point of the com-
pass is ascribed to a separate summit,
and there is one central peak. Pilgrims
first encounter the North Peak about
halfway up; its spirits guard the inte-
rior section. Moving on, climbers next
reach the East Peak, and here they
tend to make camp in order to greet
the sun (the yang) the next morning
before continuing their pilgrimage.
The next stretch leads to the South
Peak. Daoist thought traditionally
associates the south with the noonday
sun and a terrace has been built on
the South Peak from which messages
can be sent to heaven. The messages
or prayers are written on pieces of
paper and then torn up and thrown
to the wind. After this, the pilgrim's
path leads on to the Temple of the
Jade Emperor, the greatest deity in the
Daoist pantheon. From here there is a
rope ladder to the Cave of the Hermit.
The West Summit, the last station, is
reached via a steep staircase cut into

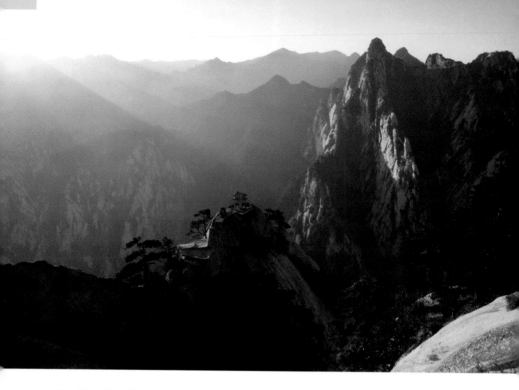

Mount Hua, Shaanxi

the rock. From this vertiginous perch, the faithful can enjoy a view over what appears to be the entire world before they descend into the valley.

Mount Song

Songshan—**Mount Song**—is a sacred place of puzzles, portents, and perils, although nowadays the mountain chain is populated less by monks and more by the many tourists who flock here. These mountains still retain some of their majesty and mystery.

Songshan's abrupt cliffs and steep summits are to be found between the cities of Luoyang and Zhengzhou in Henan Province. Symbolizing one of the five elements, it is one of the five sacred mountains of Daoism. The chain has 70 separate summits, of which Junji, the loftiest, is only 4,920 feet (1,500 m) high. The slopes are littered with countless Buddhist and Daoist temples, clear proof of the great significance this mountain has always had for the local people. Two hundred monks lie buried in the famous Pagoda Forest.

The **Shaolin Monastery** located in these mountains has achieved worldwide renown and is now open to tourists. East Asian martial arts combined with meditation are taught and practiced here, arts that are closely connected with religious notions. Shaolin monks use the martial art known as Kung Fu not principally for fighting, but rather to demonstrate to amazed onlookers the strength that can be unlocked when body and soul are trained and brought into harmony. In Chinese thought, unity is the goal of all endeavor, the result of physical and mental exertion and the interaction of every strength, both outer and inner. This is not a purely theoretical religion—it can be experienced by anyone prepared to climb a sacred mountain, or, in the meta-phorical sense, to climb the mountain of life and cross the valleys of experience.

people. The Jade Emperor put an end to the monster's activities by splitting the mountain and allowing the dragon to reach the sea. This is the spot where today the Yi River flows through the so-called Dragon's Gate. It is also the site of the most important Buddhist cave temple in China. More than 2,000 caves of all sizes, containing more than 100,000 statues, were laid out here in an ongoing pro-cess lasting over 400 years from the Wei Dynasty (after 494) to the Tang Dynasty

Shaolin monk at the monastery, Mount Song, Henan

Longmen Grottos

The name Longmen (Dragon's Gate) has its origins in an ancient legend. There was once a mountain here, behind which a dragon lived in a lake. The dragon was forever threatening the folk of the area, causing great damage and bring-ing misfortune to many

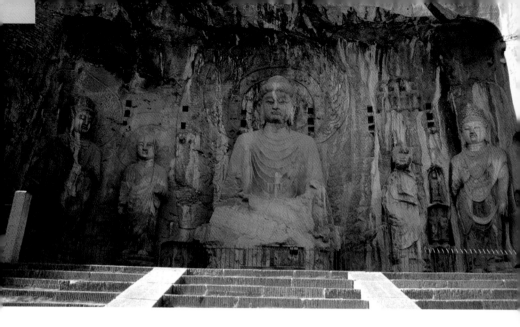

Buddha statue, Fengxian Temple, Longmen Grottos

(618–906). Believers commissioned
the work to improve their karma, giving
rise to a unique site, entirely the work of
Buddhist piety, that will fascinate all who
visit. Many of the statues were destroyed
during the persecution endured by Bud-
dhists in the 9th century, and wind and
rain have weathered some of the images
to the point of unrecognizability, but the
place has remained deeply impressive.

Qianxi Cave, with its harmoni-
ous Buddha surrounded by Bodhisat-
tvas, guardians of heaven, and pupils
is particularly beautiful. The bodies of
the figures in Binyang Cave are slender
and their robes fall in symmetrical
folds—there is an aura of serene solem-
nity within the cave. A classic arrange-
ment of figures is to be encountered in
many of the other caves: Shakyamuni
(the Buddha), sitting on a lotus flower

in the center, is surrounded to left and
right by his pupils in plain monks'
robes, and these are joined by Bodhisat-
tvas. The whole scene is framed by
fierce-looking guardians of heaven.

There are seemingly endless
Buddha figures in the Cave of 10,000
Buddhas (Wanfo Dong), with statues
and statuettes of every size—some are
barely an inch (2.5 cm) high, whereas
others are larger than life. The Lotus
Flower Cave is named after the large
lotus blossom chiseled into the ceiling.
The lotus flower symbolizes purity
and completeness in beauty, and some
of this can still be felt, even though
the carving is badly weathered.

The largest and most revered
cave is the Fengxian Temple, domi-
nating the entire complex, which is
reached via steep steps leading up to

a giant, richly decorated hollow in the rock. In the middle is an enthroned Buddha whose *mudra* or gesture is now unrecognizable, as the 57-foot (17-m) high statue has been partly destroyed. However, this does not detract from the overall impression—the sense of power emanating from the Buddha, who has mainly feminine features, is overwhelming and he is surrounded by sentinel figures.

The so-called Prescription Cave is especially odd. Here, prescriptions against diseases such as malaria, heart complaints, stomachache, and even attacks of hysteria have been carved into the rock. The representations of the Buddha in the Guyang Cave are particularly elegant and graceful. Pilgrims climb up and down the stairs to the various grottos, stopping at one or saying prayers at another. The Longmen Caves have been the goal of millions of pilgrimages, both in the past and in the present, and these visitors are by no means all Buddhists.

Suzhou

Suzhou has achieved great fame for its gardens, which are versions of paradise in miniature. The city is located

Garden of the Master of Nets, Suzhou

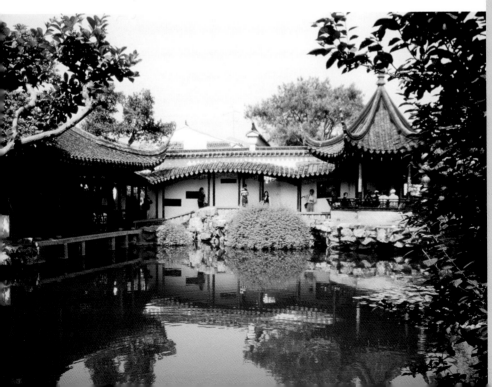

in an area known to the Chinese as the "Land of Fish and Rice"—a kind of heaven on earth. Life has always been very pleasant here. The fertile plains and mild climate delivered two rice harvests a year, and the imperial canal built in the 6th century facilitated the transportation of goods. Silk production and trading flourished, and more than 100 wonderful gardens once adorned the city. A very few have survived the centuries and are now carefully tended oases. Even the poetic names of **Suzhou's gardens** inspire the imagination: the Garden of the Master of Nets, the Garden of the Surging Waves Pavilion, the Garden of Cultivation, the Lingering Garden,

the Humble Administrator's Garden, the Forest of Lions. All of the gardens are based on a notion of a harmonious whole in which an individual can immerse himself to meditate in quiet seclusion. The gardens are still important sites for Daoists, who strive for focused emptiness here, when the greenery is not overrun by crowds. The peace and beauty of Daoist gardens help to dispel the irritations and intrusions of everyday life.

As well as the gardens, Suzhou contains a further place sacred to Daoism and Confucianism: a series of gates lead you onto the precincts of an old **Confucian temple**. The courtyard contains 13 pavilions, used for prayer but also

Hanshan Si, Suzhou

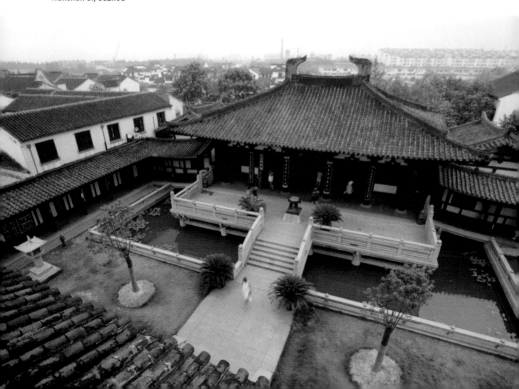

for the study of holy texts. Order gained through mutual respect is a central tenet of Confucian teaching, and an ethical system based on harmony with one's whole environment has recently increased in popularity and importance in both China and the rest of the world. Confucius saw the road to harmony in education, and much of this harmony is evident here. Adjoining the temple area there is a forest of over 1,000 stelae, carved stone markers, and here one can meditate at a slow and measured pace.

The Daoist **Temple of the Secret** (Xuan-miao Guan) was founded in 276, but all that remains of the old temple buildings is the magnificent 12th-century Hall of the Three Pure Ones, a sacred place enclosed by an elegant double-layer hipped roof. The interior contains gilded statues of the Three Pure Ones (Yuhuang—the Jade Emperor—Daojun, and Laotse), the supreme gods of the Daoist pantheon. The Xuanmiao Guan is considered the most important temple in the entire religion.

Not far from here stand the two towers of the **Double Pagodas** (Shuang Ta), built in the 10th century to improve the feng shui of the district. They bear the names Gongde ("just deserts and virtue") and Sheli ("denying one's own interests"). The names are not mere descriptions; they represent the basic tenets of Daoist ethics.

Even if at first glance the many concrete buildings mean that little remains of Suzhou's former charm, visitors still encounter everywhere they look a belief rooted in human consciousness, and this has had a considerable influence on the city.

Hanshan Si

Two Buddhist monks who lived in the 7th century are particularly well known and loved in China. One of them, Hanshan, left to his brothers and to posterity a wealth of folk poetry—he was a past master in explaining to people difficult Buddhist teachings in simple, clear, and comprehensible words. He and his fellow brother Shide were monks who lived completely independently of any of the schools, practicing meditation and trying to follow the way of the Buddha. Both were Chan (Zen) Buddhists, a branch of Buddhism incorporating elements of Daoist and Confucian religion and philosophy. Chan Buddhists meditate on the solution to paradoxical riddles called koans (Chinese: *gongan*).

Hanshan and Shide lived in the Monastery of the Cold Mountain (Hanshan Si), which had become a center of Buddhist teaching and meditation in the 6th century. Because of their independence, they are often represented in Chinese art with long beards and tousled hair, laughing cheerfully and strolling casually. Such images are to be found all over China, not only in temples but also as a popular feature of private domestic altars. The original monastery was destroyed during the Taiping Rebellion (1851–64) and rebuilt only in the 20th century. It is now a Buddhist meditation center and frequented not only by monks but also by Western seekers after truth, who live in the monastery to learn the correct way to immerse oneself in thought.

Huangshan range, Anhui

Mount Huang

The mountainous region around
Huangshan—Mount Huang—is nei-
ther one of the five mythical Daoist
mountains nor one of the four sacred
mountains of the Buddhists, and yet
it is known as the "first of the moun-
tains of China." The most familiar
views of the mountains are world-
famous, with unbelievably steep rocky
pinnacles and abrupt cliffs, gnarled
pine trees growing from bare rocks,
waterfalls, and bizarre peaks jutting
out of a sea of clouds. This moun-
tain range has inspired the imagina-
tions of Chinese poets and painters
for 1,000 years, and their works have
spread the fame of the fairy-tale
mountain throughout the world.

The Huangshan mountain range
comprises 72 peaks, of which the

highest are the Bright Summit Peak
(6,040 feet/1,841 m) and the Lotus
Peak (6,125 feet/1,867 m). The tracks
leading to the various peaks of the
mountain chain have ranked among the
most important Daoist pilgrims' paths
for more than 1,200 years. Pilgrims
use various routes to climb the sacred
mountain, but most begin their ascent
at the "pine tree which welcomes visi-
tors." From here there are countless
waypoints: at the Summit of the Heav-
enly Capital (6,004 feet/1,830 m) it is
the custom to pray at dawn before con-
tinuing on one's journey. Young Chinese
couples attach padlocks to the handrail
of the viewing platform, to symbolize
that they belong together for eternity.

Every bizarre rock, every wind-bent
tree, and every peak has a name and
a story associated with it. Some of the
peaks are dedicated to the Immortals, for
example "the Immortal who keeps his

pack dry" and "the Immortal who brings back treasures." Pilgrims will particularly shudder at the "chasm where one can lose one's body"—it is a little disconcerting for modern sensibilities to learn that one of the oldest Daoist traditions is to plunge to one's death in a chasm, following the example of Zhang Daoling, a philosopher and pioneer of religious Daoism. The "monkey who surveys a sea of clouds" seems particularly mystical; according to the legend, Monkey King Sun Wukong had been a stone before he became a divine ape. After his departure for India he is said to have left his original stone body behind to soak up the rays of the sun and the moon. "Those who have seen Huangshan," according to an old Chinese proverb, "will never regret not having seen other mountains!"

Mount Jiuhua

The Tang Dynasty poet Li Bai (701–62) loved to visit this place. He enjoyed strolling on the mountain, gazing into the distance from the countless vantage points, or meditating in the mountain's temples. In one of his poems he called the mountain "Nine Blossoms Mountain,"

Monastery on Mount Jiuhua, Anhui

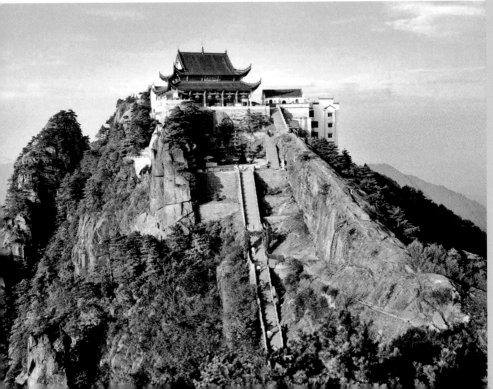

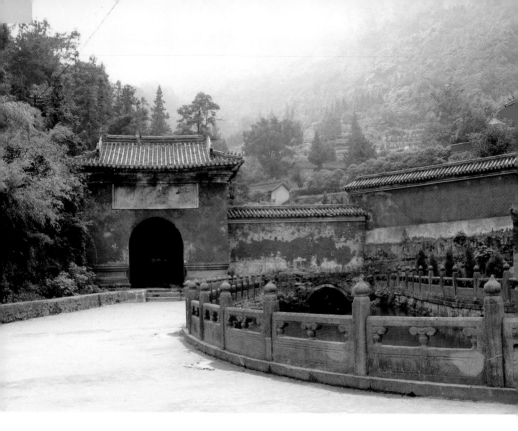

Palace of the Purple Fire of Heaven, Wudang Mountains, Hubei

comparing the highest of the 99 peaks of the mountain chain to the leaves of a lotus flower. **Mount Jiuhua**—Jiuhuashan—is one of the four sacred mountains of Buddhism, along with Emeishan, Putuoshan, and Wutaishan. It is located south of Anhui and is considered the seat of the Bodhisattva Kshitigarbha (known as Dizang in Chinese), who saves the souls of the dead from the underworld and shortens their suffering in hell. The early 8th-century monastery in the little mountain village of Jiuhuajie is dedicated to Dizang and is the most

important of the many Buddhist foundations in this part of the mountains.

The hermitage of the Daoist monk Bei Du was recorded on this site in the 3rd century. During the Tang Dynasty (618–906) the mountain slowly grew in renown as a sacred place, particularly after the Korean prince Kim Qiaoque moved to Jiuhuashan in 720 to found the **Huacheng Monastery** and live as a monk. Large sections of the monastery burnt down in 1857, though they were soon rebuilt. The oldest part of the monastery is the 15th-century library in which

important Buddhist scriptures are preserved. More and more monasteries and temples were built, and in its heyday there are said to have been up to 5,000 monks living in more than 300 monasteries on the mountain. Most of these foundations have not survived, but there are still almost 100 monasteries set in magnificent, idyllic mountain scenery, often beside crystal-clear streams or on steep rocky peaks.

The mummified remains of the monk Wuxia are kept in the **Palace of the Hundred-Year-Old-Person** (Baisui-gong). Legend has it that during a pilgrimage to the holiest mountains in China he came to Jiuhuashan and stayed there, living on nothing but rice mixed with a little earth. He typically received visitors sitting bolt upright in the lotus position with his legs tucked beneath him, as if sunk in deep meditation. He is said to have spent 102 years here before dying at the age of 126. Shortly before his death he commanded the monks to open his coffin three years after his death. When they did so, they discovered that his body had not decomposed, so they coated him in gold and installed him in his present location. Perched on a mountain peak, the temple is reached via a mile-long (2-km) steep stone staircase.

Qiyuan Monastery, an extensive complex built to resemble palace halls, dates back to the Ming Dynasty. The buildings are covered in glazed tiles and the interior contains a great number of paintings and carvings. The monastery has always been one of the most important centers of Chan (Zen) Buddhism, and the statues of the Buddha and of Guanyin, the embodiment of compassion, are especially beautifully and intricately carved.

The beauty of one of Mount Jiuhua's peaks, **Tiantaifeng** (4,350 feet/1,325 m), was celebrated in ancient poetry and, as you might expect, the 5-mile (8-km) path to the mountaintop has been trodden by many pilgrims. The path to the "Terrace of Heaven" passes tea plantations, thick bamboo groves, strange rock formations, and temples and monasteries of all sizes before reaching the **Monastery of 10,000 Buddhas** (Wanfo Si). There is a giant stone with the inscription "Not Man's Domain" and beside it a five-storey wooden temple containing thousands of statues of the Buddha of every conceivable size. It was these statues, some of which were placed here by pilgrims, that gave the temple its name.

Mount Jiuhua is a wonderful place for pilgrims and is usually extremely quiet, unless you visit during the Nine Blossoms Festival (on the 30th day of the 7th month of the Chinese lunar calendar), when thousands of Buddhists process along the path to commemorate the anniversary of Prince Kim Qiaoque's death.

Wudang Mountains

The Wudang Mountains in Hubei Province are overflowing with shrines thanks to the cult of the True Warrior, the Emperor of the North, which dates back more than 2,000 years. The north is associated with all that is dark: night,

the winter solstice, and water, especially underground watercourses. The Emperor of the North is known as the True Warrior because he succeeded in defeating the forces of darkness. There have been sacred buildings here since the 7th century, but during just 20 years (1403–24) of the Ming Dynasty the emperor Chenhgzu built eight palaces of the gods, two monasteries, 36 shrines, 72 small temples, 39 bridges, 12 pavilions, and more than 31 miles (50 km) of cobbled road—the pilgrims' path here is virtually a model for the perfect sacred ascent of a mountain.

Pilgrims would begin their journey at the Palace of Peaceful Fortune in Junzhou, a city now flooded beneath a reservoir. The next stages on the trip were the Gate of the Celestial Path, the Palace of Encounters with the Immortal, and the Palace of the Harmony of the Beginning of Everything. There was then a detour to the Palace of the Jade Chasm, before the trek continued on to the "fountain where needles are honed" and then past the Prince's Slope to the bridge over Sword River and on to the Palace of the Purple Fire of Heaven. Then followed the Prince's Chasm and the Southern Gate, the Pavilion of Ascension to Heaven, the Palace of the Southern Chasm, the Palace of the Audience in Heaven, and the Golden Hall. Pilgrims finally passed through the Three Gates of Heaven to reach the Palace of Great Harmony.

Once the challenging journey had been completed, pilgrims would find that their yin and yang energies

Bodhisattva Samantabhadra on a white elephant, Mount Emei, Sichuan

were now balanced and they could achieve the perfect harmony that is characteristic of the universe. The path through the mountains is as important as the temples and palaces along its way. Daoists believe that nature itself is divine and that mankind should revere the natural world, with its mountains, springs, rivers, caves, plants, and animals, or else harmony is impossible to achieve.

Mount Emei

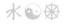

Along with its extraordinarily beautiful scenery and wealth of flora and fauna, **Mount Emei** (Emeishan) also has a suitably poetic name: the Mountain of the Curved Eyebrow. The name reflects the geological form of the mountain chain—from the air it looks like an eyebrow. Daoists have regarded this massif in Sichuan Province, Western China, as sacred since the 3rd century, and Dao disciples once lived the greater part of their lives as hermits in the mountain's caves.

Halfway up Emeishan, on the weather side of the mountain, is the **Cave of the Yellow Emperor**, the mythical ancestor of the Chinese people. Pilgrims who visit the cave light joss sticks, placing them in cracks in the rock near the cave entrance, before taking the treacherous path down into the inky depths. Visitors here soon realize that as well as loneliness the hermits had to overcome the feelings of vertigo at the emptiness beneath them.

Buddhism has claimed the mountain as its own since the 6th century. Emeishan is considered the home of Samantabhadra, the Bodhisattva of Universal Virtue, who is worshiped in East Asia as the patron saint of those who meditate; according to legend, he is said to have settled at Emeishan with his mount, a white elephant. At one time there were some 150 monasteries on the mountain, but only 20 of these have survived. The pilgrims' path is famed not so much for the sacred places that line its route as for the enchanting beauty of its scenery.

The path begins at **Serving the Country Temple** (Baoguo Si). This monastery complex is a symbol of the peaceful coexistence of the three greatest spiritual movements in China (Confucianism, Daoism, and Buddhism) and in one of the halls there are statues from each of these three philosophically based religions.

The road continues through lush forests and green valleys to the **Temple of 10,000 Years** (Wannian Si), which has recently been rebuilt after the original temple burnt down. The 16th-century Hall of Tiles (Zhuan Dian), the oldest section of the building, contains a monumental statue of the Bodhisattva Samantabhadra on an elephant. The statue is surrounded by countless small Buddhas, many of which are votive gifts from pilgrims.

The path climbs up the hill along ancient, and in places badly weathered, steps, and at these higher altitudes you may find yourself climbing through the cloud layer to the **Summit of 10,000 Buddhas** (Wanfo Ding), the highest peak at 10,170 feet (3,100 m). The view from here is magnificent, unless the mountain is swathed in mist. Occasionally, you will see unique

optical phenomena, so-called "halos" (refractions of light into all the colors of the rainbow), which are known to pilgrims as "Light Buddhas."

Leshan Giant Buddha

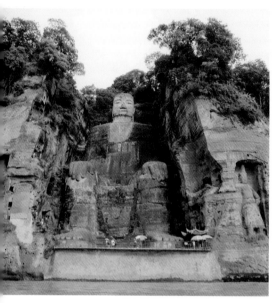

and its head alone measures 50 ft × 30 ft (15 m × 10 m); each of its feet is 36 feet (11 m) long and 18 feet (5.5 m) wide. The ears, with their long earlobes, are 23 feet (7 m) long. The head sports an artistic hairstyle of more than 1,000 spiral knots, so large you could set up a dining table on each of them—the size alone is enough to inspire awe in the observer.

The statue was carved into the rock in just 90 years, between 715 and 803, in a project begun by a monk called Haithong. The turbulent currents in the river confluence led to many vessels capsizing. Haithong wanted to prevent such accidents, so it was intended that the Buddha would offer the sailors his protection here. In one way this aim was certainly achieved since the surplus stone that fell away during the construction work altered the depth of the river, levelling out the deep spots, and since then the water has indeed flowed more peacefully. Despite this rational explanation however, the statue is regarded as a divine protector because the Maitreya Buddha is the embodiment of the loving goodness of all Buddhas. The influence exerted by this gentle-looking figure is as great as its dimensions.

The Leshan Giant Buddha

At the confluence of the Dadu, Qingyi, and Min rivers, there is a sacred place that is great in several senses—this is the location of the largest seated Buddha statue in the world, the Leshan Giant Buddha. The dimensions of the sculpture, which has been carved from the living rock, are monumental. The seated Maitreya Buddha is 233 feet (71 m) high, its shoulders are 92 feet (28 m) across,

Dazu Rock Carvings

Dazu is a small provincial town, with bustling markets and tea houses like those found all over Sichuan, surrounded by attractively terraced paddy fields. The destination that lures Buddhist, Daoist, and Confucian pilgrims

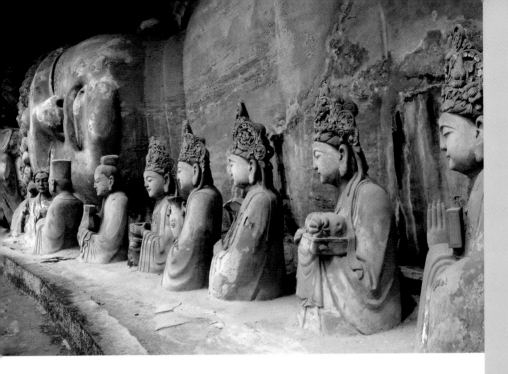

Dazu rock carvings

here lies a little to the northwest of the town—the unique Buddhist stone sculptures and rock carvings in the caves and steep slopes of Beishan, a 1,640-foot (500-m) high cliff, and those at Baodingshan, a horseshoe-shaped rock formation on the edge of a mountain canyon. More than 50,000 artworks and sculptures created between the 9th and 13th centuries.

At Beishan flights of steps lead up to more than 250 sculpture niches and caves. As well as a plethora of motifs from Tantric Buddhism there are striking depictions of Avalokiteshvara, the Bodhisattva of Compassion (transformed in later Buddhist tradition into the female Bodhisattva Guanyin).

There are nearly 10,000 stone sculptures and reliefs to be seen at Baodingshan, many of which are brightly colored and some of which are of immense size. The Reclining Buddha (known as Shakyamuni in China) Entering Nirvana and the thousand-armed Avalokiteshvara have a particular serenity. The skillfully carved Bodhisattvas in the "Cave of Perfect Enlightenment" have an enchanting beauty and elegance. In one of the caves, pilgrims are confronted with a strikingly graphic depiction of the horrors of hell that await the ungodly after death.

The rock carvings and sculptures at Dazu were intended to tutor an illiterate congregation of believers in the

basic principles of Buddhism by using Buddhist, Daoist, and Confucian precepts. As far as this artistic complex is concerned, Buddhist belief is entirely compatible with Confucian ethics.

Mount Putuo

An island of many temples and monasteries and the location of one of the four holy mountains of Buddhism, **Mount Putuo**, Putuoshan is situated in the East China Sea. The entire island is consecrated to Guanyin, the Bodhisattva of Compassion. There were once more than 200 monasteries and temples on the island, but there are now no more than 20, and

these can easily be explored in two days. The island has delightful scenery and corresponding amounts of visitors, not only Buddhist pilgrims but also many others from nearby Shanghai and the rest of the world.

Visitors arriving at the southeastern tip of the little island are immediately greeted by a 66-foot (20-m) high gilt **Statue of Guanyin**, glinting in the sunshine and imparting a blessing to sailors and all travelers. In Chinese tradition, traveling is related to the journey of life, at whose end there is transcendence to another world. One of the temple gates bears the telling inscription that "we all wish to reach the other shore together."

Puji Monastery, whose history dates back to the 10th century, is located at the heart of the island. In its heyday it accommodated 1,000 monks and nuns, but nowadays there are nearer 100. The

Statue of Guanyin, Putuoshan Island

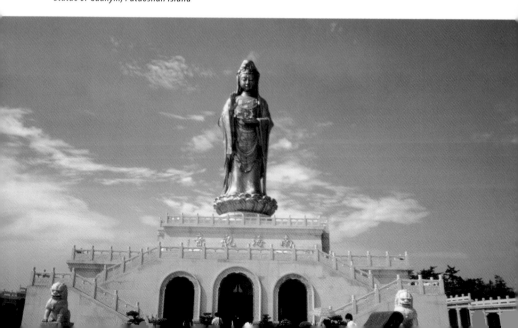

nine halls of the temple stand out in a splash of yellow against their surroundings, and each is elaborately decorated and adorned with statues and icons. The main hall of the temple contains another enormous Guanyin statue, the focal point for a colorful crowd of pilgrims—shaven-headed monks chanting sacred Buddhist scripture, business people in suits, families with children, and people from both near and far, all queuing up to light joss sticks and pray in front of the deity. As well as the joss sticks, oranges, apples, and even banknotes are deposited as votive offerings beneath the cloth banners covered with sacred verses that hang down from the high wooden ceilings.

The pilgrims' next encounter is with the 16th-century **Fayu Temple**, a short distance away at the foot of the sacred Mount Putuo. This temple is richly decorated with scenes from Shakyamuni's life, golden statues, and fierce-looking guardians. At the back of the temple there are especially beautiful water-filled troughs with floating lotuses, a flower sacred to Buddhists.

From Fayu Temple, pilgrims climb the 1,000 steps up Fodingshan to reach the **Monastery of Huji Si** situated on the summit. They continue their prayers here in the temple. Holding joss sticks in their hands, they bow to the four points of the compass. To bring good luck, people toss coins into a large metal vase.

The island of Putuoshan and its sacred mountain is a picturesque pilgrimage site and extremely popular with the hundreds of thousands of visitors who come here. You are unlikely to find meditative peace in the temple, but the paths across the island and up the mountain allow pilgrims to immerse themselves in nature and in the self.

West Lake, Hangzhou

Once upon a time, unimaginably long ago, a jade dragon and a golden phoenix were flying over the hills of Hangzhou. Seeing a gleaming white stone lying on the ground, they immediately seized it, polishing and rubbing it to such an extent that the stone was turned into the most precious pearl. Viewing the pearl with great envy, the Queen of Heaven descended from her palace and stole the jewel. The dragon and the phoenix tried to retrieve it, but in the struggle with the Queen of Heaven the pearl fell to the earth, giving rise to the West Lake (Xi Hu). In fact, it was originally a shallow sea inlet but became a lake when silted up by sand, but the Chinese prefer the legend, and rightly so. China's landscape always encourages a religious interpretation, and this lake is spectacular.

There are several pagodas, temples, and pavilions among the groves of trees on the lake's shores and on the islands at its center. Visitors come here to enjoy the variety and beauty of the gardens and the hills surrounding the lake. Little Paradise Island is particularly idyllic and has three stone pagodas on its southern shores called "Three Ponds Reflecting the Moon." The original 11th-century

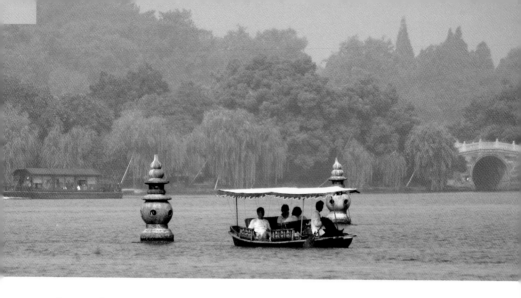

Stone pagodas, West Lake, Hangzhou

pagodas have not survived. Those that visitors now see jutting about six feet (2 m) out of the shallow water date back to 1621. Their many small openings are filled with tiny candles during the annual Festival of the Moon (on the 15th day of the eighth month of the Chinese calendar), when visitors entrust their hopes, fears, and desires to the spirits. At West Lake, you can learn a little about Chinese Daoist religion and the importance of harmonious scenery, and how it can capture and intoxicate the senses.

Lingyin Temple

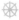

The Temple of the Soul's Retreat (Lingyin Si) is one of the most famous Buddhist temple and monastery complexes in China, and also one of the most popular. It is located in a leafy, almost primeval, wooded valley between the Beigao Feng, the northern peak, and the Feilai Feng, the "peak that flew hither."

The monastery was founded in the 4th century, and between the 10th and the 14th centuries more than 400 religious icons were carved out of the surrounding cliffs and grottos, the most famous of which—and also the most cheerful—is the Fat-Bellied Buddha (Mile Fo), who has been smiling down on the millions of annual pilgrims here since the 11th century. Stone steps lead along the cliff, and a narrow path winds its way through the enchanting landscape.

In its heyday, the monastery was one of the most prosperous in China, with up to 3,000 monks living at Lingyin Si in the 10th century, but now nothing

remains of the 270 halls, 18 pavilions, and nine towers that once comprised the complex. The monastery has been partially restored since the turn of the 20th century and pilgrims now find five great halls here. The main hall is dominated by a unique statue of Shakyamuni on a lotus throne that is almost 66 feet (20 m) tall. Exquisitely carved deities from the Buddhist pantheon, guardians of heaven, teachers of scripture, saints, and Bodhisattvas of special sanctity are encountered at every turn. Despite the flood of visitors to the temple, each of

The Fat-Bellied Buddha, Lingyin Si, Hangzhou

the five halls has a special atmosphere when the monks chant their prayers, seemingly oblivious to the many

pilgrims trying to reinforce their own petitions with thousands of joss sticks.

Mount Kailash and Lake Manasarovar

Tibet

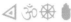

Regarded as extremely sacred by the adherents of no less than four religions, **Mount Kailash** is a 22,027-foot (6,714-m) high peak in the Gangdisê chain in southwestern Tibet. It is the source of four of the longest rivers in Asia: the Indus, the Brahmaputra, the Karnali, and the Sutlej. Followers of the ancient Tibetan Bön religion regard Kailash as the heart of the holy land of Zhang Zhung, and it was also here that their founder, Tönpa Shenrab Miwoche, descended to earth.

For Hindus, Kailash is Shiva's home. For Hindus, Mount Kailash is regarded as the home of Shiva and is the embodiment of the mythical Mount Meru, and is also inhabited by 33 million gods. The mythical Mount Meru is said to rise from the center of the earth and to be

surrounded by concentric circles—the seven oceans and seven continents. Its four faces, illuminating the four points of the compass, are made of gold, crystal, lapis lazuli, and ruby. The mountain is regarded as the axis around which three worlds turn: the heavens, the earth, and hell. With four rivers rising from near its peak, flowing toward all four points of the compass, it is not surprising that Mount Kailash is regarded as the earthly manifestation of this mythological mountain.

In Buddhism, the mountain is seen as the center of a mandala created by nature. Buddhists believe that a pilgrim may reach nirvana by completing 108 circuits of the mountain. It should be walked around but not climbed—as the center of the universe and the navel of

For followers of Jainism, walking the path around the mountain is a religious exercise, with those who complete the challenging 33-mile (53-km) course achieving inner enlightenment.

Buddhists and Hindus walk clockwise round the mountain, whereas Jains and Böns go the other way. Hindus do not restrict themselves to walking around the mountain; they also visit **Lake Manasarovar**. At a height of 15,040 feet (4,585 m) it is the highest freshwater body of water in the world, and closer than any other lake to heaven. For this reason, Hindus perform ritual ablutions here.

Mount Kailash is one of the most sacred destinations for pilgrims from all over Asia as here—and only here—people can free themselves from the bad karma of their entire existence.

Mount Kailash

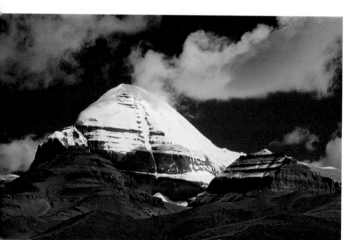

Lhasa
Tibet

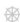

In Tibetan, Lhasa means "holy city," a title that rings true for every Tibetan and every follower of Tibetan Buddhism (Lamaism). Situated at a height of nearly 12,140 feet (3,700 m) and surrounded by high mountains, Lhasa has been at the heart of Tibet since the 7th century. In 1642 the

the world, it is so sacred that no living creature should set foot on the summit.

Potala Palace and Temple of Jokhang

fifth Dalai Lama commissioned the construction of the giant **Potala Palace,** which was to serve as his residence and administrative seat. Towering over the city and nearly 394 feet (120 m) in height, this mighty 13-storey complex with its 1,000 rooms can be seen from far and wide. The rooms are richly decorated and the great Palace Hall is adorned with some 13,200 lbs (6,000 kg) of gold and 4,000 pearls. Known as Potala ("the Buddha's Mountain" in Tibetan), the palace is divided into two sections, the White and the Red Palace. The White Palace was once the seminary for the novices and the Red Palace used to contain the monks' assembly hall, the tombs of eight previous Dalai Lamas, and religious artifacts and relics. China occupied the city in 1951 and the current Dalai Lama lives in exile in India. Lhasa and the Potala Palace are nonetheless still both regarded and revered as the center of Lamaism.

The spiritual heart of the movement is not the palace, however, but the **Temple of Jokhang** (the House of the Divine Secret), a place that has always been sacred. In 640 a Chinese princess married Songsten Gampo, the Tibetan king, but the coach bringing

The three concentric pilgrims' routes of Lhasa

A special and mysterious aura of sanctity surrounds Lhasa, Tibet's capital city. The remoteness of the Tibetan uplands holds an irresistible charm, not only for Tibetan Buddhists but also for people from across the world. Although much is now known of the city and its history—the Dalai Lama, Tibet's supreme religious leader, is famed throughout the world and revered by followers of all religions—Lhasa itself remains enigmatic. It is therefore fitting that Jokhang, the name of the most important temple, means "house of holy secrets." This temple is the powerhouse of Tibetan Buddhism and pilgrims try to absorb energy by walking round and round the temple with their prayer wheels, tirelessly reciting mantras or chanting.

Traditionally, there are three pilgrims' paths in Lhasa that circle around the old city and its temples and monasteries. The outermost route, known as "Lingkhor," follows the path of the old city limits. The central path, "Barkhor," encircles Jokhang Temple and various other temples and monasteries in the Old Town—pilgrims follow it in a clockwise direction. There is plenty of opportunity to buy ritual equipment at the many stalls along the route, and there are even professional prayer-mongers, who will perform laps of the Jokhang on your behalf. The innermost route—"Nangkhor"—circles the temple courtyard, promising particular proximity to the Divine. In following this path, pilgrims are following a path reminiscent of the eternal circle of life, gradually approaching the holy of holies, the Buddha in the center of the temple. Those who complete all three pilgrims' paths in turn will gain a clear sense of approaching a center of energy and will draw strength from this—a truly holy experience.

the princess and her dowry, a valuable statue of the Buddha, got stuck in the mud. The gods subsequently advised the construction of a temple for the Buddha on the site, and this same temple is now greatly venerated, with believers lighting thousands of candles that bathe the statue of the Buddha in a mysterious light. Tibetan Buddhists absorb the energy of this, the center of their power, by tracing the circles of a mandala as their prayer wheels whirl and constantly chanting the mantra "om mani padme hum."

Mount Heng, Hunan

Countless pilgrims have been drawn over the years to **Mount Heng**, also known as Hengshan and Nanyue (the Mountain of the South), the southernmost of the sacred mountains of Daoism. In Chinese mythology, the south represents the midday sun, and it is here that the powers of yang (in other words, the sun) are worshiped. The sacred mountain's surroundings are incredibly beautiful, with dense, almost jungle-like forests containing

more than 150 different species of trees, foaming waterfalls, mysterious lakes, exotic flowers, and misty canyons. Pilgrims to Hengshan come in search of the mountain's eight miracles: the height of the Zhurong Peak; the grace of the Hall of the Sutras, nestling in its deep valley; Fangguan Temple hidden in the midst of its primeval forest; the peace and tranquility of the area round Mojingtai; the venerable age of the Dayu stela; the magic of the Shuilian Cave with its rock carvings; the majesty of the Nanyuedamiao; and the gradient of the narrow Huixian Bridge over the Zhibo.

Of the more than 40 temples and monasteries worth visiting in the mountain range, the most important of all the temples for pilgrims is the **Nanyuedamiao**, built in the style of the Forbidden City of Beijing. It was the first temple to be documented in the Tang Dynasty (618–906), although the current buildings date back only to the end of the Qing Dynasty (1644–1911) in the 19th century.

Since there are 72 individual peaks in the Hengshan mountain range, a corresponding number of pillars have been erected in the main hall of the temple. One of the temple's unusual features is that followers of Confucianism, Daoism, and Buddhism can practice their holy rites and pray in peaceful coexistence here. The temple blends the three main Chinese religious traditions—what unites these philosophically based

Mount Longhushan, Jiangxi Province

creeds is considered more important here than what separates them.

Confucian ethics have long been important in China, Daoism plays a prominent role in day-to-day religious observance, and Buddhism helps people understand the circle of life and death. Hengshan is home to "The School of Perfect Reality" (Quanzhen),

The "Old Child," a statue of Laozi in Quanzhou

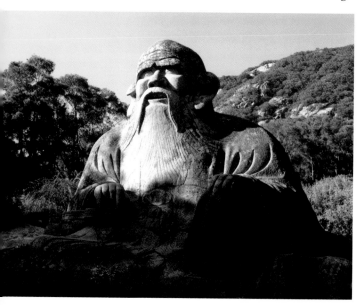

a spiritual school that seeks to amalgamate the three doctrines, has been of great influence not only in China but throughout the world. Those who ascend the mountain return as changed people, or so it is said.

Celestial Master Temple, Mount Longhu

By the 1st century of the Western calendar, Buddhism was already gaining in significance in China, and one sign of this was the growth in the number of monasteries. Concepts like reincarnation and moral responsibility were finding favor in religious life, and new forms of popular devotion and simple practices and exercises were being adopted in the search for salvation. Little is known of the early history of the Celestial Master Temple, but the status of the Celestial Masters who had settled at Mount Longhu was recognized by the imperial government from the Song Dynasty (960–1279) onward.

Rising up from a plain in Jianxi Province, Mount Longhu— Longhushan—has been the headquarters of the Celestial Masters for 1,000 years. The main temple contains the signs of the dragon and the tiger, one representing the east, the other the west, the two points of the compass where the sun rises and sets. They also symbolize the balance of forces between both directions that is essential for the sanctity of a place. Two consecutive gates indicate

the path into the temple. These elaborate entrances are decorated with trigrams, Chinese oracular symbols used in prophecy that form the basis of the *I Ching* (Book of Changes). The symbols on the first gate symbolize the old heaven and the gate leads into the Garden of the Mushroom of Immortality. The trigrams on the second gate symbolize a paradise to come and a world to follow this one—this gate is known as the "Celestial Gate." Trigrams symbolizing the earth lie buried in the ground to represent the threshold that must be crossed. Between the two gates lies the "Space before the Beginning of Time." The way in which all this fits together and is expressed in impenetrable symbols might seem curious to a Western observer, but it is an indication of the sanctity of the place that reality as it is and a striving for heaven, another reality, are inseparably intertwined.

The "Old Child"

In Daoist tradition one of the "Three Pure Ones," the three highest deities, is the "Old Child," who is also Laozi, the Master. He is often depicted sitting between two further personifications, the Jade Emperor and Lingbao Tianzong, his assistant. The "Three Pure Ones" are often found in Daoist temples. A legend tells that before his birth, Laozi recited holy texts in his mother's womb for 41 years, tearing open his mother's armpit as he entered the world. Since at birth he already had gray hair, he was called the "Old Child."

A little beyond the city of Quanzhou in Fujian Province there is a 10th-century rock sculpture representing the "Old Child," Laozi sitting in majesty surrounded by a little wood. The shrine is easily accessible, though the temple that once stood here has disappeared. His eyes, which represent yin and yang, are difficult to make out under his headgear. Pilgrims who come here meditate on the teachings of Laozi and on their own lives. Children climb the statue to rub Laozi's nose as this is supposed to bring particular good luck. Laozi represents the resolution of opposites and, according to his teaching, turning about and changing the path of life. You don't have to be a Daoist to see this as a sacred path—other religions and cultures acknowledge the concept of turning around, seeing life as a path in which there are points at which one can lose one's way, when it is right to turn around to find the correct path.

Mount Jizu

Pilgrims have been climbing Jizushan—Mount Jizu—for 1,300 years. According to legend, Shakyamuni, the Buddha himself, came to this mountain to meditate, and for this reason many of the high places on the mountain, the peaks and viewing terraces, have temples and monasteries

of various sizes built on them. The mountain quickly became one of the most important Buddhist pilgrimage sites for both the Chinese and for Tibetans, and it is especially sacred to the Bai people, one of China's many ethnic groups. During the heyday of the Ming and Qing Dynasties, more than 100 temples were to be found on the mountain, and some 5,000 monks lived here. Most of the temples fell victim to the Cultural Revolution and the majority of the monasteries were abandoned and left to decay. However, a few of these sacred places have since been restored and opened to pilgrims.

There are several paths to the 10,630-foot (3,240-m) high Golden Summit, all crossing picturesque, forested scenery with narrow steps leading up the mountain. At the summit is the Jinding Temple with its 11th-century, 13-storey pagoda. Besides Shakyamuni, Avalokiteshvara, the lord who looks down on the suffering of the world, is especially revered on Jizushan,. This Bodhisattva is one of the most popular figures in Chinese Buddhism. He was originally a male figure, but was later depicted with more and more female features. Since the 10th century, Avalokiteshvara has transformed into Guanyin, the now entirely female and still extremely popular Bodhisattva of Compassion.

Many pilgrims climb the mountain on foot, but still more reach the Golden Summit by cable car, with the result that there are always crowds of people there—an odd contrast for

"Bamboo Shoot Pagoda," Manfeilong

those who have made a leisurely ascent through the lonely mountain forests. From the top there is a wonderful view of the surrounding mountains.

Western Mountains

Rising on the western shores of Dianchi Lake in Yunnan Province, the Western Mountains (Xi Shan) are not the most sacred, but like all mountains they are important Daoist pilgrimage sites. The path up the mountain leads past numerous halls and temples dating from the 14th to the 19th centuries, dedicated to deities from the Daoist pantheon. The steps of the narrow, steep path winding along the cliff are often cut directly into the rock, and the whole journey is a sacred path. The entire mountain with its springs, caves, plants, and animals is revered as holy by the "People of the Way," the Daoists.

Shortly before the summit you will reach the Pavilion of the Three Pure Ones. Senior to all other Daoist deities, the trinity of the Three Pure Ones is worshiped at this mountain shrine: Yuhuang, the Jade Emperor and the ruler of earth and heaven, Daojun (Lingbao Tianzong), the lord of time and the regulator of the forces of yin and yang, and finally Laozi, after his apotheosis as the "Old Child." Pilgrims who take this path should ideally go on foot and not take the tourist bus that drops people off right in front of the temple. In this

way they can come into close contact with nature and also be alone with themselves. The simple act of walking, breathing, pausing, looking, and appreciating what they see are all part of the pilgrims' path. Visit the mountain in this simple way to get a sense of the harmony that pervades everything.

Manfeilong Pagoda

Two hundred steps have to be climbed to reach this gleaming-white pagoda on its base decorated in the colors of the earth, a symbol of the Buddha's throne. It is situated on a low hill surrounded by woodland. The pagoda is one of the "diamond throne pagodas," in which several small stupas (memorial mounds)— usually five—are grouped around a larger central hillock. Structures of this nature are intended as reminders of the Buddha's enlightenment. The "Bamboo Shoot Pagoda" is so-called because its individual towers resemble bamboo shoots when seen from a distance. It is also known as the "White Pagoda" because of its color.

The 53-foot (16-m) high central stupa, shaped like a lotus flower, is surrounded by eight smaller stupas. Each contains a niche with a statue of the Buddha and a relief depicting scenes from his life; a phoenix, the mythical bird of immortality, rises above each niche. The gates of each stupa are decorated with dragons, bringers of good fortune in Chinese mythology. Little bells hanging from the spires

Sculpture of the Five Goats, Guangzhou

of all nine stupas ring out enchantingly when the wind blows. One place within the sacred area contains a niche with a concave stone; according to legend, it is one of the Buddha's footprints. The stupa, built over this spot in 1204, is venerated accordingly.

Guangzhou

Visitors to Guangzhou would have to make quite an effort to imagine any sacred places in this city on the Pearl River, but the city's nickname ("City of Goats") is a clue to an old legend that still has some currency today. A long time ago there was a terrible famine in the area and in their desperation the people begged the gods for help. The gods heard these pleas and sent five of the Immortals, who descended from heaven on goats. Each held a rice shoot in his hand and instructed the locals in the cultivation of rice; from that time on, there was no more hunger. When they returned to heaven, the Immortals left their goats behind, and these turned to stone. The **Sculpture of the Five Goats** has since become the city's emblem and is greatly honored—gifts are often found at its feet.

Wuxianguan, the **Temple of the Five Immortals**, was built to commemorate this divine aid. The building had to be reconstructed after a fire in 1864. A hole in the rock of the temple courtyard reveals an imprint that is thought to be one of the Immortals' footprints and is revered as such. A few paces

further on there is a strange, plain tower, almost 130 feet (40 m) high, known as the "Naked Pagoda." It now serves as a minaret for the **Mosque in Memory of the Wise Man**, which according to legend was founded in the 7th century by an uncle of the Prophet Muhammad. It is said to have been in continuous use ever since and is an important sacred site for Muslims from the city and surrounding area.

The oldest temple in the city is the **Temple of Bright Filial Piety**, founded in the 3rd century. In the middle of the complex there is a tall, octagonal pagoda beneath which some hair belonging to the influential monk Huineng (638–713), one of the major figures in Zen Buddhism, is preserved as a sacred relic. The elegant temple with its extensive grounds as seen today dates back to the 17th century and contains a magnificent sleeping Buddha that is often visited by local women wishing to become pregnant.

A little further on you reach **Shishi Cathedral**, one of the few Roman Catholic churches in China. Locals call it the "House of Stone," a fitting epithet for this neo-Gothic church built of dark granite between 1863 and 1888. Unfortunately, the church is open to the public only when one of the rare Masses is being celebrated.

The relative proximity of Hong Kong and the city's auspicious location on the Pearl River have led to rapid expansion in the recent past. The local people are welcoming and tolerant. It is therefore not surprising to discover that shrines from various religions are to be found here.

Yonglian Temple, Luzhou

Taiwan

Mountains are considered to be the definitive seats of the gods, but not everyone is able to make a pilgrimage to one of the many holy mountains. For most believers, the usual point of contact with the Divine is a temple, but temples might also be considered "mountains within cities." One of the most impressive city temples is located in Luzhou. The Yonglian Si (Temple of the Lotus Blossom and the Spring) is in fact three temples in one. Seen from the side, the temple has three roofs. The gable of the first roof is adorned with statues of the gods of wealth, professional success, and long life. Strictly speaking, these are not gods but rather projections of popular belief, according to which, if all goes well and order is not disturbed by evil spirits, and if the forces of heaven and earth are in harmony, an individual will live to a good age. The largest of the stone sculptures in front of the portal represent the dragon and the tiger; the former symbolizes the east and the latter the west.

The temple faces northwest (hai), toward the Celestial Gate, through which the energy of heaven enters this world; the gate faces southeast (si), toward the Gate of the Earth, through which expended energy flows into the abyss. The building is based on the Guanyinshan, although only in a metaphorical sense, as Mount Guanyin lies some miles from the temple. Guanyin is the Buddhist Bodhisattva of Compassion, and scenes from her life are depicted in the magnificently ornate interior beneath the second roof, in the Buddhist portion of the temple. This section is immediately identifiable as Buddhist by the two dragons on the roof that guard a small pagoda, a Buddhist shrine. As well as the statue of Guanyin, there is another figure at the entrance to this area, which represents the enlightenment of the Buddha.

On the third roof there are two further dragons, playing with a ball of fire. This ball represents yang, the primeval force at the beginning of all life. The two dragons represent the underground watercourses that make the earth fertile. Beneath this roof you will find the Hall of the Jade Emperor, the supreme god in the popular pantheon. This hall contains a statue of Zheng Chenggong (also known in the West as Koxinga), who is venerated for freeing Taiwan from the Dutch. This part of the temple, called Moudegong, the Palace of the Love of Virtue, is thought to be the oldest section of this exceptional shrine and is a physical manifestation of how different traditions can flow into one another to create unity in diversity.

Chaotian Temple, Beigang

Taiwan

Pilgrims from all over Taiwan gather at this holy place once a year. Organized through the main Yonglian

Temple in Louzhou, the pilgrimage to the major shrines in the south always takes place in the first lunar month, and the pilgrims' goal is the Chaotian Temple dedicated to the deity Mazu in Beigang. Mazu, the goddess of the sea, is the patron deity of sailors and as such is especially venerated on the island of Taiwan; the temples dedicated to her are among the oldest in the country. Pilgrims carry ten statues of the goddess on the pilgrimage. Of these, five are usually kept in the Yonglian Temple and the other five are from various other temples.

The start date of the pilgrimage is determined by the casting of lots, ensuring that the journey will end happily. Once arrived in Beigang, believers congregate in the temple courtyard around a large incense bowl. The statue of the goddess is concealed beneath coarse material and brought to the temple on a litter. Thousands of believers assemble here in the oldest temple in Taiwan to celebrate the goddess's birthday and to ask her for further protection. The pilgrimage makes abundantly clear that this is less a Buddhist or Daoist tradition and more an expression of popular devotion that has survived and flourished through the ages. There are some indications that support for the cult has been growing for some time, which may be due to the way in which it addresses both religious and nationalistic sensibilities in Taiwan.

Chaotian Temple, Beigang

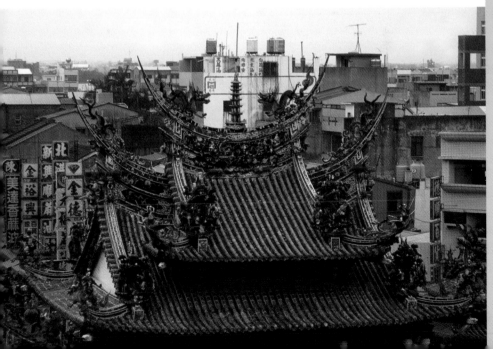

Jogyesa, Seoul

Although Confucianism is the most widespread belief in South Korea, there are also large numbers of Buddhists. Their spiritual center is Jogyesa, the most important temple of the Jogyejong Order, which is located on a site in the middle of this huge city. The temple was built here in 1938 in the traditional style of the Joseon Dynasty (late 14th century). The walls of the Daeungjeon, the main building, are decorated with a wealth of painted scenes from the life of the Buddha. The temple was built on a site containing numerous baeksong and black locust trees, some of which are up to 500 years old. As you pass through the elaborately decorated temple gate, you are immediately plunged into a special environment away from the hectic bustle of the metropolis. The Bopsa (masters) of the Jogyejong Order not only practice classic forms of Zen and study holy scriptures, they also

Lantern Festival, Jogyesa, Seoul

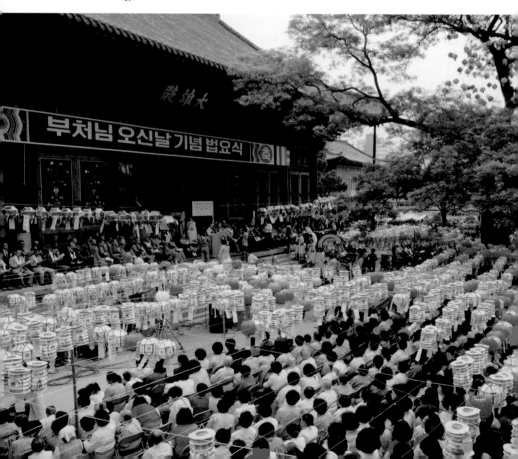

welcome their guests warmly, teaching them about the tea ceremony, breathing techniques, and meditation exercises. Numerous shops have sprung up in the streets around the temple, selling singing bowls, prayer wheels, prayer flags, joss sticks, and Buddhist texts.

Once a year, on the eighth day of the fourth month of the Chinese calendar (during May), a great lantern festival is held in the temple and the surrounding streets in celebration of the historical Buddha's birthday, and a procession of lanterns draws up to the temple itself. The trees and the façades of the houses are hung with countless colorful lanterns and up to 100,000 people congregate to pray and conduct religious rites.

There are, however, 300 small Buddha figures on the first floor of an annex. In the main building there is a stupa

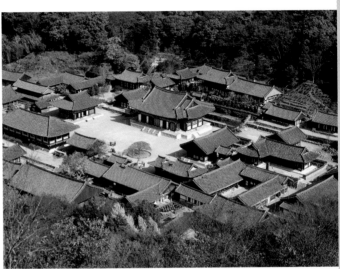

Tongdosa temple precinct, the "Temple Without a Buddha"

containing important relics: one of the historical Buddha's habits, his beggar's bowl, and a bone from his skull. One part of the temple is used as a museum, exhibiting a comprehensive collection of pictures illustrating scenes from the life of the Buddha.

The temple dates back to at least 646 and the Daeungjeon, the main building, has survived sometimes turbulent periods of history more or less unscathed. All the other 35 buildings and pavilions are more modern. It is said that the temple flame (*beobdeung*) has burned continuously for 1,300 years without being extinguished. The layout

Tongdosa, Shinpyong

✳

Tongdosa, one of the three Jewel Temples of Buddhism, is located near the little town of Shinpyong. It is also known as the "Temple Without a Buddha," as there is not a single statue of the Buddha here, either in the grounds or in the main building.

of the entire temple complex is idyllic. The so-called "Eight Scenic Views of Tongdosa" include the ancient pines at the entrance, an area of percussion instruments and bells, a pond that merges seamlessly into the cluster of buildings, a short stretch of river that flows below the "Dangerous Bridge" (which has no handrail), rocks and waterfalls around the temple, and Mount Chiseo in the background. This sacred place is visited by many pilgrims every day—most come from Korea, but foreign visitors are welcome.

The daily procession of the monks for the bell ceremony is particularly interesting— a gong in the shape of a giant wooden fish and one in the shape of a cloud hang near the bells in one part of the temple and are struck in succession. The resonating sound of the fish gong is said to encourage creatures that exist in water to live together in peace and the sound of the cloud gong is said to similarly encourage peaceful existence among the creatures of the air. At the end of the ceremony a great bell is tolled, calling mankind to live in peace with every living thing.

Jeju-do

The small sub-tropical island of **Jeju-do** is located to the south of the Korean peninsula, with a further 26 smaller, uninhabited islets grouped around this main island. Jeju-do was to all intents and purposes cut off from the outside world for centuries, so the ancient religious practices of shamanism were able to survive here. It is said that some 18,000 deities are worshiped on the island, although quite how this figure was arrived at is one of the island's many secrets. The Koreans regard Jeju-do as a mysterious place from a mythical time, and the many people who visit the island do little to change this. Newly-weds travel to the island in great numbers, devoting themselves to amorous exploration in Love Land, a theme park primarily devoted to human sexuality. What might seem an odd custom to some is explained by the fact that sex before marriage is still considered a taboo among large parts of the population. In any case it is perhaps appropriate for a holy island—sexuality is regarded as a strange and mysterious part of human nature in every culture.

There is a large number of neolithic monuments on the island, not dissimilar to the menhirs and stone circles of Europe. Their meaning and purpose can only be guessed at, but it is likely that they were used as part of ancestor worship. The **Tol-Harubang**, phallic stones decorated with faces, are particularly striking. It is assumed the stones represent gods or ancestors responsible for protection or fertility. Women who are trying to conceive often receive little replicas of these stones as presents.

A strange phenomenon on the island is the "mysterious road," which heads south from the town of Sinjejeu toward Hallasan National Park. Although appearing to go downhill, it is in fact going uphill.

This unusual illusion means that pilgrims taking this road have the spiritual experience of going uphill, even when they think that the apparently downhill gradient will be easy.

Hallasan is a dormant volcano, and at 6,600 feet (2,000 m) it is the highest mountain in South Korea. It is considered sacred and climbed accordingly. Located at its northern foot, **Gwaneumsa Temple**, the oldest temple on the island, was built during the Goryeo Dynasty (918–1392), although, like most temples in Korea, the modern building is from the 20th century.

The most important temple on the island is **Samseonghyeol** in Aka Gujeju, the old part of the capital, Jeju-si. It has extensive grounds, in the middle of which there is a depression in the ground. This hollow is the most sacred place on the island, as according to legend it was here that three demi-gods, Go, Bu, and Yang, appeared and divided the island between themselves by shooting three arrows into the hills. Each of the three received the area where his arrow fell to earth. Immediately afterwards, three young girls appeared in the shallow waters by the shore and population of the island began. Every year, on April 10, October 10, and December 10, members of the three clans assemble to honor their ancestors and ask for future blessings. The various Tol-Harubang (phallic stones) hanging at the temple entrance seem to promise such benedictions.

A Tol-Harubang (phallic stone), Jeju-do

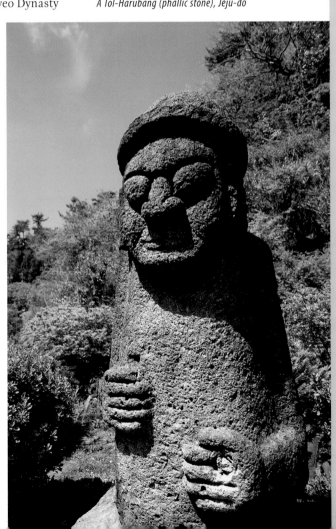

Mount Osore (Osore-zan)

Translated literally, the name of this volcanic massif means "Mount Fear" or "Mount Terror." Located on the Shimokita Peninsula to the northeast of the Aomori Prefecture, the mountain is sacred to both Japanese shamanists and Buddhists. The bare volcanic landscape, with its pungent, sulphurous springs and streams, and Usoriyamako, a lifeless crater lake, lend the area a gloomy and somewhat unsettling air. Mount Osore (Osore-zan) is considered to be the crossing-point to the underworld, and one widely held belief has led people to pile up pebbles into little cairns for the souls of dead children in the hope that Jizō Bosatsu will have mercy on them. Jizō, one of the most popular Bodhisattvas, is thought to accompany dead souls on their journey to the underworld, and as a redeemer of souls he is said to pay special attention to those of children. The Sanzu River corresponds to the Styx, the river of death in Western mythology, and there is a small bridge that souls must cross to evade death.

The mountain is also a major pilgrimage site for followers of shamanism. Many visitors come to the area in July, as at this time it is said to be possible to contact the dead with the aid of *itako* (blind female shamans). Countless cairns of stones are reminders of dead relatives, and when these are children, there are also toys and votive offerings for the spirits beside the cairns. Osore-zan is a place that confronts and involves visitors with the phenomenon of death in a particularly intense way.

The Three Mountains of Dewa

The Three Mountains of Dewa (Dewa Sanzan) are three sacred peaks in the Bandai-Asahi National Park. **Haguro-san** is the lowest of the three at only 1,360 feet (414 m), and 13 miles (20 km) to the south of here you will find **Yudono-san** (4,920 feet/1,500 m) and **Gassan**, the "Mountain of the Moon," at 6,510 feet (1,984 m). The pilgrims' path to all three begins in Koganedo Temple, the Golden Hall for all three mountain shrines, at the foot of Haguro-san. The town of Togo, situated beside Haguro-san, is the principal center of the Yamabushi, followers of Shugendō, an old Japanese syncretistic religion dating back to the 7th century whose adherents practice magic rituals and ascetic exercises in the mountains in an attempt to attain buddhahood in this life. Among their supposedly magic powers is the gift of prophecy, and many come to the Yamabushi to have their earthly fortune told.

The sacred mountains of Dewa reveal a combination of Shintoist and Buddhist notions—each of the three mountains symbolizes a Shintoist incarnation of Buddhist deities. After conducting ritual ablutions in the temple and going

through the torii separating the secular world from sacred reality, pilgrims climb the longest flight of stairs in Japan (2,446 steps) to a five-storey pagoda at the summit of Haguro-san that contains the Sanshin-gosaiden, a Shintō shrine to the mountain gods. Pilgrims spend the night in a simple hostel on the summit of Haguro-san before continuing their journey to the other sacred peaks. Gassan is the home of the moon goddess, who can be petitioned and worshiped on its summit, and Yudono-san is the home of the mountain god. The shrine on this summit is not enclosed by the usual building; it is a free-standing rock from which a hot spring bubbles. Mountains, water, forests, temples, and shrines combine to make Dewa Sanzan the important pilgrimage site it has always been and remains to this day.

Nikkō Tōshō-gū

Two weeks before his death in 1616, the shōgun Tokugawa Ieyasu told his closest friends that he wished to lie buried on Mount Kunō, his birthplace, for one year, and then be moved to Nikkō, where his soul was to rest forever. His wishes were followed to the letter and in less than two years his mausoleum was ready. Less than 20 years later, however, the shrine was almost completely demolished—only the large entrance gate and the granite font for ritual purification survived. The current appearance of

the shrine and temple complex dates back to the time of Iemitsu, a grandson of Ieyasu. The buildings have a style whose rich ornamentation is comparable with Western baroque.

Reconstruction began in 1634 and the central buildings were completed two years later, although it was to be another five years before the whole complex was finished. The site of the Nikkō shrine was already considered a sacred place, but it rose to exceptional importance with the construction of the Tōshō-gū. The stone torii marking the entrance to the shrine is 30 feet (9 m) high, the largest in Japan. Behind the gate is a richly decorated, five-storey pagoda and then more stone steps leading to Niomon, the second gate. This entrance is guarded by two sentinels whose mouths form the syllables "ah" and "un" (both of which are letters in the Sanskrit alphabet), the equivalent of alpha and omega—the beginning and the end, or breathing in and breathing out.

Behind this second gate are three plain buildings known as the "store-houses of the gods," and one of these contains the robes and utensils used every May 17 in the re-enactment of the procession that brought the mortal remains of the shōgun from Kunō to Nikkō. The next building, which once contained sacred horses, houses the world-famous statue of the Three Wise Monkeys who see no evil, hear no evil, and speak no evil. The image is understood all over the world, but has a special appeal in Japan because of a play on words. The Japanese word for monkey (zaru) can also mean "not," and so the hearing monkey becomes

"hear nothing" (kika-zaru), the seeing monkey implies "see nothing" (mi-zaru), and the speaking monkey implies "say nothing" (iwa-zaru).

Pilgrims proceed past the font for ritual ablution and enter the second

The Three Wise Monkeys, Nikkō Tōshō-gū

torii, which was the first in the whole country to be cast from bronze. Among the lotus blossoms at the foot of the gate can be found Buddhist symbols: the temple complex became a shrine during the Meiji period but it still contains many Buddhist elements, such as the pagoda and the Niomon gate. Once through this gate, pilgrims reach the magnificent Yōmei-mon; dominating the main square, the gate's wealth of ornamentation is unequaled by any other temple gate in Japan. An inscription beneath the roof attests to Tokugawa Ieyasu's status as a kami god. The carvings on the gate depict clouds (air), flowers and animals (earth), and

waterfowl (water), and a white dragon rises up to stare aloofly at those who dare to approach. It is interesting to note that a "mistake" has been incorporated into the decoration of the gate—the pattern of one of the columns is upside down, so as not to offend the gods with a perfection achieved by human hands.

Behind the gate is Honji-dō, the Hall of the Weeping Dragon, a prayer hall, and the main shrine, all of which are connected by an ornate corridor. Like the prayer hall, the shrine's inner sanctum is divided into three sections—a sacrificial hall, the holy of holies (nai-jin), and the "holiest of all holies" (nai-nai-jin), an area reserved for only the most senior members of the priesthood. Behind the shrine there is a stone flight of steps leading up the mountain to Tokugawa Ieyasu's mausoleum, a simple bronze pagoda with all the essential characteristics of a Buddhist grave: a vase, a vessel for incense, and a candle-holder.

Sensō-ji, Tokyo

A long access road lined with souvenir stalls and shops selling religious paraphernalia will bring you to the

best place in Tokyo to experience Buddhist belief in its living form. Countless people throng the Sensō-ji (also known as the Asakusa Temple), especially during the three-day Matsuri festival. The entrance to the temple precinct is formed by the Gate of Thunder (kaminari-mon), to which a blue and red painted paper lantern is affixed, symbolizing thunderclouds and lightning. The entrance is flanked to the right and left by two sentinel

Matsuri Festival, Sensō-ji, Tokyo

gods—Raiten, the bringer of thunder, and Fūten, the bringer of wind; thunder and wind are often presented as a pair in Japanese iconography. Fūten usually carries a long sack in which the winds are contained, and Raiten is surrounded by concentric circles of drums that produce thunder.

The temple precinct contains a five-storey pagoda and the main shrine, dedicated to the Buddhist god of compassion, the androgynous Bodhisattva Avalokiteshvara, known in China as Guanyin and in Japan as Kannon. According to legend, the very small statue of Kannon worshiped here is said to have been found in a net by some fishermen. Another story recounts how the two fishermen repeatedly tried to take the statue back to the Sumida River but each time found that it had returned to the spot where the temple was later built. On religious holidays, thousands of believers form a line to light their joss sticks at the incense bowls, before wafting the smoke with their hands toward the body parts that are causing them concern or for which they wish to make a special petition. An inviting garden adjoining the temple complex can be used for meditation and contemplation.

The Daibutsu, Kamakura

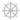

Modern Kamakura is a seaside resort, but in the period between 1192 and 1333 it was the seat of government. It declined in importance after the end of the Minamoto Shōgunate in 1333, and only recently has this picturesque village re-expanded to become a bustling and popular town. Its sheltered

The Great Buddha (*Daibutsu*) in the old Kōtoku Temple enjoys special veneration—the giant statue dates back to 1252 and has survived the ages almost completely unscathed. Depicted in a seated meditation position, the almost 43-foot (13-m) high Amida Buddha is made of several cast bronze sections that have been skillfully joined together. The statue is hollow, and visitors can even climb inside; there are two viewing windows in his back and it is an oddly arresting feeling to look from the inside out. The monumental Buddha was once enclosed by a temple hall, but after this had repeatedly collapsed it was decided not to rebuild it and the open-air statue has developed a feeling of immediacy. In Japan, Amida, the most important Buddha in Mahayana Buddhism, is known as the Pure Land Buddha and his invitation to lose oneself in meditation is still extended today.

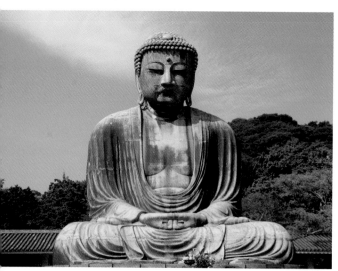

The Great Buddha (Daibutsu), Kamakura

location and warm sea currents have helped Kamakura's development into a popular holiday destination. Many of its shrines were destroyed by a devastating earthquake and tsunami in 1923, but there are still more than 60 temples and 20 shrines in Kamakura.

Mount Fuji

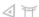

According to an old Japanese proverb, "Anyone who never climbs Mount Fuji is a fool; anyone who climbs it twice is a lunatic!" Mount Fuji (Fujisan), the highest mountain in Japan (12,389 feet/

3,776 m), is sacred to the Japanese. Like many sacred mountains, it is a volcano, and though it is dormant, Japan is a country where movements of the earth's crust are particularly intense; the last eruption of Mount Fuji took place between November 24 1707 and January 22 1708. Thousands of pilgrims visit the mountain every year and, as a result of this, countless altars and temples have sprung up. The *36 Views of Mount Fuji* by Katsushika Hokusai, an artist and illustrator from the Edo period, have achieved worldwide fame, and the mountain, which remains covered in snow until late spring, is considered a symbol of the secrets of eternity.

The Japanese believe that Mount Fuji has a soul, so it is no surprise to learn that a pilgrimage to the mountain is seen as a metaphor for a spiritual process: the physical exertion of the ascent is matched by an increased knowledge of the nature of the soul. The belief is that those who complete the arduous climb up Mount Fuji slowly draw near to immortality; pilgrims hope to achieve a closer relationship with the Divine through their ascent.

According to legend, the first pilgrim to reach the summit was not a man but a monkey who climbed the mountain in 663. The Japanese Macaque (*nihon-zaru*), the only indigenous species of monkey in Japan, crops up in numerous fairy tales and myths, often as a clumsy trickster imitating the doings of man, usually unsuccessfully. Is it coincidence that the creature biologically closest to man was the first to approach the secret of immortality?

Mount Fuji at dusk

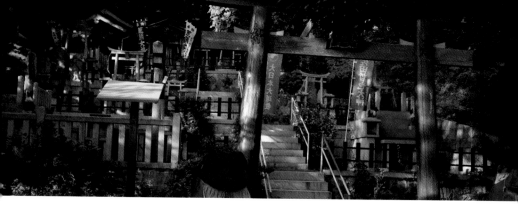

KYOTO—WHERE JAPAN IS AT ITS "MOST JAPANESE"

Founded as Heian-kyō, the "Residence of Peace," more than 1,200 years ago, Kyoto for the Japanese is a place of almost irresistible nostalgic yearning, a feeling expressed by the Japanese poet Matsuo Bashō (1644–94) in the line "even in Kyoto I yearn for Kyoto." The middle Heian period (c. 900–1000) saw the city flourish, with courtly culture achieving increasing sophistication and great advances in literary, artistic, and religious creativity. New styles of architecture, garden design, painting, and Buddhist religious art established themselves during the period and Pure Land Buddhism and the Tendai and Shingon schools pervaded the spiritual world, slowly increasing in influence.

The city was built on its checkerboard street-plan in the space of a year by Tennō Kenmu (also known as Kammu), who intended to locate his official residence here; he moved into the completed Heian-kyō in 794. The imperial surveyors considered the site ideal: surrounded by mountains on three sides and bounded to the west by the Katsura and to the east by the Kamo River, with Mount Hiei to the northeast preventing the intrusion of demonic spirits. Despite the numerous fires, typhoons, and earthquakes that have plagued the city, its basic layout has survived.

The Heian period was characterized by a refined aesthetic sensibility that still colors Japan's image to this day, but it was also a time when an awareness of the transitory nature of things made itself apparent. The pessimistic belief that the last days of mankind had arrived and that the Last Judgment was approaching shaped people's attitudes. The Japanese call this *mono no aware*—the "heart-breaking nature of things." Kyoto is a modern metropolis with a population in the millions, and yet much of the former atmosphere, a feeling it has radiated from the very beginning, can still be detected.

above: Torii in Fushimi Inari-taisha

right: Five-storey pagoda, Tō-ji

588

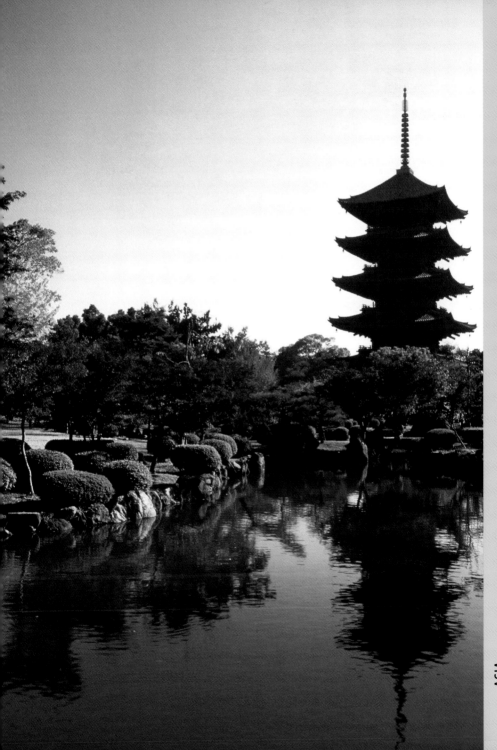

Tō-ji

The earliest plans of Heian-kyō (modern-day Kyoto) from 793 show two temples at the entrance gates to the city: Sai-ji, the West Temple, and Tō-ji, the East Temple. Sai-ji burnt down at the turn of the 13th century but Tō-ji has remained the most important temple in Japan to this day.

Construction of the two temples was intended to secure peace for the country, and every ritual or ceremony connected with both inner and outer peace or security was held in Tō-ji. The temple area is entered via the southern main gate (*nandaimon*), which has a plain appearance despite its eight pillars and gabled roof. Visitors will first notice the main hall (*kondō*); built in 1603, it is a masterly example of Buddhist architecture, incorporating stylistic elements from India, China, and Japan. Behind this there is a lecture hall for Buddhist monks. The emperor commanded the legendary monk Kūkai to come to Heian in 825 and the hall was built as a teaching-space for Shingon Buddhism, although the modern building was constructed only in the 15th century. Built in 1644, the five-storey pagoda is at 181 feet (5 m) the tallest wooden building in Japan and has become the city's emblem.

Tō-ji contains exceptional, greatly venerated sculptures. Bishamon-ten, one of the seven gods of good fortune and the Buddhist Celestial King of the North, carries a holy spear in one hand and in the other a sacred pagoda; he is said to be able to scatter the enemies of Buddhism. Behind Jikoku-ten, the Celestial King of the East, there is a large wheel symbolizing the sun. The great statue of Senju-Kannon, the Kannon of a thousand arms and a thousand eyes, is particularly impressive and awe-inspiring, even though there are no more than 40 arms and pairs of eyes. The much-revered sculpture is preserved in the temple museum. The statue of Fudō-myōō, the fearsome avatar of the Dainichi Buddha who fights evil, also draws visitors under its spell.

The most enigmatic and potent features of the temple are the two mandalas that Kūkai himself is said to have brought from China. The Diamond World Mandala shows the entire cosmos as a unity and the Womb World Mandala depicts the dynamics of the earth; together, they represent the perfect universe. The temple is thus not only a sanctuary housing the most important symbols of Shingon Budddhism; it is also an invitation to all mankind to immerse itself in the mysterious and eternal laws of the cosmos.

Fushimi Inari-taisha

It is no surprise to see this sacred place on postcards—thousands of brilliant red torii spiral for miles up the hill to the shrine. They are generally commissioned by those hoping

for success in personal or commercial ventures, and most were donated by Japanese companies. The torii are votive offerings to Inari, the Shintō rice goddess, and lead up to the summit of the hill where the shrine's holy of holies, a mirror, is kept. Unusually, this sacred area is open to outside view—an oddity among Shintō shrines. Fushimi shrine

Torii, Fushimi Inari-taisha, Kyoto

was first documented in 711, and it is not implausible that the popularity of Inari-worship is in part due to its association with Shingon Buddhism; one of its founding myths reports how Inari appeared to the monk Kūkai in the form of an old man with a sack of rice on his back.

Foxes, considered envoys of Inari, are among the most important animals in Japanese mythology. It is said that every fox has magical powers and that many of them have nine tails. They can change into human form at will or take control of a person's spirit, and are associated with all kinds of possession. Women in particular are susceptible to a fox's enchantments. Fox cults and Inari-worship were at first probably separate traditions but have slowly merged into one. Inari is the Shintō goddess with the greatest number of shrines dedicated to her as an individual; there are said to be more than 30,000, although they are often very small and easily missed. They can be recognized by the foxes standing guard at the torii. Fushimi Inari-taisha, the greatest of all Inari shrines, is

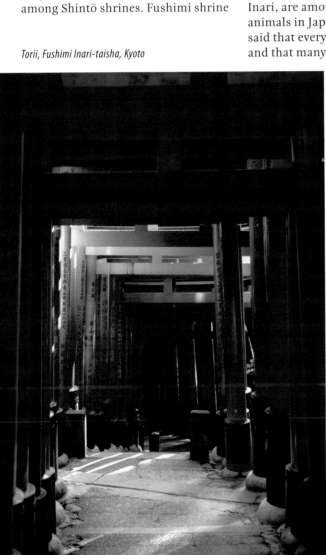

ASIA

591

an example of the animist elements in Japanese religion that have retained their importance to the present day.

Hirano Shrine

Long before man built shrines, waterfalls, islands, cliffs, particularly striking trees, and animals were worshiped as kami—the mystical spirits or powers investing nature. Kami-worship has been of great significance in Japan for thousands of years.

The 7th and 8th centuries saw a program of shrine-building at especially sacred sites and the 22 shrines from the Heian period (794–1185) are held in the highest regard to this day; a list of them was prepared as far back as 1081.

Brought to Kyoto at the behest of the emperor in 794, the Hirano Shrine is now housed in buildings dating back to the 17th century. The site consists of four main buildings (*honden*), each dedicated to a different kami: Imaki-no-kami, Kudo-no-kami, Furuaki-no-kami, and Hime-no-kami. The origins, meanings, and ambits of these kami are the subject of intense scholarly debate; it is possible that all four were worshiped as hearth gods attached to the imperial palace, or they may have been associated with various aristocratic families.

The cherry blossom festival that has been celebrated here every April 10 since 985 is one of Kyoto's oldest religious rituals. It begins in the morning with a ceremony at Kazan-Tennō's mausoleum and continues with processions across the shrine grounds and through the local neighborhood. The shrine is famed far and wide for its enchanting gardens, which were recently planted with 1,200 fruit trees to celebrate the 1,200th anniversary of the god's arrival at the shrine.

Zen

Zen is a religious practice whose aim is to achieve personal enlightenment through meditation. Zen's roots are to be found in China, where it is called Chan. There are various schools of Zen in Japan. Rinza Zen, founded by Eisai (1147–1215), a Tendai monk, emphasizes sudden enlightenment, often by means of a koan, an insoluble riddle given to a pupil by a master. Monastic discipline and meditation are methods used to reach the deepest levels of insight and enlightenment. The teachings of Sōtō-Zen, brought to Japan from China by Dōgen (1200–53), found many adherents among the peasants and among the samurai in particular. The emphasis in these teachings was on religious exercises such as seated meditation (*zazen*). According to Dōgen, enlightenment was to be reached by meditating on nothing.

Tōfuku-ji

A relatively late arrival to Japan, Zen developed as two branches during the Kamakura period (1185–1333): the Sōtō school and the Rinzai school, the latter being established in 1191. Zen's characteristic disinclination toward icons, words, and rituals lends Zen temples a particular ambience; inside you will often find little more than plain ink illustrations or calligraphy, and Zen sand and rock gardens have a particular aesthetic fascination. Sand, pebbles, water, and grasses, representing mountains, water, and rocks, become tools toward medita-tion and enlightenment. Zen art is the art of inference, and the gardens concentrate the Zen mood.

One of the most famous gardens of this kind belongs to the Tōfuku-ji, the main temple of the Rinzai school in Kyoto. The initial structure, built in 1236, was influenced by the magnificent temple complex at Nara, but when dev-astating fires in the 14th century left little of this temple standing, a completely new shrine was built. This too was destroyed in a fire in 1881, and subsequent restora-tion work was completed only in 1934. The modern complex now comprises 24 temples. The Sanmon, a 73-foot (22-m) high gatehouse, is thought to be the highest main gate ever built in the Zen

Zen Garden, Tōfuku-ji, Kyoto

tradition. The meditation hall (*zendo*) and the bathhouse have survived, but the main hall (*hondo*) and the monks' cells are reconstructions. However, very few make the journey here to admire the temple architecture; most visitors are drawn from far and wide to see the harmonious, meditative gardens designed by Mirei Shigemori, a landscape architect famed throughout Japan. They perfectly express the Zen ideal of simplicity and Shigemori has combined the features of the garden with modern and abstract art. The temple receives large numbers of visitors in the fall, when the leaves are turning yellow and an especially soft light illuminates the complex.

Kiyomizu-dera

The **Kiyomizu-dera** temple complex is very popular in Japan. Even before the city was founded there is said to have been a temple here in a wild and untamed landscape where the monks retreated to find solitude. The name of the temple, Kiyoi mizu, meaning "pure water," refers to a waterfall near the sacred site. Although the temple's history reaches as far back as 798, the present buildings, which stand on a wooden terrace suspended 43 feet (13 m) above a steep mountain cliff, date back only to 1633,

Kiyomizu-dera, Kyoto

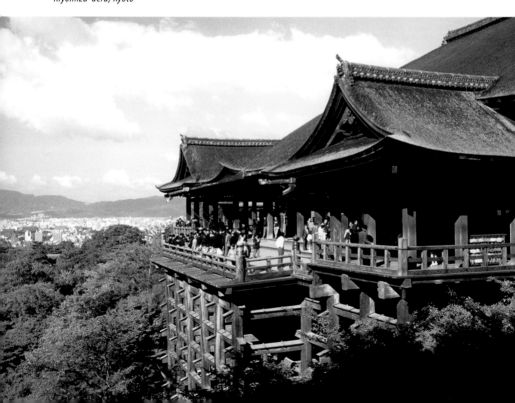

and any thoughts of peace and solitude have long been abandoned.

"To jump from the Kiyomizu terrace" is a common idiom in Japan, meaning to resolve to do something after much thought—you would certainly have to think for a while before screwing up your courage to jump from the terrace. Those who jump and survive are supposed to have all their wishes fulfilled, according to tradition, but jumping from the terrace is now prohibited. Visitors instead descend a wide flight of steps beside the main hall to the Otowa waterfall and its plunge pool, where they drink the ice-cold water, which is said to have healing powers, from metal bowls. The belief is that those who drink the water will have both health and success in life.

The **Jishu-Jinja** Shintō shrine located in the temple grounds is a place of romantic longing—it is dedicated to Enmusubi-na-kami, the god who grants relationships. At the shrine there are two stones standing 60 feet (18 m) apart, and it is said that anyone who can find their way from one to the other with their eyes shut will soon fall in love. Young girls are often to be found here trying to follow the right path.

Ginkaku-ji

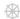

Experts describe the buildings and grounds of this late 15th-century Zen Buddhist temple as a perfect example of what is known in Japan as *yūgen*; the term is difficult to translate, but means something like "enigmatic grace and beauty." The correct name for this Rinzai temple is Jishō-ji, but it is better known as Ginkaku-ji, the Silver Pavilion. Part of the Ashikaga shōgun Yoshimasa's plan was to clad the pavilion in silver, but he died before it could be carried out. During his lifetime, Yoshimasa had seen the depredations of the Ōnin War (1467–77) raze large areas of Kyoto to the ground, and he wished to build an oasis of spiritual peace and solitude in order to forget the horrors of war. After his death in 1490, his house was turned into a Buddhist temple.

Opposite Ginkaku, the main pavilion, you will find Tōgu-dō, the Hall of the "Eastern Quest," which is of particular cultural and historical importance as the size and appointment of one of its ante-rooms are ideally suited to the tea ceremony (*dōjinsai*). The entire complex is characterized by a great harmony and beauty, with the architecture and landscape gardening merging seamlessly and sympathetically. The rich variety to be found here, despite the simplicity and order of the carefully orchestrated elements of the landscape, gives the impression that you are walking through a *tableau vivant*.

Two further enclosures were added to the gardens in the 16th century: the Sea of Silver Sand (Gishadan) and the Moon View Terrace (Kōgetsudai). As you emerge from the long corridor of hedges lining both sides of the

path to Ginkaku-ji, you are suddenly transported to another world—a place of meditation and inner peace.

Kitano Tenman-gū

⛩

The court nobleman Sugawara no Michizane (845–903) was an exceptional scholar and a politician. Although innocent, he was banished from the imperial court in the wake of a plot and died before he could have the unjust sentence overturned. His death was followed by all kinds of natural disasters, plagues, and unusual and inexplicable fatalities. The court astrologers eventually came to the conclusion that all these catastrophes were consequences of Michizane's vengeance, and to appease his spirit a shrine was built in his honor in 959.

He was subsequently worshiped as the kami of scholarship, receiving all the esteem that had been denied him during his lifetime, and he is now best known under his nickname, Tenman

Ginkaku-ji and grounds, Kyoto

Tenjin. The scholar was said to be a great lover of plum blossom and Tenjin shrines have adopted the plum as their emblem. Tenjin is worshiped as the god of scholarship, education, and creative writing, and the Tenjin shrine at Kitano Tenman-gū in Kyoto is particularly well attended when students are taking their university entrance exams. There is now an extensive network of some 10,000 Tenjin shrines.

Kamo-jinja

The Kamo shrine—Kamo-jinja—is one of the oldest temple complexes in Japan; it is surpassed in its importance for Shintoism only by the shrine at Ise. Its name refers to the Kamo River on whose banks the two-part complex stands. There are two separate shrines—the older Shimogamo-jinja, which may well date back to the 6th century, and to the north of this the Kamigamo-jinja, which is probably 7th century. Both are dedicated to the kami of thunder. Built in 1628, the main buildings (honden) and the ancillary hall (gonden) are quite well known. Although most of the 36 buildings on the Kamigamo-jinja site are closed to the public, they are nonetheless greatly venerated and often surrounded by crowds, especially during the Aoi Festival in May. Processions between the upper and lower shrines and archery competitions are held in homage to the

kami. The Kamo shrines at Kyoto are a good example of the typically Japanese way the Kami cult spread: the kami were initially worshiped by families with common ancestors before becoming protector gods for a whole region.

Shimogamo-jinja lies in Tadasu-no-Mori, the ancient "Forest Where Lies Are Revealed." However impressive the architecture may be, the location of the shrines in this enchanted forest on the banks of the Kamo River is more important: water is of crucial significance for all shrines and is usually collected in basins, with metal ladles available for believers to draw water for the ritual cleansing of hands and mouth. Ritual purity creates a pure heart.

Enryaku-ji, Mount Hiei

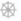

The Buddhist monk Saichō (767–822) is considered the founder of the major Tendai school of Buddhism. As well as meditation and the study of holy texts, Tendai includes mystical elements and rituals taken from esoteric Buddhism. Saichō worshiped Sannō, the mountain king and patron deity of Mount Hiei; the famous Hiei Shrine on the eastern slopes of the mountain was where the monks of Enryaku Monastery conducted their rituals in honor of Sannō, whom they regarded as the protector god of the entire monastic mountain. This incorporation of a local divinity is an example of

the efforts made by influential Bud-
dhists to temper aversion to a religion
regarded as foreign by integrating local
cults and their sacred places into the
construction of Buddhist temples.

Enryaku-ji was founded in 788
and soon flourished as a center of
Tendai Buddhism, according to
whose teachings all living creatures
have the potential to attain buddha-
hood. It was the most powerful and
influential monastery in the country
for centuries, holding vast tracts of

land free of tax and even maintaining
its own army. Enryaku-ji remained
the spiritual headquarters of the sect
even after Saichō's death, but in 1671
the monastery was almost completely
destroyed by the warlord Oda Nobu-
naga. It was never properly rebuilt,
although the original layout of the
complex, with its three great temple
precincts and many sub-temples
scattered across the whole moun-
tain chain, was to survive. Modern
visitors to this impressive mountain

Saichō and Kūkai

Saichō and Kūkai are considered the great-
est reformers of Buddhism in Japan. In 804 they
visited China together to study sacred Buddhist
scripture. Saichō went to the Terrace of Heaven on
Mount Tiantai (Tendai in Japanese) with a lega-
tion, and it is thought that the Lotus Sutra was
the holy text that contained everything neces-
sary for his enlightenment. It has been said that,
for Tendai Buddhism, meditation and intellec-
tual engagement with religion are "as important
as both wings for a bird," and the school is as
much a philosophical as a contemplative doc-
trine. The sect's Buddhism has strong monastic
characteristics, with fixed, strict rules for life.
The basic approach involves esoteric rituals and
intensive meditation, enabling the individual to
penetrate every aspect of reality and to achieve
nirvana in samsara (the world of reincarnation).
Saichō compared man's capacity for enlighten-
ment with a lotus flower growing in the dirt.
After returning from China, Saichō founded the

monastery of Enryaku-ji on Mount Hiei to the
northeast of Kyoto, the capital of the time.

Reaching China, Kūkai found his way to Chang'an
to study under Huiguo, the most famous Buddhist
master of the period, who soon made him his pupil
and tutored him in the secrets of esoteric Buddhism.
The core concept here is that man can achieve
enlightenment in this lifetime, rather than after a
long series of reincarnations. Kūkai founded Shingon
Buddhism (the school of the True Path). Initiation
followed by cosmic diagrams (mandala), secret ges-
tures (*mudra*), and mystical words (*mantra*) provide
a pupil with access to the world's innermost secrets.
The most important of these mandalas are the Dia-
mond World Mandala and the Womb World Mandala
in Kyoto's Tō-ji temple. After returning from China,
Kūkai became a priest at Tō-ji, later founding a
monastery celebrating remoteness and self-denial in
the mountain fastness of Kōya-san, which has now
become one of the major pilgrimage sites of Japan.

can therefore still get a sense of the political and spiritual power that Buddhist monasteries once exercised.

Byōdō-in, Uji

Originally built as a palace during the Heian period, Byōdō-in in Uji, about 10 miles (15 km) south of Kyoto, was converted into a temple by Fujiwara Yorimichi in 1052. It is best known as the "Phoenix Hall," partly because of a gold-plated statue of the immortal bird of legend which glints in the sunshine on the roof of the hall, and partly because, seen from afar, the layout of the complex bears a fleeting resemblance to a bird in flight.

The grounds and the Phoenix Hall (Hōō-dō) are an attempt to portray the so-called "Pure Land," Amida, which represents eternal light and

Byōdō-in Temple, Uji, near Kyoto

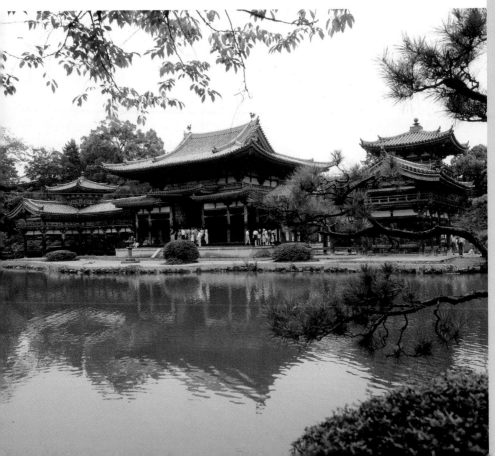

everlasting life. A masterly statue of the Amida Buddha sits enthroned on a lotus flower on the central axis of the small square middle hall, the work of the renowned sculptor Jōchō (d. 1057), who had a great influence on Japanese representative art.

The Phoenix Hall is situated on a small island in the middle of a graceful pond in whose still waters the sky and the roof of the temple are reflected. The temple is both a gate and an invitation to eternity; the soul of every individual is called to be welcomed by the Buddha in the Pure Land, and the quest for freedom from karma—the journey to the Pure Land—can begin here.

the complex had to be rebuilt after a fire. The Kondō, the Golden Hall, was completed in 690, followed a little later by the sculptures in the 103-foot (31.5-m) high five-storey pagoda. The temple precinct is entered via the Nandaimon, the Great South Gate, which leads to Chūmon, the Middle

Main Hall, Hōryū-ji, Nara

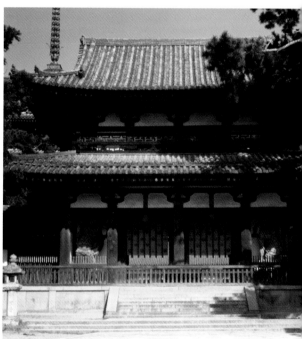

Hōryū-ji, Nara

Hōryū-ji, literally "The Temple of the Flourishing Law," is probably the oldest Buddhist temple complex. The ailing emperor Yōmei had sworn to build a temple and commission a statue of the Buddha if he were to recover, and though he did get better, he was not able to fulfill his vow as he died soon after. His son, Shōtoku Taishi, and the empress Suiko honored Yōmei's last wishes by building the temple and erecting several statues in 607, although

Gate, and the oldest part of the shrine, an area surrounded by a wall. The pagoda, the Golden Hall, and the sutra library are all to be found here.

The pagoda and the Kondō are equally revered central elements of the Hōryū-ji. The tapering architecture of

the impressive pagoda is typical and represents a striving toward heaven; it is surrounded on all four sides by clay sculptures. Several of these depict the Buddha entering nirvana, others represent divine beings from the Buddhist pantheon, and others again personify pupils who are still on the road to enlightenment; these are portrayed in expressive pain or deep reverence. Those on the west side show how the relics of the Buddha were shared out after his death. The walls of the Kondō are covered in images of the Pure Land for visitors to meditate upon. There is an altar in the hall, symbolizing the sacred mountain of Sumeru, upon which stand statues of Shi-tennō, the four Guardian Kings, watching over the holy mountain.

The East Gate is more difficult to find but leads through to another part of the temple built on the site of the former palace of Shōtoku. Here you will find the "Hall of Dreams," a small, octagonal room with a life-size statue which is said to have the power to save the world. Nara Buddhism subsumed all varieties of Japanese Buddhism, even briefly serving as the religion of the imperial court. The

Hōryū-ji bears witness to the influence that Buddhism was to exert on culture and architecture from the 7th century onward, as demonstrated in the impressive harmony and serenity of its structural and landscaped elements.

Tōdai-ji, Nara

It might be difficult for modern visitors to the rather provincial-seeming city of Nara to imagine that this was once both the political and cultural center of Japan. Nara was the national

Cosmic Buddha, Tōdai-ji, Nara

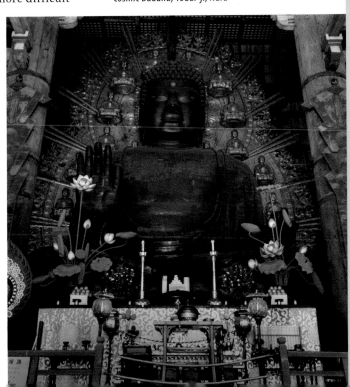

capital from 710 until the relocation to Kyoto in 784, flourishing especially under the leadership of Shōmu Tennō (701–56), who conducted an ambitious construction program that gave rise to many prestigious buildings. He was a strict devotee of Buddhism, a belief that was still new in Japan, and in 745 he commissioned the Tōdai-ji as the largest and most important place of worship in a national network of provincial temples. The temple covers an extensive area; as well as its Buddhist buildings there is a Shintō shrine to the god Hachiman, who was declared the divine protector of the Great Buddha.

The temple precinct is entered via the impressive entrance gate (*nandaimon*) with its two sentinel statues, which are almost 30 feet (9 m) tall. The main hall, the largest exclusively wooden structure in the world, is dominated by a giant bronze statue of the Vairocana (*dainichi*), the Cosmic Buddha. Construction of this monumental 50-foot (15-m) high statue took more than a decade, its ritual completion taking place in the spring of 752. Attended by monks from all over Japan, China, and even India, the Eye-Opening Ceremony, in which the eyes were painted in to represent the entrance of the soul into the physical body of the statue, was a crucially important event that immediately elevated the Tōdai-ji to its central status in Japanese Buddhism. It might be true to say that the construction of the temple and the completion of the Buddha statue were a deliberate demonstration of

Buddhist power, but it is also true that the Cosmic Buddha is still making an impression upon mankind today.

Hase-dera, Sakurai

Esoteric Buddhism was particularly influential during the Heian period (794–1185), a time when the aristocracy, enthused by Chinese culture, was developing and slowly refining an elegantly stylized aesthetic in both worldly and sacred architecture; this was to become one of the chief characteristics of the epoch of Classical Japan. Hase-dera, said to have been founded in the 7th century, was one of the most popular pilgrimage sites even during this early period. The temple's consecration in the 8th century is historically documented, and for this the emperor Shōmu commanded the famous 33-foot (10-m) high statue of the Kannon, with its 11 faces, to be brought to the site to be blessed by the monk Tokudo Shōnin.

The Hase-dera is the principal temple of the Shingon school of Buddhism, which rapidly spread through Japan after its introduction by the monk Kūkai upon his return from China (806). Its esoteric teachings promised redemption in this life rather than after a prolonged series of rebirths. Every follower could advance to nirvana and the innermost secrets of life through initiation in cosmic diagrams

(mandala), secret gestures (*mudra*), and mystic symbols (*mantra*).

The temple is at its most wonderful when the peonies are in blossom in May—more than 7,000 blooms of different varieties overwhelm the senses with their beauty. Every visitor will understand why aristocrats and courtly ladies came here over a millennium ago to praise it in their poems.

Sumiyoshi-taisha, Osaka

There are three Sumiyoshi-Kami: the Venerable Old Man of the Seabed (Sokotsutsu-o-no-mikoto), the Venerable Old Man of the Middle of the Sea (Nakatsutsu-o-no-mikoto), and the Venerable Old Man of the Sea Surface (Uwatsutsu-o-no-mikoto), and all three are worshiped as divine protectors of travelers, seafarers, and fishermen. As the sea has always presented dangers, mankind has constantly been at pains to honor and appease the spirits seen as responsible for these kingdoms, and the middle of the sea has always been a mystic and sacred place.

The Sumiyoshi-taisha is the most important of more than 2,000 shrines dedicated to these gods. The exact date of its foundation is lost in the mists of time, but it is thought to have existed since the 3rd century. The mythical empress-consort Jingū-Kōgō is also worshiped here; legend recounts how the empress commanded the women of the region to grow rice on the site where the shrine now stands. The Otaue-Shinji festival, held every June 14 in anticipation of a good harvest, involves young local girls ritually re-enacting this legend with music, dance, and offerings. More than 600 stone lanterns line the route to the sacred area and its grounds, and believers are more than happy to cross the Soribashi Bridge, as this is the dividing line between one reality and the next. There is a torii within the hall of worship (*haiden*) in one of the side-buildings, which is in itself a peculiarity, as torii are generally at the entrance to a sacred place. The Shintō shrine at Sumiyoshi is usually a mysterious place, but on July 31, the shrine's principal festival, it is crammed with people celebrating one of the most colorful and joyful Japanese occasions.

Ise Grand Shrine

The Ise Grand Shrine—**Ise-jingū**—on the eastern Kii peninsula is one of Japan's major Shintō shrines and also the ancestral shrine of the imperial family. The shrine is rebuilt every 20 years, and since the time of the emperor Tenmu (673–86) it has been demolished and re-erected some 60 times. This rather strange practice combines two key Shintoist concepts—ancestor worship and the notion of the religion's purity and renewal. Ise-jingū comprises two large shrines, the inner

Naikū to the west and the outer Gekū to the east. Naikū is dedicated to the sun goddess Amaterasu, who is also the ancestral leader of the imperial house, and Gekū is dedicated to the fertility goddess Toyuke Omikami. The shrine's roof, thatched with rice straw, towers over the simple building of pillars that it covers. The rectangular sanctuary (shōden) stands on a plinth supported by posts and surrounded by a verandah.

Ise Shrine, Kii peninsula, Mie

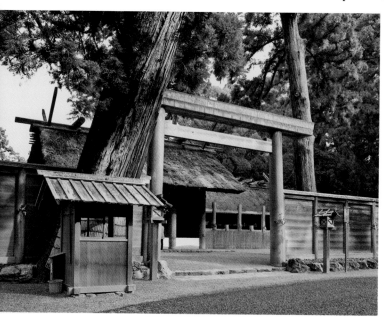

before approaching the Divine is an important part of ancient Shintō rites. These also prescribe how far one may venture into the shrine, and four rings of fencing have been installed to enforce this. Only the imperial family may set foot in the innermost area of the sanctuary, and it is perhaps this exclusivity that makes the Ise-jingū the most important Shintoist shrine. The harmony of the landscaped grounds and the noble architecture will impress every visitor to this sacred place.

The complex includes areas where the offerings for the kami are grown, and these fields are also considered sacred. The holy rice paddies (**Jingū-Shinden**) in Kusube-chō cover an area of 7.5 acres (30,000 m²) and the cultivation of the rice is accompanied by special Shintō rituals. The sacred salt for this ritual use is processed in special devices kept on the grounds of the **Mishiodono-jinja** at Shō. The fabrics for the holy robes are woven at the shrines of Matsusaka: silk in the **Kanhatori-hatadono-jinja** at Ogaito-chō and hemp in the **Kan'omi-hatadono-jinja** at Iguchinaka-chō.

The whole temple complex is situated among beautiful old evergreens on the banks of the Isuzu River. Accessible via a steep flight of steps, the shrine may be entered only after ritual bathing in the river; such cleansing

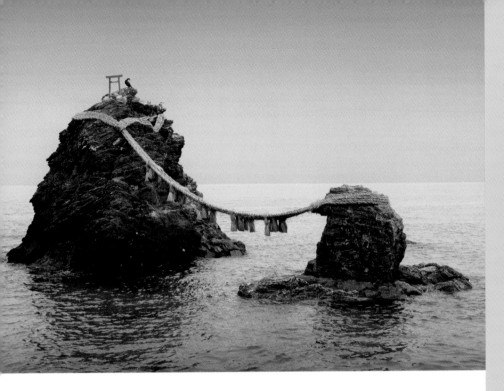

Meoto Iwa on the southeast coast

Meoto Iwa

Suspended ropes of twisted rice straw (*shimenawa*) are an essential feature of Shintō shrines. They are intended to ward off evil spirits, but their principal function is to mark the boundary between the sacred and the secular worlds; the rope is a visible sign that a holy place lies within. Situated in the Pacific Ocean off Futamigaura on the southeastern coast of Japan, Meoto Iwa, the "Husband-and-wife Rocks," symbolize the mythical divine creator couple Izanagi and Izanami, who

according to Shintoist belief brought the entire Japanese island chain into being. The two islands are connected by a heavy, braided rope, which is replaced in a ceremony held every January 5. The Shintō gate is to be found on the larger of the two rocks.

Believers accord the shrine on these rocks in Ise Bay particular reverence as they represent man and woman, and emphasize how these two belong together. In Shintō belief, the union of man and woman, as well as the balance of male and female attributes, is part of divine law. There is a belief that a couple's relationship will last forever if they

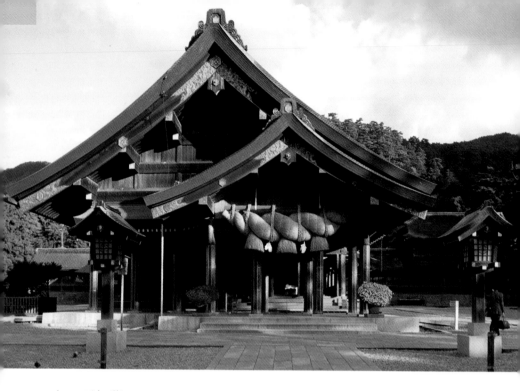

Izumo-taisha, Shimane

spend a summer morning watching the sun rise between this craggy husband and his small wife.

Izumo-taisha

Giant *shimenawa*, twisted ropes of rice straw that separate this world from the next, are a feature of this ancient shrine. One well-known legend suggests that one of your wishes will be granted if you can toss a coin so that it lodges in the coils of the rope. Along with Ise, Izumo is the most prestigious and historically most significant shrine in Japan. Its principal deity, Ōkuninushi, the "Great Land Master," is one of the most enigmatic characters in the Japanese pantheon. He first appears in the myths concerning Kojiki and Nihon-shoki, embodying the principal divinity of the earthly gods (*kuni-tsu-kami*) and providing a counterpart to Amataseru, the leader of the celestial gods (*ama-tsu-kami*). Although the myths relate how he gave up his powers to the heavenly kami and disappeared into the underworld, he is still of significance today.

The shrine was built on the spot where the mythical storm god Susanoo is said to have shrouded himself in clouds to make a private area where he and his consort Kushinadahime could sleep in peace. The shrine area is no longer as big as it once was, as archeological finds of extremely large and ancient columns have demonstrated, but every year in the tenth month of the Japanese calendar (October) all the gods of Japan assemble here. The month is known throughout Japan as the "month without gods," except in Izumo, where it is called the "month in the presence of the gods." People visit the shrine during this month to try their luck with a coin in the hope that the gods will remain well-disposed toward them.

completely unspoilt ancient forest. The principal inhabitants of the area are the famed Japanese macaques, Japan's indigenous species of monkey, which plays such an important role in so many legends and myths. The mountain is climbed in honor of Kūkai, who is said to have retreated to this area for 100 days of meditation and ascetic exercises. The legend says that he lit a fire that has never gone out and that still burns in the "Hall of the Eternal Flame" below the summit. The flame in the National Peace Park in Hiroshima commemorating the victims of the

Torii in the sea off the island shrine of Miyajima

Miyajima (Itsukushima)

The island shrine of **Miyajima**, located not far to the south of Hiroshima on the Honshū coast, has been a sacred place since the dawn of history. **Mount Misen** in the middle of the island is 1,740 feet (530 m) high and completely covered in trees; the area at its base is a

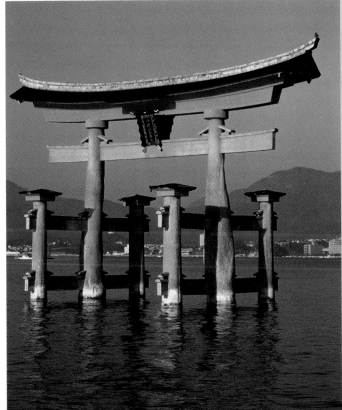

atomic explosion of 1945 was also lit here. A fire run, during which believers run barefoot over glowing coals, is held here every April and November in honor of the mountain gods.

Itsukushima is so sacred that it used to be claimed that no births or deaths have ever taken place here, as both events are considered unclean, and the bodies of those who die here now are taken to Honshū, the main island. Women have been allowed to visit the island and the town since the beginning of the 20th century. The main buildings of the **Itsukushima Shrine** are built right on the low-water mark and stand on poles that are submerged at high tide, giving the impression that the shrine is afloat. The individual sections of the shrine are connected by a long, roofed corridor. Built in 1875, a world-renowned and greatly venerated wooden torii standing about 525 feet (160 m) from the shrine marks the dividing line between the sacred area and the ordinary world. It too is completely surrounded by water at high tide.

Kōya-san in the Kii Mountains

The tradition establishing the Kii Mountains' sanctity dates back more than 1,200 years. The chain is made up of jagged peaks between 3,280 feet (1,000 m) and 6,600 feet (2,000 m) high and the mountain scenery features many rivers, streams, and waterfalls.

There are also a great number of Shintō and Buddhist shrines in the mountains, and the whole chain is laced with pilgrims' paths that have been trod by countless devotees. The major sacred places are all located at an elevation of about 2,620 feet (800 m) in a dip between the eight summits making up Kōya-san. On this mountain of monasteries there was once an entire monastic town of 1,500 buildings; although now only about 100 remain, the surviving structures are enough to give visitors a sense of the unique atmosphere. Countless weather-beaten, mossy tombs and graves, mighty cedar trees, peaceful temples, and sacred areas combine to form a unique and harmonious whole.

The Kongōbu-ji temple on Kōya-san is the center of the Shingon school of Buddhism founded by the legendary monk and scholar Kūkai (774–835). In 816 the court granted him permission to found an ascetic monastery in the remote mountain landscape of Kōya-san (Mount Koya) south of the capital. Kūkai's tomb in the Oku-no-in, the monk's mausoleum, soon became a pilgrimage site for Buddhists from all over Japan. According to their belief, Kūkai was not actually dead but was still sitting in his mausoleum, eternally meditating and awaiting the epiphany of Miroku, the Buddha of the Future. The 10,000 lamps in the Tōrō-dō (Hall of Lights) are evidence of the esteem in which Kūkai is now held. The Konpon Daitō pagoda is considered a sacred place as, according to Shingon belief, it forms the center of a mandala encom-

passing not just Kōya-san, but all of Japan. The path here is followed not only by numerous pilgrims but also by many young Buddhists preparing themselves for their spiritual lives—Kōya-san has an excellent library of holy texts and is an important university for the study of Buddhism.

mid-12th century and the 17th century by monks following in the footsteps of their master. The first documented reports, pilgrims' diaries, guidebooks, and collections of legends date back to the late 17th century. Pilgrims were certainly not required to visit every single temple in order; in fact, visiting the temples in reverse order was thought to bring good fortune. In

Shikoku Pilgrims' Path

A pilgrim on the Shikoku Path

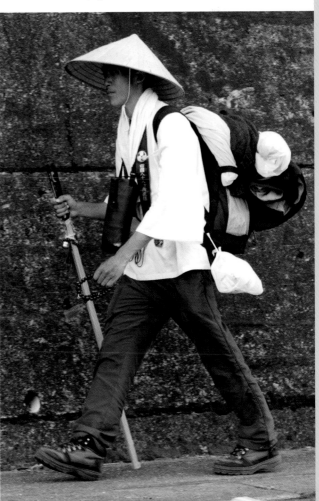

Most of the pilgrims travel by bus nowadays, but a minority, wearing traditional white robes with a straw hat on their head and a pilgrim's staff in their hand, still follow the Shikoku Path on the eponymous island on foot. The island, with its 88 temples, is a sacred place for Japanese Buddhists and pilgrims from all over the world. One popular legend suggests that one of the best-known monks in Japanese Buddhism, Kūkai (774–835), established the path himself, although there is no evidence of this. It is more likely that the path was gradually developed between the

addition, not every pilgrim was able to cover the entire 870 miles (1,400 km) of the path, but those who did manage to complete the route round the island were given the title *henro*. As well as the main path there is a miniature pilgrimage on the island of Shōdoshima, north of Takamatsu.

To prove they have visited a temple, pilgrims carry small strips of colored paper with a picture of Kūkai (*osame-fuda*) and the motto "Honor of the Pilgrimage to the 88 Sites" on them. Writing their own name on the back, they leave one of these strips at each temple. Pilgrimage is a traditional form of Japanese religious observance, and although adventure, exoticism, and a change from the everyday is high on most travelers' lists, there are plenty of pilgrims who travel in search of inner perfection.

Urakami Cathedral, Nagasaki

It might seem strange to find a Christian church in a country so strongly influenced by Shintoism and Buddhism, but the Roman Catholic Church has always claimed to be a global denomination and so it is no surprise to find that Christianity has tried to establish itself in Japan as well. The first Portuguese missionaries in the 16th century were welcomed, and the authorities even gave them the city of

Nagasaki. After this, however, Japan closed its doors to the outside world for more than 200 years (from 1633 to the mid-1860s). Followers of Christianity were subjected to the harshest persecution and repression in this period, but some Christian communities survived in secret. The Apostolic Vicariate of Japan was established in 1846 but was initially open only to foreigners. The (mostly Franciscan) missionaries were faced with the difficult task of reconciling Christian doctrine with local traditional beliefs.

Construction of a church dedicated to the Virgin Mary was begun in Nagasaki in 1895, and by 1925 the neo-Romanesque building had been completed. A mere 20 years later, it was destroyed on August 9 1945 by the atomic bomb. The ruins of the old cathedral have been left standing beside the new church (built in 1959) as a monument and a warning. The famed Japanese haiku poet Mizuhara Shūōshi has described the bombed-out ruins of the church as "the saddest, sacred ruin in the middle of burgeoning early summer;" it is visible evidence of the catastrophes that man is capable of inflicting on man.

Nagasaki's Urakami Cathedral is a sacred place of reflection, a place of penitence and of realization, and a site of solemn remembrance of the destructive power of military might. It is a reminder to all those in power to stop before the world is finally and completely destroyed.

Memorial ceremony, Urakami Cathedral, Nagasaki

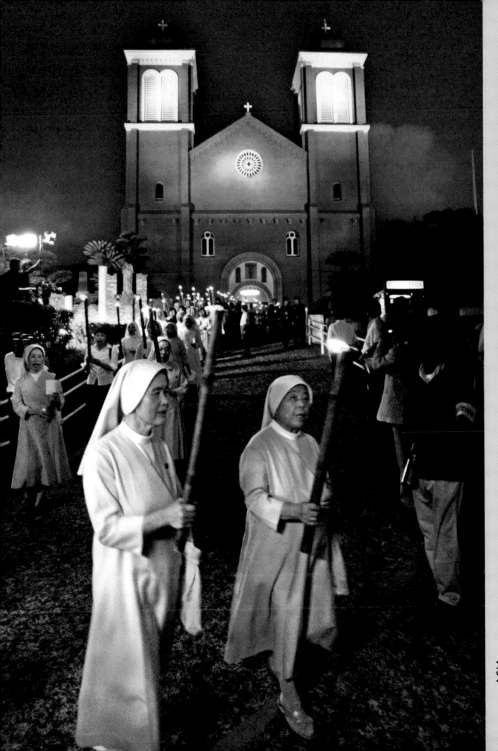

Gurdwara Panja Sahib, Hasan Abdal

The city of Hasan Abdal is some way removed from the most famous tourist attractions in the country, but it still attracts many pilgrims as it contains a greatly venerated Sikh shrine about which there is a popular legend (told in a number of variations). In 1520 Guru Nanak, the founder of the Sikh community, visited Hasan Abdal on what is now the northwestern border of Pakistan. He settled for a while under a tree at the foot of a hill. Wali Khandari, a man worshiped as a saint, lived on the summit of the hill, where there was a spring from which Mardana, one of the Guru's companions, used to fetch water every day. News of Guru Nanak's holiness soon spread and many people would come to seek his advice. This made Wali Khandari envious, and so he refused to allow Mardana to fetch water from the spring. The companion informed Guru Nanak of this, who remained calm and prophesied that water would soon rise at the bottom of the hill. Soon after, the spring at the

Believers at the Faisal Mosque, Islamabad

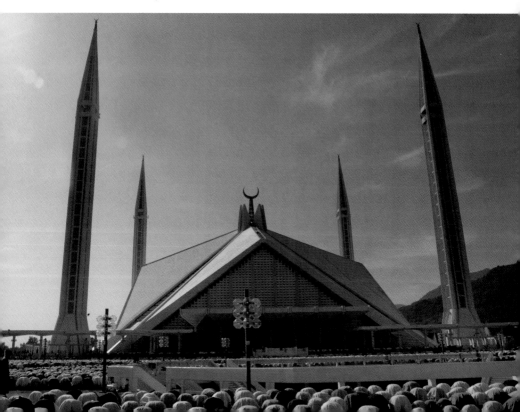

top of the hill dried up and a new one appeared beside Guru Nanak. In a jealous rage, Wali Khandari threw a huge lump of rock into the valley in an attempt to kill Guru Nanak and all the people who had gathered around him. The crowd fled, but Guru Nanak raised a hand and stopped the boulder in its tracks, leaving a mark in the rock with his palm. There is now a shrine known as Panja Sahib beside the spring and it has become one of the most sacred Sikh places.

Thousands of Sikhs visit every April to celebrate the spring Festival of Purification and to cleanse themselves in the pool surrounding the temple. The spring still flows over the boulder with its impression and the shape of the hand can be clearly seen through a thin film of water. Beside the rock there is a small temple where a copy of Sikhism's holy text, the Adi Granth, is kept. The place has a mystical atmosphere that corresponds exactly with one of the sayings of Guru Nanak: "We will never be able to understand God rationally, even if we think for centuries."

fascinating and lively city. It was completed after less than two years of construction work. Wide boulevards run through Islamabad and the center is marked by the so-called "Zero Point."

The futuristic Faisal Mosque located in the northwest of the city has become the city's emblem. Work on this gigantic place of worship began in 1976 and was completed in 1984. The snow-white mosque owes its name to Faisal, the Saudi king who paid for the marble structure. Four slender minarets like sharpened pencils rise to a height of 295 feet (90 m) around the central hall, which was built to resemble a Bedouin tent. The prayer hall thus created is almost square and has enough room for 10,000 believers. The room is lit with a futuristic lamp, a gold-anodized ball surrounded by a ring of lights, but apart from the modern mosaic tiles the room is austere. The mosque is open to followers of other faiths—it is very popular and is rightly thought of as the center of the city's spiritual life.

Faisal Mosque, Islamabad

Islamabad is a city designed on a drawing-board. Modern and expansive, with green parks, ordered traffic, and neat bazaar quarters, it has been Pakistan's capital since 1962 and is a

Badshahi Mosque, Lahore

Aurangzeb (1658–1707), the last truly great ruler of the Mughal Dynasty, had a different notion of the nature of sovereignty than his predecessors; he regarded himself as a demi-god and had no interest in promoting

the arts. Instead, he spent the greater part of his life on military campaigns, and the buildings he left behind are characterized more by functional than symbolic features. The Badshahi Mosque, built in only two years (1673–4), is a good example of this. It is the largest Mughal mosque, but despite its dimensions it is not overbearing—its stark symmetry is particularly impressive.

The mosque is a fine example of the most recent period of Indo-Islamic architecture. A flight of steps leads up to the *iwan* of the giant main portal. The enormous inner courtyard is sur-rounded by a crenelated wall at whose four corners stand octagonal minarets with domed pavilions. The fountain for ritual ablutions is situated in the center of the square. The mosque's interior is decorated with floral stucco tracery that is masterfully worked but restrained. Pilgrims often visit a little building in the mosque's extensive grounds where the relics of Muslim saints are kept; the most important of these is the Prophet Muhammad's turban. The Mughal Empire declined after Aurangzeb's death, but his mosque has survived the ages and remains the spiritual center of Lahore.

Badshahi Mosque at sunset, Lahore

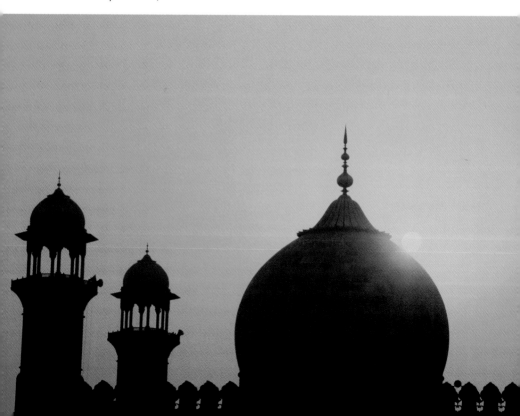

Mohenjo-Daro

The area around the old flood plain of the Indus is nowadays a salt-encrusted desert. However, when excavations carried out by John Marshall, a British archeologist, in the 1920s uncovered traces of a once great city in what was then northwestern India, many new questions were raised about Indian history. This was the site of Mohenjo-Daro, now in modern Pakistan, a ruined city dating back to the 3rd millennium BC. The city confirmed previous conjectures about

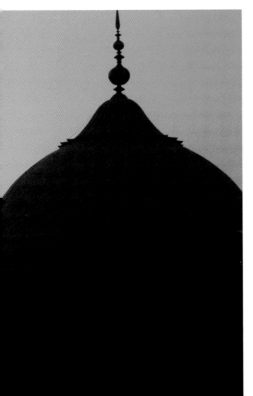

Indus culture. The settlement was of a standard design, a residential area composed of square neighborhoods surrounding a hill topped with assembly halls, granaries, and bathhouses. The identical layout of other cities of the period that have been excavated suggests that the hierarchies of these societies were strictly regimented, perhaps even being forerunners of the Indian caste system.

The people living on the Indus practiced an unknown form of religion, and the assembly halls and especially the public baths may well have been used for religious ritual purposes. Many of the seals discovered depict people in religious poses reminiscent of ascetic discipline or meditation exercises.

Mohenjo-Daro was built on a plateau of clay brick (to protect it from floods) and the population would have numbered about 40,000. The main roads were wide and the residential areas were separated by narrow alleys. The central hill on which the ruined buildings still stand was later used as a Buddhist stupa. The city was abandoned countless years ago, but Mohenjo-Daro still gives a sense of an ancient civilization that clearly had a great influence on Hindu culture and religion.

Amarnath, the Himalayas

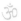

The route to this cave sacred to Shiva is probably the most arduous and dangerous of any pilgrimage in the world. Kashmir itself is not easy to get to, and the weather conditions in the Himalayas can often be difficult. To reach the Amarnath Cave requires skill in mountain climbing and a high level of fitness as well as devotion. The pilgrims who come here overcome all kinds of privations as they climb to an elevation of almost 13,100 feet (4,000 m). The most popular path begins at Baltal and follows a rapid ascent along narrow tracks, past steep cliff sides, glaciers, and moraines. The cave itself is only really accessible for a few months of the year, but pilgrims come here at all times, and the altitude, cold, and rockfalls often prove fatal.

According to myth, this was the cave where the god Shiva revealed the secret of immortality to his wife, Parvati, and they chose this remote and inaccessible location so that no mortal creature would learn the secret. However, two doves hidden in the rocks overheard the revelation, thus becoming immortal, and many of the pilgrims claim to encounter these birds on their way to the Amarnath Cave.

Once a year, during July and August, an icicle almost six feet (2 m) long forms; melt water trickling

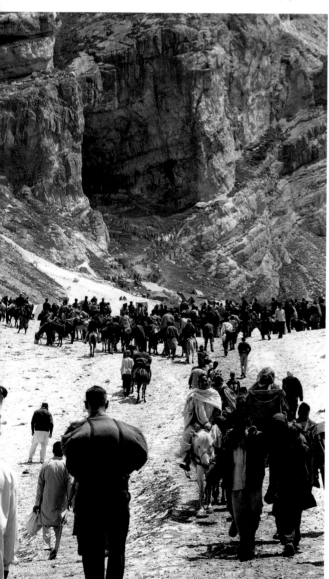

Pilgrims at the Amarnath Cave

Holi festivals

Young Prince Prahlada, a worshipper of Vishnu, was forever arguing with his father the king, a follower of a demonic religion, over which was the true faith. His father demanded obedience, but nothing could divert Prahlada from his veneration of Vishnu. The father tried to kill his son by every means possible, but Vishnu always intervened and saved the boy. Eventually the father resorted to a ruse: Prahlada was to be burnt while sitting on the lap of his sister Holika, a demon who had supposedly been made impervious to fire by magic. Owing to Vishnu's intervention, the flames spared Prahlada, while Holika burned to ashes. The Holi festival, the oldest religious feast in India, is celebrated to commemorate this myth.

Festivals in India are occasions of great merriment, a wealth of color, and much ritual and prayer, and the Holi festival is no exception.

It begins on the night before the spring full moon. Giant bonfires are built to commemorate the fire in the myth and to celebrate the defeat of the demonic Holika. There is then a giant party, and the streets are filled with cheering people spraying one another with colored water and throwing colored powders. Judicious enjoyment of *bhang ki thandai*, a drink containing cannabis, certainly contributes to the relaxed atmosphere, and much alcohol, which is normally avoided, is consumed.

This popular spring festival is also associated with the love between Krishna and Radha, and as a love festival it has decidedly erotic aspects. The spiritual interpretation of the festival is the triumph of good over evil, but it also marks the natural progression from winter to spring and has the important feature of being a festival of reconciliation—old quarrels should be ended during it.

A relaxed atmosphere at the Holi festival

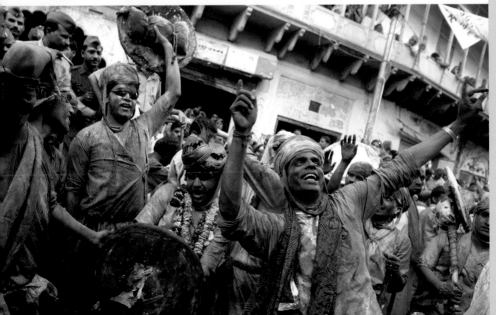

from the ceiling of the cave first forms a plinth and then a column resembling a giant lingam, one of the symbols of Shiva. This is a temporary phenomenon and the size of the column varies with the lunar phases—the icy lingam reaches its greatest size at full moon. Believers interpret this natural cycle of waxing and waning as representing the presence of Shiva.

Sadhus (holy men) have settled as guardians at this inhospitable altitude, protecting the cave and the sacred lingam. Shiva's presence attracts crowds of pilgrims every year, who leave flowers or coins in the god's honor before retracing their steps down into the valley and a life in the lowlands which is not eternal.

Vaishno Devi, Bhawan

Shakti is the name given to a primordial feminine energy force of crucial importance to the course and eventual salvation of the world. Shaktism is one of the main branches of Hinduism, and Mahadevi plays a major role in it. However, as an all-encompassing Great Goddess or Mother Goddess who appears in countless avatars, her function is often non-specific and she is worshiped in all kinds of circumstances. Taken together, all rites in honor of female deities make up the Devi cult, and one of the most sacred

Hindu temples dedicated to the worship and service of this omnipresent goddess is the Vaishno Devi Temple.

The temple and its adjoining monastery are situated in Jammu and Kashmir state in the far north of India, in harsh mountain terrain 5,200 feet (1,584 m) above sea level. Despite the altitude and the arduous climb, up to a million pilgrims come here every year. Most begin their journey in Bhawan where a great number of hostels have been built to accommodate them.

Their destination is the Vaishno Devi Temple and the Cave of Maha Lakshmi, where Maa Vaishno Devi is said to have meditated. The site is dedicated to Maha Lakshmi, the goddess of prosperity and good fortune, and to Maha Kali, the avenging and bellicose goddess whose destructive anger annihilates all that is evil and demonic; outwardly terrifying, she conceals a soft heart. Maha Sarasvati, the consort of Brahma and the goddess of eloquence, learning, wisdom, and purity, is also worshiped here, forming a female *trimurti*, or divine trinity, with Lakshmi and Kali.

The Hindu pantheon of gods and goddesses is often confusing for outsiders because of the different forms and avatars they can take. For the devout pilgrims who make the difficult journey, this remote site is a place of revelation and of the tangible presence of their goddesses.

Golden Temple, Amritsar

The name of the city of Amritsar in the north Indian state of Punjab is derived from *amrita*, meaning the nectar of immortality, and *saras*, meaning a lake of nectar, and the pool around the city's Golden Temple is said to be filled with this divine libation. Situated on its island in the middle of the Lake of Nectar, the *gurdwara*, the inner Golden Temple shrine itself, is accessed via a marble bridge. The magnificent temple complex was built in 1604 by the fifth Guru, Arjun Dev, but has been repeatedly looted and destroyed. The dome of the *gurdwara* was completed in 1802 and more than 220 lbs (100 kg) of gold now adorn its outside walls, giving it its English name. Known more properly as Hari Mandir, the "gate to the guru," it is the repository of the Adi Granth, the sacred text of the Sikhs, a collection of the teachings of the gurus that can be compared only with the Bible or the Koran.

According to Sikh teachings, the "One" is present in everything in the cosmos. The One cannot be apprehended through reason, and, just as a reflection upon water is part of the water itself, the One, or God, is a part of man. "Sikh" is a Pāli word meaning "pupil" or "learner," and in this sense all people are learners. Sikhs consider themselves the pupils of their ten gurus, the first nine of whom each

The pool at the Golden Temple, Amritsar

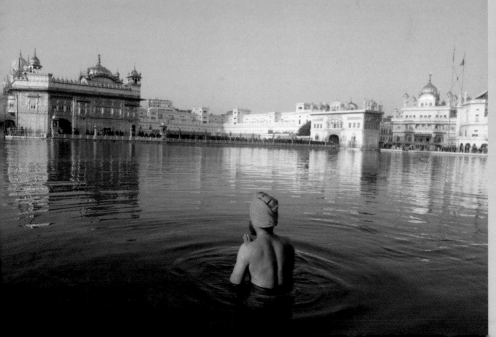

nominated his successor at the end of his life. Guru Gobind Singh, the tenth guru, refused to name a successor, instead founding the Khalsa Order (*khalsa* meaning "pure") in 1699. All male members of the order bear the name Singh (lion) and all female members the name Kaur (princess). Sikhs try to adopt the good aspects of every religion, and hospitality is sacrosanct, as can be experienced in the magnificent temple: it is always open and followers of all religions are admitted. Visitors are allowed to spend up to three nights under its arcades. They are all greeted and fed, and no one leaves the temple precinct hungry.

Just as important as hospitality is truth, for which Sikhs strive their whole lives. Their love of truth is proverbial in India: "If you don't trust anyone, find a Sikh—he won't lie to you!" New converts to Sikhism are ritually wel-comed to the community in *amrita*, the nectar of the gods, and every new member of the Khalsa undertakes to wear the "Five Ks": *kesh*, untrimmed hair and beard; *kanga*, a wooden comb as a symbol of cleanliness; *kachera*, cotton underwear as a symbol of sexual continence; *kara*, the traditional steel bangle symbolizing truth; and *kirpan*, a special curved dagger or sword, symbolizing a readiness to defend the weak and oppressed. Recogniz-able anywhere in the world by their turbans and their beards, Sikhs present a dignified and respectful appearance. They are considered courageous, and daring, characteristics which would be beneficial to anyone who strove to acquire them, whether Sikh or not.

Source of the Ganges

Rivers have long been seen as a metaphor for human life from birth (source) to death (flowing into the sea). A modest stream, initially weak and insubstantial, finds a course and slowly becomes a flowing river: ever changing in direction and widening, then losing energy and meandering until it finally merges with the sea, the source of all life. Rivers throughout the world have been thought sacred, with some even being revered as gods.

The **Ganges** is considered especially holy. It is the spiritual heart of India, in that it is considered a personi-fication of the goddess Ganga. For Hindus, water is a sacred element: not only does it make the earth fertile, but it has the power to cleanse the soul in religious rituals. As you would expect, the four sources of the Ganges—Yamunotri, Gangotri, Kedarnath, and Badrinath—have all become Hindu pilgrimage sites, although strictly speaking only Gan-gotri is the true source of the river as the others are just tributaries.

The Gangotri Glacier is located on the slopes of the Bhagirati mountain in the Himalayas, on the borders of India, China, and Nepal, a sacred place with icy winds in which pilgrims claim to hear the voices of spirits. The ice-cold water flows down the mountain at great speed to be joined by that from the other sources. The mighty river thus formed eventually flows into the Bay of Bengal 1,560 miles (2,511 km) away, the largest delta on earth.

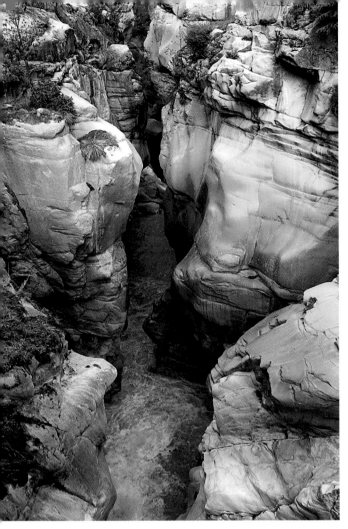

Gangotri, the source of the Ganges

Gangotri Temple was built in the 18th century at an altitude of 10,000 feet (3,050 m), but is 18 km from the actual source, which is in an inaccessible location. **Kedarnath**, the highest point of the pilgrimage at 11,650 feet (3,550 m), is where the Mandakini, another tributary of the Ganges, rises. Here Guru Shankara's charming temple, one of India's 12 *jyotirlingas* (temples to Shiva containing a lingam of light), has stood since the 8th century. The place is so sacred that in the past pilgrims have hurled themselves into the surrounding gorges in order to find salvation. **Badrinath**, at the source of the Alaknanda River, has a breathtaking view of the snow-capped peaks of Nilkantha (21,515 feet or 6,558 m).

Char Dham, the pilgrimage to the temples at the four sources, is undertaken by Hindus between May and October. **Yamunotri** is where the Yamuna, the next most sacred river after the Ganges, rises in a frozen lake 3,300 feet (1,000 m) above its temple.

Bathing in the Ganges and drinking its water have remained sacred rituals to this day, and the act of sprinkling a person's ashes in the river promises their soul immersion in the body of the goddess Ganga.

Rishikesh

It is almost compulsory for all Hindus to spend a part of their lives in an ashram, a monastic meditation center where consideration, patience, and pacifism are practiced. No one finds such requirements easy; hence the name given to these spiritual centers: ashram means "place of exertion." The city of **Rishikesh**, located at the foot of the mountain where the sacred Ganges flows onto the plain in the north Indian state of Uttarakhand, is considered a major center of ashrams and yoga schools.

The many *dharamshalas* (pilgrims' hostels) are evidence of the number of people who begin the Char Dham pilgrimage here, before ascending the mountains and visiting the four sources of the Ganges. Hindus believe that spending time at an ashram in Rishikesh is equivalent to bathing in the Ganges and more conducive to salvation than any amount of temple service, so there are crowds of people here throughout the year. Those who visit this place are not just devout Hindus, however—Rishikesh gained instant fame in the 1960s when the Beatles stayed here with their guru the Maharishi Mahesh

Street scene, Yoga Center, Rishikesh

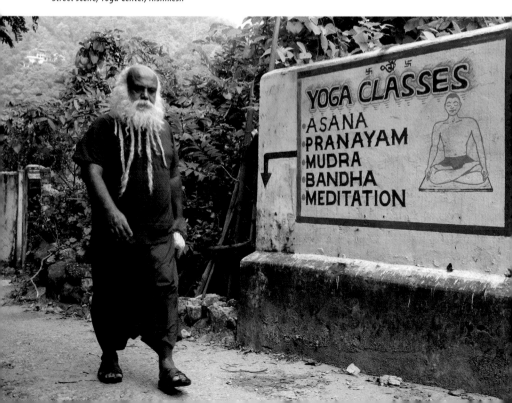

Yogi, devoting themselves to meditation and making music on the sitar, a traditional Indian musical instrument. In an age before globalization had even been mentioned, people were astounded to hear elements of Indian music in Western pop tunes.

There is a plethora of temples at Rishikesh. Many have been built relatively recently, but there are some ancient shrines that still attract visitors from near and far. The most important of the old temples is the **Bharat Mandir** in the heart of the Old Town, dedicated to the god Vishnu, which dates back to the 12th century.

Every year the imposing black stone statue of Rama, an avatar of Vishnu, is carried in solemn procession to the Ganges and immersed in the holy water, which is still extremely pure here. Thousands of devotees follow suit and bathe alongside him in the hope that the presence of the god will hasten their salvation.

Rishikesh has always been a sacred place, not only for Hindus but also for people from all over the world who have tired of modern civilization and are trying to gain some understanding of a spirituality that promises help in their stressful lives in an unpredictable world.

Kumbh Mela

The Kumbh Mela is the greatest religious festival in India and the largest in the world. It is held in four locations, for reasons that originate in ancient Hindu myths.

The Purânas, texts "from ancient times," are a poetic account of the creation of the world, the prehistory of mankind, and the heroic deeds and personalities of the gods. The Vishnu Purâna recounts the story of the Churning of the Sea of Milk and the recovery of a drink conferring eternal life. After entering into a pact with the demons, the gods, commanded by the god of all gods, began to make this ambrosia, collecting herbs of all kinds and casting them into the Sea of Milk, whose sparkling depths were as pure as a cloud in the fall. Mount Meru was turned into a "churning stick," the serpent Vâsuki transformed into a rope, and even Vishnu himself, the bringer of good fortune, offered himself in the form of a tortoise against which the mountain could be braced. They began to churn the Sea of Milk to recover the elixir of immortality; when eventually they succeeded, a host of heavenly nymphs rose up from its depths. Dressed in white, Dhanvantari, the physician of the gods, dipped a pot into the Sea, drew off some of the elixir of immortality, and joyfully toasted the gods, the demons, and the ascetics. The goddess Lakshmi, radiant with beauty and grace, rose from the clouds on a fully opened lotus flower. The Sea of Milk presented her with a personal gift

of an eternal garland of lotus blossoms, and Vishvakarman, the craftsman of the gods, created incomparably beautiful jewelry for her body. Thus adorned, she clung to the breast of Vishnu and their union was greeted with great joy by all. Or rather, by all but one—the demons had noticed that Lakshmi (and so happiness itself) had left them, and an argument began over the elixir. The demons suddenly snatched the pot from Dhanvantari, whereupon Vishnu transformed himself into female form, confusing the demons and allowing him to recover the pot. He gave it to the gods and they drank from it. Wielding their swords and other weapons, the demons leapt on the gods, but the latter had been strengthened by the drink and won the battle. The demons retreated and crept away into caves. During the struggle, four drops of the nectar (*amrita*) fell onto the earth, and the spots where they landed are now marked by the holy cities of Allahabad (Prayag), Nashik, Ujjain, and Haridwar, where every 12 years the Kumbh Mela, the Festival of the Pot, is held.

Kumbh Mela, Ujjain

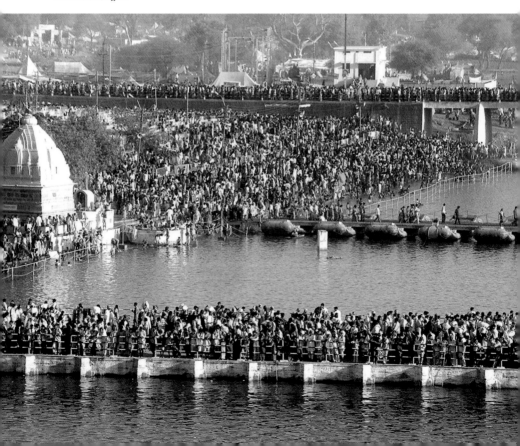

Each of the four cities has its own 12-year cycle, after which the Maha (Great) Kumbh Mela is held. In between there is also the Ardh, a half Kumbh Mela, celebrated every six years. The festival is intended to provide ritual purification at particularly auspicious times and is attended by millions of people, as bathing during the Kumbh Mela is regarded as a million times more powerful in freeing an individual from sin than any other immersion. Relatives bring the holy water back to those who are too weak to make the pilgrimage, using a *kamandula*, a vessel shaped to resemble Brahma, the creator god.

Allahabad, which Hindus still call by its old name of Prayag, is located at the confluence of three rivers in Uttar Pradesh state. The Ganges and the Yamuna are plain to see, but there is also a third, mythical river, the Sarasvati, flowing underground and hidden from human sight; here Brahma is said to have made his first sacrifices to creation in praise and celebration of the world. **Haridwar**, a city in the north Indian state of Uttarakhand, also lies on the Ganges and is considered especially sacred, as it is here that the river leaves the mountains and reaches the plain.

Ujjain is another of Hinduism's most sacred places, and this ancient city lies on the banks of the Shipra in Madhya Pradesh state. Archeological evidence has shown that there was a settlement here as early as the 8th century BC, and the city was once a flourishing hub on the trade routes between India, Mesopotamia, and Egypt.

Nashik is a city to the northeast of Mumbai (Bombay), lying on the banks of the Godavari, a holy river in Maharashtra state that flows through south central India and is one of India's main waterways after the Ganges and the Indus. The Godavari is also feared and respected as it is subject to wild fluctuations in depth; during the monsoon season it floods whole regions, whereas in summer it dries up almost completely.

Although the Kumbh Mela has been celebrated since the earliest times, written evidence dates back only to the 7th century. Records of the number of pilgrims have been kept since the beginning of the 20th century: in 1906 there were 2.5 million people in attendance, but 2001 saw 60 million pilgrims visit Allahabad to complete the sacred ritual.

Nizamuddin Dargah, Delhi

In the middle of the bustling Nizamuddin suburb of Delhi, in what was once a medieval settlement named after the Sufi sheikh Hazrat Nizamuddin Auliya, you will find the *dargah* (mausoleum) where that mystic, a member of the Chishti Order, lies buried.

Although he died in 1325, for his followers he is *zinda pir*, a living spirit who answers their prayers and hears their petitions. During his lifetime

his sermons attracted hundreds of followers and he was famous for his championing of justice. The people called him a "Friend of God" and looked to him as their champion at the Last Judgment. He has always been revered for the exceptional tolerance he displayed toward other faiths, whose followers he welcomed without reservation, even admitting them to *bayat*, the official rite of the Sufic order.

In front of the tomb, which is a magnificent white pavilion, there is a large square where countless people still assemble every Thursday evening. They listen to mystic chanting and pay homage to the saint, whose grave is covered by a cloth embroidered with rose petals. Imams constantly recite verses from the Koran, and women look in through the *jaalis*, a typical architectural feature of the Mughal period consisting of a wonderfully delicate stone latticework screen that casts a dim religious light and evokes a spiritual atmosphere. It is a very special experience to see devout Muslims celebrating the end of their fast at the tomb; the courtyard is filled with the faithful as they sit and eat and pray together, and a joyful and yet profound piety pervades the square.

This area of the city is always crowded, as there are several other sacred places in the near vicinity—in particular the red sandstone mosque of Jama't Khana, built in 1325, which dominates the west side of the square. Despite the crowds of people, the place retains a strange and inexplicable aura of dignity and peace; it is

a truly sacred place in the middle of a giant city, and an oasis of faith and tolerance, as it has always been.

Qutb Complex, Delhi

The best-preserved mosque in India is the Grand Mosque of **Quwwat-al-Islam** in Delhi, whose construction on a site once occupied by a Hindu temple dates back to 1198 and an attempt to demonstrate Islamic power. The mosque's name, Quwwat-al-Islam, means the "Might of Islam."

Like the building it replaced, the Muslim structure was erected on a raised dais accessible on three sides by flights of steps. The bas-reliefs throughout the complex display an interesting merging of Hindu motifs (tasseled ropes and luxuriant vines) with Arabic features and calligraphy, and stone columns from the old Hindu temple were incorporated into the new building. Construction was begun by Qutbuddin Aibak, but the building soon proved too small for the rapidly expanding Muslim community and no longer conformed to the expectations of rulers who saw mosques and other municipal buildings as expressions of their political power. So the planned dimensions of the Grand Mosque were tripled in size by Aibak's successor, Iltutmish.

Qutb Minar, Delhi

At the center of the mosque's grounds there stands the ancient **Iron Pillar**, 22 feet (7 m) high and likely to have been dedicated originally to the god Vishnu. This exceptional example of Indian metalwork remains a site of folk belief: those who can stand with their back to the pillar and reach round to touch their fingertips together on the other side are considered especially favored by good fortune.

The **Qutb Minar**, a triumphal tower of unparalleled magnificence begun in 1199, now serves as a minaret for the mosque. Located just beyond the old boundary wall of the mosque, this mighty structure is still the tallest stone tower in India today, at slightly more than 230 feet (70 m), and is considered one of the finest examples of Indo-Islamic architecture. It consists of five tapering sections one above the other, with 24 alternating semi-circular and triangular fluted ribs rising vertically. The tiers are richly decorated but the magnificent bands of calligraphy and delicate fields of arabesques on the lowest tier are especially impressive. Inside there is a spiral

Bahá'í Lotus Temple, New Delhi

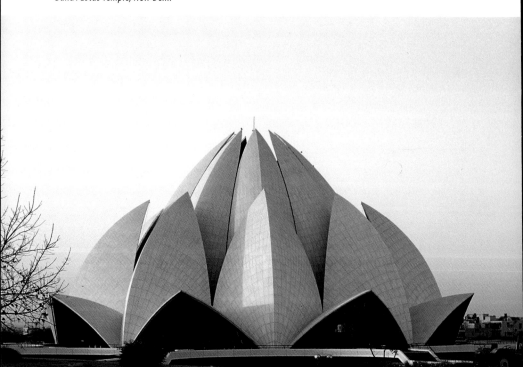

staircase of 379 steps leading to the top of the tower, which may be used only in exceptional circumstances. The wonderful view from the top takes in Mehrauli Park, an area of many ruined Indian and Islamic buildings, temples, and tombs, which is still very popular with Delhi residents.

Lotus Temple, New Delhi

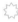

In a country of so many ancient and mysterious ornate shrines, this is one of the most modern—and the most important, at least for followers of the Bahá'í faith. Located in the southeastern suburbs of Delhi, the Temple or House of Worship is also known as the Lotus Temple because of its shape. The blinding white of this imposing building in its delightful grounds is in sparkling contrast to the earthy colors and grime of the sprawling city of Delhi.

The temple comprises a giant rotunda standing on a raised terrace surrounded by nine pools, and is shaped to resemble a giant opening lotus flower. Visitors to the temple seem to enter another world—the plain, even austere, interior is a welcome contrast to the constant stimuli that numb the senses in the city.

The temple is the principal Bahá'í place of worship in India, but it is open to followers of every religion.

There is no main portal—people of all faiths are invited in, through entrances pointing in all directions, to pray in the presence of their God. It is not necessary to know anything of the Bahá'í beliefs or of the historical persecution of this breakaway branch of Shia Islam to acknowledge the sanctity of this place. Those who seek will find themselves here, and they may even succeed in finding a center and direction for their lives; there is no frippery to distract from such a search.

The Lotus Temple is an invitation to the individual to approach god— whichever god that may be.

Kalpavriksha, Lodarva

Lodarva, an ancient royal city some 10 miles (15 km) to the northwest of Jaiselmer in Rajasthan, has always been a special pilgrimage site for Jains, and the devotees who come here do so to visit a sacred tree. Located within a complex of several yellow sandstone Jain temples, the Kalpavriksha or Kalpataru, an artificial tree made of wood and metal, has been re-created as authentically and skillfully as possible, with leaves, fruit, and even birds sitting in its branches. Scattered around the base of the tree there are representations of lions, birds, and snakes lying down peacefully with one another and symbolizing the Jainist belief in passivity, love, and friendship.

People visit the tree in the hope that their personal wishes for health, wisdom, or good fortune will be granted. Legend has it that every evening a snake slithers out of a hole in the ground in the temple to drink a sacrificial bowl of milk. Only those blessed with good fortune will be able to see it, however, a notion that may appear strange to Western thought: luck and the fulfillment of wishes have a paradoxical relationship with one another. In contrast with Western ideas, the fulfillment of a wish does not make an individual lucky; instead, wishes come true for lucky people.

The Kalpataru Tree is a place where pilgrims from all over the north of India come to dream.

Jaisalmer, the Golden City

It could be said that Jaisalmer is one of the most unusual cities in India— lying in the middle of the Rajasthani desert, the ornate sandstone buildings and the many palaces and shrines of the Golden City resemble relics from some distant fairy-tale past. Founded in the 12th century by Rawal Jaisal, Jaisalmer is a fortified city of massive stone walls, bastions, and watchtowers near the border with Pakistan. The city is accessed via two gates, one in the east and one in the west. The camel-train routes connecting India and western Asia that

Jain Temple, Jaisalmer

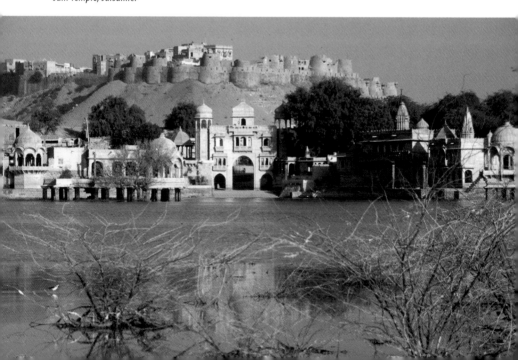

passed through here brought this oasis renown and wealth for many years, and it was always of strategic value in wars with invaders from the north.

There is a total of eight Jain temples in the city, and the oldest and most important of these is the **Chintamani Parsvanath**. The numerous annexes and countless, but never identical, pillars of this temple were built between the 12th and the 15th centuries. The arched gateways in the entrance hall are decorated with intertwined serpents. Before entering the temple precinct, the faithful are required to remove their shoes and any other leather items, as these are reminders of the slaughter of animals. The various sections of the building are richly decorated with carvings of musicians, and there is an interesting collection of Hindu deities among the sculptures, with Vishnu, Kali, Shiva, Lakshmi, Sarasvati, and Brahma vying for visitors' attention and reverence. Apart from the gods there are representations of saints, lovers, naked women, and other female figures combing their hair in front of mirrors or even kissing, while the main dome is adorned with female dancers and singers. Their bodies are often intertwined, denoting the Jain concept of the interconnectedness of all things; nothing exists in isolation and everything has an effect on everything else. For followers of this religion, respect for all forms of life is paramount, and *ahimsa*—unconditional avoidance of violence—is a moral stance that would later guide the political career of Mahatma Gandhi.

As well as the Jain shrines there are eight Hindu temples in Jaisalmer. Four of these are dedicated to Vishnu, the preserver and transformer, and four are dedicated to Shakti, the force seen by Hindus as the feminine power of the universe, and which appears as Lakshmi, the goddess of good fortune, wealth, and beauty. As might be expected, the **Lakshminath Temple** is especially beautiful. Entered through a golden gate decorated with silver and diamonds, the interior reveals a stunning array of pearl-encrusted walls.

The variety of gods represented in the temple might initially seem confusing to foreign visitors, but for believers such temples are places of communion with the Divine in all its varied forms. Worship of positive gods is important, as the belief is that the gathering evils in the universe will eventually combine as Kali, the dark side of Shakti, who will destroy all in her path.

Great numbers of pilgrims have been coming to Jaisalmer for many years to celebrate their religious festivals.

Pushkar

Pushkar is a tranquil little pilgrimage town in Rajasthan, with several lakes and an impressive array of 400 temples. Legend has it that the lakes in and around Pushkar were created from blossom that fell from Brahma's

hand, and the name of the town is also derived from this legend—*pushpa* means a flower, and *kar* a hand.

The peace is shattered once a year when hundreds and thousands of pilgrims descend on the town from all over India. During the Hindu month of Kartik (October/November), Pushkar is transformed into a gigantic camel, cattle, and horse market, and the imposing amphitheater on the edge of town becomes the scene of camel and donkey races. Camps and tents spring up everywhere, and for 12 days there is a constant atmosphere of merriment and celebration. The Pushkar Mela is one of the largest livestock fairs in all Asia and reaches its climax on the night of the full moon, when the town's streets ring with the incantation of traditional Rajasthani songs and pilgrims bathe in the holy waters of the lake. The 52 ghats on the lakeshore overflow with crowds of people devoutly carrying out religious exercises, and an almost magical atmosphere is evoked by the clay lamps drifting lazily on the water in little boats made out of leaves. Prayer bells ring out all along the shore and in the town, creating a sense of the Divine that can be felt by all those willing to open up from an otherwise rational view of the world. It is a powerful experience to witness

Rituals at the lake, Pushkar

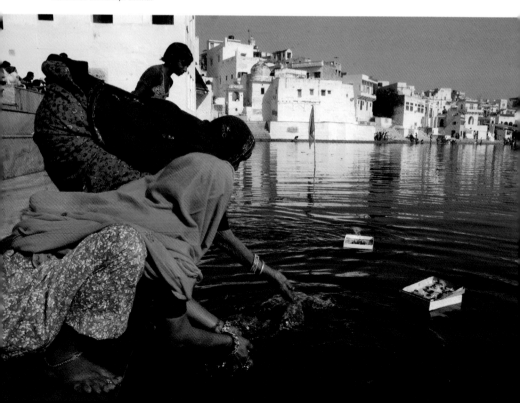

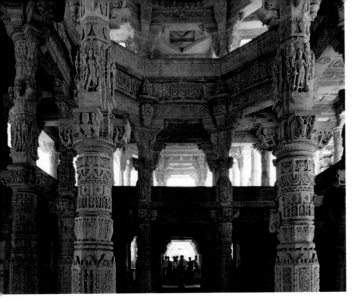

Marble columns, Adinath Temple, Ranakpur

the piety that guides every aspect of the religious lives of such devout Hindus.

Adinath Temple, Ranakpur

Meditation and a vegan lifestyle are important features of Jainism, and for this reason visitors to this sacred place in Rajasthan must remove not only their shoes but also all other leather items.

The Adinath Temple was built in honor of the *Tirthankaras* (literally "fordmakers"), pioneer figures revered as saints in Jain thought, who succeeded in conquering the four points of

the compass. The temple complex can therefore be entered from all four of the cardinal directions. Constructed over 50 years spanning the 14th and 15th centuries on a plot of land 200 feet square (60 m × 60 m), the building is of a beauty so enchanting it is hard to express in words.

Nestling in magnificent sub-tropical scenery, its gleaming white exterior stands in striking contrast to the lush green of the forest. Blessed with boundless imagination and an unerring aesthetic sense, the temple's architects created a building of countless finely carved decorative features whose every detail is astonishing. The interior contains 1,444 marble columns supporting the towers and domes, and each of these pillars is covered in delicate and intricate ornamentation.

Daylight shimmers through this stone forest, plunging the temple into light that alternates between warm and cool through the course of the day. Despite all these almost innumerable different elements, the overall impression is of a harmonious unity. This place is not sacred just for its beauty, however—it is an object lesson in how the whole and the parts always belong together, creating a harmony as they interact.

Dargah Sharif, Ajmer

He came from Persia to devote his life to the service of the indigent and the oppressed, and the name of Garib Nawaz, defender of the poor, is still mentioned in hushed tones. Said to have been possessed of miraculous powers, he has been worshiped since the 12th century by followers who turn to him for blessing and benefaction. His real name was Khwāja Mu'īnuddīn Chishtī (1143–1236) and his tomb is one of the most important pilgrimage sites in India. He should not be confused with the equally revered Salim Chishtī, who is worshiped at Fatehpur Sikri.

The most striking characteristic of this Sufi saint was the tolerance he showed to people of all faiths. He is said to have lived to the age of 114 and to have spent the five days before his death in continuous prayer, before finally expiring on the sixth morning. The *urs*, a festival commemorating the anniversary of his death, is held at Ajmer in Rajasthan during the seventh lunar month (in October), and for three days the town is filled with countless pilgrims—Muslim, Hindu, and those of other faiths all together—who celebrate a great and joyous feast. Singers perform specially

Sufi tomb at Dargah Sharif, Ajmer

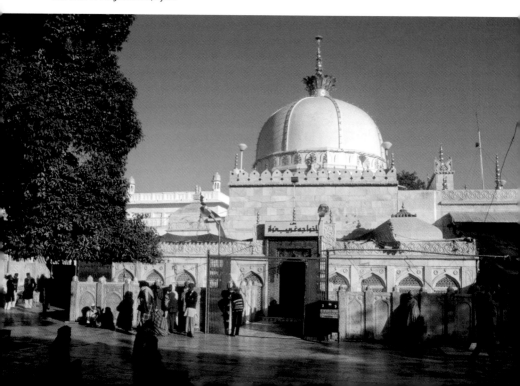

composed songs in praise of the saint, and *tabarrukh*, a particular kind of rice pudding, is prepared in great cauldrons for the pilgrims, who bring sacrificial offerings of essence of jasmine and rose-blossom and burn incense and sandalwood joss sticks, filling the air with exotic and intoxicating aromas.

Construction of the tomb began during the saint's lifetime but was only completed in the 16th century, and the inner sanctum of the Dargah is now entered through a large and imposing silver gate. Above the tomb there is a gleaming marble dome. The stone tomb is protected by silver railings and a delicate latticed marble screen.

During the festival, the magnificent Dargah is filled with all the life of a bustling village, and it is a unique experience to see how both life and death, growth and decay, can be celebrated.

Vrindavan

Play the games *Second Life* or *World of Warcraft* on the Internet, or even create a virtual persona to use the popular modern Wii™ console, and you will acquire an avatar; even those with only a passing knowledge of

Krishna in a miniature from the Bhagavatapurana

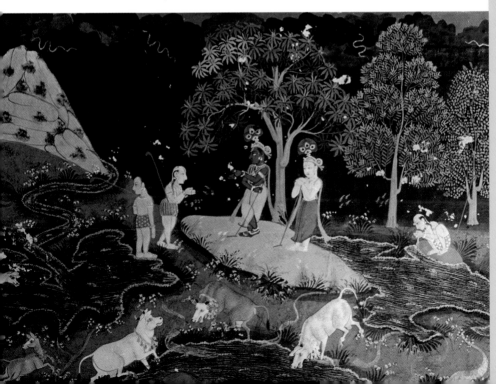

computing will know that this term is taken from Hindu mythology. Avatar is the Sanskrit word for "descent," and refers to the incarnation of a god on an earthly plane. The eighth *avatara* (manifestation) of Vishnu is love, a concept embodied by Krishna, as recounted in the Bhagav-atapurana, one of the holy texts of Hinduism. It tells of Krishna's child-hood and youth in a village of cow-herds. Legend has it that it was in the town of Gokula near the Forest of Vrindavan where the incarnate god learnt how to drive cattle, and where his charm and beauty won the favors of the cowherds' daughters. The girls' love for Krishna symbolizes mysti-cal yearning and the love felt by the soul for the Divine. One of the girls, Radha, was particularly taken with him, and the relationship that blos-somed between her and the god has a profound symbolic meaning in Hin-duism, representing the interplay between the soul and its master.

There is not much left to see of the forest where Krishna lived as a herdsman, but it still has a magical attraction; this may well be connected with the fact that love has been man-kind's principal concern since time immemorial, irrespective of religion. The city of Vrindavan in the state of Uttar Pradesh now contains countless modern temples, and there are shrines everywhere dedicated to Krishna and Radha, earning it the nickname of "city of 5,000 temples." The town and its surroundings are one of the most popular pilgrimage destinations in India, among Hindus and others.

Mathura

Mathura is a modern city in Uttar Pradesh with a population of some 300,000; it is a sacred place because it is also the source of the Yamuna, a river revered in Krishna-worship.

In the rather unspectacular Janmabhoomi Temple on the south side of town there is a small dark cell that is revered as Krishna's birth-place. Of the complex of temples, ghats, and pavilions straggling along the river, the Vishram Ghat is espe-cially popular with devout pilgrims as this is supposed to mark the spot where Krishna paused for rest after killing the tyrannical King Kamsa; pilgrims are not above taking a ritual bath here in the heart of the city.

The great national religious fes-tivals are also celebrated in Mathura, and the most popular of these is the Janmashtami feast in the Hindu month of Shrâvan (August/Sep-tember). Janmashtami is Krishna's birthday; he is said to have manifested himself as the eighth avatar of Vishnu more than 3,000 years ago, although there is of course no historical evi-dence of this. Vishnu in his many and varied incarnations is one of the most popular gods for many Hindus—embodying virtue and righteousness, he comes to the world to redeem it.

It is not only Hindus who antici-pate final redemption and the coming of a world without suffering. The notion of a god being born as a man to redeem the world and the people in it is basically the same as the

Christian world view, so this festival is comparable with the Christian Christmas. It is celebrated wherever Vishnu-worship is found, but the center of the festival is here at Mathura, the town of Krishna's birth.

Pilgrims usually prepare themselves by fasting until midnight, at which point prayer bells are rung throughout the city, the temples are decked with lanterns and flowers, and, just as in many other sacred places in India, tea lights are set afloat on little boats in the river. Devout Hindus offer prayers for their own salvation and for their dead ancestors as these lamps drift down the Yamuna.

Fatehpur Sikri

The extensive fortifications and palaces of Fatehpur Sikri lie 25 miles (40 km) to the west of Agra in Uttar Pradesh. During the Mughal period, the city was the joint capital with Agra before the court moved to Lahore in 1584. The Great Mughal Akbar chose this site in gratitude to Salim Chishtī, the Sufi sheikh who had prophesied the birth of Akbar's successor and who now lies buried in Sikri. The large-scale complex is still impressive today: the palace and the entire court wing have been restored, giving a real sense of the majesty of the period. Besides the caravanserai and the remarkable

The Shrine of Salim Chishtī, Fatehpur Sikri

individual buildings of the palace complex, there is also a **Grand Mosque** (Jami Masjid), modeled on the prototypical Prophet's Mosque at Medina, with its memorial to the Sufi sheikh Salim Chishtī. Those who ascend the steep steps to the Buland Darwaza (victory gates) and enter the mosque courtyard will get a direct view of the Chishtī shrine. The other entrance to the courtyard is the Badshahi Darwaza (royal gates) which affords a view of the two identical prayer halls of the mosque. Qandahari, a chronicler of the time, described the mosque as a "paradise on the edge of the abyss."

The entire complex has a majestic atmosphere, but special reverence is reserved for the wonderful **Shrine of Salim Chishtī**, built at great expense by Akbar and his son Jahangir in 1580–1. The saint's tomb is surrounded by elegant, intertwining marble buttresses and an almost translucent latticed screen (*jaalis*). He prophesied a descendant for the childless Mughal—this was indeed fulfilled and the shrine has always been a place where wishes come true, attracting many in need of help. People attach petitions to the delicate tracery of the screen with threads. It is surprising to see how Muslim prayer and Sufic devotion can coexist here, even being enshrined in stone, which is testament to the magnanimity and prescience of Akbar, whose tolerance has lost none of its significance

Ayodhya

Ayodhya in Uttar Pradesh has been a major center for several religions over the course of its history, and so pilgrims have always been drawn here. In the 5th century BC the site was the preserve of Buddhists: the Buddha himself is said to have visited Ayodhya several times to deliver homilies, and it contained a number of monasteries of which no trace has survived. Jains also made pilgrimages to the city, as Mahavira, the founder of their faith and a contemporary of the Buddha, is said to have come here. There are even traces of a Muslim presence, not least the Babri Masjid, a giant three-tier mosque.

Ayodhya was the scene of bloodshed in the early 1990s, when enraged Hindus stormed the mosque and destroyed it with the intention of building a temple to Rama on the ruins. Ayodhya has been a major Hindu pilgrimage site for some 600 years and Rama enjoys special reverence, because the city is said to have been his birthplace 900,000 years ago. The conflict between Hindus and Muslims has not subsided, with the result that the planned construction of the Ram Janmabhumi Temple has suffered continual delays. Despite the constant bitter skirmishing, Ayodhya is still a major destination for pilgrims, and the city is considered one of Hinduism's principal sacred places.

Kushinagar

At the age of 80, Siddhartha Gautama began preparations for his death. Accompanied by a few of his followers, he undertook what proved to be his last journey back to his home town of Kapilavastu, before dying in a wood near the little town of Kushinagar—after a meal of bad mushrooms, according to some sources—and achieving *pari-nirvana*, the ultimate nirvana. His last words are said to have been: "Behold, O monks, this is my last advice to you. All component things in the world are changeable. They are not lasting. Work hard to gain your own salvation." The year of his death, 483 BC, is disputed but represents the year zero in the Buddhist calendar.

Kushinagar, in north India not far from the border with Nepal, is still a relatively small city and its significance as a pilgrimage site rests principally on the fact that the Buddha died here; many devout Buddhists visit the place where he finally entered nirvana. Kushinagar was rediscovered after many years of decline, and excavations have uncovered a long monastic tradition here. The remains of ten monaster-

Dhamekh Stupa, Sarnath

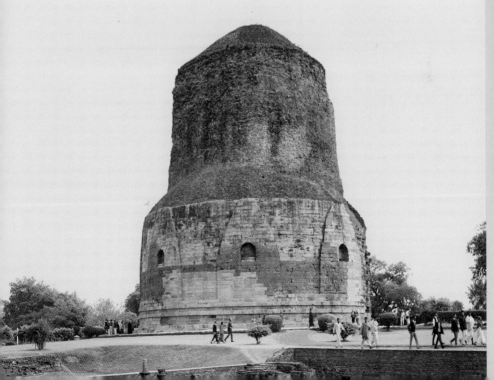

INDIA

Siddhartha Gautama

Siddhartha Gautama was born at Lumbini (in modern-day Nepal) during a full moon in 563 BC. The name given to him by his aristocratic parents could be interpreted as a sign: Siddhartha means nothing less than "he who has reached the goal." The better-known form of his name is the Sanskrit transliteration Siddhartha Gautama. He grew up at court in Kapilavastu (also now in Nepal), marrying Princess Yasodhara at 16 and living with her in a palace where they lacked nothing. He nonetheless felt an inner unrest, and from the age of 29, after the birth of his son, he began to lead a life of self-denial, leaving his palace and devoting himself to an itinerant life.

He reached enlightenment at the age of 35, sitting under a banyan tree in Bodh Gaya. He had meditated continuously for four days and nights

under constant temptation by Mara, the demon of darkness. Siddhartha recognized how the world worked and how desires and limitations could be overcome. He achieved a pure and eternal clarity, setting the *dharmachakra*, the Wheel of Law or Doctrine, in motion and thereby founding Buddhism. Soon afterward he began teaching the Eightfold Path of virtue, wisdom, and meditation at Isipatana (modern-day Sarnath).

He went on to teach for 45 years in northeastern India before dying in Kushinagar at the age of 80. The Mahaparinirvanasutra, the Nirvana Sutra, tells of his dying and his death, and since then Buddhists throughout the world have been trying to follow the Noble Eightfold Path to achieve enlightenment and entrance into nirvana for themselves.

ies from the 4th to the 11th centuries have been unearthed in an area that is now a park. In the middle of the park there is a modern temple with a large reclining Buddha statue.

Kushinagar is now also home to an international center for Buddhist meditation, and there is also a small Tibetan monastery. Being revered by Buddhists from India and elsewhere, the place has become a major pilgrimage site.

Dhamekh Stupa, Sarnath

Siddhartha Gautama recognized four truths as he became enlightened: life in the circle of existence involves suffering; the causes of suffering are greed, hatred, and ignorance; when the causes of suffering cease, suffering ceases; the way to the cessation of suffering is the Noble Eightfold Path.

He reached these insights at a place called Bodh Gaya, and here in Sarnath, about 6 miles (10 km) north of Varanasi, he is said to have first

The Buddha entering nirvana

years Sarnath was a major center for Buddhist meditation and doctrine.

With the growth of Hinduism, the site gradually lost its importance and lay abandoned for 1,000 years before its excavation and partial restoration in the mid-19th century. However, Sarnath has long since recovered its status as a major Buddhist pilgrimage site. Modern pilgrims will find a beautiful and well-tended park, the remains of several of the monastery complexes, several new Jain temples, and of course the famous Dhamekh Stupa, a remarkable monument to the power of Buddhist ideas, which have gone on to change the world since they were first preached here by Siddhartha Gautama.

preached his new insights. Buddhism has attracted many followers from the very beginning, and it is no surprise to find a stupa here erected in the 5th century BC to commemorate this event and to serve as a place of meditation for later generations. The Dhamekh Stupa, with its monumental plinth decorated with geometric and floral patterns, rises to a height of 111 feet (34 m), dominating an area where until the 7th century there were 30 Buddhist monasteries. Nearly 3,000 monks once lived and deliberated here, and for many

Varanasi

Known as Benares until 1956, Varanasi is the holiest of all the holy cities in India. The earliest history of the city is largely conjecture or a matter of legend. Hindus date its foundation to the 3rd millennium BC and greatly revere Varanasi as the "oldest city in the world," but the archeological evidence seems to suggest that while there has been a settlement for many years at the confluence of the Varana and Asi, two tributaries of the Ganges, its foundation probably dates back to King Kash Raja in the 12th century BC. The Buddha preached in the town in 500 BC, and

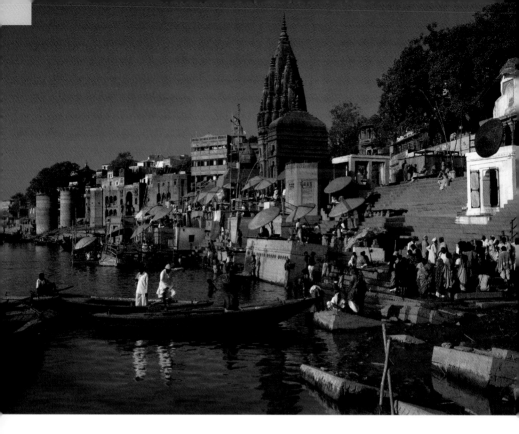

Ghats on the Ganges, Varanasi

in the first millennium AD more than 100 Hindu temples were built here on the banks of the sacred Ganges in honor of the god Shiva Vishwanath, the Supreme Lord of the World.

Varanasi, known as the "city of lights," has always been thought a place of redemption. Hindus are assured that those who die here on the banks of the sacred river will be freed of all earthly existence and rebirth; wafted on the breeze, Shiva himself will whisper the syllable revealing the secrets of the cessation of all earthly

suffering into the ears of the dying; as a consequence the terminally ill have long been coming to Varanasi. The city is not just a place for dying pilgrims, however, because all Hindus aspire to bathe in the holy waters once in their lives, thus ridding them-selves of all the sins and misdeeds of earthly existence. Great crowds of relatives bring urns with the ashes of family members and sprinkle them on the Ganges—"Mother Ganga."

At dusk the river takes on a mysterious aspect as the soft light

of the lamps lit in honor of the dead glints on the water. Then, as the sun of a new day rises, people go down to the waters from the steps and devote themselves to ritual cleansing. Dark wooden canoes filled with colorfully dressed pilgrims move about the river, and on the banks the crush of people is unimaginable. In the middle of such chaos you will nevertheless find sadhus, contemplative and holy men who devote themselves to Tantric meditation.

Varanasi is unique—stretched out along the banks of the river, the entire center of the city is an impressive summation of the Hindu faith, with temple piled upon temple and countless shrines. Crowds of people invariably fill the many ghats, places of ritual bathing and cremation which believers consider to be crossing-points where heaven descends to earth (*tirthas*). This is the most sacred place in Hinduism, and visiting Varanasi to die is the dream of every believer—when the ashes of those cremated here are strewn in the river, they escape the cycle of rebirth. Even for an outsider, visiting Varanasi will be a fascinating and unforgettable experience.

Temples in Varanasi

Pilgrims have been coming to Varanasi for more than 2,000 years. Many of the temples in the city were demolished or left to decay in the past, but since 1738 and the advent of the most recent and stable Maharaja Dynasty they have been systematically restored; new shrines were built on the sites of those that had been lost completely, and steps are currently being taken to combat pollution in the river.

The most important temple in the city is the **Vishwanath Temple**, one of the 12 *jyotirlingas*, which is also known

Golden dome of the Vishwanath Temple, Varanasi

as the Golden Temple because of its tapering gilt domes. Entrance to the shrine is allowed only to Hindus and worshipers of the god Shiva, who is known locally as Vishwanath and is venerated as the patron deity of Varanasi. Shiva the destroyer of worlds is part of a *trimurti*, a trinity, with Brahma and Vishnu.

Located immediately adjacent to the Vishwanath Temple, the **Annapurna Temple** dates back to the 18th century and is dedicated to Annapurna, an avatar of Ganga, a benevolent goddess of sustenance and the maintainer of prosperity. She is the mother of the three worlds of heaven, earth, and hell, and Hindus believe that it is she who ensures her followers do not go hungry or suffer other privations. As might be expected, she is worshiped with special fervor during the annual Annakuta ceremony, celebrated in the late fall in tandem with Diwali, the festival of lights; devout Hindus bring mountains of fruit and sweets as votive offerings and these are later distributed among the poor.

The 8th-century **Durga Temple** is dedicated to the goddess Durga, also known as Kali or Shakti Parvati, one of the avatars of the consort of Shiva. She is worshiped in three different traditions which together make up the Devi cult: Parvati, the gracious daughter of the mountains, lives with Shiva on Mount Kailash; as Durga she arms herself with a deadly arsenal of weapons and rides a tiger embodying the warlike aspects of gentle Parvati; and as Kali she wears a bandolier of skulls and her destructive rage combats evil. She is a lover of blood—bloodthirsty sacrifices were made in her name in pre-Aryan times—and there are gruesome pictures of her greedily drinking still-warm blood from the severed heads of her victims. The five tiers of the temple's impressive tower symbolize how all five of the earthly elements are subsumed in the Final Unity (Brahman). The temple roof is also open to the public, although you are likely to come up against aggressive monkeys who seem to regard it as their property alone. They are thought to be incarnations of the monkey god Hanuman, called upon by all who seek courage and daring.

Tucked away near the station, the interior of the **Bharat Mata** ("Mother India") **Temple** is quite unusual in that, instead of statues of gods, it has a giant carved marble relief of the Indian subcontinent, featuring mountains, plains, and lakes in perfect scaled-down proportions. This modern building, consecrated by Mahatma Gandhi in 1936, represents an amalgamation of Hindu piety with a yearning for national strength and might.

In addition to these four temples, there are countless others that have left their mark on this unique city—more than 2,000 places of worship are said to have been here at one time. Most of those that have survived or been restored are open only to Hindus, but the unique atmosphere of this holy city will make an impression on any visitor.

Mahabodhi Temple, Bodh Gaya

"My flesh may rot and my blood dry up, but I will rise again only when I have attained enlightenment." Such were the words of Siddhartha Gautama after settling beneath a banyan tree, according to the story. He meditated for four days and nights, while Mara, the demon of illusions, tried but failed to distract him. Finally, he saw an endless cycle of death and rebirth arrayed before him, and recognized four Noble Truths, having conquered his desires and limitations to achieve a clarity that was pure and eternal. Thus at the age of 35 he progressed from being a seeker to being an "enlightened one" or Buddha. According to the sources, this enlightenment took place at Bodh Gaya in Bihar. As might be expected, the location soon became an extremely sacred place—for Buddhists, this is the place of the Great Awakening (*maha bodhi*). He proclaimed the four Noble Truths first in Sarnath, and then during the course of a

Mahabodhi Temple, Bodh Gaya

45-year period of traveling through north India that ended with his death in Kushinagar at the age of 80.

In the 3rd century BC, King Ashoka, a zealous convert to Buddhism, had the Bodhi Tree (Tree of Awakening) surrounded by a stone barricade to create a space commemorating this world-shaking event. During the Sunga period in the 1st century BC, a diamond throne and a red sandstone platform were placed under the tree to indicate the spot where the Buddha was said to have sat in meditation. The Chankramanar, a jeweled path of stone lotus flowers that is adjacent, marks the footsteps that legend maintains were taken by the Buddha as he paced and pondered.

The stone Mahabodhi Temple was built in the 2nd century AD. The temple frieze features a great number of reliefs depicting the Buddha in various positions (*asanas*) and executing certain gestures (*mudras*) that are still practiced today. The four basic *asanas* are: sitting, standing, walking, and reclining. The four *mudras* are: *vitarka*, forming a circle with thumb and index finger in what is interpreted as a gesture of instruction; *abhaya*, in which the right hand (sometimes the left also) is raised upwards in a "stop" gesture betokening fearlessness; *bhumiparsa*, whereby the left hand is laid palm-up in the lap and the right is placed on the right knee with the fingers pointing down, to symbolize invincibility and victory over the demon Mara; and *dhyana*, in which both hands are loosely placed palm uppermost in the lap—this is the position of meditation. These gestures are now known throughout the world, and their representations in the Mahabodhi Temple are advice for life carved in stone, and a meditation for followers of the Eightfold Path. Within the temple there is a wonderful golden statue of the Buddha.

The original temple was destroyed or left to decay on several occasions, until in the late 19th century Buddhist followers reached an agreement with the British colonial regime to restore the site; the work was completed in 1889. The place is considered so sacred that monasteries run by devotees of Thai, Burmese, Tibetan, Chinese, and Japanese Buddhism have sprung up in its immediate vicinity. Modern visitors to the site are greeted by a gesture of meditation from a giant seated Buddha erected here by Japanese Buddhists in 1989. Despite its outsize dimensions— it is 88 feet (27 m) tall—it is not intimidating; instead it offers an invitation to a life devoted to meditation.

Parasnath Hill

In Jainism, *tirthankaras* are intermediaries between the material and spiritual worlds. There are 24 such mediators, although only two of them are recorded as having lived as real people: Parshavanatha was the 23rd, and Mahavira (literally, "the great hero"), who may have been Parshavanatha's son, was

the 24th *tirthankara*. There are 24 temples on Parasnath Hill, which is named after Parshavanatha and is also the location where the saint achieved enlightenment and entered nirvana.

This hill in Jharkhand state has since become a major pilgrimage site for the followers of Jainism. With a height of only 4,480 feet (1,365 m) it is hardly the most imposing of mountains, but the Jains consider it sacred. Usually beginning in the village of Madhuban, the pilgrims' route follows a path of 6 miles (10 km) to its final goal. Jains pray and offer sacrifices at each of the 24 temples in the hope that the heavenly *tirthankaras* will aid them in their own victory over the material world. The initially pure soul is polluted by worldly matters, leaving the individual in samsara, the eternal cycle of rebirth. The path to purity is through strict asceticism, moral living, and respect for all living things. Only a perfectly purified soul can aspire to heaven, where it will rest forever in eternal peace and tranquility. Such a path is not easy, and this place is where the devout pilgrims enlist the aid of the *tirthankaras*.

Kalighat Temple, Kolkata

Kolkata (known as Calcutta before 2001) in the state of West Bengal was founded as a fishing village—

an inconceivable thought when you look at the modern city. Officially there are 15 million inhabitants, but a population of more than 30 million is assumed to be living in this metropolis, or at least trying to survive there.

The fishing village of Kalikata was first documented in 1495; the name led the British to call the settlement Calcutta from 1690. Until the construction of the Suez Canal, the city flourished because of its proximity to the sea and the presence of many European trading companies. This colonial past has left the city with numerous ostentatious Victorian buildings that now seem rather incongruous in a city whose poverty and misery are so conspicuous.

As in the rest of India, religion is an important feature of daily life in Kolkata, and the greatest and most important part of this life is played out on the **Hugli River**, which forms part of the Ganges delta, where people live in abject poverty and unimaginably unhygienic conditions. The ghats on the banks of the river are filled with the dead and dying, while animal corpses, rubbish, and industrial waste are dumped in the river along with the human corpses. Nonetheless, tens of thousands of people come here every day to cleanse themselves in the sacred water. Some even drink the polluted water—belief in its sanctity is stronger than the fear of disease.

Such religious attitudes help people to bear with an unparalleled equanimity the suffering and sometimes sub-human living conditions to be found here, and Kolkata is even

known to some as the "City of Joy." Many festivals are jubilantly celebrated here. The greatest of these, the Durga Puja in honor of the goddess Durga, an avatar of Parvati or Kali, takes place in October; statues of the goddess are erected everywhere and townspeople dance and celebrate for five days.

The most important temple in Kolkata is the **Kalighat Temple**, a plain building featuring the curved roof typical of Bengali architecture. Built as recently as the 19th century, the temple has none of the atmosphere found in ancient Indian temple build-ings, but it nonetheless occupies a particular place in Hindu mythology. After the death of his wife, Shiva was overtaken by a madness, a mixture of rage and grief, in which he danced so frenetically with her corpse that the whole earth shook. The other gods tried in vain to pacify him but he would not stop dancing. Eventu-ally Vishnu threw his sun disk to cut the corpse of the goddess into 51 pieces, and these body parts fell to earth at various locations. Each of these points became a *pitha*, a place of pilgrimage where Shakti, the primordial feminine divine power, is worshiped. The spot now occupied by the present Kalighat Temple is said to be where the goddess's little toe fell to earth, and here the goddess Kali, the incarnation of the dark side of Parvati, is devoutly worshiped.

Khajuraho Temple

It is difficult to imagine why masons a thousand years ago thought that remote and inaccessible Khajuraho was a good place to construct such magnificent temple buildings. It was nonetheless chosen as a site for a complex of 85 temples that feature a wealth of sensuous and erotic sculptures whose exact interpretation is still unclear.

The complex in Madhya Pradesh dates back a thousand years to the Chandela Dynasty, which held sway over north India for several centuries; 22 of the temples have survived and their erotic statuary is world-famous and still excites the imagination today. The impressive temple architec-ture is overshadowed by the figures represented on the façade, while the temple interiors are completely plain.

Visitors may be surprised by the beautiful and uninhibited women proudly displaying their bodies, or by the couples making love in every imaginable sexual position. The base of one of the oldest and best-preserved temples, the Lakshamana, dedicated to Vishnu, features a depiction of a mass orgy. The two temples of Vish-wanath and Nandi, equally popular and well-known, feature statues of women in sexual ecstasy. All of the temples are built according to the same layout, and the sculptures on the façade and frieze are without doubt the most important features. The same figures recur constantly: beautiful, semi-divine women, nymphs, and

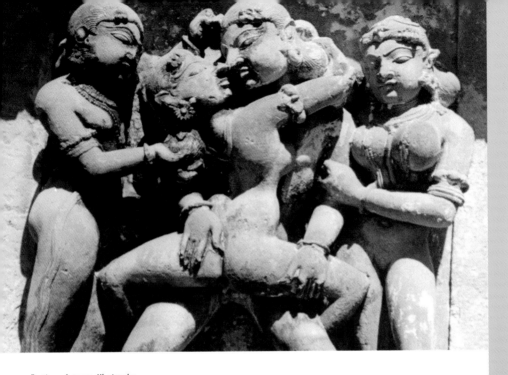

Erotic sculptures, Khajuraho

dancers, couples or groups of men and women in all kinds of sexual congress, and a mystical bestiary of hybrid creatures, usually half man and half lion, which are often being ridden by armed men. All of the figures have been skillfully and lovingly carved, with a profusion of curved and flowing lines.

Interpretation of the temples' erotic images has aroused huge controversy, but whatever the intended meaning, these unique examples of Tantric art, influenced by the teachings of the Kama Sutra, convey an impression of sensuality and are a celebration of life, nature, and sexuality.

Great Stupa of Sanchi

Stupas are Buddhism's symbols of the holy tree of life and of enlightenment (or, more correctly, awakening), in reference to the Buddha's achievement the insight of the four Noble Truths sitting under a tree. The oldest of all stupas is to be found on a low hill in the little town of Sanchi in Madhya Pradesh state. After the Buddha's death, his teachings were discovered by the Maurya king Ashoka, who then promoted the religion and enabled it to flourish. During his reign from about

286 to 232 BC he is said to have built a total of more than 80,000 stupas.

The ancient stupas at Sanchi are set in a temple complex in which even the most recent buildings date back to the 12th century. The Great Stupa of Sanchi is 57 feet (17 m) tall. It is a solid construction with no windows and is intended to fulfill a purely symbolic function—the Buddha was initially never depicted in his human form and his teachings were represented through symbols. The stupa thus stands for the Bodhi Tree, and in its earliest incarnation it was once crowned with a *dharmachakra*, the Wheel of Law. It is intended as a signpost for those who follow the Buddha's teachings. The four entrances to the circular walkway surrounding the stupa are a later addition; here richly decorated reliefs recount stories from Siddhartha Gautama's life, including his birth, the fights over his relics, and the miracles attributed to the Buddha. Four imposing statues of the Buddha stand in front of the entrances.

The present appearance of the temples and gates is due to restoration work completed at the turn of the 20th century; prior to that the site had been left to decay for hundreds of years. As well as coming here to gaze in astonishment at the 2,000-year old stupas, people also come to meditate. For Buddhists along with people of other faiths, this is a place in which to reflect on feelings of compassion, tolerance, and meekness.

Jyotirlinga Temples

The god Shiva is the embodiment of the dark side of faith, fear, and terror, and he stands for the struggle against all that is evil. Shiva is particularly revered as the Lord of Dance whose cosmic gyrations herald the end of the world, but he is often also depicted as an ascetic yogi. His principal symbol is the linga (or lingam), a conical device, usually of stone, which is often interpreted as a phallic symbol; it is found in every temple dedicated to Shiva, and the 12 most important of these temples are known as *jyotirlingas*. The name derives from the Sanskrit words *jyotis* (light) and *linga* (sign) and all 12 of the temples are located in India. In the course of a fight between Brahma and Vishnu over who was the greater god, a mighty pillar of light appeared. To find its end, Brahma flew into the sky on a swan and Vishnu dug into the earth, riding a boar. Neither could find the end of the column, but Brahma fooled his opponent by bringing back a flower and falsely claiming he had found it at the top of the column. At this juncture Shiva appeared from the column to declare that neither of them was the greatest of the gods. This column of light is represented by the *jyotirlinga*, and this is the main symbol venerated in the temples.

The oldest of the *jyotirlingas* is the **Somnath Temple** near Veraval in Gujarat state. One legend recounts how the temple was not only built by the moon god Somraj himself, but the material used was pure gold. A second building

on the site, this time silver, was the work of Ravana (the mythical demon king of Lanka, now Sri Lanka), which was replaced in turn by a temple of precious wood made by Krishna, the eighth incarnation of Vishnu. This was followed by a stone temple constructed by Bhimdev (a king of the Solanki Dynasty). There is no trace of any of these mythical structures today. The only real evidence is a report by Al Birundi, a 10th-century Arabic traveler, who records that at the time of his visit there were some 300 musicians and 500 temple dancers in residence. The shrine was destroyed in 1024 by the encroaching Muslim forces of Mahmud of Ghazni and its fabled treasures looted. The temple was to suffer further destruction later, but it was always rebuilt. The

present structure, dating back only to the end of the 20th century, is a brand-new shrine with an ancient history. The building itself is not especially impressive, but it is in what has always been considered a sacred place. The most important holidays here are the Great Pilgrimage to Shiva (Mahashivaratri) and—of course—the day of a full moon, particularly the one falling in Shrâvana, the fifth month of the rainy season.

Kedarnath Temple in the Himalayas in Uttarakhand state is the highest point of the Char Dham, the pilgrims' path to the sources of the Ganges. This beautiful 8th-century temple, built at an elevation of 11,500 feet (3,500 m) at the source of the Mandakini River, is the work of the Guru Shankara. The site is so holy that many pilgrims

Kedarnath Temple in the Himalayas

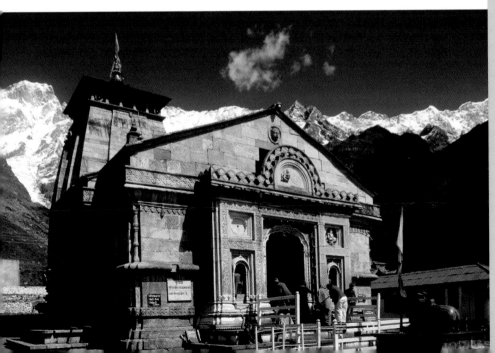

throw themselves into the steep gorges, thus gaining instant salvation. Hindus consider this to be one of the most sacred places in the Himalayas.

Varanasi in Uttar Pradesh is a particular place of Shiva's presence, and the **Vishwanath Temple** is the most important of all the shrines in this sacred city. According to legend, Shiva cut off Brahma's head for lying in his fight with Vishnu. As Brahma was also a god, this was considered a sin and the severed head stuck to Shiva's hand. Only when he visited Varanasi was this transgression expiated, and Shiva lived on as a sadhu (itinerant ascetic monk). The Vishwanath Temple has stood on the same site for more than 2,200 years, although it has been destroyed and rebuilt several times. There was a mosque here during the reign of the Mughal emperors in the 17th century and the present temple dates back to the 18th century. The tower surrounded by little turrets, and the copper-plated dome with its ornate gold panels, are especially charming. Either bathed in warm light or glinting harshly, depending on the hour of day, they always attract attention. The temple is open only to Hindus, but it will be immediately apparent to every visitor to Varanasi why they consider it one of their most sacred places.

The **Mahakaleshvar Temple** in Ujjain, Madhya Pradesh, one of the four most sacred cities, is dedicated to Shiva, who is venerated here as the Lord of Time. There has been a settlement here for 3,000 years and it has always been a center of Shiva-worship. One

peculiarity of the daily ceremonies is that the ashes of deceased believers are rubbed into the great lingam. The Kumbh Mela, the greatest Hindu festival, takes place here every 12 years.

The **Omkareshvar Temple**, also to be found in Madhya Pradesh, is located on a rock in the Narmada River, and during the monsoon season it is partially flooded. The temple's black stone lingam resembles a tortoise and Shiva is worshiped here with water from the river, which is poured over the stone as the faithful bring flowers and garlands as votive offerings.

Sri Shailam Temple in Andhra Pradesh is perhaps the least accessible but also the most mysterious of the temples; it is situated in dense jungle at an elevation of about 1,640 feet (500 m). The pilgrims' path is not without danger, because of the dense vegetation and the wild animals in the area, so pilgrims tend to travel in large groups. As a result Sri Shailam Temple is rarely visited, although it is popular during the Mahashivaratri, the great pilgrimage of Shiva. There are two other major temples nearby, one dedicated to Parvati and the other to Kali.

Vaidhyanath Temple in Jharkand state is sacred to Shiva of Great Knowledge, and *vaidhya*, meaning "one who knows," has come to mean a doctor. The water from the spring here is thought to have healing properties and the lingam is kept in the middle of the spring. It has become traditional for pilgrims to bring water from all over India to pour over the lingam.

Bhimashankar Temple is to be found at a remote location in Bhavagiri in

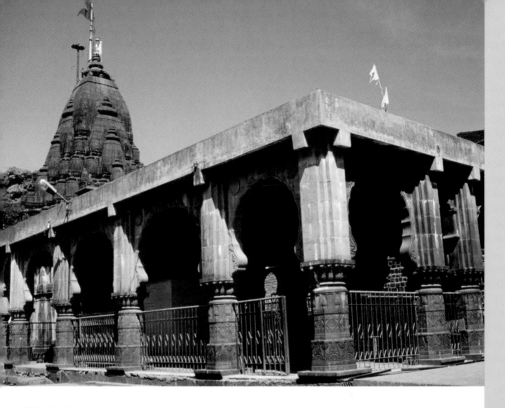

Bhimashankar Temple

Maharashtra state, at the source of the Bhima River in the Sahyadri Mountains. Located in thick jungle, this almost inaccessible temple marks the spot where Shiva is said to have rested after his defeat of the demon king Tripura. The main altar of the ancient temple continually exudes a small amount of water; there are climatic conditions that may explain this phenomenon, but for the faithful it is a clear sign of the presence of Shiva, the tamer of the Ganges. Close by there are two ancient pools that make the temple seem as if it is rising up out of primordial waters.

Grishneshvar Temple lies close to the famous Ellora caves in Maharashtra state. There is a myth that tells of Gushmar, the second wife of King Sudharma, whose first wife had been barren. Gushmar, who was particularly devout in her worship of Shiva, asked for the gift of a child. After the birth of her son she made an offering of 101 lingams to the god by dropping them in a local pool. The son was later killed by Gushmar's jealous sister, but Gushmar prayed with such devotion that her dead son arose from the pool, restored to life. His initial wish to take revenge on his murderer was tempered

by Gushmar, who begged him to spare her; Shiva was so impressed by such compassion and mercy that he granted Gushmar a long-held wish; she had always desired the constant presence of her god, and this was granted in the form of a large lingam which appeared in the pool. As a result of this myth, the pool has become a place for ritual cleansing, and bathing in the water is considered especially beneficial.

Tryambakeshvar Temple, situated near Nashik in Maharashtra state, one of the four holy cities where the Kumbh Mela is held in a 12-year cycle, also has a pool with mythological significance. After enduring a long drought, the rishi (seer) Gautama asked Varuna for a body of water, and this request was granted. The fight that broke out between the rishis over the pool ended so badly for Gautama and his wife that they were banished as pariahs, whereupon they both became strict ascetics in order to regain Shiva's favor. They installed a lingam to create a place for the god and his consort Parvati, and the legend tells us that this pleased

Kumbh Mela on the Godavari River, Nashik

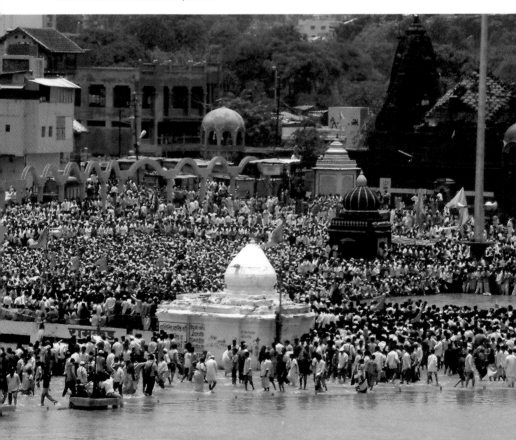

Shiva. As a result, the Ganges took on the form of the Godavari River, which flows here to this day.

Nageshvar Temple is located near Dvaraka in Gujarat state. The lingam worshiped here was originally fashioned in Shiva's honor by Supriya, a wise man held imprisoned by the demon Daruka. The demon was about to kill Supriya, but Shiva stopped him by killing the demon instead. This lingam, the mytho-logical object of the demon's rage, is now worshiped in Nageshvar Temple as part of the Shivaratri pilgrimage.

Rameshvar or **Rameswaram Temple** in Tamil Nadu, the southernmost of the *jyotirlinga* temples, is to be found near the southern tip of India on a little peninsula stretching out toward Sri Lanka. The temple precinct covers a massive area of 886 × 690 ft (270 × 210 m). The richly decorated eastern *gopuram* (rectangular tower), 174 ft (53 m) high, leads visitors to a corridor of 1,212 stone pillars that is almost half a mile (1 km) long. One important reli-gious artifact is a colossal statue of the Nandi bull, Shiva's mount. There are 22 bathing pools within the grounds, used by pilgrims for ritual cleansing, and each one has a particular meaning associated with it. The Ramayana epic records how Rama himself was responsible for erecting the lingam after returning to the mainland from Lanka, where he had killed Ravana, the demon king of the island who had previously carried off his wife. Rama then sent Hanuman, the monkey god of courage and daring, to Mount Kailash to fetch the lingam that was kept there. Hanuman dawdled, however, and

Sita made a lingam out of sand. When Hanuman returned and discovered the lingam, Rama gave him permission to remove the sand icon and to set up the one he had brought back. Hanuman was unable to remove the sand lingam, however, as it had solidified into the earth, so Rama let him erect the second lingam. Both have been worshiped in this impressive temple ever since.

Swaminarayan Temple, Ahmadabad

A sadhu (a holy man) will generally renounce secular life completely and devote himself to asceticism. Many sadhus live alone, some join communi-ties such as ashrams to meditate, and there are also sadhus who, in addi-tion to following their own spiritual journey, will devote themselves to charitable work in a community.

One such organization is the Swa-minarayan Mission, which cares for the poor and also organizes aid in the event of natural catastrophes. The group's first and most important temple is the Shri Swaminarayan Mandir Temple in Ahmadabad, built in 1822 on a plot of land provided for the purpose by the British government. Although not a place with deep roots in any religious tradi-tion, it nonetheless soon became a sacred place and a major pilgrimage site. The temple building is impressive, not least as no stone was used in its construc-

tion—the entire structure is made of teak. It is richly decorated with brightly painted carvings depicting countless scenes from the lives of the gods, forming a unique collection of myths and stories from the Hindu tradition. When you see the wide array of carving on this temple, you will be amazed at the colorful stories of the gods.

Portal of the Swaminarayan Temple, Ahmadabad

Mount Shatrunjaya, Palitana

Mount Shatrunjaya is the "place of victory" and Jainism's most sacred mountain. Located in the west of Gujurat state, this holiest of places, 2,300 feet (700 m) high, has always been a major pilgrimage site for followers of Jainism. Pilgrims reach the shrine, which is completely surrounded by a wall marking out the sacred area, via a flight of 3,500 steps across two low peaks and a valley. It is impossible to describe every shrine in detail, as there are 863 here, small and large. Many are simple meditation points, while others are richly decorated temples. The profusion of decoration and the wealth of temple sculptures give the site an irresistible charm.

The complex was begun between the 9th and the 10th centuries and one temple after another has been added since. The mountain is considered especially sacred as it is said to be the place where the "pioneers" of Jainism received enlightenment. The site is thus dotted with innumerable statues of the 24 *tirthankaras*, and every supposed footprint in stone is worshiped.

Believers are confronted at every turn with the history of their religion as a challenge to find enlightenment themselves. The temple complex on the mountain was largely destroyed during the Muslim Mughal period and only restored to use in the 15th and 16th centuries. Given such depredations, it is surprising to find within the temple's walls the tomb of one Muslim who is said to have protected the site; the grave is venerated to this day.

The **Adinath Temple**, the main place of worship dedicated to the first mythical *tirthankara*, is a place of special reverence. After its destruction by Muslim invaders, the 10th-century marble building was rebuilt around 1530. Recently made marble statues of the *tirthankaras* with dilated pupils and silver retinas captivate pilgrims immediately: to look into their eyes is to look into the eternity that the truly enlightened have glimpsed.

Shatrunjaya should not only be climbed—pilgrims should walk around it on one of the three paths that encircle this sacred place. It is said that completing such circuits will help to cleanse one's karma.

Ajanta and Ellora caves

The Ellora and Ajanta caves, located near Mumbai (formerly Bombay) in Maharashtra state, were used

Jain Temple on Mount Shatrunjaya

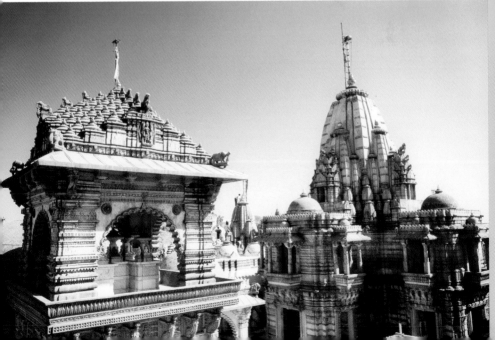

ASIA

as monastic settlements from 200 BC until the 13th century AD, with Hindu, Buddhist, and Jain monks living together peaceably.

The **Ellora complex** is the more recent of the two sites, with 34 caves cut from the living rock to provide monastic facilities and places of worship. The dimensions of the complex and all its sculptures, pillars, and ornamentation are breathtaking—the Hindu Kailasanatha Temple measures 265 × 138 feet (81 × 42 m), with a height approaching 108 ft (33 m). It took masons 150 years to remove 200,000 tons of rock during the shrine's construction. The temple's name derives from the resemblance of its interior to the sacred mountain of Kailash.

The older site at **Ajanta** has 29 caves, decorated with striking murals. The oldest of these murals do not depict the Buddha himself but show symbols of his teachings, such as the *dharmachakra*, the Wheel of Law or of Doctrine. Many of the other rock paintings depict episodes from the life of Siddhartha Gautama before his enlightenment under the Bodhi Tree. These images, known as *jataka* (birth story) murals, were painted between 200 BC and about 650 AD. Additionally, there are statues carved directly into the rock.

Of the three religions that coexisted peacefully in the Ellora and Ajanta caves, Buddhism and Hindusim have spread far and wide, whereas Jainism is still largely restricted to the Indian subcontinent. The sacred caves show that it is possible for people to live together in peace and remind us to show tolerance and patience toward others.

Sacred caves, Ajanta

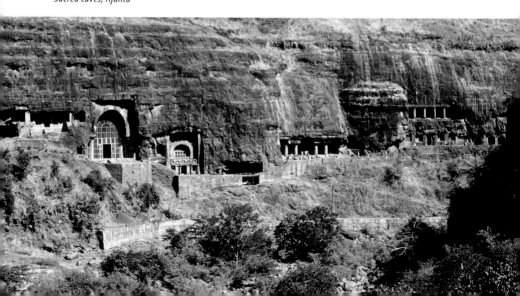

Elephanta Caves

The little island of Elephanta lying in the harbor of Mumbai (formerly Bombay) is famous for a complex of cave temples built here between the 6th and the 10th centuries, which is visited by countless pilgrims every year. The densely forested but sparsely populated island received its memorable name in the 16th century from the Portuguese, who found a stone elephant in its harbor; it had previously been known as Ghara-puri, the "city of Ghara priests."

The temple complex comprises six shrines cut from the rock, of which two are located in the northwestern hills of the island and the remaining four in the interior. With the exception of the main cave, which is a major pilgrimage site, the other temples are in a state of disrepair.

The main temple is sacred to the god Shiva and is an excellent example of a cave shrine of a kind found throughout the world. The ceiling is supported by six rows of six columns and was once decorated with murals, though these are now badly weathered and difficult to make out. The walls are carved with a great number of bas-reliefs depicting the many and various avatars and deeds of Shiva: the Lord of the Cosmic Dance (Nat-araja), Lord of the Yogis (Yageshvara), shown killing the demon Andhaka, at his wedding to Parvati, and calming the waters of the Ganges.

The cave temple consists of a main hall, four side-chambers, and three entrances. A platform in the side-caves once held various statues of the Nandi bull, Shiva's mount.

The most important feature is a shrine with a Shiva lingam in the western section of the main cave. It is a room within a room, with an opening on each of its four sides, and these entrances are always guarded by temple staff. A 3-foot (1-m) lingam, the revered symbol of Shiva, is to be found on a raised dais, and directly opposite the northern entrance to the cave there is a second major idol, a representation of the trimurti, the holy trinity, depicting various aspects of the god: the figure looking to the right is the personification of his rage, the middle figure is a youthful god, and the figure on the left has distinctly feminine traits. The reliefs read from right to left, so that visitors walk around the cave in an anti-clockwise direction, following the Hindu tradition of the Pashupatas (Shaivite ascetics of about two thousand years ago).

It is interesting to note how all these depictions of Shiva emphasize his contradictory nature. If one picture shows him as meditative and ascetic, there will be another image in the immediate vicinity illustrating the Lord of the Dance, while beside the peaceful wedding ceremony with Parvati there will be a representation of Shiva the demon-slaying destroyer. The great god unites all these antitheses in one, not unlike the humans who worship him.

Konark Sun Temple of Sûrya

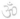

It is a sight seen almost every morning all over India: people standing with folded hands and bowed head, facing the morning sun and saluting the light. This yoga position called "greeting the sun" not only pays homage to the heavenly body itself; it is also a petition for light and enlightenment.

The light that returns each day is intended to dispel spiritual darkness. Sûrya is worshiped as the incarnation of the sun, although the sun god, like most of the other gods, is known in the form of a series of avatars. The god sometimes displays a feminine aspect as the daughter of the sun. Besides Sûrya there is Chhaya (shadow), Sûrya's consort, and they sit enthroned on a celestial chariot (*ratha*) drawn by seven horses. The Vedas, the oldest Hindu texts, describe Sûrya as the "jewel of heaven."

The Konark Sun Temple of Sûrya in Orissa state on the Bay of Bengal dates back to the 13th century and was built during the reign of Narasimhadeva I (1238–64), at which time Konark

Konark Sun Temple of Sûrya

was a flourishing port. The main temple was built to resemble the chariot driven by the sun god across the heavens, and its mighty plinth is decorated with 24 spoked wheels, each with a diameter of 10 feet (3 m). The wheels are not only part of the sun chariot; they also symbolize the universal wheel of life. The steps leading up to the entrance hall are decorated with sculptures of prancing horses with exquisite bridles, and the entire plinth is covered with a plethora of bas-reliefs depicting Sûrya himself, musicians, dancers, real and fabulous animals, and a number of men and women in various erotic positions. One green granite statue of Sûrya is accorded special reverence. The temple's tower is just a stump, and it is very likely that it was never completed.

The other buildings of the temple complex include a sacrificial hall and a hall for dancing, as well as a number of shrines and statues of other avatars of gods from the Hindu pantheon. The entire site is surrounded by a wall and was known as the "Black Pagoda" to ancient seafarers, who would use the dark mass rising up from the cliff as a landmark.

Jagannath Temple, Puri

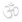

Indians love festivals, when ritual fasting and devout prayer are often accompanied by jubilant festivities lasting several days. Most such festivals are movable feasts of a religious nature; their exact date each year is determined by the lunar calendar. Ratha Yatra, celebrated annually in June or July, is a world-famous example that attracts pilgrims from India and around the world. The festival involves setting up statues of three gods on giant, custom-made carts (ratha) that are then pulled in procession through the streets. The festival is held in honor of Jagannath, the Lord of the Universe and one of the avatars of Vishnu, together with his brother Balabhadra and his sister Subhadra. These three unite to form a trimurti, a holy trinity.

Jagannath is worshiped with particular zeal in Puri in Orissa state and this is where visitors will find the Jagannath Temple, one of the largest and most important sites of Hindu Vishnuism. Hindus consider this a particularly sacred pilgrimage site and the coastal town of Puri is known as a "Holy Town." The temple was built in 1130, when Jagannath was selected as the town's patron deity. The king thought of himself as the god's vicar on earth—offenses against him were considered offenses against the god's will and were punished accordingly. The pyramidal domes, typical of the local area, and the delicate masonry

Jagannath Temple, Puri

of the spacious temple complex both date back to the 12th century.

The shrine contains three wooden statues of the *trimurti*, draped in silk and richly adorned. The wood is from the neem tree, which Hindus consider sacred. The heads are of outsize proportions and the bodies have only been roughed out. The four walls of the temple contain numerous statues depicting figures from the Hindu pantheon, all greatly revered by the devout pilgrims. The temple is open only to Hindus but other visitors are allowed to view the area from a platform. During Ratha Yatra, the statues are brought on gigantic carts from here,

Jagannath's principal residence, to the Gundicha Ghar Temple, the "summer house," about two miles (3 km) away, where they stay for the week of the festival before being returned to the Jagannath Temple. One oral tradition suggests that this is done in remembrance of the journey Jagannath is said to have made in order to spend a holiday in his garden house at the beginning of the rainy season, but the pilgrimage also has a profound spiritual meaning comparable with the eternal cyclical journey of life, with all its departures and arrivals. Even the cart itself has a religious aspect that is outlined in the Upanishads:

"the *atman* (the soul, the self) is the traveler, the body is the cart, and the mind is a charioteer." The whole procession is decked with flags, garlands, and flowers, and the crowds dress up in festive clothing to pray, dance, and celebrate in honor of their god, whom they regard as Lord of the Universe and whose tenth incarnation will bring a new world without suffering.

Velha Goa

Goa has more than 62 miles (100 km) of particularly charming coastline and attracts visitors from all over the world. The former Portuguese colony's appeal resides in a tolerant coexistence of peoples and races and the peaceful cohabitation of Christians, Hindus, and Muslims, and it has also been blessed with some of the most heavenly scenery on earth. Goa is even mentioned in the Hindu epic, the Mahabharata.

This strip of coastline was controlled by a variety of ruling dynasties until the Portuguese ousted the Muslims in 1510 and established a colony. Goa became a center of the hippy movement in the 1960s and 1970s until Indira Gandhi drove them out of paradise. With its wonderful beaches, Goa has become one of the most popular modern holiday destinations in India. The heyday of Velha Goa

St Cajetan, Velha Goa

(Old Goa) has long since passed, but this is part of its charm; areas of the city have been reclaimed by the jungle, but plenty of magnificent buildings—a complete mélange of architectural styles and religions—still stand as reminders of its more illustrious past.

Christianity has only ever established a modest footing in India, but Goa has several impressive Christian ecclesiastical buildings—defiant remnants of a time that has passed. The **Sé Catedral**, once the largest building in the entire city, is not used as a church any more. Christian pilgrims visit the church of **Bom Jesus** instead, where the relics of St Francis Xavier are kept. This Spanish Jesuit lived in the mid-16th century and came as a missionary to India, accompanied not only by fellow Jesuits but also by Dominicans, Franciscans, and Jacobites. He was not the first Christian on Indian soil by any means, but his travels across the land have become legendary. It is difficult to say for sure when Christianity first arrived on the subcontinent—many believe that St Thomas the Apostle came soon after Christ's time on earth—but Marco Polo certainly found Christian communities when he reached the coast in 1293. The church of **St Cajetan**, built as a smaller-format copy of St Peter's Basilica, is now surrounded by lush green vegetation like a relic from some long-forgotten time. Its time has indeed passed, but Goa is still basically Christian in feel and has become a sacred place for all the Christians of India.

Sangameshvara Temple, Pattadakal

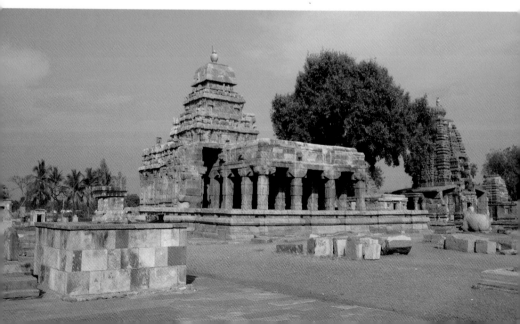

Pattadakal Temple

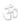

The temple complex of Pattadakal in the southern state of Karnataka is important for a number of reasons. The various temples dating back to the 7th and 8th centuries are among the oldest free-standing temples in south India. It had previously been common practice to carve temples from rock formations or caves, but during the Chaluka Dynasty free-standing temples were built in increasing numbers, often in groups of two or more. The fact that this site combines both north and south Indian building styles is of particular interest to art historians.

Pattadakal is located on a sheltered plain from which a few lonely outcrops of rock protrude, perfect places for the construction of smaller shrines. Such isolated mounds on the plain were just the place to imagine the gods residing, as has been the case in many religions and areas around the world. Pattadakal was renowned in the 8th century for the masons and artisans who built its impressive temple. The material they used was a fine red sandstone which was easily worked, making very delicate decorative features possible. The basic layout of the temple uses geometric forms, while the ornamentation is extremely varied and contrasts with the simple design. Blocks of stone have been arranged as a kind of plinth to elevate the temple, which is accessed via a flight of steps. The *mandapa* (entrance hall) leads into the *garbagriha*, the inner sanctum of the temple where the cult practices its rites. Above this ceremonial chamber there is a *vimana* (roof tower) topped with a massive capstone. As a rule, the openings of such temples point east.

The **Sangameshvara Temple** dating back to the 8th century is sacred to the god Shiva. Above the ceremonial chamber, which is surrounded by a corridor, there is a large *vimana*. There is also an anteroom leading to the entrance chamber. The niches and windows in the walls dividing the room into a checkerboard design create a charming pattern of light and shade that changes color according to the time of day.

The **Virupaksha Temple**, lying immediately adjacent, also dates back to the 8th century. It is the largest of the temples in the complex and a peculiarity in that, rather than being consecrated to one of the many gods, it was essentially built in honor of King Vikramaditya II by his wife. Its many reliefs feature a great number of motifs from the two most influential Hindu epics, the Ramayana and the Mahabharata. Demonic faces, lions, elephants, and semi-mythical beings peer at visitors from all sides, and even from the ceiling. Krishna (the eighth incarnation of Vishnu) is the focus of the stories of both the epics, and it would be reasonable to deduce that he enjoyed particular veneration here. There is a place for Shiva too, however, as he plays a pivotal role in the creation myth of the Ganges, which is recounted in an extremely expressive bas-relief on a column in the entrance chamber.

The smaller **Mallikarjuna Temple**, which also dates back to the 8th century, is to be found immediately next door. Here,

a high plinth with a frieze depicting lions forms a terrace surrounded by a walkway, and the exterior of the temple is covered with a lively succession of niches and pilasters. The changing light through the course of the day produces a magical effect here too. The *vimana* above the ceremonial chamber is divided horizontally into four and topped with a round dome. Just as with the Virupaksha Temple, it is difficult to say for sure to which of the many gods it was originally consecrated.

The attribution of the **Galganatha Temple** is unmistakable; there is a depiction of Shiva on the door lintel and another inside showing him killing Andhaka, the demon of blindess and ignorance. This story is gruesome and instructive in equal measure. Created from one of the tears given by Shiva to the childless demon king Hiranyanetra, Andhaka was nonetheless excluded from the succession because of his blindness, whereupon he undertook 10,000 years of ascetic self-denial standing on one leg. This achieved nothing, and so he took to cutting a piece from his body every day, diminishing himself to such an extent that Brahma took pity and fulfilled three wishes for him: sovereignty over the demons, the gift of the all-seeing eye, and powers of endurance such that he

Mallikarjuna and Kashi Vishwanath Temple (right), Pattadakal

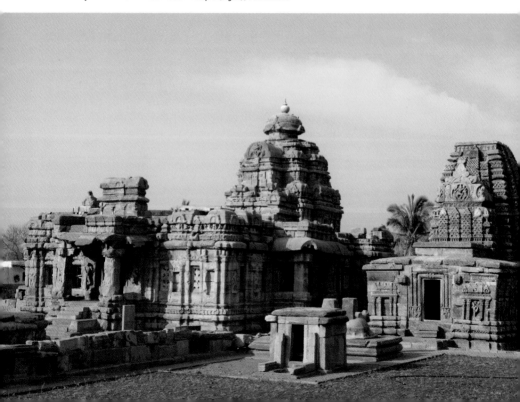

would be able to resist being killed by humans, demons, demi-gods, and even by Vishnu and Shiva. This new-found strength led Andhaka to desire Parvati, consort of Shiva, whom he challenged to a duel. Shiva badly wounded his adversary, but every drop of blood shed by the wounded demon turned into an equally invincible duplicate Andhaka. In great peril, Shiva finally managed to wound his enemy mortally with a trident. The goddess Yogeshvari licked up the remaining drops of blood, and Vishnu killed the other Andhakas with his discus as the original one slowly bled to death. This demon is usually depicted as a truly fiendish and frightening eyeless figure with many heads of great ugliness, many arms, and superhuman strength. This is another manifestation of the dark side of Shiva, the destroyer, and here he is seen destroying the evil and diabolical.

The mid-8th-century **Papanatha Temple** is also decorated with scenes from the Ramayana and the Baghavadgita (the part of the Mahabharata best-known outside India). It tells of Arjuna, the legendary and almost invincible hero who served Krishna as a charioteer. The western section of the temple contains depictions of Shiva as Gajantaka (the ecstatic dancer). Above the lintel in the interior there is an image of the goddess Lakshmi being sprayed with water by an elephant, an animal symbolizing good fortune. The three-dimensional sculptures of men and women making love that adorn the interior columns of this little temple are quite unique.

Also dating back to the 8th century, the little **Kashi Vishwanath Temple** is

similarly covered in reliefs; these closely resemble those in the Papanatha Temple apart from one particular feature found almost exclusively in south India and here visible on the ceiling of the entrance chamber: a depiction of a peaceful Shiva with his consort Parvati and his son Skanda. The corners are framed with guards at each point of the compass. Shiva is only rarely portrayed in such moments of familial harmony.

The temple grounds are dotted with several other temples, some only partly preserved, which further attest to the long history of this sacred place. At some distance there is also an almost entirely unadorned Jain temple that is presumably consecrated to Parshvanatha, the 23rd *tirthankara*.

Temple of Hampi

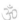

Hampi is the sacred center of Vijayanagar, a once-flourishing and mighty city in southern India. Parts of the Hindu Ramayana epic take place in the area: Shiva is said to have done penance on a nearby hill before being permitted to marry Parvati, and he is said to have conquered and burned the demon of desire here. Very few people now live at Hampi, despite efforts to open up Vijayanagar and its temples for tourists. Much of the city has fallen into ruin, but what remains is evidence of its once great glory. Vijayanagar was the capital of an empire from 1343, with a population of hundreds of thousands.

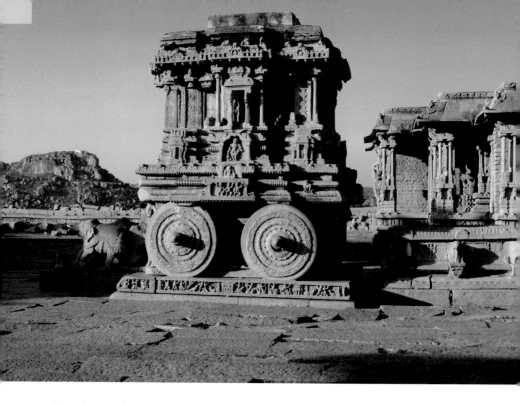

Divine chariot, Vitthala Temple, Hampi

The city's heyday ended when it was conquered by Muslim invaders. In a decisive battle of 1564 an alliance of four Deccan sultanates subjugated the kingdom, largely destroying the city and forcing the populace to flee. Few remnants of Vijayanagar's fortified walls and palaces can be seen today, but some of the impressive temples have survived the ages unscathed, of which the 15th-century **Vitthala Temple** is perhaps the most remarkable. Located in the northern part of the city near the Tungabhadra River, its sacred precincts are guarded by three high *gopurams*. The main temple is sacred to the god Vishnu, and one peculiarity of this structure is that the exterior columns resonate when they are tapped. The representation of *garuda*, the bird-like companion of the gods, is unique, and a life-size carved stone *ratha* (temple chariot) seems almost ready for use.

Another spectacular building at Hampi is the 7th-century **Virupashka Temple** with its elaborately carved *gopuram* more than 160 feet (50 m) high, and where a small tributary of the river has been channeled through the precincts to symbolize the Ganges. Religious ceremonies and annual festivals are still celebrated in the temple,

especially in December, when the marriage of Virupaksha and his consort Pampa is commemorated. This place, where religion has survived despite the decline of the city, combines a glorious past with current religious observance.

Gomateshwara Statue, Shravanabelgola

Shravanabelgola is a small town near Mysore in Karnataka state, but this sparsely populated place is nonetheless one of the principal Jain pilgrimage sites. The statue of the Gomateshwara, also known as the Bahabuli, who is venerated as a saint, is located on Indragiri Hill, similarly revered by the Jains as sacred. The hill and its temple complex are famous principally for the nearly 70-foot (20-m) high statue that was carved and installed around 985 AD.

The statue represents a typical Jain ascetic, completely naked and standing with his feet plunged deep in an anthill. The branches of a tree

are wrapped around the limbs and body of the Gomateshwara, assimilating the ascetic into the natural world that surrounds him and perhaps symbolizing a condition of total immersion in meditation. His impressively smooth and handsome features suggest a profound and joyful state of relaxation, and his gaze is directed into the far distance. He is surrounded by 52 life-size statues that seem tiny in comparison with the Gomateshwara. During the Jain Mahamastakabisheka festival, celebrated every 12 years, believers drench the statue's head in saffron, coconut milk, honey, yogurt, and *sindoor* powder, before laying votive offerings at its feet in prayer. A large

Gomateshwara Statue, Shravanabelgola

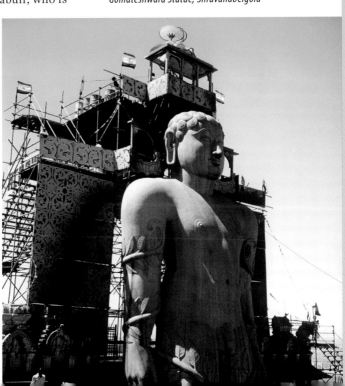

framework of decorative scaffolding is built around the statue for the festival, and it is a special feeling for the faithful to get so close to the saint. It is also quite an experience to see the Gomateshwara covered in so much colorful and sweet-smelling liquid.

Chamundeshvari Temple, Mysore

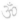

Devi (Sanskrit for "goddess") plays a pivotal role in the Indian pantheon and her importance is especially emphasized in Shaktism, one of the many branches of Hindu belief. As the Great Goddess (Mahadevi), she is a particular embodiment of *shakti*, the primordial female force. When she closes her eyes, the world is annihilated—only being restored when her eyes reopen—and she combines all the other goddesses in her

person. Durga's warlike aspects are personified by the goddess Chamundi (or Chamunda), who is named by virtue of her killing of two monsters named Chanda and Munda.

The **Chamundeshvari Temple** in Mysore, Karnataka state, one of the most important Shakti temples, was built in Chamundi's honor, on the 3,280-foot (1,000 m) Chamundi Hill a little outside the impressive city of the Maharajas of Mysore. Pilgrims laboriously make their way up the 1,000 steps to the temple's mighty *gopuram*, the 132-foot (40-m)

Nandi Bull of Mysore

entrance tower whose seven tiers are laced with delicate stone carvings. About halfway up there is a unique and very popular shrine—a granite **statue of the Nandi bull** almost 17-foot (5-m) tall. The Nandi was Shiva's mount and images of the creature are worshiped all over India. Created in 1659, the monolithic Nandi Bull of Mysore is an extremely expressive likeness—it lies peacefully and composedly on a stone plinth, gazing into the distance as if lost deep in meditation. Visitors will be impressed by its imposing size and wealth of ornamentation, and also by the fact that it was not installed in a restricted sacred area but is accessible to all. People come from far and wide to drape the beast with flowers and garlands, and devout pilgrims leave votive offerings.

Chennai (Madras)

Chennai, as Madras was renamed in 1996, is a busy, lively metropolis with a diverse—and in some respects contradictory—present and a turbulent past. The city lies on the Bay of Bengal in Tamil Nadu state and, including its suburbs and satellite conurbations, has a total population of some ten million, making it India's fourth-largest metropolitan area. Chennai has a rich cultural history, with countless shrines dedicated to a variety of religions; the temples, mosques, and Christian churches attest to the varied fortunes and religious adherence of the city's inhabitants over the two millennia of its history. The great majority (83%) are Hindu. Christianity has never established itself to the same level as Buddhism and Islam, perhaps because of the great variety of denominations and sects that probably hampered one another's work. Nonetheless, the (Roman Catholic) Portuguese and later the (Protestant) Dutch and British all established Christian communities.

During its history this south Indian city has traded with the Chinese, Phoenicians, Greeks, and Romans. Arabs and Armenians settled here, followed by the Portuguese in the mid-16th century, the Dutch at the turn of the 17th century, and then the British, under whom the city expanded and grew in importance. The granting of independence to India in 1947 ended the long period of European colonial rule.

One of the most important Hindu temples in the city is the **Parthasarathy Kovil**, dedicated to Krishna, one of the avatars of Vishnu. Partha was another name for Arjuna, one of the principal characters in the ancient Indian Mahabharata epic. He is Krishna's interlocutor in what is probably the most famous part of the epic, the Baghavadgita. Partha has lent his name to many branches of Hindu belief and there is even a legend that Krishna served as his charioteer (*sarathy*), hence the name of this very popular temple. Tasty food is served each day to all pilgrims here, irrespective of their faith.

The **Kapaleeshvarar Kovil**, another major temple, is one of the principal

sites of Shiva worship. The present temple, with its impressive reliefs depicting scenes from the lives of Shiva and his consort, was erected in the 16th and 17th centuries to replace an older structure on another site that was demolished by the Portuguese during the construction of the Church of St Thomas. A nine-day temple festival is held here every year in April or May, in which the lavishly decorated statues of Kapaleeshvarar (Shiva) and Karpagambal (Parvati) are carried in procession around the temple. Hundreds and thousands of believers attend this feast in honor of the divine pair, following an anticlockwise direction as they circle the temple in prayer and meditation.

The **Ashtalakshmi Kovil** on the coast is the third of Chennai's major temples. It is dedicated to eight avatars of the goddess Lakshmi (Sanskrit: *ashta*, "eight"); Lakshmi is not only Vishnu's consort; she is also Shiva's sister. Pilgrims come here to ask for personal good fortune, because Lakshmi is the goddess of good luck and success in all undertakings.

The site where the Kapaleeshvarar Temple once stood is now occupied by the **Church of St Thomas**. According to Christian tradition, the apostle Thomas, one of Christ's 12 disciples, came to this area called Mylapore and even died here. For this reason the Portuguese built a church in his memory in 1523. The present neo-Gothic church was built on a little mound in 1896 and its brilliant white exterior and red tiles form a conspicuous contrast to the buildings of the surrounding area. Pope Pius XII declared the church a *basilica minor* in 1956, bringing much kudos to south Indian Christianity. Besides this Roman Catholic church there are also Anglican, Methodist, and other Protestant places of worship, but Christianity remains a peripheral phenomenon.

The **Thousand Lights Mosque** in the south of the city is a major shrine for south Indian Muslims. The spread of Islam has had a more profound effect on life in India than any wars, foreign regime, or political conflict. Only south India resisted its dominance when an alliance of several Hindu kings banded together to form the kingdom of Vijayanagar on the Deccan plateau, which was eventually defeated by the Muslims in the great war of 1565. Since this time, mosques have been built throughout the Indian subcontinent and many are regarded as exceptional architectural and artistic masterpieces. The relationship between Muslims and Hindus has always been a tempestuous one, and the Thousand Lights Mosque is a center for worship and also for intercultural outreach.

All in all, Chennai is a modern city where visitors can see how faith, of whichever kind, has a place in modern life and should be cultivated and respected.

Temples of Mahâbalipuram

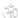

The continuing existence of this city could be regarded as a miracle. In December 2004 the tsunami in the

Indian Ocean devastated large areas of the coast of south India. The world held its breath as it became terrifyingly apparent just how fragile the equilibrium between the human world and the natural world really is, not least because the regions affected by the tsunami were a long way from the epicenter of the earthquake.

Church of St Thomas, Chennai

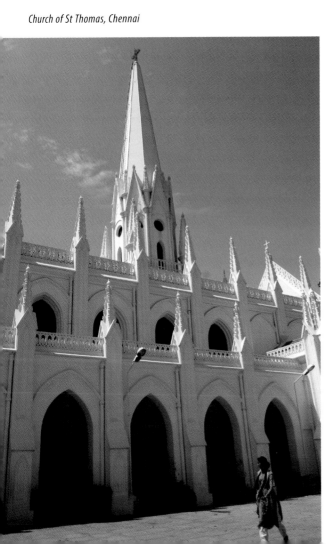

This sacred place is connected with water. The **temples of Mahâbalipuram** on the Tamil Nadu coast are among the most important shrines dedicated to Shiva and were once part of the Tamil kingdom. An impressive complex of temples gradually grew up during its ascendancy between the 5th and the 8th centuries, with some of the buildings being carved from the living rock. However, the place did not become a significant shrine for Shiva worship until after the decline of the Tamil kingdom. As the temple complex is located right on the coast, it is thought that it was constructed as a landmark for sailors as well as for ritual purposes. The reliefs depict numerous legends, myths, and everyday scenes from the period.

The extensive site comprises a great number of Hindu shrines, and the **Descent of the Ganges**, a giant bas-relief carved in the rock during the 7th century, is particularly impressive. Almost 100 feet (30 m) long and 24 ft (7 m) high, it tells the story of the Ganges as recorded in the Ramayana epic, one of the holiest Hindu texts, written in the

3rd century BC. It recounts how King Baghirata had accumulated so much power after years of self-denial that he was able to make the Ganges flow from heaven to purify the souls of his relatives. The experiment went out of control, however, and the flood of water threatened to swamp the world; only Shiva was able to stem the deluge. After Baghirata had completed 1,000 years of atonement and further self-denial on Mount Kailash, the seat of the gods, Shiva offered his help and staunched the flow of water by making it pass through his hair, thus reducing its power. There is a statue of Shiva in a gap between the two largest rocks at Mahâbalipuram.

The 8th-century **coastal temple** is the last remaining of an original total of seven. Its tapering tower still rises to a great height, the only temple to defy the corrosive effect of the sea air. The temple is dedicated to Shiva, and the holy of holies, the lingam, is concealed deep within its interior.

The **Pancha Ratha of the South** are five monolithic shrines in the southern part of the temple grounds. The name is confusing, as *ratha* usually refers to the wheels of the processional cart, but the *ratha* of Mahâbalipuram are not wheel-shaped; in this case the term is a reference to a contemporary style of temple-building. One of the temples, the Draupadi, sacred to the goddess Durga, is shaped like a hut with a thatched straw roof, while the Arjuna, dedicated to Shiva, is pyramidal in shape, and the Bhima is a classic stepped temple consecrated to Vishnu. The little Dharmaja Temple is

the only building to feature an inscription naming King Narasimhavarman I as having commissioned the complex, while the fifth and last, the Nakula Sahadeva, presumably sacred to the goddess Indra, was never completed.

The temple complex at Mahâbalipuram is visited every year by crowds of tourists. Despite its poor state of repair it is still in use as a place of worship, attracting many Hindu pilgrims.

Brihadeeswarar Temple, Thanjavur

Phases in world history have repeatedly occurred in which a single civilization exerts great influence on others. Just like the Persians, the Greeks, and the Romans in their day, from the 9th to the 13th centuries the Chola Dynasty held not only political but also cultural sway over its neighbors, particularly in Indonesia but also in south India. Tamil philosophy, religion, and poetry reached their heights during this period, and the culture was exemplified by the striking temples at the heart of everyday life.

The Brihadeeswarar Temple in Thanjavur is a fine example of a contemporary place of worship dedicated to the Tamils' protector deity, the Hindu god Shiva. The actual temple is situated on a giant square site surrounded by a wall topped with

250 statues of lingams, the phallic symbol sacred to Shiva, representing creativity and fertility. The interior of the temple area is accessible by only one entrance, facing east and marked by two *gopurams*. The outer of these two towers is 100 feet (30 m) high and a little larger than the inner one. The

Dravida gopuram, Brihadeeswarar Temple, Thanjavur

temple precinct also features one of the largest Nandi bull statues in India; the mighty steer, Shiva's mount, is greatly revered and many flowers are placed at its feet. Begun in 995 AD, the 13-tier *vimana*, or temple tower, is a typical feature of the temple's Dravida style of architecture; this steep ziggurat with its curved dome is considered one of the most perfect achievements of Hindu creativity. The entire temple complex was constructed using shaped granite blocks and no mortar. The inner sanctum contains a 13-foot (4-m) polished basalt lingam. The temple's entrance chambers date back to the 17th century. The balanced symmetry of the entire complex symbolizes the power of absolute order, lending the temple an extraordinary tranquility.

Such is the quality and importance of the complex that it was declared a UNESCO World Heritage Site in 1987.

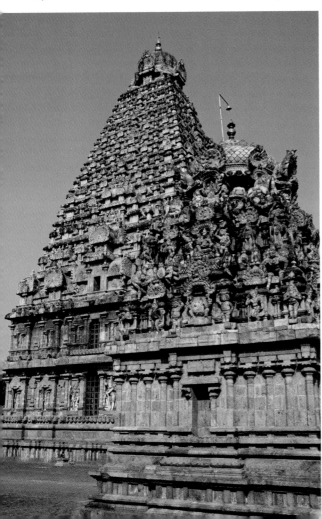

Chomolungma (Mount Everest), Nepal

The highest mountain on earth is known in Tibetan as Chomolungma (Goddess Mother of the World), and in Nepali as Sagarmatha, and is to be found in the Himalayan mountain chain. The south side of the mountain faces toward Nepal, and the north side toward Tibet. According to the latest measurements, Chomolungma is 29,029 feet (8,848 m) high, but tectonic movement of the earth's crust continues to push it upward. Mount Everest, the name common in the Western world, derives from Sir George Everest, a British surveyor who worked in India between 1823 and 1843.

The Sherpa people maintain cult worship of Chomolungma, while for followers of Tibetan Buddhism (Lamaism) the mountain is the home of the gods and goddesses. Small stupas topped with fluttering prayer flags line the paths, and these tokens of respect and humility are used by climbers and tourists as signposts on the way to the summit. The world's highest mountains have become a challenge to conquer nature through human strength and technology. The altitude and the rapidly changing weather conditions are the greatest perils during the ascent.

The first expedition set off in 1922, and there were several heroic attempts to reach the summit before the party was caught in an avalanche. It is not known whether Mallory and Irvine's second expedition actually conquered the mountain; as with so many who failed to reach the summit, their trail has been lost in ice and fog at the highest altitudes.

Chomolungma, the Himalayas

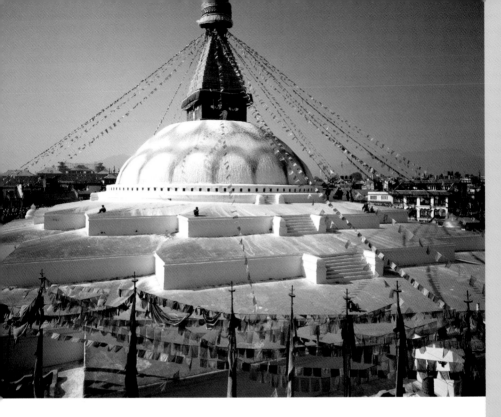

The Great Stupa in Boudhanath

The first indisputable conquest
and safe return from the summit of
Chomolungma was achieved in 1953
by Edmund Hillary, a New Zealander,
and Sherpa Tenzing Norgay, a Nepali.
The "roof of the world" has continued
to exert an extraordinary fascina-
tion to this day, and many still try to
reach the highest point on earth.

The Great Stupa, Boudhanath

The Great Stupa at Boudhanath in
the Kathmandu Valley is the spiritual
center of Tibetan Buddhism in Nepal.
After the Dalai Lama's flight into
exile in 1959, many other Tibetans
fled their native land to seek refuge
in Nepal. This small country between
India and the Tibetan highlands
is a place where Hindu and Bud-
dhist traditions meet and mingle.

ASIA

At almost 130 feet (40 m) in height, the stupa at Boudhanath is the largest religious building in the whole valley. The base of the shrine comprises three successive stepped terraces that form a mandala (concentric ritual diagram). The top terrace bears the giant half globe of the stupa. Above this there is a square, box-like structure, on each side of which there are painted representations of the eyes of the Buddha, symbolizing consciousness. Between the eyes there is the figure that represents "1," symbolizing the unity of all life. On top of this there is a tower composed of 13 tiers of ever-decreasing size, representing the 13 Buddhist heavens. Above the tower there is a golden canopy and spire, and attached to the canopy are countless prayer flags, whose bright color is intended to attract the attention of the gods. At the foot of the first terrace there is a profusion of large

prayer wheels; when these are turned in a clockwise direction, a prayer is released. Many believers congregate here, particularly at dusk and dawn, to walk clockwise round the stupa, turning either their own hand-held prayer wheels or those set into the wall around its base, chanting the famous mantra *"om mani padme hum,"* or taking part in a prayer service in one of the monasteries that ring the stupa.

Beside the monasteries are stores selling devotional paraphernalia. The stupa is whitewashed once a year by the faithful, and its saffron-colored arches are repainted to celebrate the new year.

Pashupatinath Temple, Kathmandu

ॐ

This Hindu temple was built on both banks of the sacred Bagmati River in the 5th or 6th century. The site and the river had always been sacred as they were thought to be where a legend involving Shiva took place. Attracted by the beautiful scenery and wishing to break away from his companions Vishnu

Pashupatinath Temple, Kathmandu

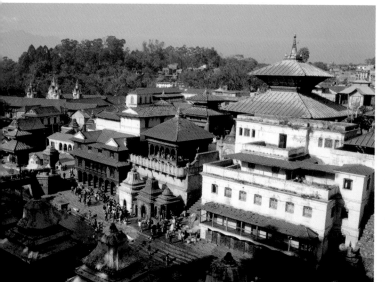

and Brahma, Shiva transformed himself into a gazelle and gamboled with Parvati, who had taken the form of a doe gazelle. Vishnu and Brahma eventually caught up with the pair, but Shiva did not wish to leave the delightful landscape. Vishnu and Brahma grabbed him by a horn to subdue him, but the horn broke and Shiva was able to escape to the opposite bank. Parvati also swore she never wished to leave the spot. Shiva then made a promise to all mankind that those who came here to seek him would never be reborn as an animal, and that the broken horn should be set up as a lingam. Shiva is worshiped here as the Lord of the Animals (*pashu pati*).

The Bagmati, which eventually flows into the Ganges, divides the two parts of the temple area in half. On the left bank there is the great Pashupatinath Temple and the Arya Ghats, the cremation sites of the higher castes, and on the other there are the Surya Ghats, where the lower castes conduct the funeral rites for their relatives. The two roof-levels of the temple form a pagoda, an architectural feature that originated in Nepal.

Open only to Hindus, the temple area is visited throughout the year by people carrying the bodies of their relatives and wishing to conduct their cremation rites. The great Shivaratri, the festival commemorating Shiva's birthday in February or March, draws crowds from all over the country to Nepal's most important pilgrimage site.

Lumbini

Lumbini is a major pilgrimage site for Buddhists from all over the world, because this little town by the Indian border at the foot of the Himalayas was the birthplace of the great Siddhartha Gautama. The sites that were to become future pilgrimage sites are identified in the earliest Buddhist texts: the places of his birth (Lumbini) and of his enlightenment (Bodh Gaya, India), and the places where he first taught (Sarnath, India) and where he died (Kushinagar, India). All these events took place under trees in the natural world.

During the Buddha's lifetime, Lumbini was surrounded by a wooded garden. The emperor Ashoka, a zealous admirer and champion of Buddhism, visited Lumbini in 249 BC to build four stupas and a tall stone pillar at the Buddha's birthplace. Lumbini later fell almost into oblivion and was left to decay. Ashoka's memorial column was rediscovered only in 1895, and further excavations uncovered the locations of the former stupas and temples. A series of temples and monasteries have recently been built by many nationalities with a tradition of Buddhism, and all welcome visitors who wish to meditate in this special place. A large Bodhi tree beside a beautiful pond is especially venerated. With its silence and various temples, Lumbini is a place of peace and spiritual power.

Somapura Mahavira

Everything on this site in north-western Bangladesh was completely overgrown until the recent discovery of a ruined monastery beneath the hill, which has now been partially excavated. The digging revealed a place that was once the "Somapura Mahavira" (Great Temple) which now offers visitors an opportunity to meditate on the Divine as they make their way through the labyrinthine ruined walls or the great mandala—a structure laid out as a concentric ritual diagram. The site acquired the name "Paharpur" (Little Temple) after the Great Temple was reclaimed by the jungle.

The temple included a monastery complex with accommodation for itinerant monks who sought shelter here on stormy nights. The building

Somapura Mahavira

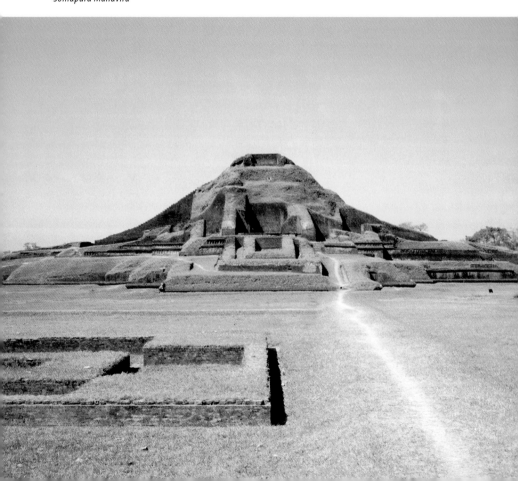

was pyramidal in form with a cruciform base and reached a height of about 70 feet (20 m), with cells for the monks at its foot. During the 500 years of the temple's prosperity, beginning in the 7th century, the complex and its monastery formed a Buddhist center of intellectual inquiry, meditation, and sacred ritual. The site now looks austere and lonely, but visitors will perhaps find it easier here, far from the bustle of the world, to approach the secret of life and a balanced way of living.

Chittagong

First documented in the 9th century, Chittagong is now the second-largest city in Bangladesh and exhibits all the problems associated with a giant hinterland. As it expands, this seaport is slowly eating into the green hills and rivers surrounding it.

Chittagong is an important pilgrimage site for Sufis and a particular place of worship for Bayazid Bistami, one of the most famous early mystics, for whom a shrine has been erected. The locals are convinced that the holy man also lies buried here, even though it is more likely that he died and was interred in Bistam (Iran); this has had no effect on the intensity of their adoration.

Bayazid (794–877 AD), the grandson of a Zoroastrian, was the first person to use the concept of ascent to heaven (mi'radsch)—a notion that would have been instantly familiar to Muslims from the teachings of Muhammad—as an image of the mystic course of a life. He left behind no written teachings, but there is a wealth of Muslim sources recording his wisdom, his ironic manner, and his absolutely autonomous essence. "Wisdom reigns," he is supposed to have said, "when the heart goes hungry," and Islamic scholar Annemarie Schimmel has observed that his "metaphysical thirst" was never quenched. Bayazid is said to have studied under 113 masters, drawing benefit from each. One of these, Sadiq, told him as he sat before his master: "Take that book down from the windowsill!" Whereupon Bayazid asked, "What window?" "In all the time you have been coming here," responded the master, "you have never noticed the window?" "No," said Bayazid, "what do I care about the window? When I sit before you, I look only at you. I don't come here to look around." "If that is so, go home," said Sadiq, "you have learnt all there is to learn."

Bayazid has come to represent a paradigm of autonomy and striving for wisdom, and his shrine at Chittagong is visited by devout Muslims hoping to benefit from his strength and clarity.

Anuradhapura

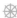

Anuradhapura has been a sacred place for more than 2,000 years. Buddhism was brought to Sri Lanka in 250 BC by Prince Mahendra, one of the sons of Ashoka, emperor of India. At the same time, so the story goes, the Indian princess Sangham-itta, daughter of the peace-loving Ashoka, brought to Anuradhapura a cutting from the Maha Bodhi Tree under which the Buddha was said to have achieved enlightenment, and the tree is still alive today, one of the oldest known trees in the world. Anuradhapura was the Sinhalese capital from at least the 4th century BC until the 10th century AD, when the Tamils conquered the place (in 993), driving out the local people. The town declined considerably after this and was overtaken by the jungle. The large sections of the city uncovered by excavations in the last 100 years or so are now once again revered as a sacred place by the country's Buddhists.

The most important pilgrimage site is the 2,000-year old **Sri Maha Bodhi**, the Great Bodhi Tree, which is now carefully tended and protected.

Ruvanveli Dagoba, Anuradhapura

In the immediate vicinity there are a number of impressive stupas and temples, as well as monasteries have returned in which young monks prepare for their duties.

The **Ruvanveli Dagoba**, a particularly impressive shrine, is one of the oldest Buddhist temples in Sri Lanka. The elephant heads carved on its base seem to support the snow-white domed building. The Dagoba is a representation of the Buddhist cosmos: above the dome, which symbolizes the earth, there is a rectangular structure with a circular opening in each of its four sides, representing the eye of the Buddha, the symbol of enlightenment. Above this there are the 13 levels of heaven, represented by a tapering ziggurat. Monks and pilgrims visiting the temple complete circuits of the building in a clockwise direction. In front of the temple there is a statue of King Dutugemunu, who commissioned the building in 140 BC but did not live to see it completed. The long history of the important temples and monasteries here makes Anuradhapura one of Sri Lanka's major Buddhist pilgrimage sites.

Gal Vihara, Polonnaruwa

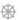

Now a small town, Polonnaruwa experienced a brief heyday of about 50 years during the mid-12th century under the rule of Parakrama Bahu I. During this time the town was both the capital and the resting-

Reclining Buddha, Gal Vihara, Polonnaruwa

place of the relic of the Buddha's tooth, which was previously kept at Anuradhapura and is now at Kandy. The rock temple of Gal Vihara is located right beside the town and contains what is surely the most famous stone artifact on the island.

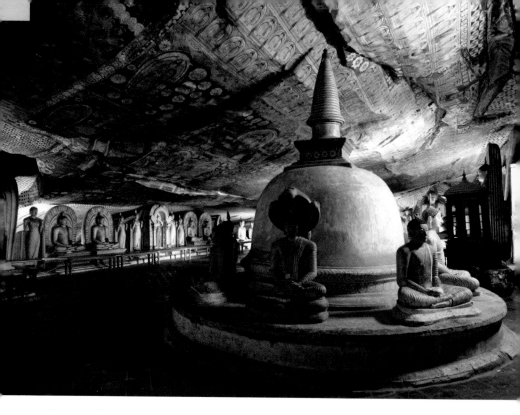

Cave temple, Dambulla

Many have said that this is the most beautiful place in Sri Lanka, and some even think it the most beautiful in the world. The four monumental figures carved from the rock are without doubt Sinhalese sculpture's most beautiful creations. The four figures—two seated, one standing, and one reclining—are firmly fixed to the rock, but they almost seem to be floating. Three of the figures are identifiable: a reclining Buddha who has already reached nirvana, a Buddha lost in meditation, and a Buddha in a cave (flanked by the Hindu gods Brahma and Vishnu); they are joined by a standing figure who is conjectured to be Ananda, the Buddha's favorite pupil—this composed, completely relaxed figure with folded arms and slightly bent knees is not part of traditional Buddhist iconography. If it were intended to represent the Buddha, it would be unique in the world.

Study the statues closely to learn something of the benevolence of Buddhist doctrine; the reclining Buddha radiates an irresistible gentleness as he lays his head on a stone cushion. Peace, relaxation,

the ability to let go of the things troubling you—this is a place to experience what following the Noble Eightfold Path has to offer.

Dambulla Cave Temples

Modern-day Dambulla is a bustling city in the middle of the island of Sri Lanka. In the year 102 BC King Vattagamini Abhaya was forced to take refuge in the caves not far from here after fleeing from Anuradhapura, the capital, in the face of the advancing Tamils. Here he spent 14 years under the protection of the monks who lived in the caves. There is a total of 80 cave temples, of which five are known as the "Great Temple" or the "Golden Temple," and together these form one of the most revered places of worship in Sri Lanka.

Located at the gates of the city, the Dambulla comb of rock is about 660 feet (200 m) high. The first of the rock temples encountered by visitors features an impressive giant statue of the reclining Buddha, already in nirvana, with his favorite pupil at his feet. The cave, entirely chiseled out of the rock, has an extremely low ceiling and is lit only by candles. Pilgrims come here to light joss sticks and place the paper lotus blossom they have brought with them on the arms of the Buddha. The second cave temple, the largest of the five, is full of statues and covered with ceiling frescos

depicting scenes from the Buddha's life, as well as likenesses of Hindu gods. A constant trickle of water from a recess in the rock is collected in a bowl and used for ritual purposes. The third cave chamber contains a number of marble and hardwood statues of the Buddha that have been donated over the ages. The fourth temple contains a model of a *dagoba*, a representation of the world according to Buddhist lore. The fifth cave contains another reclining Buddha, this time surrounded by ten others who have achieved enlightenment.

The Dambulla Cave Temples are a wonderful place whose charm will captivate every visitor.

Kandy

Kandy—the "kingdom on the hill"—was the capital of the last Sinhalese kingdom until 1815. The name Kandy is not used by the city's residents, however, who know it as Maha Nuwara, the "great city." It is not actually very big, but it has one of the most important Buddhist shrines, a major sacred place known as the **"Temple of the Tooth"** (Sri Dalada Maligawa). The modern-looking temple building features only a few elements of Buddhist architecture—in fact it rather resembles a colonial villa—but it contains the upper left incisor of the Buddha. This important relic, a cornerstone of Sinhalese Buddhism, has

always been kept in the city where the royal family was currently residing.

For ten days and one night in July or August the city is flooded with hundreds and thousands of

"sadhu, sadhu" (holy, holy), as drums beat with ever-increasing intensity, and musicians and dancers caper in ecstasy—it is a truly remarkable act of worship.

"Temple of the Tooth," Kandy

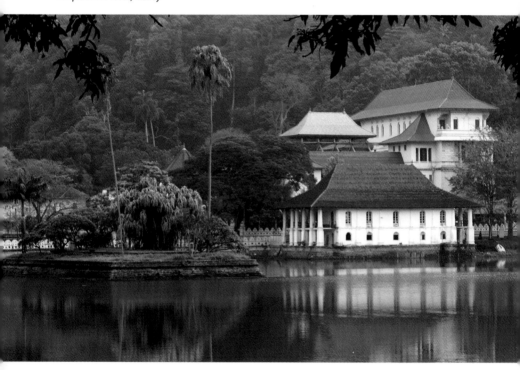

Buddhist pilgrims from every part of the country, as this is when the relic, which is otherwise displayed only rarely, is carried through the city in the Esala Perahera (a great procession in honor of the Buddha). People dressed in festive clothes accompany the train of 100 brightly decorated elephants, shouting

The **Forest Hermitage**, a meditation center for fully ordained monks (*bikkhus*), is located at Udawattakele ("upper forest garden"). This forest in the middle of the city looks as mysterious and overgrown as a jungle; as soon as you enter it, the noises of the city fall away and you find yourself in tropical stillness interrupted only

by monkey calls or birdsong. At the summit there is a monastic community (*sangha*) where the senior monks seek the most profound truths and a joyful release from this world. Besides the few rules left by the Enlightened One, there are a great many other by-laws to learn and understand, which are intended to allow the monks to reach a position of relaxed withdrawal. The monks extend a warm welcome to visitors and the atmosphere is one of calm repose; it is easy to see that these hermit monks have found a deeper meaning in life.

Alu Vihara

The Monastery of Alu Vihara was carved in the granite cliffs high above Kandy more than 2,000 years ago and ever since it has been revered as a national and religious shrine. In about the year 80 BC, 500 monks assembled here to collate, sift, order, and write down the words and the teachings of the Buddha that had previously been recorded only in an oral tradition. The monks laid the results of this convocation in a basket with three sections (*tripitaka* or *tipitaka*). The basket contained the Buddha's sermons (*sutta pitaka*), rules for Buddhist communities (*vinaya pitaka*), and philosophical treatises (*abhidhamma pitaka*), along with disciples' and pupils' interpretations of these teachings.

The work is the definitive collection of all the philosophical, psychological, and practical rules that govern Buddhist devotion and life to this day.

In 1848 the people of Ceylon (as the island was then known) rose up against the British. When some of the rebels took refuge in the monastery, a large part of the extensive library, with its valuable texts and precious manuscripts from the convocation, was destroyed. Since then the monks living in the monastery have been at pains to refill the basket, and by 1982 the first section was completed. The monks sit in their simply furnished rooms and scratch the sacred texts into *ola*, dried and specially prepared palm leaves, with ivory styli. Recording the canonical texts is not only an act of great cultural and historical significance; it is also a special form of meditation that is practiced only here.

Sri Pada

Early one morning King Vijayabahu I (1058–1114) glimpsed a sight denied most mortals: he saw angels picking flowers in his garden. When he questioned them, they replied: "We are picking flowers in honor of the footprint of Buddha on the summit of Samanalakanda." Being a devout Buddhist, he became the first to climb the 7,360 feet (2,243 m) from the plain to the summit of this conical mountain. Sri Pada (also known

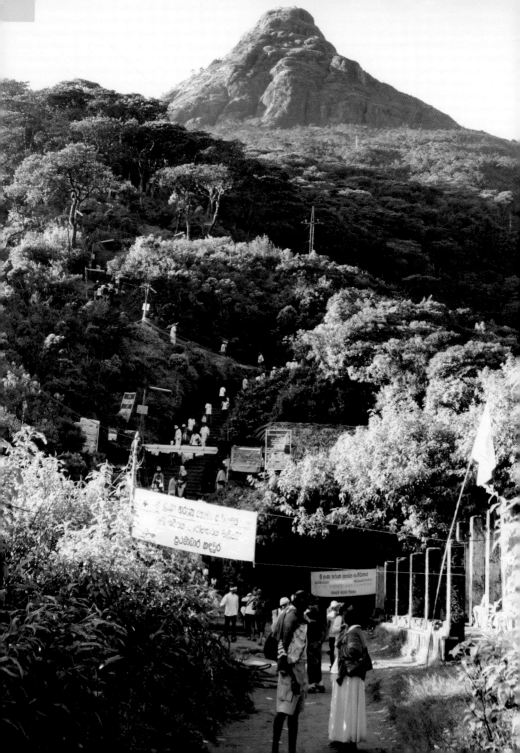

as Samanalakanda and Samanhela) is located 10 miles (16 km) northeast of Ratnapura in southwestern Sri Lanka, and from its summit there is an uninterrupted view of the surrounding tropical jungle, lush forests, and rolling hills.

The mountain and its summit have been worshiped as sacred for centuries, not least for a strange imprint in the rock; Buddhist scripture has known the formation as the "Buddha's Footprint" since 300 BC. Muslims and Christians revere the 6 × 3 ft (1.7 × 0.6 m) depression as the footprint of Adam, the first man, who came here after being driven out of Eden. Chinese (Taoist) sources describe it as the footprint of a god.

To reach the summit, visitors must first cross deep valleys via steps cut in the rock and then clamber up a steep ladder. One legend suggests that the safety chains on the southern side of the mountain were installed by Alexander the Great. Each pilgrim is allowed to ring one of the many bells at the summit, his selection determined by how many times he has already made the ascent, and then to drink from a sacred spring to bring the act of worship to a close.

Sri Pada is an interfaith shrine. The mysterious relic here has been interpreted by people of different beliefs, and every pilgrim who completes the ascent draws nearer to the heavens, in both the literal and metaphorical senses.

Ascending Sri Pada

Gangatilaka Vihara, Kalutara

Kalutara is a little town just to the south of Colombo, lying on the highway between the capital and Galle. The most important building here is the great *dagoba* and the adjoining Gangatilaka Vihara temple complex between the main highway and the banks of the Kalu Ganga River, which has become a spiritual center for the people living here. The object of their worship is a cutting brought from the Bodhi tree at Anuradhapura, but the place is most remarkable for a relatively recent custom: almost every local motorist will stop here to leave a quick offering or say a brief prayer for a good journey. They throw a few coins in a collection box and some even lay flowers beneath the trees on the opposite roadside. A simple stand with an oil lamp enables people to make a quick burnt offering in the hope of a speedy trip and a safe return. It is now not just local drivers who stop here—Western visitors have adopted the practice as if it were the most natural thing in the world. The temple complex with its *dagoba* is impressive, and this down-to-earth custom is charming. Its practice is a sign of a religion that accommodates even the most mundane elements. Every car trip is a journey, and every journey is an undertaking requiring protection.

SACRED TIMES

Mankind has always been restricted by space and time, but any attempt to understand time seems doomed to founder. Man lives from day to day, and things seem more and more short-lived—and time seems to pass more quickly—the older he gets. This personal experience of time stands in direct contrast to what man calls eternity: everything seems to pass—but not everything does! All human civilizations and religions have developed a concept of the existence of something that is less ephemeral than their own existence. Man divides time into various recurring cycles in an attempt to create fixed points and a sense of security: the alternation of night and day, the series of days forming a week, a

month, and a year, the cyclical course of the seasons—all of these provide orientation in a life that requires order.

"Eternal return" is a philosophical concept that seems to be borne out in man's day-to-day life. It has thus become a matter of significance in all recorded religions to emphasize and commemorate certain points in time. The three great monotheistic world religions (Judaism, Christianity, Islam) all have a linear concept of time, beginning with Creation and ending in apocalypse, the end of time, or the "Last Judgment." Time is divided into three sections: a mythical period of Creation, recorded history, and the "end times." Other religions (especially

Buddhism, Hinduism, and Jainism, most ethnic religions, the religion of Ancient Egypt, and modern New Age beliefs) maintain a cyclical notion of time—the cosmos is forever renewing itself within the course of universal time. New worlds are forever being created and destroyed as the eternal "wheel of time" turns. At the end of each cycle the old world is annihilated and a new eon dawns. The Jewish calendar begins with the Creation, the Buddhists calculate from the birth date of the historical Buddha, for Christians the start point is the birth of Christ, and for Muslims the Hijra, the Prophet Muhammad's flight from Mecca to Medina.

Sacred times are incorporated in the celebration of a religion's holy days, which recur in a certain rhythm and punctuate the secular year. Religious festivals have either natural or redemptive associations, and there are certain points in time, fixed by the calendar, which are used to renew man's relationship with the Divine. The great annual festivals have always had great significance in every religion—they are festivals of thanks, sacrificial atonements, or penitential ceremonies. Spring festivals are invariably joyful occasions, as winter is at an end and new life is burgeoning. Darkness is dispelled by light, temples and houses are cleansed, and the demons of the old year are driven out. Summer is the season for fire festivals—bonfires are lit at the summer solstice to ensure the continuation of the sun's powers. The fall is the time for festivals celebrating the end of the agricultural year——the harvest is brought in, wine grapes are picked, and a portion of the proceeds is offered to the gods, to spirits, or to ancestors. Light is the focus of festivals taking place in winter, the time of darkness. Annual festivals are a distraction from the people's personal concerns, and pivotal to such events is a sense of community and shared experience.

Just as each year is punctuated with festivals, each day is divided by prayers, another human attempt to establish a link with the eternal. In work there is prayer—*ora et labora* is well known as the motto of the Benedictine monastic tradition, but this formula for productive life is not limited to Christianity. Every religion on earth associates work and prayer closely with a life that is whole, and thus sacred.

The temples of Bagan

The temple complexes built in the ancient royal city of Bagan between the 9th and the 13th centuries are world-famous. Bagan was the capital of the first Burmese empire. The city covers an area of almost 20 square miles (50 km²) on the banks of the Ayeyarwaddy (Irrawaddy) and has become known as the "City of Four Million Pagodas." While this may be an exaggeration, the more than 2,000 well-preserved temples and pagodas in the city make it one of the most enigmatic sites in Southeast Asia. The temple city is not only an important archeological site; some of the temples are still in use as places of worship. You can even take a balloon ride, gliding effortlessly above the temples as they gleam in the sun, and imagine yourself rising up to heaven.

Visiting the city on foot will allow you to discover places of incredible beauty and spiritual power. Bagan is entered through the *tharabha*, a gate built in the 9th century by King Pyin Pyar Min as the entrance to the city and intended to protect those inside from the arrows of the enemy. The gate is guarded to left and right by two spirits: on one side Mahagiri (the big brother) and on the other Shwemyitna (the sister). This is the

The temples of Bagan

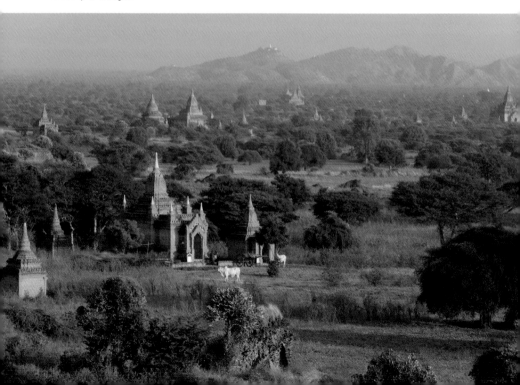

beginning of a path into a glorious past dominated by religion.

The numerous shrines are almost exclusively consecrated to Buddhist deities. The **Ananda Temple**, one of the earliest foundations, was built by King Kyansittha in 1090. Four statues of the Buddha look toward the four cardinal points of the compass, and the reliefs in the temple depict important events from the Buddha's life. The temple complex also includes a monastery with 18th-century frescos of events in the city's history and scenes from the Buddha's life.

The **Nathlaung** is the only Hindu temple in the city. It is here that the *trimurti* of Brahma, Vishnu, and Shiva is worshiped. Built in the 10th century, this must be one of the oldest structures in the city, as Buddhism was subsequently established as the religion of the royal house and use of the Hindu temple was discontinued.

The **Gawdawpalin Temple** is based on the classic form of early stupas, with a semi-circular mound (symbolizing the earth) topped with an octagonal plinth and a tapering ziggurat with the 13 tiers of the Buddhist heaven. The temple dates back to the 12th century and commands a breathtaking view of the river's flood plain and the many places of worship.

The **Shinbinthalyaung**, a rather plain, low, rectangular temple, contains an impressive statue of a reclining Buddha.

The temple city of Bagan is a remarkable example of a kingdom founded on Buddhist principles and provides an inspiration for visitors to this day.

The Golden Rock, Kyaikto

The Golden Rock, which is actually made of granite, seems to be clinging to the summit of a 3,615-foot (1,102-m) basalt peak. Situated to the south of the little town of Kyaikto, it is one of the most spectacular and important Buddhist shrines in the country. The strange, skull-shaped granite rock immediately captures the attention as gravity, a force to which everything is subject, seems to be in abeyance here. Several scientific explanations have been offered for the shape and location of this unique and enigmatic formation, but its most important characteristic is the spiritual energy it seems to radiate.

On top of the rock there is a small stupa, the Kyaikto Pagoda ("pagoda on the head of the hermit"), the name referring to the myth of the rock's creation. A hermit is said to have been given a single hair by the Buddha himself and to have worn this all his life in his own topknot. Before he died, the hermit wished to build a pagoda on a rock that resembled his own head. The king helped him to find such a rock, eventually bringing a boulder from the depths of the ocean and placing it on the mountain where it lies still. The Buddha's single hair has since prevented the rock from crashing down.

Another still more mysterious legend claims that the rock is not actually fixed to the ledge at all,

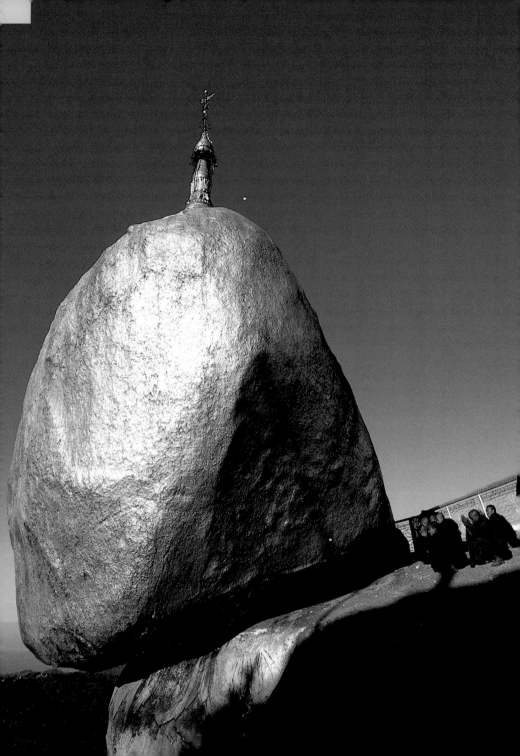

but has been hovering above it for 2,500 years. At one time there was a gap between the rock and its base big enough for a cockerel to walk through, but as the rock slowly settled, the gap was reduced to the size of a partridge, and after a further 200 years only a sparrow could fit through. There are still plenty of people who maintain that the Golden Rock remains mystically suspended.

Whether the rock is floating or fixed is immaterial to the immediate impact of this glistening shrine—the dome of the rock is entirely coated in gold. Pilgrims bring little scraps of gold leaf with them to affix to the shrine, and the bottom of the rock is now gilded to a height of about six feet (2 m). The pilgrim's path to this location is extremely challenging, crossing mountains and dense forest, but the reward comes as you stand before an absolutely unique sacred place.

Shwedagon Pagoda, Yangon

The history of Myanmar stretches back almost 2,000 years, and until the 18th century the capital Yangon (Rangoon) was known as Dagon (meaning "place of worship"). *Shweh* is the vernacular term for "golden," so

Golden Rock, Kyaikto

this sacred place is both a golden and a place of worship. The Shwedagon Pagoda, with the many surrounding smaller pagodas, its countless statues and *zedis* (bell-shaped relic shrines), *tazaung* (prayer halls), and *zayat* (meditation rooms), has become one of the major sites for pilgrimages from all over Southeast Asia.

The main stupa towers over the rest of the complex. It is a reminder of the steep path leading from the circle of rebirth to nirvana and also a representation of Mount Meru, considered symbolically as the navel of the world. The octagonal plinth is topped with three terraces; there are 64 pagodas of various sizes on the bottom terrace and the top terrace bears a giant bell and an inverted alms bowl decorated with 16 lotus flowers. Above this there is a spiral tower, symbolizing ascent into the Buddhist heaven. On top of the tower is a lotus blossom, the sacred flower of Hindu and Buddhist tradition. Above this lies a canopy (*hti*) of seven layers, encrusted with diamonds, rubies, and sapphires. At its tip there is the "diamond bud" (a real diamond) symbolizing the Diamond Sutra and thus the "apotheosis of wisdom, so sharp that it can cleave a diamond," according to the central texts of Mahayana Buddhism. There is a magnificent shrine within the stupa containing eight of the Buddha's hairs, an extremely precious relic to which supernatural powers are attributed—they can make the dumb talk, the deaf hear, and the lame walk.

The four entrances to the Shwedagon mark the cardinal points of

the compass. Pilgrims come from all corners of the earth to visit the shrine to pray, to conduct sacred rites, to meditate, or to be instructed in the art of the four *mudras*.

The records of the earliest Buddhist monks indicate that the first stupa was erected on this site during the lifetime of the historical Buddha, about 2,500 years ago, after the two brothers Taphussa and Bhallika had gained possession of the eight miraculous hairs. The first set of buildings gradually fell into disrepair before being considerably altered and extended in the 14th century, giving rise to the giant temple complex seen today.

Besides the main stupa there are countless other major temples and places of worship, and the extensive grounds are blessed with an extraordinarily peaceful atmosphere, providing an object lesson for the otherwise less than tranquil country of Myanmar. The name Yangon, borne by the capital since 1775, means "the end of conflict."

THAILAND

Wat Phra That Lampang Luang, Lampang

Wat Pra That is considered by many to be the most beautiful temple complex in all Thailand. It is an impressive walled shrine situated on a man-made hill south of the city of Lampang. As you approach the 15th-century temple, it resembles nothing so much as a defiant fortress, and temples and monasteries were indeed used as such in the turbulent past. The gate is reached via an elaborately decorated flight of steps, and here the Wheel of Law (*dharmachakra*) sets the tone of the temple for new arrivals. The gate is usually closed, however, and the more commonly used entrance is in the southern section of the surrounding wall.

The central point of the temple complex is marked by a large *chedi* (stupa) with a base plated with copper and bronze; as a result of oxidation, this now gleams green and blue. It is topped with a gilded tower crowned with a canopy (*hti*). The *chedi* represents Mount Meru, the mythical mountain from which the world was created. The courtyard surrounding the *chedi* is strewn with sand to symbolize the oceans of the world. The wooden prayer halls are built in traditional *lanna* style and are richly decorated. The prayer halls are remarkably well preserved and convey a good impression of the temple's original state. The main building is open on all sides and in the back section there is an open golden shrine (*ku*) containing a statue of the Buddha dating from 1563. There are further prayer halls, all decorated with a wealth of beautiful carvings, adjacent to the main building.

For the monks the most sacred building is located in the southern

Shwedagon Pagoda, Yangon

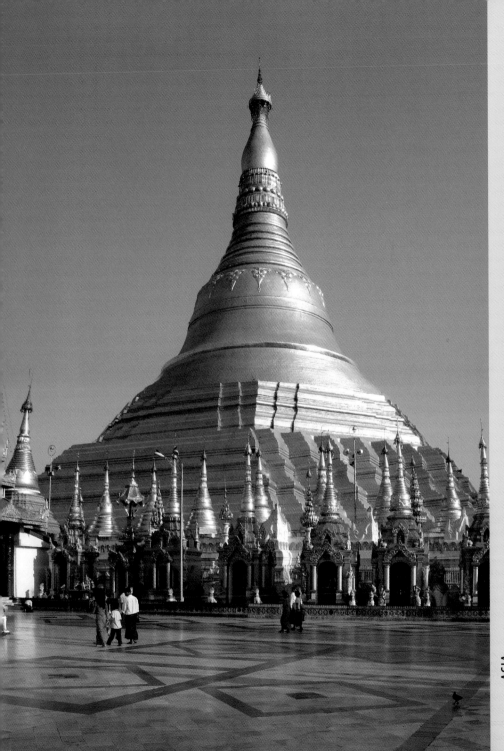

section of the temple grounds—a small *bot*, a structure surrounded by a colonnade and with special boundary stones (*bai sema*) delineating the innermost, holiest area, which is accessible only to monks. Immediately adjacent to this there is a *mondop*, a cube-shaped pavilion containing one of the Buddha's footprints. The visiting faithful conduct a pilgrimage within the temple, moving from each place of worship to the next and thus completing a spiritual journey from the creation of the world all the way through the history of their faith.

Buddha statues, Ayutthaya

Ayutthaya

The city of Ayutthaya was founded in 1350 and soon grew in prosperity due its auspicious location at the confluence of the Chao Phraya River and several of its smaller tributaries. The rivers are linked by a circular canal so that boats can negotiate them. Ayutthaya was the capital of Siam (Thailand) for more than 400 years. Its name is derived from the Sanskrit word *ayodhya* (invincible), but this proved a misnomer when the Burmese army attacked

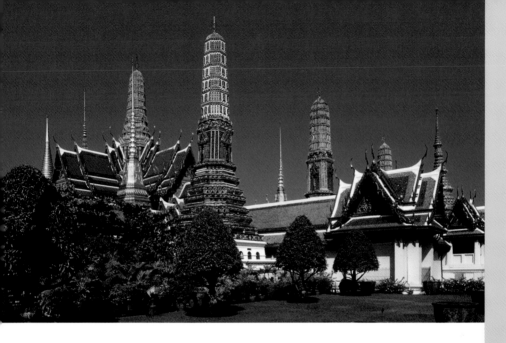

The Wat Phra Kaeo in the royal palace, Bangkok

and sacked it in 1767, almost razing it to the ground. Much was lost in the flames, but the ruins and remnants that have survived are still impressive despite their incompleteness.

Many of the statues that survive in the various monasteries are especially captivating and depict the Buddha in a variety of poses. Each one has a different face and shows one or other of the 32 *lakshana*, the characteristics of the Buddha, yet all depict him in an attitude of meditation. Perhaps the most beautiful statue is a monumental reclining Buddha portrayed leaning against a tree. Like mountains, trees play a significant role in the life and death of the Buddha, usually symbolizing enlightenment. His half-open eyes denote meditation and his gentle face and long earlobes are signs of wisdom. His soft smile embodies his insight into eternal and immutable truths and his reclining position expresses the Buddha's release from the cycle of rebirth. Whether or not you are a Buddhist, it is auspicious that a recognition of the truth evinces a smile, rather than evoking fear or terror.

Wat Phra Kaeo, Bangkok

Bangkok is a city of contradictions, and one where the gap between rich and poor is wide. Most Thais are

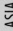

followers of Theravada Buddhism, and in the center of this modern metropolis you will find the second most important temple in the country. Along with the Buddhist center in the former capital of Ayutthaya, this sacred shrine is the goal of many pilgrimages.

Bangkok's most imposing temple complex, situated within the walls of the royal palace, is the Wat Phra Kaeo or Temple of the Emerald Buddha, containing the most important statue of the Buddha in Thailand. This greatly revered figure has been kept here in a specially made shrine since 1784. Including the throne upon which the Buddha sits, this famous statue is little more than 18 inches (50 cm) high, and despite its name it is made of jade. The statue, to which magical powers are attributed, is dressed in different clothes in a special royal ceremony held three times a year: at the beginnings of the "hot time" and the "cool time," and at the beginning of the rainy season. The throne is positioned high up, ascending to a heaven that is inaccessible to mere mortals, and surrounded by ten large statues of the Buddha standing in a circle. Two further Buddhas flank the throne to left and right. Every inch of the hall's walls is covered in paintings depicting scenes from the Buddha's life. The Chapel of the Emerald Buddha (Phra Ubosot) is the spiritual center not only of the temple but of the entire country. This most sacred area is surrounded by a low barrier, the "jeweled wall." Beyond the wall there are 12 small pavilions where

pilgrims can rest while still having a direct view of the inner sanctum.

On the temple's upper terrace there are three other shrines: the Phra Sri Rattana Chedi, containing part of the Buddha's sternum, the Phra Mondop, a cube-shaped pavilion where sacred texts written on palm leaves are stored, and the Prasart Phra Thepbidorn, a pantheon of previous kings of the Chakri Dynasty, which is still in power. Two golden *chedis* are stationed to the right and left of the entrance to the terrace, which is covered in statues of mythological beasts.

Wat Pho, Bangkok

The oldest and largest Buddhist temple in the city is to be found immediately to the south of the royal palace in Bangkok's Old Town. The present form of the temple dates back to the reign of King Rama I between 1789 and 1801, when Rama I restored and modified the temple that already existed on the site. It was known as Wat Pho to the locals, a name harking back to the Monastery of the Bodhi Tree in Bodh Gaya, India.

The temple is now known throughout the world as the Temple of the Reclining Buddha, and it is this statue that draws visitors from far and wide. They come to see the golden statue's vast size—it is 151 feet (46 m) long and 50 feet (15 m) high—and also

the expression on the face of the Buddha, his head lying on a pillow, embodying a state of ultimate happiness (nirvana). The soles of his feet are inlaid with mother-of-pearl, and there are 108 panels displaying a wealth of Buddhist symbols and a list of the virtues necessary to achieve enlightenment. It is little wonder that pilgrims approach this statue in awe, bringing lotus flowers made of paper as votive offerings.

Besides the giant effigy there are a further 1,000 statues of the Buddha dotted across the temple's extensive grounds, also nearly 100 pagodas and stupas, and a jeweled wall depicting the struggle of good and evil as recounted in the Ramayana.

Wat Pho is not just one of the most important religious sites; it is also a traditional center of informal education, a kind of teaching that goes beyond cognitive learning and includes meditation and lifestyle. Wat Pho has always been the most important center for practitioners of traditional Thai medicine and massage, and treatments and medical tuition are also available for visitors. Thailand's ancient medical lore and Buddhist tradition merge seamlessly, and this temple is a place where you can experience a balancing of spiritual and physical well-being.

Reclining Buddha, Wat Pho, Bangkok

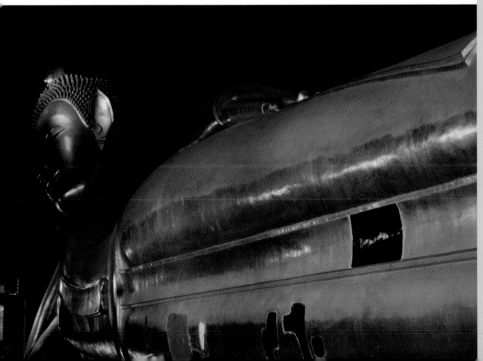

ASIA

Angkor Wat

The word *Ângkôr* means "city" and *vôtt* means "temple" in the local language, and both of these terms are applicable to this giant Khmer temple complex in the heart of the country, the most magnificent Hindu temple precinct in all of Southeast Asia.

Rice cultivation was at the heart of the earliest religious practices in Southeast Asia in a cult that associated the growing of rice with the land's fertility cycles. This may explain why irrigation systems and paddy fields were being constructed as early as the 9th and 10th centuries, yielding several rice harvests a year. The irrigated areas later framed the Hindu temple, which was intended to represent the entire universe. The inner section of Angkor Wat is surrounded by a wide, almost square moat, making it a symbolic island rising out of the oceans of the world.

The Khmer Empire founded by King Jayavarman II in about 802 AD was the dominant power in Southeast Asia for some 400 years, and its state religion was Hinduism. The influence of Buddhism rose as the empire declined in power in the 13th century, explaining the Hindu–Buddhist syncretism that is characteristic of so much of Southeast Asia. Cambodia was to be dominated by Theravada Buddhism in the following centuries, until this was brutally suppressed by the Khmer Rouge in the

The temple of Angkor Wat

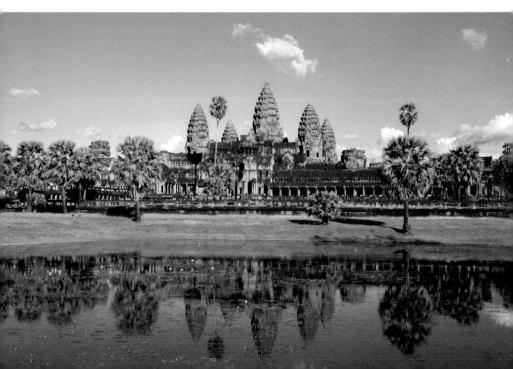

1970s, who introduced a communist re-education program that cost millions of Cambodians their lives. During these years it was almost impossible

cosmogony, with titles like "Heaven and Hell," "How the Sea of Milk Dried Up," or "The Struggle of the Gods," and represent the world's most comprehensive collection of Hindu myths.

Wat Phnom, Phnom Penh

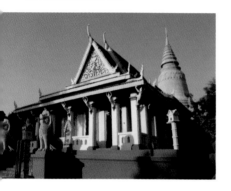

to keep up repairs on the temple. Only recently have major steps been taken in the restoration of this mystical monument. It has since returned to use as a Buddhist place of worship and is visited by great numbers of pilgrims every day.

The complex was built during the reign of King Suryavarman II between 1113 and 1150. Two bridges lead to the shrine, whose central temple with its five towers (*prasat*) resembles a lotus flower; each of the towers is lotus-shaped also. The actual temple is reached by ascending three levels—the bottom one is dedicated to the king, the middle one to Brahma the creator god, and the topmost one to Vishnu. The temple symbolizes Mount Meru, the mythical Hindu and Buddhist mountain from which the entire world was created. The beautiful reliefs carved in sandstone recount episodes from mythology and

Wat Phnom, Phnom Penh

The stupa of Wat Phnom was the germ from which Phnom Penh grew, and from it the city also derives its name. It is the most important stupa in Cambodia and is also the most important Buddhist pilgrimage site in the country, especially during the New Year celebrations. Its foundation myth tells of a rich widow who chanced upon five statues of the Buddha on the banks of the Mekong River and had a stupa built in their honor. This was called Phnom Penh, *phnom* meaning "hill" and *Penh* being the name of the lady concerned.

Nothing remains of the first building of 1372 and the stupa has been destroyed and rebuilt several times. Its present appearance dates back to the most recent restoration work in 1926. The shrine is reached via a series of ramps and ladders and is completely surrounded by a road. Critics might dismiss it as a religious "traffic island," but despite the volume of cars and its modern appearance it is nonetheless graced with the same iconography that marks out every Buddhist shrine. Wat Phnom may be a contemporary place of devotion but it follows an ancient religious tradition that is alive and well, even in this modern city.

Halong Bay

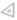

The dragon is one of the most potent symbols in human mythology. It is charged with a primordial energy that serves as the source of both good and evil powers. The Western notion of the dragon is strongly influenced by Christian doctrine which emphasizes the negative side of this energy, but in the Far East dragons are seen instead as representing positive energy. They are a symbol of man's ability to tame and combine the power of the four elements. In the West the dragon is seen as a fire-breathing monster, striking fear into the hearts of all, and is usually one of the obstacles to be overcome by the hero of a legend. In the Far East the dragon is often a wild beast, but seldom an opponent. It represents generosity, good fortune, wisdom, and even on occasion fertility, carrying a large pearl in its mouth to represent the moon, which is said to influence conception.

This notion of a protective primordial dragon is especially cultivated in Halong Bay, the "Bay of the Submerged Dragon," on the Vietnamese coast about 93 miles (150 km) east of Hanoi. Vietnamese mythology is full of dragons, as the entire culture believed itself to be descended from one king dragon and his 100 children. In an age long before that of man, the descendants of these children

Rocks in Halong Bay

were attacked and had to defend their coastline. The Jade Emperor sent a mother dragon and a whole army of baby dragons to aid them, and these fired pearls, jade, and precious stones at the invaders, putting them to flight. Islands sprang up where the gemstones fell into the sea. The legend is said to have taken place at Halong Bay, which has been held sacred ever since.

There are 1,600 large and more than 3,000 smaller islands scattered across the jade-green sea. Many of the larger ones have been named and have gradually accrued their own stories and legends. The bay and its surroundings are home to many different kinds of plants and many species of animals and marine creatures. The bay's beauty changes with the seasons and even the time of day, and the rocks jut out of the water like fabulous animals. As you might expect, Halong Bay has long been worshiped as a place where the beliefs of man are made tangible.

Cao Đài Temple, Tay Ninh

"Something is watching us—we don't know what it is, but it's there!" These few words provide an elegant summary of Cao Đài, a faith that was established only in 1926. Ngô Văn Chiêu, the founder of the religion, experienced a divine revelation in 1925 and set

about spreading this unique belief. It is now the most widespread religion in Vietnam after Buddhism and Catholicism and unites all the doctrines in the country. The central pillar of the faith is a supreme creator god looking down on all that exists. Although such a syncretist religion was banned between 1937 and 1949, its followers are now numbered in millions.

The only Cao Đài temple in existence is a truly stunning building located in the suburbs of the provincial capital of Tay Ninh. It is set in idyllic grounds, the mixture of architectural styles featured in the temple's exterior reflecting the many aspects of the religion. The giant hall resembles a barrel-vaulted, long-naved basilica, and the central feature of the interior is the great "Eye of God" looking down from a globe on the great numbers of the faithful who congregate here to pray. During their devotions they sit on the floor, and the color of their robes has a symbolic meaning: yellow for Buddhism, red for Confucianism, and blue for Taoism. The novices of the community wear white robes.

Besides elements from all the main religions in Southeast Asia, the faith also incorporates aspects of Christianity and even European culture, worshiping Isaac Newton, Joan of Arc, and Victor Hugo as belonging to the Great Spirits of world history. The spiritual hierarchy is not unlike that of the Roman Catholic Church, although the post of Cao Đài pope has been vacant for more than 70 years.

The Cao Đài Temple ("great house") contains a colorful symbiosis

of everything that has the power to
move the heart of man. Guests are
always welcome to observe the rather
strange ceremonies from galleries.

Ho Chi Minh City
(Saigon)

This metropolis on the Mekong
Delta has officially been called Ho
Chi Minh City since 1975, but it is
still known to its inhabitants as
Saigon. The dynamic, chaotic city
has long since entered the modern
era and acquired the same prob-
lems as every other densely popu-
lated area in the world, but parts of
it still retain elements of its ancient
and turbulent past. There are still
fewer cars than in other major cities,
although motorcycles and bicycles
race incessantly through the streets.

Named after Ho Chi Minh, the
revolutionary who became president,
the city is home to several places
sacred to a number of different reli-
gions. The majority of the populace is
Buddhist, but there are also Roman
Catholics; the Chinese population is
either Taoist or follows a Chinese style
of Buddhism; and the third-largest
group is formed by the Caoists. There
are also small but active Hindu and
Muslim communities. This multiplic-
ity goes some way to explaining the
wealth of shrines where residents go
to pray, hope, lament, and worship.

Cao Đài Temple, Tay Ninh

The **Xa Loi Temple**, a plain structure
built in 1956, is a place of worship that
has played a crucial role in the city's
history. It contains a large gilded statue
and a precious relic of the Buddha,
but it attracts pilgrims principally
because resistance to the regime of
Ngo Dinh Diem was co-ordinated
from here. Most visitors come to
remember the monks who immo-
lated themselves in 1963 as a protest
against oppression and persecution
and who are now revered as martyrs.

The center of the Roman Catho-
lic Church in Vietnam is the **Cathedral
of Notre-Dame**, a neo-Romanesque

edifice constructed between 1877 and 1903. Regular Masses are held here in Vietnamese and several other languages, and even Protestant services are held occasionally. The cathedral is the most striking visual reminder of the colonial period and has the air of an architectural intruder. Its continuing active use is testament to the highly successful efforts of French missionaries in the 18th century.

The colorful Taoist **Quan Am Pagoda** in Cholon, the city's Chinese quarter, is filled with statues of gods and heroes. The temple roof repays special attention, as it is covered with representations of ships, dragons, and people. The pagoda is consecrated to the goddess of mercy and was paid for by immigrants from southern China. Forever shrouded in a thick fog of incense, it is a truly sacred place and regularly used by Taoists and Buddhists of Chinese descent. The little Turtle Pond in front of the temple is named after the many terrapins that have found a home here. The turtle is a symbol of long life and its domed shell is reminiscent of Meru, the mythical center of the world.

Built in 1820, **Mieu Thien Hau** is one of the most popular Taoist places of worship. The appearance of temple has been altered several times, most recently around 1990. The temple is sacred to Thien Hau, the consort of the sky god and the patron deity of sailors, and is most popular with women. Thien Hau in all her various incarnations is considered the goddess of all female concerns, and is the protector of unborn life and newborn babies.

People of Indian descent will discover a small piece of home in the Hindu **Mariamman Temple** in the heart of Saigon. Its yellow walls stand out among the rest of the city. Many street peddlars have settled in its immediate vicinity to supply the materials and paraphernalia used in worship. Rather unusually, the temple's *gopuram* (entrance tower) is on the roof. Although other Hindu deities are also worshiped here, the temple is consecrated to Mariamman, goddess of rain and of protection against disease. She is often associated with Parvati, the goddess of good fortune.

The **Cholon Jamial Mosque**, commissioned in 1932 by Tamils from south India, is a place of peace and tranquility and now serves as the city's central mosque. The color scheme is dominated by white and azure blue and its slim and elegant minarets rise up against a clear sky. Except during prayer time it is usually closed, and so opportunities to visit the peaceful inner courtyard are rare.

Tana Toraja, Sulawesi

The region of Tana Toraja lies in the mountains in the south of the Indonesian island of Sulawesi (Celebes). The Toraja are a heterogeneous ethnic group with their own language and customs. The majority of the people are notionally Christian (Gereja Toraja Church), but this is probably only because the Indonesian government long resisted recognizing traditional tribal beliefs, so that many people were obliged to profess established religions despite adhering to the old animist belief of Aluk To Dolo ("Way of the Ancestors").

Until the arrival of the Dutch in 1905, the Toraja were living almost completely cut off from the rest of the world, preserving rites and customs that were mostly focused on death. A particularly striking example of ancestor worship is to be found in their burial sites, which are a clear sign of the survival of the old beliefs;. A duality is maintained between this world and the next, as the Toraja believe that this life is transitory and only the next world is important. The Toraja bury their dead in rock graves

Rock tomb, Sulawesi

above their settlements and believe that the dead take their possessions with them into the afterlife. This goes some way to explaining their extravagant funerary rites, which have become so expensive that the cost of the obsequies can ruin those left behind.

More impressive still—and unique—are the figures known as *tau tau*, fashioned in great detail to represent the deceased. The wooden figures are placed on balconies to guard the caves containing the tombs. The dead are buried high up in the cliff as the Toraja believe that this will ease their entrance into heaven.

Istiqlal Mosque, Jakarta

Islam's influence in Indonesia grew steadily from the 13th century onward, eventually establishing itself across the length and breadth of this enormous country. Even the arrival of the Roman Catholic Spaniards and Portuguese in the 15th century and contact with the Protestant Dutch and British in the 16th century did little to change this. About 90 percent of the modern Indonesian population is Muslim,

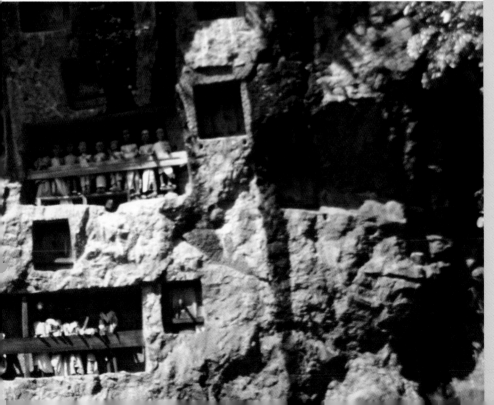

and two branches of the religion have developed here. The Agami Javi form one group, which integrates traditional elements of tribal belief with the basic principles and deities from Hinduism and Islamic doctrine. The other group is known as Agami Islam Santri, whose followers practice strict adherence to the teachings of the Koran and Sharia. *Adat* law, derived from a wide variety of religious sources, plays a crucial role in the community.

The most important Muslim building in Jakarta is the Istiqlal Mosque. This giant marble structure is the largest mosque in Southeast Asia and one of the largest in the world; the domed hall and extensive courtyard can accommodate up to 300,000 believers. The mosque was built in the 1960s and has since become the undisputed center of Islam for the entire island chain, with countless people from Jakarta swarming into the mosque every Friday. Non-believers are permitted to enter this impressive modern mosque.

Mount Merapi, Java

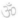

Indonesia has a greater concentration of active volcanoes than any other country on earth. Mount Merapi (Gunung Merapi), to the north of the sacred Borobudur site, is one of them. The white clouds pouring

Interior view, Istiqlal Mosque, Jakarta

out of the summit are visible for many miles and give the area a mysterious and unnerving feel. Local people regard these clouds, which can reach a temperature of 700°F (370°C), as much more than a sign of simple volcanic activity—the Javanese believe that the volcano is the royal seat of an invisible kingdom whose monarch protects the inhabitants of the surrounding area. For this reason, a priest climbs the "fire mountain" every year to appease the spirit of the volcano. The guardian of the mountain, usually an old priest, lives on the uplands and has the power to mediate between the people and the spirits.

Gunung Merapi is part of the Pacific Ring of Fire and also one of the sacred mountains of Java, whose people have retained many of their traditional beliefs.The blanket Islamization of Indonesia had only a superficial effect in many areas; most Muslims also adhere to Agami Javi, a syncretist branch of Islam that incorporates the worship of other gods while still retaining Muslim doctrine. For Indonesian followers of Hindu or Buddhist traditions, Merapi symbolizes the mythical Mount Meru, the most sacred of all mountains.

Candi Mendut

Mendut is a small village in central Java not far from the famous Borobudur site. The village contains a 9th-century Buddhist *candi* (temple) which was long buried and overgrown by the jungle before its rediscovery and excavation in the 19th century. It has since been restored as far as possible and has become a major pilgrimage site for the country's Buddhists.

The route of the pilgrimage begins in Mendut and follows a straight line to the southeast, visiting the temples at Pawon and Borobudur. The three temples were once closely associated, although the exact nature of the rituals practiced is still disputed. Mendut, the oldest of the three temples, faces west; it is about 80 feet (25 m) high, on a raised plinth, which is decorated with reliefs illustrating the history of Buddhist beliefs. The external walls are also decorated with reliefs, recounting episodes from the lives of various Bodhisattvas. The well-restored main chamber of the temple contains three finely carved statues: in the middle there is a seated Buddha Vairocana, who releases the body from physical karma; to the left there is Avalokiteśvara, who releases the individual from the karma of unjust speech; and to the right there is Vajrapani, who frees the soul from the karma of impure thoughts.

The Buddhist pilgrimage to the site takes place during the full moon in May or June. Many believers follow the path in order to acquire virtue and to free themselves from physical and mental constraints.

Candi Pawon

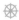

Candi Pawon (Pawon Temple), lying about halfway between Mendut and Borobudur, forms the middle stage of the pilgrims' path followed once a year by local Buddhists. Pawon is a small temple that displays stylistic similarities to Mendut and was likewise built in the 9th century, during the reign of King Sailendra or his dynastic descendants. The temple's interior is made of dark volcanic rock. Although there are no longer any statues, the reliefs on the exterior walls are enough to show that the structure was once consecrated to the god Kuvera, a generous deity responsible for good fortune and wealth. The reliefs also show the Kalpataru Tree, the mythical tree of dreams in Hindu and Buddhist tradition. Desires that are rooted in right thinking and a proper faith may come true.

The name of the temple is probably derived from the Javanese word for ritual burning, and so it would seem reasonable to assume that the funerary rites of important people were once held here, although no architectural evidence of such a cremation culture has been revealed.

Pilgrims have a short walk from this temple to the next goal of their journey, the giant site of Borobudur.

Borobudur

This sacred place was once a Hindu shrine, but it has since become a major pilgrimage site for Buddhists. The complex was built in the 8th and 9th centuries on the "Bhumisan Brabadura" (The Ineffable Mountain of Assembled Virtues).

The complex is laid out as a pilgrimage route and represents a giant mandala that can be walked around. There are three levels for pilgrims to climb, each representing a level of the world: the world of the senses and needs, the world of physical forms, and the spiritual world. These circular platforms are set on top of six rectangular platforms. On the uppermost platform 72 stupas are arranged around a central single dome, which represents the unity of the world and the realm of final enlightenment. In each of the stupas sits a Buddha. More than 2,500 reliefs have been carved in the facades of the lower platforms, telling the story of the Buddha's birth, life, death, enlightenment, and release from the cycle of rebirth, and instructing pilgrims in the workings of cause and effect. The reliefs are to be read from right to left, so that pilgrims gradually ascend in a clockwise direction. Once the top platform has been reached and all the panels read, pilgrims will have walked past more than 500 Buddhas and thus collected immeasurable virtue. Pilgrims approach the Divine by circling it, in a procession that takes place during the full moon in the astrological sign of Taurus—a day that is also a public holiday, even though most of the Javanese population is Muslim.

Borobudur Temple site, Java

Pura Besakih, Bali

Pura Besakih is the largest and most sacred Hindu temple on the island of Bali. It is situated near the city of Klungkung at an altitude of 3,300 feet (1,000 m) on the southwest face of the sacred mountain of Agung, an active volcano that is part of the Pacific Ring of Fire. The temple is also known as the "Mother Temple."

The site was used in animist worship in pre-Hindu times before various rajas, princes, and their families undertook the construction of the giant temple complex, which includes more than 200 different buildings and stretches for more than 2 miles (3 km). The rajas still visit the temple annually, to pray on the night of a full moon and to make sacrifices intended to assure the security, health, and prosperity of the dynasty and the people. Local village communities have followed their rulers' lead and erected temple buildings in the area. They come here to worship their ancestors and petition them for help and blessings.

The various temple courtyards are connected by flights of steps forming a single complex that covers several levels. The most sacred part of the site is the Pura Panataran Agung Besakih, sacred to the god Sanghyang Widhi Wasa, who represents the Hindu *trimurti* of Brahma, Vishnu, and Shiva. Next in religious importance in the temple hierarchy are Pura Kiduling Kreteg, a Brahma

shrine, and Pura Batu Madeg, sacred to Vishnu. This temple combines Hindu beliefs with elements of traditional religion, in particular ancestor worship.

From the high temple terraces there is a good view of the volcano that locals believe is inhabited by spirits who can be appeased through sacrifice. The great temple festival of Bhatara Turun Kabeh (the Assembly of the Gods) is celebrated once a year in April, but the Eka Dasa Rudra, the "Festival of Eleven Strengths," is part of a cycle of worship that is longer than a human lifespan—sacred rituals intended to purify the entire universe are conducted at the temple once every 100 years. During the most recent Eka Dasa Rudra, held in 1963, the volcano erupted at the beginning of the celebration, but the lava streams divided and spared the temple complex. The Balinese chose to interpret this as an unmistakable sign that the spirits and gods were pleased, at least for the next 100 years.

Pura Luhur Uluwatu, Bali

The southwestern tip of Bali is dominated by steep cliffs towering 330 feet (100 m) above the Indian Ocean, waves crashing against their base with great force. The spray reaches almost to the top of the cliffs and the site of

Pura Besakih, Bali

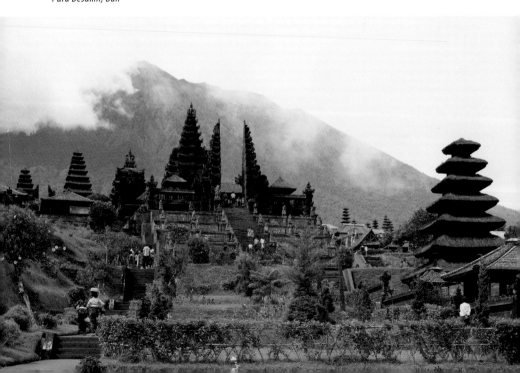

the Uluwatu Temple, whose full name, Pura Luhur Uluwatu, means "the Divine Temple at the Head of the Rock."

The shrine is constructed from white coral and is sacred to the sea spirits. Mindful of the ocean's dangerous power, humans make sacrifices to these spirits to receive protection from the forces of evil that live in the sea. Devi Danu, the god of the sea and of rivers, is also worshiped here—as in many other places in Indonesia, the temple combines Hindu tradition with local animist beliefs. At one time only the king and the clergy were allowed to enter the temple, but it is now open to all believers. The grounds contain a Padmasana shrine in the form of a chair consecrated to the Sanghyang Widhi Wasa, the *trimurti* of Brahma, Vishnu, and Shiva, the greatest Hindu deities.

A ritual is held every evening at dusk. Although its form is not that old, it has its origins in the oldest of Hindu traditions, the Kecak dance. Stripped to the waist and with black and white checked sarongs wrapped about their hips, men assemble in a group of about 100, raising their arms to heaven and beginning to sway, slowly at first and then ever faster. The dancers are accompanied by a choir, again exclusively

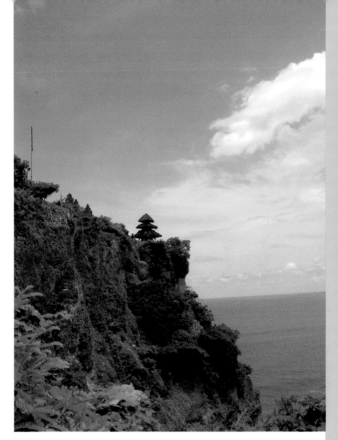

Pura Luhur Uluwatu, Bali

male, making throaty sounds that sound like the cries of animals. As the chant "kechak, kechak" grows louder and swells to a wild staccato, the dancers fall into a trance in which they can contact the divine powers and their ancestors. The precise movements and figures of the dance recount an episode from the Ramayana epic in which Princess Sita is abducted by King Rahwana, the personification of evil, before finally being freed by Rama, who enlists the aid of a mighty army of monkeys.

AFRICA

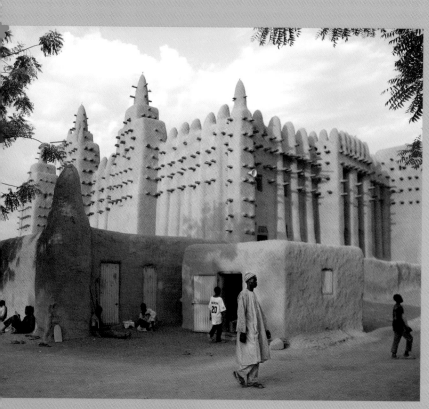

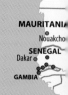

MAURITANIA
Nouakcho
SENEGAL
Dakar
GAMBIA

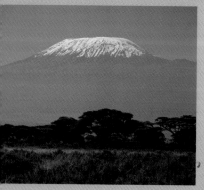

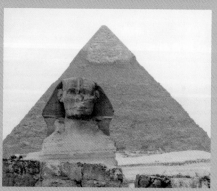

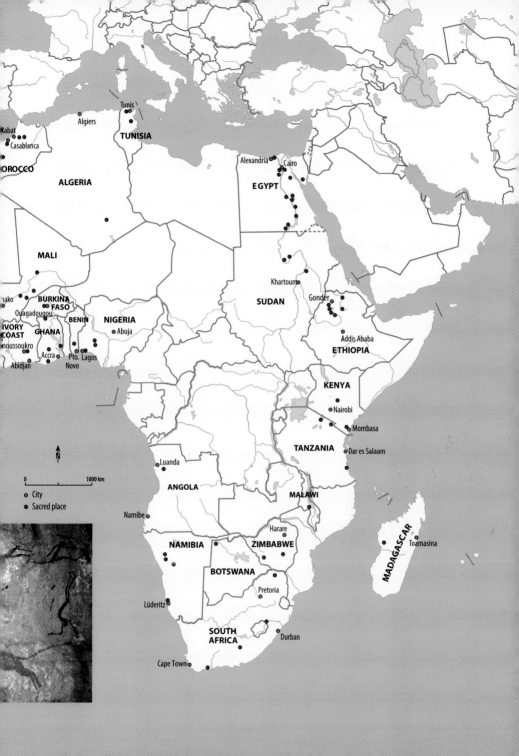

Rabat
Casablanca
MOROCCO

Algiers

Tunis

TUNISIA

ALGERIA

Alexandria

Cairo

EGYPT

MALI

Khartoum

SUDAN

Gonder

Bamako

BURKINA
FASO

Ouagadougou

BENIN

NIGERIA

GHANA
IVORY
COAST
Yamoussoukro

Abuja

Accra

Abidjan

Pto.
Novo

Lagos

Addis Ababa

ETHIOPIA

KENYA

Nairobi

Mombasa

Dar es Salaam

TANZANIA

Luanda

ANGOLA

MALAWI

N

0 1000 km

○ City
● Sacred place

Namibe

Harare

NAMIBIA

ZIMBABWE

BOTSWANA

Pretoria

MADAGASCAR

Toamasina

Lüderitz

SOUTH
AFRICA

Durban

Cape Town

Moulay Idriss

The white and sand-colored houses of this small, picturesque town nestle on a hill rising up from the plain near the ancient town of Volubilis. For Muslims, Moulay Idriss is the holiest town in Morocco. Its name is derived from Idris I, founder of the Idrisids, Morocco's first Arab dynasty. Idris arrived in the Maghreb in 786 and by 789 had been accepted as the region's political and spiritual leader. He died three years later, in 792, after being poisoned by an envoy from the Abbasid caliph Harun al-Rashid. He was buried near Volubilis and his tomb soon became one of the country's most important places of pilgrimage. His mausoleum, built in the 17th century, is still visited by pilgrims today. Topped with a pyramidal roof of green glass, it is situated at the heart of the enormous complex. A mosque, several courtyards, and a number of madrasas (Koranic schools) surround Idris's tomb.

Idris was greatly revered as a marabout and remains so to this day. In North Africa, a marabout is a devout Muslim who combines religious discipline with the fulfillment of military duties. Idris was regarded and respected as such a figure during his lifetime, but after his death this admiration was to grow into reverence. Vast numbers of

View over Moulay Idriss

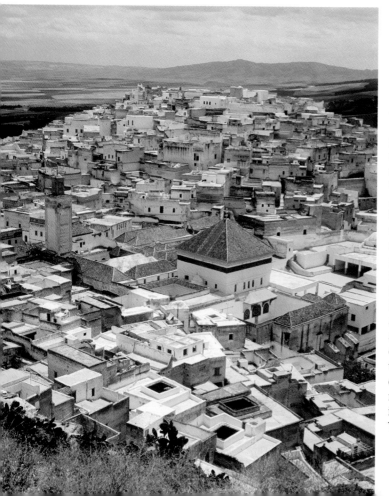

pilgrims make the journey to his tomb on no fewer than seven separate occasions, which is said to equal a hajj to Mecca. The town was closed to people of other faiths until 1917, and even today the holy district (*horm*) remains out of bounds to non-Muslims, who are not permitted to stay overnight in the town.

The atmosphere in Moulay Idriss is one of intense devotion, particularly at the end of August when the great annual pilgrimage festival of Moussem is celebrated. Thousands of pilgrims gather in Moulay Idriss at this time of year, pitching their tents outside the gates at the bottom of the town to watch the equestrian games dedicated to the revered Idris.

The Qarawiyyin Mosque, Fez

Founded in 859 by Fatima al-Fihri, an extremely devout woman of great beauty from Kairouan, the Qarawiyyin Mosque and its adjacent madrasa were extended by the Almoravids in the 12th century to form one of the country's largest mosque complexes. The university is one of the most renowned in the Maghreb and is considered the oldest seat of Islamic learning; teaching has been carried out here continuously since it was first established. The mosque's rectangular prayer hall has 21 aisles running perpendicular to the qibla wall. The central aisle is somewhat higher and wider, and is crowned by a variety of domes. The room's simplicity and brightness give it a real sense of spaciousness, drawing the eye toward the mihrab and making it the focal point. The interior is adorned with magnificent stalactite cupolas, which lend it a certain festive grandeur.

The oldest of Morocco's four imperial cities, Fez has been enlarged and enhanced consistently throughout its history. It is the undisputed center of Islamic life and scholarship in Morocco. The mosque and the university lie in the heart of the medina, the Old Town, with its souks, the old tanners' quarters, and countless other mosques, their minarets barely visible against the city skyline. Fez works its magic from the early gray light of dawn to that moment at dusk when the sun has just gone down, and this magical atmosphere is at its most potent when the muezzin makes the call to prayer, filling the air with a profoundly spiritual atmosphere.

The Hassan II Mosque, Casablanca

Casablanca became world-famous through the eponymous film starring Humphrey Bogart and Ingrid Bergman, a gripping tale of love and friendship set during World War II. At that time, Casablanca was a much sought-after haven for those on the run, full of the promise of a life of freedom. People from all over Europe met at Rick's Café, harboring hopes for a better future. The legendary café can still be visited today,

despite the fact that the movie was filmed in Hollywood rather than Casablanca. Directly opposite, there stands the second largest mosque in the world, built between 1987 and 1993 in honor of King Hassan II. The Hassan II Mosque can only be described in superlatives. Towering over the shore of the Atlantic, taken with its outbuildings it rivals in size an entire district of the city. Along with its place of worship, the mosque complex also includes a madrasa, hammams, a comprehensive library, and assembly rooms for the faithful. There is enough space for 25,000 people to pray in this massive mosque, and an additional prayer platform can hold a further 80,000 believers.

The whole area is paved with marble that gleams and sparkles in the bright sunshine. The golden orbs at the top of the tower are 690 feet (210 m) above the ground, making it the tallest minaret in the world. The sides are elaborately embellished with Arabic ornamentation and there is a total of 25,000 columns and 124 fountains. The walls are covered with glazed tiles, and the roof of the prayer hall can be opened automatically to enable the faithful to commune "directly" with God. During prayer times, an enormous laser beam shines out almost 5 miles (3 km) over the sea in the direction of Mecca. Inside the mosque there are two massive, marble-covered basins, with channels running through the middle of the prayer room and into another three-cornered basin. A glass panel in the floor offers a view of the seabed below. The woodcarvings throughout the mosque area are extremely delicate and calligraphy

adorns the walls and part of the mosque floor. Daylight streams in through the large glass side walls, gently illuminating the enormous room.

Construction of the Hassan II Mosque did not proceed without controversy, as the king looked to his citizens to contribute to the enormous building costs. Donations were not voluntary, however, and were levied like an additional tax. Anyone who refused to pay was faced with potential penalties or even a prison sentence. After the building was opened, at night the project's opponents repeatedly painted over the official lettering on the mosque with the words "Masjid ash-Shab" ("People's Mosque"), and over time it has come to live up to this name. Hundreds and thousands of people visit the impressive building every year, both to marvel at it and to pray within it.

The Koutoubia Mosque, Marrakech

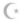

The sight of the evening sunshine illuminating the buildings of Marrakech's Old Town is spectacular. As the city begins to glow against the imposing backdrop of the snow-covered High Atlas Mountains, it becomes mesmerizingly beautiful. The old walls surrounding this legendary city were made from a mixture of clay and chalk, and have survived from the Middle Ages relatively unscathed. Marrakech is at its most vibrant in the Place Jemaael-Fna,

where people come from near and far —both foreign travelers and Morrocans from different tribes—and have long gathered to exchange tales and share traditions. The cultural influences of the desert, the Maghreb, and sub-Saharan Africa all converge here. Countless vendors crowd the square during the day, and after dark it becomes a huge theater filled with street singers, fortune-tellers, snake charmers, and artists. Not for nothing is Marrakech known as the "Pearl of the South."

Founded in 1070, Marrakech is now a city of millions with an underworld to match, but the Old Town has lost none of its charm. It is dominated by the Koutoubia Mosque, the "Booksellers' Mosque," a name it owes to the numerous shops selling manuscripts that used to surround it. Situated in the middle of a small palm garden in the southeast of the Old Town, behind the inner courtyard there is a 17-aisled prayer hall with a *minbar* (pulpit) decorated with ivory, sandalwood, and ebony. Non-Muslims can only

The Hassan II Mosque, Casablanca

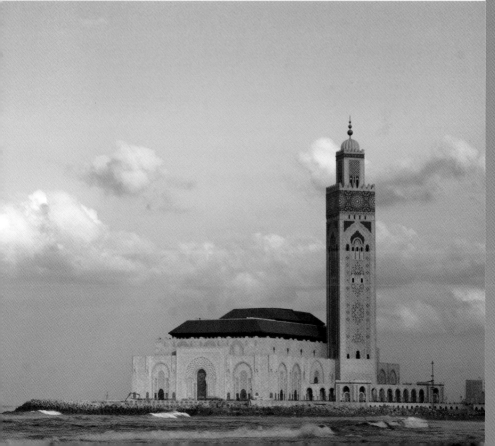

catch a glimpse of the pulpit through the gate, but the magnificent minaret is clearly visible from outside. Each of the four façades features a different kind of decoration; inscriptions, intertwined floral and geometrical patterns, majolica, and painted stucco adorn the striking six-storey, square tower, which rises to a height of 230 feet (70 m). Legend has it that the Sufi saint Sidi Abu al-Abbas as-Sabti (1130–1205), an Islamic scholar and protector of the poor who is still revered today, would ascend the mosque's minaret every evening, and only descend when all the beggars and poor people had been fed and found a bed for the night.

The Koutoubia Mosque, Marrakech

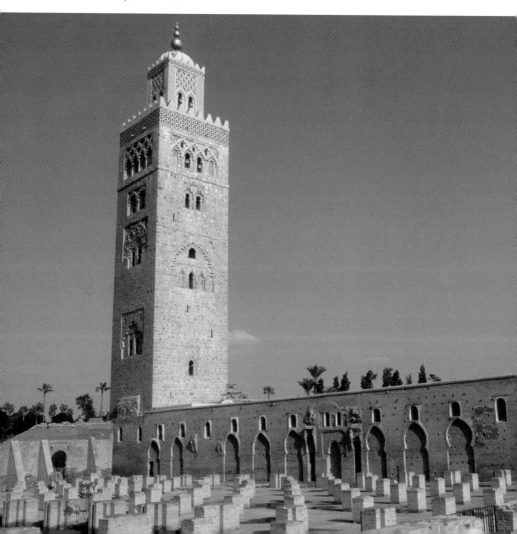

TUNISIA

Tunis

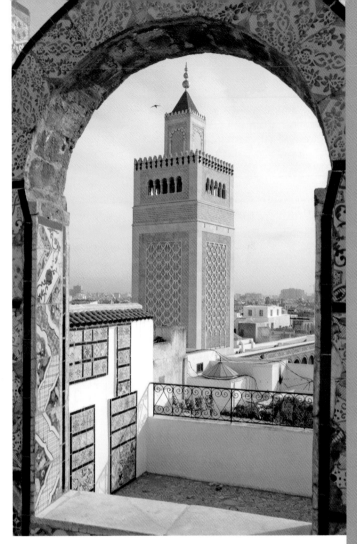

Nowhere in Tunisia is as densely populated as the capital city and its satellite towns. More than a quarter of the country's population lives here. To visitors, Tunis can seem almost European—the colonial French architecture of many of its buildings is reminiscent of the cities of the south of France. However, the Arabic town begins behind the Porte de France. Amid the colorful hustle and bustle the **Zaitouna Mosque** (Olive Tree Mosque) is the unchallenged focal point of old Tunis. An earlier, 9th-century building once existed on this spot, but the present mosque was built in the 13th century in a style that made use of local building traditions—the 15-aisled prayer hall is very austere and equipped with simple columns. Only the mihrab is lavishly decorated; its pronounced arches bear some resemblance to those found in

View of the minaret of the Zaitouna Mosque, Tunis

Andalusia or the Maghreb. During the Hafsid Dynasty (between the 13th and 16th centuries) the mosque was expanded into a university, and for a considerable time it vied with both Fez and Kairouan as one of the centers of

AFRICA

Islamic scholarship in North Africa. The University of Tunis was founded only in 1960, after which the madrasa mosque gradually waned in importance as a seat of learning. Nevertheless, it remains the religious center of the country. The souk, the Arabic market where precious goods and spices have been sold for centuries, is located immediately adjacent to the mosque. The entrance to the market is a great tiled archway, framing a view of the square minaret and its faience cladding. The mosque and the market seem to merge into one another—busy daily life and profound devotion existing quite naturally alongside each other.

The **Sidi-Mahrez Mosque** is the only mosque in Tunisia to be built in the Turkish Ottoman style. The great domed building with its roughly square floor plan dates from between 1675 and 1692, and the mosque's two-storey structure is of particular note. The enormous middle dome, surrounded by its four sub-domes, gleams white against the sky. There are other smaller domes at the corners of the roof. Four mighty pillars dominate the interior of the prayer hall.

The Great Mosque of Kairouan

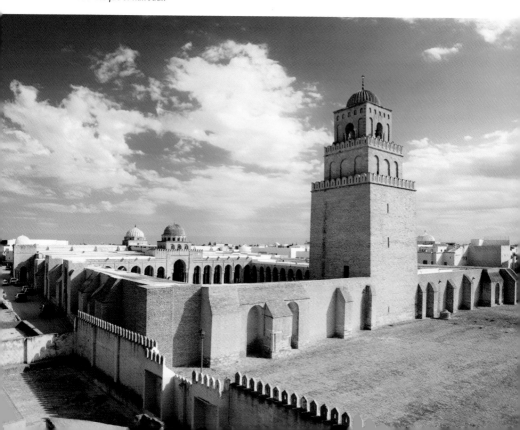

The Mosque bears the name of Sidi Mahrez as-Sadiki, a 10th-century ascetic and Koran scholar who, as his epithet suggests (*sadik* means "just"), was seen as a particularly righteous man and a paragon of virtue. He is honored as the patron saint of Tunis, and the mosque and his nearby tomb have consequently become a popular place of pilgrimage.

Kairouan

For many Muslims, Kairouan is the fourth holiest city of Islam after Mecca, Medina, and Jerusalem. As such, it has long been a place of pilgrimage, for Muslims from both North Africa and further afield. There is a saying in Kairouan that seven pilgrimages here are the equivalent of one to Mecca. However, this is simply a local belief, and it is not accepted religious doctrine. The city grew up out of one of Sidi Uqba ibn Nafi's army camps in the 7th century.

The **Great Mosque** is as old as the city itself, but its present form dates mainly from the 9th century. This ancient building lies in the midst of the white houses of the Old Town, near the city walls. The minaret standing on the northeastern side of the courtyard is composed of three sections, and is reminiscent of an ancient lighthouse or fortified tower. It has come to serve as a model for the minarets of many North African mosques. The great prayer hall, an impressive columned room with 17 long aisles, is reached across a large, simple forecourt with evenly spaced arcades and elegant columns. Totaling 414 in number, most of the columns have been salvaged from ancient buildings. The mihrab is very elaborate, with two red marble pillars standing in front of the semi-circular aperture, and the interior is covered in latticed marble slabs. Lying at the heart of the bustling city, the Great Mosque is a superb sacred place where modernity and tradition mix.

By far the oldest of the mosques is the **Ansar Mosque**, which according to legend was founded in 667 by one of the Prophet's companions, though there is no evidence that this story is based in historical fact. What is certain, however, is that the complex, restored in the mid-17th century, enjoys great favor among pilgrims, since according to popular Islamic belief, a visit to this mosque is particularly beneficial for the believer. The many handprints left on the outer wall demonstrate just how many pilgrims are still keen to visit it today.

Sidi Sahab, another companion of Muhammad, has become the local patron saint. Thanks to the story that he carried with him three hairs from the beard of the Prophet, his memorial is known as the "**Barber's Mosque**." It lies just outside the city walls. The tomb of the Prophet's companion is reached across a large forecourt and along a prettily tiled corridor. The dome and the additional *zawiya* (memorial) buildings date from the 17th century. Kairouan is always busy with countless pilgrims who come here throughout the year to fulfill their religious duty.

Sahara

This sacred place is so vast that it can be entered at many points. The desert is a place where even the invisible becomes visible—dunes stretch like endless waves into the distance, as far as the eye can see. It is a landscape that can only really be conquered by sight. The Tuareg call the desert "Ténéré," meaning nothingness—an absence that can be threatening and cruel, but one that also creates a space in which deep emotions can be stirred. It would be unwise to venture into such a place without a knowledgeable guide. The Bedouins, who spend their lives in this inhospitable terrain, are not only the rulers of the desert but also storytellers, philosophers, and masters of survival. They love the desert, and most of them would not want to live anywhere else.

The greatness of God is revealed to each of us in the desert. It is a place of total abstraction. In the shimmering heat of midday there are no discernible contours; everything flows into what appears to be an endless unity. The afterglow of the light at the end of the day creates wholly unique colors: shades of orange, beige, ocher, copper, bronze, and violet. In the desert you can learn to hear the inaudible, often heralded by a murmuring sound, which comes not from outside but from within. Spend some time alone in

The Assekrem Mountains in the Sahara

the desert and you will be able to hear your inner voice, but you must learn to determine whether this is the voice of conscience or of wisdom. The desert is devoid of stimuli, accentuating the senses in an unprecedented manner. According to a Bedouin proverb, "the desert's value lies in a few simple things." Yet these few simple things are extremes: extreme heat and dust all day, a temperature that often plummets by more than 54°F (30°C) at night, unearthly light, and the deep black of night carpeted with stars that shine like almost nowhere else on earth. The desert is utter oblivion.

On experiencing the desert you will want to return there. Perhaps to Assekrem, about 50 miles (80 km) north of Tamanrasset, in the south of Algeria, where the French mission- ary Foucauld founded a hermitage in 1911. Morning Mass is celebrated there every day by the few friars of the order, and all can take part, whether Christian, Jewish, or Muslim. At Assekrem, the gaze is inevitably drawn to the surrounding mountains tower- ing 9,850 feet (3,000 m) up from the sea of sand. Everyone sees what they want to see in the desert: the Bed- ouins see the simple things that they consider riches, others see a path toward the horizon, and yet others see nothing but sand, dust, and stones. But in looking into the endless space they can also look into their own heart—itself a truly sacred place.

Abu Mena

St Menas was one of Egypt's first Christian martyrs. Church teachings relate that he was an Egyptian soldier who followed the Christian faith and went to Phrygia to live as a hermit. According to one legend, he was tortured and martyred in 295 or 296 and his remains were brought to Egypt and buried here. The town of Abu Mena grew up around his tomb at Mariut, in the desert near Alexandria, in the 5th and 6th centuries, as increasing numbers of believers flocked to the site on pilgrimages. Another legend tells of his martyrdom in the 9th century,

A Coptic basilica in the ruined town of Abu Mena

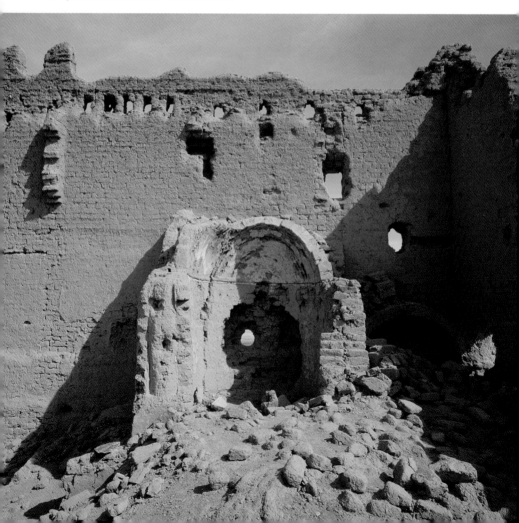

but whatever the truth behind the legends, St Menas is greatly venerated, particularly by Coptic Christians.

Abu Mena was the most important and popular place of pilgrimage in Egypt until well into the 10th century. Accounts from that time report an increasing number of miracles and even speak of people being raised from the dead in Abu Mena, as a result of which great throngs of people sought out the site. Abu Mena was seen as a place of protection and healing. In about 619 the Persians destroyed the town. Around 50 years later it was handed over to the Copts, who built a new pilgrimage town on the ruins of the old one. After Abu Mena was abandoned in the 10th or 11th century, the town sank back into the desert sands and was only uncovered when excavations began in 1905. The excavation project continues to this day. Pilgrimages undertaken by Egyptian Christians since the work began have ensured the survival of a tradition that long lay hidden in the sand, without ever quite falling into oblivion.

The Pyramids of Giza and the Great Sphinx

☥

This extraordinary pyramid complex is famous throughout the world. King Khufu chose a 130-foot (40-m) high plateau on the edge of the Libyan Desert as the site for a series of pyramids. The pyramids of Khufu, Khafre,

and Menkaure have been beacons of the Pharaonic civilization since the 4th Dynasty (2575–2130 BC). A great necropolis arose on this site over 20 years, justifiably taking its place in the ranks of the Ancient Wonders of the World. Today the area is barely 7.5 miles (12 km) from Cairo's inner city, and the ancient pyramids rise majestically above the maze of houses and the thunder of the traffic.

The formidable structures were built with remarkable precision. Not one of the individual blocks of the **Pyramid of Khufu** (the Great Pyramid) deviates more than 4 inches (11 cm) from the average width or 4/5 inch (2.1 cm) from the average height across a square plan with a side length of 755 feet (230 m). The sheer majesty of the pyramid is enhanced further by the evenness of these hand-hewn blocks of stone. However, even more exceptional than the size and precision involved is the overall impression that the Pyramids of Giza site makes on everyone who visits it, as the pyramids tower skyward in the blazing sunshine.

While Khufu clad his pyramid exclusively in fine limestone that gleams and shimmers a brilliant white-gold color in the sunlight, the lowest tiers of the **Pyramid of Khafre** are made of red granite. This mixture of materials is taken a step further at the **Pyramid of Menkaure**, where the bottom 16 tiers are covered in granite. This is no coincidence: the color red stood for Lower Egypt, and white for Upper Egypt. The pyramids are visible symbols of a mortuary cult that is not fully understood today, despite intensive and extensive

study. We do know, however, that the court hierarchy that operated in life continued to do so beyond the grave. Hence, high-ranking officials were entombed very close to the pharaohs in the mastaba tombs, arranged in rows stretching out on the western and eastern sides of the complex. To the southeast of the Valley Temple of Menkaure there lies a modern cemetery—a sign that a mortuary cult remains important even in modern-day Egypt.

The pyramids have not just been a magnet for archeologists and those interested in art and culture. Over the centuries, adventurers and grave robbers have imagined untold treasures within their chambers.

Equally famous and arguably even more mysterious is the **Great Sphinx**, which was carved out of rock strata. The colossal sculpture displays the classic combination of a reclining lion's body with the head of a Pharaoh.

The Great Sphinx and the Pyramid of Khafre, Cairo

In the New Kingdom the Sphinx was considered to be a manifestation of the sun god. Over the millennia the Sphinx has been eroded by the weather, suffering in the desert wind, and has been damaged by the rising water table. It has also been subject to malicious attacks by people.

A little is known about ancient Egyptian religion, but much is still shrouded in uncertainty and conjecture. We know about the worship of the sun, personified by the Pharaoh, and about sacred cats and ibises; all this is documented and studied in the visual arts of Ancient Egypt. However, although much has been learnt about the period, still more remains an enigma and it is precisely this enigma that makes this sacred place so alluring. The technical mastery of the architects is formidable, the sheer size and splendor of the monuments are awe-inspiring. The cultural heritage site of the tomb and temple complex at Giza ranks indisputably among the very best in the world.

What makes this a truly sacred place, however, is the sense of mystery you feel when visiting the site, the sense of the passing of time and of eternity you experience without being able to put it into words. Everything you see here, despite its location near the heart of the modern megalopolis of Cairo, has been in existence for more than 4,500 years. Looking into the eyes of the Sphinx as it gazes hauntingly and abstractedly into the distance, you will sense that human life is but a fleeting moment within the vast span of world history.

Coptic Cairo

According to legend, Mark the Evangelist was spreading the message of Jesus Christ in Egypt as early as the year 40. Many Egyptians adopted the Christian faith later, during the reign of Constantine the Great (4th century), and a great number of churches were built in the Coptic quarter of Cairo, one of the oldest areas of the city. A Pharaonic settlement ("Babylon-in-Egypt") is said to have stood on this site before the Roman conquest. Most of the local churches have associations with the Infant Jesus. On entering the Coptic quarter through the Roman gate to the south, you come immediately upon **El Muallaqa**, the "Hanging Church," a Marian church which dates from the 5th or 6th century and stands on the site of the gate to the former Pharaonic settlement. For a long time the church was the seat of the Coptic patriarchs and a center for the study of theology. The interior decoration, all cedar wood and the finest ivory, lends it an air of regal grandeur. As a repository for a number of sacred relics, including those of St Theodosius and St Damian, it has long been a place of pilgrimage for Egyptian Christians.

The oldest Christian church in Cairo is **St Sergius**, dating from the early 4th century. This three-aisled church with its slightly raised transept is a typical example of an early Christian basilica. According to legend, the Holy Family stopped on this exact spot during their flight from Herod. The

little crypt, said to be right over the place where Mary, Joseph, and Jesus found shelter, is also an important place of pilgrimage for Coptic Christians. A particularly ostentatious and well-attended Mass is held here every year on June 1, which Coptic Christians celebrate as the day marking the beginning of the Holy Family's flight into Egypt.

The "Hanging Church" in Coptic Cairo

Close by, in the Maadi district, there lies the small **Church of St Mary**, which enjoys great local devotion due to the legend that the Holy Family crossed the Nile here.

Coptic Christians also make pilgrimages to the **Church of the Holy Family** in nearby Matariya. Jesus is said to have sought shade under the mulberry tree beside the church. The story goes that the Infant found a small spring on this spot, and that He blessed it and drank from it. Mary used the water to bathe her child. An incense tree is supposed to have sprung up later from the place where the water poured out of the ground. The tree itself and the church, which is decorated with folksy pictures from the life of the child Jesus, are extremely popular among Cairo's Christians, and it has now also become a place of pilgrimage for Christians from all over the world.

Islamic Cairo

Cairo has been the Egyptian capital and the center of Sunni Islam for over 1,000 years. The city is defined by its powerful contrasts: from the treasures of Ancient Egypt to the modern day, from fabulously wealthy residents to people making their living and their home from garbage, from the (admittedly few) secluded squares and parks to the chaos of the heat, dust, and traffic, and from the air-conditioned subway to the donkey carts. All this points to the double-edged nature of this vast, modern city—on the one hand full of charm, on the other plagued by problems. Amr ibn al-As founded a town in Fustat (present-day Old Cairo) in 641, but it fell victim to fire in 750. It was founded anew in 969, when the Fatimid Egyptians conquered Egypt and established a residence there that they called al-Qahira ("the victorious"). The **al-Azhar Mosque**, with its school and university buildings, was founded only a year later. Its name means "the flourishing

The inner courtyard of the al-Azhar Mosque, Cairo

one," and it has proved apt. Today it is the most important seat of Islamic scholarship in the world. Until the 1960s theology, Arabic, and Sharia Law alone were taught at this mosque; only later were modern courses incorporated into the curriculum. The Fatimid building, modeled on a courtyard mosque, has undergone various extensions over the centuries. You enter the large main courtyard through the "Barber's Gate," the main portal, which is surrounded by an arcade with elegant columns and ogival arches adjoining the hypostyle halls. The students' halls and the library are closed to the public. On the eastern side, there is the sprawling prayer hall (4,300 square feet/4,000 sq m), which originally had five aisles. The aisles run parallel to the qibla wall. Four aisles were added in the 18th century, along with an additional prayer niche. Most of the columns in the hall were salvaged from other ancient buildings and lend the prayer hall an air of dignity. The hypostyle hall is not only a place for Muslims to meet and pray—these days students occasionally have classes there too.

The **Ibn-Tulun Mosque**, dating from the 9th century, is even older than the al-Azhar and is one of the most beautiful of the city's countless mosques. It is situated on a small hill. A local legend has it that this was where Noah's Ark landed (as opposed to Mount Ararat). The minaret in the northeastern forecourt is stunning, and many later minarets were based on the spiral design of its lower section. It is crowned with an exquisite dome. The simple yet monumental dome of the covered fountain lies at the center of the massive inner courtyard,

whose sides measure 300 feet (92 m). An arcade with ogival arches runs around the forecourt. The mihrab (prayer niche) is artfully clad in marble, and the great prayer hall has five aisles. The mosque is an oasis of calm and serenity in the midst of the noisy city.

The Cairo Citadel complex of buildings, dating from the 12th or 13th century, is now home to the imposing and somewhat unusual **Mohammed Ali Mosque**, constructed in the Ottoman style between 1830 and 1857. The imperious central dome is the most striking feature of the building, yet several smaller domes and the slender minaret temper this effect with their delicateness. The walls are covered in alabaster, giving rise to the building's popular name of "Alabaster Mosque." Finely polished alabaster tiles have been laid around the window openings, allowing a soft and mysterious light to shimmer within the mosque. The purification fountain in the forecourt is richly decorated with patterns and flower motifs, and grooved columns support its domed roof. The somewhat incongruous clock tower that can be seen from the forecourt was presented by the French king Louis Philippe to Mohammed Ali in 1846 as a gift in return for the famous Luxor Obelisk that now graces the Place de la Concorde in Paris. The clock has never worked, however— perhaps a symptom of the fact that time is measured by different standards in Egypt. The mosque's great prayer hall with its 170-feet-high (52-m) dome is bathed in scattered light. The dome is richly decorated and the hanging globe lamps make the play of light within the mosque even more mysterious.

The Red Pyramid, Dahshur

The City of the Dead, which has now merged with the sea of modern houses, is home to many impressive examples of Islamic architecture from various eras. Many people describe the **Burial Mosque of Qait Bey** as the most beautiful Islamic building in Cairo. This madrasa mosque consists of four high rooms arranged around an inner courtyard (a design known as the "four-*iwan* plan"). The magnificently decorated minaret towers above the inner portal, where the purification fountain is also to be found. Both the minaret and the central dome are decorated with delicate arabesques, evoking an air of timeless elegance, and the inlaid marble floors are sumptuous. The grand cenotaph of Qait Bey stands in front of the prayer niche, and the reliquary containing footprints of the Prophet Muhammad is popular with pilgrims.

Cairo is often dubbed the "city of a thousand minarets," and this is no exaggeration; at night a greenish light shimmers everywhere against the dark sky, proclaiming the city's sacred places.

The Pyramids of Dahshur

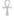

The brick pyramids of three rulers from the 12th Dynasty (1976–1793 BC) lie close to Saqqara, near the fertile region: the Black Pyramid of Amenemhat III

to the south, the Pyramid of Amen-emhat II in the center, and the Pyramid of Sesostris III to the north. All are imposing structures, albeit very weather-beaten. From here you can venture a little further into the desert to the markedly older pyramids from the time of the Old Kingdom at Dahshur, built by Snofru, the first king of the 4th Dynasty (2639–2504 BC). Standing majestic and utterly alone in the desert, surrounded by nothing but sand, wind, and sky, they look spectacular, a testament to eternity. Snofru relocated the royal necropolis to Dahshur in about 2590 BC and began building the pyramid known today as the Bent Pyramid.

Its strange shape is due to a change in the angle of inclination about halfway up. This was necessary because the subfloor was unable to bear the weight of the huge masses of stone. Unlike other pyramids, the **Bent Pyramid**, which was clad in slabs of fine limestone, has two entrances and two separate tomb chamber systems. Owing to the massive structural damage, the pyramid was not used as the king's tomb.

The **Red Pyramid** has a very different appearance, with a shallower angle of inclination from the ground, so that the structure (with an edge length of almost 720 feet/220 m) has a height of only 330 feet (100 m). This makes it

The Step Pyramid of Djoser, Saqqara

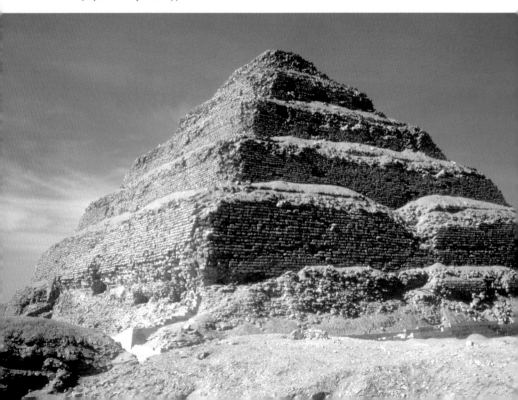

appear relatively flat. It is nevertheless remarkable how naturally this structure seems to rise out of the desert. It owes its name to the patina of the slabs that cover it, which glow red in the sun. The mortuary temple to the east of the pyramid is the only building in the surrounding cult complex to have been excavated. The valley temple and its causeway have not yet been found. Pay a visit to this pyramid and you are bound to fall under its spell.

The Step Pyramid of Djoser, Saqqara

⚲

The massive necropolis of King Djoser in Saqqara is the oldest known stone monument in the world. The whole complex of tombs resembles a royal palace and, along with the pyramid itself, includes an array of chapels, places of worship, and processional paths and courtyards. This royal tomb was built to last forever. The king acted as an intermediary between the human and divine worlds, and by the same token the Step Pyramid is not only a tomb but also a palace in the afterlife. The stepped design represents the social system in the Old Kingdom, with the king at the top and his royal household beneath him, followed by officials, public administrators, craftsmen, and finally the peasants. The pyramid's six levels suggest that it reflects a hierarchical system of society thought to be eternal.

The pyramid and all the other buildings in the palace beyond feature a kind of mock architecture. The buildings served no particular purpose, but their functions are implied and carefully defined. A curtain wall made of limestone blocks punctuated by 14 false doors surrounds the whole complex. Behind the one real entrance stretches a large, roofed atrium with columns designed and decorated to resemble bound bundles of reeds. Beyond this hall are two mock buildings, the South Palace and the North Palace, representing both the Kingdoms of Egypt, which had just been united at the time the complex was constructed. Chapels dominate the eastern and western sides of the ceremonial courtyard—these are also dummy buildings, forming a striking backdrop for the royal cult and the Sed festival celebrated here. Different stages of construction can be discerned in the pyramid—an older, three-stepped mastaba, and the final building with its six levels. Many of the chambers are richly decorated. The "blue chambers" beneath the pyramid and the South Tomb are particularly enchanting, their walls covered in brilliant turquoise-colored tiles. The only statue of Djoser to be found was the almost life-size figure in the North Chapel, the entrance to the Mortuary Temple. It shows a serious, aloof ruler with a dignity that looks almost divine. Today the statue is in the Egyptian Museum in Cairo, but even without its presence, something of a regal dignity that seems to embrace this world and the next is palpable in this sacred place.

The Temple of Ptah, Memphis

Much of the former splendor of this royal city is no longer to be seen. Memphis was founded back in prehistory and soon rose to be the most important city in unified Egypt, lying at the point where Upper and Lower Egypt once met, 12 miles (20 km) south of present-day Cairo, near the village of Mit Rahina. Along with a number of colossal statues, a massive alabaster sphinx, and the embalming place for the sacred Apis bulls, the ruins of the magnificent Temple of Ptah can also be seen here.

The enormous temple complex dates from the time of Ramesses II (c. 1250 BC/19th Dynasty). Conjuring up the atmosphere of the temple is no easy task, as only a little of it remains standing. Ptah, the principal deity of Memphis, was venerated as the creator god, embodying the human creativity that comes from thoughts and words. Together with Sekhmet, the lion-headed protector goddess, and the lotus flower god Nefertem, he was one of the sacred Memphis triad of deities. Ramesses II ordered the temple to be built in honor of Ptah and his own divinity. It once sprawled behind a mighty, 243-foot-wide (74-m) pylon. This was a profoundly sacred place for pharaohs in the Ramesside Period, and was in use up until the Ptolemaic Period. The importance of the temple complex is borne out by the immense curtain wall (2,070–1,575 feet/630–480 m) that surrounds it.

In many sacred places, the mind boggles at how mere humans could have built the structures that we see today. You will have to rely on your imagination when visiting the ruins of the Temple of Ptah, but perhaps it is precisely through our imagination that we can honor the god of expression and creativity.

St Catherine's Monastery, Sinai

The Byzantine Emperor Justinian I (527–65) founded this monastery in the 6th century. A small chapel dedicated to Our Lady previously occupied the site; according to legend, the chapel had been built on the orders of Helena, the mother of Emperor Constantine. The name of St Catherine's Monastery dates back to the Middle Ages, when the mortal remains of the eponymous early Christian martyr were reportedly discovered on the mountain. At an altitude of 5,150 feet (1,570 m), situated in a valley surrounded by steep cliffs at the foot of Mount Sinai, the monastery has a fortress-like appearance. This is the legendary place where Yahweh appeared to Moses in the burning bush.

The monastery served as a place of refuge for the monks who lived as hermits in caves on the mountain. Justinian himself placed the site under special protection. Muhammad is later said to have visited the monastery on many occasions, before following his

vocation as a prophet. He granted a writ of protection to the monks and their monastery that remains in force for Muslims today. Napoleon also promised the monastery protection at the time of the Napoleonic conquests. In all its long history, therefore, St Catherine's Monastery has never been attacked, destroyed, or dissolved.

Today the monastery is an autonomous archdiocese of the Greek Orthodox Church. On stepping through the only gate in the defensive outer walls, you will find yourself in a monastery courtyard crammed with buildings for the monks, who are once again here in numbers. It comes as a surprise to see a mosque, complete with minaret, on the site. This owes its existence to the threat of impending attack by the caliph Al-Hakim, who wanted to storm the monastery in spite of the writ of protection. The monks of the monastery built the mosque to ward off this attack, thus averting the danger.

The focal point of the monastery is its three-aisled basilica, with a nave of simple granite pillars. The side aisles are lined with chapels dedicated to the saints of the Orthodox Church. A richly painted and gilded iconostasis stands in front of the choir, while the choir itself contains the marble sarcophagus of St Catherine, dating from the 18th century. The mosaic in the apse is internationally famous as one of the most beautiful works of Byzantine art. Christ gently surveys the scene from a deep-blue mandorla, flanked by Elijah and Moses, with John the Evangelist, Peter, and James kneeling at his feet. A chain of medals containing portraits

St Catherine's Monastery, Mount Sinai

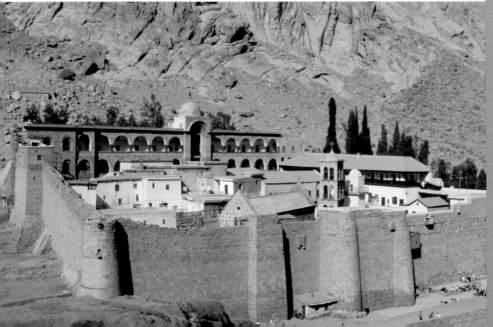

of 16 prophets and the 12 apostles surrounds the mandorla. A cross-shaped medal hovers over Jesus' head, and an image of David, Jesus' ancestor, rests at his feet. The most sacred part of the church, the Chapel of the Burning Bush, lies behind the choir. The walls are covered with bright tiles, and beneath an altar in the small apse a lamp burns continuously, marking the place where the burning bush is thought to have been. The monastery's great treasure is its vast and unique collection of icons, especially those from the early Byzantine period, which are priceless.

Mount Sinai

"And it came to pass on the third day in the morning that there were thunders and lightnings, and a thick cloud upon the mount, and the voice of the trumpet exceeding loud ... And Mount Sinai was altogether on a smoke ... and the whole mount quaked greatly ... and the LORD called Moses up to the top of the mount; and Moses went up ..." So the story goes in the Bible (Exodus 19:16–20). What happened next forms an important part of the foundations of the Judeo-Christian world, and has relevance for every world philosophy. According to tradition, Moses received the Ten Commandments here, making Mount Sinai (Djabal Musa) one of the most sacred sites for Jews and Christians. Heaven and earth seem to meet on the summit. Muslims also consider

the mountain a sacred place; it is mentioned in the Koran (Sura 95).

There is a continuous flow of pilgrims to the summit. Every day hundreds of people set off from St Catherine's Monastery for the ascent, which takes roughly three hours. Some ride the first stretch on the back of a camel, but more trudge up the steep path on foot. The stream of pilgrims generally begins during the night, as people come to watch the sun rise. The final stage of the route is too narrow and steep for camels, and the remaining leg is a scramble up an 800-step staircase. However, once you reach the top all your exertions are rewarded with the sight of a sublime sunrise. The rocks appear to smolder as the sun emerges from behind the jagged peaks across the Red Sea to the east. The dark gray dawn is dispelled by radiant red-orange and the rocks become cream-colored; when the sun is high in the sky they are blindingly bright. On the summit plateau stands the little Chapel of the Trinity and a small mosque, both normally shut. Yet even without holy buildings this sacred place evokes unforgettable feelings in all those who visit it. Moses' Mount Sinai is truly a place where heaven and earth meet.

Mount Catherine, Sinai

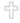

"Oh, how terribly difficult and rough is the way. The mountain towers steeply above like an attic staircase. On the way down I stumbled dangerously on

a piece of rock. If the Lord and Saint Catherine had not protected me, I would undoubtedly have perished." So wrote the pilgrim monk Felix Fabri in the late Middle Ages of his visit to Mount Catherine (Gebel Katherina), and little has changed since then. The inaccessible terrain of the Sinai Peninsula means you experience the desert and mountains in the raw. Solitude and silence are often your only companions, and the clear air, the mesmerizing, starry sky, and the sweeping, unspoiled natural surroundings enable modern pilgrims to combine adventure and devotion here. This is the place to immerse body,

The path up to Mount Sinai

mind, and soul in the world of early Judeo-Christian tradition. You can follow the tracks of early monasticism and learn about the spiritual energy that exists in Sinai, or discover how to brave heat and cold like the Bedouins who have lived here for millennia.

At 8,681 feet (2,646 m), Mount Catherine is the highest peak on the Sinai Peninsula. According to legend, the body of St Catherine of Alexandria was brought to the summit by angels who took her into their protection after her martyrdom. Catherine was a beautiful, cultured, and eloquent young woman whose stirring rhetoric managed to convert even philosophers and teachers to the Christian faith. This gift aroused the wrath of the heathen emperor, who condemned her to death on the break- ing wheel, but angels descended from heaven and destroyed the deadly device. Upon seeing this, the emperor's wife was converted to Christianity and implored her husband to desist from his cruelty. This only made him more furious and he gave orders for his wife and Cath- erine to be beheaded; milk, not blood, flowed from their wounds. To prevent wicked hands from defiling the body, angels came and carried Catherine to the mountain, where they buried her.

St Anthony's Cave

Not far from the Red Sea resort of Hurghada, where vacationers snorkel their way through the coral reefs,

there lies St Anthony's Monastery, a vast complex of churches, living quarters, and lush gardens. The extremely hospitable black-clad monks are more than happy to tell visitors about the Coptic (Egyptian Christian) Church, but the really sacred place, St Anthony's Cave, lies a few miles farther into the desert.

St Anthony is one of the most famous monks, and was one of the first to live as a hermit. Anthony was born in AD 251 in Middle Egypt. He was particularly affected by the biblical parable of the rich young man (Matthew 19:16–26), and at the age of 20 he withdrew to live in various hermitages, before retreating to the inhospitable rocky mountains of the Egyptian desert to lead a life that was full of privations, but nevertheless fulfilled. This holy man of the desert is described as an exemplary Christian who always gave comfort, counsel, and consolation to those who sought him out, despite his longing for solitude.

Finding his retreat was (and still is) a little difficult. From St Anthony's Monastery you strike out into the desert until the beginning of the ascent into the mountains. There are 1,300 steps to climb up to the cave, yet even this is a spiritual experience, especially in the early evening when the sun has already sunk behind the mountains. At the top, the cave is reached through a very narrow crevice. Legend has it that Anthony spent more than 20 years of his life here. The cave itself contains no secrets—the mystery is rather how he lived here for all those years. A unique experience is to spend the night

on the area just in front of the cave in quiet prayer, watching the stars, letting the warm sand trickle through your fingers, and contemplating the fleetingness of human life, until the sun finally rises behind the mountain and bathes the desert in a red glow.

Abydos

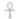

Abydos, the capital of the 8th Upper Egyptian Nome, lies a little to the south-west of the present-day town of Baljana. Abydos was the burial place of the earliest kings. Osiris, the god of the dead

Mural of the cult-image ritual in the Temple of Seti, Abydos

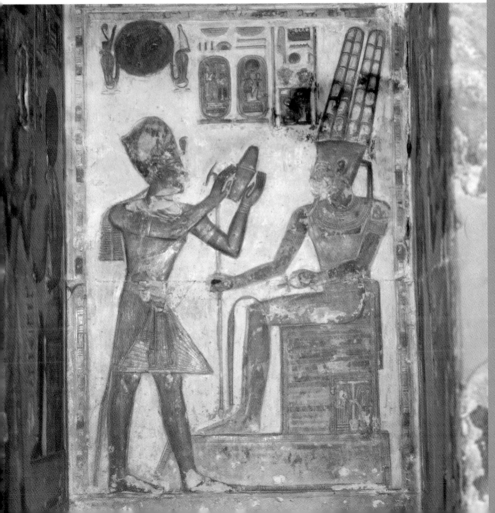

and of vegetation, was also venerated here from as early as the 3rd milennium BC. Abydos was one of Egypt's most sacred places. The **Royal Necropolis** lying in the desert plains contains the sunken, brick-lined tomb complex of eleven rulers from the 1st and 2nd Dynasties, and even some of the pre-dynastic kings (Dynasty 0). The tombs consist of a main chamber for the king and up to 200 subsidiary chambers for burial objects and for the servants entombed with him. The graves were covered with beams, matted grass, and, in places, bricks, with a mound of sand carefully piled on top, symbolizing the mound of earth that surfaced from the primordial oceanic abyss when the world was created. The design of the pyramid later evolved from these sandhills. The interior of the tombs featured false exits, which represented the dead king's route into the afterlife.

Abydos was abandoned during the Amarna Period (18th Dynasty, 1550–1292 BC) due to religious upheavals that can be traced back to the emergence of the Cult of Aten. The sun god gradually supplanted the old deities, and the ancient place of pilgrimage in Abydos waned in importance. Osiris-worship was resumed only when Seti I (1290–1279/8 BC) had a temple built on the site where the shrine to Osiris once stood. The **Temple of Seti** (c. 1285 BC) is in very good condition, living up to its epithet of "the million-year house"—the massive structure was built from the finest sandstone. Besides the divine triad of Osiris, Isis, and Horus, it is also consecrated to the gods of the Old Kingdom, Ra, Amun, and Ptah, not to mention Seti himself, who was worshiped as a god. Different levels, which appear to have had a ceremonial function, lead to a slightly raised dais, and there are two forecourts in front of the sanctum itself. The first of these contained massive pylons, which, according to a commemorative text, "reached the sky." Beyond the second forecourt were two striking hypostyle halls of great splendor. The seven sanctuaries are accessed through the second hall. Six of them contain depictions of the daily ritual worship of the god's likeness; the Tomb of Seti contains other images.

The reliefs show the sequence of the sacred ritual, which was performed every day. First, the priest (or the king himself) would enter the sanctum and open the case containing the cult image. The god would then appear, and the priest would prostrate himself before him. There followed praise and offerings to the deity, before the cult image was finally taken out, cleaned, and anointed. The floor was then swept, the image replaced in its case, the priest's footprints obliterated, the torches extinguished, and the shrine locked up and sealed once again. The exceptionally good condition and bright color of the reliefs provide important insights into the rituals surrounding religious worship.

Temple of Hathor, Dendera

Hathor was the Egyptian goddess of beauty, love, protection, joy, and healing, and Dendera is home to

one of the most spectacular of the temples devoted to her. What can be seen today dates from the Greek-Roman era (2nd/1st century BC–2nd century AD). As at other sacred cult sites, however, there is a long history of construction at Dendera, and archeological findings have shown that the Temple of Hathor is built on the ruins of a much older building.

As you enter the sacred temple complex through the formidable entry gate, the mighty hypostyle hall lies directly ahead. The pillars are carved with images of the goddess; Hathor is normally depicted as a woman or a cow, and is always shown wearing a headdress made of a cow's horns and a sun disk. The ceiling of the entrance area (or pronaos) is decorated with cosmological and astronomical images, reflecting the Egyptian belief that a temple should portray the whole cosmos. The sun is at the center of the cosmological system, pointing its rays toward the shrine at Dendera, as symbolized by the head of Hathor.

Buildings were erected on the roof of the temple itself. Two staircases lead from the temple through to the Chapel of the New Year on the roof. This part of the temple takes its name from the processions that used to take place on New Year's Day, as depicted in the mural reliefs. The cult images from the crypt on the outer wall of the temple were brought up to the roof at New Year to commune with the power of the sun. Also on the roof are two shrines to Osiris, where the resurrection of Osiris, the supreme god and judge of the dead, was celebrated.

A sanatorium (therapeutic baths for visitors to the temple) has been unearthed alongside the temple. More recent studies have suggested that Dendera was once an important center for the healing arts.

Various places of worship from later periods now stand in front of the temple complex itself, including the Roman Birth House dating from the time of Nero (1st century AD), with a sanctum containing exquisite reliefs depicting the birth of the divine child Ihy, and a Coptic church from the 5th century.

Steeped in mystery, the Temple of Dendera is a place where man has encountered the Divine for almost 5,000 years, and it is hard to escape the sense of ancient history here.

The Karnak Temple Complex
⚥

With thousands of tourists wandering through this massive complex every day, marveling at the imposing architecture, it is hard to imagine Karnak as the religious center of the whole country, which it was for centuries. The temple complex here was constructed over a period of almost 2,000 years and undoubtedly ranks as one of Egypt's greatest sights.

The complex consists of three separate areas, the Precincts of Amun, Montu, and Mut respectively. A curtain wall of bricks, made of mud from

the Nile, demarcates each of these precincts. At the center of the whole complex, in the Precinct of Amun, there stands the largest temple in Egypt, the Temple of Amun-Ra, with a total of ten pylons, the great hypostyle hall, and the enormous Middle Kingdom Court. The rulers of the Middle Kingdom (2119– c. 1550 BC, 11th–17th Dynasty) erected an early temple, and by Roman times it had been extended to form the temple complex that we see today. The somewhat smaller Precinct of Montu, the patron god of Thebes, joins it to the north. The Precinct of Mut lies south of the Precinct of Amun, and is linked to the Temple of Amun-Ra by a long avenue of sphinxes. The hall was lined on each side by 66 sphinxes.

The complex is arranged along two axes, one running west–east and the other north–south. The Precinct of Amun, by far the largest in the whole complex, houses an array of other temples and shrines; one of the shrines was the original site of the 98-foot-high (30-m) obelisk that since 1587 has stood in St Peter's Square in Rome. Framed by the two formidable Obelisks of Thutmose I, the lake on the southern side of the central temple was also held sacred. It is the largest temple lake in

The Temple of Amun-Ra on the sacred lake at Karnak

The Avenue of the Sphinxes at the Temple of Amun-Ra, Karnak

Egypt, and in ancient times its water was channeled from the Nile; it is now fed by groundwater. It may come as a surprise to learn that poultry were kept by this lake—like the ram, the goose was considered a sacred animal.

Relatively little is known about the belief system of ancient Egypt; the pantheon of gods remains largely obscure. In the dynastic period, the pharaohs finally came to be honored as deities, while this period also saw the worship of deities who took the form of animals and humans. The sun, embodied in the reigning monarch, ruled supreme. Despite the little that we know about this era, it is certain that the mortuary cult evolved in this period, based on an afterlife in the realm of the dead.

Although the temples at Karnak are no longer in use, their ruins remain as evidence of the advanced civilization of Ancient Egypt, and as a demonstration of how the Divine pervaded the everyday lives of the people and the policies of their rulers. The structures here represent a wealth of awe-inspiring shrines, built and expanded over many years and a testament to the enduring sanctity of this part of Egypt.

The Mosque of Abu al-Haggag, Luxor

A very interesting Muslim shrine is to be found only a stone's throw from the world-famous Valley of the Kings. One of the oldest in the city, this mosque stands on the foundations of a Coptic

The Abu al-Haggag Mosque, Luxor

church, which in turn was built on top of the ruins of a Pharaonic temple. It is dedicated to Sheik Yusuf Abu al-Haggag, who arrived from Baghdad in the 12th century and played a significant role in the Islamization of Egypt; he is regarded as a descendant of the Prophet Muhammad. The local Muslims consider the mosque sacred, and attempts to excavate the underlying temple have been resisted.

Once a year, on the 14th day of the Muslim month of Sha'aban, tens of thousands of pilgrims gather in the city streets to celebrate the Mawlid Festival in commemoration of Abu al-Haggag's arrival in Luxor. The festive procession includes believers carrying feluccas (small Egyptian sailing vessels) through the city, echoing the ancient Pharaonic Ipet Festival, in which the sacred barque of Amun was borne from the Temple of Luxor to Karnak. For devout Muslims, these feluccas represent the boat that Abu al-Haggag used on his travels. The custom of giving food on this special feast day, which appropriates old traditions and uses them within a fresh religious context, is considered even more important than the procession— donations from wealthy citizens pay for a dish of ground meat, onions, and cracked wheat for each pilgrim. Quite unlike the normal tourist traffic, this

festival transforms the city into a model of hospitality once a year. Hospitality has been lauded as one of the highest virtues since ancient times, and is still held in the greatest regard. According to popular belief, hospitable people often unwittingly play host to angels.

The Temple of Horus, Edfu

☥

Horus is the god of the sky and of royalty. The son of Isis and Osiris, he is depicted as a falcon or a man with a falcon's head. According to the myth, Osiris was murdered by his brother, the desert god Seth. A fight to the death then raged between Horus and Seth for power over the earth. Horus and Seth thus represent the dual nature of the world—order and chaos. Order defeats chaos, and the fight against Seth went in the young god's favor. This victory secured Horus' claim to power over a balanced and ordered world (*maat*). Every Egyptian ruler was a successor of Horus and so ruled the country as a god.

The rich reliefs in the Temple of Horus in Edfu, halfway along the Nile between Luxor and Aswan, shed light on this myth. At one time, Edfu was the capital of the 2nd Upper Egyptian Nome, and was named the "Throne of Horus." The imposing temple complex now lies in the middle of a modern city, the entire structure dating from the Ptolemaic Dynasty (3rd–1st century BC). The formidable entrance pylon is decorated with traditional scenes portraying the "Defeat of the Enemy." The entrance leads through to the first courtyard, with the first hypostyle hall (pronaos) at the end. This is where the real sacred precinct, the realm of the Divine, begins. The pronaos is richly decorated with reliefs, which were once partly embellished with gold. Two large and rather elegant

Falcon statue of Horus in the temple in Edfu

granite falcons flank the entrances to this temple precinct, loftily and solemnly surveying the people as they enter. The great hypostyle hall lies beyond, its 18 monumental columns carved with floral designs. The walls are adorned with depictions of the Ptolemaic rulers performing sacrifices, and the ceiling is decorated with astronomical designs. You then climb a slight incline to the inner sanctum, which was once closed off with doors. As you approach it the level of light changes, becoming darker and gloomier the closer you get, as light is only admitted through small windows and light wells. The inner sanctum (naos) was the dwelling place of Horus and in the half-light you will just be able to make out the granite plinth for the sacred barque. Reliefs on the walls depict scenes from the daily cult worship. Directly alongside the sanctum is the enclosure where the purification ritual was carried out during the New Year celebrations. The Temple of Horus is in a remarkably good state of preservation. There is nowhere quite like this for experiencing the true atmosphere of an Egyptian temple.

Abu Simbel

The great temples of Abu Simbel in the Egyptian part of the Nubian Desert were among the wonders of the ancient world. The fact that they can still be seen today is the result of a modern miracle. When the construction of a large reservoir was planned, this cultural treasure was almost lost beneath the waters of what would become Lake Nasser. However, an unprecedented joint effort by almost all the member states of UNESCO resulted in the temple buildings being dismantled and rebuilt on higher ground in the 1960s. Abu Simbel's two rock temples have stood on the western bank of the modern lake ever since.

The **Temple of Ramesses II** was built in 1260 BC and dedicated to the gods Ra, Amun, and Ptah, and to the pharaoh himself. It has gained worldwide fame for its four monumental statues, arranged in pairs to the left and right of the entrance area. At the feet of the pharaoh there stand statues of his children, his principal consort Nefertari, and his mother. The entrance leads through to the great hypostyle hall, also lined with four imposing statues of the pharaoh inscribed with hieroglyphics listing the divine characteristics of the ruler. Along the northern longitudinal wall is a mural of the Battle of Qadesh, perhaps the most important international event during the reign of Ramesses II, although the relief owes more to political propaganda than to historical veracity. The hypostyle hall leads into the inner sanctum, where there is a group of statues of the four gods. The figures, carved directly out of the rock, sit on a bank of thrones. On the far left sits Ptah, the patron god of Thebes, venerated as the deity who created the world through his thoughts and words. Beside him is the patron deity of southern Egypt and Thebes, Amun-Ra, and then there is Ramesses himself, with Ra-Harachte of Heliopolis, the patron deity of the northern empire, on his right. Twice a year (on February 21

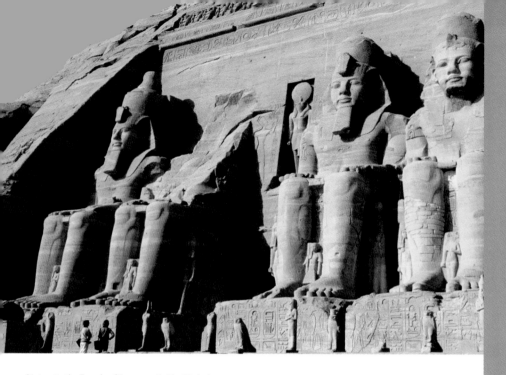

Statues in the Temple of Ramesses II, Abu Simbel

and October 21) the "miracle of the sun" occurs here, when the light of the rising sun penetrates the inner sanctum and shines upon the figures of the gods.

A little way to the north of the Temple of Ramesses lies the **Temple of Nefertari**, which Ramesses II had built for his wife. It is dedicated to the goddess Hathor, the daughter of the sun god Ra, and to Nefertari herself. Six colossal statues stand in niches on the façade, representing the king and his spouse. Nefertari closely resembles the goddess Hathor, with a set of cow's horns and a sun disk. The temple was a sacred site associated with fertility and renewal, which is particularly evident in the image of the goddess Hathor in the sanctum—portrayed in

the form of a cow, she seems to emerge from the very rock and supports the king under the chin. This gesture symbolizes the role of the goddess in ensuring the cyclical renewal of the kingdom.

The Temple Island of Philae

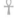

The peerless charm of this small island in the Nile south of Aswan, with its group of sacred buildings, has earned it the name "the pearl of Egypt." A unique complex of buildings dedicated to the goddess Isis was built here

from the 30th Dynasty (380–332 BC) to the Ptolemaic Period and Roman times (2nd century AD). Isis was one of the most popular deities in the Old Kingdom. According to legend, she succeeded in bringing her husband back to life after the desert god Seth had murdered him, and conceived a son, the god Horus. She is a protector goddess by virtue of her magical powers and accompanies the sun god on his journey through the night. In later years she became the most important goddess of all and was even worshiped by the Romans. Her cult survived longer than that of any other deity in Ancient Egypt; her shrine was abandoned only in the 6th century.

Exceptional as the complex at Philae is, it is all the more remarkable that the buildings have survived at all. After the construction of the Aswan Dam (1898–1902) the island was flooded for most of the year. Thanks to an international rescue program the temple complex was completely dismantled and rebuilt at a higher elevation on the island of Agilkia. The main temple at Philae is the Temple of Isis, dedicated to the goddess and her son Harpocrates, the infant Horus. The axis of the temple is out of alignment due to the rock on which the complex is built. Two statues of lions once stood in front of the entrance pylon. The reliefs on the first pylon show triumphal images of the ruler slaying his enemies and performing sacrifices. The Birth House (*mammisi*) of Horus lies to the left of the entrance.

In late antiquity, a Christian church was erected in the atrium behind the courtyard, as can be seen from the carved crosses and a small apse in the

The Temple of Isis on the island of Philae

wall. At the far end of the temple is the inner sanctum where the plinth for the sacred barque of Isis can still be seen today. A gate dating from the time of the Roman emperor Hadrian (2nd century AD) stands to the northwest of the second pylon. The most striking feature of this gate is the relief of the mythical Nile god Hapi pouring water into the river from two jars.

The complex at Philae includes a smaller temple dedicated to the goddess Hathor, where reliefs of the gnome-like god Bes also depict flautists and harpists. Music and dance played an important part in processions and temple festivities. On the eastern bank, set a little apart from the main temple, is the enormous Trajan's Kiosk, dating from late Roman antiquity. It consists of a portico of 14 columns whose capitals are decorated with delicately carved plant stems. This structure was probably a landing point for ritual processions, as there is a quay in front of the building, suggesting that barques carrying the idol of Isis cast off and moored here whenever it was carried to the Shrine of Osiris on the neighboring island.

The ruins of the Cathedral of Qasr Ibrim

Qasr Ibrim, in Lower Nubia, the southernmost part of present-day Egypt, lies close to the border with Sudan. The site takes its name from the Arabic word for a bastioned fort (*qasr*). Qasr Ibrim is home to an imposing piece of evidence of early Christianity in Nubia—a five-aisled stone cathedral, one of the oldest Nubian church buildings. In places, the walls have been preserved to their original height, giving us an idea of the former size of the cathedral.

The origins of this church go back to the 5th century, when Egyptian traders introduced Christianity. The ruins that we see today date from the 7th century; the design was clearly influenced by the "Church of the Granite Columns" in Dongola. When the area came under Arab control, the church was used intermittently as a mosque. Almost nothing is known of its interior decoration, but its importance is evident from the tombs of the bishops who were buried in their rich liturgical vestments. Extracts from the Bible in Old Nubian script, adapted from Egyptian hieroglyphics, have also been found here—extracts from Revelation, the last book of the New Testament, are carved into the stone. A fortified castle existed here as early as the Meroitic Period (8th/7th century BC), and for some time a Roman temple stood on the site.

Converts to Christianity, the Nubian rulers chose to build their church in this sacred place. The ruins now rise defiantly from a mound on a natural island in Lake Nasser. The sense is of a cathedral that would be able to withstand any adversity, vigorously defending a faith that is practiced by only a handful of Egyptians today.

The Friday Mosque of Chinguetti

☪

Modern Chinguetti is an almost forgotten town in northwestern Mauritania, its older district on one side of the river rapidly being reclaimed by the desert sands. It was not always like this, however. From the 12th to the 19th centuries, the town was one of the most important centers of Islam in Africa. In the western Sahara, Chinguetti came to prominence as a result of its location at the junction of several caravan routes.

Some Muslims regard Chinguetti as the seventh most holy city in Islam. The caravans brought this inhospitable land not only trade and prosperity but also scholars, who were attracted to the rapidly growing town with its diverse cultural influences. Chinguetti thus became a city of books and erudition. In the madrasas and well-stocked libraries, medicine, astronomy, and rhetoric were taught alongside the study of scripture. Various libraries, large and small, still exist in the city today, some housing precious texts.

The present-day inhabitants try to keep the history of the city alive for visitors, opening countless tiny libraries and museums which often exhibit little more than the owner's private book collection. In the 18th and 19th centuries Chinguetti became a magnet for scholars and pilgrims from all over the Islamic world. Pilgrims from the surrounding area also gathered in Chinguetti as the starting point for the hajj to Mecca.

The Friday Mosque, built in the 13th century, defies the encroaching desert sands to this day. This fortified, rough-hewn stone building was once used as a stronghold by the French Foreign Legion. The eggs mounted on the square minaret are a curious feature. According to a local legend, Muhammad had a birthmark the size of a pigeon's egg between his shoulder blades, which was how the monk Bahira recognized the boy as the augured prophet.

This symbol can be seen—albeit rarely—on certain other mosques. In many African religions the egg represents fertility and life. Finding the same symbol in separate contexts is indicative of the way in which African religions have mingled with Islam.

There are many old houses and businesses nestling beneath the walls of the mosque. These days the muezzin's call to prayer rings out

from four loudspeakers placed toward the four points of the compass. The sound echoes through the desert town, calling the faithful to the mosque from the new parts of Chinguetti that lie beyond the river.

The Friday Mosque of Chinguetti

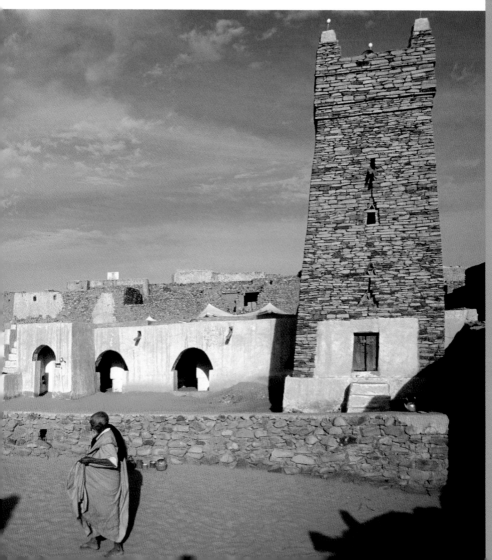

Timbuktu

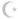

Salt, once as valuable as gold, was brought by caravan to Timbuktu, where it was bartered for gold and ivory. The city grew in status and became increasingly wealthy as a center of trade due to its auspicious location near the Niger. This wealth attracted scholars, which in turn led to the construction of libraries, mosques, and schools. The University of Sankore was founded as early as 989 and soon became an Islamic center of education, exerting an influence that was felt beyond Africa. The imams offered instruction in the scriptures, astronomy, logic, mathematics, and sacred geometry. Before long, Timbuktu had become a hub of spiritual teaching and literature, and only the trade in salt and gold surpassed that in books. By about 1330 the city was one of the world's most important centers of Islam. Besides the University of Sankore, the most important building is the Djinguereber Mosque, a structure made almost entirely of mud, straw, and wood, which can hold up to 2,000 people.

The minaret of the Djinguereber Mosque, Timbuktu

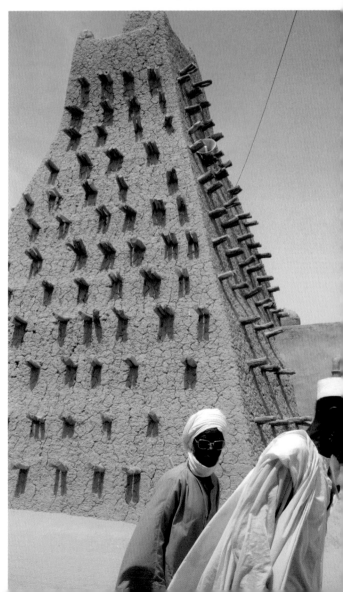

Timbuktu had a long golden age, but over time the libraries lost more and more of their precious collections to European educational institutions. To guard against this, a large number of manuscripts were hidden or buried in caves or underground tunnel systems. Excavations are currently underway to recover and preserve at least 700,000 Islamic documents containing an incalculable wealth of knowledge and culture, some of which date back to the 13th century. While serious efforts are being made to prevent the loss of this unique cultural heritage, the most immediate threat is the shortage of water that also threatens much of the rest of the world, and the resultant spread of the desert.

Timbuktu is famous for the sense of mystery that surrounds it, though for many people this mystery is just a myth. According to one proverb, "salt comes from the north, gold from the south, but the Word of God and the treasures of wisdom are to be found in Timbuktu."

The Bandiagara Escarpment

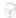

The 93-mile-long (150-km) Bandiagara massif stretching across Mali has been inhabited for millennia. The rock is riddled with caves shaped like eyes that seem to be looking into another world, and which the Dogon use as places of burial for their dead. The Dogon themselves live in adobe houses built at the very foot of the rock, so that they can be near to their departed. This ancient people venerates the snake, lizard, and tortoise and, last but not least, the crocodile, which can be seen depicted on many doors as a form of protection for those who live inside.

The gods of the Dogon are Amma, the creator; Lebe, the god of the earth; and Nommo, the god of water. Earth spirits living in plants and stones hand down their secret knowledge of the night to the priests (called *hogon*, "lords of the earth"), who are obliged to live on their own outside the village. The beliefs of the Dogon are based on the reciprocal relationship between the world of the living and that of the dead.

Even more enigmatic than this religion is the Dogon's precise knowledge of astronomy. "Po Tolo" is their name for the small star that orbits the larger Sirius, a star with a special significance in ancient cosmology. One elliptical orbit takes 50 years. The Dogon celebrate this event with religious ceremonies and a great feast. According to legend, Po Tolo, known to scientists as Sirius B, came from the seed that gave birth to the Milky Way. This star is relatively small and cannot be seen with the naked eye, yet its course corresponds exactly with the accounts left by the Dogon. Where did they get this knowledge? Talk of star spirits who pass down such knowledge about the earth beggars modern, rational belief, yet in a place as rich in culture and beauty as this we might indeed sense that there is more at work here than our rational

minds can grasp. The Dogon's deep understanding of the universe means that they are peaceful and respectful to both man and the natural world.

Sanga

Dogon country is barren and almost impassable rocky terrain encompassing the highlands of Bandiagara, its steep escarpment running parallel to the Niger. The Dogon consider the cliffs to be sacred and their settlements are strung along beneath them like a string of pearls. Ancestor and nature worship is not limited only to sacred rituals but seeps into all aspects of everyday life. There is essentially no separation between the sacred and the secular, as everything relates back to a greater whole. Even basic utensils like calabashes and baskets for millet symbolize heaven and earth. Microcosm and macrocosm are inextricably linked, something that is particularly evident in the architecture and layout of their villages.

The most sacred place for the Dogon is Sanga, lying at the foot of the rocky massif. The design of this village forms the shape of a man lying on his back. The forge and the men's houses are oriented toward the north and symbolize the head. The family houses represent the chest, and the women's houses, which stand to the left and right on the edges of the village, represent the hands. A stone for pressing oil symbolizes the female genitalia and fertility,

while an altar with phallic and other masculine symbols represents the male sex. Other altars lie to the south and are associated with the feet. Even the individual houses are modeled on the shape of a reclining man, with different areas set aside for the men, the women, and married couples.

The tribe's dead ancestors are buried and venerated in grave niches in the rocks outside the village. The life energy of these ancestors continues to affect the lives and thoughts of their descendants after their death. Food stores can also be found in the rocks, and these have a mythological significance as well as an everyday one—the food is a gift for an ancestor who is revered as a god, and is a symbol of the connection between this world and the next. Sanga is a place for those willing to immerse themselves in an ancient, deeply religious culture.

The Great Mosque of Djenné

Djenné lies in the Massina, an area of low-lying land in the inland delta at the confluence of the Niger and Bani rivers. The town is situated on an island in the middle of the Bani and can be reached across a ford and a causeway when the tide is out, or by ferry at high tide. Today Djenné is a small agricultural center, but its golden age was when caravans plied

the route from North Africa through the Sahara to Ghana. You can see a vestige of the town's former glory in its mighty Great Mosque (Friday Mosque).

Built completely from mud bricks, one of the oldest building materials used by man, the mosque is the largest adobe building in the world. The present-day town is also home to a large number of houses built in this age-old tradition. All buildings of this type have palm trunks protruding from the walls, which act as scaffolding during construction and subsequently as reinforcement for the building when it is completed. The first mosque was built in one of the sultan's palaces in the town in the 13th century, after the Soninke—the original rulers of the ancient kingdom of Ghana—adopted Islam as their religion.

After Djenné replaced Ghana's Gold Coast as the principal marketplace for gold, it became the chief town in the small yet wealthy country of Mali. Many scholars flocked here, and for a long time Djenné rivaled the fabulous city of Timbuktu itself. During the Middle Ages, Djenné rose to become a stronghold of Islamic

The Great Mosque of Djenné

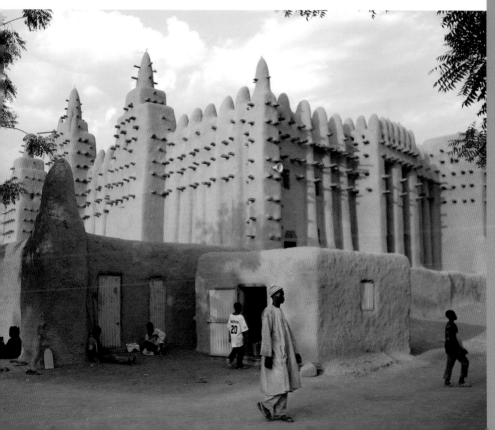

learning. Thousands of students came to the town to study astronomy, geometry, literature, and poetry alongside the Koran at the mosque.

The old mosque withstood subsequent sieges, capture, and a succession of rulers for almost 600 years, before being destroyed in 1834. The ruler at the time thought the mosque's origins as a palace building were too secular. The structure that replaced it was erected on exactly the same spot but proved to be short-lived. The Friday Mosque that we see today, once again made out of adobe, dates from 1905.

Its solid walls glow a mysterious red or muddy yellow, depending on the time of day and the position of the sun, like a beacon from a long lost world. Once a year, a group of men, both young and old alike, seal by hand the cracks that have formed during the course of the year, breathing fresh life into this sacred place.

SENEGAL

The Touba Mosque

"**W**ork as though you will never die!" and "Pray as though you will die tomorrow!"—these two exhortations underpin the mystical teachings of Amadou Bamba (1853–1927), founder of the popular Islamic Sufi Mouride Brotherhood. Bamba is venerated as a saint by his followers (known as Mourides), who often revere him more highly than Muhammad

himself. The city of Touba lies in the hot savannah and is sacred by virtue of its Great Mosque, where the marabout Bamba is buried.

Islam actually forbids the veneration of saints, but in popular Islam—particularly in West Africa— the veneration of masters such as this is not uncommon. West African Muslims identify with Amadou Bamba and see him as a role model. Every May hundreds and thousands of the Senegalese faithful make a pilgrimage to Touba; they regard a journey to Bamba's grave as equivalent to the pilgrimage to Mecca.

The Mourides are the largest religious group in the country. Young men are particularly enthused by the founder's ideals, which teach that work is a way of coming closer to God. This work ethic and the fact that the members of the sect are obliged to give a proportion of their income to the brotherhood mean that the organization is now very wealthy. The Mourides belong almost exclusively to the Wolof tribe. Their piety is marked by great zeal for the Koran, although elements of the ancient Wolof religion still play a part. They strive for wisdom, see work as a meditative path to God, and also act as healers and soothsayers in the African tradition. Wolof spirits and dances live on in the everyday practices of the brotherhood. As elsewhere in Africa, elements of ancient beliefs are blended with the principles of one of the main world religions.

The Touba Mosque

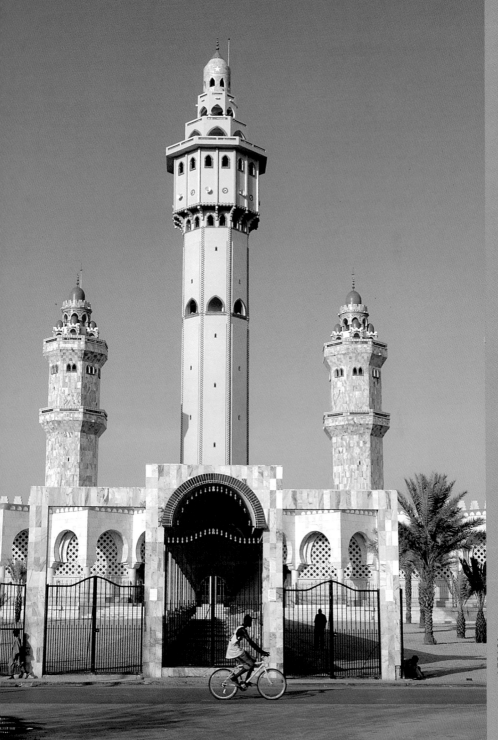

Sacred crocodile pools

What people hold to be sacred is almost always related to their immediate surroundings and finds expression in rituals, and often buildings, dedicated to a sacred entity. This sacred entity often forms part of everyday life, as at the sacred crocodile pool in Gambia, where the locals venerate this prehistoric creature out of a mixture of affection and fearful respect. The crocodile has long been credited with mythical powers and existed thousands of years before humans came on the scene—it harks back to a primordial era and is a symbol of vitality. Locals do not speak of the Western "man in the moon"; they see a "crocodile in the moon." The image of the crocodile crops up everywhere; it is as ubiquitous as a watermark on the banknotes of the Gambian currency, the Dalasi.

It is no wonder, then, that there are places where crocodiles are kept and worshiped as sacred. Apart from the **Berending Pool** near Barra in the northwest of the country and **Folonko Pool** at Kartong in the southwest, the **Sacred Crocodile Pool of Kachikally**, in the coastal town of Bakau, is the most important of these sanctuaries. The age of the pools is not known with any certainty, but it is thought that the one in Kachikally has been maintained without interruption since the 13th century. The pools at Kachikally and Folonko feature natural watering holes, while the Berending Pool is fed with water from the Atlantic Ocean. The animals in the pools are mostly Nile crocodiles, which can grow to a length of 17 feet (5 m) and reach the age of 100.

The special care that these animals receive means that they are free to breed undisturbed. All three crocodile pools are primarily fertility shrines, and women visit them to offer sacrifices of cola nuts and animals, and to ask for healthy and preferably plentiful offspring. Men offer sacrifices in the hope of warding off bad luck in their business ventures; parents ask for protection and success for their children; athletes pray for victory. Despite their varied requests, all agree that they are not worshipping the crocodiles themselves, but rather the life force and energy that these animals represent.

Senegambian stone circles

Enigmatic standing stones can be found in many parts of the world, and most of them remain a mystery despite a great deal of investigation and research. This is certainly true of the Senegambian stone circles, which form a 62-mile-wide (100-km) and 220-mile-long (350-km) band stretching along the River Gambia as it flows through the West African countries of Gambia and Senegal. This enormous area is home to over a thousand of the strange man-made sacred circles.

The most famous in Gambia are the **Stone Circles of Wassu** and **Kerr Batch**, with

their imposing, V-shaped megaliths hewn out of the rock. At both sites there are several circles of different diameters. The stones themselves vary in size; the smallest are barely a foot high (30 cm), while the largest weigh several tons and are as tall as a man. Unlike prehistoric standing stones in Portugal or western and northern Europe, these stone circles are relatively recent. The first ones were probably erected in about the 3rd century. Some of the circles clearly acted as burial and memorial sites. A great many were made during the 8th century, and several of them have been identified as memorials marking a grave. Others are simply located close to graves, while many of the circles are not near a burial site of any kind.

Most of the stone circles are in places where no traces of human settlement have been found, and so we can be fairly certain that the area on the banks of the River Gambia has been considered sacred since ancient times. The tradition remained alive among the people even after Islam gained a foothold in the country in the 11th century—the most recent finds date from the 16th century. Marveling at the standing stones today is like being transported back to a time about which we know virtually nothing. All that remains are the enigmatic stone circles, their message still beyond our grasp.

The Wassu Stone Circles

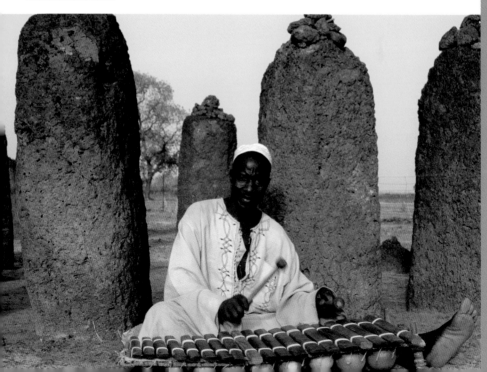

Ouagadougou

It was not until 1955 that Pope Pius XII raised the still relatively young vicariate of Ouagadougou to the status of an episcopal see. A mere 10 percent of the city's population is Christian, but they have an exceptional and striking church at the center of their spiritual life.

The **Cathedral of Our Lady of the Immaculate Conception** was built between 1934 and 1936. Traditional adobe bricks were used in its construction, and the design followed the style of European or Roman churches. From the side, the elongated structure looks well proportioned, but the façade, with its simple portal leading into the three-aisled church, has a somewhat incongruous appearance. The towers to the left and

Ouagadougou Cathedral

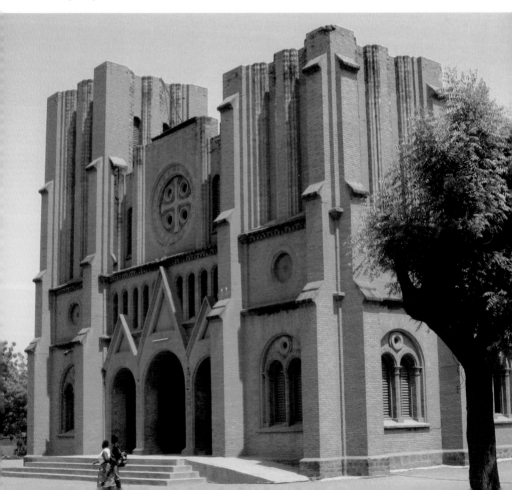

right of the portal give the impression of being unfinished. The length of the cathedral does not quite match the height. Standing in front of the building, you get the sense that this incompleteness was planned. It is quite likely that it was deliberate, the objective being to hint at a mission that has begun, but is far from finished.

Besides the cathedral, the city's **Great Mosque** is another impressive testament to faith. It is also situated in the old inner city area, not far from the church. The mosque has two three-stepped minarets on either side of the entrance, its appearance bearing a closer resemblance to Christian ecclesiastical architecture than to a typical Islamic place of worship.

Ouagadougou, the capital of Burkina Faso, is a vibrant and cosmopolitan city where Muslims, Christians, and those who practice indigenous African religions can live in peace and harmony with one another.

IVORY COAST

Notre Dame de la Paix, Yamoussoukro

The last thing that visitors to the Côte d'Ivoire (Ivory Coast) expect to see is a building like this. The Basilica of Notre Dame de la Paix in Yamoussoukro is the largest church in Christendom. In 1983 the country's first president, Félix Houphouët-Boigny, relocated the capital from Abidjan to his place of birth, Yamoussoukro. He had the idea of raising the profile of this small rural town in the bush by building an enormous church. The design of the Basilica of Our Lady of Peace was inspired by St Peter's in Rome, which it surpasses it in size by some way.

The marble of the Italian-inspired church can be seen shining in the sunlight from miles away. The stained glass windows covering several thousand square yards, were made in France. Along with Jesus and the twelve apostles, you can also spot (former) head of state Houphouët-Boigny among the disciples of Christ. It is not uncommon for the art and architecture of important churches to immortalize their patron. Here, however, there does not seem to have been much in the way of patronage, although Houphouët-Boigny always claimed to have funded the church using only private means. The overall impression of sheer pomposity does not, however, fit well with the church's surroundings. Despite its wealth of natural resources, the Côte d'Ivoire is still considered a developing country.

Coming across such a church in a country like this is bemusing for foreign visitors, especially given that the predominant religion in the Côte d'Ivoire is Islam. However, in spite of all the criticism that has been leveled at the building, the country's Christians cherish their basilica and see it as a sacred place, especially since Pope John Paul II finally consecrated it in 1990.

Sirigu

The Nankanse tribe live on Ghana's northern border with Burkina Faso. One of the most fascinating settlements of this ancient tribe is the small village of Sirigu, which is famous for its unique farmhouses—windowless mud huts with one small round arch for an entrance. Built like small fortresses, they appear ready to defy any threat from the outside. The men live in rectangular huts and the women in oval ones. The most striking thing about these houses is the rich decoration on their outer walls. Besides geometrical patterns, you can also see animals—mostly snakes, lizards, and crocodiles—and plants.

The houses belonging to high-ranking women in the community (the first wife and the mother of the master of the house) are particularly ornate. In Sirigu, there are no separate or particularly favored sacred sites; with their symbols and totems, the houses themselves are much more likely to serve as sacred places. The older women normally carry out the decorative work, as they understand the meaning of the symbols. They often depict the crook of a herder, the emblem of the man of the house, or the hourglass drum used during rituals. The animal totems help to record the membership of the group or clan.

The veneration of these animals in sacrificial rituals strengthens the bond between mankind and the gods. Symbols can also be seen in the geometrical patterns. Diamonds represent batwings; bats protect the natural habitat from insects. Abstract-looking patterns stand for calabashes and indicate a well-ordered household. Downward-pointing triangles symbolize broken fragments—these are supposed to ward off bad luck and death.

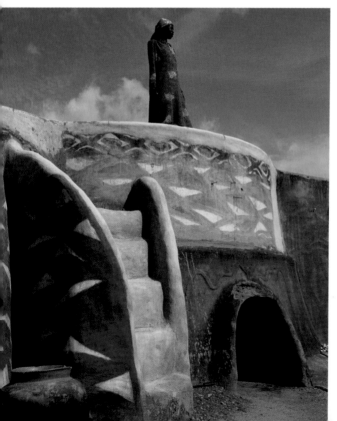

Painted adobe house in Sirigu

Upward-pointing triangles symbolize the female sex and stand for fertility.

The decorative imagery on the Nankanse huts is not only visually striking, but also expresses an aesthetic that is wholly oriented toward the worship of the Divine. The houses in Sirigu are a particularly beautiful and expressive example of a culture where the sacred and the everyday can be found alongside one another.

The Grottoes of Kpandu and Lipke

All along the eastern shore of Lake Volta there are formidable dripstone caves, often containing massive stalagmites and stalactites. People have always found such caves fascinating. Archeological finds have established that the caves at Lake Volta were once used as dwellings.

Two impressive caves can be found near the small town of Kpandu, on the lake shore near the border with Togo. The **Agbenohoe Cave**, the larger of the two, now serves as a place of Marian pilgrimage for Catholics from the surrounding area. There is a large statue of Our Lady inside the cave. People come on pilgrimage to visit the statue and bring their prayers before the Mother of God. The bizarre stalactites form an unusual backdrop for the venerated statue of the Virgin Mary. The smaller **Aziavi Cave** is used as

a place of worship by various Christian denominations. Ancient spirituality and Christian tradition come together in both these caves; for thousands of years they have been seen as a sacred place where the local people would go to honor their ancestors.

A little way from these caves, to the north of Kpandu, is the **Lipke Cave**. The people of Lipke still believe that their ancestors once lived in this cave, about 9 miles (15 km) east of the town of Hohoe. Still today, the members of this small community see the cave as a magical place, and they visit it to commune with their ancient forebears and receive their counsel. It is quite possible that the Christian missionaries simply adapted this African tradition in a Christian context. In any case, all three caves, with their millennia-old history, are an eloquent example of how belief can form a link between the past and the present.

The Golden Stool, Kumasi

In 1957 the former empire of Ashanti became part of the Republic of Ghana, although the Asante still consider Kumasi, which was founded in 1695 (or 1701, according to other sources), to be the real capital of their kingdom. Some 20 percent of modern Ghanaians are Christian and 30 percent Muslim, yet neither group sees any contradiction in

continuing to adhere to the old religions, too. This explains the great veneration of the Golden Stool in Kumasi.

The "Sika Dwa Kofi," the Golden Friday Stool, is the Asante's most important shrine. This is where the heart and soul of the nation dwell and is the result of the amalgamation of various Asante clans in the 17th century against the empire of Denkyira in the south. After the victory over Denkyira in 1701 it was important to maintain this union, but every one of the clan leaders claimed supremacy. The legendary priest Anokye was called upon to choose between them, but he put the decision in the hands of God.

According to oral tradition, he called together the elders of the clan on a Friday. They were met at the gates of the city by Osei Tutu, who had spearheaded the campaign against Denkyira. There was a sudden clap of thunder, and a gold-encrusted wooden stool fell from the sky straight into the lap of Osei Tutu—the God of Heaven had chosen him as the ruler.

To bind together the loose alliance, Anokye ordered the onlookers to cut off locks from their heads and pubic hair, along with the nails of their index fingers. He then mixed these symbols of vitality with a secret powder and blended everything together with water. He brushed some of the liquid onto the stool, and gave the rest to those present to drink, thus sealing the sovereignty of Osei Tutu as the first Asantehene (King of all Ashanti). From this moment the Golden Stool became the most important sacred object, and the new kingdom was assured good fortune, well-being, and glory as long as it remained undamaged. Over the years intricate artifacts have been added to the stool, notably bells, which have different meanings when rung, including one that called the people together and another that announced the arrival of the stool itself. Countless amulets and talismans were added during the Islamic period.

The Asante never doubted the power of the stool, even when the British conquered Kumasi in 1874, plundering the city and establishing colonial rule. The stool went missing until 1920, when it was rediscovered by chance during roadworks, but the gold inlay had been stolen. In 1925, this sacred object was reconstructed according to old descriptions of it and the Golden Stool is now shining once more with all its former luster. Stored in a special room in the Manhyia Palace, it is only displayed to the public on rare occasions and continues to represent the national and religious identity of the Asante.

The Posuban Shrine of Mankessim

The confederation of the Fante (also spelt Fanti) was an alliance of warriors from different Fante clans who came together to make a stand against Asante incursions from the north.

Later, this alliance was also to take part in anti-colonial struggles and heavily influenced the West African black elite's struggle for emancipation.

The Fante built strange shrines in their towns and villages, where they asked for blessing upon their cause. Several of these shrines, called *posubans*, are modeled on warships, defensive forts, or even churches. The bellicose appearance of the shrines is heightened by the inclusion of cannons and guns, as well as human statues. Soldiers in traditional battle dress, or even European uniforms, and wild animals (mostly lions and leopards) are used to express the ardent political determination of the Fante political movement. Both traditional and modern motifs appear alongside one another, and each of the warrior alliances builds its own shrine. The shrine that has the most colorful and diverse range of motifs is in Mankessim.

It may seem strange that a site so obviously centered on fighting and war should be considered a sacred place, yet these martial shrines express the firm belief that the indigenous gods and spirits can support the political struggle for self-determination and a better life. African religions tend to pay less attention to the afterlife than to making this life better, and so these shrines can rightly be seen as living sacred places.

The Posuban Shrine of Mankessim

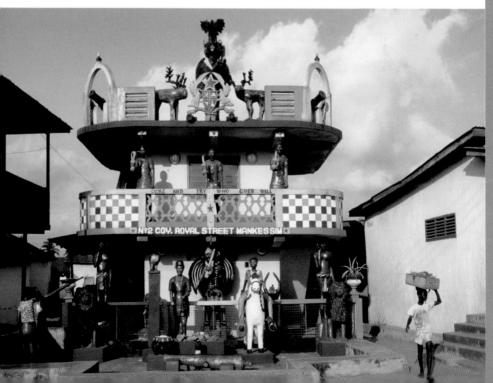

The Royal Palaces of Abomey

In the 17th century what is now known as Benin was the kingdom of Dahomey, founded by the Fon tribe. The capital of this kingdom was Abomey. The city was surrounded by an adobe wall, inside which lay houses, fields, and the palaces of the kings. These palaces formed a row of elongated adobe buildings constructed by the Fon between the 17th and 19th centuries.

Abomey lies at the heart of Benin, the place where the Voodoo religion (also spelt Wodu or Vodun) originated. The word Voodoo comes from the Fon word *wodun*, for "god." The religion recognizes a vast pantheon of gods, to whom abundant sacrifices—including humans—were offered. Voodoo was the imperial cult, presided over by priests who were also responsible for the initiation rite. Besides the sacrificial rite, ecstatic dances are the focus of the religion, as the Fon believe that spirits are in direct contact with those who are in a trance, and the gods commune with worshipers through those who have reached a state of ecstasy.

The empire of Dahomey was more infamous than famous, as for centuries it derived great profit from its participation in the slave trade, until the practice was abolished worldwide in the 19th century. Dahomey was an extremely centralized monarchy and the king was also the high priest. Of the former palaces, few of which have been preserved, the most striking is that of King Glélé (1858–89), whose name means "no animal shows its anger like the lion." It is therefore only natural to find a stone lion guarding the entrance to his palace. There is also a statue of Legba; Legba is the divine power controlling crossroads and chance; he is both the messen-

The stone lion in front of the Palace of King Glélé in Abomey

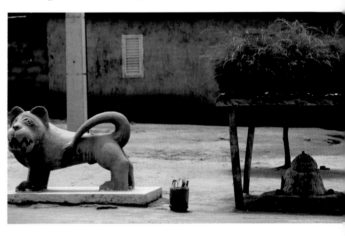

ger of the gods and an intermediary between the gods and man. There is also a shrine here to Ogun (also known as Gu among the Fon), the god of iron; he is especially venerated as he stands for the success of kings in battle. Gu is often represented by a stone jar containing rusty metal

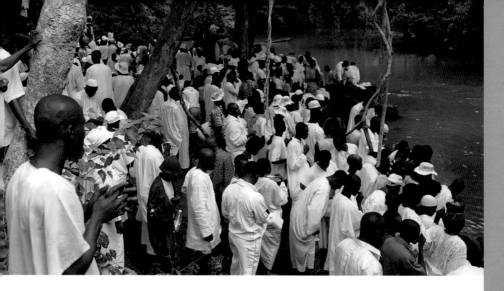

Yoruba at the Osun-Osogbo Sacred Grove

splinters—this is supposed to ward off danger and ensure blessings upon the king. Several reliefs have recently been rediscovered and added to the Palace of King Glélé. They depict the history and rites of the Fon.

NIGERIA

Osun-Osogbo Sacred Grove

The Sacred Grove of Osun, the river goddess of the Yoruba, lies in one of the last areas of unspoiled virgin forest near Osogbo, the capital of the Nigerian state of Osun. The whole area was wooded but has gradually been cultivated by the Yoruba, with mixed feelings. On the one hand the people feared the dark, dense forest

as a place of demons, and tried to face up to this deep-seated fear by taming the forest and clearing it. On the other, they felt a strong reverence for the majesty of the old trees and honored them in sacred groves.

At one time there was a grove near every Yoruba settlement, where the people would pay homage to the different deities and spirits at altars and shrines. The Osogbo shrine, thought to be the last of its kind to survive, is seen as a sacred place by every Yoruba community. The vital force revealed in the groves is present in all things—the gods, of course, but also ancestors, spirits, people, animals, plants, stones, and also words and songs, prayers, anthems, curses, and even everyday speech. This vital force (*ashe*) is at the very heart of the religious life of the Yoruba; it grows if a person is active, and declines if

they are passive. The gods are invoked and appear at the shrine, which is a place where people can come to experience the Divine face to face.

This sacred place owes its survival to a foreigner, the Austrian artist Susanne Wenger (1915–2009), who immersed herself so deeply and intensively in the world of the Yoruba that they anointed her a priestess. She designed and built the sacred grove of the goddess Osun in the 1950s.

Ilé Ifè

The city of Ilé Ifè, in the state of Osun in southwestern Nigeria, is the most sacred city of the Yoruba and the seat of their spiritual ruler, the Oòni. He claims direct descent from the supreme god Olódùmarè (also called Olorun or Odumare), who is said to have founded Ilé Ifè. The Oòni is worshiped as an Orisha—an earth or water spirit—and he is the only one who can speak with the gods and thus bring them into contact with the people. The creator god is a pure spiritual being, neither male nor female, who shuns both divine and worldly matters, but it is this god who first gave man the breath of life.

As the creator no longer plays a role in their lives, the Yoruba religion concentrates on Orishas or on deified ancestors, who have also attained the rank of Orisha. There are various myths about the founding of the city;

what is certain is that it was established more than 2,500 years ago. It had a golden age between the 12th and 15th centuries, and even now it is renowned for its valuable and expressive terracotta sculptures. Ilé Ifè is still the venue for the most important annual religious festivals and processions, including re-enactments of the creation myth. The people celebrate the Itapa Festival, held in honor of Obàtálá, one of Olódùmarè's two sons, over two weeks in January or February.

When Olódùmarè, the supreme spiritual being, wanted to create an ordered world, he sent the Orishas as his emissaries. Each of them was assigned certain tasks in the work of creation. Orishas are linked with a vast array of phenomena. Obàtálá, the one who created human beings, is one of the most important. According to myth, he became drunk on palm wine and, unable to concentrate, created strangely deformed people. As the Yoruba consider themselves to be the descendants of the Orishas and maintain a ritual relationship with them, people with physical or mental limitations are deemed to belong to Obàtálá. This myth demonstrates just how potent the social element of the Yoruba faith is. Anyone who hurts those who are "different" sins not only against their victim, but also against the Orishas, as the gods are prone to manifesting themselves in different guises.

The week-long festival of Ogún, the god of iron and war, is celebrated in October. Oral tradition has it that Ogún is one of the oldest gods. After the world had been created, the Orishas

set about their respective tasks, but they came upon a place where they could go no further. Obàtálá tried to clear the way with his machete, but his tool was ill-suited to the task. Only Ogún's tool was capable of clearing a path, but he demanded a reward for his labor. This was agreed, and after he had successfully brought the Orishas to Ilé Ifè, they gave Ogún the only crown that they had with them. As might be expected, Ogún is worshiped alongside Obàtálá in Ilé Ifè, and a special festival is held in his honor. The Orishas are venerated at shrines, temples, and groves all over the city and throughout the surrounding area.

The Synagogue, Church of All Nations, Lagos

The followers of Temitope Balogun Joshua liken him to the disciples, whose closeness to Jesus and the Holy Spirit brought them special gifts and powers. Born in 1963 in Arigidi, Nigeria, T.B. Joshua is also rumoured to possess such powers. He is seen as a prophet and a healer both in his native country and abroad, and his fame has spread rapidly throughout the world.

His church is the Synagogue, Church of All Nations (SCOAN) in Ikotun-Egbe, Lagos. Hundreds of thousands of people make the pilgrimage to this place to be healed of their infirmities. Services of praise

and healing, attended by thousands, are held every day. The place where the sermons and healing take place resembles a sports hall, although his followers regard it is a cathedral. Monitors and loudspeakers are installed everywhere so that the whole congregation can follow T.B. Joshua's sermons. Crowds of believers, as well as incredulous skeptics await the prophet's arrival. When he appears a murmur spreads throughout the throng. Delivered with great enthusiasm and charisma, his sermons are guaranteed to rouse the congregation. The people stand expectantly in a circle around the massive hall with cardboard signs around their necks upon which are written their physical and spiritual afflictions.

There is much singing and dancing, but the high point of every gathering is the healing itself, during which the person being healed seems to go into a trance. Many of the believers are so affected that they topple over as if felled by an invisible force. These kinds of syncretist movements can be found all over Africa, and are a response to the desire of many Africans for healing and spiritual growth.

The Synagogue, Church of All Nations has been regarded as a sacred place ever since it was founded in 1991. T.B. Joshua and his Church mix Christianity, the newcomer religion, with the people's deep-seated belief in the power of spirits—or, in this case, a spirit that is identified with the Holy Ghost. As far as the believers are concerned, this modern church is a piece of heaven on earth.

The Church of the Granite Columns, Old Dongola

On the left bank of the Nile in the heart of ancient Nubia there lies the city of Old Dongola. Located in the middle of three Nubian kingdoms, it converted to Christianity in the 5th century, but toward the end of the 7th century an invading Arab army destroyed the city's old church, a triple-aisled adobe basilica. Construction began immediately on a new, five-aisled "church of granite columns," built on the foundations of the old basilica. The method of construction became a model for many later sacred buildings in Nubia, and probably also for the Cathedral of Faras, which was built a few years later.

Fired red bricks were the principal building material; granite was only really used for the capitals of the columns in the interior. The ornate ceramic windows, discovered during excavations, are particularly noteworthy and feature Maltese crosses,

The ruins of the Church of the Granite Columns in Old Dongola

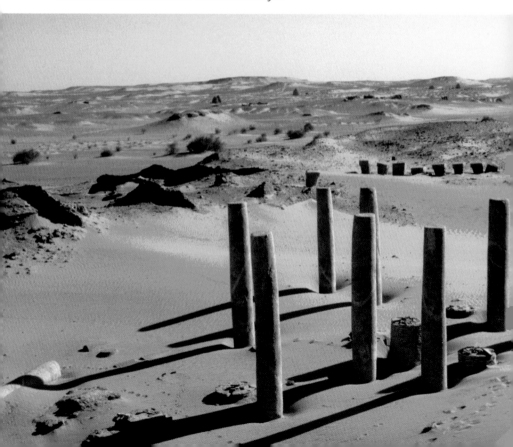

four-pointed stars, and fishes arranged in the shape of crosses. This imagery corresponds to early Christian emblems and symbols. The baptismal font was in the form of a Byzantine cross. The last major phase of building was completed at the end of the 11th century, when the interior was extended with brick pillars. The Arabs reconquered the kingdom of Makuria (6th–14th centuries) in the 14th century and the Nubian rulers converted to Islam. The church was gradually plundered for its bricks and sank into oblivion.

Some of the columns that gave the church its name have now been re-erected. The remains of a large monastery complex, dating back to the 7th century and found to contain a large number of well-preserved murals, have also been discovered nearby. The oldest grave inscriptions are written in Coptic, a form of Old Egyptian now used only for religious purposes.

The town was obviously a center of Nubian Christianity, as the remains of more than ten other churches have been found around the city, dating back to the heyday of the kingdom of Makuria in the 10th and 11th centuries. Although little of that former glory remains, the pillars of the Church of the Granite Columns point with dignity toward the sky as a testament to faith.

The Temple of Amun, Gebel Barkal

⚲

The table mountain of Gebel Barkal, lying directly on the right bank of the Nile, not far from the town of Karima, rises up about 330 feet (100 m) almost vertically from the flat land that surrounds it. The Nubian King Piye invaded Egypt in 728 BC and the Kushite Dynasty took over the Pharaonic throne until 655 BC. However, construction of the Temple of Amun on Gebel Barkal had begun under Egyptian rule as early as 1300 BC. Numerous additions were made to the building, which became the

religious center of the Kushites during the 25th Dynasty (c. 746–655 BC).

The temple remained an important religious site even after the capital was relocated to Meroë. In fact, the glory of this large Egyptian-style temple was only to fade when Christianity was adopted by the three Nubian kingdoms in about AD 500. Nowadays, only the foundations and some ruins attest to the former stature of this temple complex. A sprawling burial ground with a plethora of pyramids lies alongside it on Gebel Barkal. Although almost all the pyramids have been destroyed, the tallest and best-preserved of those that remain standing are still seen as spiritual places and are watched over by the locals. Most of them were built in the 6th century BC, but precise dating is difficult because of their poor structural condition. The ancient Egyptian mortuary cult belongs to the distant past, and there are far more impressive structures dating back to this ancient religion. Yet people come here to stand guard over the sacred sites because they sense the presence of the departed souls from that long-gone era.

The Pyramids of Meroë

The empire of Meroë gradually disintegrated into many smaller kingdoms and principalities during the 4th century, but in its heyday it stretched from the great bend in the Nile in Nubia to the mountains of Ethiopia. This empire straddled the

area where Mediterranean-influenced Egypt and sub-Saharan Africa met, but despite its very close ties with Egypt, Meroë was quite different.

The black pharoahs held sway between Aswan in Egypt and Karima in Sudan. Having adopted Egyptian culture and religion, they built a large number of pyramids. In about 700 BC they conquered their northern neighbors and for a period imposed their own pharaoh. The Nubians adopted many things from the Egyptians during this regime, including temples, tombs, handicrafts, pictorial art, and hieroglyphics. In matters of religion, the Egyptian pantheon was interwoven with their own gods, particularly Apedemak (the "Lion of the South"). After their eventual expulsion by the victorious Egyptians, in 300 BC the Nubians shifted their capital to Meroë. South of the desert, this new city was the southernmost link between the Nile and the desert road plied by the caravans.

In Meroë the Nubians began to draw on the kingdom of Kush's thousand years of tradition. The

rulers of Meroë were high priests in the Pharaonic tradition. Right up until the 4th century AD they too were buried in pyramids, but which differed from their great Egyptian counterparts by having a stepped structure and steeper sides. Their rich imagery is similar to that of their Egyptian predecessors, while texts and images from the period show that the Nubians had adopted Egyptian notions of divinity. Many graves show signs of having held several bodies, including those of animals. Sadly almost all of them have been plundered, so we know little about the grave goods that were traditionally left here. The older tombs most commonly held *ushebti*, Egyptian funerary statues, while luxury items from the Hellenic world were also found in the later pyramids, which can be interpreted as evidence of prosperity. The wealth is long gone and reclaimed by the desert sand, and only the pyramids remain from this era—mysterious testament to a mortuary cult that has an immediate resonance with people today, yet at the same time remains essentially unknowable.

A view of the Pyramids of Meroë

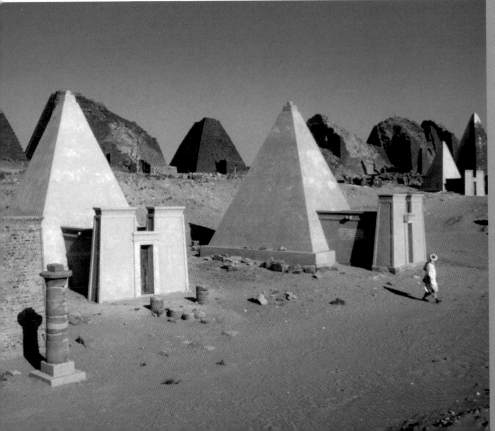

The Church of St Mary of Zion, Aksum

The former capital of the kingdom of Aksum is no longer the large city it once was. The date of its foundation is unsure, but the history of the city of Aksum is thought to date back to the 5th century. In its early golden age, the kingdom maintained trade relations with Greece and Rome, and probably also with India and China. Today, you can marvel at some of the striking remains of this ancient civilization, from the famous stela (stone slabs) of Aksum to the ruins of the ancient temple, or the Queen of Sheba's palace with its enormous basins, now used as freshwater tanks. Until relatively recently, Aksum was also the city where the Ethiopian rulers were crowned.

After the conversion of King Ezana to Christianity, Aksum became the most important place of pilgrimage for Ethiopian Christians, and it remains so today. The construction of the first church in the 4th century is attributed to King Ezana. A small chapel in the modern Church of St Mary is the resting-place of the Ark of the Covenant, which, according to Ethiopian Orthodox Christian belief, contains the Ten Commandments. People here are firmly convinced that this is the original Ark that belonged to the Israelites. According to historical records from the 12th century, King Menelik I, the son of King Solomon and the Queen of Sheba, brought the ark to the country. It has lost none of its remarkable significance. On the contrary, it is considered so worthy of reverence that one monk has the job of watching over it for life. There are replicas of this shrine in most other Ethiopian churches, but the original and center of worship are here in Aksum.

Lalibela

Lalibela is an important place of pilgrimage not only for Ethiopian Christians but also for countless people from all over the world. Once called Roha, the town is now named in honor of the legendary King Lalibela (1181–1221). A story from his childhood marks him out as being particularly favored by God. Shortly after his birth, his mother found him surrounded by a swarm of bees. After she overcame her initial shock, she understood this as a sign that the child had been chosen for something special. The infant received particular care and attention as a result, along with the name Lalibela ("chosen by the bees").

His brother, the king, feared that the gifted and popular child would want the throne for himself, and tried to poison Lalibela, who fell into a coma that lasted three days. During this time he is said to have been summoned to heaven where he was given the mission of building the unique churches that remain as places of pilgrimage for people from all over the world.

Legend has it that God even specified how the churches should be built.

Restored to life, Lalibela immediately set about bringing his vision to life, building twelve magnificent churches, hermitages, and catacombs, some of which lie well below the level of the ground. The monolithic churches were hewn from the volcanic rock using a method that remains a mystery. According to legend, the churches were finished very quickly because angels continued building them at night, when the laborers were sleeping.

The **Church of Abba Libanos**, dedicated to one of Ethiopia's most important saints, is particularly impressive; it is said that Lalibela's wife, aided by angels, built this church in a single night. A mysterious light can sometimes be seen shining from inside the church.

The **Bet Maryam Church**, dedicated to the Virgin Mary, contains a number of very well-preserved frescoes. One shows Mary with the smiling Infant Jesus on her lap, blessing all who come to Him. Women who want to conceive still bathe in a pool in front of the church in the hope that their wish may come true through the intercession of the Mother of God.

Whatever the real story behind the construction of the churches, they are an abiding testament to the way a vision can become reality, and have an impact even today.

The rock church of Bet Giyorgis in Lalibela

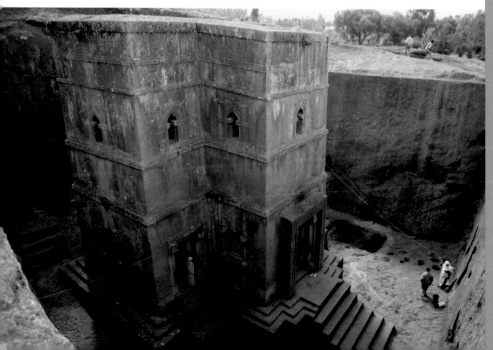

The monasteries and churches of Lake Tana

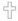

Herodotus remarked that "the divine Nile springs from Heaven." Since time immemorial the river, especially the Blue Nile, has been seen as enigmatic, both life-giving and life-threatening. From its source in Lake Tana the Nile follows a long path through the Ethiopian deserts and mountains before flowing through Egypt and into the Mediterranean Sea.

Covering over 1,160 square miles (3,000 sq km), Lake Tana is the largest lake in the country. It lies in the Ethiopian Highlands at an altitude of about 5,900 feet (1,800 m). Around the shore and on the numerous islands lie churches and monasteries, all of them built with rounded walls, as the devil is said to lurk in corners. Some of the island monasteries are very isolated and hidden away. Several of them are completely out of bounds to visitors, while others allow only male visitors.

The **Church of Saint Gabriel** on the island of Kebran is one of those open only

A rotunda church on an island in Lake Tana

to men. It is famous for its delightful, well-preserved murals. The church also houses ancient tapestries and manuscripts, which were brought here for safekeeping during the Muslim invasion in the 16th century. They now represent a unique chronicle of Ethiopian Orthodox history. Some of the manuscripts come from the neighboring island of Enton, where there is a deserted convent. The **Monastery of Ura Kidane Mehret** on the Zeghie Peninsula is open to women as well as men. It was founded in the 17th century and is decorated with vivid paintings both inside and out.

Debre Maryam Monastery, founded in the 14th century, lies near the spot where the Nile flows out of the lake. The oldest Ethiopian manuscripts, known as "gospels," are kept here.

Menelik I is said to have hidden the Ark of the Covenant with Moses' tablets of the Ten Commandments on the **island of Tana Cherkos**, and Mary is also reputed to have hidden here during the Flight into Egypt. Women are still prohibited from setting foot on the island, however. A little to the south, there lies the **island of Mitsele Fasiledes** with its 13th-century rotunda church, built from red stone.

In the middle of the lake the **island of Dega Estefanos** rises amost 300 feet (90 m) above the water and is thickly wooded. A rectangular 19th–century monastery church sits on a small mound and is also closed to women. Nearby a mausoleum contains the bodies of several Ethiopian kings in a treasury protected by massive ancient fortifications.

Dek, the only inhabited island, is also the largest. The **Church of Arsima** houses one of the oldest known Ethiopian manuscripts.

When the water is at a low ebb, the Narga Peninsula can be reached on foot. The **Selassie Church** contains rich murals, including an important painting on the door to the sanctuary that depicts the empress Mentewab (1730–55) prostrate at the feet of Mary.

The ruins of the **Palace of the Emperor Susenyus** (1607–32) are spread across the Gorgora Peninsula on the northern shore of the lake. The emperor had a Portuguese Jesuit priest build the palace in the style of an old European monastery, with a church, a cloister, and a quadrangle, and the remains of an old rotunda church can be made out in the palace courtyard.

With all its islands, churches, and monasteries, Lake Tana is a veritable jigsaw of sacred places. These are enormously important to Ethiopian Christians, and more than capable of casting their spell over any visitor.

Bahir Dar and the Tis Issat

Christian communities have existed in Africa since the early Byzantine era. Rotunda churches were built all over the country, and often five or six churches can be found right next door to one another. Many of them have their own theological schools, which combine Christianity with elements of

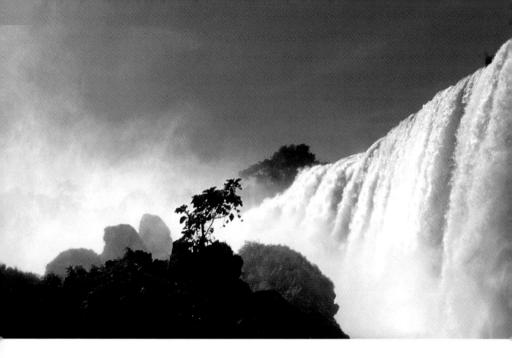

The waterfall of Tis Issat on the Blue Nile

animism. One such is the **Church of St George** in Bahir Dar, the capital of Amhara province, on the shore of Lake Tana.

The church is made up of two rooms, encircled by an outer gallery. Besides the altar, the sanctuary also contains a *tabot*, a wooden replica of the Ark of the Covenant, which is believed to contain the Ten Commandments of Moses. *Tabots* are also found in many other churches, and every year they are carried through the local streets in festive processions. These occasions serve as a reminder that God expressed His desire for people to join Him in heaven by giving them His eternal commandments. Ethiopia's round churches are among the oldest Christian places of worship in the world, and tend to be richly decorated with motifs from Christian iconography and depictions of native plants and animals.

About 19 miles (30 km) south of Bahir Dar the waters of the Abbai, the Blue Nile, plunge downward in a cataract. The powerful **waterfall of Tis Issat** is dubbed "smoking water" by the Ethiopians and is considered a sacred place. Rainbows form above the falls throughout the day. Believers see this not only as a physical phenomenon resulting from the combination of air, light, and water vapor, but ultimately as a sign of the covenant that God made with man after the end of the Great Flood.

Sacred nature

The traditional African world view sees nature as endowed with a spirit. Nature provides the African people with their habitat, and it is worth their while to protect and preserve it. They regard nature as an expression of divine power, and thus they believe that the very earth that provides both their home and their livelihood is sacred. A person's perspective, or rather their attitude toward nature, depends on whether they are hunters or farmers, nomadic or settled. There has always been a crucial difference between cultivated land and untamed nature. The world can be divided into three basic areas: the areas where people live and keep their possessions; the fields and hunting grounds surrounding the inhabited areas; and the wild, often uncharted wilderness beyond.

This wilderness is populated with gods, spirits, and demons, which manifest themselves in certain natural features. Some of these—giant trees and thick forests, rivers and islands, waterfalls, and caves—may be venerated as holy places. Even animals and plants speak the language of the Divine. Those who stray too far into the untamed wilderness sometimes fall prey to a sense of terror, as spirits there can move freely and appear in a range of different guises and may feel joyful or sorrowful, docile or wrathful. Hunters and scouts who return from the wilderness unscathed are very highly esteemed, as this proves that the spirits were well disposed toward them.

Nature is a living entity, and it lives among people. Africans consider the sun, moon, water, and earth as sacred. Actions that damage the environment have lasting consequences—droughts, floods, or other natural disasters, such as when game animals leave an area because the springs and waterholes have dried up, or when fields turn to wasteland. Religious practices are thus aimed at preserving nature, not so much for the good of the individual as for the whole community— the village or ethnic group and its rapport with nature itself. Seen in this context, the growing urbanization of Africa is not only a social problem, but also, in its broadest sense, a religious one.

The formidable solitude of the savannah

Mount Kenya

Africa's second-highest mountain, with its three main summits—Batian Peak (17,057 feet/5,199 m), Nelion (17,021 feet/5,188 m), and Lenana (16,355 feet/4,985 m), all named after Masai chieftains—lies approximately 9 miles (15 km) south of the equator. In the middle of the surrounding savannah, a swathe of rainforest has managed to establish itself on the mountain's slopes. The Masai and the nearby Kikuyu and Kamba tribes call it "black and white mountain" or "shining mountain," as the top is covered in snow and ice all year round, an unusual sight near the equator. The Bantu call the mountain "Kirinyaga" or "Kinyaa" in their own language. The country of Kenya derives its name from these two Bantu names.

All these ethnic groups regard Mount Kenya as a sacred mountain, as it is the throne of their supreme god, Ngai. The pastoral tribes of the Masai also worship Ngai as the rain god who once gave them all their cattle. Besides Ngai, the Kikuyu also worship their own ancestors, who look after the Kikuyus' everyday concerns. They pray to ancestor trees found in areas of tropical rainforest on the mountain

The peak of Mount Kenya in the evening light

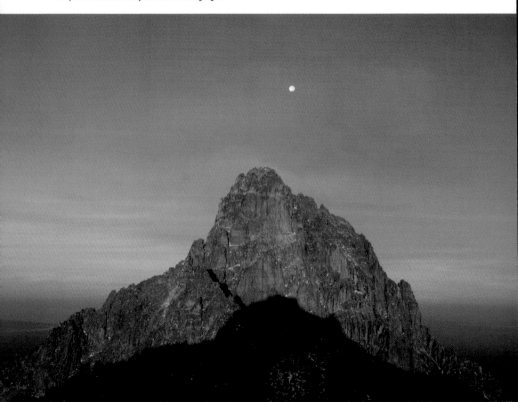

slopes. These are trees that are particularly old or interesting in shape, and the souls of the ancestors are thought to live on in them. The Kikuyu only call upon the supreme god Ngai if they are in dire straits, and they only do so as a group. The voice of a single Kikuyu is believed to be too small to be heard by Ngai. To approach the god and ask something of him, many people must be in trouble or distress. The Kikuyu believe that Ngai lives in heaven, only coming down to earth in times of extreme need and fervent prayer. They also believe that Ngai can come down to other high peaks.

For the Kamba people, however, Mount Kenya is the only earthly residence of Ngai, the creator. Besides the Masai, Kikuyu, and Kamba, other tribes and clans such as the Embu and Ameru live at the foot of the mountain, and they also hold Mount Kenya sacred. Even the most jaded visitor will sense something of the sacred power emanating from this mountain.

The Kaya Forests

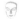

The Kaya, on the Kenyan coast, is an area of settlements abandoned by the Mijikenda people. The first of these settlements were founded as early as the 16th century, while the last was abandoned in about 1940.

Over time, however, the abandoned settlements have become sacred places of ancestor worship where people pray to their forebears and petition them for advice and support.

Extensive cemeteries were laid out in many of the settlements, so it is not surprising that the Mijikenda are now especially concerned to protect the Kaya and prevent the clearing of the surrounding forest. This deep reverence for the Kaya has meant that these wooded areas are now the very last sections of ancient and relatively unspoiled forest on Kenya's coast. The forests are now like islands in the middle of vast swathes of intensively farmed plantations. All 30 of the known Kaya settlements are spread along a 125-mile (200-km) strip of the coast. They are built on small mounds and vary in extent between 74 and 740 acres (30 to 300 ha). Houses are arranged around the center of the village, where either a grove or a hut serves as a meeting place.

Although the huts and the palisade fences that used to surround the settlements can barely be made out today, the centers of the villages, where ancestor worship is carried out, are still lively. This is where rituals and prayers take place, allowing the Mijikenda—whether as individuals or as whole clans—to commune with their dead.

Ol Doinyo Lengai

The Ol Doinyo Lengai volcano rises up from the dry savannah in the middle of the East African Great Rift Valley in the far north of Tanzania. It is still active, and its geological distinctiveness has certainly added to its age-old status as a sacred place. It is the only known natrocarbonatite volcano on earth, and the lava that emerges from it is only half as hot as that of other volcanoes. On contact with the air the lava turns light beige, giving the mountain, and particularly the crater, the appearance of being covered in snow.

The volcano is sacred to the Masai—they believe it to be one of the two dwelling places, along with Mount Kenya, of their only god, Ngai. They call it the "mountain of God." Ngai can manifest himself as either a good black god or an avenging red god. As a good god he sends rain, allowing the savannah to flourish; rain is the basis of life for the cattle that provide a livelihood for nomadic pastoral tribes. As a vengeful god, Ngai sends lightning, thunder, and destruction. The mountain is so sacred to the Masai that they never climb it, instead bringing their sacrifices to the foot of the volcano. The most common ritual offerings are goats and sheaves of grass, which are also considered sacred. The Masai honor their god and try to keep him merciful by performing dances, songs, and rituals. Volcanic activity is seen as a divine sign.

Ol Doinyo Lengai is also important to the Sonjo, a Bantu tribe. The Sonjo live on the other side of the mountain, and unlike the Masai they are a settled, agricultural people. The mountain is also called "mountain of God" in their language. They believe

The volcano of Ol Doinyo Lengai

that the sun god Khambageu lives on one of its two peaks. Since the Sonjo believe that an apocalypse is coming, when the mountain erupts they are afraid that the end of the world may be near. Their religious rituals are aimed at persuading the sun god to keep the world in existence.

Kilimanjaro

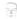

Kilimanjaro is a 19,685-foot-high (6,000-m) snow-covered mountain and the highest peak in Africa. The Masai call its western peak Ngàja Ngai ("the house of God"). Close to the western summit there is the dried and frozen carcass of a leopard. "No one has explained what the leopard was seeking at this altitude." This is the beginning of what is possibly Ernest Hemingway's most famous story, *The Snows of Kilimanjaro.* At the foot of the mountain, Harry, a big game hunter, lies delirious with fever. He dies at the end of the story, and his death is seen as an arrival, a homecoming: "and there before him, as far as he could see, as wide as

the whole world, high and unbelievably white in the sun, lay the flat peak of Kilimanjaro. And then he knew that that was where he was going."

Kilimanjaro is made up of three connected volcanoes, the highest of which is Kibo (19,341 feet/5,895 m), the only one that is still active. From a distance, the flat peak looks spectacular, a solitary mountain rising up from the savannah. From the top the view is truly awe-inspiring, and it is no wonder that the mountain is seen as the dwelling place of God. Local myths about the mountain abound, as they do about vol-

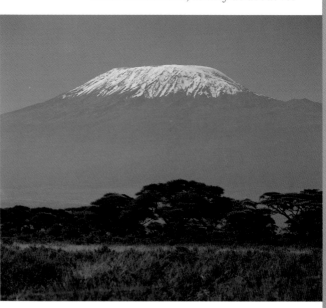

Kilimanjaro

canoes all over the world. People have been both fascinated and frightened by the energy that seethes in the bowels of

the earth for thousands of years. The crater at the summit of Kibo—1¼ miles (2 km) wide and 985 feet (300 m) deep—is covered in snow all year round, although global warming means that the snow here, as everywhere else, is rapidly melting away.

Legend has it that Enelik I, the son of King Solomon and the Queen of Sheba, was the first to climb the mountain. Hemingway's observation that a leopard had reached the peak may also belong to the realm of myth, but there is no disputing the fact that this awesome mountain exerts an almost magical pull on people. There are six different routes to the top, and the ascent itself is not particularly difficult. Acclimatizing yourself while making the ascent is somewhat harder, as from the savannah plains to the peak you pass through five different vegetation and climate zones. Climbing Kilimanjaro is more than a mere adventure—the ascent affords an insight into the insignificance of humankind when measured against the vastness of Creation.

Kilwa Kisiwani

There are now only 500 people living on Kilwa island, but this was not always the case. The earliest written Egyptian records indicate that Kilwa was a center of trade as early as the 1st century AD. This small island is less than 2 miles (3 km) from the mainland,

and for centuries its location made it an important hub for trade between Arabia, India, Africa, and even China. Brisk trade, customs revenue and shipbuilding turned the settlement into a wealthy and densely populated city. Even coins were minted here, a privilege reserved for only a few cities.

Ali bin al-Hasan, a Persian merchant in exile, purchased the whole island at the end of the 10th century and founded the trading post of Kilwa. Trading centers gradually sprang up along the coast, and Kilwa blossomed into the most important city on the Swahili coast, remaining so until the end of the 14th century. The Great Mosque, built in the 11th century, was the largest sacred building on the east coast of Africa at the time. Nonetheless, it seems not to have proved big enough to accommodate all the faithful, and was substantially extended during the 14th century.

Diverse influences from all over the world meant that Kilwa developed its own particular strain of Islam, incorporating some animistic elements as well as rituals from the Far East. At the beginning of the 16th century the Portuguese conquered the city, but their rule lasted only a few years. Kilwa subsequently fell into oblivion. There is little trace of the city's former glory, but the ruins of the **Great Mosque** are a testament to the faith that defined the city and its people all those centuries ago. The 16 remaining domes rest upon 30 columns, and one of the prayer halls is thought to date from the time of the original structure. The best preserved building on the island is the **Small Mosque**, dating from the 15th century,

which is used by the handful of
Muslims who still live on Kilwa.

ANGOLA

Church of Nossa Senhora da Conceição, Muxima

In 1589 the Portuguese conquered
Angola and built a fort and a traditional
Portuguese-style church in Muxima. In
1641 the church was razed to the ground
by the Dutch, who managed to wrest
power from the Portuguese for a mere
ten years. It was rebuilt a little later in a
slightly modified form, but essentially
in the same style. The Church of Nossa
Senhora da Conceição is located in the
Bengo district, on the left bank of the
River Kwanza (Cuanza). The history of
the colonization of Africa is anything
but glorious; the native religions of the
indigenous Bantu tribes and people of
Angola were largely eradicated due to
the aggressive efforts of missionaries.
Worse, Muxima became a major hub
for the slave trade. The church played
a tragic role in this, too, as slaves were
forcibly baptized here before being sold.

Despite this grim background, the
church is a symbol of Angola and an
important place of pilgrimage for the
country's Catholics. Most Angolans
now practice the once-foreign faith,
and flock in their thousands to this
church where national identity and
colonial past have become interwoven.

MALAWI

The rock paintings of Chongoni

The Chongoni, a mountain in the
Dedza province of Malawi, towers
7,220 feet (2,200 m) above the forest.
The richest collection of rock paintings
in Central Africa can be found on and
near its slopes. The paintings are up to
2,000 years old; the older depictions
(in red) were made by the Ba Twa, a
pygmy people of hunters and gather-
ers. Unlike the distinctly naturalistic
images found elsewhere in south-
ern Africa, abstract and geometrical
shapes predominate here. They may
represent the summoning of spirits
associated with natural phenomena.

The "white" paintings, a more recent
group, are about 1,000 years old, but
many are more recent; it is thought that
the Bantu Chewa tribe carried on the
tradition of rock painting into the early
20th century. The Chewa believe that the
spirits of people and animals remain in
contact with the living. Wearing white
masks, they perform ecstatic dances in
order to commune with their ancestors
and the souls of the dead. The Chewa are
still a matriarchal society, which has led
to speculation that the white Chongoni
paintings are linked to female initiation
rites. The paintings also include a range
of animals that resemble mythological
creatures. It is possible that they depict
burial rituals, but their exact interpreta-
tion eludes the viewer. The Chewa have
closely guarded their secrets to this day.

Rock paintings

The strange name of "Doubtful Spring" (Twyfelfontein in Afrikaans) once referred to a watercourse in the mountainous Damara region, but today it refers to the whole valley. **Twyfelfontein** is home to over 2,500 carvings and paintings, a rich legacy of Mesolithic and Neolithic African culture. The age of the paintings is a matter of some dispute, but the most ancient of the rock art is estimated to be up to 20,000 years old.

The images depict hunters and their weapons, along with animals native to the Damara region—giraffes, antelopes, zebras, lions, and rhinoceroses. Surprisingly, since the valley is almost 65 miles (100 km) from the sea, the paintings also include a picture of a seal. The most famous images depict a prancing kudu—an antelope—and a large lion. Besides the figurative drawings there is an array of abstract figures whose meaning is obscure.

It is unlikely that these works of art were purely decorative. The hunting pictures suggest that they may have had an educational purpose, particularly those depicting the tracks of an animal alongside an image of the animal itself. Most of the paintings probably had their roots in magical or religious practices, possibly in connection with initiation rites or trance rituals. Indeed, many researchers believe that the rock paintings combine images from the subconscious with figures from mythology. The most likely explanation is that they were used in magical incantations relating to hunting; the image gave power over the animal depicted. There is much that remains obscure about the meaning of the rock pictures, but their enigmatic and mysterious nature means that people still regard the area as sacred.

The same is true of the rock art in the **Phillips Cave** in the Erongo Mountains, which were formed millions of years ago in this ancient volcanic crater. The cave is named after the former landowner on whose property the cave was found. Among the vast number of paintings, the image of the white elephant is particularly noteworthy. White elephants are extremely rare in the wild, and even today magical powers are attributed to them. In many places in the cave, you can see that several layers of images have been superimposed one over the other, supporting the theory that they were used in rituals, rather than as decoration.

The Erongo Mountains are also home to the **Brandberg**, a long-extinct volcano and Namibia's highest peak, at 8,530 feet (2,600 m). The indigenous Herero people have long viewed the Brandberg as the seat of the gods (Omukuruwaro "fire mountain"). It was European colonialists who gave the mountain its present name, as it appears to glow and almost burn at sunset. It has the largest collection of rock paintings. More than 45,000 images have been found to date. There are hundreds of scenes of

Rock paintings at Twyfelfontein

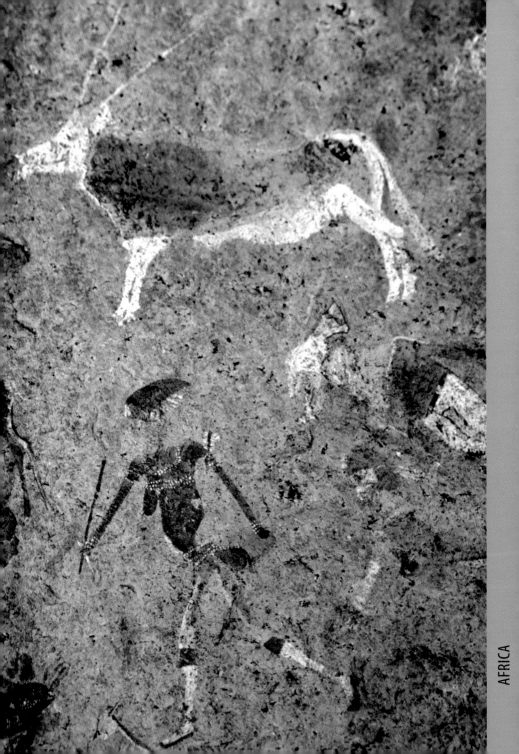

hunting and drawings of animals and dancing people, perhaps in a trance. The image of the White Lady is the most famous and the most mysterious of all: an image of a hunter (or a warrior), its uncharacteristic poise has led to the suggestion that it is a woman, although the figure does not have any explicitly female attributes.

The Felsenkirche, Lüderitz

Bounded by Angola and the Cape Colony, the Atlantic and the Kalahari Desert, there stretches an almost barren, sparsely populated region that, until the mid-19th century, was

home to few people except fishermen and whalers. The inhospitable Namib Desert sprawls along the entire coastal area. Nevertheless, the Rhenish Mission established itself here in 1847, laying the foundations for the colony of German Southwest Africa, proclaimed in 1884.

The year before, in 1883, the German trader Lüderitz had landed in the bay—then called Angra Pequena— and founded the settlement that would be named after him. The tobacco merchant from Bremen used his negotiating skills and the so-called "mile scam" to buy up almost the entire homeland of the local Orlam tribe from its chieftain. The latter believed that the contract they had agreed referred to English miles, whereas Lüderitz used the Prussian mile, which was more

The Felsenkirche, Lüderitz

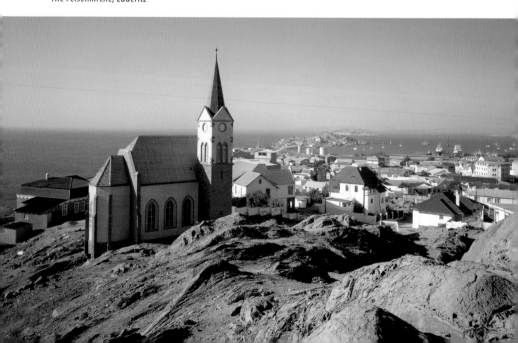

than four times as long. A small town grew up and soon required a place of worship. The foundation stone for the Evangelical Lutheran Church of the town of Lüderitz was laid in November 1911. August of the following year saw the consecration of the church, funded by German donations and designed by Albert Bause in a neo-Gothic style. The window above the altar was a gift from Kaiser Wilhelm I.

Unlike other "rock churches," the building is dubbed the Felsenkirche not because it is hewn out of the rock, but because it is perched on the rocky Diamantberg. Towering above the town and the bay, it has become the symbol of Lüderitz. Visitors to the small town will feel as though they are stepping back in time; its many houses from the German colonial era give it a distinctive atmosphere. The church is a sacred place by virtue of its location, with the wild ocean on one side and on the other the desert, stretching endlessly into the distance. Standing in the square in front of the church, it is impossible to ignore the immensity and force of nature.

BOTSWANA
The Tsodilo Hills

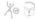

The area around the Tsodilo Hills has been settled for more than 30,000 years and is one of the oldest places on earth to show traces of human habitation. The mysterious, sacred hills are about 33 miles (53 km) southwest of Shakawe in Botswana and rise up from the otherwise flat expanse of the Kalahari Desert. The four hills form a straight line from south to north. At 1,345 feet (410 m), the southern hill is the highest and is dubbed "Male Hill." Right beside it is "Female Hill," much lower at only 98 feet (30 m) but covering three times the area of Male Hill. To the northwest of Female Hill, "Child Hill" rises to a height of about 130 feet (40 m), and the fourth hill (with no name) lies some distance beyond.

The San believe that these four hills are sacred, as the spirits of their ancestors rule the world from there. According to their beliefs, the gods and spirits bring misfortune to anyone who kills anything or causes another person to suffer in the area around the hills. The Hambukushu people, another Bantu tribe, believe that God sent humans out into the world from these hills.

Over 4,000 rock paintings are to be found in the vicinity of the hills. The paintings, some of them up to 20,000 years old, feature geometrical symbols or individuals performing ritual dances, but usually animals occupy center stage. Giraffes, elephants, and antelopes are all present, but there are also a few instances of whales and penguins. Archeologists interpret this as evidence of an early wave of human migration. The Tsodilo Hills are much more than a "desert Louvre," as a 19th-century traveler enthusiastically once called them. These hills, charged with spiritual energy, have a magical appeal.

AFRICA

The Matobo Hills

Matobo is the oldest National Park in Zimbabwe and includes the Matobo Hills and other regions. Imposing rock formations loom over the green landscape. The modern park is the habitat of many indigenous animal species, but it is sacred because of the striking prehistoric San rock paintings which can be found in its many caves. The most important of these is Nswatugi Cave, but Bambata, Inanke, and Silozwane caves also contain remarkable ancient rock paintings.

Rock paintings in the Matobo Caves

There are no clear records as to when the San bush people first arrived and settled in the Matobo Hills. More and more Bantu peoples gradually streamed into the area and displaced the San. These newcomers, particularly the Shona tribe, venerated the hills and the caves, as they believed that the god Mwari spoke from the rocks.

In the 19th century the Ndebele invaded from southern Africa and, in their turn, displaced the Shona from their territory. They also saw the caves as sacred. The first settlers, the San, had decorated the rock with elaborate paintings and images. From these we know that the act of drawing itself was performed as a sacred ritual. The Ndebele danced all through the night, falling into an ecstatic trance that allowed them to tap into creative spiritual energy (*ntum*). These dances are depicted in many of the rock paintings. Priests and shamans used the caves as places of inspiration, and it was here that they received their knowledge from the world of spirits and ancestors through dreams and visions.

These sacred places and their mysterious paintings are still visited for rituals, initiation ceremonies, and the summoning of spirits, thus keeping alive an age-old tradition.

Old Zimbabwe (Great Zimbabwe)

The ruins of Great Zimbabwe (Old Zimbabwe) easily rank among the most impressive stone buildings in southern Africa. In their arrogance

and ignorance, the earliest European explorers doubted that Africans could ever have constructed such a city. The oldest settlements date back to the 4th century, but Great Zimbabwe's heyday as a center of trade, the seat of the king, and a religious center is thought to have been between the 10th and 15th centuries.

When the Portuguese discovered the ruins of the abandoned city in the 16th century, they thought they had discovered the palace of the Queen of Sheba. The ruined city languished in obscurity for years until adventurers and treasure hunters invaded the area at the end of the 19th century, and plundered it almost completely. The statues and buildings that remain— the stone towers, monoliths, altars— all indicate that Great Zimbabwe was sacred for the Shona. In their language "Zimbabwe" means "stone house" or "honored house." The king was not only the political ruler of the people; he was also worshiped as a demigod and a mediator between god and man. This means that the buildings should be seen not simply as palaces, but also as temples.

Soapstone carvings of figures, people, and birds have all been found in Great Zimbabwe, possibly totems whose purpose was to describe the make-up of the group or clan. Sacrificial rituals strengthened the alliance between God and man, sanctifying the society itself.

The most impressive building in the whole complex is the elliptical Great Enclosure, which is thought to have contained the seat of the king. A little to the north lies the Eastern Enclosure, where monoliths that were probably surmounted by religious symbols, stand on round platforms. The conical tower, about 33 feet (10 m) high is particularly mysterious, its purpose unknown to this day. Fortunately the "honored houses" are once again being valued as a symbol of African culture and they have now been returned to the ancestors of the people who built them.

The Great Enclosure, Old Zimbabwe

Fundudzi

Lake Fundudzi lies in the northern South African province of Limpopo, not far from the Zimbabwean border. The sacred lake plays a pivotal role in the spirituality of the Venda, a Bantu tribe. They believe that their god, a water and fertility god taking the form of a python, lives in the waters of the lake which are credited with magical healing properties. The people pay homage to their god by offering millet beer, and performing ritual dances and processions on the lake shore. The places where these offerings are cast into the water are considered so sacred that no one may set foot there without the permission of a priestess of the Venda religion, the chieftain, or the king. This strict prohibition of access means that both the lake and its shores have remained relatively unspoiled and pristine.

The sacrificial rituals of the Venda strengthen the alliance between God, their dead ancestors, and the living. The "Ukodola" ritual, in which the Venda greet the lake, is particularly intriguing; they turn their backs to the sacred lake, set their legs apart, bend over, and look at the water through their legs. Foreign visitors are also obliged to approach the lake in this way out of respect for the god.

The **Thate-Vondo Forest** on the lake shore is also a sacred place. For the Venda it is the dwelling place of their medicine men and the souls of their dead ancestors. The Thate Hill in the middle of the forest contains the graves of the royal family and can only be entered at specific times and with the approval of the religious authorities; it is believed that hikers disturb the souls of the dead.

The rock paintings of the Ukhahlamba-Drakensberg Park

The common eland is the largest species of antelope. The San believe it to be sacred, as it is thought to be the closest animal to the gods. Its meat, fat, and skin were used in spiritual rituals and initiation ceremonies. A large number of these sacred creatures are depicted in the rock paintings (c. 10,000–20,000 years old) in the Ukhahlamba-Drakensberg National Park in South Africa. For centuries, the Jagged Mountains (the literal translation of *Ukhahlamba*) were settled by the San bush people. Lush grassland, abundant waterfalls, and gushing streams make this a fertile region.

The San were the first to settle this area, remaining until they were forced to move into the Namib and Kalahari deserts by the arrival of the Bantu in the 17th century. The paintings that they left behind in their cave dwellings nonetheless tell us of their everyday life and religious practices. The energy that the San hoped to gain through their paintings of animals such as the eland, could also be derived from the animals sacrificed by the shaman to gain access

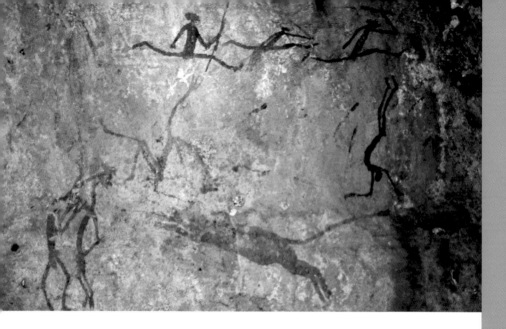

Rock paintings in the Ukhahlamba-Drakensberg Park

to the spirit world. Modern analysis has revealed that the San painted many of their pictures with blood. We can assume that this came from the antelopes, thus lending the images an even greater power. The hunting scenes may depict a magical hunting spell.

The paintings are highly detailed. The elongated human bodies—some appearing to be floating or hovering—are thought to show shamans hallucinating in a trance. Human figures are shown alongside animals, and the paintings were often superimposed, one on top of the other in several layers.

According to the traditions of the San, the world had three levels: everyday life, a world above it, and a world below. The world of everyday life is the material world, focused on survival, while the other two are spiritual worlds.

All three meld and interweave in the rock paintings of the Drakensberg Caves to form a breathtaking whole.

Table Mountain, Cape Town

At 3,566 feet (1,087 m), Table Mountain is not especially high, but its location is dramatic. Almost 2 miles (3 km) long, the mountain's flattened summit can be seen from all directions. Towering over the Cape of Good Hope, it is Cape Town's great landmark.

The Cape and the mountains have been shrouded in myth since the days of the Christian seafarers; the mountain was seen as a mountain of destiny,

symbolizing the hope of a safe return and the fear of shipwreck. Frequently wreathed in white cloud as the result of a meteorological phenomenon, which has been nicknamed the "tablecloth" by both locals and meteorologists, Table Mountain has featured in many a myth and tall tale. One of the points on the summit is called Devil's Peak (3,280 feet/1,000 m). According to legend, a pirate made a bet with the Devil here as to which of them could smoke the most. Ultimately the devil carried the pirate off to hell, but the smoke remained.

Nowadays, you can walk up one of the many trails or simply take the cable car to the top to enjoy the sublime panorama of the city and the surrounding countryside from the viewing platform. We do not know exactly how the original inhabitants of the Western Cape honored the mountain as a sacred place, but it is clear that it was steeped in myth even then. Its location, its curious shape, and its covering of white cloud all contributed to Table Mountain being thought of as the dwelling place of the gods—or the Devil.

discovered in the Blombos Cave in the Western Province, near Cape Town. The pieces of jewelry and rock paintings are up to 70,000 years old; the images show people hunting or catching fish. Among the finds were animal bones and seashells, suggesting that the cave was either lived in or—anthropologists disagree on this point— that it was used as a sacred shrine.

Some researchers interpret the predominantly geometric patterns

Cape Town's Table Mountain, wreathed in cloud

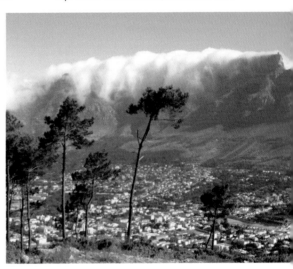

The Blombos Cave

The oldest evidence to date of human civilization—a wealth of jewelry items and superb rock paintings—was

as a form of writing or as series of numbers. Other hypotheses suggest that the ubiquitous zigzag lines might be the first sign of cosmological awareness. It is widely believed that the first abstract thoughts of *Homo sapiens* (the "knowing man") related to mankind's place within the cosmos. The

zigzag lines could also represent the sequence of night and day or other rhythms in nature. The universe was no longer perceived as chaotic; certain systems, structures, and cycles were gradually recognized. When these people painted the surfaces of the rock, they were recording their culture, way of life, and thoughts onto the earth itself. Much of their work remains a mystery, but even today it is capable of captivating those who visit the cave.

The Royal Hill of Ambohimanga

Ambohimanga is the former residence of the kings of the Merina, a Madagascan tribe who ran their own political system on the island until the end of the 19th century. The royal Rova (castle), dating back to the 15th century, is perched on a 4,816-foot (1,468-m) rocky hill and is visible for miles around. The original royal house of the legendary king Andrianampoinimerina is a windowless rosewood building, containing a single room with a hearth, beds for women and children, and two beds for the king—one on the floor and one fixed to a tree trunk high up to enable him to escape danger if necessary.

Ambohimanga village lies on a mountain ridge about 660 feet (200 m) below the castle. The higher slopes of the mountain are covered in thick forest and—apart from the royal complex—are completely unspoilt. Rice is grown in terraces on the plains. The entire area of the Rova is regarded as sacred by Madagascans even today, as the king was not only the political ruler of the kingdom but also its spiritual head. The palace complex includes other sacred shrines besides the buildings themselves: the seat of judgment; a sacred spring; large, gnarled trees, thought to ensure the protection of dead ancestors; a man-made lake, and two basins, the water for which was carried up from the surrounding area and further afield by virgins.

The complex is guarded by a thatched tower. In the past the entrance to the sacred precinct was blocked at night by a stone weighing several tons. The three old cannons that can be seen today were used not for war but for announcing to all concerned when the sacred festivals and ceremonies would take place. Burial and circumcision ceremonies, weddings, and births were accompanied by lively and spectacular plays, originating from a time over 200 years ago when Madagascar was still an independent kingdom. Hira Gasy, a mixture of opera, dancing, and acting, is still performed today. Musicians often use their dances and songs as a means of criticizing their rulers and those in power.

In its 500 years of existence, Ambohimanga has lost nothing of its significance for the Madagascans. It is a shrine to national identity, and still as much a sacred place of pilgrimage as it was in days gone by.

NORTH AMERICA

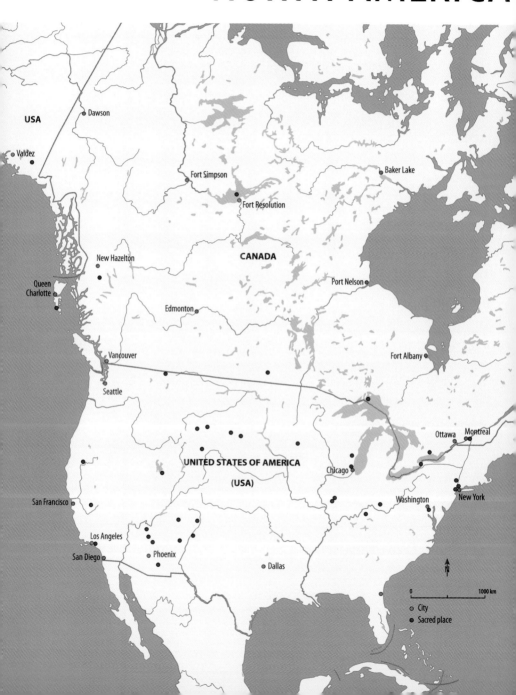

USA

Dawson

Valdez

Fort Simpson

Baker Lake

Fort Resolution

New Hazelton

CANADA

Queen
Charlotte

Port Nelson

Edmonton

Vancouver

Fort Albany

Seattle

Ottawa Montreal

UNITED STATES OF AMERICA

Chicago

(USA)

San Francisco

Washington New York

Los Angeles

San Diego Phoenix

Dallas

N

0 1000 km

○ City
● Sacred place

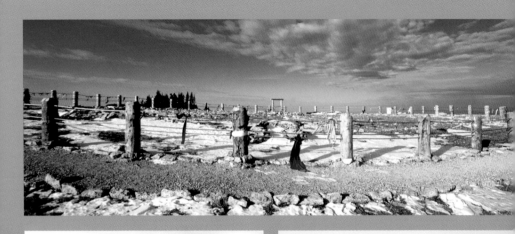

Great Slave Lake

The shores of the Great Slave Lake in Canada's Northwest Territories were once settled by the Slavey First Nation community. The tribe takes its name from the lake, which has nothing to do with slavery, as you might at first however think. The mythological history of this idyllic location as handed down by its original occupants contains a salutary lesson. On a dark night many years ago it began to snow, and the night seemed endless. The blanket of snow eventually covered every plant and bush, and the animals had trouble finding enough to eat. The council of the animals decided to send a delegation to heaven to discover the reason for the long night of snow. A member of each family living beside the lake was chosen and those that could not fly were carried into the sky on the backs of others.

The delegation finally reached heaven, whose entrance was guarded by a brown bear. From the rafters of the bear's hut hung four curious sacks. When the bear was asked what these were, he replied that the first contained the winds, the second the rain, and the third the cold, but he did not reveal the contents of the fourth sack. When the bear had left his hut, the animals took the fourth sack and tipped its contents through a trapdoor onto the earth. The sack contained the sun, the moon, and the stars, and the sun immediately began to melt the snow with its rays. The animals were convinced that this would save the earth, and flew back happily.

However, they soon noticed that their peaceful lives were at an end. After the meltwater had run off, the fish found that they couldn't live on land any more, as the other animals would eat them, while the birds only felt safe in the treetops and every other creature began looking for a place where it would be able to survive. They even forgot how to understand each other's languages. Shortly afterward, the first humans arrived at the lake and the old peace was gone forever.

The Slavey still tell this story today, and it is a striking reminder of the importance of peaceful co-existence. It is a story that every visitor to the lake should remember.

Gitanmaks (Hazelton)

When gold prospectors reached northern British Columbia in the late 19th century, they built the town of Hazelton and named it after the countless hazelnut bushes growing here. The area had been settled by the Giksan long before this, however, and they called it Gitanmaks. Like many other Northern American First Nation tribes, this people built totem poles and held potlachs, ceremonies emphasizing generosity. The ceremony involved not only a lavish communal meal but also the bestowing of extravagantly valuable gifts. Wealth was most respected when it was given away, the First Nation people did not

hoard their treasures but distributed them freely. This ritual not only increased the giver's general status but also served to reduce hostility.

These festivals were later banned by an uncomprehending government wishing to prevent the "ignorant"

Totem poles at Ninstints

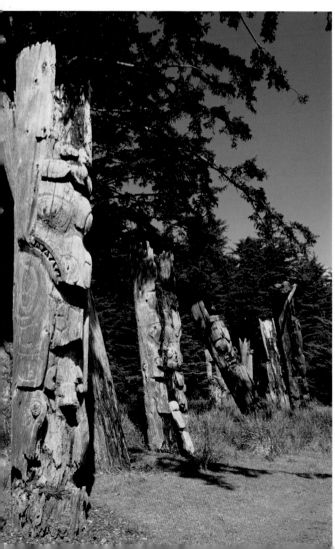

indigenous people from reducing themselves to poverty. The thinking behind the potlach was diametrically opposed to this interpretation, however—individuals won respect for their generosity and magnanimity rather than for parsimony and the churlish hoarding of their possessions. A totem pole was erected when a potlach was conducted, and impressive evidence of this deeply religious practice has been preserved at Gitanmaks. The poles should serve to demonstrate that a generous heart frees the soul and enables one to live in harmony with others.

Ninstints, Anthony Island

Now uninhabited, the village of Ninstints on Anthony Island in the Queen Charlotte chain, lying off the Pacific coast of Canada, is a rich source of artifacts shedding light on the civilization and religious practices of the Kunghit Haida people, whose capital

Ninstints once was. The place-name refers to Nanstints, one of the tribal chiefs, and means "the one who is two." When Europeans arrived on this more or less unexplored stretch of coast in the 19th century, they encountered a culture in which every object, even the most mundane utensil, was created artistically. The totem poles at Ninstints are superlative examples of sacred art, incorporating a variety of symbols, traditions, and myths. The poles are made of cedarwood, which is easy to work and yet hardy. Traditionally, figures were carved or painted on both the inner and outer surfaces of the joists of tribal houses, and this practice was also adopted in the creation of dynastic totem poles, where each figure refers to the clan or to events from history or mythology.

Totem poles are a more recent phenomenon than rock carvings or petroglyphs and date back to the period between 1850 and 1900, when Haida civilization was at its height. A typical Haida totem pole has a small human figure on the front with a raven at its base. The raven is a common feature of many of the myths told among the indigenous peoples of the Arctic Circle; it is considered a sacred creature, a representative of age and wisdom, and a valuable tutor for mankind. Higher up there are usually elaborately carved and colorfully painted masks with an occasional bear or eagle, depending on which tribe is being depicted. At the very top, there are sentinel figures which often hold so-called potlach rings, symbolizing wealth and respect. Modern visitors to Ninstints will be impressed by the majestic and dignified atmosphere evoked by these totem poles, which were often erected in honor of long-dead ancestors.

Moose Mountain, Saskatchewan

One of the most famous medicine wheels is to be found on a low hill called Moose Mountain in southeastern Saskatchewan Province, and like many similar stone shrines this one is a representation of the sun. The wheels generally consist of a central cairn of stones, forming the hub, surrounded by five stone spokes between 50 and 100 feet (15-30 m) in length. This particular wheel, made about 4,500 years ago, was considered a sacred place by the tribes who settled here. Though the purpose of these wheels is still disputed, the most likely theory associates the shapes with astronomical phenomena—as is the case with most other prehistoric stone structures. The stars and the course of the planets were of crucial importance to First Nation cultures.

Simon Kytwayhat, a Cree elder, offers another interpretation, however, which was handed down by his ancestors. The spokes of the wheel, which indicate the four points of the compass, represent the various peoples of the earth. South stands for the color yellow and the Asiatic

races, the sun, and the intellect. West represents the black races, the color black, thunder, and emotion. North is associated with the color white, the white man, winter, and the physical world. East denotes the color red, the Native Americans, spirituality, and the eagle. Hence the true meaning of the wheel is the brotherhood of all men; an individual's treatment of others is repaid by the wheel. However, charming as this interpretation might be, it does not address the fifth spoke, although the four main spokes do undeniably indicate the four cardinal points of the compass.

Mormons believe that the wheels were created by the Aztec people, and the New Age movement has incorporated the symbol into its iconography with increasing enthusiasm. However, the concern about this particular sacred place is that it is in danger of disappearing. Many visitors like to take away a stone, and while this can be understood as an expression of a religious longing, it falls short of the respect due to such a holy site.

Notre-Dame Basilica, Montreal

The first wooden chapel built on this walled hill in 1642 was run by Jesuits and dedicated to the Virgin Mary.

Notre-Dame Basilica among the skyscrapers of Montreal

A baroque church was built on a nearby site a few years later (between 1672 and 1683), as the previous building had grown too small for the rapidly growing congregation. By the turn of the 19th century, this church too had proved too small and construction work began on another new church, this time in a neo-Gothic style. Completed between 1824 and 1843, the building clearly displays influences drawn from French cathedral design, although James O'Donnell, the architect, was an Irish Protestant. He did not live to see the completion of the work and was buried in the new church after a deathbed conversion to Catholicism.

The interior, completed between 1870 and 1900 and much inspired by the multi-colored stained glass of the Sainte-Chapelle in Paris, was largely destroyed in a fire in 1978, but fortunately the damage has all been authentically restored. The entire basilica radiates a sense of warmth, perhaps because the lavish ornamentation decorating the columns, walls, and arches is carved entirely from wood and painted in bright colors. The interplay of light and shade here is not determined by the windows, as in the case of its French inspiration, but by the skillful woodcarvings. Montréal is the most French of all the cities in Canada, and both residents and visitors have clasped "their" Notre-Dame to their hearts, using it at every opportunity as a living place of worship, especially for marking significant milestones in life: baptisms, weddings, and funerals.

Peterborough Petroglyphs

Open-air rock art represents one of the most mysterious relics left behind by ancient cultures. The sites where it is found play a significant role in the civilization's mythology, and this is certainly true of the Algonquin, who created such designs in the crystalline limestone of Peterborough, Ontario.

The petroglyphs are thought to date back to the period between 900 and 1400. The main motifs are

Petroglyph, Peterborough

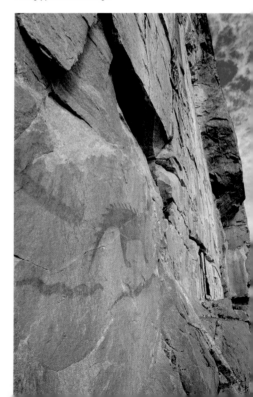

Lake Superior, Ontario

mythical figures, but there are also representations of caribou, hares, and other game animals. There are also some interesting and expressive humanoid figures whose exact identity remains a mystery. Particular attention has been paid to the representation of the "Sunboats," shamanic vessels bathed in sunlight and quite different from the boats depicted in other North American and Canadian rock carvings; these have much more in common with boats of Scandinavian or North Russian origin. Some anthropologists have interpreted them as evidence of the earliest migrations within the Arctic Circle. It is possible that the pictures are based on actual events, such as a successful hunting trip or season, but it is far

more likely that they refer to mythical tales. Cracks or other features in the rocks were often interpreted as entrances into the world of the gods, or as the symbolic womb of the world.

The rock carvings at Peterborough recount enigmatic stories from ancient times. It is understandable that the Algonquin revered this place as sacred within their religious tradition.

Lake Superior

If you look across Lake Superior and the border between Canada and the USA, you will see a low,

rocky chain of foothills resembling a reclining man. With a bit of imagination you will even be able to make out that his face is turned to the sky and his hands are folded across his chest. According to the Ojibwa, this sleeping giant is the revered Nanabozho, whose story begins when Gitchi Manitou (the Great Spirit) sent the Ojibwa a teacher—Nokomis, the wise daughter of the moon, whose own daughter, Wenonah, was then kidnapped by the west wind. Their subsequent union produced two sons, but Wenonah and one of her children died and returned to the land of the spirits. Mourning her daughter and grandson, Nokomis found a little white rabbit, which she caught and named Nanabozho ("my little rabbit"). The rabbit grew to become a mighty creator spirit and magician and now lies, turned to stone, on the banks of Lake Superior.

The area surrounding the lake formed the hunting grounds of the Ojibwa, who called the place Gichigami, the "Great Water"; it is indeed one of the largest freshwater lakes on earth. The Ojibwa believe that there are little spirits living in cracks in the rocks who play jokes on people; these had to be appeased, and the tribespeople would do this by bringing burnt offerings, a practice that has continued to the present day. Such magic rituals allow the shamans to contact the gods and receive messages from their world. The red and ocher rock pictures found here in such great numbers are evidence of the close connection between man and nature and between this world and the spirit world. The Ojibwa's legends preserve their knowledge of such supernatural beings and, as you stand on the shores of the lake, it is easy to believe in their stories.

Niagara Falls

Examination of the effects of electricity in the air has shown that there is a critical level of ionization beyond which both plants and animals find it hard to flourish. An excess of positive ions boosts the transmission of nerve impulses, but if this quotient rises too high it can damage the body, interfering with the airways and leading to stress. A high concentration of negative ions has considerable healing powers, however, speeding up the metabolism and inducing a greater feeling of well-being.

The most significant sources of ion creation are the sun, rapidly flowing water, and weakly radioactive minerals, and all of these elements are to be found in plentiful supply at this sacred place. The falls crash into the depths over a steep, semicircular lip of rock, foaming up and creating a curtain of water in which long rainbow arcs form. The thunder of the falls can be heard from a great distance, long before they are seen, and when they come into view they have an immediate and profoundly moving effect.

The immense and untamed power of this natural phenomenon would set anyone to thinking about life and death, ephemerality and eternity.

The Iroquois tribe consider this to be a sacred place as it is the home of the creator divinity and god of life Manitou. It was here that good spirits ascended to the happy hunting grounds and the souls of the evil were abandoned to the turbulence of the waterfall forever. You need not be a Native American or share this belief to be gripped by the spectacle, a reminder that there are natural forces that are sacred.

Niagara Falls, Ontario

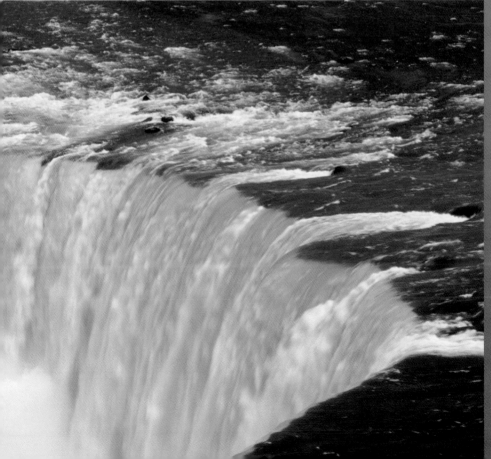

Animals in Native American Mythology

Hunting was an important activity for most Native American tribes as it was necessary to ensure their survival, but the differences between animals and humans were considered negligible. The religion practiced in First Nation tribes is animist—they believe that everything that exists has a soul, and so not surprisingly there are many tales in which animals play a significant role, or in which they take human shape or vice versa.

Most tribes worship the **bear**. Many Native Americans believe that bears were once great hunters or shamans who have assumed the form of a bear to accompany dead souls into the afterlife. The Miwok have even named themselves after their totemic animal, as *miwok* means "bear" in their language. The Chippewa call the animal "old age in a fur coat," as they believe the bear to be a human, in animal form, who wears a coat out of doors.

The Ojibwa worship the **rabbit** as it represents the god Nanabozho ("my little rabbit"). The rabbit is a trickster and a rebel but can also do great good; it also represents speed.

The **turtle** represents unhurried reflection and long life. Many stories tell of races between turtles and foxes, deer, or coyotes in which the methodical tortoise invariably emerges the victor.

Besides the bear, the **eagle** is the most majestic of the animals and is greatly revered by all Native Americans. It appears in mythology as an omnipresent storm bird, as many tribes imagine thunder as a mighty bird, creating wind and thunderbolts with a flap of its wings and shooting lightning from its eyes. The eagle is a manifestation of the supreme being.

The **raven** is also considered a sacred creature, playing a particularly important role in mythology from the Arctic Circle as a symbol of wisdom and old age; killing a raven would mean breaking a taboo. At the creation of the world, the raven helped humans and animals by bringing light and fresh water. For the Tlingit he is also a figure of derision, as he plays tricks on others and is sometimes taken in by them. The Tlingit differentiate between two different kinds of raven, one a trickster and the other a heroic figure.

The **salmon** is considered sacred because, although it migrates over great distances, it never forgets its homeland and always returns to its roots.

The **bison** is the largest animal on the great prairies. Hundreds of thousands once thundered across the grasslands, whereas now the animal is all but extinct. The bison is the herald of life, mighty and powerful. In the initiation rites of many tribes, after killing his first bison a young hunter will eat the still-warm heart of his prey, whose strength is then transferred to the hunter.

Wrangell-Saint-Elias National Park, Alaska

This is a strange sacred place, with no monument, no holy building or temple, no tower, no pyramid, not even a skillfully crafted shrine. This area on the border between Alaska and Canada is instead a landscape of mountains, lakes, rivers, and the largest glacier on earth outside the polar regions. The park is a habitat for black and grizzly bears, elk, eagles, and salmon, and the Inuit tribes of the Tlingit and the Chugach have also found a home here. The First Nation have lived on the land now occupied by the Wrangell–Saint–Elias National Park (which is named after two local peaks) for millennia and have deep roots in the natural world that surrounds them and dictates the rhythm of their lives. They know and respect the spirits living within nature. The gods control the elements, deciding which creatures are to live where. In Tlingit belief every animal carries the source of life within it; after death, the soul goes over the mountaintop to the "other side." Tlingit belief exhibits a marked dualism: everything that exists has its counterpart, and just as there are obviously visible and palpable forces, there are also hidden powers. This place is sacred as it is a reminder to leave things unspoilt, to protect what is endangered, and to preserve life—a way of living to which every culture on earth should aspire.

Nizina Glacier, Wrangell-Saint-Elias National Park

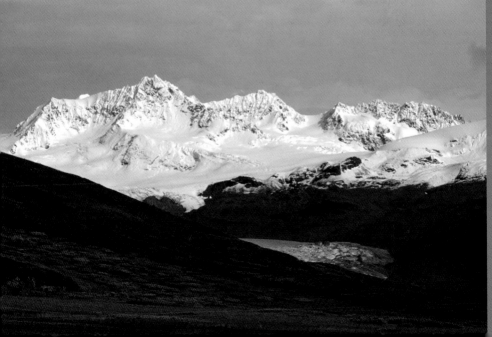

NORTH AMERICA

USA

Chief Mountain, Montana

The Blackfeet Native Americans call this Big Sky Country. The plains, the sky, and the wind are all sacred, but the mountains are especially holy. The most prominent peak is Chief Mountain, towering 9,080 feet (2,768 m) over the prairie at the edge of what is now Glacier National Park.

Native North Americans are animists, believing that everything that exists has a soul. Thus they try to live in harmony with the natural world that provides everything they need for life. The Blackfeet call their ancestral lands the "Land of Many

Gifts." The land always helped them to preserve their identity when the White Man began to make trouble for them. Chief Mountain is a sacred place for the Native Americans, who now live on reservations, and bison bones have been found at its summit, an unmistakable sign that religious rites were conducted here, although little is now known of these practices. Chief Mountain has remained a living sacred place. Native Americans come here to meditate and to strengthen themselves spiritually, smoking sacrificial pipes and gaining in strength and energy, which they seem to draw from the holy mountain.

Big Horn Medicine Wheel, Wyoming

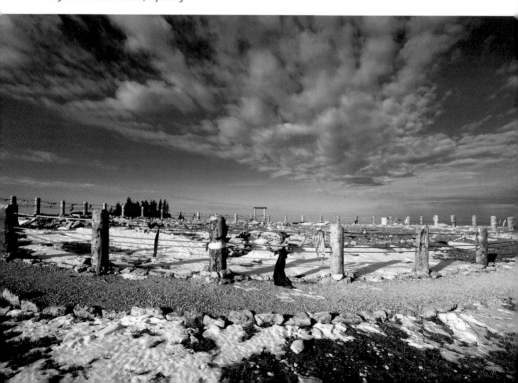

Big Horn Medicine Wheel

The northern plains and prairies of North America are littered with small mounds of stones arranged in geometrical patterns or in the shapes of people and animals. The age and origin of these likenesses are hard to determine in many cases, but it is thought that they could be up to 5,000 years old. In the middle of each arrangement is a cairn, forming a kind of hub from which spokes of stone radiate. The best-known of these sacred wheels is to be found at Big Horn.

The Big Horn Medicine Wheel is located close to Medicine Mountain, one of the tallest peaks in the Big Horn Mountains. The Native Americans who built the medicine wheel at Big Horn were presumably members of the Cheyenne, Crow, Shoshone, or Arapaho tribes, as their hunting grounds were here. There are no written records, but oral tradition suggests that the sites may refer to legendary or mythical events. There is a similar lack of information regarding the exact rites and ceremonies held here, but they may have had something to do with the sundance ritual. The wheel, with its 28 spokes and a diameter of 100 feet (30 m), certainly resembles the sundance sites known from Cheyenne culture, where there was a hut with a central post and 28 roof joists. The hut was used for sacred solar rituals. Prairie tribes consider the sundance the most important of their ceremonies, and its practice soon spread to other peoples. The Big Horn Medicine Wheel may have been shaped to resemble such a hut or used for a similar purpose. Today Native American tribes preserve the wheel in their collective memory as a traditional shrine of their ancestors.

Buffalo Heart Mountain, Wyoming

Since, for the Crow, this peak has the shape of a buffalo heart, they named their sacred mountain after it. The mountain rises distinctively from the prairie near Cody, just to the east of the Yellowstone National Park. It is a striking landmark and for the Native Americans is considered a particularly sacred place, with supernatural power radiating from its summit that caused people to have visions. Going in search of such visions was an emotionally testing and highly devout act. Senior members of the tribe were expected to submit themselves to particular privations, and as the supernatural strength required for this ordeal could only be granted by higher powers, the tribesmen had to attempt the arduous climb up the mountain to receive this.

Those who reached the summit and had prepared themselves adequately through ritual self-denial would be granted visions. Such self-denial was an expression of exceptional humility intended as a mark of respect before the powers of the Divine. Several days of fasting without water were required,

which induced a hallucinatory state. Sometimes a blood sacrifice was called for and the visionary would cut flesh from his own legs or arms. The visions were said to bestow metaphysical strength to which the tribe could have recourse in times of trouble. The majority of the visions experienced were extremely personal and while responsibility for their interpretation lay with the tribal shaman, the deeper meaning of the hallucinations was reserved for the visionary alone. These practices from the past are no longer carried out by the Native Americans but their memory is kept alive in the tales of the Crow, and the mountain remains a visible sign of their profound devotion.

were used for some sort of ritual purpose. This interpretation is supported by other likenesses scratched into the rock: enigmatic circles with larger, overlaid crosses are reminiscent of the medicine wheels to be found in particularly great numbers in Wyoming, territory that is still inhabited by the Cheyenne, Arapaho, and Shoshone. It is not impossible that the circles on the stones are symbols of a sacred ritual; the arms of the cross indicate the cardinal points of the compass or the four winds and the disk itself may represent the sun. Sun and wind have a hallowed place in Native American belief: all good things come from the sun, and the winds determine the climatic conditions to which the tribe is exposed—violent storms in summer and a wintry north wind that not only brought cold and unsettled weather but was also feared as a herald of disease and death. It is likely that such rock art was created where the Native Americans conducted their ceremonies.

Castle Gardens, Wyoming

The Wind River Reservation in central Wyoming is the site of one of the most impressive prehistoric northern Native American shrines ever discovered. Castle Gardens is named for the bizarre shapes that erosion has carved in the local sandstone rocks, which from a distance resemble the crenelations of a castle. There has been a settlement here for millennia, and evidence of past cultures and ritual practices is etched into the stones in the form of petroglyphs. The depictions of shields, probably used for hunting or war, are especially well known.

The shields are colorful and finely wrought and it is likely that the images

Devil's Tower, Wyoming

This imposing mountain, rising up out of the grass plains of northeastern Wyoming to a height of 865 feet (264 m), can be seen for miles around. Despite its resemblance to a giant tree stump, geologists have identified the mountain as an extinct volcano. The frozen column of magma has

been eroded by the action of wind and water over the course of millennia to leave the formation with its characteristic appearance. Many Native American tribes have come to revere it as a sacred place.

A comprehensive survey of the peoples and tribes who settled in the area found that 21 communities had some kind of cultural or ritual association with the mountain, and the best-known and most popular of these comes from the Kiowa. They call the Devil's Tower Mateo Tepee,

The furious bear jumped at the rock, scratching the stone with its claws. The Kiowa believe the girls can still be seen today, as stars in the sky.

Bear Butte, the Black Hills

"The White Man offered us a hundred million dollars for the Black Hills. A hundred billion wouldn't have been

Devil's Tower, Wyoming

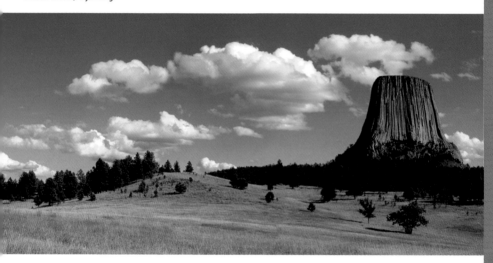

"the home of the grizzly bear." Legend has it that seven little girls were once playing at this spot when they were attacked by a bear. In desperation, they climbed on top of a rock and asked it to help them. At this the rock grew upward, reaching right into the sky.

enough, nor yet four hundred billion! It wouldn't even cover the damage that you have done. You will never be able to repay us for what you have stolen and destroyed, for all the eagles, buffalo, and game you have killed. The Black Hills are not for sale, they are

the birthplace of the Lakota and the burial place of our ancestors, and the site of our sacred ceremonies." These are the words of Noble Red Man (1902–89), a Lakota chief, and they are no lie. The Lakota claim to the Black Hills of South Dakota is indisputable; a treaty of 1868 promising them the area has often been broken but never annulled, a fact recognized by the US government, which has offered great sums in compensation. The Lakota are not looking for money, however—they want their land and have been fighting for it for decades. Bear Butte (Paha Mato in the Lakota language) is the Lakota's holy mountain, and it is also venerated by the historic Dakota, Nakota, Cheyenne, Arapaho, Kiowa, Crow, Arikara, Mandan, and Hitatsa, the so-called Bear Butte tribes. They have always come here to seek visions and it is where their identity resides.

Their long-standing dispute with the state has been compounded by a new problem with New Age followers, who have started to use the mountain for their rituals, thus desecrating the holy ground. As far as the Native Americans are concerned, this intolerable state of affairs cannot be allowed to continue. One of their songs contains the line: "Lakota are brave. Hard times are coming, but we shall survive them." It can only be hoped that those who visit the mountain approach it with respect for ancient tribal culture and religion and thus experience some of the spiritual power emanating from this sacred place.

Pipestone National Monument, Minnesota

The red stone here is called catlinite and it is found only in thin strata at this one location; mineralogical analysis reveals it to be a metamorphic rock composed of several other minerals, with hematite lending it its reddish coloration. The red stone is considered sacred, and Native Americans have been making their pipes from it for centuries. The area that is now the national park was once the property of the Lakota, who traded the sought-after stone right across the Great Plains. When they were obliged to relinquish the land and move onto their appointed reservation in 1928, they managed to negotiate a concession from the new owners, the federal government, whereby the tribes would be permitted to mine the stone in perpetuity. The rare and sacred stone is still being carefully excavated to this day.

There is evidence of pipestone use among the northern Native Americans going back more than 2,000 years. These so-called "platform" pipes were often fashioned in the form of a bird, while skillfully worked, T-shaped pipe bowls which can be placed on a long stem are even better known. Pipe-smoking has always been a sacred ritual for Native Americans and it is still practiced today at particularly holy sites. Tribes cement peaceful intentions by smoking together and believe that the smoke from the pipe carries their prayers to the Great Spirit. Even

though the traditions of the various tribes of the Great Plains are extremely varied, they all have this cult ritual in common. It is therefore no surprise to learn that there is a long waiting list for the coveted licenses to mine the stone.

Holy Hill Basilica, Milwaukee

The history of this sacred place begins with François Soubrio, a French hermit, who retreated to this lonely hill near Milwaukee in the mid-19th century. Although the local Irish immigrants initially treated him with suspicion as a religious eccentric, his lifestyle eventually won him their respect and they began to provide him with enough food to live on. German and Austrian settlers arrived in the area in 1854, building a simple oak cross on the hill, which even then was thought of as holy. This crucifix, bearing the words of Christ, "I am the way, the truth, and the life; no man cometh unto the Father but by me," is still to be seen in the present church.

The first small Marian church, surrounded by a simple path with the Stations of the Cross, was built in 1863, and the holy hill soon became the destination of pilgrimages from the local area. A few years later, in 1880, construction work began on a larger church, and this period also saw the arrival of the Discalced Carmelite Order, which took over the running of the shrine and built a monastery complex and a pilgrims' hostel. Even this church soon became too small and so the modern building was begun, which was consecrated in 1931. Various alterations and extensions were undertaken in the 1940s and 1950s to complete the present appearance of the complex.

This neo-Romanesque brick church with its marble ornamentation dominates the low hill. Despite its remoteness, every year the shrine attracts up to 300,000 visitors, who come to pray to the Virgin Mary for assistance and direction in their lives.

House of Worship, Chicago

The Bahá'í faith was founded in the mid-19th century as an offshoot of Islam. The religion is based on the practical teachings of the Muslim faith and is open and tolerant toward other beliefs. Bahá'í temples are now to be found throughout the world; the American branch is one of the oldest Bahá'í communities in the world. The foundation stone for the temple in Chicago was laid by Abdu'l Baha, the son of Baha'u'llah, the religion's founder, and the building was consecrated in 1953 after 30 years of construction work. Like all Bahá'í places of worship, the building is

nine-sided, and the nonagonal base is topped with a large central dome.

The "House of Worship," as the Bahá'í call their temples, is the centerpiece of an elaborately laid-out garden of Bahá'í symbols. The paths, the flowerbeds, and the fountains combine in harmonious unity to make the complex a place of reflection, tranquility, and inner peace. The columns of the surrounding nine-sided path are of interest in that they are decorated with symbols from various religions, an indication of the tolerance demonstrated by Bahá'í followers to other faiths. There is a cross for Christianity,

a Star of David for Judaism, and a sun wheel for ancient religions.

Those wishing to learn a little about the history and basic tenets of the Bahá'í religion may drop into the visitors' center in the building. The large windows on each floor flood the interior with light, creating an atmosphere of airiness. One little room on the lower floor conceals a rather strange sacred object: a rocking chair. The chair, said to have belonged to Abdu'l Baha, is greatly venerated by the Bahá'í, as he was the most influential figure in promoting the religion in North America.

House of Worship, Chicago

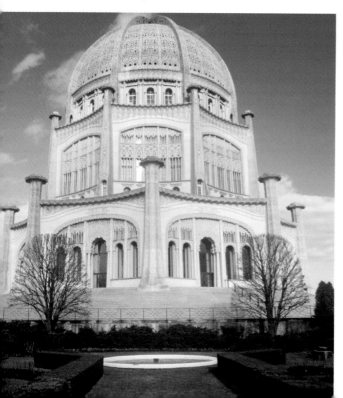

Monk's Mound, Cahokia

Relics such as those that have become world-famous in Mesoamerica are rarely found in North America, but the large pre-Columbian earthworks pyramid at Monk's Mound is an exception. The mounds at Cahokia could be described as a ceremonial city; the total of more than 100 pyramids and funerary mounds were in all likelihood used as a ritual center by at least 50 different communities. The

extensive complex is now classified as a national monument, and at its center stands the most important ceremonial hill, Monk's Mound, which was named after European Trappist friars who settled here for a period from 1809.

The mounds are thought to date back to the Mississippi civilization, which flourished between 800 and 1250. The arrangement of the mounds would suggest that this civilization's communities were subject to an ordered social structure and hierarchy similar to that known from Mesoamerican societies. Their king was known as the "Great Sun" and was presumably worshiped in some manner. Monk's Mound was the royal hill and a temple is presumed to have stood on its summit, housing the eternal flame. Human remains have been discovered on Monk's Mound that confirm that a royal burial site was located here, and it is probable that human sacrifices also took place, as many of the skeletons unearthed are missing their hands or head.

Finds of this kind are evidence of the burial site's status as an important ritual center, but it is still unclear why the once-flourishing city was abandoned. By the time Europeans were taking over the country, the city had already been deserted and the monumental earthworks were covered in undergrowth. Many of the Mississippi civilization's secrets are yet to be revealed, but visitors will get a sense of the enormous effort put into the construction of these sacred places and of the silent fascination they exert. The Divine and the enigmatic have always belonged together.

National Shrine of Our Lady of the Snows, Belleville

Snow fell on the Esquiline Hill in Rome during the night of August 4 to 5 356, and in it Pope Liberius saw the outline of the church that the Virgin Mary had commanded him to build in a dream. The church that was subsequently built, Santa Maria Maggiore, has been known ever since as Santa Maria delle Neve. The National Shrine of Our Lady of the Snows, a modern pilgrimage site in Belleville, Illinois, near St Louis and the largest such shrine in north America, also refers back to this miracle.

The extensive complex is situated in a large, wooded valley filled with greenery and flowers. Its centerpiece, a circular building intended to represent the universality of the Roman Catholic Church, is a place of worship dedicated to Our Lady of the Snows. Adjacent to the church lies a striking open-air altar surrounded by a grassy amphitheater, and other shrines and places of worship are scattered throughout the grounds. In the valley there is a reproduction of the grotto at Lourdes, an arbor laid out to resemble the Garden of Gethsemane, a path with 15 Stations of the Cross leading to the Resurrection Garden, an Annunciation Garden, a Prayer Walk, and a Memorial Wall dedicated to St Joseph and all other fathers. The Prayer Walk is lined with life-size figures portraying scenes from the Bible as an aid to meditation.

The pilgrimage site also has a center for families with children where

both young and old can learn more about the faith. The National Shrine of Our Lady of the Snows is a place for everyone, irrespective of their beliefs, and though it resembles a large park, the emphasis here is not on the natural world but on spiritual experience.

Abbey of Our Lady of Gethsemani, Trappist

This Trappist monastery in Kentucky achieved world renown through the presence of a monk whose life and work have led him to be revered as a 20th-century saint, even though he is yet to be formally canonized by the Roman Catholic Church. The books and especially the way of life of Thomas Merton (1915–68) have been instrumental in moving hundreds of young men to follow him on a lifelong search for a deeper union with the self and with God. His autobiography, *The Seven-Storey Mountain*, appeared in 1941 and its candid narration of his life-story enjoyed sensational success across the world. Many have compared it to St Augustine's *Confessions*.

Merton understood monks as people in search of God who are attempting to overcome their "false self" by renouncing a life of lies and artificial security. Toward the end of his life he turned his gaze to the east, imagining a symbiosis of Christianity

and Buddhism. Having received permission to travel to a monastic conference in Bangkok in 1968, he had meetings with Sufi mystics and even the Dalai Lama—each man left a lasting impression on the other. Support for the integration of Christian faith with Buddhist doctrine is alive and well at the turn of the third millennium, even if it has not found expression anywhere in an organized form.

Thomas Merton did not found the Abbey of Gethsemani in Kentucky— it is more than 150 years old—but his name is indelibly associated with it. The monks here live according to the strict Cistercian Rule, but every guest receives a warm welcome— especially those who have begun their search for spiritual advancement.

Serpent Mound, Ohio

Mysterious forms and sculptures have been carved in rock or marked out on the ground all over the world. In many cases there is little indication of quite what the images might represent, but it can be assumed that they were once revered as sacred places. Serpent Mound in Ohio is one of the most impressive and yet also one of the most cryptic. It is assumed that the earthworks here were laid out by the Adena and Hopewell Native Americans who lived here more than 2,000 years ago. A raised base, like a winding

hill, supports a chalk line almost 1,320 feet (400 m) long resembling a giant snake with an egg in its mouth.

This sacred place was almost lost forever, as before its discovery

The snake is a religious symbol in many cultures across the world. Egyptians, Aborigines, Celts, Maya, and Hindus all recognize the snake as a powerful and supernatural crea-

Serpent Mound, Ohio

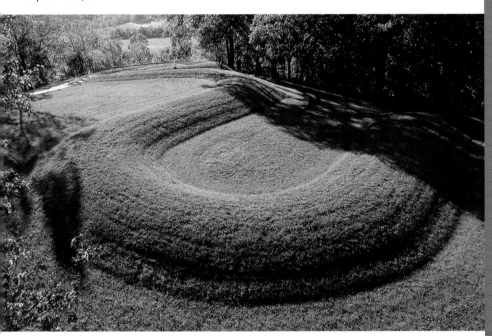

there had been several attempts to uncover buried treasure nearby and the area was to be ploughed for agricultural use. The mound was only systematically researched from the mid-19th century, although to date findings have only principally revealed that the site will not easily give up its mythical secrets. The reason for the hill's construction still remains a mystery.

ture. Snakes have always had strong symbolic importance, often representing wisdom. Early artists made use of snake motifs, as the coils of the snake's body promoted meditation and thus the raising of consciousness. In Indian mythology, a horned snake is the protector deity of the springs from which life is born. Serpent Mound lies above a plentiful source of water and the egg in the snake's mouth is likely

to have originally been a stone circle. It has been suggested that a fire was lit in this circle during sacred rituals, perhaps as a sign that the snake spirit guarding the water was now present.

There are hundreds more such earthworks in the area—similar mounds with images of various figures and animals. Our relative ignorance of the use of these mounds makes them especially sacred. The mysterious nature of the Divine cannot be controlled and is open only to those who are prepared to approach it in wonder. This is the way it has always been.

Holy Cross Monastery, New York

Holy Cross, a Benedictine monastery founded in 1884 and surrounded by extensive and historic grounds on the west bank of the Hudson River, is a place of reflection and peace in the middle of the city that never sleeps. Visitors come here to reflect upon their lives and strive toward a spiritual renewal which, according to the monks, can be like a rebirth. To this end, they organize courses in Christian meditation and other events addressing both spiritual matters and such modern problems as time management. The monks are always happy to discuss matters of morality and faith and have proven to be attentive companions on life's journey.

In addition to the simple church of St Augustine and the monks' accommodation, the monastery grounds also contain two guest houses where people in need of recuperation or in search of the spiritual are always welcome. Visitors are invited to share the life of the monks for a certain amount of time, taking in the experience of the Benedictine Rule and its motto of *ora et labora*. Besides work, the emphasis is on prayer, for which the monks have recourse to a saying attributed to Teresa of Ávila: "Pray the way you can, and not the way you can't!"

Many New Yorkers and others from further afield have taken up the invitation to visit this beautifully situated and hospitable monastery. They come to study, either alone or with the monks, and to escape the daily grind, at least for a short time. Leaving this place with a new-found calm, many choose to return.

Emanu-El Temple, New York

New York is without doubt the most Jewish city outside Israel. More than half of America's Jewish population lives in New York and almost one resident in four is Jewish. Jewish tradition, with its customs and holidays, is entrenched in public life: a modern New Yorker eats *lox* on a

bagel, many of the streets are pretty much deserted on Yom Kippur, and public schools close for all the major Jewish holidays, just as they do for Christian festivals. New York and its Jewish population are inseparable.

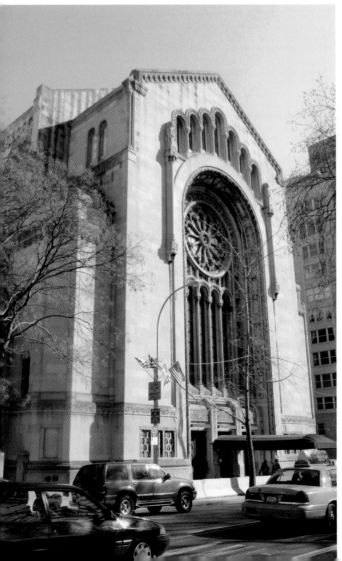

Front façade, Emanu-El Temple, New York

While there is a large number of Orthodox Jews, the great majority of the Jewish population would consider itself to be part of the Reform movement. Reform Judaism distinguishes between the religion's ethical and ritual commandments; the ethical rules are sacrosanct, but ritual may be adapted to suit the surrounding culture. Reform Jews may therefore decide which of the ritual commandments they will follow. Unlike the Orthodox, they are not awaiting a Messiah in person, but rather a Messianic era. Reform Judaism has its roots in 19th-century Germany and is now the largest branch of Judaism in North America. Reform Judaism is more than happy to have contact with other faiths and promotes the absolute equality of women in synagogue services and other rituals.

As might be expected, the Emanu-El Temple, the center of Reform Judaism established in New York in 1845, is a

lively place of faith and the reaching out to people of all beliefs. Its prominent location on Fifth Avenue, at the edge of Central Park, may have something to do with its popularity. Emanu-El is Hebrew for "God is with us" and this may be interpreted as a reminder that God is with those who are sure in their faith and yet at the same time practice a tolerance rooted in the old ideals of humanity, a tolerance that can help people to engage with one another without prejudice and in mutual respect.

Cathedral Church of Saint John the Divine, New York

✠

The stated goal of the Cathedral Church of Saint John the Divine is to be a house of prayer for all. Construction was begun at the end of the 19th century, a date you would not guess from its European Gothic lines. The original plans had in fact envisaged a neo-Romanesque/ Byzantine structure, but work on the church was put back considerably during the two World Wars and the plans were eventually altered. The cathedral was still unfinished immediately after the war—lack of funds hampered the continuation of the project. Then a fire in December 2001 destroyed large parts of the building. The church is the third largest in Christendom, although parts of it are still not completed, or rather have not yet been repaired. New Yorkers call it "St John the Unfinished." The most recent renovation work began in 2005 and was completed in 2008.

The church's floor plan is based on that of many French cathedrals, with a wide dome above the crossing and seven apsidal chapels behind the choir. Known as the "Chapels of the Tongues," they are dedicated to seven Old World saints representing the seven largest immigrant communities of the time—Saints

Interior of the Cathedral Church of Saint John the Divine, New York

The Basilica of the Immaculate Conception, Washington

Ansgar, Boniface, Columba, Savior, Martin, Ambrose, and James.

It is not just the size of this cathedral that impresses. It is rather that it is a living venue for the people of all faiths and of all nations, who live in this extraordinary melting pot of a city.

Basilica of the Immaculate Conception, Washington, D.C.

It was the first bishop of the Roman Catholic Church who placed the newly founded "United States" under the protection of St Mary of the Immaculate Conception in 1792. Pope Pius IX announced the dogma of the Immaculate Conception in Rome in 1847, thus enshrining it in official church doctrine, and St Mary of the Immaculate Conception has been the patron saint of the entire Catholic community of the United States ever since. This church dedicated to her is one of the capital's most striking buildings. Set in extensive grounds acquired by the Catholic University, it is the largest basilica in North America. Construction of the neo-Byzantine church began in 1920, but work was halted by the Great Depression in 1929, by which time only the crypt had been completed. American entry into World War

Mount Shasta, California

the original plans. The mosaics in the Dome of the Trinity are also due to be extended in the near future. The basilica contains 70 chapels dedicated to the Virgin Mary, reflecting the many different artistic traditions of the immigrant communities who donated the money for them. The chapels are an indication of the rich cultural diversity of this treasure-house of faith and tradition. Pope Benedict XVI awarded the church a golden rose in 2008, the highest distinction for a Marian shrine.

Mount Shasta

II delayed the ambitious project for several more years. Work was restarted in 1953 and the church, which was to become so important for North Americans, was finally consecrated in 1959. Since then it has been visited by more than a million people a year from the local area and further afield.

The red sandstone building is topped by the giant Dome of the Trinity, which is covered in colored tiles. The interior of the church is also richly decorated with glazed tiles. The Greek Orthodox-style mosaics may remind some visitors of St Mark's in Venice. The Dome of the Redemption (2006) and the Dome of the Incarnation (2007) have recently been decorated with mosaics according to

Although this location is not sacred to any established religion, it could be considered holy—in the widest sense—for followers of the New Age movement, a philosophy with no founder and no fixed religious practices but which nonetheless bears traces of religious or at least supernatural beliefs. People who believe a new age has dawned are seeking, in their own way, a kind of transcendental experience. As well as appealing to New Age followers, Mount Shasta, a 14,165-foot (4,317-m) volcanic cone in northern California, is sacred for all those seeking a meaning in life. Readings have been taken that indicate the presence of a mysterious gigantic field of energy that is centered on the mountain and radiates out in all directions for 95 miles (150 km).

Local people tell tales that illustrate the magic of the place. There are stories of strange happenings, ranging from the curious effects of fluctuations in the energy field to rebirths. You may regard such stories with some skepticism, but it is certain that many people who feel oppressed by modern civilization, and who have found no relief in the established religions, have discovered in Mount Shasta a place where they can experience their conception of the Divine.

El Capitán, Yosemite Valley

El Capitán is the holy mountain of the Miwok. Almost 3,300 feet (1,000 m) tall, this granite monolith towers over a river valley that was covered in ice around the time that the mountain was formed more than half a billion years ago. The smooth shape of the rockface and the strange formations are a result of the action of the water that was released when the ice melted. The territory of the Miwok is known as being a place inhabited by many bears and the tribe takes its name from the animal—*miwok* means "bear." Considered to be

The sacred mountain of El Capitán, Yosemite Valley, California

related to humans, bears have a particular status in Native American legends and are worshiped by the Miwok and by other Native American tribes. Of all the animals, the bear is believed to have a spirit closest to a human soul and to be able to understand the languages of other creatures and even of man. Nowadays the expanses of the national park, the ancestral homelands of the Miwok, are home to more bears than people; a recent census has shown that there are only around 4,000 members of the tribe left.

Tribespeople would visit the sacred mountain to receive visions and to honor the Great Spirit with dances and other ceremonies. El Capitán is now a popular destination for climbers and basejumpers, who head for the overhanging south face of the mountain, but every piton driven into the rock is another wound for the sacred peak. The only people to understand a little of the mountain's majesty are the freeclimbers who use no artificial means whatsoever to climb to the summit, although even some of these fail to recognize the holy aura surrounding this peak. The Miwok are powerless in the face of all this. One can only hope that the hordes of people who visit the Yosemite Valley will experience some of the

Mormon Temple, Salt Lake City

awe expressed by the explorer J.H. Beadle in 1871: "There is nothing to compare with it. A man should rather die and learn the tongues of angels than try to describe Yosemite."

Hsi Lai Temple, Los Angeles

Hsi Lai Temple, the largest Chinese Buddhist temple in the United States, is located in Hacienda Heights, a suburb of Los Angeles. Hsi Lai means "coming west," and this is both a name and a philosophy. The temple is intended not only for the use of Los Angeles' inhabitants of Chinese descent, but is open to all. Hsi Lai is part of Guang Shan, a relatively new branch of Buddhism established in 1967, which combines elements of Chan (Zen) and the old teachings of the Pure Land. The school's basic approach is one of "humanist Buddhism," a life-philosophy of encouragement, amicability, and compassion intended to equip its followers to live their daily lives in harmony with themselves and others.

The modern temple and its adjacent monastery complex were built in the style of the Ming and Ching dynasties and include several sacred buildings and gardens. There is a pagoda, a main shrine, and a Bodhisattva shrine, as well as lecture halls, a tea room, a museum, and of course a store where visitors can buy Buddhist religious paraphernalia.

The main shrine, dedicated to Shakyamuni, is the heart of the temple complex and contains three great statues of the Buddha: Shakyamuni, the historic Buddha, Amitabha, the Buddha of Infinite Light, and Bhaisajyaguru, the Medicine Buddha. The Bodhisattva hall on the other side of the quadrangle is entered through an elaborate portal whose three doors represent the three jewels of Buddhism—Buddha himself, *dharma* (the law), and *sangha* (community). Both monks and nuns live in the monastery. The Diamond Sutra and the Amitabha Sutra are recited during the weekly prayer ceremonies. There are also meditation courses which are open to non-Buddhists. Built between 1978 and 1988, the temple complex is a modern shrine that keeps alive an ancient religious tradition.

Salt Lake Temple, Salt Lake City

Salt Lake City is the home of the Church of Jesus Christ of Latter-day Saints, whose members are known throughout the world as Mormons. Begun in 1853 and consecrated in 1893, Salt Lake Temple is this religious community's best-known and largest place of worship. The giant building, constructed in a neo-Gothic style, is a mighty witness to a self-confident religion combining biblical and

contemporary traditions. Many of its rituals, which contain traces of Masonic tradition, are kept as secret as possible. A letter of permission from the bishop has to be obtained by outsiders wishing to enter the temple and silence is commanded during the services and ceremonies. The temple stands in the center of its own extensive grounds. Every Mormon temple is considered the "House of the Lord" and is intended to represent the restoration of the complete Gospel of Jesus Christ. The Gothic notion of the *ecclesia triumphans* (the "Church Triumphant") has found a modern architectural echo here.

Various rituals, considered holy by members of the Church of Jesus Christ of Latter-day Saints, are carried out in Mormon temples. These are baptism—including the proxy baptism of the dead—"endowment," and "sealing." These rites are concerned with life in this world, but in Mormon belief they are also a prerequisite for a believer's admittance to the kingdom of heaven (the "Celestial Kingdom of Glory"). Endowment is an initiation rite that takes the adult church member through a ceremony based on human life and world history, from the Creation and the Fall of man to redemption through Jesus Christ and final return to God in his celestial kingdom. According to church doctrine, sealing is a way of uniting individuals or even whole families forever, and in Mormon belief such ties last even beyond death. Salt Lake Temple impresses, not least for its size, but the building has a strange feeling of coldness that is difficult to overcome.

For members of the Church, however, it is the most sacred place on earth.

Blanca Peak and Hesperus Peak

The Navajo's vernacular word for their ancestral homeland is Dinétah, meaning "among people." The territory is extensive and includes large parts of northwestern New Mexico, southwestern Colorado, southeastern Utah, and northeastern Arizona. The exact boundaries were never established, but the furthest extent of their lands toward each of the four points of the compass was marked by mountains. In Navajo belief, there is a mythical mountain in the middle of the world that is the source of all life and all earthly phenomena. The mountain has no particular geographical location but is nonetheless a central feature of the Navajo's cosmological legends.

The Navajo believe that, at the beginning of time, one of the four pillars of the world rose up in the form of a mountain, to the east of the mythical mountain. Known to the Navajo as Tsisnaasjiní and considered sacred to the rising sun, this mountain with mythical origins towers 14,340 feet (4,372 m) above the Colorado prairie. Its other name is **Blanca Peak**. As its summit and flanks often remain covered in snow until well into summer, the Navajo

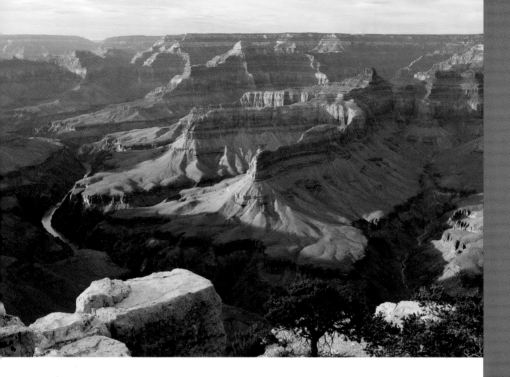

Grand Canyon, Arizona

believe it to have been created from a pile of white mussel shells by the First Man. The mountain is associated with masculine strength and is the sacred mountain of the east.

For the Navajo, **Hesperus Peak** (Dibé Ntsaa), a 13,235-foot (4,034-m) summit in the La Plata Mountains, is the sacred mountain of the north, and marks the northern extremity of the Dinétah. It is associated with the color black—according to the Navajo, the mountain is enveloped in a covering of deepest black. The legend tells how the First Man created the mountain, fastening it to the ground with a rainbow and covering it with darkness.

In addition to these two peaks, Mount Taylor (Tsoodził) marks the mythical southern pillar of the world and Humphreys Peak (Diichilí Dził) in the San Francisco Peaks marks the western pillar.

Grand Canyon, Arizona

The Colorado River which formed this great chasm has flowed through Arizona for millions of years. The canyon that it carved out, cutting

down through the rock strata, features deep gullies and strange rock formations. The scenery is breathtakingly beautiful. Natural processes continue to shape the landscape in ways that are as inexorable as they are measureless to man. It is easy to get a sense of our insignificance in such a vast natural arena. Despite the canyon's majestic peacefulness, it is not without danger: thunderstorms can be carried along it for miles and rain swells the streams into flash floods that appear from nowhere. Nonetheless, the area was inhabited by people 12,000 years ago; traces of settlements and the remains of storage buildings suggest that there were farmers and other settlers among the hunters and nomads. The territory is now divided among several Native American tribes. Although these have quite different ways of looking at the world, their myths concerning their environment and the defense of their territory show marked similarities.

The Hopi believe their ancestors came out of a cave in the canyon where the tribe still lives. These ancestors gave them permission to settle here on the condition that they took over stewardship of the canyon; protecting the area is considered the Hopi's sacred duty.

The Navajo, who began to settle here about 700 years ago, have also pledged themselves to protection of the natural world—the earth spirits should not be offended. The Havasupai have similarly assumed the task of protecting the canyon, as they believe it to be the birthplace of mankind and the site of an annual

renewal of Creation spiritually comparable with the beginning of spring.

The Grand Canyon is a unique phenomenon in the earth's natural history, and the people who live here have much to teach visitors about respectful treatment of the earth's sacred treasures.

San Francisco Peaks, Arizona

The San Francisco Peaks, north of Flagstaff in the highlands of Arizona, are the highest mountains in the state. The mountain range is sacred to both the Hopi and the Navajo. The Navajo consider the 12,630-ft (3,850-m) summit of Humphreys Peak to be one of the pillars of the world, while the Hopi believe that spirits (*kachina*) live in the mountain chain.

Considered descendants of the Anasazi, the name of the Hopi people also describes their way of life—in their language *hopi* means "accord," and they are renowned as a gentle, peace-loving, and humble people. A legend recounts how, soon after the Hopi's wanderings had brought them to these mountains, they noticed the presence of strange spirits flitting around their dwellings. One of the Hopi then climbed to the summit of a nearby mountain and encountered a human-like creature who identified himself as a spirit. Since this encounter, the Hopi have maintained good

relations with the spirits, whom they characterize as long-nosed creatures called kachina. The kachina live in everything—in the expanse of space, in the stars, in mountains, in rocks and animals—and can even take on a human appearance. Their home is in a great underground lake and they function as mediators between mankind and the highest powers. They are considered benevolent friends to both individuals and the community. There are said to be 250 kachina, and they exert great influence on the weather and the natural world. The Hopi honor them to this day with special ritual dances and sacrificial offerings from their produce at harvest time.

The Navajo refer to themselves in their native language as Diné, meaning "mankind." They too have a special relationship with mountains, as their Creation myth describes four mountains that form the pillars of the world. In the center of the universe there is a great rock whose four faces, each pointing in a different direction, shine with different colors. They call this mountain simply "the mountain surrounded by mountains" and it is the center-point of their existence. The mythical central mountain is surrounded by a wide ring of four other mountains: Hesperus Peak in Colorado is the northern mountain, Blanca Peak, also in Colorado, is the eastern mountain, Mount Taylor in New Mexico is the southern mountain, and Humphreys Peak, the highest point of the San Francisco Peaks, is the western mountain. These peaks are so sacred to the Navajo that they have recently begun to take complaints to the highest courts in the United States whenever highway-building or tourist sites are planned for the area.

Meteor Crater, Arizona

Together with the Apache, to whom they are related, the Navajo now form the largest of the Native American tribes. Their settlements are to be found in Utah, New Mexico, and especially Arizona.

The Navajo Creation myth follows four successive periods. The first phase, the Beginning, tells of the First Man's ascent to the earth from the underworld. Order is created during the second phase, the age of the animal heroes. The third phase, the age of the gods, witnesses a battle between the good and the bad spirits, and the fourth phase concerns the growth of the tribe and its migrations. For the Navajo, everything in existence has a soul. One of their most important gods is the serpent god, who not only observes man, but also teaches him, using earthly signs. A god of fire, he flew across the earth hurling lightning and thunderbolts, one of which created Meteor Crater, not far from the town of Flagstaff in Arizona. Native Americans regard this site as a sacred place as it was here that the serpent god revealed himself to man.

From a less mythological standpoint, Meteor Crater was formed

when a giant meteor landed here aproximately 50,000 years ago. It left behind a crater almost 660 feet (200 m) deep and more than half a mile (1 km) across with a raised rim. The crater attracts many visitors who come to marvel at what such mighty cosmic forces can do, and before which the might of man pales into insignificance. Unlike the Navajo, the people who come to see the crater may not associate the site with any myths, but from the vastness of the depression, it is easy to see how a mythical interpretation could come about. Man would do well not to think himself greater than nature or to underestimate its power; many would regard this crater as a lasting warning.

Meteor Crater, Arizona

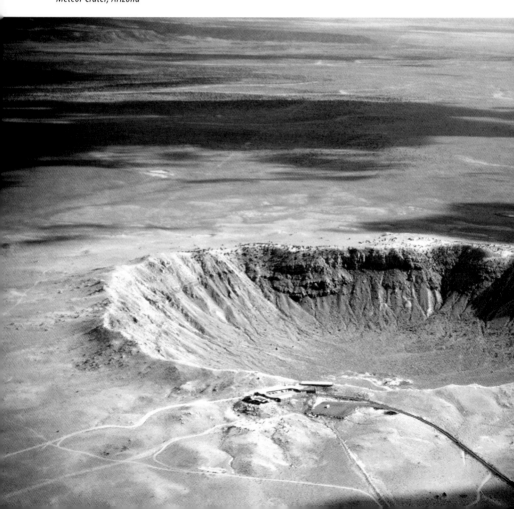

Mount Taylor, New Mexico

Almost 12,500 feet (3,500 m) high and extinct for more than a million years, this volcano is known to the Navajo as Turquoise Mountain (Tsoodził) and is regarded as sacred.

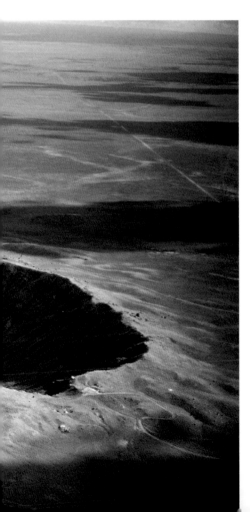

The tribe believe it to be the home of the serpent god, the lord of hostile spirits and evil monsters that also live on the mountain, and in Navajo myth it is important to gain power over them. They call any spirits that disrupt everyday lives "monsters." These spirits are the kind of forces encountered in all our lives that may prove to be extremely destructive unless tamed. These mythical forces can be likened to the destructive impulses that modern analytical psychology has identified in people. For the Navajo, there is only one way to tame such monsters and that is to call them by their proper name. Every monster, and every misfortune, has a name, and when that name is discovered, the monter loses its power. The real monster on the mountain, however, is the uranium that was mined here in great quantities between 1942 and 1968, largely for use in the manufacture of weapons.

The Navajo still visit this mountain beneath a turquoise sky, praying, invoking the spirits, and dancing to save the world from evil. When tourists and other people visit Mount Taylor, even though they know nothing of Navajo beliefs, they still feel a little of the enigmatic and unearthly power of the mountain.

Mount Taylor is the southernmost of the Navajo's four "pillar-mountains" supporting the world. The northern mountain is Hesperus Peak in Colorado, the eastern mountain is Blanca Peak, also in Colorado, and the western mountain is Humphreys Peak, the highest of the San Francisco Peaks.

Santuario de Chimayo, Chimayo

This sacred place is an extremely popular pilgrimage site and has become known as the "Lourdes of America." The story of its foundation desribes how a monk from Chimayo had a vision of a light on a small hill in 1810. He dug a hole in the ground with his hands on the site where the vision appeared and found a crucifix, which he brought to the church at Santa Cruz. Curiously, the crucifix was discovered the next day back at its original location. A solemn procession carried the crucifix back to Santa Cruz, but again it disappeared, only to reappear in its hole in the earth. The same procedure was carried out a third time, before the people realized that the crucifix wished to remain in Chimayo. A small chapel dedicated to the crucifix was then built around the hole in the ground where the cross was found, and stories soon began to spread of cases of miraculous healing, all of which were associated with earth from the hole.

The ensuing stream of pilgrims meant that a larger place of worship soon had to be built, and this red clay church with its two low towers and paved courtyard planted with shady trees has now become the most important pilgrimage site in New Mexico. Tens of thousands come here

Santuario de Chimayo pilgrimage church, New Mexico

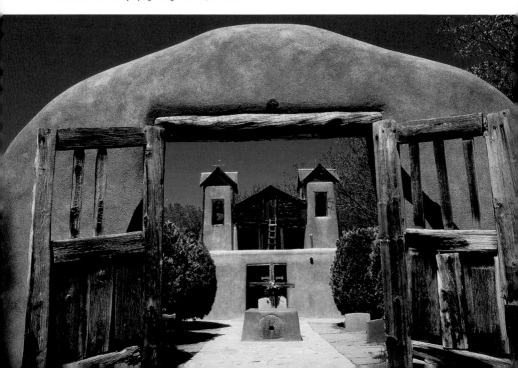

every year to seek healing for all kinds of ailments, although Holy Week is the busiest time for the shrine, with crowds turning up on the night before Good Friday in particular. Most of the faithful begin their journey at Santa Fe and some still walk the whole way from there. Many arrive by car these days, driving up to the site and covering only the last few yards under their own steam, often on their knees. Almost all will loosen some earth from the hole in the church, and this is taken home for its healing powers. Miraculous qualities have been ascribed to the soil and stories of spontaneous healing are legion here. There is a large collection of crutches, wheelchairs, votive tablets of thanks, and other paraphernalia in the sacristy. After visiting the shrine, many pilgrims climb a nearby hill where a modern cross has been erected.

Mount Graham, Arizona

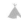

Every year since 1992, something rather unusual has been taking place on Mount Graham in southern Arizona. Thousands of people, both Native American and non-Native American, can be seen running up the mountain. The Protest Run has become a widespread demonstration organized by the Apache Survival Coalition and the Apache for Cultural Preservation Organization; the participants are protesting against the appropriation and desecration of this sacred mountain.

As with all Native American tribes, the Apache have their own sacred places, and the holiest site of all is Mount Graham, which the Apache call Ga'an on Dzil Nchaa Si An in their own language, which translates as "Great Resting Mountain." It was originally part of San Carlos Reservation but was appropriated by the federal government in 1873, which meant that while Native Americans were still allowed to set foot here, they could no longer regard the mountain as their own. As far as the Apache are concerned, however, the mountain is a living creature and the source of their identity, as it was here that they received the "32 Songs of Life" from the Great Spirit and it was here that the mountain spirits shared their skills with the medicine men. Archeological finds have shown that the mountain was also used as a burial place by their ancestors.

Construction of a gigantic telescope was begun on the mountain's summit in 1988, and legislation was passed in anticipation of the project. The mountain's unique ecosystem, with its five climate zones and a wealth of animal and plant life, was thrown out of kilter by this project, quite apart from the desecration inflicted on such a sacred place. Political arguments over the site continue to this day, but several of the states backing the project will only provide funding on condition that the telescope finds a site other than Mount Graham. One can only hope that the Great Resting Mountain will finally find true rest and once again be left alone to be what it was for centuries—a sacred and respected place.

CENTRAL AND SOUTH AMERICA

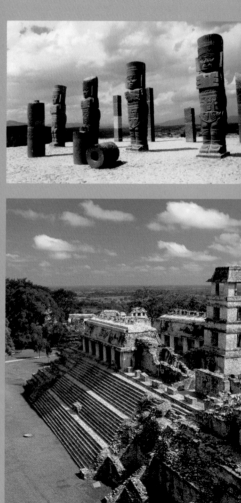

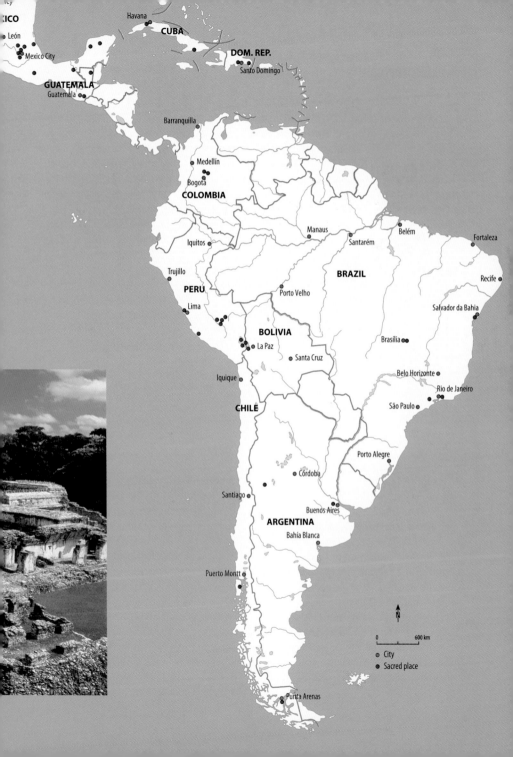

León
Havana
CUBA
Mexico City
DOM. REP.
ICO
GUATEMALA
Santo Domingo
Guatemala
Barranquilla
Medellín
Bogota
COLOMBIA
Manaus
Belém
Fortaleza
Iquitos
Santarém
Trujillo
BRAZIL
Recife
PERÚ
Porto Velho
Lima
Salvador da Bahia
BOLIVIA
La Paz
Santa Cruz
Brasília
Belo Horizonte
Iquique
Rio de Janeiro
São Paulo
CHILE
Porto Alegre
Córdoba
Santiago
Buenos Aires
ARGENTINA
Bahía Blanca
Puerto Montt

N

0 600 km

○ City
● Sacred place

Punta Arenas

Mesoamerica

Mesoamerica is the name given to the area of Central America where a series of culturally related civilizations held sway from around 1000 BC to the time of the Spanish Conquest (1519–21). Despite the many differences between these societies, there is evidence of broad similarities in culture and mythology. The people of the region all used a hieroglyphic script and employed number symbols to make astronomic calculations. They developed a calendar that recorded the days of the year and the seasons, and they all worshiped gods who fulfilled the same sorts of roles. A ritual ball game was played all over Mesoamerica involving two teams and a ball that represented the sun, but this was no mere pastime—it was an important religious ritual.

Myths emphasizing the inter-related nature of the political and spiritual worlds abounded throughout Mesoamerica. Each society regarded itself as the center of the earth and its rulers as appointed or chosen by the gods, especially the creator deities, lending the prevailing social hierarchy a divine authority. Time was understood to be cyclical and the milestones of human life (birth, marriage, death, war, and sacrifice) were seen as a repetition of the events of the past recounted as in myths. Imposing pyramids were built all over the region, emphasizing to all the god-given power of the ruling dynasties. The natural power bases of such civilizations, founded as they were on religious beliefs, were their ceremonial sites.

Although the roots of these Mesoamerican cultures stretch back to the earliest periods of human history, the civilizations to which they gave rise all but vanished after a relatively brief period of prosperity. Evidence of their existence can nonetheless be seen in the remnants of their sacred places and in the religious convictions displayed by many of the present-day inhabitants of Mesoamerica.

Chichén Itzá

The structures on the Chichén Itzá site are over 1,500 years old, making it the largest pre-Columbian palace and temple complex in Yucatán. The Maya abandoned it in about 900, but it was revived as a place of worship 100 years later when the region was conquered by the Toltecs, an infamous branch of the Itzá feared for their custom of performing human sacrifices. Maya and Toltec cultures became intermingled in the years that followed, resulting in a new, albeit brief, golden age. The focus of their religion was the worship of a feathered serpent called "Quetzalcoatl" by the Toltecs and "Kukulkan" in the language of the Maya, and the great pyramid at the center of the city was dedicated to this god.

The pyramid was built according to the laws of astronomy and astrology but was also based on mythological beliefs, with the nine platforms representing the nine realms of the underworld. Steep steps at the exact mid-point of each of the four sides lead up to the

highest platform, upon which there stands a temple. Carved serpent heads flank the foot of each flight of steps. For a few hours, on two occasions a year, an amazing phenomenon involving the interplay of light and shadow takes place here: at the spring and fall equinox (March 21 and September 23) a trick of the sunlight makes it appear as though the serpent is alive and slithering down the side of the pyramid.

Counting the top platform outside the temple, the complex has 365 steps, representing the days of the year. Another temple lies within the pyramid, watched over by an imposing statue of Chac-Mool ("Jaguar's paw"), portrayed raised on his elbows, with his legs tucked beneath him. The bowl resting on his stomach was probably a vessel to collect blood from the hearts of sacrificial victims. In the next room is a stone jaguar throne inlaid with 80 pieces of jade. The jaguar gods were among the earliest Mesoamerican deities and were associated with royalty and fertility. They played a major part in the first period of creation, the Age of the Jaguar, when giants led by Tezcatlipoca are said to have roamed the earth. After 676 years, Quetzalcoatl (Kukulkan) threw the ruler into the ocean, and jaguars devoured the world. The second period of creation, the Age of the Four Winds, came about under Quetzalcoatl's leadership, and the temple pyramid of Chichén Itzá is dedicated to him.

The ball court is evidence of a once widespread ritual, the *ullamalitzli*, a duel to the death between two teams who would try to shoot a ball symbolizing the sun through two stone hoops using their elbows, knees, hips, and buttocks. The

Pilgrims at the solstice in front of the Pyramid of Chichén Itzá, Yucatán

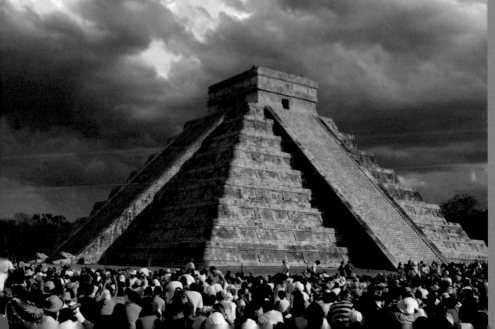

players of the losing team were sacrificed at the end of this ritual. Today the idea of human sacrifice seems utterly unthinkable, and even at that time it must have evoked fear and dread; fear and dread are, however, just the kind of raw emotions people experience in the presence of the Divine. This is not to gloss over or in any way justify the sacrifice of human beings to the bloodthirsty gods, but it does go some way toward explaining it.

Uxmal

Legend has it that Itzamná, the god of the sky, light and darkness, built the Pyramid of the Magician (Pirámide del Adivino) in a single night. Traces of the enigmatic ancient culture of the Maya linger still in their city of Uxmal, built between 700 and 1000.

Uxmal once had a population of almost 25,000. Along with the Pyramid of the Magician, many other imposing, ceremonial buildings and complexes remain from when the city was in its prime, including the ball court (Cancha del Juego de Pelota), the House of the Turtles (Casa de las Tortugas), the Platform of the Jaguars (Plataforma de los Jaguares), the Cemetery Temple (Cuadrángulo del Cementerio), some other sacred buildings of varying sizes, and a gigantic complex that the Spanish conquistadors dubbed the Nunnery Quadrangle (Cuadrángulo de las Monjas), as it reminded them of convent buildings in Europe. Its walls are

The Nunnery Quadrangle and the Pyramid of the Magician, Uxmal

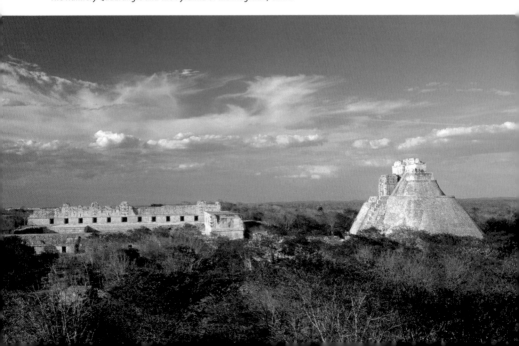

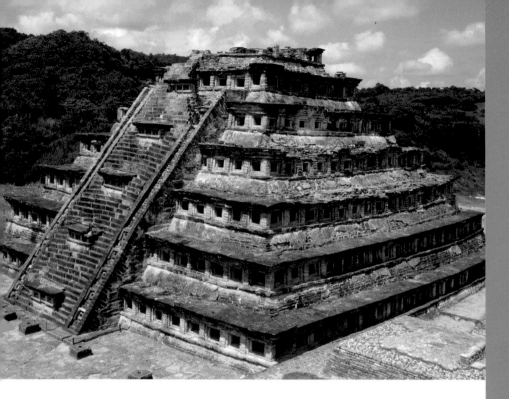

El Tajín Pyramid, with its 364 niches

elaborately carved with cosmographical symbols and religious images, of which the most famous is the quincunx pattern, made up of five points arranged like the five pips on a die. The four points at the corners refer to the cardinal points of the compass and the middle point indicates the center; the symbol may represent the portal to another realm, the source of creation. In some regions of Mexico, farmers still lay out their fields according to this pattern, tapping into the source of life by marking out these five points.

The fact that the Mayan culture has largely disappeared makes it all the more remarkable that ancient religious beliefs have survived to the present day, and that they still have a bearing on the everyday lives of people in this region.

El Tajín

The Totonac civilization flourished in the heart of the present-day state of Veracruz between 100 BC and about 1200. This major city is named after its most famous structure, the El Tajín Pyramid. El Tajín is presumed to have

been the seat of government and a ceremonial base, but it is unlikely that it was inhabited as excavations have not yet uncovered the remains of any buildings that might have been used as dwellings. Certain parallels can be drawn between these buildings and those of the Teotihuacán and Olmec civilizations. El Tajín is renowned as the "Pyramid of the Niches" and is the most striking example of this fairly localized style. Carved niches can be found not only on the large pyramid itself but also on many other buildings across the sprawling city.

The seven-tier pyramid rises to a height of 60 feet (18 m), and the vertical walls of each tier are riddled with square niches. Historians long assumed that these once housed statues of deities, but most modern experts believe this to be unlikely. It is also unclear whether the niches are a purely architectural, ornamental feature, or whether the total number of them, 364, was a reference to the number of days in a year.

The temple is surrounded by a ring of further magnificent buildings. Along with the pyramid, the Building

The Olmecs

First emerging around 1200 BC, the Olmecs were the first advanced civilization on the southern Mexican Gulf coast. Surprisingly, archeological excavations have revealed evidence of brisk trade between South American and Mesoamerica from early times. The Olmecs reaped the benefits of these trade relations, becoming the predominant power in the region, and their population boomed. One obvious explanation for this growth is that the Olmecs must have gained access to a greater variety of food and the land must have been much more fertile during this period. Sweet potatoes and peanuts came from South America but, crucially, the Olmecs improved their maize using non-local species.

The Olmecs had a pantheon of half-human, half-animal gods, including the fire god, the maize god, the rain god, a deity who regulated the cycle of vegetation and regrowth, a god who ruled the kingdom of the dead, and the Feathered Serpent (Quetzalcoatl), the

god of life, wisdom, and the wind. The Olmecs practiced ancestor worship and, at times, human sacrifice. In terms of religion and cult beliefs, their civilization was the blueprint for the cultures that later emerged all over Mesoamerica. The jaguar, the largest predator in the region, was worshiped as a divine being. Gods and rulers were often depicted as half man and half animal, and it was not uncommon for them to be shown with a split skull, said to be an indication of the ruler's lineage as a descendant of the jaguar-like god, and thus proof of his divine authority.

The Olmecs waned in importance from about 200 BC and there is little to be seen of their pyramids now. Their monumental head sculptures, whose purpose is still unclear, have been moved from their original sites and the locations of only a few of the jaguar altars have been preserved. Nevertheless, Olmec culture was to have a considerable influence on the civilizations that followed.

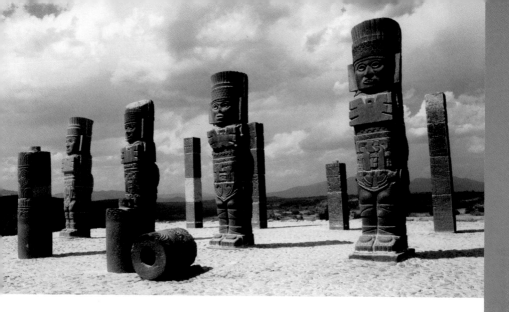

The colossal stone statues of Tula

of the Columns, every pillar of which is covered in reliefs, gives us an idea of what the city must once have been like. The reliefs depict priestly figures, winged dancers, eagle warriors, and a host of figures representing numbers.

Other fascinating monuments making up the spectacular temple city include the temple-like House of the Tunnel and Tajín Chico, another area of the site. Many of the buildings are decorated with intricate patterns and were once clad with brightly painted stone slabs. The Totonacs abandoned their sacred city in the 13th century, and by the time of the Aztecs it had been completely reclaimed by the jungle. Although it remained deserted for many years, it is still possible to experience the incredible sense of awe that El Tajín must have evoked in those who came here during its heyday.

Tula (Tollán)

The Toltecs founded Tula as their capital city in about 900, making it their cultural and religious center. The city reached its apogee in the 10th century and was inhabited well into the 12th, but it gradually declined in importance after the Toltec ruler Quetzalcoatl and his court abandoned it in favor of Chichén Itzá in about 1000.

At the heart of the city was a large square where major Toltec ceremonies were held. A number of palaces and sacred shrines are clustered around a central altar, the most imposing of which is the five-tier Great Pyramid (also called the Quetzalcoatl Temple). On the topmost platform are four massive stone statues depicting

warriors, each of whom carries a slingshot in his right hand and a bag containing incense and a curved weapon in his left. These figures have been interpreted as representing Quetzalcoatl in his guise as Tlahuiz-calpantecuhtli, meaning "morning star"—hence the pyramid's alternative name "Pyramid of the Morning Star."

Quetzalcoatl is a figure whose mythical and historical represen-tations have become blurred. As a historical character, he was the chief political and spiritual leader of the Toltecs; as a ruler, he adopted the name of Quetzalcoatl, the deity whom his people worshiped above all others. One legend has it that at the end of his life he went to the "land of the

black and the red." Here he set fire to himself, and his heart turned into the morning star that heralds the new day.

Near the Great Pyramid is situ-ated the Burnt Palace, with its many pillars. Its walls are richly adorned with figures in relief, all symbols of Toltec warriors: snakes writhe all over the friezes, devouring human corpses; jaguars prowl majesti-cally; eagles peck at human hearts. This temple city is an awe-inspiring sight, perhaps precisely because it does not reveal all the mysteries of its past civilization and culture.

A view of the temple city of Teotihuacán

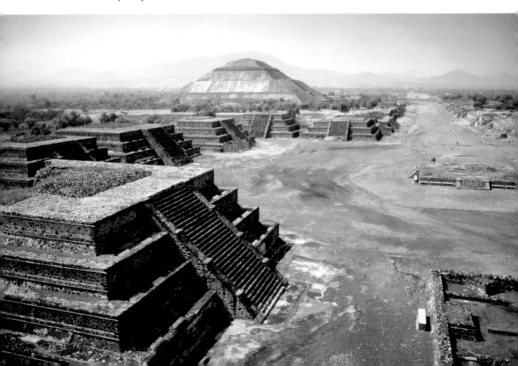

Teotihuacán

The temple city of Teotihuacán was built around 300 BC, but its founders are unknown. When the Aztecs, after migrating from northern Mexico to the highlands almost 1,600 years later, happened upon the remains of the giant pyramids, they made it their religious center. They were so impressed by the towering, enigmatic stone structures that they named the place Teotihuacán, "the birthplace of the gods." Perfectly straight roads linked the temple buildings and the abandoned palaces.

The Aztecs reserved special reverence for the two massive tiered pyramids that soared above the other structures, calling them the Sun and Moon Pyramids. Upon discovering ancient masks and mysterious statues of deities, they came to the conclusion that the gods had once gathered here during a time of great darkness to light a huge fire on the temple mountain before doing penance. Two of them ultimately sacrificed themselves, creating the sun and the moon and marking the beginning of the age of the Fifth Sun, in which the Aztecs believed themselves to be living.

Teotihuacán became an Aztec place of pilgrimage, and the rulers are said to have made a pilgrimage here from their capital, Tenochtitlán, every 20 days. It is likely that the Aztecs saw the city as a necropolis where the Toltec kings were buried. Modern historians, however, have concluded that Teotihuacán was never a necropolis, but was once home to as many as 100,000 people from a civilization that to this day remains a mystery.

The city's sacred buildings seem to be laid out according to an astronomically ordered plan. After the Sun and Moon Pyramids, the Pyramid of the Feathered Serpent (Quetzalcoatl) to the south is Teotihuacán's most striking building. The discovery of skeletons indicates that this temple was used for human sacrifices, no doubt to ensure that the gods remained merciful.

The city later went into decline and gradually disappeared from the map, though the reasons remain largely obscure. Hernán Cortés landed in Mexico in 1519 and though vastly outnumbered defeated an army of Aztec warriors. Two years later, when exploring the area around Tenochtitlán, the capital, his conquistadors uncovered the ruins of Teotihuacán. These twice-abandoned ruins are still considered a mysterious and sacred place to this day.

Nuestra Señora de Guadalupe, Mexico City

"Our solitude has the same roots as religious feelings. It is a sense of orphanhood, an obscure awareness of being wrested from the All, and a fervent search: a flight and a return, an attempt to reforge the links that bind us to the universe." Thus wrote Nobel prizewinner Octavio Paz, one of Mexico's greatest writers. It is indeed true that the conquest of Mexico brought with it a violent renunciation of Native Central American

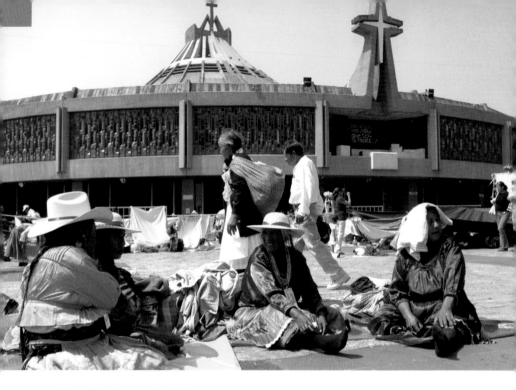

In front of the pilgrimage church of Nuestra Señora de Guadalupe, Mexico City

ideas and the old gods. Today Catholicism is the most widespread religion in Central America, but it is far removed from the Roman Catholic doctrine as issued from the Vatican. In adopting this new religion, the indigenous people retained many of their ancient rituals, and Native Central American thought still has a bearing on how Mexico's Christians practice their faith today.

According to tradition, a dark-skinned Virgin Mary appeared to Juan Diego, a Native Central American and a baptized Christian, on the morning of December 9 1531 on the hill of Tepeyac; she urged him to go to his bishop and tell him to build a church on that spot.

The bishop was convinced by Diego's story, not least because an image of the pregnant Virgin Mary, crowned with stars, had mysteriously appeared on Diego's robe. Today this garment (the Tilma) is still the most important relic at the pilgrimage site, and it is credited with the power to protect Mexico from all kinds of evil. Millions of Native Central Americans converted to the Catholic faith upon hearing of this miracle. The chapel that was built on a site where an earlier shrine to an Aztec mother goddess had once stood, has been a place of pilgrimage ever since.

Our Lady of Guadalupe is the patron saint of Mexico. Up to 20 million people

come to this sacred place in the northeast of the capital city every year, making Nuestra Señora de Guadalupe the most visited pilgrimage site in the world. The most important dates in the year are December 9, the day of the first apparition to Diego, and December 12, the day he received the Tilma. On these days, vast numbers of people descend on the church, among them the Concheros, groups who are deeply rooted in Native Central American tradition and who try to preserve or revive their ancient customs. They dress in traditional jewelry and perform dances that retell episodes from their myths or Mexican history.

The church grounds are so vast that less able pilgrims are now transported to the entrance on a two-lane moving walkway, often shuffling the last few yards on their knees. Besides the modern basilica, the huge complex also contains the old baroque church. This is usually closed, although people lay countless votive offerings outside it, as they do at various other chapels and missions. Nuestra Señora de Guadalupe is an extraordinary and awe-inspiring place where Mexicans can express their innermost hopes and beliefs.

The Cathedral, Mexico City

Only the meager ruins of the Great Temple hint at the fact that this was once the sacred district of

Mexico City's cathedral

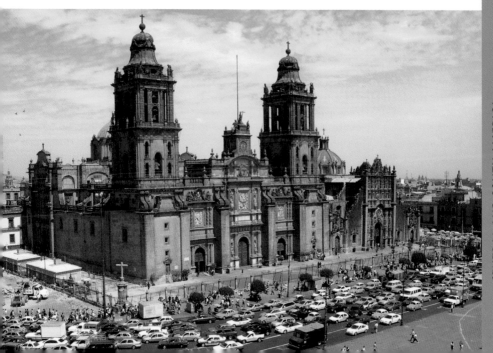

Maya

The Maya (c. 400 BC to c. 1697) were a Meso-american agricultural people whose most important crop was maize. The Mayan religion thus centered on the maize god and creator, and fertility deities. Itzamná was worshiped as the creator god who had given humans maize, writing, the art of healing, and the calendar. His rival was Hunahau, the ruler of the underworld (*Mitnal*), who had overseen the previous period of creation and had kept the maize deity imprisoned. When the maize deity was freed by the divine twins, the current period of creation began. This period of creation was ruled over jointly by the maize god, the young moon goddess, the sun god and Chac, the rain god.

The Mayan perception of the world set great store by astronomy, time, and cosmology. Their pyramids were modeled on the shape of sacred mountains and pointed toward heaven, giving them a secondary, practical function as observatories for astronomers. Mayan religious beliefs apparently drew connections between the earth and the sky, and between the past, the present, and a shadowy future. It is thought that the Mayan shamans acted as mediators between the visible and invisible worlds. The spiritual and the real were inextricably intertwined. The priests could influence the gods' treatment of mankind by studying the stars and making calculations or by performing sacrifices and rituals.

Tenochtitlán, the capital of the Aztecs. The Spanish were all too aware of the significance of this place, which was also the location of the palace of the Aztec leader Montezuma, and so they chose it as the site for the main square of the modern Mexico City. The Zócalo (Plaza de la Constitución) seems to be the meeting place for the entire nation, bordered by the National Palace and the Catedral Metropolitana de la Asunción de María de la Ciudad de México (Cathedral of the Assumption of the Blessed Virgin Mary).

This is one of the oldest cathedrals on the entire American continent, and also the largest—Roman Catholicism is more popular here than anywhere else in Latin America. Work began in 1573, but the cathedral was only consecrated in 1667, and it took nearly 150 years before it was finally completed in 1813. Today's church displays various styles, ranging from elements of Renaissance and baroque right through to Neoclassicism.

However, it is not the architecture that makes the biggest impression on visitors; the most striking thing about the cathedral is the way it is so clearly a living place of worship. Countless numbers of people flock here every day—rich and poor, old and young—to give expression to their adopted faith. A large number of workers, the vast majority of them lay volunteers, attend to the life of the church, becoming

involved in social issues and in charitable work within this vast city, a teeming metropolis with all the problems of a modern-day megacity.

that this search takes may be as diverse as the people who embark upon it.

Palenque

Tepoztlán

Tepoztlán is famous as a center of mysticism and a place frequented by healers, artists, New Agers, musicians, shamans, and clairvoyants. A colorful blend of people and their wares can be seen in the market square, the buzzing center of this small town in the state of Morelos. A pre-Columbian pyramid is perched on a 6,560-foot (2,000-m) hill above the town. Erected in the 12th century, it is now regarded by local inhabitants as a symbol of the ultimate failure of the conquistadors to completely subjugate the Mexican tribes.

Both the locals and the countless numbers of people who travel here on pilgrimage see Tepoztlán as a *pueblo mágico*, a magical place. Here, Native Central American healers not only sell the plants and ingredients needed to cure ailments, but also offer healing on the spot. New Agers look for traces of the extraterrestrials said to have been sighted here. Pilgrims struggle 1,410 feet (430 m) up to the pyramid in the hope of coming close to an age-old mystery.

Tepoztlán and its pyramid are indeed steeped in history, but the true nature of this holy place is best experienced by those who really want to be in the presence of something sacred. The forms

On August 28 638 K'inich Janaab' Pakal, the ruler of the Maya, died at the age of 80 at the end of a long reign. The present-day city of Palenque (formerly Baak) owes its fame to this ruler's prolific building activity. Surrounded by rainforest, the city was inhabited as early as 2,000 years ago, but it was Pakal who brought it to real prominence. One of the inscriptions telling of his death suggests that he ordered the building of at least five pyramids.

A stairway winds down from the temple at the top of the "Pyramid of the Inscriptions" to the tomb of K'inich Janaab' Pakal deep inside. The tomb, which Pakal planned and had built during his lifetime, looks like a scene from the underworld. A narrow shaft leads from the tomb back up to the entrance. This was the psychoduct, a channel that allowed the soul to break free of the body and rise up to the surface. The discovery of this tomb in 1952 was not only an archeological sensation, it also served as an important key to understanding the culture of the Maya, as it was evident that the pyramid was not merely the base for a temple but also concealed a sacred shrine that was probably used for ritual purposes.

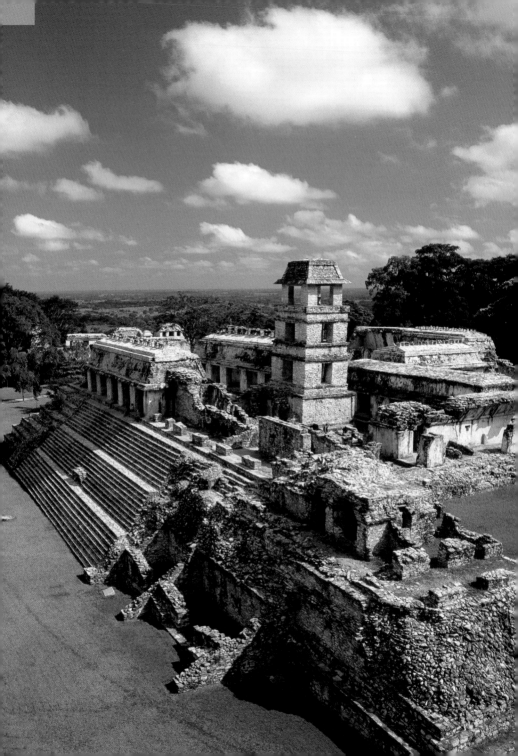

Apart from the pyramids and the Temple of the Sun, one of Palenque's most impressive sights is the great palace complex with its 13 chambers, underground rooms, and lofty tower. The purpose of the latter is unclear; it may have been used as a watchtower, and probably served as an astronomical observatory. The importance of Palenque has been thoroughly investigated by archeologists, but the sanctity of this site resides in the deep sense of mystery that still surrounds Mayan culture to this day.

Monte Albán

The "White Mountain" is famous as the center of the Zapotec civilization and as its most sacred place. Although the history of the Zapotecs remains shrouded in mystery, we do know that they had links with the Maya and the Olmecs. The shrine on top of Monte Albán is an impressive complex that was planned with precision from the very outset and is notable for the harmonious layout and proportionality of its almost identical buildings.

Leveling off the whole peak of the mountain in order to provide a flat site for this ceremonial complex must have been a huge task, especially at an altitude of almost 6,560 feet (2,000 m). Temples, palaces,

pyramids, and a ball court were built on the even expanse, stretching over three valleys. The axes of all the buildings ran parallel to one another, oriented south–north. The buildings at the center of the complex were on a slightly lower level than the others.

On seeing the complex for the first time, visitors are struck by the many broad flights of stairs. Almost all of the structures are decorated with reliefs, once brightly painted, indicating Olmec influence. The stone cladding around an earthen pyramid on the western edge of the Great Plaza was covered in unusual figures and writing, some of which can still be seen. The figures look strangely dislocated, as if performing a ritual dance, and so they were dubbed the Danzantes (the dancing ones). Until now, no one has managed to decipher the written characters because they differ from the known scripts of the Aztecs and the Maya; only the numbers here are legible.

The shrine on the top of Monte Albán is breathtaking. Its setting on the artificially leveled plateau is stunning, its sheer size is imposing, and the enigmatic symbols on its walls evoke a deep sense of mystery.

The palace and temple complex at Palenque

Tikal

Tikal is one of the largest areas of contiguous settlement in the Maya region and was inhabited from around 800 BC until 950. Scattered across this vast area are more than 3,000 individual structures, temples, and pyramids, as well as clusters of buildings that resemble small villages. Consequently, it is estimated that up to 50,000 people could have lived here. The city lies in the middle of a chain of hills, and some of its impressive constructions still tower above the lush vegetation.

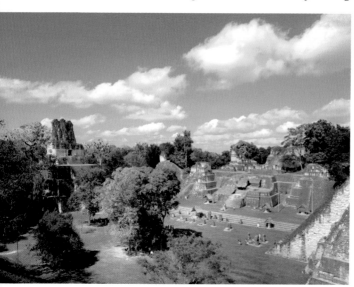

A view of the temple complexes, Tikal

The Great Plaza in the center of Tikal, around which the largest temples and other ceremonial buildings are grouped, represents not just the heart of the city but also the midpoint of the universe. The layout of the buildings, which are arranged according to a cosmological plan, was oriented to the four points of the compass. It is thought that the complex of buildings known as the Central Acropolis was the rulers' palace. The square is flanked by two pyramids whose striking appearance, silhouetted against the sky, belies their prosaic titles of "Temple 1" and "Temple 2." We know that such pyramids were stylized representations of a holy mountain with a temple on its summit, so they were clearly of religious importance. South of Temple I lies the ceremonial ball game court.

Although the heart of the city was established around 800 BC, it only emerged in the form familiar to us today between AD 695 and 734, after the ruler Jasaw Chan K'awiil erected a "three-stone place." In Mayan cosmology three stones constitute the midpoint of the universe. Here they are represented by Temples I and II, along with a third pyramid situated nearby. This sprawling area is also home to other imposing pyramids and palace complexes. Although the rainforest has long since reclaimed most of the ancient city, this only serves to deepen the sense of mystery experienced by visitors.

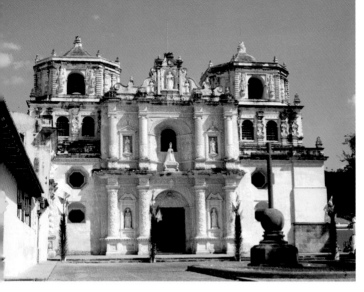

The church of La Nuestra Señora de la Merced, Antigua

La Nuestra Señora de la Merced, Antigua

La Antigua Guatemala (commonly referred to simply as Antigua) was the capital of the Spanish colonies in Central America from 1543 to 1773 and in many ways still feels like a part of Spain. The city has been badly damaged by earthquakes over the course of its history, but it was never completely abandoned. It is a city of baroque buildings and churches, the most impressive being La Nuestra Señora de la Merced, the construction of which began in 1548, shortly after the city's foundation. A small monastery lies nearby and the plaza in front of the church is a popular location for local people to relax and pass the time.

The real jewel of the church is its monastery cloister, where the inner courtyard is almost completely dominated by a fountain in the shape of a water lily. This flower is an important symbol of strength in Mayan culture, and the design of the fountain is clearly reminiscent of the ancient, mysterious pyramids of the Maya. Today almost 90 percent of Guatemalans are Catholic, but the fountain is symbolic of how they still consider themselves to be thoroughly rooted in their native culture.

The colonization of Central America was largely a story of barbarity and oppression, but here we can see evidence of an intermingling of two cultures that hints at mutual respect. Vibrant religious processions accompanied by fireworks and the ringing of bells are held on the last Thursday of every month, and Holy Week (the week before Easter) in particular sees many residents of Guatamala City, the current capital, join pilgrimage processions to the old capital at Antigua. In a world where social unrest and economic problems are commonplace, the people of Antigua throw themselves joyfully into these demonstrations of popular devotion.

CENTRAL AND SOUTH AMERICA

Santuario de San Lázaro, Santiago de Las Vegas

According to the New Testament, Lazarus, the brother of Martha and Mary of Bethany, was raised from the dead by Jesus and subsequently became one of the first people to spread the gospel. *The Legenda Aurea* (the Golden Legend), a medieval hagiography, relates how Lazarus later journeyed to France with his sisters,

The Santuario de San Lázaro, Santiago de Las Vegas

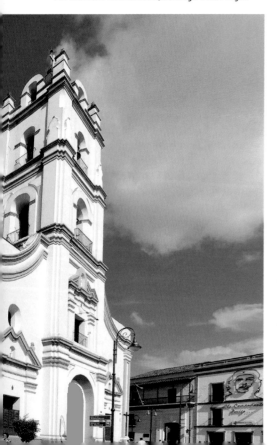

where he eventually became the bishop of Marseilles, before being martyred. In popular tradition, the details of the story of the bishop soon became confused with those of the leprous and impoverished Lazarus, the beggar who is the subject of the parable told in the Gospel of Luke (16:19–31).

Lazarus is the patron saint of many hospitals throughout the world, including Santuario de San Lázaro, which is situated on the edge of the city of Santiago de Las Vegas near Havana. In Cuba, the veneration of the saint has merged with elements of African religions. Consequently, at the Santuario de San Lázaro people also worship Babalao Ayé, an *orisha* (or spirit), and ask him for blessings. Babalao Ayé is thought to provide protection against skin diseases and paralysis of the hands or feet. It is no surprise to find *orisha* worship here—its roots can be traced back to the transatlantic slave trade of the 17th to 19th centuries, when traditional African religions found their way to the Americas.

The hospital chapel combines these different religious traditions in a truly unique way. The main intention of the pilgrims who come here is to pay their respects to the saint rather than ask for blessings. Although they are often very poor, they offer baskets of money to the saint and the hospital. The money they save all year for this purpose is usually kept in shrines dedicated to Babalao Ayé. The pilgrims hope that the money will put Lazarus and Babaloa—the saint and the *orisha*—in a merciful mood and, at the same time, protect the pilgrims against ill health.

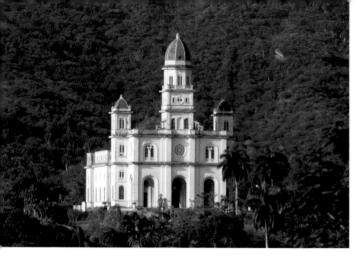

The pilgrimage church of Virgen de la Caridad del Cobre

Pilgrims come to the church to fulfill a promise or to "pay" for blessings received; people fear the wrath of the *orisha* if they fail to demonstrate their gratitude. On December 17, Lazarus' feast day, large crowds flock to the pilgrimage site. Offerings to both Lazarus and Babalao Ayé are also traditionally made at family altars on the evening before the feast.

Virgen de la Caridad del Cobre

Our Lady of Charity has been the patron saint of Cuba since 1916, but the cult of María del Cobre goes back much further. Legend has it that three fishermen discovered a statue of Mary in a cove. They immediately brought it to Cobre, where it was placed in the church, which soon became a pilgrimage site. Countless replicas of this statue of Mary, wearing a white robe and with the three fishermen at her feet, can be seen all over Cuba. In many households they are kept in purpose-built niches or shrines.

Besides Mary, the local people also venerate Ochún: African *Osún*), the African goddess of rivers and love. It is even said that Mary and the goddess Ochún bear a resemblance to each other. Many Cubans see no contradiction in using the Catholic veneration of saints and the polytheistic beliefs of their African ancestors. The Catholic Church disapproves of this intermingling of traditions, but nevertheless tolerates it as an expression of a form of popular piety. Rome is a remote authority; it is the attitude of the Cuban cardinal Jaime Ortega that holds greater sway here: "All of this can be seen as an act of faith; faith is what drives it." Faith is indeed the driving force here, as it is elsewhere, and it is this very faith that enables believers to come close to the saints and the Divine.

On September 8, the Feast of the Nativity of the Blessed Virgin Mary, a huge procession bearing the statue of Mary is led through the streets. As well as attending the procession and Mass, the faithful bring votive tablets and other offerings to give thanks to Mary or the Santería goddess Ochún.

Basílica Nuestra Señora de la Altagracia, Higüey

The name of this city—Higüey—means "sun" in the ancient Taíno language. Many of the townspeople boast that Higüey is the cradle of the Spanish colonization of the New World and that in 1494 the city was settled by the Spanish at this site in La Altagracia, the easternmost province of the country, before the foundation of Santo Domingo. The Virgin Mary is said to have appeared to Christopher Columbus here and helped him suppress a revolt by the Taíno tribe.

The modest Iglesia de San Dionisio was built to house a miraculous icon of Mary, brought from Spain at the end of the 16th century. This beautiful old building now stands in the shadow of the modern pilgrimage church situated right beside it. After Our Lady became the patron saint of the Dominican Republic in 1922, it became evident that the old cathedral was too small to cope with the increasing numbers of pilgrims coming to venerate the icon of Nuestra Señora de la Altagracia. However, instead of tearing it down, the authorities decided to build a modern church beside it. The foundation stone was laid in 1954 and by 1965 the church had been almost completed. Its most famous feature, visible for miles around, is its 260-foot (80-m)-high parabolic arch, which also forms part of the interior of the church. The gloriously colorful stained glass windows, made in Chartres in France, were fitted in 1968, and the new basilica was consecrated in

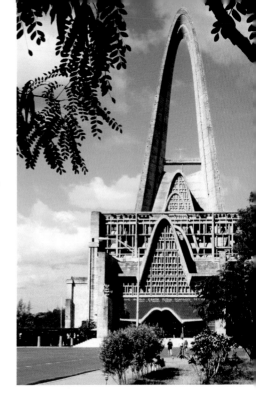

The Cathedral of Higüey

1971. Since then, the Basílica Nuestra Señora de la Altagracia, its interior flooded with an almost mystical light, has been home to the revered icon.

Santo Domingo Cathedral

Santo Domingo is far removed from the usual tourist vision of a sun-drenched Caribbean tropical paradise. The capital of the Dominican Republic is a city of glaring contrasts. There is

an area where only the wealthy live, while at the other end of the scale discontent has reached boiling point in the miserable shanty towns of the poorest inhabitants. Despite this, the people of Santo Domingo still exhibit the easy-going nature often associated with the Caribbean. They live by the saying "Tomalo suave!" (take it easy) and are always reassuring one another with the words, "No hay problema!" (no problem!).

The Zona Colonial, which dates back to the 16th century, lies in the midst of all the hustle and bustle of the capital. The Basílica Menor de la Virgen de la Anunciación, one of the most impressive churches in the New World (and the only Gothic cathedral) is to be found here. Its foundation stone was laid in 1514 by Diego Colón, the son of Christopher Columbus. The first bishop of Hispaniola arrived on the island in 1519 and immediately ordered the still unfinished cathedral to be extended. The church was consecrated to the Virgin Mary in 1540 and six years later Pope Paul III raised it to the status of the Cathedral Primada de las Indias, the most senior church in the New World. It was appointed a Basílica Menor at the turn of the 20th century, putting it on an equal footing with the major Roman Catholic churches.

The western wall of the cathedral, made of coral limestone, glitters in the sun. The statues on the ornate façade include the four evangelists and St Peter and St Paul. A notable feature of the façade is the Puerta del Perdón (Door of Forgiveness, nowadays locked), where people would be granted sanctuary. The church has three aisles and is very long. The interior is decorated in the Spanish Gothic style, with double pillared columns rising to a starkly beautiful, vaulted ceiling resembling a canopy of palm trees. The windows are unusually small for a Gothic-style building. Fourteen side chapels, added after the nave, surround the geometrically ordered space. A stroll through the cathedral reveals many different European artistic styles, including traces of the Renaissance in the arches, and superb plateresque carvings of plants and people.

The portal of Santo Domingo Cathedral

El Dorado

The "gilded man," El Dorado, is a legendary figure known through-out the world, and the search for his gold has cast its spell over count-less treasure-seekers. The setting of the legend is Lake Guatavita, a small mountain tarn in the Colombian Andes. When he was six years old, the boy who was destined to be the ruler of the local Muisca tribe was led to a cave beside the lake. He spent nine years there in study and meditation without even once being allowed to see daylight or to have contact with anyone except his teach-ers. Once his nine years of study had been completed, he had to take one last test—to spend the night in the company of exquisitely beautiful women without touching them. If he resisted temptation, it would mean that he was fit to become ruler. He passed the test and went to the lake to make an offering to the deity.

Upon his arrival at the shore, the people stripped the prospective ruler of his clothes, rubbed his body with pitch and covered him with layer upon layer of gold dust. Accompanied by ten important members of the tribe, the gilded man sailed out onto the lake on a raft that was laden with gold. As he did so, the Muisca stand-ing on the shore played instruments and sang. When the raft reached the middle of the lake, everyone fell silent and the ten attendants on the raft threw the golden offerings into the lake. When he returned to the shore, the gilded man was crowned the new ruler. This tale prompted the Spanish, and later people from all over the world, to search for the fabled hoard of gold. Time and again individual pieces of gold have been found, but to this day the legendary treasure as a whole remains undiscovered.

This beautiful lake is viewed as a sacred place, at least when its peace is not being disturbed by treasure-hunters. We can but hope that those people who visit the lake in the right spirit will sense that it is communion with nature that makes people truly happy, rather than gold, and that experiencing a sense of humility when faced with the enormity of creation is more fulfilling than the pursuit of riches.

The Salt Cathedral of Zipaquirá

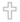

In his *Views of the Cordilleras and Monuments of the Indigenous Nations of the New Continent*, the German polymath Alexander von Humboldt describes the spectacular salt deposits in the mountains near Bogotá, which he saw on his journey through Latin America in 1801. Pressure and heat from the earth caused a solid glacier of salt to form here over the course of 200 million years. Lying at an altitude of around 8,530 feet (2,600 m), the Zipaquirá salt mines house one of the

most unusual shrines in the world, the Salt Cathedral (Catedral de Sal) of Zipaquíra, hollowed out of the mountain in the 1950s, soon became a place of pilgrimage for Colombian Catholics, but had a relatively short lifespan. In 1990 it had to be closed down as it was in danger of caving in. A new underground church was consecrated just five years later—this time, however, it was constructed 200 feet (60 m) below the old one. Illuminated by a mysterious blue, red, and greenish glow, the nave is 395 feet (120 m) long and features columns and sculptures carved out of salt and marble. Statues of angels, floating below the ceiling or seated on rocks modeled out of salt, are the principal occupants of the triple-aisled cathedral. There is room for up to 8,000 members of the faithful to gather to pray before the beautiful Nativity sculpture. The Salt Cathedral receives its greatest number of visitors at Easter and on other major Catholic feast days.

Mountains and caves are seen as sacred places all over the world, and this mountain near Bogotá is no exception. The stark, primeval atmosphere of the Salt Cathedral of Zipaquirá works its magic on visitors who spend time here in quiet contemplation.

Inside the underground Salt Cathedral of Zipaquirá

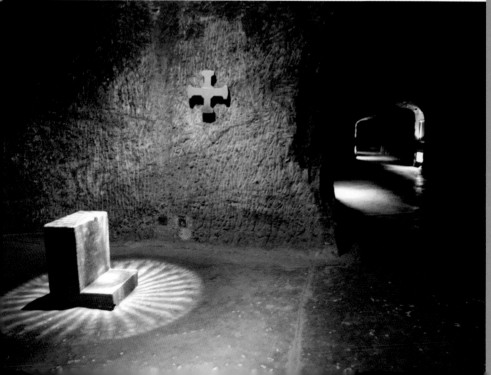

BRAZIL

The Terreiro, Salvador da Bahia

Candomblé, a syncretic religion prac-
ticed in Brazil, fuses many elements
of African religions with local Brazil-
ian traditions and Roman Catholi-
cism. There is a strong emphasis on
the ritual relationship with the *orisha*
(called *orixá* in Brazil). *Orisha* wor-
ship is the main focus of the religion
of the Yoruba people, who mostly
originate from southwestern Nigeria.

Some of the most important *orixá*
shrines (*Candomblé terreiros*) are

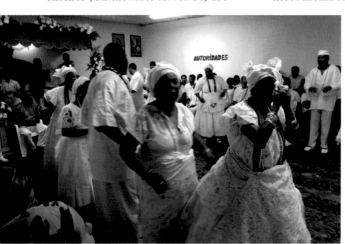

A Candomblé ceremony in Salvador da Bahia

at the Bay of All Souls in Salvador da
Bahia, the third-largest city in Brazil.
Most of the inhabitants here profess
the Catholic faith and follow Catholic
traditions (especially during the city's

carnival, which is more than a match
for the festivities held in Rio de Janeiro).
Yet the old beliefs, brought to the New
World by slaves between the 17th and
19th centuries, are still very much alive.
Unlike in Africa, however, where each
orisha is venerated in a purpose-built,
individual shrine, here the *orixá* are
worshiped as a whole pantheon.

The *terreiro* has gradually devel-
oped into a microcosm of ancient
African religious traditions. Singing,
dancing, and initiation rites perpetu-
ate belief in the ancestral spirits, who
are venerated as gods. The Catholic
Church frowns upon this practice, but
most members of the clergy tolerate the
terreiros as an expres-
sion of the vibrant sense
of faith deeply rooted in
Brazilian society. Ilê Axé
Iyá Nassô Oká (or Casa
Branca do Engenho
Velho—"White House
at the Old Sugarmill")
is arguably the most
important *terreiro*, as
it was the first to have
been built in the city and
has served as a place
of worship ever since.

Brasília Cathedral

The American architect Frank Lloyd
Wright once drew up plans for a "living
city," marking a milestone in modern
architecture. Many of his ideas were

later adopted by the famous Brazilian designer Oscar Niemeyer, when he was appointed principal architect of Brasília and given the task of planning the city. The result might well be the strangest capital city in the world. To this day there is none of the urban atmosphere that you find in other cities; this hyper-modern metropolis designed entirely on the drawing board remains strangely sterile.

Construction of the city began on October 22 1956. Over the years that followed a "city of the future" arose, although today it appears decidedly outmoded to many visitors. Brasília is built roughly in the shape of a cross, stretching out toward all four points of the compass. Architecturally speaking, its main sights are the Parliament building and the Catedral Metropolitana de Nossa Senhora Aparecida, the futuristic cathedral designed by Niemeyer and consecrated in 1970. The church, named in honor of the patron saint of Brazil, is circular in shape, with 16 pillars and very deep foundations. The exterior has been likened to Christ's crown of thorns, a flower, or the crown worn by the Virgin Mary, with four larger than life-size statues of the evangelists flanking the entrance.

The interior is almost entirely devoid of decoration, although three angels suspended from the ceiling add a certain poignancy to the austere space. In an ostensibly empty and cold world the angels appear as divine emissaries bearing a message that is intended to touch the hearts of men. Today the cathedral may not be the site of joyful and exuberant popular worship, but it

Brasília cathedral, with the statues of the four evangelists

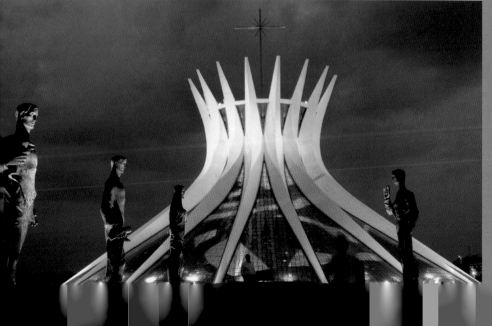

is a place whose very minimalism encourages introspection and where you can experience a real sense of the mystery of the Divine. Upon entering the church, your first impression may be one of bleakness, but then your attention is drawn to the angels suspended above, proclaiming their message of love to the world.

A congregation in the Church of Our Lady, Aparecida

Nossa Senhora Aparecida das Águas, Aparecida

In the fall of 1717 the Governor of the Province of São Paulo and Minas Gerais visited the village of Guaratinguetá, where a feast was to be held in his honor. Three fishermen, Domingos Garcia, Felipe Pedroso, and João Alves, were sent to the nearby River Paraíba to catch some fresh fish, but their nets remained empty. Just when they were about to give up and head back to the village, João looked in his net and found a headless statue of the Virgin Mary standing on a globe of the world. When he cast out his net again, he was astonished to catch the missing head. Then the fishermen witnessed another miracle; on casting out their nets once more, they caught so many fish that they filled the whole boat.

Silvana, João's wife, put the head back on the statue, but it was Felipe who took it to his house for safekeeping. He and his family prayed before the statue and received many favors. In 1726 Felipe's son built a wooden altar and a small oratory to house the statue, and soon pilgrims began to flock to the shrine. In 1745 a larger chapel was built, but before long this was also outgrown. In 1834 work began on the present-day Basílica Velha (Old Basilica).

In 1904 the iconic statue was ceremoniously crowned and ever since has worn a cloak of royal blue and a golden crown. In 1928 the Virgen Aparedica das Águas ("the Blessed Virgin who appeared out of the water") was named the patron saint of Brazil. The pilgrimage site was expanded again and a new basilica constructed in 1955. Each year up to ten million pilgrims flock to this place, which was renamed in 1928 in honor of the apparitions. What was once a small fishing village has grown into one of the most famous pilgrimage sites in South America.

Cristo Redentor, Rio de Janeiro

The monumental statue of Christ that looks out over Rio de Janeiro from the 2,330-foot (710-m) Mount Corcovado is unquestionably one of the most famous religious landmarks in the world, as well as being the largest art deco statue on earth. The cornerstone for the monument was laid in 1922, and the foundations and the figure of Christ (almost 100 foot (30 m) high) were completed by 1926. On October 12 1931 the statue was consecrated and the Ordem Arquidiocesana do Cristo Redentor (Archdiocesan Order of Christ the Redeemer) was founded to maintain the statue and provide assistance to pilgrims. In 1960 this order was disbanded and the mountain was placed under the jurisdiction of the Archdiocese of Rio de Janeiro. Since the completion of a wide-ranging and expensive phase of technical renovation in 2003, this unique monument has shone with a new luster. An Internet survey in 2007 asked people to nominate their seven new wonders of the world, and Cristo Redentor emerged as one of the seven, along with the Taj Mahal in India, Machu Picchu in Peru, Chichén Itzá in Mexico, the Colosseum in Rome, the ruins of Petra in Jordan, and the Great Wall of China.

In 2006, to coincide with its 75th anniversary and to give a stronger emphasis to its religious significance, a chapel was consecrated under the statue by the Archbishop of Rio de Janeiro, and a special Mass was held to declare Cristo Redentor a sacred shrine. Ever since then, Masses, baptisms, and weddings have been celebrated in this chapel.

The statue is now fitted with elevators that ascend Mount Corcovado and the statue of Christ itself. Unperturbed, the Redeemer merely seems to smile gently and indulgently over the buzz of tourist activity down below.

The statue of Christ on the Corcovado, Rio de Janeiro

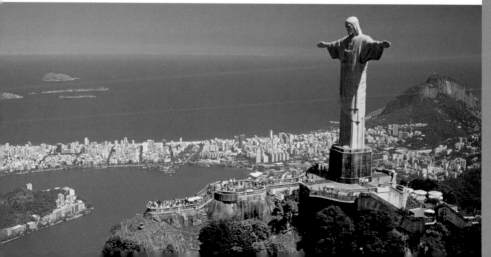

Santa Rosa of Lima

The first person from the New World to be canonized was Rosa (Rose), born Isabel de Flores in Lima in 1586. There are two versions of the story of how the woman who was to become the patron saint of Peru and the whole of Latin America acquired her name. In one

St Rose's well, Lima

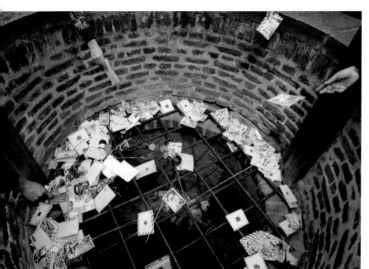

tale her mother saw a rose blooming over the face of the sleeping child, and in the other, a similar tale, a Native South American woman called the child "Rose" because of her great beauty.

Even as a young girl, Rose proved herself capable of great self-discipline and devotion. As she grew up, she began to have mystical experiences, during which she became consumed by a great fervor and piety. Her more worldly mother was keen to see her married, but Rose turned away all suitors, and in 1606 she entered the Third Order of St Dominic. The order did not allow her to live within the convent, so Rose withdrew to a humble hut in her parents' garden to undertake acts of penance. She spent 12 hours of every day in prayer, and devoted ten hours to manual labor and caring for the poor and the sick. Only two hours were set aside for rest and recuperation. She bore terrible physical and spiritual afflictions with great patience, and was granted many mystical favors in return.

Courageously, she spoke out against the shameful acts perpetrated by the Spanish conquistadors, and listened meekly when people spread lies about her in return. When she died on August 24 1617, a physical wreck at the age of only 31, her body appeared radiant, miraculously restored to its former beauty. So many people came to her funeral that it had to be postponed several times. A number of miracles occurred at her tomb, and Pope Clement X canonized her in 1671.

St Rose is greatly venerated in Peru as "South America's first blossom of sainthood." She is universally loved for her ability to respond to people's

needs and her unstinting charity toward all those who suffer deprivation. In the old part of Lima pilgrims seek out various sites associated with her, which are clustered close together. In particular, they visit the small church that was built over the place where she was born. Pilgrims throw notes on which they have written their prayer requests into the well in the garden behind the church. The house where she died is only a stone's throw away and has been incorporated into a church. The last stop for pilgrims is St Rose's final resting place, her tomb in the Convent of St Dominic. Her mortal remains are contained in a silver urn in the Rose Chapel of the convent.

Almost every house in Lima contains an image of the saint, and it is said that in 1746 St Rose protected the city of Lima from the worst effects of a massive earthquake. Her feast day, celebrated on August 30, is of great importance for Peruvian Catholics.

Valle Sagrado, the Sacred Valley of the Inca

The Sacred Valley (Valle Sagrado) is near the major Peruvian city of Cusco. The name is an indication of how important this valley was for the Inca. Their sacred sites have a special significance in their myths and have long played a part in the religious life of the region. Called *huaca*, these sites could take the form of rivers, springs, lakes, mountains, or caves. The tombs of dead ancestors were also considered to be *huacas*—people people would erect narrow stone pillars (*apacheta*) and place offerings of coca leaves or stones at the tombs, and also at crossroads. Alternatively they would leave some *chichi*, maize beer, as a drink for local deities.

This ancient tradition served to reconcile the people with the natural landscape, which they believed to be populated with gods and spirits. The mythology of the Inca revolved around the creation of the world and ancestor worship, and also reflected the grandiose landscape of the Andes. The weather on the mountains is marked by extremes, the region contains many active volcanoes, and massive earthquakes are not infrequent occurrences. The myths tell of the very first Inca, who are said to have emerged from lakes; of rocks that turn into people and back again; and of how the gods imposed social order on humankind.

The most important Inca god, and the mythical progenitor of all the Inca kings, was Inti, a sun god represented by a golden disc surrounded by a wreath of stars. The Inca thought of themselves as children of the sun. Inti's companion was the moon goddess Mama Kilya, whose movements determined the calendar. Ilyap'a was the god of thunder, who also brought rain. Votive offerings to these deities, and to the ancestors venerated by the Inca, are to be found all over the Sacred Valley.

Pisac in the Sacred Valley of the Inca

Pisac

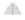

Pisac is a city of two faces: the present-day town and the sacred district, which dates from the time of the Inca. To reach the royal seat of the Inca ruler Pachacútec, visitors mount a long, steep stairway, at the top of which is a fortified complex containing palaces, living quarters, and a ceremonial area. The story goes that travelers were only allowed to approach the town if they were carrying a heavy load on their shoulders, so that their bowed gait would demonstrate their humility to the ruler.

On the plateau is a carved stone, scored with geometric markings, with a protruding "hitching post" for the sun. In the language of the Inca this was called the *Intihuatana*, and it marks the place where the sun was "trapped" at the end of each day. The exact purpose of the stone is unclear, but it is thought that it was used in drawing up the calendar according to the position of the sun. It may also have functioned as a kind of sundial and been used to honor the sacred heavens. The stone marks the center of the ceremonial area, and Inca temples, priests' palaces, and tombs can be made out all around it.

The buildings themselves are astonishing. It is still a mystery how the blocks of stone, each weighing several tons, were fitted together so precisely without the use of mortar. Remarkably, the complex at Pisac has survived even the severest of earthquakes almost unscathed. Perhaps the aim of the ancient architects was to build something that would last forever.

Machu Picchu

Much about the vanished culture of the Inca remains an enigma. Perhaps it is this sense of mystery that arouses people's curiosity and awe. The Kingdom of the Inca expanded in the 15th century, and a string of settlements was built high above the Urubamba river valley, which stretches northwest from the ancient capital city of Cusco.

One of these was Machu Picchu, a site that is magnificent even in its ruined state, with an array of stone houses, palaces, and temples, built on saddle-like mountain terraces. The city is hemmed in on all sides by steep mountain slopes, making it very difficult to reach. There are spectacular views down into the surrounding chasms and the river valley. The city consists of an outer and an inner district. The latter could only be entered by a single gate and is thought to have been a sacred area, although there are many theories as to what is actually meant by this. It is possible that it was an area set aside for the *acclas*, specially chosen women who were devotees of the sun god, Inti. More than 170 tombs have been discovered in the city, 150 of which contain the remains of women.

The massive *Torreón* altar to the sun god, hewn out of an enormous rock, is particularly impressive. Other monolithic altars also attest to the significance of this Inca city, made all the more important by the fact that most of the religious structures at other Inca sites were destroyed by the Spanish conquistadors, who considered them pagan.

The ruins of Machu Picchu in the Andes

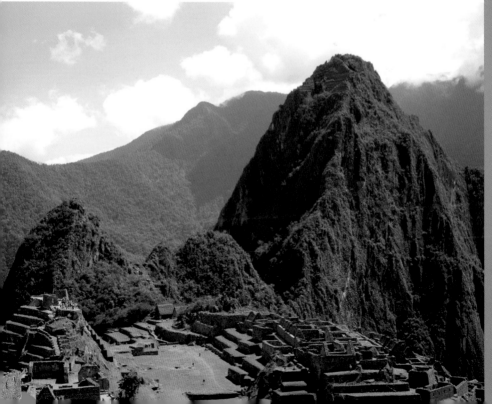

The Inca

The Inca civilization flourished for just 100 years. The empire had its roots in the area around Cusco, but the origins of the people remain a mystery. There are, however, various legends about the founding of the city. The most famous of these tells the story of Manco Cápac and his sister (and wife) Mama Ocllo, who came down to the waters of Lake Titicaca on the orders of their father, the sun god Viracocha, in order to civilize humankind. This was believed to have happened around AD 1200, and thenceforth the ruler, who was believed to be the reincarnation of Manco Cápac, was called the Inca. "Inca" was therefore the name given to the ruling dynasty, rather than the people as a whole. It was only later that all the inhabitants of Cusco and the Sacred Valley came to be known as the Inca. They rapidly grew in influence in the region, giving the sun cult of the Andean highlands new impetus through their belief that their ruler was the offspring of the sun god himself.

The ninth Inca Cusi Yupanqui, awarded himself the title of Pachacútec ("He who remakes the world") after his victory over the Chanca tribe in 1438. Within 50 years the despotic and expansionist Inca regime had gained control over a vast area that reached from Cusco all the way to Chile and northwest Argentina in the south, and over the whole of Ecuador to the north. The Inca cleverly built their culture on the achievements of the people they conquered and on earlier cultures, integrating them into their centralistic sun cult. The Inca Empire was short-lived, however, and came to an end after the death of the last Inca, Huayna Cápac, in 1528.

Cusco

The city of Cusco, high in the Andes, means "navel of the world" in Quechua, the language of the Inca. It was especially important during the period between 1438 and the middle of the 16th century. In 1438 Prince Cusi Yupanqui came to power as ninth Inca and named himself Pachacútec, "He who remakes the world." It was not unusual for Inca rulers to take this title, as the Inca saw time as a succession of turning points, moments when the present era ends and a new one begins.

The Inca legend has it that Cusi Yupanqui captured the sun and vowed never to let it go. The sun chose to grant him a special favor and to help him against the Chanca. His wise father, Viracocha, did not want to go to war, and so withdrew to his mountain fortress. But Cusi Yupanqui, his youngest son, had the sun on his side, and, although vastly outnumbered, he defeated the Chanca in a bloody battle. Pachacútec was to be the leader of the new world. The Inca believed that the world had already seen four eras, so this was the time for the "fifth sun." As the captor of the sun, the king was the one to bring light to his kingdom, even if he had to do

it by force. Led by Pachacútec, the Inca had rapidly subjugated almost all the peoples in the surrounding lands, ruling over them absolutely. Pachacútec reordered the calendar, giving the months new names, and introduced monthly feasts, which consisted of a series of rituals renowned for their barbarity.

A slightly less bloody creation myth has it that in ancient times the entire region was mountainous, and the people lived as wild beasts in darkness and chaos, without religion or social order. They went naked and fed on human flesh and wild plants. Their chaotic existence moved the sun to pity, and he sent two of his children, a boy and a girl, to earth so that they could impart the basic principles of civilization to the people, who would then honor the sun as their god. The pair were set down on an island in Lake Titicaca and instructed to roam throughout the land. Anywhere they stopped, they were to drive a golden rod into the earth. The place where this rod slid easily into the soil was to be the site of the capital of the new world.

The children traveled north and eventually came to a desolate valley. They thrust the golden rod into the earth, and it met no resistance. The siblings then split up, heading in different directions in order to summon everyone to come to the place where they had driven the rod into the ground, which became the city of Cusco. The gigantic fortress of Sacsahuaman was built here, surrounded by three encircling walls, and the buildings and temples of the rest of the city stretched out to the south. The layout of the city resembles the shape of a puma; the fortress forms the head, and the sun temple of Coricancha the genitals. Pachacútec ordered stone pillars to be erected around the edge of the settlement, which astronomers used to make their predictions.

When the Spanish overran the area, they destroyed only buildings which had a religious or political function. Christian places of worship were built in their place. The cathedral stands on the foundations of the palace of Viracocha, the eighth ruler of the Inca; St Catherine's Convent is on the site of the Temple of the Virgins of the Sun; a Jesuit church was built on the old walls of the Palace of Huayna Cápac, and a Dominican priory on the remains of the Coricancha temple.

The Nazca Lines

The desert that stretches along the southern Peruvian coastline, the Pampa Colorada, is like a giant canvas covered in mysterious signs only properly visible from the air. Between 200 BC and 600 AD, unknown artists gouged enigmatic geoglyphs and street-like lines out of the earth. These depict mythical animals, abstract or figurative shapes, trapezoidal forms and miles of lines. The lines and images were only discovered by chance in 1920, when the first plane flew over the area in search of water.

The geoglyphs of the Pampa Colorado are possibly the most spectacular features ever created to honor

the gods or the forces of nature. The Nazca made them by removing from the ground the top layer of oxidized brown rubble and exposing the yellow rock underneath. New Agers believe these immense features are the work of aliens, but most experts believe they were created as a vast, yet continuous, ritual landscape.

toward the mountains has led some anthropologists to argue that the Nazca worshiped the mountains and wanted to point the way to hidden and inaccessible temples. The Nazca Lines clearly express a high level of religious fervor. Recent discoveries have revealed small hills and sacrificial shrines close to the lines, which probably served a ritual purpose.

The Nazca Lines

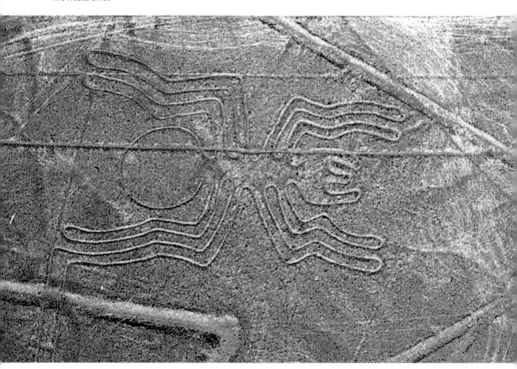

Some of the lines may have traced the routes of processions leading to *huacas*, sacred places that had a particular significance in Nazca myths. The fact that many of the lines are oriented

Approximately 800 years after the peak of the Nazca civilization, the region was hit by a long period of torrential rain, as a result of which the area was abandoned. All that remains

of this mysterious people today are the giant images they left behind.

Lake Titicaca

Cusco is the undisputed center of the Inca Empire, yet Inca creation myths locate their origins not in this city, but in the area around Lake Titicaca in the Andes. According to Inca mythology, the world was created out of the duality of light and darkness. The Inca believed that the gods perfected their work only gradually. One legend has it that the god Viracocha initially created a dark world populated by giants made of stone. These giants proved disobedient, so Viracocha sent a great flood to destroy them. Only one man and one woman managed to escape, as they were carried off to the dwelling place of the gods.

In his second attempt, Viracocha formed people out of clay and painted them different colors in order to tell them apart. He breathed life into them, sent them down to earth, and had them emerge from particularly distinctive lakes, caves, and mountains. The people later erected altars to honor their creator at these sites. When Viracocha saw that his work was done, he created light so that the people could see, and instituted social order so that they would live in a civilized manner. He commanded the sun and moon to rise from one of the islands in the lake. Since then,

Lake Titicaca and its environs have been considered sacred. A number of imposing burial towers can be found here, where high-status individuals were interred in a fetal position.

The Bolivian Aymara people also consider the lake sacred. The present-day inhabitants of the area around the lake live in much the same way as their early ancestors, building dwellings from totora reeds, bamboo, and clay from the lakeshore, and fishing from simple rafts or canoes made of woven reeds. Their creation stories are a combination of their own ancient myths, tales of the Inca creator god, and even Christian motifs. The latter were woven into the legends much later, under the influence of Christian missionaries, but are nevertheless now seen as integral.

One myth tells the story of Thunapa, a charismatic, bearded, and blue-eyed man who preached against war, drunkenness, and polygamy. Thunapa was passing through the town of Carapucu carrying a cross on his back, when one of his companions fell in love with the daughter of the chieftain, Makuri. When Thunapa returned, he baptized the daughter, which so enraged Makuri that he killed him. The body of Thunapa was laid in a reed boat, which suddenly set sail of its own accord, hitting the edge of the lake with such force that it made a channel that bore the hero all the way to the Pacific Ocean.

At an altitude of 13,100 feet (4,000 m), Lake Titicaca's setting is awe-inspiring. It is small wonder that the lake is revered as a place where humanity and nature come together as one.

Copacabana, Lake Titicaca

The name Copacabana first brings to mind that celebrated slice of Brazil's Atlantic coast at Rio de Janeiro, but there is also a Bolivian Copacabana, right on the shores of Lake Titicaca, 12,500 feet (3,800 m) up in the *cordillera*. Many Catholic pilgrims come here to honor Our Lady, the patron saint of Bolivia, at the **Basilica of La Virgen de la Candelaria de Copacabana**. According to legend, the Virgin Mary appeared to a male descendant of the Inca in a dream in either 1576 or 1580. On waking, he carved what he had seen in his vision out of a piece of wood, and it was not long before people started attributing miracles to the statue that came to be known as the Black Madonna (*Virgen Morena*).

Construction of the town's cathedral began in around 1600, and the statue was eventually housed there. The exact date on which the building work began is not known, but the present-day Moorish-style church was consecrated in 1820 and has since become one of the most important pilgrimage sites in Bolivia. The statue of Our Lady is approximately 3 feet (1 m) high and wears a crown of pure gold. The icon attracts a constant stream of visitors, who arrive in even greater numbers at the weekends and on important Catholic feast days. They come here to receive blessings either from the Catholic priests or from shamans of the Aymara tribe.

The Aymara have always viewed the mountain above Copacabana on the lakeshore as a sacred place, and it is here that they worshiped the mythical cat's head, Titicaca, which gave the lake its name. Today the mountain is known as the **Cerro Calvario** (Calvary Hill), for the 14 Stations of the Cross that pilgrims pass on the way up to the top. At each station people leave behind items from their everyday lives in the hope of gaining God's blessing on their families, houses, and even their cars. The goal of the pilgrimage is the golden statue of the Madonna on the top of the mountain.

On Good Friday a long procession makes its way to the summit. Christian tradition is, of course, very much apparent here, but the ancient rituals of the Aymara and Inca religions are also evident. Shamans sit at the edges of the path, telling fortunes, and some of the pilgrims make offerings of stones and coca leaves at the Stations of the Cross—an ancient tradition that is supposed to bring the people into closer communion with nature and the gods.

Tiwanaku

On the southern shore of Lake Titicaca lies a ruined settlement that is shrouded in mystery, has always fired people's imaginations. The fact that the surrounding land is almost barren, and that many of the buildings that have been discovered may well have served a religious function, has led many people to believe that this

was once the site of a shrine, possibly a place of pilgrimage visited by the indigenous people of the Andes.

The central plaza in Tiwanaku was the Kalasasaya, which means "Plaza of the Standing Stones" in the language of the Aymara people. This square area is slightly raised and encircled by standing stones. To the east, on a slightly lower level, lies a temple with a stairway leading up to a gate, which is aligned in such a way that you can see the exact point where the sun rises during the equinox. A row of pillars on the western side of the plaza marks the divisions of the year.

Another interesting feature of the site is the Acapana, a seven-tier pyramid with a sunken court on its uppermost terrace. Acapana means "the place where men die," so it seems reasonable to suppose that human sacrifices were once carried out here. In 1922 Bolivian archeologist Arthur Posnansky dated this cult site to around 15,000 BC, making it the earliest evidence of human civilization and unleashing fierce debate among archeologists and geologists about how old Tiwanaku actually is, and which gods were worshiped here.

Regardless of the conflicting views of researchers and the fact that modern reconstructions of the monuments do not comply with international scientific and cultural standards, Tiwanaku still exerts a curious pull on the visitor. It is easy to see why this place was considered sacred—even today, it is imbued with a mystical atmosphere.

Standing stones at Tiwanaku

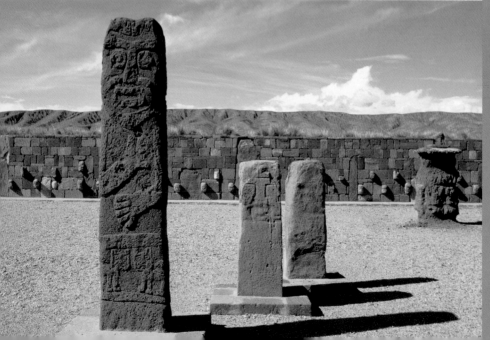

Chiloé

✠

Chiloé is an island off the coast of Chile that has managed to preserve the features that make it so special. The architecture here differs markedly from that on the mainland. One example of this difference is the *palafito*, a house erected on stilts. *Palafitos* are typical of Chiloé and built according to traditional methods.

The Jesuits first reached the island in 1608 and set about bringing the gospel to the indigenous Huilliche people. In 1612 they constructed the first of the 150 wooden churches that would come to be so characteristic of Chiloé. They are

A wooden church on Chiloé

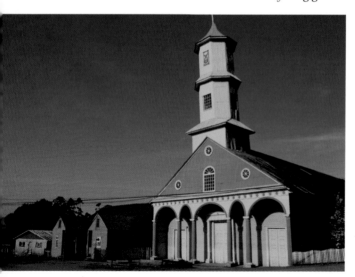

wood gives them great warmth of character. Many are now specially protected and have been designated a UNESCO World Cultural Heritage Site. The most famous of the wooden churches is the Iglesia Apóstol Santiago de Castro, the cathedral dedicated to St James in the island's main town. These churches are living sacred places as most of the islanders are nominally Catholic.

"Nominally" is the operative word here, however, as ancient Huilliche myths are still being handed down today and have been combined with Christian teachings in the belief system of the islanders. One cautionary tale has it that you must be careful when walking in the sprawling forests, as this is where El Trauco lives, a small, ugly, and troll-like man. His favorite pastime is to hypnotize young girls and lead them into the forest. They return pregnant to the village. Large numbers of *voldoras*, flying witches, are also believed to inhabit the island and appear when you least expect it. Another legend tells of the *Caleuche*, a phantom ship, with a crew made up of magicians. The *Caleuche* is said to be able to turn itself into the trunk of a tree or a rock in an instant.

Chiloé, a remarkable island with fascinating natural features, is a destination for many

mostly based on the style of churches in central and southern Europe, but the who want to explore a civilization that is both sacred and unfathomable.

Punta Arenas Cemetery

Punta Arenas was founded in 1850 and is now the largest city in southern Patagonia. In the middle of this vibrant city lies a sacred place, a monument to the city's dead. The Cemetery of Punta Arenas reads like a chronicle of colonization; English, Spanish, Italian, German, Lithuanian, and Croatian names can be seen on the tombstones and the enormous, ornate mausoleums built for the landowners of the past. Much of the city lies derelict and the trees have been bent over by the prevailing westerly wind, subject to an almost constant gale. Life at the "end of the world" seems to have stood still since 1914, the year when the Panama Canal opened and Punta Arenas went into rapid decline.

Visitors may be surprised to find that the Cementerio Municipal appears to be the liveliest pace in town. Many of the inhabitants of the city say that having a decent grave has always been more important than having a decent house. Consequently, the cemetery has a special atmosphere. The most splendid tomb of all is the mausoleum of José Menéndez, who established the cemetery in 1893. His name is inextricably linked with the history of the city and the local Braun family.

The estates of these two clans, linked by marriage, were vast. Menéndez owned huge sheep farms, a whaling fleet, mines, banks, and his own railroad company. His tomb is crowned with an angelic herald shown blowing a trumpet, and the entrance gate is carved with symbols of his power.

The alcoves of the *columbaria*, where the funerary urns were kept, contain plaques telling the life stories of many of the people buried here and ensuring that they are not forgotten. The tomb of a Turkish family who—for whatever reason—converted to Catholicism is particularly striking. It is now very weathered and there is an air of melancholy about it. You can just make out the poignant inscription on the tombstone: "Death is a black camel. It is always kneeling outside someone's door."

Yet the most important tomb of all is undoubtedly that of the *Indiecito Desconocido* (the Unknown Young Native), the monument to a nameless Native South American boy. This grave is there to remind people of the indigenous people of Patagonia, and the bronze statue is venerated like that of a saint. The numerous votive plaques with messages of thanks for answered prayers and the many wreaths and crosses left here demonstrate just how much the people still identify with their ancestral past. Elderly people stand before the monument in prayer, and lovers stare dreamily up at the smiling boy. The statue's palm has been touched so many times that its surface has been polished to a shine, a sign of the devotion that the people feel toward the statue.

The Difunta Correa Shrine, Vallecito

María Antonia Deolinda y Correa is venerated all over Argentina. Even though she has not been canonized a saint by the Catholic Church, monu-

A statue at the Difunta Correa Shrine, Vallecito

ments and small altars to her are to be found at many roadsides. During the civil war in 1841, the Spanish took many indigenous prisoners and forced them to make rapid route marches to the north. One of these prisoners was Audilio Correa. His young wife Deolinda, who had recently given birth, was utterly distraught, and set out to follow the men who had been captured. After 21 miles (34 km) she collapsed from exhaustion and thirst, and died.

A few days later her body was found, with her still-living child at her breast. Deolinda was buried in the place where she had been found, which soon became an unusual pilgrimage site.

The Difunta ("deceased") Correa Shrine is in Vallecito, about 37 miles (60 km) east of San Juan. Thousands of pilgrims come to it every year, bringing diverse offerings—mainly bottles of water, but also small models of houses, family photos, certificates, football shirts, and wedding dresses. Even old cars are left at this bizarre shrine. The Difunta Correa is particularly popular with truck drivers, who have to cross the vast expanses of Argentina and come to ask for protection and help; the shrine is a good example of how sacred and secular needs can coincide. A great festival takes place every year at the main shrine of the Difunta Correa in Vallecito. The site is surrounded by souvenir stands, snack bars, and motels where the pilgrims, who have frequently come from far afield, can stay the night.

Basílica of Nuestra Senhora de Luján

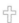

Sometimes the most unlikely events can have a huge impact. This is certainly true of Luján, a city to the east of

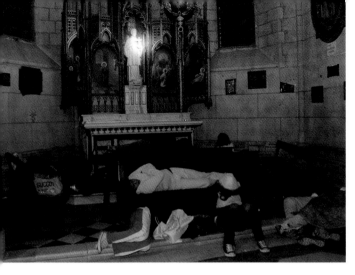
Exhausted pilgrims in the Basilica of Luján

chapel built on the site. This soon became a place of pilgrimage for people from the surrounding area, and a young slave became its first priest.

When good roads were built some time later, they completely bypassed the site, and the chapel was almost forgotten. Happily, in 1671 a woman from Luján offered to pay for a new chapel to house the statue. The work was carried out, but the statue kept miraculously disappearing, always returning to its original site. Only when the people began to hold special Masses for it in the new chapel, make processions there, and, last but not least, when they reinstated the slave as the priest of the new chapel, did the statue at last remain in its new home.

The cornerstone of the present-day basilica was laid in 1887, and the building was completed in 1935. The neo-Gothic, seven-aisled church now houses the highly venerated statue as its most important relic. Luján and the statue attract so many pilgrims that they now form the most important source of revenue for the city.

Buenos Aires, which has developed into the most important place of pilgrimage in Argentina. Tens of thousands of people travel to the city's enormous basilica every year, especially in December, when a huge procession wends its way from Buenos Aires to Luján, a distance of some 47 miles (75 km). On important feast days the basilica and the vast square in front of it are packed with pilgrims, who outnumber the population of the city.

In 1630 the Portuguese-born António Faria de Sá ordered a statue of the Virgin Mary to be brought from Brazil. A short distance from his house, the cart that was carrying the statue stopped dead and could not be shifted. After trying and failing to bring the statue closer to António's house, the people recognized this as a divine sign that the statue should remain where it was. It was given to the owner of the land, who had a

AUSTRALIA, NEW ZEALAND, AND THE PACIFIC ISLANDS

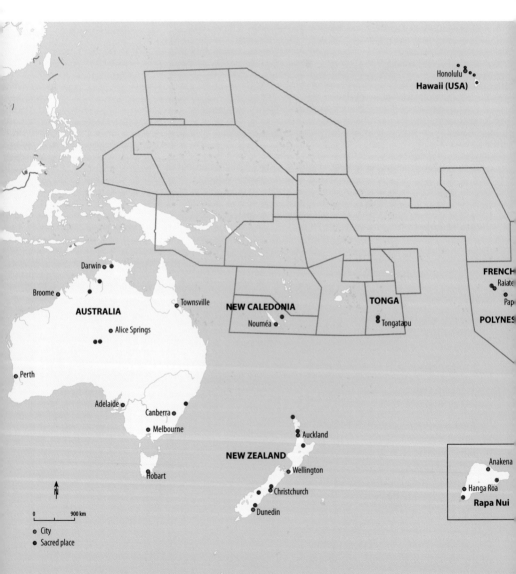

Honolulu
Hawaii (USA)

FRENCH
Raiate
Pap
POLYNES

Darwin
Broome
AUSTRALIA
Townsville
Alice Springs
Perth

NEW CALEDONIA
Nouméa

TONGA
Tongatapu

Adelaide
Canberra
Melbourne
Hobart

Auckland
NEW ZEALAND
Wellington
Christchurch
Dunedin

Anakena
Hanga Roa
Rapa Nui

N

0 900 km

- City
- Sacred place

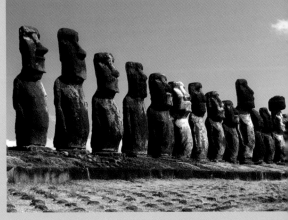

Victoria River

The Aborigines believe that Dream Spirits used to wander the earth, creating rocks, trees, watercourses, and other natural phenomena. Where the spirits left such traces of their passage, the routes became known as dream paths or "songlines." The Australian landscape is riddled with these tracks, some only a few miles long, others hundreds of times longer. At the end of their path through the Dreaming, the spirits turn into the features they represent or return to the earth, but the marks of their progress across the earth are preserved forever. Places that feature in the Dreaming are sacred to Aborigines of all tribes. Natural phenomena are much more than their visible manifestations, and their true meaning is often difficult to express in terms of Western phenomenology.

An impressive example of such a sacred layer of meaning is to be found in the meanderings of the Victoria River, as it twists and turns past the steep cliffs near the little town of Timber Creek. The Yarralin Aborigines regard this 340-mile (550-km) river in the north of the Northern Territory

as the path of the spirit Walujapi, a dream ancestor of the black-headed python. Walujapi left a snake-like trail as he passed over the earth, and the place where he finally rested is now marked by a depression in the earth—a sacred feature of the landscape.

Kakadu National Park

This national park in northern Australia is home to countless plant and animal species, and humans have lived

Rock paintings, Kakadu National Park

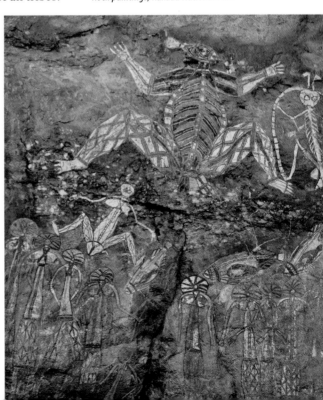

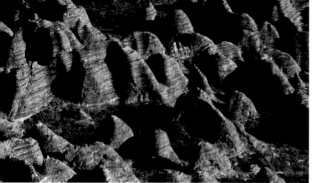

Rock formations, Purnululu National Park

here for 40,000 years. Australian Aborigines consider it to be one of the most important sites of the Dreaming.

The first human inhabitants were well versed in living in harmony with nature, and the region was also the home of the Mimi spirits; the Aborigines believe these to have chosen the area during the Dreaming and to have left portraits of themselves in the many surviving rock paintings. The spirits appear only on windless nights to avoid being harmed by potentially dangerous storm winds, and are depicted with exceptionally thin bodies, most often in the form of hunters or dancers. Most of the drawings were executed on the rocks using red ocher paint with a high iron content; as this pigment closely resembles human blood, it is considered the most sacred shade. Magical powers are attributed to the places where the paintings are found, and the sites are accessible only under auspicious circumstances; many are still closed to the public at certain times.

The "Devil's Marbles," mysterious and striking rock features formed through the solidification of molten lava and known to the Aborigines as *Karlu Karlu*, are worshiped as the eggs of the Rainbow serpent. If you could observe them throughout a whole day you would discover that in the early morning they look as though they have been covered with steel blue lacquer, but over the course of the day they take on various brown and yellow tones before glowing bright orange against the setting sun. The rugged scenery is overwhelmingly beautiful and this seemingly supernatural place is awe-inspiring.

Purnululu National Park

Revered as sacred, this wilderness was kept secret by Australia's Aboriginal population for over 20,000 years. The Aborigine creation myth, with its close connections to bodies of water, rocks, and other geological phenomena, remains the basis for their spirituality.

The Bungle Bungle Range was formed through the gradual erosion of a layer of sandstone to reveal beehive-shaped features in underlying gray and orange strata; these can reach a height of 1,000 feet (300 m) above the trees and scrubland of the plains. Now specially protected as a national park, the area has a wealth

The Dreaming

Only the Aborigines know anything for sure about the Dreaming, and their knowledge is passed on sparingly—only select individuals learn the secrets of the "dream places," usually in mysterious initiation rites.

Aborigines recognize two eras, each inseparably connected with the other—the present and the Dreamtime. The Dreamtime was the era of the earth's creation, in which mythical beings—half-man, half-animal—undertook journeys and performed heroic tasks to create rivers and springs and other natural phenomena. Once the creation was completed, they hid themselves away in the bowels of the earth, taking forms recognizable in the natural world. The Rainbow Serpent, a central figure in the creation myth, awoke during the Dreamtime and began to wander the earth. This sacred snake impressed upon man the importance of taking from nature only as much as was necessary to sustain life—appropriating any more would incur lasting punishment.

The existence of the Dream Spirits is made visible in "songlines," the paths they followed and the tracks they left during the Dreaming, and such songlines are a source of information about events of the Dreamtime. Places involved in the Dreaming are sources of great spiritual power, and *karadjis*, men of great respect, are able to read their signs and interpret them. Such men are also able to fly to the spirit realm, a gift denied other members of the tribe. However, all are united in the belief that the soul of the individual and the landscape are inseparably bound up together, and severing this connection means ending life.

of places that were considered sacred, and these still retain a magical aura even though nothing is now known of the spiritual practices of the original indigenous population. Over millions of years, wind and weather have scoured the silica sand from the Echidna Gorge to reveal a unique landscape of steep cliffs and narrow passages through which the sunlight shimmers.

This part of the world has a breathtaking natural beauty that is emphasized by the light of the setting sun, inspiring awe and humility at the greatness of nature in all those who experience it, irrespective of their beliefs.

Kata Tjuta

Somewhere in the outback, in the desert in the southern part of the Northern Territory, there are 36 dome-shaped rocks rising out of the land. Their red coloration is due to the high iron content of the soil and the rocks. In conjunction with Uluru (Ayers Rock), which lies only a few miles away, they form the Uluru-Kata Tjuta National Park, a vast territory considered sacred by the Aborigines, in whose language Kata Tjuta means "field of many heads." The Anangu Aborigines believe the rocks to be the homes of spirits from the Dreaming, and since the area was

legally returned to its original owners in 1995, the site is once again being used for religious initiation ceremonies.

The countryside around the rocks is virtually unspoilt and, as might be expected, attracts great numbers of people who come to visit the National Park and its geological treasures. This has its dangers, as unthinking visitors can unwittingly desecrate rock formations or scenery that the Aborigines consider to be as old as life itself. Entry to Kata Tjuta is therefore strictly controlled by park rangers, for just as the white settlers once almost entirely wiped out Aboriginal culture, unrestricted access would destroy this sacred place. It took a long time for this realization to be established, and the need to approach a sacred site with humility and respect in order to avoid its desecration is still not universally accepted. The religious legacy of the Aborigines was long threatened with extinction. Only recently have attitudes changed, shoring up Aborigine civil rights and promoting respect for the culture of a people who have lived in this country since the beginning (Latin: *ab origines*).

Uluru (Ayers Rock)

The sacred mountain of Uluru ("Seat of the Ancestors"), one of the most famous geological formations in the

Sacred Uluru; the rocks of Kata Tjuta can be seen dimly in the background

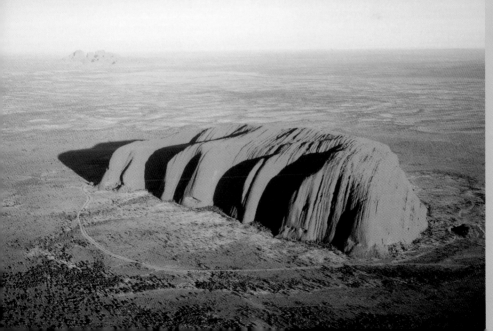

world, is a monolith about 5.5 miles (9 km) in circumference, rising to a height of 1,142 feet (348 m) above the Australian desert. The rock has stood here for millions of years and is considered so holy by the Aborigines that it is never climbed—they worship it from afar. Visitors are allowed to climb the mountain but the practice is discouraged, not least as the climb is challenging and accidents are not infrequent. Geologists would call the formation a monadnock ("island mountain") and most of it lies beneath the sands of the plain. Its position in the middle of the desert is unusual in itself, but the way it changes color as it reflects light during the course of the day is even more curious. It appears to be orange at dawn and a kind of rusty red in the morning, before glowing amber under the merciless midday sun and turning a deep red at dusk. The coloration is due to the high iron content in the sandstone of which it is formed.

The legend of Uluru's creation tells of a struggle between venomous and non-venomous serpent people. Bulari—Mother Earth—eventually took the side of the non-poisonous tribe and breathed out a deadly toxic cloud to force the enemy to retreat. The lifeless bodies of the venomous serpent people were collected into an enormous pile, which slowly turned to stone and became Uluru.

The world-famous monolith was first discovered by white men in the course of an expedition in 1870 and was given its English name of Ayers Rock in honor of the South Australian Chief Secretary, Sir Henry Ayers. Uluru was re-adopted as its official name in 1995.

Mary MacKillop Place, Sydney

The World Youth Day held by the Catholic Church in Sydney in 2008 drew the attention of Australians and Catholics around the world to Mary Helen MacKillop, to date the only Australian to have been beatified, and the chapel dedicated to her became the central pilgrimage site of the entire youth event.

Mary MacKillop was a nun and the co-founder of the Sisters of St Joseph of the Sacred Heart. The eldest of eight children, Mary was born in Melbourne in 1842 and from a young age was considered both an intelligent pupil and a particularly determined person. These virtues were to stand her in good stead in her later endeavors, as she went on to found a school with two of her sisters in 1866. The congregation she founded a year later was also principally devoted to the education of children from poor families. The order rapidly flourished and soon there was a network of schools stretching across Adelaide and the surrounding area.

Despite her undeniable success, Mary MacKillop was not popular with the Church authorities. They were suspicious or even dismissive of her

Pope Benedict XVI at the tomb of Mary MacKillop, Sydney

egalitarian and emancipated educa-
tion methods, and in 1871 MacKillop
was excommunicated. After a trip to
Rome, she was able to obtain permis-
sion for her order to continue and the
excommunication was rescinded. Her
style of leadership continued to attract
controversy, however, and she eventu-
ally moved her order to Sydney. Mary
MacKillop died in 1909, by which
time more than 1,000 sisters had
joined the order to continue her work.
She has always been greatly venerated
and all kinds of signs and miracles
have been reported at her graveside.
The beatification process was set in
motion in 1992, and she was beatified
by Pope John Paul II in 1995. As
devout pilgrims persisted in remov-
ing earth from her grave, believing
it to have magical healing proper-
ties, her mortal remains were moved
to the chapel of the order's home
church in North Sydney, where they
continue to enjoy great reverence.

Ratana Church, Te Kao

In Te Kao, in the far north of New Zealand's North Island, stands a little wooden church. This is the northernmost outpost of the Ratana movement, a syncretist Maori religious community. The indigenous population has been turning away from the mostly Protestant missionaries and the established churches since the mid-19th century. The most important and still most influential of the alternative religious and political movements bears the name of its founder, Tahupotiki Wiremu Ratana (1873–1939). In 1918 Ratana claimed to have had a vision identifying him as God's messenger and began to preach a "pure" version of Christian beliefs.

The various denominations of the Church initially acknowledged this as a revival of Christian faith, but it soon became apparent that it actually represented the advent of a new religious community. Ratana's sermons attracted ever more people, and in 1925 this separate branch of the Church was officially founded and Ratana was acknowledged as Te Mangai ("mouthpiece of God"). The first church was built in 1928. From this point on, T.W. Ratana began to pursue political goals and for decades the religious organization represented Maori interests in the New Zealand parliament.

Ratana churches very similar to this one are to be found all over the country, as the community unites the Maori across all tribal differences. The wooden church in Te Kao con-

sists of a barn-like structure with two simple, squat towers, each bearing a rounded dome topped with a crescent moon and a star. One is inscribed Arepa and the other Omeka, the names of the sons of the religion's founder and a reference to Alpha and Omega, the beginning and the end. There is no trace of the richness of Maori culture within the church, and yet it differs from other Christian places of worship in not adopting a European style of church design.

One Tree Hill

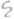

Polynesians reached New Zealand's two islands around 800 and established the first settlements soon after; it is now known that several waves of immigration reached the island group between the 9th and 16th centuries. The oldest stories tell of great canoes, and in particular of the legendary canoe "Tākitimu" in which a priest caste came to New Zealand. They set off from a place in the Pacific named in the legend as Hawaiki, the old name for Raiatea, although this is thought not to refer to the actual island; Hawaiki's name was merely borrowed as it was thought to be associated with the spirit world.

The Polynesians brought several gods with them, and these gradually merged to form the basis of a rich oral tradition. Maori society accorded a position of respect to its priests.

There is a wealth of legendary landing places on both islands, and these were where the first purpose-built hill fortifications (*pa*) were built.

One such *pa* is at One Tree Hill near Auckland. The *pa* was constructed on the cone of an extinct volcano and its terrace-like structure is still clearly visible. A lone tree once stood on this hill. The Maori used such forti-fied complexes as both dwellings and shrines, and an area of the hilltop was often reserved for priests (and consid-

One Tree Hill, Auckland

ered *tapu*, a word meaning "forbid-den things"). Maori religious life was strictly regimented and the breaking of taboos was severely punished, some-times even incurring the death penalty.

Little or nothing remains of the Maori's historical buildings, but their *pa* are evidence of a martial and pugnacious civilization at whose center stood religious leaders.

St Faith's Anglican Church, Ohinemutu

Many people visit Rotorua for the close contact with Maori culture that it affords. There is hardly a house or a town where you will not see typical Polynesian carvings, although most of these are crude and garish versions produced for tourists. The air over the town and sea hangs heavy with the vapor and unpleasant sulfurous odors emanating from the countless geysers and cracks in the earth's crust. Recon-structed Maori forts, Maori dance performances, every kind of Maori kitsch—there is no shortage of these. Although Rotorua is an acknowledged center of Maori culture, the latest generations of descen-dants have learnt how to make hard cash out of their cultural legacy. However, Ohinemutu, a working tra-ditional village community, is only a few miles away.

Encounters with the materialist culture imported from the West gave rise to so-called "cargo cults" (refer-ring to the freight carried on ships), religious movements with syncre-tist traits. These could be under-stood as traditional responses to contemporary experience and an attempt on the part of the locals to reconcile the arrival of the Euro-peans with their own traditions.

The myth of the Three Brothers gained widespread popularity. The first brother was the father of the people of the prairie and the second was the father of the people of the forests. The third brother went away forever to a land where he gained knowledge of previously unknown possessions and magical abilities; his children have access to cars, clothes, and tools, all of which come from a great hole in the bed of the ocean. Men travel there in boats, and spirits descend on ladders to retrieve the goods from the depths of the sea. The third brother clearly represents the Europeans, who also brought Christianity with them. St Faith's Anglican Church in Ohinemutu is a good example of a merging of old and recently imported religious practices.

Built in 1810, the church has an interesting exterior and further treasures lie within: it is covered with both Maori and Christian symbols, and these are most strikingly mingled in the windows of the side nave, a later addition to the structure. Along with the view of the lake, there is a representation of Christ bearing the regalia of a Maori chief, seemingly strolling across Lake Rotorua as he once walked on the waters of the Sea of Galilee.

Christchurch Cathedral

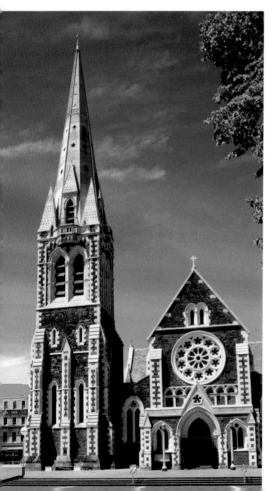

Christchurch Cathedral

European settlers of the mid-19th century initially established communities on natural harbors that cut deep into the land south of the mountains. The surrounding steep hills proved to be a natural barrier when they wished to expand these towns, however, and so the flatter land beyond the hills was chosen as the site of a city that has since been described as the "most English outside England."

Named after its cathedral, Christchurch is the largest city on

South Island and home to a third of the island's population. Many of the earliest buildings were constructed in an English neo-Gothic style and the greatest of these is the cathedral, which dominates the square in the heart of Christchurch.

It was planned and built as the center of the new city in 1864 so that the first settlers would have a place where the Anglican diocese could demonstrate to them the advantages of a "decent, industrious, and honest lifestyle." The planners had imagined a model Anglican city, but the reality proved to be rather different; what was required were pioneers who were not afraid of clearing the land or living for years in very modest circumstances, and the notion of a "Church state" collapsed.

All that remains of the project is the impressive cathedral, where members of the Christchurch Association of Bellringers meet daily to pull on the ropes that ring the mighty bells in the tower to call the faithful to prayer. As you enter through the portal in the west façade, you will notice four stone tablets in the porch, recounting the history of the church and the city. The second is a reminder to visitors of the purpose of the institution: "Pray for God's blessing on our City, our Nation and our World that He may teach us and all men the Beauty of Truth, the Wisdom of Love and the Spirit of Fellowship. And go forth from this Sanctuary of God with renewed strength to witness more gratefully for Him in your daily life. The Lord preserve thy going out and thy coming in."

The wide, single-nave church is richly decorated with symbols and artwork from several different cultures. The beautiful and serene seven-armed menorah on the right-hand side of the nave is a reminder of Christianity's roots in Jewish tradition, and the beautifully carved oak lectern, decorated with an eagle, the symbol of St John, was a gift from the wife of the first bishop; a Bible reading has been given here daily since 1881. The main altar is of a similar beauty and depicts Anglican pioneers, the first bishops, and other Christian symbols. The charming mosaics and paneling display traditional Maori motifs, and the rose windows admit a warm light.

Church of the Good Shepherd, Lake Tekapo

The Church of the Good Shepherd is an idyllic little stone church that overlooks the waters of Lake Tekapo—turned a milky color by meltwater—beneath the mighty peaks of the Southern Alps. The area round the lake is known as Mackenzie Country, a reference to a legendary shepherd who is said to have rustled a herd of sheep across the mountains to a wide plain, aided and abetted by his dog, Friday. There is a famous bronze memorial to all sheepdogs, the shepherds' faithful companions, on the lake shore by the church. The church is a reminder

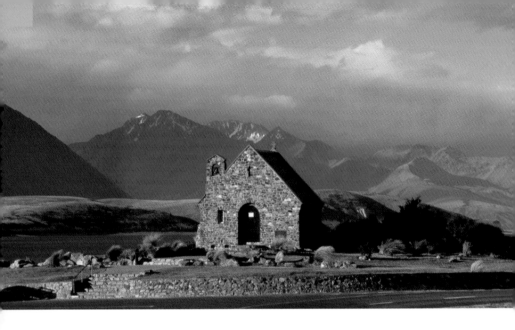

The little stone church at Lake Tekapo

of how important a good shepherd is to a herd; he will protect them from danger and lead them to a wide and fertile valley, as stated in the 23rd Psalm: "The Lord is my shepherd, I shall not want" (Psalms, 23:1).

Built in 1935, the church is a simple stone structure and there is a fantastic view of the lake and the mountains from the altar window. Three different Christian denominations use the church for their services and as an education and outreach center for the local community. Whatever their faith and beliefs, some time spent in this beautiful place should help visitors to feel more in tune with nature and simply glad to be alive.

Moeraki Boulders

According to Maori legends telling of the journey from the underworld (Hawaiki) and of the settlement of Aotearoa (New Zealand), canoes were wrecked on this stretch of coast after crossing the Pacific from Hawaiki an unimaginably long time ago. As some of the canoes were dashed on the rocks, their baskets of provisions were washed ashore and changed into stone spheres, which then collected at a place that is now magical for the Maori and every visitor who encounters these strange formations.

Located just to the south of the town of Oamaru, the Moeraki Boulders are something of a geological curiosity in that their basic shape was formed

not by wave action but by a chemical process of crystallization; the legendary explanation in the myth seems almost plausible. The boulders weigh several tons and can reach 13 feet (4 m) in diameter. They are submerged at high tide, but as the waters recede they rise out of the sea, transforming the beach into a magical landscape.

Each boulder is different and shimmers mysteriously for the duration of low water until being submerged once again, only to return a little while later to remind the Maori of their ancient legend.

Unfortunately, souvenir hunters have stolen many of the smaller boulders over the years, and the larger ones are protected more by their weight than the force of law. Such a strange and rare phenomenon should be approached with awe and respect.

The enigmatic Moeraki Boulders, Oamaru

The sacred places of Kamapua'a, Kauai

Some might think that this is a place of natural beauty and nothing more, but many of the mountains jutting out of the sea, the cliffs and springs, the lakes, and the imposing canyons are places sacred to one of Hawaii's countless deities—Kamapua'a, the infamous trickster and god of transmutation.

According to legend, Kamapua'a approached the island of Kauai as a large black fish before turning himself into a wild boar and stilling his hunger with yams and sugar cane. One day he was trapped by 20 men and brought back to their village, where they intended to roast and eat him. Just as the villagers were about to kill him, he broke the ropes and turned himself into a handsome warrior. When the guardian spirits of a spring refused to allow him to drink, he changed back into a boar and tossed two of the spirits across the valley, where they became two great cliffs. Kamapua'a fell asleep and the giant Limaloa tried to kill him by throwing a great boulder at him. Kamapua'a immediately transformed himself into a warrior and threw a stone, which split the boulder. Limaloa and Kamapua'a became friends and together they wandered the island. Kamapua'a was almost invincible in battle as, apart from the hand in which he held his club, he was invisible, and he would steal trophies from those he defeated and hide them under his

bedding. The search for the thievish and mutable Kamapua'a went on for some time, even though it was known that he had injured his hand, but eventually he was caught and given the choice between death or banishment; he chose to leave the island forever.

This well-known myth is still told today in reference to many of the special natural features found on this island with the oldest geology on earth. Kauai is not only famed for its natural phenomena, however. Parts of the film *Jurassic Park* were shot here, an interesting parallel to the old myth of Kamapua'a.

Oahu

Oahu is the third largest and most densely populated island in the archipelago and also the hub of its commerce and tourism. Situated above the town of Makaha on the west coast, **Kaneaki Heiau Temple** is a fine reconstruction of a place of worship once used in the old beliefs of the island's second population group, who arrived from Tahiti in the 12th century and supplanted the original inhabitants' animist beliefs with their own. The mighty priest king Paao decided that his people were too lax in their worship of the gods and introduced a strict system of human sacrifice and taboos (*tapu*). Those who broke the taboos were usually sentenced to

death, although certain delineated areas were established where the condemned could live—if they reached safety before being intercepted by their pursuers—and after a set time they could be forgiven by a holy man and allowed to continue living. In 1819 Kamehameha II and Queen Kaahumanu abolished these beliefs and most of the religious sites were demolished.

Kaneaki Heiau was reconstructed in the 1970s and is an eloquent example of a lost religion: the temple was originally dedicated to a harvest god called Lono and then to Ku, the god of war. Such temples were always built on sites rich in *mana*, a particular kind of spiritual energy. A surrounding wall was built around the sacred area using volcanic rocks, and within it there stood thatched huts, sacrificial platforms, and carved statues of gods. Heiaus, which were always dedicated to Ku, the god of war, always had a place for the human sacrifice he demanded. The cultural history is all very interesting, but it is difficult for modern visitors to come here without feeling a chill.

Most of the islanders would consider themselves Christians, but there are also a few Shintoists on Oahu. These are descendants of Japanese immigrants who came to the island in the 1860s. Their spiritual home is located in the Valley of the Temples, a cemetery just to the north of the town of Kaneohe on the east coast, where a Japanese temple was built in 1968. The **Byodo-in** (Temple of Equality) was constructed along strictly classical Japanese lines and is now used

for Shintō worship. A pool in front of the temple is filled with countless carp, the symbol of order, perseverance, and determination. The Byodo-in in Oahu is an oasis of peace and tranquility and attracts visitors of many faiths; its setting alone, against the breathtaking backdrop of the Koolau Mountains, is enough to suggest the order and balance it can offer for the benefit of mankind.

Haleakalā Crater, Maui

The sun once used to travel so quickly across the sky that the goddess Hina did not have enough time to finish all her tasks in daylight—the day was just too short for all the gardening, food preparation, and drying of laundry. She complained about this to Maui, her son, and he decided to slow down the sun. Arming himself with stout ropes, he climbed to the summit of a volcano crater and waited for the sun to appear. When it finally began to peep over the lip of the crater, Maui caught one sunbeam after another in his ropes and tied them tightly. Once the sunbeams were caught like this, the sun could not climb any higher and was forced to stand still. Maui would agree to let the sun go only on the condition that it pursued a more leisurely pace

across the heavens. The sun agreed and Maui released the sunbeams. The sun did indeed slow its course, the days grew longer, and both Hina and everybody else had more time to do their daily chores. The legendary site of this occurrence came to be called Haleakalā, the "House of the Sun."

You are more than likely to believe the legend when you catch sight of the Haleakalā Crater; located in the national park of the same name, it is particularly spectacular at dawn. The present appearance of this dormant volcano is due to erosion, not eruption. The scenery strongly resembles the surface of the moon, and as day breaks across this unique landscape, it seems as though the sun and the moon are merging.

Garden of Gods, Lanai

Serenely beautiful Lanai is the small-est of the inhabited Hawaiian islands, and legend has it that long before man arrived here it was a realm of evil spirits. At that time a young prince named Kaululaau, a disobedient young man who was always playing

The bizarre rock formations in the Garden of Gods, Lanai

terrible tricks on his parents, lived on the neighboring island of Maui. His father eventually reached the end of his tether with the boy and banished him to the uninhabited island of Lanai, in the full knowledge that this would spell the boy's doom—the island was inhabited by night spirits and for this reason no one had ever dared set foot on the island before.

Kaululaau was as fearless as he was disobedient, however, and he succeeded in outwitting the spirits who did indeed try to kill him. During the day he would wait on the beach and though he encountered the spirits there, they could not harm him, as they were night spirits. They tried to find out from him where he spent each night so they could catch him and kill him, and he told them that he spent the night in the sea. The spirits spent every night in the surf, looking for their victim, but Kaululaau was not to be found. They continued their search until they were so exhausted that they drowned. The young prince told the story again and again and each time the spirits fell for the ruse, until eventually all 400 had drowned. The boy's relatives, who had long given the banished prince up for dead, noticed one day that a bonfire had been lit on a hill. When they came over to the island, they found

Kaululaau alive and well and learnt that Lanai had been freed of spirits. The boy was forgiven and subsequently honored as a hero on Maui, and Lanai has been inhabited ever since.

The Garden of Gods in the northwest of the tiny island is a strange and impressive landscape of bizarre rock formations shaped by wind and weather, although it is just as possible that they are actually likenesses of the mythical night spirits. What visitors see in the rocks is left to their imaginations, although most people will stare in amazement as the sun picks out the glowing colors of the stones.

Kilauea, Hawaii Big Island

Kilauea is one of the most active volcanoes on earth, with enormous volumes of magma constantly rising to the surface, but as the lava flows reasonably slowly, it is not considered especially dangerous. Halemaumau, the great crater of the volcano, was once filled with a vast bubbling sea of molten rock. Hawaiians considered this a sacred place as it was the home of Pele, the goddess of fire and volcanoes. Although the ancient

Kilauea volcano, Hawaii

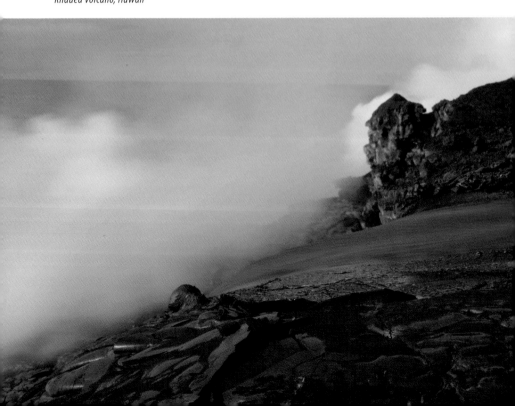

Hawaiian religion had died out by the turn of the 19th century, the locals still come here to lay flowers, fruit, and other offerings beside the crater. The people believe that the ancient goddess still lives here and they perform their old traditional dances in her honor. Though cantankerous and quick to anger, Pele is also extraordinarily beautiful and generous, and temples, long since vanished, were built beside the lava flow. It was believed the goddess was creating new land with the streams of molten rock.

The Hawaiian archipelago has existed for 44 million years—the blink of an eye in geological time—and there is no end in sight for the volcanic activity, so not surprisingly even the Christians pay their respects to Pele, the ancient volcano goddess. Her home is indeed one of the most fascinating places on earth—geysers, steamy, sulfurous springs, and a resemblance to the surface of the moon combine to give an impression of how the creation of the world must have looked.

Raiatea

Raiatea, the second largest of the Society Islands, is a major religious center and the home of the now

Sacred rocks, Raiatea

Taputapuatea Marae is a particularly significant site near Opoa in the southeast of the island, as the remains of a stone temple complex can still be made out here. Pilgrims from all over Polynesia visit this mystical place, situated in a coconut grove right by the sea. The **Temehani Rani** plateau in the mountains is also revered as 'Oro's birthplace. The cult was spread principally by members of the secret society of Arioi, a strict and exclusive religious community resembling a monastic order and led by aristocratic chieftains. Their mandate to lead rested principally on their genealogy: the land belonged to them and not only were they the undisputed religious authorities, but they were also the priests of the blood-

widespread 'Oro cult. 'Oro was the son of Tangaroa, who had previously been worshiped as a creator and fertility deity. Warlike and promiscuous, he delighted in human blood, and the 'Oro cult involved human sacrifice and ritual cannibalism in which the celebrants consumed the blood and thus the characteristics of their victims.

thirsty god, 'Oro. The Arioi society was open to men and women, and prospective members had to undergo eight levels of initiation before they received a religious rank. Besides human sacrifice on ceremonial platforms (*ahu*), their religious rites also involved ecstatic dancing, which was conducted in *marae*, areas reserved for ritual purposes.

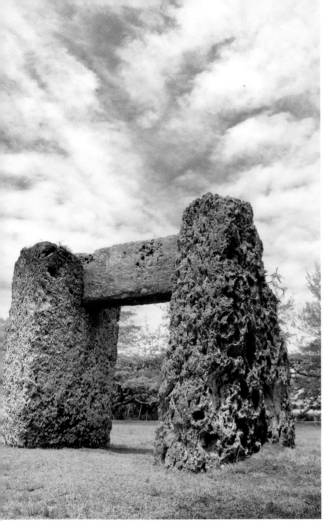

Ha'amonga 'a Maui, a gate-like monument made of coral slabs

Ha'amonga 'a Maui, Tongatapu

Some have described Tonga as a rather sleepy kingdom with an excess of palm trees and time on its hands and not much else. Tonga is still ruled today by the last of the Polynesian ruling dynasties. Time does seem to pass more slowly than elsewhere and the people that James Cook met were so amiable that he named the island group the "Friendly Islands" after a visit in 1773. Tongatapu is the largest of the islands belonging to Tonga and more than two-thirds of the Tongan population live here. The island is, however, rather atypical for the otherwise idyllic South Sea Islands— there are few of the world-famous beautiful beaches and the island is flat and devoid of the breathtaking natural phenomena usually associated with the South Pacific.

Yet Tongatapu has always been a major Tongan religious and cultural center, and some of its archeological sites date back 2,500 years. One such is the impressive and enigmatic Ha'amonga, a stone gate-like structure composed of three enormous rectangular slabs of coral. To this day, no one has discovered the purpose of this portal or who built it, a mystery that is part of the awestruck reverence accorded to the monument. The

current king of Tonga considers the huge trilithon to be an instrument for astronomical calculations, as various grooves and markings upon it indicate the direction of sunrise and sunset.

infirmities. The islanders see the worship of Catholic saints, particularly the Virgin Mary, as compatible with their old beliefs and traditional rituals, which were concerned with the cycle of life or the summoning of spirits.

Notre-Dame de Lourdes, Lifou

Lifou is the largest of the Îles Loyauté (Loyalty Islands) and is part of the South Pacific archipelago of New Caledonia. The islands of Ouvéa and Maré lie approximately 62 miles (100 km) from the main island, and Lifou is located between them. The impossibly beautiful beaches, dense forests, and warm sea make Lifou an area that some would describe as idyllic. The village of Easo nestles in Santal Bay in the northwest of the island. Just outside the village there is a little hill, which affords a breathtaking view and also hosts a great annual pilgrimage involving the inhabitants of the entire island. The goal of this pilgrimage is the Chapel of Notre-Dame de Lourdes, which stands like a landmark on the flat summit of the hill. The building is an extremely plain stone church topped with a golden statue of the Madonna based on the one at Lourdes. The church is named after the Madonna and, much as at Lourdes, pilgrims from all over the Pacific Islands flock to their Madonna seeking cures for their ailments and

Ahu Tongariki, Rapa Nui

This mysterious triangular island is located in the middle of the Pacific Ocean, 2,640 miles (4,250 km) from Tahiti to the east and 2,175 miles (3,500 km) from Chile to the west, which has had sovereignty over the island since 1888. The Polynesians know it as Te-Pio-Te-Henúa, the "navel of the world," and another name for it is Marakiterani, "eyes that stare to the heavens." It is known throughout the world as Easter Island (Rapa Nui), because Europeans first glimpsed its coast on Easter Sunday in 1722 with the arrival of the Dutch explorer Jacob Roggeveen. The two indigenous names hint at the mystery surrounding the island. The most enigmatic aspect is perhaps that the former inhabitants felled every tree, thus destroying for good their principal means of sustenance on the island. The foliage was replaced with *moai*, peculiar monolithic sculptures with staring eyes fixed on the sky, which are to be found all over the island. Of an original total of more than 1,000,

about 600 have survived in a reasonable state of preservation. At several sites the mighty monuments stand in groups on specially constructed platforms (*ahu*), which usually point out to sea. An encounter with these impressive megalithic figures is an

is Ahu Tongariki, a site impressive for the size alone of its 15 *moai*, some of which are more than 13 feet (4 m) tall. The curious expressions of the individual statues are striking, with some apparently smiling or biding their time in joyful expectation. Some

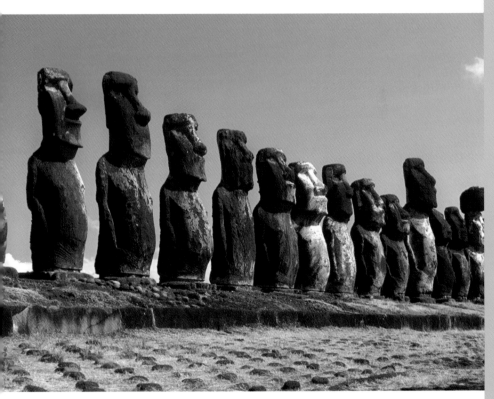

The Ahu Tongariki group of statues, Rapa Nui

encounter with a culture that has preserved its secrets to this day, although it has prompted wild flights of fantasy. The most famous of the groups

are staring absently at the sky, blinking in the sun, as if they were waiting for something or someone, yet displaying no signs of impatience.

One legend preserved by the indigenous population tells how a sunbeam would strike the heads of the *moai* once a year and bring them to life, whereupon they would move to another position. Unsurprisingly, the whole island is considered sacred, as every site where a statue stands is an impressive reminder of how time and eternity can cheerfully coexist with one another. The sun, sea, and bright skies of these latitudes give the impression that you can see several rainbows at once after rain.

Orongo, Rapa Nui

Orongo is a sacred place on the southwestern tip of Easter Island, closely associated with the "birdman cult." After the ancient cult of ancestor worship was abandoned—for reasons that are still obscure—and the erection of *moai* had ceased, the birdman cult gradually gained in importance. The people assembled once a year at the Rano Kao volcano crater to perform the *Tangata manu* (birdman) ceremony. Striking carvings have been cut into the rocks; the most common motif is the zoomorphic birdman, followed by mask-like heads with owlish eyes—likenesses of Makemake, the creator deity.

As the Sooty Tern—a bird considered an incarnation of Makemake—was about to begin the incubation of its eggs, the high priests would lead the people to the shrine, which included carefully constructed stone huts with thatched roofs. These were not routinely inhabited and were used only for ritual purposes. Sacrificial rites were carried out in which chickens, yams, and pieces of cloth were offered up, and children were also sacrificed to appease the creator god of fertility.

After the sacrifices had been made, certain family members would send trained youths (*hopu*) to swim to the nesting island of Motu Nui, which lies about half a mile (1 km) off the coast, and an observer would take up position on the Motu Kao Kao cliff, high above the sea. As soon as one of the *hopu* had found the first Sooty Tern egg, the fact was signaled to nearby Motu Kao Kao and from there relayed to Orongo. The *hopu* had to bring back the egg without breaking it, and the first to achieve this handed over his trophy to the priest and was crowned "birdman" for the year, which involved living in reclusive solitude and ruling over the islanders. All this is recounted in the great numbers of wonderful rock carvings found at the site.

The cliffs at Orongo, Rapa Nui

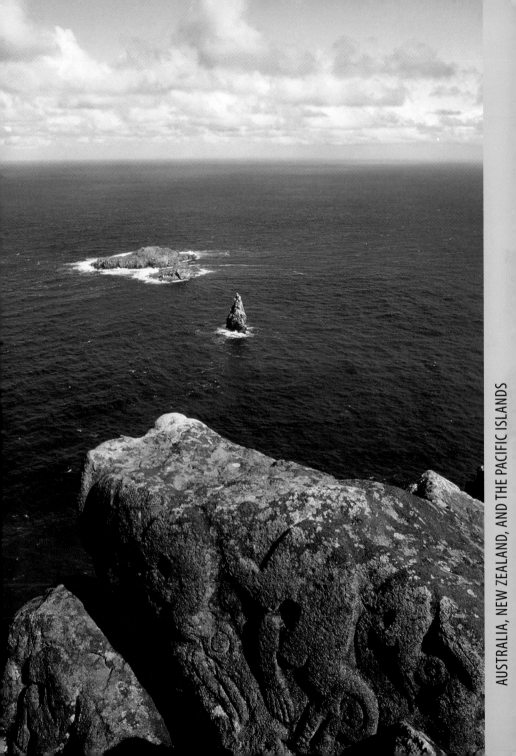

AUSTRALIA, NEW ZEALAND, AND THE PACIFIC ISLANDS

SACRED PLACES IN POPULAR CULTURE

Besides the places revered as sacred by the religions of the world, there are other locations which could be considered sacred places simply because they are revered by those who visit them. Great numbers of people accord such places a special status and perform "pilgrimages" to them because they provide access to something that transcends everyday life. These locations might be connected with a certain emotion or associated with a revered person, and they stand out from the "landscape of the mundane." They have become modern pilgrimage sites without ever being connected to any particular religion, yet the veneration of them can often take on quasi-religious traits; religious feelings are not restricted to faiths or religious institutions or even to an institutionalized community. In a sense, such a community arises from the shared reverence that becomes manifest at these places. The Latin word "religio" literally means "I bind," and this is what is happening here, in a wider sense: visitors to modern pilgrimage sites unite in a community of ideas that proves to be sustainable and coherent. Such places might be locations with a resonance in popular culture—music, art, a certain lifestyle—which enriches and pervades contemporary life.

The thousands of visitors to Jamaica who make the pilgrimage to **Bob Marley's house in Kingston Town**, which is now a museum, will find a peculiarly Jamaican lifestyle represented there. Bob Marley spread the message of Rastafarian culture throughout the world with his songs—reggae has not only enriched the world of music; it is an expression of a culture that was long oppressed and to a considerable degree still is. Rastafarians consider themselves sons of Zion and their longing for their homeland and their roots is unceasing; freedom, cultural identity, and political emancipation are the principal concerns of Rastafarianism. Countless visitors, especially young people, turn up at the famous reggae musician's house every year, and mementos of Bob Marley's life are treated as sacred relics. The larger-than-life statue in front of the house can be

seen from some distance away. Hundreds of people gather in the yard in front of the house every day to talk, swap experiences and memories, and play the music they love to hear. In their idol they also find inspiration and strength for their political activism.

It has been called "America's Main Street" and it is probably the most famous road in America: **Route 66** begins in Chicago and ends 2,448 miles (3,930 km) away in Los Angeles. Peter Fonda and the other stars of the film *Easy Rider* (1969) made the road famous as they rode their Harley-Davidsons into the sunset, heading west like the first pioneers, in search of a freedom untrammeled by hidebound conventions. If you insist on four wheels, you would have to pick a red Corvette, a car as legendary as the road of dreams itself. Route 66 has retained its mythos, attracting thousands of bikers every year, especially in summer; they come to feel the wind of freedom in their hair, eat in authentic diners, stay in the roadside motels, drink watery coffee from cardboard cups, and dream their personal dreams of the land of unlimited opportunities and the "American way."

It is well known that soccer fanaticism can take on quasi-religious dimensions in some countries, and the great community of football fans has its own "temples." The **Maracanã Stadium in Rio de Janeiro** was built between 1948 and 1950 to be the greatest stadium in the world, and it is still one of the largest, seating up to 200,000 fans who come here either to cheer and rejoice or groan and commiserate. The stadium is much more than a sporting venue; essential human emotions are lived out, with keen competitiveness, victory and defeat, euphoria and desperation, hope and success, vying for a place in the hearts of the hundreds and thousands of people in attendance. Legendary concerts have been held here as well as soccer games, and Pope John Paul II celebrated a mass for 250,000 people in the stadium during a visit to Brazil. Undying love and deep friendship have perhaps never been

portrayed more touchingly in movies than in *Casablanca*. Michael Curtiz made the film in 1942 as anti-Nazi propaganda. Although the main plot is a love story, there is more than a touch of film noir in the tale of danger, desperation, and hope that it relates. Humphrey Bogart and Ingrid Bergman immortalized themselves as Rick Blaine and Ilsa Lund, while the characters of Victor László (Paul Henreid), Sam (Dooley Wilson), and Captain Renault (Claude Rains) have indelibly imprinted themselves on the memories of countless cinemagoers, many of whom would consider this the best film of all time. You can even visit **Rick's Café Américain in Casablanca** now—a replica of the legendary café has been built on the

Place des Nations Uniés opposite the Hassan II Mosque, and people come here every day to listen to the strains of *As Time Goes By* and lose themselves in their personal longing for love, friendship, and liberty.

"Peace and Love" was the motto of a festival originally planned as an advertising junket for the Media Sound music label, whose studio was located in **Woodstock**. The festival, which has gone down in history as the high watermark of the American hippy movement, officially took place between August 15 and 17 1969, but actually finished several days later. Organization on the farm where the event took place was chaotic, with rain, mud, and dangerously unsanitary conditions,

but all this unpleasantness was unable to stop hundreds and thousands of people from flocking to the site to express their joy at being alive. Free love, a lifestyle free of convention, music that was lyrical as well as political—these were the elements that combined to make the festival a legend. People still make the pilgrimage to Woodstock to this day; the original hippies come to wallow in nostalgia, and younger people come in search of a lifestyle at whose center peace and love can be found. In essence, they are yearning for emotional warmth in the middle of a cold and technocratic world. Many people who attended the festival now live in the area around where it was held. They have gone a

little gray in the intervening years, but their hearts are still alive to the message of peace and love; they are mocked by some and envied by others.

The last shout of "cut" on December 22 2000 wrapped shooting for a film-making project the like of which had never been seen before. Director Peter Jackson had taken upon himself no less a task than filming one of the greatest epics of recent years: the *Lord of the Rings* trilogy, comprising the three films *The Fellowship of the Ring*, *The Two Towers*, and *The Return of the King*. JRR Tolkien's fantasy story has cast its spell on more than a hundred million readers since its publication in 1954-5. It tells of a mythical age in Middle Earth

and the arduous and perilous journey undertaken by the hobbit Frodo to Mount Doom, a volcano in the heart of the Kingdom of Mordor, into which the ring fashioned by Sauron, the Dark Lord, is to be thrown to break the power of evil. Tolkien, a British medievalist based at Oxford University, used his three-volume work to develop a complete mythology incorporating motifs from the worlds of Nordic and Germanic legend. Middle Earth resembles the Midgard of Old Norse mythology and the ring itself has much in common with the Ring of the Nibelungs in the Middle High German *Nibelungenlied* epic. The plot emphasizes the struggle between good and evil and there is a final reckoning at the end. The film of the book

was shot in New Zealand and the various **locations used for *Lord of the Rings***—all of which are impressive landscapes with a mystic aura—have become pilgrimage destinations. Tours of the locations are popular with visitors from all over the world, and several organized "pilgrimage routes" are already available. The book that spawned the fantasy genre in literature now has a lasting effect on the spiritual sensibilities of the people who visit these places.

It is impossible to overestimate the importance of bars and cafés in people's lives, and this is true the world over. They are meeting-places whose function greatly exceeds the practical uses of the facilities

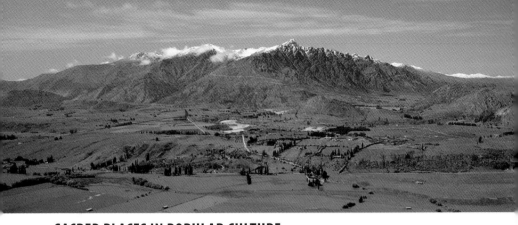

SACRED PLACES IN POPULAR CULTURE

provided; you may be having a *caffè al bar* in Italy or getting together for an evening in a pub in Ireland; you may be in a diner in the depths of North America or putting the world to rights at a regulars' table in Germany; you may be eating in a roadside restaurant in the Far East or Southeast Asia or in a *kafenion* on a little Greek island; you may be playing *tavla* (backgammon) and smoking a hookah pipe in one of the countless cafés in the Near East or visiting a tea room in Eastern Anatolia—everywhere you go there is a sense of community which, though mundane, nonetheless transcends expectations of the ordinary. You don't come here to work, you come here to talk and live, and the owners of

little cafés and restaurants are the everyday priests and confessors of the world. One of the most famous bars on earth is to be found in **Venice: Harry's Bar**, opened by Giuseppe Cipriani and his American backer, Harry Pickering, on May 31 1931. Cipriani was not only an imaginative chef; he succeeded in making his bar the meeting-place of the international jet set. The bar has been owned by the same family since the 1950s and has lost nothing of its fascination. A visit here has been a pilgrimage for visitors to Venice since Ernest Hemingway brought it literary immortality in his novel *Across the River and into the Trees*. Countless famous people lie buried in **Père Lachaise Cemetery in Paris**, but none of the

graves attracts as many visitors as that of Jim Morrison, the singer with The Doors, a performer whose music articulated and lived out the fantasies, fears, and self-destructive tendencies of the late 1960s. Morrison was born in Florida in 1943 and died in Paris in 1971. The circumstances surrounding his untimely death have never been satisfactorily cleared up, and this may have contributed to the legends that have grown up around him. His motto "time is short, make something of it" had a lasting influence on the lives of many of his contemporaries. His final resting-place is Paris' East Cemetery, known as Père Lachaise, and the Greek inscription on his tombstone means "true to his own spirit," an enigmatic epitaph to a wild

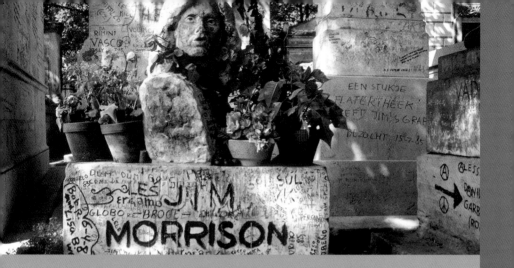

and mysterious life. Morrison's grave was declared a protected monument in 1996. Visitors from all over the world, usually young people, come here to lay fresh flowers, often roses, at the graveside. The grave at section 6, row 2, plot 5, is truly a sacred place for the modern age.

Other sacred places in everyday use are without doubt private and personal spaces and locations—the places where an individual feels safe and at home, and where he or she finds orientation and a meaning in life. These places are sacred in a broader sense: the things that promise security in an unpredictable world, or help overcome life's vicissitudes, or even just represent home,

a place to put down roots—all these are often described as "sacred." Rituals are not limited to religious practices; mundane routines and repetitive actions can often help to give a sense of reassurance. To some people, the first cup of coffee in the morning is as sacred as the dawn ritual of greeting the sun is to a Hindu. For many, the **kitchen** is the place where "real" life takes place. It is no coincidence that the kitchen god is the most revered in popular religion in China. The Hungarian writer Sándor Márai considered the **windowsill of his flat** where he smoked the last cigarette of the evening to be sacred, and he would not be alone in such a practice. Some people regard their **bed** as sacred—it is a

place of refuge and a sanctuary. Thinking of your **garden** as sacred is not so far from the Persian or Arabic notion of paradise as a garden. Washing is a highly sacred act for many people and a dip in a **bathtub** is reminiscent of the ritual practices of many religions; it can be taken to cleanse the soul as well as the body. The **table** at which a group sits for a communal meal or to entertain guests is also sacred—hospitality is one of the oldest human virtues—and a **desk** or a **study** is sacred for those whose world consists of words.

RELIGIONS

ᔕ **Aborigines**—see box, page 884.

ᛣ **Ancient Oriental Cultures**—This collective term includes the civilizations and religions of the Old Orient (Mesopotamia, Asia Minor, and Elam). Although the exact timeline is still disputed, it is generally agreed that these cultures come to an end in Classical Antiquity.

☥ **Ancient Egyptian Religions**

The glorious history of Ancient Egypt covers a period of almost 3,000 years, from about 3000 to 300 BC, and many elements of the religion remained unchanged throughout this entire period, even though they often came to be associated with different deities. The basis of the religion was a creation myth in which heaven, earth, and the air came into being. There was a belief in a dualist struggle between good and evil and the originally chaotic state of things was viewed negatively; the result of all the creation myths, some of which vary wildly, is order. The greatest reverence was reserved for the sun god, and life in Ancient Egypt was regulated by the passage of the sun across the sky; the Egyptians believed that it entered the realm of the dead as it set in the west and it was the pharaoh's responsibility to make it rise again in the east. The alternation of day and night and the reassurance that another day would dawn after each night was not a cosmological given in Ancient Egypt; it was entirely the work of the divine pharaoh.

One lasting aspect of Ancient Egyptian religion was the sanctity of the person of the ruler, who represents the apotheosis of cosmic order (*maat*) and is a mediator between the heavenly and human spheres. **Maat** is not only an ordering principle, it is also worshiped as a goddess in its own right. The great royal tombs of Egypt mark a crossing-point through which the pharaoh ascends from being a divinity on earth to being a god and part of the Egyptian pantheon. Ancient Egyptian religious practices were controlled by the influential priesthood class led by the pharaoh himself.

Many of the gods were associated with a particular region or city, but from the second millennium BC a central role was played by **Amun**, the "King of the Gods," a deity known as "the Hidden One," who was considered an imperial god, along with Ptah and Ra. Amun is depicted as a man with a tall crown of feathers, as a ram, or as a goose. **Anubis** is the lord of the afterlife and the "Keeper of Secrets." He is thought to judge the dead, watching over them during the night, and can be recognized by his dog-like head.

Atum is the creator god who gave form to space and time, to the human race, and even to the gods from within himself; associated with the sun god Ra, he represents Ra in his old age, in the aspect of the setting sun in the evening. Atum is portrayed as a man with a double crown and occasionally as a snake. The cat-headed god **Bastet** was originally the pharaoh's protector deity; her peaceful and protective aspects were extraordinarily popular and many feasts were held in her honor. The moon god **Chons** is represented as a vengeful and punitive deity in the texts of the Old and Middle Kingdoms, but this perception changes in the New Kingdom, by which time he is revered as a protector of humans during the span of their lifetime and as a healing and oracular deity. Chons is depicted with a falcon-like head surmounted by a full moon and a crescent moon.

Hathor, daughter of the sun god Ra, is associated with love, protection, and joy and is depicted as a cow or a woman with cow's horns carrying the disk of the sun. **Horus** (the Distant One) is incarnate in the person of the ruling monarch and is depicted as a falcon or a man with a falcon's head and a double crown. Horus, the son of Isis and Osiris, is the god of the sky and of the kings; he represents the world of order and is engaged in a constant battle with Seth, the god of wild and untamed nature. **Seth** is the brother of Osiris and in the afterlife he appears as a companion to the sun god and helps to thwart the attacks of **Apophis**, the destroyer of worlds.

Isis is the great mother goddess and together with her consort Osiris is one of the greatest of the Egyptian deities. In the New Kingdom Isis becomes an omnipotent goddess, replacing all the other female divinities, and she was even worshiped in the Roman Empire. She has magical powers, wears a stylized throne on her head, and is worshiped as an omnipresent protecting goddess. **Mut**,

another daughter of Ra, is considered a mother goddess and a goddess of the sky; she is the apotheosis of the wise old crone and often appears with a double crown on her head or as a vulture.

Osiris, the judge, is the greatest of the gods of the dead. He was originally a vegetation god and thus the counterpart of his brother **Seth**, the god of the desert. The myths present him as an absolute ruler who is killed by Seth. His consort Isis succeeds in reviving him and he then becomes the god who guarantees life in the next world for those who adhere to the accepted norms in this life. He is represented as a mummy holding the regalia of royal rule.

Ptah, the god who created the world from his thoughts and words, is also the god of creativity and art. He can be recognized by his mummy-like appearance and the cap covering his head, and he often carries a scepter bearing the symbols for permanence, life, and well-being. **Ra** is recognizable as a falcon or falcon-headed man with a large sun-disk on his head; he is the father of the pharaohs and is the sun god, the god of regeneration in nature, and the god of the cycle of the seasons. **Sachmet** is a lion-headed protector deity and is also worshiped as a healer goddess; her priests could be regarded as one of the first medical associations. Sachmet nonetheless has dangerous aspects and a bellicose nature. Like Chons, **Thot** is a moon god; he represents creation and wisdom and is credited with the invention of writing and lawmaking. He is depicted as an ibis-headed man or a baboon.

☼ Bahá'í

In essence, the Bahá'í faith is a monotheistic religion of revelation whose roots are to be found in Shi'a Islam, although Islamic orthodoxy does not recognize Bahá'í beliefs. The religion was founded by two Persians in the 19th century: Sayyid Ali Muhammad (1819–50), the founder of a Shi'ite revivalist movement, and Mirza Husain (1817–92). Calling himself Baha'u'llah, the "Glory of God," the latter regarded himself as the latest link in a chain of divine emissaries and saw in himself the fulfillment of the teachings of Christ, Krishna, and Muhammad, with an obligation to impart a new revelation to mankind. Bahá'í belief thus has much in common with other world religions in its core ethical tenets, but it also contains many other elements essential for peaceful co-existence between peoples.

Besides Baha'u'llah's original writings, including the *Most Holy Tablet* and the *Book of Certitude*, there is a wealth of mystical texts held in high regard by the faithful. Baha'u'llah recommends moderation in all things, and strict asceticism is rejected in the same breath as a hedonistic life. The principal virtues that determine Bahá'í ethics are love of one's neighbor, gratitude, trustworthiness, and faith in God. These virtues promote social activism—service to all mankind—as the central criterion of true humanity. The heart of religious understanding is a tripartite unity—the indivisibility and uniqueness of the one true God, the mystical unity of divine revelation, and the unity of all mankind combine to promote tolerance of other faiths. Reason is a gift of Creation and faith may never contradict reason, although for its part reason may never fully comprehend the Divine; this requires prayer and profound meditation.

Most modern Bahá'í live in India, but the world center of the faith is in Haifa in Israel. The religion has hardly any prescribed rituals, and observance is more focused on the individual than the community of the faithful; for Bahá'í followers, the individual's inner attitude is more important than any external appearance or religious practice.

❁ Buddhism

Buddhism bears few of the traits of a religion; it more closely resembles a philosophy and is often called the "religion without a god." The route to man's self-redemption that it describes is characterized by great asceticism and self-discipline. Buddhism was founded by Prince Siddharta Gautama on the borders of India and Nepal more than 2,500 years ago; after much asceticism and meditation he recognized the four Noble Truths that were later to shape Buddhism: (1) human existence—the cycle of birth, aging, sickness, and death, also the sensations of love, pain, fear, anger, and the like—is suffering; (2) the causes of suffering are desires and passions (longing, hatred, ambition, illusion); (3) if the causes—the passions—are removed, suffering

ceases; (4) the road to this is the "Noble Eightfold Path." If an individual follows this path he will eventually remove himself from samsara, the cycle of eternal rebirth. The Eightfold Path describes the eight levels of the road to enlightenment (or rather, "awakening"), and these are arranged in three stages (divisions). The first two levels (the division of wisdom) school the individual in attitude (perception), understanding, and wisdom, and thus right mindset, right intention, and complete resolution. The next three steps of the path (ethical conduct) include right speech, right action, and the right way of living. The last three steps (concentration) build on all these: they consist of right effort, leading to the practice of right mindfulness, and, as a last step, right composure, immersion, and concentration.

The teachings of the Buddha were first recorded in the Pāli Canon, 400 years after his death, and this has remained the basic text of southern Theravada Buddhism. It includes the *vinaya*, the rules of the monastic order, the sutras, the Buddha's teachings, and the *abhidharma*, philosophical tracts and commentaries. Northern Mahayana Buddhism is based on the Sanskrit texts contained in the *Tripitaka* ("three baskets"), which principally contain the Mahayana sutras and are focused on compassion and wisdom. The end of the Buddhist path is marked by nirvana—extinction—a state of no suffering where karma, the interplay of cause and effect, has been extinguished.

✵ Buddhism in China

The teachings of the Buddha spread along the Silk Road, reaching China in the 1st century. Buddha wrote down none of his teachings, but shortly after his death the two main branches of his beliefs appeared: Theravada Buddhism (the "Teaching of the Elders") and Mahayana Buddhism (the "Great Vehicle"). The latter has spread throughout China, Tibet, Japan, and Korea.

The path of Mahayana offers redemption to all, and both monks and laity can reach nirvana. Besides the Buddha, the most important figures are the **Bodhisattvas** (**pusa** in Chinese), people or beings who have already reached self-awakening but have renounced nirvana to help others; cult worship of these has developed in

Chinese Buddhism. Historical Buddhism began to be absorbed into folk religion from the 10th century onward and more than a few Buddhist figures are worshiped in Taoism and other popular beliefs. **Avalokiteshvara**, the originally male Bodhisattva of compassion, has over time become a female, almost Madonna-like deity (**Guanyin**). **Maitreya**, the Buddha of the Future, is depicted as a fat-bellied joker (**Mile Fo**) in China. **Bhaisajyaguru** became the Medicine Buddha and the lord of healing (**Yaoshi Fo**). **Manjushri** (**Wenshu**), the Bodhisattva of wisdom, has made his home on Mount Wutai (Wutaishan), one of the sacred mountains of Buddhism. **Samantabhadra** (**Puxian**), the Universal Worthy, is enthroned on Mount Emei (Emeishan), another of the sacred mountains and is immediately recognizable by his steed, a white elephant. **Ksitigarbha** (**Dizang**) is the savior of souls and the protector of travelers. His home is at Mount Jiuhu (Jiuhushan), yet another sacred mountain.

Besides the Buddhas and the Bodhisattvas there are also **arhats** (**luohan** in Chinese), Buddhist saints, who have broken the cycle of rebirth: the **Four Celestial Kings** guard the cardinal points of the compass and also watch over scholarship. Often recognizable by their armor, they usually look fierce and demons lie trampled beneath their feet. The warrior **Skanda** (**Weituo**) is worshiped as one who bravely defended the teachings of the Buddha, and in Chinese temples he is often portrayed back-to-back with the fat-bellied Mile Fo.

Chinese Buddhism is a fragmented faith, subdivided into many "schools;" the most important of these include Chan Buddhism (often referred to in the West using the Japanese term "Zen"), which derives from **Kashyapa**, a pupil of the Buddha; the latter instructed him in his teachings in a particularly intuitive way. According to Chan Buddhism, masters hand on enlightenment directly to their pupils, irrespective of dogma and holy texts. The most popular branch is the **Pure Land school** (**Qingdu**), focused on worship of **Amitabha**, the mild Buddha. This school has attracted numerous lay followers as it promises them rebirth in the Pure Land (analogous to paradise), a land in which enlightenment is promised to all who call on the name of the Buddha.

 # Buddhism in Japan

The native religion of Japan is Shinto, which grew out of ancient shamanic practices. Shinto is an optimistic religion emphasizing ritual purity and a belief in luck, blessing, and good health. Buddhism began to reach Japan in the 6th century, via Korea, and though it was initially regarded as essentially a foreign religion, it found particular favor with the aristocracy.

The worship of **Yakushi**, the Medicine Buddha, became especially popular, as this was most easily reconciled with the earthly aspects of Japan's religion. The most important figure in the early history of Buddhism in Japan is Prince Shōtoku (572–622), a proponent of Buddhism of such zeal that he was venerated as a reincarnation of the Buddha himself from the 8th century onward; countless temples can trace their foundation back to him. One legend has him saying "everything is an illusion, only the Buddha is real." The Hōryū-ji in Nara, the capital at the time, grew to become the most important temple of the movement.

Japan's religious culture changed rapidly, with a shift toward the historical Buddha and a closer reading of the teachings contained in the sutras in search of the path to enlightenment. Both schools of Buddhism grew during this period, with **Theravada** teachings emphasizing the search for Buddhahood and **Mahayana** stressing the ideal of the compassionate Bodhisattva (*bosatsu* in Japanese). Saichō and Kūkai, two monks of great influence, visited China at the turn of the 9th century, returning to Japan in 806 with various other schools of thought: Saichō brought back the **Tendai School**, which entails study of the Lotus Sutra (*Hoke-kyō* in Japanese) and mystic rituals, with a strong monastic bent, while Kūkai established the **Shingon School** (the "school of true words"), the principal branch of esoteric Buddhism, which stresses the importance of mandalas, mantras, and *dharani*, mystical syllables containing the essence of a sutra. Buddhism nonetheless remained the preserve of the nobility and the monasteries well into the 10th century; its transformation into a religion that would find favor with the people would not come until the Kamakura period (1185–1333). The **cult of Amida** (Sanskrit:

Amitabha) had been spreading since the 10th century, promulgating a belief in redemption in a paradise in the west, the **Pure Land** (*jōdo*).

Worship of Amida, the Buddha who ruled the Western Paradise in which followers hoped to be reborn, was to become the greatest religious movement of the Middle Ages. The Pure Land School taught that redemption was to be achieved only through the recitation and invocation of the name of Amida. Other schools of Japanese Buddhism cede this position to other Buddhas and Bodhisattvas, supreme among which are the *nyorai*, enlightened beings who have succeeded in breaking the cycle of rebirth. **Shaka**, the historical Buddha, is the final authority, and is easily recognizable as he is portrayed with a raised hand, identifying him as a teacher of doctrine. Amida, the Buddha of the Western Paradise, is usually portrayed deep in meditation; **Yakushi**, the Medicine Buddha, often carries a small phial of liniment in his hand; **Dainichi**, the Cosmic Buddha, is usually portrayed grasping the index finger of one hand in his other hand; **Miroku**, the Buddha of the Future, always seated in a pensive pose, is shown thinking deeply or occasionally smiling softly. Shaka represents the past, Amida the present, and Miroku the future. Besides the *nyorai* there are also *bosatsu* (Sanskrit: Bodhisattvas), creatures who generally have human characteristics. The best-known and most popular of these is **Kannon** (Sanskrit: *Avalokiteshvara*; Chinese: *Guanyin*), who has come to display female traits. **Jizō** is portrayed as a monk, often with a pilgrim's staff in one hand and a jewel in the other; he is the protector of journeymen, pilgrims, and of dead children, whose souls he accompanies to the land of night. There is also a whole raft of Buddhist divinities whose roots lie in Hinduism: these are the **Shitennō**, the Celestial Kings, who are often depicted in great rage, and the **Myō-ō**, the Kings of Secret Knowledge.

Christianity

Christianity is based on the teachings of Jesus of Nazareth, an itinerant Jewish preacher born in Bethlehem, then a city in the Roman province of Galilee, in about the year now reckoned as 4 BC. His life, his ministry, and the initial

effects of his teaching are recounted in the New Testament, the second major part of the Christian Bible, which leads on from the Jewish traditions of the Old Testament. These Holy Scriptures are still used by observant Christians as the source of guidance on the right way to act and live according to God's law. The Gospels (the "good news") in the New Testament tell of Jesus' itinerant preaching, how he was able to heal the sick, and how he devoted his attention especially to those at the very margins of society. He was brought before the high priests to be tried for blasphemy, was found guilty, and crucified. Three days later, some of his female followers said they had seen him alive in the flesh. They joined Jesus' former disciples in worshiping him after his death on the cross and his resurrection, calling him "Christ" (a direct Greek translation of the Hebrew word *Mashia*: "Anointed One").

The missionary activities of these first followers soon spread the new belief, and the journeys of the apostle Paul in particular were responsible for the foundation of Christian communities in Asia Minor, Greece, and Rome, and later along the Mediterranean coast of Africa. The emperor Constantine made Christianity the state religion of the Roman Empire from the beginning of the 4th century, It spread throughout the known world during late antiquity and the Middle Ages, and reached America, Asia, and Africa in the wake of Europeans' explorations and conquests in those continents from the 15th century onward. The oppression, enslavement, and exploitation of the indigenous populations that went hand-in-hand with such missionary work was in crass contrast with Christianity's central tenet of "loving one's neighbor."

Since its foundation, the Christian community and its basic organizational form, the Church, have undergone a range of developments and changes: established Christianity split into the Roman Catholic and the Orthodox churches in the 11th century, and the second schism of global importance came with the Reformation in the 16th century, a reform movement with which the name Martin Luther is closely associated. His teachings and dissatisfaction with the old church resulted in the rise of the Lutheran Protestant Church, which since the 19th century has been known as the Evangelical Church, as well as a host of other reformed denominations (such as the Anglican Church and John Calvin's Reformed Church).

Christianity has now spread to every corner of the earth. The Christian faith maintains that every individual is capable of spiritual salvation by accepting Jesus as the Son of God and as able to redeem them from their sins and suffering. Christians throughout the world regard the advent of Christ as a turning point in world history, and for this reason the calendar is divided into the time before and the time after Jesus' birth.

Classical Antiquity

The common denominator for the religions of Classical Antiquity is polytheism, the worship of several gods. Many elements of the period's religions date back to Aegean Bronze Age civilizations or to Etruscan and Italian tradition, while others were imported from the Orient, Mesopotamia, or Egypt. None of these societies, which were in regular contact with each other, claimed to possess the complete truth, or at least not as far as religion was concerned. Although monotheistic religions usually have a holy text, Greek and Roman faiths have nothing comparable; divine revelation is mutable and the gods are usually encountered in orally transmitted myths and songs. Besides Hesiod (c. 700 BC) who systematized the genealogy of the gods in his *Theogony* ("origins of the gods"), it was principally Homer whose epics established the family tree of the 12 Olympic gods and listed their personal names (and thus areas of responsibility). The Greek word for god (*theós*) had previously referred to the experience of a moment (*kairós*) that fulfilled the life of an individual—a divinity was not a supernatural being but a revelation in an actual experienced event. Shrines were built for such divinities in which a dedicated priesthood would conduct rituals and make sacrifices.

The most important temples, at whose center a cult image was always to be found, were sacred to the Olympic gods (known as the *Dodekatheoi* in Greece and the *Dei consenti* in Rome). The 12 Olympic gods and goddesses were: **Zeus (Jupiter** to the Romans), the god of heaven and the state; his consort **Hera (Juno)**, the patroness of the state and of women; **Poseidon (Neptune)**, the god

of the oceans and seas; **Athene (Minerva)**, goddess of the arts and artisans; **Ares (Mars)**, the god of agriculture and war; **Aphrodite (Venus)** the goddess of love; **Apollo (Apollo)** the god of healing, music, and moderation; **Artemis (Diana)** the goddess of the forest, of hunting, and of safe childbirth, also the protector of plebeians and slaves; **Hephaistos (Vulcan)**, the god of fire; **Dionysus (Bacchus)** the god of wine and intoxication; **Demeter (Ceres)** the goddess of agriculture and the fertility of the earth; and **Hermes (Mercury)**, the messenger of the gods and the god of merchants and travelers.

As well as the temples dedicated to these 12 main gods there was a wealth of altars and shrines for the chthonic deities (gods of the earth) and the demi-gods, heroes born of the union of a god and a mortal. Each civilization's year was punctuated with annual religious festivals for gods, demi-gods, or heroes, and the festivities often included dramatic performances; tragedies and comedies were intended to promote *catharsis*, a cleansing of the soul. There were also contests in honor of the gods and processions of cult images or holy objects.

✳ Confucianism

Kong Fu Zi (Latinized as Confucius) lived from 551 to 479 BC. Born in Qufu in Shangdong Province, he spent the greater part of his life in the city and died there.

Confucius did not found a religion in the accepted sense; instead he promulgated an altruistic moral philosophy whereby individuals are obliged to promote the happiness and well-being of those for whom they are responsible. There are five cardinal virtues: humanity (*ren*), right actions (*yi*), morality (*li*), knowledge (*zhi*), and truthfulness (*xin*). Order in human affairs arises from these, and this is itself based on five basic relationships: the relationship between master and servant, between father and son, between husband and wife, between an elder and younger brother, and between two friends. In each of these relationships there is a mutual obligation and all are subject to the will of heaven, the source of all order and morality.

Confucian teaching and pedagogy can be understood as a "doctrine of the harmony of the whole," and this is the most widespread expression of the humanism of the

Far East. The Confucian creed always pairs reason with notions of a kind of eternal order. Myths and legends have been interwoven about Confucius' person and pupils; he set great store by regular sacrifices and rituals. The "cult of heaven" requires an emperor to commune with heaven twice a year in the temple at Beijing. Sacrifices are also offered to the earth, the sun, the moon, and the ancestors of the emperor. Confucius has also been adopted into certain aspects of Chinese folk religion—believers especially seek his aid when answering examination questions. The conservative and hierarchical moral teachings of Confucianism were soon adopted as a state philosophy; they went on to resemble ever more closely a religion with strong ethical components and still exert a considerable influence on Chinese thinking. Confucian ethics dispense with metaphysical speculation, primarily recognizing the network of human relationships and the duties that these impose. The Confucian tenet "do as you would be done by" (*Lunyu*, 15:23) could hardly be more modern.

☯ Daoism (Taoism)

Taoism is a gathering of philosophical and religious traditions that dates back more than two thousand years in China. The ideal of Taoism is that of a simple man who has retained the character of a child and lives in harmony with everything. The most important principle in life is known as *wu wei*, best translated as "not acting." This principle is also applied on a national level; the ideal is a small state with a contented populace. The best ruler is one who is barely noticed, raising few taxes, conducting no wars, and engaging in little contact with neighboring states, thus avoiding envy and disagreement: "Small countries/with few people/ten times as many tools and a hundred-fold the yield/things did not used to be like this/but the people were taught/to fear death and foreign travel/ […] food tasted good then/clothes fitted the body/and it was good to be home./People were happy with a healthy life/ […] and died at a great age" (*Tao Te Ching*, Chapter 80).

Over the course of the centuries, the purely philosophical doctrine of Taoism was augmented with a religious folk Taoism much concerned with longevity and closeness to nature. **The Three Pure Ones** are

the supreme deities of the pantheon. The first of these is **Yuhuang, the Jade Emperor**, who rules over heaven and earth. **Daojun** is the lord of time and of the forces of yin and yang. The third of the Three Pure Ones is the philosopher **Laotse**, immortalized as the **"Old Child."** Besides these three there are the **Lords of the Five Mountains**, emissaries of the Jade Emperor who guard the five sacred mountains of Taoism: Hengshan (Shanxi), Taishan (Shandong), Songshan (Henan), Hengshan (Hunan), and Huashan (Shaanxi). The Lords of the Five Mountains control the five elements of water, fire, wood, metal, and earth, and also guard the gates of the underworld. **Guandi**, the god of war, protects the gods against demons and is considered a guardian of peace.

The **Kitchen God** is extremely popular and is to be found in almost every Chinese household. It is his task to watch over and protect the family. Once a year he reports events in the family to the Jade Emperor, and it has become traditional in China to smear honey around the mouth of his effigy, so that he says only good things. The **twin door gods** are intended to protect against nightmares and to ward off evil and are often found flanking the doorways of Chinese houses. **Wenchang**, the god of literature and creativity, is worshiped by scholars in particular; he rewards the diligent with good fortune and prosperity and it is his task to announce the decisions of the Jade Emperor. **Shouxing** is the god of long life; he is usually portrayed as an old man with a stick, while in his other hand he carries a peach, the fruit of immortality, and a vessel containing the elixir of life. The mushroom of immortality is to be found with the **Eight Immortals** on the Isles of the Blessed, which lie in the Eastern Sea. The Immortals represent various phases or circumstances in life: youth and old age, masculinity and femininity, wisdom and stupidity, poverty and wealth. They occasionally interfere in the world of human events and are thus feared and loved in equal measure.

Followers of Tao hope to achieve spiritual contentment and harmony with the natural world. Besides these principal gods, Taoism acknowledges many thousands of lesser gods, who are much lower down the hierarchy and often have only local importance.

Folk religion

Throughout the course of world history, indigenous communities and their religions have generally been influenced by more powerful, expanding civilizations; some traces of the local religion have nonetheless been able to survive and a great number of these can still be found today in living beliefs and rituals. Many myths around the world tell of ancestors who pass on their strength to their descendants. In general, no distinction between a rational, fact-based world of causal relationships and the religious world is observed in folk religions—despite their many differences, they all display a close and inseparable connection between the everyday and religious aspects of life, and this is particularly apparent in a tendency to explain life in terms of divine forces (ancestors, spirits, natural phenomena, powers, and demons).

While modern and post-modern societies give weight to scientific fact and so-called critical reason, regarding myths as merely symbolic narratives, folk religions regard them as historical truths providing answers to the basic questions posed by human existence. The rituals practiced as part of folk religions tend to have two areas of emphasis: they are essentially initiation rites marking turning-points in life and rituals intended to deal with life's vicissitudes (weather conditions, sickness, or tensions within the tribe, community, or clan).

The greatest differences within the many folk religions are encountered in their manner of communication between the mundane world and the religious plane; shamanism and possession are the two most important of these, and initiated priests are charged with keeping these channels of communication open.

Folk religion in Africa

African religions focus less on salvation in the next world than on the well-being, prosperity, and survival of the community of the living. Religious observance in Africa is principally concerned with assuring good fortune and warding off bad luck. Individuals can ask the entities they worship for personal protection or support, but most of the religious activity is carried out by priests, who are generally prepared for their life-long role through

arduous apprenticeships and initiation rites. Shamans, prophets, and priests are the intercessors between the world of humans and the world of spirits, and they are the only people who can communicate with their deities. The central objects of religions in Africa are gods, spirits, and demons, and religious ceremonies serve to explain the world, to provide prophesies, and to underpin the basic assumptions of the societies, as well as to strengthen the community. For this reason, public spaces—the village or market square, for example—are used for rituals, while awe-inspiring ecclesiastical architecture such as is common in Christianity or Islam is unknown in African folk religions. The power resides in close social contact—from village to village but also in the cities and across continents.

Before the spread of Christianity and Islam, most African languages had no word that would satisfactorily translate the concept of "religion." In the light of such an absence, it is possible to define "religion" as any relationship between living human beings and the spiritual beings or unseen forces that are believed by the humans to influence their lives. Most ethnic groups have a (usually male) creator divinity, and creation myths have always been handed down orally.

Fundamental changes in religious ideas and practices were brought about by the spread of Christianity and Islam through Africa: the notion of a life in paradise, the concept of personal sin, and the worship of a single god in a church or a mosque changed all previous religious habits. Many old ideas were nonetheless retained and merged with the basic tenets of the incoming religions. Traditional beliefs exhibit powers of survival and adaptability which mark them out from other faiths, and ancient African convictions live on, even if they portray themselves as enthusiastic or charismatic Christianity or Popular Islam.

◁ Folk religion in East and Southeast Asia

Much of the East Asian population now belongs to one or other of the great world religions, but this does not mean that they have forgotten their ancient roots; ancestor-worship is rarely neglected, prayers are offered to

countless gods, and oracles are consulted. Such rites and beliefs are rooted in a faith that has survived to the present day in the face of all kinds of changes and cultural influences. Inscriptions on oracular bones have shown that there was a culture in China some 3,600 years ago (during the Shang Dynasty, 1600–1040 BC) whose principal characteristics were ancestor-worship and belief in oracles. The power of deceased ancestors provided an identity, and the belief that the ancestors intervene either beneficially or disadvantageously in everyday life persists to the present day. This belief is so deeply rooted that the influence of other religions, foreign rulers, and the efforts of both Christian and Muslim missionaries have been unable to shake it.

Ancestor-worship and the consultation of oracles are practices firmly entrenched not only in China, but also in Japan, Korea, continental Southeast Asia, and Indonesia. East Asian cultures are noted for the peaceful coexistence of their various religious communities, and this pluralism is apparent not only in the way that religions happily rub shoulders but also in the way that an individual can belong to a number of religions, either successively over a period of time or concurrently. An exclusive declaration of faith in one god or one religion would seem an extremely strange notion to most East Asian cultures. Besides ancestor-worship, their devotions incorporate elements such as shamanist practices; geomancy (the interpretation of lines and shapes in the sand or in rocks); *feng shui* (a doctrine of two opposing forces: *qi*, a life-enhancing, positive energy, and *sha*, all that is negative and dangerous, and the science of shaping man's living-space and actions in harmony with the natural lie of the land); and also the philosophy and ethics of Confucianism, Taoism (in China), Shintoism (in Japan), and later Buddhism.

"Folk religion" dispenses with the order and limits of systematized Western thought; there are no refined theologies and thus no priesthood or institutionalized organizations. The rites are handed down and can be carried out by anyone, with no formal spiritual initiation. In contrast with the logical and philosophically discursive forms of Western thought, East Asian approaches are more intuitive and aesthetic.

Folk religions of the First Nations and Arctic peoples

The roots of the original inhabitants of North America can be traced back some 20,000 to 30,000 years, when small groups of central Asian tribespeople migrated from Siberia into northern America across the land or ice bridge that existed at the time. These hunter-gatherers followed the migrations of the animals on which they subsisted. Over the course of generations, some crossed the Rocky Mountains and other groups settled in the east on the Atlantic coast. Others again journeyed ever further south to the plains of Mexico, the rainforest, and the Yucatán peninsula.

The roots of the Indigenous Peoples of the Circumpolar Region are to be found in Central Asia, with tribes migrating to Siberia, Alaska (Inupiaq and Tlingit peoples), Canada, and Greenland (Inuit); Scandinavia also has a small group of Sami.

There were hundreds of tribes, all with their own religious practices, but despite the many differences there were some similarities. The most important myths invariably tell of the activities of the gods, and of the creation of the world and of humans in particular. Most tribal traditions recount Creation as a joint effort between natural forces, heavenly bodies, and animals.

Such myths are narrated only at certain times of the year, and during the rest of the time there are other stories that are told for educative purposes, as moral instruction, or even as initiation. Every tribe believes that everything that exists has a soul, and the animist world view admits of countless spirits, which can appear in all kinds of forms or manifestations. All natural phenomena possess a great power, against which only amulets or other talismans provide any protection. That the term "Great Spirit" is now used to describe all these beings is probably due to the adaptation of an indigenous term by the Christian missionaries whom the tribes encountered. Their religious ceremonies have both individual and collective rituals and the elders or the shamans are ascribed a particular religious authority. Chants and dances, communal festivals—which are often held as a competition—sacrificial rites, and the retelling of old stories provide hope for the people, as they stand in the path of the forces of fate.

✳ Germanic religions

The ancient myths of the north usually involve a struggle between gods and giants and the conflict of order and chaos. The myths were recorded in sagas that were usually handed down orally. There are no original written versions—the runic alphabet had a largely mystical meaning—and most of the major literary sources for Germanic mythology are supplied by outside observers such as the Roman historian Tacitus. By far the most important source of Norse mythology is Snorri Sturluson's comprehensive account, which dates back to the 13th century. According to Norse myth, life on earth began with the combination of ice and fire, while at the end of the world, called Ragnarök ("Twilight of the Gods"), flames will rise to heaven and then the earth will sink into the sea. Their belief was that a shadow would be cast over the world and a long, icy winter would render all life on earth unsustainable. Such apocalyptic notions were no doubt prompted by their way of looking at the natural world, and in particular their volcanic island home.

A tripartite world was imagined: on the top level, one set of gods called the Æsir lived in Asgard, another set of gods called the Vanir lived in Vanaheimr, while the elves lived in Álfheimr. Humans inhabited the middle level, Midgard, while giants lived in Jötunheimr, the Dark Elves in Svartalfheim, and dwarves in Nidavellir. The upper and middle levels were connected by Bifröst, a flaming bridge that was also portrayed as a rainbow. The lowest level was ice-cold Niflheim, the realm of the dead. The great ash tree **Yggdrasil** inhabited all three levels and its branches encompassed the entire world. Omniscient eagles lived in the top of the tree and the evil dragon Níðhöggr lay coiled around its roots, gnawing at them and threatening the order of the world.

Worship of the Norse gods was associated with a variety of sacrifices at shrines erected for each of the main gods. The most important Viking (6th to 10th century) gods were Tyr, Odin, Thor, and Freyr. **Tyr** (also known as **Teiwaz**) was considered the oldest of the gods and

none of the pantheon could match his courage; he alone could tame **Fenrir**, a mythical wolf who personified evil and violence. **Odin** (also known as **Wotan** or **Wodan**), a descendant of the Æsir, was known as a consummate sorcerer, and was the god of kings, poetry, and magic. He was married to beautiful **Frigg**, who ruled over the prophesy of an individual's fate. **Thor** (also known as **Donar**), the thunder god, was the son of Odin and was usually involved in a struggle with the giants who threatened the order of the world. He was famed for his strength, and armed with his hammer Mjöllnir he was well-nigh invincible; one blow from the hammer was invariably fatal and it always hit its target before returning to Thor's hand. The gods called on his assistance in the fight against the giants, but humans also could have recourse to his aid. **Freyr** (also known as **Fol**), one of the Vanir, was a fertility and vegetation god who commanded rain and sunshine. His powerful and beautiful twin sister **Freyja**, goddess of fertility, love, and magic, was considered the greatest of the goddesses by the Vanir. It was she who received the dead and accompanied them on their journey to Thule, the legendary land beyond the ice. **Loki** was an ambiguous god and both a friend and a foe to the other gods. He was thought quick-witted and cunning, sneaky and machinating. He is Odin's blood brother, but at the same time he is also the source of all lies and falsehood. His double-edged nature becomes most apparent when he makes trouble for the gods, only then to come to their aid with his guile and advice.

Germanic mythology found great resonance across all the countries of northern Europe and its influence lasted well into the time when Christianity was being established there.

ॐ Hinduism

Hinduism is India's most widespread religion. It has no established dogma and no fixed system of behavioral rules; instead, it unites a wealth of philosophical and religious tendencies, allowing pantheist and monotheist belief systems to coexist. One thing that all schools of Hindu thought have in common, however, is a belief in reincarnation—remaining in the world of suffering (Sanskrit: samsara). Rituals, understanding, and devotion to God may lead individuals to release themselves from this (*moksha*); such a removal of the boundaries between the individual soul and the soul of the world brings the greatest bliss (*ananda*). The paths to such a liberation are many and various: meditation and yogic exercises offer one way, worship of God and moral behavior another. All of these combine to create dharma, religious living. Each Hindu is responsible for his own redemption, and in this respect Hinduism is an individualist religion.

The Hindu pantheon is as varied as human nature. The gods are represented as supernatural powers, but they are also subject to the laws of cause and effect (karma). **Brahma**, born from a golden egg, is the supreme Hindu god and the creator of Vishnu and Shiva and all the other gods in heaven. He also created the sun, the moon, and the stars, the earth with all its people, plants, and animals, and the subterranean realms where all the demons and creatures of hell live. Every part of creation is subject to the cycle of rebirth. When Brahma dies, the earth stands still, and only when a new Brahma is born will a new world be created. Brahma's consort is **Sarasvati**, the goddess of knowledge and correct speech.

Vishnu, who maintains the world, is the favorite god of many Hindus and is worshiped in nine incarnations (avatars): as a fish, a turtle, a boar, a man-lion, a dwarf, as the axe-wielding Bala, as Rama (the hero of the Ramayana myths), as Krishna, and as Buddha. His tenth incarnation as a white horse (Kalki), in which he will liberate and redeem the world, is still awaited. Vishnu's consort is **Lakshmi**, the goddess of good fortune, beauty, and wealth. She appears in human form as Rama's consort **Sita** and as Krishna's lover **Radha**.

Shiva, the destroyer of worlds, represents dark energy and is often portrayed with a third eye (placed in the middle of his forehead as a symbol of omniscience). He is also worshiped as the ecstatic dancer of the cosmic dance, whose stamping feet threaten to crush the world. Shiva's symbols are the trident and especially the lingam, a phallic symbol found in every Shiva temple. Shiva's spouse **Durga**, also known as **Shakti Parvati** or **Kali**, has no specific role and is often referred to as the "great goddess."

RELIGIONS

Although **Parvati** is gentle, **Durga** embodies her war-like side, and as **Kali**, who is rather bloodthirsty herself, she combats evil. She is often depicted wearing a belt of skulls, dripping in blood and carrying the severed head of an opponent. **Ganesha** is the amiable, elephant-headed son of Shiva and Parvati—he overcomes obstacles and is thought of as a mediator between humans and the gods, with many Hindus calling on him when faced with important tasks. When courage or bravery is required, however, people turn to **Hanuman**, the monkey god, Rama's faithful companion. Besides these gods there are countless local and private gods.

The gods are usually worshiped in temples but many devout Hindus have small shrines in their houses as well, where daily prayers (pujas) are offered up. There are also countless ashrams (literally, "places of effort"), monastic meditation centers with a guru as spiritual head. The Kumbh Mela, Hinduism's greatest festival, is also the largest in the world; it takes place every 12 years at four different locations: Haridwar, Ujjain, Nashik, and Allahabad.

Islam

Sources indicate that the Prophet Muhammad was born around the year 570 in Mecca. Little is known of his childhood and youth, but around the age of 40 he is said to have had the first of a series of revelations from God in a cave near Mecca. These revelations were to continue for the next 20 years of his life and were collected together as the Koran shortly after his death.

The 114 sections (sura) of the Koran contain warnings about the Last Judgment, calls to repent, prescriptions for correct living, teachings about human responsibilities, meditative texts and prayers, and legends of pre-Islamic prophets. Above all they contain praise of the one true God. For Muslims, the Koran is the literal revelation of the word of God in Arabic. Besides the Koran there is a second major source of religious teachings, the Hadith, containing accounts of the words and deeds of the Prophet; these were initially passed down orally and only collected in the 9th and 10th centuries to form the Sunnah. These two sources (Koran and Sunnah) are the principal foundations of sharia, the comprehensive

system of laws governing Islam. Sharia is not only a set of instructions for worship and religious life; it also contains regulations and recommendations for every conceivable area of day-to-day living.

Soon after the death of Muhammad, the Muslim community split into various factions over the question of who was to be the new leader of Islam. The Sunnis, who derive their name from their adherence to the practices instanced in Muhammad's life (Sunnah), are by far the largest Muslim faction, and the other major group is the Shi'as or Shi'ites, who derive their name from their support of Ali bin Abi Talib during early Muslim schisms (*Shiat Ali* means "Ali's faction"). The Shi'as are further divided into various camps, of which the largest is that of the Twelvers, who are particularly widespread in Iran, Iraq, and Lebanon. Besides the words and deeds of the Prophet they also set great store by the teachings of their first 12 leaders, the imams, whom they regard as the rightful leaders of the entire Islamic community.

Islam means "submission" and a Muslim is thus a person totally devoted to God. Five basic tenets govern Muslim religious life, and these interconnected and interdependent "Five Pillars" of the Muslim faith play a key role in life as a Muslim: *shahada*, the creed ("there is none worthy of worship except God and Muhammad is the Messenger of God"), *salah*, ritual prayer facing Mecca five times a day, *sawm*, fasting during the month of Ramadan, *zakat*, alms-giving to the poor and needy, and hajj, the pilgrimage to Mecca which all believers, health and finances permitting, must undertake once in their lives.

Jainism

Jainism is an Indian religion much influenced by philosophy and with an extremely complicated cosmology. Its roots stretch back to the 6th century BC. In contrast to Hindus and Buddhists, its followers (Jains) believe in the irreducibility of the world and the cosmos, although these undergo changes: they are created through the interaction of so-called eternal substances that are divided into living and non-living beings. The goal of the path described by Jainism is to slough off the shell of physical being and to enable the metamorphosis of the soul in freedom.

The religion's founder, Mahavira (599–527 BC), is revered as Jina, the victor over the world and all things material, and as one of the *tirthankaras*, the "ford-makers," the name given to those who mediate between the material and spiritual worlds. The Kalpasutra, one of Jainism's holy texts, tells of 24 *tirthankaras*, although only two of these have appeared as historical personages: Parshavanatha (9th century BC) was the 23rd and Mahavira the 24th *tirthankara*. The three pillars of Jainism are absolute non-violence against all living things (*ahimsa*), independence of unnecessary possessions (*aparigraha*), and truthfulness (*satya*). A distinction is drawn between the so-called "small vows" of the laity and the "great vows" for monks and nuns. Digambars ("those dressed in air"), particularly strict ascetics, represent unconditional respect for all life forms and live naked in their monasteries. Svetambars ("those dressed in white") are less radical and allowed some material possessions. Because of their veneration of life, all Jains are strict vegetarians, and Digambars are usually vegan, maintaining a lifestyle and diet free of animal products, including their clothing and household items.

♆ Judaism

The history of the world's oldest monotheistic religion begins as a family history some 3,800 years ago. Jews regard Abraham as the founding father of their faith and of their people. Abraham left the Mesopotamian city of Ur in Chaldea with his wife Sara and his children, and wandered through the Arabian desert to Canaan, the land promised to him by God. He abandoned the idolatry of his tribe, believing instead in one God, who had promised him many descendants. Abraham, his son Isaac, and his grandson Jacob are known to the Jews as the "patriarchs" and the 12 sons of Jacob are the founding fathers of the 12 tribes of Israel. The name Israel ("he who wrestles with God") is a nickname acquired by Jacob, who was obliged to wrestle with an angel one night and would not let him go until he had received a blessing. The God of Israel, the people of Israel, and the land of Israel form a single redemptive unity, and the modern state of Israel is based on this premise.

The suffering of the children of Israel began during the reign of the pharaoh Ramesses II (1279–1213 BC). Moses led his people out of slavery in Egypt to the border of the Promised Land and made a covenant with God. Moses also received the Ten Commandments on Mount Sinai, and these commandments regulate both God's relationship with humanity and relationships among people. King David (1004–965 BC) was the first ruler of Israel to unite the country. Since his reign and the arrival of the Ark of the Covenant with the tablets of stone in Jerusalem, the city has been the capital of the Jewish people and the religious center of the Jewish faith. It is said that the coming Messiah, the "anointed one" who will finally establish God's rule on earth, will be of the House of David.

Judaism is a historical religion of "the book." The Jewish holy scriptures are known collectively as the Tanakh, a tripartite acronym referring to the three components of the text: the Hebrew Bible includes the Torah, the "teaching" (the five books of Moses); the Nevi'im (books of the prophets); and the Ketuvim, the "writings" (psalms, books of wisdom, histories) recorded during the period of captivity in Babylon (587–537 BC).

The main festivals of Judaism are: Rosh Hashanah (New Year), Sukkot (Feast of Tabernacles), Yom Kippur (Day of Atonement), Simchat Torah (Rejoicing with the Torah), Hanukkah (Festival of Lights), Purim (Festival of Remembrance, commemorating Esther's deeds to save the people of Israel), Pesach (Passover, commemorating the flight from Egypt), and Shavuot (commemorating the gift of the Ten Commandments and the Torah). They are all concerned with marking the benevolence shown by God to the people of Israel throughout history; the Hebrews, or Israelites, regard themselves as the chosen people of the one true God. Great store is set by ritual purity in interpersonal relationships and diet, and Jewish belief closely associates the Jewish creed ("Hear, O Israel, the Lord our God is one Lord," Deuteronomy, 6:4) with worship of God, piety, love of one's neighbor, and a sense of justice (right actions). Judaism recognizes relatively few sacred places, but those few include the Wailing Wall in Jerusalem and the Cave of Machpelah (Abraham's grave). The name of God (JHVH) is considered most sacred, and strictly observant Jews never pronounce it.

⛰ Latin American civilizations—see boxes on the Maya, p. 850; on the Olmec, p. 844; on the Inca, p. 870.

◎ Magical or mystical places—Such places radiate a particular atmosphere but are not always exclusively associated with one religion and its rites. These sites transcend specific beliefs and are to be understood as places where the Divine or a reflection of it can be experienced in some way.

☌ Prehistoric sites—This refers to sites where evidence of a pre-literary culture or religion has been found.

⛩ Shintoism

Shinto—the "way of the kami"—is the indigenous religion of Japan. It originated as an adaptation of shamanistic beliefs from the Old Period of the Empire and it concerns itself with the worship of powerful spiritual beings, the kami. Before Buddhism arrived and spread throughout Japan in the 6th century, Shinto included countless unconnected regional ancestor-worship cults and the worship of fabulous animals and natural phenomena. Fertility rites were often also included. The homes of the kami could be found in the sky, in rivers, in trees, in the sea, in waterfalls, or on islands, and their messengers included foxes, deer, and other animals. Only priests and shamans were able to interpret the wishes of the kami. There is no written record of early Shinto, and initially there was no fixed pantheon; any creatures to which magical powers were attributed could be thought of as kami.

The first Japanese mythological epics to be recorded, the *Kojiki* and *Nihon shoki*, delineate a hierarchy of the gods, at whose head there stand **Izanagi** and **Izanami**, a mythical divine couple who brought the islands of Japan into being. Izanami died giving birth to the fire god and though Izanagi followed her into the underworld, he was driven back by the stench of rotting corpses. He cleansed himself in a river and created other gods, of which the most important are **Amaterasu**, the sun goddess, and

Susanoo, the wind god. Amaterasu is also considered the ancestral goddess of the imperial household and has since become one of the greatest divinities in Shintoism. Images of Shinto divinities were only developed later under the influence of Buddhism.

The secular world is separated from the sacred by a torii (gate) and within a Shinto shrine you will often find a mirror, through which the kami can enter the material world when they are summoned. Devout Japanese clap their hands twice in the shrines to attract the attention of the kami before outlining their personal petitions or offering their sacrifices. Many of these rituals are carried out every day at home, and there are all kinds of festivals held at the major shrines across the country.

☬ Sikhism

There are more than 20 million Sikhs, making the Sikh community one of the largest independent religious groups in India. Sikhism was founded by Guru Nanak Dev (1469–1539), a Hindu of the merchant caste who came from what is now Pakistan. He found all the religions of his area to be lacking, but during his travels in northwestern India he heard a divine voice commanding him to teach a message of compassion, purity, devotion, belief in one God, and service, and from that moment he attempted to unite the best aspects of Hinduism and Islam with the piety of Sufism in particular. Sikhs believe in a transcendental God who created the world and who is present in all things: God is unique, and yet has countless forms in every living thing, and cannot be comprehended or grasped through reason alone.

Human souls slowly ascend through a series of reincarnations before eventually becoming one with God. The guiding principles of life include work, worship, and compassion for one's neighbors. Particular store is set by truthfulness, an essential principle in overall Sikh ethics which makes lying impossible. Sikh doctrine thus prescribes respect for others as an indispensable virtue in its followers.

Guru Nanak Dev was the first in a series of ten gurus, nine of whom named his successor during his lifetime. The holy text of Sikhism, the Adi Granth ("ancient book"), was

collected during the lifetime of Guru Arjun (1563–1606), the fifth guru, and the verses it contains preach neighborly love, devotion, and decency in a direct address to the faithful. Gobind Singh (1666–1708), the tenth guru, nominated no successor, and there have been no gurus since. Modern Sikhs thus recognize no earthly authority, only the Adi Granth. Gobind Singh did, however, found the most important Sikh community, the Khalsa, whose followers are recognizable to this day by the five external symbols of membership: *kesh* (uncut hair), *kanga* (a wooden comb symbolizing purity), *kirpan* (a small dagger symbolizing courage), *kara* (an iron or steel bangle, a symbol of protection against attacks), and *kachera* (white underwear symbolizing chastity). The most important ceremony in Sikhism is *amrit*, a ritual similar to baptism whereby initiates bathe in and then drink holy water. After the ritual, the men are given the name "Singh" (Lion) and women "Kaur" (Princess). The spiritual headquarters of the religion is the Golden Temple at Amritsar in Punjab State, India.

Sufism

Islam spread rapidly during and after the lifetime of the Prophet Muhammad and by the turn of the 8th century its area of influence extended from Andalusia to the steppes of Central Asia and from modern Pakistan to Africa. Encounters with other cultures and religions brought a secularization that devout Muslims sought to counter with stronger emphasis on the Koran and the Sunnah. In Iran, Iraq, and Syria in particular, this gave rise to orders and fraternities for whom fulfillment of Muslim duties and adherence to the law (sharia) was not enough. Instead, they sought to discover the "inner" richness of the Koran and in this way to devote themselves most completely to God. The term "Sufism," which is used to refer to all of these various mystical branches within Islam, is reminiscent of both the Greek word for wisdom (*sophia*) and the Arabic word for purity (*saf*); others have seen it as a derivation of the Arabic word for wool (*suf*), in reference to Sufis' habitual clothing (a short woolen jacket).

Hasan al-Basri (640–728) from the Iraqi town of Basra is considered one of the founders of the Sufi movement. Besides moderate Sufism, other tendencies developed ("drunken Sufis"), shocking Islamic orthodoxy with ecstatic capers and provocative speeches. Sufi Mansur al-Halladj was executed as a heretic in 922 for uttering blasphemous words in contradiction of the faith. The verse he left behind expresses a yearning for death, so that the barrier between the world of creation and the world of the spirit may be lifted; the goal of Islamic mysticism is "unbeing," becoming how things were, before things were.

In Islamic mysticism, techniques to achieve union with God have a central role comparable with the close relationship between pupils and their masters in many orders. Such mysticism reached its highpoint in Jalal al-Din Rumi, who preached in Konya in Anatolia until 1273. His *Masnavi*, a poem of some 25,000 lines, tells of a yearning to reunite his soul with God. Sufis respectfully refer to the work as a "Koran in Persian." Rumi's son established the Mawlawi, the famous order of dancing dervishes.

Zoroastrianism – Zoroastrianism is an ancient Oriental religion that has survived to the present day and whose roots are to be found in Old Persia. Notes regarding the history and principles of this religion can be found in the text describing Yazd in Iran (p. 521).

GLOSSARY

Agora (Greek: "assembly") In Greek antiquity, a market or assembly place surrounded by columns.

Altarpiece (also reredos, retable) Altar decoration, usually in the form of an elaborately decorated screen, placed either on the altar, directly behind it, or on the wall behind it.

Animism (Latin: *animus*, "soul, spirit") A belief, particularly widespread among indigenous cultures, in the existence of a living soul in plants, inanimate objects, and natural phenomena.

Annex (Latin) Architectural term for an ancillary building.

Apotheosis (Greek, Latin) The transformation of a human to divine status.

Apse (Greek: "vault, arch") A usually rounded recess adjoining the main space of a church, topped with a semicircular cupola. When at the end of the chancel, it often contains the altar.

Architrave (Greek, Latin) A load-bearing lintel supported by columns or pillars.

Areopagus (Greek) A major hill in Athens and the site of the highest court of appeal in classical antiquity.

Ark of the Covenant Israelite shrine in the form of a portable, gilded wooden chest, said to have contained the stone tablets on which the Ten Commandments were inscribed.

Baal (Hebrew: "Lord") A West Semitic weather and fertility god; worshiped ecstatically as the supreme deity of the Canaanites.

Baptistery (Latin) A usually separate chapel used for baptisms.

Barrel vault In architecture, a roof in the form of a continuous semicircular arch, creating a half-barrel shape.

Basilica (Greek, Latin: "king's hall") Originally a term describing an ancient market hall, subsequently used for a three- or five-nave Christian church building. The central nave is flanked on either side by one or two smaller side-naves. From the 4th century on, a transept with an apse, and later a choir, were sometimes added.

Basilica, minor (Latin) A title awarded by the pope to honor outstanding churches. Pilgrimage churches in particular are often awarded this recognition, entitling the recipient to affix the papal coat of arms to the building. The award is not an aesthetic or architectural commendation and refers only to the church's influence within its parish. The title "major basilica" is more prestigious still, and consequently rarer; most churches with this title are in Rome.

Bodhi tree (Sanskrit: *bodhi*, "enlightenment") In Buddhist tradition, the banyan fig tree under which Siddharta Gautama achieved enlightenment. The Bodhi tree has therefore become a symbol of the Buddha.

Bodhisattva (Sanskrit) In Buddhism, one who has attained enlightenment but renounced personal liberation to show the path to enlightenment to others, thus allowing them to enter nirvana.

Calabash (Arabic, Spanish, French) A vessel fashioned from the dried-out fruit of the calabash (or bottle gourd) tree.

Calvary (Latin: *calvaria*, "skull") Originally referred to the place of Christ's execution (Golgotha). It has come to refer to small devotional mounds featuring reconstructed crucifixion scenes or the Stations of the Cross.

Campanile (Italian: *campana*, "bell") A free-standing bell tower often found in Italian ecclesiastical architecture.

Capital (Latin: *caput*, "head") A three-dimensional feature, often ornamented, forming the top section of a column or pillar.

Caryatid (Greek, Latin) In architecture, a female figure serving as a support in place of a column.

Catacomb (Latin, Italian) An early Christian underground burial site arranged as a labyrinthine series of passageways.

Cella (Latin: "chamber") The main space and inner sanctum of a classical temple, where the icons of the gods were kept.

Cenotaph (Greek, Latin) A tomb or monument commemorating a person or people buried elsewhere.

Chapter house The assembly room of a monastery, where meetings of the chapter (administrative body) are held.

Chedi (Sanskrit) Dome-shaped monument, part of a Thai Buddhist temple.

Choir (Greek, Latin) The altar space of a church. Often square and slightly raised, this is where the choir sings and the priest offers prayers.

Christogram (Greek, Latin) A symbol for the name of Christ formed from the two initial letters of his name in Greek. The Greek characters and resemble the Latin letters X and P.

Ciborium (Latin) A protective canopy above an altar, usually supported by columns.

Collegiate church A church where worship is maintained by a college of canons (a secular community of clergy) who, in contrast to regular religious canons, are not aligned with any particular monastic order.

Colonnade (Latin: *columna*, "column") A sequence of columns topped with an entablature (a horizontal lintel).

Columbarium (Latin) A place for the storage of cinerary urns containing the ashes of the dead.

Copts (Greek, Arabic) The (Orthodox) Christian descendants of the Ancient Egyptians.

Corinthian An architectural order developed in the 4th century BC, most often encountered in columns and characterized by elaborate scrolled capitals, often with floral ornamentation (acanthus leaves) and a richly decorated entablature.

Cornice An architectural feature in the form of a horizontal molded projection, crowning a building or separating an interior wall from the ceiling.

Cosmati work A form of decorative inlay technique used in mosaics of marble or glass, often found in ecclesiastical architecture and most common in the 12th to 13th centuries. The name derives from a family of Italian artisans in which the name Cosimo was extremely popular; the "Cosmati" are not limited to family members, however, and include other artists, such as Vassalletto.

Crossing The square space formed at the intersection of the nave and transept in a church.

Crypt (Greek, "hidden") A space underneath the choir of a church, often used as a funerary chapel or to store relics.

Curia (Latin) The papal court and its associated authorities and institutions.

Dagoba (Sinhalese) A Buddhist reliquary shrine or a building used for this purpose.

Decagon (Greek) A building with a ten-sided floor plan.

Diaspora (Greek: "scattering") A description of any ethnic or religious minority or its geographic distribution.

Domed gallery A walkway, open on one side, surmounted with a dome.

Domed kiosk In Islamic architecture, a dome with a partly open, pavilion-style construction.

Doric Pertaining to the Greek Dorian tribe. In the 7th century BC, the tribe formulated a particular style of architecture characterized by compact columns with no base and simply fashioned capitals.

Double-tower façade A type of façade found in Romanesque and Gothic churches in particular, whereby both towers are completely integrated into the building.

Druid (Celtic, Latin) A priest of the Celtic or heathen tribes of Britain or Wales who acted as a healer, sorcerer, and judge.

Enclosure (Latin) The practice of keeping a separate area of a monastery reserved for members of the order; such an area.

Entasis In Greek architecture, the inclusion of a slight convex curve in a wall, column, joist, or other feature.

Fan vault In architecture, a vault in which the curved ceiling surface is decorated with fan-like ribs.

Finial (Greek, Latin) In Gothic architecture, a narrow, tapering stone ornament on top of a buttress.

Flute A vertical channel running the height of a column.

Friday Mosque A mosque most commonly attended for prayers on a Friday; Friday prayers are the most important of the Muslim week and in contrast to other prayers are preceded by a Friday homily (*chutba*).

Frieze A narrow strip of ornamentation used to divide a wall.

Funerary culture A civilization's methods of conducting burials and dealing with death.

Geoglyphs (Greek) Large-scale designs on the ground composed of images or figures.

Ghat (Hindi) A stepped bank leading down to the Ganges, where Hindus practice ritual bathing.

Gopuram (Tamil) In Indian ecclesiastical architecture, a tower affording access to a temple.

Groin vault In architecture, a curved edge formed by two intersecting barrel vaults, supported at each corner with columns or pillars.

Hajj (Arabic: *hajj*) The great pilgrimage to Mecca; one of the basic duties of an observant Muslim, to be completed once in a lifetime.

Hammam (Turkish) A Turkish bath.

Heresy (Greek, Latin) A theological doctrine not officially recognized by the religious authorities (often synonymous with apostasy).

GLOSSARY

Hierophany (Greek) The appearance of divine phenomena in the everyday world.

Icon (Greek, Russian) In Eastern Christianity, a sacred image painted on a wooden panel. The style of such paintings is strongly based on Byzantine tradition.
Iconoclasm (Greek, Latin) The removal (and destruction) of sacred images from Christian churches. Doubts have been cast on the propriety of icon-worship at several points in Church history, such as during the Byzantine iconoclasm of the 8th and 9th centuries and in the Reformation.
Iconostasis (Greek) A wall of icons (with a door or doors) separating the altar space from the rest of the nave in Orthodox churches. The icons adorning the iconostasis usually include at least one of Christ and the Virgin Mary.
Imam (Arabic: "leader") One who leads the Muslim community in prayer at a mosque.
Incarnation (Latin: *incarnatio*, "becoming flesh") Describes a deity's appearance in human form.
Incrustation (Latin) Decoration of walls and floor with various stone materials, usually marble.
Ionic (Greek, Latin) Refers to the art and architecture of the Greek Ionian tribe (c. 6th century BC) and describes in particular the characteristic order and shape of their columns; these rested on a carefully shaped base and were topped by a capital, an ornamental structure with a pair of volutes (spiral scrolls).
Iwan (Persian, Arabic) In Middle Eastern architecture, a vaulted hall opening out onto a courtyard. The

often forms the entrance to a building or mosque.

Kaaba (Arabic, "cube") The holiest shrine in Islam and the goal of Muslim pilgrimages to the Grand Mosque at Mecca. The Kaaba, said to have been used by Abraham as a place of worship, contains the "black stone," a relic dating back to the pre-Islamic period.
Kami (Japanese) spiritual beings in Shintoism. Kami are the divine aspects of human traits, abstract ideas, or natural phenomena.
Karma (Sanskrit: *karman*, "deed") In Buddhism and Hinduism, the notion that every form of existence is the consequence of a previous existence. The thoughts and actions of an individual determine his next existence in the cycle of rebirth.
Khan (Mongolian, Turkish) The title of a Turkish or Mongolian ruler, usually added to a personal name.
Kufic An Arabic script with almost geometric forms, named after the city of Kufa.

Lancet arch A pointed arch often found in English Gothic architecture.
Lantern (Latin) A narrow translucent architectural feature placed on a dome to admit daylight.
Lavra (Greek) In Eastern Christianity, originally a term for a community of hermits, now used as a mark of distinction for outstanding monasteries.
Linga/Lingam (Sanskrit) A phallic symbol and emblem of the Indian god Shiva, representing male potency and creativity.

Madrassa (Arabic, Turkish) An Islamic college or Koran school associated with a mosque.
Majolica (Italian) Glazed ceramics used as decoration.
Mandala (Sanskrit) In Indian religions, an image composed of round or rectangular shapes symbolizing certain spiritual connections used in meditation.
Mandorla (Greek, Latin, Italian) An almond-shaped halo in artistic representations of holy persons.
Mantra (Sanskrit: *mantra*, "speech") A magical or mystical formula that is repeated constantly to aid concentration. Buddhism and Hinduism make use of mantras in meditation as a way of approaching the Divine.
Marabout (Arabic) A North African term for a Muslim saint or his tomb.
Mastaba (Arabic: "stone bench") Ancient Egyptian tomb with a rectangular plan and inward sloping walls.
Megalith (Greek) A large stone slab used in the construction of prehistoric grave sites or shrines.
Metropolitan (Greek) A bishop in the Orthodox Church presiding over a diocese. The term is also used in the Roman Catholic Church.
Mihrab (Arabic) A prayer niche in a mosque. The mihrab indicates the direction in which to pray.
Minaret (Arabic, Turkish, French) The tower of a mosque, from which the muezzin recites the call to prayer.
Minbar (Arabic) The pulpit of a mosque, principally used for preaching on Fridays.
Minor basilica See Basilica, minor.

Monotheism (Greek: *mónos*, "single," and *theós*, "god") A religious or philosophical doctrine positing a personalized god as the creator of the world. Christianity, Islam, and Judaism are all monotheistic religions.

Mudra (Sanskrit: *mudrā*, "seal") In Buddhist and Hindu worship, a magical or symbolic hand gesture, often characterizing a particular deity.

Muezzin (Arabic) In Islam, one who announces prayer-times, charged with calling the faithful to prayer from the minaret five times a day.

Nave The longer section of a church, consisting of a main aisle and side-aisles and stretching from the west front to the crossing or the chancel.

Narthex (Greek) The entrance hall of early Christian and Byzantine church buildings, either within the nave (esonarthex) or beyond it (exonarthex).

Necropolis (Greek: "city of the dead") An extensive graveyard dating back to antiquity or prehistory.

Nimbus (Latin) A halo, as portrayed in Christian art.

Novitiate (Latin: *novus*, "new, fresh") A probationary period of at least a year in the education of a novice wishing to join a Roman Catholic monastic order.

Obsidian A variety of dark glass of volcanic origin. It is formed through the cooling of lava with a specific water and gas content.

Octagon (Greek, Latin) An eight-sided figure; a building with this shape.

Ogival arch A curved arch, tapering to a point, much used in Islamic and Gothic architecture.

Oratory (Latin: *orare*, "to pray") A separate prayer-room in a church or monastery.

Pagoda (Dravidian, Portuguese) In Buddhist architecture, a tower-like structure of several tiers, each with a vestigial roof.

Pantheism (Greek: "doctrine of all gods") A philosophy whereby God and the natural world are identical and no individual god is worshiped.

Pantheon (Greek: *pan* "everything," and *theós*, "god") The totality of all the gods worshiped in a religion; a shrine devoted to these.

Patronage (Latin) The rights and duties of the founder of a church or their heirs (e.g. official appointments or the livings of certain parishes).

Perestroika (Russian, "restructuring") A general term for the political and economic reforms introduced by Mikhail Gorbachev to the Soviet Union in the 1980s.

Peripteral temple (Greek) A temple form whereby the main structure (*peripteros*) is surrounded by a colonnade.

Petroglyphs (Greek) The earliest rock carvings and art.

Pier buttress A load-bearing buttress, especially in Gothic cathedrals, supporting the weight transmitted by the arch of a flying buttress.

Pietà (Italian: "piety, compassion") In representative art, a portrayal of the Virgin Mary with the body of Christ on her lap, depicting the pain of a mother confronted with her dead son.

Pilaster (Latin: *pila*, "pillar") A structural column built into a wall, with a base and a capital.

Plateresque (Greek, Latin, Spanish) An architectural and artistic style featuring a playful combination of late Spanish Gothic and early Italian Renaissance elements.

Polytheism (Greek) Worship of multiple deities, all of whom are believed to coexist.

Portico (Latin: *porticus*, "colonnade, hall") A hall or porch, supported by columns, adjoining the entrance to a building.

Postament The pedestal or base of a column or statue.

Prayer flag In Tibet, a colorful cloth flag printed with prayer texts and attached to sacred places, principally mountain tops. Buddhists consider the continual movement of the flags to be a constant prayer, carried on the wind.

Prayer wheel In Tibetan Buddhism, a revolving cylindrical vessel inscribed with or containing prayer texts. Using physical energy to turn the device on its axle releases spiritual energy in prayer.

Pronaos (Greek, Latin) The antechamber of a Greek temple.

Pylon (Greek, "gate") An imposing gatehouse with two corner towers, forming the entrance to Egyptian temples.

Qibla (Arabic) A term for the prescribed direction of Muslim prayer (toward Mecca).

Quatrefoil An ornamental form in Gothic architecture composed of four equal lobes in a cloverleaf formation; often used in window designs.

Refectory (Latin: *refectio*, "restoring, recovery") A monastery dining room.

Reincarnation (Latin: *incarnatus*, "become flesh") The prevailing notion in Buddhism and Hinduism of the transmigration of the soul; the immortal soul undergoes various stages of existence, whether as a plant, animal, or human, in a cycle of birth, death, and rebirth leading to eventual liberation (nirvana).

Sacrament stela A freestanding, usually decorative pillar in which a container for sacred objects (e.g. the Host) is concealed.

Sacramentals Paraphernalia used in religious worship, such as a rosary, a crucifix, or icons of saints.

Sanctuary (Latin) A place where a reliquary is stored.

Schism (Greek, Latin) A division within the Church with legal, rather than doctrinal, roots.

Screen façade A richly decorated front elevation whose dimensions can exceed those of the building behind.

Shaman (Sanskrit, Tunguskan) A priest with magical powers; one capable of contacting the spirit world and the souls of the departed by means of magical ritual.

Sharia (Arabic) Islamic law derived from divine revelation. contains both legal prescriptions and a wealth of rules governing correct behavior in everyday life.

Shia (Arabic: "faction") A religious and political branch of Islam. Shi'ites, in contrast to Sunnis, regard themselves as supporters of Ali bin Abi Talib, whom they recognize as the only legitimate successor (*Imam*) to Muhammad.

Shogun (Japanese) The title of a series of Japanese generals who, for an extended period, held sway over Japan in place of the emperor.

Souk (Arabic, French) An Arabic market or commercial district.

Spandrel In architecture, the space formed where the outer curve of an arch meets the wall and the ceiling.

Spolia (Latin) Masonry, usually columns or similar, reclaimed from other buildings for reuse.

Stave church A single- or triple-nave wooden church in a Nordic style. The walls of the rectangular nave are formed by vertical posts (staves). The gable roof of a stave church is composed of a series of smaller, stepped roofs.

Stupa (Sanskrit) A Buddhist shrine in India; originally a semicircular grave mound, were later used to store relics.

Syncretism (Greek, Latin) The incorporation of diverse religious ideas or philosophical doctrines into a new system.

Tabernacle (Latin: *tabernaculum*, "hut, tent") An elaborately decorated cabinet used in the Roman Catholic Church to store the Host; in Gothic architecture, a canopied frame resembling a miniature building, usually housing a statue.

Tambour A dome supported by a cylindrical structure; the latter often features apertures to admit light.

Tantra (Sanskrit: *tantra*, "weave") A Buddhist and Hindu philosophy seeking to attain fulfillment and wisdom through magical rituals. The "absolute" is to be reached by the sensual, and sensuality and sexual techniques provide ecstatic experiences as a source of energy and the summation of positive living. Such mystic union enables an individual to find identity with their own nature and to become part of an absolute reality.

Thingstead During the Germanic and Frankish period, an open-air place used for assemblies and legal proceedings; the term was later adopted by the Nazis to describe any historically important or scenic place that could be used as an impressive backdrop for traditional gatherings. *Thingsteads* are now only rarely used for such events.

Tiara (Persian, Greek, Latin) The high, narrow headgear of Ancient Persian kings, later the pope's crown.

Tol-Harubang Phallic stone sculpture fashioned to resemble a figure. A fertility symbol in Korea, thought to ward off demons.

Torii (Japanese, "bird perch") A usually wooden gate consisting of two stakes and two lintels. Toriis are typical features of Shintoist buildings.

Totem (Native American, English) A component of ancestor worship among indigenous cultures; a plant, animal, or natural phenomenon is associated with a mythical idea and both worshiped as an ancestor of an individual or of the tribe and respected as a protector deity.

Transept In ecclesiastical architecture, a structure intersecting with the nave at right angles, forming a cross; the junction of the nave and transept is called the crossing.

Transubstantiation (Latin) The transformation of bread and

wine into the body and blood of Christ, as symbolically enacted in Holy Communion.

Triforium (Latin: *tres*, "three," and *foris*, "door, opening") Often found in Gothic churches, a section of a wall consisting of a series of triple arches, sometimes forming a corridor open on the church side.

Trilithon (Greek) A prehistoric stone monument. A trilithon consists of two pillar-like stones topped by a lintel.

Trimurti (Sanskrit) In Hinduism, the trinity of Brahma (the creator), Vishnu (the preserver), and Shiva (the destroyer).

Trinity (Latin) In Christian tradition, the tripartite unity of one Godhead. The doctrine of the Trinity reveals the nature of God in the unity of three persons: the Father, the Son (Jesus), and the Holy Spirit. The Father represents creation, the Son redemption, and the Holy Spirit is a symbol of community and the spiritual power of God, leading to salvation. The concept of the Trinity distinguishes Christianity from Islam and Judaism, the two other monotheistic religions.

Triptych (Greek: *triptychos*, "threefold") A tripartite image comprising a central picture or carving and two side-panels. When used as an altarpiece, the side-panels are often hinged and can be folded to cover the central section (a winged altar).

Triumphal arch Originally a free-standing gate-like structure that can be passed through or passed under, dedicated to a secular ruler; afterward used in ecclesiastical architecture to refer to the arch between the nave or crossing and the choir.

Trompe-l'œil painting (French: *tromper*, "to deceive," and *l'œil*, "the eye") Paintings that create an almost lifelike illusion, often distorting the viewer's perspective and standpoint.

Trumeau (French) A pillar in the middle of a portal or supporting an arch, often disguised as a figure.

Tumba (Greek, Latin) A sarcophagus-like tomb of stone or bronze, sometimes covered with a baldachin, and surmounted by a supine sculpture of the deceased.

Tympanon (Greek) A flat surface within a gable or above a portal, door, or window, often decorated with a bas-relief.

Votive statue (Latin: *votum*, "oath") A statue erected at a pilgrimage site, often in thanks for averted danger or answered prayers.

Vulgata (Latin: *vulgatus*, "widespread") A Latin translation of the Bible, largely the work of St Jerome. A revised version of the old Latin New Testament was followed by a translation of the Old Testament from Hebrew. In 1546 the Roman Catholic Church declared the Vulgate the definitive version of the Bible.

Wayside cross A usually wooden or stone cross placed by the devout by the side of the road or path. Used as way markers, although a recent practice is to place such crosses at sites associated with unfortunate events.

Yin and Yang (Chinese) A dual concept underlying the world in Chinese philosophy. Defined through opposing characteristics, yin and yang complement and determine one another. Yin represents darkness, femininity, passivity, softness, and the earth; yang represents light, masculinity, activity, strength, and the sky. The world and its order arise from the interplay of both elements.

Yom Kippur (Hebrew) The holiest Jewish festival. The last of ten days of atonement in September/October, marked with fasting and a solemn confession of sins.

Ziggurat (Assyrian, Babylonian) In Babylonian ecclesiastical architecture, a stepped pyramid or tower.

INDEX

A

INDEX

INDEX

D

F

G

INDEX

L

INDEX

INDEX

N

O

INDEX

INDEX

INDEX

V

W

Front cover images:
© picture-alliance/Guy Edwardes (*see* p. 133)
© picture-alliance/Pictures/Helga Lade (*see* p. 461)
© picture-alliance/David Jerome Ball (*see* p. 885)
© picture-alliance/Christiane Eisler/transit (*see* p. 730)
© picture-alliance/Franz-Peter Tschauner (*see* p. 162)
© Anke Moritz (*see* p. 586)
© picture-alliance/Rainer Binder (*see* p. 668)
© picture-alliance/Veintimilla (*see* p. 843)
© picture-alliance/epa Yossi Zamir (*see* p. 462)

Back cover images:
© picture-alliance/Bildagentur Huber/Picture Finders (*see* p. 607)
© picture-alliance/Pirozzi (*see* p. 305)
© picture-alliance/Bernd Hoefel (*see* p. 903)
© picture-alliance/epa Nabil Mounzer (*see* p. 507)
© picture-alliance/John Shaw (*see* p. 815)
© picture-alliance/Imaginechina/Sun zhongguo (*see* p. 538)
© picture-alliance/epa Raminder Pal Singh (*see* p. 619)
© picture-alliance/Bildagentur Huber/Gräfenhain (*see* p. 865)
© picture-alliance/Lars Halbauer (*see* p. 565)

© 2010 Tandem Verlag GmbH
h.f.ullmann is an imprint of Tandem Verlag GmbH

Original title: *1000 Heilige Orte – Die Lebensliste für eine spirituelle Weltreise*
ISBN 978-3-8331-5479-9

Project manager: Anke Moritz
Author: Christoph Engels
Proofreading: Frank Joachim Schmitz
Layout and typesetting: Yvonne Schmitz
Maps: Kartographie Huber
Cover: Martin Wellner

© 2010 for the English edition: Tandem Verlag GmbH
h.f.ullmann is an imprint of Tandem Verlag GmbH

English translation: JMS Books LLP (Malcolm Garrard & Maisie Fitzpatrick)
Design and typesetting
English edition: cbdesign

Overall responsibility
for production: h.f.ullmann publishing, Potsdam, Germany

Printed in China

ISBN 978-3-8331-5480-5

10 9 8 7 6 5 4 3 2 1
X IX VIII VII VI V IV III II I

If you would like to be informed about forthcoming h.f.ullmann titles,
you can request our newsletter by visiting our website (**www.ullmann-publishing.com**)
or by emailing us at: newsletter@ullmann-publishing.com.
h.f.ullmann, Birkenstraße 10, 14469 Potsdam, Germany

Acknowledgments

First and foremost, I would like to thank Manfred Abrahamsberg and Lucas Lüdemann at my publishers, h.f.ullmann, for the unswerving faith they have demonstrated from the very outset in both this extensive project and in myself.

I am grateful to the many travelers, past and present, who have published accounts of their journeys to the ends of the earth and made them available to the world.

A special thank you is reserved for those who have assisted in my research: Jan Moritz for Africa, Julia Kahlert for peerless help from Japan about Japan, Swetlana Dadaschewa, without whom I would have been lost in Russia, Rebecca Renz for northern Europe, Semina Busch for Switzerland and England, Małgorzata Meys for Poland, Michiel Decaluwe for Belgium, Bernd Borchardt and Irene Eidemüller for Albania, Deniz Erönder for helpful hints about Turkey, Padma Latha Devi Kanikanthi for India—and all the many others in the course of the project who have told me about "their" sacred places.

I would also like to thank those who have offered their academic expertise: Jan Breder for Classical Antiquity, Michael Wagner for Ancient Egypt, Hendrik Neubauer for Africa, Françoise Hauser for China and Japan, and Andreas Görke for global Islam.

I would especially like to thank Frank Joachim Schmitz for his careful proofreading, not to mention a wealth of important suggestions, the picture captions, the glossary, and above all for making our collaboration so agreeable. Thanks are also due to Kirsten Lehmann and Felicitas Pohl, whose many suggestions shed much light in the darkness, and to Gesine Engels, who read, researched, and compared to the very end. Grateful thanks are reserved for Yvonne Schmitz, without whose dedication in compiling the text and images the book would never have been possible.

I would like to thank my family and friends for the interest they have shown throughout the project and for the wealth of information, literature, and images they have sent my way. I would like to thank Michael Stöhr for accompanying me and especially for the days cloistered in Lugano. I cannot thank Anke Moritz enough—not only has she overseen the project from beginning to end, she was also the only one to retain a sense of the project as a whole. She has encouraged me, worked countless hours, and has always believed in the book's success, however well or badly things were going. She has always been at my side with advice and help, and she has been kind enough to share my life.

Christoph Engels, November 2009

Picture References

© Achim Bednorz / Tandem Verlag GmbH 224 • © Bengali School/Paharpur, Bangladesh/Giraudon/Bridgeman Berlin 680 • © Annette Brosi 357 • © China by Bike 577 • © Henning Christoph/Das Fotoarchiv 769, 770 • © Stefan Diller 282 • © Documentation Centre of Sacred Mounts, Calvaries and Devotional Complexes in Europe/Franco Andreone 254 • © Christoph Engels 245 • © Fabian Engels 44, 178 • © Gesine Engels 60, 294 • © Getty Images/John William Banagan 901 • © Getty Images/Wayne Levin 896-897 • © Dominik Hellpointner 701 • © Inga Hellpointner 715 • © Interfoto München 890, 892 • © laif/Malherbe 572 • © Anke Moritz 586

© picture-alliance 140, 270, 599
A. MARCHI 296 • A.A. Johnson 723 • AFP Francois Guillot 171 • akg-images 64, 180, 222, 372, 344, 498 right • akg-images/Herbert Kraft, 291 • akg-images/Juergen Raible 55 • Alain Evrard 614 • Alan Blair 127 • Alejandro Ernesto 856 • Alfons Rath 286 • Andrea Jemolo 149, 214, 252, 298, 307, 315, 317, 375, 377, 378 • Andreas Heimann 500 left • Andy Holligan 812 • Angela Merker 443 • Angelo/Leemage186 • ANSA, 250 • ansa Pinto 297 • AQUILA 264, 794 • Ariadne van Zandbergen, 763, 766 • Art Media, 649 • Axel M. Mosler, 102 • Backhaus 637, 639, 669, 670 • Backhaus-Pohl, 48 • Band Photo 134 • Barbara Heller 137 • Gaetano Barone 223, 225, 233, 269, 281 • Beppe Arvidsson 25 • Bernd Hoefel 903 • Bernd Settnik 564 • Bernd Thissen 59 • Bildarchiv Monheim 303 • Boris Roessler 277 • Burkhard Juettner 179, 155, 163, 166, 193 • Carmen Jaspersen 38 • Carsten Schmidt 77 • Castello-Ferbos/Godong 427 • ChinaFotoPress 542 • Christiane Eisler/transit 730 • Christina Krutz 783 • Christophe Bluntzer 351, 536 • Chromorange 111, 425, 698, 831, 882 • Chromorange/Bildagentur Waldhäusl 272 • Clemens Emmler 889 • CM Dixon 736 • Colin Jones 777 • CTK Michal Dolezal 383 • Dallas & John Heaton 846 • David Jerome Ball 885 • DB NASA Earth Observatory 120-121 • Dieter Klöppel 217 • Dinodia 634, 651, 653, 656, 657, 660, 664, 666 • Dirk Renckhoff 206, 207 • Don Johnston 806 • Donatella Giagnori/Eidon 622 • dpa Christine Knäble 878 • dpa/Photoshot 13, 455, 504, 549 • Dr. Rolf Philips 566 • E&E Image Library 123, 124, 129, 139, 142, 143, 675, 683, 688 • Edmond van Hoorick 811 • efe 210 • efe Enrique García Medina 879 • efe Gabriel Tizon 212 • efe Mario Guzmán 848 • efe Paolo Aguilar 866 • Electa/Leemage 533 • Elmar Hartmann 80 • Elsen Reiner/Chromorange 56 • Emile Loreaux 146 • epa 654 • epa afp Sahib 513 • epa Ali Haider 381 unten • epa ansa De Renzis 380 • epa ansa Giglia 300 • epa Brown 611 • epa Bruce Omori 898-899 • epa Harish Tyagi 621 • epa Jim Hollander 468 • epa Louisa Gouliamaki 391 • epa Michael Reynolds 535 • epa Mohamed Messara 511 • epa Nabil Mounzer 507 • epa Nic Bothma 759 • epa Piyal Adhikary 381 Mitte • epa Raminder Pal Singh 619 • epa Sergey Chirikov 415 • epa Sergey Dolzhenko 394 • epa Shaw - Pool 887 • epa T Mughal 612 • epa Yossi Zamir 462 • epa Zurab Kurtsikidze 439 • Erich Lessing 17, 161, 314, 368, 374, 446, 448, 489 • Erika Kanne 690 • Euroluftbild.de 91 • Everett Kennedy Brown 609 • F. Herzog/Helga Lade 72 • Fabrizio Villa 337 • Fehim Demir 340 • FLAC 309 • Florian Profitlich 47 • Florian Profitlich 85 • Forum Krzysztof Kuczyk 388 • Forum Marek Maruszak 390 • Forum Marek Skorupski 393 • Foussat 834 • Francis Apesteguy 192 • Franck Robichon 585 • Frank Duenzl 689, 601 • Frank Mächler 87 • Franz-Peter Tschauner 162 • Fred Bruemmer 32 • Fred de Noyelle/Godong 167 • Fred Krüger 900, 905 • Friedel Gierth 428 • Gaetan Bally 100 • Gazioch 749 • Gerard Degeorge 418 • Gerhard Trumler 113 • Gerig 381 unten 4 • Gero Breloer 828 • Gert Schütze 211 • Gierth 76, 858 • Giovanni Mereghetti 774 • Göran Billeson 76, 173, 28 • Grambo Photography 803 • Grimm 726-727 • Gueroult Serge 196 • Guido Meisenheimer 710 • Guy Edwardes 133 • Hanan Isachar 470, 479, 495, 739, 741 • Hans Kanne 798 • HB Verlag 293 • Hedda Eid 444 • Heinz Hirndorf 691 • Henning Kreft 503 • Hermann Wöstmann 90, 413 • Hilbich 65, 263 • Hinrich Bäsemann 14 • HOP 713 • Horst Ossinger 58, 62 • Horst Zanus/OKAPIA 276 • imagestate/Spectrum 169, 367, 518, 531, 642 • Jacito Kanek 841 • Jack Kurtz 906 right • Jacques A Schaefer 567 • Jan Bauer 46 • Jan Woitas 554 • Janet Wishnetsky 751 • Janfot/OKAPIA 362 • Jemolo 315 • Jens Kalaene, 230, 266, 424, 704 • Jens Wolf, 15 • Jerome da Cunha 400 • Jesus Diges 201 • Jochen Krause 70 • Joe Sohm 818 • John Shaw 815 • Jon Spaull 821 • Jonne Roriz 864 • Jörg Modrow 633 • Jörg Schmitt 457, 472, 473, 477 • Jose Fuste

Raga 855, 869, 854 • Joseph Martin 194 • Juergen Sorges 145, 449, 797 • Julius Lando 784 • Jürgen Effner 359 • Jürgen Hörstel 678 • Kai Ulrich Müller 188 • Karl Schnörrer 643 • Karl Thomas 106, 158, 183, 342, 346, 382, 385 • Käthe deKoe 498 left • Keystone 189 • Kheirkhah 516, 520, 521 • KNA-Bild Esser 94 • KNA-Bild Wolfgang Radtke 491 • Koch, 584, 658 • KPA 435 • KPA/Francolini 257 • KPA/Franken 246 • Kremer 69 • L. M. Peter 184 • Landov 460 • Landov Ruckemann 907 • LaPresse Silvio Fiore 249 • Lars Halbauer 118, 292, 311, 327, 565, 721 • Lartigue Stephane 181 • Laurent Gillieron 99 • Lehtikuva Heikki Saukkomaa 36-37, 861 • Lehtikuva Jussi Nukari 464 • Lehtikuva Roni Rekomaa 35 • Lehtikuva Sari Gustafsson 499, 673 • Lehtikuva Timo Jaakonaho 534 • Lou Avers 238, 244 • Lusa Paulo Novais 241 • Marcus Wilson Smith 421 • Marianna Day Massey 826 • Mark Henley 445, 805 • Markku Larjavaara 782 • Marthelot 510 • Matthias Schrader 325 • Matthias Stolt/Chromorange 502 • Matthias Toedt 733 • Mauri Rautkari 849 • Maurizio Gambarini 684, 686 • Mehmet Biber 420, 508-509 • Mel Longhurst 355 • Meng Chenguang 544 • Michael Bader/Transit 630 • Michael Reynolds 560 • Michel Gounot/Gogong 645, 755 • Miguel Vazquez 236 • Mike Grandmaison 807, 809 • Mike McQueen 827 • Money Sharma 616, 617 • ms Grundmann 361 • Natalie Barner 458, 487 • Newscom 823 • Norbert Guthier 786 • Oleg Semenenko 396 • Olivier Matthys 550 • Onome Oghene 771 • Ott 57 • Pascal Deloche 159, 500 right, 706, 722 • Pascal Deloche/Godong 176, 432, 501, 641 • Patrick Horton 883 • Paul Paul Simmons 551 • Paul Ruthven 703 • Peruvian Aerophotographic Service 872 • Peter Endig 50 • Peter Hirth 42 • Peter Hirth/Transit 40 • Peter Kneffel 84 • Peter Thompson 104 • Peter Zimmermann 379 • Phil Wood 436 • Philippe Lissac 452, 476, 761 • Philippe Lissac/Godong 168 • Pictures/Helga Lade 461 • Piero Baguzzi 370 • Pirozzi 305, 308, 319, 320 • Piyal Adhikary 632 • Polfoto Jakobsen Niels 30 • Polfoto Jedbo John 31 • Pressensbild code 9998 22 • Prismaarchivo 202, 216, 588, 604, 605 • Q. Daniels/VWPics 824 • R. Lichius/Chromorange 697 • Rabatti-Domingie 273, 285 • Rainer Binder 26, 668 • Rainer Binder/Helga Lade 375 • Rainer Großkopf 836 • Rainer Hackenberg 41, 331, 338, 422, 433, 594, 596, 606, 857, 859 • Rainer Jensen 486 • Rainer Kiedrowski 255, 371 • Ralf Freyer 78 • Ralf Hirschberger 53, 862, 863 • Raymond Schmit 89 • Reinhard Kungel 349 • Richard Nowitz 480, 482, 493 • Robert Aberman 795 • Robert B. Fishman 83 • Robert Gibbs 876 • Robert O'Dea 324 • Roberto Vignoli 312 • Rodemann 91, 92, 116-117,199, 205, 248, 267, 329, 332 • Roger L. Wollenberg 825 • Rolf Philips 529 • Rompres 353 • Sandhofer 911 • Sanjeev Gupta 624 • Sascha Montag 708-709 • Sauschlager Markus/Chromorange 105 • Scanpix code 4597 23 • Scanpix code 90000 21 • Schnörrer 718 • Selva/Leemage 151 • Siegfried Kuttig 868 • Stadler 86 • Stefan Drechsel 185, 191 • Suzanne Held 593 • Tass 399, 411, 440, 441 • Tass Maisterman 397 • Tass Matytsin Valery 438 • Tass Sergei Metelitsa 404 • Tass Vladimir Smirnov 403 • The Print Collector 153, 279 • Thomas Haltner 74 • Thomas Härtrich/Transit 19, 628, 791 • Thomas Schmidt 910 • Thomas Schulze 779 • Thorsten Lang 227 • Tilman Billing 523 • Tolga Bozoglu 431 • Tom Kumpf 147 • Tom Schulze/Transit, 406, 412 • Trippmacher 259 • Tristan Lafranchis, 321, 363 • Tschanz-Hofmann 408 • Ulrike Koltermann 756 • united archives, 702 • UPI 909 • UPPA Ren Zhenglai 587 • UPPA Rick Strange 131 • Uwe Gerig 108, 234, 335, 748 • Uwe Zucchi 402 • Veintimilla 843 • von Linden 114 • W. Steinmetz/Okapia 496 • Werner Forman 600, 635, 845 • Werner Otto 67, 229, 747 • Winter 780

© picture-alliance / Bildagentur Huber 545, 642, 908
Bernhart 322 • F. Damm 242, 364, 714 • Giovanni 558 • Gräfenhain 39, 115, 198, 219, 526, 527, 865 • Kiedrowski 173 • Kolley 677 • Leimer 110, 199 • Mehlig 386 • O. Stadler 692 • Orient 676, 694 • Picture Finders 97, 278, 348, 381 oben right, 466, 475, 746, 752 • Popp&Hackner 893 • R. Schmid 107, 451, 456, 724, 732, 792, 852 • Stadler 842 • von Dachsberg 200 • Picture Finders 591, 607, 627, 682, 699

© picture-alliance / Imaginechina 537, 548, 552, 562, 569, 574
Jing aiping 561 • Li shaobai 547 • Shi yong 570 • Shui xiaojie 556 • Sun zhongguo 538 • Wang shunling 555 • Yin nan, 543 • Zhuge ming 550

© Bettina Reichardt 430 • © Scaruffi Piero 764 • © SDS Korea 578, 579, 581 • © Yann Arthus-Bertrand/CORBIS 128

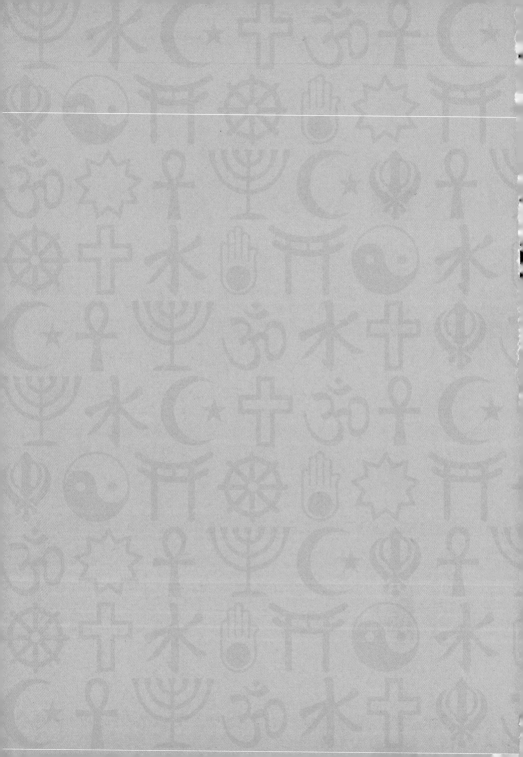